Artemisia Gentileschi
AND THE AUTHORITY OF ART

ALSO BY R. WARD BISSELL

*Orazio Gentileschi and the Poetic
Tradition in Caravaggesque Painting*

CRITICAL
READING
AND
CATALOGUE
RAISONNÉ

Artemisia Gentileschi
AND THE AUTHORITY OF ART

R. Ward Bissell

THE PENNSYLVANIA STATE UNIVERSITY PRESS
UNIVERSITY PARK, PENNSYLVANIA

MM

Publication of this book has
been aided by a grant from the
Millard Meiss Publication Fund
of the College Art Association.

Library of Congress Cataloging-in-Publication Data

Bissell, R. Ward.
 Artemisia Gentileschi and the authority of art : critical reading
and catalogue raisonné / R. Ward Bissell.
 p. cm.
 Includes bibliographical references and index.
 ISBN 0-271-01787-2 (cloth: alk. paper)
 ISBN 0-271-02120-9 (paper: alk. paper)
 1. Gentileschi, Artemisia, ca. 1597–ca. 1651—Criticism and
interpretation. 2. Gentileschi, Artemisia, ca. 1597–ca. 1651
—Catalogues raisonnés. I. Title.
ND623.G364B58 1999
759.5—dc21
 97-48437
 CIP

Published by The Pennsylvania State University Press,
University Park, PA 16802-1003

It is the policy of The Pennsylvania State University Press to use acid-free paper for the first
printing of all clothbound books. Publications on uncoated stock satisfy the minimum requirements
of American National Standard for Information Sciences—Permanence of Paper for Printed
Library Materials, ANSI Z39.48-1992.

For

TINA

Always There

and

For

MARVIN EISENBERG

Inspired and Inspiring

CONTENTS

LIST OF ILLUSTRATIONS

All works are by Artemisia Gentileschi unless designated otherwise. Numbers in square brackets refer to Catalogue numbers.

··

BLACK-AND-WHITE ILLUSTRATIONS

PREFACE

It is only when we escape this disturbing fascination with her life and return her work to its context within a specific time, place and school of painting that we can fully appreciate her activities as a painter.

— ROZSIKA PARKER AND
GRISELDA POLLOCK, 1981

The personal tragedies of other artists have conditioned their work but their art is not usually seen as a specific restaging of those tragedies. It seems that Artemisia's pictures were admired in just this way.

— GEORGE HERSEY, 1993

From commonplace incidents to events of considerable moment, a substantial biography of Artemisia Gentileschi has begun to take shape. With this has come spirited debate. Seemingly objective documentation has served as springboards for interpretations of Artemisia's pictures as manifestations of a complex personality shaped early on by sexual violence and thereafter committed to combatting misogynist views of women and women artists. Such readings in turn have influenced judgments concerning attribution and dating. Once convinced that providing a

reliable catalogue and chronology of Gentileschi's canvases would be a relatively straight-forward matter, I have found it imperative to grapple with these and other new and consequential issues. The challenge has been vitalizing; how successfully I have met it is not for me to say.

But for the dictates of modesty, it might be said, on the other hand, that the appearance of this book gives the term "long-awaited" new meaning. With a priority that I like to think was not bias-driven, I began to collect information on Artemisia thirty-five years ago during the course of dissertation research on the art of Orazio Gentileschi. But my first findings of particular merit involved the daughter, and were published as "Artemisia Gentileschi: A New Documented Chronology," in the *Art Bulletin* of 1968; I did not fully survey Orazio's career until 1981, with *Orazio Gentileschi and the Poetic Tradition in Caravaggesque Painting*. In the meantime, I was alerted by feminist scholarship to consider the possibility that Artemisia's art was gender-directed—potentially in a number of ways.

The greater magnitude of the task was brought into focus especially by studies of Artemisia's *Allegory of Painting* (Fig. 175) and Pommersfelden *Susanna* (Fig. 10) by Dr. Mary Garrard of American University, to be followed in 1989 by Garrard's exhaustively researched and superbly written *Artemisia Gentileschi: The Image of the Female Hero in Italian Baroque Art*. Here were the contexts—"Historical Feminism and Female Iconography," visual histories of Susanna, Lucretia, Cleopatra, Judith, and *La Pittura*—that were so obviously required but which I simply could not have provided. Among the new questions, then: Did Artemisia Gentileschi participate in the emerging feminism of her time? Are the interpretive/expressive dimensions of her art substantively different from those of male painters? And do such would-be differences constitute valid criteria for connoisseurship decisions? Garrard's study is liberally referenced and quoted throughout the present volume. When my own sense of the nature of Artemisia's achievement is at odds with that of Garrard's I have said so. I hope that my debt to what she has accomplished is equally clear.

Since Garrard's stimulating volume remains the central presentation of a feminist understanding of Artemisia Gentileschi, and since it has been so influential on thinking about the artist, the various challenges which I raise might be taken as a critique of feminist art criticism per se or perhaps an implied questioning of the particular orientation, among the several, which Garrard's feminist criticism assumes. My approach is not to be construed in either way, nor is the purpose of my book to be considered a critique of Garrard. When I take exception to certain feminist interpretations of Gentileschi's art by Garrard and others, it is because I find them problematic with reference to the particular matters at hand.

Of course, my very adoption of the conventional monographic form, with catalogue raisonné no less, will be seen by some as a negative gesture, as embracing the terms of male art history into which art produced by women is forced but which ought rather to be dismantled. For these critics this kind of art-historical scholarship is based upon discredited notions, including a romantic myth of genius and a misguided commitment to

the concept of intentionality. Feminism, it is thought, will be disabled and the present social system reinforced unless there is a rejection of modernist art history and its beliefs in authorship and universal values, its dedication to "high art," and its presumed disregard for social explanations—among other perceived faults.[1] Further, I continue to hold to the proposition that, unassailable documentation lacking, the reconstruction of an artist's oeuvre must privilege considerations of style over interpretive strategies, without at all discounting the latter's potential, when solidly grounded, for informing connoisseurship. I anticipate that, to some extent, assessments of the value of my study will differ in proportion to the evaluators' dedication to such ideas.

The reader will observe early on that I adopt a flexible methodology, being convinced still that "it is far preferable to conceive of art history as a broad humanistic discipline whose primary datum is the work of art and whose angles of vision may be adjusted to many foci."[2] And the attention which I give to formal analysis upholds the contention that "it is impossible to lay any claim to meaning without specifically (and I would say initially) speaking of form."[3]

Valuable contributions to the literature on Artemisia Gentileschi (the development of which up to 1989 is summarized by Garrard) continue to be made. In 1991 Roberto Contini and Gianni Papi mounted in the Casa Buonarroti at Florence an exhibition of some twenty-seven paintings assigned to Artemisia and Orazio Gentileschi, with emphasis on the first decade of Artemisia's career. The accompanying catalogue expanded the factual base while essentially avoiding the female/feminist question and proposing a number of controversial attributions. The fund of facts has likewise been enriched by Roberto Fuda's discovery of a letter from Gentileschi to Ferdinando II de'Medici, by Elizabeth Cropper's findings in the Archivio dell'Opera del Duomo and Archivio di Stato (records of the Accademia del Disegno) in Florence, by Gérard Labrot's monumental publication of Neapolitan inventories, and by Christa Wachenfeld's additions to the testimony of the Tassi rape trial. Monographs on Massimo Stanzione by Sebastian Schütze and Thomas Willette, on Viviano Codazzi by David Marshall, and on Domenico Gargiulo by Giancarlo Sestieri and Brigitte Daprá, as well as Antonio Vannugli's articles on the Stanzione-Gentileschi-Finoglio Saint John the Baptist cycle for the Buen Retiro, have helped give focus to Artemisia's sometimes collaborations. Credit for keeping the discussion dynamic is also due to the reviews of Garrard's volume and of the Casa Buonarroti *mostra* by, among others, Claire-Lise Bionda, Sheila ffolliott, John Gash, Ann Sutherland Harris, Francis Haskell, George Hersey, Kristen Lippincott, Kerstin Merkel, Rodney Palmer, Griselda Pollock, Barbara Rose, Richard Spear, and John Spike.

As noted, the present book is monographic in nature. The introductory text, principally a chronological exploration of Artemisia's career, draws upon the documentation and critical opinions assembled and evaluated in three extensive catalogues ("Autograph Paintings," "Incorrect and Questionable Attributions," and "Lost Works") and in four appendixes ("Register of Documents Concerning Artemisia Gentileschi's Life and Work," "Artemisia Gentileschi's Daughter(s), Painter(s)," "Supplemental Documenta-

tion," and, by Melville Holmes, "Amber Varnish and the Technique of the Gentileschi"). I have approached the matter of authorship solely in the spirit of scholarly investigation, although no doubt with a predisposition (born of a conception of Artemisia Gentileschi's elevated artistic standards) to be conservative in assigning pictures to the category of authentic works. I have likewise been cautious in proposing specific alternative attributions, while attempting to define the parameters within which the solutions might be sought.

The text functions also to buttress many of the conclusions reached in the catalogues by revising the current charting of Artemisia's travels and by addressing more fully than heretofore such areas as the adaptability of the artist to patronage requirements and to the artistic traditions of the cities in which she worked, the links between the painter's financial situations and the artistic decisions which she made, the impact of the pictures of Orazio Gentileschi at key moments in Artemisia's career, and the expressive range (from the reflective to the startlingly dramatic) of which Artemisia was capable.

The sixth and final chapter—"Myths, Misunderstandings, and Musings"—is rather more argumentative in confronting the sometimes sensitive issues of Artemisia's given name, her reported skill as a still-life painter, her access to professional organizations, her level of literacy, the nature of her subject matter, her feminism, and the presumed interrelationships between Gentileschi's life experiences, the state of her psyche, and her art. In great part, then, these are matters that are absolutely central to the inquiry. Yet they also presuppose the understandings of Artemisia's biography and paintings already arrived at in the previous chapters, upon which they draw heavily, and thus are most logically and effectively debated at the end of the text.

That this work should have been in progress for so long is not to be blamed on any unresponsiveness to my endless requests for access to paintings and documents, for information, for photographs, and for anything else that had a chance of being relevant. Proprietariness has been rare; indeed, those most involved with the subject have been the most generous. I am deeply grateful to two individuals above all others: To my wife, Tina, for her unwavering support and the sharpness of mind and eye with which she critiqued the manuscript, and to my friend Mary Garrard, for her passionate involvement with Artemisia Gentileschi and her innumerable kindnesses. Ronald Cohen, Richard Feigen, Barbara Piasecka Johnson, Judith Mann, Maurizio Marini, Patrick Matthiesen, Wolfgang Prohaska, and Nicola Spinosa have been liberal with their expertise and hospitality. I am greatly appreciative, too, of the insights which Shelley Perlove, John Spike, Michael Stoughton, John Varriano, Wendy Watson, Thomas Willette, and my students have shared in conversation with me. Sincere thanks go to Melville Holmes (a painter dedicated to consummate craftsmanship in his own work and moved by finding it in the pictures of the Gentileschi) for his illuminating essay. I also warmly acknowledge the innumerable considerations extended to me by Joseph Bailey, Elaine Banks, Alexander Bell, Rod Boucs, Arnauld Brejon de Lavergnée, Etienne Bréton, Elizabeth Broun, Jonathan Brown, Caterina Caneva, Raffaello Causa, Marco Chiarini, Piero Corsini, Jon Culverhouse, Robin Crum, Giuseppe De Vito, Craig Felton, Burton Fredericksen,

Catherine Glascow, Gómez Piñol, Józef Grabski, Marco Grassi, Mariana Haraszti-Takács, Alexander Haas, Nicholas Hall, Ann Sutherland Harris, Mary Jane Harris, William Hutton, Tina Johnson, Alexandra Lapierre, Jacques Leegenhoek, Domenic Leo, Ann Tzeutschler Lurie, Cynthia Lutz, David Marshall, Nannette Miciejunes, Renata Mikula, Alessandro Morandotti, David Miller, Teija Mononen, Serge Nikitine, D. Stephen Pepper, Ann Percy, Alfonso E. Pérez Sánchez, Jeanne Chenault Porter, Sofía Rodríguez Bernis, William B. Russell, Carmen Saen, Luigi Salerno, Sebastian Schütze, Marc Seidner, John Somerville, Fiorella Gioffredi Superbi, Mark Tucker, Enrique Valdivieso, Antonio Vannugli, Marie Wallet, Mark Weil, Zelma Weisfeld, Ralph Williams, Brian Young, and Patrick Young, and by the staffs of the University of Michigan Fine Arts Library, the Biblioteca Hertziana, Istituto d'Archeologia e Storia dell'Arte, Archivio di Stato, and Archivio del Vicariato at Rome, and the Kunsthistorisches Institut and Archivio di Stato in Florence.

Let these same people be put on notice that I will be calling on many of them again! It would be extremely disappointing were there not much more work to be done. I hope, for example, that under the impetus of the catalogues and illustrations contained herein paintings now considered lost will emerge from obscurity or misattribution, and that discretion in elevating canvases of Artemisian character to autograph status will be observed. Other goals will have been met if the new facts, corrections, and questionings found here have cleared up misconceptions and have suggested certain limits beyond which conclusions regarding Gentileschi and her pictures are likely to be untenable. It may be, too, that Artemisia's oeuvre and chronology are now sufficiently well defined so as to permit more intensive investigations of the give-and-take between Gentileschi and the painters in the cities in which she worked.

I have found it necessary repeatedly to disown claims that I made previously in print; I expect no less of this volume. I do not expect, however, to cease urging that Artemisia Gentileschi's works be permitted to speak, first and last, in ways that only paintings can.

Postscript

With page proofs of the present manuscript imminent, there appeared Alexandra Lapierre's *Artemisia: un duel pour immortalité*, Paris, 1998. Best but rather inadequately characterized as a historical novel, this book brings alive, excitingly and often touchingly, the ambiences in which Artemisia Gentileschi and those who participated in the drama that was her life moved. It speaks with the strength of an impressive knowledge of published literature, of the most complete transcriptions to date of crucial depositions from the second phase of the trial of Agostino Tassi for the rape of Artemisia, and of a remarkable trove of the author's own archival discoveries. Interpretations are distinguished from fact; artistic license is identified as such.

With typical generosity, Philip Winsor—whose support through it all has been extraordinary—and his colleagues at Penn State Press responded positively to my request to add to Appendix I (Register of Documents) those new notices that bear directly upon Artemisia Gentileschi. And while it was impossible to contemplate at this late moment extensive revisions to the text, those that could be effected should indicate the scope and importance of Lapierre's findings and proposals.

I

THE EARLY CAREER IN ROME, 1609–1612

Precociousness and Power

On July 3, 1612, at a moment of personal urgency, the Tuscan-born master painter Orazio Gentileschi wrote from Rome to the Dowager Grand Duchess Cristina di Lorena in Florence: "I find myself with a daughter and three sons, and this woman, it has pleased God, having been trained in the profession of painting, has in three years become so skilled that I can venture to say that today she has no peer; indeed, she has produced works which demonstrate a level of under-standing that perhaps even the principal masters of the profession have not attained, as I will show Your Very Serene Highness at the proper time and place."[1] Less than two months earlier this daughter, Artemisia, had been tortured by devices tightened

around her fingers as she swore one final humiliating time to the truth of her accusation that in the spring of the previous year she had been raped by the landscapist, *quadratura* specialist, and incorrigible miscreant Agostino Tassi.[2] Orazio had learned that Tassi's influential Florentine friends were attempting to secure his release from the Roman prison which had been his home since the charges were filed. Recounting the attack and reviewing Agostino's scandalous past, he begged the Grand Duchess's intervention so that "justice would not be defrauded and stifled."[3] Then, before extending the mandatory verbal bows, he proposed to send to Florence a sample of Artemisia's work.[4]

At the time of Orazio's plea Artemisia Gentileschi was about to celebrate her nineteenth birthday, having been born at Rome on July 8, 1593, and baptized two days later in the church of San Lorenzo in Lucina.[5] Had she arrived as well at the level of artistic maturity claimed for her by her father? What had been the nature of her professional training to this point? And what implications might her status as a woman and the painful events of the preceding fourteen months have had for her art?

The search for answers must begin with the *Susanna and the Elders* in Schloss Weissenstein at Pommersfelden, signed on the face of the bench at the lower left "*ARTIMITIA. / GENTILESCHI. F./ 1610.*" (Figs. 10, 15; Color Plate I). Furthermore, what has been made of this picture—characterized with reason as "the principle *[sic]* touchstone for the artist's earliest works" and "a pivotal work for Gentileschi studies"[6]—has had a profound bearing on how Artemisia Gentileschi's subsequent achievement has been understood. The canvas therefore requires an extended analysis.[7] Observations on Artemisia's earliest interpretations of the themes of Lucretia and Judith (Figs. 18–19, 21–22, 31; Color Plates II, III, IV), followed by an account of the ordeal of answering magistrates and enduring Tassi and the glare of public scrutiny, will then complete this examination of Gentileschi's extraordinary beginnings.

The *Susanna and the Elders:* Theme, Date, Sources, Attribution

The viewer familiar with the Susanna story as told in the Apocryphal Book of Daniel would be prepared to construe the imagery here as a conflation of incidents, discrete moments over time telescoped into an instant: the elders hatching their plot, vaulting upon the defenseless woman, demanding that she submit sexually on pain of public denunciation on a trumped-up charge of adultery with a young man, cautioning silence; Susanna startled, feeling violated, confronted with a moral decision, and resisting. Untutored, however, or even reacting to the canvas on that visceral level to which it most immediately appeals, one might see little more than a young woman frightened at her bath by the sudden arrival of conniving older men whose designs upon her she has scarcely had time to grasp. Viewed in this way, the picture is first and foremost a frank and highly concentrated presentation of very human distress. Distanced neither from the elders and their oppressive weight nor from us, Susanna, her body in a quandary of

opposing twists, thrusts out her left arm as much in alarm as in defense or disdain, and clenches her right arm to her chest in an equally instinctive gesture of protection. The austere and limited setting, at once specific (a brownish-gray stone bathing font with nicks, cracks, and pseudo-antique leaf reliefs) and abstract (its location and extension undefined), offers no comfort or distractions.

Immediacy of impact is sustained by the physical type of Susanna, heavy, fleshy, inelegant, and of a particularized naturalism that appears to have been taken from the living model.[8] While disavowing both ideal beauty and explicit sexuality, the artist certainly does not banish the sensual. Except for a swath of drapery over one thigh, Susanna is totally nude, her bare left breast at the geometrical midpoint of the canvas, accessible to both elders and to a voyeuristic observer.[9] Surely, in consonance with the theme, desirability was to be among the attributes of this young woman.

Notwithstanding this forthrightness and the presence of the signature, the Pommersfelden *Susanna* has stirred considerable debate. At issue: the date of the picture; the role of Orazio Gentileschi in its conception, design, and execution; the character of its responsiveness to tradition; and the extent to which, expressively and interpretively, it manifests a unique personal sensibility, gender-distinct and shaped by encounters with men in general and with Agostino Tassi in particular.

At the core of this debate, the strands of which are tightly intertwined, has been the question of exactly when the canvas was painted. Every measure now indicates that the date inscribed on the *Susanna* documents the year of its execution is, and always was, "*1610*." Irrespective of the matter of attribution, scholarly opinion has strongly favored this reading,[10] although the possibility[11] and even probability[12] that the final cipher should be interpreted as a "*9*" have also been contemplated. The results of laboratory analysis[13] urge the conclusion that the entire inscription—its pigment, structure, *craquelure*, and lighting—is integral to the picture and has been neither overpainted nor altered.

When during 1610 the *Susanna and the Elders* was created, Artemisia Gentileschi was at most seventeen years old. Some authorities, correctly reading the date as "*1610*" but operating under the misconception that Artemisia was born in 1597, assigned to Orazio a preponderant share, from invention to execution.[14] A recent, related viewpoint, strongly inclined to attribute the design of the figure of Susanna to the father, features the painting as "a collaboration directed by Orazio who, in an understandable reversal of workshop tradition, proudly encouraged his daughter-assistant to take the credit."[15] Other scholars accord Artemisia primary responsibility for the picture, the father's assistance "with the planning of the design" and "on a modest technical and stylistic level" being assumed.[16] In the minds of still others, it would seem, the dispute has now been resolved in favor of Artemisia's sole authorship of the canvas.[17] Bearing upon this issue are the fact that there is not a shred of documentary evidence that Artemisia's artistic education to this point had been other than the exclusive province of Orazio and the unassailable observation that the *Susanna* is unthinkable outside the context of the Gentileschi studio. Is it unthinkable also without Orazio's direct participation?

The composition of the *Susanna* is controlled by Orazian principles of centralization and compactness, the elders in echoing postures compressed into a semicircular configuration and arching over Susanna, the graphic equivalent of her entrapment. In a comparable manner Judith and Abra enfold Holofernes' head and the executioners close in upon Christ in Orazio's pictures at Hartford (Fig. 33) and Braunschweig (Fig. 17), respectively.[18] Locked into rigid schemes and manifestly posed, the figures even in Orazio's occasional forays into the arena of physical action—e.g., the *Mocking of Christ*, the *Saint Michael Overcoming the Devil* of ca. 1605–8 (Fig. 13),[19] and the *David Slaying Goliath* from about the same moment (Fig. 14)[20]—appear transfixed. So also does Susanna, who shares specifically with David the positions of her head, arms, and torso and with David and Saint Michael her pained facial expression of bunched brows, immobilized and shadowed eyes, and open mouth.[21] It is not by chance, therefore, that the elder at the left in the Pommersfelden canvas should approximate the tormentor at the right in Orazio's *Mocking of Christ*—in hunched posture, physical type, coloration, and garment (down to the touches of white shirt at the chest and cuff).

Considered with regard to other possible sources of inspiration, the *Susanna and the Elders* again takes its place securely within the Gentileschi shop around 1610. Furthermore, it has been posited that the borrowings from tradition are such as to resolve the problem of attribution in favor of Artemisia Gentileschi. This latter conclusion will be challenged below, but I must immediately state my position that a presumption of direct literary underpinnings is not indicated. Erudition is notably lacking throughout Orazio Gentileschi's life and oeuvre. As of 1612, according to her own admission at the Tassi trial, Artemisia was basically illiterate ("Io non so scrivere et poco leggere").[22] In view of society's attitude toward the education of individuals (especially women) who plied trades, this is not surprising. In any event, neither of the Gentileschi can be expected to have researched patristic texts and the like for exegeses of the Susanna story or to have been well informed about such matters.

Much more accessible to them would have been visual material, including works whose possible iconographical complexities on the other hand might have been situated outside their fields of expertise. As is often and understandably the case when one makes a deep commitment to the object of one's investigation, prototypes for the *Susanna* have been identified among the most time-honored works of art, for through such alliances the picture might be claimed to join exalted ranks and take on special seriousness and interpretive richness.[23] Thus the name of the great Michelangelo has been invoked. Convinced that the canvas belongs to Artemisia's Florentine period, one writer identifies the *Doni Tondo* as the origin of the hovering placement of the elders, of Susanna's "parrying gesture" and the torsion of her body, and of the balding elder.[24] For another, "the twisted body of the nude figure seated tensely on a hard stone bench closely recalls [Michelangelo's] *ignudi*," while the specific hues and their modulations are also likened to the Sistine Ceiling.[25] Michelangelo Buonarroti the Younger's patronage of Artemisia, of which there is in reality no sign before 1615, is introduced as corroboration by association.[26]

Yet Michelangelesque coloration was adapted in the Olgiatti Chapel at Santa

Prassede by the Cavaliere d'Arpino, a Gentileschi family friend,[27] and in the *Susanna* the salmon hue of the older man's cloak and the brownish-gold of his companion's coat may be found in Orazio's *Mocking of Christ*. Would the artist of the *Susanna*—and observers of the picture—have thought of the Sistine *ignudi* at the time when painted and graphic models (see below) for the female nude were readily available in Rome? For the placement of the elders vis-à-vis the young woman and for the *contrapposto* of the latter's body, the *Doni Tondo* is a much less likely source than Rubens's *Susanna and the Elders* (Fig. 11), executed by the Flemish master during his Italian years and then as now in the Borghese Collection.[28]

The Sistine Ceiling is thought to figure again in a chain linking Michelangelo's *Expulsion of Adam and Eve*, the *Susanna*, and a Roman Orestes sarcophagus of the second century (Fig. 9).[29] Specifically, it has been argued, both Buonarroti (for the anguished Adam) and the painter of the Pommersfelden canvas (for Susanna herself) appropriated the recoiling female nurse who stands above the slain Aegisthus. By this reasoning the *Susanna* gains art-historical weight and moral strength, and the Orestes story is mustered to enhance the picture's psychological resonance.

That the artist of the *Susanna* was familiar with one or both of the already famous Orestes sarcophagi in Rome takes on a high degree of probability in view of Orazio Gentileschi's *David Slaying Goliath* (Fig. 14), in which the hero above the fallen Philistine seems to have been based upon the sword-wielding Orestes above Clytemnestra in the center of the action and, for the position of his left arm, upon the gesture of the nurse.[30] It does not follow from this, however, that the same painter would never have contemplated utilizing the relief in two such different contexts and that therefore Artemisia Gentileschi's "creative imagination" alone must inform the *Susanna*.[31] And the notion that the *Susanna* is somehow infused with intimations of the Orestes drama is compromised by the fact that the subject of the relief was then a mystery, even to the learned Bellori.[32]

Furthermore, a direct connection between the *Orestes Sarcophagus* and the *Susanna* does not have to be postulated. Orazio's *David Slaying Goliath* stood as a potential intermediary. But I take it as a truism that the search for prototypes, justified by the venerable custom of receptivity among artists to the creative acts of others, is consistently more rewarding and leads to more defensible conclusions when it is focused upon examples of the same or related subject matter. Thus it is that the Cavaliere d'Arpino's *Diana and Actaeon* of ca. 1603–6 (Fig. 16) becomes relevant.[33] The Susanna in the Gentileschi canvas reacts to the appearance of the elders in a manner that strikingly recalls the response of the nymph behind Diana to the intrusion of the hunter. Although playful and openly erotic, the Cavaliere's panel of female nudes interrupted in their bathing by a clothed male parallels the iconography of Susanna. The goings-on in the ancient Roman sculpture simply do not. One might even care to recognize analogies between the punishment of Actaeon and the sentence of death soon to be meted out to the elders. Yet (there being exceptions to all generalizations) it can be noted that d'Arpino's composition availed itself of, precisely, the *Orestes Sarcophagus*, for the striding Actaeon, his right arm

5

traversing his chest and his left arm at his side,[34] as well as for the central bather. Only in an incidental, nonsubstantive way, then, can the *Susanna* be said to relate to the classical relief.

The artist of the *Susanna* would have had every motivation and opportunity to find inspiration in Giuseppe Cesari's art. In 1594 d'Arpino was present, perhaps as godfather, at the baptism of Orazio Gentileschi's son Giovanni Battista (d. 1601), and in about 1600 had supervised Gentileschi's work in San Giovanni in Laterano.[35] In 1603 Orazio listed the Cavaliere as among the first class of painters in Rome,[36] while for his mosaics of 1609–10 of the Madonna and an Angel on the crossing dome at St. Peter's he worked from d'Arpino's cartoons.[37] And in the Gentileschi versus Tassi proceedings of 1612 a witness testified that to his recollection Orazio had accepted a drawing pupil on d'Arpino's recommendation.

The *Diana and Actaeon*, the likely source for Susanna's extroverted reaction compounded of surprise and consternation, held out no hints as to how a seated Susanna and the elders in proximity to her might be posed. Other models were at hand should such indications have been sought. Annibale Carracci's engraved and etched *Susanna and the Elders* of ca. 1590–95[38] (Fig. 7) exerted a magnetic attraction on Baroque artists, including Rubens, whose picture for Scipione Borghese (Fig. 11) has already been cited. The Pommersfelden canvas may have been touched by this print.[39] More pertinent still is another example of male voyeurism, Francesco Brizio's *Satyr Spying on a Sleeping Nymph*, engraved in 1604 after Agostino Carracci (Fig. 8).[40] With the obvious exception of the arms, the poses of the Brizio and Gentileschi nudes (both with V-shaped configurations of drapery over their left thighs) approach interchangeability. The dense foliage in Brizio's engraving, if not that in Annibale's *Susanna*, could have suggested the carved leafage in the painting.

The supposed prototypes all fall within a twenty-year period, and I find nothing in the pattern of borrowing that permits one to differentiate the attitudes of Orazio and Artemisia Gentileschi. What, then, of the proposition that the high degree of accuracy and specificity in the rendering of the female body points unequivocally to the daughter,[41] who almost certainly had access to nude women models? While it may be true that by preference or policy male artists of the time generally adapted male models for their female nudes,[42] it is conceivable that Orazio, during this period in which his Caravaggesque naturalism is most pronounced, would not have been content with this practice.[43] A witness told the court on June 20, 1612, that he had heard a rumor that Orazio had made Artemisia pose in the nude.[44] Although this assertion fits the conspiracy of slander concocted by Tassi's friends and cannot be accepted as fact, it does hint that the use of female nudes in male painters' Roman studios was not out of the question. Moreover, after individual styles are taken into account the realism of Rubens's Susanna and of Brizio's nymph seems no less accentuated than that of the Gentileschi young woman. On the other hand, as writers who favor Artemisia's authorship of the *Susanna* have noted,[45] there is an appreciable gulf between this down-to-earth figure and the idealized and would-be elegant Magdalens and Danaës that came from Orazio Gentileschi's brush

6

(e.g., Figs. 107, 108).[46] Yet in the decade that separates these reclining nudes from the *Susanna*, Orazio's art in general had undergone irreversible changes. The most legitimate comparison to the *Susanna* is the bulky *Cleopatra* from Genoa (Fig. 211), believed by some to embody Artemisia's perceptions but by me and others to have been painted by Orazio about 1611–12.[47]

The *Susanna and the Elders:* Personal Sensibility, Personal Situation?

Holding that in the Pommersfelden canvas "the expressive core . . . is the heroine's plight, not the villains' anticipated pleasure" and offering a series of visual comparisons, Garrard considers the painting to be a "uniquely sympathetic treatment of the Susanna theme" such that only a woman could have conceived.[48] Biased, unhappily, by the presuppositions that a man would have been incapable of empathizing with Susanna's dilemma and would instinctively have put himself in the place of the elders,[49] these conclusions nonetheless deserve more extensive review than they can be given here. It should be noted, however, that no interpretations by women artists of the Susanna story are introduced as frames of reference. Furthermore, while male pictorializations of the theme can indeed be seductive (Cavaliere d'Arpino, ca. 1607, from the Ospedale di Santa Maria della Scala, Siena)[50] and downright pornographic (Alessandro Allori, 1561, Musée Magnin, Dijon),[51] Annibale Carracci's print (Fig. 7) stands as proof that this need not be so. Only by willing it, in my opinion, can Annibale's *Susanna* be likened to the d'Arpino painting in Siena and the woman deemed "sexually available and responsive," "looking beseechingly at the elders," as if she "was the one who was tempted," Carracci thus suggesting "that Susanna welcomed the advances of the old men."[52] All of this fails to observe that Annibale seized upon a different stage of Susanna's plight, wherein the young woman momentarily struggles with the painful options ("I am straightened on every side: for if I do this thing it is death unto me: and if I do it not, I cannot escape your hands"). Just before crying out and thereby knowingly subjecting herself to public condemnation Susanna, in a brief instant of conflict, looks toward the old men even as she seeks to cover her nakedness. And if the garden and the water, features mentioned in the Book of Daniel and canonical in art, are "erotically suggestive,"[53] the overflow of sexual desires is to be imputed to the elders alone. Caravaggesque inclinations toward the basic and the nonenvironmental, not a need to eliminate the connotations of lushness, might well have dictated the sparseness of the Pommersfelden version.

 None of this is to deny that the observer is faced above all with an image of a young woman anguished at the sudden appearance of lecherous men, or that Susanna's dramatic reaction cannot be read on two levels—as instinctual and as psychologically motivated. Accompanying her are the words *"ARTIMITIA GENTILESCHI."* Confident that it is Artemisia's work, some commentators have found in the *Susanna* manifestations of Artemisia's personal situation.[54] There are undeniable parallels[55] between the tone and conduct of

the rape trial of Agostino Tassi in 1612 and the Susanna narrative. And while it is questionable that the court records themselves intimate that indecent sexual designs had been made upon Artemisia by Tassi or other men as early as 1610, one can hardly exclude the possibility that they had.[56] Indeed, this hypothesis is considerably less problematic than that which recognizes the two elders as Agostino Tassi and Orazio Gentileschi and thus the picture as alluding both to Tassi's sexual dealings with Artemisia and to incest, or that according to which the *Susanna* may express not only "the intimidating presence of the threat of sexual assault" but also an "oedipal girl's struggle against yearnings for her father."[57] Whatever the particulars of these contentions, all presume that the facts of Artemisia's biography illuminate the expressive content of her pictures, that—consciously or unconsciously—her works were invested with her personal feelings. This position has been pointedly defended by Garrard.[58] Haskell takes quite a different stance.[59] And firmly but not rigidly, Silvers, again in writings touching upon Gentileschi, argues that "there is no reason to insist that what is true of an historically documented personage and of the artist manifested in that historical person's aesthetic products must be the same, as these are characters situated in different sorts of narratives, discourses with different functions."[60] She demands rigorous demonstration of presumed connections.[61]

Although convinced that special caution is imperative, I am certainly not dissuaded from the presumption that experiences in the real world might well inform creative acts.[62] Nonetheless, the *Susanna and the Elders* need *not* be self-referential. Let it be supposed for the moment that by the time the picture was created Artemisia had been sexually besieged, and that this had come to the attention of her father, who upon the death of his wife and Artemisia's mother Prudentia on December 26, 1605,[63] had taken on full responsibility for the upbringing of his daughter and sons. The *Susanna*, if one were inclined to so theorize, might document Orazio's sensitivity to what Artemisia had been through.

In any case, there is no justification for believing that personal concerns dominate the Pommersfelden *Susanna*. It cannot be assumed that its creator, least of all a teenager at the beginning of her career, selected the subject or would have chanced painting on speculation a six-foot-high and time-consuming canvas. Unfortunately, the early history of the picture is not documented; it is first mentioned—as a work by Orazio Gentileschi—on July 15, 1715, in a letter from Benedetto Luti, to whom it then belonged, to the Hofrat Bauer von Heppenstein.[64] Yet what is known of seventeenth-century practice strongly suggests that much more often than not artists worked on orders from specific individuals or at least had a definite clientele in mind. This crucial issue of the *Susanna*'s intended audience, that is of embedding the work in a social milieu, has been boldly underscored by Pollock.[65] The odds are overwhelming that the recipient of the *Susanna* was a man, and unless the painter was prepared to risk rejection—a most unlikely gamble—he or she would have attempted to determine the patron's taste. The male desire for depictions of female nudes was already storied, and the Pommersfelden canvas, with its own dose of sensuality, was in all probability intended in part to appeal on this basic

level. Whether the artist knew or sensed or hoped that the owner-to-be of the *Susanna* would approach the picture in other ways as well, and oriented the work accordingly, remains a point of discussion.[66] Even a woman painter, eager to sell her art, would not have been above tailoring a representation of *Susanna* to patronage expectations.[67]

The *Susanna and the Elders* and Artemisia's Training

Of course all of this debate as to the authorship of the canvas would count for nothing were it to be concluded that Orazio placed Artemisia's signature on his *Susanna* as an advertising ploy to hustle commissions for his promising apprentice-daughter, or that in 1610 Artemisia did not have the technical skill to execute a picture of such high quality. The first suggestion is without foundation and unacceptably cynical, while as regards the latter the opposite seems to have been the case. Very early in life Artemisia must have been encouraged to draw and to dabble with oil paint. Her training was probably an ongoing concern, one that increased in intensity as she grew older and more adept, and perhaps as she was given opportunities to contribute here and there to her father's pictures. Orazio's letter of July 3, 1612, to the Dowager Grand Duchess of Tuscany implies that in mid-1609 Artemisia had begun to work on canvases of her own.[68] Her *Madonna and Child* in the Palazzo Pitti (Figs. 1, 6), to all appearances based on living models with hints from representations of the theme by Orazio and others, is here identified as one such early painting.[69] In spite of certain awkwardnesses and its less than optimum condition, the Pitti canvas shows considerable technical promise. On the day of the rape in 1611 Artemisia was again working from life, doubtless on another *Madonna and Child*.[70] Orazio's boast to Cristina di Lorena concerning his daughter's standing in the profession may have been exaggerated but not idle, for he was prepared to back it up with an example of Artemisia's art. And although in 1611 Artemisia was still learning to master perspective under the tutelage of none other than Agostino Tassi,[71] simultaneously she was conducting painting lessons of her own.[72]

In these lessons she would have passed on such distinguishing features of the Gentileschian manner as acuteness of observation founded on a reverence for the true qualities of things, "refined and elegant linear precision,"[73] and solid modeling through a sensitive manipulation of *chiaroscuro* (the force of which is thoughtfully varied with respect to subject matter and ambient). The Pommersfelden *Susanna and the Elders* is faithful to these precepts. It does not display, however, the astonishingly sophisticated lighting effects and dazzling drapery configurations of such contemporary works by Orazio as the *Mocking of Christ* and the *Judith and Her Maidservant* (Figs. 17, 33),[74] and in this sense remained on an attainable, nonexperimental plane. It would have been Orazio's prerogative as teacher to intervene directly in his daughter's canvases, and no doubt he did so.[75] But I am persuaded that, as the signature proclaims, the *Susanna* as we see it came substantially from the brush of Artemisia Gentileschi.[76]

9

Notwithstanding, from its earliest notice in 1715 until the mid-nineteenth century, when the rediscovery of the signature occasioned a reattribution, the canvas was thought to have been painted by Orazio Gentileschi. As the arguments presented above have ventured to show, this was an honest error. The *Susanna and the Elders* is intimately connected in compositional type, color, motifs, expressive peculiarities, and stylistic particulars to pictures executed by Orazio in the years around 1610, to which are added impressions of other contemporary works of art readily available in Rome. Neither the pattern of its borrowings nor its portrayal of the female body nor its message is so distinctive as automatically to exclude Orazio and point inexorably to Artemisia. Some will question these assessments, perhaps agreeing with Garrard that the interpretive thrust of an early seventeenth-century Caravaggesque painting, especially when read in the light of biographical information, might be a reliable guide to "gender distinction," and that the supposed "feminist cast" of subsequent pictures by Artemisia Gentileschi may be enlisted in assigning to her the conception of the *Susanna*.[77] Such methodological assumptions must be exercised with great care, and only after principal consideration is given to what can be ferreted out concerning the expectations of a socialized and demanding patronage. Works of art, speaking across the centuries, hold new meanings for successive generations, but it can be hazardous to ascribe these meanings to the artist or period under review.[78] Still, it would be unwise and arrogant summarily to dismiss sincerely held convictions that Artemisia Gentileschi's paintings evince a female and even feminist perspective and mirror her life experiences.

At appropriate moments in these pages, and especially in the final chapter, I intend further to acknowledge and assess such views. As for the *Susanna and the Elders*, let it be recognized that if the evidence does not permit a definitive accounting of the relative roles of daughter and father in the genesis and development of the picture, neither does it allow one to deny credit to Artemisia for having brought her own sensitivity to bear on the story and her own creative capacities on its visualization. Besides having acquired by 1610 the skill to see ideas to fruition on a piece of canvas, she shows no hesitancy in working in the Caravaggesque mode, where human drama is reduced to the core and presented close up, where idealization is rejected in favor of truth, where frankness counts more than beauty. She dedicates herself to history painting in the face of conventional wisdom that women artists were better suited for portraiture or still-life.

The *Lucretia* and Two *Judiths*: Visual and Psychological Verisimilitude in Female Imagery

Her courage no doubt fortified by the success of the *Susanna*, within the next two years[79] Artemisia executed three paintings whose subjects made equally decided demands upon an artist committed to credibility in its psychological as well as physical dimensions— *Lucretia* (Figs. 18–19; Color Plate III), *Judith Decapitating Holofernes* (Figs. 21–22; Color

Plate II), and *Judith and Her Maidservant* (Fig. 31; Color Plate IV). Although of oft-treated themes, these canvases command uncommon attention, and with them Gentileschi acquired that reputation as a specialist in female imagery which, whether cultivated or responsive to the insistence of the market, was to fix the direction of her entire career.

In a gesture clearly reminiscent of nursing, Lucretia proffers her left breast as if to the suspended dagger, an instrument that would end life as quickly as a lifted and expressed breast could sustain it.[80] No wound yet marring her flesh nor blood tinging her weapon, she teeters on a bed of turbulent drapery, trussed by her shift and gripped by psychic anxiety. It was for Lucretia, not for Artemisia Gentileschi, to impose the ultimate fate. History recounts that the virtuous Roman matron, having yielded to Sextus Tarquinius upon his threat to fabricate an adulterous situation between her and his servant, committed suicide. For Gentileschi's woman, however, historical inevitability gives way to the torment of personal decision when faced with distressing options.[81] It submits as well to the recognition of every human's need for succor, as Lucretia raises her eyes toward the upper right in appeal to a higher power.[82] Yet the light that strikes this mortal falls from the left; darkness closes in upon her robust body, her anguished face, her poised blade.

For Artemisia's Judith (Fig. 21; Color Plate II), having pushed up her sleeves accordian-like to free her arms for action, any doubt has long since been resolved. With her equally unwavering maid, undeterred by a blow to the jaw, pinning down the victim's left arm, Judith smashes her right knee into Holofernes' rib cage as she drives cold steel through his neck. The two women, in garments of unsubtle crimson and bright blue and struck by a brutal light, have ensnared the evil general in a web of rigid crossing and interweaving limbs. Although differentiated in station through facial type, coiffure, and costume, Judith and Abra are peers in combat,[83] three determined arms springing from a single node, and three hands, viselike, strung on a single arc. The torrent of blood that flows over the mattresses is played with excruciating irony against the vertical fall of a delicately fringed bedcover. Holofernes, at once reflexive and conscious, agonized and imploring, breathes his last.

Ferocity turns to arrested drama in Gentileschi's canvas in the Palazzo Pitti (Fig. 31; Color Plate IV).[84] Imagined as having looked into each other's eyes but a second before, the women now pivot their heads as if in reaction to a stirring from without. Their arms and shoulders form an embracing ellipse, in meaning a negation of the evident contrasts in their social status, in the intensities with which their faces are lit, and in the clarity of their profiles. A screaming Medusa on the sword pommel is paired across space with the gentle staying and reassuring hand of Judith on her companion's shoulder, while the visual and emotional gravity of Holofernes' head counteracts the rightward pull of the glances. The drama of the narrative is one of apprehension, in large part communicated by a composition of tension held in suspense.

It may be that Artemisia realized the inventions of two of these three pictures in concert with canvases of related themes by her father. The *Lucretia* and Orazio's *Cleopatra* (Fig. 211),[85] another historical female suicide, entered the same Genoese collection,

while copies on slate in the Galleria dell'Arcivescovado at Milan (Figs. 28, 29) suggest that a variant of the Naples *Judith* and a version of Orazio's *David in Contemplation After the Decapitation of Goliath* (cf. Fig. 24) were also intended for a common client. One can therefore envision the solicitous Orazio assuming the role of guarantor of his daughter's success in such undertakings. And as these paintings and the Pitti *Judith* demonstrate, Artemisia for her part continued to be receptive to Orazio's counseling and to his art.

Even to the probable use of the same buxom model, her head and legs now rotated to the right, and to the pained visage familiar from Orazio's oeuvre (e.g., Figs. 12–14), the *Lucretia* follows closely upon the *Susanna* (Fig. 10; Color Plate I). As a figure frozen in anticipation of guidance from beyond, Lucretia likewise recalls the Saint Jerome in Orazio's painting at Turin.[86]

For the Naples *Judith Decapitating Holofernes* Caravaggio's unforgettable canvas from the Casa Coppi (Fig. 38) was the primary source: Judith, her arms in stiff parallel diagonals that simultaneously suggest resolve and avoidance of a potential bath of blood, drawing the sword through Holofernes' neck while applying an iron fist to a knot of his disheveled hair. Yet Judith's rotund face with its expression skewed by eyes that are slightly out of line is inimitably Orazian (cf. Figs. 208, 210, 211) and turns up in a more dreamy guise for the similarly posed Salome in a picture formerly in the Musée d'Art et d'Histoire at Geneva (Fig. 20). Artemisia's *Judith* cannot be imagined apart from the *Salome*, which certainly issued from the Gentileschi studio and which, if it came specifically from the brush of Orazio as I suspect it did, most likely took precedence. In addition, the father's forays into the field of dramatic action in the *David Slaying Goliath* and *Mocking of Christ* (Figs. 14, 17), to which the *Susanna* had responded, are again relevant: the former for the obliquely placed, bent-legged Holofernes, his arm thrust upward in agony and defense,[87] the latter for the hunched Abra clutching the victim's arm. Finally, it is likely that Rubens's *Great Judith*, known today (in reverse) by way of Cornelius Galle the Elder's engraving of ca. 1610 (Fig. 25), and Adam Elsheimer's picture at Apsley House (Fig. 26), were mined in effecting this considered synthesis.[88]

The debt to Orazio of Artemisia's *Judith and Her Maidservant* is more profound. While the Naples *Judith* and its later elaboration in the Uffizi (Figs. 77–79; Color Plate XII) have fired writers and helped create the myth of Artemisia Gentileschi as primarily a painter of sanguineous spectacle, the Palazzo Pitti example shows her to have been capable early on of reflection, and sensitive to the gift for understatement upon which her father's fame deservedly rests. Rejecting the tradition of Abra as a crone, dignifying her role, and fixing upon an anxious moment between the commotions of beheading and full flight, Orazio created in his *Judith and Her Maidservant* now at Hartford (Fig. 33) one of his most innovative works.[89] The Hartford painting, for which Artemisia posed for the figure of Judith, was surely a spiritual fount for the young artist. The figures and composition of the Pitti canvas, however, sprang from two other interpretations by Orazio of Judith and Abra halted in their tracks by danger sensed (Figs. 39, 40): the maidservant in a turban-like shawl seen from the back, head twisted to the right, her left arm arched over the basket containing the human trophy (on its side) and a hanging napkin,

as well as Judith's gentle touch and bejeweled accessories, from Orazio's picture at Oslo; and the stocky, moon-faced conqueror in strict profile, sword above her right shoulder, curls caressing her cheek, from the ex-Sotheby's version.

The exercises in prototype identification to which these three works by Artemisia Gentileschi from the years 1611–12 have just been subjected prove to be invaluable. Besides clarifying chronology and context, they underscore Artemisia's independence of mind. Less blunt and eccentric than the New York canvas and less decoratively demonstrative than the Oslo one, Artemisia's Pitti *Judith* equals or surpasses these two models in sheer authoritativeness. More in tune with Orazio's painting at Hartford, her Abra, transformed from the youthful, almost caricatured maids of her father's other renditions, is mature and convincingly capable, participatory both in the act and in the anxiety. Artemisia's deviation in the *Judith Decapitating Holofernes* from its origin in Caravaggio's *Judith* is particularly revealing. Much has been claimed concerning the interpretive content of the latter, but it begs to be read essentially as a burlesque on high drama and high art, including Michelangelo's *Cumaean Sibyl* (which, I believe, is satirized in the craggy, turbaned maid with her outstretched apron), and as an exposition of the power of the new realism, as a pictorial strategy, to unsettle. Gentileschi's image is not meant to inspire an insider's smile of recognition and amusement. Earnest and authentically brutal, it rejects the typecasting, ornamental brilliance, and magniloquence of Rubens's *Great Judith*, while being considerably more monumental in impression as in fact than Elsheimer's miniaturistic depiction.

In all, Artemisia's pictures of determined women from these first years of her career are endowed with moral seriousness. While displaying elaborate drapery configurations and stunning effects of light—in advance of the *Susanna and the Elders* and approaching Orazio Gentileschi's finesse in those areas—these paintings are not beautiful by orthodox standards. They make demands before they offer visual delights, while not disallowing the erotic and sexually allusive which patrons had been conditioned to find in pictorializations of these themes. Certainly the gesture of Lucretia's right hand, for all its poignancy within the context of the story, calls attention to her very full breast, and her bare leg crowds the picture plane.[90] That the bed on which Lucretia was raped becomes now the site of her suicide imparts sensuality by implication.[91] The gown in which Judith dressed to arouse Holofernes permits an ample cleavage or unbroken expanse of chest. Yet in these years Artemisia's females are not comely in the way that the Lucretias and Judiths of Giorgione, Veronese, Stanzione, Caravaggio, Allori, Rubens, and others were meant to be. Although not devoid of sexual appeal, they do not explicitly spur fantasies of sexual availability,[92] nor does eroticism prevail over meaning. All of these women have minds. The Judiths are formidable, unyielding, worldly-wise, affording no satisfaction to those who would take comfort in thoughts of female vulnerability.

It is therefore evident that the artistic and interpretive decisions which Artemisia Gentileschi made were deeply meditated, and the solemnity of these canvases is not diminished by the probability that their creator was unaware of literary disputations on the character and conduct of Lucretia and Judith.[93] Artemisia had before her examples

of Caravaggesque forthrightness and Orazian integrity. And as a woman she was singularly able to project herself into the stories, to imagine how they might have been, rather than accepting uncritically their previous pictorializations: not, I think, out of indignation that male artists had warped these subjects, but from a fervent belief in the validity of her own perceptions.

The Rape, the Trial, and the Inevitability of Marriage

The theory that these perceptions of Lucretia's vexations and Judith's victories were conditioned specifically by Gentileschi's own experiences with men, and the viability of Freudian forays into deeper meaning, can be adequately assessed only against the totality of her career, and will later be taken up in detail. It is a fact, however, that during the period to which these paintings are to be assigned, Artemisia underwent an ordeal of sexual attack, mortification, and dashed hopes. In May of 1611, Agostino Tassi, with the complicity of one Tuzia (a tenant to the Gentileschi and once a cherished companion to the young artist), shoved Artemisia into her bedroom and raped her. Ten months later, having learned of the assault and subsequent intimacies and having been subjected to other indignities by Tassi and his partners-in-malice, Orazio Gentileschi filed charges against Agostino before the Governor of Rome.[94]

With this was initiated a protracted operation of legal interrogations of the principals and of numerous and disparate witnesses at various venues throughout the city.[95] Notaries recorded the questions posed by deputies and judges and the responses of the deponents. Apparently informed beforehand of standard judicial guidelines for such cases, Artemisia testified to resistance to Tassi's aggression, to her virginity prior to the attack and to bleeding following it, and to Tassi's pledges of marriage.[96] Charges and countercharges, truths and falsehoods, heartrending drama and despicable charades, verbal barbs and physical abuse were but part of an acrimonious business in which Agostino, by enlisting cohorts to impugn Artemisia and thus deflect guilt from himself, in effect succeeded in making Artemisia's virtue a central issue.[97]

In view of the number of witnesses and the inflammatory nature of much of their testimony, it is highly unlikely that this case, although conducted in semiprivate, escaped the court of public opinion.[98] Since Orazio Gentileschi must have known that in taking legal action against Tassi he risked exposing himself and his family to the most vicious newsmongering, it must be supposed[99] that a combination of factors had pushed him to intolerable limits.

To the father's perception within the context of early seventeenth-century Rome, the physical violation per se of his daughter might not have been the gravest of the offenses. Still, it is important to be clear about this aspect of a most complex situation and about Artemisia's state of mind at the time, for it is with the conviction that Artemisia had been raped and upon the assumption that she thereafter bore hatred toward men

that Gentileschi's art has often been interpreted. Other commentators, to the contrary, have found suspect some of the Gentileschi allegations.

Let it therefore be observed, first, that even after being unmercifully slandered, Artemisia kept alive hopes of marrying Tassi—certainly so that she might reclaim her honor (see below), but also, it seems, because of positive feelings toward him. Thus she testified that with the promise of marriage Tassi "induced [her] later on to yield lovingly, many times, to his desire," and Orazio himself appears to have made a distinction between the initial intercourse forced upon his virgin daughter—the "deflowering"—and the ensuing carnal relationships between Agostino and Artemisia ("una figliola dell'Oré [Oratore] è stata forzatamente sverginata, e carnalmente conosciuta piu et piu volte da *Agostino Tasso Pittore*").[100] Further, a prison meeting between Agostino and Artemisia is reported to have ended on notes of love.[101]

Yet when Agostino tried to sweet-talk her into recanting her charge and blaming another man, Artemisia—who certainly was wise already to many of the ways of the world—stood firm.[102] Nonetheless, and for all of the indications of Tassi's guilt (to be explored shortly), writers from the seventeenth century to our own day have not been able to resist intimating scandal. Thus Giambattista Passeri, conceding that Artemisia had been raped but questioning whether the rapist had been Tassi, pictures Artemisia as "very good looking and very adroit in capitalizing upon it such that Agostino became infatuated with her," and claims that she "would have been worthy of all respect had she been of a more honorable and honest nature."[103] For Pugliatti, three hundred years later, "it is not clear whether he [Tassi] was guilty or innocent, and in any case the girl seems to have been anything but ingenuous. . . ."[104] The present author once spoke of the "alleged rape" and allowed, uncritically, that Orazio Gentileschi's opening statement that the lovemaking had been repeated "time and time again" could "only have weakened Orazio's accusation and cast doubt on his daughter's character."[105] Especially unpleasant echoes of the reproachful voices of 1612 are heard in the characterizations of Artemisia Gentileschi as "lascivious" and as "so much a part of the louche Caravaggesque drinking and drag scene around the high-living Vatican entourage that the scurrilous epitaph accusing her of loose behavior may well have been more than just jealous gossip."[106]

In point of fact, the evidence is overwhelming that Tassi took Artemisia by force and that this was a traumatic experience for the seventeen-year-old woman. The odds are that the Tribunale Criminale del Governatore would not have heard the case had it reason to believe that Artemisia was a nonvirgin before the commission of the crime being alleged[107] or had it judged that the charges were implausible. Tassi's unsavoriness was already legendary, and he was tossed into Corte Savella even before evidence was collected. He had boasted to his friends of his conquest. Since glaring inconsistencies in his story emerged and some seemingly trustworthy witnesses (among them Giovanni Battista Stiattesi, his wife Porzia, and the friar Pietro Giordano) stood in Artemisia's defense, the authorities were openly scornful of Agostino's professed inculpability, remarking—to cite but one instance—"that the witness [Tassi] dared insist on bearing false witness, in spite of the fact that the Curia knew for certain that the witness had not

only had carnal relations with the said Artemisia more than once but also had raped her with violence and had deflowered her, as it clearly appears from the deposition of the same Artemisia. . . ."[108] Artemisia's torture by a form of thumbscrews was decreed, the transcript records, "in order to remove any mark of infamy and any doubt that might arise against [her] . . . or about the things she had said, from which she could appear to be a partner to the crime, and most of all *to corroborate and strengthen her statement* [italics mine], as well as to all other good ends and results . . ." and in any event was not an exceptional measure.[109] Until recently, the extent and nature of Tassi's punishment, beyond the eight months of imprisonment (from early March to late October) implied by the then available information, were not known. Lapierre's surprising archival discoveries now tell the real story.[110] On November 27, the court rendered a provisional "judgment in favor of Agostino Tassi, painter, imprisoned in the Corte Savella, for presumed defloration and witness [or evidence] tampering, in the criminal process pitting him and Orazio Gentileschi. The excellent and very illustrious Hieronimus Felicius, judge, condemns him to choose between a punishment of five years of hard labor or banishment from Rome. In the event that Agostino Tassi should choose exile, he will swear on the Holy Scriptures not to break that exile under any pretext and never to attempt to wreak vengeance upon Orazio Gentileschi. In the event that Orazio Gentileschi finds himself persecuted by the vengeance of Agostino Tassi, the latter will be sentenced to a fine of 200 scudi. Agostino Tassi will be released today and accompanied to the gates of the city." On the following day, Tassi apparently having made his choice, an amended sentence condemning him to exile for five years was pronounced. Yet the cunning Agostino seems not to have left the city as ordered, and within little more than four months, no doubt through the offices of influential patrons, he had maneuvered a revocation of the ruling. So much for justice!

However deep his concern for the physical and psychological damages suffered by Artemisia, Orazio Gentileschi also construed Tassi's assault on his daughter to be a serious assault upon him as well. In the aforementioned letter of July 3, 1612, to Cristina di Lorena, Orazio made his position clear, following up an account of Agostino's transgressions with an expression of confidence that the Dowager Grand Duchess would "have anguish for such a great attack (*assassinamento*) made on me under pretext of friendship by the most infamous man in the world."[111] Above all else it was this blow to his honor which he simply could not let go unchallenged:

> In honor culture a person's sense of worth lies not in internal virtue—as manifested in good intentions and a guiltless soul—but in the externals of bearing and deed, and in society's appreciation of them. Public respect certifies honor; public ridicule induces shame. Virtue and vice thus exist only when visible to onlookers. Honor is highly vulnerable and men must be vigilant in its defense. I say men deliberately, for, as the code is usually presented, males are responsible for its active implementation. An attack on honor is anything which shows to the audience of society that he cannot protect what is his—his face, his

body, his family, his house, his property. Thus, injury, rape, theft, derision, or defilement all may signify loss of honor and must be revenged with a counter-attack.[112]

Along with Artemisia Gentileschi's virginity, taken against her will, went her honor. Marriage, preferably but not obligatorily to Tassi, could restore her respectability.[113] The young woman acknowledged as much when she told the authorities that "what I was doing with him [Tassi] I did only so that, as he had dishonored me, he would marry me."[114] And there is abundant testimony that Agostino was liberal with promises of marriage,[115] thereby disposing Artemisia to continue the sexual relationship. However, after ten months, when assurances still had not been translated into action and no other honor-saving arrangements had been worked out,[116] the Gentileschi must have anticipated that Tassi would finally make good under judicial pressure. By refusing to recant her accusation, Artemisia continued to hold the trump card. But, as it happened, there were questions as to whether the woman whom Tassi had married about ten years before and left in Tuscany was still alive or, if not, by what manner (a contract let out by Tassi, according to one witness) she had met her death.[117] Presented with this uncertainty in addition to the long list of Agostino's distasteful qualities, Orazio may in the end have concluded that Tassi was too great a risk and in truth too morally objectionable to be his daughter's husband.[118]

Tassi was not the only scoundrel who had stirred in Orazio legitimate animosity and who in besmirching his reputation had to be called to account. Thus, for example, a Cosimo Quorli had deviously come into possession of a painting of *Judith* belonging to, and probably by, Orazio[119]—another instance of Orazio losing control of what was rightfully his. Besides, Quorli had babbled that he, not Orazio, was the father of Artemisia, whom he claimed looked like him.[120]

As if that were not vexation and motivation enough, by 1612 marriage for Artemisia would have emerged as a pressing matter had the Tassi affair never been. Having turned nineteen during the course of the trial, the young woman was fast approaching the age of highly diminished marriage opportunities. The very fact that she had remained unwed for several years after Roman culture would have deemed her sexually mature, more likely than ever to let her female passions rule, and fully ready for a husband would have set tongues wagging. This in turn would have cast doubt on Orazio Gentileschi's ability to control Artemisia, and thus once more put his honor to the test. Surely it was in awareness of such prejudices, and not just to win sympathy for his daughter, that he falsified Artemisia's age in his petition, intentionally understating it by four years.[121]

And another indignity still: If I am correct [X-1], it was about this time that Giovanni Baglione, long Orazio's enemy on the Roman artistic scene, took advantage of the situation by producing a perverse adaptation of Cesare Ripa's *La Pittura* (Fig. 205). Making reference to aspects of the Gentileschian style in general, to Orazio's buxom nudes (e.g., Figs. 210, 211) in particular, and to the woman painter Artemisia, this obscene joke of a picture was intended to vilify the father.

Orazio Gentileschi was therefore compelled to press charges; residing in Baroque Rome, he had no other legitimate options. Perhaps, then, he was not tormented by second thoughts as he looked back at the rancorous proceedings. Still, one need not presume that he remained unmoved as his daughter's now public vulnerability began to be exploited. From a very early moment receptivity to and reliance upon rumor, and then misreadings of the testimony (as it was known in extremely reduced form), distorted the truth, much to Artemisia's personal and professional disadvantage. For as I will attempt to demonstrate, the conception of Artemisia Gentileschi as a woman of dubious rectitude, first provoked above all by the events of 1611–12, was to have an effect on the nature of the commissions she was awarded and upon how her pictures were to be received.

Whether out of trust, sympathy, affection, desire, financial incentive, or any and all of these, Pietro Antonio di Vincenzo Stiattesi (born 1584) wed Artemisia Gentileschi on November 29, 1612, in the Roman church of Santo Spirito in Sassia, one day after Agostino Tassi had been sentenced to exile.[122] The groom, brother of the Giovanni Battista Stiattesi who had corroborated Artemisia's account,[123] and, like him, a Florentine, must have felt that Rome was not a congenial place for these particular newlyweds. In July Orazio had reestablished contact with Florence by means of his letter to Cristina di Lorena, and it is probable that the picture by Artemisia which he offered as a gift to the Dowager Grand Duchess is precisely the *Judith and Her Maidservant* in the Palazzo Pitti. The couple and the canvas may have arrived more or less simultaneously in the Tuscan capital. There Artemisia Gentileschi's art, until then free of sophisticated airs, was to undergo a marked transformation.

II

RECOGNITION, 1613–1620

Florence and Florentinism

North of Rome, away from Agostino Tassi and vindictiveness, far from whispered innuendo and shouted insult, lay the Grand Ducal City of Florence. Artemisia and Pierantonio Stiattesi may have judged to be minimal their chances of living and working in a Roman atmosphere free from harassment. Since on December 10, Pierantonio legally entrusted his brother, the notary Giovanni Battista, with his Roman affairs, it is probable that he and his new wife set off for Florence before the year 1612 was out, although the earliest notice of their presence there is that of the baptism of their first child, a son, on September 21, 1613, in the parish of Santa Maria Novella.[1] This chapter chronicles Artemisia's Florentine years, from her

reception and professional recognition in the Tuscan capital, to the impact of patronage, local tastes, and personal impulses upon the themes, expressive thrust, and style of the pictures she produced there, to the decision to return to Rome.

Reception and Recognition

Ironically, Agostino Tassi had a number of Florentine connections, having previously worked in that city.[2] But this potential complication was insufficient seriously to compromise the other reasons why Florence should be the couple's choice. As noted in the marriage certification, Stiattesi was himself Florentine, and other records signal the existence of Stiattesi family members in the city.[3] Pisan born, and thus a Tuscan, Orazio Gentileschi was proud of identifying himself as "Florentinus" or "Fiorentinus." In Florence Artemisia had relatives also on her father's side, among them her uncle Aurelio Lomi (1556–1622),[4] who as a member of the Accademia del Disegno and supplier of altarpieces for Florentine churches (including Santo Spirito and Santissima Annunziata) was well known there. Indeed, Artemisia seems to have felt that it was in her professional interests to adopt the Lomi surname while in Florence, and she did so almost exclusively, reverting definitively to the Gentileschi name upon her return to Rome.[5] It is doubtful, however, that she likewise used the name Lomi in order to dissociate herself from her father.[6]

Was the decision to relocate to Florence, a city renowned for its support of the arts, also prompted by guaranteed patronage for Artemisia? It has been suggested that her "instant Florentine success is probably to be explained by her arrival as a protégé of a prominent Florentine, Michelangelo Buonarroti the Younger, who was a strong advocate of Artemisia Gentileschi in Florence, and who may have been a close family friend."[7] Observing further that in letters to Buonarroti dated September 7, 1615, and sometime between then and November 13 Artemisia and Pierantonio address him as "*Compare*," scholars have inferred that Michelangelo the Younger served either as Artemisia's godfather or as a witness at her wedding.[8] The evidence evaluated in Appendix II of the present study indicates that neither of these theories is supportable and that, rather, Buonarroti was most likely godfather to one of the Stiattesi children born in Florence.

Michelangelo the Younger's "wholly special friendship"[9] with Artemisia is also thought to be manifested by his generosity in compensating her for the *Allegory of Inclination* in the Casa Buonarroti (Fig. 64; Color Plate VIII), paying the artist for this ceiling canvas an amount judged by several writers to be 34 florins and thus more than three times greater than that received by the painters of the other Personifications in the Galleria. In actuality, Gentileschi's fee for the *Inclination* amounted to 20 florins (still sign of particular favor, but not as startlingly so), and (contrary to what has been asserted) she remained in debt to Buonarroti for the balance.[10]

As a woman painter of exceptional talent, Artemisia was a novelty in Florence and

certainly very conspicuous, and it would have been much to Michelangelo the Younger's fame as an enlightened individual and ultimately to the end of advertising the room dedicated to his great Renaissance forebear to have secured Artemisia's services.[11] But there is no proof prior to August 24, 1615, when he advanced Gentileschi 10 florins for the *Inclination*, that he had done so.

In short, there is no sign from any quarter that while still in Rome Artemisia had obtained promises of support from Buonarroti or even that she received his backing soon after her arrival in Florence.[12] The same conclusions must be reached with regard to Medici patronage of Gentileschi—although once again specific documentation to the contrary is lacking. Orazio had introduced Artemisia to the Florentine court by way of his letter of July 3, 1612, to Cristina di Lorena, and then apparently made good on his offer to present a painting by his daughter to the Dowager Grand Duchess.[13] A prerequisite for this latter action may have been a response on behalf of Cristina, who might have been moved by Orazio's narrative of Tassi's treatment of Artemisia.[14] But it is not until March 16, 1615, in a note from Andrea Cioli, Secretary of State to Grand Duke Cosimo II, to Pietro Guicciardini, Cosimo's Ambassador to Rome, that Medici familiarity with Artemisia's art is confirmed. Writing at Cosimo's behest, Cioli sought verification of Orazio Gentileschi's reported excellence as a painter, being disposed to believe these accounts by "the works that one meets with by his daughter Artemisia, of the same profession."[15]

To this hint that by early 1615 at the latest Artemisia Gentileschi had begun to enjoy Medici patronage may be added others. Thus there is the fascinating proposal that the "sig.ra Artemisia" who sang a gypsy's role in the *Ballo / Delle Zingare* performed at court during Carnevale of 1615 was none other than the painter.[16] The music for this production was composed by a woman, Francesca Caccini. And in Florence Artemisia was in personal contact with dramatists, who sometimes enlisted artists as cast members.[17] More directly to the point, the *Saint Catherine* (Fig. 54) and the *Penitent Magdalen* (Fig. 68; Color Plate VII) were in all likelihood Medici commissions from the first half of Gentileschi's Florentine period. Orders from Cosimo II and his wife Maria Maddalena of Austria were then to consume a significant part of Artemisia's studio time into the year 1620 and her departure for Rome. It was certainly at the Grand Duke's urging, moreover, that Gentileschi was admitted in 1616 to the Accademia del Disegno.[18]

The cumulative thrust of the available evidence therefore intimates that it was not with assurances either from Michelangelo Buonarroti the Younger or the Medici that Artemisia Gentileschi settled in Florence, and that once there she had to come to grips with Florentine artistic tastes and display her skill—perhaps over a period of more than a year—before commanding their patronage.

She was up to the challenge. Her assimilation into Florentine life also seems to have been effected without particular difficulty. As might be expected, Artemisia associated with other creative personalities: with the painter Cristofano Allori, who worked with her in the Galleria Buonarroti and who on November 9, 1615, stood as godfather to her son christened Cristofano;[19] with Jacopo Cicognini, writer of secular and religious

musical drama and festival celebrations,[20] whose wife Lisabella appeared as godmother at the baptism on October 14, 1618, of Gentileschi's daughter Lisabella; with the poet Jacopo di Bernardo Soldani, godfather at this same christening.[21] The church records of other children born to Artemisia and Pierantonio list as godfathers members of venerable Tuscan families—Lorenzo di Vincenzo Cavalcanti on September 21, 1613, for Giambattista, and Cavaliere Anea di Silvio Piccolomini Aragona on August 2, 1617, for Prudenza. Artemisia, in turn, was at least twice designated godmother to newborns named after her;[22] it may be that her presence in Florence inspired the choice of her name for most of the very few Florentine girls christened Artemisia during these years.[23]

Yet the most extraordinary indication in Florence of the persuasiveness of Artemisia Gentileschi's art and person and position is her matriculation into the Accademia del Disegno on July 19, 1616.[24] Although in existence for more than half a century following its founding in 1563 under Medici sanction, the Accademia del Disegno had never inscribed a woman.[25] Whatever the number of close friendships among artists she had cultivated, no matter how distinguished her pictures, and however unique (and in this sense privileged) her situation as a female painter in the city, Artemisia too would no doubt have suffered the same lack of official recognition but for one fact—she enjoyed the support of Grand Duke Cosimo II de'Medici, whose grandfather Cosimo I had authorized the Academy at its inception, who promoted it as an instrument of politics and social control, and who was represented there by a *Luogotenente* serving at his bidding.[26]

On the other hand, the Grand Duke's probable advocacy of Artemisia need not be taken to mean that he insisted that she be entitled to all of the Academy's privileges or that the full range of artistic and intellectual benefits afforded her male colleagues— including Galileo Galilei,[27] with whom she was to correspond on October 9, 1635—was accessible to her. The program of the Accademia del Disegno,[28] intended to mold the liberal artist through a union of practice and theory, led the membership through a prescribed sequence of disciplines, beginning with mathematics and moving progressively through anatomy (complemented by life drawing), natural philosophy,[29] and the study of inanimate objects (drapery foremost among them). Inasmuch as Artemisia's formal education in Rome had been rudimentary at best—four years before her matriculation into the Academy she could not write and could read but little[30]—her ability truly to assimilate the theoretical material almost certainly would have been limited. But did she attend the anatomy lessons held annually for the Academy's profit in the hospital of Santa Maria Nuova? Was she permitted to participate with the other academicians in sketching from the male nude? Tradition has it that women artists were denied formal instruction into this seemingly indispensable activity of life drawing, but it may be unwise to insist that in the second decade of the seventeenth century the Florentine Accademia del Disegno deprived Artemisia Gentileschi of this training. It had not set a precedent for doing so, for with no earlier female members it had never faced this decision.

Nonetheless, with the possible exception of the *Allegory of Inclination* (Fig. 64;

Color Plate VIII)—presumably female models would have been available to Artemisia in her studio[31]—the paintings of Gentileschi's years in Florence do not proclaim study of the nude from life, not even when approached with the recognition that clothed figures as well could gain conviction from such an enterprise.

Patronage Programs and Subject Selection

A survey of Artemisia Gentileschi's professional situation thus accomplished, it is time to confront her Florentine pictures:

Saint Catherine of Alexandria, Florence, Uffizi (Fig. 54; [6]), ca. 1614–15

Female Martyr, New York, Newhouse Galleries, Inc. (Figs. 55–56; Color Plate VI; [7]), ca. 1615

Allegory of Inclination, Florence, Casa Buonarroti (Fig. 64; Color Plate VIII; [8]), documented 1615–16

Penitent Magdalen, Los Angeles, Marc A. Seidner (Fig. 68; Color Plate VII; [9]), ca. 1615–16

Conversion of the Magdalen, Florence, Palazzo Pitti (Figs. 69–70; Color Plate V; [10]), ca. 1617–20

Jael and Sisera, Budapest, Szépmüvészeti Múzeum (Figs. 72–73; [11]), signed and dated 1620

Judith Decapitating Holofernes, Florence, Uffizi (Figs. 77–79; Color Plate XII; [12]), ca. 1620[32]

To these can be added three lost or unidentified paintings:

Diana at Her Bath, inventoried in Florence, Palazzo Pitti, 1619 [L-26]

Hercules, commissioned by Cosimo II de'Medici, 1620, but perhaps not brought to completion [L-39]

Saint Apollonia, Medici Villa Imperiale, by 1625 [L-68][33]

Lest unwarranted conclusions be drawn from this list, two significant qualifications are here introduced. First, logic demands that Artemisia painted pictures at a rate considerably in excess of an average of one per year, and in this case there is a revealing piece of corroborating evidence: in the five months between November 24, 1614, and April 18, 1615, a joiner billed Gentileschi and her husband for seven stretchers which he had fabri-

cated (Fig. 57). The sizes of all of these *telaii* are duly recorded,[34] but it is impossible conclusively to connect any of them to any extant or registered canvas. Secondly, the image of patronage portrayed by the list may be skewed. As will be contended below, no fewer than seven of the ten pictures were for the Medici; but since paintings carried out for the Ducal family are more likely to have remained in the city and/or have come down to us by way of inventories than are those done for other private clients, the impression that seventy percent of Artemisia's artistic efforts in Florence were exerted on behalf of the Medici may be incorrect.

Subject to these stipulations but certainly not without value because of them, the data on Gentileschi's production in Florence prompts certain judgments whose implications extend even beyond Artemisia's Florentine years. To begin: All but one of the pictures present either the isolated female figure or narratives in which women are the protagonists. This pattern is familiar from Artemisia's early years in Rome, and would appear to be consistent with hypotheses regarding the artist's personal involvement with the iconographies of female heroes and, for the *Jael and Sisera* and *Judith Decapitating Holofernes*, most deeply with themes in which women get the better of lustful men.

Considered with reference to specific subjects and to patronage, however, the catalogue of Artemisia Gentileschi's Florentine paintings challenges rather than bolsters these presumptions. Thus, personifying one of the great Michelangelo's attributes, the *Inclination* was assigned to Artemisia by Buonarroti the Younger.[35] The theme of the penitent Magdalen for Gentileschi's two Florentine paintings of that title honors the patron saint of the Grand Duchess Maria Maddalena of Austria.[36] Similarly, the canvas of *Saint Catherine* may be seen as a tribute to Caterina de'Medici, the Grand Duke's sister, who resided in Florence until 1617.[37] Veneration of Saint Apollonia in that city being particularly strong, the existence there of a representation of her needs no wider explanation.

But what of the *Judith Decapitating Holofernes* and the *Jael and Sisera*, the kinds of subjects that have come to be declared quintessentially Artemisian? The former could take a place in the same context as that of the *Biblical Battle Series* by Antonio Tempesta, twenty-four plates etched in 1613 and dedicated to Cosimo II de'Medici. Parallels between the Hebrew conquests and Grand Ducal triumphs were to be drawn, and to this meaning the print of the *Murder of Holofernes* (Fig. 76) adds a comment on women's wiles and a moral lesson on drunkenness. A desire to call up the same associations on a monumental scale may have prompted Cosimo II to order Gentileschi's picture. Besides being, like Judith, a standard part of the fashionable Fatal Power of Women topos (see Fig. 71), the story of Jael and Sisera was to enjoy uncommon popularity in Florentine art following Ludovico Cigoli's canvas of ca. 1595–96 (Fig. 74), a picture which to all indications whetted the very Florentine appetite for a diet of this theme that Artemisia was called upon to help satisfy. Conceivably—although one cannot insist upon this—the courageous Jael was to serve as a positive model in allusion to the Grand Duchess, who between 1623 and 1625, Cosimo II having died in 1621, was to see her new Sala dell'Udienza in the Medici Villa del Poggio Imperiale decorated with ten lunette frescoes

of queens and holy empresses and four large canvases (Rutilio Manetti, *Sophonisba*, Fig. 128; Francesco Rustici, *Lucretia*; Francesco Curradi, *Artemisia*; Matteo Rosselli, *Semiramis*) representing "women of antiquity celebrated for moral and civic virtues."[38]

Were one to conclude that Gentileschi's *Hercules* was to recount the tale of Hercules and Omphale, then a case tying this painting to Artemisia's presumed personal preferences might be made, but nothing in the documents permits this identification. Rather, one can be virtually certain that the painting was to show the ancient hero either at rest—a *Hercules at the Crossroads*—or engaged in one of his labors—that is, Hercules, in allusion to rulership, signifying various princely attributes and carrying a complex of political meaning. Pointed references to the Medici Grand Duke in particular could hardly have been missed; one might have thought above all of the marble Hercules groups by Vincenzo de'Rossi and others in the Sala dei Cinquecento in the Palazzo Vecchio, set there on the baptismal day of Cosimo II de'Medici in the spring of 1592 but originally intended for a gigantic *Fountain of the Twelve Labors of Hercules* celebrating Cosimo I, the scheme of which Ferdinando I de'Medici, Cosimo II's father, had revived.[39]

Of the pictures on the above list, only the *Female Martyr* and the *Diana at Her Bath* appear to stand apart from such thematic imperatives. In fact, the *Female Martyr*, being beyond much question a self-portrait, must have held intimate meaning for Artemisia, and the small size of the panel suggests an equally private function. As for the *Diana*, no specific explanation as to why the subject might have been selected presents itself—beyond that of the Baroque craving for representations of female nudes. Yet the choice even of that theme might have been that of the Medici, who owned the painting by 1619.

Thus with good probability seven of the ten known pictures from Artemisia's Florentine years were Medici commissions, and an eighth was for the Casa Buonarroti. If this is correct, then except for the *Female Martyr* and the *Jael and Sisera*, the patrons can be specified, and except for the *Female Martyr* and the *Diana* the subjects can reasonably be linked to definable patronage requirements. It may be that Cosimo II and Michelangelo Buonarroti the Younger believed that as a woman Artemisia Gentileschi was ideally positioned to take on themes in which women are featured. Surely they did not leave the choice of subjects up to her, did not allow the artist to determine out of subjective requisites precisely what she painted for them.

Roman Training, Florentine Tradition, and Again the Question of Private Motivations

Once presented with the themes, did Artemisia, consciously or not, make interpretive and stylistic judgments which indicate individual predilections? She certainly surveyed the situation in which she found herself. Did she shape her paintings accordingly?

25

Consideration of these issues might begin with the most ambitious, spectacular, and, from a critical standpoint, the most complex among the works actually painted by Artemisia in Florence—the so-called *Penitent Magdalen* in the Palazzo Pitti (Figs. 69–70; Color Plate V), datable ca. 1617–20 and thus during the second half of the artist's Florentine stay. Like the *Susanna* from Gentileschi's Roman years, it can serve as the core around which an image of a major period in the artist's career can be shaped. Scholarly discussion of the *Magdalen* has been marked by a compulsion to find in it autobiographical and feminist significance or by the seeming need to declare the picture disappointing or unsuccessful when such meaning is not discerned. Judgments as to the content of the painting have sometimes been based to an undue degree upon the inscription at the right, *OPTIMAM PARTEM ELEGIT*. At the same time, the place of the canvas in the wider contexts of patronage and artistic climate has not received concentrated attention.

But before any interpretive jumps or art-historical pronouncements can be made, the *Magdalen* should be declared a dazzling display of the craft of painting. The golden-yellow dress, rendered with stirring confidence, is set between the deep maroon of the velvet chair back and the deep green of the table tapestry. The action of light over mirrored, lustrous, creamy, or matte surfaces, and the shadows, transparent in drapery folds, engulfing in the ambient, are uncannily true. Lavishing extraordinary attention upon every aspect of the picture, Artemisia, now in her mid-twenties, appears to have intended the work as testament to artistic maturity fully achieved. It should also be recognized that contentually the emphasis in the picture is upon conversion from faithlessness to belief, not upon expiation. The young woman, rejecting the vain and profane life attested by the skull, costly garb, coiffeur, and mirrored jewelry box, grasps her breast as she pushes aside and turns away from the looking glass to lift her eyes Heavenward. The death's head, which in Gentileschi's somewhat earlier and more austere *Magdalen* now in Los Angeles (Fig. 68; Color Plate VII) is the instrument of the saint's penitential exercises, still lurks in the shadows. The Magdalen's reddened eyes and tear-stained cheeks can therefore be taken to proclaim a newfound joy that overwhelms as much as to signify contrition for sins committed.[40] Her past life of luxury and fleshly pursuits is recalled; her future life of piety is called forth. The picture thus interpreted, the "opulence of her rose-pearl shoulders and heavy gold gown" are not "irrelevant";[41] nor is the "barely repressed sensuality" to be judged an element that undermines meaning.[42] Nor, then, need there be a conflict between the canvas as a gorgeous object and a carrier of religious meaning.

Whether that meaning as conveyed here is regarded as profound or not, it is consistent with conventional iconography. Is the picture, at the same time, reflective of Artemisia Gentileschi's own life and state of mind? Garrard, reviewing the Magdalen legend, terms Mary "a rather confusing female model . . . with little to inspire a woman,"[43] thereby interjecting feminist concerns into a painting whose message would surely not have sent mixed signals to the woman for whom it was apparently designed, Maria Maddalena of Austria. Then, as if to rescue the Pitti *Magdalen*—and Artemisia—from

that body of opinion which finds it to be singularly without "feminist expression," she posits that the saint's "sanctioned, transforming meditation could be seen to carry women to an intellectual and spiritual plane normally occupied only by men."[44] Another scholar, wishing as well to view Gentileschi as sustaining here the image of the female hero, describes the saint as being of "heroic proportions."[45] In the end, however, the painting is deemed to be "perhaps not among her most successful in psychological terms" and of an "overdramatization that lacks credibility," and its creator is seen as "overstating the case in dramatic terms," "not being temperamentally attracted to a heroine of the contemplative life," and having the "need to identify personally with her characters in order to bring them to life."[46]

The *Magdalen* has been personalized further still, having been called a "kind of self-portrait" and a self-portrait.[47] And, holding that the picture "is probably allusive to [Artemisia's] own life," another writer proposes that "the attitude and gesture of the Magdalen, criticized for excessive emphasis . . . seem instead fully respondent to the act of self-questioning on the part of the artist regarding her destiny as a woman. And who is to say that the love-hate entertained by the painter for her seducer was not the cause of her perplexity, of her doubt as a woman divided between two opposing passions? It is not to be excluded that the painter wished to portray herself in the Magdalen, identifying herself with the 'Mary who selected the better part,' meaning the dictates of her conscience as a woman rather that the formalisms of traditional morality. The evidence of the inscription on the frame of the mirror, [the mirror] a symbol of vanity, could be a clear message of a programmatic intent of life and of action."[48] In a similar vein, and with the words from Luke 10:42 cited once again, Gentileschi is viewed as having selected the path of "faith in her own talent for a career as a professional artist, where professionalism resides also in practicing well one's craft, rather than giving in to the uncertain enticements of passion."[49] According to a different reading, and apparently with reference to the psychological damage inflicted on Artemisia by Agostino Tassi, one can detect in the Magdalen "a lingering psychic resistance to submission, even submission to Christ" at the point "when the critical issue is posed, and when, between virtue and vice, she seems to contemplate the futility for her of both."[50]

In my opinion, the imagery of the Pitti *Magdalen* (and this includes the action of Mary's left arm which, rather than being a rhetorical gesture bordering on the melodramatic, is that of rejecting worldly vanity as epitomized by the mirrored jewelry box) is not ambiguous. The ambiguity results, rather, from viewing the visual evidence through the lens of preconceived notions of what one hopes or expects to find in a painting by Artemisia Gentileschi. Further, the phrase OPTIMAM PARTEM ELEGIT, while reinforcing the message of the Magdalen as having chosen the better way of the spiritual life, is in all probability a gloss added to the canvas by a later hand, one responsible as well for the showy signature.[51] If the inscriptions were not part of Artemisia's conception, those proposals that imply a link between the signature and the Biblical quotation, and therefore couple Artemisia Gentileschi and Mary Magdalen, lose much of their power to convince.

The suspicion arises that it has proved difficult to take the *Magdalen* for what it actually seems to be also because of its sentiment—excessively, even hypocritically, pietistic, it might be thought. No doubt many would be inclined to level the same charges against the several other Florentine paintings and theatrical performances which took Mary Magdalen as their theme in explicit honor of the Grand Duchess Maria Maddalena and her patron saint.[52] Among these, none better conveys how it was that the "Santa Granduchessa" wished to bear witness to the depth of her faith than Justus Susterman's *Maria Maddalena of Austria as Saint Mary Magdalen* in the Uffizi, executed between 1619 and 1631.[53] Artemisia's *Magdalen* in the Palazzo Pitti, questionably interpreted with regard to the artist's biography, is clearly illuminated by what is known of the devotional fervor of Cosimo II's wife.[54] Concurrently, the beauty of the picture would have suited well its regal destination.[55] The Medici court, like the Magdalen, must have experienced a tension between luxury and piety, but Gentileschi's painting leaves no uncertainty as to which alternative the saint and, one was to believe, the saint's namesake, embraced.

The sentiment of Artemisia's *Magdalen* must also figure in any assessment of how and to what extent the picture responded to the artistic culture in the midst of which it was created. The attention to emphatic gestures and pronounced facial expression as external manifestations of the soul's stirrings has been associated with the concept of *affetti* in general[56] and with Florentine Baroque management of *affetti* in particular.[57] Indeed, concern with emotional states has been identified as the single most salient attribute of art produced in seventeenth-century Florence.[58] As regards specifically the theme of the Magdalen as interpreted in that city, the authority of Giorgio Vasari's appreciation of Titian's *Magdalen* for Philip II has been invoked.[59] In this passage the Aretine author speaks of the saint, hair cascading over her neck, shoulders, and breast, as shedding tears of sorrow, her remorse-reddened eyes raised toward Heaven, such as deeply to move the observer.[60] Remarking too on the extreme loveliness of the Magdalen, Vasari maintains that this physical beauty inspires spiritual, not lascivious, thoughts. Of Florentine pictures of the Early Baroque, Cristofano Allori's *Saint Mary Magdalen in the Desert* in the Palazzo Pitti (Fig. 65) is among the most memorable, and in many respects accords well with Vasari's account, with what is known of Titian's lost canvas for Spain and copies and variants of it, and with the related *Magdalen*s painted by the Venetian master.[61] Allori's image, as Titian's, was much admired, and in 1612 an autograph version of the Pitti composition (or so it is generally thought) was presented by Cosimo II to Enea Piccolomini of Siena. As noted, Allori, one of the contributors with Artemisia to the Galleria in the Casa Buonarroti, was designated godfather to Artemisia's son Cristofano on November 9, 1615, while on August 2, 1617, Cavaliere Anea di Silvio Piccolomini Aragona (the same noble recipient of Allori's canvas?) stood as godfather to Gentileschi's daughter Prudenza. The particular relevance of each of these prototypes and circumstances to Artemisia Gentileschi's *Magdalen* in the Palazzo Pitti cannot now be specified, but some of them must have played a role in the conception of the picture, a conception clearly in tune with Florentine attitudes. Yet if the kind of pietistic ardor typified by Allori's *Magdalen* helped guide Artemisia, she refrained from appropriating its overt

eroticism. In Gentileschi's case, the Medici may have designated a *Conversion of the Magdalen*, a moment in the saint's legend which, unlike that of the penitent in the wilderness, does not provide a ready excuse for a display of female flesh but encourages merely intimations of the voluptuous life. The principle of decorum would likewise have dictated reasonable modesty in a work befitting the Grand Duchess. Artemisia's measured approach to sensuality in the Pitti *Magdalen* might also represent her conscious decision not to capitulate to contrary forces[62]—an instance, in other words, where claims for Artemisia as having taken an adamant individual stance can muster especially persuasive evidence.

In designing the gown sported by her figure, however, Artemisia exercised no such restraint. This sumptuous garment, elaborately arranged and scintillating with highlights, while not unsuited to meaning, puts on a show of decorativeness and refinement. In considering these features with reference to Florentine art, scholars have reached different conclusions. On the one hand, to cite representative opinions, the display of fabrics and accessories in Artemisia's *Magdalen* has been regarded as having been consequential for the painters of Florence,[63] as has its exquisite color of gold, green, and red,[64] while Gentileschi's *Judith and Her Maidservant* (Fig. 31; Color Plate IV) has been deemed influential in particular upon Cristofano Allori's rendition of the theme (Fig. 67).[65] For others, on the contrary, the "precious effects," "elegant stuffs," and "refined esthetic"[66] of the *Magdalen* were inspired by traditional Florentine concerns. Thus it is, too, that Allori's famous *Judith* is seen from this perspective as of potential significance *for* Artemisia's version.[67]

There may be ways of reconciling these opposing viewpoints. That much Florentine art is distinguished by a flair for the opulent is incontrovertible and needs little demonstration. It might suffice to indicate that in sheer audacity the show of brocades, embroideries, fringes, and lace that is Ludovico Cigoli's *Joseph and Potiphar's Wife* in the Galleria Borghese at Rome[68] far surpasses Gentileschi's *Magdalen*. Signed and dated 1610, Cigoli's canvas was acquired by Scipione Borghese at or near the time that Orazio Gentileschi was working in that same Cardinal's garden Casino of the Muses. Its importance for subsequent Florentine art, including that of Cigoli's student Giovanni Bilivert, who returned to Florence from Rome approximately five years before Artemisia's arrival in the Tuscan capital and was to work with Artemisia in the Casa Buonarroti, is uncontested.

Luxuriousness also characterizes one of the most prized of all Florentine Baroque pictures, the previously mentioned *Judith and Her Maidservant* by Cristofano Allori (Fig. 67). What is the connection, if any, between Allori's eye-catching painting (its heroine dressed in a golden brocaded gown and red mantle against the green of a tasseled cushion) and Gentileschi's canvas (Fig. 31; Color Plate IV)? In disagreement with prevailing opinion, which holds that Artemisia's *Judith* was painted in Florence, I believe[69] that it was executed in Rome about 1612 and sent or taken to Florence, being the gift promised to Cristina di Lorena by Orazio Gentileschi in that year. If so, art in Florence, and Allori's *Judith* specifically, could not have influenced Artemisia's image. Rather, Artemisia's fondness for complex draperies and other ornamental effects would have been nur-

tured by the pictures of her father, including by the prototypes for her Pitti *Judith*, versions by Orazio of the theme of Judith with her maidservant (Figs. 39, 40). Equally as instructive, the initial conception of Cristofano's *Judith* may fall within the years 1610 and 1612 and thus predate Artemisia's work.[70] Finally, it has been suggested that the qualities of light and surface displayed by Allori's picture owe something to that "most 'Tuscan'" of Caravaggio's followers, Orazio Gentileschi.[71]

The following solution to this part of the puzzle is therefore proposed (in full recognition of its complexity): Artemisia Gentileschi arrived in Florence predisposed, by virtue of the instruction and example of her father and her own practice, to the decorativeness and attention to clarity of line of much Florentine art, which in turn helped determine, along with Artemisia's assessment of patronage tastes and, conceivably, a brief appearance of Orazio Gentileschi in Florence in 1616,[72] the course her own painting in the city was to take. And as her clients were destined to be receptive, so also might Florentine painters have found in Gentileschi's works reinforcement of their traditional position.

Yet in opting for decorative effects, Artemisia did not abandon in the *Magdalen* the "sensational naturalism"[73] of her Caravaggesque beginnings, the potential implications of which for art in Florence must now be explored. The rich and varied materials in the Pitti canvas utterly convince in an emphatic texture-and-form-defining light. Sharp and directional, this illumination is not the Leonardo/Correggio-inspired *sfumato* which, soon to be a trademark of Florentine Baroque painting (as in Vignali, Dolci, and Furini), gives an unearthly softness—that ubiquitous *morbidezza*—to form and sentiment and which had already begun to assert itself in Cristofano Allori's *Magdalen* (Fig. 65) and his *Saint John the Baptist in the Desert*, also in the Palazzo Pitti. The *Saint John* of about 1612 has been termed Allori's "response to the [different] language of the Caravaggeschi" in which, "as in the *Judith*, Cristofano chooses an elegant solution between extreme realism and classicizing idealism."[74] Although markedly assertive as works of art, Allori's mature pictures are not designed to enter into association with reality as it might possibly be experienced.[75] Artemisia Gentileschi's *Magdalen*, for all its refinements, aspires to be a living presence.

It is, however, possible to exaggerate the extent to which this incisive realism and the oblique light which gives it such concreteness would have amazed Florentine artists at the time, even those who had not been to Rome, and to lose objectivity in supposing that these aspects of Gentileschi's work would have made an immediate impact. Florentine art was not in need of external salvation from the *Maniera*, having experienced the "reforms" of the likes of Santi di Tito, who had come to believe that "before art is a vehicle of style, it must be an efficient mimesis, legible in form and explicit in content,"[76] and Ludovico Cardi, Il Cigoli, creator of pictures of extroverted emotion, penetrating observation, and rich *chiaroscuro* (Fig. 74). Francesco Curradi's *Saint Lawrence* of 1608 in Santa Maria Maddalena de'Pazzi (Fig. 66) yields nothing in verity and tangibility to Artemisia's *Magdalen*, although it precedes it by as much as a decade and was itself preceded in 1600 by Gregorio Pagani's *Saint Lawrence* in the Madonna delle Grazie at San Giovanni Valdarno.[77] Of the latter it has been said: "The new element, exemplary

for the succeeding generation, is adherence to the model and the marvellous 'presence' of the figure, which seems to emerge from the frame."[78]

Moreover, of the preserved Florentine pictures by Artemisia Gentileschi, it is the *Magdalen* which is the most pictorially aggressive, as if in compensation for the otherworldly focus of the saint's thoughts. The other canvases of this period are further removed in character from what she had created in Rome. There, during the first few years of her career, she had come forth with the authentic passion of the *Susanna*, the *Lucretia*, and the Naples *Judith*, with the genuine humanity of the Pitti *Judith* (Figs. 10, 19, 21, 31; Color Plates I, III, II, IV)—robust pictures with no idealization to distance them from the observer. In Florence a conscious sophistication, a Florentinism, enters Artemisia's art, as Caravaggism is attenuated to produce the dreaminess and delicacy of the *Female Martyr* and the Seidner *Penitent Magdalen*, the remoteness of the *Saint Catherine*, the startling detachment of the *Jael and Sisera* (Figs. 56, 68, 54, 73; Color Plates VI, VII).[79]

Then there is the *Allegory of Inclination* of 1615–16 for the Galleria in the Casa Buonarroti (Fig. 64; Color Plate VIII). This canvas has become a focal point of opinion concerning Gentileschi's importance for Florentine painting, in that it is precisely dated and belongs to a ceiling complex which engaged fourteen artists in all. For a picture of a single figure, one-third of which is covered by drapery that did not come from Artemisia's brush, this is a great burden to bear. Scholars have singled out Sigismondo Coccapani's *Michelangelo Crowned by the Arts* (Fig. 61) and Giovan Battisa Guidoni's *Pietà cristiana* (Fig. 62) as being indebted to Artemisia's *Inclination*, speaking of the lucidity of the figures wherein palpable light plays over polished, marmoreal surfaces to produce pearly reflections and endow form with solidity and volume.[80] Yet Coccapani's picture is so quintessentially Coccapani—inflated draperies and flesh, differentiation of textures that is for the most part illusory rather than concrete in keeping with the rarefied world conjured up by the artist, geometrized physiognomies, ornamentality—that the would-be influence of Artemisia Gentileschi is hardly self-evident.[81] And the style of Guidoni's contribution is in essence that of his teacher, Coccapani. If the authority of Artemisia's *Inclination* was in fact exerted on the Personifications of Casa Buonarroti, it might best be seen in Zanobi Rosi's *Lo Studio* (Fig. 63) of 1617–20, with its special sensitivity to caressing light and its romantic flavor.[82] With justification, then, the notion of a "shared Florentine style," in part responsive to the need for stylistic uniformity in the ensemble, has been introduced, a style which Artemisia may have helped sustain but which does not mark her as the moving force.[83]

Since only a portion of Artemisia's Florentine production has survived, we do not see what her contemporaries saw.[84] What we do have indicates that between 1613 and 1620 the art of Artemisia Gentileschi was more touched by Florentine painting than Florentine painting at the time was by Gentileschi's manner.[85] Artemisia was on new turf, and surveying her surroundings she took the decision to adapt her art to them[86] by moderating in various ways her Caravaggesque beginnings.

The above overview of Gentileschi's period in Florence, besides offering a partial explanation for the nature of that achievement, contains lessons which analyses of later

developments in Artemisia's art should bear in mind. It underscores the need for caution (already addressed in Chapter 1) in attributing aspects of Gentileschi's pictures to personal imperatives and, concomitantly, the need to evaluate the roles of patronage and other external factors, insofar as these may now be recovered. The foregoing demonstrates as well that within five years of its emergence, Artemisia's art began to be fashioned by an artistic mode other than that in which the painter had been trained. Early on, then, Artemisia Gentileschi showed herself to be flexible and receptive to the efforts of others.

Certainly it was the undiscerning, unwise, or arrogant artist who in the seventeenth century remained oblivious to the expressive and esthetic qualities likely to be favored by his or her clients. Many will judge, however, that as regards specifically her time in Florence, Artemisia's adaptability compromised the power of her pictures. Additionally, there is the intriguing possibility that Gentileschi might have misread the situation. Prompting this suggestion is the fact that between 1617 and 1620 Cosimo II, assuming a broad-minded stance, showed an interest in full-strength Caravaggism, to the point of importing it into Florence.[87] Thus on April 16, 1617, Cosimo II's Ambassador in Rome (from 1611 to 1621), Pietro Guicciardini, authorized payment to Bartolomeo Cavarozzi "in esecuzione d'un ordine" which Andrea Cioli, acting on Cosimo's behalf, had transmitted to him by way of a letter of February 14.[88] It may be that Cavarozzi's splendid *Saint Jerome with Two Angels* in the Palazzo Pitti, which came from the Medici Collections, is to be related to this payment.[89] In 1618 the Neapolitan master Giovanni Battista Caracciolo spent several months in the city upon the invitation of the Grand Duke, and left paintings there, including (according to a document of October 9, 1618) portraits of Cosimo II and Maria Maddalena of Austria.[90] By 1620 four canvases by the Roman-based Bartolomeo Manfredi had entered the Grand Ducal Collection.[91] From September and October 1620 date other letters between Andrea Cioli and Piero Guicciardini concerning six pictures by Gerrit van Honthorst for sale there; at least some of the paintings by the Dutch master in Florence today must have formed part of this group.[92] Between October 8, 1619, and April 9, 1620, the Ambassador had paid Honthorst for his part (*Adoration of the Shepherds*, Uffizi) in the pictorial embellishment of the Guicciardini family chapel in Santa Felicita at Florence, having already ordered on September 17 of that year altarpieces of identical sizes from Giovanni Antonio Galli, Lo Spadarino, and Francesco Boneri or Buoneri (Cecco del Caravaggio; *Resurrection*, Chicago, Art Institute).[93] While Artemisia had left Florence before the negotiations for Honthorst's easel pictures were undertaken, and before the large Santa Felicita works were set in place, she might possibly have known of the interest which had motivated these dealings. She certainly was aware of the presence in Florence of Caracciolo, who in 1614 had come into contact with Orazio Gentileschi in Rome.

Perhaps Artemisia came to these understandings after her commitment to modifying her Roman manner was not easily abandoned. It also seems to say something about ingrained Florentine attitudes and about the guardedness of the city's painters in the face of Caravaggism that by October 18, 1620, Guicciardini, not satisfied with Cecco del

Caravaggio's magnificent *Resurrection*, an unyielding picture if there ever was one, had disposed of it, and that it was not until the third and fourth decades that native artists—at least those who had visited Rome—were notably inspired by the Caravaggesque movement,[94] which in other parts of Italy was on the defensive.

Finances, Family, and the Departure from Florence

Early in 1620 Artemisia Gentileschi set in motion plans to return to Rome. Her decision to leave Florence was driven by a complex of factors to which she alludes in a letter of February 10, 1620 (New Style), to Cosimo II: "So that Your Very Serene Highness will not be offended by [or 'kept in the dark regarding'? *Acciò non sia di ombra a V. A. S.*] the short trip to Rome that I have resolved to take, I wanted to inform Your Very Serene Highness of it with this letter. My being on the move has been the cause of many of my past indispositions, to which are to be added not a few pains for my home and family. In order to recover from these various troubles, I will spend a few months there with my own people. . . ." Artemisia was not exaggerating her misfortune so as falsely to create a sense of urgency and thereby obtain the Grand Duke's blessing. Her personal difficulties and setbacks had in fact been many, were often severe, and had come at her from all angles. Whether in sapping some of her energies they had an effect upon the vitality of her Florentine works is a highly speculative matter. The troubles are worth detailing, however,[95] for they give the measure of Gentileschi's toughness and perhaps help explain why it was that by the spring of 1623 she and Pierantonio Stiattesi had parted company, leaving her freer to direct her life.

Bills piling up, Artemisia was beset by creditors, among them a joiner (Fig. 57), a druggist (Fig. 53), a confectioner, and a tailor.[96] Although her debts to artisans and shopkeepers are not documented until after she had matriculated in and therefore was represented by the Accademia del Disegno (which heard the creditors' petitions, took appropriate action, recorded the decisions, and preserved the invoices), it is certain that even before 1616 Artemisia was vexed by money problems. Thus in late 1615 she begged Michelangelo Buonarroti for advances on her fee for the *Inclination* and for loans; a year later, the ceiling canvas finished, she still owed him money.[97] Buonarroti's generosity suggests compassion for Gentileschi's straits. One learns also of a complaint—another financial one?—lodged by a Francesco Lomi.[98]

Apparently the money was being spent faster than it was being earned, although Artemisia does not seem to have wanted for work or to have been a particularly poor businesswoman. But she did not have exclusive control over the family funds, and her husband—whose profession as a painter appears to have yielded little or no profit—served the cause badly. On June 5, 1619, a letter addressed by Gentileschi to Cosimo II was brought before the Council of the Accademia del Disegno. In it the painter asks the Grand Duke's intervention in a judgment brought against her by the Academy for debts

run up by Pierantonio to a *bottegaio*. Arguing that "as a woman she could not incur debts while her husband was still with said woman," Artemisia lamented that Stiattesi had already helped himself to her dowry and had kept her ignorant of his spending.

Every florin would have helped, for between September of 1613 and October of 1618, Artemisia had given birth to two boys and two girls.[99] No baptismal records for Gentileschi children in the years 1614, 1616, and 1619 have been found, but there could have been other pregnancies, and periods of confinement or of limited capacity to work might be expected.[100] And yet by the Lenten season of 1621 only one child had survived.[101] The cost of burials had to be borne. The grief of losing so many so fast must have been the greatest burden of all.

Following through on her resolve, Artemisia returned with what was left of the family to Rome. Even as in that city Honthorst, Cecco, and Spadarino worked on their canvases for the Guicciardini Chapel, Artemisia Gentileschi was engaged on what was probably her last commission from Grand Duke Cosimo II, the *Judith Decapitating Holofernes* (Figs. 77–79; Color Plate XII). Back home, drawing upon her earlier composition (Fig. 21; Color Plate II), and perhaps emboldened now by knowledge of the Santa Felicita project, Artemisia created for the Medici a painting in which the fire returned.

III

ROME AND VENICE, 1620–1628

From Reassertion to Reassessment

There was determination in Artemisia Gentileschi's words when on February 10, 1620, she told Cosimo II of her need to return to Rome. There were also professional obligations in Florence that had to be honored, among them a *Hercules* [L-39] for the Grand Duke (Artemisia promised to finish it within two months) and probably still the *Jael and Sisera* (Figs. 72–73). Apparently Cosimo empathized with the painter's adversity and sensed the strength of her resolve, for five days after Gentileschi's letter to him he ordered the restitution of some household goods which had been confiscated from Artemisia as collateral for some ultramarine that she had received in connection with the *Hercules*.[1] He may also have ordered the

Judith Decapitating Holofernes (Figs. 77–79; Color Plate XII) at this moment. Staying together for the time being, the family was gathering its possessions preparatory to departure.

The Return to Rome, and Other Travels

When, exactly, Artemisia, Pierantonio, and Prudentia quit Florence is not known, but it may not have been very long after all this activity. The inscription formerly on the reverse of Artemisia's *Portrait of a Condottiere* (Figs. 81–82)—"ARTEMISIA. GĒTILESCA. FA =/ CIEBAT ROMAE *1622*"—has been featured as the earliest notice of Gentileschi's reentry into Rome, and its accuracy is confirmed by the Roman census from Lent of 1622, which places the family on Via del Corso.[2] It can now be reported that the Gentileschi-Stiattesi are documented on that same street in March of 1621.[3] Their absence from the parish register of 1620 does not necessarily signify their presence elsewhere in that year, however: Artemisia and her husband may not have arrived in Rome before Easter, that is until after the yearly tally of souls had been compiled; or if, as her note to Cosimo states, Artemisia intended to remain in the city of her birth for "some months" only, she and her husband would not have been disposed to secure permanent quarters, in which case they might have stayed with Orazio Gentileschi and his sons in a yet-to-be-located apartment; or, as another alternative, the family may at first have settled in another parish, the census records of which remain to be consulted.

Still, there is an undocumented gap of a year, and this might continue to encourage theories as to the painter's whereabouts (other than in Rome) for most of 1620 and into 1621—in spite of the fact that it is inherently unlikely, given her insistence that she had to spend time "with my own people," that Artemisia would have again packed traveling bags soon after she left Florence.

Mostly for obvious reasons, it is essential that Gentileschi's travels be charted as precisely as possible: matters of dating and attribution, of artistic interchange, of the routes by which Artemisia established patronage connections, and of how her art was received, are best examined against this framework. Regarding this, Artemisia's purported trip to northern Italy at the beginning of the third decade stands as the prime object lesson, and for misjudgments on this issue the present author must bear principal responsibility.[4] Assigning to Artemisia Gentileschi the *Lucretia* (Figs. 18–19; Color Plate III) and the *Cleopatra* (Fig. 211), and noting the presence of these canvases in a Genoese collection as early as 1780,[5] I inferred that they were painted in the North Italian port. Although aware that in her letter of January 30, 1649, to Don Antonio Ruffo Gentileschi did not mention Genoa as among the cities in which she had worked, I found ways of mitigating that objection and of placing the artist there in 1621. Thus Soprani's claim that the nobleman Giovan Antonio Sauli invited Orazio Gentileschi to Genoa was given credence by the knowledge that before Gregory XV assumed the papacy on February 9,

1621, Antonio Maria Sauli, Archbishop of Genoa, had been a major candidate and Giovan Antonio had come to Rome for the papal balloting.[6] It did not seem illogical, then, to imagine that Artemisia (thought to have jettisoned Stiattesi by this point) accompanied her father to Genoa, or to declare Orazio Gentileschi's *Annunciation* now in San Siro at Genoa the prototype for his daughter's painting of the theme (Fig. 114). Furthermore, in 1617 Orazio had written to Don Giovanni de'Medici, then in the employ of the Republic of Venice, in an effort to secure work in the Palazzo de'Dogi.[7] Since, as well, paintings by Artemisia were known to have been in Venice by 1627, I posited that Artemisia made the trip north with the expectation of patronage from this son of her former protector, Grand Duke Cosimo II.[8]

Most scholars have favored without question this proposed reconstruction of Artemisia's situation around 1621.[9] Recently, however, the lack of direct documentation has been invoked as grounds for caution in accepting the theory of a stay by Artemisia in Genoa, while leaving unchallenged the attribution and dating of the *Lucretia* and *Cleopatra*, which according to the modified position could have been shipped from Rome to Genoa.[10]

As painful as it is to admit that even the best logic may be fatally flawed, I must now insist upon a complete dismantling of my hard-won hypothesis, for the following reasons and assessments: Artemisia, husband, and child, with servants, were in Rome in March of 1621; the *Cleopatra* is by Orazio Gentileschi and was executed about 1611–12; the *Lucretia*, while being the work of Artemisia, is to be set in that same period; and both the *Cleopatra* and the *Lucretia* had arrived in Genoa long before Orazio's appearance there.

In addition, it is here argued (see [24]) that Artemisia's *Annunciation* of 1630 was inspired not by Orazio's Genoese painting but rather by those works which informed her father's conception—that is, by Florentine interpretations of the Annunciation theme, with which toward the end of the third decade Artemisia had become reacquainted. Only by postulating this second visit by Gentileschi to Florence can one plausibly explain above all the almost certain influence of Rutilio Manetti upon specific pictures by Gentileschi from the early 1630s[11] and of Tuscan painting in general upon the direction which Artemisia's art took in those first Neapolitan years.

And it was Artemisia's trip from Rome to Venice in 1627 and/or the return journey in 1628/29 that could have provided the occasion(s) for a stop (or stops) in Florence.[12] By Lent of 1623 Pierantonio Stiattesi was no longer at the Via del Corso address,[13] and with his departure the idea of traveling again may have seemed to Gentileschi more feasible. Yet her presence in Rome from that point and into 1627 is attested by the census records and by the inscription on Jérôme David's engraving of (part of?) Gentileschi's *Portrait of Antoine de Ville* (Fig. 102), first published in 1628 but claiming to figure the *condottiere* as he looked in 1627. There being no evidence to the contrary, it would appear that the painted portrait was completed in 1627 and in Rome. However, 1627 was also the year of an unsigned pamphlet printed in Venice which contains verses dedicated to three paintings by Artemisia Gentileschi, one of them in the Venetian collection of Jacomo Pighetti

37

and another headlined "Opera della Sig. Artemisia Gentileschi / Pittrice Romana in Venetia" ([L-1], [L-54], and [L-105]). That the canvases so lauded were painted in that city in 1627,[14] and not during some earlier moment, is intimated as well by a notice which has been overlooked in the Gentileschi literature, a payment of 1628 to Artemisia, *then in Venice*, for a *Hercules and Omphale* she was painting for King Philip IV of Spain, and by encomia to Artemisia contained in Antonio Colluraffi's *Lettere*, published in Venice in 1627.[15]

Acting as intermediary in this transaction was Philip's Ambassador to the Holy See, the Conde de Oñate. Then in July of 1629 a former Spanish Ambassador to Rome and collector of Artemisia's pictures, the Duque de Alcalá, became Viceroy of Naples. Surely it is not coincidental that by 1630 Artemisia Gentileschi, after perhaps only a brief return to Rome, had established a studio in that vital southern Italian city, where but for a trip to England she was to work for the remainder of her life.

Critical Reception: Artist and Individual

During her earlier years in Florence, Artemisia seems to have been supported by a relatively small group of illustrious local connoisseurs. During the 1620s her patronage network expanded, her paintings became widely praised, and her identities as a woman and a woman painter became subjects of ever greater fascination. Of this, Jérôme David's engraved *Portrait of Artemisia Gentileschi* (Fig. 101), reflecting an earlier Artemisia-painted self-portrait, is especially suggestive. The bust of the artist, enshrined like sculpture in a shallow niche, is enframed by the inscription "ARTEMISIA GENTILESCHI ROMANA FAMOSISSIMA PITTRICE ACCAD. Ne'Desiosi," while below a scroll bears the encomium "EN PICTVRAE MIRACVLVM / INVIDENDVM FACILIVS QVAM IMITANDVM." It is a curious fact that the designation "ACCAD. Ne'Desiosi" has provoked very little comment, for there is sufficient information with which to speculate. Thus—as the first of three possibilities that emerged from a considerably longer list—the term *desiderosi* (interchangeable with *desiosi*) was used to characterize young novices who, before they could be evaluated for admission to the Accademia di San Luca at Rome, were obliged to present to the Principe of that body a drawing after a work by a respected past master. The *desiderosi* stood third in rank to the *utili* (established artists) and the *studiosi* (artists well on their way).[16] Since in the mid-1620s, the approximate date of the print, Artemisia Gentileschi was neither young nor a beginner but rather, to hear David tell it, "FAMOSISSIMA" and "EN PICTVRAE MIRACVLVM," and since Artemisia's name was never to appear on the roll of women members of the Accademia di San Luca,[17] this particular group should be eliminated from consideration. The same must be said of the Accademia de'Desiosi, properly named, founded at Rome in 1626 by Cardinal Maurizio of Savoy, son of Carlo Emanuele I, in emulation of the Accademia de'Solinghi (also Solitari and Desiosi) which he had already set up in Turin.[18] Literature of moral, philosophical, and historical import, archaeology, dance, geometry and mathematics, fortifications, and

other studies engaged the minds of these academicians. Artemisia Gentileschi painted portraits of two *condottieri* of the Turin-based Order of SS. Maurizio e Lazzaro (Figs. 82, 102; Color Plate IX), one of them an expert on fortifications, and Cardinal Maurizio owned (or was to own) two canvases by Orazio Gentileschi.[19] Nevertheless, there are no grounds for supposing that Artemisia would have been invited to join this very exclusive club, whose membership lists contain no painters and no women.

Although less known and poorly documented, it is the Accademia de'Desiosi of Venice that is most likely to be the academy in question. Recorded only by Cicogna in relation to a collection of Latin and vernacular sonnets published in Venice in 1629,[20] it counted among its members Gianfrancesco Loredan and Pietro Michiele. This is significant in the present context, in that Loredan composed two intimate letters to Artemisia Gentileschi, was almost certainly responsible for the aforementioned verses issued in 1627 and dedicated to paintings by her, and was joint author with Michiele of the *Cimiterio, epitafij giociosi* of 1653, which contains two posthumous epitaphs to Artemisia.[21] Additionally, the *impresa* of the Venetian Desiosi was a beehive with the motto "AD INVICEM" and emblems of the Fine Arts. The scarcity of information concerning it hints that this Accademia de'Desiosi was a rather informal and perhaps short-lived affair, and one can imagine Loredan, little more than twenty years old and enamored of the painter's beauty and spirit (see below), introducing Artemisia Gentileschi into this group of other creative personalities. If I am correct, then David's print would date about 1628, following Gentileschi's arrival back in Rome.

Recognition of another kind came in the form of an anonymous bronze medallion (Fig. 99) showing a profile portrait of Artemisia aureoled with the words "ARTHEMISIA GENTILESCA PICTRIX CELEBRIS."[22] To judge by the apparent age of the sitter, who is dressed in contemporary clothing, and by analogy in facial type to the *Judith*, *Aurora*, and *Cleopatra*, this medal is to be dated about 1625. Even less expected is Pierre Dumonstier le Neveu's drawing of Artemisia's painting hand (Fig. 98),[23] precisely documented as to place, date, and inspiration by the hand-written inscriptions reading "Faict à Rome par Pierre DuMonstier Parisien, Ce dernier de Decemb. 1625. / aprèz la digne main de l'excellente et sçavante Artemise gentil done Romaine.[?]," and, on the back, "Les mains de l'Aurore sont louées pour leur rare beauté. Mais celle cy plus digne le doit estre mille fois plus, pour sçavoir faire des merveilles, qui ravissent les yeux del plus judicieux. S." In comparing Artemisia's hand to those of the "rosy-fingered Dawn" of literary fame, and finding Gentileschi's a thousand times more beautiful because, guided by knowledge, it could produce "those miraculous works that delight the eyes of the wisest connoisseurs," Dumonstier indulged in what seems an altogether uncomplicated commendatory conceit. Surely there is little reason to presume that because the dedication "links the painter's achievement in art with an image of a part of her body" it is to be seen "as a continuation of a Petrarchan tradition in which woman was depicted as a composite of details . . . that results . . . in the dismemberment and distortion of the original whole woman."[24]

Poetry, too, was inspired by Artemisia Gentileschi's person and pictures. How,

exactly, these verses are to be construed, however, will no doubt remain a matter of debate. One modern perspective on the lines penned by the Venetian Gianfrancesco Loredan (or so I maintain) to the now-lost canvases by Artemisia of *Lucretia*, an *Amoretto*, and *Susanna*, finds in them little homage but a great deal of typical male stereotyping.[25] Thus the verse to the *Lucretia* is suspected of harboring "an underlying chivalric assumption that for a woman to paint a woman victim was a betrayal of her sex." That to the *Amoretto* is taken as a "succinct expression of masculine jealousy of female procreativity—and hence masculine appropriation of artistic creativity . . ." the poet minimizing Artemisia's achievement because, after all, she herself could give birth, while extolling the superiority of art practiced by a man. And the poem to the *Susanna*, this point of view continues, "stubbornly reasserts the . . . concept of Susanna as a half-guilty victim. . . ."

It does not require a contrary mindset to read these writings in a very different way. The lines on the *Lucretia* do indeed appear stereotypical, but in the sense that they expound the conventional notion of the power of painting to bring the dead to life (in this case in order to die again!). The idea is familiar, for example, from Gaspare Murtola's appreciation of Caravaggio's *Fortune-teller* and from a poem dedicated to a *Cleopatra* by Guido Reni as published by Malvasia.[26] In attributing such magic to a female painter, Loredan might be seen to applaud by implication her ability to compete with any male artist. That the *Amoretto* was created by a woman opened up new poetic possibilities, fresh images, and certainly need not have struck Loredan as a chance to impugn Gentileschi's talent. And the interpretation of the remaining verse as attributing to Susanna some responsibility for having enticed the old men rests on the debatable translation of key words.[27]

It was when writers acclaimed Artemisia Gentileschi's physical attributes that they ran a special risk of doing her a disservice by emphasizing that aspect of her person at the expense of her mind (indeed by implying that she owed her art to her beauty) and by opening the way to those who associated female good looks with lasciviousness and a host of related negative qualities.[28] From Loredan ("una bellezza sorahumana"; " 'l mio cuor è assoggettito da maggior potenza, che dalla bellezza del tuo volto"; "quel bello, che trionfa del tempo"; "Poiché la tua bellezza infiamma"; "Le richezze d'Amore non hanno altro traffico, che nel suo seno, ne'tuoi occhi, e nelle tue chiome") to Giovanni Canale ("Stupido Spettator del bel Sembiente"; "Mostri d'alta Beltà nel tuo bel viso") to Tommaso Gaudiosi ("Questa, in cui tutte le gratie sparte"),[29] praise of Artemisia's beauty is effusive. At times the motives of the male writers were patently malicious, as when Passeri characterized Artemisia as "assai bella nelle sembianze" while claiming that "sarebbe stata degna d'ogni stima, se fosse stata di qualità più onesta, ed onorata."[30] Baldinucci was so taken by the story of the violent jealousy of Romanelli's wife upon seeing her husband's portrait of Artemisia and hearing his panegyric to the painter that he devoted more words to what turns out to be a legend than he did to Gentileschi's art.[31] In suggesting that it was in part because of her comeliness that Artemisia succeeded, Morrona paid Gentileschi a backhanded compliment that her reputation could

have done without: "Colle paterne cure sí unì la Natura a favoreggiar grandemente Artemisia dotandole d'estraordinario talento l'animo gentile, e la corporea parte fregiando delle più belle, ed attraenti forme. Egli è indiubitato, che per tali prerogative, ambedue molto essenziali, non le mancassero Mecenati, e Adoratori."[32] And Loredan questioned whether Artemisia could ever capture on canvas "il divin lume . . . degli occhi suoi," the "her" being Gentileschi herself.[33]

One can be virtually certain that none of these writers, however progressive he considered himself, had rejected the deep-seated belief in the relative inferiority of women's intellectual and creative capabilities, or that which defined a woman by her beauty. In fact, in one of his letters to Artemisia, Loredan writes: "Perché non dirò che sei Donna, per non recar pregiudicio alla vitalità de'tuoi pensieri. . . . Non dirò, che sei bella, per non accomunarti i pregi d'ogni semplice dona." In singling out Artemisia Gentileschi as an extraordinary woman, he was in effect guilty of diminishing women in general. But surely Loredan and most of the other male commentators approached their observations on Artemisia in what to them was a positive spirit to be recognized as such. They even seem attentive that their comments on her physical charms not eclipse their admiration for her mind and her creative genius. Loredan speaks of the sublimity and vitality of Artemisia's thoughts, of "the perfection of a beautiful soul" as well as of "the proportion of a beautiful face"; for Canale, Gentileschi paints "celestial forms," "with marvelous effort" satisfies the age-old concept of painting as "mute poetry," and outshines Apelles with her brush even as she bests Venus with her face; and Gaudiosi wonders "whether that graceful prodigy is superior of face or hand."

We today might well accuse Loredan and the rest of insensitivity, of having their priorities misplaced. We do not really know how Artemisia responded, or would have responded, to what they wrote, although she was to acknowledge prejudice against female painters. What does seem admissible, however, is that in their comments about Artemisia the majority of these writers were not edgy about being threatened by women, nor were they on campaigns to devalue them. How we understand this can have an effect upon how we judge the reception of Artemisia Gentileschi's paintings and how we choose to interpret them—excellent reasons why pondering these matters is worth the effort.[34]

Patronage Network and Production

The known recipients of Artemisia's pictures during the 1620s belonged to distinguished and sometimes power-wielding segments of European society:

EXTANT PAINTINGS OR PAINTINGS KNOWN FROM VISUAL EVIDENCE

Judith Decapitating Holofernes, ca. 1620, for Cosimo II de'Medici (Figs. 77–79, Color Plate XII, and [12])

Portrait of a Condottiere, 1622 (Figs. 81–82, Color Plate IX, and [13])

Judith and Her Maidservant, ca. 1623–25 (Figs. 83–84, Color Plate XIII, and [4])

Aurora, ca. 1625–27, for Niccolò Arrighetti, Florence (Figs. 87, 90, 94 and [15])

Penitent Magdalen (two examples), one example acquired 1625/26 by the Duque de Alcalá (Figs. 96, 97, Color Plates X, XI, and [16] and [17])

Venus and Cupid (Sleeping Venus), ca. 1625–27 (Figs. 103–104, Color Plate XIV, and [18])

Portrait of Antoine de Ville, 1627 (cf. Fig. 102 and [19])

Self-Portrait, 1620s (cf. Fig. 101 and [20])

Penitent Magdalen, ca. 1627–29 (Fig. 111 and [21])

Cleopatra, ca. 1627–29 (Fig. 110, Color Plate XV, and [22])

LOST OR UNIDENTIFIED PAINTINGS

Cupid and Psyche, inventoried 1624 in the Patrizi Collection, Rome [L-17]

Christ and the Little Children (Suffer the Little Children), acquired 1625/26 by the Duque de Alcalá [L-14]

David with a Harp, acquired 1625/26 by the Duque de Alcalá [L-20]

Amoretto, 1627, Jacomo Pighetti, Venice [L-1]

Lucretia, 1627, in Venice [L-54]

Susanna and the Elders, 1627, in Venice [L-105]

Hercules and Omphale, 1628, for Philip IV, Madrid [L-40]

That is to say: Gentileschi supplied paintings to rulers—the Grand Duke of Tuscany and the King of Spain; to the Duque de Alcalá, wealthy Sevillian connoisseur and, as Spanish Ambassador to the Holy See, official representative of a ruler; to other noblemen—the Patrizi of Rome, perhaps the Brancaccio of Naples (for the *Judith and Her Maidservant*), two *condottieri* of the Order of SS. Maurizio e Lazzaro (one of them, Antoine de Ville, a noted military engineer and author); and to academicians and literary figures—the Florentine Niccolò Arrighetti (friend to Michelangelo Buonarroti the Younger and Galileo Galilei), Jacomo Pighetti (Bergamese lawyer resident in Venice), and, very conceivably, Gianfrancesco Loredan, famous-surnamed literary man-about-Venice (the patron of the *Lucretia* and the *Susanna*?). Capitalizing upon ten years of working experience and responsive to the standards of quality insisted upon by such patrons, Artemisia Gentileschi's canvases reached new heights of technical mastery. It

was also during the 1620s that the artist established her reputation as a portraitist and acquired a subspecialization—that of rendering the female nude—that thereafter would be promoted in more than half of her extant canvases. Tackling new subjects and facing increasingly classicizing tastes, Artemisia again adjusted her style. Toward the end of the decade, perhaps unwilling to go further in this direction yet rightly sensing a very uncertain future in Rome for painters in the following of Caravaggio, she took off for Naples.

The Pictures: From Caravaggism Toward Classicism

The decade began, however, with the *Judith Decapitating Holofernes* for Cosimo II (Figs. 45, 77–79; Color Plate XII). A variant upon Artemisia's picture now in Naples (Fig. 21; Color Plate II), the Uffizi canvas may thus be said to have been nurtured by the same sources—above all Caravaggio's Coppi *Judith* (Fig. 38) and Orazio Gentileschi's *David Slaying Goliath* (Fig. 14), with further influences from pictures by Rubens and Adam Elsheimer (Figs. 25, 26). Yet the very relationships to the Naples *Judith* point up the maturation which Artemisia's art had undergone in the interim. Rejecting the rudimentary blue-and-red color scheme of the earlier example, the painter now works with more developed relationships of brocaded golden yellow, dark blue, and burgundy, punctuated by spurting blood and at the women's sleeves by rich red and purple. Artemisia's brush moves with much greater confidence, fluidly establishing contours, dashing on highlights, differentiating textures with prodigious fidelity. In creating this variant Artemisia reintroduced into her art the powerful illumination and explicit drama that had become attenuated during her time in Florence. Her selection of the earlier *Judith* as a model and thus her return in 1620 to a more emphatic Caravaggism reveal the impact not only of subject matter—the *Jael and Sisera* (Figs. 72–73) turned out to be a tame affair, notwithstanding its theme—but also of Gentileschi's reencounter with her roots[35] and initial confrontation with that trove of pictures by *Caravaggeschi* that had been added to the treasures of Rome during her seven-year absence.

Is this to say, then, that except on the level of technical virtuosity the Florentine experience was left behind? The answer to this question cannot be as definitive as once it might have been, in that the Naples canvas has been trimmed to the left and above and the ambient has darkened to an impenetrable blackness where once a tent curtain could be seen. Consequently, the "urgency . . . *terribilità*, and . . . obtrusive physicality,"[36] the aggressiveness with which it attacks the spectator, would not originally have been so formidable, thus bringing the Capodimonte example closer in this respect to the Uffizi one. Still, these mental adjustments made, it is obvious that the earlier painting always had a more faithful Caravaggesque bluntness. With its sophisticated chromatic scheme and complex drapery configurations, and with the heroine sporting even more fashionable attire (including a cameo bracelet in apparent ironic comment on the action),[37] the later picture assumes a decorative dimension that is at once absent from the Naples *Judith*

and indicative of her full exposure to and exploitation of this quality during her Tuscan period.

For some modern scholars much of this rings false,[38] being intrusions into an otherwise brutal moment. For others the contrast heightens the picture's shock value.[39] While judging the work to be "very beautiful," Baldinucci declared that "merely a glance at such a painting as this incites no little horror,"[40] thereby implicitly acknowledging that for him pictorial splendor and expressive potency were not mutually exclusive. Relative to the Naples version, the Uffizi *Judith Decapitating Holofernes* holds a greater number of esthetic delights, and its imaginative appeal is more multidimensional. Its sensationalism extends beyond the larger sword, the geyser of blood that sprays Judith's gown, the route of Holofernes' right arm which in its upward thrust must have stroked the inside of his murderer's thigh. This is a picture that was designed to attract instant attention to an act that induces more intense shivers by virtue of the more calculated way in which the effects are achieved. And at the lower right Artemisia affixed her signature: "EGO ARTEMITIA / LOMI FEC.," as if to say "Yes I, a woman, made this!" Artemisia knew that most observers, male and female, would be astonished at learning that a woman painter was capable of such art and such ferocity, even as they recoiled from the frightful spectacle before them. Perhaps she was teaching a lesson about false assumptions regarding what women artists and women in general could and could not do. Whether the picture is also autobiographical, is meant to "elicit solidarity or sympathy" from women and guilt from men,[41] and cries out for sexual justice are issues to be explored in due course. One thing is certain: Artemisia Gentileschi, professional, businesswoman, was capitalizing on her technical prowess and on her sex. Perhaps somewhat too self-consciously, and on the brink of artificiality, she set out to astonish. In the intense reactions which the *Judith Decapitating Holofernes* has excited over the centuries lies the proof of how absolutely she succeeded.

Gentileschi's wizardry in capturing the look and feel of things and her inventiveness, as well as her willingness to consider the preferences of patrons, also recommended her as a portraitist. Unfortunately, few portraits by her hand have been identified, and the reliability of literary references to Artemisia's activity in this field[42] cannot always be checked. In a letter from Naples to Cassiano dal Pozzo on December 21, 1630, she cited a recently completed portrait of a duchess, and Dominici wrote that Neapolitan acclaim for Gentileschi's art was stimulated "above all by portraits of important individuals." In 1653, after the artist's death in Naples, Pietro Michiele asserted that she "acquired infinite merit in the world" by "painting the likenesses of this one and that one." A quarter of a century earlier, Michiele's friend and Venetian compatriot Gianfrancesco Loredan had called upon Gentileschi in verse to fashion "un ritratto della sua Donna." Sandrart, who met Artemisia in Naples, pronounced her portraits "extremely good." If Walpole is to be trusted, during her two years in London (1638–40) the artist portrayed "some of the royal family and many of the nobility." According to Baldinucci, at the beginning of her career Artemisia "dedicated herself to doing portraits, of which she made very many in Rome," a statement upon which Morrona embellished. No doubt there is hyperbole in

Baldinucci's account, and Morrona's comment that initial training in portraiture was "almost habitual among other women painters" repeats an old cliché. However, the mention during the Tassi trial of a portrait of the cleric Artigenio which Artemisia had painted in 1611 [L-63] confirms Gentileschi's early involvement with portraiture.

Yet more than a decade was to pass before anything else is heard of Artemisia as portrait painter. In Florence she may have been distressed when for images of himself and his wife Cosimo II called upon another *Caravaggesco*, Caracciolo. To judge by the brilliance of the *Portrait of a Condottiere* of 1622 (Figs. 81–82; Color Plate IX), produced in Rome within two years of her departure from Florence and thus relatively close in time to the Uffizi *Judith*, such a reaction on her part would have been justified. The basic type and the trappings of this standard-bearer of SS. Maurizio e Lazzaro are conventional, and may have been required of the artist. Jacopo da Empoli's *Portrait of Concino Concini* of 1610 (Fig. 80) is representative.[43] Everything else about Artemisia's work is uncommon. The painting dazzles, first, by its truth to appearances. Ceremonial armor, touched with silvers and golds, is enwrapped with a dark olive-green sash. The metallic colors are repeated for the decoration on the red flag, the red in turn by the table covering and some of the plumes on the helmet. Details are rendered with care and convincingness, reflections and shadows with exceptional verisimilitude. Strong light from the left gives relief to the forms within a shallow space alive with atmosphere.

Still anonymous as to identity, in spite of his individualized features, the *condottiere* is nonetheless recognizable as to personality. For Artemisia, the communication of what she discerned of the sitter's character, including of how he saw himself, was a greater challenge than that of capturing a likeness. A nobleman's pride in status and service is proclaimed by a composition of exquisite poise—fingers making gentle contact with the table top, as much to create visual stability as to permit holding the pose, while the other hand rests casually on the hilt of the sword; the left upper arm running parallel to the extended foot, the forearm to the back foot, the diagonal direction of the latter continued by the thin line of shadow cast by the weapon's point; the obliquely placed sword paralleled by the edge of the papal banner, whose tasseled braid still seeks the vertical, adding vitality. Although of small stature, the man stands tall, taller than his shadow and—were he to don his helmet—the available space. Before this canvas the popular tendency to equate the success of a portrait and the physical attractiveness of the individual portrayed has never seemed more arbitrary.

Of the other two portraits by Artemisia Gentileschi from the 1620s, the *Self-Portrait* and the *Portrait of Antoine de Ville*, only Jérôme David's engraved records are known (Figs. 101, 102). In both, Gentileschi seems to have insisted again upon accurate rendition of fashion and unglossed description of physiognomy. By means of the inscription surrounding the bust-length portrait and the legend below it, David proclaimed the painter's fame. Artemisia, recording what she saw in a mirror, let her image, finely dressed but free of allegorical trappings, speak for itself.

Within the period bracketed by the painted portraits of the *condottiere* and Antoine de Ville, Artemisia Gentileschi created a picture before which Jérôme David's declaration

on Artemisia's behalf seems understated—the *Judith and Her Maidservant* in the Detroit Institute of Arts (Figs. 83–84; Color Plate XIII). Their bloody act accomplished, their escape threatened, the Israelite women suffer a moment of apprehension in the midst of a drama of resoluteness and triumph. A real or imagined stirring from without the tent impels Judith to screen the candle flame and arrests Abra in her task of bagging the grisly trophy, sinister in its oppressive closeness and inky shadow. Reinforcing the tension of imminent detection, the sword, its hilt in the exact center of the canvas, appears suspended between the end of an upward swing and the beginning of a downward stroke, while in the sweeping folds of Judith's gown and the sliver of space between the two women the slicing path of the weapon as it sought Holofernes' neck lives on. The competing movements of Judith's left arm and the curtain, severe contrasts of intense light and impenetrable shadow, crisp and glowing white linens, and assertive colors of green, golden yellow, burgundy, violets, and blues heighten the dramatic pitch.

The Detroit *Judith* may be regarded as a magnificent synthesis of directions which Artemisia had already taken with the *Judith and Her Maidservant* in the Palazzo Pitti (Fig. 31; Color Plate IV) and the *Judith Decapitating Holofernes* in the Uffizi (Figs. 77–79; Color Plate XII)—a meditated union of the former's atmosphere of anxiety and temporarily frozen action with the latter's overt drama, considerations of the former purging the latter of its rather too obvious effect-seeking. Abjuring for the moment brocades and most bejeweled accessories, Gentileschi joins a new broadness of vision to a realism that is arguably more persuasive for being less particularized. And she introduces truly monumental figure types, mighty women who had the Lord behind them but whose ability—in all respects—to accomplish the mission on their own one does not doubt.

In discussing the Uffizi *Judith Decapitating Holofernes*, I suggested that its more pronounced Caravaggesque orientation relative to Artemisia's Florentine pictures was attributable in part to her encounter—a kind of spiritual renewal—with pictures from which her art had sprung and with others in the Caravaggesque manner that had been painted in Rome during her seven years away from the city. Theoretically, however, Gentileschi could have produced the Uffizi *Judith* in Florence (if we forget for the moment that its model, the Naples canvas, was almost certainly still in Rome), in the sense that there is nothing about its character, more specifically, that presupposes the artist's presence in Rome during the early 1620s. Conversely, the conclusion that the Detroit *Judith and Her Maidservant* can only have been conceived in that place and at that time seems compulsory.[44] Before returning to Utrecht in 1620, Gerrit van Honthorst had left in Italy a body of night pictures in which the figures, worked into an emphatic geometry by the intense light, assert themselves from their dark ambients with great authority. Artemisia could have known of the interest which Cosimo II and his Ambassador to Rome Pietro Guicciardini had taken in "Gherardo delle Notti," Guicciardini having commissioned from the Northerner the *Adoration of the Shepherds* for his family chapel in the Florentine church of Santa Felicita and having corresponded with the Grand Duke's Secretary Andrea Cioli regarding six pictures by Honthorst on the Roman art market.[45] Among the works by Gerrit in Florence today, some must have come from

this source; one or more, however, might have been purchased by Cosimo II prior to Gentileschi's departure from Florence. Artemisia is likely to have seen the *Decapitation of Saint John the Baptist* of 1618 for Santa Maria della Scala at Rome.

Honthorst's manner likewise informs Simon Vouet's *Temptation of Saint Francis* (Fig. 86) of 1623–24 in the Alaleone Chapel in San Lorenzo in Lucina, the church in which Artemisia had been baptized. And it is Vouet's canvas, with its bold candlelight effects, its striding cross-armed temptress, and its juxtaposition of standing and earth-bound figures, that most strikingly parallels Artemisia's *Judith and Her Maidservant*. Affinities also have been observed between the latter picture and Antiveduto Gramatica's *Judith and Her Maidservant* at Stockholm (Fig. 85), of a concentrated force that Gramatica never surpassed, wherein the profile head of the heroine, powerful in form and lighting, bears comparison to Gentileschi's Judith.

Although the relationships do not seem to have been fortuitous, the uncertain chronology of Gramatica's works and the lack of a precise date for the Detroit painting make it hazardous to assign priority to one or the other painter in this instance. It is more judicious simply to emphasize that Antiveduto's art matured and Artemisia's was nourished in the same Roman environment and with inspiration from the same artists, including Caravaggio and Orazio Gentileschi, and that repeatedly pictures by Gramatica have been misassigned to Artemisia.[46]

The paintings of the elder Gentileschi likewise engaged the Frenchman Vouet, whose canvases in turn Orazio might have brought to the attention of his daughter upon her return to Rome. A situation in which Simon and Artemisia then benefited from reciprocal influences can be imagined, and artistic ties between the two artists were to be sustained even into Artemisia's Neapolitan years.[47] They are most immediately evident in Gentileschi's *Penitent Magdalen* (Figs. 96, 97; Color Plates X, XI), one of the versions of which was purchased in Rome by the Duque de Alcalá in 1625 or 1626. In the effulgence of decoratively arranged draperies, as in the hushed sentiment, this suave and curiously provocative *Magdalen* not only recalls Artemisia's Florentine experience but as well a number of Vouet's Italian pictures, among them the *Magdalen* (Fig. 91) now in the Los Angeles County Museum of Art. As proposed in the Catalogue [14], the great *Judith and Her Maidservant* in the Detroit Institute of Arts, easily one of the most splendid Caravaggesque pictures ever to come out of Rome, may have been ordered by a member of the Neapolitan nobility. In Artemisia's home city the appetite for authentic Caravaggesque fare had definitely waned, and it is a remarkable fact that with the exception of the *Cupid and Psyche*, with the Patrizi by 1624, not a single canvas among the extant and lost works by Gentileschi from the 1620s can be traced back to a Roman collector. It may have been this shift in taste and consequent decline in local business that prompted Artemisia to cultivate Spanish patrons and to move for a time to Venice. For the same reasons, she may have renewed her contacts with Florence, producing for Niccolò Arrighetti the splashy *Aurora* (Figs. 87, 90, 94).

Partially clothed in a white veil and a maroon-brown cloak with yellow highlights, the virile figure of Dawn pushes away, as it were, the night sky, as the first rays of the

sun appear over the distant blue mountain to animate the materials and stroke the flesh. The pose of this equally monumental woman, in reverse and excluding the arms, is that of the Judith in the picture at Detroit (Fig. 84)—body bent in a C-shape, one foot thrust to the front limits of the canvas, neck stretched, shoulders obliquely positioned. Comparable, too, are the moon-shaped heads, again in profile, with braided hair encircled by strands of pearls (cf. Figs. 93 and 94).

Back to working directly from the nude, to which the definitive figure remains faithful, and firmly modeling its form, Artemisia nonetheless ended up with a work which, for all of the resemblances to the Detroit *Judith*, is only distantly Caravaggesque. Nor are there antecedents in her art for the whipped-up drapery and for the rapidity bordering upon the slapdash with which sections of it are rendered. These features must be viewed as unique responses to the specific subject matter and to other works which apparently aided Artemisia in confronting what for her were new problems. The theme called for a landscape setting, and thus the tenebristic lighting and the restricted ambient which mark the *Judith* were no longer germane. Even at the beginning of her career, as a comparison of the *Susanna* and the *Lucretia* has demonstrated, Gentileschi made comparable adjustments. In addition, she turned to the kinds of artistic sources which she does not seem to have utilized previously. Thus Guido Reni's *Aurora* and one or more ancient depictions of female figures in moments of maenad-like frenzy are brought to mind. Most suggestive is the Neo-Attic *Maidens Decorating a Candelabrum* (Fig. 92), in Artemisia's day in the Villa Borghese and a companion relief to Reni's antique prototype, the so-called *Borghese Dancers*.

Yet to these images, before her eyes in Rome, Artemisia appears to have added impressions of the precocious *Piramus and Thisbe* (Fig. 88) by the Florentine master Gregorio Pagani (1558–1605). She could have come into contact with Pagani's canvas anytime between 1613 and 1620, but it is also possible that Arrighetti, in awarding her the commission for the *Aurora*, recommended the *Piramus and Thisbe* for selective emulation. If, as I have conjectured, Artemisia stopped in Florence en route to Venice, the *Aurora*, as another example of Gentileschi's sensitivity to Florentine propensities, may belong to that moment.[48]

Notwithstanding the mythological subject matter and the models upon which it drew, the *Aurora* is basically nonclassicizing, and the particular incongruity between the imitative and the candidly realistic contributes to the picture's singularity. The *Venus and Cupid* (*Sleeping Venus*) of approximately the same time (Figs. 103–4; Color Plate XIV) approaches more closely a unity of classical content and pseudo-classicizing form. Cooled by the breezes from a peacock fan flourished by her son Cupid, Venus, nude but for a swirl of transparent veil, sleeps upon a blue bed covering and a pillow of maroon velvet tasseled and trimmed in gold. Behind the figures a curtain, also of maroon velvet and gold fringe, opens to a balustraded loggia and to a moonlit landscape centered upon a circular temple to the goddess of love. Venus's facial type—full cheeks, heavy lids, prominent nose, and small protruding chin—mirrors the physiognomies of Judith and Aurora (cf. Figs. 93, 94, and 95) and thus of Artemisia Gentileschi herself. Comparable as well

to the *Aurora* are the puffy-faced putto and the physically formidable goddess with her accentuated abdomen.

Now, however, a note of idealization is struck. For this her turn to two Bolognese works available in Rome—the *Danaë* of 1605 from the workshop of Annibale Carracci (Fig. 106) and Annibale's print of the *Sleeping Venus with a Satyr and Cupid* from 1592 (Fig. 105)—is to be held partly accountable. As in Artemisia's *Venus and Cupid*, both Carracci conceptions contain female nudes reclining with their legs touching but not crossed before curtained backgrounds that yield at the left to partially enframed landscape views. And as the *Danaë* provides precedent for the figure clutching in her left hand an edge of the drapery that encircles her, so the *Venus, a Satyr, and Cupid* appears to have been the most immediate source for the sleeping woman with her right hip thrown upward and her right hand resting on her abdomen, for the attendant Cupid, and for the tasseled pillow. Thus the Venetian influence, beyond question discernible in the subject and disposition of Artemisia's picture, could have reached Artemisia via the Carracci examples and prior to her residency in Venice.

Artemisia cannot have been unaware of the interest among Roman patrons in classicizing pictures or of that art which, although more coloristically rich, fluidly composed, and expressively extroverted than that of the "classicists," was nonetheless judged by many to be more heroic and decorous than the blunt approach of Caravaggio and his followers. Orazio Gentileschi had already seen this coming, and the Carraccesque *Danaë* was a major prototype for the canvas of the same theme (Fig. 107) which Orazio painted about 1621 for Giovan Antonio Sauli.[49] Around 1612 Orazio had inaugurated the Gentileschian line of reclining nude women with the *Cleopatra* (Fig. 211) and the small *Danaë* (Fig. 210), but by the end of the decade his art had taken a decided turn away from the trenchant realism of such works to a refined mode which, based on an a priori ideal of beauty, placed ever-increasing emphasis on the elegant and aristocratic. If the elder Gentileschi had visited Florence in 1616 and had done some paintings there—such as the *Rest on the Flight into Egypt* in Birmingham[50]—Artemisia could have discerned the transformations in her father's style. Between the time of her return to Rome and Orazio's departure for Genoa, she would then have had a full-scale exposure to Orazio's latest manner.

Artemisia did not adopt the blonder tonalities of many of Orazio's later Italian pictures, however; the shadows in the *Venus and Cupid*, an interior scene once again, are dense, the effect still powerful. And, as will be argued shortly, she was not caught in the approach-avoidance situation with respect to female sensuality into which Orazio had worked himself. Yet two of her pictures from the later 1620s—the *Penitent Magdalen* (Fig. 111) and the *Cleopatra* (Fig. 110; Color Plate XV)—continue to show the impact of works produced by her father almost a decade earlier.

The Magdalen, a blue mantle over her thighs, her upper body uncovered except for gathers of a white undergarment over one breast, reclines on reddish drapery as she lifts her eyes and thoughts Heavenward. A dark grotto opens at the upper left to a cloudy blue sky, the clouds tinged, or so it would appear, with the golden-orange light of the

setting sun. All the familiar attributes—ointment jar, crucifix, death's-head, book, and scourge—complete this fundamentally conventional presentation of the penitent saint. The *Cleopatra* is considerably more innovative. Stretched out on a field of white sheets and a pinkish-maroon pillow, the body of the queen, the skin with an appropriately grayish cast and the lips and eyes bluish gray, is discovered by two maidservants, the foremost one (in a burnt-orange dress over a white blouse) parting a maroon curtain brocaded in gold. The deadly asp, plucked but moments ago from a basket of multicolored flowers, slithers away. Manifestly comparable in pose, restricted color range, bold lighting, and darkling mood, these two paintings may have utilized the same model as they continue the basic type and format of the *Venus and Cupid*.

Yet her from-life rendering of the female body, with the faces retaining an individualized realism, was mediated compositionally by references to pictures which Orazio Gentileschi had executed in the years around 1620. Artemisia's *Magdalen* and *Cleopatra* depend variously[51] upon Orazio's *Magdalen* of the Sauli type (Fig. 108), on a now-lost *Magdalen* by him (reflected in Claude Mellan's engraving, Fig. 109), and upon Orazio's other canvases for Sauli (including Fig. 107) or versions of them. And now, with the introduction of a more slender body canon, the process of idealization that had slowly begun to inform Artemisia Gentileschi's art continues.

New Patterns, New Emphases

In Artemisia's production of the third decade there are other new features as well, toward an appreciation of which a review of the subject matter of her pictures from this period, excluding the portraits but including lost as well as known works, can contribute. Two of these canvases, the *David with a Harp* and the *Christ and the Little Children*, are of subjects so unexpected in Gentileschi's oeuvre that only what amounts to documentation prevents one from dismissing the attributions. Obviously these were special cases, the themes having been determined by the Spanish Ambassador to Rome, Fernando Enríquez Afán de Ribera, the Duque de Alcalá, and the paintings intended from the beginning to be sent back to passionately orthodox Spain. Conversely, twelve of the thirteen remaining pictures follow a familiar pattern for Artemisia in depicting women as the protagonists, and seven of these are of subjects—Judith, Magdalen, Lucretia, Susanna—with which Artemisia had dealt previously. None of this is surprising. Her reputation having been established with pictures of this sort, Gentileschi must have been sought out when patrons required more of the same. One suspects that Artemisia had come to view herself as a specialist in female imagery, had perhaps even advertised herself as such, and that she supposed that she was best able to interpret it—even as by the very fact that she was a woman she was in a special position to relate to her characters. And, of course, there was her oft-remarked access to female models. In some cases more specific considerations can be identified: the appropriateness of the *Judith Decapitating Holofernes* to the iconography of Cosimo II's reign; the role of the *Hercules and Omphale* in the

program of the Salón Nuevo in the Alcázar Real at Madrid; and, I suspect, the relevance of the *Aurora* to the literary or scientific interests of Niccolò Arrighetti.

But new patterns have begun to emerge. Up to sixty percent of the thirteen paintings[52] feature the female nude, and if the chronology here constructed is correct, all of these nudes were created during the second half of the 1620s. More than this, sensuality is more overt than in Artemisia's early paintings (Figs. 10, 19; Color Plates I, III), more a central element of the pictures' intended appeal.

Surely it may be taken as a given that, whatever symbolic or allegorical or religious significance can be imputed to them, paintings of nude women were ordered by seventeenth-century male patrons primarily for the erotic pleasure they would provide. Artemisia Gentileschi agreed to paint female nudes knowing full well what her clients had in mind. Or, if it is supposed that she executed some of these large canvases on speculation (which is unlikely), she knew the tastes she would be expected to gratify. Yet simultaneously conceding and being uncomfortable with these notions as they apply to Artemisia, some scholars believe that in the process of arriving at the finished product Gentileschi—in the words of one writer[53]—"subverted the very principle of the passively available female body and reversed traditional expectations of the nude" so that she "must have disappointed patrons." Words such as homely and uncomely, and the phrase "plain in face and limb" have been used to characterize Artemisia's nudes.[54] The physical attractiveness and sexual attraction of Gentileschi's women thus denied, one is free to state that the "image [of *Cleopatra*; Fig. 110; Color Plate XV] joins other characters created by Artemisia to exemplify her radical reconception of female excellence, as a reflection of inner worth rather than of conventional external beauty, for she suggests . . . that Cleopatra possessed a beauty of spirit, that might be found in plain women as well as queens."[55]

This would be a very admirable enterprise for anyone, male or female. At issue, however, is whether in fact these representations of female nudes lend themselves to such judgments. It is true that while the nude women painted by Gentileschi during the 1620s become increasingly less robust, never do they pretend to reach the level of idealization of ancient marbles or the rarefied realm occupied, for example, by the Venuses or Lucretias of Guido Reni or even the comeliness of her nudes from the 1630s (Figs. 130, 159, 162; Color Plates XXIII, XXIV). One must take into account changing standards of feminine beauty. Let it be observed too that Artemisia's Baroque patrons continued to order female nudes from her, and that for this the suspicion that Gentileschi's "collectors and admirers were probably more erotically stimulated by the idea of the woman painter than by the images she created"[56] does not appear to offer a fully satisfactory explanation, although they may have vicariously pictured Artemisia in the place of her nude women.[57] The reader would also do well to study again Artemisia's *Aurora* (Figs. 87, 90) and then hear what Filippo Baldinucci had to say about it:

In the house of the noble Florentine Giovanni Luigi Arrighetti is a beautiful work by Artemisia's hand, in which she represented, in slightly less than life-sized proportions, Aurora, a lovely nude female with long wind-blown hair

51

and arms spread out and raised toward Heaven, in the act of rising above the horizon, on which appears the first brightness, and moving to disperse the dark mists of night. On the parts opposite [the light source] the figure is quite gracefully cast in penumbra, in such a manner, however, as not to forsake a display of the beautiful proportions of the limbs, and of the pleasing complexion, merely stroked by the rising early light from the opposite side. And it is truly a beautiful work, one that indicates the height which the genius and skill (*l'ingegno, e la mano*) of one such woman attained.[58]

The visual evidence is most eloquent in speaking of the degree to which Artemisia had in mind quickening the pulse beats of male viewers. It is significant that an accentuation of the physically desirable also marks works by Gentileschi from this third decade which do *not* feature nudes. By adorning herself so as to feign availability, Judith baited the trap that was to cost Holofernes his head, and in her depictions of the decapitation (Figs. 21, 77; Color Plates II, XII) Artemisia discloses the heroine's sexuality without evident intent to titillate the spectator. In the *Judith and Her Maidservant* at Detroit (Fig. 84; Color Plate XIII), with the Persian general no longer in a position to admire anyone's charms, Judith's bodice is lightly veiled. But through the transparent material may be glimpsed a prominent nipple—not just cleavage now—tantalizing. And this stratagem of simultaneously covering up and revealing is extended to Abra, for no other apparent reason than to entice. It is difficult for the viewer not to imagine that the garments of the young woman in Artemisia's *Penitent Magdalen* (Fig. 96; Color Plate X), having already slipped off her left shoulder to reveal much of a firm breast, might continue their fall. The Magdalen, lost in reverie, cannot attend to her dress or in other ways discourage the potentially less-than-pious thoughts of those who gaze upon her. She is vulnerable, unlike the similarly attired but stronger and more alert women in Gentileschi's canvases of *Lucretia* (Fig. 19; Color Plate III) and the *Magdalen* (Fig. 70; Color Plate V) from the first decade. It must have been in recognition of the provocativeness of the *Penitent Magdalen* that another hand, I believe, was called upon to supply an extra sweep of drapery in the Seville version of the picture (Fig. 97; Color Plate XI), perhaps just before the painting left the private Casa de Pilatos for the sacred space of the cathedral.

The slipping-blouse motif appears again in the other *Penitent Magdalen* (Fig. 111) attributable to Gentileschi from these years. No scourge marks or other signs of penitential exercises mar the glowing nubile body, one breast totally exposed, which has been tipped toward the front plane and set against the dark grotto, iconographically the Magdalen's refuge from worldly temptations but artistically a device to tempt. The bent right arm might be interpreted on two levels—as a sign of lassitude and, not being fully limp and with the fingers of the hand spread, as engaged in dialogue with the unseen toward which the young woman looks, more in longing than in spiritual anguish. In the *Aurora* (Figs. 87, 90), what little drapery actually covers the nude form serves to elevate sensuality through its strategic placement and caressing action. Dawn strides toward the gazer, her arms raised in a nonprotective, almost exhibitionist attitude, but her head turned away.

A winged putto, looking like Cupid, admires from on high. Was it in order to moderate the association with desire, or rather to allow Aurora, in all her nudity, to stand naked before us, that the putto was painted out in the seventeenth century?

Posed similarly to the Magdalen, but uncovered from the waist up, Cleopatra (Fig. 110; Color Plate XV) expires from the serpent's bite—or, is not one tempted to say, falls into a swoon from love's sting? The attributes of the penitent are exchanged for a crown, a tasseled pillow, a basket of flowers, a gold-brocaded bed curtain, texturally rich items that speak of luxuriousness.[59] Unequivocal eroticism characterizes the *Venus and Cupid* (Figs. 103–4; Color Plate XIV). Totally nude and her pubic area in evocative shadow, the goddess of love is deep in sensual sleep, comfortably dreaming during, and perhaps about, a warm summer night. Situating this picture within the context of the sleeping female type in art, Kultermann has rightly noted here "elements of explicit voyeurism" and "an element of desire, a pleasure motif previously non-existent in such a sophisticated form," the work thus "projecting an image of female vulnerability for the male viewer, who is turned into the artist's accomplice."[60] There is a substantive difference between this presentation, in which with little modification the distinctive face and body of the live model became the uncanonical face and body of Venus, and the glossy skinned, de-eroticized, esthetically removed *Danäe* (Fig. 107) of Orazio Gentileschi, a paragon of chasteness when compared to Artemisia's available woman. At the same time, Artemisia's picture far distances itself from Giovanni Baglione's lewd nudes.[61]

The conclusion seems inescapable: With varying degrees of obviousness, Artemisia Gentileschi's paintings of this type from the 1620s catered directly to male patrons who found in such pictures outlets for sexual desire. Wherever one may locate this on the hierarchy of art's worthy goals, I see no reason why it should be regarded as having compromised Artemisia. However she might have felt personally about featuring the female body for male delectation (and her later comment to Don Antonio Ruffo that "out of fifty women who undress themselves, there is scarcely one good one" indicates irritation with rather than sympathy for her models),[62] Gentileschi made her living through her art. She won a share of the market with her female nudes. Further—in addition to the other positive explanations offered earlier in this chapter as to why Artemisia developed this subspecialization—one must consider the following unfortunate probability: the range of subject matter for which she would have been deemed "suitable" was restricted because she painted erotic nudes and because she was Artemisia Gentileschi, that woman around whom charges of promiscuity had swirled in 1612, that woman no longer with her husband, that woman who simply by being an independent artist would have raised eyebrows in some quarters.[63]

How many large pictures of reclining female nudes by women artists of the sixteenth and seventeenth centuries come to mind? The answer to that question underscores the degrees of courage, self-confidence, and even boastfulness displayed by Artemisia Gentileschi in taking up the challenge of a genre in which by tradition male painters had excelled.[64] And there certainly was nothing tentative about the results. These are paintings of great pictorial impressiveness, of monumental figures dominating

space, of equilibrated compositions, of powerful lighting and deep colors, of technical finesse—in short, canvases of merit which ought to command attention irrespective of the facts that they are by a woman and by Artemisia Gentileschi. In reflecting upon the works which came from Artemisia's brush during the quarter-century that remained to the artist, one should never forget this obvious but sometimes overshadowed aspect of her achievement.

IV

NAPLES AND LONDON, 1629–1640

Grandiosity and Grandeur

As the 1620s drew to a close, Artemisia Gentileschi may have felt an uneasy sense of isolation. For almost ten years she had witnessed substantive shifts in Roman artistic taste and patronage under Pope Gregory XV Ludovisi (1621–23) and his successor Urban VIII Barberini. Simultaneously, and in part consequentially, the number of artists in Rome who with varying degrees of faithfulness and success had drawn upon Caravaggio's revolutionary vision and who were still in the Eternal City when Artemisia returned there from Florence in 1620 had fallen off dramatically. Some—among them Manfredi, Cavarozzi, and Gramatica—had died. Others—including Vouet, Tournier, Honthorst, Baburen, and Terbrugghen—had returned to their homelands. Regnier had

found it expedient permanently to relocate to Venice, while after stays in Genoa and Paris Orazio Gentileschi had made his way to London. From the group of truly significant would-be *Caravaggeschi* centered in Rome, only Valentin, Serodine, and Artemisia remained.

Artistic and monetary considerations certainly motivated many of these painters to quit the city, where Caravaggesque bluntness had become increasingly undesirable in the face of demands for heroic pictures of densely intellectual or loftily emotional content, satisfied by the formidable talents of Domenichino, Poussin, Lanfranco, Pietro da Cortona, Andrea Sacchi, and others. Willing to modify but not to abandon that manner which had launched her professional life, Artemisia, having worked for several non-Roman clients, having temporarily switched her field of activity to Venice, and perhaps apprehensive about a future in Rome, made a major career change: she moved south to Naples.

Naples and London: Why and When

Artemisia Gentileschi had reasons to believe that the cultural climate in Naples would be more sympathetic to her art. Caracciolo had come to Florence in 1618 with knowledge already of Orazio Gentileschi's work,[1] and may have informed Artemisia of the passion for things Caravaggesque which gripped Neapolitans from the moment that Caravaggio set foot in the city. Massimo Stanzione, in Rome in 1617–18 to execute an altarpiece for Santa Maria della Scala (the site of Honthorst's *Decapitation of Saint John the Baptist* from the same years), apparently returned there for one or more brief stays between 1625 and 1630.[2] In addition, through Simon Vouet and/or her French contacts, Gentileschi may have learned that Vouet had been awarded two major Neapolitan commissions (Figs. 115, 116).

The first artistic evidence and the first written record of Artemisia's presence in Spanish-owned Naples both belong to the year 1630, being respectively the large signed and dated *Annunciation* (Fig. 114) and a letter of August 24 from Artemisia to Cassiano dal Pozzo in Rome.[3] By this time Gentileschi had already undertaken "some works for the Empress" (no doubt Maria of Austria, who made a grand entry into Naples on August 8)[4] and had received from Cassiano the commission for a self-portrait. In a follow-up letter of August 31 to her Roman patron the artist expressed the desire to return to Rome as soon as the heat had abated.

Since by late summer of 1630 Artemisia had not only established a studio in Naples but was contemplating packing it up, her transfer must not have been recent.[5] It also seems certain that, however problematic the job situation in Rome, Gentileschi would not have journeyed to the southern Italian city without having been guaranteed employment. The aforementioned Fernando Enríquez Afán de Ribera, Duque de Alcalá, was in the best position to make such promises.[6] Sometime between July of 1625 and February

of 1626, that is during his tenure as Spanish Ambassador to the Papacy, Alcalá had acquired three paintings from Artemisia Gentileschi.[7] Following visits to Naples, Venice, and Madrid, and almost two years in his native Seville, he returned to Italy, arriving in Naples on July 26, 1629, in his official capacity as Spanish Viceroy. Between then and his removal from office in April of 1631, the Duke purchased a *Saint John the Baptist* from Gentileschi, obtained two portraits—doubtfully *Self-Portraits*—of the artist,[8] and may have secured for her the patronage of the Empress Maria.

It is therefore likely that, emboldened by an invitation from her old acquaintance and new Viceroy, Artemisia set off for Naples in the later months of 1629. Yet it was to Cassiano dal Pozzo, a Roman connection, that she turned in August of 1630. When did Gentileschi first establish contact with Cassiano, and what was the Commendatore's role, if any, in facilitating the Neapolitan arrangements? Antiquarian, collector, and insatiable seeker after knowledge, the distinguished Cassiano dal Pozzo also served as Secretary to Cardinal Francesco Barberini, and therefore would have been aware of papal business, including the reception of Spanish ambassadors. Accompanying Barberini to Spain in 1626, Cassiano thought to recognize in the Madrid collection of the Marqués de la Hinojosa a *Mystic Marriage of Saint Catherine* as by Artemisia Gentileschi's hand. Although this particular painting may in fact have been the work of Bartolomeo Cavarozzi,[9] the very record of it hints that by the mid-1620s Cassiano dal Pozzo had become aware of Artemisia's existence. It is even conceivable that he recommended Gentileschi to the Duque de Alcalá's successor as Ambassador to the Holy See, the Conde de Oñate, who on behalf of King Philip IV ordered from her the *Hercules and Omphale*, for which Artemisia was paid in Venice in 1628.[10] Or, as an alternative at the other extreme, Gentileschi's affiliation with Cassiano may have been forged only in the relatively brief space between the painter's presumed return to Rome from Venice and her departure for Naples; this hypothesis does not exclude, however, the possibility that Cassiano added his authority to the Neapolitan negotiations.

Cassiano dal Pozzo knew good painting when he saw it, but his desire for a *Self-Portrait* by Artemisia Gentileschi was prompted by more than just esthetic considerations. The choice of subjects for his portrait gallery reflected his interest in "persons singular for their longevity or physical peculiarity, for precocious intelligence, or for some other reason."[11] As a major woman artist Artemisia certainly satisfied the requirement for singularity. The same can be said of Giovanna Garzoni, best known today for her exquisite still-lifes, who also enjoyed Cassiano's friendship and patronage. Only Garrard[12] has recognized certain striking similarities in the biographies of Gentileschi and Garzoni (to which recent scholarship has added others), relationships which may shed further light on Artemisia's life and more specifically upon the circumstances of her transfer to Naples. Born in 1600, Giovanna spent many years in Venice, her father's birthplace, and she was there in 1627 and 1628 during Artemisia's sojourn.[13] Garzoni was still residing in Venice on February 21, 1630, the date of a letter in which through the intermediary of a Spanish gentleman there the artist's services are offered to none other than the Duque de Alcalá in Naples. After a brief stop in Rome, Giovanna continued

on to Naples, from where on June 15, 1630, she sent the first of her known letters to none other than Cassiano dal Pozzo in Rome, thanking him for his support and noting the Viceroy's pleasure in receiving her. Garzoni remained in Naples for somewhat more than a year, telling the Commendatore of her fervent desire "to live and die in Rome" when in April of 1631 the stormy Viceroyship of Alcalá was terminated and Giovanna, who according to her letters to Cassiano had been greatly favored by the Viceroy, found herself without a fixed stipend.[14]

On the assumption that all these parallels cannot be accidental, and in consideration of the specific dates involved, I propose very cautiously the following chain of events: In 1629, Artemisia Gentileschi, surveying her position in Rome, aware that her former patron the Duque de Alcalá had just been appointed Viceroy in Naples, optimistic about the potential market for her art in that city, and backed by the prestigious Cassiano dal Pozzo, received assurances of sponsorship from Alcalá and journeyed south. Once established in Naples, Artemisia communicated with Giovanna Garzoni, seven years her junior, whom she had seen in Venice as late as 1628, and offered to speak with the Viceroy and Cassiano dal Pozzo on her behalf. The negotiations were successful, and by the spring of 1630 Garzoni had left Venice on a trip that would take her to Rome, where she met Cassiano for the first time, and then on to Naples. Alcalá provided an annual allowance, as he must have done for Gentileschi as well, and Garzoni settled into a comfortable living until her benefactor was dismissed by the King of Spain and she returned to Rome.

This presumed Gentileschi-Garzoni friendship offers the first and, sadly, the last indication of Artemisia's contact with an individual who could have shared her experiences of making a living as a woman professional in a field dominated by male painters and male buyers, and makes one regret that any letters that might have passed between the two artists have not been identified. As compensation, the preserved record from 1630 onward provides increasingly revealing testimony to Artemisia Gentileschi's awareness of what she was up against and to how she went about fashioning her self-image. Before this evidence can be considered, however, it is necessary to set the chronology and chart the catalogue of this most productive decade in Artemisia's career, a period during which, probably not by chance, the paths of Artemisia Gentileschi and Giovanna Garzoni may again have crossed.

Whether because Cassiano dal Pozzo and other potential Italian benefactors failed to provide Gentileschi with sufficient incentive to fulfill her stated wish to leave Naples, or because Neapolitan commissions, first under the administration of the Duque de Alcalá and then under the new Viceroy, the Conde de Monterrey, provided adequate employment, Artemisia—to all signs—continued to work in Naples. But along the way, pressure on her to go to distant England mounted. Especially revealing in this regard is Gentileschi's letter of July 20, 1635, to Ferdinando II de'Medici.[15] Announcing the arrival in Florence of her brother Francesco bearing gifts of two of her paintings,[16] the artist informed the Grand Duke that Francesco was back in Italy under orders from Orazio Gentileschi to conduct her to the service of King Charles I. This brother had been to

Naples before, armed with the same invitation, which Artemisia had more than once declined by pleading her commitment to paintings for Philip IV.[17] Charles I, having then received news that Artemisia had discharged this obligation, renewed his command, but Gentileschi, obviously reluctant to make the arduous journey and seeking compelling reasons to postpone if not avoid it, proceeded on her own initiative to ship pictures to Francesco I d'Este (Duke of Modena), Cardinal Antonio Barberini and, now, Ferdinando de'Medici, in each case with the end of securing patronage.[18]

Some of the forces which impelled Artemisia's English journey may have been set in motion as early as the fall of 1626 when her father arrived in London following a two-year stay in France, where in May of 1625 he may have witnessed the marriage by proxy of Henriette Marie, daughter of Marie de'Medici and thus sister to Louis XIII, to Charles I.[19] In 1627 Francesco and Giulio Gentileschi were sent to Italy on a buying trip for the English King, and in the spring of 1628 Giulio was in Venice where he caught up with Nicolas Lanier, Master of the King's Music, who was charged with financing the brothers. Giulio must have visited with Artemisia, then also in Venice, and it could have been at this moment that Artemisia's *Tarquin and Lucretia*, a painting framed in England in 1633/34, was acquired.[20]

By July 20, 1635, although writing to the Grand Duke of Tuscany and retaining some hope of insured Italian patronage, Artemisia had apparently begun to resign herself to the inevitability of an English journey. For, as she told Ferdinando II by way of dramatizing the urgency of her request for his support,[21] she had secured from the Duchesss of Savoy promises of a letter and a passport (which items her brothers were to pick up in Turin) so that she would be able "to proceed without impediment for France (*camminare senza inpedimento per la Frangia*)" on her way to England. She cannot have been totally unmoved by expectations of monetary rewards and by the prestige attendant upon working at one of Europe's great courts.[22] Furthermore, while Gentileschi consistently speaks of the summons to London as having come from Charles I, a claim certain to impress, it is very conceivable that Henrietta Maria had involved herself in the matter.[23] From a personal standpoint, it would have been particularly difficult for Artemisia not to respect the Queen's urgings.

Yet still she resisted, perhaps deterred in part by news of the plague in London in 1636 and 1637. When on October 24, 1637, Gentileschi once again contacted Cassiano dal Pozzo, she is silent about any English plans, as she had been in all the known correspondence from the previous two years. On the other hand, as Artemisia had already informed Andrea Cioli in Florence in April of the previous year and reported to Cassiano on October 24 and again on November 24, 1637, the burden of providing a dowry for her daughter had fallen to her. She was not prepared to go anywhere, and certainly not to London, until the money had been collected, the proposed marriage accomplished, and Prudentia's welfare no longer her prime responsibility.

It is not until December 16, 1639, in a letter from London to Francesco I d'Este in Modena, that Artemisia is documented in England. When had she arrived there, and what was it that, after all this time, had driven the journey?

In a way that parallels her first communications from Naples to Rome, Gentileschi's letter to the Duke of Modena shows the artist desirous of leaving England, not being content there in spite of the "honors and most signal favors" which had been bestowed upon her.[24] She had contributed to her father's ceiling ensemble for the Queen's House at Greenwich. Since (for reasons adduced in the Catalogue) that extensive project was probably finished in 1638, and since Artemisia was still in Naples in late November of 1637 and is not likely to have undertaken a voyage until the return of good weather (even assuming that the marriage contract of her daughter had been signed), her arrival in England can be set to the year 1638.

Research into the routes and vicissitudes of seventeenth-century travel might produce an approximation of Gentileschi's itinerary and its duration. In the summer of 1635 Artemisia was already in the process of obtaining assurances of safe passage to France from Cristina di Francia, Duchess of Savoy, the sister of Louis XIII and—be it noted—of Henrietta Maria. By November of 1632 Giovanna Garzoni had come to Turin, called there by the same Cristina.[25] Gentileschi may have asked her old friend (or so I have imagined Giovanna as being) to intercede in the matters of the recommendation and passport, Garzoni thus returning the favor of Artemisia's presumed intercession on her behalf with the Duque de Alcalá and Cassiano dal Pozzo.[26] And then, most appealing of all: Giovanna Garzoni's whereabouts in 1638–41 are not precisely documented, but there is persuasive evidence that during this period she almost certainly visited France and, possibly, England as well.[27] One can therefore visualize Artemisia Gentileschi embarking from the Bay of Naples in the spring of 1638, meeting up with Giovanna Garzoni at the port of Genoa, and the two women artists sailing together to Marseille!

Whether Artemisia spent any time in France before continuing on to England is another question for which no definitive answer is forthcoming. Writing to Galileo Galilei on October 9, 1635, Gentileschi claimed that she had received favors from the King of France, the implication being that she had sent a picture (or pictures) to Paris from Naples. One of these may have been the *Child Sleeping near a Skull* (known today by way of engravings by Jean Ganière, Pieter de Jode II, and John Oliver; Figs. 112, 113), while the "S. Familie avec Zacharie et S. Elisabeth" (said to be recorded in another de Jode print) might have preceded or have accompanied Gentileschi's trip to England via France.[28]

In 1638 a lengthy stopover in France would not have been indicated. Artemisia had committed herself to England, there not only to serve Charles and Henrietta but to visit and assist her father, whom she probably had not seen since 1621. Orazio was to die on February 7, 1639, and that which finally compelled the trip might well have been news of the septuagenarian's declining health[29] even at the very moment of his engagement on the most extensive project of his career (Fig. 170; Color Plates XXV, XXVI).

Artemisia remained in England with her brothers Francesco, Giulio, and Marco following their father's death, but by Christmas of 1639 she was more than ready to return to her own country and sought from the Duke of Modena monetary incentive to do so. It is logical to suppose that Artemisia was resolved to wait for Francesco I d'Este's

reply before making a move. She may have grown impatient, because the response, which turned out to be only generically encouraging, was not posted to London until March 16, 1640. Before long she must have been back in Naples[30] where, now under the impact of Orazio Gentileschi's late works, her art entered still another phase.

Facing Economic Realities

From the foregoing it is clear that the internationalization of Artemisia Gentileschi's patronage, begun during the 1620s, continued during the fourth decade. To the names of non-Italian collectors already cited can be added those of Prince Karl Eusebius von Liechtenstein and Charles of Lorraine, Fourth Duke of Guise.[31] The distinguished nature of this group and the very extent of Artemisia's artistic production in the years 1629–40 imply considerable financial security. Her correspondence, however, seems to tell a rather different story. Eleven of the fifteen letters from Gentileschi preserved from this period show the artist soliciting (and sometimes importuning) patronage, and even taking active steps to put her prospective benefactors in awkward positions were they not to reward her through money and/or offers of continued support. Like many of her male counterparts, Artemisia was shameless in professing her exclusive and undying devotion to whomever she happened to be addressing at the moment.[32] Although there may have been a man in Artemisia's life,[33] it apparently fell to her as an independent woman to provide for herself and her daughter(s)—not an easy task in Italian Baroque society. Pierantonio Stiattesi may still have been residing in Rome,[34] but she could not count on him. And it made good business sense not to sit idly by in hopes that orders would flow in.

Nonetheless, by this time Gentileschi apparently found herself in the position of executing some works on speculation, without prior pledges from buyers, perhaps even such a very large and ambitious picture as the *Christ and the Samaritan Woman with the Twelve Apostles* which, along with a *Saint John the Baptist in the Desert*, she proposed to send to the Barberini in 1637. On February 11, 1636, she lamented to Andrea Cioli the "hard life and the high cost of living (*il male vivere, et delle cose care*)" in Naples, and on April 1 informed him of her need to sell some of her holdings ("*alcuni miei beni*") in Pisa in order to raise her daughter's dowry. The full dowry was still to be amassed when on October 24 and November 24 of the next year Artemisia made it clear to Cassiano dal Pozzo that it was for this purpose that she was offering the *Christ and the Samaritan Woman* and the *Saint John*, "being without other sources of funds (*non avendo altro capitale o assegnamento*)."

While there is no justification for believing that Artemisia Gentileschi was in dire straits, neither can we visualize an artist at financial liberty to be particularly selective as to the kinds of commissions she would accept. Whether she liked it or not, some of these situations apparently dictated that she take on collaborators. And, when gambling

on interesting a potential buyer, she seems to have chosen the subject matter in order to maximize her chances of success and not necessarily out of personal preference. An assessment of Gentileschi's artistic production from the 1630s must bear these points in mind.

It is also true that in her joint ventures with Viviano Codazzi, Domenico Gargiulo, and Bernardo Cavallino, to be discussed below, Artemisia was the designer and usually the dominating brush, an indication that the male painters may have accounted it a privilege (and probably something of a thrill) to work with the high-profile woman painter. Beyond doubt they recognized her talent, as did the Spanish Viceroys and the others who had ordered or received Gentileschi's canvases. Brief comments made by Joachim von Sandrart hold out the possibility that Neapolitan masters, generally finding it difficult to abide "foreigners" in their midst, accorded Artemisia a singular honor. In the later months of 1631 the German painter and writer, having already come into contact with Orazio Gentileschi in England and having been to Rome, paid a visit to Artemisia in Naples, and was later to report of her in his *Academie der Bau-, Bild-, und Mahlerey-Künste* that "sie hat auch überaus gute Contrafäte verfärtiget und auf der Academie fürtreflich [vortrefflich] gezeichnet," from which it is to be understood that "she also painted extremely good portraits, and drew excellently from the live model."[35] Now Sandrart's notice concerning Artemisia is found in the XXII Capitel (Zweiten Buch, Zweiten Teiles) of his manuscript; the XXI Capitel ends[36] with lines devoted to Aniello Falcone's practice of life drawing, that is to say to the activity in that "Accademia del Nudo" which according to De Dominici was held in the house of the celebrated battle painter.[37] To my knowledge, Falcone's life-drawing sessions, which other painters attended, were the nearest thing to an artists' academy then existing in the city of Naples.[38] The closeness of the two accounts in Sandrart's text alerts one to a possible connection between Aniello's studio and the "Academie" which Artemisia drew so skillfully. But even if not insinuating this link, Sandrart's words, along with the very fact of Artemisia's induction into the Accademia del Disegno at Florence, require one to reexamine the seemingly obligatory contention that as a woman Gentileschi was excluded from studying the male nude.

It is conceivable that Artemisia Gentileschi's concerns over money were in some degree attributable to a Neapolitan scale of remuneration that was unexpectedly and uncomfortably low,[39] for she seems to have produced paintings at a significantly faster rate—perhaps more than double the speed—than ever before. One counts almost four dozen pictures, approximately half of them extant, from the period 1629–40,[40] thirty-three in all from the previous *two* decades. In addition, some of the canvases mentioned in Neapolitan documents after 1640 were certainly painted during the 1630s, further swelling the number. Once again, however, the raw data are subject to interpretation. Thus a combination of an unusually large cache of preserved Neapolitan and English inventories and of special scholarly efforts in locating and publishing them[41] may distort the overall view. Adopting a tactic that her father had used to good advantage, Artemisia now began as a matter of routine to repeat rather than re-create pictorial ideas when

interpreting the same theme (there are three *Bathshebas* and three *Susannas* from this time) or to use a similar figure in different contexts (cf., for example, Fig. 159 and Fig. 164; Color Plates XXIII and XX). She may have enlisted the assistance of her daughter Prudentia, whom she had trained as a painter, in transposing such compositions or figures and even for portions of the finished products.[42] Then there were the other partners already signaled. And paintings conceived as pendants or in groups of three began to leave Artemisia's studio—package deals, perhaps.[43]

Artemisia's travels and her financial situation during the 1630s thus reconstructed, closer analyses of the paintings can now be undertaken. Following an overview of the subject matter of Gentileschi's art during this busy period, with particular emphasis on a series of self-referential works, the text surveys the development of the artist's narrative canvases through a chronological progression of three seemingly definable stages.

Old Themes, New Themes

With regard to the nature of the relatively extensive production of the fourth decade, there are some predictable aspects, some surprises. The reports of Sandrart and De Dominici, and the artist's own reference on December 21, 1630, to a *Portrait of a Duchess* assure us that in Naples Gentileschi continued her activity as a portraitist to the prosperous.[44] The latter in turn calls to mind the *Portrait of a Noblewoman* (Fig. 120). Although still surrounded by uncertainties as to identification and date, and even by lingering doubts as to authorship, this painting remains one of consummate quality and breathtaking effect, a combination worthy of an artist of the highest rank and of the beauty of the person depicted. Seated obliquely on a red velvet chair, its metal finial mirroring her form, the young woman in magnificent garments of black and gold and a lace collar turns her head as if in dignified communication with someone to her right. The picture is part of a tradition of sumptuous and detailed aristocratic portraits that included most immediately Justus Sustermans and Lavinia Fontana. Yet while hardly a casual record, it strikes a new note of naturalness through its easy *contrapposto* and its avoidance of an aura of self-consciousness on the part of the sitter. Capable in any case of acuteness of vision and deftness of touch, as demonstrated by the *Portrait of a Condottiere* (Fig. 82; Color Plate IX), Artemisia Gentileschi was no doubt following the dictates of convention, propriety, and the expressed wishes of the patron in faithfully transcribing all the particulars of the costly raiment.

Unexpected, on the other hand, are the three religious paintings for the choir of the Cathedral at Pozzuoli, south of Naples (Figs. 146–49; Color Plate XXI). For what may be the first and last time in her career, Artemisia was called upon to produce canvases for a public ecclesiastical setting.[45] Only the *Birth and Naming of Saint John the Baptist* (Fig. 139) is comparable, but even it was designed as part of a cycle of paintings

for a private retreat, the hermitage of San Juan Bautista reserved for the Conde-Duque Olivares on the grounds of the Buen Retiro in Madrid. In the previous chapter I suggested that in reflecting upon Artemisia's personal reputation and the prominence of erotic female nudes in her oeuvre, patrons might have judged it inappropriate to commission public religious works from her. In a sense she was starting afresh in southern Italy, where stories of scandal and the like involving her might not have been so current and where, therefore, patronage prejudice might not have been a determinant. Still, the *Saints Proculus and Nicea*, the *San Januarius in the Amphitheater*, and the *Adoration of the Magi* were but three among ten pictures, the rest by others, and were neither altarpieces nor meant for a church in Naples proper. Furthermore, for the *Birth of Saint John* Artemisia appears to have been subcontracted by Massimo Stanzione, not hired directly by the Conde de Monterrey, and at Pozzuoli something of the same thing may have obtained, with a single painter (in this case Giovanni Lanfranco?) charged by the Bishop Martín de Leòn y Cárdenas with overseeing the whole and free to select his associates.

The works by Artemisia for Pozzuoli and Madrid are clustered in the years 1633–34. Those which flank and overlap them in time are collector's pictures, often large in scale. The portraits aside, three-quarters of these canvases—whether of profane, allegorical/literary, historical, Biblical, or saintly themes—feature women or give women equal billing. It is of course true that female-oriented paintings are precisely those which scholars have most readily recognized as being by Artemisia Gentileschi or to which they wish to attach her name. But even if allowances for this bias are made, it seems obvious that the general pattern of subject matter that had its genesis at the very start of Artemisia's career and was consolidated during the Florentine and second Roman periods remained constant in Naples and London.

Among these same paintings, however, the percentage depicting female nudes shows a precipitous decline, from up to sixty percent of the works of the 1620s to approximately twenty-five percent (fifteen percent of the extant pictures) during the fourth decade. Only the unsettling *Venus and Cupid Embracing* (Fig. 130) is of the reclining nude type; not even Cleopatra (cf. Figs. 110 and 136; Color Plates XV and XIX) is rendered as such. In all likelihood this departure from established routine was dictated by Neapolitan/Spanish religious scruples; revealingly, two-thirds of the nudes are known to have been painted for or sent to non-Neapolitan clients (Karl Eusebius von Liechtenstein, Charles I of England, Cardinal Barberini).

Another subject type, the single-figure allegorical/literary presentation, shows a marked increase, from the *Inclination* (Fig. 64; Color Plate VIII) and (probably) the lost *Amoretto* from the preceding two decades to the *Memento Mori*, *Clio*, *Minerva*, *Allegory of Painting*, *Polyhymnia* and *Arithmetic* (Figs. 112, 113, 121–23, 156, 175, 171; Color Plates XVIII, XXVII, XXVI), and the lost *Fame*. Once more, not one of these works appears to have been designed for a client in Naples, but rather—one can determine with different levels of certitude—for Louis XIII, Charles of Lorraine, Ferdinando II de'Medici, and Charles I.

64

Professions of Self-Worth

Some of the just-named allegorical pictures are also clearly self-referential. Viewed in conjunction with two *Self-Portrait*s (one extant, the other recorded in an English inventory), they reveal an artist intent as never before on self-presentation, a mission which cannot be fully understood, I believe, apart from Artemisia's economic condition as outlined above and from the tone of her correspondence. Whereas not a single letter has come down to us from the years between Gentileschi's return to Rome from Florence and her appearance in Naples, fifteen letters from the 1630–40 period have been identified. Without forcing correlations, it would be wise to consider what Gentileschi painted in the light of what she said—or did not say.

At several points Artemisia expressed pride in her achievement or otherwise indicated a sense of self-worth. Thus she held up to her patrons or potential benefactors the social positions and names of those whom she had served—the Empress, a Duchess, the Duke of Guise, "all the kings and rulers of Europe," including those of Spain, France, and England, who honored her "not only with very great gifts but also with most favored letters."[46] While reluctant to travel to London, she was not averse to publicizing Charles I's persistence in luring her there. Notably absent, however, are instances in which Artemisia lauds her art as such. Indeed, her claim to Cassiano dal Pozzo[47] that the landscape in her *Christ and the Samaritan Woman* was "very beautifully rendered" stands alone. Against this can be set those passages in which she speaks of her "meager talent," of the defects in her works, of their lack of perfection, and of her "innate lack of ability."[48] Too much should not be made of these declarations, for in their forced humility they are stereotypical of artists' dealings with patrons. They begin to strike a note of insecurity, however, in the context of the letters in which they appear, two among the eleven in which Artemisia entreats commissions.

As if in compensation for this insecurity and for what may have been a certain feeling of humiliation in having so openly to seek work, Gentileschi produced several pictures during the 1630s which, even if ordered from her rather than independently conceived, are so oriented as to be first and foremost professions of self-worth.

Of this group, the earliest in time is likely to be the *Self-Portrait* in the Galleria Nazionale at Rome (Fig. 119), in which the dark-haired Artemisia crowned with laurel and lavishly attired in a greenish dress over a full-sleeved white garment and a golden-yellow mantle fixes her gaze upon the observer.[49] The artist holds a palette, brushes, and a mahlstick in her left hand, while her painting hand is poised before an oval portrait of a man. Another brush (?) and a chalk holder rest on a table. Some of these attributes can be found in Cesare Ripa's recipe for the Personification of Painting, *La Pittura*, while the brooch with its reflecting surface could be an allusive substitute for the mask pendant, signifying the imitative function of art, also prescribed by Ripa.[50] The prominence accorded the oval portrait likewise commends the art of painting as a mirror of reality, again evoking the pendant ("che é ritratto della faccia dell'huomo," in Ripa's words). Decked out in anything but everyday studio garb, Gentileschi defines herself as a gentle-

person and in so doing places her profession on a respectable social plane.[51] And the laurel wreath, a conventional symbol of Poetry, recalls the notion of *ut pictura poesis*. In his canvas of 1626 (Florence, Palazzo Pitti), Francesco Furini represented Painting and Poetry, both with laurel in their hair, as sister arts,[52] and Bernardo Cavallino was to grace his *Allegory of Painting* (Naples, Novelli Collection) with laurel.[53] The pervasiveness in the seventeenth century of the *ut pictura poesis* equation is also attested by, among many examples, the *Self-Portrait*s of Judith Leyster (Washington, National Gallery) and Nicolas Poussin (Paris, Louvre).

At the same time, Artemisia's homage to herself and her calling does not remain on an aloof plane. The painting instruments represented, to the exclusion, for example, of the square and calipers associated with *La Pittura* on the reverse of Felice Antonio Casoni's portrait medal of Lavinia Fontana (Fig. 173), emphasize craftsmanship over intellectual concerns. Through the elaborateness and particularization of stuffs the artist exhibits her technical skills, and these garments are not generic robes but apparently echo current middle-class fashion.[54] The portrait on the easel also embeds the picture in reality by advertising Gentileschi's standing as a much sought after portraitists even as it suggests that the man portrayed (still unidentified) held some special meaning—personal and/or intellectual—to Artemisia and/or her patron. It is in the tradition of the Friendship Picture (*Freundschaftsbild*) as represented for example by Luca Cambiaso's *Self-Portrait in the Act of Portraying His Father* from the 1570s (Guala Collection) and Nicolas Regnier's *Self-Portrait of the Artist at His Easel* of the early 1620s (Cambridge, Mass., Fogg Art Museum).[55]

The patron was probably Cassiano dal Pozzo, who as noted was putting together a gallery of portraits of singular individuals and to whom in late December of 1630 Gentileschi was about to ship a *Self-Portrait*.[56] The complicated question of the subsequent history of this picture is addressed in the Catalogue, which acknowledges as well the fact that almost seven years later, in a letter of October 24, 1637, Artemisia offered Cassiano an incentive to act on her behalf in the form of "my portrait . . . in conformity with that which you once requested, to be numbered among [your other portraits] of illustrious painters."

I have concluded that two separate *Self-Portraits* are at issue and that the second version accompanied Gentileschi to London in 1638, there to be inventoried in 1649 at Hampton Court ("Arthemesia gentelisco. Done by her selfe") and then sold to Mr. Jackson in the Commonwealth Sale of 1651 as "Arthemesia gentilisco. done by her selfe." Moreover, I maintain that the *Self-Portrait* thus cited has been lost and therefore cannot be the famous picture now at Kensington Palace (Fig. 175; Color Plate XXVII) which, datable to Artemisia's English stay, is to be identified as "A Pintura A painteigne: by Arthemisia" listed at the same time among the same Royal holdings at Hampton Court and purchased, it too, by Jackson.

Comparisons of the features of the woman in the Kensington canvas to known likenesses of Artemisia Gentileschi (e.g., Figs. 99, 100, 101) reveal that the artist has not depicted herself here—as much as tradition and partiality urge the contrary. Analysis of

the imagery of this spirited painting buttresses the case and eventually leads back to the "Arthemesia gentelisco. done by her selfe." A palette in her left hand and a brush in her right, the resolute young woman with dark, unkempt hair reaches forward, about to apply the vital first strokes of color to a large primed canvas. She wears a lace-trimmed white undergarment, rich brown dress with low bodice, full green sleeves shot through with highlights of gray, pink, and white, and a gold chain fitted with a mask pendant. The Barberini *Self-Portrait* calls up aspects of Ripa's Personification of Painting to dignify a living individual artist. The woman here *is* Painting, *La Pittura*, her attributes pointedly selected from the *Iconologia*: the brush and palette; the disheveled hair, symbolic of the inspired painter's neglect of appearance; the *drappo cangiante*, as art pleases by its variety; the mask pendant, denoting painting as imitation, inseparably attached to the chain, its links standing for the interdependence of all aspects of the noble profession. Before her awaits the tabula rasa, added by Artemisia to Ripa's instructions in order to "stress the primacy of the artistic idea, as superior to the particular depicted image on the canvas that follows in its wake."[57]

The London *Allegory of Painting* presented Artemisia with an opportunity not afforded male painters: to feature herself, in all her recognizability, as the personification, and to cement this connection with a full and prominent signature. But in my opinion she did not do so; in type the female is more Polyhymnia (Fig. 171) than Artemisia, and the modest initials "A. G. F." on the right corner of the tabletop are threatened by shadow. What Gentileschi has done is to vitalize an abstract construct and, through a dazzling technique, to acclaim her mastery as *La Pittura*'s sister.[58]

One of the four corner roundels (Fig. 170; Color Plate XXV) in Orazio Gentileschi's ceiling decoration for the Queen's House, to which his daughter contributed, shows *La Pittura* working on an image of Minerva, as she does in illustrated editions of Ripa's *Iconologia*. The Kensington *Allegory of Painting* belongs, I think, to the same moment, and should be seen in connection with the now lost "Arthemisia. gentelisco. done by her selfe." The meaning of these two pictures, meant to be hung and understood together, is clarified by Casoni's medal of Lavinia Fontana from 1611 (Fig. 173), which may have been decisive for Artemisia's conception.[59] The obverse displays a profile portrait (traditional in numismatics) of Lavinia, and the reverse *La Pittura*, faithful to Ripa down to the gagged mouth. It has been observed[60] that this arrangement "carries an implied possibility of interpreting Fontana the artist and the Allegory of Painting as overlapping identities," with Artemisia taking "the idea one step further, fusing artist and allegory in a single image." I propose, rather, that Gentileschi, who may have known this tribute to the Bolognese woman painter, was to contrive the *Allegory of Painting* as a companion to the *Self-Portrait* that she carried from Naples—two sides of the coin. The former picture does indeed suggest that "art and craft, concept and execution, inner vision and outer manifestation . . . are equally essential to painting,"[61] but in the interpretation offered here the full relevance of this specifically to Artemisia Gentileschi would have been asserted by the *Self-Portrait* intended in 1637 for Cassiano dal Pozzo and later inventoried at Hampton Court.

67

While the *Self-Portrait* in Rome was probably painted on the command of Cassiano dal Pozzo, Artemisia seems to have executed the second example on her own with the end of currying Cassiano's continued favor. Then, stimulated by the idea of the Greenwich roundel and perhaps by the Lavinia Fontana medallion, she conceived the *Allegory of Painting*. By their very nature these pictures were ideal showcases for the artist's proclamation of self and standing, insisting visually on that which is notably lacking from her correspondence at this time. The *Clio, Muse of History* (Figs. 121–23; Color Plate XVIII) from 1632 appears to have been a direct order from Charles of Lorraine, Duke of Guise, then in self-imposed exile in Florence, who had a personal and political stake in its message. The dedicatory inscription in the Book of History refers in all probability to François Rosières (1534–1607), former vigorous supporter of the Lorraine line, whom upon the twenty-fifth anniversary of his death the Duke of Guise is now honoring and recommending to posterity while simultaneously promoting his own virtue and fame. Most provocative, however—the names of Rosières and Guise not generally being occasion for excitement—is that aspect of the painting as a "meditation on the role of the artist in the assurance of human fame. . . ."[62] The idea for a picture of the Muse of History, here dressed in a greenish-blue mantle with rust-colored sleeves over a white undergarment and steadying a trumpet fitted with a braided cord, was no doubt Charles of Lorraine's. But the written dedication, in which the name ʀᴛᴇᴍɪꜱɪ figures prominently, is to be understood by the viewer as having originated with Gentileschi herself. But that which truly secures for Artemisia Gentileschi a noteworthy page in the record of history is the brilliance of the painting as painting. Perhaps nowhere else in Artemisia's oeuvre is creative fire so much in evidence, jabbing on or pulling out succulent highlights to conjure folds into existence, laurel leaves materializing from the twist of a loaded brush, eyes moistened by who knows what magic. Motivated by the knowledge or suspicion that her benefactor enjoyed the delights of connoisseurship, Artemisia appears here at her most pictorially liberated moment.

Perhaps with the experience of the *Clio* behind her and the companion canvases of *Self-Portrait* and *Allegory of Painting* on her mind, Gentileschi was to produce a picture variously described in the English sources: as "a woemans picture . . . in some bluish draperie = with a trumpett in her left hand Signifying ffame with her other hand having a penn to write . . ."; as "A Halfe figure of a Woeman houlding a Trumpett in her left hand, and a penn in her right being called Fame . . ."; and as "Posea wth a trumpett. . . ."[63] With this picture of Fame Artemisia may have repeated the performance of the *Clio*, to which it was obviously closely related both in iconographical type and appearance.

Approximately midway between the *Clio* and the *Fame* there came from Artemisia's easel still another self-referential painting, the *Minerva* (Fig. 156) in Florence. This canvas may have played a role in Gentileschi's negotiations of 1635 and 1636 for Medici commissions, otherwise documented by a series of letters. Certainly as a subject that presupposed some familiarity with symbolism, it would have appealed to Ferdinando II, his Secretary Andrea Cioli, and other members of the Ducal court. It would have been

flattering in another way to the male branch of the Medici and those associated with it: As Pope Leo X from 1513 to 1521, Giovanni de'Medici had identified himself with Minerva, whose figure was then to appear on the tomb of Leo XI (Alessandro de'Medici) for Saint Peter's, commissioned from Alessandro Algardi in 1634.[64]

Yet there are also autobiographical references which add some sparkle to a painting marked by a strange lassitude in sentiment and a corresponding lack of painterly passion, so unlike the *Clio*. With her lance, olive branch, and huge gunmetal and golden-brown Medusa shield, this woman in a dress of lavender tones presents many of the conventional trappings of Minerva. Being, however, of decidedly un-warlike disposition and wearing a laurel crown in place of her helmet, Minerva appears here as Sapienza personified. For Wisdom, as detailed in Cesare Ripa's *Iconologia*,[65] is fortified externally and internally against outside forces, is born of exterior and interior peace, and has severed herself from all bad habits. Artemisia Gentileschi, avoiding further abstraction by not fitting Minerva with her usual breastplate, openly appropriates the virtues of Sapienza. As the canvas bears her signature, ARTEMISIA GENTILESCHI FACIEBAT, so does the shield bear her name as an integral part of its gold embellishment. From this the way is short to the association of Minerva with the Arts, and specifically with the Art of Painting, a traditional affiliation given visual form in innumerable examples, among them Orazio Gentileschi's *tondo* once at Greenwich, Federico Zuccaro's *Apotheosis of the Artist* of 1598 in the Palazzo Zuccaro at Rome, and engravings in Giovanni Baglione's *Le vite de'pittori, scultori et architetti* of 1642 and the *Teutsche Academie* by Artemisia's acquaintance Joachim von Sandrart. Finally, the classicized physiognomy of Minerva, to some extent relatable to the general direction which Artemisia's art began to take in the mid-1630s, might also be attributed to the painter's desire to fit the style to the historical era and to suggest that the concepts which the picture embodies belong to time immemorial, to which, then, Gentileschi links herself.

The paintings discussed thus far are distributed throughout the 1630s, but remain constant in conveying the artist's image of herself and her occupation. Conversely, they undergo stylistic changes which are consistent with shifts in Gentileschi's art as a whole during this decade. Of the narrative canvases three clusters, each with distinct characteristics, are identifiable: private commissions, 1630–35; public projects, 1633–35; and private commissions, 1635–40.

Grandiosity and Melodrama: 1630–1635

The *Annunciation* (1630), *Esther Before Ahasuerus* (ca. 1630–35), *Cleopatra* (ca. 1630–35), and *Corisca and the Satyr* (ca. 1633–35) speak for the first group of private narrative works with special eloquence (Figs. 114, 125, 136, 131; Color Plates XVI, XIX, XVII). In broadest terms, they are marked by a heightened theatricality, of which a new conception of the viewer–painting relationship is the first indisputable sign. The viewer now becomes a

member of an audience, rather than someone who finds him/herself suddenly confronted one-on-one with reality, that is with an event which, but for the organizing power of art, might have been experienced more or less as presented. Thus the dramas are acted out on perspective groundplanes, on shallow stage spaces. As witness the *Jael and Sisera*, *Judith and Her Maidservant*, *Penitent Magdalen*, *Portrait of a Condottiere*, and *Aurora* (Figs. 73, 84, 111, 82, 87; Color Plates XIII, IX), this is not without some precedent in Artemisia's oeuvre. Yet in the *Jael*, *Judith*, and *Magdalen* any space that might have intervened between the observer and the depicted event is crowded out by the figures; the *Condottiere*, in adopting the conventional portrait type with a table displaying objects, required a perspective ambient; and the exterior setting of the *Aurora* carried with it implications of a field of activity.

Now, although the figures are not physically set back at any appreciable distance, they have an air of being "over there," performing in a realm that no longer encourages an intimate rapport between the actual and the action. The space becomes more exclusive to the figures and the objects within it. The bed of Cleopatra (Fig. 136; Color Plate XIX) is behind her, not pressed against the picture surface (and thus imposed upon us) as in Gentileschi's earlier rendition of the subject (Fig. 110; Color Plate XV) or as in the *Lucretia*, the *Venus and Cupid*, and the two compositions of *Judith Decapitating Holofernes* (Figs. 19, 104, 21, 77; Color Plates XIV, II, XII). Corisca (Fig. 131; Color Plate XVII) strides toward the left side of the picture in a motion that could take her out of sight, quite unlike Judith and Aurora (Figs. 84, 87; Color Plate XIII) who, were they to continue their paths, would enter our space. The draperies of Gabriel and Esther (Figs. 114, 125; Color Plate XVI) and Cleopatra flow to the sides, not forward as in the *Magdalen*s and the *Jael and Sisera*. These are all minor details, perhaps, except in cumulative effect.

The performers are decked out by a costumier with a taste for the opulent, driven by a will to dazzle, who experiences her finest hour in the *Esther Before Ahasuerus*, in which the Queen and King vie with each other in the splendor of their garb. Draperies billow, sometimes in layers, from undergarments to dresses to mantles, flirting with the overabundant. Ravishing, too, are the colors: golden yellows, deep reds and maroons, varied shades of blue, plums and lilacs, all punctuated by radiant whites. And a full complement of textures is put on display—linens and laces, silks and satins, gleaming woods and light-absorbing marbles.

It must be emphasized, however, that Artemisia the costumier was also possessed of good taste, and that even at their most lavish the garments do not upstage the figures and their psychological reactions, points lost on Gentileschi's imitators (contrast to Figs. 225, 243, 244). And her characters are not aloof in historical time, for the clothes which they wear are of the artist's day.[66] Reflecting women's lesser social importance, literary sources for seventeenth-century female fashion in Naples are less plentiful and less informative than are those for the dress of males.[67] Artemisia Gentileschi knew the attitude behind this imbalance, and through the garments in these paintings she becomes, consciously or not, a champion of middle-class women. Unlike the Spanish-inspired rigidity and decorum of dress which noblewomen had to suffer, Artemisia's females with their

natural hairdos sport garments that are ample but free and flowing, soft linen shifts trimmed with bits of lace, usually beneath low-cut gowns that reveal expanses of chest, and puffed sleeves. Additionally, Gentileschi, lavishing all her technical brilliance on these masterpieces of decorative painting, makes sure that the act of creation remains in evidence, energizing all and exciting us by its very daring.

Still, the movements of the figures in the four paintings under consideration appear almost too carefully choreographed. There is more than a touch of melodrama, not in the sense that the emotional pitch is high, but rather in the tendency of the characters to posture. Cleopatra swoons, her eyes rolled back in her head. Esther faints, as the libretto has her do, but without assuming an undignified limpness. Gabriel alights with a demonstrativeness that is guaranteed to startle the Virgin. As if fixed in a tableau, Corisca feigns flight.

Committed still to the verity of things represented and to exploiting the complex possibilities of light to differentiate textures, establish form, vitalize, and dramatize, and envisioning Ahasuerus as a Caravaggesque dandy, Artemisia otherwise takes further steps away from a genuine Caravaggism. No one can fail to recognize the ultimate derivation from the Caravaggesque mode of much of what Gentileschi does here on the level of style; no one can fail to see that her decision to pursue an ornamental and rhetorical grand manner does not respect the premises upon which Caravaggio had founded his revolution.

I noted above that Neapolitan masters had been deeply moved by Caravaggio's paintings, and suggested that in knowledge of this Artemisia Gentileschi may have surmised in 1629 that she would find in Naples a cultural climate disposed to value her approach. Thus the fact that already in her earliest dated Neapolitan picture, the *Annunciation* (Fig. 114) of 1630, her art took a new turn, assuming features that were to inform as well the Barberini *Self-Portrait*, the *Esther Before Ahasuerus*, the *Cleopatra*, and the *Corisca*, demands explanation. Something must have convinced Artemisia not long after her arrival in the southern Italian city that a further change in the character of her pictures would be professionally advantageous. And in order to effect this transformation, Gentileschi must have accumulated artistic experiences upon which she would draw more directly than previously or which she would now tap for the first time.

To those who have become exasperated with what has been called "influence-mongering art history,"[68] this last allusion to sources will likely bring a shudder. With respect to much scholarship on Neapolitan art, as attested by the catalogues accompanying the exhibitions entilted *Civiltà del seicento a Napoli* of 1984 and *Battistello Caracciolo e il primo naturalismo a Napoli* of 1991, warnings issued in 1983[69] concerning the pitfalls of claiming influences here and influences there with little attempt to account for the presumed borrowings have unfortunately not been heeded. What follows conveys my belief that Artemisia Gentileschi, like a great many fine painters, not only kept an open mind when viewing the art of others but was confident and intelligent enough to absorb features of this art into her own when to do so suited her purposes. The challenge is to attempt to discover what those purposes were, recognizing that even specific appropriations, identi-

fiable with reasonable degrees of certainty, were likely to have been stimulated by personal and patronage requisites rather than by mere attraction.

A Neapolitan painter who had never visited other major centers would be excused from being unsettled by the influx of imported art and "foreign" artists which his city experienced between 1620 and 1635. In 1622 Simon Vouet sent from Rome his *Circumcision of Christ* for Sant'Angelo a Segno, to be followed in 1626 by the *Appearance of the Virgin to Saint Bruno* for the Certosa di San Martino (Figs. 115, 116).[70] By about 1630 there had arrived the *Meeting of Christ and Saint John the Baptist* and the *Ecstacy of Saint Francis*, commissioned of Guido Reni by the Girolamini in 1621. In 1631, after several false starts, the decoration of the vast Cappella del Tesoro in the Cathedral was set into motion under Domenichino, who was to work in Naples until his death in 1641. For twelve years (1634–46) Giovanni Lanfranco labored there, moving from one big project to another. And in the midst of this a true phenomenon, Artemisia Gentileschi, made her entrance.

Our native Neapolitan artist would also be forgiven were he to have been overwhelmed by the range of styles which accompanied this invasion, most of which had nothing to do with that Caravaggism with which he would have been familiar by way of pictures by Caravaggio himself and by such as Caracciolo, Sellito, Stanzione, and of course Ribera. The grace and delicacy of Reni's manner, sweetly lyrical in sentiment, would have stood in sharp contrast to the bursting energy of the frescoes of Lanfranco, so different in turn from the Neo-Raphaelesque classicism of Domenichino. The supplantation of Caravaggism is dramatized by Vouet's two altarpieces, the *Circumcision* conserving some aspects of Caravaggesque tenebrism and earthy figure types, the *Appearance of the Madonna to Saint Bruno* looking to the Bolognese in its lighter color, softer handling, and atmospheric surround.

To Artemisia Gentileschi, who had spent most of the third decade in Rome, none of this would have been startling—except as it was now being cultivated by Neapolitan patrons. And except that it may have persuaded her, as it did even Caracciolo (whose *Assumption of the Virgin* of 1631 [Fig. 117] contains no hint that since 1607 he had been a devoted *Caravaggesco*), that further accommodations were in order. By early 1630 Artemisia must have become aware of the growing Neapolitan taste for the latest in Roman-based art that was soon to deliver many of the major jobs in the city to non-Neapolitans. A Roman herself, as she would later boast to Ruffo of Messina, she may have entered Naples ready to impress with that fact and with her qualifications for being up-to-date. Apparently Gentileschi calculated that through the deliberate staging of more "decorous" characters, attention to *affetti*, and decorative flourish she could do exactly that—but without having to sever all Caravaggesque ties or to embrace either Domenichino's cerebral approach or Lanfranco's emotionalism.

She had the tools to carry this off, including a storehouse of pictorial impressions. Some of these had come from Simon Vouet, who had been drawn to the art of both the Gentileschi and to whose pictures such works by Artemisia as the *Judith and Her Maidservant* and *Penitent Magdalen* (Figs. 84, 97; Color Plates XIII, XI) have already been

compared. Relevant also are now Artemisia's Neapolitan paintings, beginning immediately with the *Annunciation* and the *Self-Portrait* (Figs. 114, 119), in connection with which Vouet's Naples *Circumcision* (Fig. 115) and his canvases in San Lorenzo in Lucina have been introduced.[71] The former pictures recall the *repoussoir* women in the latter ones, garbed in ample and rhythmic garments with puffed sleeves and each extending one arm while with the other hand clutching something. Then there is Gentileschi's *Minerva*, strikingly reminiscent in presentation of the French master's *Saint Ursula* (cf. Figs. 153 and 156), assignable to the same moment (that is, about 1625) as Vouet's *Angels with the Instruments of the Passion*,[72] likewise engulfed by effulgent materials, whose splendor and virtuosic craftsmanship must have gripped Artemisia as they grip us today. But Gentileschi was highly selective. In these works, as in the *Esther*, the *Cleopatra*, and the *Corisca* (Figs. 125, 136, 131; Color Plates XVI, XIX, XVII), she still paints individuals, not universal beautiful people. Her rendering of stuffs has a particularized palpability lacking in Vouet's more generalized and more inflated draperies, which would never be mistaken for contemporary fashion. Gentileschi is more rigorous, not about to emulate Simon's facileness.

Vouet was never as confirmed a follower of Caravaggio as was Artemisia, and while still in Italy had distanced himself from that allegiance to a considerably greater degree than she had. Nonetheless, he and Gentileschi had shared many common experiences and had faced some of the same basic decisions. Thus if the relationships deduced above can be granted, the Frenchman's steps toward a grand manner in such works as the *Investiture of Saint Francis*, the *Circumcision*, and the *Birth of the Virgin* for San Francesco a Ripa[73] could have had an impact upon what Artemisia was to do in Naples. It has been written that Vouet's two large altarpieces for Naples "prepared the ground for the acceptance of Artemisia Gentileschi's work" in that city.[74] It may be that Gentileschi understood that too, and judiciously turned it to her advantage.

Needless to say, Artemisia did not suddenly acquire a taste for luxurious fabrics and other ornamental effects as such upon seeing Vouet's works, which may simply have reinforced her training by Orazio Gentileschi, "the most marvelous tailor and weaver who ever worked among painters,"[75] and her seven-year exposure to Florentine art. It is, however, in her pictures executed in Naples between 1630 and 1635 that this taste is more overtly and consistently exhibited than ever before and more than it ever would be again. As noted, there were reasons for Gentileschi to demonstrate to her new Neapolitan clients the heights of artistry to which she could rise. Yet I also believe that this full liberation of Artemisia's decorative instincts owed something as well to an event not long past—a second visit of the artist to Florence, most logically set to 1627 on her journey from Rome to Venice and/or to 1628/29 on her way back home.

A hint that Gentileschi returned to Florence toward the end of the third decade is provided by her *Annunciation* of 1630 (Fig. 114), compositionally comparable to those Florentine works that seem to have inspired her father's *Annunciation*s (Genoa and Turin), among them Donatello's tabernacle in Santa Croce and pictures by Alesso Baldovinetti (now Uffizi) and Santi di Tito (Santa Maria Novella). But the case for such a

trip rests above all upon Artemisia's *Esther Before Ahasuerus* (Fig. 125; Color Plate XVI). Although the setup of this canvas derives from one of Paolo Veronese's conceptions (e.g., Fig. 127) which Gentileschi could have seen in Venice, other aspects lead directly to pictures created for Florence after Gentileschi's first appearance there. Years ago I made a passing reference to the Sienese master Rutilio Manetti's *Roger and Alcina* (Fig. 129) in connection with Artemisia's *Esther*.[76] With the addition of Manetti's *Massinissa and Sophonisba* (Fig. 128), another male-female encounter, the argument has recently been taken up and the numerous points of contact between Artemisia's picture and the canvases by Manetti revealed in an exemplary way.[77]

The *Roger and Alcina* was painted in 1622–23 for the Casino Mediceo as part of a cycle of pictures illustrative of tales from Ariosto, Tasso, and the Bible.[78] It was closely followed by the *Massinissa and Sophonisba*, completed by 1625 for Maria Maddalena's Sala dell'Udienza in the Medici Villa del Poggio Imperiale, where it hung with three other paintings of celebrated women of antiquity.[79] Like Gentileschi's *Esther*, both are lavish costume displays. In the former, Roger, a foppish youth in boots and a wide-brimmed feathered hat, is seated at the right in a pose remarkably similar to that assumed by Ahasuerus. In the latter, which shares with Artemisia's painting a melodramatic flavor as Massinissa begins to collapse in another's arms not unlike Esther in those of her companions, the faces of Sophonisba and of Massinissa's supporter—one tilted backward in foreshortening, the other in profile—resemble those of Esther and Ahasuerus, respectively.[80] Very pointed comparisons between the *Esther* and Tuscan art are also afforded by a *Theseus and Ariadne* (Fig. 126), dated to the 1620s and tentatively assigned to Bartolommeo Salvestrini.[81] From the posture of her body to the inclination of her head, from her closed eyes to her crown and cascade of drapery, Ariadne forcefully brings to mind Gentileschi's Esther.

There is more. Besides the *morbidezza* of sentiment and the accent on gorgeousness which parallel various Florentine pictures with which Artemisia would have been familiar, the pose of Gentileschi's Cleopatra (Fig. 136; Color Plate XIX) when seen in reverse is alike to that of Rutilio Manetti's *Penitent Magdalen with an Angel* in a private collection in Siena, now placed at the end of the 1620s.[82] To argue that these shared features may be attributable to a common prototype, one by Guido Reni for example, would be to ignore the fact that in Manetti's work an angel with a flaming torch stands at the left. It is as if Artemisia substituted in the same spot her symbol of now ineffectual profane love for Manetti's Divine consoler. It is therefore not a total surprise to find that the head of Gentileschi's Cleopatra and that of the woman (head on hand and pained of expression) at the shoulder of Manetti's Sophonisba (Fig. 128) are virtually interchangeable. The would-be urgency, the striding pose, and the complex fluttering draperies of modern stamp in Artemisia's *Corisca* (Fig. 131; Color Plate XVII) call up another scene with sexual overtones of women fleeing danger, Rutilio's *Lot and His Daughters* (Siena, Private Collection), which has been bound stylistically to pictures executed by the Sienese artist between 1628 and 1633.[83] Finally, light playing over their crumpled surfaces,

the materials painted by Gentileschi often have a shiny and almost brittle quality, bringing her closer in this respect to Manetti than to Vouet.[84]

Once More the Question of a Personal Agenda

The *Corisca and the Satyr* also calls forth certain works by Massimo Stanzione and the question of what it was that Gentileschi took from and gave to Neapolitan painting of the time. But before more is said about the art-historical context of the *Corisca* and of the other pictures—the *Annunciation*, the *Esther Before Ahasuerus*, and the *Cleopatra*—which I have grouped with it, consideration must be given to the issue of the possible relevance of these canvases to Artemisia Gentileschi the woman. Are they consistent with the artist's presumed identification with heroic female characters? Even more particularly, do they give evidence of a feminist bias? I have featured the Rome *Self-Portrait*, the *Clio*, the *Minerva*, the *Allegory of Painting*, and the lost *Self-Portrait* and *Fame* as proclamations by Artemisia of self-worth and of high professional standing. Do the narrative works just mentioned likewise embody personal concerns, and more specifically seek to overturn sexist presumptions of how the women ought to present themselves and therefore how their stories ought to be visualized?

Unfortunately, nothing is known of the circumstances under which these pictures were created. It seems safe to infer that the *Annunciation* (Fig. 114), of conventional layout (including the Heavenly apparition) and orthodox sentiment, was commisioned by an individual whose progressiveness did not extend to matters of iconography, and thus that the *Annunciation* lies outside the matters at hand. As an extremely rare large-scale pictorialization of a more or less contemporary literary text, the *Corisca* (Fig. 131; Color Plate XVII) has the hallmarks of a special-order item. The subject of Esther and Ahasuerus could be made to articulate a precise religious/political position,[85] but for Gentileschi's *Esther* (Fig. 125; Color Plate XVI), as for her *Cleopatra* (Fig. 136; Color Plate XIX), the lack of patronage information restricts analysis. Throughout the previous chapters warnings have been issued against the tendency to interpret Artemisia's pictures on the tacit assumption that their subjects were selected by the artist with her own agenda in mind, even when patronage is acknowledged. In what ways, now, might these three paintings figure in the argument?

Any reading of the *Esther Before Ahasuerus* must properly recognize Gentileschi's textual source, which was the Apocryphal Book of Esther, wherein Ahasuerus rises from his throne in mildness of spirit, not the Biblical account which has the King extending his golden scepter, an act and a symbol of male authority that Artemisia avoids:

> And it came to pass on the third day, when she had ceased to pray, that she
> . . . dressed herself in splendor. When she was magnificently clad, she invoked
> the aid of the all-seeing God and Savior, and took with her two maids; on one

75

she leaned languishly, while the other followed her carrying her train. She was radiant with her perfect beauty, and her face was happy as it was lovely, but her heart was in agony for fear. When she had gone through all the doors, she stood before the king. He was seated on the royal throne, clad in all his magnificence, and covered with gold and precious stones; he was an awe-inspiring sight. And he raised his face, burning with splendor, and looked at her with the fiercest anger; and the queen fell down and turned pale and fainted, and she collapsed upon the head of the maid who went before her. Then God changed the king's spirit to mildness, and in great anxiety he sprang from his throne and caught her in his arms, until she came to herself. . . .

From this it will be seen that with regard to the number of figures, the splendid garments of King and Queen, and the actions and reactions, the painting is true to the Apocryphal account. Responsibility for the exact characterizations and for the disposition of the figures was assumed by the artist. Thus Ahasuerus is unexpectedly young and gives little indication of special wisdom or decisionmaking powers (but, then, he is also a figure from Artemisia's Caravaggesque repertoire), while Esther seems more mature and possessed of unity of purpose. Monumental as form, she dominates the left side of the canvas as Ahasuerus does the right, and in her shiny gold she ultimately becomes the center of the spectator's attention as she already is of the King's. Instead of collapsing into a heap Esther remains essentially upright so that her head, even in its slumped position, is almost on the level of Ahasuerus'.[86] She is a formidable woman, dignity intact.

But is Ahasuerus "outnumbered by three women" because Gentileschi wished to make some statement about female dominance, or rather because the Apocrypha stipulates one King and a trio of women, and is Ahasuerus really negatively portrayed, peeping birdlike at his Queen?[87] Is it permissible to conclude that the "visual subtext . . . hints at a reversal of roles, that she is the reigning monarch, he the young upstart"?[88] The theatricality of the *Esther Before Ahasuerus* is the product of a seasoned dramatist who knew how to make an impact on an audience. Was it at the same time intended to exalt women by deflating a man? Alongside any proposition that Artemisia is here identifying with the Old Testament Queen might be placed the following recapitulation of the Esther story: "King Ahasuerus' first wife, Vashti, had been deposed for her insolence in refusing to come at the king's command. Esther, in contrast, submitted meekly to him. . . . Esther's power resulted from her submission and her chaste beauty. She accomplished her great deed by means of the virtues of the ideal woman, not in spite of them."[89]

The personality traits of Corisca were anything but consonant with those of the seventeenth-century ideal of womanhood. Gentileschi's *Corisca and the Satyr* (Fig. 131; Color Plate XVII) is based upon act II, scene 6 of Giovanni Battista Guarini's pastoral tragicomedy *Il pastor fido*, first issued in the 1590s.[90] The wanton nymph Corisca, having exploited a satyr's passion for her and having under false pretenses repeatedly made him

the fool, finds herself caught by the hair in the goat-man's grip. Unable to sweet-talk her way out of this predicament, she commands her captor to tug hard, whereupon her wig comes free as the satyr, left to clutch it only, tumbles to the ground and laments: "Thou all made up of wiles, / Wasn't not enough thy heart, thy face, thy smiles, / Thy looks and speeches falsified were, / But thou must likewise falsifie thy hair?" The painted imagery is faithful to the text even, I suspect, to the point that Corisca's garb is meant to allude to Daphne's gown and Silvia's buskins which the nymph had previously conned the satyr into stealing for her.

Yet the only published discussion of the theme to date, while acknowledging that the depth and breadth of Corisca's wickedness is the point for Guarini and his commentators, posits that Artemisia Gentileschi saw the nymph in more positive terms.[91] Corisca's cleverness in concocting a ruse to escape the satyr's lechery (even though she had aggressively inflamed it) is seen as being consistent with the supposed personal appeal to Gentileschi of narratives in which a woman is headlined as "resisting, outwitting, and besting a physically more powerful male" and as potentially impressing female viewers of the Baroque period "as a mischievous but psychically liberating breaking of the rules."[92] Other artists have visualized the climactic moment as one of greater physical abandon, but the relative restraint of Artemisia's image need not signal an underlying seriousness of purpose. Decorously dressed, Corisca is not the proverbial sexual temptress, but then the literary context implies a clothed figure and the mores of a Neapolitan client may have insisted upon it. The animalism of the satyr is underplayed, but then Artemisia Gentileschi was not in the comic caricature business. I cannot find in this painting aspects that deviate from *Il pastor fido* and can be thought somehow to right the male wrong visited by the goat-man upon the nymph. One must know the text to know precisely what is transpiring here, and I think it almost a certainty that *in the seventeenth century* to be familiar with the text was not to be in the least inclined to find redeeming values in Corisca. It may be enough to view Gentileschi's contribution—a vision of richly arranged draperies of golden yellow, maroon-lilac, and white—as that of having painted the most beautiful representation to date of a scene from one of history's most popular literary achievements.

The recently discovered *Cleopatra* (Fig. 136; Color Plate XIX) does not fit the paradigm which many expect Artemisia Gentileschi to observe, and thus it is central to the present discussion. Her lover Mark Anthony done in by his own hand and the conquering Octavian planning a further humiliation, Cleopatra in a white blouse and golden dress commits suicide, the venomous asp, plucked from the basket at the right, still sinking its fangs in her left nipple. The Queen of Egypt is seated between regal parentheses of deep red curtain and golden-brown carved bedpost, her head supported by her right arm and the latter in turn by stacked pillows. It has been written that "by far the most popular conception of Cleopatra in the seventeenth century . . . was a romantic and sexual one."[93] In this Gentileschi's *Cleopatra* is absolutely stereotypical, for while on a literal level Cleopatra's state may be read as having been induced by the reptile's bite, here even more than in the Rome *Cleopatra* it comes in the guise of a swoon from love's

sting. The cupid-like figure, the flame which he holds, and the dolphin on which he rides (the fish's tail between the youth's legs) are attributes of Venus, that other goddess of love. Now the messenger of love turns his back on the doomed woman.

Reciprocity and Conservatism Toward Mid-Decade

Neapolitan masters must have realized that in the creator of the *Esther*, *Corisca*, and *Cleopatra* they had a major artist in their midst. Still in dispute, however, is the extent to which Artemisia Gentileschi helped shape the future of painting in the city. To one scholar's view that Artemisia represented the most important importation into Naples of external artistic ideas since Caravaggio's visit has been opposed in effect that opinion which maintains that her significance for Naples has been greatly exaggerated.[94] Another writer, properly cautious, notes that while traditionally Gentileschi's position vis-à-vis Neapolitan art has been thought of more as that of giver than receiver, "her exceptional . . . receptive capacities and [her ability] to adapt to the ambient should not be underestimated, for without this the fact that she emerged as one of the protagonists of that important moment could not be fully explained."[95] Although an in-depth investigation of this complex issue must await another forum, that evidence of influence, interchange, and collaboration which appears directly to affect those matters (attribution, chronology, and interpretation) which are at the core of this study must be evaluated.

And so we are led first to Bernardo de Dominici's account of Artemisia Gentileschi's importance for Massimo Stanzione.[96] As the Neapolitan historian would have it, Massimo was on such familiar terms with Artemisia that daily he could observe her at work, and was so taken by her art that he made copies of her pictures and imitated "the freshness of the beautiful color used by her," a *bel colorito* which Gentileschi is supposed to have learned directly from Guido Reni. The value of Dominici's information is very limited. Since the phrase *bel colorito* could refer to color choice, handling/quality of surfaces, or overall effect (e.g., refinement à la Reni), or a combination of these attributes, it is difficult to know precisely what the writer had in mind in this instance. He was also ill-informed or uninformed as to Artemisia's biography,[97] placing the painter (and her husband!) in Naples years before she actually arrived there and having her advise Stanzione to go to Rome to study Reni and Annibale Carracci (whereas Massimo had been to Rome several times before Gentileschi had moved south). Elsewhere Bernardo puts Artemisia in contact with Guido in Naples, an impossibility in that the former was in Rome during the latter's extremely brief Neapolitan visit in 1621, and he concocts a story involving the same two painters and an altarpiece of the Crucifixion in San Giorgio dei Genovesi which is in fact by Domenico Fiasella.[98]

Nonetheless, with the benefit of many and better-preserved pictures by both of them before his eyes, Dominici clearly sensed a relationship between the two painters, and this perception is upheld by various extant works. Artemisia's *Corisca* (Fig. 131; Color

Plate XVII) is an immediate case in point. One thinks particularly of the central female in Massimo's *Death of Orpheus* (Fig. 135)[99]—somewhat idealized, in an animated emotional state, her dress whipped up behind as she rushes forward—and the landscape with its rolling hills.[100] Significantly, even before the reemergence of the *Corisca*, Gentileschi's name had been invoked in connection with the women on the second plane of the *Orpheus*.[101] There are intimations that at least with respect to the production of paintings of profane subjects Massimo and Artemisia entered into something of a competition. Thus in 1635 Stanzione created a *Rape of Proserpina* for Francesco d'Allegria of Naples,[102] and it is possible that Gentileschi's *Rape of Proserpina* recorded in Florence by Filippo Baldinucci was one of the two large works which the artist sent in the same year 1635 to the Grand Duke Ferdinando de'Medici.[103] Almost a decade and a half later, on January 5, 1649, Massimo received his first payment from Don Antonio Ruffo of Messina for a *Judgment of Paris*.[104] Is it merely coincidence that in her letter to Ruffo on November 13, 1649, Artemisia spoke of a *Judgment of Paris* which a Cavaliere in Messina wished to commission of her?

Whether operating from knowledge or intuition or dealing in anecdotal embellishment, Dominici appears to have been correct in according Stanzione access to Gentileschi's studio. The reverse was also true beyond much doubt. One such opportunity for this kind of intimate interchange was provided by the cycle of six paintings on the Life of Saint John the Baptist, destined for the chapel in the Ermita de San Juan Bautista on the grounds of the Buen Retiro at Madrid, on which Stanzione, Gentileschi, and Paolo Finoglio began work in 1633 under orders from the Viceroy of Naples, the Conde de Monterrey (Figs. 137–45).[105] Since Stanzione took primary charge of four of these six paintings (five of which are preserved), it is likely that he was awarded the contract and then, under pressure to complete the project in record time, enlisted assistance. That the female Artemisia should be assigned the scene of the washing of the baby must have seemed as logical to Massimo as it appears annoyingly predictable today. Gentileschi made sure that she received due recognition by placing her signature on an isolated, trompe l'oeil scrap of paper that is aligned vertically with Zacharias's momentous act of inscribing the name of his just-born son.

Perhaps seizing upon this special situation to demonstrate that she was more than able to compete with the male artists whose works were to be hung with hers, Artemisia made certain that the *Birth and Naming of Saint John the Baptist* (Fig. 139) attracted attention in other ways. The picture is something of a tour de force of atmosphere.[106] Figures within an interior gradually emerge from engulfing shadows in the left background toward the light of the right foreground, in the direction of the narrative flow, the tonality shifting from near black to gleaming white. Illumination from the landscape in the right distance sweeps a balustraded loggia but is unable to enter a vaulted hall, where a swath of shadow marks the point where neither exterior nor interior light can reign. Forms are set at different angles of incidence to the imagined light source, intentionally complicating the painter's task, and the seated midwife wears a shawl of lilac shot through with yellow, recalling the *drappo cangiante* advised by Ripa for *La Pittura*

and best explained here as an advertisement for the variety of effects which art—Artemisia Gentileschi's art—can capture. As the midwife tests its temperature, the water in the large basin ripples and bubbles. Supported by this pictorial versimilitude, the psychological and physical states of the women surrounding the child—pondering, inquiring, moving into action, and assisting—also ring true. The Caravaggio-based realism of which Artemisia is still capable, evident in any case, is underscored when her rendition is compared to Cesare d'Arpino's *Birth of the Virgin* (Rome, Santa Maria di Loreto) from only three or four years earlier, wherein the Cavaliere "paints not reality but appearances of life, dreamy pantomimes. . . ."[107]

In making the various decisions, Gentileschi had to bear in mind that her canvas was one of six. Considerations of artistic unity within such cycles are to be expected during this period.[108] It seems clear that the artists consulted with one another at every turn and, given the deadline under which they had to operate, may have contributed to one another's pictures. Artemisia's declaration on July 20, 1635, to Ferdinando II de'Medici that she had worked on "some works" (*alchune opere*) for Philip IV may not have been exaggerated since, for example, figures in her *Birth of Saint John* appear as well in Stanzione's *Saint John Preaching* (Fig. 143). There are even suggestions that Bernardo Cavallino participated as a member of Stanzione's workshop, and other features have clear implications for the career of the Master of the Annunciation to the Shepherds.[109]

For all that the Saint John cycle was executed by three, four, or more hands, it was essential from an esthetic standpoint that it present a harmonious impression. When fresh, the canvases may have displayed a tight unity of light and color. The need for consistency also apparently led to mutual stylistic adjustments.[110] The physiognomies of Artemisia's women, more generalized than is characteristic for her up to this moment, and the studied composition may represent responses to Massimo's increasingly suave manner, while Massimo drew in a deliberate way upon his Caravaggesque experiences and, as in the armor and sweeping mantle of the soldier in the *Decapitation of Saint John* (Fig. 145), showed himself receptive to Gentileschi's sensitivity to texture-defining light and her penchant for exhibitions of blue and yellow materials.[111]

Circumstances of shared responsibility also helped shape the three paintings which Artemisia Gentileschi executed about 1635 for the Cathedral of Pozzuoli. Her *Saints Proculus and Nicea, Saint Januarius and His Companions in the Amphitheater*, and *Adoration of the Magi* (Figs. 146–49; Color Plate XXI) were conceived as part of a cycle of pictures for the choir of that venerable church. Recounting the lives of Christ and the Virgin and of saints who were of special importance in the history of Pozzuoli, the series fell to a team comprising Gentileschi, Stanzione, Finoglio, Lanfranco, and Cesare Francanzano. At least three restorations and one fire in the Cathedral later, the canvases have come down in poor condition; no analysis of them, least of all that which follows, can proceed free of apprehension.

Gentileschi's contributions do not hold any surprises in color, which is consistent with her usual preference for variations on red, yellow, and blue, here with accents of dark green and burnt orange. Her insistence upon the verity of depicted things, down to

Januarius's miter, the lion's coat, and Caspar's gift, and her concomitant dedication to an exciting range of lighting effects, are fully in evidence, supporting the representations with a Caravaggesque backbone. Passages of great skill and pictorial beauty abound, from the white fabrics throughout to the dalmatic of Proculus in the *Saint Januarius* and the cloak beneath Melchior's left hand in the *Adoration*. In other respects these paintings are characterized by a conventionality which precisely for that reason is difficult to define. Dignified, even solemn,[112] and approached with a seriousness of purpose, they are nonetheless without much expressive passion. For the *Saints Proculus and Nicea* (Fig. 146), Gentileschi may have deemed an iconic presentation to be the most viable one for this nonnarrative picture type—although there was always the electrifying solution adopted by Donatello on the bronze doors of the Old Sacristy in San Lorenzo at Florence, which Artemisia knew. The composition of the *Adoration of the Magi* (Figs. 148–49) is predictable, while its sentiment oscillates between the reverential and the somnolent—although in the Sala del Capitolo at the Certosa di San Martino there could be seen Caracciolo's stirring *Adoration of the Magi*, as urgent (if more mannered and less true to appearances) as Gentileschi's is reticent. And while the *Saint Januarius in the Amphitheater* (Fig. 147; Color Plate XXI) offered definite dramatic possibilities, the men-versus-beasts organizational scheme and the rather obvious ascending scale from ferocity to meekness among the animals do not exploit them.

Judged against the private commissions from the previous five years, Gentileschi's works for Pozzuoli seem less innovative and less individual. The rich offering of costumes in the *Adoration of the Magi* is expected for this gathering of royalty, and only Melchior gives a modish impression. Standard ecclesiastical vestments were required for three among the grand total of seven prominent figures. Golden yellows no longer provide commanding notes of splendor. Overall, the urge to electrify with fashionable garments of complicated creasings and foldings and with other sophistications has been reined in. Artemisia's Cathedral paintings reward interest; her easel pictures from the early 1630s demand it.

Explanations for the essential differences between these two groups of works can be proposed.[113] The subjects which Gentileschi was required to interpret at Pozzuoli were not standard to her repertoire, nor were they the kinds of themes certain automatically to involve her deeper self. As such, they would have taxed her ingenuity and her ability to enter into the spirit of the narratives.[114] Yet even if she reached the point where she could visualize ideas that might have brought the Pozzuoli pictures closer to her private commissions, she may have felt constrained from putting these ideas into practice—and for some very legitimate reasons.

Considerations of subject and site might have been foremost. What was easily contained within the bounds of decorum for an Old Testament scene or a literary conceit was not necessarily permissible for the Magi's recognition of the Savior of the World or for a miracle of the patron saint of Naples. At Pozzuoli the audience ranged from learned to illiterate, from the connoisseur to the untutored, and thus the advisability of finding a common denominator must have occurred to Gentileschi, an artist always sensitive to

the experiences and tastes of her intended viewers. Since two of the paintings were to hang above the choir stalls and the third, the *Proculus and Nicea*, above a door to the left of the apse, they could not be and were not meant to be scrutinized as one would a picture displayed in a private residence. (The care which Artemisia took with them is admirable in light of the viewing conditions.) Furthermore, while the original disposition of the canvases within the cycle cannot now be fully reconstructed, it is clear that the compositions of the individual works were not left completely to the inventive faculties of their creators but, rather, had to be tailored to the positions of the works on the walls. Before the fire of 1964, Gentileschi's *Adoration of the Magi*, the first canvas mentioned in the bishop's report of 1640, was immediately to the right as one entered the choir. In all probability this was its assigned spot, its composition oriented toward the left, that is to say toward the high altar. The slightly narrower format, the lighting from above, and the centralized arrangement of the *Saints Proculus and Nicea* suggest that it too had come down in the place for which it was designed. The *Saint Januarius in the Amphitheater* was the central painting on the left wall, its focus being therefore toward the right. Somewhat constricting, too, was the tall format of the canvases; to compose in space and therefore to give more breathing room (as did Stanzione in his *Saint Patroba Preaching*, for example) was to reduce the sizes and force of the figures; to bring them close up (as did Artemisia and Finoglio, for example) was to crowd the surfaces.

Either by contract or oral agreement or because of the press of time, another requirement seems to have been imposed upon Artemisia: that of accepting collaborators.[115] The design elements of the vaulted hall and temple structure in the *Saints Proculus and Nicea* recall Viviano Codazzi, although more likely the execution is by Domenico Gargiulo. Gargiulo's mind and brush were surely responsible for the ampitheater and its tiny figures in the *Saint Januarius*. In the *Adoration of the Magi* the trio of the turbaned Balthasar flanked by a hooded man and a youth in a red cap who turn toward the Magus is a virtual repetition of the same three figures in the same spot in Massimo Stanzione's *Adoration of the Magi* from the 1620s in a private collection at Philadelphia,[116] and since Stanzione also worked at Pozzuoli[117] it is not impossible that he contributed this (now much darkened) section to Gentileschi's picture.

Collaboration Continued, Grandeur Reinstated: The Later 1630s

Gentileschi's involvement with projects for the Buen Retiro and the Cathedral at Pozzuoli—the painters with whom she came into contact, the artistic manners which they represented, and the changes in her own art which these assignments occasioned—was to have an impact on the pictures which she produced in the later 1630s for private collections. This, in any event, is the conclusion to be drawn from the few works from this period which have survived,[118] and in particular from the *Bathsheba*, *Susanna and the Elders*, and the *Lot and His Daughters* (Figs. 157, 159, 162, 163–66; Color Plates XXIII,

XXIV, XX), followed by the *Allegory of Painting* and Artemisia's contributions to her father's ceiling decoration for Greenwich (Figs. 175, 170–72; Color Plates XXV, XXVI, XXVII).

Together when first cited in the eighteenth century, the *Bathsheba* and the *Susanna* were specifically designed to form a harmonious pair, linked visually through repetitions of poses, elements of setting, and compositional weights and counterweights. They may be imagined hanging side-by-side, the *Susanna* at the right, the balustrades and pavements seemingly continuous as they pass behind the elaborate fountain, the attention of the kneeling maid echoed in reverse by the glances of the elders, and the pier (painted over a previously existing baluster) in the *Bathsheba* and the jutting bench in the *Susanna* acting as parentheses to embrace the dramas of matron and maiden under the eyes of lustful men. With the *Lot and His Daughters*, possibly for the same patron, they may have been begun in the same year of 1636 in which Artemisia received final payment for another set of paintings of famous women—a *Bathsheba*, *Susanna*, and *Lucretia* destined for Prince Karl Eusebius von Liechtenstein.[119]

So kindred as to suggest that they were conceived during a single rush of inspiration, the three extant canvases define a new stage in Gentileschi's art, one which is best understood in juxtaposition to most of the private commissions of 1630–35 (Figs. 114, 125, 131, 136; Color Plates XVI, XVII, XIX). Simply put, the *Bathsheba*, *Susanna*, and *Lot and His Daughters* are as measured as the paintings in the earlier group border on excess. Gone is the fashion-show component of the *Esther*, the *Cleopatra*, and of the works related to them, as intricately configured draperies of seemingly endless layers give way to more simplified and broadly designed materials. Brocaded borders and expensive carved furniture disappear. Restrained as well is the sentiment, as posturing for instant impression is substituted by more subtle, interiorized drama. Seated within a brown stone loggia and on pinkish drapery, Bathsheba, white linens encircling her legs, is preened by two ladies in waiting, one in a dark maroon garment combing her mistress's hair and the other in a golden-yellow gown with white sleeves and a blue shawl proffering a string of pearls. A maid dressed in blue over white, ruddier than the others and lower on the social hierarchy, kneels between a silver basin and a golden ewer, the latter with a Harpy handle. An emotionally agitated King David appears on the far balcony, too tiny and too distant to disturb the quietude. Bathsheba, eschewing an active role even in the primping, clutches her chair and turns away from David and the voracious winged monster on the handle of the ewer to contemplate the moral dilemma in which the King's call has placed her and—to imagine again the companion picture at the right—as if to show compassion for the plight of Susanna, much less experienced than she but already subjected to male sexual advances. The twist of Susanna's body is without great tension, her facial expression more reflective than pained, her gesture of surprise and fright absorbed into the form of the elder rather than dramatically isolated against a background foil. The declamatory has no appeal to Artemisia at this moment. Gentileschi surrounds the episode of Lot and his daughters with an almost sacramental aura, as her women offer bread and wine to Lot in order to "guide their father solemnly toward the necessary acts

of incest in order that their people might continue."[120] The glowing flesh of the sisters, the blues and whites in their garments, and the positions of their arms (bridged by the arm of Lot) link the two women as their glances centralize the composition around the ruddy old man in a lilac coat and salmon-colored mantle—all toward the emphasis on ritualistic formality.

In endowing the *Lot and His Daughters* with a unique sobriety, Gentileschi rejected those titillating features—bare breasts, slung legs, groping hands, warm embraces, drunken leers and the like—which singly or in combination had become almost compulsory in representations of this Old Testament theme, even among Artemisia's Neapolitan contemporaries (Figs. 167, 168).[121] Artemisia's young women are fully clothed and show no cleavage. One rests her hand gently on her father's shoulder, seemingly more to reassure than to entice, while Lot grasps his other daughter's shoulder, more a familial than an amatory touch. As she moderates the luxuriousness of outward trappings, Gentileschi also understates the sexual. Bathsheba's bent left arm covers her nipples; Susanna's youthful breasts are cast in half-shadow. The bathing pool before Susanna, the intimation of steps in front of Bathsheba, and the displacement of both women from the front plane are barriers to voyeurs who might fancy themselves as the elders or King David, keeping them at physical and psychological arm's-length. The *Lot and His Daughters* does nothing to encourage erotic thoughts, while the appeal of the *Bathsheba* and the *Susanna* to that level of appreciation is hushed. Within a decade and less after the aggressive nudes of the later 1620s (Figs. 104, 110, 111; Color Plates XIV, XV), Artemisia Gentileschi opts, for the moment, for the more removed and the less obvious.

Part of this new orientation involves the greater idealization of Gentileschi's female protagonists, whose radiant beauty is accentuated by the juxtaposition of Lot's smooth-skinned daughters to their furrowed father, of the long-legged Bathsheba to the robust kneeling servant, of Susanna's delicateness to the harshness of the conspirators. Predicted by the *Clio* and the Madonna in the *Adoration of the Magi* (Figs. 121, 149; Color Plate XVIII), and by the leading characters in a *Judith and Her Maidservant* and a *Samson and Delilah* conceived about 1635 and known by way of copies (Figs. 150–51, 152),[122] this more elegant female type now becomes a permanent part of Artemisia's vocabulary.[123] And in the balletic movement of Bathsheba's lady-in-waiting gracefulness of a kind hitherto unfamiliar to Gentileschi's art makes its entrance.

Although visually less flashy and emotionally more subdued than the cabinet pictures from the first half of the decade, the *Bathsheba*, *Susanna*, and *Lot and His Daughters* might be said to surpass them in sheer pictorial force. Draperies, *chiaroscuro*, color, and *factura* are bold, so that notwithstanding the idealizations these paintings, monumental in feel as in fact, approach in impact the most formidable of Artemisia images, the *Judith and Her Maidservant* (Fig. 84; Color Plate XIII) included.

Artemisia Gentileschi's full responsibility for the compositions and overall expressive thrusts of the *Bathsheba*, *Susanna*, and *Lot* seems beyond question. Yet for the designs and execution of the settings and, with good probabilty, for the execution of some of the figures, she enlisted the participation of other artists. Bernardo De Dominici saw

in the Neapolitan collection of one Luigi Romeo "due quadri grandi con figure al naturale, che esprimono le storie di Bersabea, e Susanna, che sembran di mano di Guido son dipinti dalla famosa Artemisia Gentileschi, e l'architettura di Viviano, con gli arbori, e vedute dello Spadaro." Dominici's judgments are borne out by the two paintings under consideration, almost incontestably the Romeo versions. Thus the magnificent palace in the *Bathsheba*, its members delicately lined with light, is achieved with all the architectural knowledge, draftsmanlike precision, and perspectival skill that Viviano Codazzi could muster. Against it are played the fluidly rendered sculptural elements and figure of David and the whispy trees, all typical of Domenico Gargiulo, called Micco Spadaro. One among the many examples of the Codazzi-Gargiulo partnership should suffice to illustrate the points (Fig. 158).[124] With his patented dexterity Gargiulo feathered in the landscape of the *Susanna*, and his brush can likewise be discerned in the architecture there, which appears to lack the detailed crispness and light-enlivened quality of Codazzi to whom, on the other hand, the draft should probably be assigned. The sky, the burning city of Sodom, and the tiny figure of Lot's wife in the *Lot and His Daughters* (which, as noted, may also have been owned by Romeo) find their closest equivalents in the art of Domenico Gargiulo.

The visual evidence encourages speculation that some of the figures, too, might betray other hands. The lissome and lovely young woman in blue and yellow garments who presents jewelry to Bathsheba brings to mind the elegant females of Bernardo Cavallino, most especially the maidservant at the right in Cavallino's later *Finding of Moses* (Fig. 160).[125] Can Bernardo's name be added to the list of contributors to the *Bathsheba*, which contains as well a shadowy figure at the far right of a sort that is found repeatedly in his work? And what of the elders in the *Susanna*? The younger man, his head at a raking angle, his lips red, hairline receding at the right temple, eyes so deeply shadowed as to appear almost closed, and face dusky with a few days' growth of beard, is of a darkly intense type frequently painted by Cavallino. His like may be observed, for example, in four figures in the *Meeting of David and Abigail* (Fig. 161),[126] companion picture to the *Finding of Moses*. The more heavily bearded elder is familiar also from Cavallino's work, including the same *David and Abigail* and the *Erminia Among the Shepherds* (Naples, Capodimonte).[127] When, then, one confronts the vivid blue and red of the nearer elder's garments and the burnt-orange robe with watery yellow highlights of the other, the connections between Cavallino and Gentileschi become incontrovertible. By the mid-1630s, in canvases larger in scale and less high-strung than those in which he was soon to specialize, Bernardo Cavallino had already settled upon male physiognomies which parallel those in the *Susanna*.[128] It is therefore entirely conceivable that in the shared productions that are the *Bathsheba* and the *Susanna*, Gentileschi, having sketched out the most basic configurations of the ladies-in-waiting at the right in the former and of the elders in the latter, turned over the actual painting to the talented young Cavallino. If Bernardo's predilection for the graceful is indeed exhibited in the *Bathsheba*, was it he who encouraged Artemisia in this direction? Or was it Gentileschi who introduced this element into her art, there to influence Cavallino? Whatever the reality of the situation,

these Cavallinesque figures are further signs of the fluidity of the Neapolitan artistic scene.

In attributing the *Lot and His Daughters* to Bernardo Cavallino, scholars have nonetheless acknowledged its Gentileschian stamp. In my opinion the *Lot* is still another work by Artemisia Gentileschi with a highly probable Cavallino component.[129] For the ruddy old Lot (Fig. 165) the aforementioned elder is relevant, and the astonishingly delicate gray highlighting and the exquisite lilac of the father's jacket read like Cavallino signatures, the handling recalling the garment of the younger man in the *Susanna*. Interpretively, however, the *Lot and His Daughters* is utterly different from Bernardo's independent depictions of the theme.[130]

The three canvases may have been in progress simultaneously, with Codazzi, Gargiulo, and Cavallino called to Gentileschi's studio at those times when their contributions could best be integrated into the developing wholes. The motivations behind this group effort led by Gentileschi can only be surmised. Contractual deadlines may have played a part; but these are likely to have been less urgent than for pictures ordered for the Conde-Duque Olivares's retreat at the Buen Retiro or for the choir of the newly remodeled Cathedral at Pozzuoli, and artists were notoriously cavalier in sticking to private agreements. While extensive, expertly designed architecture such as appears in the *Bathsheba* and *Susanna* was outside of Artemisia Gentileschi's sphere, she was obviously competent to paint Lot's head and coat and some landscape. Thus one imagines rather an exciting partnership, a consortium that was reconstituted as the orders came in. Perhaps one of the attractions for patrons was that they were assured of a sampling of some of the best that contemporary painting in Naples had to offer, done by distinctive artists, one of them a woman, with particular specializations. A determination to present clients with this option could account for Artemisia's decision to factor in backgrounds that would afford Codazzi and Gargiulo opportunities to show their talents and, at least in the *Bathsheba*, to conceive secondary figures that would take advantage of Cavallino's gifts.

Relationships in the *Bathsheba* and the *Lot* to Neapolitan painting of the period extend beyond the artists who literally left their marks on the canvases. In the Catalogue I have suggested a complicated pattern of interconnections between interpretations of the Lot-and-his-daughters narrative by Gentileschi, Massimo Stanzione, and Agostino Beltrano (including Figs. 167, 168). Of greater significance is Artemisia's adoption of a standard of beautiful young womanhood, at a time when Stanzione's commitment to a classicizing manner was resolute and when painters such as Francesco Guarino and Pacecco De Rosa were following Massimo's lead.[131] Although avoiding both the rarefied and the academic, and setting her figures within a concrete reality, Gentileschi shows her awareness of this idealizing trend and surely knew that potential Neapolitan customers would be sympathetic to it.

Working with Stanzione on the Buen Retiro and Pozzuoli commissions, Artemisia could have observed his art at close quarters and spoken with the artist about its rationale. It was apparently through these projects that Artemisia also established that network of

collaborators which was to involve itself with the *Bathsheba*, *Susanna*, and *Lot and His Daughters*. And in attuning her paintings at Pozzuoli to a large and diverse audience, so different from those which she had addressed previously, Gentileschi moderated a manner that was in danger of lapsing into decorative and expressive magniloquence. This process of rethinking the direction of her art was to bear fruit, I believe, in the control and force of her pictures from the later 1630s.

The little that remains of Artemisia Gentileschi's English production sustains that strength. Comparative analysis can go some way toward identifying her presence in the *Allegory of Peace and the Arts Under the English Crown* (Figs. 170–72; Color Plates XXV, XXVI), an ambitious assemblage of ceiling canvases for the Great Hall in the Queen's House at Greenwich which Orazio Gentileschi undertook about 1636 and on which he was still working when Artemisia arrived in London. Trimmed when they were installed at Marlborough House between 1711 and 1736, heavily damaged and repaired, these paintings had united father and daughter in a common purpose. Still, Artemisia's independent spirit was permitted to assert itself. Thus the *Polyhymnia* (Fig. 171; Color Plate XXV), in a silver dress (the white designated by Cesare Ripa as symbolic of purity and sincerity) and red mantle, is a strongly modeled, energetic woman, her form penetrating space, weighing down on her cloud support, her draperies vibrating with light. In this she contrasts strikingly to the planar and lethargic *Muse Euterpe* by Orazio accompanying her. For the *Polyhymnia* Artemisia modified the *Arithmetic* (Fig. 170; Color Plate XXVI), in green and lavender garments, who, similarly endowed with convincing substance and life, appears to be her only contribution to the central roundel (which must therefore have been all but finished before she came upon the scene). The garlanded *Clio* (Fig. 172; Color Plate XXV), holding a long trumpet and dressed in tan and faded purple, and the viol-bearing *Erato* (Fig. 170; Color Plate XXV), both of whom seem truly aware of external reality, may also be assigned to Artemisia.

In subject type, model, and manner, the *Polyhymnia* and *Arithmetic* conduct one directly to the *Allegory of Painting* (Fig. 175; Color Plate XXVII) which (paired, in my opinion, with a *Self-Portrait*) further proclaimed the confidence and artistic prowess of Artemisia Gentileschi, now thirty years after Orazio had taught her how to paint in a studio on Via Paolina.

Artemisia's opportunity to work alongside Orazio in England was more to his benefit than to hers. Exposure to the artificialities of her father's late pictures and to the court scene were to contribute to an enervated late style of her own. On the cusp between Gentileschi's final days in London and her first days back in Naples, still another *Bathsheba* (Fig. 180) begins the last and sometimes difficult chapter of the story.

V

THE LATER YEARS IN NAPLES, 1641–1652

Refinement, Reiteration, Resignation

It is not to be wondered why less has been written about the sum total of Artemisia Gentileschi's late works than about her *Judith Decapitating Holofernes* (Figs. 77–79; Color Plate XII). Simply put, the paintings which Artemisia created between 1640 and 1652 defy the usual expectations and dash hopes. With a few partial exceptions, none shows a heroic woman performing a brave deed. The sexual appetites of men are often indulged, not in the least avenged. In pictures seemingly without meaningful messages, connections to Gentileschi's biography or psyche have not appeared to be there for the analyzing. The artist once in the vanguard of the Caravaggesque movement signals final retreat.

Obstacles to Understanding

Additionally, Artemisia's last period is poorly documented, further discouraging investigation. Her thirteen letters to Don Antonio Ruffo of Messina all fall within the years 1649–51, and of the more than eight pictures cited in the Ruffo correspondence only two (Figs. 195, 198; Color Plate XXII) can be identified with any degree of certainty. Otherwise, the register of documents, so full for the preceding three decades, is almost empty. Conjecture must serve repeatedly in place of hard facts.

Of this the problem of when and where Gentileschi began her final period is symptomatic. To all indications the artist was sincerely interested in returning to Italy when from London on December 16, 1639, she sought the Duke of Modena's patronage. Simultaneously, or following Francesco d'Este's less-than-inspiring reply of March 16, 1640, Artemisia might have explored other job possibilities, as in Rome and Florence. If any such arrangements were realized, however, they have left no trace, and reluctantly or not Gentileschi seems to have returned to Naples, site of her last long-term address and presumably still home to her daughters. Filippo Baldinucci's claim that Artemisia was working in Naples in 1642[1] was extrapolated from the publication date of Giovanni Baglione's *Vite*, upon whose few words on Artemisia Baldinucci was here relying directly.[2] Baglione's information was secondhand, by his own admission ("hora dicono, che nella Città di Napoli si ritruovi"),[3] and it is not certain exactly when his lines on Artemisia were penned. Nonetheless, there being no contrary evidence, one must assume that Artemisia Gentileschi arrived back in Naples about 1640 or 1641[4] and that she lived there continuously until her death—the precise date of which, as will be seen, is also undocumented.

Thus the major burden falls to comparative analysis, by means of which it does seem possible to assemble a group of late paintings and, with the aid of a succession of canvases on the Bathsheba theme, to fix a chronological sequence. Attentive readings of the pictures and letters yield important insights, often hard to admit and thus often slighted, but as central as ever to understanding.

The Parma Suite, and Related Works

This chapter takes as its point of departure three ambitious canvases which issued as a suite from Artemisia's studio between 1645 and 1650: *Bathsheba*, *Tarquin and Lucretia*, and *Judith and Her Maidservant* (Figs. 188–90, 192). Declared "very beautiful" by Giacomo Barri when in 1671 he visited the Palazzo del Giardino of Duke Ranuccio Farnese II at Parma, and described in detail a decade later, these large paintings may have been commissioned of Artemisia through a network of Gentileschi-Medici and Medici-Farnese contacts.[5] Then during the 1730s they were probably swept up in the flow of art from Parma to Naples under Carlo di Borbone, son and heir to Elizabetta Farnese. But

by 1773, misattributed and trimmed, the *Bathsheba* and the *Tarquin and Lucretia* had been permanently installed in the Obere Galerie of the newly completed Neues Palais at Potsdam (Figs. 185–87), there with other canvases and stucco reliefs to chronicle fates endured by women upon the actions of men—more for entertainment in eighteenth-century terms, surely, than for edification, in this the ballroom of the sumptuous palace. The *Judith* remained in Naples, its theme of female dominance ill-suited to the program envisioned for the Obere Galerie.

In centering around women, the Parma paintings typify Artemisia's career as a whole and her late production in particular, which latter is here calculated as comprising twelve preserved canvases, one destroyed in 1940 but not before being photographed, and eleven lost works whose attributions to Gentileschi and whose dating between 1640 and 1652 seem assured.[6] But now, in a conspicuous reversal of the direction of the previous decade, the women who command fifty-five percent of these twenty-four pictures may be classified as nudes—or, more accurately, as nude female bodies put on display, first and last, for the delectation of the men depicted within and of the men without who ordered the depictions. In the Potsdam *Bathsheba* the wife of Uriah the Hittite, undressed but for a spray of transparent cloth over one thigh, affixes a strand of jewelry to her hair, a trivial gesture guaranteed not to distract. Garments piled in the foreground accentuate the state of nudity thus paraded. Startlingly, the obviousness of this presentation, which Artemisia would take up again in her *Bathsheba* for Florence (Fig. 201) and in that once at Gosford House (Fig. 200), constitutes something of a stepping back from what Gentileschi had devised earlier in the decade for paintings now in Vienna and Rome (Figs. 180, 184). In these interpretations Bathsheba, by steadying a mirror on her leg while with the other arm holding aloft braids of hair, tenders her body in full. No inhibitions in the flaunting of the female form mark the Potsdam *Tarquin and Lucretia* (Fig. 190), however, whose sensuality vies in blatancy with the gratuitously bared breast of Bathsheba's attendant in the Vienna picture. A position of vulnerability may therefore be imagined for the maiden chained to the rock in the lost *Andromeda Liberated by Perseus*, and the pictures of *Diana at Her Bath* are easily visualized as tableaux of nude women, each female form no doubt exhibited from a different angle—pageants of pulchritude.

In the high percentage of nudes the pattern of the 1620s is repeated (cf. Figs. 87, 104, 110, 111; Color Plates XIV, XV), and gratification of male erotic impulses is the principal goal of both groups. Yet the robustness, the powerful carnal presences, the sheer authority of the *Aurora*, the *Venus*, the *Cleopatra*, and the *Magdalen,* give way to slender, rather too delicate, cosmetized beauties so posed as overtly to acknowledge the existence of eager voyeurs. The mirror goes some way toward making Bathsheba "connive in treating herself as, first and foremost, a sight," and raises the specter of female vanity, the male gazer thus simultaneously enjoying and (hypocritically) moralizing.[7] The nudes in the prototype canvases began as studio models, if we are to believe what Artemisia told Don Antonio Ruffo regarding the *Diana* she was preparing for him, but in the translation they were finessed into artificiality. Obviousness does not necessarily

equate with honesty, and one need not occupy the moral high ground, nor even deny the success of these pictures as interior decoration, to be put off by their false airs.

One's exasperation is compounded by the fact that in most of her late paintings Gentileschi abandons all pretense of speaking to deeper human concerns. The moral dilemma into which Bathsheba was forced and to which Artemisia's impressive picture of 1636–37/38 (Fig. 159; Color Plate XXIII) subtly but effectively testifies is foreign to the Potsdam version. There, as in its repetitions (Figs. 200, 201) and as a variation upon the *Bathsheba*s in Vienna and Rome (Figs. 180, 184), Bathsheba primps in a mirror, rendering herself more pleasing, she would have it, with one final embellishment to her coif before going to lie with David. Of the Tarquin and Lucretia theme, it has been written, with Gentileschi's picture very much in mind:

> The most suggestive images . . . show . . . Tarquin threatening Lucretia just before the rape. In all the prints and paintings of the subject Lucretia is completely nude in bed, whereas Tarquin is usually fully clothed. This increases the contrast between . . . the pure whiteness of her skin and the darker shades of his clothing, between her vulnerability and his power. This contrast could make the viewer share Lucretia's feeling of terror and helplessness, or it could have the opposite effect, making her seem all the more desirable because of her vulnerability. The second interpretation is reinforced . . . where Lucretia is shown as if she were on display, encouraging the viewer to identify with Tarquin in his lustfulness or with the slave who observes the rape like a voyeur."[8]

The thrust of Artemisia's work becomes even more patent when it is recognized that Tarquin seeks to spread apart Lucretia's legs even as Lucretia seems more disposed to clutch the dagger than to parry it. And Susanna (Fig. 197), with histrionic gesture and would-be averted eyes, protests perhaps a little too much in the presence of the now less conspiratorial and more aggressive elders (cf. Figs. 10, 162; Color Plates I, XXIV), the older of whom positions his left hand inches away from the maiden's breast. It is not automatically to Artemisia Gentileschi's credit that some male artists happened to have pushed to even greater extremes the potential for lewdness inherent in all of these subjects.

The ex-Parma canvases epitomize as well other trends in Gentileschi's career which took on dominating proportions during the painter's later years. Thus their subjects, as in fact of three-quarters of Artemisia's pictures from 1640 onward, were long since part of her repertory, and the final period is in great part defined by reiterations of a few select themes—five *Bathsheba*s, two *Susanna*s, four *Judith*s, two *Diana*s, perhaps three *Galatea*s. Moreover, in marketing the paintings for the Farnese of Parma as a set, Gentileschi continued the strategy which she had adopted at least as early as the *Bathsheba*, *Susanna*, and *Lucretia* of 1636 for the Prince of Liechtenstein and the Romeo *Bathsheba* and *Susanna* (Figs. 159, 162; Color Plates XXIII, XXIV).

Analysis of the third of the Farnese narratives, the *Judith and Her Maidservant* (Fig. 192), reinforces and enriches the story of Artemisia's last years which the *Bathsheba* and the *Tarquin and Lucretia* have begun to tell, while providing reassurance that the artist's capacity for genuine expressiveness had not been entirely spent. The Naples canvas, the last of Artemisia's known stagings of this moment in the Judith legend, draws upon her relatively recent rendition of the theme now in the Musée des Beaux-Arts at Cannes (Fig. 191). The latter is itself an adaptation of the masterpiece in Detroit (Fig. 84; Color Plate XIII), and it is against the evident similarities that the unique features of the Cannes version,[9] and then of the closely related Capodimonte picture, become especially evident. Modifications from the first to the second canvas are substantive, and add up to an image in which earthiness and dramatic urgency have been diminished. With greater space between the figures, the composition begins to lose its forceful compactness, setting the women more aloof from each other and, in interpretive terms, somewhat diluting the sense of their joint participation in the dangerous endeavor. Judith's right arm, pulled inward to her body, and the weapon she brandishes, its blade now swallowed by darkness rather than standing out against the lighter gown, are deprived of their lethal allusions. In a related manner her left hand, now turned away in profile, is but a shield for the candlelight, losing that aspect which had made it as well a signifier of defense and defiance.

As a type the new Judith, of smaller head and more slender physique, aspires more to elegance than to strength, while her accomplice, although still of ample girth, is also more genteel. Decorative restraint gives way to the heroine's swelling mantle, to the elaborately embroidered hem of her gown, to the shield with a similar border and the fringed drapery before it, to bracelet, plumed helmet, and Abra's luxurious shawl. Contrasts of light and shadow, more strongly marked in the Detroit version than the glow of the candle would dictate, are softened by transparencies, and the impenetrable background becomes an atmospheric surround containing notations of a tent curtain.

From these and other changes, however, a new interpretation—mysterious, equally unsettling in its own way—emerges.[10] The more extensive, atmosphere-shrouded ambient threatens to weigh down on the women before escape is attained. The helmet is to be pondered as that into which Holofernes had once fitted his head, and the corner drapery might be thought to conceal the remainder of the general's armor (parts of it are actually depicted in the Naples variant), that which in his lust he had shed, that which had protected the very body from which the head has been severed. The sense of the unknown, and with it of the potential defenselessness of even heroic humankind, is greater still in the canvas in the Museo di Capodimonte. Empty space between and around the forms has been augmented. Abra's separation from her companion is complete. No longer appearing resolutely to hold her ground, Judith is fully a balletic figure gliding down a tilted floor.

Although Gentileschi's patron may not have been aware of it, the *Bathsheba*, *Tarquin and Lucretia*, and *Judith and Her Maidservant* for Parma somewhat mechanically restate compositional solutions, figure types, and accessories which the artist had devised

93

previously. The *Judith* has already testified to this, and it is likely that the *Tarquin and Lucretia* was dependent upon Artemisia's picture once in the English Royal Collection and/or upon the *Lucretia* for Karl Eusebius von Liechtenstein (if indeed that depicted the rape scene). The status of the Parma *Bathsheba* as a repository of earlier ideas is of course beyond question. Thus in the version in Rome (Fig. 184) Bathsheba, her coiffeuse, the washbasin, and the terraced and balustraded foreground stage repeat with some variations these features of the Vienna picture (Fig. 180), while the pyramid of drapery with Bathsheba's undergarment casually tossed upon it has merely been shifted to the right. The left side in the second redaction is now dominated by a maid holding a pitcher who, along with Bathsheba's lady-in-waiting, looks leftward in apparent obliviousness to the presence of King David on the balcony of the distant palace. The Farnese canvas then follows, sharing the design of the loggia, the vessel-bearer (the ewer substituted by a pot!), and the *repoussoir* drapery, while adapting the pose of Bathsheba and including the by now ubiquitous basin. (For her final paintings of the theme [Figs. 200, 201] Artemisia was even less inclined to engage her inventive faculties.) The background setting for the ex-Parma *Bathsheba* is an unimaginative appropriation of Codazzi and Gargiulo. The tasseled pillow, already used in the *Venus and Cupid, Cleopatra,* and *Susanna* (Figs. 104, 110, 162; Color Plates XIV, XV, XXIV) and in the two *Bathsheba*s from the earlier 1640s, also cushions Galatea (Figs. 195–96; Color Plate XXII) in her ride over the waves, that Galatea whose billowing cloak is borrowed from the *Judith*s in Cannes and Naples.

It may now be seen that the three Farnese pictures and Gentileschi's other works from 1640 to 1652 likewise share a number of stylistic features. Seeking elegant effects, the artist paints more attenuated figures which, when not nude, model layered garments that bring to mind Artemisia's stance as a costumier during the early 1630s. Decorative frills and fills proliferate, from flashy vessels to materials not just arranged on bodies now but accumulated in corners for independent display. Other affectations—the mincing gestures of Bathsheba, the *maniera*-like attitude and obtrusiveness of the vessel-bearers, the slipping posture of Judith, the forced alarm of Susanna—contribute to the overall aura of preciousness. And the last *Bathsheba*s have a special lightness of tonality and coloristic brightness that announce Artemisia's definitive rejection of Caravaggesque *chiaroscuro.*

Comprehending the Late Manner

Artemisia Gentileschi's late manner, with all its expressive and stylistic hyperrefinements, with all its undisguised (if fragile) sensuality, has been termed "incomprehensible."[11] What follows takes exception to that judgment. It operates on the conviction that Artemisia's art after 1640 shows no signs of diminished technical skills. The *Tarquin and Lucretia* (Fig. 190), for example, is as great a tour de force of painting as Gentileschi ever achieved. Thus the magnificence of the color: Tarquin in a violet tunic over a green

jerkin, his gold cloak with pinkish lights flying behind; and the Moor, pulling back a burnt-orange bed curtain fringed in gold, garbed in a light blue tunic over a golden shirt and tan leggings. Thus also such bravura passages as the dazzling illusionism of Tarquin's crumpled drapery, its highlights brushed in with supreme confidence; the dark profile of the servant against gold; the remarkable corporeality of Lucretia's flesh. The Potsdam *Bathsheba* (Figs. 188–89) boasts any number of notable passages, among them the subtly lighted head of the woman with the mirror, the filmy fabric over Bathsheba's thigh and at her left ankle, the reflections of the yellow cloth in the silver basin. As the golden tonality of Judith's gown in the Naples canvas (Fig. 192) moves toward red in approaching the maidservant's dress, or as the light gleams off metallic surfaces, animates Judith's puffy white sleeve, or expends itself in folds and corners, the high qualitative level to which Gentileschi was still able to rise becomes manifest once again. Pictorially the three ex-Parma pictures are more than striking, especially when imagined in pristine condition, intact, and together, their tonalities varied by Artemisia in keeping with the subject matter and as if in demonstration of her utter competency, from the sunny *Bathsheba* to the somewhat more shadowed *Tarquin and Lucretia* to the candle-lit *Judith.*

The Farnese set was cited as being by Artemisia Gentileschi within twenty-five years of its completion. The tapestry (Fig. 199) taken from the Florence *Bathsheba* and labeled "D. ARTEMI. PINX." was woven in 1663, little more than a decade after Gentileschi's death. Such contemporary testimony supports the visual evidence in affirming Artemisia's responsibility for these and the other pictures here assigned to the artist's final period. Nevertheless, serious misgivings as to the authenticity of most of the late canvases have been voiced, principally out of profound (and understandable) discomfort with the thought that Artemisia could descend to such levels of "expressive emptiness" and worse, and in the process seem to offer a new and unsympathetic image of herself.[12] Yet just as suggested barometers of the presence of Artemisia's temperament or female perspective have often proved unreliable,[13] it cannot be assumed that the absence of such would-be indicators excludes Gentileschi's authorship.

It is therefore Artemisia Gentileschi herself whom we confront in the late paintings. And before any deep-seated reasons for the character of these pictures may be posited, practical matters, and in particular the associated domains of personal finances and patronage, must be addressed. In Chapter 4, on the evidence of Gentileschi's recorded business dealings, I argued that during the 1630s the painter's fiscal picture was not especially bright, and thus that she was not in a position as a matter of course to be very selective in attending to her patrons' requirements. For most of the 1640s there is no primary documentation concerning Artemisia's monetary circumstances. Although her works were apparently purchased in these years by several Neapolitan nobles, it is probable that she had been unable to set aside much cash. For by the end of the decade she was in financial distress.

Had it not been for Don Antonio Ruffo and his brother Don Flavio, Artemisia Gentileschi's very last years would have been even more trying. Don Antonio Ruffo (1610–78) was a member of the patrician class in the Sicilian city of Messina, his wealth

the combined result of inheritance and maritime commerce.[14] A major collector, commissioning works from such masters as Rembrandt, Ribera, Guercino, Pietro da Cortona, and Stanzione, Don Antonio had also developed a taste for Gentileschi's art. Thirteen letters from Artemisia to Ruffo (beginning on January 30, 1649, by which time the *Galatea* had already been delivered, and ending on January 1, 1651) and the latter's account books bear witness to the artist's money problems. The marriage of her daughter on March 13, 1649, she tells her Messinese messiah on the day of the wedding, had left her "broke (*fallita*)" and (possibly) "dispossessed (*mi ha scasato*),"[15] and that because of her "very great need (*grandissimo bisogna*)" she would be grateful to Ruffo for any news of employment opportunities in Messina. Other letters are to similar effect: In order to afford the cost of models and thus to complete the *Diana at Her Bath* for Ruffo, she requires a 50-ducat advance; her need is so pressing that she cannot possibly lower the fee she has quoted, and that in fact she has to renegotiate an agreement with the Prior Fabrizio Ruffo because the original deal was made under duress of the "extreme necessity (*estrema necessità*)" of obtaining another advance; if Don Antonio will send her money up front, she will reduce her asking price.[16]

While claiming that as a Roman she followed the Roman pricing structure and not the Neapolitan habit of requesting 30 scudi and then letting the work go for 4, and that even in Naples she had once commanded 100 scudi per figure, she forced herself to accept a total of 160 scudi for the *Galatea* (here identified as Figs. 195–96; Color Plate XXII), which contained five tritons in addition to the sea nymph.[17] By the beginning of 1651, in her last known letter to Ruffo, Gentileschi proposed to sell to Don Antonio an *Andromeda Liberated by Perseus* and a *Joseph and Potiphar's Wife*, each the size of the large *Galatea*, for the mean sum of 90 scudi per picture, having on a previous occasion with regard to the *Diana* written: "Signor Don Antonio, my Lord, I beg you for the love of God not to make me lower the price that I quoted."[18] Even when allowance is made for exaggeration on Gentileschi's part as a way of engaging Ruffo's sympathy and opening his purse, the image of an artist under great financial strain remains.

What, then, had pushed Artemisia into such straits that she had to endure cut-rate fees, which in turn obviously exacerbated the situation? The effect may have been cumulative, but once again specific evidence exists only for the end of the decade. As will be shown, by at least 1649 her health had begun to decline, and with it her rate of work. But above all, it was tough to make a living in the Naples of those years. Within the huge population of the swarming and noisy metropolis there was a glaring disparity between great wealth and unspeakable poverty.[19] A rigid class structure relegated painters to the lower rung of the bourgeoisie, the plebeians beneath them. The demands, monetary and otherwise, made by Spain upon the city which it ruled were enormous. On July 7, 1647, the steaming poor exploded into the revolt of Masaniello, a popular uprising not suppressed (notwithstanding the leader's almost immediate execution) until April of the following year. Artemisia Gentileschi identified herself as a victim of contemporary circumstances when she told Ruffo that her price of 100 scudi per figure had been met in Naples "when there was more money there" and lamented that "the shortages of the

times" severely limited opportunities for work.[20] Even for the prolific and always delightful Bernardo Cavallino money was hard to come by during the 1640s,[21] and a sense of mutual need may have in part impelled the Gentileschi-Cavallino collaboration on the *Galatea.*

Aspects of Artemisia's late works seem to be explainable, then, in light of the artist's financial condition. The various *Bathsheba*s alone refute her boast to Don Antonio Ruffo on November 13, 1649, that she never repeated her inventions, indeed not even a single hand ("et mai sie trovato ne'quadri miei corrispondentia d'inventione etiam in duna mano").[22] They and the other repetitions conjure up shades of a production line, whereby pictures could be turned out more quickly and thus with a more attractive price tag. They also speak to Gentileschi's reputation for specializing in certain types of imagery, and their particular character, when considered with reference to what is known of Artemisia's finances, strongly suggests that to a greater degree than ever patronage tastes mandated what and how the artist painted.[23] Obviously what was wanted by male clients from the woman who was excellently trained and positioned to supply them were above all refined, decorative pictures of alluring female nudes, visually and erotically stimulating but psychologically unchallenging, verisimilar in detail but overall at a remove from reality. Whether, on the other hand, they and other patrons ever considered Artemisia "a threatening and ferocious prodigy"[24] in whose taming they had a vested male interest is subject to debate.

Gentileschi's late style must also be viewed as a further accommodation to the turn toward idealization which, as observed, was well under way in Neapolitan art during the 1630s and which was to lead such artists as Stanzione, Guarino, and Cavallino to increasingly rarefied manners. It is indicative of the extent to which Gentileschi's two canvases now in Potsdam approach the classicizing ideal that in the eighteenth and nineteenth centuries they were thought to have been executed by the Bolognese master Giovanni Battista Ruggieri (1606–40), pupil of Domenichino and Francesco Gessi. Even if during the 1640s Artemisia had been operating under unprecedented conditions of creative freedom, she surely would not have painted then in the manner of her earlier years.

How Artemisia felt personally about the expressive and stylistic directions in which she steered the art of her later years is difficult to gauge, but there are reasons to believe that internal forces, and not just external demands, were at work. Under the impact of the Caroline court—its theater, its literature, its political illusions—Orazio Gentileschi's pictures had assumed a hyperartificiality, and the artist himself, who dined with noblemen and served on diplomatic missions, may have taken on aristocratic airs.[25] In the two or more years of her English stay, following more than a decade and a half of running her own households in Rome and Naples, Artemisia may have found to her liking her encounters with the regal life-style.

What is certain is that once again renewed exposure to the art of her father was of consequence for her own work when, back in Naples, she began her succession of *Bathsheba*s. Among the leitmotifs of Orazio Gentileschi's English production the following are immediately relevant: Half-dressed (or half-naked) women, their breasts exhibited;

characters in elaborate, turban-like headdresses, and other costume shows; figures who turn away from the observer; raised arms and affected pointing gestures. All of these late Orazian trademarks—and, everywhere, the suprarefinement that accompanied them—can be found in such canvases as the *Apollo and the Muses*, the last versions of the *Finding of Moses* and *Lot and His Daughters*, the *Muse Urania* from the Greenwich ceiling, the *Joseph and Potiphar's Wife*, and the Hampton Court *Sibyl* (Figs. 182, 181, 183, 170; Color Plates XXV, XXVI). And all of them return in concentration in Artemisia's *Bathsheba* in Vienna (Fig. 180). Further, among the figures introduced by Orazio with boring sameness during his last years was also a would-be elegant type seen from the rear, striding inward, head twisted to the left, clutching some object. The Muse-cellist in the *Apollo and the Muses* (but see the *Joseph and Potiphar's Wife* and, in the Musée des Beaux-Art at Nantes, the *Diana*) appears to have been Artemisia's direct model for the ewer-carrier in the *Bathsheba* now in Rome;[26] even the positions of the arms (the right hand holding the pitcher in place of the bow) and the arrangement of drapery over the woman's back are comparable. And then Gentileschi simply repeated this form, with minor variations, in her *Bathsheba*s for Parma and Florence and in the canvas formerly in Scotland (Figs. 188, 200, 201). Before such paintings one cannot resist quoting Robert Herrick's "Delight in Disorder," itself so redolent of the precious climate within which Orazio Gentileschi had created his final pictures:

A sweet disorder in the dresse
Kindles in cloathes a wantonnesse.
A lawn about the shoulders thrown
Into a fine distraction:
An erring lace, which here and there
Enthralls the crimson stomacher:
A cuffe neglectful, and thereby
Ribbands to flow confusedly:
A winning wave (deserving note)
In the tempestuous petticote:
A carelesse shooe-string, in whose tye
I see a wilde civility:
Doe more bewitch me, then when art
Is too precise in every part.

There may have been deeper motivations still for Artemisia Gentileschi's late style. Of this, the following is especially suggestive: "As she grew older, Artemisia's work became more graceful and 'feminine,' and while this was to some extent part of the general shift in taste and sensibility, it must also have resulted from the artist becoming more and more self-consciously a woman painter. Her transformation from artist to woman artist would have been aided by both her successes and her failures in the tough

competitive world in which she lived—the successes encouraging her to draw upon her strong suit, and her failures prompting a comforting retreat into the convenient (but also real) handicap of gender."[27] This wise insight has not received the attention it deserves. As will be documented in the next chapter, in her letters to Ruffo (and only in these among the whole of the correspondence), Gentileschi repeatedly called attention to her status as a woman and a woman artist and to what she believed this meant to her career—to patronage skepticism and expectations, to how her demands for proper remuneration were received, to what clients thought they could get away with. With words she continued to protest. But at a certain point, contemplating the image which her art was to project and cognizant as she did so of all the other forces which seemed more and more to ordain a "feminine" manner and an exploitation of the female nude, Artemisia might simply have become weary of fighting the battle.

As Gentileschi neared and then surpassed fifty years of age, her tremendous expenditure of psychic energy over the course of three decades of creative effort might also have caught up with her. Having absolutely mastered the craft of painting, she could have accomplished the actual physical execution of a picture without great drain upon her mental capacities. Mining previous motifs, turning out repetitions, then, was one thing; tackling new subjects and sentiments, inventing the requisite new compositions, was quite another. One senses in Artemisia's late works a mood of resignation. True, there are no exact copies; even the Florence *Bathsheba* (Fig. 201), although fundamentally a restatement of the Potsdam picture (Fig. 188), varies the coloration, most especially in the servant at the left (now in a blue dress) and the maid holding pearls (now a black woman garbed in gold), and introduces new designs for the garments of the figures flanking Bathsheba, for the decoration of the bucket, and for the washbasin. But these changes, as others effected in the ex–Gosford House pictutre (Fig. 200), are merely cosmetic, although Artemisia was capable of much more. Then there is the example of Gentileschi's *Madonna and Child* at the Escorial (Fig. 198). Signed and, as I have attempted to show in the Catalogue, also documented, this small painting on copper seems at first unthinkable for Artemisia. Yet the pose of the Virgin may be read as an adaptation in reverse of that of the Bathsheba in the canvas at Rome (Fig. 184), in which the young woman toys with a braid of her hair. A similar dainty gesture serves for the display of strings of pearls in Gentileschi's final renditions of the Bathsheba story. The facial types of the Rome Bathsheba and the Madonna—small and dreamy, with lowered lids and plucked eyebrows—are likewise comparable. And the usual late-period artificialities obtain even in this painting of a traditional religious theme. Still, there is about it a uniquely touching quality, perhaps bespeaking a special later-in-life susceptibility to tenderness. Pinkish-red roses emblematic of sorrow on the bench beside her, Mary dangles a rosary above her baby, who reaches toward its terminal cross. Both playing and accepting with this gesture his mission of sacrifice, the Child grasps in his right hand a cross-shaped stem of three white roses, the central flower open, another blossoming, the third but a bud.

Illness, Death, Epilogue

As the year 1651 began Artemisia was unable to work, convalescing from a serious illness which had forced her to bed at Christmas ("io questo natale, l'ho fatto in letto et ero stata assai male, et al presente sto ancora convalescente").[28] This ailment appears to have been the latest in a line of health problems of which Gentileschi gave notice in the same letter ("gli molti acciacchi et travagli, che ho havuto in questo anno passato") and which, along with the Neapolitan heat, had already slowed her down by the fall of 1649 ("perchè essendo li caldi eccessivi e molte infermità, io procuro conservarmi, e travagliar poco à poco").[29] How quickly and completely Artemisia recovered is not known.[30] Apparently she was able to return to work, if only intermittently, for Alessandro da Morrona saw in the Florentine collection of Averardo de'Medici a *Susanna* signed and dated "*Artemisia Gentileschi F. 1652.*"[31]

Then there was published at Venice in 1653 the *Cimiterio, epitafij giocosi* of Giovan Francesco (Gianfrancesco) Loredan and Pietro Michiele, in which the following epitaphs appear:[32]

> *Epitafio XXXIX D'Artemisia Gentilesca*
>
> Co'l dipinger la faccia a questo, e a quello
> Nel mondo m'acquistai merito infinito;
> Ne l'intagliar le corna a mio marito
> Lasciai il pennello, e presi lo scapello.
>
> In painting the portraits of this one and that one,
> I acquired infinite merit in the world.
> In carving the horns [of the cuckold] that I gave to my husband,
> I abandoned the brush and took up the chisel.
>
> *Epitafio XL—Dello stesso soggetto*
>
> Gentil'esca de cori a chi vedermi
> Poteva sempre fui nel cieco Mondo;
> Hor, che tra questi marmi mi nascondo,
> Sono fatta Gentil'esca de vermi.
>
> Gentle bait I always was to the hearts of those
> Who saw me in this blind World.
> Now that I am hidden beneath these marbles,
> Gentle bait I am to the worms.

The urge to comment immediately upon the tone of these unsettling verses is almost overwhelming, but for the moment I must restrict myself to observing that they are certainly posthumous and could therefore not have been composed before 1652, the

date on the just-mentioned *Susanna*. Artemisia Gentileschi must have died, then, in 1652 or 1653. The circumstances of Artemisia's burial are even more uncertain. Repeating information provided by Averardo de'Medici in tomo IV of his *Uomini illustrati pisani*, Morrona reported in the 1812 edition of his *Pisa illustrata* that Gentileschi was interred in the Neapolitan church of San Giovanni de'Fiorentini beneath a large marble slab inscribed with two words only: "*HEIC ARTIMISIA*."[33] At the time of Averardo's writing, this stone had disappeared—perhaps, the author speculated, beneath the new pavement which had been laid upon the occasion of the "sumptuous restoration" of the church.

Unfortunately, this notice of Gentileschi's resting place can neither be confirmed nor disproved. When not gathered from primary documents or direct observation, Morrona's information is sometimes unreliable. It is conceivable that with Tuscan pride and no facts to the contrary, Averardo de'Medici simply manufactured the story of a remarkable woman painter with Tuscan roots being buried in the church of the Florentines in Naples. Still, it is a logical tale made more credible by what is known of that church. San Giovanni dei Fiorentini, until 1557 a Dominican establishment built in the fifteenth century with a dedication to San Vincenzo Ferrer, was located on Via dell'Incoronata.[34] It underwent a major modernization just prior to 1788 and another in 1845, only to be destroyed after World War II during a campaign of urban renewal. According to what I have learned from Neapolitan authorities, before 1800 San Giovanni was attached to the parish of Santa Maria (now San Liborio) alla Carità. In the archives of San Liborio can be found today the *Liber Quintus In quo adnotantur Nomina et Cognoma Defunctorum Parochialis Sancte M.e Charitatis Ab Anno Domini 1687*. The earliest preserved *Libro dei Morti* in the archives, it nonetheless contains on folios 39–70 an index, beginning with the year 1635, to the missing volumes. Yet the ledger is blank under "Gentileschi," "Lomi," and even—perish the thought!—"Stiattesi."[35]

If, by some unexpected route, Averardo de'Medici's account were to prove accurate, what would one make of the cryptic nature of "*HEIC ARTEMISIA*"? For Morrona it was "a very brief inscription but enough to serve as the most ample praise of the eminent Painter (*brevissima epigrafe ma bastante a formare il più amplio elogio della egregia Pittrice*),"[36] and a recent interpretation of the words as implying "the one and only" is to the same effect.[37] Conversely, the epitaph, when considered against the "honorific commemorations" accorded such artists as Raphael and Caravaggio, has been viewed in much less positive terms.[38] I suspect that Morrona properly understood the sense intended by his Florentine source; Artemisia needed no further introduction.[39]

But what, now, of the Loredan-Michiele epitaphs? How are *they* to be understood? Between the view that finds them "shockingly irreverent," "mean-spirited," and stereotypically misogynist in their fixation on woman as sexual object, and that which holds that "while hardly reverential they are reasonably sincere tributes to Artemisia's sexual freedom, fame, and beauty" there is no common ground.[40] Many seventeenth-century male readers would no doubt have been amused by these four-line verses, but surely the laugh was at the expense of Artemisia Gentileschi, cheap shots at one who could no longer defend herself. Although within the section labeled *IV Centuria*, and therefore

written specifically by Pietro Michiele, they appear in a volume issued jointly by him and Gianfrancesco Loredan, both once members of that Venetian Accademia de'Desiosi with which Artemisia might also have been associated. This is the Loredan who had earlier written love letters to Gentileschi and, I believe, poetry to her pictures. If this libertine had firsthand knowledge of adultery committed by Artemisia, his reference to it reeks of hypocrisy. Had he been jilted by the painter, and through the words of his friend Michiele thought to get even with her? Had he grown jealous of her talent, such talent in a woman no less?[41] Or did Michiele think he was being more clever than—as it seems to modern sensibilities—highly offensive?[42]

And so this chronological overview of Artemisia Gentileschi's career ends as it began—with questions, speculations, differences of opinion. The final chapter takes up overarching issues, those which for the most part are prepared for yet merely acknowledged in the preceding pages. It discloses myths and misunderstandings. It challenges some generally accepted notions and embraces others. And it suggests lines for continuing debate about a subject so complex and, yes, controversial, that the present study is at best but one more step toward understanding.

VI

MYTHS,
MISUNDERSTANDINGS,
AND MUSINGS

In the process of pursuing the laudable goal of resurrecting women artists from the critical depths to which gender biases and other prejudices confined them, modern scholarship has sometimes found itself in danger of creating new mythologies. Deification can sidetrack assessment of the achievement of any creative personality. Theories have a way of perpetuating themselves until through sheer weight and repetition they pass for certainty.

Artemisia Gentileschi has not escaped mythmaking, and it is one of the purposes of this chapter to call attention to such barriers to understanding, dismantling them when I believe the facts—many of them set out in the previous chapters—permit. I am under no illusion, however, that with

my own inevitable stake in magnifying Artemisia's stature I have resisted the lure of legend. Further, although skeptical of various positions, I am not always committed to one of my own, which cases I hope to make clear. In an effort to ensure that the interpretations of other scholars are represented as accurately as possible, I will make liberal use of quotations. Transcending individual pictures, the issues raised here range from the peripheral in the grand scheme of things to the pivotal—from a theory as to why Artemisia was called Artemisia, to proposals regarding her skill as a still-life painter and her level of literacy, to the most thoughtfully formulated convictions that Gentileschi's paintings are gender-directed and are projections of a determined feminism and/or of a psyche wounded forever by rape.[1]

Artemisia as a Name

Artemisia ("devotee of Artemis"), the name of two famous women of antiquity, "resounds with power, military and artistic prestige, and tragic love."[2] Did Orazio Lomi Gentileschi and Prudentia Montoni so christen their daughter because they "admired such *femmes fortes*"; and, if so, is it not reasonable to suppose that it was in part because of "a family tradition of powerful female self-esteem" that Agostino Tassi was hauled into court and that Artemisia's art displays a "resolute feminism."[3] As corollary support for this proposal, reference is made to the belief[4] that the bracelet of Gentileschi's *Judith* (Figs. 77, 45; Color Plate XII) bears images of Diana (i.e., Artemis), and signals the painter's "proud identity with a strong and independent female mythological figure."

It remains to be seen whether Artemisia Gentileschi's pictures are resolutely feminist, and the Roman honor culture in itself was enough to demand rape charges against Tassi.[5] If Artemisia identified with her historical namesakes, and with the wife of King Mausolus in particular, it is curious that not one among the more than 160 extant and lost paintings attributed to her takes up this popular Baroque theme; Gentileschi would not have needed a commission to paint a small, single-figure painting. But, then, why would Gentileschi have wanted to pay homage, indirectly, to her own husband? After all, depictions of Artemisia invariably center around the drink in which the Queen had dissolved Mausolus' ashes, a sign of continuing devotion.

Of the cameos from which Judith's bracelet is fashioned, two and one-half are visible. To my perception, that in the center shows a full-length male warrior, posed frontally, a sword or lance in his right hand and a shield in his left, recollective of an early Hellenistic type known from Roman coins and gems (cf. Fig. 44), the Mars Ultor or Ares figure.[6] A closely related warrior is represented on the brooch in Judith's hair in Artemisia's canvas in the Palazzo Pitti (Fig. 31; Color Plate IV).[7] The lower cameo clearly depicts a dancing female in a chiton, here presented mostly from the back, her left arm raised as she moves toward our left and turns her head in the opposite direction. This, too, is familiar from ancient art as the bacchante/dancer/Maenad type (cf. Figs. 43, 46).[8]

If any iconographical significance is to be attached to these figures in Artemisia's painting (that is, if they are more than decorative accessories, consistent with the iconography of Judith, and technical tours de force), one would have to conclude that the artist intended ironic contrasts between the Ares/Mars and the helpless general Holofernes and between the dancing bacchante and the death-dealing action of Judith.

Nothing more complicated than the record of Artemisia's baptism need be considered to account for her given name: listed there is the newborn's godmother, Artemisia Capizachia (actually Capizucchi) of the Roman nobility.[9] In like manner, Gentileschi, first in Florence and then in Rome, was to receive at least three children named after her.[10]

Artemisia Gentileschi as a Still-Life Painter

"Ebbe costei un altro bel talento, che fu di ritrarne al naturale maravigliosamente ogni sorte di frutti. . . ."[11] In thus claiming for Artemisia Gentileschi outstanding skill in the rendering of still-life, Filippo Baldinucci initiated toward the end of the seventeenth century a tradition that has been tapped by modern authorities to extol Artemisia's genius and extend her oeuvre. Critical readings of Baldinucci's account and of other written material thought to corroborate it virtually prove, however, that in this Gentileschi scholarship has been poorly served.

Working from what he took to be reliable information provided by Roman sources ("molte fedeli notizie venutemi dalla città di Roma"), the Florentine Baldinucci reported a remarkable collaboration between Artemisia and a youthful Giovan Francesco Romanelli, the Viterbese painter then under Barberini patronage in Rome.[12] Romanelli, the narrative goes, arranged for his close friend Gentileschi, "from whose brush issued very beautiful paintings of fruit," to execute such a still-life, leaving free however an appropriate space in which he might portray her engaged in painting. Giovan Francesco's wife, moved to jealousy by her consort's effusive praise of Artemisia's beauty, virtues, and skill, attacked the portrait with a hairpin "especially in those places where the qualities most lauded by her husband resided." Recognizing then the love his wife held toward him, Romanelli kept the picture but forswore further encomia. Little wonder, then, that Robert Browning embraced the story for his "Beatrice Signorini"!

The crux of Baldinucci's account has never been challenged.[13] Indeed, the accuracy both of Baldinucci's *Notizie* in general and of the Gentileschi-Romanelli report in particular has been explicitly affirmed.[14] It has also been argued[15] that the supposed Gentileschi-Romanelli encounter must have taken place in the 1630s, when in fact Romanelli served the Barberini, or later, and not in the 1620s, when Giovan Francesco, born in 1612, had not yet produced his earliest identifiable work. Yet by immediately following his chronicle of the portrait by reporting that Artemisia had "in the end moved to Naples between 1630 and 1640" and was still working there in 1642 (not coincidentally the publi-

cation date of Baglione's *Vite*), Baldinucci implies what is an impossibly early date for the meeting. And although as noted previously Gentileschi twice (October 24 and November 24, 1637) expressed to Cassiano dal Pozzo her wish to return to Rome, there is no documentation that such a trip ever materialized, either then or upon Artemisia's return from England.

Nonetheless, support for Baldinucci's claim for Artemisia Gentileschi as an expert in still-life has been found in the texts of Alessandro da Morrona and Baccio Dal Borgo.[16] Upon inspection, however, the comments of these last-named authors emerge as totally without value as independent testimonies to Artemisia's practice of this genre. The Pisan Morrona merely summarized the Gentileschi-Romanelli encounter as detailed by Baldinucci, whom he specifically cites as his authority in this as in other instances, having prefaced his summary with a tacit admission that he did not have any firsthand knowledge of Artemisia's mastery of still-life: "Altra nobil prerogativa della nostra bella, e dotta Dipintrice or mi convien additare, che fu quella di pinger con naturalezza somma ogni sorte di frutta. *Ciò è fuor di dubbio, se dobbiam credere agli Scrittori di quel tempo* [italics mine]." From Dal Borgo comes the following passage, identified by Alessandra Giovannetti and quoted by Papi:[17] ". . . in appresso pittrice di fiori e frutta, e ne è celebrattisimo il quadro della Galleria Filomarino in Napoli, rappresentante S. Giovanni Battista nel deserto addormentato, ove trionfa un tal genere di pittura." Only his fellow Pisan Morrona among Dal Borgo's published predecessors had cited a Gentileschi *Saint John the Baptist* in the Filomarino Collection at Naples. Dal Borgo may therefore be seen as having creatively conflated Morrona's accounts of Artemisia as the author of still-lifes and of a *Saint John*, the latter a picture in which fruit and flowers would be out of keeping with the subject and which may have been destroyed forty years before Dal Borgo wrote (see [L-77]).

Thus information concerning Artemisia's would-be command of still-life, itself supplied to Baldinucci by a second party, was perpetuated by Morrona and Dal Borgo without the support of any visual evidence. And there is every reason to believe that Baldinucci was misinformed by sources who either manufactured the entire Gentileschi-Romanelli yarn or relayed to him an already garbled tradition. For some time now I have assumed the latter to have been the case—the story would seem incredibly fanciful otherwise—and that the woman painter was to be identified as none other than Giovanna Garzoni, who counted among her specialties precisely that of producing still-lifes of fruit. And Garzoni's biography—stays in Venice, Rome, Naples, Florence, and perhaps even London; patronage of Cassiano dal Pozzo, the Barberini, and the Duque de Alcalá—displays such a striking number of parallels with that of Artemisia as to explain the confusion.[18] Giovanna, born in 1600, was in Rome just before 1630, at which time she established contact with Cassiano and the Barberini, in all probability was there again in 1631–32, and is documented in Rome from 1642 to 1646 and from 1651 until her death in 1670. Clearly she would have had innumerable opportunities to meet G. F. Romanelli, including in the early 1630s when she had just passed her thirtieth year and he his twentieth and when both enjoyed ties to the Barberini.

In not recognizing the unreliability of Baldinucci and company with respect to the issue of Artemisia and the practice of still-life, scholars have been guilty of a number of unwarranted deductions. Thus, for example, a *Woman with Flowers* was touted as "the only preserved example of the talent, extolled by Baldinucci, of Artemisia as a flower painter." The work in question may be one of two depictions of Saint Dorothy by Antiveduto Gramatica (Fig. 251; [L-108]). Other paintings have been singled out as displaying Gentileschi's proficiency in nature still-life: the *Annunciation, Cleopatra, Saint Cecilia, Female Martyr,* and *Child with Roses and Cherries* (Figs. 114, 110, 245, 213, 202; Color Plate XV).[19] Yet the still-life components in all these pictures are modest in scope, and represent no more than any good artist with an acute eye would be capable of rendering. Baldinucci has been invoked[20] in support of the ascription to Artemisia of another *Saint Dorothy* (Fig. 237), which painting in turn is believed to give validity to Baldinucci's story. The attributions to Artemisia Gentileschi of the *Female Martyr,* the *Child with Roses and Cherries,* the *Saint Cecilia,* and the last-mentioned *Saint Dorothy,* in part prompted by their still-life elements, are to varying degrees and for various reasons questionable (see [X-9], [X-5], [X-30], [X-31]). In a consideration of the Budapest *Salome* (Fig. 254) as a possible work by Artemisia, a complex interweaving of arguments has been offered to demonstrate ties between Gentileschi and the Master of the Acquavella Still-Life (for which see [X-38]).[21] Yet the *Salome* almost certainly originated not with Artemisia but with Angelo Caroselli. Faith in Baldinucci's narrative and in the attribution to Artemisia of the *Female Martyr* led one scholar to entertain the possibilities of discovering autonomous still-lifes by Gentileschi's hand and of recognizing her influence upon certain Tuscan paintings of this class.[22] This again is a risky jump from most insecure footing. Nor can it be assumed from the apparent fact that *Orazio* Gentileschi produced still-lifes ("Un quadro grande con diversi frutti e fiori del Gentileschi con tre putti cornice nera" figures in an inventory dated January 26, 1631, of the Savelli Collection at Rome) that he had trained his daughter in this category of painting.[23] Finally, the picture itself being lost or unidentified, one cannot draw any conclusions from the "St laying his hand. on fruite by Artemesio" that was sold in 1651 from the English Royal Collection at Greenwich (see [L-79]). There remains, in essence, no unimpeachable evidence that Artemisia Gentileschi was markedly skilled in or made any substantive contribution to the art of still-life.

At this point a *Still-Life with the Allegory of Painting* (.97 x 1.345 m.; Fig. 253) with the Galleria Voena at Turin enters the argument.[24] Scholars are agreed that the figure of the woman artist steadying a folio and holding a short brush (as I see it) and shown amidst an elaborate still-life of fruit and flowers is by the hand of Giovan Francesco Romanelli, but the remainder has not found a universally accepted attribution.[25] Supposed parallels between the objects here and the works of the Master of the Acquavella Still-Life and yet perceived differences in handling and composition have prompted the hypothesis that the Voena picture might possibly be by the Master at an advanced moment in his career.[26] Yet, this same scholar, gripped by the temptation to relate this very painting to Baldinucci's narrative, a temptation to which he does not fully succumb in

the end, muses upon the possibility that the still-life is by Artemisia and that the face of the woman artist is Romanelli's rejuvenated, idealized image of her. Independently of this opinion, it has been concluded that the *Still-Life with the Allegory of Painting* is in all probability the Gentileschi-Romanelli collaboration detailed by Baldinucci.[27]

But Artemisia Gentileschi's physiognomy, however transformed, is simply not recognizable here. And if, as believed, the canvas dates from the 1640s, or no earlier than ca. 1637–40, Artemisia would have been at least forty-five years old, and an undocumented return to Rome on her part must be presumed.

Could, then, the Turin *Still-Life with the Allegory of Painting* be indeed the work described by Baldinucci but with the author of the still-life and the subject of the figure being Giovanna Garzoni, here painting in oils on canvas upon Romanelli's request rather than in her usual tempera medium in miniature? (As her very early *Saint Andrew* in the Accademia at Venice demonstrates, Garzoni was trained in the oil medium and had worked in large scale. Already during her years [1632–37] in Turin she was producing small still-lifes of fruit and flowers, and the brush and folio of the Voena picture could allude to her specialty.) As noted, the chances of a Romanelli-Garzoni encounter are appreciably greater than of a Romanelli-Gentileschi one. And while there are no true parallels in Artemisia's art to the still-life elements depicted here, Garzoni's oeuvre repeatedly displays each and every one of them. Furthermore, the parrot revealed by X-rays beneath the present surface at the lower left reminds us that Giovanna also painted birds, among them the chickens in the memorable *Old Man of Artimino* of the Palazzo Pitti.

Unfortunately, to judge from the earliest among the portrait likenesses of Garzoni, the red-and-black chalk self-portrait at the age of about fifty which serves as the frontispiece to her herbarium at Dumbarton Oaks, it is difficult (but perhaps not impossible, unlike the case of Artemisia) to see Giovanna's features in the gently smiling young woman of the Turin *Still-Life*, even granting Romanelli some artistic license and supposing that the Voena painting might have preceded the drawing by as many as twenty years. If only we knew the "quadro con il retratto della Sig.ra Giovanna giovane in tela di tre palmi" that was inventoried among her possessions following her death! For the moment, one can therefore more confidently link Baldinucci's report to a story told about Giovanna Garzoni than connect that report specifically to the *Still-Life with the Allegory of Painting*.

Artemisia and the Academies

When on July 19, 1616, the exclusive men's club that was the Accademia del Disegno in Florence added the name of Artemisia Gentileschi to its rolls, thereby inscribing a female for the first time in its fifty-three-year history, it was almost certainly acting upon the urging if not the orders of Grand Duke Cosimo II de'Medici.[28] Beyond this, the Acad-

emy would have been disinclined by its very attitude toward women to extend to Artemisia the full benefits of membership. Only the absence of concrete evidence prevents the certain conclusion that Gentileschi was denied such instructional benefits as life drawing and lectures on mathematics, anatomy, and natural philosophy.[29]

The Grand Duke's authority notwithstanding, it took a woman of remarkable artistic skill and fortitude to be deemed worthy in the first place of matriculation in the Accademia del Disegno. But because of these qualities Artemisia Gentileschi was also considered a curiosity in early seventeenth-century Italy. If, as the tantalizing fragments of information evaluated in Chapters 3 and 4 might imply, Artemisia was also associated with the Accademia de'Desiosi in Venice and Falcone's Accademia del Nudo in Naples, this same combination of attributes again worked to her advantage. In addition, it is conceivable (more than in the case of the Florentine Academy) that the Venetian and Neapolitan organizations, respectively, afforded Gentileschi intellectual stimulation and a chance to study the male nude.

Thus it may be that Artemisia's access to advantages enjoyed by many male artists as a matter of course was not as restricted as is generally believed. As a woman she would have encountered resistance, but in assiduously avoiding the stereotypes of the "typical" woman artist she put herself in a high-profile, even special position, and forced recognition of her abilities. And, so long as too many women did not come knocking on Academy doors, men may have been intrigued by the presence of such a phenomenon, such an exception, in their midst.

Artemisia's Literacy

The sonnets of Michelangelo, the letters of Poussin—indispensable founts among a richness of primary source material from which to draw knowledge of the artists' qualities of mind and intellectual interests. For Caravaggio, conversely, one has a secondhand report or two regarding what the painter is supposed to have said and testimony given in court under defensive circumstances and thus not necessarily trustworthy—although this paucity of information has not discouraged scholars from portraying the Lombard master as one of the great thinkers of the age. Artemisia Gentileschi speaks directly in thirty letters written over three decades as well as from the pages of the trial transcript. These have been mined in order to identify pictures and establish chronologies, to ascertain Gentileschi's attitudes toward her patrons and herself, to glimpse her state of mind. They have also served in the construction of an image of Artemisia's literacy, broadly understood, which has had an impact on interpretations of her art. A reexamination of this evidence is indicated.

On one point there is general agreement: namely that, predictably for the daughter of a painter, Artemisia's early formal education was minimal at best. In an effort to convince the authorities that Artemisia had lovers all over Rome, Agostino Tassi submit-

ted on May 30, 1612, that she "wrote and sent letters to various persons many times and on various occasions. . . ."[30] On June 8 a witness for the defense, following the same line but simultaneously undermining its credibility, claimed that he had "seen said Artemisia read letters that were printed as well as handwritten," but that he had "not seen Artemisia write because she cannot write."[31] Both Agostino and his accomplice thought to counter Gentileschi's own admission of May 14 that she could not write and could read very little ("io non so scrivere et poco leggere"), while in the opening narrative prepared for Orazio Gentileschi it is noted that on one particular occasion Tassi read letters aloud to Artemisia.[32]

Since there is every reason (including the contradictions on the defense side) to take Artemisia at her word, it may be observed that at the age of nineteen she was to all intents and purposes illiterate. With a brief note to Michelangelo Buonarroti the Younger in late 1615 and then a letter of February 10, 1620 (1619 Florentine Style) to Cosimo II de'Medici, the known correspondence of Artemisia Gentileschi begins. Had she thus learned to read and write at least by the beginning of the third decade?[33]

The search for an answer to this question is unexpectedly complicated. It can begin toward the end of Artemisia's life, specifically on June 12, 1649, when in a postscript to a letter to her Sicilian patron Don Antonio Ruffo the artist wrote: "Do not wonder about the different handwritings, because I dictate letters while I am painting. When you see my signature . . . you will observe that this letter is mine (*Non si maravigli de la maniera variata de li mani de lo scrivere perche io mentre dipingo et detto le lettere e quando vedera la mia sotto scritta mano da suo . . .* [words not transcribed] *se cura chè la mia*)." Thus it is, for example, that Gentileschi's letters to the Grand Duke of Tuscany on February 10, 1619, that to Cassiano dal Pozzo on August 31, 1630 (Fig. 118), and that to Andrea Cioli on December 11, 1635, exhibit three different styles of calligraphy.[34] And indeed the form of the signature on the latter is appreciably different from that on the letter to Cassiano.[35] Moreover, within the Ruffo correspondence, spanning but two years, the orthography (as it appears from the transcriptions) is inconsistent: *bacio, bascio,* and *bagio; ducati* and *docati; oggi* and *hoggi; quadro* and *quatro; lettera, litera,* and *letre; ho hauto* and *ò auto*—to provide a selection. Among the three letters cited above, the handwriting on that to Cassiano dal Pozzo has a spontaneity lacking in the other two, which seem to have been penned with greater care, as if for more formal presentation. It might logically be supposed, then, that the letter to Cassiano is most likely to have come from Artemisia Gentileschi's own hand, but of this there is as yet no proof.[36]

The major issue, however, is not whether Artemisia learned to write and, if so, in what style, but rather what her correspondence reveals of her level of intellectual sophistication and the like. Garrard holds that "the letters display impressive linguistic skills—an ability to use the flowery and elegant courtly language of her day, and at the same time to manipulate it, so that she delivers some hard truths with grace and wit."[37] "Word play," metaphor, "shades of meaning" have been detected.[38] Greer, assessing the same letters but reaching very different conclusions, asserts that they are "garbled in syntax, tending to heap clauses in apposition, as if [Artemisia] were dictating. Their

clumsiness with honorifics does not bear out the claims made by her chivalrous biographers, while her occasional vivid colloquialisms smack more of the habits of speech of the *popolino* than elegant raillery."[39]

In my opinion there is very little in the letters of Artemisia Gentileschi with respect to word choice, phrasing, or thought that speaks of any particular sophistication. In courting her patrons she falls back on formulaic flattery. What I *do* find, with Garrard,[40] is an engaging "wry humor." Telling Cassiano dal Pozzo on December 21, 1630, that she will send him her *Self-Portrait* with the next messenger, Artemisia adds: "You can rest assured of my ready willingness to serve you, and when that does not satisfy you, you may at your convenience flog the image of the artist, who, shivering from the cold in doing such work, will nevertheless expect that the innate kindness of your Lordship will relieve her of this misfortune by sending her gloves and slippers, lest she suffer more."[41] Morrona, too, with Gentileschi's letters to Cassiano in mind, remarks on the artist's "humorous disposition (*lepidezza dell'umore*)."[42] Artemisia tells Ruffo that she would not have sold the *Diana* to her father for the little she charged him, suggests that only through "the hand of the Almighty" would that painting survive the combined dangers of Don Antonio's nephew (to whom Gentileschi had consigned the canvas) and the four-hour sea trip to Messina, and uses colorful language to describe the expense and aggravation caused by her female models ("grandissimo stipendio, e gran rompimento di capo e dele volte quando se ritrova qualche cosa di bono me pelano à pelo rinverso").[43]

Each and every one of the preserved letters of Artemisia Gentileschi is a business letter, announcing the imminent arrival of pictures, seeking proper compensation, soliciting commissions or entreating assistance in arranging introductions to potential patrons. They are eminently practical. Only once, when writing to Ruffo on November 13, 1649, does Gentileschi touch upon what might properly be called theoretical matters; distressed that one of her drawings had been turned over to another painter for execution in oil, she insists that "when the concept has been worked out and fixed with lights and darks and established on planes, the rest is nothing (*quando è fatta l'inventione, et stabilito con li suoi chiari et uscuri, e fundati sul'loro piani tutto il reso ei baia*)." This privileging of invention is part of the academic tradition,[44] yet by Artemisia's time it was surely a studio commonplace. Not a single authority, ancient or modern, is cited. No literary references are to be found.[45] Similarly, the few allegorical canvases which Gentileschi painted (e.g., Figs. 64, 121, 156, 175; Color Plates VIII, XVIII, XXVII) find explanations in nothing more esoteric than the popular artists' handbook that was Cesare Ripa's *Iconologia*.

Finally the point of all of this: The image of Artemisia Gentileschi that emerges from her letters is of a clever, alert, pragmatic, outspoken, altogether human human being, susceptible like all of us to mood swings (which she does not shrink from revealing), capable of moving from the obsequious to the aggressive. The letters do *not* present Artemisia as a well-read and cultured individual given to recondite allusion and abstract speculation. If interpretations of Gentileschi's pictures which appear to require of the painter familiarity with a range of texts or theoretical thinking are to be sustained, they must find support from other than her own words.

Might not it still be possible, however, to enlist the correspondence and the trial testimony in support of feminist and psychoanalytical readings of Artemisia's canvases? Until the current popular conception of the subject matter of Gentileschi's art is examined, this question cannot be addressed.

The Subject Matter of Artemisia's Pictures

The present study catalogues fifty-seven works by Artemisia Gentileschi: fifty-one extant canvases,[46] one photographed before its destruction in 1940 (Fig. 200), two recorded in seventeenth-century copies (Figs. 150–51, 152), and three known by way of prints executed during the artist's lifetime (Figs. 101, 102, 112, 113). Since Gentileschi created for more than forty years, the identifiable paintings must constitute a relatively small portion of what actually came from her brush. Any thought of extending this number by counting lost works is discouraged by the fact that for various reasons the attributions of a great many of the pictures cited by the sources are suspect; thus decisions as to which of these paintings to include in the census would often involve an unacceptable level of arbitrariness. Consequently, theories in which the themes of the preserved canvases figure prominently require faith that what has survived is in subject matter a representative sampling of Artemisia's total output.[47]

Fifty-two of the known paintings are nonportraits; and, of these, forty-nine works, or ninety-four percent, feature women as protagonists or, occasionally, give them equal billing with men. Since, as previously remarked, these are precisely the kinds of pictures which scholars have come to recognize as being by Artemisia's hand, her actual production may not have been quite so heavily weighted on the side of female-oriented themes. Still, it may be supposed that they very much dominated her output. Now "writings about women from the late middle ages through the seventeenth century offer a consistent picture of the virtuous woman—chaste, silent, modest, humble, obedient."[48] In his *De claris mulieribus* of about 1370 Giovanni Boccaccio spoke for many men when he wrote: "I thought that these achievements were worthy of some praise, for art is very much alien to the mind of women, and these things cannot be accomplished without a great deal of talent, which in women is very scarce."[49] So well known as to require little comment, like sentiments echo through the centuries, as when a nineteenth-century personality declared of Artemisia's *Magdalen* (Figs. 69–70; Color Plate V) that without the signature "no one would have imagined that it was the work of a woman," the brushwork being so bold and certain and the whole so without signs of timidness and obvious effort.[50] And so it goes even in our own day, when Gentileschi's *Esther* (Fig. 125; Color Plate XVI) is said to exhibit "all the sensitiveness and sweetness (*toute la sensibilité et la douceur*) that characterize the female sex."[51] For every word of encouragement that Orazio Gentileschi gave his daughter, there were probably others from other men (and no doubt from some women as well) who ridiculed Artemisia's plans to enter the paint-

er's profession or who, sensing her determination, warned her to restrict herself to still-life or portraiture. Artemisia Gentileschi had then to battle traditional attitudes and psychological submission to this brainwashing,[52] and surely jealousy of her obvious talent.

As will be documented shortly, Artemisia was well aware of what men expected and did not expect of women and of women artists. From the beginning of her career she appears to have taken a stand against those forces that sought to check her ambition. Early on, her chastity had been brutally violated, and in a sense that may have helped liberate her from some societal pressure.[53] She certainly did not play the demure role, although when it seemed to her to suit her purposes she could pass from self-assertive-ness to the deferential. While Gentileschi did practice portraiture, she presents herself in her letters and in her preserved oeuvre as primarily a master of "history" painting. Her canvases are often large in scale and pictorially forceful, and only in her last years, and perhaps partly out of weariness from having for decades fought the good fight, do they show signs of giving in to contemporary notions of "femininity."

Women rule Artemisia Gentileschi's pictures, and some of them are most assuredly nonsilent, nonhumble, powerful personalities. Understandably, scholarship has focused on the most strong-willed of Artemisia's characters, so that one might be forgiven for thinking that she painted mainly variations on the theme of Judith and Holofernes. Some cold figures, never before compiled, ought to disabuse one of that perception and in so doing prepare the way for a critical look at theories which have often depended too exclusively upon it. Thus:

Known works (see above): 57

Known works featuring women as protagonists or co-protagonists: 49, or 94 percent of the nonportraits

Most frequent subjects among known works: Judith (7), Bathsheba (7), St. Mary Magdalen (6), Susanna (3), Madonna (3), Lucretia (2), Cleopatra (2). Thus 30, or 58 percent, of the known works (exclusive of portraits) are devoted to variations on only seven themes.

Subject breakdown among known works:
 Old Testament and Apocryphal subjects: 21
 New Testament subjects: 4 (all include the Madonna)
 Saints and saints' lives: 10 (8 female, 2 male), plus Saints Proculus and Nicea
 Allegories/personifications: 6
 Mythology: 4
 Historical subjects: 4
 Literary subjects: 1
 Genre: 1
 Portraits and self-portraits: 5

Known works in which women directly control or directly attempt to control men: 11

Known works in which women are subjected to male control or male lust or otherwise owe their fates to men: 15

Known works whose subjects carry implications of sexuality (consummated, desired, or used as a lure): 29, or 56 percent of known works, exclusive of portraits

Known works containing female nudes: 19, or 37 percent of known works, exclusive of portraits

Especially when set out graphically in this way, Gentileschi's oeuvre clearly exhibits a number of patterns which must be factored into any attempt to recognize relationships between the subjects and interpretations of her pictures and her life.

Artemisia's Art and Artemisia's Life

Calling into question an oft-made assumption "that what is true of an historically documented personage and of the artist manifested in that historical person's aesthetic products must be the same," a recent study goes on to relate this to investigations of art produced by women: "To propose that the properties of the real (historical) fabricator of an art work are of a different kind from those of its apparent (art historical) artist challenges the claim that the biological, social, cultural, political and economic conditions of historically real women artists cannot help but have determined the personal qualities of the works they made."[54] The relevance of this argument to scholarship on Artemisia Gentileschi specifically is duly noted by this same writer, for whom claimed ties between gender and the art produced by women have yet to be convincingly demonstrated.[55] This plea is accompanied by a warning against the expectation "that researching the circumstances of an artist's life reveals rather than reiterates the greatness of the artist's work."[56]

The danger of preoccupation with biographical information to the relative neglect of the primary evidence of Artemisia's pictures is highlighted as well by the following statement: "It is only when we escape this disturbing fascination with her life and return her work to its context within a specific time, place, and school of painting that we can fully appreciate her activities as a painter."[57] For another historian, taking an intemperate position, the fact that Gentileschi "was female is important only because the misogynist Germanic art historical establishment in conjunction with the Italian attitude toward women as madre/madonna have worked against understanding what she actually accomplished as an innovator and as a sometimes great painter."[58]

Additional opinions, all along the philosophical spectrum, could be cited. As against my wary although flexible approach, some scholars are convinced that relationships between Artemisia's pictures and her life and gender, whether consciously intended by the painter or unconsciously arrived at, are at the very heart of the matter. The most

extensive and thought-provoking study in this area is of course that offered by Mary Garrard, who believes that the differences in female and male "perception, experience, and expectations of the world . . . cannot help but have been carried into the creative process" and who speaks of Artemisia as having "drawn subconsciously from the well-spring of her female being and experience."[59] Others have followed Garrard's lead in declaring that "Artemisia Gentileschi's painting is intimately bound with the events of her life" and that "we have no trouble seeing these pictures as autobiographical."[60] What she encountered as a woman is thought to have resulted in a feminist perspective that helped give rise to the themes and expressive orientation of her paintings. Her rape by Agostino Tassi in 1611 has been considered the formative event of her life, affecting in one way or another what and how she painted for most of her career. And aspects of her art have been given additional psychoanalytical readings involving the Oedipal complex, castration, and childbirth. It is for the remainder of this section to test the validity of these major contentions.

Every day Artemisia Gentileschi is likely to have met with various forms of oppression attendant upon being accorded inferior intellectual and social status because of her sex. With pride in her own capabilities, did she see this injustice for what it was and resolve to oppose it? Might she legitimately be called a feminist (or proto-feminist, if one prefers) and, if so, did her feminism have an impact on her art? Can her pictures be seen as weapons in the struggle—demands, calls to action, and/or case studies, for the edification of other women, of female heroes who had triumphed over inequity and who could serve as role models?

Common sense alone tells us that Gentileschi could not have remained oblivious to conventional male attitudes toward women and women artists. Her correspondence with Don Antonio Ruffo documents this awareness.[61] "I have the greatest sympathy for Your Lordship, because the name of a woman makes one doubtful until one has seen the work (*Io fo tanto gran compassione a V. S. perchè il nome di donna fa star in dubbio sinchè non si è visto l'opra*)," Artemisia confesses to her patron, and elsewhere she simultaneously acknowledges and dissociates herself from the notion that owing to limited imaginations women painters were reduced to turning out repetitions of their works ("che per gratia di Dio et della Gloriosissima Vergine vengono ad una donna che è piena di questa merentia cioè di variar soggetti in dela mia pittura; et mai sie trovato ne'quadri miei corrispondentia d'inventione etiam in duna mano").[62] Because she was a woman, she implies, she was taken advantage of in the matter of her drawing for a painting of Souls in Purgatory ("che se fusse homo i [*sic*] non sò come se passarebbe").[63] Pleased with how her *Bath of Diana* was turning out, she asserts: "And I will show your Most Illustrious Lordship what a woman can do. . . ."[64]

Such statements as these and a conviction that in her art Gentileschi rejected stereotypical depictions of women have helped prompt the inference that Artemisia's "creation of powerful female characters was supported by the climate of her time, that the feminist and anti-feminist battles did not pass her by, and that the important contribution she made to the feminist side of the question may not have gone entirely unrecog-

nized in the seventeenth century."[65] Could it be that the painter's supposed feminism, first activated by what she faced in day-to-day living, was reinforced and given direction by contemporary debates familiar to Artemisia in published form and/or directly from women dedicated to challenging conventional attitudes? The names of Anna Maria van Schurman, Bathsua Makin, Marie de'Medici, and Henrietta Maria have been introduced for consideration in this regard.[66] Inasmuch as Makin, for whom van Schurman was inspirational, served as governess to the English royal children beginning about 1641, and Queen Henrietta Maria was the daughter of Marie de'Medici, who was also in contact with van Schurman,[67] connections between all four of these women can be demonstrated. Henrietta Maria and Marie de'Medici (the latter in England if not also previously in France) knew Artemisia Gentileschi's art, in which beyond question they would have taken special interest.[68] Since Artemisia was in England from 1638 until at least 1640, the possibility of face-to-face discussions with the two queens existed; yet, as has been scrupulously acknowledged,[69] the protocols of class and status might have ruled out such conversations. Further, if my assessment of the degree of her intellectual sophistication is correct, it seems improbable that Gentileschi would have sought out literature devoted to feminist issues.

Hard evidence that Artemisia was aware of movements advocating gender equality is therefore lacking.[70] However, the presumption that she was would at first appear to be strengthened by certain moments in her letters to Ruffo. Such pronouncements as "I will show your Lordship what a woman can do," "when I demand a price I do not follow the Neapolitan custom. . . . I am Roman, and therefore I wish always to proceed in the Roman manner," and "you will find the spirit of Caesar in the soul of a woman (*ritrovera uno animo di Cesare nell'anima duna donna*)" seem powerful expressions of self-worth.[71] Considered in context and closely analyzed, however, they lose some of their bite. The first two are as much defensive as assertive in the most positive sense, for they represent Artemisia's reactions to the usual male view (here implied) of a woman artist's minimal capabilities and to predictable attempts—part of the conspiracy against her—to get her to lower her fees. This is not equivalent to the self-laudatory posture which she assumed in the allegorical paintings and *Self-Portrait* (Figs. 121, 156, 175, 119; Color Plates XVIII, XXVII) of the previous decade. Gentileschi's linking of herself to a celebrated male figure from antiquity brings to mind what Renaissance men were fond of doing.[72] It also recalls the following comment on Boccaccio's *De claris mulieribus*: "Those women who were most unequivocally admirable in Boccaccio's collection were praised for being like men, a way of removing them from the larger class of women and making them exceptions rather than examples of other women."[73] Is not this in effect what Artemisia is doing—separating herself from her sisters? If so, cannot one understand her utterance as "you will find the spirit of Caesar in the soul of one woman, at least"?[74]

Another among Gentileschi's oft-cited remarks to Don Antonio is relevant to the present argument. Writing to Messina on March 13, 1649, she tells Ruffo: "I shall not weary you any longer with this female chatter, but the works themselves will do the talking (*non starò più a fastidirlo di queste chiacchere femenili, ma l'opere saran quelle che*

parleranno).” If this is evaluated within the framework of all of Artemisia's dealings with Ruffo as rehearsed in the correspondence, it emerges not as “playful self-deprecation to disarm her patron”[75] but rather as the clearest signal of the artist's need to balance aggressiveness with diffidence,[76] to counter as it were every forward “masculine” comment with a meek “feminine” one. While demanding what was due her, Gentileschi had to be careful not to offend Ruffo, who no doubt harbored definite ideas, familiar to Artemisia, about how a woman properly should approach him. Viewed in this light, the obsequious language with which Artemisia often addresses Ruffo might be seen as more than simply standard artist-to-client practice, calculated phrasing to keep the commissions coming. “I also want Your Very Illustrious Lordship to promise me that as long as I live you will have custody over me and regard me as if I were born a slave in your house (*desidero anco che V. S. Ill.ma mi prometta che mentre io vivo tenga patrocinio sopra mia persona, e faccia conto, che io sa nata schiavotella in casa sua*)”; “I make a humble bow to your Very Illustrious Lordship, assuring him that while I live I will be alert to his every command”; and “I have made an ardent resolution that while I live I will always be a vassal and tributary of Your Very Illustrious Lordship”[77]—these are not words expected of a woman determined to break out of the straitjacket of male domination. How hard was it for Artemisia Gentileschi to pronounce them? It may also be that while insisting that she be treated as a male painter would be, she may have feared forfeiting a sense of her own womanliness.[78] Society had placed her in a bind, and she had to do her best to lessen its distress.

Artemisia's letters to Ruffo, constituting almost half of her known correspondence, were written toward the end of her life and at a time when her art had undergone substantive changes. Thus one must be careful in attributing the attitudes expressed in these letters to Gentileschi's career as a whole, although there are no sentiments in earlier letters that conflict with them. In any event, in my opinion her own words do not buttress the case for Artemisia as a woman of feminist convictions.

And so we must return to the paintings, in which Artemisia's feminism is often found to be given unambiguous form. Unfortunately, claims to that effect fail sufficiently to consider the full range of subject matter which she painted and the extent to which these subjects were chosen not by her but by the men who commissioned her works. These crucial considerations, already raised in the preceding chapters, will be taken up again shortly. The immediate order of business should be to begin to evaluate the profeminist position with regard now to Artemisia Gentileschi's pictures and, as it must be, with reference to the particular terms on which feminist criticism of Gentileschi's art has proceeded to date.

Once again, the major presentation is from Mary Garrard, for whom Artemisia, in depicting even exceptional women as real women of flesh and blood and emotional depth rescues them from the “realm of emblem, legend and panegyric” and introduces them into “the world of heroic action, not as would-be men, but simply as women who partook equally of the human condition.”[79] Thus relocated, they could be perceived by men as threats to male dominance. Indeed, for Hersey, Gentileschi's canvases “explore women's

117

demands for sexual justice" and "demand justice and vengeance."[80] "From women," he continues, Artemisia's pictures "may elicit sympathy. From males they should elicit guilt," and "do not simply complain [but] seek to change behavior."[81] The artist's depictions of Susanna and Judith, almost always the paintings featured in such arguments, are then analyzed in some detail.

If this is what Artemisia Gentileschi had in mind, it may be questioned whether she succeeded with those to whom her paintings must have been primarily addressed. "There is no evidence that her patrons, all men as far as we know, explicitly recognized the powerful feminist expression of her paintings,"[82] a statement that commands special attention since it comes from an advocate of Gentileschi's feminism. Artemisia began her career with pictures of Susanna, Lucretia, and Judith. Thirty-five and more years later, she was still interpreting the stories of these same women. Apparently the men who kept requesting paintings of such themes from Gentileschi found ways not to feel personally upbraided or menaced by their messages, and if they experienced guilt they certainly did not say so. A kind of perceived threat might be found in the anecdote that upon finding Artemisia's signature on the Uffizi *Judith* (Figs. 77–79; Color Plate XII) a nineteenth-century personality remarked that "the woman who painted such a work could not have married"; but even that judgment was challenged on the grounds that the "person erred in ascribing to the heart that which belongs rather to the mind," that is to the creative imagination of the artist.[83] From Baldinucci[84] onward viewers, male and female, have remarked on the feelings of horror inspired by Gentileschi's renditions of *Judith Decapitating Holofernes*, and some have been put off by it (even when the Naples version [Fig. 21; Color Plate II] was thought to be by Caravaggio),[85] but to my knowledge it is only in our own day that a feminist outlook or agenda has been detected in these and other pictures by Gentileschi.

Lack of recognition does not perforce signify absence, however, and it is possible to show that occasionally (at the very least) Artemisia executed paintings which expound ideas that in some situations would be called feminist and which spotlight women to whom, unquestionably, the artist relates. Thus, in accenting creativity and intellect the *Allegory of Painting* (Fig. 175; Color Plate XXVII) might be enlisted in a campaign against male deprecation of female competency.[86] Artemisia allied herself with this message above all by pairing the *Allegory of Painting* with a *Self-Portrait*, now lost. Intimations of *La Pittura* and of the time-honored *ut pictura poesis* formula mark the extant *Self-Portrait* (Fig. 119), a proclamation of personal and professional dignity. By means of the conspicuous signature on the shield of Minerva (Fig. 156) Gentileschi appropriated the goddess's virtues of wisdom and strength and called up the association of Minerva with the art of painting. And she guaranteed herself a place in history by inscribing her name in the book of Clio, Muse of History (Figs. 121–23; Color Plate XVIII) and putting her painterly magic on display.

That Artemisia Gentileschi should ennoble herself and her profession by connecting herself and her art to virtue, fame, and liberal studies need not strike one as singular, and does not in itself point to feminist sympathies specifically. Minerva of course, and

the personifications of History and *La Pittura* by tradition, were female; it would be more surprising, then, had Artemisia passed up these opportunities to affirm self-worth. For many reasons, one *expects* Gentileschi's pictures to center around women. All the dominant subjects in her oeuvre, many embodying violence and eroticism, were favored at the time, and were treated often by male painters.[87] As a woman she would quite naturally have felt special rapport with the triumphs and tragedies of historical women, and as a woman painter a desire to interpret them.[88] As suggested earlier in this study, Artemisia might have had particular confidence in the validity of her perceptions of what her female characters had experienced, and may have publicized herself as best qualified by gender and practice to interpret female imagery. And she could point to paintings that she had already executed to back up her claim. Before Gentileschi's career was much advanced the pattern for what was to come had been set, the artist's strengths announced, and potential clients informed as to where to go should they wish pictures of Judith, Susanna, Lucretia, and Saint Mary Magdalen. Once reputations based on specializations are established, an artist—Carlo Dolci with his pietistic Madonnas and female saints, Francesco Furini with his melting female nudes, Bernardo Cavallino with his spirited Biblical narratives in small scale, no less than Artemisia Gentileschi—would not have found it easy to expand his/her repertory, even if motivated to do so.

One might just as fruitfully consider why Artemisia painted male figures so infrequently rather than why she rendered women so often. Once more, predisposition and (above all) patronage decisions must have been at work. Apparently Gentileschi's verbal and pictorial self-advertisement got through. Conversely, there was little she could show in the way of pictures featuring men, and it is conceivable that clients did not want to take a chance that the woman who sometimes placed other women in an heroic light might not depict men with the nobility deemed to be due them. It is also my contention that Artemisia's personal reputation, compounded of fact and fabrication, and her sub-specialization in erotic nudes (which, ironically, were just what men ordered), conspired to render her inappropriate in the eyes of many patrons as an interpreter of the character and actions of men.

Any exploration of the matter of Artemisia Gentileschi's feminism and its implications for her art must not become preoccupied with those pictures by her (*Judith, Jael, Delilah*)—representing only one-sixth of her known production, be it noted—in which against all odds courageous women conquer men. The image of a capable woman need not automatically be a projection of a feminist ideology. Furthermore, cases that ignore exceptions and other inconveniences or depend upon forced arguments are unconvincing. In the previous chapters I have noted instances of what I take to be such debatable evidence. Some of this needs to be reiterated, some expanded, and additions made in the context of the argument at hand.

The *Jael and Sisera* (Figs. 72–73) is an instructive example. In it the Kenite woman is balanced compositionally by the pier in which the letters ARTEMITIA. LOMI / FACIBAT / M. D. CXX are chiseled. Artemisia seems to stand with Jael at the moment of her triumph. But just as one is disposed to declare the painting a signboard of feminism, its lack of

passion intervenes. Even as Artemisia sets up what would appear to be an optimal situation for a rallying cry, she backs off—the reverse of "I shall not weary you any longer with this female chatter, but the works themselves will do the talking" but to similar effect. Discussions of Gentileschi's *Esther and Ahasuerus* (Fig. 125; Color Plate XVI) overstate Esther's commanding role and understate the extent to which the Queen "accomplished her great deed by means of the virtues of the ideal woman"[89] and not of the woman who is determined to contest these stereotypes. Corisca (Fig. 131; Color Plate XVII), on the other hand, epitomized the un-ideal woman, but one must question the suggestion that Artemisia considered the nymph's cleverness (in outwitting the satyr whom she had wantonly inflamed) to be a positive value. Then there is the Pitti *Magdalen* (Figs. 69–70; Color Plate V), which some have interpreted as reflective of Gentileschi's life and state of mind and others as being so without such references as to be relatively unsuccessful as a picture. Even less credible is the attempt to turn Saint Catherine (Fig. 54) into a Gentileschian heroine par excellence. Within a period of ten years Artemisia created two versions of *Cleopatra* (Figs. 110, 136; Color Plates XV, XIX), the first considered a role model in terms attributed to Artemisia, while the second cannot be accommodated to the stated feminist viewpoint. How would one explain such supposed inconsistencies? Wavering on Gentileschi's part, or the artist's ability to adapt to different patronage tastes?

What is one to make, too, of the female nudes featured in one-third of Artemisia's pictures and previously discussed here? Sensuality, present even in the nudes painted in the early years, increased in explicitness as the intent of the canvases to indulge male sexual appetites, to display the female body for the voyeur, became ever more patent. Writing to Ruffo on June 12, 1649, Gentileschi complained: "The expenses for hiring female nudes are high. Believe me, Signor Don Antonio, the expenses are intolerable, because if fifty undress hardly one is good. In this painting [*Bath of Diana*] I cannot use one model only because there are eight figures and one must paint various [or different] beauties [or charms] (*le spese son molte per ocasione di tenere queste femine igniude credetemi s.re d. Antonio che le spese sono intolerabili per che se ne espoglino cinquanta e apena gine bona una, in questo quadro non mi posso servire di un modello solo per che sono otto personaggi è bisognia far varie belezze*)." Surely this is less recollective of the Renaissance conception of the ideal as a combination of the best parts of many than it is of Titian's correspondence with Philip II in which the Venetian master explained that having depicted Danaë from the front he chose to show Venus from the back so as "to make the room . . . more pleasing to the eye."[90]

Artemisia's impressions of her female models, who tried to squeeze every ducat out of her and who more often than not lacked the physical attributes she required, do not reveal any compassion for women trying to make their way in the world. In her seven renditions of *Bathsheba* (Figs. 159, 169, 180, 184, 188, 200, 201; Color Plate XXIII), only in the canvas in Columbus does she seem at all concerned with Bathsheba's presumably conflicted state of mind upon receiving David's command to come to him. The element of psychic struggle, to which Gentileschi's first pictures of the themes of Susanna and

Lucretia (Figs. 10, 19; Color Plates I, III) do indeed seem to testify, is not sustained in the later interpretations (Figs. 190, 197). In order to find feminist meaning in the first *Cleopatra* (Fig. 110; Color Plate XV)—in this instance a conception of "female excellence as a reflection of inner worth rather than of conventional external beauty"[91]—it is necessary, among other strategies, to exaggerate the ordinariness of the Queen's face while passing over the sensual appeal of the nude body. Deep in sleep, the Venus (Fig. 104; Color Plate XIV) is defenseless, and most of the *Bathsheba*s do nothing to dispel the stereotype of female vulnerability.

Some other received ideas about women are in a sense perpetuated by many of Artemisia's pictures, although certainly not intentionally. Jael, Delilah, and Judith accomplished their missions "using their female wiles, which is to say sexual power, to overwhelm men. . . ."[92] The predisposition of seventeenth-century men to read sex into these paintings is not likely to have been fully neutralized by the fact that these women are not presented by Gentileschi in openly alluring guises. Levels of meaning or not, Artemisia's first *Lucretia* (Fig. 19; Color Plate III) and her *Cleopatra*s (Figs. 110, 136; Color Plates XV, XIX) cannot have totally upset "fixed notions about women's inevitable bent toward self-sacrifice," "men's psychic needs to define women as passive victims," or the erotic fascination which such images apparently had.[93] Associations between the mirrors in the *Bathsheba*s (Figs. 180, 184, 188, 200, 201) and vanity would have been easily made.

Significantly, as charted above, more than half of Gentileschi's known works carry implications of sexuality—consummated, desired, or used by the women themselves as a lure. Is it permissible to turn what in men would be exploitative into something admirable for women so long as liberation of the female spirit results? It has been suggested that Artemisia found Corisca "much more interesting than her morally impeccable counterparts" and "Potiphar's wife . . . a more interesting character than the priggish, self-righteous Joseph" (and thus embraced "the sexual adventurer rather than the sexual object").[94] Galatea (Figs. 195–96; Color Plate XXII), like Corisca, taunts a man. What message could the artist's male contemporaries be expected to carry away from such representations?

This question prompts the reintroduction of a related line of thought, one much more worthy of exploration than this study has thus far acknowledged: What of those *female* viewers who, if rarely figuring among Artemisia Gentileschi's patrons, were potentially part of her audience? Did Gentileschi purposefully address aspects of her works to them?

The self-referential canvases of the 1630s (Figs. 119, 121, 156, 175; Color Plates XVIII, XXVII) might be seen to embolden women to ally themselves with the female creator's claims, but it appears more probable that they served Artemisia as personal confirmation and as signals to the male picture-buying public of her status. Are there really enough clues in the *Corisca and the Satyr* (Fig. 131; Color Plate XVII) to support the proposal that Gentileschi wished her female contemporaries to find vicarious liberation in the nymph's ruse? If in the earlier nudes, among them the *Cleopatra* (Fig. 110; Color Plate

XV), the emphasis is considered to be upon inner beauty, then it might be conjectured that this was meant to strike a responsive chord in women. If, on the other hand, Cleopatra, Venus, and the other undraped models were designed to be physically alluring, can it be supposed that Artemisia understood that women might take pleasure in identifying with this attribute of their counterparts even as the messages of the pictures involved notions of female vulnerability?[95] Or, would women viewers have judged (and taken positively) that part of Gentileschi's agenda "was to awaken in the male voyeur, enjoying the female as spectacle, the shame that comes from discovering that someone is watching him"?[96] Would they have objected to seeing themselves possessed, via art, by the male gaze?[97]

Might it have been taken as a given by Artemisia and her male patrons alike that even those rare women who would have been trained to look at pictures would have learned to do so with male eyes? Was an aspect of the artist's mission that of reeducating female spectatorship?

I do not pretend to have demonstrable answers to such questions. It does seem clear enough, however, that in overwhelming part seventeenth-century women were discouraged by patriarchal society from developing anything like a feminist sensitivity. Furthermore, recent interpretations of many of Gentileschi's canvases as being charged with feminist ideas of potential relevance to women of the period are open to legitimate challenge. Consider also the painter's involvement with the theme of Saint Mary Magdalen. The Magdalen has been labeled "a rather confusing female model . . . with little to inspire a woman,"[98] yet Artemisia painted her image almost as often as she did that of Judith, including in two pictures (Figs. 96, 111) with erotic appeal. And no matter what fortitude and other virtues one might find in the moral characters of Gentileschi's Susanna, Lucretia, Cleopatra, and Bathsheba, they owed their fates to what controlling men had in mind for them.

It may be that implicit in attempts to locate feminist meaning in some rather unlikely places is the recognition that in point of fact Artemisia Gentileschi's subject matter is not easily reducible to a couple of simple categories of unequivocal images. Any uneasiness with the seeming contradictions within Artemisia's oeuvre might be lessened by granting the probability that the themes which she painted were in large part determined by the wishes of her patrons. For many of the extant canvases it is possible to show that they were ordered by specific individuals, or at least to suggest external reasons why the subjects were chosen. In Chapter 2, for example, I have attempted to tie the majority of Artemisia's works from the years 1613 to 1620, including the Uffizi *Judith Decapitating Holofernes* (Figs. 77–79; Color Plate XII), to Florentine and predominantly Medici requirements. The early *Lucretia* may have been conceived in concert with Orazio Gentileschi's *Cleopatra* (Figs. 19, 211), and a variant of the Naples *Judith Decapitating Holofernes* was apparently designed to be paired with a version of Orazio's *David in Contemplation After the Defeat of Goliath* (Figs. 21, 24, 29, 30). The *Aurora* no doubt promoted the poetic mission of Niccolò Arrighetti, while Charles of Lorraine's politics occasioned the *Clio*, and Buonarroti family pride dictated the *Allegory of Inclination* (Figs. 87, 121, 64; Color

Plates XVIII, VIII). Artemisia's women for the Greenwich ceiling (Figs. 170–72; Color Plates XXV, XXVI) articulated Caroline propaganda. The *Galatea* (Figs. 195–96; Color Plate XXII), recounting a Sicilian legend of the sea, was tailor-made for Don Antonio Ruffo, Messinese shipping tycoon. Referring to the now lost *Bath of Diana* for Ruffo, Artemisia wrote on March 13, 1649: "I acknowledge [am aware of] as well what you have asked of me concerning the painting that I am to do for you (*sento poi, quel che mi commanda circa l'opera che li devo fare*)." Gentileschi probably had little or no say regarding the subjects of the *Annunciation*, the *Birth and Naming of Saint John the Baptist*, and the three Pozzuoli canvases (Figs. 114, 139, 146–49; Color Plate XXI). Further research may turn up the names of other clients and with them explanations for subject selection, as for example for the *Minerva* (for the Medici?) and the *Corisca* (Figs. 156, 131; Color Plate XVII). At times, Artemisia took it upon herself to send pictures as "gifts" in order to secure new clients or retain old ones. (Some of these might have been ordered by other patrons but, because of disagreement over the price or dissatisfaction with other aspects of the works, suddenly became available.) The themes of several of them are not known.[99] In other such instances where Gentileschi offered pictures or actually acted on speculation, the subjects are reported: *Saint Catherine*; *Christ and the Samaritan Woman with the Apostles*; *Saint John the Baptist in the Desert*; *Andromeda Liberated by Perseus* ("Antrometa [*sic*], quando fu liberata da un tal Cavaliero"); *Joseph and Potiphar's Wife* ("the story of Joseph whom Potiphar's wife was trying to seduce [*istoria di Gioseffo che la moglie di buttifar li fa forza*]").[100] Women play key roles in four of these five paintings, their subjects conceivably selected by Gentileschi herself. Otherwise, it seems impossible to integrate their themes into current theories of the feminist orientation of Artemisia Gentileschi's art.

This case can draw some support, however, from those moments in Artemisia's production in which the artist appears to speak of a sisterhood of all women and to impute to all women strength of body and spirit—not through the mere choice of subject matter but through how the women look, act, and interact. In her representations of Judith, Gentileschi closes the traditional age gap between the heroine and her maidservant; the former is not the usual young beauty and the latter is not the almost canonical old hag. In spite of differences in social status, revealed through costuming and physiognomy, the two women appear united in action and mind. Of the same size, their bodies overlapping, Judith and Abra turn as one toward the source of imagined danger, Judith touching her companion's shoulder (Fig. 31; Color Plate IV), a gesture of affection and caution and a sign that understanding has passed between them. Abra, her head at the apex of the composition and her body bearing down upon Holofernes, disdains her conventional assignment as bystander to become a full, courageous participant in the ghastly but necessary business (Figs. 21, 77–79; Color Plates II, XII). All of this and much more has been observed by Garrard, for whom, too, the two women reverse roles in the Uffizi *Judith* and even more in the canvas in Detroit (Fig. 84; Color Plate XIII).[101] With full justification other scholars[102] as well have been moved by this undeniable emphasis upon female solidarity in the face of a common danger. The strength of the bond

has inspired suggestions that the painting may hold within it Artemisia's own yearning for female companionship and support, particularly following her betrayal by Tuzia, Agostino Tassi's facilitator in the plot to dishonor the young woman,[103] the young woman who now found in the examples of Judith and Abra "a liberating courage."[104]

In assessing the contribution of personal imperatives to the selection of the theme of Judith and/or to the interpretive dimensions of the pictures, one must consider other potential reasons for the appearance of this subject matter in Artemisia's oeuvre[105] and the extent to which her imagery is unprecedented. Thus it may be possible to view Gentileschi's *Judith*s as part of a wider movement at the time to redefine the relationship between Judith and her maidservant. Federico della Valle's *Iudit* drama of 1627 has been cited as indicating an attitudinal change.[106] Furthermore, many of the salient aspects of Artemisia's renditions—the more mature Judith, the more youthful Abra, the physical proximity of the two women, the feeling of joint psychic involvement, and even certain compositional solutions and details of dress—were already there for creative adaptation in the *Judith*s of Orazio Gentileschi (Figs. 33, 39, 40).[107] Earlier, in an invention by Andrea Mantegna (shown here [Fig. 36] in an engraving by Girolamo Mocetto of ca. 1500–1505),[108] Judith and Abra huddle together, two of their feet seeming to touch, to participate jointly in the act of bagging Holofernes' head.[109] As with half-closed eyes they concentrate on the task at hand the two women also appear to contemplate the implications of what they have done in God's name—in all a serious, unsexy, and uncaricatured interpretation, worthy to have left its mark (if indeed it did) on the canvases of the Gentileschi. Even more radical in the face of tradition, and dating from the same moment as the pictures by Orazio and Artemisia, is the nocturnal *Judith and Her Maidservant* painted by Jacopo Palma il Giovane and etched by Giacomo Franco (Fig. 37).[110] The two women are virtually mirror images of each other—muscular, young, their faces and hairdos almost interchangeable, their garments of similar style, their bodies leaning in and arms extended to the center of the etched plate as they hover above the blood-gushing body to place the severed head in the sack. Since, also, it is Abra alone who with full breasts and bare back even intimates sexuality, one must locate the sword in order securely to distinguish Judith from her companion. Solidarity could hardly assume more obvious form.

Along with the early *Susanna* and the *Judith*s, Artemisia's first representation of Lucretia (Figs. 18–19; Color Plate III) has figured prominently in discussions of her female reworkings of time-honored themes and feminist challenges to deep-rooted male presumptions. The anxiety on the young woman's face as she confronts an agonizing decision, the dagger not yet directed toward her bosom, is evidence for the proposals that Gentileschi thought deeply about what rape meant—psychologically, biologically, and socially—to a woman who had suffered it.[111] Once again, however, and as is to be expected of any artist interpreting any familiar subject, the painting is not without its antecedents. In Marcantonio Raimondi's engraved *Lucretia* after Raphael of ca. 1510–11 the Roman matron (fully clothed but for the breast that is to receive the stab wound) throws out her left arm as she turns her head from the weapon in her right hand, seem-

ingly transfixed by inner conflict.[112] Here is an image of impressive nobility and moral weight. Thoughtfulness and tension also characterize the *Lucretia* engraved about 1510 by Jacopo Francia, like the Raimondi based upon an ancient Roman statue then thought to represent Lucretia.[113]

The tradition established by these works finds an echo in the *Lucretia* of the Palazzo Reale at Naples (Fig. 216). While recognizing the differences between this sophisticated picture and the Genoa *Lucretia*, Garrard assigns the former to Artemisia Gentileschi as well, holding that the interpretation of the theme points to Artemisia and away from any male artist.[114] Yet majority opinion, with which I concur, favors an attribution of the Naples *Lucretia* to Massimo Stanzione or a *Stanzionesco*.[115]

The spiritual states of Artemisia's Susanna, Lucretia, and Judiths carry conviction by the physical "thereness," the realism of substance and detail, which the figures exhibit, and it has been implied that both owe much to Gentileschi's "gender identification" with her characters.[116] In response to this sentiment, Gash has written: "Naturalistic styles like Caravaggism . . . are especially likely to confuse gender traces by their commitment to the visually true and psychologically plausible. . . . A sympathetic naturalism militates against stereotypical thought, as well as execution."[117] Surely it is significant that while Artemisia was in Florence, and thus no longer in the birthplace and showcase of the Caravaggesque movement, her art lost some of its plainspoken edge, only to find it again upon the artist's return to Rome in 1620. With notable exceptions it is also true that the longer Gentileschi was away from her Caravaggesque beginnings, and the older, more worldly-wise, and more technically proficient she became, the less robust and psychologically forthright her pictures became.[118]

This is not to say that interior and exterior truthfulness were automatically assured by Artemisia Gentileschi's training in Caravaggism. Provided with this orientation, Gentileschi then tapped her ability keenly to relate to her characters, and the Caravaggesque style in turn provided the vocabulary with which to give her perceptions visual form. Were these the kinds of perceptions which only she, the woman Artemisia Gentileschi, could have? Clearly she would have found female characters—more often than not selected for her by patrons—to be particularly accessible, and some of her own experiences were relevant to those of her characters. Yet empathy, I hope, is not the province of women alone.

As I interpret the evidence, Artemisia Gentileschi was endowed with special gifts of insight and artistic skill and, choosing thoughtfully from among the interpretive options available to her and adopting a naturalistic style, she produced an art that makes penetrating observations about humankind by way of women of monumental stature and independent mind. This dedication to speaking truth might be called a mission, but it is not a mission restricted to women or driven perforce by a proto-feminist ideology.

Were there also more particular psychological factors which influenced the interpretive directions taken by some of Gentileschi's pictures? Scholars, emboldened by the knowledge that in 1611, while still a teenager, Artemisia had been raped, have found this a fertile area for speculation, sometimes without sufficiently pondering the fact, as Silvers

puts it,[119] that "Artemisia's rape is relevant to her history just in virtue of its having happened to her, but it is relevant to her art only through the additional demonstration that it is manifest in her paintings." At one extreme of the issue stands Hersey: "It is largely because of a youthful psychic wound that her pictures so often meditate on sex, victimization, and sanguinary death. In this they are unusual, perhaps unique, for they are personal protests couched in the language and trappings of public art. . . . The personal tragedies of other artists have conditioned their work but their art is not usually seen as a specific restaging of those tragedies."[120] Although with less punch, convictions that Gentileschi's career was shaped by her rape, that this experience provides the key to understanding her art, and that it led her to themes of women threatened by men or of men vanquished by women have been voiced by many writers.[121]

As noted above, reverberations from Tassi's attack on Artemisia have been detected in the *Lucretia* (Figs. 18–19; Color Plate III). Even the *Susanna* (Fig. 10; Color Plate I) of 1610 has been brought to bear on the question, in this case on the suspicion that the reaction of the young girl to the lascivious elders registers Gentileschi's own victimization by sexual harassment some time before the ultimate violation of rape.[122] But for obvious reasons the *Judith Decapitating Holofernes* (Figs. 77–79; Color Plate XII) in Florence has been the focus of such hypotheses, the ferocious assault on Holofernes thought to externalize Artemisia's need to revenge her brutal treatment by Agostino and, more, by all men.[123]

The deflowering and its legal aftermath made Artemisia a public figure deprived of some of the "virtues" which women were supposed to have, and thus left her freer than she might otherwise have been to develop an art unfettered by traditional expectations.[124] What is also evident is that fixation with the rape and certainty that it was decisive for Gentileschi's art have given rise to such curious terminology as "reverse rapes" (with reference to those images in which "women turn sanguinary violence against males"), "ceremonial rape" (Artemisia's *Bathsheba*s), and "ocular rape" (Actaeon spying on Diana).[125] Garrard, properly warning against sensationalism and facile, oversimplified associations, pleads for a multidimensional reading of the situation.[126] On one level, she believes, the violence of the *Judith* may reflect the rape, which Artemisia described to the magistrate in vivid detail, and signify imagined retaliation against Tassi (whom in actuality she had slightly wounded during and just after the attack). Garrard then extends the notion of revenge to a private one "against the patriarchal world that had imposed upon her the need to dissemble and to trick," and sees it as well as an emotional catharsis for the painter. In the midst of this reasoning she makes the following points: "It is essential that we recognize the positive and healthy elements of the artist's identification with her character. . . . For it is not so much the male character who is acted upon, but the female character who acts, that is of interest to Artemisia, and who offers her an avenue for psychic self-expansion. Through the central character of the Uffizi *Judith and Holofernes*, Artemisia was able not simply to carry out psychic vengeance against her sexual oppressor, but also to justify rebellious, anti-social instincts—which she understandably may have held—through the celebration of the *legitimate* aggressive deeds of the . . . avenger of the Jewish people."

In assessing these various proposals, one would do well to recall the extreme complexity of the problem: "After all, to study Judith is not only to stray across disciplinary lines but also to address the conjunction of nothing less than our central conceptual dualities: woman-man, virtue-vice, art-artifice, appearance-reality, life-death."[127] Moreover, two writers who are devoted to psychoanalytical explication of works of art concede that there are not enough facts to permit informed conjecture concerning the impact upon Artemisia Gentileschi of the circumstances of her early life and thus not enough evidence to make a fully satisfactory psychoanalytical case for the connections between her known traumatic experiences and her paintings.[128] The insistence in much of the literature upon the rape as critical to interpretation of Gentileschi's art has drawn fire from Lippincott, who not only faults it on scholarly grounds but considers it offensive to women, for it "perpetuates the myth that a woman is completely 'undone' by rape."[129]

Alternative or at least additional reasons for the existence and the emotionalism of the Uffizi *Judith* can be identified.[130] Most are located outside of Artemisia's psyche, some within. The lives and legends of exemplary individuals, many of them (including Judith and Holofernes, David and Goliath, and innumerable martyr-saints) involving extremes of violence, enjoyed immense popularity during the Baroque period.[131] The craving for pictorializations of such themes was insatiable, and in Rome alone representations of Judith and her maidservant (e.g., from Orazio Gentileschi, Angelo Caroselli, Carlo Saraceni, Simon Vouet, Antiveduto Gramatica; Figs. 33, 39, 40, 85, 219, 221) and Judith decapitating Holofernes (e.g., from Caravaggio, Rubens, Adam Elsheimer, Valentin; Figs. 25, 26, 38) are numerous.[132] Apparently, too, the very idea of a female of exceptional strength and daring appealed to a seventeenth-century taste for the marvelous.[133] An important unpublished study devoted specifically to Artemisia's *Judith*s has shown that the Apocryphal Book of Judith occasioned a striking number of exegeses, poems, plays, and operas in the Italy of Gentileschi's lifetime, and concludes that "the dispassionate bluntness" of Artemisia's interpretations is "directly related to the Church's position on the meaning and the contemporary applications of the Book of Judith" and that "in certain ways her paintings are closer to the officially sanctioned view of Judith than are those of any other painter of the time."[134] Judith was associated with the Virgin Mary and the Church, and her encounter with Holofernes was invoked in the Catholic battle against religious heresy.[135]

To this I would add suggestions put forward earlier in the present text to the effect that the special ferocity and virtuosic fireworks that characterize the Uffizi *Judith* may say something about a need on Artemisia's part to demonstrate the unjustness of the conventional view of women artists' capabilities, and that as a businesswoman Gentileschi capitalized on her technical prowess and her sex.[136]

I would therefore offer for consideration the following hypothetical re-creation of the genesis and development of Artemisia Gentileschi's *Judith Decapitating Holofernes*, proposing a sequence that in my opinion best respects the historical situation and the facts as we know them. Serving the official position of the Catholic Church and satisfying various tastes of the period, the story of Judith's triumph over Holofernes gained

special currency in Early Baroque Italy. Commissions to artists followed, with works of art then reinforcing the popularity of the theme. Artemisia's canvas was ordered by Cosimo I de'Medici, who knew what Gentileschi could do with themes of women and who had political as well as Catholic propagandistic reasons to acquire such a picture. For Gentileschi the opportunity to place another painting with the Grand Duke of Tuscany was also a chance to exploit and advertise her talents at the most mature stage they had yet reached. The very act of executing a large-scale work dedicated to a female hero of the past must have been liberating to Artemisia. And as she mused upon the subject and turned back to her first rendition of it (Fig. 21; Color Plate II), she may have been gripped once more by memories of her battle with Agostino Tassi; recollection of this experience could have helped her retain the unique intensity of her interpretation. These latter, more deeply personal elements, I propose, are likely to have informed the work only after the other considerations came into play. The ideas that Gentileschi's presumed hatred of Tassi, of all men, and of patriarchal society are sublimated here and that the canvas proclaims a feminist message are highly debatable; that the picture owes its very being and character to these supposed hostilities and/or to this presumed ideological bent is unacceptable. The reader will then judge the extent to which this understanding of how Artemisia's *Judith* came to be is useful to examinations of other paintings by her.

Gentileschi criticism is not done yet, however, with the *Judith Decapitating Holofernes* or with that other featured image, the Pommersfelden *Susanna* (Fig. 10; Color Plate I). It is in the nature and training of most art historians not to be content with granting the straightforward to the seemingly straightforward. I must admit, nonetheless, to sharing the skepticism of others with regard to Freudian interpretation, in part because of questions about the validity of Freudian theory itself and in part because such analysis sometimes loses sight of the particular circumstances under which the art was produced, assuming an unconscious origin for features for which historical explanations and artistic prototypes might more credibly be advanced.[137]

Those psychoanalytical readings of the *Susanna* and the Uffizi *Judith* which have not yet been reviewed here dramatize these issues. For the *Susanna*, they begin by ignoring the argument that Orazio Gentileschi may have played a significant role in the very conception of the picture. Slap then offers an alternative proposal to that put forward by Garrard in accounting for the presumed differences between the interpretive dimension of the Pommersfelden *Susanna* and those of paintings of the theme by male artists.[138] He hypothesizes that the story of Susanna had been perpetuated "because it embodies some primal phantasy of universal interest. Analogous to the Oedipus story, it may deal with a young girl's incestuous yearning for her father, her wish to display her pretty body and win him from her mother." Could it be, it is then asked, that Artemisia Gentileschi treated the Susanna and the elders incident "as a vividly realistic assault, a reflection of what she was experiencing at the time," that is to say "the oedipal girl's struggle against yearnings for her father"? By this reasoning Artemisia's desires and the conflict caused by them must have persisted long after the source of hostility had been removed. The *Susanna* was painted in 1610. Artemisia's mother had died on December 26, 1605.

While we are on the subject of the *Susanna* and family ties, Berti's speculations should be scrutinized. Holding that the physiognomy of the older voyeur resembles that of Orazio Gentileschi (as recorded in Van Dyck's portrait drawing) and suggesting that the other elder may be Agostino Tassi, Berti envisions an Artemisia-Agostino-Orazio triangle of fornication and incest. In 1610, Artemisia's father was age forty-seven, younger by some years than the elder in question and, unlike the latter, still had a full head of hair at about the age of seventy, when Van Dyck portrayed him. I see no significant resemblance, then. Neither Berti nor I am aware of any likeness of Tassi; Berti's case is not helped by his citation of a description of Agostino from 1611 as being "very little, very fat, and with a scanty beard (*piccolotto, grassotto et di poca barba*)," features which are not indicated on the canvas. It is true that on April 12, 1612, during one of his interrogations, Tassi testified that Artemisia had told him that her father "wishes to use me exactly as if I were his wife (*lui vuole usar meco a punto come se li fosse moglie*)."[139] In the court record this tidbit follows Agostino's claim that he had admonished Artemisia for lascivious behavior, which he says had resulted in syphilis, and precedes Tassi's contention that he had reproached Artemisia for telling such a lie about such an honest man. Managing to impugn both daughter and father in a single paragraph, all the while playing the moralist and feigning disbelief, Tassi is, as usual, so obviously self-serving as to be totally untrustworthy.

It has been written in summary of a Freudian notion that "for a boy the castration complex resolves the Oedipus complex (under the threat of castration, he ceases to desire his mother), [whereas] for the girl it initiates the Oedipus complex by paving the way for the transferral of her affections from mother to father (seeing the mother's inferiority and blaming her for her own lack, she achieves a heterosexual love object)."[140] Although unintentionally, the reference here to the Oedipal complex recalls Slap's proposal concerning the *Susanna*, while that to castration relates to interpretations of the *Judith Decapitating Holofernes*, which like the picture itself are more dramatic still.

It is not at all surprising, given the literature devoted alone to Donatello and Caravaggio,[141] that Freud's well-known equation of decapitation and castration has been enlisted in psychoanalytical connection to Artemisia's picture. To Kleinschmidt's perception, "the powerful, heavy arms of Holofernes resemble thighs, and his head, partly covered by hair and foreshortened, could well be mistaken for the genital area at first glance. The impression is unavoidable that the iconographic ambiguity—this, so to say, incomplete displacement of the action from below to above—is intentional: this is a scene depicting castration."[142] Jacobus recalls Freud's idea of penis envy, whereby a woman "acknowledges the fact of her castration, and with it, too, the superiority of the male and her own inferiority; but she rebels against this unwelcome state of affairs."[143] If one is looking for a representation of Judith in which allusion to castration is more than a construct involving unconscious displacement, one need look no further than Felice Ficherelli's *Judith and Holofernes* in a private collection at Florence.[144] Here the heroine, one breast bare, reaches out to grasp the hair of Holofernes, who twists about on the

bed. The point of the sword held in her other arm is dangerously close to Holofernes' crotch, where beneath a flap of drapery, front row—center, there is an erection.

For Pointon the *Judith* in all probability gives expression to Artemisia Gentileschi's "deep fears and apprehensions" by way of allusions to the "raw and physical brutality of parturition," the viewer witnessing then "the shocking conjunction of birth and death."[145] Citing a study by Joseph Slap, who in Pointon's words "observed that in analysis a woman may experience the delivery of a child as a castration and that this is associated with fantasies of revenge against a man or men,"[146] and apparently remembering Klein-schmidt's remarks, she describes the imagery in the following vivid terms: "Apart from one section of his left knee at the top of the canvas, all we see of the body of Holofernes are his brightly lit arms split into a 'V.' Between this shape, which is characteristic of the 'V' formed by the open thighs of a woman at the point of giving birth, we see the wrinkled brown face of Holofernes, with its agonized mouth, in a grizzled mass of beard-like pubic hair. Judith attends to the 'delivery' of the head while her maid appropriately exerts pressure on the abdomen. Their positions in relation to the body of Holofernes are precisely those of midwife and assistant."[147] And so, this argument continues, "Artemisia creates the image of Judith's vengeance through the sexuality that she had used to achieve her end," as "the punishment of Holofernes is conveyed through [a] dramatic and sadistic inversion of the natural order."[148]

Slap finds the allusion to childbirth "inescapable," holding that "the nurse's posture and action in pressing down on the 'abdomen' do not seem to be susceptible of any other explanation."[149] And why, psychologically? "Perhaps impressions arising from her mother's experiences contributed to a belief that childbirth was a horrible, bloody and dangerous consequence of acts men did to women and should be avenged."[150] Taylor, labeling Pointon's interpretation "extremely convincing," adds that "the anterior folds of Holofernes' neck resemble a woman's labia."[151] Referencing neither Pointon nor Slap, Jacobus too envisions midwives at a childbirth.[152]

As it happens, and unknown to these investigators, Artemisia herself had given birth to at least four children by the time the Uffizi *Judith Decapitating Holofernes* was executed. Yet since the original conception, the painting in Naples (Fig. 21; Color Plate II), almost certainly predates the first of these births, this particular biographical fact is irrelevant. And the theory that Artemisia's canvas alludes to childbirth is, I think, groundless. It seems to assume that Gentileschi at least subconsciously viewed the bringing of a child into the world as without redeeming value, horrid and joyless. Secondly, it grossly misreads the visual evidence. Holofernes' arms are not spread in a "V"; they run parallel to each other and perpendicular to the shoulders. His *right* knee is most prominent, the left barely showing at the left edge (but cf. Fig. 75). Thus Abra's hands are nowhere near the Persian general's abdomen; rather, they both grasp his left forearm, restraining it, pushing it toward his *chest*. As Judith pulls the sword through Holofernes' neck, she knees him in the side, a section of her brocaded dress passing behind the free arm. Compositionally all of this is somewhat jumbled, but there is no ambiguity as to the action intended.[153]

With Artemisia's *Judith and Her Maidservant* from about 1645–50 at Naples (Fig. 192), a way has been found to incorporate the childbirth *and* the castration theories. Pointing to the plumed helmet and what he labels a cuisse (or the thigh-piece of a suit of armor) on the table at the left, and maintaining that Judith and Abra focus upon these objects, Slap writes: "If one accepts the premise of a childbirth scene, then the objects on the table may represent the valued products of this event; if a castration, then these objects represent the genitals of the murdered general. And, it may be argued, the round helmet by virtue of its shape is symbolic of a scrotum and the plumage is symbolic of pubic hair; the cuisse would then represent a phallus. The head of Holofernes is treated like an afterbirth, something ugly and uninteresting, something to be disposed of."[154] There is no acknowledgment that the disposal of Holofernes' head in a sack and the presence of parts of his armor, including the helmet, are frequent in the history of *Judith* representations. Judith and Abra are concerned with danger from without the tent, not with the armor. Furthermore, the so-called cuisse is actually the much smaller gauntlet, and has nothing to do therefore with the area between the legs. The helmet in Artemisia's painting is that which had protected the head that has now been separated from the body, the gauntlet that which was worn by the once-grasping hand. Holofernes had removed both in preparation, he thought, for lovemaking. With clear and present meaning, these objects are as eloquent as one could ever hope. Sometimes a glove is only a glove.

Artemisia, Attitude, and Attribution

A dominating principle of Mary Garrard's monograph on Artemisia Gentileschi is that art produced by women, like the female experience itself, must necessarily be different from that produced by men. Concentrating upon the expressive/interpretive character of Artemisia's pictures and detecting there an evident female perspective, Garrard judges that this may be "as valid as connoisseurship of style" when dealing with questions of attribution.[155] I have argued that there are fewer "gender-distinct" signs than have been claimed and more cases where Gentileschi's art does not meet current expectations. Principles derived from readings of the visual evidence easily turn into potentially distorting presuppositions. Thus one encounters situations—e.g., the three large canvases for Parma (Figs. 188–90, 192)—when attributions to Artemisia are considered suspect because the paintings fail to live up to assumptions. Other works believed to embody Artemisia's thought processes have been assigned to her without sufficient recognition of those stylistic (and even expressive) features which point to other artists. These include the Princeton *Madonna and Child*, the Genoa *Cleopatra*, the St. Louis *Danaë*, the Fogg *Joseph and Potiphar's Wife*, and the Naples *Lucretia* (Figs. 218, 211, 210, 214, 216)—in my opinion not by Artemisia but rather by three different male painters, the first three by Orazio Gentileschi and the others by Paolo Finoglio and Massimo Stanzione or a fol-

lower, respectively. And the example of the newly discovered *Corisca and the Satyr* (Fig. 131; Color Plate XVII) warns against imposing feminist meaning upon autograph pictures by Artemisia Gentileschi that will emerge in the future. No line of inquiry is to be rejected, for each may be illuminating; none must be so favored as to threaten to obscure.

Imagine if Michelangelo da Caravaggio had worked exclusively for Cardinal Francesco Maria del Monte and the Marchese Vincenzo Giustiniani and had never produced the *Calling of Saint Matthew*, the *Madonna di Loreto*, or the *Burial of Saint Lucy*. Or if, with a field of activity limited to the Villa Borghese, Gianlorenzo Bernini had not expanded into the crossing of Saint Peter's, the Cornaro Chapel, the Ponte Sant'Angelo. With bigger spaces and more critics to contend with, and larger audiences and diverse constituencies to stir and persuade, Caravaggio and Bernini drove themselves to their greatest triumphs. Artemisia Gentileschi could boast patronage as distinguished as any of the time; as a result of the quality of her art, her acumen, and the novelty of her position as a gifted female painter of portraits and histories, she placed her pictures with an empress, kings and queens, grand dukes and a grand duchess, dukes and princes, viceroys, cardinals and a bishop, and monied men of varied interests. Yet with as few as three exceptions from an extant production of more than fifty works, her paintings were designed for consumption by a highly restricted, private audience. Artemisia found herself in a relatively circumscribed arena in which to maneuver thematically and expressively. She became a specialist, fifty-eight percent of her known pictures, exclusive of portraits, being variants upon only seven subjects, almost half of them presenting the female nude.

Still, although responsive to imposed, and to some extent self-imposed, limitations, Artemisia Gentileschi's art variously serves devotion, secular propaganda, and other patronage strategies; extols the artist and her profession; restores to women spirit of body and mind and thereby the dignity that men had thought to deny them; terrifies, amazes, stirs, commands, delights, or dazzles; puts one in a reflective frame of mind, engages the imagination, or stimulates erotic thoughts; shames out of existence the fiction that women artists are incapable of competing with their male counterparts; and provides immense pleasure to anyone who loves painting.

For all of Artemisia's innate talent and her training in the elevated technical standards of her father, such accomplishments were not realized without great effort. Traditional prejudices against women and women artists had to be challenged, the rape and the humiliation of the trial surmounted, the barriers of access to professional organizations confronted. Early in her career, when the struggle to establish a competitive position would have been especially demanding, she had to suffer a husband who went through the dowry and summon strength through (who knows how many) successive pregnancies and at least four childbirths. Subsequently, the responsibility of raising two daughters and providing for their marriages fell solely to Artemisia, whose art was the only source of family income.

These and other facts of Gentileschi's biography provide clues as to what it was that gave her the toughness to face up to the establishment, emboldened her to play the

patronage game with the best of them, kept her sane, and aided her in conceiving resolute female characters and sustaining the intensity of their stories of triumphs and trials. They also help to account for what she did and did not paint and suggest links between her financial situation and the expressive and stylistic changes which her art underwent.

Yet, ironically, the current keen interest in Artemisia as a *woman* painter and in the particulars of her life, and in how these circumstances might have impelled her work, threatens to situate the artist outside the mainstream of the Italian Baroque. The arguments that would differentiate Gentileschi's canvases from the paintings of her male contemporaries are obviously not now the same as those which in past centuries contributed to the artist's neglect. But they tend nevertheless to confer isolated status upon her. And to shift the focus away from the creative act. The riveting force of the Detroit *Judith and Her Maidservant* (Figs. 83–84; Color Plate XIII) emanates preeminently from the drama of abstract shadows against intense light, from the contest of competing curves, from the potency of rich color and stark white, from passages of prodigious verisimilitude, from forms so monumental as to overwhelm the space assigned to them. To be mesmerized by this picture is to conclude that the calling which Artemisia Gentileschi accepted above all others was that of proclaiming the power of art.

APPENDIXES

APPENDIX I

Register of Documents Concerning Artemisia Gentileschi's Life and Work

In conformity with the pattern established in the text and Catalogue, frequently cited literature is noted with the author's name and date of publication only. Complete references appear in the Bibliography. Manuscript references, however, are here given in full, with the exception of the following abbreviations:

AD Accademia del Disegno, Florence
AOD Archivio dell'Opera del Duomo, Florence
AS Archivio di Stato
AV Archivio del Vicariato, Rome
PRO Public Record Office, London

...

1593

July 8 Artemisia Gentileschi is born in Rome, as the record of her baptism on July 10 attests (following entry).

July 10 Baptized in the Roman church of S. Lorenzo in Lucina, the daughter of Orazio Gentileschi and Prudentia Montoni residing on Via Ripetta near S. Giacomo degli Incurabili: "Artemisia filia d. Horatii Gentileschi florentini, ed d. Prudentia Montone Romanae eius uxoris degens in nra Par.ª ad Ripettam prope d. Jacobi Incurabilium nata die 8 Huius baptizata fuit a me Juvenale Prisco de Monte Bono dioc. Sabinen, et suscepta ad. Offredo de Offredis Cremon et ad. Artemisia Capizachia Ro." (Rome, AV, *Liber Baptizatorum: 1590–1603*, S. Lorenzo

in Lucina, VII, fol. 78, no. 157; Bissell, 1968, p. 153). In a document of September 16, 1599 (below), Artemisia's mother is more fully identified as Prudentia di Ottaviano Montoni. Drawing upon the biographical source-books of Gaetano Moroni and Teodoro Amayden, which no other scholar had thought to consult in these matters, Lapierre (1998, pp. 47, 428) has shown that the Cremonese Offredo de Offredis had served as papal nuncio to Florence and Venice and that Artemisia Capizacchia (or rather Capizucchi) was a member of the Roman nobility.

1594

December 6 Baptism of a brother, Giovanni Battista, in the parish of S. Maria del Popolo (Rome, AV, *Liber Tertius Baptizatorum: 1584–1595*, S. Maria del Popolo, fol. 128).

1595–1596

The continued residence of the Gentileschi in Rome during these years is affirmed by documents referring to paintings undertaken by Orazio in that city (Bissell, 1981, pp. 99–100).

1597

June 11 Baptism of a brother, Francesco. Living in Platea SS. Trinità, parish of S. Lorenzo in Lucina (Rome, AV, *Liber Baptizatorum: 1590–1603*, S. Lorenzo in Lucina, VII, fol. 167v, no. 154).

1598

January 26–December 29 Series of documents regarding Orazio Gentileschi's paintings in the Abbazia di Santa Maria at Farfa (Bissell, 1981, pp. 100, 135–37 cat. 4). While Orazio may have spent extended periods at Farfa, there is no indication that the Gentileschi discontinued residence in Rome.

1599

September 16 Baptism of a brother, Giulio (born September 6); living on Via Paolina (Rome, AV, *Liber IV Baptizatorum: 1595–1619*, S. Maria del Popolo, fol. 52v; G. Hoogewerff, "Nederlandsche Kunstenaars te Rome, 1600–1725. Uittreksels uit de parochiale Archieven: 1, Parochie van Santa Maria del Popolo," *Mededellingen van het Nederlandsch Historisch Instituut te Rome*, VII, 2d series [1938], 112).

1601

After March 26 Living on Via Paolina toward Via Margutta (Rome, AV, *Status Animarum*, S. Maria del Popolo, LXIII, 1601, fol. 25).

September 24 Death of her brother Giovanni Battista (Rome, AV, *Libro de'Morti IV: 1595–1620*, S. Maria del Popolo, LI, fol. 96v; and above, December 6, 1594).

October 13 Baptism of a brother, Giovanni Battista, the second to bear this name (see above, December 6, 1594, and September 24, 1601); living on Via Paolina (Rome, AV, *Liber IV Baptizatorum: 1595–1619*, S. Maria del Popolo, fol. 80v).

1602

Between February 28 and March 14 Living on Via Paolina toward Via Margutta (Rome, AV, *Status Animarum*, S. Maria del Popolo, LXIII, 1602, fol. 15).

1603

February 2 Death of her brother Giovanni Battista, the second to bear this name (see above, October 13, 1601) (Rome, AV, *Libro de'Morti IV: 1595–1620*, S. Maria del Popolo, LI, fol. 114).

Between February 27 and March 4 Living on Via Paolina toward Via Margutta

(Rome, AV, *Status Animarum*, S. Maria del Popolo, LXIII, 1603, fol. 67v).

1604

March 17 Living on Via Paolina toward Via Margutta (Rome, AV, *Status Animarum*, S. Maria del Popolo, LXIII, 1604, fol. 129).

1605

March 17 Living on Via Paolina toward the Corso with her father and mother, and her brothers Francesco, Giulio, and Marco, the latter age one (Rome, AV, *Status Animarum*, S. Maria del Popolo, LXIV, 1605, fol. 15v).

June 12 Confirmation day for the eleven-year-old Artemisia in S. Giovanni in Laterano (Lapierre, 1998, p. 428, as from Rome, AV, *Cresime III: 1601–1608*).

December 26 Death of Artemisia's mother Prudentia, age thirty, in childbirth, with burial in S. Maria del Popolo (Rome, AV, *Libro de'Morti IV: 1595–1620*, S. Maria del Popolo, LI, fol. 140). For the transcription of the document, see Lapierre, 1998, p. 427.

1606

February 23 Living on Via Paolina toward Via Margutta (Rome, AV, *Status Animarum*, S. Maria del Popolo, LXIV, 1606, fol. 17).

1607

March 1 Living on Via Paolina toward Via Margutta (Rome, AV, *Status Animarum*, S. Maria del Popolo, LXIV, 1607, fol. 13).

1608–1609

The census records of the parish of S. Maria del Popolo for the years 1608 and 1609 are lost, but that of 1610 (following entry) and documents relating to Orazio Gentileschi (Bissell, 1981, pp. 101–2) suggest the contin-

ued presence of Artemisia in Rome during these years.

1610

March 20 Living on Via Paolina toward Via Margutta (Rome, AV, *Status Animarum*, S. Maria del Popolo, LXIV, 1610, fol. 39).

Unspecified Artemisia's earliest dated painting, the *Susanna and the Elders* at Pommersfelden (Figs. 10, 15; Color Plate I; and [2]).

1611

February 16 Living on Via Margutta (Rome, AV, *Status Animarum*, S. Maria del Popolo, LXIV, 1611, fol. 33).

April 10–July 16 Period of residence on Via della Croce, according to testimony presented at the trial of Agostino Tassi (Menzio, 1981, p. 57; Garrard, 1989, pp. 419–20; also below, March–October, 1612).

May 6 Raped by Agostino Tassi (see below, March–October, 1612).

Mid-July Another change in residence, this time to Borgo Sto. Spirito in Sassia, according to testimony presented at the trial of Agostino Tassi (Menzio, 1981, pp. 55–57; Garrard, 1989, pp. 419–20; and March–October, 1612).

October Artemisia is designated godmother to the son of the Spaniard Pietro Hernandes (Pedro Hernández), according to testimony presented during perjury proceedings against witnesses at the Tassi trial (Garrard, 1989, p. 485; and next entry).

1612

March–October In February or early March 1612, Orazio Gentileschi addressed a petition to Pope Paul V in which he accused his supposed friend and sometime collaborator

Agostino Tassi of having raped Artemisia in the spring of the previous year (specifically on May 6, 1611, according to my calculations from other evidence) and having subsequently known her carnally on numerous occasions. With this was initiated a trial, or more precisely a series of formal interrogations conducted at various venues (private homes, Tor di Nona prison, Corte Savella prison, office of the Curia, notary's office), beginning with the deposition of Gentileschi's tenant Tuzia on March 2 and ending on October 29, 1612, to be followed by preliminary sentencing of Tassi on November 27 and definitive sentencing on November 28 (see those dates below). Preserved in the Archivio di Stato at Rome under the title "Stupri et Lenocinij—Pro Curia et fisco Con^e Augustinum Tassum Pictorem" (Archivio del Tribunale Criminale del Governatore di Roma, busta 104, anno 1612, fols. 270–448), the trial records were first brought to the attention of scholars in 1876 by A. Bertolotti, who transcribed small portions of them. They consist of two parts: the first, prosecution and defense, involving the principals and their witnesses and ending July 5; the second, perjury proceedings, from July 27 intermittently until October 29, instituted by Orazio against Tassi's deponents. To this collected material can now be added five folios, filed elsewhere in the Archivio di Stato and discovered independently by Anna Modigliani and the author (Tribunale di Governatore di Roma, Miscellanea Artisti, secolo XVII, busta 2, fascs. 108a, 108b, 108c), containing dockets of witnesses and additional testimony, including by Orazio Borgianni on May 30 (transcribed by Gallo without citing Garrard and with the incorrect date of March 30). Bertolotti's article and/or the original document were mined more or less at random by various authors (including Longhi, Bissell, Wittkower, and Pugliatti) until the publication in 1981 by

Eva Menzio of transcriptions of essentially all of the material prior to the perjury proceedings. Then, using Italian translations by Anna Modigliani of the court officials' Latin, introducing the newly found supplement, and checking Menzio's transcriptions against the original, Efrem Calingaert rendered almost the entire prosecution-defense portion of the manuscript—or approximately half of the document—into English, while preparing synopses of all the material postdating June 8. In 1989, Calingaert's translation and synopses were edited, annotated, and published by Mary Garrard. In 1992 Christa Wachenfeld provided German translations of Menzio's transcriptions, to which she appended excerpts in German, based upon the original manuscript, of *portions* of the later testimony as summarized in Garrard. Most recently Lapierre has returned to the assembled folios, more fully transcribing some of the testimony and evaluating its import. References to the trial may be found throughout the text (especially Chapter 1) and Catalogue of the present study (Rome, AS, see above; Bertolotti, 1876, pp. 200–204 and passim; Menzio, 1981; Garrard, 1989, pp. 20–22, 205–7, 403–87; M. Gallo, "Orazio Borgianni, l'Accademia di S. Luca e l'Accademia degli Humoristi: documenti e nuove datazioni," *Storia dell'arte*, no. 76 [1992], 332–33; Wachenfeld, 1992, pp. 38–168; Lapierre, 1998, pp. 427, 431–32, 434–35, 437–38, 445–49).

March 18 Living on Borgo Sto. Spirito in Sassia near the hospital of that name, according to testimony presented at the trial of Agostino Tassi (Menzio, 1981, p. 45; Garrard, 1989, pp. 413–14; and the preceding entry). The existing *Stati d'Anime* of Sto. Spirito in Sassia do not begin until 1626.

May 14 During her testimony of this date at the trial of Agostino Tassi, Artemisia speaks of a portrait which she had painted

(probably in 1611) of a certain cleric named Artigenio, about whom more is said on June 8, 1612, by the witness Nicolò Felice da Pesaro (Menzio, 1981, p. 123; Garrard, 1989, p. 463; and [L-63]).

July 3 Letter from Orazio to the Dowager Grand Duchess of Tuscany, Maria Cristina, in Florence begging her aid in squelching attempts to secure Agostino Tassi's release from prison (see above, March–October, 1612), and offering to send her a painting by Artemisia (Tanfani-Centofanti, 1897, pp. 221–24, as from Florence, AS, *Mediceo*, fil. 2.LVI segn. di N. moderno 6003, 1612; also [5]).

November 27–28 Testimony in his trial for the rape of Artemisia having been concluded in the previous month, Agostino Tassi is sentenced provisionally by the court on November 27 and definitively on the next day. Agostino was still in Rome during the following spring, however, when the court revoked the sentence of November 28, 1612 (as well as a condemnation to exile dated April 8, 1613, rendered in another suit against him). (Lapierre, 1998, pp. 214–15, 456–57, as from Rome, AS Tribunale Criminale del Governatore, *Registrazioni d'Atti*, busta 166, fols. 101r, 103r, and busta 167, fols. 165v, 183r, 192r, 222v.). See my Chapter 1 for the text of the November 27 pronouncement.

November 29 Married in the church of Sto. Spirito in Sassia to Pietro Antonio di Vincenzo Stiattesi, a Florentine (Rome, AV, *Libro de'Matrimoni II: 1607–1630*, Sto. Spirito in Saxia, XVII, fol. 17). Her husband was to refer to himself as Pierantonio.

December 10 Pierantonio Stiattesi assigns power-of-attorney to his brother, the sometimes notary Giovanni Battista, entrusting him with his Roman affairs, including his contractual obligations to Orazio Gentileschi. This newly discovered document, suggesting as it does that Pierantonio was wrapping up business in Rome, confirms the suspicion that he and Artemisia were already preparing to leave the city for Florence. (Lapierre, 1998, pp. 444–45, as from Rome, AS, 30 Notai capitolini, *Officio 36*, vol. 24, 1612, fols. 646r and v.)

. .

1613

September 21 A son, Giovanni Battista, born to Artemisia (called Artimisia d'Oratio Gentileschi) on September 20, is baptized in the Florentine parish of S. Maria Novella, Lorenzo di Vincenzo Cavalcanti standing as godfather (Florence, AOD, Registro di Battesimo, *Maschi*, 1612–13 [September 1613], fol. 108v. This, the earliest notice of Artemisia's presence in Florence, was discovered by Cropper, 1993, p. 760, incl. n. 2).

. .

1614

November 24 Through January 23, 1616 (New Style) An itemization of charges and partial payments for artists' materials and household furnishings (including a cabinet with compartments and doors for the storage of drawings and colors) supplied in Florence to Artemisia by a joiner (Fig. 57). Listed as well are several stretchers for canvases, their sizes stipulated, and a walnut panel, also to serve for a painting (here identified as Fig. 56; Color Plate VI; [7]). To pressure Artemisia into paying the outstanding balance, the carpenter appealed to the Accademia del Disegno (Florence, AS, AD, *Atti e Sentenze*, LXV, fol. 877 by count; discovered independently by Bissell, 1968, p. 154, and Del Bravo, 1967, p. 82 n. 11, who gives September 24, 1614, and April 26, 1615, as the inclusive dates, as does Gregori, 1968, p. 419 n. 11. The document is discussed in some detail by Cropper, 1992, pp. 205–6, for whom November 14, 1614, is the date of the initial entry; also Cropper, 1993, p. 760, incl.

n. 4). See too below, December 6, 1617, and January 24, 1618.

...

1615

March 16 Letter from Florence dated March 16, 1614, Florentine Style, by Andrea Cioli, Secretary of State to Grand Duke Cosimo II of Tuscany, to Pietro Guicciardini, Cosimo's Ambassador to Rome, seeking information regarding the fame of Orazio Gentileschi and noting that Artemisia had already established a reputation in Florence (Orbaan, 1927, p. 284; Crinò, "More Letters," 1960, p. 264, as from Florence, AS, Mediceo 3508; Bissell, 1981, pp. 35, 80 n. 3, 87 n. 19).

July 10 In the Florentine parish of San Piero Maggiore Artemisia (now called Artimisia d'Oratio Lomi) stands as godmother at the baptism of a child named after her, a daughter born on July 9 to Annibale di Nicolo Caroti and Ottavia di Marcantonio Coralli. The painter Cristofano Allori is designated godfather (Florence, AOD, Registro di Battesimo, *Femmine*, 1614–15 [July 1615], fol. 3; Cropper, 1993, p. 760, incl. n. 7). Also below, November 9, 1615.

August 24 Advance of 10 florins from Michelangelo Buonarroti the Younger to Artemisia in connection with the ceiling canvas of *Inclination* (Fig. 64; Color Plate VIII; [8]) which she was executing for the Galleria in the Casa Buonarroti. (The various records of payment to Artemisia—see also 1615 and 1616 below—were cited and in part quoted by Sricchia, 1963, p. 266 n. 24, and subsequently transcribed in full by Procacci, 1967, pp. 12–13, and Vliegenthart, 1976, pp. 172–73, as from Archivio Buonarroti MS 101-4[A]. The document here in question appears on fol. 32.)

September 7 Note by Artemisia's husband to Michelangelo Buonarroti the Younger re-

spectfully requesting 4 or 5 ducats. Buonarroti is addressed as "godfather (*Signore Compare*)," and Stiattesi writes that his entreaty was occasioned by the "number of misfortunes that had befallen him (*quanti disastri io ho passato*)" (Procacci, 1967, p. 13; Vliegenthart, 1976, p. 171 n. 747, as from Archivio Buonarroti MS 103 fol. 69). For the wording and interpretation of this and the following three documents, see Appendix II. Stiattesi's request was immediately recorded and honored, as witness Buonarroti's entry of September 7 in his account book (Procacci, 1967, p. 13; Vliegenthart, 1976, p. 171 n. 747 and p. 172, as from Archivio Buonarroti, MS 103 fol. 69 and 101–4[A] fol. 32 respectively).

Between September 7 and November 13 Addressing him as *Signore Compare*, Artemisia requests of Michelangelo Buonarroti the Younger 21 lire (i.e., 3 florins), which she claims she will reimburse as she had her previous debts to him (Procacci, 1967, p. 13; Vliegenthart, 1976, pp. 171–72 n. 748 as from Archivio Buonarroti, MS 103, fol. 67).

November 9 A son, Cristofano, born to Artemisia on November 8 and named after his godfather, the painter Cristofano Allori, is baptized in the Florentine parish of Sant'Ambrogio (Florence, AOD, Registro di Battesimo, *Maschi*, 1614–15 [November 1615], fol. 74; Cropper, 1993, p. 760, incl. n. 6).

November 13 Payment to Artemisia of 3 florins from Michelangelo Buonarroti the Younger, pursuant to—his account book explains—a note (see two entries above) requesting same. This disbursement was received in bed by Gentileschi, who informed Buonarroti of her "great need" for the funds, "being in childbirth (*essendo in parte* [for which see the previous entry])." (Procacci, 1967, p. 13; Vliegenthart, 1976, p.

172 as from Archivio Buonarroti MS 101-4[A] fol. 32). Also Appendix II.

. .

1616

February 3, April 2, June 18, and August 20 Four payments totaling 16 florins to Artemisia, 2 of them stipulated as being in connection with her ceiling canvas for the Casa Buonarroti (also above, August 24, September 7, and November 13, 1615). The entry of August 20 notes that the painting had been delivered (Procacci, 1967, p. 13; Vliegenthart, 1976, pp. 172–73, as from Archivio Buonarroti MS 101-4[A] fols. 32, 36).

May 9 Through January 6, 1617 (New Style) An itemized account (Fig. 53) of charges totaling 32 scudi, 3 baiocchi for goods supplied to Artemisia by a druggist and not yet paid (Florence, AS, AD, *Atti e Sentenze*, LXIV, fol. 422 by recent numeration; Bissell, 1968, p. 154 n. 14; Cropper, 1992, pp. 206, 218 n., and 1993, p. 760, incl. n. 9, with however the final date as June, 1617). As with others among the Accademia del Disegno documents referring to Artemisia, this one serves best to dramatize the artist's indebtedness and to help establish her continued presence in Florence.

July 19 Two documents recording Artemisia's matriculation on this date into the Accademia del Disegno at Florence. The first: "Artimisia donna di Pagolantonio stitesi e figliuola di Oratio Lomi Pittora di contro de havere addi 19 di luglio 1616 y [lire] quatro recho il Cavaliere vasari p principio di sua matricola aent[a] E riconobbe per il padre [ac 54]" (Florence, AS, AD, *Debitori e creditori delle Matricole: 1596–1627*, LVII, fol. 152; Pevsner, 1932–34, p. 129; Bissell, 1968, p. 154 n. 14). The reference contained therein is to "152/ Da mad.[na] Artimisia di Oratio Lomi Pittrice y 4 p sua mat.[a] con il benef.[o] di Oratio suo Padre addi 19 di lug.[o] ———y 4———"

(Florence, AS, AD, *Entrata et Uscita: Entrata E dal 1602 al 1624*, CIII, fol. 54, located by the author, and by Pizzorusso, 1987, p. 72 n. 53). The issues concerning Orazio Gentileschi's supposed membership in the Accademia del Disegno, his physical presence in Florence in 1616, and the circumstances surrounding Artemisia's matriculation are addressed in Chapter 2.

August 20 Notation by Michelangelo Buonarroti the Younger that his account with the artist for the ceiling canvas in his gallery was closed, although Artemisia remained indebted to him (Procacci, 1967, p. 13; Vliegenthart, 1976, p. 172, as from Archivio Buonarroti, MS 101-4[A] fol. 32).

August 26 Through December 16 Identified as a confectioner's bill directed to Artemisia. Is this in fact the same document as that cited above, May 9, 1616, through January 6, 1617? (Del Bravo, 1967, p. 82 n. 11, as from Florence, AS, AD, *Atti e Sentenze*, LXIV, c. n.n.).

. .

1617

May 31 Artemisia's name appears twice in this mostly illegible document, identified by Cropper as the financial judgment made against the painter to which she refers in her letter to Grand Duke Cosimo that was brought before the Accademia del Disegno on June 5, 1619 (Florence, AS, AD, *Partiti e Deliberazioni*, segn. B, XVI, fol. 41, and *Atti e Sentenze*, LXV, no. 152; Bissell, 1968, p. 154 n. 14; Cropper, 1992, p. 206, and 1993, p. 761 incl. nn. 18 and 21).

August 2 A daughter, named Prudenza after her deceased maternal grandmother and born to Artemisia on August 1, is baptized in the Florentine parish of San Salvadore, the Cavaliere Anea di Silvio Piccolomini Aragona standing as godfather (Florence, AOD, Registro di Battesimo,

Femmine, 1616–17 [August 1617], fol. 59v; Cropper, 1993, p. 761 incl. n. 12). For more on Prudenza/Prudentia, who apparently also answered to the name Palmira, see Appendix II.

December 6 The carpenters Bartolommeo Porcelli and Salvestro Susini, summoned by the Accademia del Disegno in Florence, estimate a reduced amount for the bill (Fig. 57) which Artemisia had run up with another carpenter in 1614 and 1615 and had not yet paid in full (Florence, AS, AD, *Atti e Sentenze*, LXV, no. 169 attached to fol. 877 by count; Cropper, 1993, p. 760, incl. n. 11). Also above, 1614; and below, January 24, 1618.

1618

January 24 Dated January 24, 1617, Florentine Style, this document is characterized by Cropper as "the final judgment against Artemisia" for the debt to a carpenter which she had accrued in 1614 and 1615 (Florence, AS, AD, *Partiti e Deliberazioni*, segn. B, XVI, fol. 47; Cropper, 1993, p. 760 n. 47). See also the previous entry.

March 3 Payment dated March 3, 1617, Florentine Style, on behalf of the Grand Duke of Tuscany to Artemisia for paintings executed or to be executed (". . . date all'artemisia pitturessa p quadri fa. . . .") (Borea, 1970, p. 71, as from Florence, AS, Mediceo 344, fol. 386v).

March 5 Through April 20, 1619 An itemized account, beginning on March 5, 1617, Florentine Style, of charges and partial payments for items of clothing supplied to Artemisia by a tailor (Florence, AS, AD, *Atti e Sentenze*, LXIV, fol. 437 by recent numeration; discovered independently by Bissell, 1968, p. 154 n. 14, and Del Bravo, 1967, p. 82 n. 11; Cropper, 1992, pp. 206, 218 n.).

June 26–27 "Mad.a Artemisia Lomi Pittora in suo nome proprio" argues successfully before the Council of the Accademia del Disegno in Florence that a certain judgment made against her by a Francesco Lomi before the Council of the Arte degli Speziali was invalid, since as an artist she was entitled to the privileges and subject only to the rules of the Accademia. Generally thought to be Artemisia's brother of the same name, this Francesco was in fact the son of the Pisan jeweler Matteo Lomi, residing in the Florentine parish of S. Trinita. (Florence, AS, AD, *Atti e Sentenze*, LXIV, fols. 651r and v by recent numeration; Bissell, 1968, p. 154 n. 14; Cropper, 1992, pp. 207–8, 218 n., and 1993, p. 761, incl. n. 20, with the date as June 26, 1619; Lapierre, 1998, p. 466.)

October 14 A daughter born to Artemisia on October 13 is baptized in the Florentine parish of Sta. Lucia sul Prato with the name Lisabella after her godmother, wife of the dramatist Jacopo Cicognini. The poet Jacopo di Bernardo Soldani stood as godfather (Florence, AOD, Registro di Battesimo, *Femmine*, 1618–19 [October 1618], fol. 29v; Cropper, 1993, p. 761, incl. n. 13).

1619

February 28 Notice of February 28, 1618, Florentine Style, that a *Diana at Her Bath* by Artemisia had that day entered the collection of the Grand Duke of Tuscany (Florence, AS, Guardaroba Mediceo 373, Inventario Generale, segn. B, fol. 29; in large part transcribed by Gregori, 1968, p. 420 n. 19, and cited by Borea, 1970, p. 71; also [L-26] for details).

June 5 A letter addressed by Artemisia to the Grand Duke Cosimo II of Tuscany is introduced to the Accademia del Disegno and undersigned on this date by one Curtio Pulina. The artist requests Cosimo's inter-

vention in a judgment brought against her by the Accademia for debts incurred by her husband to a Michele *bottegaio*. She claims that Pierantonio Stiattesi, having already taken over her dowry, had kept her ignorant of the debts and the judgment, and that, in any case, "as a woman she could not incur debts while her husband was still with said woman" (Florence, AS, AD, *Atti e Sentenze*, LXIV, fol. 724 by recent numeration; discovered independently by Bissell, 1968, p. 154 n. 14, and Del Bravo, 1967, p. 82 n. 11, and discussed in some detail by Cropper, 1992, pp. 206–7, 218 n.; also Cropper, 1993, p. 761, incl. n. 19).

June 9 Death of Artemisia's daughter Lisabella (born October 13, 1618). (Lapierre, 1998, p. 463, as from Florence, AS, *Grascia*, 194, fol. 316r.)

July 4 In the Florentine parish of Sta. Lucia sul Prato, Artemisia stands as godmother at the baptism of a child named after her, a daughter born to Filippo d'Antonio Stinelli and Lisabetta di Alessandro Sapiti (Florence, AOD, Registro di Battesimo, *Femmine*, 1618–19 [July 1619], fol. 3; Cropper, 1993, p. 760 n. 7).

December (?) 18 The Council of the Accademia del Disegno hears a demand for 70 lire made by a creditor against Artemisia, and orders her to pay (Florence, AS, AD, *Atti e Sentenze*, LXV, fol. 160 by count).

..

1620

January 13 An order dated January 13, 1619, Florentine Style to give Artemisia 1½ ounces of ultramarine so that she might finish a painting which the Grand Duke had ordered. Three other documents, the first of which identifies the picture as a *Hercules*, refer to this commission (below January 16, February 10 and 15, 1620; and [L-39] for the transcription) (Florence, AS, Guardaroba

Mediceo 390, inserto 2, fols. 77–78; cited by Sricchia, 1963, pp. 251 and 266 n. 24, as on fol. 27).

January 16 An order of January 16, 1619, Florentine Style, that Artemisia pay for the 1½ ounces of ultramarine which she had received in connection with a *Hercules* that she was executing for the Grand Duke (also above, January 13, 1620, and below, February 10 and 15, 1620; and [L-39] for the transcription) (Florence, AS, Guardaroba Mediceo 360, Memoriale, fol. 146; cited by Gregori, 1968, pp. 419–20 n. 18).

February 10 Letter dated February 10, 1619, Florentine Style, from Artemisia to Cosimo II informing the Grand Duke of a proposed trip of some months to Rome and promising to send him within two months at the most a painting—surely the *Hercules* [L-39]—for which she had already received 50 scudi (also above January 13 and 16, 1620, and below February 15, 1620) (Crinò, 1954, pp. 205–6, as from Florence, AS, Mediceo 998, fol. 204; Garrard, 1989, pp. 374, 377).

February 15 An order dated February 15, 1619, Florentine Style, to return to Artemisia those household goods of hers which had been sequestered because of her failure to pay for the 1½ ounces of ultramarine she had received. Francesco Maringhi obligates himself to see to it that Artemisia delivers the finished painting—the *Hercules* [L-39]—within six months or to pay the bill himself (also above, January 13 and 16, 1620, and February 10, 1620) (Florence, AS, Guardaroba Mediceo 390, inserto 5, fol. 455, replacing numeration of 293; cited by Sricchia, 1963, pp. 251 and 266 n. 24). For Maringhi, see also below, October 9, 1635, and Appendix II.

Unspecified Date on the *Jael and Sisera*, Budapest, Szépmüvészeti Múzeum (Figs.

72–73; and [11]), no doubt executed in Florence or in Rome for a Florentine client.

..

1621

March Artemisia is back in Rome, living on Via del Corso with her husband Pierantonio Stiattesi, her daughter Palmira, and servants (Rome, AV, *Status Animarum*, S. Maria del Popolo, LXIV, 1621, fol. 9).

November 17 For reasons now unknown, Artemisia, already established on Via del Corso, sublets a small apartment on Via della Croce. (Lapierre, 1998, p. 472 as from Rome, AS, 30 *Notai Capitolini*, Officio 19, vol. 121, 1621, fols. 385r and v, 396r.)

..

1622

Lent Living on Via del Corso with her husband, her daughter Palmira, her brothers Giulio and Francesco, and servants (Rome, AV, *Status Animarum ab Anno 1622 usque ad 1649*, S. Maria del Popolo, LXV, 1622, fol. 20; Bousquet, 1978, p. 106; Spike, Review, 1991, p. 734 notes to no. 21).

June Finding a group of Spaniards on his Via del Corso doorstep, apparently there on a mission to serenade his wife Artemisia, "Pierantonio pittore" is now accused of having slashed one of the unwelcome visitors in the face. (Lapierre, 1998, pp. 462, 471 as from Rome, AS, Tribunale Criminale del Governatore, processo no. 181, anno 1622, fols. 52–55.)

Unspecified Date formerly on the reverse of the *Portrait of a Condottiere*, Bologna, Palazzo d'Accursio painted in Rome (Figs. 81–82; Color Plate IX; [13]).

..

1623

Lent Living on Via del Corso with her daughter and servants. By this date Artemisia's husband had departed, and sometime thereafter she lost track of him (see below, October 24, 1637) (Rome, AV, *Status Animarum ab Anno 1622 usque ad 1649*, S. Maria del Popolo, LXV, 1623, fol. 11; discovered independently by the author and by Papi in Contini/Papi, 1991, p. 61 n. 74).

..

1624

February 27 A painting of *Cupid and Psyche* by Artemisia is inventoried in the Patrizi Collection at Rome, where it is again recorded in July of 1647 (Rome, AS, 30 *Notai Capitolini*, Officio 2, vol. 92, 1624, Leonardus Bonanni, fol. 380, and Officio 11, vol. 187, 1647, Jo. Mattheus Massarius, fol. 465v; and [L-17]).

Lent Living on Via del Corso with her daughter and a servant (Rome, AV, *Status Animarum ab Anno 1622 usque ad 1649*, S. Maria del Popolo, LXV, 1624, fol. 11v; Bissell, 1968, p. 157 n. 42). Her residence is cited as the "casa della Sᵃ Artimisia Pittrice."

..

1625

March 17 or Later A *Saint Apollonia* painted by Artemisia on copper figures in an inventory begun on March 17, 1624, Florentine Style, of the Medici Villa Imperiale (Florence, AS, Guardaroba Mediceo 479, fol. 19v, noted but not transcribed by Gregori, 1968; and [L-68]).

Lent Living on Via del Corso with a daughter, here called Prudentia (see Appendix II), and servants (Rome, AV, *Status Animarum ab Anno 1622 usque ad 1649*, S. Maria del Popolo, LXV, 1625, fol. 27v; Bissell, 1968, p. 157 n. 42).

June 20 For reasons now unknown, Artemisia, her home and studio still on Via del Corso, sublets an apartment on Via Rassella (Via dei Serpenti). (Lapierre, 1998, p. 472 as from Rome, AS, 30 Notai Capitolini, Officio 19, vol. 136, 1625, fol. 735.)

July–February 1626 Within this period three paintings attributed to Artemisia—a *Christ and the Little Children*, a *David with a Harp*, and a *Saint Mary Magdalen* (Fig. 97; Color Plate XI)—were acquired in Rome by the Duque de Alcalá, Spanish Ambassador Extraordinary to the Holy See (see, respectively, [L-14], [L-20], and [16]).

September 15 Appealing to the civil tribunale, Artemisia's servant Dianora Turca demands back pay in the amount of 30 scudi, of which she is awarded twenty. (Lapierre, 1998, p. 472, as from Rome, AS, Tribunale Civile del Governatore, *Sentenze*, busta 309, 1621–32.) See entry of October 18.

September 29 The artist witnesses as godmother the baptism of another Artemisia, daughter of a Luca from Siena and a Domenica from Zagarolo (Rome, AV, *Liber V Baptizatorum: 1620–1639*, S. Maria del Popolo, fol. 47; Bissell, 1968, p. 157 n. 42).

October 18 Dianora Turca's claim that Artemisia still owed her 10 scudi for services rendered (see entry of September 15) is rejected by the magistrate on the grounds that the artist had already paid her in kind. (Lapierre, 1998, pp. 472–73 as from Rome, AS, Tribunale Civile del Governatore, *Sentenze*, busta 309, 1621–32.)

December 9 Artemisia enters into an agreement with her landlord concerning work to be done by him on her Via del Corso residence. (Lapierre, 1998, p. 472 as from Rome, AS, 30 *Notai Capitolini*, Officio 19, vol. 138, 1625, fol. 523.)

December 31 Drawing of Artemisia's right hand, inscribed in Rome by its creator Pierre Dumonstier "Ce dernier de Decem. 1625" (see Chapter 3 and Fig. 98).

1626

March 16 Artemisia witnesses as godmother the baptism of Prudentia, daughter of Giovanni de'Rossi, Bolognese, and his wife Marta, a Roman (Rome, AV, *Liber V Baptizatorum: 1620–1639*, S. Maria del Popolo, fol. 52v; Bissell, 1968, p. 157 n. 42).

Lent Living on Via del Corso with her daughter and a servant (Rome, AV, *Status Animarum ab Anno 1622 usque ad 1649*, S. Maria del Popolo, LXV, 1626, fol. 6; Bissell, 1968, p. 157 n. 42). Although this volume of the S. Maria del Popolo census runs through the year 1649, Artemisia Gentileschi's name does not appear after 1626. The census records for the years 1627–29 of the nearby parish of S. Lorenzo in Lucina are lost, and in that of 1630 Artemisia is not mentioned.

Unspecified A *Mystic Marriage of Saint Catherine* thought to be by Artemisia but possibly by Bartolommeo Cavarozzi (for which see [L-60]) is recorded by Cassiano dal Pozzo in the Madrid collection of the Marqués de la Hinojosa (Gerard, 1982, p. 12, as from Biblioteca Vaticana, Barb. Lat. 5698).

1627

Unspecified Date of the engraving by Jérôme David after Artemisia's *Portrait of the Engineer Antoine de Ville* (Fig. 102 and [19] for complete details and bibliography).

Unspecified Date of a pamphlet printed in Venice containing verses (probably by Gianfrancesco Loredan) dedicated to three paintings—*Amoretto*, *Lucretia*, *Susanna and the Elders*—by Artemisia. The *Amoretto* was then in the Venetian collection of Giacomo Pighetti, and the *Lucretia* is described as an "Opera della Sig. Artemisia Gentileschi Pittrice Romana in Venetia." Inasmuch as Artemisia's presence in Venice in 1627 (see following entry) is documented, a date of 1627, if not earlier, for her trip there is likely (Toesca, 1971, pp. 89–92, as from Biblioteca Vaticana, cod. Ottoboniano Latino 1100,

fols. 100–101v; Grabski, 1985, pp. 59–61. For further discussion and bibliography, see the text, Chapter 3; and for the specific pictures, now presumably lost, [L-1], [L-54], and [L-105]).

Unspecified Publication in Venice of the *Lettere di Antonio Colluraffi*, in which Artemisia's presence in the city at that time is noted and she and her talent extolled by way of letters, Latin inscriptions, and madrigals. Colluraffi requests from the artist a drawing of "l'orsa che lambisce il proprio parto" to serve as an emblem for the newly founded Accademia degli Informi and as frontispiece to *L'Accademia. Orazione dell'illustre Signor Alvise da Mosto, recitata nell'aprirsi dell'Accademia degli'Informi in casa propria, fondatore e rettore Antonio Colluraffi*. Lapierre's discovery of the *Lettere* confirms the proposal (Chapter 3) that Gentileschi was in Venice by 1627, while Colluraffi's position as tutor to young aristocratic Venetians, among them Gianfrancesco Loredan, supports my view ([L-1]) that Loredan was the author of three verses dedicated to pictures by Artemisia. (Lapierre, 1998, p. 473.)

1628

Unstated Artemisia is in Venice, where she receives a payment of 1,467 giulii, 14 baiocchi for a *Hercules and Omphale* commissioned by Philip IV of Spain through the intermediary of the Conde de Oñate (Gerard, 1982, pp. 11–13, as from Archivio General de Simancas, Tribunal Mayor de Cuentas 2633, 1626–28; [L-40] for details and further bibliography).

1629

July–May 1631 Within this period a *Saint John the Baptist* and two paintings described as portraits of Artemisia were acquired by the Duque de Alcalá, Spanish Viceroy to Naples (see [L-75], [L-61], and [L-62]).

1630

Unspecified Date on the *Annunciation*, Museo di Capodimonte, Naples ([24] and Fig. 114).

August 24 Letter from Gentileschi in Naples to Cassiano dal Pozzo in Rome, notifying him that she had received the measurements for a picture to the execution of which she would turn as soon as she had completed—by mid-September she hoped —"some works for the Empress" (Bottari/Ticozzi, 1822, I, pp. 348–49 CXXXVII; Garrard, 1989, pp. 377–78; also below, August 31 and December 21, 1630; and [25] and [L-100] for further discussion).

August 31 Letter from Artemisia in Naples to Cassiano dal Pozzo in Rome, informing him again that he would have the portrait commissioned by him as soon as she finished "some works for the Empress." In addition, she asks his help in arranging a "license to bear arms" for the cleric Diego Campanili(e), then living in her house, and hopes that with the arrival of cooler weather she will be able to come to Rome to serve Cassiano in person (Morrona, 1792, II, p. 266; Bottari/Ticozzi, 1822, I, pp. 349–50 CXXXVIII, the original letter now in the possession of Mr. Thomas Brumbaugh, Greencastle, Pa., Fig. 118; Garrard, 1989, p. 378; also above, August 24, 1630, and below, December 21, 1630; and [25] and [L-100] for further discussion).

December 21 Letter from the artist to Cassiano dal Pozzo in Rome reporting that she had returned to Naples after a period of absence during which she had painted a portrait of a Duchess, and assuring him that the *Self-Portrait* he had commissioned would be dispatched to Rome with the next messenger. She also thanks him for his kindness in the matter of Diego Campanile(i), who had

become gravely ill (Morrona, 1792, II, p. 266; Bottari/Ticozzi, 1822, I, pp. 350–51 CXXIX; Garrard, 1989, pp. 378–79; also above, August 24 and 31, 1630; and [25] for further discussion of the *Self-Portrait*).

1631

August 21 A payment of 12 ducats to Artemisia in full satisfaction of a 20-ducat fee for a *Saint Sebastian* which the artist was then completing for Giovanni d'Afflitto of Naples (Nappi, 1992, p. 74, as from Naples, Archivio Storico del Banco di Napoli, Banco di San Giacomo, Giornale copiapolizze, matr. 147, 21 agosto 1631). Gentileschi may have been responsible only for the head of the *Sebastian* ([L-85]), which along with a *David* and a *Saint Eustace* (the heads of these figures said to be by Artemisia as well) was recorded in 1700 among the holdings of Ferdinando d'Afflitto.

Autumn Artemisia is visited in Naples by the German painter and writer Joachim von Sandrart, who saw a *David with the Head of Goliath* in her studio (Sandrart, 1675, ed. 1925, p. 290; Klemm, 1986, p. 337; also [L-23] and Chapter 4).

1632

Unspecified Date on the *Clio, Muse of History*, Private Collection, New York (Figs. 121–23; Color Plate XVIII; [27]).

1633/1634

Unspecified A bill, perhaps specifically of 1634 according to modern reckoning, for the framing of three pictures identifiable as works by Orazio Gentileschi (Bissell, 1981, pp. 190–92) and for an unattributed *Tarquin and Lucretia*, the latter likely to be the painting of this subject by Artemisia recorded in other documents cataloguing the English Royal Collection of 1637–39, 1649, and 1650

(Chettle, 1937, p. 104, as from London, PRO, A.O. 1, 63/2427; and [L-106] for details).

1634

March 15 and 18 The English traveler Bullen Reymes, retainer of the Duke of Buckingham and bearer of letters of recommendation on behalf of Orazio Gentileschi, visits Artemisia and her daughter in their Neapolitan residence. Prudentia is said to be both a painter and a player on the spinet. (Lapierre, 1998, pp. 374, 476–77, citing Edward Chaney, *The Evolution of the Grand Tour*, London, 1998.)

1635

January 21 Letter from Artemisia in Naples to Cassiano dal Pozzo in Rome announcing that her brother Francesco was to arrive in Rome with a painting by Artemisia which, through the good graces of Cassiano, she wished to present to Cardinal Antonio Barberini (Morrona, 1792, II, p. 268; Bottari/Ticozzi, 1822, I, pp. 351–52 CXL; Garrard, 1989, pp. 379–80; also below, January 25 and July 20, 1635; [31]; and, for Francesco Gentileschi, Bissell, 1981, pp. 113–17 and passim).

January 25 Letter from Gentileschi in Naples to Francesco I d'Este in Modena apprising him that, having sent some paintings (*sic*) by her hand to Cardinal Antonio Barberini in Rome ([31]), she had instructed her brother Francesco to proceed to Modena with pictures ("quelle" and "queste operette") for the Duke. Artemisia claims that her brother had been dispatched by King Charles I to bring her to England, but that she would prefer Francesco d'Este's patronage (letter first noted by A. Venturi, 1882, p. 218 n. 2, then transcribed by Imparato, 1889, p. 424; Garrard, 1989, pp. 380–81, as from Modena, AS, Archivio Segreto Estense,

Cancelleria Ducale, Archivio per Materie, Arti Belle e Pittori, busta 14/2; see also the preceding entry and below, March 7, May 22, and July 20, 1635; and [L-98]).

March 7 Letter from Francesco d'Este in Modena to Artemisia in Naples thanking her for her gift of pictures, which paintings he had found beautiful (Imparato, 1889, p. 424; Garrard, 1989, p. 381; also the preceding and following entries; and [L-98]).

May 22 Letter from Artemisia in Naples to Francesco I d'Este in Modena expressing her gratitude that the paintings (referred to as "le Cose picciole") which she had sent him by way of her brothers (*sic*) had found favor. She entreats the Duke to provide her with the means of serving him in person, saying that she would extend to Modena a planned trip to Florence (Imparato, 1889, p. 424; Garrard, 1989, pp. 381–82; also above, January 25 and March 7, 1635; and below, July 20, 1635; and [L-98]).

July 20 Letter from Artemisia in Naples to Ferdinando II de'Medici (App. III) announcing the arrival in Florence of her brother (surely Francesco Gentileschi) and with him two recently executed paintings by her hand to be presented to the Grand Duke with the blessing of the Viceroy of Naples, the Conde de Monterrey. The artist informs Ferdinando that her brother, under orders from Orazio Gentileschi, will then proceed to Naples to conduct her to the service of Charles I of England. Artemisia claims that she has had to decline many previous invitations to London because through the intermediary of Monterrey she was under obligation to finish some works for Philip IV of Spain, but that Charles, having subsequently learned that these pictures had been completed or were nearing completion ("ero alla fine delle dette opere"), renewed his call.

Nonetheless, apparently reluctant to make the trip, Gentileschi proceeded on her own initiative to execute paintings for the Duke of Modena, Francesco I d'Este, and for Cardinal Antonio Barberini in Rome, followed by the canvases for Ferdinando, to whom she extends the usual obsequious regards. Without the Grand Duke's patronage, Artemisia implies, she could no longer postpone the English journey, having already obtained promises from the Duchess of Savoy in Turin of a letter and a passport according her safe passage for France (Fuda, 1989, pp. 167–71, as from Florence, AS, Mediceo 4157, fols. 194–194v. For further discussion of Artemisia's English trip, see Chapter 4; and for additional references to the pictures for Francesco I d'Este, Cardinal Barberini, and Ferdinando II, see above, January 21, January 25, March 7, and May 22, 1635, and below, October 9 and October [?] 20, 1635. Also see [31], [36], [L-66], [L-98]).

September 24 Letter from Andrea Cioli, Secretary to the Grand Duke in Florence, to Artemisia in Naples, as recorded in Gentileschi's note to Cioli dated October (?) 20, 1635 (below).

October 9 Letter from the artist in Naples to Galileo Galilei in Arcetri asking his help in determining whether the two large paintings which she had sent to Florence (see also July 20 and October [?] 20, 1635) had pleased the Grand Duke. She reminds Galileo of his previous most positive intervention on her behalf with Grand Duke Cosimo, to whom she had presented a *Judith* (see [12]), and expresses consternation that, in striking contrast to the gifts and laudatory letters she had received from the Kings of France (see [23]), Spain (see [32] and [L-40]), and England (see [L-106]), and from the Duke of Guise (see [L-95]) and other princes, Ferdinando II, whom she wished to serve above all, had made absolutely no acknowledg-

ment (Galilei, 1905, XVI, pp. 318–19, as from Florence, Biblioteca Nazionale, MSS Gal. P.I.T. XIII, car. 269–70; Garrard, 1989, pp. 383–84). The two pictures in question cannot be identified with certainty, but see [36] and [L-66]. Artemisia concludes with instructions to Galileo that, should he respond, his letter should be addressed in care of Francesco Maria Maringhi (see also above, February 15, 1620).

October (?) 20 Letter from Gentileschi in Naples to Andrea Cioli in Florence. Crinò reads the date as "li 20 de 7bre 1635," but inasmuch as the artist speaks of correspondence from Cioli on the "ventiquattro di sett.e," the date might better be read "li 20 di 8bre 1635." Artemisia asks him if her "efforts (*fatiche*)"—two large pictures as it happens (see above, July 20 and October 9, 1635)—had pleased the Grand Duke, whose patronage in Florence through Cioli's graces she now seeks (Crinò, "More Letters," 1960, p. 264, as from Florence, AS, Mediceo 1416, inserto 8, fol. 748; Garrard, 1989, pp. 382–83; and below, December 11, 1635, and February 11 and April 1, 1636).

December 11 Letter from Artemisia in Naples thanking Andrea Cioli in Florence for his courtesies, and proclaiming her desire to send him a *Saint Catherine* by her hand and a painting by her daughter. These pictures were in effect down payments to Cioli for his future efforts in securing for Artemisia the patronage of the Grand Duke of Tuscany. She notes that she would be free to come to Florence in March when, she understands, the Count (otherwise unidentified, but possibly the Conde de Monterrey, as Garrard suggests) will be leaving Naples (Crinò, "More Letters," 1960, p. 264, as from Florence, AS, Mediceo 1416, inserto 8, fol. 780; Garrard, 1989, pp. 375, 385; also [L-69]; and, for the daughter, Appendix II).

1636

Unspecified The *Hercules and Omphale* for Philip IV of Spain, for which Artemisia was paid in 1628 (above), is inventoried in the Alcázar Real in Madrid ([L-40]).

February 11 Letter to Andrea Cioli from Artemisia who, lamenting the "tumults of war" and the poor quality and high cost of life in Naples, again seeks employment in Florence. She awaits Cioli's instructions as to whether the painting intended for him should be shipped or delivered in person (Crinò, "More Letters," 1960, pp. 264–65, as from Florence, AS, Mediceo 1416, inserto 9, fol. 860; Garrard, 1989, pp. 385–86; also above, October [?] 20 and December 11, 1635, and below, April 1, 1636).

April 1 Letter from Artemisia in Naples to Andrea Cioli in Florence, once again asking his assistance in arranging the Grand Duke's patronage. Planning to journey to Pisa in May to sell some of her holdings ("alcuni miei beni") there, and thus acquire the means to marry off a daughter ("una mia figliuola"), the artist proposes also a stop in Florence for a period of four months (Crinò, "More Letters," 1960, p. 265, as from Florence, AS, Mediceo 1416, inserto 10, fol. 892; Garrard, 1989, pp. 386–87; also above, October [?] 20 and December 11, 1635, and February 11, 1636; and, for the daughter, Appendix II).

May 5 Receipt of 250 ducats from Lorenzo Cambi and Simone Verzone, acting on behalf of Prince Karl Eusebius von Liechtenstein, in final satisfaction of a payment of 300 ducats owed to Artemisia from a total of 600 ducats. The painter was forthwith to consign three canvases on the subjects of Bathsheba, Susanna, and Lucretia (Nappi, 1983, p. 76, as from Archivio Storico del Banco di Napoli, Banco dello Santo Spirito,

giornale del 1636, matr. 270, partita di ducati 250, estinta il 5 maggio). See [37].

December 19 Transfer of 20 ducats from the bank account of Bernardino Belprato to Artemisia, as final payment of a total of 60 ducats for a painting—subject unspecified—she was to deliver (Nappi, 1983, p. 76, as from Archivio Storico del Banco di Napoli, Banco di San Giacomo, giornale del 1636, matr. 198, partita di ducati 20, estinta il 19 dicembre; also [L-96]). A *Galatea* and a *Portrait* [?] *of Gioseppe Giusto*, both by Artemisia, figured in the Belprato inventory of 1667 (see [L-34] and [L-36]), but there is no evidence specifically to link either to this payment.

1637

October 24 Letter from Artemisia in Naples to Cassiano dal Pozzo in Rome, informing him of her need for money in order that she might conclude her daughter's marriage pact. To this end she proposes, pending Cassiano's approval, to send paintings to Cardinals Francesco and Antonio Barberini, together with one for Monsignor Filomarino and two for Cassiano, among the latter the *Self-Portrait* which he had previously commissioned. Adding that she would like to return to Rome as soon as she has married off her daughter, Artemisia concluded by asking Cassiano to tell her whether or not her husband was still living (Morrona, 1792, II, p. 268; Bottari/Ticozzi, 1822, I, pp. 352–53 CXLI; Garrard, 1989, pp. 387–88; and, for the daughter, Appendix II). In a follow-up letter dated November 24 (below), the artist identifies the large pictures intended for the Cardinals Barberini. For the *Self-Portrait*, see [25]; for the painting for Mons. Filomarino, [L-77].

November 24 Letter from Artemisia in Naples to Cassiano dal Pozzo in Rome, identifying the large pictures to which she had referred (preceding entry) and which she intended for Cardinals Francesco and Antonio Barberini as a *Christ and the Samaritan Woman* and a *Saint John the Baptist in the Desert*. Once again she expresses her wish to return to Rome (Morrona, 1792, II, pp. 266–67; Bottari/Ticozzi, 1822, I, p. 354 CXLII; Garrard, 1989, p. 388; also [L-15] and [L-76].)

1637–1639

Unspecified In the inventories of the English Royal Collections compiled within these years by Abraham van der Doort, three pictures by Artemisia are listed: *Fame, Susanna and the Elders*, and *Tarquin and Lucretia* (Van der Doort, 1960, respectively pp. 46, 177, and 194, as from MS Ashmole 1514, fol. 61 no. 22, fol. 178 no. 34, and fol. 179v no. 2; also above, 1633/1634, and below, 1649 Unspecified; and, for details, [L-30], [L-103], and [L-106]).

1638

March A *David with the Head of Goliath* by Artemisia is inventoried in the collection of the Marchese Vincenzo Giustiniani at Rome (see [L-23]).

March 1 A *Judith Decapitating Holofernes*, unattributed but conceivably identifiable as Artemisia's painting now in the Uffizi at Florence, is entered on March 1, 1637, Florentine Style, in a Medici inventory of the Palazzo Pitti (Florence, AS, Guardaroba Mediceo 525, "Inventario de Pitti," 1 marzo 1637, fol. 32v; cited by Borea, 1970, p. 76; also Figs. 77–79, Color Plate XII, and [12] for details).

March 3 Artemisia's *Judith and Her Maidservant*, then as now in the Palazzo Pitti at Florence, is entered on March 3, 1637, Florentine Style, in a Medici inventory (Florence, AS, Guardaroba Mediceo 525,

"Inventario de Pitti," 3 marzo 1637, fol. 45v; transcribed by Borea, 1970, p. 75; also Fig. 31, Color Plate IV, and [5] for details).

1639

December 16 Letter from Artemisia in London to Francesco I d'Este in Modena telling the Duke that her brother would arrive from England to present a painting ("questa mia piccola fatica") to him. The artist claims that, notwithstanding the great honors she had received from the English court, her desires had remained unsatisfied, and she speaks in terms calculated to secure an invitation to Modena under the Duke's patronage (letter first noted by A. Venturi, 1882, p. 218 n. 2, then transcribed by Imparato, 1889, p. 424; Garrard, 1989, pp. 388–89, as from Modena, AS, Archivio Segreto Estense, Cancelleria Ducale, Archivio per Materie, Arti Belle e Pittori, busta 14/2; also the following entry).

1640

March 16 Letter from Francesco I d'Este in Modena to Artemisia in London, thanking her for the paintings (*sic*) she had sent him and for the sentiments accompanying them (Imparato, 1889, p. 425; Garrard, 1989, p. 389; also the preceding entry).

Unspecified Document listing Artemisia's *Saints Proculus and Nicea* and *Saint Januarius in the Amphitheater*, and almost certainly her *Adoration of the Magi*, for the Cathedral at Pozzuoli (D'Ambrosio, 1973, pp. 29–30, as from Archivio Segreto Vaticano, Sacra Congregazione del Concilio, *Relationes ad limia*, fasc. Pozzuoli, relazione dei vescovi, vescovo Martino de Leòn y Càrdenas, 1640, fol. 3; Figs. 146–49, Color Plate XXI, and [33] for details).

Unspecified Date of the engraving by Jean Ganière after Artemisia's *Child Sleeping near a Skull* (Fig. 112, and [23] for details and bibliography).

1644

Unspecified A painting by Artemisia described as "a woman with an Amore" is inventoried in the collection of Cardinal Antonio Barberini in Rome, and may possibly be identified as the *Venus and Cupid* formerly at Kreuzlingen (Figs. 130, 133; [31]).

1646

November 17 A *Judith* attributed to Artemisia, having been inherited by the Pio Monte della Misericordia at Naples from the estate of D. Cesare di Gennaro, Principe di San Martino, is evaluated by Filippo Vitale and Andrea Abate. See [L-46].

1648

September 5 Payment of 30 ducats to Gentileschi in Naples made by D. Fabrizio Ruffo, Prior of Bagnara, for a painting on which she was working, probably one of the three pictures for the Prior to which the artist refers in her letter of June 5, 1649, to Fabrizio's uncle, D. Antonio Ruffo of Messina (below) (Strazzullo, 1955, p. 44 doc. no. 128, as from Archivio Storico del Banco di Napoli, Banco della Pietà, gior. 359, fol. 406. For the text of the document, see [L-101]).

1649

Unspecified In the inventory of the English Royal Collections under this year, five pictures by Artemisia are listed: *Fame*, *Susanna and the Elders*, "A S^t laying his hand. on fruite," *Diana at Her Bath* (elsewhere identified as *Bathsheba*), and *Tarquin and Lucretia*. Three of these paintings had been signaled by Van der Doort between 1637 and 1639 (see above) (London, PRO, *Pictures, Statues, Plate . . .*, LR 2/124, 1649, respectively fols.

190v, 192, 6; also British Museum Harley MS 4898, fol. 231 no. 281 and fol. 137 no. 73; and, for details, [L-30], [L-103], [L-79], [L-25], and [L-106]).

Unspecified A *Sacrifice of Isaac* and a *Saint Cecilia* appear under Gentileschi's name in the Neapolitan collection of Vincenzo D'Andrea (see [L-67] and [L-72]).

January 5 Payment of 160 ducats to Artemisia for a *Galatea* (here identified as [49]) painted in Naples for Don Antonio Ruffo of Messina. The transaction was effected by Don Fabrizio Ruffo, Prior of Bagnara, acting on behalf of his uncle (Ruffo, 1919, p. 48; also below, January 30, March 13, and August 5, 1649; Figs. 195–96, Color Plate XXII, and [49] for details).

January 30 Letter from Artemisia in Naples to Don Antonio Ruffo in Messina announcing the prior shipment of a picture (identifiable as the *Galatea*) to him and defending her fee of 160 ducats on the grounds that wherever she had worked—Florence, Venice, Rome, Naples—she had in fact received 100 ducats per figure. The artist speculates that Don Antonio might be apprehensive about receiving a painting executed by a woman until he had actually seen it, and adds that if it pleases him she will also send a *Self-Portrait* (Ruffo, 1916, p. 48; Garrard, 1989, pp. 390–91; also, for the *Galatea*, the preceding entry, March 13 and August 5, 1649, below, and [49]; and, for the *Self-Portrait*, also June 5 and July 24, 1649, and [L-89]).

February 21 Letter from Don Antonio Ruffo in Messina to Gentileschi in Naples containing a bill of exchange in the amount of 100 ducats as an advance—other documents demonstrate—for a *Diana at Her Bath* intended for Ruffo (Ruffo, 1916, p. 48; also all but two of the remaining dated entries from March 13, 1649, through April 30,

1650; and [L-27] for the complete documentation).

March 13 Letter from Artemisia in Naples to Don Antonio Ruffo in Messina reporting the receipt of his correspondence of February 21 with its bill of exchange for 100 ducats (for the *Diana at Her Bath*) and lamenting the fact that her *Galatea* shipped in January (above, January 5, 1649) had suffered from the sea journey. The painter adds that she will send Ruffo her *Self-Portrait* and a small picture by her daughter (see Appendix II), whom that same day she had married off to a Knight of St. James. Artemisia ends with instructions that further letters from Ruffo should be addressed in care of Tommaso Guaragna (Ruffo, 1916, pp. 48–49; Garrard, 1989, pp. 391–92; also all but two of the remaining dated entries from February 21, 1649, through April 30, 1650; and [L-27]).

May 24 Letter from Don Antonio Ruffo in Messina to Artemisia in Naples, signaled in Artemisia's letter of June 5, 1649 (following entry).

June 5 Letter from Gentileschi in Naples to Don Antonio Ruffo in Messina acknowledging his correspondence of May 24 and informing him that because of the indisposition of the model who was posing for her the picture (identifiable as the *Diana at Her Bath*) intended for Don Antonio was not yet finished. Artemisia speaks again of her *Self-Portrait* (above, January 30 , 1649; below, July 24, 1649), and notes as well three paintings, subjects unspecified, which she had done for the Prior (Don Fabrizio Ruffo, Prior of Bagnara and Don Antonio's nephew; [L-101]) (Ruffo, 1916, p. 49 and n. 3; Garrard, 1989, p. 392; also all but two of the remaining dated entries from February 21, 1649, through April 30, 1650; and [L-27]).

June 12 Letter from the artist in Naples to Don Antonio Ruffo in Messina requesting

50 ducats (identifiable as an advance for the *Diana at Her Bath*) to help defray her high expenses for female nude models, finding only one in fifty acceptable and requiring more than one because of the eight figures contained in the painting (Ruffo, 1916, pp. 46–48, and 1919, pp. 48–49; Garrard, 1989, p. 393; also all but two of the remaining dated entries from February 21, 1649, through April 30, 1650; and [L-27]).

June 22 Two advances to Artemisia from Don Antonio Ruffo in Messina for the *Diana at Her Bath* (that of 100 ducats ordered by the bill of exchange of February 21 and that of 50 ducats requested by the artist on June 12 and acknowledged on July 24) are recorded under this date in Ruffo's account book. The payments were made in Naples by Ruffo's bankers Giovanni Battista Tasca and Andrea Maffetti (Ruffo, 1919, p. 52; also all but two of the remaining dated entries from February 21, 1649, through April 30, 1650; and [L-27]).

July 24 Letter from Artemisia in Naples to Don Antonio Ruffo in Messina acknowledging receipt of his bill of exchange (identifiable as an order for the advance of 50 ducats for the *Diana at Her Bath*, preceding entry). The painter again announces that the delivery date of the *Diana* must be deferred, this time claiming that the picture demanded triple the work she had expended on the *Galatea* (above, January 5 and 30, March 13, 1649; below, August 5, 1649). And, for the third time (also above, January 30 and June 5, 1649; and [L-89]), Artemisia speaks of her *Self-Portrait* (Ruffo, 1916, pp. 49–50; Garrard, 1989, pp. 393–94; also all but two of the remaining dated entries from February 21, 1649, through April 30, 1650; and [L-27]).

August 5 An accounting by Don Antonio Ruffo of Messina of expenses incurred in Naples by his nephew, Don Fabrizio Ruffo, in connection with various works of art, including that for a shipping crate for Artemisia's *Galatea* and for a frame and its crate made for the same by Sebastiano Gallone (Ruffo, 1919, p. 52; also all but two of the remaining dated entries from February 21, 1649, through April 30, 1650; and [49]).

August 7 Letter from Gentileschi in Naples to Don Antonio Ruffo in Messina announcing receipt of his voucher (probably a second acknowledgment of the 50-ducat advance for the *Diana at Her Bath*; above, June 22 and July 24, 1649) and the imminent completion of the picture, which the artist describes as containing eight figures and two dogs (Ruffo, 1916, p. 50; Garrard, 1989, p. 394; also all but two of the remaining dated entries from February 21, 1649, through April 30, 1650; and [L-27]).

September 4 Letter from Artemisia in Naples to Don Antonio Ruffo in Messina explaining that she had not met the delivery deadline for the *Diana at Her Bath* because a change in the vanishing point of the perspective had necessitated redoing two of the figures, and because the excessive heat and various illnesses demanded that she pace herself (Ruffo, 1916, p. 50; Garrard, 1989, p. 395; also all but two of the remaining dated entries from February 21, 1649, through April 30, 1650; and [L-27]).

October 12 Letter from Don Antonio Ruffo in Messina to Artemisia in Naples, its substance summarized by Artemisia on October 23, 1649 (following entry).

October 23 Letter from the painter in Naples to Don Antonio Ruffo in Messina acknowledging his correspondence of October 12 and making known her mortification upon hearing that he wished to cut by one-third her fee for the *Diana at Her Bath*, the price already being 115 scudi less than what

she had received from the Marchese del Guasto for a picture that contained two fewer figures (Ruffo, 1916, pp. 50–51; Garrard, 1989, pp. 395–96; also all but two of the remaining dated entries from February 21, 1649, through April 30, 1650; and [L-27]).

October 26 Letter, now lost, from Don Antonio Ruffo in Messina to Artemisia in Naples, its substance summarized by the artist on November 13 (below, second letter of that date).

November 13 Letter from Artemisia in Naples to Don Antonio Ruffo in Messina informing him that she had finished the *Diana at Her Bath* but could not let it go for less than the stipulated price. She speaks again (see above, June 12, 1649) of the intolerable expense for models and refers to another picture (subject unspecified) which apparently Ruffo had commissioned (Ruffo, 1916, p. 51; Garrard, 1989, pp. 396–97; also all but two of the remaining dated entries from February 21, 1649, through April 30, 1650; and [L-27]).

November 13 A second letter of this date from Artemisia in Naples to Don Antonio Ruffo in Messina. In correspondence of October 26, Ruffo had informed the artist of a Cavaliere in Messina who wanted works by her hand, specifically a *Judgment of Paris* and a *Galatea*, the latter to be different from that for Don Antonio [49], and a preliminary drawing. Artemisia takes offense at both these specific requirements, claiming the talent always to vary her paintings and noting her resolve never again to submit drawings, since one for the Bishop of St. Agata de' Goti representing souls in purgatory [L-93] had been turned over to another painter for the picture itself. The artist continues to defend her fees, announcing that as a Roman she follows the pricing structure in Rome, not in Naples (Ruffo, 1916, p. 52; Garrard, 1989, pp. 397–99; and preceding entry).

December Letter from Gentileschi in Naples to Don Antonio Ruffo in Messina bringing him Christmas greetings while apprising him that if he wanted the painting (the *Diana at Her Bath*) he had to intervene, given the ill will that had developed between her and Don Antonio's nephew and intermediary in Naples, the Prior Don Fabrizio Ruffo (who for three months now had relegated the picture to virtual oblivion) (Ruffo, 1916, pp. 52–53; Garrard, 1989, p. 399; also all but two of the remaining dated entries from February 21, 1649, through April 30, 1650; and [L-27]).

1650

February 26 An advance of 25 ducats given to Artemisia (for the *Diana at Her Bath*) in October of 1649 through the Neapolitan bankers Tasca and Maffetti (see also above, June 22, 1649) is recorded in Don Antonio Ruffo's account book (Ruffo, 1919, p. 51; also all but two of the remaining dated entries from February 21, 1649, through April 30, 1650, especially the last; and [L-27]).

April 12 Artemisia receives a final payment in the amount of 80 ducats for the *Diana at Her Bath* from Don Flavio Ruffo in Naples acting on behalf of his brother Don Antonio in Messina (see following entry).

April 30 Three notations in the account book of Don Antonio Ruffo in Messina to the effect that with the final payment on April 12 of 80 ducats to Artemisia for the *Diana at Her Bath* and the painting having been consigned, the artist had received her total fee of 230 ducats. A fourth notation refers to 25 ducats for which the bankers Tasca and Maffetti were now being reimbursed (see above, February 26, 1650). Apparently these 25 ducats were now viewed, for accounting purposes, as part of the 80 ducats mentioned above (Ruffo, 1919, pp. 49–52;

also all but two of the remaining dated entries from February 21, 1649, through the present one; and [L-27]).

August 13 Letter from Artemisia in Naples to Don Antonio Ruffo in Messina expressing her gratitude that he had reopened communications with her and her hope of sending to him before long a "little Madonna in small scale (*questa Madonina in piccolo*)" which, she believes, will please him as much as did her large pictures. This *Madonna* may be identified as the small work on copper to which Artemisia refers in her correspondence of January 1, 1651 (following entry) and in all likelihood with the painting now in the Escorial (Fig. 198 and [51]) (Ruffo, 1916, p. 53; Garrard, 1989, pp. 399–400).

1651

January 1 Letter from Artemisia in Naples to Don Antonio Ruffo in Messina informing him that she is still convalescing from an illness that struck her at Christmastime, and that as soon as she is able to paint again he will be the first to be served, specifically with the "small copper (*rametto*)" then half-finished. This picture on copper may be identified as the "Madonina in piccolo" mentioned by the artist on August 13, 1650 (preceding entry and [51]). Artemisia reports as well that she has in her studio two half-completed paintings as large as the *Galatea* [49] representing *Andromeda Liberated by Perseus* ([L-2]) and *Joseph and Potiphar's Wife* (see [L-45]) which she would finish by April for 90 scudi each, providing that Ruffo advances her 100 ducats (Ruffo, 1916, pp. 53–54; Garrard, 1989, pp. 400–401).

1652

Unspecified Date reported to have appeared on a *Susanna and the Elders* with Averardo de'Medici in Florence (Morrona, 1812, II, pp. 487–88; and [L-104]).

1653

Unspecified Publication date in Venice of the *Cimiterio, epitafij, giocosi* of Giovanfrancesco Loredan and Pietro Michiele which contains two posthumous epitaphs disrespectful of Artemisia (Battisti, 1963, p. 297; Garrard, 1989, p. 137; and the text, Chapter 5).

APPENDIX II

Artemisia Gentileschi's Daughter(s), Painter(s)

As part of her campaign to acquire the patronage of Ferdinando II de'Medici of Tuscany, Artemisia wrote from Naples on December 11, 1635, to the Grand Duke's secretary Andrea Cioli, seeking his continued assistance and underlining her resolve by offering to send him a *Saint Catherine* by her hand and a painting by her daughter:

> Sono sempre stata sicura delle sue Cortesie, et hoggi più che mai ne vedo l'effetti di quelle, e per che habbia magg.r memoria della sua Serva, desideraria sapere per che mezzo inviarli un quatro che un pezzo fa ho finito con l'Imagine di Santa Catarina dedicato per V. S. Ill.ma come per un altra mia li scrissi mesi sono, et anco In compagnia un premitio fatto dalla mia figliola che come figliola si non se ne farà burla, et queste saranno per Caparra si cossì Idio permette che a marzo come si dice vadi via Il Conte, et Io fusse degna di servire il mio Prencipe naturale che sarei sicura per mezzo delli favori di V. S. Ill.ma d'essere In sicurissimo porto.

There is no evidence here, or elsewhere, that Gentileschi trained her daughter with the expectation that she would practice her art professionally. Thus no conclusions can be drawn from this regarding the extent to which Artemisia, even in the face of the obstacles with which as a woman painter she

was confronted, was comfortable with her own career. One may reasonably assume, however, that her daughter's artistic production did not begin and end with the single work proffered to Cioli. Conceivably certain canvases, which while strongly Gentileschian do not speak of Artemisia herself (e.g., Figs. 243, 244), may be by this daughter (and/or another daughter—see below). It is above all this possibility which prompts an investigation of Artemisia's family.

Thanks to the recent discoveries of Elisabeth Cropper, we now possess the complete baptismal records of four children born—all of them in Florence—to Artemisia and Pierantonio Stiattesi, their names and birth/baptismal dates as follows:

Giovanni Battista	September 20/21, 1613
Cristofano	November 8/9, 1615
Prudenza	August 1/2, 1617
Lisabella	October 13/14, 1618

Prior to Cropper's research, the birth to Artemisia of only one child—Cristofano, as it turns out—was indicated by the Florentine documents, specifically by a notation dated November 13, 1615, in the account books of Michelangelo Buonarroti the Younger that monies he had sent to Artemisia were received by her in bed, the artist "sendo in parto": "E addì 13 di Novembre fiorini tre portò detta da me per mano di Francesco mio servitore, gli riceve nell'letto, e me ne aveva scritta una polizza [see below] mostrando averne bisogno grande sendo in parto. . . . fior. 3."

There are hints that during their stay in Florence the Stiattesi had at least one child in addition to the four offspring listed above. On September 7, 1615, Pierantonio directed a request for money to Buonarroti the Younger, for whom Artemisia was preparing the *Allegory of Inclination* (Fig. 64; Color Plate VIII; [8]): "Molto illustre Signor Compare, pigliandomi ardire delle offerte che mi à fatto V. S. vengo con questa mia a pregarla mi favorisca di mandarmi quattro ovvero cinque ducati, che sa S. V. quanti disastri io ho passato; e con tal fine me le offro e raccomando e mi perdoni della briga. Di casa il dì 7 di 7bre 1615. Di V. S. Molto illustre affezionatissimo per servirla, Pierantonio Stiattesi." (On the same day, Buonarroti responded to this plea and entered the following in his book: "E addì 7 di Settembre fiorini [= ducati] portò mona . . . sua serva mandata da lei, e me ne aveva prima mandata una polizza Pierantonio suo marito; e detta Artimisia dissemi averli ricevuti. . . . fior. 5.") Sometime thereafter, but before Buonarroti's notation of November 13 (see above), Artemisia had petitioned for an additional 21 lire (= 3 florins or ducats): "Magnifico Signor Compare. Desidero una grazia de lei che mi favorissi d'accomandarmi di lire ventiuna che io gliene restituiro quanto prima. Di V. S. Affezionatissima come figliola Artemisia Lomi."

Procacci, observing that Buonarroti is greeted as "Signor Compare," suggests that he must have served as Artemisia's godfather during one of his trips to Rome. As an alternative Garrard, followed by Contini, posits that Michelangelo the Younger was present as a witness to Artemisia's wedding—a signification which, at least in modern usage, the word *compare* can bear. There are, however, problems with these proposals. It is now known that it was in fact one Offredo de Offredis who on July 10, 1593, witnessed Artemisia's baptism, as the notice of that event attests. Had Buonarroti been designated godfather, his name certainly would have been recorded. Furthermore, in her testimony on March 18, 1612, during the trial of Agostino Tassi, Gentileschi identified the painter Pietro Rinaldi as her godfather ("cosi m'ha detto il mio compare chiamato Pietro Rinaldi pittore"); possibly Offredo had died. And there is no

indication in the marriage record of Gentileschi and Stiattesi that Buonarroti was present, and no reasonable explanation for why he should have been. Finally, since both husband and wife address Michelangelo the Younger as "Signor Compare," and since the use of *compare* by godparents (see *Dizionario della lingua italiana*, Turin, 1964, III, pp. 389–90) to designate the father of the baptized child cannot apply in this instance (Michelangelo the Younger never married, and did not name a natural heir), only one conclusion seems possible: Buonarroti was godfather to a child of the Stiattesi. If so, either Buonarroti had assumed these duties from Lorenzo di Vincenzo Calvalcanti, designated godfather in November of 1613 to the baby Giovanni Battista Stiattesi, or another son or daughter had been added to the family midway within the more than two years separating the births of Giovanni Battista and Cristofano. (The painter Cristofano Allori, not Buonarroti, would stand as godfather to Cristofano, the child whom Artemisia was carrying at the time of the correspondence in which Michelangelo the Younger is called *Compare*. Interestingly, however, on July 26, 1614, Buonarroti appeared as godfather to a daughter of Jacopo Soldani, the same Soldani who in 1618 would perform this function to Artemisia's daughter Lisabella). Pierantonio Stiattesi's mention of "quanti disastri io ho passato," disasters with which Buonarroti is said to have been familiar, may possibly refer to the deaths of one or more of his children prior to September of 1615.

Whatever the explanation, the sad fact is that by early 1621, with both Artemisia and her husband now back in Rome, only one of the four or more children had survived. Perhaps Artemisia made an oblique reference to the deaths of so many when in a letter to Cosimo II de'Medici on February 10, 1620 (New Style), she spoke of a proposed trip to Rome in order to make up for the indispositions and pain which her being on the move had caused her and her "house and family":

Acciò non sia di ombra a V.A.S. un puo di viaggio che mi sono risoluta di fare In sino a Roma, ho voluto con la presente farlo sapere a V.A.S. essendo Qta mia mossa cagionata dalle molte mie indispositioni passate alle quali si sono giunti anche non pochi travagli dalla mia casa e famiglia, che per ristorare l'uno e l'altro mio danno me la passerò colà tra miei per qualche mese. . . .

The census reports, filed each year during Lent, of the parish of Santa Maria del Popolo, are definitive with regard to what remained of the family. In 1621 and 1622 one child, a daughter, lived with Artemisia (called Lomi) and Pierantonio, and from 1623 to 1626 with Artemisia (called Gentileschi) alone. Her name and age are entered in the census as follows:

1621	Palmiria	3
1622	Palmira	6
1623	Palmiria	5
1624	Palmira	6
1625	Prudentia	6
1626	Palmira	—

As often with records of this kind, this list is erratic. It seems certain, nonetheless, that only one daughter is involved. Although listed as Palmiria/Palmira five times and as Prudentia but once, this girl must surely be identified as the Prudenza born at Florence in August of 1617, who in the spring of 1621 would indeed still have been three years old, as in the springs of 1623 and 1624 she would have been five and six, respectively. The glaring inconsistency that occurs

in 1622 must be a stenographic error. Having been named after her maternal grandmother, Prudentia would on March 16, 1626, give her name to a daughter of Giovanni de'Rossi, Bolognese, and his Roman wife, Marta, at whose baptism Artemisia appeared as godmother. Finally, although volume v of the Santa Maria del Popolo baptismal registers spans the years 1620–39, no child of Pierantonio Stiattesi and Artemisia Lomi (or Gentileschi) is recorded.

After the appearance of the name of Palmira (sometimes called Prudentia) in the census of 1626, nothing else is heard of a daughter until entries of March 15 and 18, 1634, in the diary of the English traveler Bullen Reymes, where Prudentia figures as both a painter and a player of the spinet, and then the aforementioned letter from Artemisia to Andrea Cioli on December 11, 1635, which also identifies the young woman as a painter. Two more letters to Cioli, one of February 11 and the other of April 1, 1636, follow, and the latter in part explains the urgency of Gentileschi's desire for employment in Florence. In it the artist reported that in May she would travel to Pisa in order to sell some of her holdings there and thus secure the means to marry off a daughter: "Io per collocare una mia figliuola mi trasporterò questo maggio in Pisa a vendere alcuni miei beni, e con questo opportunità venirò in Firenze." Apparently the Pisan trip never materialized or the proceeds of the sale were insufficient; for, more than a year and a half later, on October 24, 1637, Artemisia, now seeking the patronage of the Barberini, informed Cassiano dal Pozzo in Rome of her need to put together a dowry:

> La confidenza, che ho sempre tenuta nella gentilezza di V. S., e l'occasione urgente ch'ora mi sia rappresenta di collocar mia figlia in matrimonio, mi spingono di ricorrere alla sua benignità, e per aiuto e per consiglio. . . . Sig. mio, per concludere e perfezionare questo matrimonio, mi manca qualche poca somma di danari. . . . e l'assicuro che, scaricatami del peso di questa figliuola, voglio subito venirmene a cotesta volta per godermi della patria, e servirgli amici e padroni.

In a follow-up letter to Cassiano on November 24, Gentileschi again mentioned the hoped-for marriage of her daughter: "Resta solo ch'ella s'adopri, come ne la prego, a favorirmi quanto può, acciò col suo mezzo potessi io sentire, come spero, questo così grande utile, e quiete, com'è il collocare questa figlia quanto prima, e sbrigata poi venirmene, come già dissi, a godermi della patria, e servir gli amici e padroni."

As Garrard, Contini, and Cropper have also recognized, the daughter thus proposed for marriage in 1636 cannot have been other than the eighteen-year-old Palmira/Prudentia, the only child of Artemisia and Pierantonio still alive in 1626. Significantly, Gentileschi's correspondence of October 24, 1637, ends with a request that Cassiano inform her if her husband were still living: "Sia servita darmi nuova della vita o morte di mio marito." Obviously Artemisia believed that Pierantonio's responsibility for their daughter should extend to her dowry.

There is a gap in the documents, this time for more than eleven years, before a daughter of Artemisia's is again recorded. In a letter of March 13, 1649, to Don Antonio Ruffo in Messina, the artist promised to send her Sicilian patron a *Self-Portrait* "together with some small work by my daughter, whom I married today to a Knight of the Order of St. James": "Quanto prima manderò il mio ritratto insieme qualche operetta dalla s.ra figlia la quale hoggi l'ho maritata con un Cavalier dell'Abito di San Giacomo, et mi ha scasato. . . ." What is one to make of this? Did Artemisia mean by "et mi ha scasato" that she had relinquished her living quarters to the newlyweds, and is that why she ended this correspondence with instructions to Don Antonio that subsequent letters to her be sent in care of a Sr. Tommaso Guaragna ("Le lettere

che mi favorirà le mandai sotto nome del S.ᵣ Tomaso Guaragna")? Had the provision of a dowry bankrupted her? Surely, as Garrard and I have written, it is unlikely that Palmira/Prudentia, primed for marriage in 1636 and 1637, would still be single at the age of thirty-one in 1649! Could the ceremony of March 13, 1649, have been the second wedding for Palmira, her first husband having died, and is that why Artemisia refers to her daughter as "s.ra figlia"? Yet would Gentileschi have been obligated in this instance to provide a dowry?

The only other explanation, of course, is that Artemisia had had another daughter, whom she also trained as a painter. This possibility is held out, as Garrard and I have supposed, by the fact that in her note to Andrea Cioli on April 1, 1636, Artemisia spoke of "una mia figliuola," translatable as either "a daughter of mine" or "one of my daughters." If, for the moment at least, the notion of another daughter is entertained (as it is also by Merkel and Lapierre), one is confronted with the questions as to when she was born and by what father. These are legitimate enquiries with possible implications for separating autograph paintings by Artemisia from closely related pictures by her daughter or daughters, and are thus entered into here even at the risk of amusing those who are titillated by such things.

Pierantonio Stiattesi had left or been ousted from the family by the spring of 1623, and by 1637 Artemisia had lost track of him. There is little reason to assume that at some point between these dates he had returned, if only for a brief time. Since no other child appears in the census of Santa Maria del Popolo up to 1626, and none in that parish's baptismal books covering the entire third decade, the supposed second daughter would have to have been born in Naples no earlier than about 1630 (and thus would have been nineteen in 1649). By Church law Artemisia could not have divorced Stiattesi and remarried. In letters to Cassiano dal Pozzo of August 31 and December 21, 1630, Gentileschi mentions a "chierico Diego Campanili" who was living in her house:

> Mi occorre supplicar V.S. illustriss. che voglia restar servita scrivere a monsignor Herrera Nunzio qua in Napoli, ma di buona forma per la licenza di poter portar l'armi al chierico Diego Campanili, chè, per esser tutto di casa mia per interesse mio proprio, resterò contentissima di tal favore.

And:

> Nel mio ritorno in Napoli [after painting a portrait of a Duchess, [L-64]] . . . ho ricevuta la gentilissima di V. S., alligatavi l'altra diretta a quest monsignore Nunzio. Le rendo ora quelle grazie che dovero far prima se fossi stata qui all'arrivo di quella, pregandola ad ammetter la mia scusa per legittima. Il successo non l'avviso, perchè il sig. Diego Campanile si ritrova ammalato con grandissimo pericolo di sua vita, e perciò non è stata presentata.

The reader will judge whether Artemisia's account of her relationship with Diego is merely unclear or, per Alfred Moir, "rather equivocal."

A more likely candidate for the father of Artemisia's presumed second daughter is Francesco Maria Maringhi. Concluding her letter to Galileo of October 9, 1635, Gentileschi stipulated that any response from him should be addressed in care of Maringhi: "Se V. S. si compiacerà rispondermi, resterà servita scrivermi sotto la cuperta del S.ᵣ Francesco Maria Maringhi." Fifteen years earlier and in Florence this same man, undoubtedly, had on February 15, 1620 (New Style), guaranteed the timely completion of Gentileschi's *Hercules* (see [L-39] for details) or to

pay the artist's outstanding debts to the Medici himself. Garrard suggests only that Maringhi, who in fact had overseen the Medici *Guardaroba* at the Palazzo Pitti, may have been "Artemisia's clerical assistant, or perhaps a close friend." Finally, Lapierre supposes that the father of a woman married to a Knight of St. James must have been highly placed, and considers the Duque de Alcalá as a possible candidate.

Much of this must for the time being remain speculative. No daughter of Artemisia's is cited in the *Libro II dei Matrimoni, 1633–1668* or in the Index, beginning with the year 1635, of the death registers of San Liborio della Carità, the Neapolitan parish in which Gentileschi may have lived (see Chapter 5). And without the name(s) of the husband(s) of the daughter(s) one cannot reasonably approach the marriage records in the Archivio Diocesano (Archivescovile) at Naples.

The following conclusions seem to be admissible, however: at least four children had been born to the Stiattesi by late 1618, but by the spring of 1621 only their daughter Prudentia (also called Palmira), born in Florence in 1617, survived; this daughter was trained as a painter by her mother, and prepared for marriage by 1635; and another daughter, also to be instructed into art, may have been born in Naples about 1630 and married on March 13, 1649.

BIBLIOGRAPHY. Rome, AV, *Liber Baptizatorum: 1590–1603*, S. Lorenzo in Lucina, VII, fol. 78 no. 157; Florence, AOD, Registri di Battesimo, *Maschi*, 1612–13 [September 1613], fol. 108v, 1614–15 [November 1615], fol. 74, and *Femmine*, 1616–17 [August 1617], fol. 59v, 1618–19 [October 1618], fol. 29v; Rome, AV, *Status Animarum*, LXIV, fol. 9 (1621), *Status Animarum ab Anno 1622 usque ad 1649*, LXV, fols. 20 (1622), 11 (1623), 11v (1624), 27v (1625), 6 (1626), *Liber V Baptizatorum: 1620–1639*, fol. 52v (1626) S. Maria del Popolo; Rome, AV, *Libro de'Matrimoni II: 1607–1630*, S. Spirito in Saxia, XVII, fol. 17; Florence, Archivio Buonarroti, MS 103, fols. 67, 68v, and MS. 101–4[A], fol. 32; Florence, AS, Guardaroba Mediceo 390, inserto 5, fol. 455 (formerly fol. 293), and Mediceo 998, fol. 204; Bottari/Ticozzi, 1822, I, pp. 349-54, letters CXXXVIII–IX, CXLI–II; Galilei, ed. 1905, XVI, pp. 318–19; Ruffo, 1916, pp. 48–49; Crinò, 1954, pp. 205–6; Crinò, "More Letters," 1960, p. 264, from Florence, AS, Mediceo 1416, inserto 8, fol. 780, inserto 9, fol. 860, and inserto 10, fol. 892; Moir, 1967, I, p. 100 n. 109; Procacci, 1967, pp. 13, 34 n. 22; Bissell, 1968, pp. 157 n. 42, 158 n. 49; Vliegenthart, 1976, pp. 171–72 n. 748; Bousquet, 1978, p. 106; Menzio, 1981, p. 52; Garrard, 1989, pp. 384 n. 28, 391, 418, 496 n. 41; Contini in Contini/Papi, 1991, pp. 72–73, 127, 183; Papi, ibid., p. 61 n. 74; Berti, ibid., p. 13; Merkel, 1992, p. 346; Cropper, 1992, pp. 203, 207; Cropper, 1993, pp. 760–61, incl. nn. 2, 6, 12–14, 25; Lapierre, 1998, pp. 374, 472, 476–77. For quick reference, see Appendix I under the dates of the many documents cited above.

APPENDIX III

Supplemental Documentation

The texts collected below contribute variously to our understanding of Artemisia Gentileschi's business negotiations and to how she and her pictures were received during the artist's lifetime and shortly thereafter. Thus they are worthy additions to the seventeenth-century literary material brought together in Mary Garrard's *Artemisia Gentileschi: The Image of the Female Hero in Italian Baroque Art* of 1989. Except for the letter to the Grand Duke of Tuscany, which appeared after the publication of Garrard's monograph, these texts are relatively inaccessible.

Item A, Gentileschi's letter of July 20, 1635 from Naples to Ferdinando II de'Medici in Florence, testifies to the intricacy of her patronage network, the painter working to balance loyalties and obligations while seeking to establish the most financially advantageous position. It also clarifies the circumstances under which Artemisia was invited to London by Charles I, complements other documents concerning her dealings with Ferdinando II, Francesco I d'Este of Modena, Cassiano dal Pozzo and the Barberini, the Conde de Monterrey (Viceroy of Naples) and, through him, with Philip IV of Spain. And it has proved central in refining the dating of the Saint John the Baptist cycle for the Buen Retiro at Madrid, to which Artemisia contributed. Discussion of this correspondence throughout the present study (Chapter 4, Appendix II, and [32]) underscores its importance.

The letters and verses gathered under B, C, and D laud Artemisia Gentileschi's physical beauty and her mind and pictures. While fleshing out the historical record, these flowery and intentionally demanding encomia tend to divert attention from the true nature of Artemisia's artistic achievement. From a modern point of view, their male authors had their priorities misplaced, and on balance did not render great service to the artist. This material is reviewed in Chapter 3 in the wider context of seventeenth-century fascination with Gentileschi's person and paintings.

The intimate letters from Gianfrancesco Loredan (1606–61) to Artemisia (Item B) are undated, but in all probability were composed during Gentileschi's stay in Venice in 1627–28, at which time Loredan, then in his early twenties, had obviously become hopelessly enamored of the painter. It was also at this moment—see [L-1] for a brief biography—that Gianfrancesco had begun rising to prominence on the Venetian literary and social scenes and, in my opinion, authored poetry dedicated to works by Artemisia in the city ([L-1], [L-54], [L-105]), including perhaps in his own collection.

A prolific author of secular and sacred verse in the tradition of Giambattista Marino's *lirica concettista*, Giovanni Canale (for whom see C. Mutini in *Dizionario biografico degli Italiani*, Rome, 1974, XVII, pp. 690–91) exercised the profession of notary, first in Naples and then for a considerable period in Abruzzo, where (for reasons now unclear) he became an exile sometime after the revolt of Masaniello in 1647. Among the friends to whom in writing he lamented this expatriation was Tomasso Gaudiosi, who in his *Arpa poetica* of 1671 (Item D) praised Canale's literary efforts on behalf of Artemisia Gentileschi (Item C). These latter, then, must have been included in Giovanni's *Poesie* issued in 1667 and then republished as part of an expanded anthology in 1694 (from which the verses here reproduced are taken), after the poet's return to the Neapolitan area, where he died about 1722.

A. LETTER FROM ARTEMISIA GENTILESCHI IN NAPLES TO GRAND DUKE FERDINANDO DE'MEDICI IN FLORENCE, JULY 20, 1635

[Published by Roberto Fuda, "Un'inedita lettera di Artemisia Gentileschi a Ferdinando II de'Medici," *Rivista d'arte*, XLI (1989), 170–71, as from Florence, Archivio di Stato, Mediceo del Principato 4157, c. 194–94v]

Altezza Serenissima,
fu destra ventura la venuta di mio fratello, mandato con dui quadri per mio padre per presentare a V.A.S.ma; et poi, per ordine suo, di doveva il detto mio fratello trasferirsi in Napoli per condurmi al servitio di Sua Maestà d'Inchilterra, che molte volte prima mi haveva richiesto a quel servitio et inviato l'istesso mio fratello; ma perché mi trovavo in Napoli al servitio di questo viceré, per dar fine ad alchune opere cominigiate per S.M. Cattolica, non potei in nessuna maniera contentare la Maestà d'Inchilterra. E perché di Napoli detto re fu informato come ero alle fine delle dette opere, con la congentura che si trovava il detto mio fratello, li diedi ordine che mi dovesse condurre al suo servitio. Però, havanti che fare passaggio in quelle parti, mi accinsi operare in servitio di V.A.S.ma le presente opere, doppo havermi affaticato per servitio del signor duca di Parma et di Modena e del signor cardinale Barbarino. Come dalle lettere che tengono l'istessi mie fratelli V.A.S.ma potrà vedere, ho lasciato per ultimo complimento della mia gloria l'A.V.S.ma, per poter, con tutto quel riposo e contento del'animo mio, dipingere le presente opere, acciò come serva antica della felice memoria del granduca Cosimo, Suo padre, e come debetrice di tante gratie et favori da quella Altezza recevute, mi è parso confirmare con V.A.S.ma l'istessa servitù con dedicarli le presente opere, le quali invio reverenti alli piedi di V.A.S.ma con grandissimo gusto del signor viceré, mio signore, che le vidde, et gustò che io havesse inpiegato in V.A.S.ma queste poche pennellate, non apportando scusa a li difetti del mio pennello, appagandomi del Suo finissimo giuditio, che, con occhio purgato, non può fallire

nel giudicare, scusando l'ardire di me, che come sua serva à, imitatrice di mio padre, come dalla favoritissima [favoritissima?] lettera e regalo con che V.A.S.ma si degnò honorarlo, che tutto tengo appresso di me, ché per ancora il detto mio padre non ha potuto godere tanto honore per non essere il detto mio fratello passato in quelle parti, spettando la comodità della mia partenza. Come anco sto spettando una lettera della S.ma duchessa di Savoia, che mi ha promesso inviarmi acciò possa camminare senza inpedimento per la Frangia, havendo ordinato all'istessi miei fratelli che arrivino sino a Turino per ottenere la detta lettera et passaporto. Perciò supplico reverentemente V.A.S.ma che voglia agradire il mio puro affetto et connumerarmi nel numero delle più infime serve, ché nel medesimo tempo pregarò Sua Divina Maestà per il colmo di ogni Sua grandezza.

Napoli, lì 20 luglio 1635
Di V.A.S.ma
Umilissima et obligatissima serva
Artimisia Gientileschi

B. LETTERS FROM GIANFRANCESCO LOREDAN (1606–1661) TO ARTEMISIA GENTILESCHI CIRCA 1627–1628

[Published by N. Ivanoff, "Gian Francesco Loredan e l'ambiente artistico a Venezia nel seicento," *Ateneo veneto*, III, N.S. (1965), 189–90, as they appear in *Lettere del Signor Francesco Loredan*, I, decimo impressione, Venezia, 1673, pp. 262, 466]

(1) p. 189 (262):

Alla Sig. Artemisia Gentileschi. Padoa.

Le cose, che si fanno in fretta, riescono di rado con lode. I parti dell'ingegno si rassomigliano a quelli dell'Orsa: bisogna lambirli ben bene, chi vuole, che non riescano aborti. Havendo pensato un poco sopra i Quadernari, che composi hieri alla presenza di V. S. ho regolato il terzo in questa maniera.

> Queste pompe superbe, e d'ostro, e d'oro
> D'un fugace piacer vano ornamento,
> Io ridono la Terra, e vò contento
> Che la gratia del Ciel sia il mio tesoro.

Se le sono riuscito cattiva Poeta, sappia però, che le sarò buon servitore, e le bacio le mani.

(2) pp. 189–90 (466):

Alla Sig. Artemisia Gentileschi, San Fantino

Vorrei, o Artemisia, con la semplice dichiarazione di questa penna publicar il vassallaggio, che deve all'ampiezza de'tuoi meriti l'humilità del mio cuore; ma temo che la sublimità de'tuoi pensieri sdegnando la bassezza delle mie offerte non disperda i miei desideri nel demerito, e nella confusione. Ogni vapore, ch'esce dalle viscere della terra non diviene ornamento del Cielo. Le gratie non accompagnano sempre i voti.

Confido però nella gentilezza della tua anima, che ambisce purità di devotione, non ricchezza di vittime, che gradirà l'oblatione della mia servitù, dovitiosa de'meriti del tuo nome. Anche le Comete sono semplice esalationi, e pure della benignità del calore del Sole si cangiano in lumi del Cielo.

Dubitarei, che la mia debolezza tendesse a gli eccessi, se non conoscessi, che non ammette eccessi d'amore una bellezza sorahumana. Temeri, che 'l senso non mi allucinasse la ragione nel prorompere 'in soverchia tenerezza d'affetto, se non mi sovenisse, che 'l mio cuor è assoggettito da maggior potenza, che dalla bellezza del tuo volto.

Quella forma, che finalmente tiranneggiata dalla forza del tempo, non ha fiore, che non si secchi, non m'alletta solamente il desiderio, idolatro ancora quel bello, che trionfa del tempo, e ch'è riserbato illeso dalla corruttione de gl'anni, ritrovandosi fuori delle giurisdittioni della morte.

Ogni cosa è possibile alla volontà humana: ma nella proportione d'un bel volto, e nella perfettione d'un bell'animo perde tutti i privilegij della sua autorità l'abitrio libero della volontà dell'huomo. È dunque debito, non elettione l'affetto, che io ti porto. Perché eccedendo il tuo merito ogni conditione ordinaria, debbono tutti i cuori sagrificarsi alla tua virtù, ed esser vittime delle tue compiacenze.

Mi sento lusingar da un prorito di nobilitar la mia penna col soggetto delle tue lodi; ma volendo celebrarti tacci, e t'ammiro. I grandi encomi pigliano la meraviglia, che non sa, se non riverir col silentio. È ordinario quel merito, che si può celebrar con la lingua. Col Deto alla veneravano il Sole gli Antichi.

E poi la lingua non ha parole degne per inalzare i tuoi pregi. Perché non dirò, che sei Donna, per non recar pregiudicio alla vitalità de'tuoi pensieri. Non dirò, che sei Dea, accioche non chiami assentatrice la sincerità della mia voce. Non dirò, che sei bella, per non accomunarti i pregi d'ogni semplice dona. Non dirò, che mi formi miracoli col penello, per non gli defraudare le glorie. Non dirò che partorisci meraviglie con la lingua; perché tu sola sei degna di celebrarle. Dirò solamente, che la singolarità della tua virtù necessita il mio ingegno ad inventare nuovi vocaboli degni della grandezza delle tue doti, et espressivi della mia divotione.

Chiamo soavità le mie fiamme, libertà le catene; delicie i miei affanni; consolationi le mie pene; Paradiso il mio Inferno. Poiché la tua bellezza infiamma, non consuma: annoda, ma non stringe: sollecita, ma non tormenta: affligge, ma non eccede: affanna, ma non dispera. Anzi contraria alla violenza della tirannide, caccia, ma diletta: opprime, ma consola: addolora, ma rallegra: annoda, ma con dolcezza: accende, ma non consuma. Fuoco dunque soave, lacci graditi, affanni, incontrati, dolori richiesti, Inferni bramati.

Questo solo rende disperata la consecutione de i miei desideri nel vedere, che né per merito di Natura, né per concessione di Fortuna mi posso rendere degno possessore della tua bellezza, che supera la cupidità di quel cuore, che non mira solamente con gli occhi. Le ricchezze d'Amore non hanno altro trafico, che nel tuo seno, ne' tuoi occhi, e nelle tue chiome. Chi ambisce i tuoi tesori inchini il suo volto, adori il tuo bello.

Ma non vorrei, che l'humilità di queste voci introducesse il mio animo ad altra contemplatione. Di Vittime, e d'Incensi si rendono degne le tue prerogative, che sono il trono della maraviglia. Le parole scemano i pregi. Proprio sagrificio alla singolarità del tuo volto dee essere il cuore, non la lingua.

C. VERSES OF GIOVANNI CANALE TO ARTEMISIA GENTILESCHI. FIRST PUBLISHED IN NAPLES IN 1667 AND REPRINTED IN NAPLES IN 1694

[Giovanni Canale, *Poesie del Sig.. Giovanni Canale divise in Murali, Varie, Eroiche, Di Lode, Funebri, Sagre,* al Em.mo e Rev.mo Principe il signor cardinale P. Vincenzo Maria Orsini, per li Socii Dom. Ant. Parrino e Michele Luigi Mutii, Napoli, 1694, p. 67 (under *Poesie Varie*) and p. 465 ff. (under *Poesie Funebri*)—copy in Florence, Biblioteca Nazionale 3F5.202. Cited by Don Fastidio, "Poeti ed artisti," *Napoli nobilissima,* VI, fasc. VII (1897), 110]

(Poesie Varie)
Alla Signora Artimisia Gentileschi
 Pittrice Famosissima.
Per uno Apollo con la Lira senz'Arco
 donato al Sig. Girolamo Fontanella.

Lasciato il Cielo, e il Pierio Coro
 Della bella Artimisia or fatto amante
Il biondo Nume, il vago Dio canoro
 Trae per farla armonia Lira Sonante.
Stupido Spettator del bel Sembiante,
 Cedo al pennello tuo l'Arco sonoro
Disse, e à ingrandir le tue grandezze tante
 Mia Lira è roca, e col tacer t'onoro.
All'or la man Gentil trasse, e dipinse
 Immoto sì l'armonioso Divo,
 Ch'emulò la Natura, e l'Arte vinse.
Non odi 'l suon, perche dell'Arco è privo;
 Ma così vivo in tela ella lo finse,
 Che 'n dubbio stassi s'è dipinto, ò vivo.

Alla detta per la Bellezza, e per la Pittura.
Mostri d'alta Beltà nel tuo bel Viso,
 E gli Amor stessi innamorati io scemo.
 Scopri in picciolo Spazio un Paradiso,
 Ch'allegra il Mondo, e illustra il cieco Inferno.
Dell'Arte un gran miracolo superno
 Veggio ne'tuoi colori e immoto, e fiso
 Torno per gli occhi vaghi al lume interno,
 Mi credo in Ciel fr à quella Idee diviso.
Chi lo stupor, che 'n tè stupisce or vede,
 Scesa fr à Noi dal Regno delle Stelle
 Sotte spoglia mortale Angel ti crede.
Del Ciel, nel Volto hai le sembianze bella;
 Forme Celesti pingi; onde ti cede
 Venere al Volto, e alla Pittura Apelle.

(Poesie Funebri)
Alla Signora
Artemisia Gentileschi
Pittrice famosa.
Per la Morte del Sig. Cavaliere fra Gio: Battista Donati
 ODA XXXIX
Tu, che col dolce sguardo anco dipingi
 Vivo Pennello a tuoi divoti cori
 Il bel sembiante, ond'innamori, e fingi
 D'allettar gli occhi, e porgi all'alme ardori.
Di te stessa non men Pittrice industre,
 Ma chiara ad animar cose insensate
 L'alata Dea spande il tuo nome illustre,
 In cui non può divoratrice etate.
Non saprei dir, s'a tua maestra mano
 Cedon gli occhi Pittori, ò se mi lice
 Creder, ch'a i lumi tuoi, vanto sovrano
 Porga; e s'inchini la tua man pittrice.
Se quanto bella sei, tanto famosa
 Artemisia gentil ti loda il Mondo,
 Prenda, deh, prego la tua ma pietosa
 De'sublimi Pennelli il lieve pondo,
Ma pria, che ne color gli adopri il pianto
 Stagna negli Occhi, e 'l tristo umor cadente,
 Che riversi dal core, or vaglio intanto
 I colori à stemprar bella, e dolente.
D'Apollo il lume, et il valor di Marte,
 Ch'estinto piangi, e 'l suo morto destino
 Poscia ritraggi, or ch'io lo pingo in carte
 Dandoli nuova vita in nobil Lino.
Non di forte Cimier, cui Piuma altera
 Insuperbisca habbia la Fronte grave,
 Nè al manco lato stria spada guerriera,
 Che teme il Trace, e 'l Belga, e 'l Franco pave.
Ma d'Alloro pregiato il verde eterno
 A cui non puote il Tempo, e cede or vinto
 Di fortuna, e d'Invidia illustre scherno
 Alla Fronte verdeggi intorno cinto.

Soave Plettro, che dolcezza spira
　　Tratti la Destra armoniosa, e forte,
　　E al fianco arcata la sonora Lira
　　Rapisca l'Alme dalla man di Morte.
L'Abitatrici Vergini d'Elicona
　　Formin co i Versi suoi nuovi Concenti,
　　E 'n torno à lui vaghissimo Corona
　　Risuonando Donati in aria i Venti.
Ei con musico stile in aurei Fogli
　　Espresse tua beltà Pittor canoro;
　　Muto Poeta or tu l'imprimi, e accogli
　　In Tela con mirabile lavoro.
Quindi ne' tuoi color fatto immortale
　　Livor d'infedeltrade, e ingiusto oltraggio,
　　Se pria l'infidiar la spogli frale
　　Non potranno adombrargli il vivo raggio.

　　Dal tuo saggio Pennello egli rinato
　　Non havrà più dal Tempo ingiuria, e offesa,
　　E 'l tuo Nome con suo nel Cielo alzato
　　Renderà Morta d'alta invidia accesa.

D. VERSE FROM THE "ARPA POETICA" OF TOMMASO GAUDIOSI, NAPLES, 1671

[Published by Don Fastidio, "Notizie d'artisti," *Napoli nobilissima*, VII, fasc. 1 (1898), 16]

Al signor Gio. Canale per le lodi a Artemisia Gentileschi bellissima Dipintrice
Si ben descrive il tuo purgato inchiostro,
　　Delle pitture altrui Pittor sovrano
　　Artemisia, stupor del secol nostro
　　Che la mira presente occhio lontano.
E dal volto gentil l'avorio, e l'ostro,
　　E l'ingegno Divino in corpo humano,
　　Fan dubbio altrui, se quel leggiardo mostro
　　Con l'aspetto prevaglia, ò con la mano.
E non parvi, per Dio, dice Natura,
　　Questa, in cui tutte son le gratie sparte,
　　Dipintrice dal Ciel, del Ciel Pittura?
Anzi'l suo caro stil soggiunge l'Arte,
　　Alla fabbra del mondo il pregio fura:
　　Tanta forza, Canale, han le tue carte!

APPENDIX IV

Amber Varnish and the Technique of the Gentileschi

by Melville Holmes

The paintings of Orazio and Artemisia Gentileschi potentially offer a rare window into the practice of seventeenth-century oil painting. That is because they are the subjects of one of the few references to the materials used by identified artists to gain their effects to be found in a reliable contemporary source: namely, the manuscript of Sir Theodore Turquet de Mayerne which is at the core of this study.[1] The reported use by the Gentileschi of amber varnish in their painting process tends to support the thesis advanced by Sir Charles Eastlake in his *Materials for a History of Oil Painting*,[2] recently called "the first systematic study of the technology of art in England,"[3] and, if substantiated, would speak with authority into what became a protracted and still unresolved debate. The following pages attempt to examine the links between the documentary sources and what can be determined of the truth of the actual practices of the Gentileschi. Some preliminary remarks may be useful, however, in placing the subject in historical perspective.

Historical Perspective

Historically a certain mystery has surrounded the material used by seventeenth-century and earlier artists to achieve their painterly effects, witnessed by the persistent concept of "the secrets of the Old Masters." The idea that the perfection of technique

visible in their masterworks was made possible through the use of a particular medium, the formula for which has been lost, can be traced back to the eighteenth century[4] and may be followed right on through into our own times.[5] Contrary to this extreme position—that the excellence of the earlier technique was owed to specially kept secrets, handed down from master to selected students—is the more prosaic view, namely that what one has been tempted to look for as an almost alchemical secret is nothing other than the skilled application of common sense to very ordinary, well-known materials. The opinion that the search for secrets is a kind of fool's errand seems to have accompanied those dedicated to the quest, as a voice of warning, all the way along,[6] and is the prevailing attitude today. Between the extremes of seeking an artistic philosophers' stone and overzealous debunking, there remains the fact that, while there may not have been the closely guarded secrecy imagined by some (although surely some artists would likely have been individually secretive, if they thought they had a unique method), a good deal of uncertainty remains as to how artists during the Golden Age materially attained their fluid virtuosity.

This is not to deny the considerable light that has come through recent scientific analysis. The historical use of pigments is both well documented and scientifically supported, especially insofar as most "Old Master" colors are essentially stable, inorganic compounds, identifiable through straightforward spectral analysis. The mystery, though, was never to do with pigments as much as with the vehicle that binds the pigments together and exhibits the special flow and optical properties seen in the most admired works; and binders for oil paintings are organic compounds, not always so stable, requiring more subtle tools and more ingenuity on the part of the researcher, as will be discussed below.

It is the vehicle, the binding medium, that determines the tactile, working properties of the paint. This, in turn, is not independent of the pigments, for each of them possesses different properties. Some require more oil, some less, to make a brushable paint. They dry at different rates, with some, such as carbon black and madder lake, drying extremely slowly. Some combine readily with oil, while others are reluctant to stay in suspension, in storage, or even on the canvas, leading to what Mayerne called "la mort des couleurs," the oil floating on the surface forming a darkened skin.[7] The potential need of the artist/craftsman to modify the vehicle to suit the pigment suggests not one medium but possibly many. Here we are faced with something of the complexity of the analytical task and are confronted by a fundamental hurdle.

To those accustomed to ready-made materials for the do-it-yourselfer, the technical world of the artist of the Baroque period is not readily comprehensible. The painter of that time was required to balance and compensate for a considerable number of factors in order to gain satisfactory results or, one might say, in order to paint in oils at all. However one may assign primary causation for it, a gradual increase in commercial preparation of artists' materials, outside the studio, worked together with the unbalanced notion that the craft of art is so inferior to the expressive and philosophical content as to be separable from it, to replace the workshop with the academy, ending with the alienation of the artist from his or her materials.

Even before the nineteenth century had fully dawned, the methods and materials of the "Old Masters" had become the subject of earnest inquiry instead of an ongoing tradition, a somewhat paradoxical situation in that there had as yet been no corresponding rift in basic pictorial aims. Sir Joshua Reynolds, whose own pictures are known among conservators for their frequently poor craftsmanship, is recorded to have scraped down old paintings layer by

layer in hope of discovering the secrets of their manufacture.[8] The last century is slightly notorious for the rapid deterioration of works skillfully executed by artists who, at first, seem to have regained the tradition. Otherwise intelligent painters were unable to resist the seductive appeal of megilp, a gel medium made of linseed oil heated with lead driers and mastic resin dissolved in turpentine which, it is universally agreed, imparted a marvelous ease of working when added to ordinary oil colors, but which in its documented use is associated with premature cracking,[9] not generally found in the seventeenth-century pictures the later works may superficially resemble.

Similar warnings against undue reliance upon the feel and imitative properties of alleged Old Master media appear in our own century. The insightful and knowledgeable Max Doerner advised his students to add soft resins (mastic or dammar) and balsams (i.e., Venice turpentine) to their paint in order to attain the enamel smoothness of blending seen in seventeenth-century Dutch paintings. Yet his counsel proceeded upon no other solid basis than that it seemed certain to him that the old artists must have done so. Doerner described a copy after Rachel Ruysch by a student following his method that appeared to him "as if cast from a mold."[10] Solubility tests carried out in 1962 by the restorer Helmut Ruhemann, on paintings created by Doerner's students between 1936 and 1940 using those materials, revealed paint films more easily soluble than the varnish (i.e., paintings that cannot be cleaned).[11] If seventeenth-century painters had used those resins as prescribed, their pictures would be expected to exhibit the same defect, which they generally do not, as attested by the same restorer[12] and corroborated by the experience of conservators with whom the present author has conferred. Clearly this is a journey fraught with perils for the unwary, if one is led to trust intuitive conjecture without sound evidence.

One more recent example will serve to emphasize the need for accurate scholarship. The infamous Maroger medium (the ingredients of which are strikingly similar to those of megil), was heralded by its discoverer/inventor as the lost secret recovered at last, claiming to be derived directly from Van Dyck via the Mayerne manuscript.[13] Once again, results closely resemble some of those from the seventeenth century, but the direct link is erroneous. The distinguished former director of the laboratory of the Louvre neglected to be certain that he had a primary source. A series of errors led to the misattribution to Mayerne of a manuscript of uncertain provenance that turned up at auction in 1845.[14] Maroger had, however, the right general idea. What is wanted is a reliable contemporary source that describes the materials used in the practice of an identified artist. Judicious examination of the state of that artist's paintings, with the help of available methods of scientific analysis, would then permit the formation of reasonable and sound conclusions.

The application of this approach to Mayerne's references to Orazio and Artemisia Gentileschi does not pretend to propose something new, but rather seeks to follow through with a line of reasoning begun much earlier. When in 1847 Sir Charles Eastlake published his *Materials for a History of Oil Painting*, the goal, as stated in his preface, was "to trace the recorded practice of oil painting from its invention; and, by comparison of authentic traditions with existing works, to point out some of the causes of that durability for which the earlier examples of art are remarkable."[15] Without recourse to analytical chemistry, which was not yet ready to help in determining media components of old paintings, Eastlake sought to discover the "authentic traditions" and the basis of sound practice by careful organization and thoughtful analysis of available literary evidence, including previously unpublished material. His central thesis

was that the origin of oil painting as we know it, which supposedly derived from the remarkable invention of Jan Van Eyck, was not a matter of grinding pigments in a drying oil, which practice is recorded in earlier medieval manuscripts,[16] but rather of the addition of a varnish made with a natural resin, most notably amber, which imparted a new brilliance, rapidity of drying, and durability to colors ground in oil, and enabled the paint to flow and blend beautifully.[17]

This idea—that the painterly effects of the Old Masters were achieved in large measure with an oleo-resinous vehicle—became the generally accepted theory, finding its way into artists' manuals up to our own time. Diversity of opinion has centered largely around what kind of varnish to add for a glazing medium or to alter the paint's consistency, whether it should be a "boiled" oil varnish made with a "hard" resin, such as fossil amber (from trees now extinct), or a semi-fossil copal (from dead trees of existing species), or a spirit varnish, made by simply dissolving one of the "soft" resins, such as mastic or dammar, in a volatile solvent like turpentine (which class would also include the balsams, liquid exudations from trees that are a kind of natural spirit varnish; e.g., Venice turpentine).[18]

Some of the difficulties of the application of chemical analysis to the historical use of resins in paint media will be mentioned below. So far, evidence of anything approaching universal reliance on resins has not come forward, although recent reports have indicated the use of a small amount of mastic in the technique of Sir Peter Lely[19] and of amber by Ferdinand Bol, a member of Rembrandt's circle, also noted below. Common pine resin (rosin or colophony), which is always thought to make an inferior varnish[20] and does not appear in formulas designed to imitate those of the Old Masters, has reportedly been found in a number of seventeenth-century paintings.[21]

Perhaps the weakest link in Eastlake's overall argument is his heavy reliance on the account of Giorgio Vasari (1511–74) concerning the invention of oil painting by Van Eyck, notwithstanding his insightful exegesis of the implications of Vasari's text. The link between the early Flemish painter and the Late Renaissance biographer is too attenuated for the latter's description of the former's technical discoveries to be taken as anything more than, at most, the definitive version of the legend of the advent of oil painting. But although sufficient evidence has not appeared to support the claim that the foundation of early Flemish technique, of which later methods were thought to be variations, involved the addition of varnish, Eastlake's brilliant linguistic study of resin terminology, his consistent reasonableness with the material available to him, his breadth of scope, and the quality of other sources adduced by him ensure his work the position of a landmark of scholarship in the field.

References in the Mayerne Manuscript

Undoubtedly the most valuable source for seventeenth-century painting methods and materials, rescued from obscurity by Eastlake, is the manuscript in the British Museum Library entitled *Pictoria Sculptoria & quae subalternarum artium*,[22] commonly known as the Mayerne MS after its author, Sir Theodore Turquet de Mayerne (1573–1655), renowned physician to kings both of France and England, chemist, and amateur of the technical aspects of the arts. Unpublished during his lifetime, the manuscript is a compilation of formulas and observations relevant to the fine and applied arts, consisting of 170 folios written either in the doctor's hand or in that of an assistant, mostly in French, but also in Latin, Italian, English, Dutch, and

German.[23] Of importance to us here are its offerings of rare insights into the technology of Baroque painting: the priming of canvas, procedures of painting, lists of pigments with their grinding requirements and applications, the refining of oils, the care of brushes, and varnish recipes of all kinds.

The manuscript is best known for its references to Rubens and Van Dyck, with whom the author was on familiar terms and from whom he was able to gain technical anecdotes for his collection. The physician made a practice of seeking out artists and craftsmen so as to record their methods, and it is this firsthand character of many of the entries that gives the document much of its value to the student, along with the overarching influence of the author's lively and inquisitive mind. His practical interest in chemistry led him to test many items himself, the results of which are found in the text and numerous marginal notes. (He seems to have recorded whatever came to his attention, later adding new insights, noting what he had personally observed or proved to be true or false, as part of an ongoing but never completed process of refinement.)

Mayerne had a special interest in amber varnish, listing a number of recipes and detailing his own experiments in making it. In this connection appears the mention of the Gentileschi, significant because it is possibly the unique, solid, contemporary reference that inclines to prove what had seemed obvious to Eastlake and many others after him: evidence of two "Old Masters" adding varnish to their paint to enhance its optical and working properties.[24]

Let us look at what Mayerne has to say. The first mention appears on folio 9 as an undated marginal note accompanying a definition of and remedies for "La mort des couleurs":

> Speculation. M. Gentileschy excellent peintre florentin adjouste sur la palette vne goutte seulement de Vernix d'Ambre venant de Venise, dont on vernit les luths, principalement à la charneure, & ce pour faire estendre le blanc & l'adoucir facilement & faire aussi qu'il seiche plus tost. Par ce moyen il trauaille quand il veult, sans attendre que les couleurs seichent tout à fait & le vernix quoy que rouge ne quaste point le blanc. Vidj.[25]

> (Observation [or speculation]. M. Gentileschi, excellent Florentine painter, adds on his palette a single drop of Amber Varnish coming from Venice, with which they varnish lutes, chiefly to the flesh areas, and this is to spread the white and soften it easily, and to make it dry sooner. By this means, he works when he wishes, without waiting for the colors to dry entirely. The varnish, although red, does not spoil the white. Vidi.)

Gentileschi's amber varnish is described in more detail on folio 146, at the end of a section treating the bleaching of linseed oil:

> Chés touts les vendeurs de couleurs en Italie on vend vne huile espaisse, qu'ils appellent Huile d'Ambre de Venise. Elle est fort trouble, mais ils ont vn artifice ou auec de briques pilées o auec de la crouste de pain, de l'esclaircir & blanchir. Ceste huile meslée sur la palette auec les couleurs desja broyées à l'ordinaire auec huyle de lin, ou de noix, les faict couler, empesche qu'elles n'entrent, & s'emboijuent,[26] & les rend lustres comme verre, d'vn esclat excellent. Je croy que c'est ceste huyle dont m'a parlé & se sert Gentileschj. Elle ne put point.[27]

> (At the shops of all the color sellers in Italy, they sell a thick oil that they call Amber Oil of Venice. It is strongly turbid, but they have an artifice, either with crushed bricks or

with bread crusts, to clarify and bleach it. This oil, mixed on the palette with the colors already ground as usual with linseed or walnut oil, makes them flow, prevents them from entering [TRANSLATOR's NOTE: the sense here seems to be that the colors do not bleed into one another] and sinking in, and renders them lustrous like glass, of an excellent brilliancy. I believe that this is the oil of which Gentileschi spoke to me and of which he makes use. It has no foul odor at all.)[28]

Finally, on folio 150, under the heading "Vernix d'Ambre," Mayerne explains that he is about to repeat a recipe already given earlier because it relates to a method used by painters in Italy of oiling the surface of the canvas prior to a new layer with a mixture of this varnish and walnut oil. The information was received from a Ms. Carlisle, "femme virtueuse qui peint très bien," who received it from M. Lanire, said to be an excellent musician who took pleasure in painting. The proportions are given for three parts nut oil to one of the varnish, and the method was said to be to coat lightly the underpainting ("les premieres couleurs, qu'on appelle les couleurs mortes") with the mixture, allowing it to dry before repainting. There follow instructions for making the varnish, after which Mayerne continues in this manner:

> Ce Vernix est fort rouge & est celuy des faiseurs de Luths. Ayant depuis moy mesmes demandé audict Mr. La Nire l'usage de ce Vernix, il m'a dit qu'il fault mesler deux parts d'huile de noix fort claire, auec vne part dudict Vernix d'Ambre, & les faire bien incorporer ensemble à un chaleur fort lente; que pour s'en seruir, il fault passer legerement vne esponge fort doulce imbeue dudict vernix sur les couleurs mortes & incontinent peindre dessus, que cela fait couler les couleurs, & faict qu'elles entremeslent parfaittement, de sort que quand la besoigne est seiche, en la refrottant du vernix le travail est aisé a quelque heure que l'on s'y mette. Il dit auoir appris cecy, & en auoir eu la recepte de Signora Artemisia fille de Gentileschj qui peint extremement bien, & de qui j'ay veu plusiers grands tableaux.[29]

(This varnish is strongly red and is that of lutemakers. Having since myself asked of said Mr. La Nire [Lanier] the use of this varnish, he told me that it is necessary to mix two parts of very clear walnut oil with one part of said Amber Varnish, and to combine them well over a very slow heat; that to make use of it is necessary to pass a very soft sponge imbued with said varnish over the dead colors and immediately paint over; that this makes the colors flow and intermix perfectly, so that when the piece of work is dry, in rubbing it again with the varnish the work is easy at whatever time one puts oneself to it. He said that he had learned this and had the recipe from Signora Artemisia, daughter of Gentileschi, who paints extremely well, and by whom I have seen several large pictures.)

It may be prudent at this point to pause momentarily to consider the degree to which what is reported by Mayerne may be relied upon. His overall sincerity should be obvious to anyone familiar with his text and aware of his distinguished medical career.[30] Regarding Orazio, we are told that the artist had spoken to the author about the varnish and that the latter had also seen it ("Vidi"), but there is a slight, hovering doubt for us in the word "speculation," a suggestion that, although it was clear that on occasion the artist mixed a thick oil/varnish with his paint, and how this material affected the colors, it was not altogether certain where it came from, although the doctor believed it was the "Huile d'Ambre de Venise." It is possible that

his personal familiarity with Gentileschi was not as great as with, say, Van Dyck, who agreed to try some of Mayerne's own varnish to mix with the colors "à la façon de celuy de Gentileschj,"[31] and that he never had the opportunity to question the Italian master deeply about the matter.

There is no mention of personal dealings with Signora Artemisia; his knowledge of her practices is strictly secondhand, derived from M. Lanier. What do we know of the latter and his connections with the Gentileschi? This was certainly the Nicholas Lanier, Master of the King's Music, whose exquisite portrait by Van Dyck is thought to have inspired Charles I to invite the artist to his court.[32] Ms. Carlisle seems to have misunderstood the proportions of varnish to oil used by Italian painters, and Mayerne turned directly to her source, Lanier, who gained his information from Artemisia. A marginal note dates these communications as occurring in 1634. Lanier is recorded to have had dealings with Artemisia's two brothers, Giulio and Francesco (who was also a painter) some years earlier. They were in Italy in 1627–28, having been sent there by the King, and found it necessary to seek money for their expenses through the agency of Lanier, who was then residing in Venice.[33] Documentation places Artemisia in that city at precisely the same time and, given Lanier's interest in painting and the fact that Artemisia did not come to England until 1638, it is probable that Lanier established acquaintanceship with Gentileschi and learned of her amber varnish in those years.[34]

The essential reliability of the sources thus established, an evaluation of the content of the text becomes the next task. There are two main aspects to our subject: the Amber Oil of Venice itself, and the uses to which it was put by the Gentileschi. With respect to the latter, we have the artists' own word to go by. There is less absolute certainty about the varnish. Starting with the fact that they used some thick varnish/oil medium, we are told by Mayerne that it was an amber varnish, for which he provides the recipe. Clearly, the proportions of oil to varnish were supplied by Artemisia. But what of the way the varnish was made and its ingredients? The recipe given on folio 150 is the same as that which appears on folio 43 under the title "Le vray vernix des luths & violes," which is said in the margin to have derived from an excellent lutemaker.[35] What connection there may have been between this and the product sold in Italy is not stated, nor is there sufficient evidence to link the Gentileschi with certainty to this specific varnish.

The nature of the varnish determines its potential usefulness. A consideration of its properties is distinguished from the question of the identity of the resin. Because we are provided with quite specific information about the performance of the varnish, a review of the artists' techniques with it may lead to insights into the possible combinations of materials that would yield these effects.

Amber Varnish in the Artists' Techniques

Two different techniques are ascribed to the Gentileschi. The father is said to have mixed a mere drop of the varnish directly with the colors on the palette (presumably to the quantity of paint anticipated for the passage before him), especially in the flesh areas. The handling property of the paint was improved, facilitating a smoother blending of the white. Its siccative property enabled him to work at his convenience, imparting sufficient hardness to permit overpainting, without lifting previous work, before thorough drying.

When we turn to the daughter's usage, we learn that her varnish/oil medium was not an

isolating layer, but was used for the procedure known as "oiling out," which served to blend the upper layers into what lay beneath, promoting both an aesthetic and a physical adhesion. Her method is said to be that of Italian painters generally. One is led to wonder if both artists used the varnish both ways, a question with implications as to the source of Artemisia's practical method and her essential, technical autonomy; but with this the text offers no further help. It is clear, however, that both techniques exploit the same properties of the varnish: its viscosity and its drying properties. Subtle gradation of blending was enhanced, whether by greasing the surface or by direct admixture with the paint. Added to plain oil or to ground colors, it seems to have imparted just the right resistance to flow and drying rate to serve the artist's pictorial demands and natural rhythms of labor and rest.

The list of qualities which Mayerne attributes to paint formed with the addition of so-called amber varnish defines something of a standard or ideal of what was desirable in the appearance of paint during this period, and marks some of the limitations of raw oil alone. Despite their film-forming properties, drying oils exhibit certain defects as paint films. The excessively slow drying with some pigments has been mentioned. Oil colors show a propensity to develop a dull, matte appearance through imbibing of the vehicle, whereby light scatters at the surface and colors lose their strength, commonly known as "sinking in," an effect that may not be uniform throughout the painting. Unmodified oil dries too slowly and remains too fluid for a good glazing or oiling-out medium, potentially allowing the work to slide down the canvas before it has had time to set, also wrinkling when used in excess; and unpigmented, raw oil yields an eventually dull coating of limited integrity. Addition of the varnish enabled the worker to overcome these liabilities. The luster became like glass, with an attractive surface gloss and increased color saturation. The paint would flow under the brush, but would not bleed or run.

Possible Identity of the Varnish Resin

What kind of material that fits Mayerne's descriptions is capable of embodying these various virtues? Sun-thickened oil dries rapidly, as does oil polymerized by heat with added driers, both of which also improve the flow and blending properties of the paint and help level the brushstrokes; but they are not red. The color itself implies the presence of a natural resin, one that had been strongly heated, which would tend to exclude any but the oil-varnish resins that require thermal processing before they are soluble. The addition of a resin in proper quantity imparts a stickiness and solidity that permit flow but prevent sagging of the applied paint. Moreover, the various natural resins increase gloss, enhance the saturation of color and the overall transparency of the paint.[36]

The varnish in question would certainly seem to have been an oil varnish, not a spirit varnish. Mayerne's description of his own experiment in making amber varnish dissolves the heat-solubilized amber in oil of turpentine,[37] and it was apparently this material that he offered to Van Dyck, who told him that it thickened the colors too much,[38] which would naturally occur as soon as the solvent evaporated. The formula given for the lutemakers' varnish is, in fact, an oil varnish without added solvent, thus correlating with the lack of odor in the Amber Oil of Venice. Was the varnish of the Gentileschi truly made with amber? Amber itself possesses an undeniable mystique of ancient lineage. It is classed as a semiprecious stone, and the idea of liquefying its refractive powers and glassy luster so as to impart its evident virtue to

artistic painting has a natural, emotional appeal. In spite of the large number of recipes for it in old manuscripts, the question of whether true fossil amber was ever much used in historical varnishes or found its way into paint media has been a matter of much disagreement. The skeptic's view was most curtly expressed by the early twentieth-century paint chemist Maximillian Toch, who called amber varnish "always a delusion and a snare."[39] A similar position came to be held by the distinguished A. P. Laurie, who was well aware of the Mayerne MS, and who did much to place the understanding of old paint media on a scientific basis, but whose unsuccessful attempts to make a pale amber varnish led him to consider it probable that "the name amber was applied to the varnish because of its color resembling amber."[40] The same opinion found wide circulation in the highly influential *Artist's Handbook* by Ralph Meyer, who held oil varnishes in disdain generally, listing the cooked copal varnishes among the causes of cracking and darkening of paintings,[41] a view not held by Laurie, who considered the possibility that hard, African copal was early confused with amber and that "the perfect preservation of pictures at certain periods may have been due to the accidental inclusion of this resin in varnish making."[42]

The terminology of natural resins has always been beset by a lack of precision. Resins of different botanical origin and chemical composition often visually resemble one another. Prior to the twentieth century, the collecting, sorting, and grading of natural resins was not well regulated, and middlemen were unreliable, leading Henry Violette in 1866 to advise the varnish man not to buy lots of resin of pure botanical origin, for they did not exist, but to learn how to select the least adulterated.[43] The modern term "copal" itself is applied to a range of different materials, roughly tied together by the fact that they can be used to make oil varnishes, for which they must be thermally processed.

There are two main classes in which resins may be divided, as mentioned earlier: soft, or spirit-varnish, resins and hard, or oil-varnish, resins. In a related way, old recipes sometimes appear in pairs, with one in which the resin and oil combine easily over moderate heat, while the other requires a very high temperature, usually until the resin is melted first.[44] It has been suggested that the name "amber" was formerly used much the same as "copal" has been more recently, only "restricted to the hard and valuable resins."[45] In practice, varnish recipes calling for amber could quite easily have been applied to any resin the worker happened to have on hand that had an amber-like appearance and was hard and insoluble in character, requiring it to be premelted or "run," such as sandarac or copal.

Eastlake points out early confusion between amber and sandarac, and between amber and copal as well. According to Eastlake, one old name for amber, "Karabe," derives from the Persian "Ká-ruba," which means "straw-stealing," a reference to its power to attract small, light objects after friction,[46] a property observable among the copals also. The resin called for in the varnish said to have been used by Artemisia Gentileschi is called by Mayerne "Carabe," which he says is otherwise known as "Ambre."[47] Immediately following the description of her technique is another recipe that calls for a resin from the Indies, found at Marseille and known as "Charabre" or "Charabe," which a marginal notation suggests could refer to copal or Indian amber.[48] (The note, in Latin, is dated 1641, making this possibly the earliest appearance of the term "copal" in the literature of varnishes.) From the physical description and the difficulty of melting the Charabe, it is plain that some form of copal was available in Europe during the seventeenth century. Copal was found as an article of commerce and purchased in large quantity at Zanzibar by James Lancaster, captain of the English ship *Edward Bonaventure*, in 1592.[49]

Zanzibar copal had long reached Europe via India under the name "Animé,"[50] a term which also appears at the top of Mayerne's list of varnish resins.[51] The possibility that copals were used in seventeenth-century amber-type varnishes does not seem unlikely at all.

Mayerne's recipe for the lutemakers' varnish is a two-stage operation in which the resin is melted and later combined with oil that had been heated with litharge to speed drying. This would be the appropriate method for copal or sandarac varnish as well. In another place, Mayerne gives an amber varnish recipe taken from the *Secreti Universali* of Timotheo Rosselo, published in Venetia in 1575.[52] Here, the amber is melted into a portion of the oil, after which the remainder is added. The present writer has proved the workability of this method with genuine amber (although not with Congo copal or sandarac, which polymerize, becoming completely insoluble). The color became dark, but with exercise of finesse in heating and with light material to start with, a reddish varnish would likely be achievable, especially through adjusting the proportion of oil. Interestingly, while Rosselo's Venetian varnish does not call for driers, he does add the ground bricks to the finished varnish as with Mayerne's Amber Oil of Venice, whereas the lutemakers' varnish recipe adds bread crusts to the oil first, to purify it.

A varnish fitting the description could conceivably have been made using either method, depending upon the particular resin. From the textual evidence, some assurance can be expressed that the artists used an oil varnish made with a more-or-less hard resin, very possibly amber or copal, possibly with a lead drier, but without volatile solvent. The possibility cannot be ruled out that a varnish made with a softer resin, heated excessively so as to counterfeit an amber varnish, was sold under the name of amber; nor can the possibility that a soft resin (i.e., common rosin, which aids in the fusing of hard resins) was added in some portion. Identification of the type of resin upon which the varnish of the Gentileschi was based would only be derived from chemical analysis, some of the difficulties and progress of which will be described shortly. Before that, a view to the paintings of the Gentileschi will help refocus upon the central purpose of this inquiry, namely the artistic function of the Amber Oil of Venice and the long-term effects of its use.

Evidence in the Paintings

Bearing in mind that Mayerne's report does not pretend to account for the techniques of the Gentileschi throughout their careers, and that an artist's practice will likely go through modifications, we may reasonably conjecture that, if we have a substantial number of the artists' works before us, spanning the extent of their careers, at least some of what we see will probably contain the varnish medium, especially works done around the time of the manuscript passages. There are two things to look for in our connection: the look of the paint, to see if it is consistent with either the addition of varnish or the oiling-out method, and any aspects of the condition of the paint film that might be owed to the varnish.

Systematic study of the Gentileschi in this regard has yet to be done, but a broad gaze reveals that both artists were certainly refined craftsmen. An enamel-like modulation of tone in the flesh, such as can be facilitated by the addition of varnish, can be noted in various works, such as Orazio's *Madonna and Child* in the Fogg Museum at Harvard University and the Berlin *David with the Head of Goliath* (Fig. 24), and Artemisia's *Susanna and the Elders* (Figs. 10, 15; Color Plate I).[53] Given the fact that such subtle blending can be accomplished in more

ways than one, it seems safest to say that the look of the paint is not inconsistent with the addition of varnish.

The same may be said with regard to the practice of oiling out. Portions of Orazio's *Young Woman Playing a Lute* (Washington, D.C., National Gallery of Art) indicate a wet-in-wet technique,[54] which is related in principle to oiling out, although the latter would be less directly visible than painting into a pigmented glaze. Properly done, oiling out would produce only the thinnest possible coating to enhance blending, which would be painted over before dry and hence would be mingled with the new layer of color. It is quite natural to expect occasions where more has been oiled than could be painted over in time, in which case the unpigmented layer would dry and remain intact between actual paint layers, which has indeed been reported as a common occurrence in pictures by Claude Lorraine, where this possibly excessive oiling out is associated with lack of adhesion for the superimposed layer.[55] No observation of such unpigmented layers in the Gentileschi have yet been reported.

Scant attention has been given to the evaluation of the relative quality of an artist's craftsmanship by the condition of his or her paintings. Precise information as to the true condition of paintings is difficult to accumulate, and the author has found some conservators reluctant to take up this perspective. Old pictures have generally suffered so much from the vicissitudes of time and at the hands of restorers that poor condition may be no reflection on the artist or his materials. There will be cases where it may be very difficult to attribute causation for a defect clearly to the artist, the materials, or some other agency, such as a heavy-handed restorer, but it is equally true that poor workmanship will become apparent. A fine *craquelure*, a moderate yellowing of the medium, a decrease in solubility, with an increase in transparency, are all to be expected as natural effects of aging. Wide shrinkage or drying cracks, peeling between the paint layers, and severe discoloration, on the other hand, all represent some flaw in the artist's practice or choice of materials. For the present purpose, it may be enough to say that for an artist's pictures, especially a good number of them, to have remained reasonably intact such as to be admired for three hundred or more years would represent a reasonable standard of technical virtue.

An overview of the works of the Gentileschi brings an impression, especially in the case of Orazio, of paintings that are especially well preserved, at least when they have not obviously been mistreated, even in an age noted for a high level of technical excellence. In such works as his *Young Woman Playing a Lute* and the Fogg *Madonna and Child*, the colors appear mostly fresh and bright, the whites essentially unsullied.[56] The Bucharest *Madonna and Child* (Fig. 5), badly damaged in the political turmoil there in 1989 but since carefully repaired, was observed to be in superb condition, apart from the effects of shrapnel.[57] The uncharacteristic nature of a poorly preserved Orazio seems well expressed in the following description of the *Joseph and Potiphar's Wife* at Hampton Court. Before restoration, "the painting was so obscured by multiple layers of discolored varnish and repaint that it was impossible to appreciate the clarity of color and precision of detail which are so characteristic of Gentileschi's painting technique."[58]

In the case of Artemisia, two examples underscore the difficulty of evaluating successful technique on the basis of condition. Her *Esther Before Ahasuerus* (Fig. 125; Color Plate XVI) has been so damaged by vandalism, inept repairs, and overcleaning as to render it rather useless as a base from which to draw conclusions.[59] The Detroit *Judith and Her Maidservant* (Figs. 83–84; Color Plate XIII) displays a form of surface distortion known as cupping, possibly owing more to the relationship between ground and support than to paint formulation, and

the paint film is otherwise essentially sound.[60] Further investigations regarding this particular piece would seem particularly valuable, for it is datable to about 1625 and thus close in time to the information imparted by Artemisia to Lanier and then recorded by Mayerne.

A visual survey of the collected works of the Gentileschi offers nothing to refute the testimony of Mayerne. Neither do the works exhibit the discoloration often assumed to accompany amber or sandarac, or the inordinate cracking some have associated with copal. At this point it may also be mentioned that conservators who have cleaned pictures by the Gentileschi speak of essentially insoluble paint films,[61] which implies an absence of soft resins. (An exception is noted in Orazio's apparently uncharacteristic use of bitumen in the *Joseph and Potiphar's Wife*, which does show both cracking and easy solubility in the bituminous areas.)[62] But one has not yet any assurance of the presence or absence of the varnish in any particular painting. That would require substantive evidence from scientific analysis, to which we now turn.

Chemical Analysis

The application of science to the fine arts has followed scientific advances fairly closely all the way along. Pioneers in chemistry were seen to turn their attentions to furthering the understanding of painting, seemingly out from a broad and overflowing humanism. The German chemist Max von Pettenkofer applied the microscope to the study of pictures in 1870.[63] In 1905 the Nobel Prize winner Wilhelm Ostwald proposed microchemical staining tests as a means to distinguish different paint media.[64] The twentieth century has seen the rise of museum laboratories employing professional scientists devoted to the study of paintings. The end of the Second World War brought a renewed impetus to the application of all available means to the scientific understanding of art objects with a view to their extended preservation, the best efforts of which are seen in the classic study of the Ghent Altarpiece, *L'Agneau Mystique au laboratoire*, published in 1953. The careful use of methods of traditional chemistry suggested findings that, in fact, Van Eyck did employ some natural resin in certain areas,[65] although these findings were later challenged.[66]

The invention of highly sophisticated instrumental analytical tools since that time has offered the possibility of analysis upon very tiny samples not previously possible, but at the same time the field has become more purely technical, largely the domain of scientific specialists. Hence, the now rather profuse literature has come to be characterized by highly technical jargon, unfamiliar to the average intelligent and well-educated reader, or lacking in crucial specifics necessary to assess the results. Although no attempt can be made here at a thorough overview of the issues and techniques of media analysis or the chemistry of natural resins, for which the reader is referred to the existing literature,[67] some salient points seem worthy of consideration.

First of all, there are no methods as yet that will be of help in our inquiry that do not require a sample to be taken from the painting. Avenues of study are limited at the outset, owing to the ethics of the treatment of artifacts. Only very small samples, mere nicks in the surface, are permitted, generally only as part of a project of repair, preferably from an inconspicuous place, such as under the frame or on the edge of a tear. This means that chance governs the samples available for study, which may not be had from pictures most interesting to the student of technique (e.g., those that are exceptionally well preserved). Then there is the fact that natural resins, and oil/resin varnishes in particular, are chemically very complex and present significant

problems for the researcher. The difficulty of their detection in part accounts for the relative lack of drive to get to the bottom of the long-standing debates over their use by the Old Masters, with focus placed more upon aspects where results were more forthcoming, such as distinguishing between linseed and walnut oil or oil and protein (e.g., egg).

It is somewhat ironic that the motivation to study natural varnish resins largely diminished as the means better to understand their chemistry advanced. Much scientific attention was given to natural resins up through the 1940s because they formed a large part of the varnish industry. Progress in polymer chemistry and new analytical methods were applied to synthetic resins, to the neglect of the natural ones, which suffered a severe commercial setback because of political turmoil in regions of supply, and industrial interest faded away. In conservation circles, research attention is naturally devoted mostly to issues of preservation and, in the case of resins, the work has mostly been on picture varnishes. Because oil varnishes are hard to remove, and hence violate the cardinal principle of reversibility, conservators tend not to study them. The most notable exception has been the Scientific Department of the National Gallery, London, where more detailed work on the subject of natural resins has been done in recent years than anywhere else in the world.

One of the most fruitful methods applied there has been gas-liquid chromatography (GLC). By this means, intimate and complex mixtures of chemical compounds, such as occur in oils and resins, can be separated and registered quantitatively and characteristically on a graph. The process itself and the interpretation of the resulting chromatogram require much care, for there are many variables to consider. One finding of special importance here is the apparent discovery of amber varnish in a painting by Ferdinand Bol (1610–81), a member of Rembrandt's circle.[68]

One of the limitations of gas chromatography is that the chromatogram conveys very little chemical information about the compounds separated on it; those compounds must be identified by comparison with known standards. Much help is gained by linking the output directly with a mass spectrometer, which can determine actual molecular weights. Descriptions of the limitations of these techniques and the inherent difficulties of resin analysis, along with examples of analysis in practice, are given in several places.[69] Another drawback to gas chromatography itself is that it requires volatile compounds. Much of the material in old oil-varnish films is of a nonvolatile, polymeric character. To overcome this, a technique of pyrolysis, coupled with gas chromatography, has been proposed. By this, the sample is heated strongly without oxygen until volatilized, after which the pyrolysis products are run through the chromatograph for separation. The meaning of the resulting pyrograms is a study in itself. For the present, they largely serve as "fingerprints" to compare with reference standards.[70] Pyrolysis has been applied to amber and pseudo-amber resin artifacts,[71] but published pyrolysis studies of oil varnishes, as of yet, are lacking, although further progress in this area is anticipated.

From another angle, spectrographic methods have also been considered, since chemical compounds also have characteristic infrared spectra. With regard to varnish components in paint media, optimism may stray overly beyond the present frontiers of the possible, the spectra yielding insufficient detail to identify partially polymerized, partially decomposed resin components.[72]

Another method with much appeal, especially for institutions without lavish financial endowments for equipment, is differential staining of broad classes of materials (i.e., oil, protein, resin, etc.). For this, a sample is embedded in a nonreactive, synthetic resin, which is then

finely ground to reveal a clean cross section. Various selective dyes have been proposed, which have not always proved reliable,[73] although the technique theoretically offers the advantage of characterizing the basic class of material, which can later be analyzed with more precision, although a disadvantage is that a new sample would then be required.

While no published analyses of the media of the Gentileschi have come forward, the author is aware of potentially interesting results from cross-sectional staining upon a sample from the badly damaged Bucharest *Madonna and Child* (Fig. 5), which had been sent to the Getty Museum for restoration. A minute fragment of the Child's flesh revealed four layers: two ground layers, an underpainting to the flesh, and the flesh paint proper. The upper ground layer fluoresced strongly in the presence of antimony pentachloride, a reagent suggested as specific for resins.[74] Unfortunately, corresponding results were not obtained with Alkanna,[75] another proposed resin indicator.[76] Clearly, further study of these reagents is in order.

Conclusion

The scientific tools necessary finally to solve the mystery of the place of varnish in the methods of the Old Masters appear potentially poised for readiness. Current findings indicate that varnish additions were at least occasionally employed, but the real extent of their successful use is difficult to prove. With regard to amber and copal oil varnishes, it should be borne in mind that these materials are first chemically altered in the process of rendering them soluble, then further changed by cooking together with the oil, and changed yet more by the drying process and later degradation owing to aging. In addition, the varnish, according to Mayerne's report, was added to the paint in relatively small quantity. The likelihood that identifiable components will remain under these circumstances to be easily detected in all cases where they are present is slim.

A full understanding will require a balance of all available analytical techniques, together with attention to the needs of the artist's actual practice. What kind of mixtures, in what proportions, can be manipulated to give particular paint qualities? The paintings of the Gentileschi, viewed in conjunction with the account in the Mayerne manuscript, can serve as valuable models. A determination of the minimum quantity of resin necessary to have a demonstrable effect on the optical and working properties of the paint can be of help to the analyst in knowing what may be expected. It is hoped that the cooperation necessary to this endeavor will be found to aid a future generation of fine craftsmen.

CATALOGUE RAISONNÉ

AUTOGRAPH PAINTINGS

With the exception of five lost or unidentified pictures by Artemisia Gentileschi for which seventeenth-century prints or painted copies provide visual records, the works catalogued in this section are judged to fall into the following categories: (1) paintings executed wholly by Artemisia; (2) paintings executed by Artemisia in collaboration with recognizable masters; (3) paintings executed by Artemisia with anonymous studio assistance. They are arranged chronologically according to the dictates of the surviving evidence. Pictures of unknown location and an additional few which I have been unable to study in the original are so identified. The ideal entry contains the following information, in measures commensurate with the problems involved:

1. *Basic facts.* Catalogue number; subject; location; medium, support, and size, height preceding width; documented or suggested date; figure number; signature, putative signature, and/or inscription; previous collections, the earliest known first.

2. *Condition and color.* Over the years many of Artemisia's paintings have been subjected to conservation measures—sometimes more than once, and often incompetently. I have consulted existing technical reports and X-rays when they have been made available, but for the most part the remarks on condition are based upon what a nonscientific eye can see and upon an art historian's accumulated experience. I have tried to restrict these comments to matters that appear to affect critical judgment of the works, including their authenticity, date, and relevance to source material. The brief descriptions of color are directed to the same issues; cer-

tainly they do not pretend to re-create the coloristic impact of the canvases.

3. *Iconography.* Discussions of iconography appear when necessary to establish the exact subject of a painting, when a theme and its interpretation reflect specific patronage tastes, intellectual interests, and political pretensions, or when a picture must be viewed as part of a wider iconographical program. Questions regarding the potential personal significance to the artist of a given subject are generally taken up in the text.

4. *History, documentation, and dating.* This section is designed to establish the authenticity and chronological position of each work. Stylistic analysis, often of a comparative nature, is limited here to these considerations. The text explores broader points of expression and style.

5. *Copies of extant paintings*

6. *Bibliography.* Frequently cited literature is noted with the author's name and date of publication only; complete references can be found in the general Bibliography.

The Catalogue of Incorrect and Questionable Attributions and the Catalogue of Lost Works have their own preambles.

..

[1] *Madonna and Child*

> Florence, Palazzo Pitti
> Oil on canvas, 1.18 x .86 m.
> ca. 1609–10
> Figs. 1, 6
>
> Inscribed on the reverse: *Da Pitti 9 ag. 1773*
>
> COLLECTIONS: Palazzo Pitti, by 1664(?); Uffizi, 1773; Palazzo Pitti, 1928

The restoration of 1969/70, conducted under microscope and scalpel, rendered legible a picture once greatly marred by extensive overpainting, innumerable crude retouchings, and blackening of the Virgin's blue mantle and of the maroon shadows of her pink dress. However, the engraving of the painting published by Réveil and Duchesne, who found praiseworthy only the management of the materials, records complex drapery configurations over the Madonna's legs that are no longer in evidence.

In spite of the consequent leap in quality following conservation, the attribution of this canvas remains under debate, complicated by

the presence in the Galleria Spada at Rome of a related *Madonna and Child* of almost identical size (1.165 x .865 m.; Fig. 230 and [X-19]), without consideration of which the problem cannot be resolved. The following review of the attributional histories and pictorial sources of both works, bolstered by comparative stylistic analysis, argues that the Pitti *Madonna* is an autograph painting by Artemisia Gentileschi of ca. 1609–10 and that the Spada picture preceded it and came from the circle of Giovanni Baglione.

An inventory of the Palazzo Pitti begun on December 30, 1663, lists "Un quadro in tela entrovi dipinto la Madonna San.ma à sedere con Giesù Bambino in collo in atto di volerlo allattare con. ador.o tutto dorato alto B. 2¼ largo 1²/₃ di mano [blank]." Borea has suggested that this unassigned *Madonna and Child*, measuring 1.31 x .97 m. in its metric equivalent, is the picture in question here, which was transferred from the Pitti to the Uffizi in 1773 (as the inscription on the reverse testifies and where in 1837 it was signaled by Réveil and Duchesne as a work of the Cavaliere d'Arpino). Modern opinion begins in 1931 when Porcella, rejecting the obviously untenable ascriptions of the Spada example to Bernardo Strozzi (Barbier de Montault) or Francesco Cozza (Hermanin), gave both *Madonna*s to Artemisia Gentileschi. Subsequent published views, some of them excessively laudatory, regarding the authorships of these canvases may be charted as follows:

Pitti *Madonna*

> Artemisia Gentileschi: Jahn-Rusconi; Francini Ciaranfi; Bissell (tentatively); Borea; Gregori (1984); Contini; Berti; Stolzenwald; Bionda; Szigethi
>
> Artemisia Gentileschi (possibly): Volpe; Schleier
>
> Artemisia Gentileschi (with varying degrees of doubt): Nicolson; Papi (in Contini/Papi, 1991; although not by Guerrieri); Gregori (1991; although not by Guerrieri)
>
> Giovan Francesco Guerrieri: Zeri; Emiliani (1958); Natale
>
> Giovan Francesco Guerrieri (possibly): Spear ("more reasonable"); Emiliani

(1988); Garrard ("not incompatible" with Guerrieri)

Anastasio Fontebuoni (tentatively): Sricchia Santoro

Florentine painter, ca. 1620, very close to Andrea Commodi: Papi ("Guerrieri," 1991)

Spada *Madonna*

Artemisia Gentileschi: Lavagnino; Bissell (tentatively); Gregori (1984; in 1991, not by Artemisia); Garrard; Gash ("plausible"); Papi; Contini; Berti; Stolzenwald

Giovan Francesco Guerrieri: Zeri; Natale

Giovan Francesco Guerrieri (possibly): Emiliani (1988)

Angelo Caroselli (tentatively): Moir

Giovanni Baglione: Longhi (suggested); Paolucci

Baglionesque artist: Emiliani (1958)

From this labyrinth four main points emerge: (1) while there is anything but general accord on the attribution of either picture, or even as to whether they are by the same hand, the names of Artemisia Gentileschi and Guerrieri have been most frequently proposed; (2) the complexity of the issue is dramatized by the fact that over the years several scholars have found it necessary to change their previous opinions; (3) Borea and Contini have been the most forceful spokespersons for Artemisia's authorship of the Pitti example, Garrard and Papi for her responsibility for the Spada one; (4) neither painting has been dated earlier than ca. 1605 or later than 1620.

That these *Madonna*s (exhibited together in 1991) were created by different artists now appears to me absolutely certain; for quite aside from more particularized stylistic considerations (see below), two distinct mentalities are at work, one clinging to convention, the other transforming tradition through a confrontation of reality. First in this respect, it is here suggested that the major source for the *Madonna* in Rome was an engraving of the Holy Family from the school of Marcantonio Raimondi (Fig. 2) or, less likely, Agostino Carracci's print of 1576 directly after the Renaissance example.

Beyond the obvious compositional similarities, individual motifs coincide: the nursing gesture of the Virgin and her projecting knees; the Christ Child posed from the back and reaching toward his mother; the intricate drapery at the lower left. Yet by rotating the head of Christ inward, the Baroque artist has established a closer rapport between the Madonna and Child. In effecting this transformation, as in altering the position of the Child's right leg, he embraced the example of the Cavaliere d'Arpino *Holy Family with the Young Saint John* of ca. 1593–95 (Madrid, Prado; Fig. 3), which itself appears to have adapted the Raimondi engraving.

Overlaying these borrowings in the Spada canvas is a would-be humble domesticity that recalls the *Holy Family with Saints Elizabeth and John* of ca. 1588–90 by Scipione Pulzone (Rome, Galleria Borghese; Fig. 4), from which the artist also appropriated the concentric loops of drapery over the Virgin's legs (as Zeri noted) and the features of the sweet, silky-haired baby.

In view of these relationships, too patent to be fortuitous, there is little reason to invoke, as has been done with reference to the Spada canvas, the *Moses* and Sistine Sibyls of Michelangelo or the works of Raphael and the Sansovini.

While sharing self-evident features with the painting in Rome, the Pitti *Madonna and Child* offers something new, for the Christ Child assumes a less heroic posture. Gently caressed by the fingers of his mother's left hand, as the Child taken from art in the Spada example is not, he has the air of a baby observed. In fact, the Florentine *Madonna* is in all ways fresher. Expressively the somnolent Spada picture is overlaid with a veil of sentimentality, and stylistically as if by a veil of gauze, quite in contrast to the solemn Madonna and the sharper, more solidly modeled forms of the Pitti canvas. The extent to which the former holds fast to the creative acts of others and the nature of the differences between these two works probably establish the priority of the Spada picture, to which the Pitti *Madonna* would then provide an answer in the direction of a greater naturalism. Except for Papi, all authorities who have expressed an opinion on the question of dating, regardless of their particular inclinations concerning the attributions, give precedence to the *Madonna* in Rome.

The artist of the picture in Florence may well have been urged along this more progressive path by the example of Orazio Gentileschi, as Porcella, Emiliani, Garrard (substituting the Spada *Madonna*), and Contini have sensed. Particularly relevant is Orazio's *Madonna and Child* in the Muzeul de Arta at Bucharest (Fig. 5) with its refreshingly unaffected Christ Child, its attractive Virgin (how different from the ostensibly democratic but in fact homely type in the Spada canvas!), and a sentiment which, taken up in the Pitti *Madonna*, manages to be intimate without being cloying. The recent discovery of the date "1609" on the reverse of the Bucharest painting (which in 1981 I assigned with a slight question mark to the years 1609–10) in effect removes the uncertainty expressed by Contini as to whether Orazio's *Madonna* predated his daughter's effort.

The straightforwardness of the Pitti painting, its temperamental ties to Orazio, the strength of its *chiaroscuro* (likewise placing it in the Caravaggesque ambient), and the physiognomy of the Virgin (hair falling in somewhat unkempt strands, pinched bow mouth, small cleft chin) which brings to mind Artemisia Gentileschi's early female type (e.g., Figs. 56, 68), together recommend Artemisia as the artist. More specifically, it may be claimed as her earliest identifiable picture. It lacks precisely, in the uneasy integration of the two figures, the "coherence of design" (Garrard) that informs the *Susanna and the Elders* of 1610 (Fig. 10; Color Plate I), perhaps precisely because, unlike the Spada canvas, it reveals a willingness to experiment.

Furthermore, there is intriguing evidence, first adduced by the author and recently underlined by Garrard, Contini, and Berti, that Artemisia began her career painting this most sought-after of Christian subject matter. In March of 1612, during opening arguments at the trial of Agostino Tassi for having raped Artemisia in May of the previous year, it is reported that on the day of the attack "Agostino, having found the door of Artemisia's house open, entered the house uninvited and went to Artemisia, whom he found painting, accompanied [or assisted] by Tuzia [a boarder in the Gentileschi household] with her son seated on her lap (*Agostino, havendo trovato la porta di casa Artimitia aperta insalutato hospite entrò in casa et sene andò da Artimitia, et la trovò che dipingeva et con lei assisteva Tutia con il figlio suo fra le gambe asedere . . .*)." This account was twice corroborated, first by Artemisia on March 18 ("I was painting for my own pleasure an image of one of Tuzia's boys"; *stando io pingendo un ritratto di un putto di Tutia per mio gusto . . .*), and then, on March 23, by Tuzia ("and one time in particular he came when Artemisia was painting an image of my son"; *et una volta in particolare ci venne che Artimitia stava depingendo un ritratto del mio figlio . . .*). In short, one can imagine Artemisia at her easel, completing from life a composition of a Madonna and Child, even though it is unlikely that the Pitti *Madonna*, being less technically accomplished than the *Susanna* of 1610, is the picture in question or, as suggested by Berti, is the example of Artemisia's work that Orazio promised to send to Florence in 1612 (see rather [5]).

What, then, of the attribution of the more conservative if in some ways more assured Spada *Madonna*? The links between the two paintings suggest a familiarity between the artists, which in turn was thought to point to Giovan Francesco Guerrieri as the author of the Spada canvas. The question as to whether or not in other instances Guerrieri's debt to Orazio Gentileschi is demonstrable cannot be addressed here; yet, with Contini, I simply do not find in the Spada painting decisive affinities to the works of Guerrieri, not even to the oft-cited *Penitent Magdalen* of 1611, his earliest signed and dated work. The style of Giovan Francesco's pictures prior to this time can only be surmised, and I see no artistic evidence that would lead one back to the *Madonna* in Rome. Conversely, the Madonna of the Spada picture recalls the frumpy women repeatedly offered by Giovanni Baglione (e.g., *Rinaldo and Armida*, Rome, Palazzo Pallavicini-Rospigliosi, 1614; *San Carlo Borromeo Venerating the Madonna*, Viterbo, Arcivescovado, ca. 1605–10), and Papi has likened the coloration to Baglione's art. Emiliani's initial proposal that the Spada *Madonna* is by an artist from Baglione's circle—probably, I would add, one also conversant with Orazio Gentileschi's paintings of the first years of the new century—is therefore most convincing at present. Any relationships that one may care to see between the Pitti canvas and Bagli-

one need not have been occasioned by other than the example of the Rome *Madonna*.

BIBLIOGRAPHY: Rome, AS, *Archivio del Tribunale*, 1612, fols. 6–7, 17, 37; Florence, AS, Guardaroba Mediceo 725, "Inventario del Palazzo de Pitti," 1663, fol. 113v; A. Réveil and J. Duchesne, *Museo di pittura e scultura, ossia raccolta dei principali quadri, statue, e bassi rilievi delle gallerie pubbliche e private d'Europa*, ed. Florence, 1837, III, p. 63 tavola 276, with engraving opp.; X. Barbier de Montault, *Les musées et galeries de Rome*, Rome, 1870, p. 447; Rome, Galleria Spada, *Inventario*, 1925, no. 298; Porcella, 1931, pp. 7, 215; Lavagnino, 1933, pp. 9, 12; A. Jahn-Rusconi, *La R. Galleria Pitti in Firenze*, Rome, 1937, pp. 138–39; Longhi, 1943, p. 41 n. 28; Zeri, 1954, pp. 88–89 no. 298 and pl. 107; Francini Ciaranfi, 1956, p. 63; Emiliani, 1958, pp. 19–20, 50, 66; Paolucci, 1967, p. 78; Bissell, 1968, pp. 154–55; Borea, 1970, pp. 74 no. 46, 125; Nicolson, 1970, p. 641; Volpe, 1970, pp. 116–17; Schleier, 1971, p. 89; Spear, "Caravaggisti," 1971, p. 109; F. Sricchia Santoro, "'La Madonna di Pistoia' e l'attività romana di Anastasio Fontebuoni," *Commentari*, XXV (1974), 44; M. Natale in Geneva, Musée d'Art et d'Histoire, 1979, p. 65, incl. n. 9; Menzio, 1981, pp. 40, 48, 64; M. Gregori in Naples, *Civiltà del seicento*, 1984, I, p. 147; A. Emiliani in San Severino Marche, 1988, pp. 15, 33–35; 68–69 cat. 3; Garrard, 1989, pp. 22–25, 32, 411, 415, 423 and n. 57, 492–93 nn. 19–20; Gash, 1990, p. 67; Mina Gregori, Florence, letter to the author, March 26, 1991; Contini in Contini/Papi, 1991, pp. 135–38 cat. 14; Papi, ibid., pp. 34, 114–15 cat. 8; Berti, ibid., pp. 19, 24; Stolzenwald, 1991, pp. 18, 25 fig. 18; Papi, "Guerrieri," 1991, pp. 150–51; Bionda, 1992, p. 26; A. Szigethi in Milan, Palazzo della Permanente, 1993, p. 93.

For the comparative material: Guglielmi, 1954, pp. 318–19, 324; F. Zeri, *Pittura e Controriforma. L'arte senza tempo di Scipione da Gaeta*, Turin, 1957, pp. 74–76, figs. 76–77 and color pl. III; Röttgen, 1973, pp. 84–85 cat. 15 and pl. 15; E. Vaudo, *Scipione Pulzone da Gaeta, pittore*, Gaeta, 1976, pp. 33–35 and figs. 32–33; Bissell, 1981, pp. 71–72, 146–47 [16] and fig. 33; DeGrazia, 1984, p. 74 cat. 3 and 3a, and figs. 30 and 30a; Möller, 1991, p. 126 cat. 56 and fig. 24.

..

[2] *Susanna and the Elders*

Pommersfelden, Schloss Weissenstein, Dr.
Karl Graf von Schönborn-Wiesentheid
Oil on canvas, 1.70 x 1.21 m.
1610
Figs. 10, 15; Color Plate I

Signed and dated on the face of the stone bench, lower left: ARTIMITIA. / GENTILESCHI. F. / 1610

COLLECTIONS: Benedetto Luti, Rome, until ca. 1715

Insofar as precise calculations are possible, given fluctuating values of measurement, it appears from the various Pommersfelden catalogues that the canvas did not suffer any substantive reduction in size during the eighteenth or nineteenth century. Apart from some scattered damage and several *pentimenti* (along the right arm of the younger man, around Susanna's head, and along her outstretched arm, right thigh, and knee), the picture is in good condition. The Marburg photograph (no. 64.016), taken before the last restoration, indicates damage around the edges (now covered by the frame) and reveals that the picture was fabricated from three pieces of canvas, the largest of which contains the entire figure of Susanna and the elders to the top of the right eye of the whisperer. As regards specifically the crucial area of the inscription, Garrard writes: "Ultraviolet photography revealed no overpainting of a previous date or signature, and in Mrs. Sack's [Susanne P. Sack, Chief Conservator of the Brooklyn Museum] opinion, the character of the pigment, the structure of the lettering and its conformity with the internal lighting of the painting, and the craquelure of the surface all strongly indicate that the signature and date originated with the painting." The colors sing out clearly, with one elder in a plum-colored coat (maroon in the shadows) and olive cloak and his balding companion in a salmon-red mantle (a glimpse of blue sleeve beneath), both against a blue sky, and the rosy-skinned young woman, naked but for a white cloth over her left thigh, within a brownish gray stone font.

The recorded history of the *Susanna and the Elders* begins, as Rave has documented, on July 15, 1715, with a letter from Benedetto Luti, the Florentine-born painter then active in Rome, to his protector the Hofrat Bauer von Heppenstein. Luti offers "to send, at the approval of Your High Excellency, a painting by the hand of Orazio Gentileschi which I possess in my small picture gallery (*di inviare al gradimento di S. A. E. un quadro della mano di Orazio Gentileschi, che possiedo nella mia piccola quadre-*

ria)." In order to facilitate the Privy Councillor's decision, Luti proposes to forward a copy of the canvas by his own hand, adding that it depicted "the chaste Susanna" ("Lo suggeto, come riconocerá V. S. ill. da la copia, viene espresso da l'autore la casta Susanna"). The results were positive for, according to Rave, in 1719 the Gentileschi original ("Susanna im Bad, lebensgross ganze Figur. Von Horatio Gentilesco") was numbered by Byss among other paintings at Pommersfelden once in Luti's possession. By this time Orazio's *Madonna and Child* had probably also been added to the Schönborn Collection. Unless Luti intended to deceive, one can only suppose that either Artemisia Gentileschi was an unknown entity to Benedetto and his patron or that the signature had already become obscured in whole or in part by darkened varnish and surface soil. Rave also reports that in an engraving of 1728 by Salomon Kleiner the *Susanna* bears Orazio's name, as it does in the *Verzeichnis* of 1772. With Heller's catalogue of 1845, however, the attribution to Artemisia is introduced, to be retained thereafter. Obviously the full signature had been discovered, most likely (as Boll, followed by Rave and Contini, posited) during a restoration by the Nürnberg conservator to whom Graf Franz Erwein Damian von Schönborn had entrusted some of his pictures in 1839.

Modern scholars, while acknowledging the authenticity of the signature, have been of diverse minds as to the extent of Artemisia's personal responsibility for the painting. And some (including the author) once questioned whether the date as it actually appears on the picture might not be interpreted as *1619*. Hagen and Berti consider the possibility that the canvas was backdated, and Rave argues that originally the last cipher was a "*6*" or a "*9*" and was altered to an "*o*" to perpetuate the mystique of Artemisia. Bringing no scientific evidence to bear on the issue, Rave was apparently urged to this singular conclusion by his conviction that the style of the work (including one of its putative sources) and its former ownership by Benedetto Luti set the *Susanna* firmly within Artemisia's Florentine period.

Universally in the Gentileschi literature (see the Bibliography below, and Chapter 1) since Garrard's monograph of 1989, and justly so in my opinion, it is considered certain that the

date has not been tampered with and is indeed to be read as *1610*. Yet the problem of the *Susanna*'s debt to Orazio Gentileschi—his works, his instruction, his design, his brush—is still pressing. So also are other issues: the impact upon the picture of the latest developments in the art of Rome; the importance of ancient and Renaissance prototypes; the breadth and depth of Artemisia's familiarity with the Susanna theme in literary tradition; the relationships between the painting's imagery and expressive orientation and the events of Artemisia's life. Different judgments concerning these matters yield widely different answers to the overriding questions: What were Artemisia Gentileschi's intellectual, creative, and technical capacities in 1610? To what degree was her art in fact bound up with her life, and in particular with her experiences as a female? Did she, consciously or not, place a feminist stamp upon the *Susanna*? How did she respond to the tastes of an almost exclusively male Roman patronage? And finally, what implications does all of this have for the authentication, dating, and interpretation of Artemisia's pictures, and not only those that immediately followed?

The *Susanna and the Elders* is Artemisia's earliest documented work and the second picture, after the Pitti *Madonna and Child* (Figs. 1, 6), that can be assigned to her. How we understand it sets the tone for how we might choose to understand much of what Artemisia Gentileschi was to do. It is therefore with the *Susanna*, and with an intensive exploration of many of the points of debate outlined above, that this book opens, and it is to that discussion that the reader is referred for the full particulars.

BIBLIOGRAPHY: *Verzeichnis der Schildereyen in der Gallerie des hochgräflichen Schönbornischen Schlosses zu Pommersfelden*, Anspach, 1772, p. 14 no. 91; G. Waagen, *Kunstwerke und Künstler in Deutschland*, Leipzig, 1843, 1, pp. 118, 124; J. Heller, *Die gräflich Schönborn'sche Gemälde-Sammlung zu Schloss Weissenstein in Pommersfelden*, Bamberg, 1845, p. 23; *Katalog der gräflich von Schönborn'ischen Bilder-Gallerie zu Pommersfelden*, Würzburg, 1857, p. 80 no. 564; Parthey, 1863, 1, p. 484; T. von Frimmel, *Kleine Galeriestudien*, 1, Bamberg, 1891, p. 73; idem, *Verzeichnis der Gemälde in gräflich Schönborn-Wiesentheid'schem Besitze*, Pommersfelden, 1894, p. 75 no. 191; Voss, 1925, p. 463; W. Boll, "Zur Geschichte

der Kunstbestrebungen des Kurfürsten von Mainz, Lothar Franz von Schönborn," *Neues Archiv für die Geschichte der Stadt Heidelberg und Kurpfalz,* XIII, (1928), 235–36; Ortolani et al., 1938, p. 45; Longhi, 1943, p. 47 n. 38; Emiliani, 1958, p. 42; Voss, 1960–61, p. 81; Longhi, *Scritti,* I–II, 1961, fig. 192; Moir, 1967, I, p. 100; Bissell, 1968, p. 157; Gregori, 1968, p. 415; Borea, 1970, p. 71; Harris in Harris/Nochlin, 1976, pp. 120–21 cat. 10; Greer, 1979, p. 191; Bissell, 1981, p. 92 n. 5; Marini, 1981, p. 370; Garrard in Broude and Garrard, 1982, pp. 146–71; Slap, 1985, pp. 339–41; Hagen, 1988, pp. 78–79; Garrard, 1989, pp. 15–18, 183–209 and corresponding notes, 491 n. 10, and passim; idem, 1989a; Harris, 1989, p. 9; Spear, *Review,* 1989, p. 604; Rave in Nürnberg, Germanisches Nationalmuseum, 1989, pp. 374–76 cat. 292, with additional bibliography; B. Barnes in Russell, 1990, pp. 32, 35 n. 35; Lippincott, 1990, p. 444; Nicolson/Vertova, 1990, I, p. III; Stolzenwald, 1991, pp. 18–19, 69–72; Contini in Contini/Papi, 1991, pp. 109–33 cat. 7; Papi, ibid., pp. 34, 58 n. 9; Berti, ibid., p. 21; Spike, *Review,* 1991, pp. 732–33; Palmer, 1991, p. 278; Merkel, 1992, pp. 350, 352; Cropper, 1992, pp. 195, 202; Bionda, 1992, pp. 21–22; Mann, 1996, pp. 42–43.

For the comparative material: See notes to the text discussion.

..

[3] *Lucretia*

Genoa, Pagano Collection
Oil on canvas, 1.00 x .77 m.
Ca. 1611
Figs. 18–19; Color Plate III

COLLECTIONS: Palazzo Pietro Gentile, Genoa; Palazzo Durazzo (then Cattaneo)-Adorno, Genoa, until the 1980s

When exhibited in Florence in 1991 the *Lucretia,* recently restored and relined, remained a patchwork affair fashioned from a central piece of canvas measuring 1.00 x .77 m. extended on all sides by strips of varying sizes to a total measurement of 1.37 x 1.30 m. (Fig. 19). Morassi, Bissell, Garrard (on the authority of P. Pagano), and Contini have considered the narrow fields to be later additions, presumably to adapt the painting to a larger frame (Contini reporting that the augmentations took place toward the end of the eighteenth century during a redoing of the interior decor of the Palazzo Cattaneo-Adorno). This conclusion would seem to be supported by the fact that the main canvas, heavily cracked, darkened, and repaired, differed conspicuously in its crackle, weave, and physical condition from the surrounding strips. By the time the *Lucretia* was shown at Düsseldorf in 1995, all the strips had been removed. However, when viewed apart from the enlargements the composition is decidedly illogical (Color Plate III). The sense of ambient, enhanced in its greater scope by a brown-toned fluted column at the right, at once appropriate to this event from Roman history (it appears, for example, in *Lucretia* engravings by Marcantonio Raimondi and Barthel Beham) and as an anchor for the curtain (a tassel of which appears in the shadows at the upper right), is compromised. More crucially, the extra space was necessary to accommodate Lucretia's left leg beneath a cascade of the maroon bedcover/mantle, the foot to be imagined as resting on the bed. The maroon curtain at the left effectively balanced the column, and was a motif that Artemisia was soon to employ in her first *Judith* (Figs. 21–22; Color Plate II). Moreover, deprived of the space below her calf Lucretia, while ostensibly seated, appears to hover incongruously under her own power. Equally arbitrary in the picture's larger size is the truncation of the leg just above the ankle. And there is ample precedent, including Artemisia's *Susanna* (Fig. 10; Color Plate I) and Orazio Gentileschi's *Young Woman with a Violin* (Fig. 32), for the use of a canvas consisting of several pieces of different dimensions.

Were, then, the surrounding strips damaged and partly repainted remnants of Artemisia's original, minus a fillet of canvas below? Substitutions by a later hand of Gentileschi's canvas, its pictorial elements now reconstructed, which having been ruined or folded under could not be salvaged? Whole-cloth imaginings of a late eighteenth-century intervention? Pending analysis of the pigment and of the manufacture of the added pieces of canvas, no definitive solution seems possible, but I do not believe that the painting in its smaller, present dimensions can be taken as respecting the original format. Finally, it appears certain that the drapery over Lucretia's left breast is a later addition, an observation with which John Spike (oral communication) agrees. Neither above nor below is it organically a part of the white shift, *over* which it is in fact painted, a prudish cover-up.

The documented history of the *Lucretia* begins in the late eighteenth century, when it was signaled by Ratti ("Lucrezia uccidentesi") along with a *Judith with Her Maidservant*, a *Sacrifice of Isaac*, and a *Cleopatra*—all assigned to Orazio Gentileschi—in the Palazzo Pietro Gentile at Genoa. Subsequently transferred to the Palazzo Adorno, the four pictures, the *Judith* by then correctly under Guido Reni's name, were catalogued by Gandolfi and by Alizeri ("Lucrezia che si svena"). Both the *Sacrifice of Isaac*, which has now passed to the Palazzo Spinola in Genoa, and the *Cleopatra* (Fig. 211) are by Orazio's hand. Conversely, the *Lucretia*, which significantly does not figure with the other pictures given to Orazio in the *Description des beautés de Génes et de ses environs* (Genoa, 1788) and by Alessandro da Morrona in his *Pisa illustrata nelle arti del disegno* (Pisa, 1792, II), is an autograph work by Artemisia Gentileschi, as Morassi was the first to recognize.

The attribution of the *Lucretia* to Artemisia, now universally accepted, is most forcefully demonstrated in my opinion through comparison to the signed and dated *Susanna and the Elders* of 1610 (Fig. 10; Color Plate I), likewise involving a victim of men's sexual appetites. Brows knitted, eyes wide, mouths open, and hair in partial disarray, these women of anguished expressions, sanguine complexions, and robust physiques appear to be based, adjustments made for the age differences of the protagonists, on the same model in variant postures. Even details—the curiously wooden quality of the lower legs, the dimpled knuckles, the creases of the bent limbs—coincide.

In previously assigning the *Lucretia* to the early 1620s, a suggestion which has been strongly supported by Garrard, Contini, and Papi, and unchallenged elsewhere, I was prompted by three considerations: the probability that the date inscribed on the *Susanna and the Elders* was to be read 1619, not 1610; a lacuna in Artemisia's chronology for the year 1621 which could reasonably be filled by postulating that she accompanied her father to Genoa; and the similarities between the pose of Lucretia and that of the Magdalen in Artemisia's painting of ca. 1617–20 at Florence (Fig. 70; Color Plate V).

However, a reevaluation of these suppositions and new evidence urge that the *Lucretia*

be backdated by a decade. That the *Susanna* was painted in 1610 is now secure, as is Artemisia's presence in Rome in 1621 (see Appendix I and Chapter 3). Furthermore, the appearance of the signed and dated *Jael and Sisera* (Fig. 73), a canvas not considered by Garrard, provides a documented touchstone for Artemisia's manner in 1620 and, in spite of its severe subject, an additional indication that by that time Gentileschi had begun to moderate the stylistic and expressive austerity that characterizes the *Susanna*, the *Lucretia*, and those paintings, including the *Judith Decapitating Holofernes* (Figs. 21–22; Color Plate II), which immediately follow them. And, their related poses aside, Lucretia and the fashionable, more conventionally viewed Magdalen are not of the same lineage. Nor is the orientation of the *Lucretia* compatible with the newly discovered *Venus and Cupid*, *Cleopatra*, and *Penitent Magdalen* (Figs. 104, 110, 111; Color Plates XIV, XV), all datable, I believe, within the 1620s. And it is surely not a coincidence that the *Lucretia* and Orazio Gentileschi's depiction of female suicide, the *Cleopatra* (Fig. 211), formed part of the same Genoese collection; both were probably shipped to northern Italy by the middle of the second decade at the very latest.

As noted, in now assigning a date of ca. 1611 to the *Lucretia* I am in disagreement with Garrard, Contini, and Papi. Spike, seeing an impact upon Artemisia's painting of Guido Reni's style of the late second decade, likewise holds to a date in the 1620s, as do Berti (1621–22), Cropper (following the *Jael* of 1620), Volland (most probably 1621), and Mann (ca. 1621). While Contini and Papi correctly point out that a trip by Artemisia to Genoa in the early 1620s is not documented and posit as a probable alternative that the *Lucretia* was sent to Genoa from Rome, for them the picture is still to be located in the early 1620s. Contini writes that "lo stile del dipinto è sintomaticamente in accordo—in qualche aspetto—con quello del padre, e pare esserci stato, a quest'altezza del percorso di Artemisia—a Roma tra l'estate del 1620 e l'inizio del 1621?—un reciproco scambio di vedute tra Orazio e sua figlia." As regards the influence of Orazio, be it on the facial structure, frowning expression, or physique of Lucretia, Contini points variously to the Fabriano *Magdalen*, the Ancona *Circumcision*, the

Farnese *Saint Michael*, the Spada *David*, and the Braunschweig *Mocking of Christ* (Figs. 12, 13, 23, 17). As I have emphasized in the text, there is indeed much that is Orazian about the *Lucretia*. But Contini, in the wake of Claudio Pizzorusso's arguments concerning Orazio's pictures in the Marche ("Rivedendo il Gentileschi nelle Marche," *Notizie da Palazzo Albani*, XVI, no. I [1987], 57–75), would place the *Magdalen* and the *Circumcision* (to which he would join the *David*) toward the end of the second decade. For my part, I continue to be convinced that all of the works by Orazio just cited fall between ca. 1605 and ca. 1610. If so—and by necessity my defense of this position would be too complex and extended even to summarize here—a date of ca. 1611 for Artemisia's *Lucretia* is again indicated. Surely one should not allow a supposed date of ca. 1620–22 for the *Lucretia* to color how one views the chronology of Orazio's canvases in Ancona and Fabriano. Finally, an assessment of Contini's claim that the *Susanna* of 1610 and the *Lucretia* are not comparable must take into account that the more pronounced spotlighting and deeper tonality of the latter, and hence its "vigorosissima imponenza e il deciso—quasi prepotente—realismo," are consistent with the interior setting versus the open-air locale of the *Susanna* (Orazio's *David* and *Mocking of Christ* offer related cases). Once the probability of such adjustments is admitted, Artemisia's two paintings may be seen to share an unremitting pictorial aggressiveness which, combined with the other particulars signaled above, including the nature of their indebtedness to Orazio, suggests that they are more or less contemporary productions.

BIBLIOGRAPHY: Ratti, 1780, I, pp. 119–20, 122; Alizeri, II, pp. 431–32; Gandolfi, 1846, III, p. 294; Morassi, 1947, p. 102 cat. 138, and fig. 84; Bissell, 1968, pp. 156–57; Torriti, 1970, pp. 200 and 201 fig. 217; Bissell, 1981, p. 172 cat. 43, and figs. 94–95; Marini, "Caravaggio e il naturalismo internazionale," 1981, p. 370; M. Gregori in Naples, *Civiltà del seicento*, 1984, I, p. 147; P. Pagano and M. C. Galassi, *La pittura del '600 a Genova*, Milan, 1988, pl. 364; Garrard, 1989, pp. 54–56, 105, 137–38 n. 81, 210–44 (and corresponding notes), and color pl. 9; Spear, Review, 1989, p. 604; Lippincott, 1990, p. 448; Nicolson/Vertova, 1990, I, p. 110; Contini in Contini/Papi, 1991, pp. 109, 160–62 cat. 22; Papi, ibid., pp. 49–50; Berti, ibid., p. 25; Spike, Review, 1991, p. 734; Cropper, 1992, p. 209; G. Volland in Düsseldorf, 1995, pp. 300–301; Mann, 1996, p. 44.

For the engravings cited: B. Barnes in Russell, 1990, pp. 44 cat. 6, 47 cat. 10.

..

[4] *Judith Decapitating Holofernes*

Naples, Museo di Capodimonte
Oil on canvas, 1.59 x 1.26 m. (see below)
Ca. 1611–1612
Figs. 21–22; Color Plate II

COLLECTIONS: Signora Saveria de Simone, Naples, 1827

In mediocre condition, notwithstanding the cleaning of 1981 which rejuvenated the whites and brought surprising intensity to the blue of Judith's gown and the red of her companion's dress. Earlier overpainting, damage (as around Holofernes' mouth and neck, where a squeamish owner may have attempted to soften the horror), deterioration of the dark shadows, and skinning of the linens and flesh areas compromise the painting's quality. The background curtain (cf. the X-radiograph) is no longer visible.

The canvas has also been reduced in size, although where and by how much is a matter of debate, a matter which must be considered in detail if one is to assess as accurately as possible the relationship of this conception to Artemisia Gentileschi's *Judith Decapitating Holofernes* in the Uffizi (Fig. 77; Color Plate XII), determine if the present picture can be linked to any inventory citation(s) and, related to both of the above, address properly the recently opened question as to whether the work is by Artemisia or Orazio Gentileschi. And the issue of the original size of the Naples *Judith* requires examination of the copies of or related to it—one in storage at the Pinacoteca Nazionale in Bologna (Fig. 27), another known by way of a photograph in the Istitito Centrale per il Catalogo e la Documentazione at Rome (no. E44973; Fig. 28; hereafter identified as IC), and a third in the Galleria dell'Arcivescovado at Milan (Fig. 30).

The Bolognese example, a canvas of 1.614 x 1.385 m., was featured as a Caravaggio when in the Palazzo Zambeccari, where it made vivid

impressions upon visitors, among them Charles de Brosses and Nicolas Cochin. Claimed by the present author and others to be based on Artemisia Gentileschi's *Judith* in the Uffizi, it in fact replicates the version in Naples, as Emiliani and Papi have realized. The picture is of appreciable quality, leaving open for Emiliani and Perini some possibility that it came from Artemisia's brush. Papi's judgment that with respect to the Naples canvas it exhibits "i panneggi più duri e i contorni e i trapassi luministici più grevi" such as to mark it as a copy seems, however, correct. (Papi also attributes to the copyist the substitution of "verde veronese" for the blue of Judith's dress, but I suspect that this green is the result of chemical instability to an originally blue pigment.)

The IC version is patently by a inferior hand. An artist of similar limited skills was responsible for the arch-shaped example in Milan, which is paired with a version of Orazio Gentileschi's *David in Contemplation After the Defeat of Goliath* (Fig. 29). These small works, measuring .32 x .22 m. and executed on touchstone, were assigned to Guercino in the *Instrumentum donationis et inventarium tabularium picturam* of 1650, by means of which Cardinal Cesare Monti, Archbishop of Milan, passed on paintings in the Archepiscopal Palace to his successors: "Duoi Quadri del Guercino da cento, sopra la pietra paragone ovati nella parte di sopra, Una Iuditta, che con la mano sinistra taglia la testa ad Oloferne, con la destra tiene i cappelli, un'altra figura, e un Scabello con lume sopra acceso, l'altro un David nudo con poca pelle, e panno bianco sopra una spalla, piede alzato sopra una pietra, la Testa del Gigante, Cornice d'Ebano con frontespicio, alti in mezzo onz. 6, e mezza, larghi onz. 4."

Since these pictures were not recorded in the inventory of the Archepiscopal Palace drawn up in 1638 (of which 103 paintings reappear in 1650), they were no doubt acquired by Cardinal Monti after that date, either by purchase, exchange or, more likely, as gifts. Although during his years in Rome and Madrid, and through his association with the Barberini and Cassiano dal Pozzo, Monti could have become familiar with Artemisia's art, he apparently did not; that, at least, is initimated by the fact that the Gentileschi-derived paintings bore Guercino's name. (Their subsequent attributional history is traced by Frangi, who has published the works in detail.)

The figures in the *David* are close to, but not identical with, Orazio Gentileschi's painting on copper of this subject in the Staatliche Gemäldegalerie at Berlin (Fig. 24), and appear here against a dark background. The figures in the Milan *Judith* echo those in the autograph rendition in Naples, but the former, besides showing Holofernes' right leg down to the knee, has at the lower left a table with a candle upon it. Conversely, it does not contain the lowest layer of the three-tiered bed as seen in the Capodimonte original and in the other two copies. Further, its color, with the maid in blue and Judith in golden yellow, and the relationship of forms to space (see below), bear comparison to the Uffizi version. One is therefore persuaded by Papi's suggestion, seconded by Frangi, that the two works in the Arcivescovado might possibly have been based upon similar Gentileschian compositions now unknown. In this connection it has not been noted previously that on April 13, 1923, there appeared at Christie's–London (Lot 88) two pictures described as "Gentileschi: The Murder of Holofernes; and David with the Head of Goliath.2." The property of the Rt. Honorable Cornelia, Countess of Craven, Coombe Abbey, Coventry, they were purchased by Field for 7 pounds, 7 shillings and have since disappeared. Without additional information, one cannot determine how closely these two works resembled either the copies on touchstone or any of the still-extant originals by the Gentileschi of these themes. Although the attribution of both of them merely to "Gentileschi" and their low valuation suggest that they were not considered autograph, their citation adds additional weight to my proposal, to which Frangi subscribes, that a single collector owned the two pictures upon which the Milanese copies are based. This in turn might be used as evidence (see below) in the matter of attribution.

For the moment, the relevancy of all of this to the question of the initial size of the Naples *Judith* must be defined. Today the painting is the same height as the Bologna copy, but before its restoration in 1981 it had affixed along the top a band of fabric of approximately 6 cm. wide. Since the vertical canvas seam that runs though Holofernes' left elbow abutted against

it, this strip was obviously an addition. Yet the IC example has such a zone, and in the Milan version there is considerably more space above, even if the arbitrary lunette area were to be removed.

In that the Naples and Bologna pictures are now identical in height, it is reasonable to assume that the latter was produced before the former was augmented. This in turn would imply that the IC copy, its upper space so close to the pre-1981 state of the Naples canvas, was made after the augmentation. However, while this reasoning may prove that the specific strip added to the Naples picture was not original, I do not think that it demonstrates beyond doubt that the present height of the Naples canvas is that intended by the painter. For while the figures in the Arcivescovado *Judith* relate to those in the Capodimonte painting, its format (minus the lunette space) recalls that of the Uffizi variant. And the maid in the Naples picture now functions uncomfortably as a caryatid for the frame.

Furthermore, there can be no doubt that the Naples example has been reduced in width (almost entirely on the left). It is now 12.5 cm. narrower than the Bologna copy, which shows (as does the IC version) a triangle of Holofernes' bare leg, and Garrard notes the lack of a stretching garland on the left side. Papi supposes that the initial width of the Capodimonte *Judith* was basically that of the Bologna one as it stands. Garrard, however, holds that the whole of Holofernes' bent right leg, pressed into the pillow, and even a portion of his left leg, were once depicted. In favor of this second proposal are above all the source for Holofernes' pose in Orazio Gentileschi's *David* at Dublin (see below) and the composition of the Uffizi variant. Additionally, as noted, the victim's right leg down to the knee appears in the Milan version. And what of the still-life of table and candle in the latter? To ascribe these details to the whim of a copyist, either of the Naples picture or of a related one, would be to ignore the facts that they appear on an area of canvas not present in the Naples *Judith*, in Adam Elsheimer's *Judith Decapitating Holofernes* of 1601–3 which the artist apparently knew (Fig. 26; below and [14]), and in Artemisia Gentileschi's later renditions of *Judith and Her Maidservant* in Detroit, Cannes, and Na-

ples (Figs. 84, 191, 192; Color Plate XIII)—but not, admittedly, in the Uffizi example. Moreover, the strength and pattern of lighting on the figures and bedcover are consistent with the position of a candle flame slightly above the level of Holofernes' left elbow. And both the Bologna and IC copies contain unexplained dark intrusions at their lower-left borders.

If, to maintain the same proportions that it now has, the Capodimonte *Judith* were to be increased by 12 cm., so that it would be equal in width to the Bologna picture, and by a corresponding 12 cm. above, it would measure 1.71 x 1.38 m. But some of the arguments presented above intimate that the canvas could have been as large as, very roughly, 1.80 x 1.55 m. The disappointing conclusion must therefore be that the conflicting evidence renders a firm decision impossible, leaving one with a range of possible sizes and thus with rather too much flexibility in potentially accommodating the known picture to inventory references. And there is no clue as to exactly when any presumed trimming and later augmentation of the Naples original took place.

What has always seemed certain, on the other hand, is the attribution of the present *Judith* to Artemisia Gentileschi. But in 1991 Mario Modestini, supported by John Spike, reassigned the canvas to Orazio Gentileschi upon its appearance in the Casa Buonarroti exhibition. Before reviewing and evaluating the major components of this new proposal, I would like to present verbatim what I had written prior to 1991—that is, to proceed first as if I were unaware of the entry in the *mostra* catalogue and of the suggested reattribution. In this way it may be judged more clearly the degree to which my cases for authorship and dating received reinforcement from the opinions of the exhibition organizers, while at the same time a firm basis for consideration of the alternative attribution will have been established.

Thus: Ortolani labeled the Naples *Judith* a copy by F. M. Retti of the Uffizi picture, whereas Retti's name is to be associated rather with a copy of Artemisia's later *Judith and Her Maidservant* (Fig. 192; [48c]). Moir speculated that the earlier Capodimonte canvas may be "by Orazio . . . or (more likely) by a close and skillful imitator," conceivably Artemisia in a pre-Neapolitan phase, but such doubts as to

authorship have not been entertained in subsequent literature. Until relatively recently, all scholars with the exception of Pointon considered the *Judith* to be a variant of the Uffizi composition. Borea, misinterpreting a passage in Artemisia's letter of October 9, 1635, to Galileo—the artist refers to a related situation of unappreciative patronage, not to a painting similar to the Uffizi *Judith*—supposed that the Naples example might possibly be dated 1635, as did Pérez Sánchez, for the same reason. Longhi suggested ca. 1630, and Rinaldis, Bissell, and Whitfield, noting the picture's Neapolitan provenance, theorized that it was either painted by Artemisia in Naples or brought there by the artist. Pointon, however, gave precedence to the Capodimonte version, and following its cleaning Garrard and I came independently to the conclusion that the painting belongs to Artemisia's earliest years and prior to her Florentine stay.

The evidence for a dating of ca. 1611–12 is varied and cumulatively commanding. The X-radiograph of the canvas (Fig. 22), taken for and discussed in detail by Garrard, reveals a pattern of experimentation inconceivable for a repetition of an established composition (i.e., the Uffizi *Judith*). Creating as she went, the artist altered the positions of Judith's arms and of Holofernes' right arm, tried different drapery configurations, and painted the pommel of the sword above the fully rendered right hand of Abra.

The X-rays confirm the priority of the Naples picture, and the extent to which it is bound to the Roman artistic milieu of the first decade of the century, a condition upon which Garrard rightly insists, specifically locates it in Gentileschi's early career. Artemisia's point of departure was unquestionably Caravaggio's Coppi *Judith Decapitating Holofernes* of ca. 1598 (Fig. 38), where Judith, her arms in stiff parallel diagonals that at once suggest resolve and avoidance of a potential bath of blood, draws the sword through the neck of the screaming Holofernes while applying an iron grip to a knot of his disheveled hair. From Caravaggio comes too the three-tiered bed. Yet the transformations wrought by Artemisia are fully as consequential, and for these the example of Orazio Gentileschi was central, a relationship which in this instance at least has not been sufficiently

recognized. The female type, embraced by Artemisia in the *Susanna* and the *Lucretia* (Figs. 10, 19; Color Plates I, III) as well, is Orazian, as Moir and Garrard have observed, and behind the equality of participation accorded Judith (now mature) and Abra (no longer the usual crone) stands Orazio's *Judith and Her Maidservant* of ca. 1611–12 (Fig. 33). And while the father's *Judith*, as his related *Young Woman with a Violin* in Detroit (Fig. 32), is as notable for its poetic sentiment as his daughter's Naples picture is for its ferocity, it should not be forgotten that during the later years of the first decade—in the *Saint Michael Overcoming the Devil* for San Salvatore at Farnese and the *David Slaying Goliath* (Figs. 13, 14)—Orazio had experimented with action scenes. As in Artemisia's *Susanna* and the *Lucretia*, this phase of Orazio's oeuvre is again recalled, now combined with impressions of his contemporary canvases. It was in fact not Caravaggio's *Judith* but rather the giant in Orazio's Dublin *David* that provided the most familiar model for the attitude of Holofernes in Artemisia's *Judith*. Nor is it a major leap from the men who bear down upon Christ in Orazio's *Mocking of Christ* of ca. 1610 or slightly later (Fig. 17) to the maid in the Naples canvas. (The tormentor at the right had already been adapted for one of the elders in the *Susanna* [2].)

In stressing here the expressive and compositional precedents of Orazio Gentileschi, I must urge a reconsideration of the roles thought to have been played by two other pictures, Adam Elsheimer's *Judith Decapitating Holofernes* (Fig. 26) and Rubens's *Great Judith* (known by way of Cornelius Galle the Elder's engraving of ca. 1610, showing the composition in reverse; Fig. 25). Naturally Artemisia would have been intrigued by other artists' renditions of the Judith theme. The orientation of Elsheimer's Holofernes of raised arm and clenched fist may have been instrumental in her recasting of Orazio's Goliath who, unlike Elsheimer's figure on the other hand, shows both legs, with the right one flexed, not kicking. The German master's picture was then consulted by Rubens, who owned it, and merged with features of Caravaggio's *Judith* for his now lost *Great Judith*. Artemisia's presumed debt to Rubens was first argued by Hofrichter and reinforced by Garrard, who writes that "Rubens' painting ap-

pears to have served Artemisia primarily as a Caravaggesque model for a more operationally explicit and dramatically convincing depiction . . . than Caravaggio himself afforded." Yet impetuous movement, if not convincingness, also characterizes Orazio's *David Slaying Goliath* which, like Artemisia's *Judith*, avoids the idealized types, the heroic posturing, the decorative brilliance, and the magniloquence associated with Rubens. It may be, therefore, that the Flemish artist's *Judith* was of interest to Artemisia not as an epitome of expressive intensity but for its details—the spurting blood, the relative positions of Judith and her assistant, the "intricate interlocking of arms" (Garrard).

There are other indications, beyond Artemisia's utilization of sources available in Rome, for the early date of the Naples *Judith*. As noted above, the small version on touchstone accompanies a copy, furnished with a dark background, of one of Orazio Gentileschi's depictions of *David in Contemplation*, the design of which, in my opinion, was formulated in Rome about 1610. Then there is the *Salome with the Head of Saint John* formerly at Geneva (Fig. 20). While Natale's attribution of this now-destroyed canvas to Giovan Francesco Guerrieri is to be questioned (see [X-39]), the *Salome* is patently a product of the Gentileschian orbit in Rome and is extremely close to Orazio himself. In pose and facial type this picture bears undeniable relationships to Artemisia's *Judith*.

Most tellingly, the style of Artemisia's painting, as its no-nonsense communication, is consistent with the *Susanna* from 1610 and the *Lucretia*. While the unsatisfactory condition of the canvas must be taken into account, it is probable that the handling was never particularly fluid or inspired—some areas, as Abra's white sleeves, are rather labored—and that the color scheme did not go beyond its present rudimentary character. Technically, then, the picture speaks of an early production, while its pictorial power testifies to an artist of special dramatic gifts. When the search for sources is through, the painting stands as an original, unparalleled invention.

This, then, is where my thinking on the issues of attribution and date stood before Gianni Papi catalogued the Naples *Judith* in exhaustive detail and came essentially to the same conclusions. Proceeding, as I had, on the assumption that the canvas was by Artemisia, Papi underscored the X-ray evidence and pointed to various aspects of style (including the lack of those decorative refinements that later would characterize Artemisia's art; a decisiveness of handling relatable to the Pommersfelden *Susanna*; and connections to the Roman artistic milieu, above all to Caravaggio and Orazio Gentileschi) which for him, as for Garrard before him, indicated a date for the picture in Artemisia's early, pre-Florentine years. Berti, Stolzenwald, and Hersey concur with this judgment. Bionda holds—incongruously—that the canvas was painted in Florence about 1612–13 and Baumgärtel sets its execution in Florence after 1612. Daprà, without assessing recent scholarly opinion, continues to place the *Judith* about 1630.

Very unexpected, therefore, is the contention of Mario Modestini, reported and favored by John Spike, that the Naples *Judith* is the work not of Artemisia but of Orazio Gentileschi. Spike finds acceptable the dating of the Capodimonte picture to the early years of the second decade. Yet for him this painting and Artemisia's signed *Judith Decapitating Holofernes* in the Uffizi (Figs. 77–79; Color Plate XII), which he portrays as "the Naples composition seen through the wrong end of a telescope," seem the product of two distinct points of view and hands. The Naples picture, urgently dramatic, physically aggressive, and "indescribably more volumetric in conception," is contrasted to the "gratuitous . . . special effects" and "drier, harder, more linear" handling of the later Uffizi version. The affinities between the Capodimonte *Judith* and Orazio's *Mocking of Christ* and *David Slaying Goliath*, which Spike too recognizes, are taken to point to the father's authorship of, rather than influence upon, the *Judith*. Even the Pommersfelden *Susanna* is mustered to help secure the reattribution of the *Judith*, for in Spike's view the *Susanna* is not only "wholly consistent with Orazio's style" but is likely to be Orazio's invention. Were Artemisia to be credited with the Capodimonte example, Spike concludes, one must believe that by the time she executed the Uffizi example she had undergone "a kind of personality shift" and had become "incapable of understanding her previous work."

I am not at all convinced by the Modestini/ Spike viewpoint, in part because of the conviction with which I had already arrived at my understandings of the painting and in part because the proposal itself is subject to challenges. Thus, to extend (as one must in one's mind) to the left and above the space around the figures, even by the minumum amount calculated above, would be to lessen the force with which the picture attacks the viewer and thus to move the Naples *Judith* closer in feel to the Uffizi version. Further, it may be questioned whether Orazio ever sought this level of brutal directness, not even with the *David Slaying Goliath*. The aforementioned *Salome with the Head of Saint John*, while it may well be a prototype for the Naples *Judith*, is more in line with Orazio's particular interpretive leanings. Nor to my perception does the present *Judith* meet Orazio's extraordinarily high standards of quality in the years just after 1610, as established for example by the Hartford *Judith* and the Detroit *Young Woman with a Violin*. Only Orazio's *Judith with Her Maidservant* now in London (Fig. 39), painted between 1605 and 1610 and one of the sources for Artemisia's canvas of the same subject in the Palazzo Pitti (Fig. 31), strikes one as comparable in its broad and severe execution to the unsubtle handling of the Capodimonte canvas.

The intensive exposure to Florentine art on its own ground that Artemisia underwent during her lengthy stay in the Tuscan capital and her awareness of Medicean taste, both of which are clearly reflected in the likes of the Pitti *Conversion of the Magdalen* (Fig. 70; Color Plate V), can account for the changed flavor of the Uffizi *Judith*; one need not assume that Artemisia had forgotten what it meant to be a strict Caravaggist. And although I think it likely that the Naples picture was still in Rome when Artemisia returned there from Florence, and that it was in Rome about 1620 that she executed her Uffizi *Judith* (in many details so identical to the earlier work as to presuppose a direct confrontation with it; see [12]), I fail to understand why Artemisia, more than ten years into her career and having worked independently in Florence for about seven of them, would have felt the need to replicate a composition that according to the Modestini/Spike thesis was her father's.

At this point, two additional observations conceivably in support of the reattribution of the Naples *Judith* must be weighed. First, one could contend that the pair of small paintings in Milan, the *Judith* and that *David in Contemplation* based beyond doubt on an Orazio conception, implies not only that the originals from which these copies were made were in the same collection but that both of the originals were by Orazio. But would not a patron have found even more attractive the chance to own one picture each by father and daughter, a "diptych" of male and female heroes, the former by the man and the latter by the woman? Second, the present *Judith* was in Naples when in 1827 it was sold as a Caravaggio by Signora Severia de Simone. Thus the following citation in a Neapolitan inventory entitled "Quadri dell'eredità del Marchese Ferdinando Vandeneynden" as compiled by Luca Giordano and dated November 17, 1688, is of potential significance: "Un quadro di pal. 5 e 7 con cornice indorata la Giuditta che taglia la testa ad Oloferne mano di Oratio Gentilesco" (an entry transcribed by Colonna as "Un quadro di palmi 3 [*sic*] e 7 con cornice ind.ta la 'Giuditta, che toglie la testa ad Oloferne,' m.o di 'Oratio Gentilesco'"). This register was occasioned by the marriage in 1688 of Giovanna Van den Eynden to Principe Giuliano Colonna di Galatro, a third of Ferdinando's artistic patrimony, including the *Judith*, then passing to the Casa Colonna. Van den Eynden had himself inherited in 1674 (the year of his death) ninety pictures from Gaspar Roomer's extensive collection, and the *Judith* may have been among them. The size of the Roomer?–Van den Eynden–Colonna work, no doubt merely approximated in the inventory as was the custom, was 1.32 x 1.85 m. (.264 m. for the Neapolitan *palmo*), not impossibly far from the dimensions of the Naples *Judith* in one of its several presumed original states. Since, however, Luca does not follow a pattern when recording height and width, there is no certainty that the *Judith* was of vertical format. And was the picture actually by Orazio Gentileschi? The subject and location immediately bring Artemisia to mind, and Giordano might not have been expected to have recognized Artemisia's style in a picture executed almost twenty years before her Naples trip.

It may also be that the present *Judith* is recorded instead in other Neapolitan inventories (see [L-46] and [L-48] for full details). The first, citing "Una Giuditta de palmi 5 e 6 con cornice indorata de mano d'Artemisia Gentileschi," is of pictures that passed to the Pio Monte della Misericordia upon the death on September 11, 1646, of D. Cesare di Gennaro, Principe di San Martino. Then on November 17, the painting was evaluated for subsequent sale by the Monte as "Una Giuditta di 5 e 6 con cornice indorato mano d'Artemisia Gentileschi 40 (40–50)." The third and fourth citations, from 1648 and 1649 ("Una Giuditta della medesima misura [sei palmi e cinque] di mano di Artemitia Gentilesca con cornice inorata, et intagliata" and "Uno quatro di Giuditta di mano d'Artemisia"), concern a work owned by the Carafa dei Duchi di Maddaloni. It is probable, although not provable, that the Carafa and ex-Gennaro canvases are one and the same, the Carafa having acquired the *Judith* from the Monte della Misericordia sale.

If the sizes reported in the above inventories did not include the frames, the canvas(es) thus measured approximately 1.58 x 1.32 m., extremely close to the present size of the Capodimonte *Judith*. Still, given that the original measurements of that canvas are open to dispute, the lack of certainty that one or both of the recorded *Judith*s were of vertical format, and the necessity for pure speculation regarding the mode of passage of the Capodimonte *Judith* from Rome to Naples by the 1640s (e.g., Artemisia somehow still had it in her possession upon her move south about 1629), one has no choice but to concede that a securely documented trail of the *Judith* prior to the nineteenth century is nonexistent.

BIBLIOGRAPHY: F. Colonna, "Inventario dei quadri di casa Colonna fatta da Luca Giordano," *Napoli nobilissima*, IV, fasc. II (1895), 31 no. 60; Longhi, *Scritti*, 1961, I–I, pp. 258–59, 275 n. 32; London, Christie's, *Pictures by Old Masters*, April 13, 1923, Lot 88, p. 16; Rinaldis, 1928, p. III no. 378; Ortolani et al., 1938, p. 45; Berne-Joffroy, Paris, 1959, pp. 115–16; Moir, 1967, I, p. 135 n. 19; Bissell, 1968, p. 158; Borea, 1970, pp. 76–78 cat. 49; Nicolson, 1979, p. 51; Hofrichter, 1980, pp. 9–15; Bissell, 1981, pp. 149–50 cat. [19], 154; Pointon, 1981, p. 343 n. 2; Ruotolo, 1982, pp. 7–8, 12, 15, 34, 39; Whitfield in London, Royal Academy, 1982, p. 168 cat. 60; A. E. Pérez Sánchez in Madrid, Palacio de Villahermosa, 1985, pp. 164–65 cat. 56; E. Schleier in New York, Metropolitan Museum, 1985, pp. 155–57 cat. 43; Garrard, 1989, pp. 32–34, 305–13, 494–95 nn. 35–36, 554 esp. nn. 85 and 89, and passim; Nicolson/Vertova, 1990, I, p. III; Papi in Contini/Papi, 1991, pp. 116–19 cat. 9; Berti, ibid., pp. 22, 29 n. 18; Stolzenwald, 1991, pp. 33, 64, 82 fig. 54; Spike, Review, 1991, p. 732; idem in "The Gentileschi Papers," *Journal of Art*, IV, no. 9 (1991), 12; Palmer, 1991, p. 278; R. Feigen, New York, letter to the author, October 10, 1991; Bionda, 1992, pp. 22–24; Hersey, 1993, pp. 327–28; B. Daprà in Chambéry, Musée des Beaux-Arts, 1995, pp. 90–91; B. Baumgärtel in Düsseldorf, 1995, pp. 244–47 cat. 106. Also [L-46] and [L-48].

For the copies in Milan and Bologna: C. De Brosses, *Lettres d'Italie du Président De Brosses*, ed. F. d'Agay, Paris, 1986, I, p. 276; C.-N. Cochin, *Le voyage d'Italie de Charles-Nicolas Cochin (1758)*, ed. C. Michel, Rome, 1991, p. 278; "Inventario particolare di tutti li quadri e Mobili ritrovati nella Galleria del fu Mse Giacomo Zambeccari. 1796, Adi 15 Marzo. Rog. di Ser Cristoforo Locatelli. Not. Coll.," Bologna, Archivio Storico della Soprintendenza; C. Masini, "Stima Artistica della Galleria Zambeccari in Bologna," 29 aprile 1871, Bologna, Archivio Storico della Soprintendenza; M. Oretti, *Le Pitture che si ammirano nelli Palaggi, e Case de'-Nobili della Città di Bologna e di altri edifitii in d.a Città*, MS B. 104, I, c. 87, B. 105, I, c. 272, and B. 105, II, c. 14; G. Nicodemi, "La Pinacoteca dell'Arcivescovado di Milano," *Rassegna d'arte*, XIV (1914), 287 n. 2; E. Mauceri, *La Regia Pinacoteca di Bologna*, Rome, 1935, p. 165; Moir, 1967, I, p. 135 n. 19; Bissell, 1968, p. 156 n. 24; *La Pinacoteca Nazionale di Bologna*, Bologna, 1969, p. 149; Moir, 1976, p. 124 n. 186; A. Emiliani in Bologna, Pinacoteca Nazionale, *La Collezione Zambeccari nella Pinacoteca Nazionale di Bologna. Indagine di metodo per la realizzazione di un catalogo storico e critico delle raccolte statali bolognesi*, ed. A. Emiliani, 1973, pp. 25, 30, 53, 134, 257; R. D'Amico in *La Raccolta Zambeccari*, exh. cat., Bologna, 1979, p. 213 cat. 12; Nicolson, 1979, p. 51; Cinotti and dell'Acqua, 1983, p. 515; M. Gregori in New York, Metropolitan Museum, 1985, p. 257; Papi in Contini/Papi, 1991, pp. 116, 119; Milan, Palazzo Reale, *Le stanze del Cardinale Monti 1635–1650: la collezione ricomposta*, exh. cat., 1994, pp. 123 nos. 47–48, 224–25 cat. 93 and 94 (entries by F. Frangi, with additional bibliography), and passim (for Cardinal Monti's biography and collection); G. Perini in "Caravaggio a Bologna," *Napoli, l'Europa. Ricerche di storia dell'arte in onore*

di Ferdinando Bologna, ed. F. Abbate and F. Sricchia Santoro, Catanzaro, 1995, pp. 201–2 and fig. 153.

For the additional comparative material: [X-39]; K. Andrews, *Adam Elsheimer: Paintings, Drawings, Prints*, New York, 1977, p. 144 cat. 12; D. Bodart in Rome, Gabinetto Nazionale delle Stampe, Villa Farnesina, *Rubens e l'incisione*, 1977, pp. 18–19 cat. 19; Bissell, 1981, pp. 145–46, 152–54, 293, 205–7 [14], [15], [24], [25], [X-9], [X-18]; Cinotti and dell'Acqua, 1983, pp. 515–17 cat. 55; B. Barnes in Russell, 1990, pp. 72–73 cat. 32.

..

[5] *Judith and Her Maidservant*

Florence, Palazzo Pitti
Oil on canvas, 1.14 x .935 m.
Ca. 1612
Figs. 31, 47; Color Plate IV

On the reverse, before relining, the numerals 1246, 1089 A, 1028, 469, 216

COLLECTIONS: Palazzo Pitti, Florence, by 1638

In spite of—or no doubt in part because of—more than one campaign of "conservation," the painting came down in a critical, and in certain sections wretched, state of preservation. Blisters and countless small areas of paint loss pockmarked the surface. Some damaged areas may have been re-created; thus the napkin beneath the basket, brushed in with expressionistic verve, is surely too amorphous to be faithful to Artemisia's design (as the copy last in Lugano, Fig. 35, and that in Genoa likewise suggest). A restoration and relining in 1969/70 consolidated the canvas while removing from its top a 3 cm. strip. As Garrard supposed, the work had previously been cropped, especially above and at the left (where Judith's sleeve, complete or virtually complete in copies, is now arbitrarily severed). An average of the picture's measurements as reported in two seventeenth-century inventories (see below) yields—the Florentine *braccia* at 58.36 cm.—a painting of 1.27 x 1.07 m., the approximate size of the De Boer/ex-Lugano copy. Thus it appears that the canvas was originally larger by as much as 13 cm., or 5 inches, in both dimensions. Indeed, the engraving published in 1837 indicates slightly more space to the left, right, and above.

Throughout its documented history the *Judith and Her Maidservant* has remained in the Palazzo Pitti, where it is recorded, correctly attributed, on "3 marzo 1637" (1638 New Style) as "Un Quadro Intela entrovi Judit con la sua compagna con la testa di Oloferne in una paniera di mano dell'Artimisia con cornice di noce alto B. 2 o/2 largo B 1²/₃ Inc.a." and again in an inventory begun on December 30, 1663, as "Un Quadro in tela entrovi dipinto la Juditta con la spada in su la spalla, con un'altra figura che ha in una cesta la testa di Leoferne con adornam.to di noce alta B. 2¹/₆ e largo B. 2 di mano dell'Artimisia."

All scholars have situated the picture in Gentileschi's early career, with Bissell, Whitfield, Hagen, Papi, and Hersey judging that it was painted in Rome before the artist's departure for Florence, Garrard, Berti, Stolzenwald and Bionda assigning it to Artemisia's first Florentine years (ca. 1613–14), and Contini undecided between these two possibilities. Upon a resolution of this seemingly inconsequential difference of opinion hang major implications for the genesis of the canvas. The resolution may hinge in significant part upon an evaluation of testimony presented during the rape trial of Agostino Tassi, and certainly upon the role of two paintings by Orazio Gentileschi, compositions (Figs. 40, 39) of *Judith and Her Maidservant* in the Nasjonalgalleriet at Oslo and formerly with Colnaghi's (then sold Sotheby's, New York, January 15, 1993, lot 46).

To address each of these issues in turn: The infamous trial began in March of 1612 with Orazio's petition to the Pope, in which it is claimed that

> . . . also meddling in this obscene business was Cosimo Quorli, your Paymaster. By this I mean that, beyond the rape, the same paymaster Cosimo, through his machinations, wrested from the hands of the same young woman some paintings of her father's, and in particular a Judith of large size.
>
> (. . . essendosi anco intromesso In questo negotio osceno Cosimo Quorli suo Furiere; Intendendo oltre allo Sverginamento che il med.ᵐᵒ Cosimo furiere con sua Chimere habbia Cavato dalle mane della med.ᵐᵃ Zitella alcuni quadri di Pitture di suo padre et In specie una Iuditta di capace grandezza.)

The specifics of Cosimo's complicity are detailed in an accompanying narrative:

> That Cosimo wrested from the hands of Artemisia a painting of a Judith can be seen from a note in Cosimo's handwriting in which he orders Agostino to give it to him. But the note is a forgery and is neither written nor signed by Artemisia, but rather was written during Carnival on the small marble table in Cosimo's house. And in spite of the fact that the painting was sequestered in Agostino's house by Signor Bulgherello [assistant deputy], Agostino's brother-in-law Filippo took it from the house by night to bring it to Cosimo's house, with Cosimo's servant carrying it. And when Signor Orazio demanded it back the Guardia di Borgo confiscated it and the painting remained in the hands of the Caponotaro di Borgo.

> (Che Cosimo habbia Caviato delle Mane di Artimitia Un quadro di Una Giuditta questo si vedrà p[er] via di Una polizza scritta di pp.a mano di Cosimo p[er] la quale si ordina a Agostino che gliele Dia ma la polizza é falsa et no[n] é scritta ne sottoscritta da Artimitia ma é scritta In Casa Cosimo sul tavolino di Marmo nelli giorni di Carnevale; et Il quadro é sequestrato dal Sig.ʳ Bulgherello In Casa Agostino, et nonobstante questo Filippo suo Cognato di notte lo Caviò fuori di Casa p[er] portarlo a Casa Cosimo et lo portava il Servitore di Cosimo et Il Sig.ʳ Horatio Rivolendolo dettono nella Guardia di Borgo et il quadro Restò nelle mane del Caponotaro di Borgo.)

On March 24 the facts concerning the *Judith* affair were confirmed by the witness Giovanni Battista Stiattesi:

> I know that Artemisia had an unfinished painting of a Judith which a few days earlier she had sent to Agostino's house. And I know that during the last days of Carnival, while Artemisia was in his [or her] house, Cosimo, with his tricks, forged a note in order to wrest the painting from Agostino's hands, as though Artemisia had authorized this. And I was present when Cosimo wrote it in the name of Artemisia, and for this I reprimanded Cosimo, telling him that he should not take from a young woman's hands a painting of that sort.

> (Io sò che Artimitia haveva un quadro di una Juditta non fornito [finito?] quale pochi giorni a dietro ella lo mandò ad casa di Ag.no, e sò che Cosimo con sue chimere nell'ultimi giorni di Carnevale, mentre Artimitia fù in casa sua, gli fece una polizza finta p[er] cavare questro quadro di mano ad Ag.no di ord.e di lei et a q.to io fui pnte [presente], che Cosimo la scrisse di sua mano in nome di Artimitia e sopra particolare io ne feci una riprensione a Cosimo dicendoli che non dovrebbe cavare di mano ad una zitella un quadro di quella sorte.)

Finally, Stiattesi's claim that he upbraided Cosimo was supported by a letter, introduced as evidence, which the former had written to the latter, containing the following line: "And also you should be ashamed for having snatched a painting of that kind from that young woman (*Et anco doveresti vergongnarvi di pigliare da questa fanciulla un quadro di quella sorte . . .*)."

As several scholars have noted, this body of evidence, being not without ambiguity, prompts such questions as these: How should one transcribe and interpret the modifying phrase used by Stiattesi on March 24 to characterize the *Judith*? Under what conditions did Tassi come into possession of this picture? Which of the Gentileschi painted it? And, related to the preceding, which if any of the extant Gentileschi *Judith*s would seem best to qualify as the work at issue?

According to Menzio's transcription, Stiattesi told the authorities: "Io sò che Artimitia haveva un quadro di una Juditta *non fornito* [italics mine]. . . ." The reading *non fornito* is accepted by Garrard and Papi, the former interpreting the words to mean that the painting was "not commissioned" or, more likely, "not delivered"; the latter—in the same vein—as *non ancora consegnato* ("not yet consigned"). To my perception, these words might as accurately be transcribed *non finito*, or "unfinished." In either case, "unfinished" was probably intended, for *fornire* is a now obsolete variant of *finire*.

Was it as a result of blackmail or rather as a

gift, Papi asks, that Tassi obtained the *Judith* from Artemisia? Stiattesi states only that Artemisia had sent the picture to Agostino's house. In Orazio's opening petition, in the narrative immediately following, and in Stiattesi's testimony, it is Quorli, not Tassi, who is accused of having "wrested (*cavato, caviato, caviare*)" the painting from Artemisia, although it was in Tassi's lodgings. Cosimo forged a letter in Artemisia's name obviously in the belief that his only chance of getting the *Judith* was through feigning Artemisia's approval of a transfer. There is no indication that Tassi considered the work to be his permanent property, and every sense that it was merely on loan to him through Artemisia's good graces.

That the *Judith* had been in Artemisia's possession suggests to Papi that it was by her own hand. Artemisia's authorship of it is assumed by Rose and argued by Cropper. However, as seen, the first mention of the picture was at Orazio's instigation and carries the implication that it was painted by the father. Garrard addresses the seeming contradiction by theorizing that the *Judith*, while perhaps meant to be passed off as an Orazio, was in fact a copy by his daughter of an Orazio canvas, and was specifically the *Judith and Her Maidservant* in the Pinacoteca Vaticana, so close to Orazio's picture in Hartford (cf. Figs. 219, 33). In my opinion, evidence for such a proposed deception and/or for such a direct copy is not to be found either in the trial records or in actuality; surely it is wishful thinking to recognize Artemisia's brush or mentality in the Vatican example (see [X-15]).

Menzio and Papi have realized that the coupling by Orazio Gentileschi of reports of the rape of his daughter and the abduction of the *Judith* indicates the importance which Orazio attached to that particular painting. Rose speculates that the father had been looking forward to realizing financial gain from one of his daughter's productions and that the loss of this prospect troubled him more than the loss of his daughter's virginity. Cropper also believes that the *Judith* was by Artemisia, but hypothesizes that Orazio felt dishonored by the links between the affair of the *Judith* and the situation in which his daughter had been forced. Specifically, she suggests that Artemisia would have been held up to public scorn by Quorli

who, displaying a picture by and of her (either as Judith or the maid) of a theme with sexual overtones and involving the death of a man at the hands of a woman, insinuated an association of Artemisia with that tradition which had labeled Judith a prostitute. Finally, Hersey suggests that the *Judith* under discussion at the trial might have been the Pitti canvas, a work more or less completed by Artemisia in 1611 and then taken by her to Florence, where it was finished and sold to the Grand Duchess.

Although recognizing the acuity of many of these proposals and the fact that the evidence does not lend itself to definitive pronouncements, I remain of the opinion that the *Judith* in question came from Orazio's brush, that the father considered it his property, and that he had placed it at Artemisia's disposal as a teaching tool or guide (see below). In 1981 I thought to identify the work as the *Judith* at Oslo, which I have since studied in the original and whose attribution to Orazio I have come to accept without the misgivings that I expressed at that time (Fig. 40). However, a better candidate for the "trial picture" has since emerged, the ex-Sotheby *Judith and Her Maidservant* (Figs. 39, 42; 1.31 x 1.00 m.). A detailed demonstration, based on the Bibliography presented below (and upon a close examination of the original, including its reverse) of Orazio's responsibility for the ex-Sotheby canvas is beyond the scope of this entry. However, several facts regarding it, most of which I brought together in 1984 in an extensive report to Colnaghi which has been tapped but not acknowledged in some subsequent literature, seem crucial to the present issue. This *Judith* bears inscriptions by at least four different hands: on the front, below, "B. Capranica No. 618"; and on the back of the eighteenth-century relining canvas, on four randomly staggered lines, "N° [number obliterated] / Horazio Gentileschi A°. 1612 . Piz². / G. M. R. / C. 2 N. 150[?]." It can be shown that these notations offer absolute proof that the painting came from the Palazzo Rondanini in Rome where it was inventoried in 1662 and from where it was sent, still assigned to Orazio Gentileschi, to exhibitions at San Salvatore in Lauro in 1694 and 1710. The canvas subsequently passed to the Marchese Giuseppe Rondanini ("G.M.R." = "Giuseppe, Marchese Rondanini," died 1801)

and in 1809, by division of the inheritance of Don Camillo Zacchia Rondanini, to Bartolomeo Capranica ("B. Capranica"). Contrary to what Pepper holds, this *Judith* cannot have been painted by Orazio in 1612 (or very close to 1612, in Papi's judgment), for its style is that of the first decade, as Whitfield, Banks, and the Sotheby's catalogue have likewise observed. In particular, it is bound to the Dublin *David Slaying Goliath* (Fig. 14) and above all to Gentileschi's *Way to Calvary* in the Kunsthistorisches Museum at Vienna. In agreement with Whitfield/Banks and Pepper, I believe that some of the information on the back of the *Judith*, including the date, may well be a record of the vicissitudes of the trial canvas. The abbreviation "Piz²." has been translated "Pisano," with reference to Orazio's birthplace, notwithstanding the peculiar spelling and the fact that it does not follow the artist's name as would be expected. It can only refer back to the date. Thus one is led to the verb *pizzicare* and, following the trail of references in the *Grande dizionario della lingua italiana*, from *pizzicare* ("prendere un oggetto, impadronirsi") to *impadronire* ("appropriarsi di qualcosa, per lo più con la violenza o con la frodde") to *frodde* ("artificio diretto a sorprendere la buona fede altrui"). In short: To lay hold of that which belongs to another through false pretenses and trickery—precisely as in the case of the *Judith* cited at the trial. Still another explanation for the designation "Piz²." has been offered by Lapierre, who has determined that both Orazio Gentileschi and Tassi were represented by the notary Tranquillo Pizzuti, whose notarial documents repeatedly abbreviate his name under the form "Pizz°." The characterization of the *Judith* as *non fornito* (or *non finito*) could explain why the painting was still with the Gentileschi in 1612. It may be that Natale Rondanini (1540–1627), the founder of the collection, soon purchased the by-then-notorious canvas.

As detailed in the text, Artemisia Gentileschi's *Judith and Her Maidservant* at Florence contains features that appear individually in the Oslo and ex-Sotheby pictures. Before the appearance of the latter canvas, Borea, Greer, and Bissell identified the Oslo version as Artemisia's prototype, not unreasonably given the visual evidence, the early date of the Pitti painting, and the daughter's special debt at that moment to her father's art. Pepper, while rejecting the Oslo *Judith* as a work by Orazio, argues for the influence of the ex-Sotheby example upon Artemisia's image.

Gregori, in my opinion, is correct in viewing Artemisia's *Judith* as having drawn upon *both* pictures by Orazio. This conclusion would be contested by Garrard, for whom Artemisia should be conceded the maximum stylistic and interpretive originality. Finding it "impossible to reconcile the unusual style of the Colnaghi picture with Orazio's known works, particularly in the period around 1612"—to which it surely does not belong in any case—Garrard also contends that the Oslo version, for which Orazio remains the "leading candidate," is based upon Artemisia's picture, which she believes was painted in Florence where Orazio would have seen it during his trip in 1616. (For Pepper, the Oslo *Judith* may be a derivation from Artemisia by Giovan Francesco Guerrieri, while Contini, noting the connections between the three compositions of *Judith*, does not take a stand concerning their relative chronological positions.)

For reasons stated above, I am of another mind, the more so as a date of 1616 for the Oslo painting is at least a few years too late. Furthermore, Garrard considers "germinal" for the moment selected by Artemisia and for the youthful Abra another Orazian precedent, the Hartford *Judith and Her Maidservant* of ca. 1611–12 (Fig. 33). It seems that Artemisia, after the *Susanna*, *Lucretia*, and *Judith Decapitating Holofernes* (Figs. 10, 19, 21; Color Plates I, II, III) to which Orazio's previous works of dramatic emphasis were fundamental, now found inspiration in the more introverted quality of the majority of Orazio's productions, including those from the beginning of the second decade.

All of this is not to relegate Artemisia Gentileschi to secondary status. Her Pitti *Judith* represents an original reworking of her sources, and in its compositional concentration as in its restricted yet rich color scheme of deep maroon, golden yellow, and white, and its sophisticated drapery patterns, it is a more compelling picture than the rather harsh ex-Sotheby *Judith* but less decoratively oriented than the Oslo one. Artemisia also made expressive use of the medallion in Judith's hair and of the sword handle. The latter comes alive with the scream-

ing head of a Medusa or Gorgon (recalling the Holofernes of the Naples *Judith*, Fig. 21). On the former, Garrard thought to recognize a warrior of the Saint George/David type, but this figure, frontally posed, with a sword or lance in his right hand and a shield in his left, is probably based upon the Mars Ultor depicted on Roman coins and gems. He was to reappear on the central cameo of the bracelet worn by Judith in the Uffizi *Judith* (Fig. 45 and Chapter 6, where specific ancient examples are cited) and there, as here, serves as an ironic contrast to the defeated Holofernes.

If, then, Artemisia's *Judith and Her Maidservant* was painted in Rome following Roman prototypes, there is no need to postulate, as has been done, the impact upon it of Florentine courtly tastes or of Florentine models such as Michelangelo's *David*. Similarly, the precedents of Orazio's Oslo and ex-Sotheby *Judith*s were, in my opinion, so determinant that suggestions of other relationships—to Caravaggio's *Calling of Saint Matthew*, to a fresco by Cigoli in the Cappella Paolini in Sta. Maria Maggiore at Rome, to Baglione, Salini, Spadarino, and Antiveduto Gramatica—carry little conviction.

Artemisia's painting either could have accompanied her to Florence or preceded her there. On July 3, 1612, Orazio wrote to the Dowager Grand Duchess of Tuscany in an attempt to elicit her support in the matter of Agostino Tassi, offering her an incentive in the form of a work by his daughter (see Chapter 1). The *Judith* in the Palazzo Pitti, a painting which I find to be more accomplished than the *Judith Decapitating Holofernes* at Naples, may have been the promised gift, a possibility held out as well by both Papi and Contini.

Artemisia's conception has enjoyed considerable fame, as the number of replicas of it still preserved attests. Two of them have occasioned more than passing discussion: an example first signaled by Longhi in the Palazzo Corsini at Florence (Fig. 34), and one with the dealer Hilmer Klages at Lugano in 1972 (here taken to be Fig. 35). The former, reportedly no longer in the Palazzo Corsini, appears from the photograph to be too brittle to be judged autograph. As Contini has observed, the decorative detailing of Judith's dress varies from that of the Pitti version, and there is no trailing of napkin beneath the basket. Conceivably the copy was

made after this lower left corner of the Pitti canvas had been so badly damaged (see the remarks above) that the copyist was left without sufficient clues as to what Artemisia intended.

Special confusion surrounds the ex-Klages *Judith*. Thus the sale catalogue claims the following sequence with regard to the known history of the canvas: (1) Zurich, Helmhaus; (2) Naples, Capodimonte, 1952, exhibition entitled *Fontainebleau e la maniera italiana*; (3) antiquarian P. de Boer, Amsterdam, 1957; (4) Carlo Neuhaus, Lima, Peru; (5) Giovanni Perico, as of 1972. Yet in point of fact no such painting appears in the catalogue of the Fontainebleau *mostra*, and it was in 1958, not by 1952, that a *Judith* with the dealer P. de Boer was shown at the Helmhaus in Zurich. Furthermore, the De Boer picture was said to measure 1.22 x 1.13 m., while the size of the Lugano work is reported as 1.14 x .935 m. However, the latter canvas, as the former, approaches a square format, both indeed showing proportions in the ratio of roughly 1.08:1.00, not the approximately 1.22:1.00 which dimensions of 1.14 x .935 would yield. On the other hand, these last dimensions *are* those of the Pitti *Judith* as it has come down to us (but not as it was originally or even as it was as late as 1969/70), and thus one suspects that the compiler of the Klages catalogue inadvertently recorded rather the size of the painting in Florence (which, curiously, is not even mentioned in the entry). In view of such careless scholarship one might also question the assertion that the De Boer and Klages pictures are one and the same, but comparisons of the published photographs suggest that indeed they are. The photos also testify to a painting of appreciable quality but one which, as the ex-Corsini version, is marked by a certain hard, unsupple handling and textural uniformity that speak of a copyist (Contini judges the Corsini work to be a copy, the Klages one to be an autograph replica). Nonetheless, once they are located, both pictures should be subjected to closer scrutiny than they have ever been accorded.

A crude and ruined copy (1.27 x .95 m.) is in storage in the Palazzo Rosso at Genoa, and the following additional versions have been cited (respectively by Richardson, Ortolani, Ainaud and Pérez Sánchez, and Garrard): in the Galerie Charpentier at Paris (March 24, 1953, no.

13, from the collection of Compte J. de B., Paris, described in translation as "Judith and her maid pausing on their flight to look back toward the Assyrian camp"); in the possession of Barone Staffa of Montegiorgio (1938, "Giuditta eretta che impugna la spada"); in Málaga (1965, Colección Puerto Seguro [Aveyro], "Judit y la serviente"); and in the Quirós Collection at Madrid.

BIBLIOGRAPHY: Rome, AS, *Archivio del Tribunale*, 1612, fols. 4, 11, 48–49, 68; Florence, AS, Guardaroba Mediceo 525, "Inventario de Pitti," 1637, fol. 45v, and Guardaroba Mediceo 725, "Inventario del Palazzo de Pitti," 1663, fol. 69v; Florence, Palazzo Pitti, 1937, I, p. n.n.; Tanfani-Centofanti, 1897, pp. 221–24; Voss, 1925, p. 463; Longhi, *Scritti*, 1961, I–I, pp. 258, 281; Bissell, 1968, p. 155 incl. n. 22; Borea, 1970, pp. 75–76 cat. 48, 119, 120, 122; S. Battaglia, *Grande dizionario della lingua italiana*, Turin, 1986, XIII, pp. 614–15, to 1972, VII, p. 388, to 1970, VI, p. 374; Greer, 1979, p. 194; Nicolson, 1979, p. 50, and Nicolson/Vertova, 1990, I, p. III; Gorsen, 1980, p. 76 and passim; Bissell, 1981, pp. 155–56 cat. [27]; Menzio, 1981, pp. 20–21, 39, 43, 72–73, 76; Whitfield in London, Royal Academy, 1982, p. 168; E. Banks, Colnaghi, New York, letter to the author, March 13, 1984; M. Gregori in Naples, *Civiltà del seicento*, 1984, I, p. 147; Hagen, 1988, p. 80; Garrard, 1989, pp. 7, 39–40, 313–20, 410, 413, 428 incl. n. 64, 437, 497–98 esp. nn. 55–56, 555 nn. 93, 99, and passim; Papi in Contini/Papi, 1991, pp. 41–43, 46–47, 59 n. 29, 95; Berti, ibid., pp. 23, 25; Contini, ibid., pp. 22, 120–24 cat. 10; Stolzenwald, 1991, pp. 22–23, 86 ff., and passim; Rose, 1991, p. 14; Bionda, 1992, pp. 24, 26; Hersey, 1993, pp. 327, 333 n. 50; Lapierre, 1998, pp. 144, 146–47, 157, 445–48.

For the copies of the Pitti *Judith*: O. Grosso, *Catalogo della Galleria di Palazzo Rosso, della Pinacoteca di Palazzo Bianco e delle collezioni di Palazzo Comunale*, Genoa, 1931, p. 77; Ortolani et al., 1938, pp. 45–46; J. Ainaud de Lasarte, "Ribalta y Caravaggio," *Anales y boletín de los museos de arte de Barcelona*, V, nos. 3–4, 1947, 402; Richardson, 1952–53, p. 83 n. 2; Zurich, Helmhaus, 1958, p. 12 no. 21; Longhi, *Scritti*, 1961, I–I, pp. 258, 281, and I–II, fig. 129; Pérez Sánchez, 1965, p. 500; Bissell, 1968, p. 155 n. 22; Borea, 1970, p. 76; Lugano, Hilmer Klages, *Asta d'arte / Kunst Auktion, Primavera/Frühjahr '72*, April 28–30, 1972, lot 920 with ill.; Contini in Contini/Papi, 1991, p. 122.

For Orazio Gentileschi's ex-Sotheby *Judith*: G. Ghezzi, *Quadri delle Case de'Prencipi in Roma*, MS, binding marked 1700, Rome, Palazzo Braschi (Museo di Roma), fols. 40 (1694), 159 (1710); L. Salerno, *Palazzo Rondinini*, Rome, 1965, pp. 30–31, 32, 41, 42, 44, 73, 74, 77, 279, 303; Bissell, 1981, pp. 154, 218; C. Whitfield and E. Banks, *Italian, Dutch, and Flemish Baroque Paintings*, New York, Colnaghi, April 4—May 5, 1984, pp. 26–27 cat. 11; Pepper, 1984, pp. 315–16; R. Ward Bissell, report to Colnaghi, New York, 1984; Garrard, 1989, pp. 498 n. 56, 555 n. 93; Papi in Contini/Papi, 1991, pp. 36, 93–95 cat. 2; New York, Sotheby's, *Important Old Master Paintings*, January 15, 1993, lot 46.

..

[6] *Saint Catherine of Alexandria*

Florence, Galleria degli Uffizi
Oil on canvas, .76 x .62 m.
Ca. 1614–15
Fig. 54

On the reverse, before relining, the numerals 123, 39, 4344, 1725, 4778

COLLECTIONS: Galleria dell'Accademia, Florence, late nineteenth century; Soprintendenza alle Gallerie, Florence, until 1970

Restored in 1966, it is reported, and relined prior to the Pitti exhibition of 1970, the canvas was once held to be too poorly preserved for public display. Then, showered by debris from the June 1993 bombing near the Uffizi, it was repaired by Lucia and Andrea Dori, who had to make up losses that included a long diagonal cut over Catherine's right hand, a slivver from her nostrils to her upper lip and, most crucially, a vertical loss through the Saint's right eye.

In the Accademia in the late nineteenth century as a work by a follower of Artemisia Gentileschi, the *Saint Catherine* was assigned directly to Artemisia by Luciano Berti, with whom Borea, Nicolson, Schleier, Volpe, Bagnoli, Gregori, Garrard, Contini, and Hersey have concurred. Yet with Berti I cannot share the enthusiasm with which the picture has generally been received, finding it expressively, compositionally, and technically uninspired, conditions from which it is not fully redeemed by the colors—the red dress, the shift of this red to lilac beneath the translucent shawl, and the brownish gold of the mantle. The jeweled crown, over whose details the artist lingered excessively, sits uneasily on the woman's head; perhaps this is why she is, in Garrard's words, "static and zombie-like"!

I am persuaded, however, that in excluding the picture in 1968 from the list of Artemisia's

autograph works I was probably mistaken. My previous view appears to be refuted above all by the recently discovered *Female Martyr* (Fig. 56; Color Plate VI), unquestionably by Gentileschi, to which the *Saint Catherine* bears obvious similarities in type and pose. Perhaps the Uffizi painting slightly preceded the Newhouse panel, a conclusion implicitly arrived at by Garrard who, while unaware of the *Female Martyr*, dated the Florence canvas to ca. 1614–15. Contini hesitates to assign the picture a precise chronological position within Artemisia's Florentine period.

Citing the Saint's legendary beauty and erudition and her refusal of Maxentius's advances, Hersey labels Catherine "an Artemisian heroine if ever there was one." Much more convincingly, Garrard speculates that the popularity in Florence of images of Saint Catherine might be connected with the residence there until 1617 of Caterina de'Medici, the Grand Duke's sister. Surely Artemisia's versions of the *Magdalen* (Figs. 68, 69–70; Color Plates VII, V) were produced in honor of Cosimo II's wife, Maria Maddalena of Austria. In view of Garrard's observation and of the seeming ease with which the painting now takes its place in Artemisia's Florentine period, it cannot be the "quatro che un pezzo fa ho finito con l'imagine di Santa Caterina" which in a letter to Andrea Cioli on December 11, 1635, Artemisia offered to send to Florence from Naples. It is unlikely that the artist was pawning off a work that she had executed more than (by some twenty years) "un pezzo fa." Nor, then, can the *Saint Catherine* be identified as the "premitio fatto dalla mia figlia" which was to accompany Artemisia's canvas.

BIBLIOGRAPHY: Crinò, 1960, p. 264, as from Florence, AS, Mediceo 1416, inserto 8, fol. 780; Bissell, 1968, p. 167; Borea, 1970, pp. 72–73 cat. 44; Nicolson, 1970, p. 641; Volpe, 1970, p. 116; Schleier, 1971, p. 89; A. Bagnoli in Siena, Palazzo Pubblico, 1978, pp. 103–4; M. Gregori in Naples, *Civlità del seicento*, 1984, I, p. 147; Garrard, 1989, pp. 48, 499–50 n. 72; Contini in Contini/Papi, 1991, pp. 147–49 cat. 18; Berti, ibid., p. 25; Hersey, 1993, p. 329.

..

[7] *Female Martyr*

New York, Newhouse Galleries, Inc.
Oil on panel, .32 x .245 m.
Ca. 1615
Figs. 55–56; Color Plate VI

Inscribed on the reverse: *Di Mano di Artemisia figlia di A—rili—Lomi / pisano nipote di Orazio F [G?] E/*

COLLECTIONS: Martha Beavan née Wollaston, Leintwardine, Herefordshire, by descent; to be sold Sotheby's, London, December 9, 1987

A sensitive intervention of 1989 liberated the surface of discolored varnishes and accumulated grime and repaired the edges which had been damaged all around—most notably in the lower-left corner—by a frame. The young woman's cloak (part of it superimposed upon the neckline of the white undergarment that has reasserted itself as a *pentimento*) and her fingers above it show a continuous pattern of *craquelure*. Although the presence of an attribute (e.g., a section of Saint Catherine's wheel, Sant'Apollonia's pincers) in addition to the martyr's palm would be expected, there are no signs that the panel has been cut down, thus raising special issues of interpretation (see below).

The attribution to Artemisia of this beguiling picture, now confirmed by Contini, Papi, and Spike, is not at issue, and the evidence situating it specifically in Gentileschi's Florentine period is varied and conclusive. As a type, the young female costumed here is familiar from several paintings of these years (cf. Figs. 54, 68, 70; Color Plates V, VII), as is the candid observation and convincing physicality. The flesh, however, is modeled with singular subtlety, and *chiaroscuro* contrasts have been softened, encouraged by the smoothness of the prepared panel and perhaps by the previous example of Orazio Gentileschi's exquisitely crafted, small-scale works on copper (e.g., the *David in Contemplation* at Berlin-Dahlem, Fig. 24). These delicate tonal shifts then play against impasto accents on the lapis blue turban and pink mantle.

The partially faded inscription, while being certainly a later record of a somewhat garbled tradition—Artemisia was, of course, the niece of Orazio Lomi Gentileschi's brother Aurelio—corroborates the dating arrived at through comparative stylistic analysis. As demonstrated in Chapter 2, for professional reasons Artemisia assumed the surname Lomi during her years in Florence, where Aurelio Lomi had established a reputation.

There is likewise independent testimony that Artemisia produced small paintings of fe-

male saints while in Florence: her *Saint Apollonia*, a copper oval less than 58 cm. high, is cited in the Medici Collection on March 17, 1625 (New Style), and a *Testa di Santa*, once again as by "Artemisia Lomi," was lent by the painter, connoisseur, dealer, and *professor* of the Accademia del Disegno, Ignazio Enrico Hugford to an exhibition at SS. Annunziata in 1767.

Especially intriguing in the present context is a bill for household furnishings and artists' materials, including stretchers for canvases, supplied to Artemisia by a joiner (Fig. 57). Recorded there: "e adi 12 di febraio [1614, by Florentine reckoning] una tavoletta di noce p[er] dipingere [*sic*] sopra," modestly priced at 1 lira, 5 baiocchi. Since in this same account the word *tavolino* is used with reference to a table upon which a cabinet was to rest, there can be no confusion as to the sense of the term *tavoletta*. And inasmuch as the *Female Martyr* is the only painting on wood assignable with certainty to Artemisia (but see below), and is fully compatible with a date of ca. 1615, it is tempting to consider the joiner's notation as constituting precise documentation. The Newhouse picture may also have been the *Testa di Santa* in the collection of the Pisan-born Englishman Ignazio Hugford before its dispersal in 1779. Conceivably the inscription was added for purposes of bookkeeping when the painting was sent to the *mostra*, and it could have been a meditated decision on Ignazio's part to include the designation *pisano* after Aurelio Lomi's name. Moreover, Hugford's *Head of a Female Saint* was not otherwise identified, just as the martyr is without a specifying attribute. Finally, the designation "Una testa, dell'Artimisia" in an anonymous Florentine collection of the seventeenth century ([L-38]) may possibly be an earlier citation of the *Testa di Santa*.

Such an unorthodox depiction of a "generic" saint, combined with the intimate scale and the young woman's arresting gaze, suggests that the panel was designed for devotion of an other-than-religious nature. Its fascination heightens when it is realized that we are surely privy to a self-portrait of Artemisia, as I suggested in 1987 and as Keith Christiansen has observed (oral communication) and Contini reaffirmed. Of the several pictorial records of Gentileschi's appearance, the engraving executed in Rome about 1625 by Jérôme David after—the designation "Artem. Pinx."

claims—a painted self-portrait is most revealing (Fig. 101). The physiognomies of the women are comparable throughout. One reading of this image of self-sacrifice might feature Artemisia as a sufferer for love. A less romantic explanation—alas!—could involve circumstances of a professional life that was not without its burdens (see Appendix II and Chapter 2). At the same time, this delicate picture of "provocazione sentimentale" (the words are those of Cantelli with general reference to Seicento art in Florence), reveals Artemisia's receptivity to Florentine taste as it provides an additional reason to modify Papi's impression that the date of the panel oscillates between Gentileschi's Florentine period and her return to Rome.

In the course of advancing the closely related *Female Martyr* in the Zeri Collection at Mentana (Fig. 213) as an autograph work by Artemisia, Contini has recently supported my conclusions concerning the authenticity, dating, and identification of the sitter of the Newhouse painting, while introducing a possible second candidate for the *tavoletta* cited in the joiner's account and/or for the picture owned by Hugford. Yet inasmuch as the lovely Mentana panel appears rather to be a variant of Gentileschi's composition by a Florentine hand ([X-9] for the reasoning), I am not moved to revise my published proposals.

BIBLIOGRAPHY: Florence, AS, A. del D., *Atti e Sentenze*, LXV, 1595–1616, fol. 877 by count; Fleming, 1955, pp. 106–10, 197–200, 203–6; Del Bravo, 1967, p. 82 n. 11; Bissell, 1968, p. 156; Borroni Salvadori, 1974, p. 89; Cantelli, 1980, pp. 151–52; London, Sotheby's, *Old Master Paintings*, December 9, 1987, pp. 22–23 Lot 13, and cover; R. W. Bissell, letter to Sotheby's, London, April 19, 1987; Garrard, 1989, pp. 36, 377 n. 4, 497 n. 47; A. Williams, Newhouse Galleries, New York, letter to the author, June 7, 1989; R. W. Bissell in New York, Newhouse Galleries, Inc., *Old Master Paintings*, October–November 1989, cat. 3; Contini in Contini/Papi, 1991, pp. 141, 143; Papi, ibid., p. 51; Spike, Review, 1991, p. 734. And Appendix I under the dates cited in the entry.

..

[8] *Allegory of Inclination*

Florence, Casa Buonarroti, Galleria
Ceiling canvas, 1.52 x .61 m.
Figs. 58–60, 64; Color Plate VIII

Documented August 24, 1615—August 20, 1616

Artemisia's canvas is fixed within an elaborate scheme devised by Michelangelo Buonarroti il Giovane for the walls and ceiling of his Galleria (here adapted as Fig. 59). The impressive room of 10.10 x 4.16 x 4.20 m., its south or window wall on the Via Ghibellina, outspokenly glorifies the Buonarroti name through association with the patron's great-uncle, the Divine Michelangelo. Simultaneously, it pays tribute to Michelangelo the Younger's wealth and taste, engaging as it did the best among the established and the young artists then active in Florence. The ceiling, to which this entry must be restricted, is divided into fifteen painted compartments echoing the pattern of the floor (cf. Fig. 60): Five "histories" (each 1.57 x 1.38 m.) down the spine, flanked by putti bearing coats of arms and eight Personifications (four of 1.52 x .61 m., four of 1.57 x .61 m.) of qualities and virtues claimed for the Renaissance master. The *Allegory of Inclination*, holding a compass tipped toward the polar star, symbolizes Michelangelo's natural disposition to greatness.

Gentileschi's picture is properly oriented for visitors entering through the door at the southeast corner of the Gallery, respects in a general way the conditions of lighting within the room, and is paired across the ceiling—as per Michelangelo the Younger's instructions (see below)—with the *Ingegno* (*In-Born Talent*, or *Genius*) by Francesco Maria Buonavita. In my opinion, however, it and its companion do not occupy their original positions within the whole, with the result that intended compositional and iconographical relationships are concealed. The two canvases are now set into the first bay, as also they were said to be in an inventory compiled about 1684 by another Michelangelo, the eldest son of Leonardo de Buonaroto, Michelangelo the Younger's heir. Yet this source describes the *Inclination* as being nude, with two pulleys at her feet ("ed ai piedi ha due carruccolette, ed è nuda"), whereas in actuality by 1684 the woman was anything but nude (see below) and the pulleys were never painted. These discrepancies are explained by the fact, emphasized by Vliegenthart, that the inventory account was based not upon direct observation of the ensemble but rather upon Michelangelo the Younger's final written pro-

gram. On the other hand, the inventory did *not* respect the definitive scheme for the Personifications as it is known from a drawing by Michelangelo the Younger (cf. Fig. 59). In this drawing, which terminates the written instructions, are sketched all eight Personifications in their compartments. Here the *Ingegno* and the *Inclination* are assigned to the *second* bay.

This, I believe, was indeed where they were meant to be. The extended legs of the figures would have formed parentheses around the centrally placed, equally bare extended leg of the Fame in the painting which they would have flanked when properly disposed— Francesco Curradi's *Fame Exalting Michelangelo*. In that position, too, these Personifications would have made iconographical sense. Today there is no apparent connection in meaning between the *Ingegno-Inclination* duo and Tiberio di Tito's *Erection of the Tomb Monument at Santa Croce* which they now attend. Exchanged for the pair of Girolamo Buratti's *Tolerance* and Zanobi Rosi's *Study* (Fig. 63) currently in the second bay, they would relate to Curradi's *Fame* with perfect iconographical logic. When Il Volterrano made his ill-advised additions (see below), Artemisia's painting would have to have been removed from its gilded frame. It is possible that at least the *Ingegno* was also taken down; Vliegenthart comments that the red drapery swirling around Buonavita's figure is "painted in a superficial manner and gives the impression of having been added later"— perhaps, one can speculate, for the same reasons. I suspect that some of the other Personifications were also altered. It may have been at that time that the order was switched or, alternatively, that at some later moment all the ceiling canvases were removed for cleaning or restoration and then reset according to the 1684 description which, as regards the ceiling paintings, was correct except for the Personifications in precisely the two bays at the south end.

More lamentably, the *Inclination* does not retain its original appearance. Baldinucci reports that Leonardo de Buonaroto, for reasons of decorum and out of deference to his wife and children, hired Il Volterrano (Baldassare Franceschini, 1611–89) to cover what had been a once nude figure ("Era questa figura del tutto ignuda . . . ma Lionardo . . . per lo decoro, e

modestia con che volle, che comparisse adorn-
ato ogni luogo della propria casa alle caste luci
d'un bello stuolo di piccoli giovanetti suoi fig-
liuoli, e della nobile Ginevra . . . sua consorte,
volle che da Baldassare Volterrano a'preghi di
chi queste cose scrive, fusse quella nudità rico-
perta, il che fece il Volterrano fino a quel segno,
che al pio sentimento di Lionardo giudicò, che
bene accomodar si potesse, senza nulla del bello
alla pittura levare"). This passage can be con-
sidered half-accurate. It does not appear that
the woman was ever totally nude. After all, as
Vliegenthart shows, Baldinucci was following
the aforementioned inventory of 1684, which
itself derived from a written account rather
than from a confrontation of the paintings.
Furthermore, since Buratti's *Tolerance* and
Sigismondo Coccapani's *Michelangelo Crowned
by the Four Arts* (Fig. 61) contain women with
prominently displayed breasts, there would
have been no pressing reason for Franceschini
to have covered the breasts of the *Inclination*.
The handling of the white drapery, through
which part of the left breast can be seen and
which wraps around the figure's shoulder, is
very conceivable for Artemisia. In the area to
the left of Inclination's lower elbow one can de-
tect the remains of cloth which must have been
transparent or semitransparent and, perhaps
flicking Inclination's right elbow, swept across
the abdomen and pubic region. This detail, still
vaguely indicated, was apparently rubbed out
when the grayish-blue drapery shot through
with yellow highlights ("a la Veronese," Longhi
wrote) was added. Interestingly, in an early
planning stage Buonarroti had directed that the
figure "sia nuda ma le vergogne velate." (Spike
takes the dark patches on the abdomen to be
shadows painted by Volterrano.) Baldinucci
was certainly correct, however, in attributing
the heavy drapery over the lap and right arm to
Volterrano. It is fully consonant with his style
(cf. the *Magdalen*, Museo Civico, Udine) and
with his drapery studies (as those for the an-
gelic musicians in SS. Annunziata). Precisely
when these mutilations were effected is not
known. Obviously they occurred before Leo-
nardo's death in 1684, and possibly after Volter-
rano's trip to Venice in 1662.

The documentation for Artemisia's dealings
with Buonarroti, brought together by Sricchia,
Procacci, and Vliegenthart, is very rich. Re-
cords of the disbursement of 34 fiorini

(= ducats) to Gentileschi, from the advance
to the final installment, are preserved in Mi-
chelangelo the Younger's account book:

> Artimisia di Orazio Lomi ovvero Gen-
> tileschi moglie di Pierantonio Stiattesi
> dee dare addì 24 d'agosto 1615 fiorini dieci
> portò a buon conto per il quadro che mi
> fa per la soffitta della mia galleria, dove
> va dipinta la figura della Inclinazione; il
> quadro glielo mandai mesticato come feci
> a tutti i pittori.fior. 10.
> E addì 7 di settembre [1615] fiorini cinque
> portò mona . . . sua serva, mandata da lei
> e me ne aveva prima mandata una polizza
> Pierantonio suo marito; e detta Artimisia
> dissemi averli ricevuti.fior.5.
> E addì 13 di novembre fiorini tre portò
> detta da me per mano di Francesco mio
> servitore; gli ricevè nel letto e me ne aveva
> scritta una polizza mostrando averne bi-
> sogno grande sendo in parto.fior.3.
> E addì 3 di febbraio fiorini dua portò
> detta in casa sua.fior. 2.
> E addì 2 d'aprile 1616 fiorini quattro portò
> . . . suo fattore, che venne con una lettera
> di lei per la quale me le domandava
>fior.4.
> E addì 18 di giugno fiorini quattro portò
> Lorenzo suo garzone disse volergli ella in
> presto, ma gliene do debito a conto del
> quadro.fior. 4.
> E addì 20 d'agosto fiorini sei portò detta
> in casa sua per resto già che mi aveva
> mandato il quadro a casa.fior. 6.

Related documentation includes the notes from
Stiattesi and Artemisia alluded to in the entries
of September 7 and November 13, 1615, respec-
tively (see Appendix II); a payment of 2 florins
on March 28, 1616, to one Guasparri for having
supplied Artemisia with an ounce of *cenere di
azzurro* to be used for the painting (obviously
for the sky); and Michelangelo the Younger's
final reckoning:

> Artimisia di Orazio Lomi ovvero Gen-
> tileschi dee avere addì 20 di agosto 1616
> fiorini 34 tanti se le fanno buoni per pit-
> tura del quadro come di contro, dove in
> questo dì apparisce il saldo et ell'è pagata
> dell'intero; e mi riman debitrice a altro
> conto al mio libro segnato B di Debitori
> e Creditori.fior.34.

It has often been remarked that this sum is more than three times that received by the painters of the other Personifications (who were paid 10 florins, with the exception of the 12 florins tended to Jacopo Vignali, whose *Amore verso la patria* also contained two putti), and virtually equal to the 35 florins awarded each of the artists for the five histories on the ceiling. However, in the running account reproduced above, only three of the seven items—totaling 20 florins as Cropper points out—refer specifically to the picture, and in his reckoning Buonarroti makes it clear that Artemisia remained in his debt.

An evaluation of the originality and potential influence of Gentileschi's *Inclination* must take into account the built-in requirements of the commission. Buonarroti stipulated the order of the paintings, the directions in which the heads of the figures were to be turned, the attributes, and obviously too the blue sky and clouds. Each pair of Personifications had to be worked into compositional unity, as in the *Ingegno* and *Inclination* with their extended legs toward the walls, their raised legs toward the center. In this case Artemisia's painting appears to have set the design. Buonavita did not receive an advance until December 16, 1615, nor the prepared canvas until May 4, 1616 (while Gentileschi got both on August 24, 1615), and did not deliver the *Ingegno* until June 12, 1617.

The *Inclination* is notable for its exquisite modeling (recalling the *Female Martyr* also, I believe, of ca. 1615; Fig. 56) and sense of living presence. She is a familiar type in Artemisia's pictures to date, and Papi and Berti, comparing the face of the Inclination to Orazio's representation of his daughter in the Casino of the Muses (Fig. 100), rightly see allusions to Artemisia's own physiognomy in the former. But the woman is subjected to an emerging idealization and refinement that point to the future. Does this represent an inevitable progression, comparable to that which the style of Orazio Gentileschi underwent? Or does it reveal the impact of Florentine art and tastes? These questions are investigated in Chapter 2, but one possible Florentine quotation observed by Berti should be cited here: Inclination holds aloft her compass in a manner that is extraordinarily similar to that of the rock-wielding man at the far left of Michelangelo's *Battle of the Lapiths*

and Centaurs, then as now displayed in the Casa Buonarroti.

BIBLIOGRAPHY: Florence, Casa Buonarroti, Archivio Buonarroti, MSS 97 (cc. 15r, 16r, 17r), 101–4[A] (fols. 32, 36), 103 (fols. 67, 68v, 69); Morrona, 1792, II, p. 271; Baldinucci, ed. 1812, X, pp. 251–53; Voss, 1925, p. 463; Longhi, *Scritti*, I–I, 1961, pp. 257, 281; Sricchia, 1963, p. 266 n. 24; Procacci, 1967, pp. 12–13, 34 n. 32, 177–78, 222; Bissell, 1968, p. 156; Vliegenthart, 1976, esp. pp. 22–23, 49–51, 77, 170–73 no. 16, 174–76 no. 17, 229; Paris, Louvre, Cabinet des Dessins, *Dessins baroques florentins du Musée du Louvre*, 1981, pp. 170–71 cat. 105, 179; Garrard, 1989, pp. 41–45, 496 n. 42: Contini in Contini/Papi, 1991, pp. 124–28 cat. II, 183; Berti, ibid., pp. 11–14, 29 n. I; Papi, ibid., p. 44; Spike, Review, 1991, p. 733; Cropper, 1992, p. 205; Bionda, 1992, p. 26.

..

[9] *Penitent Magdalen*

Los Angeles, California, Marc A. Seidner Collection
Oil on canvas, .657 x .508 m.
Ca. 1615–1616
Fig. 68; Color Plate VII

The canvas was restored and relined in 1981 by Andrea Rothe of the J. Paul Getty Museum Conservation Department, liberating the surface of overpaint and reinstating areas of pigment loss. X-rays indicate that the artist repositioned the Magdalen's left thumb to bring it into contact with the skull. Auburn tresses with yellow highlights cascading over her shoulders, the Magdalen wears a golden dress with red lining and a maroon mantle as, clutching her breast and steadying a brown death's-head, she is gripped by thoughts of worldly vanity.

Neither the attribution nor the dating of this unpublished picture presents particular difficulties. The plump young woman of rosy complexion, small bow mouth, and dimpled chin is as a twin to several figures found in Artemisia Gentileschi's art of the second decade. Most strikingly, she resembles (in reverse) the Judith in the Naples *Judith Decapitating Holofernes* of ca. 1612 (Fig. 21; Color Plate II), even to the circle of light on her darkened cheek and the dash of illumination at the corner of her mouth, and the slimmed-down woman of the signed *Magdalen* in the Palazzo Pitti (Figs. 69–70; Color Plate V). Predictive of the Flor-

ence example as well is the increasingly painterly handling of the materials, while the luxuriousness of that canvas appears here in nascent form. It is probable that both *Magdalen*s were intended for the Florentine court of Grand Duke Cosimo II and his wife and the Saint's namesake, Maria Maddalena. Unfortunately, the history of the Seidner picture remains to be traced.

The dating of ca. 1615–16 suggested here is supported by the apparent position of the *Magdalen* between the Naples *Judith* and the more aristocratic *Jael* of 1620 (Figs. 72–73), and by its recollections in subject, half-length type, pose, color, and long flowing hair of a *Penitent Magdalen* conceived about 1611–12 by Orazio Gentileschi, for which Artemisia herself modeled. The evidence is a canvas with Piero Corsini at New York (.823 x .685 m.) that is closely related to Orazio's *Young Woman with a Violin* in the Detroit Institute of Arts (Fig. 32) and, as it happens, to a composition of a *Magdalen* revealed by X-rays beneath the present surface of the Detroit picture. (In my opinion the autograph status of the Corsini *Magdalen* has not been thoroughly established; there can be no doubt, however, that the invention is to be assigned to Orazio Gentileschi.)

It may be hoped that the addition of the Seidner *Penitent Magdalen* to Artemisia's oeuvre will lead to a further expansion of the artist's Florentine production, still disappointingly meager in view of her six or seven years of activity in that city.

BIBLIOGRAPHY: Letters to the author from Burton Fredericksen (August 2 and 30, 1985) and Marc A. Seidner (November 26, 1985, and September 7, 1989), Los Angeles, Calif.

For the Corsini *Magdalen*: New York, Piero Corsini, Inc., *Important Old Master Paintings and Discoveries of the Past Year*, November 1–29, 1986, pp. 62–63 cat. 18.

..

[10] *Conversion of the Magdalen (Penitent Magdalen)*

Florence, Palazzo Pitti
Oil on canvas, 1.465 x 1.08 m.
Ca. 1617–1620
Figs. 69–70; Color Plate V

Signed (by a later hand?) on the wooden upright of the chair back: *ARTIMISIA LOMI*

Inscribed at the top of the mirror, far right:
OPTIMAM PARTEM ELEGIT
On the reverse, the number 2985

COLLECTIONS: Palazzo Pitti, Florence, first mentioned in 1826

The *Penitent Magdalen* (or, as indicated in the text, more accurately the *Conversion of the Magdalen*) is fashioned from three pieces of canvas: A large section of approximately 118 x 86 cm. embracing the figure down to the level of the chair seat; a band of ca. 28.5 cm. wide across the entire bottom; and, at the left, a strip of ca. 22 x 118 cm. abutting with a slight distortion the lower band. While such piecing was common practice, it is a notable fact here that the vertical seam at the left is the dividing line between the tonal shifts on the background and on the back of the seat, the color of the latter changing from the deepest maroon to a burgundy with such abruptness and regularity as to be inconceivable as a cast shadow. (The picture was cleaned before the Florence show of 1970.) The tonality and handling of the golden-yellow gown, on the other hand, are consistent throughout, the pigment having been laid over the horizontal seam by, certainly, Artemisia's brush.

The pattern of illumination on the background could be taken to designate a break between a wall and a darkened doorway. But the peculiar division of the chair back has no logical visual explanation, and could not have been intended to read in this manner. However, as Wendy Watson suggested to me, had the physical properties of the pigments employed for the now distinct areas of the chair back been different, one might expect inequalities of deterioration or chemical change. It may be supposed that if Artemisia herself were responsible for the left strip of canvas as it exists today, she—fully aware, of course, of how she prepared her medium—would have made certain that the velvet chair (if not the background as well) was, and remained, of one coloristic piece. One is led, then, to the conclusions reached by John Spike, with whom also I enjoyed a fruitful discussion in front of the picture: the strip in question represents an "insert" by a later hand, one thus responsible as well for "the filigree seat and the calligraphic signature." To this intervention would also belong, as Spike observes, the inscription *OPTIMAM PARTEM*

ELIGIT. This phrase from Luke 10:41–42, wherein Christ informs Martha that her sister Mary, having forsaken housework in order to listen to his teaching, had "chosen the better part," is not inappropriate to the theme of the painting, and it figures prominently on the Florentine Alessandro Allori's *Christ in the House of Martha and Mary* of 1605 in the Kunsthistorisches Museum at Vienna. Nonetheless, in character it accords perfectly with the putative signature, whereas it is askew to the perspective plane of the mirror. Still to be answered: Are there any other such showy "signatures" on paintings in or from the Florentine Ducal Collection? Is the epigraphy even possible for the seventeenth century?

Since the Magdalen's gown, executed in its entirety by Artemisia, extends even slightly beyond the lower-left corner of the painting, the "insert" must be considered a replacement for original canvas which surely would have contained some indication of the remainder of the chair and, possibly, an authentic signature. Spike, believing that the ointment jar at the lower right (which *was* painted over the gown) may also be a later addition, cautiously posits that the various modifications might have been made to change the subject from an *Allegory of Vanity*, and, further, that Gentileschi's "composition originally extended far enough at the left to include another figure," that of Death or Time. However, since a death's-head may be dimly discerned to the left of the mirror, and the format of the picture and the placement of the figure within it are satisfying as they stand, I suspect that the alterations were effected to increase the sumptuousness of the whole and/or, in the case of the strip at the left, to substitute for damaged canvas.

Yet the best evidence that from the beginning Artemisia had in mind a Saint Mary Magdalen is the appropriateness of this subject to the context within which her picture was created. Although the *Penitent Magdalen* is not cited in the Palazzo Pitti until 1826, there can be little question but that it was painted on behalf of the Florentine court and, as I and other scholars have already proposed, specifically of Maria Maddalena of Austria, Grand Duke Cosimo II's consort. Theatrical productions and works of art dedicated to the Grand Duchess's patron saint appear to have been a con-

stant part of the court scene. Examples brought together by Garrard, Pizzorusso, and Mosco include Riccardo Riccardi's *Conversione di Santa Maria Maddalena* of 1609, the dialogue between Martha and Mary performed in July of 1621, Jacopo Cicognini's five-act *commedia* of the same year, Francesco Bracciolini's *Festa di S. Maria Maddalena* of 1629, the lunettes on the life of the Magdalen executed about 1625 by Francesco Curradi for the Medici villa at Poggio Imperiale and, in a special conflation of namesake and saint, Justus Sustermans's *Maria Maddalena of Austria as Saint Mary Magdalen* (Florence, Uffizi, ca. 1625). Artemisia's woman, while resembling more the artist than the Grand Duchess, is manifestly a part of this tradition.

The worldliness of the Pitti picture as an art object and the details of Gentileschi's biography in themselves suggest a date prior to Cosimo's death in 1621. Contrary to what I once supposed (and others have repeated), the painting promised by Artemisia to the Grand Duke in a letter of February 10, 1620 (New Style), was almost certainly the now-lost—or never executed?—*Hercules*, not the *Magdalen* (see Appendix I, January 13 and 16, February 10 and 15, 1620). Contini has also reached this conclusion. Nonetheless, the use of the Lomi surname, even if the "signature" is a later replacement or addition, is one indication that the *Magdalen* falls within Artemisia's Florentine period (see Chapter 2). And the technical brilliance of the canvas, in advance of all her previous works, and its greater refinement, argue for a dating of ca. 1617–20. Garrard, Contini, Bionda, and Mann (initially) have likewise located the painting within the second half of Gentileschi's stay in Florence. More recently, however, Mann has proposed that certain compositional awkwardnesses, the "overtly 'showy'" aspect of the picture, and a presumed borrowing from the lower half of Michelangelo's seated effigy of Lorenzo de'Medici set the *Magdalen* within the first years (ca. 1613–15) of Artemisia's Florentine sojourn. The latter two elements, and the conspicuous signature, are believed to represent self-advertising by the artist in order "to establish a foothold in her newly adopted city." And the *Lorenzo de'Medici* in particular is held to inform the meaning of Gentileschi's *Magdalen* as an image combining the active and the

contemplative and testifying to the "wisdom of Mary Magdalen's choice." The visual relationships between the frontally posed Duke, his right ankle over his left, and the obliquely posed Saint, her left foot forward, and therefore the interpretative implications thought to stem from these would-be connections, seem to me to be extremely tenuous.

Much can and has been said regarding the extent to which the *Magdalen* is spiritually as distinct from decoratively charged, represents Gentileschi's response to contemporary Florentine tastes and art, and may reflect Artemisia's own experiences, doubts, and decisions. These issues are adressed in the text. I would simply note here the necessity of weighing considerations of Gentileschi's personal involvement with the theme against such factors as the requirements of the commission, the authority of Titian's *Magdalen* in the Palazzo Pitti, and the likelihood that the inscription OPTIMAM PARTEM ELEGIT (thought to be one interpretive key) was not supplied by the artist herself.

BIBLIOGRAPHY: Florence, Palazzo Pitti, 1834, p. 30 no. 142; idem, 1837, I, p. n.n.; Voss, 1925, p. 463; Longhi, *Scritti*, I–I, 1961, pp. 258, 281; Bissell, 1968, p. 156; Borea, 1970, pp. 74–75 cat. 47; Harris in Harris/Nochlin, 1976, p. 121 cat. 11; Greer, 1979, p. 194; Nicolson, 1979, p. 51 and Nicolson/Vertova, 1990, I, p. 111; Cantelli, 1980, p. 156; C. Whitfield in London, Royal Academy, 1982, pp. 166–67 cat. 58; C. Pizzorusso in Florence, Palazzo Pitti, 1983, p. 35 cat. 14; M. Mosco in Florence, Palazzo Pitti, 1986, pp. 155, 157, 159, and 161 cat. 55; Garrard, 1989, pp. 40–41, 45-48, 499 n. 71; Spear, Review, 1989, p. 604; Lippincott, 1990, p. 447; Contini in Contini/Papi, 1991, pp. 128, 129–32 cat. 12; Papi, ibid., p. 45; Berti, ibid., p. 25; Spike, Review, 1991, pp. 732–34; Stolzenwald, 1991, pp. 33, 50 color pl. 36, 125 n. 21; Bionda, 1992, p. 26; Mann, 1996, pp. 42, 44; Mann, 1997, esp. pp. 165, 171–72, 174–75, 177–79, and corresponding notes.

..

[11] *Jael and Sisera*

Budapest, Szépmüvészeti Múzeum
Oil on canvas, .923 x 1.275 m.? .86 x 1.25 m. (Szigethi, 1993)?
Figs. 72–73

Signed on the forward pedestal:
ARTEMITIA.LOMI / FACIBAT / M.D.CXX

On the back of the frame, the initials *KK* (branded) and the numerals 1115

COLLECTIONS: Sent from the Imperial Collection at Vienna to the Royal Palace at Pozsony-Bratislava (Pressburg), 1781 (conjectured); from there transferred to the Royal Palace at Buda, 1784, from which sold July, 1856 (conjectured); Enterprise des Magasins de Commission, Budapest, Sale 38, 1974, cat. 85; purchased by the Szépmüvészeti Múzeum, 1975

By 1978 the lengthy process of restoring the picture had been completed by Veronika Ember. Szigethi's remarks of 1979 and the accompanying photographs taken during and after the restoration alone dramatize the deplorable state which the *Jael* had reached: almost totally repainted, severely rubbed and damaged (with extensive paint losses in the upper-left and lower-right corners), and folded under. Inspection of the original reveals additional injuries and several problematic areas. Thus the dark background is blistered, probably from the heat of an earlier relining, the yellow of Jael's dress is muddy, the blue of Sisera's skirt has taken on a greenish cast, and repairs (some to tears) pockmark the surface. Most glaringly, at some point the highlights on Sisera's skirt were certainly coarsely strengthened, some of the shadows are too mechanical and unmodulated to be faithful to the artist's intentions, and Jael's white sleeve is uncharacteristically hard in handling.

Conversely, the signature, carefully executed as if chiseled into the stone, seems to have survived without major intervention. In animating the surface of the pedestal and exerting a visual attraction it is crucial to the maintenance of compositional equilibrium, while its prominence adds an interpretive dimension. The spelling of the forename—ARTEMITIA— appears on other canvases by the master (Figs. 77, 139, 147, 198), who in this matter did not observe a set pattern, and the use of the Lomi surname is appropriate for a canvas surely meant for a Florentine patron (see below).

The weight of the evidence argues that beneath all the damage and interventions lies an autograph work by Artemisia Gentileschi but that, were the picture to be judged merely on the basis of its presented quality, this conclusion could not be reached.

In good part the provenance of the *Jael and*

Sisera can only be conjectured. The initials *KK* burned into the back of the frame in which the painting was discovered refer to the Imperial Court at Vienna (Königlich Kaiserhaus). The canvas itself, however, does not figure in the 1659 inventory of the Archduke Leopold-Wilhelm's holdings; a *Jahel unndt Sisarae* assigned to an otherwise unidentified "Cataneo" was of vertical format (A. Berger, "Inventar der Kunstisammlung des Erzhogs Leopold Wilhelm von Österreich," *Jahrbuch der Kunsthistorischen Sammlunghen des Allerhöchsten Kaiserhauses*, 1 [1883], CXIII no. 492). According to Szigethi the frame is of the eighteenth century (Louis XVI) and was added at Buda after the picture had already been damaged. Nonetheless, the *KK* designation may not be irrelevant to the history of the *Jael*. In 1765 Maria-Teresa sent a number of paintings from Vienna to Pozsony (Pressburg), where her daughter Maria-Christina resided with her husband the Archduke Albert. When in 1781 the royal couple vacated Pozsony, their collection was returned to Vienna, to be replaced by a new shipment of works, among them "2 Jael und Sisera das andere die ihrer Tochter zuspricht. Auf Leinw. einer breit 4 Sch. – hoch 2 Sch. 10 Zoll" (*Zweyte Gemälde und Rahmen Sendung nach dem Königl. Schlosse zu Pressburg den 28t Herbstem 1781*, nos. 49–50). Transferred to Buda in 1784, this second wave of paintings was then dispersed in the mid-nineteenth century, the principal part of it in July of 1856. Garas and Szigethi speculate that Gentileschi's canvas is that cited in 1781. The Austrian *Zoll* (or inch) measuring 2.634 cm. and the *Schuh* (or foot) therefore calculated at 31.6 cm., the work in question would have measured approximately 1.26 m. wide by .90 m. high, almost identical to the size of the Budapest *Jael*. Although the lack of a specific attribution in the Pozsony inventory is puzzling—unless, as is conceivable, Artemisia's signature had become obscured— the evidence favors the Garas/Szigethi conclusion (as Papi also believes), and thus may prove helpful in tracing the early fortunes of the picture.

The history of the *Jael and Sisera* no doubt begins in Florence, for as emphasized in Chapter 2, Artemisia used the family name Lomi almost exclusively when involved with Florentine patrons. Furthermore, the painting appears to

have influenced Ottavio Vannini's *Jael and Sisera* (Florence, Seminario Maggiore) of the early 1640s. Yet as Papi has realized, there is some question as to whether the canvas was executed in the Tuscan capital or immediately after Gentileschi's return to Rome and then sent back to Florence. Documents concerning the *Hercules* she was executing for Cosimo II ([L-39]) place Artemisia in Florence in mid-February of 1620, but in that of February 10, a letter from the artist herself, a proposed trip to Rome is announced. (Grandducal orders of January and February 1620 concerning ultramarine supplied to Artemisia refer to the *Hercules* and not, as Baumgärtel has speculated, to the *Jael*.) All these documents are dated 1619 according to Florentine reckoning, and thus a canvas inscribed in Florence with the date 1620 would presumably have been finished after March 25. The expression and style (including the colors and the elaborateness of Jael's attire) are consistent with what Artemisia had done in Florence. Back in Rome, she was to reinvigorate her Caravaggesque roots. And if, as Szigethi remarks, the modeling appears less robust than might be expected of Gentileschi at this time, this may well be attributable to the rubbed state of the canvas.

Physical deterioration cannot account, however, for the passionless, stilted, and derivative nature of this painting. The Kenite woman sets about the bloody task of driving the tent stake into the Canaanite general's skull without the least sign of feeling, her raised arm stiff and the hammer held at a nonfunctional angle. One's suspicion that Artemisia was not taking penetrating looks at reality is confirmed by the striking relationships between her Jael and the figure's probable source (recognized also by Papi and Szigethi), Ludovico Cigoli's highly influential *Jael and Sisera* of ca. 1595–96 (Fig. 74), a further sign of the Florentine connections of Gentileschi's picture. And, on a page containing drawings by Cigoli for the *Jael* and for the *Dispute of Saint Catherine*, the compositional sketch for the former shows Sisera oriented as Artemisia was to depict him. Also suggestive of the dependency of Artemisia's design are the numerous parallels between it and several other interpretations of this popular Baroque subject, including the following: a Guercino drawing from about 1619–20 (Institut

Néerlandais, Paris) and a painting of the same theme by or after Guercino (photograph in the Fondazione Cini, Venice); G. B. Coriolano's wood engraving; and Philips Galle's engraved *tondo* of ca. 1610 (Fig. 71). The Guercino, Galle, and Coriolano versions all contain a column pedestal or stone pier at the left, this inscribed in the Coriolano print with the words *sic / STERNITVR / ERROR / VERITAS / PVNCTO.*

The importance of this relatively recent addition to Artemisia Gentileschi's oeuvre is therefore minimal, and its reticence hints that Artemisia's personal involvement with the subject was no deeper than Jael's emotional neutrality.

BIBLIOGRAPHY: Florence, AS, Guardaroba Mediceo 390, inserto 5, fol. 455, replacing numeration of 293; K. Garas, "La collection de tableaux du château royal de Buda au XVIIIe siècle," *Bulletin de Musée Hongrois des Beaux-Arts*, nos. 32–33 (1969), 91–95, 97–98, 102 n. 29, 116; M. Haraszti-Takács, Budapest, letter to the author, April 21, 1978; Szigethi, 1979, pp. 35 n. 4, 38–44; *Capolavori da musei ungheresi*, exh. cat. (Lugano), Milan, 1985, pp. 44–45; Hagen, 1988, p. 79; Papi in Contini/Papi, 1991, pp. 49, 143–47 cat. 17; Spike, Review, 1991, p. 734; Stolzenwald, 1991, p. 30 fig. 23; A. Szigethi in Milan, Palazzo della Permanente, 1993, pp. 90, 92–93; B. Baumgärtel in Düsseldorf, 1995, pp. 232–33 cat. 101.

For the comparative material: D. Mahon, *Il Guercino: catalogo dei disegni*, Bologna, 1968, pp. 71–73 cat. 52 and fig. 52; A. Bartsch, *The Illustrated Bartsch: Italian Masters of the Seventeenth Century*, ed. J. Spike, New York, 1981, XLI, no. 68; A. Bartsch, *The Illustrated Bartsch: Philips Galle*, ed. A. Dolders, New York, 1987, CVI, p. 99 no. .024:3; P. G. Passini, *Guercino e dintorni. L'attività e l'influenza di Giovan Francesco Barbieri a Rimini e a San Martino*, Bologna, 1987, pp. 98–99 cat. 44; L. Salerno, *I dipinti del Guercino*, Rome, 1988, p. 143; C. d'Afflitto in Florence, Palazzo Strozzi, 1986, I, pp. 236–37 cat. I.110; A. Cecchi, "Cigoli's 'Jael and Sisera' Rediscovered," *Burlington Magazine*, CXXXIV (1992), 82–91.

..

[12] *Judith Decapitating Holofernes*

Florence, Galleria degli Uffizi
Oil on canvas, 1.99 x 1.625 m.
Ca. 1620
Figs. 45, 75, 77–79; Color Plate XII

Signed at the lower right: *EGO ARTEMITIA / LOMI FEC.*

On the back of the frame, the number 344

On the reverse, before relining, the numerals 575, 1090

COLLECTIONS: Florence, Palazzo Pitti, until 1774

Although restored and relined in 1969/70, the canvas shows signs of its previous neglect, most obviously in the numberless in-paintings and the damage to Holofernes' fist and the maid's left eye. Since (Paolo dal Poggetto reports) there was also a gash on Holofernes' arm and "una svelatura" on his hair, and because pre-restoration photographs indicate injury to his face, one suspects that after Judith got through with him the general was attacked by an irate observer, a not uncommon reaction to evil figures in art and testimony to the potency of Artemisia's image. Fortunately, the canvas, although hung in the Corrodoio Vasariano, sustained only relatively minimal damage from the Florence bombing of June 1993; a year later it awaited restoration, seven losses from flying debris (none on the faces of the figures) being stabilized by rice paper, the rest showing tiny nicks here and there. A distinct *pentimento* indicates that Gentileschi herself altered Holofernes' drapery to reveal slightly more of his right leg. Barely discernible highlights sweep throughout the blackness above, vestiges of the tent curtain (shown in pl. LXXXIV of Marco Lastri's *L'Etruria pittrice* of 1791 [Fig. 75], and even in Voss's photograph) that once backed the figures.

Given the picture's grand size and spectacular theme, it is a curious fact that its history cannot be reconstructed in its every detail. Two seventeenth-century documents, presented only in part by Borea and quoted in full here, have been thought to refer to the painting. Under "1 marzo 1637" (1638 New Style) an inventory of the Palazzo Pitti registers "Un Quadro Intela poco piu minore del sù d.o : entrovi dipinto una Juditta che ammazza Leoferne con ornam.to: sim.e al d.o." The previously mentioned work (*suddetto*) is an *Annunciation* "alto B 4 ½ inc.a e largo B. 3 ½ inc.a con ornam.to di legno nero filettato d'oro." The same *Judith* appears in a Pitti inventory begun on "30 dicembre 1663" as "Un quadro in tela entrovi dipinto Juditta, con un'altra figura, che

ammazza Leoferne nel letto, con adornam.to nero, intagliato a baccelletti, filettato d'oro, con foglia dorato p[er] cantonata alta B. 4-e largo B 3⅓." Then in 1774 a *Judith* was transferred from the Palazzo Pitti to the Uffizi under Caravaggio's name.

Borea identifies the latter as Artemisia's canvas, which she connects as well to the citations of 1637/38 and 1663. Inasmuch as Gentileschi's picture was certainly executed for the Florentine court (see below), and since toward the end of the seventeenth century it was seen in the Palazzo Pitti by Baldinucci, who recognized its correct authorship and extolled it for its quality and vividness ("opera al certo, che ogn'altra di sua mano avanza in bontà, e tanto ben pensata, e sì al vivo espressa, che solamente il mirarla così dipinta mette non poco terrore"), these are not unreasonable inferences. However, Gianni Papi has questioned their validity, wondering (as had Borea) why a signed picture should have come down unattributed and then misattributed, and if the painting that passed to the Uffizi in 1774 is in fact that recorded in the aforementioned inventories. Papi speculates that the seventeenth-century citations, at least, may have been of a *Judith Decapitating Holofernes* (1.96 x 1.52 m.) now in storage in the Palazzo Pitti by a still-anonymous Tuscan Baroque painter.

Papi's skepticism is partly justified. On the one hand, Artemisia's signature, being in dark pigment in a dark area of the canvas, might have escaped notice, and the number 575 noted by Borea on the back of the painting before its relining is the same number as that assigned to the *Judith* attributed to Caravaggio when it entered the Uffizi in 1774. Conversely, there is the issue of size. The *Judith* mentioned in 1637/38 and again in 1664 was appreciably larger than Artemisia's canvas (contrast Borea's "di simili misure," repeated by Papi). In those inventories (to convert the measurements into modern equivalents), the picture was said to measure, respectively, "slightly smaller than" 2.45 x 1.87 m. (the Florentine *braccia* at 58.36 cm.) and 2.33 x 1.95 m. Yet the print published by Lastri in 1791 records Artemisia Gentileschi's *Judith* essentially in its present format, and in 1828 Benvenuti gave the measurements as "Alto Pal. 9 On. 1½; Largi Pal. 7 On. 5" (i.e., 2.01 x 1.65 m., the *palmo* at 22 cm.). Unless the seventeenth-

century calculations included the frame—and they did *not* do so for Gentileschi's *Judith and Her Maidservant*, then and now in the Palazzo Pitti (Fig. 31; Color Plate IV)—there is a significant discrepancy. And the same can be said of the *Judith* in the Pitti storage. It should also be emphasized that the example of the Naples version (Fig. 21; Color Plate II) and common sense preclude an extension of the Uffizi canvas below, that the maid is even now in danger of being swallowed by the space above, and that there are no reasons to postulate substantive additions to the sides.

Thus, in addition to Artemisia's letter to Galileo in 1635, to be discussed below, the unequivocal notices of her *Judith* prior to the nineteenth century are as follows: the transfer of 1774 (referenced by Borea to A. G. U., F. VII, a3, n. 575); Baldinucci's account; the print published by Lastri in 1791; Alessandro da Morrona's description of 1792 (in which the signature is recorded); and the remarks of Luigi Lanzi, which go back to the 1790s.

The *Judith Decapitating Holofernes* is a variant of Artemisia's painting now at Naples, which before its darkening and mutilation displayed a tent curtain behind and was larger than it is today (Figs. 21–22; Color Plate II). But its leaps in sophistication and technical virtuosity (detailed in the text) place the Uffizi *Judith* several years in advance of its Naples prototype, while the presence of the Lomi surname in the signature still connects the painting to Florentine patronage (see Chapter 2). Garrard tentatively identifies it as the unnamed picture which in a letter of February 15, 1620 (New Style), announcing a proposed trip to Rome, Artemisia promised to send to Grand Duke Cosimo "within two months at the most" and for which she had already received some ultramarine. This canvas, according to Garrard's rather inconsistent argument, was completed either in Florence or in Rome, to be shipped back to Florence. In fact, as Papi has realized, the documented work was a *Hercules* (Appendix I, January 13 and 16, February 10 and 15, 1620).

Nonetheless, there is evidence that the *Judith Decapitating Holofernes* was Gentileschi's last work for Cosimo but that it was executed entirely in Rome (a view to which Cropper also inclines), where Artemisia is documented in March of 1621 and where no doubt she had es-

tablished herself by mid-1620. On October 9, 1635, Gentileschi, then in Naples, wrote to Galileo in Arcetri seeking his intervention with respect to "the two large paintings that I recently sent to His Serene Highness [Grand Duke Ferdinando II]," regarding which she had received no written or monetary acknowledgment. The artist likened this situation "to that concerning that Judith which I presented to His Serene Highness the Grand Duke Cosimo II of glorious memory and which would have been lost to memory had it not been revived by Your Lordship's help, thanks to which I obtained excellent remuneration (*un'altra occasione simile a quella di quel quadro di quella Giudith ch'io diedi al Ser.^mo Gran Duca Cosimo gloriosa memoria, del quale se n'era persa la memoria, se non era ravvivata dalla protettione di V. S., in virtù della quale n'ottenni buonissima ricompensa*)." The Uffizi canvas is the best candidate for the *Judith* presented to Cosimo, and since the Grand Duke died on February 28, 1621, the picture must have been finished by that date. Papi, connecting the painting to the Galileo correspondence, has also reached this conclusion. Garrard supposed that Galileo's assistance would not have been necessary were Cosimo still alive. However, Gentileschi's letter does not state that the astronomer interceded with Cosimo's *heirs*, and it may be that Artemisia turned to Galileo because she was no longer in Florence and thought it wise not to deal from a distance directly with Cosimo, whose poor state of health was known to her before she returned to Rome. Furthermore, there is no later record of the *Hercules*, a subject for which Artemisia probably had little sympathy and even less training.

It might be hypothesized that the *Judith* was a substitution of Artemisia's own choosing intended to mollify the Grand Duke upon nondelivery of the ordered *Hercules*. However, it is much more likely that the subject was stipulated by Cosimo. This is suggested above all by the *Biblical Battle Series* of 1613 by Antonio Tempesta, twenty-four etched plates dedicated to Cosimo II. The frontispiece, which records this dedication, "makes it clear," in Barnes's words, "that the victories of the Hebrews were meant to be seen as parallel to Cosimo's own conquests." "With this identification in mind," Barnes continues, "it is of some interest that the story of Judith is included in the group at all, since it is the only one in the series that focuses on a female." The inscription to Tempesta's *The Murder of Holofernes* (Fig. 76) reads in Barnes's translation: "Here where the foul canopies are made red, sprinkled with gore, you, the leader, lie slain, overpowered by the art of a woman. That beauty had adorned itself to bring about your ruin, but you hasten death in the night by your drunkenness." Since there are close relationships between Tempesta's depiction of Abra and she in the canvas of *Judith and Her Maidservant* which Artemisia was to execute about 1623–25 (Fig. 84; Color Plate XIII), it is probable that Gentileschi was familiar with Antonio's series and that these prints and Cosimo II himself had apprised her of the meanings which the Grand Duke attached to the Judith story.

Back in Rome and with the commission for the *Judith Decapitating Holofernes* in hand, Artemisia could study her early rendition of the theme (see [4])—or rather would have to have studied that picture in order so accurately to reproduce its composition and scores of its details. Obviously she made a conscious decision to renew her Caravaggism under the impact of being once again in the city where it had all started and where, if my attributions and chronology are correct, her father had already painted the *Cleopatra* and she the *Lucretia* (Figs. 211, 19; Color Plate III), canvases to which Papi has likened the Uffizi *Judith*.

The sophistication of this picture has been thought to extend to symbolism of the bracelet and the sword hilt. Garrard, who was the first and only scholar to scrutinize these elements, believes that the cameos may represent Diana (i.e., Artemis, a "proud identity [of Artemisia] with a strong and independent female mythological figure"), and that the cruciform shape of the hilt may allude to Christ's victory over Satan following a literary association of "Christ's death [with] the holy sword used by Judith." In Chapter 6, I have presented my own very different identifications and interpretations of the cameos, while in my opinion the sword of Judith is best viewed as simply a part of the artist's stock-in-trade. The prominence given the bed has prompted Barthes to recall that in the Latin text the bed is called a *lectulus* and therefore can be understood simultane-

ously as a nuptual bed (with its implications of sexuality), as a dining couch (the presentation of Holofernes' body likened to the display of meat in a butcher's shop), and as a bier.

Notice must also be taken of the recent proposal of Topper and Gillis wherein the blood, shooting out from Holofernes' neck in distinct curves, a few of which assume more-or-less parabolic form, is related to Galileo Galilei's discovery of the parabolic path of projectiles. The authors muster support from those inventive theories (Artemisia's awareness of Ludovico Cigoli's cratered moon in the Cappella Paolina in Santa Maria Maggiore and of Galileo's drawings of the moon) and probabilities (connections of both individuals to the Grand Ducal Court in Florence; joint membership in the Accademia del Disegno; Galileo's intervention with Cosimo II in the matter of the *Judith*) that Gentileschi had come into contact with Galileo and his ideas by the time she produced the *Judith*. Topper and Gillis, conceding that without actually knowing that the artist intended true parabolas it is impossible to prove their existence in the Uffizi picture, "are more than reasonably sure that the forms are indeed parabolas . . . mainly because of the high improbability of them being otherwise." This argument also presupposes that Galileo shared his discovery (apparently made in 1608) with Artemisia Gentileschi almost two decades before it was published, and that it would have occurred to the artist to transfer the mathematician's findings from cannonballs to blood.

Topper and Gillis suggest that her Caravaggesque "quest for bold realism" prompted Artemisia to take over Galileo's law. Much more likely, I believe, is that in her determination to be utterly convincing and to startle, Artemisia looked not to science but to memories of animals being slaughtered in the marketplace and to the arcs of spurting blood in Rubens's *Great Judith* (Fig. 25).

The *Judith Decapitating Holofernes* has repeatedly been deemed central to considerations of Artemisia's personal involvement with the subjects of her pictures and, of course, has not escaped Freudian analysis. For my thoughts on such matters, see Chapter 6.

A large-scale version of the Uffizi canvas is claimed by a photograph in the Bibliotheque du Louvre to be in the Luiz de Rocka Machado Collection in Funchal, Madeira, but the small

photo did not permit Papi (who brought it to the attention of scholars) to judge the quality of the picture. A *Judith* in the Pinacoteca Nazionale at Bologna (Fig. 27), sometimes claimed (including by the present author) to have been copied from the Uffizi composition, is in fact a nonautograph replica of the *Judith Decapitating Holofernes* in Naples (Fig. 21 and [4]).

BIBLIOGRAPHY: Galilei, 1905, XVI, pp. 318–19, as from Florence, Biblioteca Nazionale, MSS Gal. P. I. T XIII, car. 269–70; Baldinucci, ed. 1812, X, pp. 253–54; M. Lastri, *L'Etruria pittrice, ovvero storia della pittura toscana* . . . , Florence, 1791, II, pl. LXXXIV; Morrona, 1792, II, p. 269; P. Benvenuti, *Reale Galleria di Firenze*, serie I (Quadri di storia), III, 1828, p. 120; Rosini, 1846, VI, pp. 160–61; Lanzi, ed. 1834, p. 214; Voss, 1925, p. 463 and pl. 119; Milan, *Mostra*, 1951, p. 62 cat. 101; Zurich, Helmhaus, 1958, p. 12 no. 20; Longhi, *Scritti*, I-I, 1961, pp. 258, 281; Bissell, 1968, p. 156; Borea, 1970, pp. 76–78 cat. 49, 120, 123, 124; Greer, 1979, pp. 189, 191; Nicolson, 1979, p. 50 and Nicolson/Vertova, 1989/90, I, p. 111; Gorsen, 1980, p. 76 and passim; Hofrichter, 1980, pp. 9–15; Pointon, 1981, pp. 350–59; Parker and Pollock, 1981, p. 21; E. Ciletti, address to the College Art Association, Toronto, February, 1984; Slap, 1985, pp. 335, 337–38; Garrard, 1989, pp. 36, 38–39, 51–53, 321–27, 383–84, 500 n. 77, 501 n. 79, 557 nn. 110 and 116, and passim; Papi in Contini/Papi, 1991, pp. 49–50, 150–53 cat. 19; Berti, ibid., p. 25; Stolzenwald, 1991, pp. 85–86; Spike, Review, 1991, p. 732; Cropper, 1992, pp. 204, 209; Wachenfeld, 1992, pp. 30–31, 33–34; Barthes, ibid., pp. 12–13; D. Topper and C. Gillis, "Trajectories of Blood. Artemisia Gentileschi and Galileo's Parabolic Path," *Woman's Art Journal*, Spring/Summer 1996, pp. 10–13. Also [4] and the references to Appendix I cited above.

For the aforementioned Pitti inventories: Florence, AS, Guardaroba Mediceo 525, "Inventario de Pitti," 1637, fol. 32v, and Guardaroba Mediceo 725, "Inventario del Palazzo de Pitti," 1663, fol. 54v.

For Tempesta's frontispiece and etching of *Judith*: M. Sopher, *Seventeenth-Century Italian Prints*, exh. cat., Stanford University Museum of Art, 1978, pp. 57–58; B. Barnes in Russell, 1990, p. 70 cat. 30.

[13] *Portrait of a Condottiere*

Bologna, Collezioni Comunali d'Arte, Palazzo d'Accursio
Oil on canvas, 2.08 x 1.28 m.
1622

Figs. 81–82; Color Plate IX

Inscribed on the reverse, before relining:
ARTEMISIA. GÉTILESCA. FA =/CIEBAT ROMAE <u>*1622*</u>

COLLECTIONS: Agostino Pepoli (heirs), Bologna, by whom given to the city, 1920 (?); Pinacoteca, Bologna, until 1934

Restored in 1964, the picture is in excellent condition. The lettering on the reverse of the original canvas (salvaged after the relining) lacks the precision of Gentileschi's previous signatures, and to my knowledge Artemisia only once (or perhaps twice) spelled her surname *GENTILESCA* (Figs. 174, 179, 180), a form that was used by others to underline the fact that the artist was a woman. Yet niceties of lettering need not be observed on the backs of pictures, and the information—Gentileschi is documented in Rome in 1622—is correct. Whether or not a signature per se, the inscription can be considered an accurate contemporary record.

Regarding the identity of this highly individualized nobleman Garrard writes:

Although the subject of this full-length portrait of a man in armor has not been identified, the Maltese cross on the chest indicates that he was a member of SS. Maurizio e Lazzaro, a military order of North Italian origin. The family of the *condottiere* (perhaps more accurately described as a *gonfaloniere*) was evidently meant to be designated in the coat of arms depicted on the tablecloth at the left, but the cleaning of this painting in 1964 showed this detail to be more puzzling than informative. The overlaid design, nine squares in checkerboard of dark and light contained in an ovoid frame, proved to have covered an earlier pattern of three chevrons, points downward, two silvers flanking a black one. The earlier coat of arms had been thought to be a variant of the family arms of the Pepoli, who donated the painting to the Pinacoteca in Bologna in the 1920s (the Pepoli arms, however, consisted of five, not three, rows of squares), but after the cleaning no known heraldic connections could be established for the chevron design. The superimposed checkerboard design, on the other hand, may easily be connected with a Gentileschi patron of

that period, for its form is identical to the arms of the Gentile family of Genoa. Pietro Maria di Cesare Gentile, who owned Artemisia's *Cleopatra* and *Lucretia* and who was an active military figure in the 1620s, would seem a good candidate. The unusual and unidentifiable character of the earlier armorial device suggests the possibility that this might have been a meaningless emblem, a kind of blank, as it were, painted by Artemisia in Rome for a patron whose family arms were to be filled in later—for reasons that can only be guessed at.

There are a number of misconceptions in this passage that must be cleared up, lest the issue become hopelessly obscured. First, the coat of arms removed by the cleaning had *five* rows, as Zucchini (and recently Papi) observed and as can be seen in the old photograph. There were thus *fifteen* squares (four of them truncated by the curves of the oval frame at top and bottom) in a checkerboard design. Zucchini supposed that this armorial device was that of the Pepoli, although the Pepoli arms has *six* rows of six squares each. This was a reasonable assumption given the provenance of the picture, the numerous *condottieri* in that family's history, and the limited space available on the shield. But this checkerboard design was easily dissolved, revealing the "pattern of two silver chevrons, points downward, flanking a black one" that I reported in 1968. Garrard has theorized that the chevron arrangement was painted by Artemisia as a "meaningless" fill, intended from the beginning to be covered by a proper coat of arms. One wonders whether an artist would have bothered painting anything that was to be obliterated. Furthermore, as Wendy Watson pointed out to me, in the space above the upper chevron and still within the oval field a Maurician cross, echoing that on the man's breastplate, is sketched in.

However, to assume for the moment that the alternation of squares was in fact the arms of the individual depicted, and that he is not a Pepoli (e.g., the Marchese Taddeo Pepoli, 1567–1624), can the suggestion that he is Pietro Maria di Cesare Gentile be sustained? The Gentile escutcheon had three rows, not five. Even to discount this basic objection with a claim, for example, that the painter incorrectly

copied the Gentile arms is not to resolve the matter. There is no evidence that Artemisia was in contact with the Gentile in the early 1620s. In my opinion, the *Cleopatra* (Fig. 211; [X-6]) is by Orazio Gentileschi, and Artemisia's *Lucretia* (Figs. 18–19; Color Plate III; [3]) should be backdated to ca. 1611. Both pictures were probably sent to Genoa between 1612 and 1615, and while in the late eighteenth century they are cited in the Palazzo Gentile, there is no proof that they were commissioned by Pietro Maria di Cesare (who in 1612 was how old?). And the presumption that Artemisia was in Genoa in 1621 is now extremely fragile (see Chapter 3).

Finally, it is to be doubted that Pietro Gentile was a member of the Order of SS. Maurizio e Lazzaro to which this *condottiere* belonged. The cross emblazoned on his chest is the trefoil Maurician cross, not a Maltese one (the arms of which terminate in "V" shapes). The Lazarian cross, however, was of the Maltese type. In 1573 the Maurician and Lazarian Orders, both then under the leadership of Emanuele Filiberto of Savoy, were united by Pope Gregory XIII. Their crosses were likewise combined, and under Carlo Emanuele I (1562–1630) at the end of the sixteenth century the Maurician cross was given precedence by being superimposed upon the Lazarian one. While the latter is not indicated in Artemisia's portrait, the soldier can confidently be identified (as Zucchini recognized) as a member of the Order of SS. Maurizio e Lazzaro, particularly since he wears a green sash and is accompanied by a banner bearing a papal tiara, a reference to the Order's vows to fight in defense of the papacy. (In 1627 Artemisia was to portray another member of the Order, Antoine de Ville; Fig. 102.) Since, as Garrard notes in another place, Pietro Maria Gentile "played an important role as Genoese patriot in the city's struggles against the House of Savoy in 1624–25," he could hardly be the Savoy-sponsored Knight of SS. Maurizio e Lazzaro depicted here.

Thus the *condottiere* retains his anonymity. Although it is highly likely that his escutcheon bore three chevrons, Gentileschi may not have been responsible for painting it. For while in the Bologna picture the chevron-decorated oval is surmounted by a helmet with red and black plumes in emulation of the helmet on the table, the entire armorial affair, far from being projected in correct perspective, lies parallel to the picture plane in a visually incongruous manner. It could be an addition wished by a later generation proud of its ancestry.

The form of portraiture employed here can provide no clue as to the man's identity; for as Harris and Garrard have stressed, the pose and the trappings are conventional. Among the many examples Artemisia might have known is Jacopo da Empoli's *Portrait of Concino Concini* of 1610 (formerly London, Christie's; Fig. 80). Full-length and standing, Concini rests his right hand on a tapestry-covered table on which a plumed helmet sits, while grasping the pommel of his sword with his left hand. Even the directions of the lighting (and hence of the cast shadows) and the treatments of the upper-right corners are comparable. Closer at least to the *condottiere*'s base of operation is Giovanni Carracha's *Portrait of Carlo Emanuele I* of ca. 1605 (Saluzzo, Casa Cavassa), the Duke sporting a ruff collar and armor emblazoned with the trefoil cross of Saint Maurice and accompanied by the ubiquitous table and plumed helmet. Potentially relevant too, as Papi has posited, is Andrea Commodi's *Portrait of Michele Peretti* of ca. 1605 (Rome, Palazzo Chigi). Artemisia's "sensational" (Gregori and Papi; see the text) picture, in turn, may have had implications for Caravaggesque portraiture, as witness Orazio Riminaldi's *Portrait of Curzio Ceuli* (Florence, Private Collection) cited by Gregori in this connection.

BIBLIOGRAPHY: J. H. Lawrence-Archer, *The Orders of Chivalry*, London, 1887, pp. 133–37 and pl. XXV (opp. p. 140); F. Malaguzzi Valeri, "I nuovi acquisti della Pinacoteca di Bologna, *Cronache d'arte*, III, fasc. 1 (1926), 30, 33; Spreti, n.d. (1928–36), III, p. 396, and V, pp. 242–45; G. Zucchini, *Catalogo delle collezioni comunali d'arte di Bologna*, 1938, pp. 22, 24; Bissell, 1968, p. 157 incl. n. 39; Harris in Harris/Nochlin, 1976, p. 122 cat. 12; Greer, 1979, p. 195; M. Gregori in Naples, *Civiltà del seicento*, 1984, I, p. 147; idem, "Un ritratto di Orazio Riminaldi," *Paragone*, nos. 419, 421, 423 (1985), pp. 227–29 and ills.; Garrard, 1989, pp. 56, 59–61, 502 n. 94; Nicolson/Vertova, 1990, I, p. 111; Papi in Contini/Papi, 1991, pp. 50, 157–60 cat. 21.

For the additional comparative material: A.

Griseri in *Mostra del barocco piemontese*, 1963, II, p. 46 cat. 5 and pl. 2; Cantelli, 1983, p. 41 and pl. 121.

..

[14] *Judith and Her Maidservant*

Detroit, Michigan, Institute of Arts
Oil on canvas, 1.84 x 1.416 m.
Ca. 1623–25
Figs. 83–84, 93; Color Plate XIII

COLLECTIONS: Prince Brancaccio, Rome, sold through the offices of Alessandro Morandotti and Adolph Loewi; gift of Mr. Leslie H. Green, 1952

Contraction of the paint during the drying process created an erroneous impression of unstable pigment adhesion, most noticeably on Judith's dress. The canvas had also dished inward, the stretcher as a result imprinting its edges around the circumference. To my knowledge there is no physical evidence for the suggestion that the transparent drapery over Judith's bodice could be a later addition.

Following my publication in 1968 of new information concerning Artemisia's birthdate and activity, scholars have been unanimous in assigning the Detroit picture to the 1620s, with Spear, Harris, Garrard, and Papi supporting my view that it was executed about 1625, and Contini proposing that it might belong to the first years of this third decade. The expressive thrust of this great painting and its Roman bias argue for this position. Thus Garrard, following Agnew's insight, has pointed to the Cavaliere d'Arpino's fresco of *Judith and Her Maidservant* (1602–3, Villa Aldobrandini, Frascati) as an "important antecedent" in its full-length figure of Judith and its "interpretation of the theme as a dramatic narrative, focusing upon the two women." To this can be added d'Arpino's *Judith and Her Maidservant* in the University Art Museum at Berkeley (Fig. 41), dated by Röttgen ca. 1610–12, which may have attracted Artemisia for the manner in which Judith holds the sword as she pivots toward the left in reaction to a perceived danger. It is worth recalling Artemisia's previous interest (Figs. 1, 10; Color Plate I; [1], [2]) in the Cavaliere's art. Back in Rome, she apparently remembered Adam Elsheimer's *Judith* (Fig. 26), its figures, curtain, and table still-life in the gleam of candlelight. And Gentileschi may also have had in mind Antonio Tempesta's etching

of *The Murder of Holofernes* from 1613 (Fig. 76), in which the turbaned Abra, her arms stiff and parallel as she bends to cover the severed head with a cloth, could have provided a precedent in pose for Artemisia's maid. As noted, Tempesta's print forms part of his *Biblical Battles Series* dedicated to Cosimo II, for whom just a few years earlier Gentileschi had painted the *Judith Decapitatiing Holofernes* still in Florence (Figs. 77–79; Color Plate XII).

Yet d'Arpino's blandness and Elsheimer's miniaturistic approach were not to Artemisia's taste, and she was certainly aware of the by-now conservative standings of these artists. The progressive stance of the *Judith* is best seen within a context that includes the night pictures of Gerrit van Honthorst (e.g., the *Decapitation of Saint John the Baptist* of 1618 in Santa Maria della Scala), Simon Vouet's *Temptation of Saint Francis* (Fig. 86) of 1623–24, and Antiveduto Gramatica's *Judith and Her Maidservant* (Fig. 85). The various relationships, specified in Chapter 3, help also to fix a date for Artemisia's canvas and in so doing define it at once as easily one of the most impressive and one of the last authentically Caravaggesque pictures in Rome.

How long Gentileschi's painting remained in Rome, and even if it was intended for a client there, are unresolved questions, for the canvas's history is almost completely obscure—strangely in view of its size and magnificence. The picture appeared forty-six years ago in the Roman collection of Prince Brancaccio, whom Garrard has tentatively identified as Carlo Brancaccio (b. 1870), Prince of Triggiano; one should also consider Marcantonio Brancaccio (b. 1879), Principe di Roviano. Although Princes Carlo and Marcantonio were born in Rome, the Brancaccio family is, in Spreti's words, "one of the oldest and most illustrious families of the *Neapolitan* [italics mine] nobility." And in the Laboratorio Fotografico della Soprintendenza alle Gallerie at Naples a photograph (neg. no. 6156; Fig. 83) of a detail of the *Judith*, taken before its restoration, bears the following information: "Napoli, Ufficio Esportazione, Ignoto secolo XVII, Giuditta e Oloferne (particolare)." Brancaccio origins and this hitherto unreported fact intimate that the canvas has a Neapolitan provenance. This would be consistent with the actuality of patronage tastes around 1625, when the appetite for paint-

ings in the Caravaggesque mode was considerably stronger in Naples than in Rome, and would help explain how a quarter of a century later Artemisia, then in Naples, could produce a *Judith and Her Maidservant* (Fig. 191) whose composition so closely approximates that of the Detroit version. Finally, the type of kneeling woman with arms outstretched which Gentileschi here introduced into her art reappears in three other Neapolitan canvases (Figs. 139, 159, 169; Color Plate XXIII), as if at one point the artist had had the opportunity to restudy her *Judith*.

BIBLIOGRAPHY: Spreti, n.d. (1928–36), II, pp. 173–74; Richardson, 1952–53, pp. 81–83; E. C. Korany, New York, letter of May 2, 1954, DIA files; A. Moir in Detroit, 1965, pp. 29–30 cat. 8; Moir, 1967, I, p. 101; Bissell, 1968, pp. 157–58; Spear, *Caravaggio and His Followers*, 1971, pp. 96–97 cat. 28; Gabhart and Broun, 1972, unpaginated; Harris in Harris/Nochlin, 1976, p. 122 cat. 13; J. L. Greaves, conservation report, October 29, 1976, DIA files; Gorsen, 1980, pp. 77–78 and passim; M. Gregori in Naples, *Civiltà del seicento*, 1984, I, p. 147; Garrard, 1989, pp. 67–72, 328–35, 504 n. 110, 557–58 n. 119, 558 nn. 120, 122; Nicolson/Vertova, 1990, I, p. 111; Papi in Contini/Papi, 1991, pp. 53–54, 62 n. 80; Contini, ibid., p. 141.

For the comparative material: R. Judson, *Gerrit van Honthorst*, The Hague, 1959, pp. 31–35, 158 no. 30, and fig. 6; Borea, 1970, pp. 44, 48–49 cat. 29, and figs. 29–29a; Röttgen, 1973, fig. 15, and pp. 123–24 cat. 42 and pl. 42; Spear, *Caravaggio and His Followers*, 1971, pp. 108–9 cat. 34; M. Marini, "L'opera di Simon Vouet nella Cappella Alaleoni in San Lorenzo in Lucina," *Arte illustrata*, VII, no. 58 (1974), 197–99, 201–2 n. 2, 203 n. 22; B. Barnes in Russell, 1990, p. 70 cat. 30; Papi, 1995, pp. 20, 95–96 cat. 18 and color pl. XI.

..

[15] *Aurora*

Rome, Private Collection
Oil on canvas, 2.18 x 1.46 m.
Ca. 1625–27
Figs. 87, 90, 94

COLLECTIONS: Niccolò Arrighetti, Florence; by inheritance to Giovanni Luigi Arrighetti, Florence; Palazzo Baglioni, Perugia; Art Market, Florence, before 1974

The canvas was apparently subjected in the past to a very harsh cleaning, leaving areas of Aurora's flesh in a rubbed and mottled state, and there are indications that a later hand attempted to moderate the protuberance of Aurora's abdomen through additional drapery, now removed. The winged putto, having been totally concealed beneath overpainting, was unveiled during a relatively recent restoration.

Writing in the 1680s, the celebrated connoisseur and historian Filippo Baldinucci lauded an *Aurora* by Gentileschi:

In the house of the noble Florentine Giovanni Luigi Arrighetti is a beautiful work by Artemisia's hand, in which she represented, in slightly less than life-size proportions, Aurora, a lovely nude female with long windblown hair and arms spread out and raised toward Heaven, in the act of rising above the horizon, on which appears the first brightness, and moving to disperse the dark mists of night. On the parts opposite [the light source] the figure is quite gracefully cast in penumbra, in such manner, however, as not to forsake a display of the beautiful proportions of the limbs, and of the pleasing complexion, merely stroked by the rising early light from the opposite side. And it is truly a beautiful work, one that indicates the heights which the genius and skill of one such woman attained

(In casa Gio. Luigi Arrighetti nobile Fiorentino è un bel quadro di mano dell' Artemisia, in cui rappresentò ella in proporzione poco meno di naturale l'Aurora vaga femmina ignuda con chiome sparse, e braccia stese innalzate verso il Cielo, ed essa in atto di sollevarsi dal suo orizzonte, nel quale veggonsi apparire i primi albori, e di portarsi a sgombrare alquanto le fosche caligini della notte. La figura per la parte dinanzi è tutta graziosamente sbattimentata in modo, che non lascia però di far mostra della bella proporzione delle membra, e del vago colorito, restando solamente percossa dalla nascente mattutina luce dalla opposta parte, e veramente ell'è opera bella, e che fa conoscere fino a qual segno giungesse l'ingegno, e la mano d'una tal donna.)

Baldinucci's failure to mention the putto, who with flaming torches lowered in deference to the oncoming light of nature is iconographi-

cally significant, intimates that already by the late seventeenth century this figure had been painted out. Less explainable is the author's silence regarding the highly distinctive drapery. There can be little question, however, that Filippo was describing the present large and eye-catching picture.

Art-historical and patronage considerations secure the case. Artemisia's canvas made an almost immediate impact in Florence, especially upon the works of Giovanni Bilivert. Thus Bilivert's *Apollo and Daphne* in the Stattsgalerie at Stuttgart, monogrammed and dated 1630 (Fig. 89), owes easily as much to Gentileschi's conception—in the striding Daphne with her accentuated abdomen, long flowing locks, outspread arms, oblique torso, and elaborate fluttering mantle—as it does to Bernini's Borghese group. The Artemisian drapery with its luminescent highlights is recalled again in Bilivert's *Echo and Narcissus* of 1633 (Schleissheim, Staatsgalerie), the pendant to the *Apollo and Daphne*, and in an extremely analogous way in the *Apollo and Marsyas* of the Palazzo Pitti (Fig. 203). The traditional ascription of the latter canvas to Bilivert has been questioned by Contini, who first in 1985, while noting the painting's strong Florentine quality, characterized it as "un quadro di cultura certo romana, meditato su episodi reniani del tipo dell'*Ercole* [*sic*] *e Deianara* del Louvre, in un'accezione 'terribilistica' che fa venire in mente Artemisia Gentileschi. . . ." More recently, Contini has considered an attribution of the *Apollo and Marsyas* to Gentileschi herself, a suggestion which I find unacceptable (see [X-3]) but which implicitly acknowledges the precedent of Artemisia's *Aurora*, a picture presumably unknown to Contini. In view of Bilivert's references at least in 1630 and 1633 to the *Aurora*, it is understandable that his pupil and biographer, Orazio Fidani, should also have turned to it, most notably in the *Pan and Siringa* (Florence, Private Collection), where the figure of Siringa is closely the reverse of Artemisia's Aurora and in which a winged putto with two lighted torches flies in from the upper left.

It is therefore a virtual certainty that Gentileschi's patron was Niccolò Arrighetti, for whom Bilivert is documented as having worked and in whose family palazzo the *Aurora* was seen by Baldinucci. Philosopher, poet, mathe-matician, and inveterate academician, Niccolò Arrighetti (1586–1639) was an intimate of Artemisia's former patron Michelangelo Buonarroti the Younger. His portrait figures in Bilivert's *Turkish Sultan Sending His Ambassador to Michelangelo* in the Galleria of the Casa Buonarroti, and he was the object of one of Michelangelo the Younger's *Satire* and the recipient of *intermezzi* written by Buonarroti for his *commedia* of 1628, *La Gratitudine*. Arrighetti was also on close terms with Galileo Galilei, whom in 1623 he succeeded as Consul of the Accademia Fiorentina. Gentileschi may have been introduced to Arrighetti by one of these distinguished mutual friends. It would not be surprising were a methodical review of Niccolò's writings to turn up lines on the Aurora theme.

Future research might also clarify the subsequent history of Artemisia's painting. Alessandro da Morrona's reference to the work in 1792 relies upon Baldinucci's account (a portion of which is quoted) and upon "altre memorie." Maurizio Marini has informed me that prior to its appearance on the Florentine art market the *Aurora* was in the Palazzo Baglioni at Perugia, but its date of acquisition by the Baglioni remains to be determined. The painting is not cited in Baldassare Orsini's *Guida al forestiere per l'augusta città di Perugia* (Perugia, 1784, and 2d ed., 1818) or in the pages dedicated to the Palazzo Baglioni in Serafino Siepi's *Descrizione topologico-istorico della città di Perugia* (Perugia, 1822, II, pp. 642–44). On the other hand, the date of execution of Artemisia's *Aurora* can be set within relatively precise limits. Bilivert's *Apollo and Daphne* of 1630 establishes a *terminus ante quem*, and the style of the *Aurora* places it in advance of Gentileschi's departure from Florence in 1620. Its closest parallels, detailed in the text, in Artemisia's own oeuvre are with the *Judith and Her Maidservant* at Detroit, here dated ca. 1623–25 (Fig. 84). The remarkably virile canon for the female body and the chubby-cheeked, pinched-mouth putto likewise mark Artemisia's *Venus and Cupid* (Fig. 104), while those notes of idealization that had been struck during her Florentine years and are to be heard again in the *Penitent Magdalen* and the *Cleopatra* (Figs. 111, 110; Color Plate XV) have been temporarily silenced.

The approximate date of the *Aurora* recom-

mended by such comparisons is intimated as well by Gentileschi's probable sources. Guido Reni's *Aurora*, hypothesized by Garrard as a possible prototype for Gentileschi's *Aurora* on the basis of Baldinucci's description, and ancient female figures in moments of maenad-like frenzy (e.g., the Neo-Attic *Maidens Decorating a Candelabrum;* Fig. 92) are recalled. The *Piramus and Thisbe* (Florence, Uffizi; Fig. 88) by the Florentine master Gregorio Pagani (1558–1605) also appears relevant, and might have been called to Artemisia's attention by Arrighetti. Since, as discussed in Chapter 3, there is reason to believe that Artemisia stopped in Florence on her way to Venice in 1627, the *Aurora* may possibly date to that time.

The particularities of patronage and the nature of the theme, including its call for a landscape setting, dictated solutions that diverged from the previous directions of Artemisia's career; the tenebristic lighting and restricted ambient which, along with the trenchant realism, mark the contemporary *Judith and Her Maidservant* as a masterpiece in the Caravaggesque mode, were no longer germane.

The classical goddess is evoked by the inscription on the reverse of Pierre Dumonstier's drawing, produced in Rome in 1625, of Artemisia's right hand (Fig. 98; also Chapter 3): "The hands of Aurora are praised for their rare beauty. But this one here is worthy of a thousand times more praise for knowing how to make those miraculous works which delight the eyes of the wisest judges (*Les mains de l'Aurore sont louées pour leur rare beauté. Mais celle cy plus digne le doit estre mille fois plus, pour sçavoir faire des merveilles, qui ravissent les yeux del plus judicieux. S.*)." Garrard supposed that reference is made here to Gentileschi's painting, but it is likely that the French draftsman had in mind not the canvas but rather conventional literary encomia to the beautiful hands of "rosy-fingered Dawn."

As Baldinucci's citation provides the context for the *Aurora*, so also does it caution us against imposing our standards of beauty upon the past. The seventeenth-century Florentine writer found Artemisia's nude very much to his liking, considering her to be lovely, graceful, and well proportioned.

BIBLIOGRAPHY: Morrona, 1792, II, p. 271; Baldinucci, ed. 1812, X, p. 253; Longhi, *Scritti*, 1961, I–I,

p. 281; A. Dolci in *Dizionario biografico degli Italiani*, Rome, 1962, IV, pp. 309–10; M. Marini, *Pittori a Napoli 1610–1656: contributi e schede*, Rome, 1974, fig. 58; Vliegenthart, 1976, pp. 11, 108–11 cat. 2, and pl. 11; Marini, "Gli esordi," 1981, p. 67 fig. 39; Marini, "Caravaggio e il naturalismo internazionale," 1981, p. 370; Garrard, 1989, pp. 51, 500 n. 76.

For the comparative material: Cantelli, 1983, p. 22, and pls. 39–40, 43, 348; Contini, 1985, pp. 55, 99–100 cat. 33, 105–6 cat. 41, 158, 161, 163, and pls. XIII, 43, 55; Bober and Rubenstein, 1986, p. 96 cat. 59A–59B, and figs. 59A–59B; C. Thiem in Florence, Palazzo Strozzi, 1986, I, pp. 108–9 cat. 1.18, and II, p. 115 cat. 2.59 and color pl. VII.

...

[16] *Penitent Magdalen*

Seville, Cathedral
Oil on canvas, 1.22 x .96 m.? (see below)
1625/1626
Fig. 97; Color Plate XI

COLLECTIONS: Most likely Fernando Enríquez Afán de Ribera, Third Duque de Alcalá, Casa de Pilatos, Seville, by 1626

As if exhausted from her penitential pleadings, the Magdalen slumps in her chair and almost into sleep, her right hand still grasping those effulgent locks with which she had wiped Christ's feet and, we are to imagine, tears from her eyes. She wears a golden dress over a white blouse and a brownish shawl. The brown wooden chair is fitted with dark green upholstery, while a swag of maroon-red curtain and a band of subdued light animate the background.

Before its recent restoration the canvas was badly in need of conservation, having so darkened that the curtain and the table with the ointment/perfume jar and mirror at the left were barely visible, and having sustained extensive paint loss along its lower edge and, it seems, blistering. Valdivieso reports the size of the canvas as 122 x 64 cm., but its proportions are in the ratio of 1.276:1. Taking 1.22 m. as the accurate measurement, the width of the Seville *Magdalen* would then be .96 m., very close to that of the version in a European private collection (Fig. 96; Color Plate X; [17]) which by virtue of greater space above measures 1.365 m. in height. Whether the Seville example has been trimmed at the top by 14.5 cm. is an open question; there is no sense of cramping, and in the somewhat smaller format the Magdalen is a more dominant figure.

The present *Magdalen* also differs from the other picture in the more extensive expanse of the Saint's shawl, apparently accomplished by a rather skillful addition of cloth to what was originally an arrangement identical to that of the second picture. Partly of a different tonality and showing beneath its transparency the now meaningless curved shadow on the Saint's shoulder, this addition and that of its cast shadow were almost certainly made in the interests of modesty when—surely before the mid-seventeenth century—the painting was transferred from a private home to the public religious setting of Seville Cathedral (see below).

In the inventory of the Duke of Alcalá's collection in Seville, compiled between 1632 and 1636 by Juan de Arroyo and published by Brown and Kagan, the following picture is noted "En el oratorio alto pieca prim^a": "Una Mag^na sentada en una silla durmiendo sobre el braço de artemissa Gentileça romana." Since, as Brown and Kagan explain, this painting is not further designated by a crate number, in contrast to the goods shipped by Alcalá from Naples in 1631 following his stormy tenure as Viceroy, it almost assuredly figured among the Duke's purchases in Rome, where he served as Ambassador to the Holy See from July 1625 to February 1626. With the death of Alcalá's daughter in 1638 and the lawsuits attending his nephew's inheritance of the estate, much of the collection was scattered. And in all probability Alcalá's "Magdalen seated on a chair, sleeping on her arm" is the picture here under consideration.

How reliable is Arroyo's compilation, and can, then, the attribution to Artemisia Gentileschi be taken as a documented fact? Inasmuch as approximately eighty percent of the works of art in the inventory are unassigned, it seems that Arroyo scrupulously avoided speculation, and it is highly doubtful that within a decade of its acquisition the *Magdalen* would have been given a false pedigree. Furthermore, Arroyo may have been aided in his task, as suggested to me by Vicente Lleó Cañal, by the knowledgeable Francisco Pacheco, who in his *El arte de la pintura* wrote: "Antes de pasar de aquí, haré memoria de otras famosas mujeres pintoras italianas como . . . Artemisa [*sic*] que vive hoy en Roma (de quien traxo el duque de Alcalá algunas pinturas)." Pacheco's passage was echoed by Lazaro Díaz del Valle in 1656: "Artemisia gentilesca. Pintora de Roma; desta mujer trajo el Duque de Alcalá a España algunas famosas pinturas." Only the presence in the Casa de Pilatos of two other paintings said to be by Artemisia of subjects otherwise unknown in her oeuvre—*David with the Harp* [L-20] and *Christ Blessing the Little Children* [L-14]—casts any doubt at all on Arroyo's accuracy.

This uneasiness is allayed, however, by the canvas itself. The *Magdalen* was first signaled by Valdivieso, who because of the poor viewing conditions hesitated to declare it an autograph work by Artemisia Gentileschi rather than a copy after her. But even before the restoration of the picture, Brown and Kagan assigned it directly to Artemisia, an attribution which "warrants serious consideration" in the 1989 opinion of Garrard, for whom both the facial type and the bent wrist, the latter likened to the *Cleopatra* (Fig. 110; Color Plate XV), appear characteristic of Artemisia. The Cleopatra, her head supported by her bent wrist, her other arm hanging limply, is indeed relevant. So also is the *Saint Mary Magdalen* formerly the property of the Barone della Gulfa (Fig. 111), where a similar play between the two arms obtains and where the physiognomy of the model, allowances made for her open eyes, seems especially related to that of the *Magdalen* in Spain. The picture may also be inserted within the wider context of Roman art of the period. As an iconographical type it reverts ultimately to Caravaggio's *Penitent Magdalen* in the Galleria Doria-Pamphili, while many of its formal properties—seated figure depicted from the knees upward, the broad expanse of her lap dominating the foreground; the head bent, shoulder and neck thus forming an unbroken line; elaborate undulating garments—may be likened to Orazio Gentileschi's *Madonna and Child* of ca. 1615–20 in the Schloss Weissenstein at Pommersfelden. Moreover, the *Magdalen* evokes a number of Simon Vouet's paintings, most especially the *Virginia da Vezzo as the Magdalen* (Fig. 91), wherein a lace-trimmed blouse slips off the shoulder of a dreamy Magdalen, strands of whose flowing hair run through her fingers. Such affinities, discernible in spite of the trenchant Caravaggesque realism of Artemisia's picture, are prob-

ably not fortuitous, and lend support to the argument that Vouet's *Magdalen* dates from his last years in Rome rather than immediately after his return to France.

A Vouet-Gentileschi connection has already been postulated with regard to the *Judith and Her Maidservant* of ca. 1623–25 (Fig. 84; Color Plate XIII; [14] and Chapter 3). These links, those which tie the Seville *Magdalen* to Artemisia's *Cleopatra* and ex-della Gulfa *Magdalen* (both of which I have set on independent evidence to ca. 1627–29), and the date at which the Duque de Alcalá augmented his collection through purchases in Rome, all fix the execution of the Seville canvas to the mid-1620s.

In 1665 a work (or works) by Artemisia figured among the quantity of pictures lent to the festival at Sta. María la Blanca in Seville. F. Torre Farfán (*Fiestas che celebró la Iglesia de Santa María la Blanca de Sevilla . . .* , Seville, 1666), quoted by Angulo, speaks of "la suavidad de Artemisia." Conceivably the *Magdalen* was one of the loans.

BIBLIOGRAPHY: F. Pacheco, *El arte de la pintura*, ed. F. J. Sánchez Cantón, Madrid, 1956, I, p. 148; L. Díaz del Valle, 1656–59, in Sánchez Cantón, 1933, II, p. 361; E. Valdivieso, *Catálogo de las pinturas de la Catedral de Sevilla*, Seville, 1978, p. 131 no. 511 and pl. cv (1); D. Angulo Iñiguez, *Murillo*, Madrid, 1981, I, pp. 341–42; Brown and Kagan, 1987, pp. 236–37, 239–40, 248 no. 3; Garrard, 1989, pp. 91, 510 n. 155; Vicente Lleó Cañal, Seville, letter to the author, December 28, 1989; Carmen Saen, Seville, various letters to the author, 1995.

For the comparative material: Bissell, 1981, p. 165 [35] and fig. 82; London, Trafalgar Galleries, 1983, pp. 8–11 cat. 3, with color ill.

...

[17] *Penitent Magdalen*

Private Collection
Oil on canvas, 1.365 x 100 m.
Ca. 1625/1626
Fig. 96; Color Plate X

At the lower right, the (inventory) number *159*

Before the recent restoration small losses dotted the surface (the damage being most extensive near the lower border), and rubbing of the background had exposed the preparatory ground. Reportedly the canvas had not been subjected to conservation measures for more than a century. With the Magdalen in a golden-yellow dress, white blouse, and brownish shawl, the color scheme is essentially that of the picture in Spain (Fig. 97; Color Plate XI; [16]), except that the curtain, maroon-red in the Spanish example, is here a deep pink.

For reasons advanced with respect to the *Magdalen* now in Seville Cathedral, which—I have concluded on the basis of the available evidence—was probably purchased in Rome in 1625 or 1626 by the Duque de Alcalá and installed in his Casa de Pilatos at Seville, this enchanting conception is clearly Artemisia Gentileschi's invention. Is the present painting autograph as well?

Mary Garrard confirms its attribution to Gentileschi and proposes that it, and not the version in Seville (which Garrard had previously considered a possible work by Artemisia), is that bought by the Duque de Alcalá. Repetitions in Artemisia's oeuvre are common; identical replicas are not. Exact duplications sometimes imply copies, and it is known, for example, that Alcalá had had a copy made of Artemisia's *Christ and the Little Children*, keeping the former with him and sending the original to the Cartuja de Santa María del las Cuevas in Triana (see [L-14]). To judge from the photographic evidence of the Seville *Magdalen* (which I could not locate during a trip to Spain in the spring of 1997), the handling of the privately owned *Magdalen* is crisper, the draperies less supple (there being a regularization in the delineation of the folds), the ruddiness of the ear and right hand exaggerated, and the skin of the Saint's face rather more polished. Yet the canvas seems to have come down in considerably better physical condition, rendering comparisons more problematic, while its recent—and, I think, rather too earnest—cleaning has enhanced the impression of slickness. Further, the curtain, which is of a single painterly piece, is more extensive (the Seville *Magdalen* may or may not have been trimmed above) and is of a slightly different color, while its more liquid highlights and sheen imply a different material. This is not the kind of subtle alteration that one would expect of a copyist. And the size and configuration of the shawl is that of the same detail in the Spanish version *before* the addition of more fabric for decorum's

sake. Since that augmentation may date to soon after the death of the Duque de Alcalá's daughter and heir in 1638, which led to the dispersal of the collection and, I suspect, to the transfer of the *Magdalen* to the Cathedral, the period during which any copy could have been made was probably very short.

Only a side-by-side viewing of the two canvases, and research into the inventory number that appears on the present *Magdalen*, may provide final answers. For the moment, it is more prudent to consider the latter, of high quality and dazzling impression, an original replica executed in Rome of the composition now in Seville, which latter Artemisia perhaps knew from the beginning was destined for Spain and thus could be repeated more or less verbatim without chancing in Italy potential accusations of lack of inventiveness, a charge sometimes leveled against women painters in particular.

BIBLIOGRAPHY: Private correspondence, July 1995 and August 1997. Also the related bibliography under [16].

..

[18] *Venus and Cupid (Sleeping Venus)*

Princeton, New Jersey, The Barbara Piasecka Johnson Collection Foundation
Oil on canvas, .94 x 1.44 m.
Ca. 1625–1627
Figs. 95, 103–4; Color Plate XIV

COLLECTIONS: Private Collection, Rome, 1981?

First published by Grabski in 1985, the *Venus and Cupid* may confidently be attributed to Artemisia Gentileschi. It joins other recent additions to Artemisia's oeuvre—most notably the *Aurora*, the *Cleopatra*, and canvases of the *Penitent Magdalen* (Figs. 87, 96, 97, 110, 111; Color Plates X, XI, XV)—to augment what had previously been a meager catalogue of works produced by Artemisia during her second Roman period. For Józef Grabski as well the *Venus and Cupid* should be assigned to the 1620s. In advocating below refinements to Gentileschi's chronology and in introducing new comparative material, I offer modifications rather than radical alterations to Grabski's dating.

Noting the compositional type and the "eroticism and sensual rendering of the female body," and likening them to works by Titian,

including the *Venus and Cupid* in the Uffizi, Grabski argues that the execution of the painting followed immediately upon Artemisia's stay in Venice and thus before her arrival in Naples, events judged to have taken place in 1627 and 1630, respectively. The artist's presence in Venice in 1627 is now absolutely certain, yet she is documented as having remained there into 1628, and her removal to Naples apparently occurred in 1629 (see Chapters 3 and 4 and Appendix I). To follow Grabski's reasoning would thus necessitate situating Gentileschi's picture within an even more restricted period than that which he has proposed. A more substantive suggested revision of Grabski's thesis involves the question as to precisely how the Venetian influence, beyond question discernible in the subject and disposition of the Princeton canvas, reached Artemisia. As Grabski was aware, Titian's *Venus and Cupid*—which also boasts a balustraded vista—was presented to Cosimo II de'Medici in 1618, and thus Gentileschi would have had ample opportunity to study it in Florence. Yet the solid modeling of form in Artemisia's picture, still respecting her training in Caravaggesque tenebrism, betrays no attempt at Venetian illusionism, and the closest compositional parallels of which I am aware are to be found not in paintings by Venetian masters but in two Bolognese works available in Rome: the *Danaë* of ca. 1605 from the workshop of Annibale Carracci formerly at Bridgewater House and Annibale's print of the *Sleeping Venus with a Satyr and Cupid* from 1592 (Figs. 106, 105). To the visual evidence, reviewed in the text, may be added the highly influential status of Annibale's print (DeGrazia) and the fact that the Carraccesque *Danaë* was a major model for Orazio Gentileschi's Danaë of 1621 (Fig. 107). With his *Cleopatra* (Fig. 211) from the early years of the second decade, Orazio had initiated the Gentileschian tradition of reclining nude women. It must also be recalled that at least by 1624, when a *Cupid and Psyche* by her was inventoried in the Patrizi Collection at Rome ([L-17]), Artemisia had entered this arena.

If, then, the salient technical, compositional, and thematic aspects of the *Venus and Cupid* need not necessarily be explained by postulating Artemisia's confrontation with Venetian painting on its own ground, one is not con-

strained to date the picture to the last years of the 1620s at the earliest. Thus liberated, the picture may more clearly be seen to bear relationships, discussed in the text, to the *Judith and Her Maidservant* (Fig. 84; Color Plate XIII) and the *Aurora* (Fig. 87), both considered here to have been created between approximately 1623 and 1627.

By locating the *Venus and Cupid* within Artemisia's second Roman period, and thus accepting in general terms Grabski's proposal, I am in disagreement with the opinions expressed in 1986 (exhibition catalogue, Matthiesen Fine Art Ltd.) and by Garrard, according to which, respectively, the painting should be dated 1630 and ca. 1630–35 (i.e., to Gentileschi's first years in Naples). Central to the judgments of these scholars are the obvious links between the *Venus* and the ex-London *Cleopatra* (Fig. 110; Color Plate XV), the latter also thought to belong to the early 1630s. In addition, Garrard suggests that the Princeton canvas may be the "quadro con una donna con un'amore senza cornice coperta con suo tafetta verde della *Gentilesca*" registered in 1644 among the holdings of Cardinal Antonio Barberini at Rome, a painting which she connects in turn with the unnamed work that (in her letter of January 21, 1635, to Cassiano dal Pozzo) Artemisia cited as intended for Cardinal Antonio (see [31] and Appendix I).

However, like the *Venus*, the *Cleopatra* and the kindred *Penitent Magdalen* (Fig. 111) appear to have preceded Artemisia's move to Naples (see [22] and [21]). And while the canvas inventoried in 1644 and that mentioned in Gentileschi's correspondence of early 1635 may prove to be identical, for reasons of style another *Venus and Cupid* to be attributed to Artemisia is a better candidate for the Barberini picture (Fig. 130, and [31] for a full discussion).

A definitive positioning of the *Venus and Cupid* may demand a reconstruction of the painting's history and an explication of the character of its landscape. Marini's reference in 1981 to a "Venere dormiente con un amorino" by Artemisia Gentileschi in a private collection at Rome is as suggestive as the silence regarding the provenance of the Johnson *Venus* is unpromising. More evocative still is the monochromatic landscape washed by moonlight and dramatically punctuated by the glowing Tem-

ple of Venus. Succulent, animated, and assured, it stands in contrast to the relatively conventional landscape of the *Aurora*. Did this romantic view come from Artemisia's brush? Or, occupying as it does a circumscribed area, is it the work of a landscape specialist, one distinctive enough to be identified? Whatever the answer, the painting is of a piece in communicating the sensual sleep of Venus, and in its eroticism (see Chapter 3) presents contrary visual evidence to the feminist reading of Artemisia Gentileschi's art.

BIBLIOGRAPHY: Marini, 1981, p. 370; Grabski, 1985, pp. 56–63; London, Matthiesen, 1986, p. 52; Garrard, 1989, pp. 108–9; Kultermann, 1990, pp. 137 fig. 8, 139–40; Contini in Contini/Papi, 1991, p. 85 n. 40.

For the comparative material: Posner, 1971, II, p. 69 cat. 120 and pl. 182; Wethey, 1975, p. 199 cat. 49 and pl. 107; Bissell, 1981, pp. 49, 90 n. 31, 176–77 [40]; DeGrazia, 1984, pp. 237–38 cat. 17 and fig. 337; Kultermann, 1990.

..

[19] *Portrait of Antoine de Ville*

Lost or unidentified
1627
Fig. 102

Soldier, military engineer, author, and draftsman-engraver, Antoine de Ville was born at Toulouse in 1596. Following his studies and a stint in the French cavalry, he entered the army of the Duke of Savoy, as had his brother, a Sergeant Major in the regiment of Prince Thomas. A *condottiere* of the Turin-based Order of SS. Maurizio e Lazzaro, Antoine rejoined the French troops upon the Spanish invasion of Picardie and, after the peace of 1648, undertook the fortifications of areas ceded to France. He died in 1656, proud recipient of the title Maréchal de Camp.

The portrait here reproduced serves as the frontispiece (measuring 200 x 150 mm.) to the text of *Les fortifications dv chevalier Antoine de Ville, contenans la maniere de fortifier tovte sorte de places . . .* , first published at Lyon in 1628, and to the subsequent folio editions of 1636 and 1640. Engraved by Jérôme David after a painting by Artemisia Gentileschi, it is surrounded by a rather fierce cartouche inscribed within "ANTONIVS. DE. VILLE TOLOSAS AET XXXI 1627

EQVES ST MAVRITII. ET. LAZARI" and labeled below "Artemisia Gent. P." (at the left) and "Hieron. Dauid F." (at the right). The conceit is completed by a laudatory verse composed by L. Garon: "Ni Zeuxis, ni Le docte Apelle / Ne sçauroient peindre Son esprit, / Son Discours mieux te Le d'escrit / Qu'il ne paroist en ce modelle. / Veux Au donc Ses Vertus apprendre / Qui surpassent l'art du pinceau: / Regard en un mesme tableaux / Ulysse, Minerue, Alexandre."

By 1623 the Parisian artist Jérôme David (ca. 1605–ca. 1670) had arrived in Rome and established residence in the parish of Sant'Andrea della Fratte, not far it may be supposed from Artemisia's lodgings on Via del Corso in the parish of Santa Maria del Popolo. While the printing of de Ville's *Fortifications* was not completed until the first of August, 1628, the portrait claims to show Antoine in 1627 at thirty-one years of age. There being no evidence to the contrary, the latter date may be taken as the date as well of Artemisia's picture. Since neither David nor Gentileschi is known to have visited Turin, the portrait was presumably executed during a stay by the Cavaliere de Ville in Rome. Conceivably Artemisia's initial contact with the Turinese milieu was arranged by her father, who in 1622 had sent a canvas of *Lot and His Daughters* (almost certainly the example now at Berlin-Dahlem) to Carlo Emanuele. Or it may be that the commission from Antonie de Ville was precipitated by Artemisia's success with her portrait of a another Knight of SS. Maurizio e Lazzaro (Fig. 82; Color Plate IX; [13]), painted at Rome in 1622.

Less certain is the extent to which David's print faithfully records Gentileschi's painting. That the image is reversed, a condition often to be expected of an engraving in any case, is indicated by the counterlighting of the form from the right and by the greater effectiveness of Antoine's penetrating gaze when presented directly to the observer. Furthermore, while the absence of an emblazoned cross of SS. Maurizio e Lazzaro might be explained by the relatively informal nature of de Ville's attire, the figure is truncated at the breast by a meaningless fill of parallel lines; the painted portrait may have been both more extensive and reversed. Thus the value of the engraving per se to an understanding of Artemisia's talent as a

portraitist is limited, although one can hope that this graphic record will lead to the discovery of the canvas itself.

BIBLIOGRAPHY: Antoine de Ville, *Les fortifications dv chevalier Antoine de Ville, contenans la maniere de fortifier tovte sorte de places . . .* , Lyon, 1628; *Biographie universelle (Michaud) ancienne et moderne*, Paris, 1854, X, p. 584; Le Blanc, 1856, pp. 99–100; *Nouvelle biographie générale*, Paris, 1866, XLVI, p. 179; Vollmer, 1913, p. 456; Voss, 1920, p. 409; Paris, Bibliothèque Nationale, 1954, p. 373 no. 252.

[20] *Self-Portrait*

Lost or unidentified
1620s
Fig. 101

Known today by way of the Jérôme David engraving (140 x 82 mm.) illustrated here, this Artemisia *Self-Portrait* was to all indications a candid and thoroughly unallegorized likeness. The bust-length figure is surrounded by a simple oval band inscribed "ARTEMISIA GENTILESCHI ROMANA FAMOSISSIMA PITTRICE ACCAD. Ne'Desiosi" and flanked at its base by the notations "Artem. Pinx." and "H. David F." Two scrolls, one lauding the artist and the other dedicating the print, act as visual supports to the image: "EN PICTVRAE MIRACVLVM / INVIDENDVM FACILIVS QVAM IMITANDVM" ("Behold, a marvel in the art of painting, more easily envied than imitated," as translated by Garrard) and "Al molto Ill.re et Ecc.me Sign.re Gioseppe Marini = H. David sculpt. DD."

The inscription "Artem. Pinx." notwithstanding, Levey considered that its source may have been a drawing rather than a painting. And Garrard, retreating from a former position, writes of the engraving that it is "allegedly, but not necessarily, after a self-portrait." I believe that David should be taken at his words, including those reading "H. David sculpt. DD," which must denote that he delineated the image before engraving it. Since there is not a single extant and only one recorded drawing by Artemisia, the probability that she rendered a *Self-Portrait* in pen or any other graphic medium is inherently slim. Moreover, the same David certainly confronted a canvas by Gentileschi to produce his portrait, designated "Artemisia Gent. P.," of Antoine de Ville

(Fig. 102). In contrast, however, to what I have argued with respect to the de Ville frontispiece, the engraved *Self-Portrait* may not reverse the original. Although the light proceeds from the right, a direction generally unexpected when a figure's glance is focused on the observer, the head and body are now comfortably oriented toward the left. Both of these features parallel Artemisia's *Female Martyr* (Fig. 56; Color Plate VI), itself most likely a self-portrait.

The available information intimates that the engraving was executed between 1623, when Jérôme David is first documented in Rome, and 1629, the probable year of Artemisia's departure for Naples. It may be possible to be more precise than this. The *Portrait of Antoine de Ville*, although published in 1628, claims to show the sitter as he appeared in 1627, the presumed date then of Artemisia's painted version. There may also be a connection, the result of friendship and mutual interests, between David's involvement with works by Gentileschi and the drawing of Artemisia's hand executed in Rome on the last day of December, 1625, by the Parisian artist Pierre Dumonstier (Fig. 98; Chapter 3).

Particularly intriguing is the notation "ACCAD. Ne'Desiosi" on the engraved portrait of Artemisia. Exploring this reference in the text, I have concluded that of the several institutions of this title which existed at the time, the little known Accademia dei Desiosi at Venice, with which Artemisia could have been associated during her stay in that city in 1627–28, is most likely to be the one in question. If so, David's print, as that of Antoine de Ville, may date to 1628, following Gentileschi's arrival back in Rome; David is not recorded as having visited Venice.

While Artemisia's Venetian trip may provide the *terminus post quem* for Jérôme David's *Portrait of Artemisia Gentileschi*, the painting upon which it was based need not have been absolutely contemporary. Indeed, Artemisia appears in the print to be younger than thirty to thirty-five years of age, the range established by the evidence presented above, and more youthful too than in the bronze portrait medallion to which the women in three of her paintings from the years around 1625 can be related (Figs. 84, 87, 99, 93, 94, 104; Color Plates XIII, XIV; again Chapter 3). I suspect that the painted *Self-Portrait* was created by Artemisia

not long after her return from Florence in 1620. But since it is notoriously difficult accurately to judge the ages of sitters from such representations, I cannot insist upon this hypothesis. Still, in 1701 a "ritratto grande al naturale di Artemisia gentileschi di sua mano" was in the Genoese collection of Francesco Maria Balbi ([L-92]), and it is possible that the commissioning of that *Self-Portrait* originated with the presence of Orazio Gentileschi in Genoa during the early 1620s.

A definitive dating of the print, if not of its painted model, may rest upon the identification of the "most illustrious and excellent Signor Giuseppe Marini" to whom David's engraving is dedicated. Garrard proposes that he "could be . . . the poet Giovanni Battista Marino, despite the differing first name, since both the image and the inscriptions are in the spirit of the word portraits of men and women in Marino's *Galeria*, written in 1620." It is not likely that David would have erred in recording his patron's first name.

BIBLIOGRAPHY: Le Blanc, 1856, pp. 99–100; Vollmer, 1913, p. 456; Voss, 1920, p. 409; Paris, Bibliothèque National, 1954, p. 366 no. 132; Levey, 1962; Garrard, 1980, p. 111 n. 67; Garrard, 1989, pp. 64, 503 n. 105; Hersey, 1993, p. 329.

...

[21] *Penitent Magdalen*

Naples, Private Collection?
Oil on canvas; no measurements recorded
Ca. 1627–1629
Fig. 111

COLLECTIONS: Barone Franco della Gulfa, from whose collection sold in Rome, 1985

Auctioned from the Palazzo Borghese at Rome on March 1, 1985, as the property of Barone Franco della Gulfa and said to have entered a Neapolitan collection, this haunting canvas is known to me only from the color photograph in the sale catalogue, where it is assigned to Artemisia Gentileschi on the authority of Maurizio Marini.

While the often deceptive nature of photographic evidence and the seeming lack of enthusiasm with which the appearance of the *Magdalen* was greeted give one pause, a substantial case for the attribution of the picture to Artemisia Gentileschi can be built. Its frame-

work is a *Penitent Magdalen* engraved by Claude Mellan (Fig. 109), inscribed at the lower left "Cl. Mellan Gall.' in. / pinx. et sculp. Romae." Dated ca. 1629 by Thullier and ca. 1629–30 by Barbara Brejon de Lavergnée—that is, to the middle of the French master's Roman stay (1624–36)—the print bears self-evident relationships to the ex-Barone della Gulfa *Magdalen* (see also below).

Yet Mellan's work is likewise strikingly reminiscent of Orazio Gentileschi's interpretations of the *Penitent Magdalen*, as Thullier and Brejon de Lavergnée have observed. The designation "pinx." on the engraving implies that it was preceded by a painting by Mellan himself, and Mellan is known to have produced canvases and prints of the same composition. Equally conceivable, however, as Brejon demonstrates, is that the "pinx." refers rather to a drawing, in this case that (*pierre noir* and sanguine, .152 x .202 m.) in the Musée Boucher de Perthes at Abbeville which, its composition reversed, is certainly preparatory to the engraving. Whatever the truth of this matter, it is the print that parallels Orazio's conception, and specifically Gentileschi's version of the *Penitent Magdalen* at London (Fig. 108). Among the features shared by the Mellan and the Orazio are the extended right arm, the hair over the right shoulder, the fall of drapery across the abdomen and left thigh and—unlike Gentileschi's later variants of the theme (Vienna, Kunsthistorisches Museum; New York, Richard Feigen)—strands of hair over the right arm and the oblique placement of the skull on the ground.

The issue is complicated by the fact that certain details are common *only* to the Mellan engraving and the painting here given to Artemisia: the head resting on the palm of the hand and turned so that both eyes are entirely visible; the garments defining the fullness of both legs and arching upward to caress the left breast; and the accumulation of drapery behind the legs. It is therefore obvious, first, that Mellan did not merely copy a known canvas by Orazio. Still, his figure is so close in some particulars to Orazio's idea as to suggest (as I did in 1981) that its source was a now-lost *Magdalen* executed in Rome by Gentileschi before his trip to Genoa in 1621. The interest of members of the French artistic community in the art of

both Gentileschi would therefore extend from Pierre Dumonstier (Fig. 98) and Jérôme David (Figs. 101–2) to Claude Mellan.

In my opinion, then, the prototype for Mellan's rendition was most likely a painting by Orazio Gentileschi, features of which he may have varied, rather than a canvas by Artemisia. Artemisia, in turn, may be supposed to have looked as well to her father's invention, not to Mellan's reflection of it. Orazio's picture, as still the London *Magdalen*, would have exhibited a powerful *chiaroscuro* that he abandoned in his subsequent versions. An Orazian source for Artemisia is further indicated by the presence in the ex-Barone della Gulfa *Magdalen* of details found in the London painting but not in Mellan's print: the opening to the sky, with ivy silhouetted against it; the rock support; the book; and the almost fully extended right leg. It can be hypothesized that the lost Orazio contained these features as well, although Artemisia might also have recalled the canvas now in London. Giovan Antonio Sauli of Genoa, for whom the latter was produced, was in Rome in early 1621, and might well have ordered the *Magdalen* at that time. If so, Artemisia, who in all likelihood did not accompany her father to Genoa as she is generally thought to have done (see Chapter 3), would have been familiar with it. Moreover, the limp right arm of her woman, which does not appear in any of the other *Magdalen*s discussed above, brings to mind the Lot of Orazio's *Lot and His Daughters*, as in the version for the same Sauli (Thyssen-Bornemisza Collection), and the Saint Joseph of his *Rest on the Flight into Egypt*, the first example of which (Birmingham, England, City Museum and Art Gallery) was possibly painted in 1616 at Florence, where Artemisia was then working.

In the realism of the Saint's face, however, Artemisia abjures Orazio's generalized type, while the facial expression recalls her earlier *Magdalen* (Fig. 70; Color Plate V) and the white undergarment at the figure's waist brings to mind the "sash" of the maid in the Pitti *Judith* (Fig. 31; Color Plate IV). Only the drapery on which the woman lies, being broadly rendered in regularized folds, strikes a somewhat unexpected note. Artemisia's authorship of the *Magdalen* then finds final affirmation in the conspicuous similarities between this picture,

the *Magdalen* at Seville (Fig. 97; Color Plate XI), here identified as the canvas of this subject by Gentileschi purchased in Rome in 1625 or 1626 by the Duke of Alcalá, and the *Cleopatra* once in London (Fig. 110; Color Plate XV) and universally attributed to her.

If the thrust of the foregoing is valid, the *Penitent Magdalen* must be considered to have issued from Artemisia Gentileschi's brush in Rome and thus prior to her departure for Naples sometime in 1629. A dating specifically to ca. 1627–29 is consistent with the painting's position vis-à-vis Artemisia's *Venus and Cupid* at Princeton, here placed on independent evidence to about 1625–27 (Fig. 104; Color Plate XIV; [18]). Although these pictures are linked in type, darkling mood, composition, color, lighting, and aggressive verisimilitude, the canon of the Saint's body is more slender, in a new direction that also characterizes the *Cleopatra*. Can the *Cleopatra*, assigned by other scholars to Gentileschi's Neapolitan period, be dated as well toward the end of the 1620s? The next catalogue entry proposes that it can.

BIBLIOGRAPHY: Rome, Palazzo Borghese, *Vendita all'asta delle raccolte del Barone Franco della Gulfa*, February–March 1985, cat. 986.

For the comparative material: J. Thullier, "Poussin et ses premiers compagnons français a Rome," *Nicolas Poussin*, CNRS, Paris, 1960, 1, p. 86 ff., esp. p. 92 and fig. 58; B. Brejon de Lavergnée, "La sainte Madeleine pénitente de Claude Mellan," *Revue du Louvre*, XXIX, nos. 5–6, 1979, 407–10; Bissell, 1981, pp. 167–68 [38], 173–75 [45–47], and figs. 85, 96–98, 103; B. Brejon de Lavergnée and L. Ficacci in Ficacci et al., 1989, pp. 254–58 cat. 64–65.

..

[22] *Cleopatra*

Formerly London, Matthiesen Fine Art Limited
Oil on canvas, 1.17 x 1.755 m.
Ca. 1627–1629
Fig. 110; Color Plate XV

Although the blue of Cleopatra's drapery has undergone chemical change, the flesh has lost its final glazes, and darkening of the background shadows has lessened the illusion of spatial depth, the painting appears on balance to be satisfactorily preserved.

Another recent discovery, its history unknown or confidential, the *Cleopatra* was pub-

lished in 1984 by Gregori who, rejecting the attribution to Massimo Stanzione which it reportedly bore, assigned the canvas to Artemisia Gentileschi. Artemisia's authorship, affirmed as well by Józef Grabski, Mary Garrard, Patrick Matthiesen, Erich Schleier, Nicola Spinosa, Ferdinando Bologna, Raffaello Causa, and Roberto Contini, now finds additional support from the *Penitent Magdalen* here introduced into the Gentileschi literature (Fig. 111). Comparable in pose, color, and lighting, these two paintings may have been developed from the same model.

The *Magdalen* was inspired by a now lost, Roman-period canvas of the theme by Orazio Gentileschi, or so I have contended on the evidence of Artemisia's picture and of an engraving produced in Rome by Claude Mellan about 1629–30 (Fig. 109). To this principal source Artemisia apparently added remembrances of another Orazio *Magdalen*, specifically of the London type (Fig. 108), appropriating the rock support, the book, the fully extended right leg, and elements of the landscape. While unaware of Artemisia's penitent saint, Matthiesen, Grabski, Gregori, Garrard, and Contini have connected the *Cleopatra* precisely to Orazio's known *Magdalen*s, the last three scholars introducing as well Mellan's print. If, as is entirely possible (see [21]), the London version issued from Orazio's Roman studio in 1621, it would have been familiar to Artemisia and could have served her in the *Cleopatra* (contrast her *Magdalen* in these respects) for the motif of the head resting on the *back* of the hand and for the total exposure of the left arm and the left side of the torso. Potentially relevant also is Orazio's *Danaë* (Fig. 107), it too of ca. 1621, wherein an attendant opens a background curtain.

Published opinions consider the *Cleopatra* to be a work of Artemisia's Neapolitan period: Matthiesen and Stolzenwald (ca. 1630); Grabski (ca. 1630–35); Contini (probably 1630s); Gregori (1630s or later); Hagen (ca. 1640). Garrard entertained the notion that it was produced at Rome in the late 1620s before opting tentatively for a date in the early 1630s. Garrard's initial inclination is likely to be correct, a point worth arguing in view of the different implications that the painting would have had for Roman and Neapolitan artists and

of additional impressions which Gentileschi is supposed to have absorbed in Naples. The proposals advanced with regard to the latter are many, sometimes contradictory, and debatable: that the drapery style may owe something to Van Dyck, an artist increasingly touted as having been a force for change in Neapolitan art; that the "crudezza realistica" (Gregori, seconded by Matthiesen) of the *Cleopatra* reveals a confrontation with the art of Ribera while, at the same time, the "softened and sweetened light and colouring" (Matthiesen) are attributable to the influence of Vouet and Stanzione; that Caravaggio's *Penitent Magdalen*, copied by Finson and others and well known in Naples, stands behind the expression and lighting of Artemisia's picture; that the maidservants are Neapolitan in character; that the still-life recalls Giacomo Recco's flower pieces; and that the shadowy raised curtain brings to mind Cavallino and the Master of the Annunciation to the Shepherds.

Counter to this position—that is, in defense of a pre-Naples dating for the *Cleopatra*—I submit, first, that its relationships to the aforementioned paintings by Orazio, at least one of which (the now-lost *Magdalen)* was still in Rome, are decisive. Furthermore, while the subject and eroticism of Artemisia's canvas are certainly not impossible for Naples, they are inherently more appropriate for a Roman or Venetian clientele. And although the type of the reclining nude need not have been determined by Artemisia's exposure in the years 1627–28 to Venetian painting on its own ground (witness the *Cupid and Psyche* by Gentileschi cited in 1624 in the Patrizi Collection at Rome [L-17]), among the four works by Artemisia recorded in connection with her appearance in Venice, three contained female nudes—*Hercules and Omphale* [L-40], *Susanna* [L-105] and, most relevant in this context, a *Lucretia* [L-54], itself a depiction of suicide by a female from ancient history. In addition, the back-and-forth slashes of impasto on the bedcover are arguably Titianesque.

Conversely, the presumed Neapolitan ties are tenuous. Thus, Matthiesen explicitly denies any connection to Van Dyck. Ribera's name need not be invoked for an artist whose training and inclinations were toward realism, and it is Orazio's *Magdalen* (in its lighting and in the position of the foreshortened head, with the right eye only partially revealed), not Artemisia's *Cleopatra*, that most closely parallels Caravaggio's conception. The foremost maidservant in Artemisia's canvas, while of a type that does indeed appear in some of her Neapolitan pictures (e.g., Figs. 139, 159), is most strikingly similar, in reverse, to the Jael of Gentileschi's *Jael and Sisera* of 1620 (Figs. 72–73). The still-life is too undistinguished to warrant comparative stylistic analysis, and the use of a background curtain not only recalls Orazio's *Danaë* but was a device favored by Artemisia from ca. 1611 onward.

It is not, therefore, as has been maintained, to Artemisia's *Esther* (Fig. 125; Color Plate XVI) or to her paintings for Pozzuoli (Figs. 146–49; Color Plate XXI) that the *Cleopatra* can most profitably be likened. More germane, rather, are the newly discovered *Penitent Magdalen*s in Naples (?) and Seville (Figs. 111, 97; Color Plate XI) and, as Grabski has demonstrated convincingly, the *Venus and Cupid* in Princeton (Fig. 104; Color Plate XIV), which Grabski and I have assigned to the later 1620s but which by virtue of the less idealized body canon must predate the *Cleopatra*.

BIBLIOGRAPHY: M. Gregori in *Civiltà del seicento*, 1984, I, p. 306; Grabski, 1985, pp. 56–63; London, Matthiesen, 1986, pp. 49–52 cat. 5; Hagen, 1988, p. 84; Garrard, 1989, pp. 105–6, 108, 274–76, and color pl. 17; Contini in Contini/Papi, 1991, pp. 70, 73 fig. 59, 85 nn. 30–31; Stolzenwald, 1991, pp. 41, 52–53 (fig. 38 in color).

. .

[23] *Child Sleeping near a Skull (Memento Mori)*

Lost or unidentified
Probably small-scale, possibly on copper
Ca. 1629–1630?
Figs. 112–13

Although the fate of Artemisia's painting is unknown, its composition and something of its quality are recorded in three prints:

1. Pieter de Jode II (Antwerp 1606–England? 1674), engraving, 157 x 222 mm. (exclusive of the legend), Stedelijk Prentenkabinet, Museum Plantin-Moretus, Antwerp, Inv. II/J.298. Inscribed below "*Artemisia Gentilesca*

pinxit Napoli" and "*Petrus de Iode Iunior fecit*" beneath the lines "*Stulte quid est somnus gelidae nisi mortis imago? / Longa quiescendi tempora fata dabunt.*"

2. Jean Ganière (ca. 1615–d. Paris, 1666), engraving, 157 x 220 mm. (exclusive of the legend), Cabinet des Estampes, Bibliothèque National, Paris. Inscribed below "*Artemisa Iantillessa inuentrisse,*" "*Aug. Quesnel excud rue Betizi au Chesne d'Or. 1640. Auec Priuilege du Roy,*" and "*Ganiere fecit*" beneath the verse "*Aprenez o Mortels / Que cet Enfent qui dort / Montre que sommes tels / Et freres de la mort.*" The impression of the print in the Print Room of the British Museum at London (157 x 222 mm.; V 10–73 under Italian Masters C 59) has been squared off (see below).

3. John Oliver (London 1616–London 1701), engraving, described by Le Blanc as "*Un Enfant endormi; près de lui, une tête de mort: Art. Gentilescha. In-4. Très rare.*"

Of the two prints which have been located, that by Jean Ganière, with the head of the child at the right, probably respects the positioning of Artemisia's figure, being illuminated from the left and without the tension between the dramatic core and the natural shifting of the eye rightward that marks de Jode's reversed image. The supposed orientation of Artemisia's original would therefore have been consistent with that of Caravaggio's *Sleeping Cupid* in the Palazzo Pitti and of the majority of Caravaggesque pictures based upon that now famous example, including works by or attributed to Caracciolo, Orazio Gentileschi, Orazio Riminaldi, Cecco del Caravaggio, and Pietro Paolini. Most tellingly, among these variations upon Caravaggio's conception Artemisia's *Child Sleeping near a Skull*, with the infant's left arm stretched at his side and his right hand resting on his abdomen, is the most faithful, and may be taken as having been inspired by the Lombard's work as known to Gentileschi from her years in Florence.

There is no conclusive proof, however, that Ganière directly confronted Artemisia's painting, and it is impossible to assign absolute priority to one or the other engravings. The Ganière example in London is squared off, as if for transfer to another plate (but conceivably as a guide for a picture). On the other hand,

there is no inherent reason why de Jode's print might not have taken precedence, reversing the original as is so often the case; with Ganière's engraving—of exactly the same size and extraordinarily similar in detail—being based upon the de Jode, and the Oliver (or another work) copied in turn from the Ganière version.

This latter explanation requires that de Jode must have had access to Gentileschi's picture, and Ganière access to de Jode's print. From the inscription on the Ganière engraving, which places its publication in France, and from the scarce details of de Jode's biography, which locate him in Paris in 1631–32, the conjunction of the artists would seem to have taken place in Paris. While, as de Jode records, Artemisia's original was created in Naples, neither de Jode nor Ganière is known to have visited Italy. The Flemish printmaker could have learned in Paris of the Neapolitan provenance of the picture which he now had permission to engrave. Highly suggestive in this regard is the letter of October 9, 1635 (see Appendix I), from Artemisia in Naples to Galileo in Arcetri in which the artist claims that she had received favors from the King of France. From the whole of Artemisia's production, only the *Child Sleeping* or "La S. Familie avec Zacharie et S. Elisabeth," also by de Jode after Gentileschi (see [L-42]), may reasonably be proposed as the commission (or, more likely, gift) in question.

If this letter and the *Memento Mori* are indeed to be connected, the date of execution of the picture would have to be set several years prior to the 1640 publication date of Ganière's engraving. This is indicated as well by de Jode's known presence at Paris in 1631–32, by Henkel's characterization of his print as an early work in the manner of Pieter de Jode the Elder, and by the apparent style of Gentileschi's work. Strongly Caravaggesque in lighting, it also evokes the *Venus and Cupid* (Fig. 104), here dated ca. 1625–27, with which it shares elements of pose (cf. Venus) and physiognomy (cf. Cupid). Although unfamiliar with the *Child Sleeping*, Garrard proposed that the Princeton canvas had looked to Caravaggio's *Sleeping Cupid*. And to 1627 dates a verse to a sleeping *Amoretto/Amore* (implying a winged Cupid; [L-1]) by Gentileschi in Venice.

In all, this admittedly incomplete evidence

suggests that the *Child Sleeping* was painted by Artemisia about 1629–30 during her very first years in Naples and shipped to France, where it was engraved by Pieter de Jode II in 1631/32 and where it came to the attention of Jean Ganière, either directly or by way of de Jode's print.

What became of the picture, about which the French sources are silent? On March 15, 1715, "Un Bambino, misura 2 e 1½, cornice intagliata dorata, mano d'Artemisia Gentilescha" was inventoried in the Casa Antinori of Giacomo Capece Zurlo at Naples (see [L-13]). Did this represent the Christ Child, as might be implied by the capitalization of "Bambino," or was it a version of the *Memento Mori*? More intriguing is the *Child Sleeping*, painted on copper and measuring 9 diti by 5 diti, attributed to Artemisia in inventories of the Orsini Collection at Rome in 1698 and 1722/23 (see [L-11]). The engravings accurately reflect this small painting, described as "un puttino, che dorme posano il Capo nel coscino rosso, ed un panno bianco, che lo cinge di sopra per traverso. . . ." Whether the work by Gentileschi here hypothesized as having been sent from Naples to France had made its way back to Italy by the end of the seventeenth century, or whether the Orsini copper was another example executed by Gentileschi in Rome or directly for the Orsini of Naples, cannot as yet be determined.

A possible elaboration of this composition painted by Artemisia and, almost certainly, a collaborator specializing in still-life is called up by a *Child Reclining, Encircled by Flowers* inventoried in 1716 in the Neapolitan collection of Domenico Perrino ([L-12]). It too apparently served as a *memento mori*.

BIBLIOGRAPHY: G. K. Nagler, *Neues allgemeines Künstler-Lexikon*, Munich, 1841, X, pp. 338–39; Le Blanc, II, 1856, p. 267 no. 14, and III, 1858, p. 116 no. 6; L. Burchard in Thieme/Becker, *Allgemeines Lexikon*, Leipzig, 1920, XIII, p. 160; Voss, 1925, p. 460; M. Henkel in Thieme/Becker, *Allgemeines Lexikon*, Leipzig, 1926, XIX, pp. 33–34; Hollstein, n.d., IX, pp. 210 and 212 no. 32; E. Bénézit, *Dictionnaire critique et documentaire des peintres, sculpteurs, dessinateurs et graveurs*, ed. Paris, 1976, III, p. 8; C. Joubert in Caen, Musée des Beaux-Arts, *Images de la destinée: graveurs des XVI et XVII siècles*, exh. cat., 1991, p. 62 cat. 69, with ill. And the Bibliography under [L-11] and [L-13].

[24] *Annunciation*

Naples, Museo di Capodimonte
Oil on canvas, 2.57 x 1.79 m.
1630
Fig. 114

Signed and dated on a trompe l'oeil piece of paper, lower right, ÆRTEMISIÆ GENTILESCHA / F. 1630

COLLECTIONS: Cavaliere Francesco Saverio di Rovette, Naples, by whom sold in 1815

Severe crackle and some cupping, as well as pigment loss and flaking (most gravely along the edges of the canvas), call for prompt conservation measures. Contrary to what I once hoped, the cherub heads are likely to be part of the original conception. Although obtrusive and unparalleled in Gentileschi's oeuvre, they are integral to the *craquelure* pattern, and a fourth cherubim, overpainted in all probability by Artemisia herself, can dimly be discerned as a dark patch between the angel's raised hand and Mary's head. Further, Gentileschi's pattern for the Heavenly apparition was adapted by Paolo Finoglio for his *Annunciation* now in the Szépmüvészeti Múzeum at Budapest.

Opulently dressed in a golden gown over white sleeves and sporting a red scarf, Gabriel kneels before a platform on which the Virgin, in a red dress and a mantle that varies in color from dark blue in the obscuring shadows to steel gray in the light, has risen from a cushioned prayer desk.

This large *Annunciation*, the earliest securely datable work of Gentileschi's Neapolitan period, is also the first among her extant canvases that beyond question could have served as an altarpiece. Unfortunately, its history prior to its acquisition on January 9, 1815, from Cavaliere Francesco Saverio di Rovette for 100 ducats is not documented. Many of the pictures added to the Royal Gallery in 1815 had previously been seized from monasteries and churches in Naples, and that coincidence prompted me to identify the *Annunciation* as the unnamed painting by Artemisia that, pursuant to an order of February 26, 1811 (published by Strazzullo), was to be removed from San Giorgio de'Genovesi. This proposal, recently revived by Garrard, Contini, and Stolzenwald, was misguided. The altarpiece then and now in San Giorgio is in fact the Genoese master Domen-

ico Fiasella's *Crucifixion with the Madonna, Saint John, and the Magdalen*, which figured in Neapolitan guidebooks (e.g., Catalani, 1853) with an erroneous attribution to Artemisia Gentileschi and regarding which Bernardo De Dominici wove a tale of collaboration between Artemisia and Guido Reni! Thus the original location of the *Annunciation*, ecclesiastical or otherwise, remains unknown.

The distinction of Artemisia's canvas as having inaugurated a new direction in her art is discussed in the text. Here I must disown still another observation of mine that has been taken up in the literature, namely that the composition of the *Annunciation* is a variation in reverse upon Orazio Gentileschi's altarpiece of ca. 1622 in San Siro at Genoa. The relationships are undeniable, and when it seemed probable that Artemisia had also visited Genoa in 1621–22, the influence of her father's picture could be presumed. However, a Genoese trip by Artemisia is no longer demonstrable (see Chapter 3). And since the composition and gestures of the Naples *Annunciation* are altogether traditional, it can as well be argued that Artemisia was recalling those *Annunciations* which may have inspired Orazio, among them Donatello's tabernacle in Santa Croce and pictures by Alesso Baldovinetti (Uffizi) and Santi di Tito (Santa Maria Novella; 1602). Indeed it is probable (see *Esther Before Ahasuerus* [28], *Cleopatra* [29], and Chapter 4) that Artemisia had revisited Florence in 1627 and/or 1628/29, and that this recent exposure to Tuscan art helps explain the particular decorative richness of her *Annunciation*.

BIBLIOGRAPHY: A. Filangieri di Candida, "La Galleria Nazionale di Napoli," *Le gallerie nazionali italiane*, Rome, 1902, v, p. 243; Voss, 1925, p. 463; Rinaldis, 1928, p. 112 no. 375; Longhi, *Scritti*, I–I, 1961, p. 259; M. Gregori in Naples, *Civiltà del seicento*, 1984, I, p. 147; Garrard, 1989, pp. 91–92, 510 n. 156; Contini in Contini/Papi, 1991, pp. 65–66, 84 n. 2; Stolzenwald, 1991, p. 39.

For Fiasella's *Crucifixion*: Dominici, ed. 1844, III, pp. 82–83; L. Catalani, *Le chiese di Napoli*, Naples, 1853, II, pp. 141–42; F. Strazzullo, "Un progetto di Marat per una galleria di pittori napoletani," *Napoli nobilissima*, II, fasc. I (1962), 31; F. Bologna in V. Pacelli and F. Bologna, "Caravaggio, 1610: la 'Sant'-Orsola confitta dal Tiranno' per Marcantonio Doria," *Prospettiva*, no. 23 (1980), 38–40, 42 fig. 15.

And for Finoglio's *Annunciation:* E. Nyerges in Milan, Palazzo della Permanente, 1993, pp. 86–88 cat. 20.

..

[25] *Self-Portrait*

Rome, Galleria Nazionale, Palazzo Barberini
Oil on canvas, .93 x .745 m.
1630?
Fig. 119

COLLECTIONS: Acquired in 1935 (from the Barberini Collection?)

Stripped of their surfaces through abrasion and/or savage cleaning, the flesh areas and the whites reached a state of irreversible deterioration, and sections of the background were reduced virtually to the preparatory ground. Wisely, L. de Lama's restoration of 1957–58 and (apparently) a more recent one made no attempt to disguise these conditions.

The rich iconography of this canvas is explored in the text, where it is noted that some of the attributes are those of the Personification of Painting, *La Pittura*, while the laurel wreath relates to the honored concept of *ut pictura poesis*. Yet since the artist, dressed in contemporary costume, speaks as well of the craft of painting, the picture is not concerned solely with the aloof realm of ideas. Further, the portrait on the easel advertises that one of the artist's callings was that of portraitist, even as it continues the tradition of the "Friendship Picture," wherein the portrait within a self-portrait is of an individual who on one or more levels held special meaning to the painter.

While scholars agree that the picture is a true portrait of a woman painter, her strongly individualized features and particularized costume being inconsistent with a generic allegorical representation (contrast G. D. Cerrini's *Allegory of Painting* in the Pinacoteca at Bologna), there has been no unanimity regarding other aspects of the work. Are we in the presence of Artemisia Gentileschi? Did the painting come from her brush, as a self-portrait, or is it her likeness by another hand? Nolfo di Carpegna, Ortolani et al., Whitfield, Contini, and Papi recognize Artemisia's visage, and Greer and Garrard are inclined to do the same. Surely this woman, with her loosely hanging hair (barely visible now against the darkened ground), high forehead, rather puffy eyebrows,

pinched mouth, double chin, and earring, resembles Gentileschi as she appears in Jérôme David's engraving of ca. 1628, based (I believe) on an earlier self-portrait, and in the portrait medallion of Artemisia probably struck in the later 1620s (Figs. 101, 99). Especially telling is a comparison between the artist in the Palazzo Barberini canvas and the fashionable female painted in fresco by Orazio Gentileschi in 1611–12 (Fig. 100). First identified as Artemisia by Levey on the basis of David's print, the Casino of the Muses portrait shows a more mature Artemisia than her actual eighteen or nineteen years, the result of artistic license or of a conscious decision by Orazio to portray his daughter as her mother (who died on December 26, 1605, at the age of thirty) may have looked.

The issue as to whether this is a self-portrait has proved to be more complex. Paolucci denies Gentileschi's authorship of the picture, assigning it rather to a minor Neapolitan working in the manner of Pacecco de Rosa. Garrard rejects the attribution on both interpretive and esthetic grounds, while Greer believes that the presence of the laurel crown most probably excludes a self-portrait. Further, Garrard, by analogy to G. D. Cerrini's picture in which *Pittura* presents a portrait of Cerrini himself, suggests that "the face on the easel should represent the artist who painted the picture. . . ." And Greer, although not prepared summarily to dismiss Artemisia's authorship, considers it "*a priori* more likely that this is a flattering portrait of Artemisia by someone else, perhaps Romanelli, whose portrait of Artemisia was attacked by his wife. . . ." (For the Romanelli story and its irrelevance to Gentileschi, see Chapter 6.) Moir equivocates, stating that the painting "is probably Artemisia's work but not certainly a self-portrait," essentially the position of Nolfo di Carpegna. For Ortolani et al., Whitfield, Contini, and Papi, on the other hand, the canvas is a self-portrait by Artemisia Gentileschi.

I am convinced by this latter view (which I first affirmed less securely in 1968). Artemisia, in her desire to extol herself and her profession, certainly would not have been proscribed from conjoining reality and a light touch of allegory. And while the poor state of preservation for the most part renders impossible subtle compara-tive analysis, the golden-yellow drapery over the figure's left arm, which has miraculously survived the maltreatment of the canvas, might be taken as a Gentileschi autograph. In particular, it can be related in both color and handling to the gowns of Gabriel in Artemisia's *Annunciation* and Esther in the *Esther Before Ahasuerus* (Figs. 114, 125; Color Plate XVI), with which pictures the Roman work shares an especially opulent display of diverse materials. The aforementioned tradition of the *Freundschaftsbild* proves that the portrait on the easel need not be that of the artist himself. Whitfield's tentative identification of this man as Poussin suggested a link between the canvas and Artemisia's dealings with Cassiano dal Pozzo (see below). Unfortunately, the features here bear but superficial resemblance to the French master's face with its broad nose and thin, taut lower lip. And the physiognomy is neither that of Cassiano himself, as known from Pietro Anichini's engraving, nor—as tentatively proposed by Contini—that of the bushy-haired Diego Velázquez.

The stylistic affinities between the *Self-Portrait* and the signed and dated *Annunciation* of 1630 intimate that the former was also executed at the beginning of the fourth decade. The apparent age at which Artemisia has recorded herself is not incompatible with this date, and the presence of allegory is consistent with the *Clio, Muse of History* of 1632 and the *Minerva* of ca. 1635 (Figs. 121, 156; Color Plate XVIII). And while the open-weave canvas type helps locate the painting in Naples, the mode of garb recalls—as Contini has observed—various pictures by Simon Vouet which Artemisia would have seen while still in Rome. Three letters written by Gentileschi from Naples to Cassiano dal Pozzo at Rome are therefore most suggestive. In the first, dated August 24, 1630, the artist informs the Commendatore that she had received from him the measurements for a picture to which she would turn upon completing some paintings for the Empress ("Ho visto la misura che V. S. illustrissima mi ha fatto grazia mandarmi; e l'averei servita subito, se non mi occorresse fare alcuni quadri per la Imperatrice . . ."). A week later, on August 31 (Fig. 118), Artemisia identifies the canvas ordered by Cassiano as a portrait ("il ritratto, finiti che haverò alcuni quadri per la Im-

peratrice la servirò . . ."), and on December 21 as a self-portrait ("l'imagine dell'autrice"). This she promises to dispatch to Rome with the next courier ("Per servire V. S. ho usato ogni diligenza in farle il mio ritratto, il quale l'invierò con il seguente procaccio").

What became of this painting for Cassiano? In a letter to him on October 24, 1637, Gentileschi speaks of "my portrait . . . in conformity with that which you once requested, to be numbered among [your other portraits of] illustrious painters (*mio ritratto . . . conforme ella una volta mi comandò, per annoverarlo fra'pittori illustri*)." Taken at face value, this statement would seem to imply that Artemisia had never shipped the *Self-Portrait* mentioned in 1630. Levey and Garrard have pointed out that no such picture is recorded in Gabriel Naudé's *Epigrammatum* written in 1641 (published in 1650) and devoted to forty-two of Cassiano's portraits, nor in the accounts of the dal Pozzo Collection offered by deCotte (ca. 1689) and Giuseppe Ghezzi (1715). Neither, one can add, does it figure in the postmortem inventories of Carlo Antonio dal Pozzo and Gabriele dal Pozzo of 1689 and 1695, respectively (published by D. Sparti, "The dal Pozzo Collection Again: The 1689 and 1695 Inventories and the Family Archive," *Burlington Magazine*, CXXXII [1990], 560–69), nor in any of the other registers brought together by Sparti in her monograph of 1992. It is, however, a curious fact (and one not yet explored in the Gentileschi literature) that in the "Inventario de Quadri, Mobili lasciato dal Signore Commendatore Cosimo Antonio dal Pozzo appresso, et in Casa della Marchesa Anna Theresa Ginnetti Lancellotti sua Madre, del mese di Aprile 1729 fatto detto Inventario" there is listed "Un Quadro in tela di palmi quattro Ritratto di Artemisia Gentileschi pittrice, cornice color di noce, et oro di Vouet." Measuring as it did .894 m., this work was essentially the same size as the present canvas, and the temptation is to suppose that the compiler of the inventory of 1729 mistakenly although understandably (see above) assigned the portrait to Simon Vouet's hand rather than to Artemisia's own. Nonetheless, there is no concrete support for this supposition, and in view of the many artistic relationships between Gentileschi and Vouet noted in these pages, it is wholly conceivable that the French master

portrayed Artemisia prior to his departure from Rome in mid-1627—or, for that matter, that the woman painter depicted in the canvas cited in 1729 was actually Vouet's wife, Virginia da Vezzo, and even that the picture was by her hand.

The following alternative is thus proposed as being the more reasonable: Artemisia, who had sought and received favors from Cassiano, had implied in her note of December 21, 1630, that the *Self-Portrait* was ready for shipping, and to have reneged on her pledge at this point would have been a serious violation of trust. Furthermore, she continued to call upon her Roman patron's generosity and well-placed position. It is therefore likely that the *Self-Portrait* arrived in Rome more or less on schedule, but that by late 1637 had been presented by Cassiano to another collector who had admired the painting for its artfulness and its subject. The logical recipient of this presumed gift would have been a member of the Barberini family. (The present canvas was acquired by the State in 1935, the same year in which some Barberini pictures were sold by the Galleria l'Antonina in Rome.) Cassiano was Secretary to Cardinal Francesco, to whom and to Cardinal Antonio Gentileschi proposed to offer by way of Cassiano two religious paintings (correspondence of October 24 and November 24, 1637), having previously sought the Commendatore's assistance in arranging the presentation to Cardinal Antonio of another canvas (letter of January 21, 1635). My hypothetical reconstruction of the events along the above lines has recently found favor with Contini. Thus the *Self-Portrait* "conforme ella una volta mi comandò" contemplated in the fall of 1637 may have been conceived as a replacement.

Nothing indicates that a second version ever reached Rome. And the next known letter from Artemisia, one to Francesco d'Este, was written on December 16, 1639, from London, where Gentileschi seems to have arrived sometime in 1638 (Chapter 4). Among the paintings by her in the English Royal Collection were, precisely, a *Self-Portrait* ("Arthemesia gentilisco. done by her selfe") and an *Allegory of Painting* ("A Pintura A painteinge"). Was the former initially intended for Cassiano dal Pozzo? And what of Artemisia's canvas at Kensington Palace (Fig. 175; Color Plate XXVII), a consideration of

which is conspicuously absent from the above discussion? I will argue [42] that this famous image is to be identified as the "Pintura A painteinge" and dated to Artemisia's English period, and thus does not figure in the Artemisia-Cassiano story, and that the *Self-Portrait* of 1637 for dal Pozzo may have been brought by Gentileschi to London.

BIBLIOGRAPHY: Bottari/Ticozzi, 1822, I, pp. 348–54 letters CXXXVII–CXLII; Ortolani et al., 1938, p. 318; N. di Carpegna, *Pittori napoletani del '600 e del '700*, Rome, 1958, p. 18 cat. 16 and fig. 7; Zurich, Helmhaus, 1958, p. 12 no. 23; Moir, 1967, I, p. 100 n. 104, and II, fig. 162; Paolucci, 1967, p. 78; Bissell, 1968, p. 162; Greer, 1979, p. 199; Garrard, 1980, pp. 111–12 with notes; C. Whitfield in London, Royal Academy, 1982, p. 167; Garrard, 1989, pp. 86–87, 346, 351, 353, 508–9 n. 140; Contini in Contini/Papi, 1991, pp. 66, 172–75 cat. 26, with two color pls.; Papi, ibid., p. 109; D. Sparti, *Le collezioni dal Pozzo: storia di una famiglia e del suo museo nella Roma seicentesca*, Modena, 1992, p. 238.

..

[26] *Portrait of a Noblewoman*

Princeton, New Jersey, The Barbara Piasecka Johnson Collection Foundation
Oil on canvas, 1.283 x .959 m.
Early 1630s?
Fig. 120

COLLECTIONS: Sir Foster Cunliffe, Action Hall, England; Sotheby and Co., London, February 1, 1950, lot 135; Richard Wolheim, London; Trafalgar Galleries, London, 1983

Sold some forty-five years ago as a work by Justus Sustermans, the canvas reappeared in 1983 with the attribution to Artemisia Gentileschi first proposed by Voss and supported by Zeri, Spinosa, R. Causa, and others. "One gets the feeling that this is what formal portraits of women by Artemisia Gentileschi should look like," I have written, and such is my sense today. Garrard has expressed reservations, while for Papi the picture has "buone possibilità" and "molte chances [*sic*]" of being by Gentileschi. Notwithstanding the beauty of the color (described in the text) and the consummate craftsmanship, Artemisia's authorship of the *Portrait of a Noblewoman* is not demonstrable beyond question, and what follows here does not pretend to deny this fact.

One is reminded, first, of the tradition of sumptuous aristocratic portraits epitomized in Italy by Sustermans, favorite of the court at Florence (cf. *Portrait of Maria Maddalena of Austria and Her Son Ferdinando II*, Florence, Uffizi), and the Bolognese master Lavinia Fontana (cf. *Portrait of Costanza Alidosi* from the Palazzo Isolani at Bologna). At the same time, as discussed in the text, in the Princeton painting the formality of such portraits is relaxed. The handling of the golden stomacher and sleeves is also distinctive, the material shimmering with impasto passages and a rich range of lights and transparent shadows. Artemisia Gentileschi, the creator of the *Portrait of a Condottiere* (Fig. 82; Color Plate IX) of 1622 with its extraordinary optical truth, was capable of such effects, even if, as Garrard has observed, there is no truly comparable tour de force of meticulousness (see the buttons and brocades) among her universally accepted canvases. Whether or not Gentileschi would have opted personally for such treatment, it may be imagined that the requirements of the commission would have moved her in that direction.

The visual evidence for Artemisia's activity as a portraitist is disappointingly slim (Figs. 82, 101, 102, 119). Conversely, literary references attest to more than an occasional foray into this genre throughout her career:

1. Letter from Gentileschi in Naples to Cassiano dal Pozzo in Rome, December 21, 1630, referring to a portrait of a duchess that she had just completed ([L-64]).

2. Filippo Baldinucci: "Artemisia aveva imparata l'arte del padre, si diede prima a far ritratti de'quali fece moltissimi in Roma." See the *Portrait of the Cleric Artigenio*, 1611 ([L-63]).

3. Alessandro da Morrona, following Baldinucci: "Ma il valor nell'Arte della nostra Artemisia rintracciando sappiamo, che primo studio di essa (quasi comune alle altre femmine Pittrici) fu il ritrar l'effigie di varj Signori dell'età sua, e che fu in tal genere eccellente."

4. Gianfrancesco Loredan, most likely (see [L-1])), verses published in Venice, 1627: "Le chiede un ritratto della Sua donna" and "Per la medesima."

5. Bernardo de Dominici: "Fu grande il grido, che si sparse per la città [Naples] delle di lei opere di pittura, e specialmente de'ritratti di

gran personaggi ch'eccellentemente ella avea dipinti. . . ."

6. Joachim von Sandrart: "Sie hat auch überaus gute Contrafäte verfärtiget. . . ." See also below.

7. Horace Walpole: "Artemisia Gentileschi was also in England, was reckoned not inferior to her father in history, and excelled him in portraits. She drew some of the royal family and many of the nobility." Walpole was then echoed by Pilkington: "She was the daughter and disciple of Orazio Gentileschi, and proved far superior to him in portrait painting. . . . She had the honour to paint the portraits of some of the Royal family at London, and a great number of persons of first rank."

8. Pietro Michele, in a disrespectful epitaph, 1653: "Col dipinger la faccia a questo, e a quello / Nel mondo m'acquistai merito infinito. . . ."

While Garrard is justified—see Morrona's comment—in suspecting that Artemisia's "reputation as a portrait artist may have been enhanced by a stereotyped coupling of women artists and portraiture," the testimony of her works and words and that of written accounts should not be minimized.

Attempts have been made to identify the woman and to set her mode of dress within a specific locale and span of years. Thus Voss, noting the fleurs-de-lis on the turned cuffs, suggested that the sitter might be a member of the Farnese family. Of this the Trafalgar catalogue writes: "The fleur-de-lys adopted by the Farnesi is however somewhat different in shape from the one depicted here, which also differs from that usually adopted respectively by the Medici and Bourbon families. Sir Colin Cole, Garter King of Arms, has suggested that this motif may perhaps not be heraldic at all, but may merely be a favoured device of the lady's costume-maker, or indicative of her Christian name which could have been Mary. (A lily has been from antiquity the symbol of purity and, as such, is an attribute of Mary.)" With these musings and Artemisia Gentileschi's spheres of patronage or potential patronage in mind, I considered a number of possibilities, among them: Maria Maddalena of Austria, wife of Cosimo II of Tuscany, or their daughter Margherita; Maria Farnese, Duchess of Modena,

wife of Francesco d'Este; Isabella, Queen of Spain, daughter of Marie de'Medici; and Maria of Austria, wife of the Holy Roman Emperor Ferdinand II, who arrived in Naples on August 8, 1630, and for whom (the "Empress") by August 24 Artemisia was executing "some works" (see [L-100]). However, the woman in the London canvas simply does not resemble these prominent persons as they are known from existing portraits. One might expect that Gentileschi would have been called upon by the wives of the Spanish Viceroys to Naples. Indeed Sandrart, who visited Artemisia in the latter months of 1631, claims that "dannenhero sie auch nicht bey des Vice Re Gemahlin, sondern allen andern Prinzessinnen wehrt gehalten und bey männiglich grosses Lob und Ruhm erlanget hat," and this in the sentence immediately following his comment on Artemisia's work as a portraitist. Gentileschi is known to have been patronized by the Duque de Alcalá and the Conde de Monterrey (see the Index), Viceroys between the years 1629 and 1637, but by virtue of her apparent age the woman in the Trafalgar portrait cannot be either of their wives (married 1597 and 1607 respectively). And the artist does not identify the Duchess whom she portrayed in late 1630. It may be significant in this context that some of Artemisia's Neapolitan paintings of the early 1630s appear definitely to reflect a renewed interest in Tuscan art, prompting the proposal that on her way to Venice in 1627, or following her departure from the lagoon city about 1628, she stopped in Florence (Figs. 114, 125, 131, 136; the corresponding catalogue entries; and Chapter 4). There Artemisia would have been introduced to the fashionable portraits of Sustermans, including the aforementioned *Portrait of Maria Maddalena of Austria and Her Son Ferdinando II* which had entered the Medici Guardaroba in 1623.

As regards fashion, again the Trafalgar catalogue has made a start: "Dr. Aileen Ribeiro of the Courtauld Institute of Arts has intimated that the costume is likely to be Florentine, but could equally well be from any of the Italian courts where the fashions were strongly influenced by Spain (this is especially discernible in the use of the decorated hanging sleeve, and the Spanish standing collar edged with lace). In Dr. Ribeiro's opinion the costume is probably

datable c. 1620. Dr. Silvia Neloni of Florence has suggested a dating circa 1620–30." Professor Zelma Weisfeld, a costume specialist at the University of Michigan, has thought of Florentine and Genoese fashion and, agreeing with Dr. Ribeiro, would date it ca. 1620. Yet the comparative examples which Professor Weisfeld cites, and which to my perception most closely approximate thus far the costume in the Trafalgar portrait, were executed by Velázquez or his studio about 1630, including the *Portrait of a Lady* and the full-length *Portrait of Maria of Austria*, both in the Staatliche Museen at Berlin. It will be recalled that Velázquez was in Naples in the fall of 1630 and while there portrayed Maria (Madrid, Museo del Prado).

Finally, Ronald Cohen (letter to the author) has posited that the portrait may have been commissioned on the occasion of an engagement or marriage. This is an attractive idea, particularly in view of the flowers in the lady's hair and the ring on her finger. In fact, the types of flowers—a pink and three white blossoms—were traditionally associated with betrothal and purity. It is unlikely that their choice was arbitrary, and the symbolism of the fleur-de-lis would be consistent with this. In the light of such an interpretation, the turn of the young woman's head could be taken as implying a pendant portrait of her betrothed or husband.

BIBLIOGRAPHY: Sandrart, 1675 (ed. 1925), p. 290; Baldinucci, ed. 1812, X, p. 251; Morrona, ed. 1792, II, p. 266; Bottari and Ticozzi, 1822, I, p. 350 letter CXXIX; Walpole, 1765, II, p. 130; Pilkington, ed. 1777, p. 248; Dominici, ed. 1844, III, p. 178; Battisti, 1963, p. 297; Toesca, 1971, p. 92; R. W. Bissell, letter to Ronald Cohen, London, May 21, 1983; Ronald Cohen, London, letters to the author, January 25, 1983 and April 19, 1983; London, Trafalgar Galleries, 1983, pp. 70–73 cat. 27; Garrard, 1989, pp. 378–79, 502 n. 98; Papi in Contini/Papi, 1991, pp. 61 n. 73, 157; Zelma Weisfeld, Ann Arbor, Mich., letter to the author, November 13, 1995.

On the portrait traditions of Sustermans and Fontana: Florence, Palazzo Pitti, 1983, including p. 21 cat. 1; M. T. Cantaro, *Lavinia Fontana bolognese "pittora singolare," 1552–1614*, Milan, 1989.

On the portraits by Velázquez and his school cited above: J. López-Rey, *Velázquez: A Catalogue Raisonné of His Oeuvre*, London, 1963, pp. 248 cat.

379 and pl. 67, 248 cat. 381 and pl. 353, and 325 cat. 593 and pl. 352.

[27] *Clio, Muse of History (so-called Fame)*

New York, Private Collection
Oil on canvas, 1.27 x .975 m.
1632
Figs. 121–23; Color Plate XVIII

Inscribed on the open book, left page:
[1]632 / ÆTEMISIⱭ / [fa]ciebat / all Illu^te M.. / Sme.^re [or ^ro] 'Rosiers

Inscribed on the open book, right page:
Serin.. deb.. / TIQ—or an approximation thereof

COLLECTIONS: Arcade Gallery, London, by 1940, from whom purchased by Oswald Toynbee Falk, Esq., Oxford, by 1950; C. R. Churchill, Colemore, Alton, Hampshire; Arcade Gallery, London, 1955; Sotheby and Co., London, February 26, 1958, purchased by Wildenstein and Co.

Transferred to an oak panel, perhaps as early as the eighteenth century, the painting has been provided with a new canvas support. To the earlier operation are attributable the vertical surface cracks and a slight trimming of the left side (the woman's fingertips, the first digit of the date *1632*, and the "*fa*" of "*faciebat*" are missing) and, as Harris postulates, possibly some loss at the top as well.

The young woman, crowned with laurel and dressed in a greenish-blue mantle with rust-colored sleeves over a white undergarment, steadies a trumpet on a tapestry-covered table, which also bears a large book, opened to reveal the dedication. Thus decked out, the figure has traditionally been interpreted as a personification of Fame, as was another painting by Artemisia cited in the English Royal Collection [L-30]. Garrard, however, acting upon a suggestion made by Harris, and now supported by Contini, has convincingly identified the woman as Clio, Muse of History. According to Cesare Ripa's authoritative codifications, *Fama buona* and Clio share as attributes trumpets in their right hands. Exclusive to the former are an olive branch in her left hand, a golden necklace bearing a heart pendant, and white wings, while the latter has a book and is garlanded with laurel. As definitively constituted, Artem-

isia's figure was certainly meant to depict Clio, its trappings those of such more or less contemporary representations of this Muse by Orazio Gentileschi (London, Marlborough House), Giovanni Baglione (Arras, Musée des Beaux-Arts), and "Ribera" (St. Petersburg, Hermitage). Garrard hypothesizes that the lettering on the right page of the tome is intended to be Greek and to allude to Thucydides, whose volume of history accompanies Clio in Ripa's prescription.

Nonetheless, the subject may have been conceived initially as Fame. With the cleaning of the picture (and another one has just been completed) there emerged on the woman's left shoulder a dark ovoid configuration, accompanied by a prominent *pentimento*, that can better be interpreted as a small, lightly foreshortened wing than as a flounce of drapery. Furthermore, the left hand may easily be imagined as having held an olive branch—before Gentileschi, while simultaneously painting out the modest wing, transformed the gesture into one of clutching a train of cloth.

The choice of Clio was no doubt made in order more specifically to tailor the painting to the individual whose name appears in History's book. The most substantial attempt at identifying this man is from Garrard (whose intuitions have found favor with Contini):

> According to the inscription, the painting was dedicated by the artist to a "Signore Rosiers" or "Trosiers," names that have not been found in Neapolitan sources. The name might be connected, however, with the Rosières family, an old branch of French nobility, many of whose seventeenth-century members served the Dukes of Lorraine. One of these, Antoine de Rosières II, Seigneur d'Euvesin, and the first Maître d'Hotel of the Duke of Lorraine, died in Paris in 1631. Rosières's protector is likely to have been Charles of Lorraine, Duke of Guise, to whom Artemisia sent a painting in 1635. Quite possibly, the *Clio* was not ordered by Rosières, but dedicated to him, and we may speculate that a man recently deceased, Rosières, was here commemorated, perhaps by his protector the Duke of Lorraine, or perhaps by the artist herself, who might have been his friend. The

inscription may then be understood as follows: "*1632 / Artemisia faciebat / all Illus^te M(emoria) / Sngre. Rosier(e)s.*"

Artemisia's picture for the Duke of Guise, and the circumstances under which she might have obtained his patronage in that instance, are discussed under [L-95]. Garrard's proposal that the *Clio* was executed as a posthumous tribute is attractive, and may find confirmation in the abbreviation immediately preceding the proper name. One would expect this to be a variation upon "*Signore,*" and as such it has been considered by all commentators except Harris, who tentatively suggests "*SENE.*" Yet a transcription rendered without preconceptions yields "*Sme.^re*" or "*Sme.^ro.*" And this, juxtaposed to the "*M.*" (in its context no doubt signifying "*Memoria*"), recalls the adjective *smemorato*, meaning "forgotten" or "out of memory" as employed, for example, by Dante (*Convivio*, IV, xiv, 8).

Among the Rosières clan signaled by Garrard, the best candidate for this "forgotten" individual, and for a painting commissioned by Charles of Lorraine to revive his memory, is François de Rosières (1534–1607). Born at Bar-le-Duc, François came under the protection of the Cardinal de Guise, who named him Archdeacon of Toul and Conseiller du Duc de Lorraine. In recognition of the Cardinal's beneficence, François published at Paris in 1580 his *Stemmata Lotharingiae ac Barri ducum*, in which, with the aid of spurious and altered documents, he traced a direct line of descent from Charlemagne to the Lorraine princes while offending the King of France. The deception having been discovered and the *Stemmata* suppressed, only the intervention of the Guise and Queen Louise of Lorraine saved Rosières from the gallows. On April 26, 1583, he was reinstated by the King, to take up his duties at Toul, where he died on August 29, 1607. The author of other writings, including panegyrics to Popes Clement VIII and Paul V, surely François (and his *Stemmata Lotharingiae*) had not passed from the memory of Charles of Lorraine. In fact, I believe it probable that the monogram is composed of the letters "F" and "R," rather than "T" and "R" as has been supposed; the crossbar is twice as long to the right of the vertical of the "R" on which it rests than to the left of it.

Furthermore, in 1632, the twenty-fifth anniversary of Rosières's death, the Duke of Guise (b. 1571, d. 1640 in Cuna, Italy) would have had every reason, personal and political, to invoke this former supporter of his line and to recommend him to posterity. As detailed by René de Bouillé, author of the well-documented four-volume *Histoire des Ducs de Guise*, the prominence which Charles had achieved by virtue of his posts as Governor of Provence and Admiral of Levant had ultimately brought him into conflict with the jealous and ambitious Cardinal Richelieu and thus with Louis XIII. While protesting the long-standing legitimacy of his claims, as in his *Deffence de l'admirauté du Levant*, Guise recognized the threat which Richelieu posed, and under pretext of a pilgrimage to Loreto received the King's permission to travel to Italy, never to return to France. In a letter to Louis from Cannes, dated August 22, 1631, he wrote:

> Sire, ma fame présantera à Vostre Majesté cete letre et luy dira la résolution que je suis contraint de prandre après avoir servi le feu Roy et Vostre Majesté trante cinq ans fidellement et sans avoir jamès manqué de porter ma vie an toutes les occasions qui se sont présantées pour vostre service. Il n'est pas possible que Vostre Majesté an ait perdu la mémoire ni de la cause de mon malheur. . . .

By September 10, 1631, again in correspondence with the King, Guise was in Florence. Sometime thereafter, he wrote to a friend in what has been characterized by de Bouillé as a kind of political testament:

> Si mon oppression est plus longue que ma vie, la postérité qui conserve chèrement la mémoire des mes pères jugera sainement de la mienne, louera ma constance et ma fidélité, blasmera les autheurs de ma persécution et sçaura bien dire ce que par les gens de bien est congneu que je n'ay point d'aultre crime que la gouvernement de Provence.

The relevance of the *Clio, Muse of History* to Charles of Lorraine's situation is therefore self-evident. Through the vehicles of allegory and inscription, it serves in an allusive way as a memorial to declare Guise's fame and honor as much as Rosières's.

BIBLIOGRAPHY: Ripa, ed. 1603, pp. 142–43, 346; *Vocabolario della lingua italiana già compilato dagli Accademici della Crusca*, ed. G. Manuzzi, Florence, 1840, II, pt. 2, p. 1215; R. de Bouillé, *Histoire des Ducs de Guise*, Paris, 1850, III, pp. 96–98, and IV, pp. 364–422; Fröhlich-Bume, 1940, pp. 169 and 165 fig. B; London, Arcade Gallery, *Cross-Currents in Baroque Painting*, 1943, cat.14; idem, *Baroque Paintings*, March 3–25, 1948, no. 15; London, Royal Academy, *Exhibition of Works by Holbein and Other Masters of the 16th and 17th Centuries*, 1950–51, p. 143 cat. 368; "Notable Works of Art," 1955, pl. XIX; *Art Prices Current*, XXXV, London, 1957–58, no. 2452; London, Sotheby and Co., *Fine Old Master Drawings and Paintings*, February 26, 1958, p. 11 lot 55; Bissell, 1968, p. 159 and n. 51; Harris in Harris/Nochlin, 1976, pp. 122 cat. 14 and 342; M. Gregori in Naples, *Civiltà del seicento*, 1984, I, p. 147; Garrard, 1989, pp. 89, 92–96, 509 n. 148, 510 n. 157; Northampton, Mass., Smith College Museum of Art, *Baroque Painters in Italy*, November 17, 1989–February 18, 1990, n.n.; Contini in Contini/Papi, 1991, p. 66; New York, Wildenstein, *Women in Art*, September 1, 1995–January 31, 1996, no. 2. See also [L-30] and [L-95].

..

[28] *Esther Before Ahasuerus*

New York, Metropolitan Museum of Art
Oil on canvas, 2.08 x 2.73 m.
Ca. 1630–1635
Figs. 124–25; Color Plate XVI

COLLECTIONS: Harrach'sche Gemäldegalerie, Vienna; Morandotti Collection, Rome, by 1956; Acquavella Galleries, New York, by 1959; Mrs. Nathaniel P. Hill, on loan to the Metropolitan Museum, 1960; gift of Elinor Dorrance Ingersoll, 1969

The pavement tile at the very base of the riser, immediately below the deep shadow, is enlivened by two hatched patterns of brushstrokes that are exclusive to this tile alone. That to the right, being of a light tan pigment, almost blends with the surrounding tones. Conversely, the overlapping strokes at the left are of a whiter impasto visible from some distance (and even in photographs) and to my perception—or wishful thinking?—form themselves into the large interlocked letters "AF," for "Artemisia Fecit (or Faciebat)," recalling somewhat

the "AG [interlaced] F." of her *Saints Proculus and Nicea* from the same period ([33a]).

In the course of the recently completed painstaking restoration, the *Esther* bore vivid witness to the vicissitudes of Old Master paintings and to Artemisia Gentileschi's working method. It is therefore a story worth recounting in some detail. Against the measurements of 8'4" x 9'10" (or 2.54 x 3.00 m. by modern reckoning) recorded in the Harrach catalogue of 1856 must be considered, first, the photograph of the picture published by Voss in 1925, showing an additional run of canvas at the top. By 1956, the *Esther* having entered the Morandotti Collection in Rome, this upper portion had been removed, although it contained the remainder of the higher plume of Ahasuerus' hat. Apparently it was judged to be a later augmentation, perhaps because of some indications (observed by Garrard and me, but questioned by Ms. Jane Weber of the Metropolitan Museum Conservation Laboratory) of the presence of a stretching garland at the top of the painting in its reduced dimensions. However, Voss's photograph also illustrates the composition as deprived of the lowest section of pavement, suggesting that the lower edge, which today shows considerable damage, had been folded under.

Inasmuch as absolute correlations between nineteenth-century Austrian measurements and the present metric system cannot be supposed, the restored height of the *Esther* as of 1925 may have approximated that of Artemisia's original. If so, the now-removed upper section of canvas with its plume and breathing space would in fact have been autograph, a piece salvaged after having been turned under at some earlier moment (at which time the painting was restretched at the top to its smaller size) or a replacement for an unsalvageable piece of the original canvas. In any case, in view especially of the present uneasy crunching of the frame upon Ahasuerus' hat, it seems clear that Artemisia's composition extended upward. The cramping at the left is also no doubt the result of trimming (cf. the 1856 measurements of the width); significantly, the left edge, unlike the right one, is not badly damaged.

Gentileschi's painting has suffered the further indignities of slashing and pigment loss and of severe abrasion, which on thinly painted areas, as the pavement, has revealed major *pentimenti*. Surface wear and X-radiography (Fig. 124) have brought to light a fascinating pattern of experimentation on Artemisia's part. In particular, she tested out alternative positions for the King's throne and for the platform. A spread-legged dog, posed frontally but with its head turned toward Esther, once stood on the jutting riser beneath the throne. This animal was then painted out and substituted by a snarling dog in an alert attitude in front of Ahasuerus and most likely straddling the lower step, its rump overlapped by the King's extended foot. The latter hound was accompanied by a page, both later obliterated as well by the artist, much to the benefit of the drama of empty space.

Still appreciable, however, is the exquisite coloring. Esther, in a golden-yellow gown with gold-embroidered white sleeves and a blue mantle, is flanked by her maidservants in dresses of rust and olive tones. Ahasuerus the dandy wears a dark green outfit with slit sleeves and breeches and tan leggings trimmed with green fur. A plum-colored scarf and green plumed hat complete his ostentatious attire. The figures are set within an interior ambient distinguished by a light brown dais, a maroon curtain, and a floor set with pink and olive tiles.

In interpreting this encounter between Queen Esther and her husband, Artemisia was faithful to the Apocryphal Book of Esther (quoted in the text). In contrast, the Biblical account (Esther 5), which features the moment when Ahasuerus extends his golden scepter, is devoid of the very characterizations of the emotional states of wife and husband and of the activities of the attendants that Gentileschi adapted to her own ends.

After bearing ascriptions to El Greco and Alessandro Allori, the *Esther* was assigned to Artemisia by Voss, an attribution that has won universal acceptance. And with one exception among scholars, the painting has been located in Gentileschi's Neapolitan years. The dissenting opinion is from Garrard, for whom the *Esther* should be dated rather to ca. 1622–23, during Artemisia's second Roman period, for the following reasons: the Caravaggesque attire of the King; the style, thought to more closely approach that of the Detroit *Judith* (Fig. 84; Color Plate XIII; [14]) of ca. 1623–25 than that

of the *Birth of Saint John the Baptist* (Fig. 139; [32]) of 1633–34; the relationships of the picture to Venetian tradition, and specifically to a composition by Paolo Veronese (see below) which Gentileschi is supposed to have experienced firsthand about 1621; and the "heroic" interpretation of the Queen.

Ahasuerus' garb is indeed as familiar to Caravaggesque art of a Manfredian stamp as it would be rather novel in Naples after 1630, but as I will attempt to demonstrate below one cannot assume that it was inspired by paintings in Rome. The other evidence adduced by Garrard is likewise subject to different analysis, after which the canvas emerges more credibly as a product of Artemisia's first years in Naples. As a lavish display of technical virtuosity, the *Esther* is linked to the *Annunciation* (Fig. 114), signed and dated 1630, and to the *Cleopatra* (Fig. 136; Color Plate XIX), not to the more austere, less blatantly showy *Judith* of several years earlier—points upon which I have elaborated in the text. And again unlike the *Judith*, the expression of the *Esther* toys with the melodramatic. Further, it may be questioned (see the text) whether Esther is heroicized and Ahasuerus ridiculed to the extent that some opinion would have it.

On a more particularized level, the head of the maid at the left approximates in position and physiognomy that of the Gabriel in the *Annunciation*, while in general types the maid-servants reappear among the midwives in the *Birth of Saint John*, as does the un-Caravaggesque perspective setting (which Gentileschi also employed in the *Saints Proculus and Nicea* of ca. 1635, Fig. 146). And I do not find the Prado picture to be "more idealized and refined" than the *Esther*.

The aforementioned parallels to Veronese also argue for a date well in advance of the early 1620s. Artemisia's major source, as Garrard has recognized independently, was the *Esther Before Ahasuerus* in the Louvre, or a replica of it (one was once in an Austrian collection). The execution of the Paris canvas, the painting cited by Ridolfi in 1648 in the Casa Bonaldi at Venice, is believed by Pignatti to be essentially by Benedetto Caliari (Fig. 127). From this Artemisia appropriated the basic composition, the rounded, two-tiered podium, and the group of Esther and her attendants, one boring in upon

the Queen's neck while extending a supporting hand, the other steadying Esther's left arm. Furthermore, Veronese's work suggested the (subsequently eliminated) page at the foot of the steps and dog at the lower right. Since Gentileschi is documented in Venice in 1627–28 (see Chapter 3), not about 1621 when Garrard places her there, it may logically be supposed that her *Esther* was not created before the end of the third decade.

Although the painting has been relined, the crackle pattern (as on the Queen's left hand and the King's right knee) of regular rows of tiny squares hints that the original canvas was of traditional seventeenth-century Neapolitan type. Additionally, Artemisia's gorgeous picture might have been crucial for Bernardo Cavallino, from whose brush issued at least four canvases of *Esther Before Ahasuerus*.

Opinions published subsequent to Garrard's monograph have reaffirmed the traditional dating of the *Esther* to Artemisia's time in Naples. Contini, although expressing some uncertainty as to whether the canvas should be assigned to the artist's first or second Neapolitan period, appears inclined to place it just before Gentileschi's trip to England, as does Spike. Papi inserts it more generally "among the Neapolitan works," while Bionda suggests ca. 1640. In my opinion, the stylistic comparisons adduced above in themselves locate the painting in the early years of the fourth decade.

Another line of reasoning, pursued in Chapter 4, leads to the same conclusion, because the *Esther* speaks of an exposure to art in Florence, and in particular to works by Rutilio Manetti and Bartolommeo Salvestrini (Figs. 128, 129, 126), that can only have taken place in the later 1620s. In not considering Veronese's *Esther Before Ahasuerus*, beyond much doubt Artemisia's starting point, Contini too heavily skews the relationships in favor of the just-mentioned Tuscan examples. Nonetheless, the Florentine ties are so close and many that, with Contini, I do not believe that they are merely coincidental. Thus: (1) Gentileschi's *Esther* predates 1622, having been painted in Florence or soon sent there from Rome, and had an almost immediate influence on Manetti; or (2) Artemisia had returned to Florence sometime after 1625, there to absorb so fully features of the *Roger and Alcina*, *Massinissa and Sophonisba*, and *Theseus*

and Ariadne as to incorporate them into her *Esther*. As seen, the first hypothesis does not adequately explain the compositional relationships to Veronese and the stylistic relationships to works known to have been executed by Artemisia in Naples. With respect to the second hypothesis, while a reappearance by Gentileschi in Florence is not documented, the *Esther* and other pictures by Artemisia from the same time (again Chapter 5) leave little doubt that it took place. Contini suggests that this trip may be set to the spring of 1636, for in her letter of April 1 of that year to Andrea Cioli the artist writes that she "will go to Pisa this May to sell some of my holdings and will take this opportunity to come to Florence" (see Appendix I). Yet Contini also notes the greater convenience of a journey from Rome to Florence, rather than from Naples. In my opinion, in her passage from Rome to Venice in 1627, or on her way back to Rome in 1628/29 (see Chapter 3), Artemisia must have stopped in Florence.

This postulate holds further implications. First, it is not necessary to link Artemisia's figure of Ahasuerus to Roman Caravaggism as an indication of the earlier date proposed by Garrard. The King finds his counterpart in Florence, not only in Manetti but in the likes of Jacopo Ligozzi's *Pope Clement IV and the Blessed Manetto dell'Antella* (Florence, SS. Annunziata) of 1602. Second, the usual notion that Artemisia's art was crucial to the adoption by Manetti and other Tuscans of the Caravaggesque mode needs to be reevaluated. It is above all to Contini's astute observations that we owe this most important point.

Finally, speculation as to the early history of the canvas supplies a hint that it also would set the date of execution to the early 1630s in Naples. Voss, seconded by Salerno et al., Kaufmann, and Contini, proposed that the picture was purchased in Naples by Alois Thomas Raimund, Count Harrach and Neapolitan Viceroy from 1728 to 1733. The same has been posited by Lurie with regard to Cavallino's *Esther Before Ahasuerus* now with the Harrach family at Schloss Rohrau. These are wholly reasonable suggestions. However, Jusepe Ribera's *Immaculate Conception* of 1637, likewise at Rohrau, was given in 1676 to Count Ferdinand Bonaventura von Harrach, then in Madrid as Imperial Ambassador. It is conceivable that Artemisia's picture arrived in Austria by the same route and that, along with the *Birth of Saint John the Baptist*, it was among the paintings ("alchune opere") that according to the artist's letter of July 20, 1635 (see Appendix I), she had painted for Philip IV through the intermediary of the Conde de Monterrey, Viceroy of Naples from 1631 to 1637. This letter and others from earlier in 1635 demonstrate that the works for the Spanish King had been finished at least by 1634 (see [32]). In any case, the Harrach'sche Gemäldegalerie is dominated by pictures of Neapolitan provenance, and the Harrach counts may have been especially on the lookout for themes of royalty; Schloss Rohrau also has the distinction of housing Mattia Preti's *Solomon and the Queen of Sheba*.

BIBLIOGRAPHY: *Verzeichniss der gräflich Harrach'schen Gemälde-Gallerie zu Wien*, cat. by A. Gruss, Vienna, 1856, p. 71 no. 320; Voss, 1925, pp. 462–63; L. Salerno et al., *Il seicento europeo*, Rome, Palazzo delle Esposizioni, 1956, p. 131 no. 114; *Burlington Magazine*, CI (November 1959), xxxi; New York, *Metropolitan Museum of Art Bulletin*, XIX (October 1960), 59; Bissell, 1968, p. 163; T. DaCosta Kaufmann, "Esther Before Ahasuerus: A New Painting by Artemisia Gentileschi in the Museum's Collection," *Metropolitan Museum of Art Bulletin*, XXIX (1970), cover and pp. 165–69; Greer, 1979, pp. 197–98; Spinosa, 1984, pl. 420; Garrard, 1989, pp. 72–79 and notes; Perlove, 1989, pp. 135, 138; Contini in Contini/Papi, 1991, pp. 70, 165–69 cat. 24, 189–91; Papi, ibid., pp. 51, 53; Spike, Review, 1991, p. 734; Bionda, 1992, pp. 27–28.

For comparative material: T. Pignatti, *Veronese*, Venice, 1976, I, p. 200 no. A237, and II, fig. 924; Percy and Lurie, 1984, pp. 72–73 no. 12, 90–91 no. 21, 172–73 no. 61, 174–75 no. 62; M. Bacci in Florence, Palazzo Strozzi, 1986, I, pp. 91–92 cat. 1.7. Also A. Bagnoli in Siena, Palazzo Pubblico, 1978, pp. 100–101 cat. 35, and Chapter 2, note 38, for the paintings by Manetti.

..

[29] *Cleopatra*

Paris, Société Labatut & Cie., 1997
Oil on canvas, 1.87 x 1.34 m.
Ca. 1630–35
Fig. 136; Color Plate XIX

The canvas may have been trimmed slightly at the left; the lion's claw and the attribute held by the putto, part of the sculpted furniture, were probably complete originally.

To the text discussion of the iconography, which is conventional in its allusions to love and sexuality, it can be added that according to Ripa a boy riding a dolphin personifies "pleasing disposition, docile and loving (*animo piacevole, trattabile & amorevole*)," the dolphin being by nature most agreeable. Ripa also recounts Pliny's story, from the time of the Emperor Augustus, of the dolphin who died of sadness upon the passing away of a youth whom he had once transported to Pozzuoli. Might the artist have intended reference to these traditions as well?

This visually stunning picture was brought to my attention by D. Stephen Pepper, who kindly arranged for the photograph and color transparency by which I know the work, and who correctly recognized it as an autograph canvas by Artemisia Gentileschi from the 1630s. Its quality is of a very high order. A knowing treatment of light establishes altogether convincing textural differentiations, as where the artist plays Cleopatra's satin gown, its complex folds scintillating with deftly applied highlights, against the polished surfaces of the sculpture. The color of golden yellow and deep red is also typical of Artemisia. Further, the *Cleopatra* exhibits the same decorative flair as the *Annunciation* of 1630 (Fig. 114; cf. the angel's gown and puffed sleeves) and the *Esther Before Ahasuerus*, here dated ca. 1630–35 (Fig. 125; Color Plate XVI; cf. Esther's attire). Relationships to the *Esther*, a painting of similar melodramatic tone, are even more specific, given the probability that the buxom and swooning protagonists, their heads thrown back and foreshortened, were developed from the same model.

Both the attribution to Artemisia and a date in the first half of the fourth decade are likewise indicated by what I take to be the impact of Tuscan art on the Labatut picture, specified in the text. This is consistent with what I have postulated (see Chapter 4) regarding the renewed Florentinism of the *Annunciation* and the contribution of the art of Rutilio Manetti to the *Esther* and possibly to the *Corisca and the Satyr*, leading to the further conclusion that Artemisia revisted Florence either in 1627 on her way to Venice or in 1628/29 on her trip back to Rome, or both.

It is obvious that the stereotypical interpretation of the theme did not induce me to exclude the attribution of the *Cleopatra* to Artemisia Gentileschi. The *Cleopatra* once in Milan (Fig. 211) is thought to diverge from the conventional and thus to signal Artemisia's thinking. Yet in my opinion the Milan picture is by Orazio Gentileschi and therefore cannot be used as a touchstone of Artemisia's interpretive proclivities. If so inclined, one might just as easily argue that the emphases of the Labatut painting actually point to Artemisia and refer to her own situation in love—in 1632, around the time of the picture, Gentileschi was thirty-nine, as was Cleopatra at her death, and, like Cleopatra, had borne the children of more than one man (see Appendix II), the first of whom, at least, was with her no longer. In any case, the dark drama and relative starkness of Artemisia's *Cleopatra* once in London (Fig. 110, Color Plate XV) do not characterize the canvas at Paris, a final argument for a post-1630 date for the latter (and a pre-1630 date for the former).

BIBLIOGRAPHY: C. Ripa, *Nova iconologia*, Padua, 1618, ed. P. Buscaroli and M. Praz, Turin, 1986, 1, pp. 49–51; D. Stephen Pepper, Leesburg, Va., letter to the author, May 4, 1992; Jacques Leegenhoek, Société Labatut, Paris, letter to the author, June 23, 1992.

..

[30] *Corisca and the Satyr*

Naples, Private Collection
Oil on canvas, 1.55 x 2.10 m.? (see below)
Ca. 1633–1635
Fig. 131; Color Plate XVII

Signed on the tree at the right: ARTIMISIA / GENTILES / CHI.

COLLECTIONS: Private Collection, Naples, as of 1989; Christie's, Rome, March, 1990

Cleaning of the canvas after its sale in 1990 revealed a striking color scheme: The woman in a golden-yellow dress over a white blouse, a maroon-lilac cloak, and blue bushkins, fleeing a ruddy-skinned satyr within a landscape setting. A signature, here recorded in the location and form reported by Garrard, also emerged. Inasmuch as the height:width ratio of the painting is 1:1.33, its size is apparently that given by Rocco (1.55 x 2.10 m.) rather than that (1.50 x 2.30 m.) claimed in the sale catalogue and repeated by Garrard.

Although labeled by Christie's *Fanciulla insidiata da un satiro* and in 1991 with the equally generic title of *Satiro e ninfa*, the painting had already been recognized by Novelli as depicting an episode in Giovanni Battista Guarini's (1537–1612) *Il pastor fido*, a pastoral tragicomedy first issued in the 1590s. As Garrard (likewise unaware of Novelli's contribution) subsequently pointed out, the moment is specifically act II, scene 6, the essence of which I have summarized in the text.

To my knowledge the first published notice of the picture is that of 1989 by Novelli, who assigned it to Annella de Rosa during the 1630s. Remarking upon the Stanzionesque character of the figure of Corisca, but finding greater expressive force, Novelli then likened the canvas to the *Drunkenness of Noah* formerly in the Calabrese Collection at Rome, for which Longhi and others had proposed an attribution to Annella. Yet the *Drunkenness of Noah* is *not* Stanzionesque, is questionably given to Annella de Rosa (Bologna, for example, suggests Filippo Vitale), and does not in any case bear striking relationships to the *Corisca and the Satyr*. Furthermore, the latter is not comparable to the only two paintings for which Annella's responsibility seems secure, the *Birth of the Virgin* and the *Death of the Virgin* in the Pietà dei Turchini at Naples. (Novelli, with the *Corisca* as touchstone, then proceeds to attribute also to Annella de Rosa a scene of witchcraft with which Artemisia Gentileschi's name was once tentatively associated. This is the so-called *Circe* now in the Stanford University Museum of Art under the name—most reasonably—of Guidobono.)

Between its appearance at Christie's–Rome as attributed to Massimo Stanzione and the re-emergence of its signature during restoration, the painting was assigned to Artemisia Gentileschi by Spinosa. Bologna and Rocco have concurred, as has Garrard in the first and only detailed presentation of the canvas. I have not confronted the picture directly, but I am persuaded by the photographic evidence to include the *Corisca and the Satyr* among Artemisia's autograph works and concurrently to accept the signature as authentic.

Garrard has argued that, beyond the palette and female type, the interpretation of the theme is a clue to Artemisa Gentileschi's au-

thorship. Guarini limns Corisca as wanton, cunning, and false, as "not only lustful and impudent, but wicked and cruel," as, in Garrard's words, "diabolical" and a "manipulative villain." Nonetheless, Garrard suggests that "not only Artemisia, but any woman living in seventeenth-century Italy might have found vicarious delight in Corisca's triumph." Under this proposal Corisca's "worldly *savoir-faire* and Machiavellian cynicism," her ability "to defeat a man by her wits and by using sex against him," her powers of deception, are viewed positively: after all, the end was to flee male lechery. In the text, where further quotations from Garrard are provided, I question the conclusion that Artemisia identified with Corisca and in the bargain provided us with a tool for connoisseurship.

Unquestionably indicative of authorship, on the other hand, is, first, the extent to which this painting takes its place in the Neapolitan Baroque artistic milieu. For Rocco, the satyr recalls the devil in Filippo Vitale's *Guardian Angel* for the Pietà dei Turchini; closer still is the hellish presence in Ribera's *Ixion* at Madrid, signed and dated 1632. (Pagliarulo has also invoked Ribera's name in connection with the satyr.) Simon Vouet's contact with Naples is detected in the figure of Corisca by Rocco, who may have had in mind above all the striding woman in the *Triumph of David* presented under Vouet's name in the same exhibition in which the *Corisca and the Satyr* appeared. Without debating here that attribution, I would note that the decorative flair of the *Corisca* does find equivalents in Vouet, as in the temptress of the French master's *Temptation of Saint Francis* (Fig. 86). More binding still are the ties with Stanzione (e.g., Fig. 135), detailed in the text, which both Novelli and Rocco recognize but do not specify.

Much of the evidence mustered above points to a date in the first half of the 1630s for the *Corisca and the Satyr*, precisely where Spinosa, Bologna, and Rocco locate it. Garrard sets it "after 1630" (and then to the early 1640s) by virtue of its provenance, the sizes of the figures relative to the format, and the landscape, the latter thought to reflect the artist's contact with the works of Domenico Gargiulo. In style the *Corisca* is compatible with Artemisia Gentileschi's canvases of the earlier 1630s,

especially with the *Annunciation*, the *Esther Before Ahasuerus*, and the *Cleopatra* as regards the display of draperies, and with the *Judith* formerly with Relarte and the *Samson and Delilah* at Capodimonte, both most likely copies of now-lost pictures by Artemisia from about 1635, to which the contemporary character, facial type, and low bodice of Corisca may be compared (Figs. 150, 151–52). For the satyr, however, dictated by a specific text, there is no parallel in Gentileschi's oeuvre.

Finally: I have attempted to demonstrate (Chapter 4) that the *Esther* and the *Cleopatra* testify to Artemisia's encounter with the art of Rutilio Manetti during a return to Tuscany in 1627 and/or in 1628/29. The *Corisca* may be (see the text) another case in point.

BIBLIOGRAPHY: Novelli, 1989, pp. 149 fig. 3, 151–52; Rome, Christie's, *Importanti dipinti antichi*, March 8, 1990, lot 129; L. Rocco in Naples, Castel Sant'Elmo, 1991, p. 326 cat. 2.97 with ill.; F. Bologna, ibid., pp. 160, 162; Nicola Spinosa, Naples, letter to the author, October 24, 1992; Garrard, 1993, pp. 34–38; Pagliarulo, 1996, pp. 152–53.

For the painting by Stanzione cited, see Chapter 4, note 99. For the other comparative material: A. Bagnoli in Siena, Palazzo Pubblico, 1978, p. 120 cat. 54; V. Pacelli in Naples, *Civiltà del seicento*, 1984, I, pp. 500–501 cat. 2.275; J. Thuillier in Rome, Palazzo delle Esposizioni, 1991, pp. 143–48; Rocco in Naples, Castel Sant'Elmo, 1991, pp. 81–82 color pls. 21–22, 280 cat. 2.31; Bologna, ibid., pp. 87 color pl. 28, 300–301 cat. 2.57; A. E. Pérez Sánchez and K. Christensen in *Jusepe de Ribera, 1591–1652*, exh. cat., New York, 1992, pp. 95–98 cat. 26.

..

[31] *Venus and Cupid Embracing*

Kreuzlingen, Switzerland, Heinz Kisters, as of 1963
Oil on canvas, 1.21 x 1.60 m.
Mid-1630s (1634?)
Figs. 130, 133

COLLECTIONS: Segesser de Brunegg family (with F. von Segesser, Lucerne, by 1958). For a conjectured previous history, see below.

On the urging of Hermann Voss, who judged that crudely painted habiliments meant to render the goings-on less morally offensive had once been foisted upon the bodies, the canvas was cleaned in Milan. Off came the shift, the drapery that covered Venus's right upper arm

and thigh, the cloth concealing Cupid's navel and inserted between his buttocks and the caressing hand of his mother. Embracing and embraced by her son with red-tinted wings, Venus, nude except for violet drapery over her left leg and right arm, stretches out on a white pillow and bed trimmed in gold as she toys with Love's arrow. The figures cavort under a canopy of greenish-brown curtains with maroon fringe, Amor's brown quiver now tossed aside on a bundle of red cloth.

The restored *Venus and Cupid* appeared under Artemisia Gentileschi's name in exhibitions at the Helmhaus in Zurich (1958) and the Musée des Beaux-Arts at Bordeaux (1959) before being published in greater detail (although without references) by Voss. The attribution to Artemisia, confirmed by Schleier and Marini, has been rejected by Garrard, following my dismissal of the picture from the Gentileschi catalogue on the grounds of its academic stamp, and by Contini, who considers it "eventualmente più vicina al Guerrieri." The technique, to judge from the photographs by which alone I know the work, seems with the exception of the curtain to be almost slick, and one would prefer that Artemisia had not created a canvas that so blatantly panders to prurient interests.

Nonetheless, there is evidence that she painted precisely this subject, and an unbiased examination now appears to me to point to Gentileschi's authorship. Thus, in the early eighteenth century, a "Venus and Cupid Kissing. Big as the life," assigned to "Gentileschi, Artemisia Lomi or Orazio Lomide," belonged to the English diplomat, author, and collector Matthew Prior (1664–1721). As Wright and Montgomery indicate, Prior may have begun his collection during his tenure (1690–97) as secretary to the English Ambassador to the Hague, and enriched it through purchases at Paris in 1698–99 and 1711–15. Upon his death the "Venus and Cupid Kissing" was bought by Edward Lord Harley, to be sold by Harley's widow in 1742. Obviously the canvas had come down with a traditional attribution to one of the Gentileschi, as did a drawing of *Venus and Cupid* assigned to Orazio in the Cornelis Utenbogaert sale of 1711.

The picture later owned by Prior, or one like it, may possibly be identified as the "donna con un'amore" by Artemisia once in the Palazzo

Barberini at Rome. Writing from Naples on January 21, 1635, to Cassiano dal Pozzo, Gentileschi announced the imminent arrival in Rome of her brother Francesco and with him a painting which she wished to present via Cassiano to Antonio Barberini: "Viene costá il sig. Francesco mio fratello per accompagnare un quadro mio, e di quello farne offerta in mio nome all'eminentissimo sig. cardinale D. Antonio, quando lo trovo di suo gusto." Four days later, in a letter to Francesco d'Este of Modena, the artist (perhaps exaggerating in an attempt to impress) speaks of this donation as "some works of painting": "Con l'occasione ch'io mando all'Em.mo Card.le D. Antonio alcune opere di Pittura di mia mano mi è parso bene mandar'anco à V.ra Alt.za S.ma quelle. . . ." Then in 1644 "un quadro con una donna con un'amore senza cornice coperta con suo tafeta verde della *Gentilesca*" was inventoried among D. Antonio's holdings in the Palazzo Barberini. (Garrard's statement that it is "recorded in the Barberini inventories sometime between 1614 and 1636" is not supported by the documents known to me.) It is logical to assume that this mythological canvas, most likely a *Venus and Cupid* (even if the compiler was loath to say so), was Artemisia's offering of early 1635.

Admittedly, the evidence that would link the Barberini and Prior canvases is at best circumstantial, although the canvas could have accompanied Cardinal Antonio in his exile to France in 1645. This does not in itself prove the attribution to Artemisia of the ex-Kisters painting. More directly relevant are the obvious ties between the *Venus and Cupid* and Gentileschi's *Bathsheba* now in Columbus, Ohio (Fig. 159; Color Plate XXIII). The facial types of these women are virtually identical (cf. Figs. 132 and 133), as are their bodies, neither buxom nor enervated but with long, elegant legs, exceedingly so from knees to toes. The same model must have posed for the artist. In the advancing pose of Cupid and the motif of dual embrace the picture is extraordinarily like Cavaliere d'Arpino's *Venus and Cupid Kissing* of ca. 1600 at Rome (Fig. 134). Gentileschi may have known this picture or a version of it: two paintings of "Venere con Amore" by d'Arpino, one of them 1.56 m. wide, are recorded in the Patrizi inventory of February 27, 1624, the same inventory in which a *Cupid and Psyche* by Ar-

temisia appears ([L-17]). Echoes of Bronzino's *Venus, Cupid, and Satyr* (Rome, Galleria Colonna), which Artemisia could have seen in the Salviati Collection at Florence, can also be postulated.

If, as is argued in the following entry, the Columbus *Bathsheba* was executed about 1636–37/38, the *Venus and Cupid* would belong to approximately the same time. Without adducing comparative material, the compilers of the catalogues for the exhibitions at Zurich and Bordeaux dated the picture to ca. 1635. Thus placed, it might well be the painting intended for Antonio Barberini in early 1635, that hidden from innocent eyes by a curtain of green taffeta. Voss assigned the *Venus and Cupid* to the period of the *Bathsheba* and *Tarquin and Lucretia* at Potsdam (Figs. 188, 190), but the mannered women in the latter canvases seem much more products of the mind and of art than of direct observation. Conversely, the ex-Kisters picture is at the end of a progression that leads from the Princeton *Sleeping Venus* (ca. 1625–27) through the *Cleopatra* and the *Penitent Magdalen* (both ca. 1627–29), during which the female form becomes more slender while the images retain a Caravaggesque aggressiveness that is now compromised (Figs. 104, 110, 111; Color Plates XIV, XV).

None of the foregoing can disguise the fact that the *Venus and Cupid* bears only tenuous relationships to such contemporary works by Artemisia as the *Birth of Saint John the Baptist* and the three pictures for the Duomo at Pozzuoli (Figs. 139, 146–49; Color Plate XXI), although the highlights on the curtain are strikingly similar to those on the dalmatic of Saint Proculus in the Pozzuoli *Saint Januarius in the Amphitheater*. An explanation for this dichotomy is offered in Chapter 4. In all, the *Venus and Cupid* may be accepted, if reluctantly, as an autograph painting by Artemisia Gentileschi from a moment when a classicizing tendency is clearly discernible in Neapolitan painting in general.

BIBLIOGRAPHY: Bottari/Ticozzi, 1822, I, pp. 351–52 CLX; Imparato, 1889, p. 424; H. Mireur, *Dictionnaire des ventes d'art*, Paris, 1911, III, p. 288; H. B. Wright and H. Montgomery, "The Art Collection of a Virtuoso in Eighteenth Century England," *Art Bulletin*, XXVII (1945), 197, 199; Zurich, Helmhaus, 1958, p. 12 cat. 22 and ill.; Bordeaux, Musée des

Beaux-Arts, *La découverte de la lumière des Primitifs aux Impressionnistes*, cat. by G. Martin-Méry, 1959, pp. 36–37 cat. 69 and pl. 52; Voss, 1960–61, pp. 79–82; Bissell, 1968, p. 167; Schleier, 1971, p. 89; Lavin, 1975, p. 165; Marini, "Caravaggio e il naturalismo internazionale," 1981, p. 370; Garrard, 1989, pp. 109, 507 n. 133; Contini in Contini/Papi, 1991, p. 85 n. 40.

For the comparative material: Röttgen, 1973, pp. 109–10 cat. 31 and pl. 31; Rome, Galleria Colonna, *Catalogo sommario della Galleria Colonna in Roma*, cat. by Eduard Safarik, Busto Arzizio, 1981, pp. 41–42 cat. 32; Willette in Schütze/Willette, 1992, pp. 213 cat. A55, 323 fig. 194.

..

[32] *Birth and Naming of Saint John the Baptist*

Madrid, Museo del Prado
Oil on canvas, 1.84 x 2.58 m.
1633–1634
Fig. 139

Signed on a trompe l'oeil piece of paper, lower left: ARTEMITIA / GINTILES (see below)

COLLECTIONS: Buen Retiro, Madrid, Ermita de San Juan, from where transferred already in the seventeenth century to the Palacio del Buen Retiro; Palacio Real Nuevo, Madrid, Capilla de la Calle del Tesoro, by 1772; to the Prado by 1820

Brittle, coarsely in-painted, and suffocating under layers of muddy varnishes, this picture was distressingly unattractive as late as 1984 when exhibited in Naples. By the fall of 1985 the canvas had been restored, to considerably better effect. In the process the clearly visible letters "CHI" of the artist's signature were removed, presumably on the grounds that they were nonautograph replacements for lost characters. The coloration consists primarily of whites, greens, oranges and red-oranges, brown for the ambient, and, for the shawl of the seated midwife, a virtuoso moment of lilac shot through with yellow.

Even as during the 1630s painting in Spanish-owned Naples was undergoing fundamental transformations, the monastery of San Jerónimo at the eastern limits of Madrid was being absorbed into the Royal pleasure palace of the Buen Retiro. At several points these stories are intertwined. The following entry details but one such moment, one in which Artemisia

Gentileschi participated. It repeats verbatim large portions of my manuscript entitled "Artemisia Gentileschi, Stanzione, and Finoglio at the Buen Retiro: The Date and Function of the *Saint John the Baptist Cycle*," which in the fall of 1990 was accepted for inclusion in the *Papers in Art History* series of Pennsylvania State University. Shortly thereafter I learned that in a richly detailed "digressione" in his book *La collezione Serra di Cassano* of 1989, Antonio Vannugli had already confronted precisely the same problem and, bringing together and evaluating essentially the same evidence, had come to startlingly similar conclusions. In fact, again unbeknownst to me, Vannugli's study was an expansion of a lecture which he had delivered at the Institute of Fine Arts of New York University in December of 1988 (and which was then to appear in Spanish in the *Boletín del Museo del Prado*, x, 1989, published in 1991). Under these circumstances, I judged it proper to withdraw my manuscript. Since then, Vannugli has issued an expanded, fully documented, and in part rethought study of the cycle, which must now be taken as the definitive version. To the ends of crediting the Italian scholar and, it is hoped, enhancing the strength of the argument, the many points at which our procedures and insights proved to meet will repeatedly be signaled in the pages that follow, even as new ideas—in good part stimulated by Vannugli's work—will be introduced.

The earliest known references to the paintings in question were jotted down by Lázaro Díaz del Valle between 1656 and 1659: "El cavallero Máximo grandissimo pintor. . . . En el Buen Retiro está la historia de S. Juº de su mano, cosa famosa" and, regarding Artemisia Gentileschi, "Pintora de Roma; desta mujer trajo el Duque de Alcalá a España algunas famosas pinturas. En el Buen Retiro desta Corte ay una pintura del Nacimiento de San Juan, que es cosa excelente. Prosigue con sus pinturas esta Historia el Caballero Máximo." Decades later, in the exhaustive inventory of the Buen Retiro from 1701 to 1703, published by Fernández Bayton and minutely analyzed by Von Barghahn, the presence of the impressive series is finally underscored (on May 18, 1701):

Ottra de tres baras de largo y dos y quarta de alto con la degollaçion de San Juan Bauptista Original del Cauallero maximo

Con marco tallado y dorado tasada en settenta doblones 4.200 [reales].

Una Pinttura de ttres Uaras de largo y dos y quarta de alto de San Juan Baupttista Niño quando Se despedio de Casa de sus Padres Original del Cauallero Maximo con marco tallado y dorado tasada en sesenta doblones 3.600.

Una Pintura de ttres Uaras de largo y dos y quarta de alto con San Juan Baptistta en la prision Original de Pablo fenollo Con marco tallado y dorado tasada en Zinquenta doblones 3.000.

Una Pinttura de quatro Uaras de largo y dos y quarta de alto quando el Anjel anunçio el naçimiento de San Juan Bauptista Original del Cauallero Maximo Con marco tallado y dorado tasada en Settentta Doblones 4.200.

Una Pinttura de quatro Uaras de largo y dos y quarta del alto con San Juan Baupttistta Predicando en el desierto original del Cauallero Maximo con marco tallado y dorado tasada en Settenta Doblones 4.200.

Ottra de tres Uaras menos quartta de largo y dos y quarta de alto Con el Naçimiento de San Juan Baupttista de mano de Arttemise Genttileschi hija del Cauallero Maximo Con marco tallado y dorado tasada en settentta doblones 4.200.

Three of Stanzione's canvases, still at the Buen Retiro, were restored in 1758. Then in 1772, as Vannugli has shown, four of the Saint John pictures were recorded in the "Capilla de la Calle del Tesoro" of the Palacio Nuevo in Madrid: "Retiro — 456, 468, 470, 471. Quatro pinturas de la vida de San Juan Bautista; una de la Natibidad otra de la Degollación otra quando profetizaron a Zacarías y la otra de la Predicación los dos primeros de tres varas de largo y dos y quarta de caida los dos restantes de quatro varas de largo y dos de caida todos originales el primero firmado de Artemisia Gentileschi y los otros tres al paracer del Caballero Máximo." There they were registered as well by Antonio Ponz ("En el cuerpo de la capilla hay cuatro cuadros grandes pertenecientes a la Vida y muerte de San Juan Bautista: tres de ellos los hizo el caballero Máximo, y uno, que es el nacimiento del santo, lo pintó Artemisia Gentileschi"), followed by Antonio Conca in 1793

("Havvi un'altra Cappella in una casa vicina chiamata del Tesoro, che possiede molte opere di penello esposte alla pubblica vista. I due quadri del delicato Pantoja, tre del Cavalier Massimo, e la Natività del Signore di Artemisia Gentileschi figliuola di Orazio Gentileschi pittore pisano, portano il vano sopra tutti gli altri") and by the Palacio Nuevo inventory of 1794 (in which the three Stanzione pictures were attributed to Orazio Gentileschi). The Saint John in Prison had by then dropped from sight, while the Saint John Taking Leave of His Parents remained at the Buen Retiro. By 1820 the five canvases had been united in the Museo del Prado (Figs. 140–43, 145).

From this documentation three crucial points immediately emerge: the cycle was originally composed of six rectangular canvases; Paolo Finoglio was involved in the undertaking; and although it has sometimes been assumed that a Baptism of Christ must have figured in the overall scheme, the above accounts are silent regarding a depiction of this crowning moment in the Precursor's career.

The stylistic evidence, discussed below and in the text, confirms what these written records and common sense imply: namely, that the painters worked in close consultation with the intent of producing an esthetically and iconographically coherent set. Yet there had been no unanimity among scholars concerning the date of the series. Indeed, the canvases were located along a line stretching from the 1620s to 1650 until Pérez Sánchez (who dates the series 1634–35) observed that Francesco Guarino's Annunciation of the Birth of Saint John of 1637 in San Michele at Solofra adapts Stanzione's conception of the subject for the Buen Retiro cycle. Subsequent opinion, for the most part dependent upon stylistic readings, ranged the paintings between the late 1620s and the later 1630s.

It is both essential and possible to be more precise. Thus as Vannugli (followed by Schütze) also observed, the role of Paolo Finoglio alone suggests that the Life of Saint John was completed by the middle of the fourth decade, for in January of 1635 Finoglio is already documented in Puglia, in which region he then seems to have remained almost continuously until his death in 1645.

The chronological gap can be narrowed still further. Brunetti, Gregori, Pérez Sánchez,

Marshall, and Vannugli have advanced the direct or indirect presence of that master of architectural settings, Viviano Codazzi, in the vaulted loggia of Gentileschi's *Birth and Naming of Saint John*. While Viviano's distinctively precise hand cannot be detected in this unambitious structure, and although Artemisia was capable on her own of inventing perspective effects per se, the general appearance of the vaulted space may well reflect Codazzi's influence in Naples. (He was to collaborate with Gentileschi on other occasions—i.e., Figs. 157, 159, 162; Color Plates XXIII, XXIV.) The earliest document placing Viviano in Naples dates from January of 1634, and if (as some scholars believe) he had not arrived in that city before 1633, a reflection of his art in the *Birth of Saint John* would set the earliest limit for the painting.

A proposed reconstruction of the circumstances under which the commission was awarded likewise indicates a date of 1633 for the inception of the cycle and provides new insights into its character. As Brown and Elliott, Gregori, and Garrard submitted, and as now seems certain to Vannugli and the present author, the intermediary between the artists and the Spanish court was Manuel de Guzmán, Conde de Monterrey and Viceroy to Naples between May 14, 1631, and November 12, 1637. While it is not impossible that Monterrey let out separate contracts, Stanzione's primary responsibility for four of the six pictures suggests that he enlisted the assistance of Gentileschi and Finoglio under what may have been (see below) pressured conditions.

Thus it was that Garrard's realization that a solution to the dating problem might lie with specific activities at the Buen Retiro opened up for me—still unaware of Vannugli's contribution—an extremely promising line of inquiry. She recalled that a large shipment of pictures from Monterrey arrived in Spain from Naples in November of 1633, and that the Count returned home in August of 1638 with another cache of works, some of them for the Buen Retiro. Noting Guarino's adaptation of 1637 of Stanzione's *Annunciation of the Birth of Saint John*, Garrard (supported then by Contini) concluded that the Saint John series must have been part of the earlier consignment, as indeed Justi has proposed more than a century ago. (To

this can now be added the fact of Finoglio's absence from Naples beginning in 1635.) In itself this hypothesis is not conclusive for the dating of the Baptist group, for it seems to presuppose that Monterrey had seen to only two shipments from Naples. Notwithstanding the lack of precise documentation to the contrary, this need not have been the case, as Vannugli also stresses. Yet it did prompt the following question: For what location, specifically, within the vast Buen Retiro complex were the Saint John pictures designed?

In addressing this question Vannugli and I proceeded independently on extraordinarily similar lines. Von Barghahn writes that "the inventory of 1701, complete in its listing of the pictures in the Retiro, may be used to establish a hypothetical disposition of paintings during the reign of Philip IV." It is upon the assumption that very little of the interior decoration had been altered in about sixty years that she proceeds to construct iconographical programs for the rooms. For that containing the Saint John cycle, von Barghahn's elaborate interpretation more than strains credibility; the most diverse subjects are linked by the most tenuous threads. In my opinion, in many instances groups of similar pictures, supplemented by others, were simply hung together where there was space.

However, since one would expect that initially there was some thematic rationale, a logical explanation, as Vannugli also realized, would be that at least some of the works in the locations under issue here had been transferred from other venues. An ordering of the Saint John cycle in narrative sequence (a pattern *not* respected in 1701, it should be noted) is very revealing in this regard:

Annunciation to Zacharias, 1.88 x 3.37 m. (1701: 1.88 x 3.34 m., the *vara* at .835 m.)

Birth and Naming of Saint John, 1.84 x 2.58 m. (1701: 1.88 x 2.30, and thus apparently folded under at that time or incorrectly measured)

Saint John Taking Leave of His Parents, 1.80 x 2.63 m. (1701: 1.88 x 2.51 m.)

Saint John Preaching to the Multitude, 1.87 x 3.35 m. (1701: 1.88 x 3.34 m.)

Saint John in Prison, lost (1701: 1.88 x 2.51 m.)

251

Saint John Decapitated, 1.84 x 2.58 m. (1701: 1.88 x 2.51 m.)

While all six works are the same height, two of them (Figs. 140, 143) are wider by approximately 80 cm. And these two pictures, being first and fourth in the chronological sequence, begin groups of three canvases each. These facts prompted Vannugli and me to argue that the Saint John suite was conceived for a predetermined setting with its own defined measurements and architectural articulation. Years ago Tormo hypothesized that the site was a chapel dedicated to Saint John, an idea that was seconded by several scholars.

The next step beyond this general conclusion led Vannugli and me to the chapel of the Hermitage of San Juan at the Buen Retiro. One of seven such garden retreats there bearing the names of saints who had retired to the desert or had founded monastic orders, and built primarily of brick with a slate roof and pointed tower, the Hermitage of San Juan stood to the north of the main palace, on a site occupied since 1905 by the central post office (Figs. 137, 138). More or less paralleling the construction schedule of the palace, it began to rise in the spring of 1633, possibly in March, with the initial payment to the builders dating from May 30. On March 11, 1634, Bernardo Monanni, Secretary to the Tuscan delegation in Madrid, reported the completion of the Hermitage of San Juan, although it was not until April 25 that the bill from the carpenter who had provided six windows for its chapel was satisfied. Concurrently disbursements were made for the interior embellishment—May 21, 1633, "on account" to Miguel Viveros for painting and gilding the architectural framework of the altarpiece; May 25 to the Italian sculptor Giovanni Antonio Ceroni for the altarpiece then in progress; and July 30 to Pedro Núñez the low sum of 27 ducats for some paintings for the chapel. Obviously work for the interior was carried on elsewhere while the building itself was going up, to be installed after the structure was finished.

In the aforementioned inventory of 1701–3 the contents of three of the *ermitas* were found worthy of being recorded. In that of San Antonio only Velázquez's now famous *Saints Anthony and Paul the Hermit* was found. That of Santa María Magdalena contained three pic-

tures of the Magdalen's life. The hermitage of San Juan was bursting with paintings which Luca Giordano had produced for Charles II after 1692, to which were added a few minor pictures (including a *Baptism of Christ* measuring 1.05 m. wide x .835m. high and small images of Saint Francis de Paul and Saint Anthony of Padua "en el Vaçiado del Pedestal de la Coluna"), and an altarpiece described as "A Painting the main panel of the Altarpiece of three *varas* in height and two in width [2.51 x 1.66 m.] with a Saint John the Baptist in the desert original by Jacopo Tintoretto valued at two hundred doblones (*Una Pinttura la principal del rettablo de ttres Uaras de alto y dos de ancho con Vn San Juan Bapttistta en el desierto original de Jacopo tinttoreto tasada en doçientos Doblones*)." Von Barghahn has tentatively identified this as Tintoretto's (actually Domenico Tintoretto) *Baptism of Christ* in the Prado, but at 1.37 m. high x 1.05 m. wide that painting is much smaller. In other words, the Hermitage of San Juan had as its altarpiece not a *Baptism of Christ* but, as more appropriate to the retreat setting, a *Saint John in the Desert*, no doubt representing the saint in prayerful solitude. The canvases of the Saint John series had been transferred to the palace proper, probably, as Vannugli has suggested persuasively, following the fall from power in January of 1643 of the Hermitage's principal tenant, the Conde-Duque Olivares.

In consideration of the evidence regarding the Hermitage of Saint John, Vannugli theorizes that the Saint John cycle, while unlikely to have been included in the shipment of late 1633, could have been commissioned in that year, and was finished in 1634 or 1635. Given the astonishing speed with which everything at the Buen Retiro was pushed forward, it is probable that any canvases for the Hermitage would have been ordered as soon as the architectural plans had been drawn up—especially since the Hermitage of San Juan was on June 23, 1633, declared the official residence-retreat of the Conde-Duque Olivares, Gaspar de Guzmán, the moving force behind the entire Buen Retiro enterprise, who would have insisted that it be made ready posthaste. Fortunately for Olivares, his brother-in-law, the Conde de Monterrey, was then Viceroy of Naples and was in a posiion to command pictures of the best Neapolitan masters.

I submit that the Baptist cycle was ordered

in the spring of 1633 for the Hermitage of San Juan and that, possibly, it was among the cartloads of pictures that arrived in November of 1633—although to accomplish their feat Massimo, Artemisia, and Paolo would have to have executed their multifigured compositions at a breakneck pace. Vannugli speculates that Tintoretto's altar canvas was the *Saint John the Baptist* by the Venetian master which on November 28, 1633, Jerónimo de Villanueva bought from Diego Velázquez and intended for the Buen Retiro. This does not mean, however, that the iconography of the Saint John cycle—assuming for the moment that it was destined for the chapel—could not have been set before that point. It is entirely possible that months earlier the Tintoretto had been reserved for the altar but that the actual purchase was not made until November 28, 1633. Is it merely coincidental that two days earlier the arrival of Monterrey's consignment was announced?

Still, one must admit that even the notice of March 11, 1634, which signals the completion of the Hermitage of San Juan need not imply the termination of its embellishment. Construction of the first retreat, that dedicated to Saint Paul the Hermit, was finished already by January 15, 1633, yet a few more months were needed for its decoration, including the architectural/sculptural portions of its altarpiece. If, then, the Saint John narratives were destined for the Hermitage of San Juan, they would have been begun no earlier than 1633 and delivered no later than 1634.

This is fully consistent with a letter of July 20, 1635, from Artemisia Gentileschi in Naples to Grand Duke Ferdinando II de'Medici in Florence. Published by Fuda in 1989 and not considered by Vannugli, it begins:

> Altezza Serenissima,
> fu destra ventura di mio fratello, mandato con dui quadri per mio padre per presentare a V. A. S.ma; et poi, per ordine suo, si doveva il detto mio fratello traferirsi in Napoli per condurmi al servitio di Sua Maestà d'Inchilterra, che molte volte prima mi haveva richiesto a quel servitio et inviato l'istesso mio fratello; ma perchè mi trovo in Napoli al servitio di questo viceré, per dar fine ad alchune opere comingiate per S. M. Cattolica, non potei in nessuna maniera contentare la Maestà

> d'Inchilterra. E perché di Napoli detto re fu informato come ero alla fine delle dette opere, con la congentura che si trovava il detto mio fratello, li diedi ordine che mi dovesse condurre al suo servitio. Però, havanti che fare passaggio in quelle parti, mi accinsi operare in servitio di V. A. S.ma le presente opere, dopo havermi affaticato per servitio del signor duca di Parma et di Modena e del signor cardinale Antonio Barbarino.

Thus Charles I had dispatched Artemisia's brother (Francesco) to Naples to conduct the artist to England, where her father had been working since 1626. She had declined previous such invitations, pleading her need to finish "some paintings" which the current Viceroy (the Conde de Monterrey) had ordered from her on behalf of His Catholic Majesty (Philip IV of Spain). Hearing that these pictures were in their final stages, Charles renewed his command, but Artemisia, obviously reluctant to make the long trip and seeking compelling excuses to postpone if not avoid it, proceeded on her own initiative to execute works for the Duke of Modena (Francesco I d'Este), Cardinal Antonio Barberini, and Ferdinando II de'Medici with the hope of securing their patronage. The present letter, one to Galileo Galilei on October 9, 1935, and another of October (?) 20, 1635, to Andrea Cioli in Florence document Gentileschi's petitions to the Grand Duke, while correspondence between her and Cassiano dal Pozzo (January 21, 1635) and Francesco d'Este (January 25, March 7, and May 22, 1635) confirms her dealings with Rome and Modena, respectively (for the references see the relevant dates in Appendix I).

Artemisia turned to these canvases for Cardinal Barberini and the Duke of Modena *after* she had met her commitment to Spain, and since they were ready by January of 1635, the completion of the pictures for Philip IV must be set at least some months earlier. The *Birth and Naming of Saint John*—as the only Neapolitan work by Gentileschi now known to have been done for the Spanish King—was certainly among the paintings for Philip to which Artemisia refers (in the imperfect tense) in her letter of July 30, 1635. By this route as well we arrive at a terminal date of 1634 for the *Life of Saint John*.

Much less certain are where and how the pictures were hung in the Hermitage of San Juan, of which neither the interior arrangement nor the measurements are known. In his last contribution, that of 1994, Vannugli constructs and evaluates three schemes. One of them views the six paintings as part of the altarpiece of the chapel. According to this plan, Tintoretto's *Saint John in the Desert*, surmounted by the anonymous *Saint John Baptizing Christ*, would have been located on the central spine, flanked by the Saint John narratives stacked vertically three-by-three: the *Annunciation to Zacharias*, *Birth of Saint John*, and *Saint John Taking Leave* on the left, their left edges aligned; the *Saint John Preaching*, *Saint John in Prison*, and *Decapitation of Saint John* on the right, their right edges aligned. Through this alignment and by locating the two widest canvases (the *Annunciation to Zacharias* and the *Saint John Preaching*) at the summits, Vannugli respects chronological order and symmetry and creates space for the *Saint John in the Desert* and the *Baptism* in the center.

As the Italian scholar was well aware, there are problems with this conception. First, the proposed altarpiece, even without any framing elements, would have measured 5.64 m. (18½ feet) high and 7 m. (23 feet) wide, and thus (for example) would have been fifty-eight percent larger in overall size than Titian's gigantic *Assumption of the Virgin* for the Frari at Venice. The Hermitage of San Pablo, recorded in an etching of ca. 1665, was relatively impressive in scale, yet Velázquez's painting of *Saints Anthony and Paul the Hermit*, perhaps painted for its altar, is eight times smaller than the presumed altar of San Juan. And while, to judge from Texeira's map of 1656 (Fig. 137), the hermitage dedicated to Saint John was larger than that to Saint Paul, it is highly unlikely that the altar wall of its chapel could have accommodated the huge *retablo* suggested by Vannugli. Further, the horizontal orientation and the staggered design of the imagined altarpiece, its wings larger than and capable of overpowering the central image, seems infelicitous. On the other hand, an altar composed of Tintoretto's *Saint John in the Desert*, the *Baptism* (by Pedro Núñez?) above, and perhaps the small paintings of Saints Francis de Paul and Anthony on the base, set within a framework of poly-chromed and gilded architecture and of decorative (?) sculpture by Miguel Viveros and G. A. Ceroni, respectively, is feasible (and is hinted at by the Buen Retiro inventory of 1701). As noted above, the altar of the Hermitage of San Juan was in progress by May of 1633.

Schütze, apparently bothered as well by the grand dimensions of Vannugli's altarpiece scheme as presented already in 1989, supposes that the Saint John cycle decorated one of the other ambients—possibly the library—in the Hermitage of San Juan, with one of the larger canvases on each of the short walls and the others paired on the long walls. Vannugli has now carried further this proposal, noting that one could thereby read the narratives clockwise in chronological order, and on balance he finds it the most feasible. Yet as implied by its appearance on Texeria's plan, the Hermitage of San Juan was liberally supplied with windows all around, and as such would probably have excluded this alternative as well.

I believe that the chapel would be the most logical place to house the Saint John canvases and, further, that the first of Vannugli's three reconstructions—with three pictures on each of the long walls, the groupings introduced by one of the two wider pictures and mirroring one another—is the most likely. Tintoretto's *Saint John in the Desert* would then have served as a very fitting centerpiece. Even a chapel of modest length, thirty-five feet or so, would permit such a distribution. Conceivably two portals, one on each of the long sides, led from/into the adjacent apartments, thereby determining the relative sizes of the paintings.

I cannot insist upon this scheme, however. Quite aside from the lack of sufficient information regarding the plan of the Hermitage, this arrangement would not have permitted a continuous reading of the narrative and does not account for the fact that all the canvases are lit from left to right (although this is by far the preferred pattern).

What is clear is that the artists consulted with one another at every turn and—given the deadline under which they had to operate—may have contributed to one another's pictures. Artemisia's declaration in her letter to Ferdinando II de'Medici that she had worked on "alchune opere" for Philip IV may have been accurate. Surely it is not fortuitous that the

pensive woman, her chin resting on her hand, in Gentileschi's *Birth of Saint John* appears also among the listeners in Stanzione's *Saint John Preaching*, even as the very Cavallinesque shadowed maidservant in the left background of the former finds her counterpart in the onlooker at the far right of the latter. The tattered beggar in the *Annunciation to Zacharias* is also of a kind that was to turn up repeatedly in the pictures of Bernardo Cavallino, beginning with the *Adoration of the Shepherds* (Braunschweig, Herzog Anton Ulrich-Museum), probably contemporary with the Saint John series. Since Cavallino's early *Meeting of Joachim and Anna at the Golden Gate* (Budapest, Szépmüvészeti Múzeum) is unthinkable without Stanzione's *Saint John Taking Leave of His Parents*, Bernardo's participation as a member of the workshop in the Buen Retiro project is not to be excluded.

The rusticity and particularized realism of these canvases by Cavallino have called to mind the art of the Master of the Annunciation to the Shepherds. Among the Prado set, the *Saint John Taking Leave* stands out by virtue of its plainspoken naturalism. Moreover, as types, Saint Elizabeth in her turban-like headdress, the just-mentioned pensive woman, and the *repoussoir* seminude in the *Saint John Preaching* find correspondences in the Master's pictures. It is likewise true that the Buen Retiro cycle, the monumental *Leave-Taking* included, does not give evidence of the uniquely coarse qualities and heavy impastoes generally associated with the Master of the Annunciation to the Shepherds. There would therefore be little justification for assigning him a role in the series, as it would be risky to claim precedent for one or the other artist in the invention of the details signaled above. Nonetheless, these connections cannot be ignored, and they have implications for our understanding of the Master's sphere and dates of activity.

No doubt the unity of impression, including that of light and color, to be expected of such a cycle has been compromised by the varying conditions of the pictures. As discussed in the text, the need for consistency also apparently led to reciprocal stylistic adjustments.

Finally, in devising chronologies and recognizing influences, one should not underestimate the power of subject matter over stylistic decisions. The possibilities for rhetoric inherent in the themes of the *Annunciation to Zacharias* and *Saint John Preaching* may have induced Stanzione to muse upon the works of Domenichino in Naples, while the intimate scenes of the *Birth* and *Leave-Taking*, not lending themselves to grandiloquence, encouraged greater naturalism of the sort that would have attracted the Master of the Annunciation to the Shepherds. As for the *Decapitation*, in any event a moment of brutality set in a dungeon, it would have been difficult to forget Honthorst's version in Santa Maria della Scala at Rome (where Stanzione had also worked in 1617–18) and Caravaggio's in the Cathedral of Malta.

Before long Artemisia Gentileschi, Massimo Stanzione, and Paolo Finoglio were to be involved in another joint venture, this time for the Cathedral at Pozzuoli. It may now be seen that the dating of the Pozzuoli canvases, the object of considerable scholarly discussion, is clarified by the circumstances of the Buen Retiro cycle.

BIBLIOGRAPHY: L. Díaz del Valle, 1656–59, in Sánchez Cantón, 1933, II, pp. 339, 361; A. Ponz, *Viaje de España*, 1772–94, ed. Madrid, 1947, p. 536; A. Conca, *Descrizione odeporica della Spagna in cui spezialmente si da notizie spectante alle belle arti*, Parma, 1793, I, p. 148; K. Justi, *Diego Velázquez und sein Jahrhundert*, Bonn, 1888, I, p. 344 n. 1; Longhi, 1920–21 (in *Palazzo non finto*, 1995, p. 194); idem, *Scritti*, 1961, I-I, pp. 263, 281; A. De Rinaldis, "Massimo Stanzione al Prado," *Napoli nobilissima*, 2d series, I (1920), 45–46; E. Tormo y Monzó, *España y el arte napolitano (siglos XV al XVIII)*, Madrid, 1924, p. 17; Voss, 1925, p. 546; Brunetti, 1956, pp. 63 n. 28, 65; Pérez Sánchez, 1965, pp. 394, 452–54, 499; M. L. Caturla, *Pinturas, frondas y fuentes del Buen Retiro*, Madrid, 1947, pp. 38–44 (for the hermitages); Moir, 1967, I, pp. 137, 167; Bissell, 1968, p. 161; A. E. Pérez Sánchez in Madrid, Casón del Buen Retiro, *Pintura italiana del siglo XVII*, exh. cat., 1970, pp. 272–73 cat. 83, 530–37 cat. 175–78; M. L. Barreno Sevillano, "La restauración de pinturas de las colecciones reales durante el siglo XVIII," *Archivo español de arte*, LIII, no. 212 (1980), 488; Brown and Elliott, 1980, pp. 67–68, 73 fig. 39, 76 fig. 42, 77, 78 fig. 46, 80–82, 89, 92, 123, 125, 217, 244, 251, 254, 263 n. 52, 264 n. 87, 266 n. 27; G. Fernández Bayton, *Inventarios reales, testimentaria del Rey Carlos II, 1701-1703*, Madrid, 1981, II, pp. 313–14 nos. 455, 463, 465, 467, 469, 470, and 346 no.

869; L. Giusti in London, Royal Academy, 1982, p. 258 cat. 156; M. Gregori in Naples, *Civiltà del seicento*, 1984, I, p. 304 cat. 2.113; P. Leone de Castris, ibid., pp. 178, 475–78 cat. 2.254 and 2.255; A. E. Pérez Sánchez in Madrid, Palacio de Villahermosa, 1985, pp. 162–63 cat. 55, 306–13 cat. 131–34; B. von Barghahn, *Philip IV and the "Golden House" the Buen Retiro*, New York and London, 1986, I, pp. 29, 34, 152, 302, 306–8, 391–99, 447 n. 29, 449 n. 234, 553 n. 423; Garrard, 1989, pp. 97–99, 511 n. 163; A. Vannugli, *La collezione Serra di Cassano*, Salerno, 1989, pp. 64–61, 138–41 nn. 33–61; idem, "Stanzione, Gentileschi, Finoglia. Serie de San Juan Bautista para el Buen Retiro," *Boletín del Museo del Prado*, X (1989; publ. 1991), 25–33; Fuda, 1989, pp. 167–71; Contini in Contini/Papi, 1991, pp. 67–70, 178; Stolzenwald, 1991, pp. 39, 54 fig. 39; Schütze in Schütze/Willette, 1992, pp. 39 color pl. XI, 200–203 cat. nos. A30–A30IV, 297–99 figs. 144–46 and 147; Marshall, 1993, p. 155; A. Vannugli, "Stanzione, Gentileschi, Finoglia: le *Storie di San Giovanni Battista* per il Buen Retiro," *Storia dell'arte*, 80 (1994), 59–73, with extensive bibliography.

..

[33] Canvases for the Cathedral at Pozzuoli

Either partially misinformed or inclined to assign the most dramatic narratives to the creator of many *Judith and Holofernes* compositions, the Pisan writer Alessandro da Morrona nonetheless pointed the way to Artemisia Gentileschi's contributions to the series of paintings above the choir stalls in the Duomo at Pozzuoli: "le due grandi tele che adornano le pareti del Presbiterio della Cattedrale di Pozzuolo colle dipinte storie di S. Gennaro, che sono l'esposizione di lui nell'anfiteatro alle fiere, e la decollazione." More than a century was to pass, however, before Roberto Longhi, checking on Morrona's attributions, correctly identified Artemisia's canvases as the *Saints Proculus and Nicea*, the *Saint Januarius and His Companions in the Amphitheater*, and the *Adoration of the Magi*. Having survived the conflagration of May 16–17, 1964, which destroyed all but the areas of the choir and high altar and the Cappella del SS. Sacramento, the three pictures, all bearing authentic or putative signatures (see the individual entries below), were removed to Naples.

As Longhi may be credited with introducing

Gentileschi's works for Pozzuoli into modern art-historical literature, Angelo d'Ambrosio above all is to be credited with embedding them in the history of the Cathedral. This church, first cited in 1026, originated between 27 B.C. and A.D. 14 as a temple dedicated to Octavian Augustus. By June 28, 1631, when Martín de Leòn y Cárdenas assumed the Bishopric of Pozzuoli, it had fallen into disuse and disrepair. Less than six months earlier Naples had been spared from a violent eruption of Vesuvius, the faithful having invoked the name of Saint Januarius. The sorry condition of the Cathedral at Pozzuoli, dedicated to Saints Proculus and Januarius, and the miraculous salvation, would have provided impetus enough for campaigns of restoration, new construction, and embellishment.

The contract for redoing the original fabric dates from May 13, 1632, to be followed, as two inscriptions attest, by a consecration on April 30, 1633. Leòn y Cárdenas also ordained the building of a large choir with a separate space for the high altar, and in his *Relatio ad limina* of May 16, 1635, the Bishop testified to the completion of these areas. There appears to have been little or no break in activity. An inscription stone in the choir, above which Artemisia's *Saints Proculus and Nicea* hung, reads *"IN HONOREM. SS. MART. PROCVLI / ET IANVARII EPÎ TVTELARIVM / À FVNDAMENTIS. / AN. DÑI M D CXXXIII,"* while another, above the door to the side entrance of the Duomo, bears the date 1634 and the words *"EXCITAVIT, CONCINNAVIT, ET CONSECRAVIT."* Finally, a plaque on the high altar is inscribed "1636."

The *Relatio ad limina* of 1635 is silent regarding the pictorial decoration of the choir by Gentileschi, Lanfranco, Francanzano, and others, although it does list Agostino Beltrano's *Martyrdom of Saints Proculus, Januarius, and Philip* for the high altar. In recent years it has been assumed that the choir canvases were not commissioned until 1636, at the moment when all construction was terminated. Yet while it would have been most crucial from a liturgical standpoint to provide as soon as possible for the altar painting, the others could have been ordered at any time after the architectural plans had been finalized. Furthermore, one of the contributors to the Pozzuoli cycle was Paolo Finoglio, whose painting (also Museo di San

Martino, Naples) was described in 1640 as "s. Celso consecrato vescovo da s. Pietro." Already in 1635 Finoglio is documented in Puglia, in which region he then seems to have remained continuously until his death in 1645. It is therefore quite conceivable that some or all of the pictures in the series were in progress by the spring of 1635.

Eleven of them had been supplied by the time of the Bishop's *Relatio ad limina* of 1640, where they are ascribed to "Equite Joanne Lanfranco et aliis diversis famosis, et peritioribus Pictoribus." Three of the paintings in this important document (discovered by Alina Cuoco as reported by Bologna, and featured by d'Ambrosio) are listed as a *Nativity of Jesus, Saint Proculus and His Mother*, and *Saint Januarius and His Companions Exposed to the Beasts in the Amphitheater*. The last two citations are unquestionably to Artemisia's canvases of those subjects. Her *Adoration of the Magi* may confidently be identified as the *Nativity*, notwithstanding the presence of Francanzano's *Adoration of the Shepherds* and mention in the *Relatio* of 1646 of three pictures of the *Nativity*. It is wholly consistent stylistically with her other offerings here, and in the account of 1640 the *Nativity*, the first item, is followed by the *Christ on the Mount of Olives* which was once displayed above the *Adoration of the Magi*.

In March of 1640 Artemisia was in London, where she had arrived in 1638 (Chapter 4). Thus, although there are indications of collaboration in her pictures for Pozzuoli (see below), the canvases must have been delivered or at least were more or less ready by no later than the end of 1637 or the beginning of 1638. Within the wider limits of 1635–37/38, I would now set them to ca. 1635. Novelli, Gregori, and Garrard, with the benefit of new information that had come to light and therefore able to correct earlier opinions (e.g., Longhi, 1640–50; Bologna, 1646 and after; Scavizzi, ca. 1645; Causa, ca. 1644), have dated Gentileschi's part to 1636–37.

Beyond the issues of collaboration and, perhaps, that of a perceived need by the team of painters for decorative unity, judgments of Artemisia's canvases as a group must also consider their intended locations within the scheme and their physical condition. The *Relatio* of 1640 indicates that the "program" of the choir paintings began with scenes in the lives of Christ and the Virgin and then moved to the legends of saints who were of special importance in the history of Pozzuoli. However, since there is no narrative sequence to the latter, and since the pictures were removed for restoration on at least two occasions and additions and substitutions to the initial group were made, it is impossible to visualize the first setup. Still, as proposed in the text, the original positions of Artemisia's canvases were likely those which they occupied before the fire of 1964.

Gentileschi's canvases have undergone at least three restorations. In 1762 the Bishop of Pozzuoli, noting that the choir pictures "quae temporis diuturnitate pene consumtae erant," reported on one such operation under his sponsorship. Another was carried out in 1929, again on the authority of the residing Bishop. Prior to its appearance in the Naples-Athens exhibition of 1963, the *Saint Januarius* was worked on again, as were the others after the fire. Darkened, pulling away from their stretchers, their edges ruined, spotted with losses, and overcleaned in parts, the pictures had reached a poor state, which the subsequent restretching, cleaning, and repairs (some seemingly of a first-aid variety) only partly mitigated. Opinions regarding the quality and the stylistic stance (see Chapter 4) assumed by Artemisia's Pozzuoli works must therefore be put forward prudently.

BIBLIOGRAPHY: Morrona, 1792, II, p. 268, and ed. 1812, II, p. 485; P. Guérin, *Vies des saints*, Paris, 1866, IX, pp. 405, 409–15; Longhi, 1920–21 (in *Palazzo non finito*, 1995, p. 195); S. Bottari, *Storia dell'arte italiana*, Milan and Messina, 1943, II, p. 347; Brunetti, 1956, p. 65; R. Causa, *L'eruzione del Vesuvio nel 1631*, Naples, 1956, pp. 1–2 (n.n.); F. Bologna, *Francesco Solimena*, Naples, 1958, p. 127 n. 19; Réau, 1958, III, pt. II, pp. 706–8; Longhi, *Scritti*, 1961, I–1, pp. 263–64, 277 n. 66, 281; G. Scavizzi in Naples, *Caravaggio e i caravaggeschi*, 1963, p. 37 cat. 26; R. Causa in Naples, Castel Nuovo, 1964, p. 20; Moir, 1967, I, p. 100 n. 105; Bissell, 1968, pp. 159–60; A. d'Ambrosio, *Il duomo di Pozzuoli*, Pozzuoli, 1973, esp. pp. 21, 23, 27–31, 33–37, 63–67, including citations of documents in the Archivio Vescovile di Pozzuoli and the Archivio Segreto Vaticano; Novelli, 1974, pp. 68, 79 n. 10; P. Leone de Castris in London, Royal Academy, 1982, p. 43; P. Leone de Castris and M. Gregori in Naples, *Civiltà del seicento*, 1984, I, respectively p. 178 and pp. 305–6 cat.

2.114; Garrard, 1989, pp. 101–4, 512 nn. 166–72; Contini in Contini/Papi, 1991, pp. 66–67; Stolzenwald, 1991, p. 40; Marshall, 1993, p. 155; Sestieri in Sestieri/Daprà, 1994, pp. 91–92.

..

[33a] *Saints Proculus and Nicea*

Naples, Museo di San Martino (on deposit
from the Cathedral of Pozzuoli)
Oil on canvas, 3.00 x 1.80 m.
Ca. 1635
Fig. 146

Signed at the lower right: *AG* [interlaced] *F.*

Inscribed below, the second line redone: *S.
PROCVLUS LEVITA ET. NICEA EIVS MATER / MARTIRES ET
CIVES PVTEOLANI*

Deacon of Pozzuoli and companion to Januarius with whom he suffered martyrdom in A.D. 305, Proculus wears a dalmatic of deep red with gold trim over an alb. He stands within a vaulted hall that gives onto a temple, the latter presumably an allusion to the Roman structure that was to serve as the Duomo of Pozzuoli. Proculus is accompanied by his mother Nicea in a dark green mantle over a burnt-orange dress with sleeves of steel blue, and a white veil. Iconically disposed, the Saints hold martyrs' palms and look Heavenward.

In addition to the indignities noted above, the canvas was subjected to punctures and gashes. Some of the repairs had begun to break away, perhaps from the moisture which deposited salts on the surface.

The poor condition of the painting complicates the issue of collaboration which has been raised with respect to all of Gentileschi's contributions to the Pozzuoli series. Moir found (unspecified) workshop participation in the *Saints Proculus and Nicea*, while, more directly to the point, Bottari likened its setting to the art of Viviano Codazzi. Gregori has recognized Codazzi's hand in the architecture here and Marshall finds Viviano's intervention "plausible," a reasonable conclusion in view of its style (plunging perspective, the structural members picked out with lines of light, the careful execution of the temple which was apparently painted over a preexisting landscape) and of Codazzi's presumed role in Agostino Beltrano's *Martyrdom of Saints Proculus, Januarius, and Philip* for the high altar at Pozzuoli and beyond question in Artemisia's *Bathsheba* (Figs. 157,

159). Yet the rendering lacks Codazzi's crispness. I am inclined to attribute this not to surface abrasion but rather to the presence of another brush, specifically that of Domenico Gargiulo, whose responsibility for the architecture in Gentileschi's *Saint Januarius in the Amphitheater* ([33b]) appears to me certain. The background of Gargiulo's *Last Supper* in Santa Maria della Sapienza at Naples bears comparison.

For Garrard "the faces and upper drapery of Nicea are inconsistent in style with the figure of Saint Januarius," and the picture, "though probably composed by Gentileschi, is likely to have been finished by another artist." I do not find sufficient evidence for this contention, but it should be noted that the face of Nicea brings to mind Stanzione's female saints, in particular the *Saint Agnes in Prison* in the Museo di Capodimonte.

BIBLIOGRAPHY: See [33].

..

[33b] *Saint Januarius and His Companions in the Amphitheater at Pozzuoli*

Naples, Museo di San Martino (on deposit
from the Cathedral of Pozzuoli)
Oil on canvas, 3.08 x 2.00 m.
Ca. 1635
Fig. 147; Color Plate XXI

Signed at the lower right, beneath the tip of
the lion's tail: *Artemi . . . / Gentilesc. / F*

Saint Januarius, the Neapolitan-born Bishop of Benevento, returned to his hometown in A.D. 305 to encourage the Christians then under persecution by Diocletian. After surviving a furnace and exposure to wild animals in the amphitheater at Pozzuoli, he and his companions—including Proculus, no doubt the deacon at the left in Artemisia's picture—underwent martyrdom by decapitation. Gentileschi presented the details of the amphitheater incident with great fidelity to the legend: the setting; Januarius making the sign of the cross as others raise their eyes and praying hands to Heaven; the beasts as lion, lioness, and bear (not a mastiff as has been claimed); and the behavior of the animals, from ferocity to the meekness of the lion licking Januarius's foot.

The signature reported above appeared when the painting was cleaned after 1964, having been covered by what was considered by the conservators to be a spurious signature reading *"ARTEMITIA / G.ᴿᶜᴬ / F."* Like the other Pozzuoli canvases, the *Saint Januarius* has been treated unkindly by time and restoration, with particular damage suffered by the proper left side of Januarius's face. Against a setting of brown tones, the Bishop stands in his red cope over an alb, and golden mitre. Saint Proculus wears a maroon dalmatic with gold trim over white, the man above him a garment of steel blue.

Once again at Pozzuoli, the question of collaboration must be confronted. Bologna has assigned the sophisticated architecture to Viviano Codazzi, a suggestion accepted by Garrard with the qualification that Artemisia "gave the composition its final painterly unity." Brunetti, seconded by Gregori, finds rather in the amphitheater the hand of Domenico Gargiulo (Micco Spadaro), a frequent associate of Viviano's who could emulate the Codazzian architectural style with a more painterly touch. Sestieri inclines to this view, while Marshall entertains the ideas that Codazzi may have invented the architecture, its execution to be carried out by either Artemisia or Gargiulo. In my opinion, Gargiulo's responsibility for both the design and rendering of the amphitheater, as for the tiny spectators within it and for the trees and sky (Gregori), is probable. Conversely, the possible participation of Stanzione, posited but not specified by Leone de Castris, is very uncertain.

BIBLIOGRAPHY: See [33].

..........

[33c] *Adoration of the Magi*

Naples, Museo di San Martino (on deposit from the Cathedral of Pozzuoli)
Oil on canvas, 3.08 x 2.05 m.
Ca. 1635
Figs. 148–49

Before 1964 a would-be signature reading *"AR-TEME*[or *I*]*TIA G."* could be seen in the cut of the rock below the Madonna. Removed during cleaning, it was in all probability a later addition (cf. *Saint Januarius in the Amphitheater*).

The deterioration of the canvas has had especially dire consequences for the figures in the background, including the black Magus Balthazar, which have darkened and/or been absorbed into the preparatory ground.

Following pictorial convention, Artemisia indulges in a richness of costumes and color. The old Caspar sports a blue frock with ermine collar and a gold mantle as he kneels before the Madonna garbed in gray and blue. More splendid still is the youthful Melchior in his gold doublet over ruffed white shirt, dark blue sash, and wine-colored mantle highlighted in pink and trimmed in gold. Saint Joseph, dressed in blue and golden brown, assumes—as so often—a position in the shadows.

As with the *Saints Proculus and Nicea* and the *Saint Januarius*, scholars have discerned the presence of another artist's brush in this picture. Moir speaks generically of workshop participation, Longhi of the possible responsibility of Massimo Stanzione for the head of the Virgin, a suggestion which I once repeated. Garrard, however, while acknowledging "some generic relationships to Stanzione's female figures," is not convinced of Massimo's direct participation, the more so, she observes, as the head of Bathsheba in Gentileschi's painting at Columbus (Fig. 159) bears a strong similarity to that of the Pozzuoli Madonna. Nonetheless (see the text), the group of the turbaned Balthazar flanked by a hooded man and a youth in a red cap who turn toward the Magus may have been supplied by Stanzione. Finally, for the disposition of her Virgin and Child Artemisia seems to have found inspiration above all in Simon Vouet's *Saint Bruno Receiving the Rule of the Carthusian Order* (Fig. 116) for the Certosa di San Martino.

BIBLIOGRAPHY: See [33].

..........

[34] *Judith and Her Maidservant*

Copy after Artemisia Gentileschi
Milan, Relarte, 1964
Oil on canvas, .75 x .92 m.
Original ca. 1635
Figs. 150–51

Inscribed on the sword blade: *ARTEMYSIA / JAN?*

COLLECTIONS: Sotheby's, London, July 16, 1958, lot 155, by whom sold to Frampton;

259

Sotheby's, London, June 17, 1959, lot 102, by whom sold to Dent

The inscription "*ARTEMYSIA*" reported in the Relarte catalogue appears from the photograph to be continued on a second line by the letters "*JAN*." This misspelled "signature," its poorly formed characters disrupting the highlighting on (and thus flattening) the blade of the sword, was no doubt added when the painting entered an English collection.

Nonetheless, this would-be documentation may reflect a venerable attribution to Artemisia, and the claim for her authorship put forward in 1964 cannot be summarily dismissed. Even beyond the theme, references to Gentileschi's art abound: in the face of Judith, reminiscent of the *Clio* of 1632 (Figs. 121–22; Color Plate XVIII) and in all probability based on the same model who posed for the *Minerva* (Fig. 156); in the decorated U-shaped bodice with pendant over a lacy blouse, again closely comparable to the *Minerva*; and in the Abra with furrowed brow and rolled-up sleeve, a more wizened version of the typically Artemisian maidservant found, for example, in the Columbus *Bathsheba* and Madrid *Birth of Saint John the Baptist* (Figs. 159, 139; Color Plate XXIII). Thus while as a compositional type the picture stirs memories of those *Judith*s by Artemisia and her father from the beginning of the second decade (Figs. 31, 33, 40), its particulars locate the invention in the years around 1635.

Definitive judgments as to the *Judith*'s autograph status must await the reappearance of the painting. The photographic evidence in this instance seems particularly unreliable. The photograph reproduced here as Figure 150 records the *Judith and Her Maidservant* (28¾ x 36 in., or .73 x .914 m.) attributed to "A. Gentileschi" that turned up in the London trade in the late 1950s. It reveals a deteriorated canvas in dire need of conservation, executed with a liberal use of impasto which on the forehead of the maid takes on a heavy, corrugated quality more recollective of Ribera than of Gentileschi. Conversely, the illustration published by Relarte (Fig. 151) presents a picture with no apparent damage and of polished handling. Yet with the exception of slight variations in the napkins that hang from the baskets, the compositions and details of these canvases, as their sizes, are identical. Since, also, the picture that passed through Sotheby's in 1958 and 1959 was said to be "signed," the two *Judith*s must in reality be one and the same work, which by 1964 had been extensively restored and its true character further distorted in the process of being photographed and illustrated.

It is therefore best tentatively to regard the *Judith and Her Maidservant* as a seventeenth-century copy of a now lost original of Artemisia Gentileschi's most productive period in Naples and as a reaffirmation of a meditative strain in her personality. Contini, citing my reference of 1968, considers that at worst the *Judith* would be "a seventeenth-century copy of a painting by Artemisia datable to 1630–1635," while Bologna, unaware that the painting had been previously published and judging as well from a photograph, has illustrated it as an autograph work by Gentileschi. Bologna correctly likens it to the *Samson and Delilah* (Fig. 152) which canvas, however, he proposes to assign to Onofrio Palumbo (see [35]).

BIBLIOGRAPHY: Sotheby and Co., London, *Old Master Drawings and Paintings*, July 16, 1958, p. 22 Lot 155; idem, *Old Master Paintings*, June 17, 1959, p. 15 Lot 102; Milan, Relarte, *Maestri italiani del '600 e '700*, 1964, p. 46 and pl. 21; Bissell, 1968, p. 159 n. 51; Contini in Contini/Papi, 1991, p. 124; F. Bologna in Naples, Castel Sant'Elmo, 1991, pp. 142 fig. 146, 162.

[35] ***Samson and Delilah***

Copy after Artemisia Gentileschi
Naples, Museo di Capodimonte, Banco di Napoli Collection
Oil on canvas, size not recorded
Original ca. 1635
Fig. 152

Delilah in a low-cut purple gown passes locks of Samson's hair to her maid, who wears a white blouse and blue dress. The victim, garbed in a brownish maroon jacket and blue sleeves, has not yet awakened to his fate. The gesture of the accomplice may perhaps be interpreted as indicating the Philistines who will soon set upon the once invincible man.

The *Samson and Delilah* was restored before 1963, having suffered a number of paint losses and sinking of pigment (particularly on the flesh areas) into the reddish ground. This latter

feature and the coarse open-weave canvas, both of which call to mind above all the pictures of Bernardo Cavallino, immediately situate the work in Naples, while the pose of Samson is remarkably similar to that of the sleeping shepherd in various *Annunciation to the Shepherds* compositions by the Master of that name. Other elements point unequivocally to Artemisia Gentileschi, who might be expected to have treated the Samson and Delilah story. Thus the almost girlish Delilah finds her counterparts in Artemisia's depictions of Susanna and Bathsheba from ca. 1636–37/38 (Figs. 162, 169; Color Plate XXIV), and the maid could easily take her place among the servants in the *Birth of Saint John the Baptist* (Fig. 139) of 1633–34. As a compositional type the *Samson and Delilah* parallels the *Judith and Her Maidservant*, the conception of which I have dated to the years around 1635 (Figs. 150–51; [34]).

Understandably, then, the canvas bore an attribution to Artemisia Gentileschi when it entered the Banco di Napoli Collection. Artemisia's authorship has recently been affirmed by Papi and, more forcefully, by Contini, the latter dating the work to Gentileschi's Neapolitan years. In my opinion, which I first stated in 1968, the quality of the execution does not come up to Artemisia's standards, and the picture is best classified as a copy (as Garrard, followed by Stolzenwald, has also realized). Textures are uniform and the light lacks vitality, producing an unattractive sameness of surface for which the painting's state of preservation cannot, I think, be held accountable. Some of the shadows are too schematic, others rather crudely rendered. Gentileschi's original of ca. 1635 has not been identified, but it should be noted that in 1820 a picture described as "A. Gentileschi: Dalia und der schlafende Simson" was catalogued as no. 914 in the Esterházy Collection at Budapest.

In assigning the invention of the Naples composition to Artemisia I have given due consideration to the following alternative proposals: Building upon an oral suggestion made by Ferdinando Bologna in 1979, Riccardo Lattuada argued for a probable attribution of the *Samson and Delilah* to Domenico Fiasella (1589–1669) during the 1620s, a point of view subsequently embraced by Rossana Muzii and Sebastian Schütze, although all authors observe the picture's ties to Artemisia. This proposed ascription to Fiasella is simply not sustainable, as also Contini has observed, the more so as some of the paintings introduced as comparative evidence are themselves dubiously given to the Genoese master. Furthermore, Bologna has now rejected the Fiasella attribution for which he was originally responsible in favor of Onofrio Palumbo. While thus placing the canvas in its proper ambient, Bologna presents no evidence for Palumbo's authorship, and undermines his claim by correctly likening the *Samson and Delilah* to the aforementioned *Judith and Her Maidservant* which he considers to be an autograph work by Artemisia Gentileschi.

BIBLIOGRAPHY: S. Meller, *Az Esterházy Képtár Története* (Histoire de la Collection Esterházy), Budapest, 1915, p. 233, as reported by Szigethi, 1979, pp. 36 n. 8 and 42, incl. nn. 20–21; Bissell, 1968, p. 167; R. Lattuada in B. Molajoli, N. Spinosa et al., *Il patrimonio artistico del Banco di Napoli*, Naples, 1984, pp. 40–43, with two color pls.; R. Muzii in N. Spinosa, *Capolavori della collezione d'arte del Banco di Napoli*, exh. cat., Naples, 1989, pp. 30–31, with color pl.; Garrard, 1989, p. 518 n. 234; Contini in Contini/Papi, 1991, pp. 79–80, 189; Papi, ibid., p. 145; Stolzenwald, 1991, pp. 46, 56 fig. 41 in color; F. Bologna in Naples, Castel Sant'Elmo, 1991, pp. 142 fig. 147, 162; Schütze in Schütze/Willette, 1992, pp. 26, 62 n. 62.

..

[36] *Minerva (Sapienza)*

Florence, Soprintendenza alle Gallerie
Oil on canvas, 1.31 x 1.03 m.
1635–1636?
Fig. 156

Signed in a quarter-circle on the shield:
ARTEMISIA GENTILESCHI FACIEBAT

COLLECTIONS: Acquired by the Soprintendenza in 1926 from the Ufficio Esportazione, and subsequently on deposit in the Uffizi and Palazzo Pitti

Abraded, and honeycombed with fine cracks, as if having been baked, the canvas is in mediocre-poor condition.

The iconography of this Personification of Wisdom and its self-laudatory orientation are discussed in the text. Garrard does not consider the self-referential nature of the work, but

rather argues at length for an identification of the painting as an *Allegorical Portrait of Anne of Austria as Minerva*, Anne who in November of 1615 became the wife of Louis XIII of France and thus daughter-in-law to Marie de'Medici. Garrard constructs her case upon five main arguments: namely, that (a) the picture has a Medici provenance; (b) imagery linking both Marie de'Medici and Anne of Austria to Minerva was widespread; (c) Marie would have been apprised of Artemisia's reputation and Artemisia of Marie's activities, to the point that the commission for the *Minerva* might well have originated with the Queen Mother; (d) although significantly transformed, the features of Anne are recognizable in Gentileschi's portrait; (e) the canvas dates to Artemisia's Florentine period, specifically around 1615, the year of Anne's marriage.

Even if it is assumed for the moment that the *Minerva* is without those allusions to the artist claimed in the text, Garrard's hypothesis may be challenged on several counts. First, while allegorical portraits of Anne of Austria and Marie de'Medici abound, as Garrard clearly demonstrates, all of them are later than the date assigned by Garrard to Gentileschi's painting. Artemisia's *Minerva* would therefore have been unprecedented—not an impossible but surely not a predictable circumstance. Second, although Artemisia's ties to Florence during the second decade and Orazio Gentileschi's presence in Paris from 1624 to 1626 provided occasions for Artemisia and Marie de'Medici to have become aware of each other, the artist's letters are silent about any association between the two formidable women (as Garrard concedes). Inasmuch as Artemisia repeatedly attempted to use to her business advantage the names of her prominent patrons, this is a conspicuous silence. Furthermore, a Medici provenance for the *Minerva* is not documented, although some connection of the canvas to the Florentine court is possible (see below). The painting was acquired in 1926 from the Ufficio Esportazione, presumably in Florence but with an otherwise unknown history. The designation "Inventario Gallerie, 1890, n. 8557" now assigned to the *Minerva* means that, as in hundreds of other instances, the picture has been added to the base inventory of the Florentine Galleries compiled in 1890 and not, as has

been thought, that already in 1890 it was listed as state property.

In addition, as Hersey also observes, the features of Gentileschi's woman simply are not recognizably those of Anne of Austria—not even behind the idealization to be expected of a personification. In 1615 Anne was but fourteen years old, and while it is in the nature of allegorical portraits to render their subjects more youthful than in fact they were, it may be wondered why about 1615 Artemisia would figure Anne as a stalwart mature woman. And to locate the *Minerva*, signed "GENTILESCHI," in the artist's Florentine period would be to identify it as one of only two exceptions among the many documents (artistic and written) of those years in which Artemisia's surname Lomi does not appear (see Chapter 2).

Finally, the style of the *Minerva* is incompatible with that of Artemisia's Florentine productions. The realism that had characterized the *Conversion of the Magdalen* of ca. 1617–20 (Fig. 70; Color Plate V), a female figure seated in a comparable position, is here exchanged for a "stereotyped classicism" (Borea). Gone is that intense probing of the presented, the eye and the brush that lingered over portrait features and small anatomical details, that were not content until every drapery fold was intricately described and accurately rendered as to texture. Now, with a feeling of mastery that came with decades of work, Gentileschi paints Minerva's body and dress with a broadness bordering, relatively speaking, upon the perfunctory. Granting that the *Minerva* would be "atypically classicizing" for Artemisia during the second decade, Garrard thinks to find here an "underlying vitality," "naturalistic touches," and, in the Medusa head, a "crude liveliness" that make of the picture "a somewhat awkward hybrid of the real and the ideal" explainable by the picture's supposed conflation of Anne of Austria and Minerva.

In my opinion, the most salient stylistic and expressive parallels are to be found among some of Gentileschi's canvases from the 1630s (in Borea's view even later than that). Specifically, it is best likened to the *Self-Portrait* (Fig. 119) of 1630 (?) and the *Clio, Muse of History* from 1632 (Figs. 121–23; Color Plate XVIII). In these three pictures of similarly posed women with various allegorical attributes, as probably

in the now-lost *Fame* for Charles I ([L-30]), Artemisia proclaims her personal and professional status.

It may be possible to establish the date of the *Minerva* with some precision. Seven letters from the years 1635 and 1636 written by or to Gentileschi, then in Naples, reveal that the artist was in contact with Florence at that time, the first such documentary evidence of her dealings there since 1620. A composite reading of these letters (see Appendix I under the dates May 22, September 24, October 9, October 20, and December 11, 1635, and February 11 and April 1, 1636) yields the following: Artemisia, wishing to obtain the patronage of Grand Duke Ferdinand II, to whom in one instance she wrote directly, enlisted the aid of Galileo Galilei and the Grand Duke's Secretary Andrea Cioli, and sent Ferdinand two large paintings ("dui quadri grandi"). As, in effect, down payments for future efforts on her behalf, Gentileschi informed Cioli of her desire to present him with a *Saint Catherine* by her hand and a painting by her daughter. Two months later, on February 11, 1636, she asked the Secretary whether the picture intended for him should be shipped or delivered in person. Beginning on May 22, 1635, and as late as April 1, 1636—on which date the known Florentine correspondence stops—the artist spoke of proposed trips to Florence.

It is not known whether Artemisia actually made one or more of these journeys, but the two large canvases for the Grand Duke did arrive in Florence. The *Minerva*, by virtue of its relatively modest size, would not appear to qualify as one of these gifts; conceivably it is the work promised to Cioli in February of 1636. In any case, during the years into which the *Minerva* appears to fit on stylistic grounds, Artemisia had reintroduced her art to the court at Florence, in which city the *Minerva* was to turn up centuries later. And the appropriateness of its allegorical theme to the Medici seems clear enough (see the text).

BIBLIOGRAPHY: Ortolani et al., 1938, p. 317; Bissell, 1968, p. 161; Borea, 1970, pp. 79–80 cat. 52; M. Gregori in Naples, *Civiltà del seicento*, 1984, I, p. 147; Garrard, 1989, pp. 48–51, 159–64 and corresponding notes; Contini in Contini/Papi, 1991, pp. 70, 85 n. 29; Stolzenwald, 1991, pp. 24, 28 fig. 21, 33; Her-sey, 1993, p. 333 n. 65. And the relevant items in Appendix I specified above.

..

[37] *Bathsheba*

Columbus, Ohio, Museum of Art
Oil on canvas, 2.65 x 2.10 m.
Ca. 1636–1637/38
Figs. 132, 157, 159; Color Plate XXIII

COLLECTIONS: Almost certainly Luigi Romeo, Barone di San Luigi, Naples, by 1742; Antiquario Tarchini, Rome, from whom purchased by Carlo Sestieri, Rome, ca. 1960, and thence to P. and D. Colnaghi, London, June, 1962; acquired by Columbus from Colnaghi, February, 1967, Frederick W. Schumacher Trust Fund

The canvas was restored in 1979 in the Intermuseum Laboratory at Oberlin, Ohio, and again in 1996 by Mark Tucker of the Philadelphia Museum of Art, who has recognized four or five previous interventions. Reports detailing the damages (including a large tear across the torso of the kneeling servant and the severely rubbed landscape), the construction of the support, ground, and pigment, and the conservation treatment are on file with the Registrar at the Columbus Museum. *Pentimenti* are prominent throughout, most notably in the architecture, whose pedimented doorway was first conceived as being larger and higher and displaced toward the left. Parts of the large balustrade also assert themselves through subsequently superimposed forms. In fact, the execution of the setting in all its elements preceded that of the figures and vessels.

To the text discussion of the iconography can be added the fact that the sculptural embellishment of King David's palace serves at least in part as a gloss to the narrative. Thus, above the shell niche is a stone relief depicting seven figures, one of whom reclines and two of whom carry bundles. Not a gratuitous decorative fill, its imagery can be related to David's plans for Uri'ah, Bathsheba's husband, as recounted in II Samuel 11: 8–9: "Then David said to Uri'ah, 'Go down to your house and wash your feet.' And Uri'ah went out of the king's house, and there followed him a present from the king. But Uri'ah slept at the door of the king's house with all the servants of his lord, and did not go down to his house." While another relief, to the right of the niche and partially obscured by

a tree, is indecipherable, the statue of a lion topping the corner of the balcony may be taken as a traditional guardian figure and as referring to David as the "Lion of Judah" and to the lion(s) which as a youth he is said to have slain. Finally, the pediment supports a stone ensemble of two reclining women framing a heraldic shield (discussed below).

The *Bathsheba* was first published in 1963 and identified as the painting signaled in 1742 by Bernardo de Dominici in his biography of Domenico Gargiulo (Micco Spadaro): "In casa del fu dott. Luigi Romeo, barone di S. Luigi. . . . Due quadri grandi con figure al naturale, che esprimono le storie di Bersabea, e Susanna, che sembran di mano di Guido son dipinti dalla famosa Artemisia Gentileschi, e l'architettura di Viviano, con gli arbori, e vedute dello Spadaro." This identification, and the claim that the *Bathsheba*'s "pendant, the *Susanna,* accompanied it until quite recently," necessitated considerable faith, being unsubstantiated by documentation. The *Bathsheba* was purchased at Rome by Colnaghi in 1962 from Carlo Sestieri, who informed me that he had acquired it from the dealer Tarchini, since deceased, who professed no knowledge of the *Susanna.*

However, in spite of the strange silence regarding its earlier peregrinations, the Columbus canvas can confidently be assigned a Romeo provenance (a viewpoint which other scholars, with the exception of Contini, would accept with varying degrees of certitude). First, as detailed in the text, it reveals beyond question the participation of Viviano Codazzi and Domenico Gargiulo. It is also characteristic of Gargiulo, as witness his contribution to the *Triumphal Arch with Saint Peter Healing the Lame* in the Museo di Capodimonte at Naples, that relief sculpture should comment upon the wider story. Second, a *Susanna,* its history even more shrouded in mystery and its size identical to that of the Columbus picture, turned up in London. In full stylistic harmony with the *Bathsheba,* this *Susanna* was once almost certainly its companion (Fig. 162; Color Plate XXIV; [38]). Furthermore, a *Bathsheba* by Francesco Solimena once with Heim was inspired by Artemisia's rendition, indicating that the latter was accessible in Naples.

That the *Bathsheba* was painted specifically for a member of the Romeo family cannot be determined, although the escutcheon, which I have examined with a magnifying glass, tauntingly holds out this possibility. It is composed of a vertical staff without crook flanked by two shell-like configurations, hinges upward. The letter "M," followed by now illegible letters and/or numbers, appears below. A search through Vittorio Spreti's eight-volume *Enciclopedia storico-nobilare italiana* has yielded only two armorial devices which at all resemble that in the Columbus picture. One (Fig. 154), with a pilgrim's staff bearing a calabash and flanked diagonally by pilgrims' shells is, appropriately, that of the Pellegrini, a noble family of Capua near Naples. The other (Fig. 155) shows a pilgrim's staff between three shells and a branch of rosemary. Further removed than is the Pellegrino escutcheon from the Columbus coat of arms, this is nonetheless the shield of, precisely, the Romeo. Conceivably Gargiulo was aware that the Romeo crest contained references to pilgrimage but made no attempt to provide more than a generic equivalent.

I have attempted to confirm a Romeo pedigree for the Columbus *Bathsheba* in full awareness of a document discovered by Eduardo Nappi among the Banco di Napoli books, according to which on May 5, 1636, Artemisia received 250 ducats as final payment on a contract of 600 ducats for three large pictures of *Bathsheba,* *Susanna,* and *Lucretia,* which were to be consigned immediately to Prince Karl Eusebius von Liechtenstein: "A Lorenzo Cambi e Simone Verzone D. 250. E per loro ad Artemisia Gentileschi, dite se li paghino a compimento di D. 300 che li altri D. 50 l'ha recevuti contanti, dite in conto di D. 600 che l'ho dato d'ordine dall'eccellentissimo principe Carlo de Lochtenten si li pagano per valore di tre quadri consistenti in una Betsabea, una Susanna et una Lucretia, ognuno del quale d'altezza d'undici palmi e mezzo da dare e consignare di tutto punto. E per lei all'Alfiere Costantino del Cunto per altritanti." The height of the Columbus canvas is smaller by some 39 cm. (15⅓ inches) than were the declared heights of the pictures that Artemisia had ready by the spring of 1636 (11½ Neapolitan *palmi* = 3.04 m.). Yet since reported measurements are often approximate only, this discrepancy would not in itself exclude the present painting. Moreover, no other versions of *Bathsheba* and *Susanna* by

Gentileschi can be connected to the 1636 account (for reasons stated or implied under [40], [45], [46]). Nonetheless, Artemisia, having received full compensation, would surely not have reneged on her obligations to Prince Karl through his agents in Naples, and thus have sold the three pictures to an Italian buyer. Dominici does not cite a *Lucretia* in Romeo's collection, and a canvas of this theme has never been associated with the Columbus *Bathsheba* and the London *Susanna*, whose very compositions appear to have been conceived as a *pair* (again Chapter 4). And one can mount something of a tenuous argument that the *Bathsheba* for Vienna closely resembled Artemisia's painting now in Halle (Fig. 169; for the details, see [40]), even if the two canvases cannot reasonably be identified as one and the same.

The Banco di Napoli document does prove, however, that as early as 1635–36 Artemisia was involved with the iconography of Bathsheba and Susanna in paintings designed as part of a set. The Codazzi-Gargiulo partnership had probably been forged by this time, and about 1635 Gargiulo assisted Gentileschi, I believe, with two of her three canvases for the Duomo at Pozzuoli (Figs. 146, 147; Color Plate XXI; [33a] and [33b]). Just before that (ca. 1633–34) Artemisia had been involved in another collaborative project, working with Massimo Stanzione and Paolo Finoglio on a cycle of the Life of Saint John the Baptist for the Buen Retiro at Madrid ([32]). Particularly relevant to the present discussion is the fact that the maid with rolled sleeves who leans on a basin in the *Bathsheba* is an adaptation in reverse of the kneeling midwife in Gentileschi's *Birth of Saint John*, while her facial type is that of the midwife holding the child. Comparable as well are the physiognomy and pose of the attendant who combs Bathsheba's hair and the standing woman in the Prado picture. Conversely, the contemplative Columbus *Bathsheba* is at some remove from the *Bathsheba*s that follow (Figs. 180, 184, 188, 200, 201), canvases under the impact of Artemisia's stay in England (1638–ca. 1640) and marked by expressive superficiality. These considerations, as also the forceful lighting and powerful physical presences, signs still of Artemisia's Caravaggesque leanings, indicate a date of ca. 1636–37/38 for the *Bathsheba*.

I must therefore reject my earlier contention that the work belongs to the years 1640–45. This suggestion, at one time generally followed in the literature, has also been reevaluated by others. Thus Garrard, although assigning the canvas to the early 1640s, has considered that it might be backdated to the later 1630s, and the Sotheby's sales catalogue appears to entertain either possibility. Stolzenwald places it ca. 1640, Contini to the 1630s, and Sestieri to shortly after 1635. And Marshall, confronting in detail the nonfigurative elements of the *Bathsheba* (with reason he gives also the large balustrade to Codazzi), concludes that "the evidence of . . . Codazzi's and Gargiulo's contribution favours a date either after, or shortly before, Artemisia's trip to England"; that is, "shortly before 1638, or ca. 1641." While his inclinations are to prefer the later dating, Marshall allows that "an analysis of Artemisia's contribution is likely to be more conclusive on the question of dating." Such an analysis, as I have attempted to show, points to a brief period just prior to Artemisia's departure for London. This conclusion is not contradicted by the virtual interchangeability (observed by Marshall) between Gargiulo's pediment figures in the Columbus *Bathsheba* and those above the Saint Peter frescoed by Gargiulo on the altar wall of the Coro dei Fratelli Conversi at the Certosa di San Martino, part of that extensive project to which Codazzi apparently contributed, for which the total payment to Domenico was recorded in March of 1640, and which most authorities set to the years 1638–40. Further, by 1641, the year of his earliest known signed pictures, Codazzi was already a mature master in full control of the kinds of features that mark the *Bathsheba*. One's conception of the reciprocity between Neapolitan artists of this period is enriched by the character of the young woman presenting jewelry to Bathsheba, for she bears the hallmarks (see the text) of the art of Bernardo Cavallino, who may also have participated in the execution of the *Susanna*.

BIBLIOGRAPHY: Dominici, ed. 1844, III, p. 414; Spreti, 1932, V, pp. 783–85; "Notable Works of Art Now on the Market," *Burlington Magazine*, CV (1963), suppl. III, opp. p. 292; London, Colnaghi and Co., 1963, Lot 25; M. Waddington, "Esposizioni di maestri antichi nelle gallerie londinesi," *Antichità viva*, II, no. 7 (1963), 52, 54, 55 fig. 4; M. S.

Young, "Three Baroque Masterpieces for Columbus," *Apollo*, LXXVI, no. 65 (1967), 78–79; Bissell, 1968, p. 163; Fredericksen and Zeri, 1972, pp. 55, 78, 80; F. Richardson in *The Frederick W. Schumacher Collection*, Columbus Museum of Art, 1976, pp. 173–75; Catherine Glascow, Columbus Museum of Art, letter to the author, May 1, 1978; Greer, 1979, p. 205; Gorsen, 1980, pp. 80–81; E. Schleier in London, Royal Academy, 1982, p. 47; Nappi, 1983, p. 76; G. Briganti et al. in *I pittori bergamaschi dal XIII al XIX secolo: il seicento*, I, Bergamo, 1983, p. 689 cat. 15; Carlo Sestieri, Rome, letter to the author, November 15, 1984; Garrard, 1989, pp. 121–22, 516 n. 213; Patrick Matthiesen, London, letter to the author, October 30, 1989; Contini in Contini/Papi, 1991, pp. 178–79; Stolzenwald, 1991, p. 95 fig. 59; Marshall, 1993, pp. 6–7, 9, 11, 153–55 cat. VC55 and p. 155 cat. VC56; Sestieri in Sestieri/Daprà, 1994, pp. 3, 90–91 cat. 22; London, Sotheby's, December 6, 1995, Lot 53; Pagliarulo, 1996, p. 154.

For the comparative material regarding Codazzi and Gargiulo: F. Bologna in G. Doria et al., *Settecento napoletano*, Naples, 1962, p. 60 and pl. XVIII; Marshall, 1993, pp. 116–17 cat. VC32, 132–33 cat. VC 41; Sestieri in Sestieri/Daprà, 1994, pp. 28–29, 206–7 cat. 84, 271–72 cat. 130; Daprà, ibid., pp. 120–21 cat. 43, 130, 412.

For the relevant Cavallino bibliography, see Chapter 4, note 125.

..

[38] *Susanna and the Elders*

London, Sotheby's, sold December 6, 1995
Oil on canvas, 2.65 x 2.10 m.
Ca. 1636–1637/38
Fig. 162; Color Plate XXIV

COLLECTIONS: Almost certainly Luigi Romeo, Barone di San Luigi, Naples, by 1742; Private Collection, London

Susanna, seated on a maroon tasseled pillow and white linens enwrapping her right thigh, is cautioned to silence by an elder in a blue coat and vivid red mantle. The other elder wears a coat of burnt-orange with watery yellow highlights. It would appear that the tonality of the whole would lighten with the removal of yellowed varnishes.

For reasons best known to others, my efforts over several years to ascertain the name of the owner of the *Susanna* and the circumstances under which it came into his possession were unprofitable. I did not then have the opportunity to view the painting during its brief recent

appearance on the art market. In partial compensation, the color transparency and a body of circumstantial evidence convince me of Artemisia Gentileschi's prime responsibility for the canvas.

In his biography of Domenico Gargiulo (Micco Spadaro) published in 1742, the Neapolitan writer Bernardo de Dominici located "in casa del fu dott. Luigi Romeo, barone di S. Luigi" large paintings of *Bathsheba* and *Susanna* which he attributed to Artemisia in collaboration with Gargiulo and Viviano Codazzi: "Due quadri grandi con figure al naturale, che esprimono le storie di Bersabea, e Susanna, che sembran di mano di Guido, son dipinti dalla famosa Artemisia Gentileschi, e l'architettura di Viviano, con gli arbori, e vedute dello Spadaro." As detailed under [37], the *Bathsheba* is undoubtedly the picture now in the Museum of Art at Columbus, Ohio (Figs. 157, 159; Color Plate XXIII). It may be argued with equal authority that the London canvas is the *Susanna* that once accompanied it in the Romeo Collection, even though documentary proof of a Romeo provenance is lacking. The Columbus work was acquired about 1960 by Carlo Sestieri from the Roman dealer Tarchini, who according to Dott. Sestieri (letter to the author) professed no knowledge of the *Susanna*. However in 1963, when the *Bathsheba* appeared on the London art market, an (unsubstantiated) claim was made that "its pendant, the Susanna, accompanied it until quite recently." Inasmuch as the facts concerning the later history of the London *Susanna* have been obscured, these inconsistencies must for the moment remain puzzling.

Yet coincidences between the two paintings are manifest. The dimensions of the *Susanna* are identical to those of the Columbus picture, and *pentimenti* in both canvases indicate that a similar pattern of superimpositions over previously painted sections of the balustrade was observed. As Spinosa and others have recognized, in the *Susanna* Artemisia again profited from the Domenico Gargiulo-Viviano Codazzi partnership; specifically, as I have contended in the text, Gargiulo painted the landscape and in all likelihood the architecture as well, the latter following Codazzi's design (as Marshall also believes). Furthermore, the *Bathsheba* and the *Susanna* form a harmonious pair composition-

ally, particularly when the *Susanna* is placed at the right (see the text).

And as the lady-in-waiting offering jewelry to Bathsheba bears unmistakable relationships to the art of Bernardo Cavallino, so do the elders in the *Susanna*. Noting close parallels to autograph pictures by Cavallino, I have in the text concluded that Bernardo may well have executed the elders following Artemisia's instructions. I have done so while conceding that, for reasons advanced with respect to the Columbus *Bathsheba*, the London canvas is to be dated about 1636–37/38; that is, to the years just prior to Artemisia's English journey and thus at least a decade in advance of some of the paintings by Cavallino cited for comparison.

It may be the collaborative character of the painting that has prompted Contini to equivocate regarding its attribution, finding the canvas "notevole, ma difficile" while noting similarities between the head of Susanna and that of Delilah in the *Samson and Delilah* at Capodimonte (Fig. 152).

BIBLIOGRAPHY: Dominici, ed. 1844, III, p. 414; "Notable Works of Art Now on the Market," *Burlington Magazine*, CV (1963), suppl. III, opp. p. 292; London, Colnaghi and Co., 1963, cat. 25; Carlo Sestieri, Rome, letter to the author, November 15, 1984; Spinosa, 1984, color pl. VII and pl. 424; Patrick Matthiesen, London, letter to the author, October 30, 1989; Contini in Contini/Papi, 1991, p. 113; Marshall, 1993, pp. 153–55; Sestieri in Sestieri/Daprà, 1994, pp. 3, 92 cat. 23; London, Sotheby's, December 6, 1995, Lot 53, color ill.; Pagliarulo, 1996, p. 154.

For the relevant Cavallino bibliography, see Chapter 4, notes 126–28.

..

[39] *Lot and His Daughters*

Toledo, Ohio, Museum of Art
Oil on canvas, 2.305 x 1.83 m.
Ca. 1636–1637/38
Figs. 163–66; Color Plate XX

COLLECTIONS: Luigi Romeo, Barone di San Luigi, Naples (conjectured); Private Collection, Switzerland; New York art market, 1983, when purchased by Toledo, Clarence Brown Fund

Painted on a coarse Neapolitan canvas, its warp and woof forming distinct and regularized rows of small squares, the picture is marked by un-equal states of conservation, from the well-preserved azures, the dress of the daughter at the right, and Lot's coat to the extensive deterioration of the mantles of Lot and his other daughter. Spinosa has spoken of an "old, ill-advised cleaning," but, as explained by Gabrielle Kopelman, the degeneration noted is to be imputed chiefly to the artist's technical procedures: "All oil paint, when thinly applied, tends to become somewhat translucent with the passage of time, but when the proportion of medium to pigment is exaggerated, this tendency becomes pronounced. The pigment is lost—almost drowned—in a sea of medium. The delicate paint layer, opaque when applied, turns in time into a glaze, allowing the ground—in this case a dark one—to shimmer through and darken the color."

The *Lot and His Daughters* was acquired by the Toledo Museum of Art in 1983 as a work by Bernardo Cavallino, and as such it was catalogued (with an equivocation or two) by Nicola Spinosa for the Cavallino exhibition at Cleveland the following year. Concurrently, the ascription to Bernardo was rejected by the organizers of the show, Percy and Lurie, while other scholars suggested attributions to Antonio de Bellis, Francesco Guarino, Onofrio Palumbo, or Artemisia Gentileschi. In a talk delivered at Cleveland in November 1984, I proposed that the canvas was by Cavallino following precise guidelines established by Artemisia. Subsequent published opinions continued the debate by assigning the picture to Agostino Beltrano (Grabski, admitting some reservations), to Annella de Rosa (Novelli), or to Artemisia (Stoughton and, with even greater conviction, Garrard, whose arguments regarding attribution and date Contini finds "molto persuasivi"). Apparently they also persuaded Sestieri, who illustrates the picture under Artemisia's name.

The case for Artemisia Gentileschi's major responsibility for the *Lot* now seems to me to be virtually irrefutable. As several authorities have observed, extremely close relationships exist between this canvas and Artemisia's *Bathsheba* in the Columbus Museum of Art (Fig. 159; Color Plate XXIII). The daughter at the left, in a blue dress over a white blouse, is a twin to the kneeling woman wearing almost identical garments in the *Bathsheba*, as is the

other daughter to the lady-in-waiting, likewise in golden yellow and blue, who offers pearls to Bathsheba. Furthermore, the poses of the daughter at the right and of Lot echo that of Bathsheba, except that the father's right arm traverses his chest, his left arm is raised, and his head is tilted upward. These exceptions, however, find parallels in a painting that has not been introduced heretofore in connection with the *Lot and His Daughters*, namely the *Susanna* (Fig. 162; Color Plate XXIV) last sold in 1995 and formerly the pendant to the *Bathsheba*, where also a somewhat younger version of the old Lot serves as an elder. Harmonious as well in their quietude, monumental figures, surface textures ranging from heavy impasto to veilings, and strong lateral illumination that endows materials with great palpability, these three paintings seem to have been governed by a single mind during a single moment of inspiration. And Garrard's characterization of the interpretive tone of the *Lot*, which is indeed one of ritualistic formality, submits that this mind was Artemisia's. Once all of these features affirm Gentileschi's authorship of the *Lot and His Daughters*, the following passage from Bernardo de Dominci's life of Domenico Gargiulo (Micco Spadaro), published in 1742, becomes suggestive: "In casa del fu. dott. Luigi Romeo, barone di S. Luigi. . . . Due quadri grandi con figure al naturale, che esprimono le storie di Bersabea, e Susanna, che sembran di mano di Guido son dipinti dalla famosa Artemisia Gentileschi, e l'architettura di Viviano, con gli arbori, e vedute dello Spadaro. Di questa virtuosa donna è eziandio un S. Michele Arcangelo, che discaccia Lucifero dal Paradiso, ed *un Loth con le figliuole* [italics mine], e tutti alla grandezza del naturale." Did this large painting of *Lot and His Daughters* by Artemisia accompany the *Bathsheba* and *Susanna* in the Romeo Collection, as the context of Dominici's report implies and as Garrard and Contini believe, or was the Neapolitan writer simply reminded of the *Lot* as he viewed the very canvases, now in Columbus and London respectively, to which the Toledo *Lot* is so inextricably bound? One need not resolve this issue to posit that Dominici's reference is, precisely, to the present picture, which by virtue of its affinities to the *Bathsheba* and *Susanna* is to be dated contemporaneously with them, that is—as argued under [37]—to about 1636–37/38,

rather earlier then than a date in the 1640s as proposed by Garrard (tentatively) and Contini.

Yet to embed the *Lot and His Daughters* in Artemisia Gentileschi's career is not to dismiss the notion that Bernardo Cavallino had some part in its execution. Since Cavallino's oeuvre is dominated by small cabinet pictures, one is hard-pressed to find meaningful correlations in scale. Only the large *Galatea* (Figs. 195–96; Color Plate XXII), traditionally assigned to Bernardo, has been singled out by scholars. But as Grabski and Garrard have maintained, and as Contini suspects, the *Galatea* is certainly the product of a collaboration between Cavallino and Gentileschi during the late 1640s, with Artemisia supplying the one figure—the Galatea herself—that bears comparison to the *Lot* (see [49]). Furthermore, Grabski and Percy correctly distance the sentiment of the Toledo painting from that which rules Cavallino's renditions of the theme (Paris, Louvre; Campione d'Italia, Switzerland, Silvano Lodi). The former is as reserved and even idealized as the latter are ribald and low-life. And where Bernardo's compositions are notable for their dynamism, that of the Toledo *Lot* has been called "bland, nerveless," "rigidly static," and "humdrum artificial," descriptions that do not give sufficient credit to Gentileschi's understanding of the moment as one of ceremonial import, but which succeed in underlining the non-Cavallino nature of the design. Nor, Grabski notes, would Bernardo be expected in an independent work to have repeated Artemisia's female types with but minor variations. In addition, while the landscape in the *Lot* has been likened (Percy; Stoughton) to the backgrounds in early works by Cavallino, it finds its closest equivalents in the art of Domenico Gargiulo and, for the sky, specifically in the London *Susanna*, for which Domenico supplied the landscape. It is therefore probable that the sky, the burning city of Sodom, and the tiny figure of Lot's wife as a pillar of salt in the Toledo painting were executed by Gargiulo, who worked with Gentileschi on other occasions as well (Figs. 146, 147, 159, 162; Color Plates XXI, XXIII, XXIV).

Moreover, as postulated in the text, the figure of Lot may be in part by Bernardo Cavallino. Spinosa and Stoughton raise and then dismiss the idea of an Artemisia-Bernardo collaboration on the *Lot*, and the Matthiesen cata-

logue of 1986 finds such a partnership "possible to imagine." I believe that Cavallino did in fact contribute to the painting—most likely the father from the waist upward and, conceivably, the softly shadowed face of the daughter at the left (the latter thought by Contini to indicate Cavallino's influence on Gentileschi). One might wonder why Artemisia would have bothered to enlist the younger man's assistance— unless, of course, Cavallino were already a visitor in Gentileschi's studio to work on the *Susanna* and the *Bathsheba*, all three canvases in progress simultaneously.

A clear indication of the wider context of the Toledo painting is provided by Grabski's tentative attribution of it to Agostino Beltrano, the creator of a *Lot and His Daughters* (signed) in the Molinari Pradelli Collection at Marano di Castenaso (Fig. 167) and, it is generally held, of another formerly with the Heim Gallery at London. The parallels as regards figure types, landscapes, and compositional principles adduced by Grabski are not, in my opinion, sufficiently close to demonstrate Beltrano's authorship of the present picture. The primary source for the ex-Heim canvas was surely Massimo Stanzione, to whom it was once assigned, and perhaps in particular Stanzione's *Lot and His Daughters* at Besançon (Fig. 168). Massimo's Lot, his partially stockinged leg extended at an angle, may in turn have inspired these details in Artemisia's version. Then, for his picture in Marano di Castenaso, Beltrano appears to have looked again to the Stanzione prototype and, for the daughter at the right, to the Toledo painting. In other words, it seems that Beltrano's variants, which date from the 1640s and display a peculiar combination of polished elegance and rusticity that sets them apart from the Toledo *Lot*, availed themselves of previous works by both Stanzione and Gentileschi, as earlier Artemisia had found features to her liking in the Stanzione—a complex but not untypical situation for Neapolitan painting in these years.

Still, the current state of scholarship on Neapolitan painting, as fluid as it is, will not accommodate every proposal. Thus Bologna, reconfirming his earlier opinion, assigns the Toledo *Lot* to Onofrio Palumbo, using as corroboration the *Samson and Delilah* at Capodimonte (Fig. 152), which he also gives to Onofrio but which, for me, is a copy after a lost

work by Artemisia Gentileschi. Surely the little that on the other hand is certain of Palumbo's oeuvre does not point to the *Lot*. Equally unindicated is Novelli's attribution of the Toledo canvas to Annella de Rosa. Novelli's argument depends most heavily upon accepting as Annella's work (and not that of her husband Agostino Beltrano) the ex-Heim *Lot and His Daughters*, which is likened to a canvas of the *Drunkenness of Noah* formerly in the Calabrese Collection at Rome. Yet the claim of Beltrano's responsibility for the ex-Heim picture remains the most convincing, the attribution to Annella de Rosa of the *Drunkenness of Noah* is itself in doubt, and there is an unbridgeable gap between the Toledo *Lot* and those two (and only) paintings which with great probability are indeed by Annella, the *Birth of the Virgin* and the *Death of the Virgin* in the Pietà dei Turchini at Naples.

A *Lot and His Daughters* of horizontal format (1.58 x 2.10 m.) is listed under Artemisia Gentileschi's name in inventories (1786, 1837, 1856, 1857) of the Carafa holdings in Naples, having been assigned in the seventeenth century to Francesco Antonio Giannone. Its attribution to Gentileschi is suspect (see [L-50]).

BIBLIOGRAPHY: Dominici, ed. 1844, III, pp. 414–15; Percy in Percy/Lurie, 1984, pp. 16–17; Spinosa and Kopelman, ibid., pp. 107–9 cat. 29; Grabski, 1985, pp. 23–40; M. Stoughton, review of *Bernardo Cavallino in Naples* in *Burlington Magazine*, CXXVII (1985), 194; London, Matthiesen, 1986, p. 72; Garrard, 1989, pp. 123, 516 nn. 214–17, and color pl. 24; Novelli, 1989, pp. 152–53; Contini in Contini/Papi, 1991, pp. 76, 79, 87 n. 86; Stolzenwald, 1991, p. 94 fig. 58; F. Bologna in Naples, Castel Sant'Elmo, 1991, p. 162; Sestieri in Sestieri/Daprà, 1994, p. 88. Also see [37] and [38].

For the comparative material, see my Chapter 4, note 130, Grabski, and the following: L. Ambrosio in Naples, *Civiltà del seicento*, 1984, I, p. 193 cat. 2.9; Spinosa, 1984, pls. 41, 217; A. Brogi in Bologna, Palazzo del Podestà, 1984, p. 135 cat. 99; Schütze in Schütze/Willette, 1992, pp. 230 cat. A81, and 361 fig. 278.

...

[40] *Bathsheba*

Halle, Germany, Private Collection, as of 1978
Oil on canvas, 2.05 x 1.55 m.
Ca. 1637/38
Fig. 169

269

COLLECTIONS: Purchased in Italy about 1865 by Baron Deichmann; thence by inheritance to Freifrau Ady von Rüxleben, by whom lent in 1961 to the Museum der bildenden Künste at Leipzig and subsequently bequeathed to a physician in Halle

Photographs taken during Martin Wolff's restoration of the *Bathsheba* dramatize the tears, abrasions, losses, and repainting which the canvas had sustained. Those passages which appear to have survived in acceptable condition, such as sections of the golden-yellow drapery over Bathsheba's thighs, are qualitatively high; others, including the previously overpainted head of the standing woman and the area of the balcony, where the figure of David has been reduced to a ghostly suggestion, markedly distort the original.

Acquired in the nineteenth century as a work by Alessandro Allori, the *Bathsheba* was published and correctly located in the Neapolitan ambient by Helga Birringer who, being familiar only with Artemisia Gentileschi's last interpretations of the theme (Figs. 188, 201), was reluctant to assign the picture to Artemisia. An attribution to Gentileschi has been advocated by Harris, Garrard, Contini, and implicitly by Marshall, all independently of Birringer's study. In view of the inaccessibility and physical state of the painting, I cannot profess absolute confidence that its execution is entirely by Artemisia; it is not impossible that her daughter, identified as a painter in Gentileschi's letter of December 11, 1635, to Florence (Appendix II), put her brush to the canvas.

The design of the *Bathsheba*, however, is undoubtedly Artemisia's, and stands between the companion pictures of *Bathsheba* in Columbus and *Susanna* formerly in London (Figs. 159, 162; Color Plates XXIII, XXIV), on the one hand, and the *Bathsheba* (Fig. 180) in the Haas Collection at Vienna, on the other. The servant in a blue dress drying her mistress's legs is a variation upon the kneeling maid in the Columbus example, a painting recalled also by the other lady-in-waiting and the position of Bathsheba's left arm. Otherwise, the surprisingly young woman, head upturned and both legs revealed, more closely approximates the figure of Susanna in the ex-London canvas. Moreover, in the Columbus *Bathsheba* (and, some believe, in the *Susanna* as well), Viviano Codazzi, documented in Naples between 1634 and 1647, sup-

plied the precisely drafted and finely detailed palace, and the architecture in the Halle version is strongly Codazzian, if not actually by his brush (see below). Less certain is the continued participation even in an advisory capacity of Domenico Gargiulo, who added the landscapes to the Columbus and ex-London pendants; the modest and undistinguished landscape in the ex-Leipzig *Bathsheba* may merely emulate Gargiulo's manner.

The present picture also looks forward, most immediately to the Haas *Bathsheba*, where again Bathsheba's right leg overlaps her left and where both she and her maid attend to her hair. In turn, the Vienna painting—the kneeling woman now removed, the basin shifted to the center, and the fully nude Bathsheba seated on a tasseled pillow—anticipates the *Bathsheba* in Rome (Fig. 184).

If then, as contended in this Catalogue ([37] and [38]), the Columbus and ex-London paintings are to be dated to the years 1636–37/38 and the Haas picture reflects Artemisia's experiences in England (ca. 1638–40), the ex-Leipzig *Bathsheba* can be supposed to have issued from Artemisia Gentileschi's studio about 1637/38. This is consistent with Contini's recently expressed views, wherein the painting is related stylistically to the *Samson and Delilah* (Fig. 152; for Contini by Artemisia Gentileschi, for me a copy of a lost original of ca. 1635, [35]) and is conjectured to have followed "in the wake of" Artemisia's Pozzuoli canvases from the mid-1630s (Figs. 146–49; Color Plate XXI; [33]–[33c]). Harris and Garrard have assigned the picture to the 1640s, however. And Marshall would date it no earlier than the later 1640s on the perception that the architecture is the invention of Viviano Codazzi's former pupil and close follower Ascanio Luciano, who began to produce independent works at that time. Marshall's opinions on matters Codazzian are always to be accorded serious consideration; yet, as argued above, the figurative elements of the *Bathsheba* speak for a date toward the end of the previous decade, and they cannot easily be reconciled with those in what certainly were Artemisia's last interpretations of the theme (Figs. 184, 188, 200, 201).

There is a remote chance that the date suggested here finds confirmation in Vincenzio Fanti's *Descrizzione completa di tutto ciò che ri-*

trovasi nella galleria di pittura e scultura du sua altezza Giuseppe Wenceslao del S. R. I. principe regnante della casa di Lichtenstein, published in Vienna in 1767. Fanti records (p. 82 no. 403) a "Bersabea nel bagno, due Donzelle di cui una asciuga le piante, e l'altra le sostiene lo specchio in cui ella si mira, mentre si sta da per se stessa pettinando; Davidde in lontananza spora una Loggia, che in veder tal bellezza se ne innamora, di *Carlo Maratti*—Altezza piedi 8 once 6¼ larghezza 6 piedi once 3½." The imagery of the Halle painting obviously fits this description, and in 1636 Artemisia is documented as having painted a *Bathsheba* for Prince Karl Eusebius von Liechtenstein (for which see [37]). Still, the work catalogued in Vienna in 1767 was appreciably larger (approximately 2.60 x 1.92 m.), and that cited in the document of 1636 larger still (3.04 m. high). Thus even if the attribution to Maratta was incorrect, it would be imprudent to identify the present painting as the Austrian example. The very best that can be said is that Fanti's entry may testify to the existence during the second half of the 1630s of a Gentileschi *Bathsheba* of the Halle type.

BIBLIOGRAPHY: Birringer, 1963, pp. 393–97; Harris in Harris/Nochlin, 1976, p. 123; Drs. Winkler and Heiland, Museum der bildenden Künste, Leipzig, letter to the author, May 5, 1978; Garrard, 1989, pp. 128–29; Contini in Contini/Papi, 1991, pp. 66, 79, 80 fig. 66, 87 n. 88; Marshall, 1993, pp. 154–55, 435 ff.

..

[41] *Muse Polyhymnia, Personification of Arithmetic, and Other Figures*

London, Marlborough House, Main Hall, ceiling
Oil on canvases, within a scheme of 8.92 x 10.70 m.
Ca. 1638
Figs. 170–72; Color Plates XXV, XXVI

COLLECTIONS: Greenwich, England, Queen's House, Great Hall, ceiling, until the early eighteenth century

Impelled more by filial devotion than by thoughts of personal gain, Artemisia Gentileschi came to England in 1638 and assisted her aged father with the most extensive undertaking of his career, the *Allegory of Peace and the Arts Under the English Crown* for the Great Hall in the Queen's House at Greenwich. Carved and gilded wooden frames divide the ceiling of this room, a perfect square of 12.2 m., into nine sections: a dominating square of 6 m., four rectangles of 6 x 2 m. to the sides, and four squares of 2 m. each at the corners, with circular frames inserted within the central and corner blocks.

The iconographical scheme is even more ambitious. Jacob Hess, first to explore the program in detail, interpreted it as an "encyclopedic survey" with reference to Francis Bacon's "systematization of knowledge" and to the group of intellectuals gathered around Lord Arundel. Against this I have set (1981) a reading that parallels the claims endlessly propounded by the politically oriented Caroline court masques. In this view, recently supported by Garrard, the ceiling decoration was intended to strengthen and perpetuate the image of the Utopian state of England under the rule of Charles I and his Queen at a time when the need to reinforce the mystique of an ideal realm was more desperate than ever. In the central *tondo* Peace, surrounded by Victory, Strength, Concord, Religion/Love of God, Meditation, and personifications of the Trivium and Quadrivium, extends an olive branch. Under these conditions, as asserted by the Nine Muses (in the rectangles) and Painting, Sculpture, Architecture, and Apollo (in the smaller roundels), the Arts flourish.

Orazio Gentileschi's role in devising this propaganda as such was surely minimal, although he must have taken more than a passing interest (Garrard) in the ongoing debate concerning the status of the visual arts vis-à-vis the Liberal Arts. When Artemisia arrived in London the project was well advanced. Construction of the Queen's House had been completed in 1635, followed by the framework of the Great Hall's ceiling in 1636 and its tile floor (which repeats the pattern of the ceiling) in 1636–37. Since (see below) father and daughter worked together on individual canvases, it is likely that the paintings were ready, if not fitted in place, by Orazio's death in February of 1639.

The "nyne peeces in ye seeling," evaluated at 600 pounds in 1649 and offered for sale in 1651, did not find a buyer, and remained at Greenwich until sometime between 1711 and 1736, when they were transferred to Marlbor-

ough House. Unfortunately, the main hall in this new venue was both smaller and oblong (8.92 x 10.70 m.), necessitating the trimming of the canvases. This mutilation, coupled with faulty preparation initially and with severe paint loss and repainting, brought the pictures to a deplorable state, which the extensive restoration finished in the early 1960s could but in part improve (while incorrectly orienting the corner *tondi*).

Pointing to the personification of Arithmetic in the central roundel (Fig. 170), Hess was also the first to signal the presence of Artemisia Gentileschi at the Queen's House. Subsequently I proposed that she created as well the Muse Polyhymnia and, conceivably, Euterpe and Clio. For Garrard, believing that "among the Muses only Calliope, Thalia and (perhaps) Euterpe appear to been executed by Orazio," Artemisia was responsible in whole or in part for six of the Muses. Upon reconsidering the visual evidence, including the fact that the soft lighting of the *tondi* generally gives way in the rectangular compartments to more pronounced *chiaroscuro*, I am inclined to concur with Garrard's conclusion that Artemisia's contribution was more substantial than has been supposed. Still, the problem of differentiating hands remains, made more knotty by the poor state of conservation, the collaborative nature of the undertaking, and by confusion introduced into the literature by me in 1968 (in misidentifying Polyhymnia as Urania) and by Garrard (in bypassing my attributions of 1981, and in transposing Thalia and Clio in the caption to fig. 107). Once again, then, I must equivocate, assigning to Artemisia the figures of Polyhymnia and Arithmetic (Figs. 170, 171; Plates XXV, XXVI) and, with less conviction, those of Clio and Erato (Figs. 170, 172). The text details my reasons for these attributions.

BIBLIOGRAPHY: London, PRO, *Pictures Statues Plate . . . 1649–1651*, LR 2/124, fol. 60, and publ. by Millar, 1970–72, p. 137 no. 3; Vertue IV, p. 113; W. G. Keith, "The Queen's House, Greenwich," *Journal of the Royal Institute of British Architects*, XLIV, pt. III (1936–37), 943–47; Chettle, 1937, pp. 90–91 and passim, and pls. 43, 86–87; Hess, 1952 (reprint 1967), I, pp. 241–57, 421–22, and II, pls. 171–83 (figs. 1–25); Bissell, 1968, p. 161; Bissell, 1981, pp. 60–61, 91 n. 47, 195–98 [70], and figs. 135–42; M. Gregori in Naples, *Civiltà del seicento*, I, 1984, p. 150; Garrard, 1989, pp. 112–20 and notes; A. MacGregor, ed., *The Late King's Goods: Possessions and Patronage of Charles I in the Light of the Commonwealth Sale Inventories*, London and Oxford, 1989, p. 158 color pl. 28 of the entire ceiling (printed in reverse); Stolzenwald, 1991, pp. 42–45.

..

[42] *Allegory of Painting* (so-called *Self-Portrait as "La Pittura"*)

London, Kensington Palace, Collection of Her Majesty the Queen
Oil on canvas, .965 x .737 m.
Ca. 1638–1639
Fig. 175; Color Plate XXVII

Initialled on the right corner of the tabletop:
A. G. F.

COLLECTIONS: English Royal Collection, Hampton Court, by October, 1649; acquired by Jackson and his dividend, October 23, 1651; restored to the Crown (Col. Hawley MS, fol. 32), and in turn at Whitehall, Kensington, and Hampton Court

A cleaning of the canvas in 1972 removed later repainting on the background. Certain passages (e.g., the background at the upper right, the shadowed left hand and wrist) were painted so thinly on the finely woven canvas and/or have suffered the loss of glazes that the dark preparatory ground is again visible, resulting in a false impression that the picture is unfinished.

As Michael Levey was the first to reveal, and as reviewed in the text, the impressive woman here depicted is Painting, "La Pittura," her attributes selected from Cesare Ripa's *Iconologia*. It has become canonical to identify the artist at work in this superb and much discussed canvas as specifically Artemisia Gentileschi herself—a *Self-Portrait as "La Pittura."* Scholarly opinion is less unanimous regarding the circumstances surrounding its execution. In my view, visual and documentary testimony dictates the following conclusions: (a) the woman depicted is not Artemisia in the guise of or conjoined with "La Pittura," but a semi-idealized if exceptionally contemporary and spirited personification of that Art; (b) the painting was executed by Gentileschi about 1638–39, that is in England, where it was acquired by King Charles I; and (c) the canvas was designed to accompany a fully recognizable *Self-Portrait*.

Accustomed as they are to seeing here the

face of Artemisia, one's eyes are reluctant to focus elsewhere. Yet not only does this female figure seem less individualized than, for example, the Judiths in Florence and Detroit and the Esther (Figs. 77, 84, 125; Color Plates XII, XIII, XVI), but she bears little more than a generic relationship to Gentileschi as she is known from an anonymous portrait medal (Fig. 99), the engraving by Jerôme David (Fig. 101) and, surely, from the *Female Martyr* (Fig. 56; Color Plate VI). For while untidy hair "seems a trait of Artemisia herself" (Levey), it is also an essential aspect of Ripa's codification, and it is not parted in the middle. Missing too are the double chin and the somewhat puffy eyebrows, both of which the profile view would have accentuated; here cheek and chin, forehead and eyebrows, become generalized blocks, for which the raising of the head cannot account. Significantly, Garlick has spoken of "the supposed self-portrait," while to Gregori, dating the painting to the later 1630s, "it seems . . . improbable that the young woman of Neapolitan type represented here is the self-portrait of Gentileschi. . . ." Papi has characterized the *Self-Portrait* in the Palazzo Barberini (Fig. 119) as "quell'unica effige sicura di Artemisia rimasticici dipinta da lei," and for Haskell only tradition and some supposed documentation (see below) recommend the painting in England—"by comparison with other recorded likenesses of her . . . so flattering"—as a self-portrait. And even Contini, although recognizing Artemisia in the Kensington canvas, finds echoes of the female types ("il volto triangolare e gli occhi a fessura") of Orazio Gentileschi's English period. One may also question whether Artemisia would have committed herself to the awkward two-mirror arrangement and to the leaning and bending necessary, Garrard explains, to achieve a self-portrait in unconventional profile. That "La Pittura" is "turned slightly away from her canvas," and that there is a "lack of direct physical connection between the depicted canvas and the depicted right hand," need not imply such a process; the former can be explained by the desire to avoid a lost profile, the latter as a means of dramatizing the fact that the first creative gesture of the brush is but imminent.

It is to Artemisia's contributions of 1638 to Orazio Gentileschi's ceiling for the Queen's House at Greenwich ([41]) that the *Allegory of Painting* can be most profitably compared, as Gregori has realized. In particular, the positions of the arms and heads, the classicizing facial types, robust physiques, fluidly applied, shining highlights, and bold *chiaroscuro* of the *Muse Polyhymnia* and *Arithmetic* (in green drapery) find their equivalents in the Kensington picture (Figs. 170, 171; Color Plates XXV, XXVI). Echoes of the latter are to be heard even during the 1640s, as from the figures of Abra in the compositions of *Judith and Her Maidservant* at Cannes and Naples (Figs. 191, 192). To assign the *Allegory of Painting* to the English period is again to challenge its identification as a self-portrait. In 1638 Gentileschi was forty-five years old; the woman depicted here is appreciably younger (cf. Berti's remarks).

A case constructed on such subjective impressions may be considered vulnerable, but I believe that there is documentation to defend it. According to the Kensington catalogue of 1818, the picture was "Bought by King Charles I," a statement supported by a torn label (signaled by Collins-Baker, who entitled the work *An Artist Painting*) reading ". . . by the King." More consequential is "A true. Inventory of the Pictures in Hampton Court Viewed and Apprised ye 3. 4 & 5 Octobr 1649," part of the *Pictures Statues Plate and Effects of King Charles I: 1649–1651* (London, Public Record Office, Inventories, LR 2/124). On folio 117v there appears as item 5 "Arthemesia gentelisco. done by her selfe 20.000." This picture is recorded with almost identical wording in manuscripts (BM, Harley MS 4898; BM, Addington MS 23,071) based upon the prime inventory, and was sold on October 23, 1651, to the dividend of Charles I's creditors headed by Jackson. *However*, the same list of the Royal holdings at Hampton Court registers (on fol. 119, no. 97) a second canvas as "A Pintura A painteinge : by Arthemisia 10.00.00," which likewise passed to Jackson on October 23, 1651.

Of the "A Pintura A painteinge" Garrard wrote: "Although it is of great interest, it is not necessarily a self-portrait. Since the word 'painteinge' is probably a noun, not a gerund, the description is less likely to apply to the picture under consideration here [the Kensington canvas] than the description cited in n. 1 [i.e., 'Athemesia gentelisco. done by her selfe']."

Quite aside from the fact that it would be redundant to designate a work "a painting" in a list headed "A true. Inventory of the Pictures . . . ," the word "painteinge" certainly denotes an action. One recalls Robert Herrick's *To the Virgins, to make much of Time* published in 1648 ("Gather ye Rose-buds while ye may, / Old Time is still a Flying. . . .") or "A Venus A Bathing" recorded about 1657 among Ralph Bankes's pictures (Laing, 1993, pp. 109, 121). In short, the citation may be interpreted as signifying *A Personification of Painting in the Act of Painting* and therefore, I think, as referring specifically to the present picture, unquestionably an *Allegory of Painting* and dubiously a *Self-Portrait*, which was restored to the Crown, inventoried in 1687–88, and mentioned repeatedly thereafter in the English Royal Collection. Levey presumes that the Kensington picture, the "Arthemesia gentilesco. done by her selfe," and the "Pintura A painteinge" are one and the same, but provides no explanation as to why a single canvas should have appeared twice in the same list and with different evaluations. The reference to the "Pintura A painteinge," being embedded within the inventory, is in no way an addendum, and there are no other cases among the many citations to pictures by Orazio and Artemisia where such repetition occurs. Charles I's creditors often took more than one work by the same artist and if, as I will argue, Artemisia's *Self-Portrait* and *Personfication of Painting* were meant to be paired, Jackson would have had a special reason to acquire both. Even if one were to be convinced that only one picture was involved, its identification in 1649 as a *Self-Portrait* by Artemisia could have been based not upon known fact but upon the same kinds of assumptions that later scholars have made. Finally, it is not surprising that the canvases by Artemisia at Hampton Court in 1649 do not figure in Abraham Van der Doort's catalogues of ten years earlier. Neither does Orazio Gentileschi's *Sibyl*, obviously executed before the artist's death in February of 1639, also sold out of Hampton Court in 1651 and later returned. And Van der Doort began his inventories—which are not complete—in 1637, before Artemisia had arrived in England.

The validity of my proposals can be tested against previous hypotheses, according to which the painting may be connected with one or the other of the *Self-Portrait*s referred to by Artemisia in her correspondence from Naples to Cassiano dal Pozzo in Rome. I have dealt with this correspondence in [25], but it should be summarized here. In a letter of August 24, 1630, Gentileschi informed Cassiano that she had received the measurements for a picture which he had ordered and to which she would soon turn. A week later, on August 31, the artist identified the work as a portrait (Fig. 118), and on December 21 as a self-portrait, which she promised to dispatch to Rome with the next courier ("l'inverò con il seguente procaccio"). Nothing further is heard of a *Self-Portrait* until October 24, 1637, when Artemisia wrote to Cassiano that among the paintings she proposed to ship to Rome, pending his reply, were "another for Your Eminence, in addition to my portrait in conformity with that which you once requested, to be numbered among [your other portraits] of illustrious painters (*un altro per V.S. col mio ritratto a parte, conforme ella una volta mi comandò, per annoverlo fra'pittori illustri*)."

Several scholars, among them Millar, Spear, Garrard, Werkmäster, and Stolzenwald, believe that the Kensington picture is likely to be the self-portrait mentioned by Artemisia in 1630 or, at least, that it was painted at that time. (Levey, who initially entertained this possibility, appears now to equivocate.) For them this date is suggested by the age of Artemisia, the young woman (of thirty-seven?) supposed to be depicted here, and by the style of the work. Curiously, however, discussions of the painting's style have often been slight. Levey and Spear offer no analysis, while Garrard's attempt to place the canvas in 1630 somewhat defeats its purpose by seeming to define a position for it between the *Judith and Her Maidservant* of ca. 1623–25 (Fig. 84; Color Plate XIII) and Gentileschi's productions of the 1640s. In any event, the assumption is made by proponents of this theory that Artemisia must have retained for seven years the *Self-Portrait* intended for Cassiano and brought it with her to London in 1638. As Contini, who dates the Kensington canvas to Gentileschi's stay in England (as does Cropper), has also observed, this would be unusual under any circumstances, and it is highly improbable that Gentileschi would break her promise to send the painting to Rome without delay, a pledge to a patron from whom she then continued to seek favors. I have hypothesized

([25]) that the picture was indeed delivered by early 1631, that before 1637 it had been presented by the Commendatore to Cardinal Francesco Barberini, whom he served as Secretary, and that it is now in the Palazzo Barberini at Rome (Fig. 119). This would have necessitated a replacement to be included with Cassiano's other portraits of famous individuals. Yet none of the accounts of the dal Pozzo collection cites a painting by Artemisia Gentileschi. (With some probability the "Quadro in tela di palmi quattro Ritratto di Artemisia Gentileschi pittrice, cornice color di noce, et oro di Vouet," inventoried in 1729 among the holdings of Cosimo Antonio dal Pozzo, was one of the French painter's depictions of his artist wife Virginia da Vezzo or a self-portrait by the latter; again [25].) And in the artist's last known letter to Cassiano, dated November 24, 1637, no mention is made of the *Self-Portrait*, although it is clear that Cassiano had not yet responded to her letter of the previous month.

What became of this *Self-Portrait*? I believe that when Artemisia set off for England, probably in the spring of 1638, she took it with her, and that this is the painting later entitled "Arthemesia gentelisco. done by her selfe." Soon becoming involved with her father's ceiling decoration at Greenwich, which contains a corner roundel of *Painting*, Gentileschi conceived the idea of her own *Allegory of Painting*, perhaps inspired as well by the medal of Lavinia Fontana cast by Felice Antonio Casoni in 1611 (Fig. 173). It will be recalled that in her letter of 1637 she told Cassiano that the *Self-Portrait* would be "in conformity with that which you once requested." The word *conforme* might imply, among other things, identical measurements. If so, and if the first *Self-Portrait* for Cassiano is that in the Palazzo Barberini, then that of 1637 would also have measured approximately .93 × .745 m. This is almost exactly the size of the *Allegory of Painting*, the probable companion picture to the *Self-Portrait*. Further, one is tempted to identify the latter as the *Artemiscia Gentoleschi* by "Artemiscia Gentoleschi" which was sold in Great Britain by Sandys on January 24, 1801, lot 601 ([L-91]).

Two additional points must be emphasized. First, my proposals regarding the date and title of the Kensington canvas need not rise or fall on how one interprets Artemisia's dealings with Cassiano dal Pozzo or on whether the portrait in Rome is accepted as being by and/or of Gentileschi. Second, I do not wish to minimize the value of Garrard's thought-provoking study (enriched by Werkmäster) of the painting in England. As it illuminates that picture and provides a wealth of material regarding artists' self-portraits, so as it happens does it have much to say about the two works by Artemisia Gentileschi, one lost or unidentified and the other among her finest extant paintings, that I have thought to reunite.

BIBLIOGRAPHY: Ripa, ed. 1603, pp. 404–5; London, PRO, *Pictures Statues Plate . . . 1649–1651*, LR 2/124, fols. 117v no. 5 and 119 no. 97, and publ. by Millar, 1970–72, pp. 186 no. 5, 191 no. 97; London, BM, Harley MS 4898, "The Inventory of the Effects of Charles I, 1649–1652," fol. 280 no. 5; Vertue IV, pp. 90, 96; Law, n.d., p. 66 cat. 320; Voss, 1925, p. 463; C. H. Collins-Baker, *Catalogue of the Pictures at Hampton Court*, Glascow, 1929, p. 60 cat. 226, with additional bibl.; *Mostra del ritratto storico napoletano*, Naples, 1954, p. 115; Levey, 1962, pp. 79–80; M. Levey, *The Later Italian Pictures in the Collection of Her Majesty the Queen*, Greenwich, Conn., and London, 1964, pp. 14, 82 cat. 499; Spear, *Caravaggio*, 1971, pp. 98–99 cat. 29; O. Millar in London, Tate Gallery, *The Age of Charles I: Painting in England 1620–1649*, London, 1972, p. 65 cat. 90; Tufts, 1974, p. 60; Garrard, 1980, pp. 97–112; C. Whitfield in London, Royal Academy, 1982, pp. 167–68 cat. 59; *Women's Art Show*, Nottingham, 1982, no. 7; M. Gregori in Naples, *Civiltà del seicento*, 1984, I, p. 150; Hagen, 1988, p. 83; Garrard, 1989, pp. 85–88, 337–70, and extensive notes; Haskell, 1989, p. 37; Gash, 1990, p. 69; Nicolson/Vertova, 1990, I, p. 111; Contini in Contini/Papi, 1991, pp. 74–75, 172–75; Papi, ibid., p. 109; Berti, ibid., p. 28; B. Werkmäster, "Av bild–själv bild–bild själv. Om kvinnliga konstnärers självporträtt," *Konsthistorisk tidskrift*, LX, no. 2 (1991), 80; Stolzenwald, 1991, p. 41; M. Levey, *The Later Italian Pictures in the Collection of Her Majesty the Queen*, 2d ed., Cambridge, England, 1991, p. 91 cat. 499; Cropper, 1992, p. 215; Wachenfeld, 1992, pp. 27–28.

..

[43] *Penitent Magdalen (so-called Dido Abandoned or Cleopatra Abandoned)*

Oslo, Nasjonalgalleriet
Oil on canvas, 1.13 × 1.35 m.
Early 1640s?
Figs. 177–78

COLLECTIONS: Acquired in England, probably before 1854, by Diderik Cappelen; bequeathed to the Nasjonalgalleriet, 1866, by Betzy Cappelen

Garbed in a white blouse with lace trim, yellow dress, and blue mantle, this long-haired woman most likely figures Mary Magdalen at the moment of conversion when, having cast aside on a table covered with a red cloth her necklace of vanity, she throws out her left arm (the hand holding a comb or hairbrush?), clutches her breast, and looks longingly Heavenward. The traditional identification of the subject as that of *Dido Abandoned*, recently reiterated by Papi, fails to explain the absence of the canonical crown and/or of the pyre on which the Queen was to commit suicide. Bologna, in suggesting the title *Cleopatra Abandoned*, mistook for an asp the blue ribbon affixed (on both ends, in fact) to the string of pearls.

Attributions of the Oslo canvas—which unfortunately I know from photographs alone—have been equally varied. Thus Paola della Pergola has likened the woman to the figure of Philosophy in G. F. Guerrieri's *Triumph of Science* in the Palazzo Borghese at Rome. For Papi in 1990 the picture was beyond doubt by Antiveduto Gramatica, but it was clear that even the most flexible view of Gramatica's achievement could not accommodate this work. With convincing justification, other scholars, now followed by Papi, have located the canvas in the Neapolitan milieu (to which it was thought to belong even in the nineteenth century when it was sold as a Ribera) by assigning it to Onofrio Palumbo (F. Bologna) and to Artemisia Gentileschi (Federico Zeri and the present writer). Although, in my opinion, the *Magdalen* lacks the Stanzionesque-Guarinesque stamp that marks the few certain paintings by Onofrio Palumbo, it is of a pictorial type that was popularized in Naples by Massimo Stanzione (e.g., *Saint Catherine*, Rome, Lemme Collection; *Saint Agnes*, Barcelona, Museo d'Arte Catalunya).

It remains Artemisia Gentileschi's art above all that the Oslo picture evokes—in its strong *chiaroscuro*, in the loving attention to materials (including the yellow dress), and in the woman's face, which is extraordinarily close to that of Galatea in the Gentileschi-Cavallino canvas of 1648 (cf. Figs. 176, 177). Yet the monumental-

ity of the Magdalen's form and the solemnity of the presentation also bring to mind the daughter at the right in the Toledo *Lot and His Daughters* (Figs. 164, 166). With the appearance of the hitherto unknown *Cleopatra* (Fig. 136), the attribution to Artemisia of the *Magdalen* gains further credibility, particularly if the latter is viewed as a classicizing variation upon the former effected by Artemisia either during her English period (at the time of her figures for the Queen's House, Figs. 170–72; Color Plates XXV, XXVI; note the English provenance of the *Magdalen*) or immediately following her return to Naples about 1640, there to predict the more demonstrative and less genuine *Tarquin and Lucretia* and *Susanna* (Figs. 190, 197). My decision to include the Oslo picture in this Catalogue of Autograph Paintings carries with it lingering doubts, which a confrontation of the original might well allay.

A *Saint Mary Magdalen* of the same size but of vertical format (5 *palmi* high x 4 *palmi* wide; i.e., 1.32 x 1.06 m.) was inventoried in 1672 in the Neapolitan collection of Davide Imperiale ([L-80]) with an attribution to Artemisia, while what may have been another *Magdalen* by her, said to measure 4 x 5 *palmi*, belonged in 1659 to Ettore Capecelatro of Naples ([L-81]).

BIBLIOGRAPHY: P. della Pergola, 1956, p. 220; Mr. Leif Ostby, Oslo, letter to the author, summer, 1970; R. W. Bissell, letter to L. Ostby, September 19, 1970; Oslo, Nasjonalgalleriet, *Katalog over utenlandsk Malerkunst*, 1973, pp. 345–46 cat. 766; Papi, *Paragone*, 1990, p. 77 and fig. 50; idem, in Contini/Papi, 1991, pp. 53 fig. 38 and 63 n. 80; F. Bologna in Castel Sant'Elmo, 1991, pp. 146 fig. 155 and 162; Papi, 1995, p. 17.

..

[44] **Still Life with a Pastry Eater**

In collaboration with Giacomo Recco
Location unknown
Oil on panel, .435 x .75 m.
Ca. 1640?
Figs. 174, 179

Inscribed on the reverse: *Artemisia Gentilesca Giacomo Recco Fe.ᵗ*

The publication of this panel, a carefully fashioned and unusually well-preserved inscription on its reverse (Fig. 174), came as a complete surprise in view of Giacomo Recco's modern reputation as a specialist in flower still-lifes and

of the total lack of literary references to Gentileschi's involvement with genre painting. Indeed, Ferdinando Bologna implies irreconcilability between the claim of the inscription and the stylistic evidence. Yet as regards Artemisia one can argue that the putto, his puffy cheeks in part attributable here to a mouthful of dough, finds a correspondence in her *Child Sleeping near a Skull* as recorded in three prints, one of them dated 1640 (Figs. 112, 113). Gentileschian too, DeVito observes, is the design of the loose-sleeved shirt (cf., among several examples, the woman at the right in the Toledo *Lot and His Daughters* of ca. 1636–37/38, Figs. 164, 166; Color Plate XX) and—conceivably—the tenebristic lighting that informs the whole. DeVito has also marked the similarity between the ice chest and this object as it was to turn up in several works by Giacomo's son Giuseppe (e.g., the *Still Life with Prosciutto and Peasant Pie*, Molinari Pradelli Collection, Marano di Castenaso), who was born in 1634 and whose earliest-known dated still-life was executed in 1664.

Still, it is improbable in the extreme that on the basis of style alone the names of Artemisia Gentileschi and Giacomo Recco would have been assigned to this painting. Faith in the authenticity or accuracy of the inscription is required. This is clearly by a single hand, and in a letter to the author DeVito has suggested that of Recco, who might be expected to have referred to his female collaborator as "*Gentilesca.*" It should be noted, however, that this form of the surname is used in the seemingly autograph signature on Artemisia's *Bathsheba* in Vienna (Fig. 180; [45]), and earlier on the reverse of her *Portrait of a Condottiere* (Figs. 81–82; Color Plate IX; [13]). And to suppose that the inscription on this unprepossessing picture originated with anyone but a seventeenth-century Neapolitan is either to believe that it reflects a recorded tradition or to attribute to its fabricator an imagination of a most extraordinary sort. Further, there is an indication in the form of the following picture inventoried in 1716 among the possessions of Domenico Perrino at Naples that Artemisia and Giacomo Recco (or another of the great Neapolitan flower painters) collaborated on at least one other occasion: "Uno quadro di palmi cinque, e quattro, con cornice indorata liscia, con chierchio di fiori, nel mezzo de quali vi è dipinto un bambino corcato, mano di Artimisia . . . 10." See [L-12] for discussion and bibliography.

To accept the inscription of the *Still Life with a Pastry Eater* is not to specify a date for the half-length figure, and at least until the panel reappears it is impossible to determine if the boy and the pie are of a single painterly piece. DeVito has assigned the work ("almeno per quanto riguarda Giacomo") to the late 1640s. Surely this modest picture was created at a single moment, and for Artemisia this would appear to be no later than about 1640 by virtue of the comparisons drawn above and of the handling which, being free and liberally impastoed, is better associated with Gentileschi's production of the 1630s than with her later works.

If these conclusions are just, the *Still Life with a Pastry Eater* emerges as an early example in the line of such joint ventures in Neapolitan art which include Aniello Ascione and Andrea Vaccaro (*Still Life with Baby Satyrs*, Sorrento, Museo Correale di Terranova) and Andrea Belvedere and Francesco Solimena (*Still Life with Winged Putti*, San Sebastián, Museo de San Telmo).

BIBLIOGRAPHY: G. DeVito, "Un giallo per Giuseppe Recco ed alcune postille per la natura morta napoletana del '600," *Ricerche sul '600 napoletano*, Milan, 1988, pp. 75–77 and 112–16 figs. 29–33; G. DeVito, Milan, letter to the author, July 26, 1990; Bologna in Naples, Castel Sant'Elmo, 1991, p. 179 n. 296.

For the comparative material: Spinosa, 1984, pls. 7, 48; S. Stagni in Bologna, Palazzo del Podestà, 1984, p. 56 cat. 15.

..

[45] *Bathsheba*

Vienna, Alexander Haas Collection
Oil on canvas, 2.25 x 2.26 m. (but see below)
Ca. 1640
Fig. 180

Signed on the base of the balustrade at Bathsheba's feet: ARTIMISIA GENTILESCA / FECIT

COLLECTIONS: Princes of Liechtenstein, purchased 1918; Friedrich Otto Schmidt, Vienna, by whom sold in 1940 to Eduard Haas

The *Bathsheba* was restored and relined in 1965, but not before it had suffered irreversibly from

abrasion, color changes, overpainting, and cropping. Thus the surface has been stripped of its final glazes, the (formerly dark blue?) robe of the lady-in-waiting and the dress of the woman in a turban and white blouse have been absorbed into the dark ground, and major areas (including the faces, hands, landscape, and architecture) have been extensively repainted. At the sides and below, forms are severed at meaningless points. Moreover, since a square format in a picture of this size is unexpected and would not be significantly recast by an estimated addition of 15 cm. (6 in.) at the bottom, and since the six other versions of *Bathsheba* by Artemisia (Figs. 159, 169, 184, 188, 200, 201; Color Plate XXIII) respect (or, in the case of the Potsdam picture, once respected) an average height-to-width ratio of 1.30:1, it is probable that the canvas has been drastically trimmed above, perhaps by as much as 65 cm.

One may be confident nonetheless that the Haas *Bathsheba*, brought to my attention in 1968 by Renata Mikula, to whom I am most indebted, was an autograph work by Artemisia Gentileschi. The signature may have been strengthened, but the actual spellings of the given name and surname—*ARTIMISIA* and *GENTILESCA*—are feasible in the artist's work (cf. respectively the Pitti *Magdalen* and the *Portrait of a Condottiere* in Bologna, [10] and [13]). Compositionally unique among Artemisia's interpretations of the theme, the picture also contains *pentimenti* (as around Bathsheba's buttocks) and several passages (most notably the steps beneath the gold-brocaded red material at the lower left) which have reappeared as with time the overlying pigment became transparent. The qualitative level is high for those parts which have managed to survive in reasonably good condition—e.g., the impastoed whites, the yellow mantle of the seated woman, the basin.

In fixing the date of the Haas canvas one must rely solely on visual evidence. Inasmuch as the picture is in Vienna, once belonged to the Princes of Liechtenstein, and may originally have measured up to 3.00 m. in height, there is a temptation to identify it as the *Bathsheba* of 11½ Neapolitan *palmi* that (along with a *Susanna* and a *Lucretia*) Artemisia painted for Prince Karl of Liechtenstein and for which she received final payment on May 5, 1636 (re-

viewed under [37]). However, according to Mikula a document of 1918 establishes the purchase of the *Bathsheba* by the Liechtenstein in that year, suggesting that it had not previously been in their possession. There is no record of a *Susanna* and/or a *Lucretia* having accompanied it, and no paintings assigned to Artemisia Gentileschi are listed in Vincenzio Fanti's *Descrizzione completa di tutto ciò che ritrovasi nella galleria di pittura e scultura di sua altezza Giuseppe Wenceslaio del S. R. I. Principe Regnante della casa di Lichtenstein* [*sic*], published in Vienna in 1767. Further, even if the *Bathsheba* that appears in Fanti's catalogue under the name of Carlo Maratta was actually by Artemisia, it would have much more closely resembled Gentileschi's picture in Halle (Fig. 169; for the details, see [40]).

There are two issues of genuine consequence for the dating of the canvas and, with them, for definitively dissociating it from the *Bathsheba* which Gentileschi had ready by 1636: expressively and stylistically it differs substantively from those *Bathsheba*s (Figs. 159, 169) which, in my opinion, Artemisia painted about 1636–37/38; and it is informed throughout by Artemisia's experiences in London during the years 1638–40. Her exposure to the late works of her father was in fact decisive, for here—as discussed in detail in the text—Artemisia seized upon many of the leitmotifs of Orazio's English production. They appear in such force that the relationships to her father's paintings cannot be fortuitous. In addition, the poses of the maidservants at the right are comparable to those of figures executed in England by Artemisia herself—the turbaned woman, her body placed obliquely and her right arm stretched into space, reminding one of the *Allegory of Painting* (Fig. 175; Color Plate XXVII) and the semireclining attendant of the Muse Polyhymnia and the Arithmetic (Figs. 170, 171; Color Plates XXV, XXVI), two of Artemisia's contributions to the Greenwich ceiling.

Indeed, the catalogues of the Spencer Collection at Althorp from 1746 and 1750 cite a *David and Bathsheba* by Artemisia Gentileschi, and along with a "Gentileschi" *David and Bathsheba* at Christie's–London on March 11, 1808 (Lot 68), could indicate that Artemisia was involved with this theme while in London. It appears more likely, however, that these ref-

erences concern the painting formerly at Gosford House, a canvas which was created during Gentileschi's very last years (Fig. 200; [53] for the bibliography). Of demonstrable relevance is the fact that Artemisia was to repeat closely elements of the Haas *Bathsheba* (the protagonist and the woman braiding her hair, the tasseled cushion and the basin beneath it, the *repoussoir* drapery in reverse) in the *Bathsheba* in Rome (Fig. 184), which because it leads in turn to her latest interpretations of the subject (Figs. 188, 201) must have been painted after her return to Naples. Unless then, the artist had retained a drawing, the Vienna version should have been accessible to her when she designed the work now in Rome. And because conceptually the Haas picture breaks definitively with the aforementioned *Bathsheba*s of ca. 1636–37/38, it would seem to postdate them by at least a few years. In it Gentileschi abandons all pretense to a message of moral dilemma, for Bathsheba (and, quite gratuitously, one of her maids) is exposed for the simultaneous pleasure of David and the male viewer. In any case, a date no later than the early 1640s is indicated for the Haas canvas.

BIBLIOGRAPHY: Renata Mikula, Vienna, letters to the author (December 4, 1968; March 24 and May 22, 1969; July 27, 1971); Harris in Harris/Nochlin, 1976, p. 123 n. 28;

For the comparative material: Bissell, 1981, pp. 188 cat. 61, 190–91 cat. 63–64, 191–93 cat. 66–67, 195–98 cat. 70, and figs. 124–25, 129, 131–32, 139.

...

[46] *Bathsheba*

Rome, Private Collection
Oil on canvas, 2.80 x 2.20 m.
Ca. 1640–1645
Fig. 184

COLLECTIONS: Ramunni Collection, Castello di Conversano (Bari); sold at auction, Franco Semenzato, Villa La Castelluccia, Rome, May 28, 1978

Maintaining that it is merely a copy of a lost original, the owner of the canvas has refused my requests to study it. Some pigment loss, particularly along two vertical seams and around the edges, may be discerned from the photograph.

The *Bathsheba* was published by Hermanin in 1944 as an autograph work by Artemisia Gentileschi. With the exception of Garrard, who (disturbed by its expressive shallowness) would prefer to exclude it and several later pictures from Gentileschi's oeuvre, scholars have confirmed Hermanin's attribution (although most have not actually seen the painting). It appears to be of elevated quality, and may be assigned a precise place within the long procession of Artemisia's interpretations of the theme. Thus, as reviewed in the text, it restates features of the *Bathsheba* in Vienna (Fig. 180) while adding the pitcher-bearer which Artemisia adapted from paintings by Orazio Gentileschi that she had studied in London (including Fig. 182). She must have made a sketch of her father's figure as, incidentally, did Rubens in his drawing after Orazio's *Apollo and the Muses* (Rotterdam, Museum Boymans–Van Beuningen). This same maidservant returns in Artemisia's *Bathsheba* at Potsdam of ca. 1645–50 (Fig. 188), which otherwise shows a number of changes that are to be duplicated in Gentileschi's last known versions of the subject (Figs. 200, 201).

Somewhere along the way, perhaps in England, the artist was moved to pay homage again to the art of Paolo Veronese; the architecture with its Ionic columns flanking a niche figure recalls Veronese's frescoes in the Villa Barbaro at Maser and, less directly, the composition that had once served as a prototype for Artemisia's *Esther Before Ahasuerus* (cf. Figs. 125 and 127).

In proposing a date of ca. 1640–45 for the ex-Bari painting I am in general agreement with other scholars; only Gregori, who locates the *Bathsheba* with the *Annunciation* of 1630 (Fig. 114), believes that it falls outside Artemisia's second Neapolitan period.

BIBLIOGRAPHY: F. Hermanin, "Gli ultimi avanzi d'un'antica galleria romana," *Roma*, XXII (1944), 46–47 and pl. VII; Voss, 1960–61, p. 81; Bissell, 1968, p. 163; Harris in Harris/Nochlin, 1976, p. 123 n. 28; Rome, Villa La Castelluccia, "Vendite giudiziare e per commissione di Franco Semenzato & Co.," May 26–28, 1978, p. 90 no. 961; Marini, "Caravaggio e il naturalismo internazionale," 1981, p. 370; M. Gregori in Naples, *Civiltà del seicento*, 1984, I, p. 150; Grabski, 1985, p. 52; Garrard, 1989, pp. 129–31; Contini in Contini/Papi, 1991, p. 179.

For Orazio Gentileschi's *Apollo and the Muses*: Bissell, 1981, pp. 190–91 [63] and figs. 128–29.

[47] *Judith and Her Maidservant*

Cannes, Musée des Beaux-Arts
Oil on canvas, 2.35 x 1.72 m.
Ca. 1640–1645
Fig. 191

Inscribed (signed?) on the sword blade: *ART. GEN.*

COLLECTIONS: Gift of Mme. Derive to the Musée de la Castre, Cannes, June, 1933

Relined and restored in 1973. In contrast to the related compositions in Detroit and Naples (Figs. 84, 192; Color Plate XIII), Abra's left shoulder and arm are cropped by the frame, the maid thereby in danger of becoming but a *repoussoir* element echoing the shield and drapery at the left. Since also the gauntlet and plumed helmet on the table are disconcertingly incomplete, it can be supposed (with Contini) that the Cannes picture has been trimmed at the sides, most especially on the right and perhaps as much as the 19 cm. required to proportion its format to that of the Capodimonte example.

Catalogued by Bilous as an autograph work by Artemisia Gentileschi, and so considered also by Biedermann, Contini, and Muzii, the Cannes *Judith and Her Maidservant* is best approached first with regard to its position conceptually within Artemisia's career, and specifically by way of inescapable comparisons to the aforementioned versions in Detroit and Naples, here dated respectively to ca. 1623–25 and ca. 1645–50. This particular presentation of the Judith theme in Gentileschi's oeuvre originated with the Detroit painting (the compositional setup, poses, and various details of which even Artemisia herself may not have been able to emulate without having access to her first rendition), for which a Neapolitan provenance can be posited on independent grounds as well (see [14]). It was likewise with the Detroit *Judith* that the artist had introduced the motif of the kneeling woman, which she then repeated frequently during her years in Naples (e.g., Figs. 139, 159, 169; Color Plate XXIII).

Against such comparisons the unique stylistic and expressive features of the Cannes canvas clearly present themselves, a point to which the text devotes considerable attention. Among the several substantive changes is an increase in elegance and a lessening of pictorial boldness, both consistent with the general direction of Artemisia Gentileschi's art. In this, the *Judith* at Cannes stands much closer to the Naples version than to the Detroit one, while the differences in the painting in Italy with respect to that in France locate the latter to a somewhat earlier moment. If, then, the Naples example can be dated to ca. 1645–50, for reasons adduced also from the style of the two pictures that once accompanied it at Parma ([48a], [48b]; Figs. 188, 190), the present *Judith* may be placed in the first half of the fifth decade.

What, now, of the attribution to Artemisia's hand of the Cannes variant (which I know from a color photograph alone)? An inventory of ca. 1680 records that Francesco Maria Retti had made copies of Gentileschi's three Parmese canvases. These, however, were of the same size as Artemisia's originals (then 2.79 x 2.25 m.), and thus Retti's copy of the Parma/Naples *Judith* was appreciably larger than the Cannes one, even were the latter to be augmented by the hypothesized additions of lateral strips of canvas. Furthermore, in the French example the maid wears a brownish, not red, dress; and throughout (e.g., the drapery at the lower left and Abra's sleeves and shawl) the designs of details are dissimilar. Neither would one expect a presumed member of Gentileschi's workshop to effect the transformations from the Detroit to the Cannes paintings. Could, then, the present work be a copy of a lost original? Total faith should probably not be placed in the authenticity of the initials "*ART. GEN.*" on the blade of Judith's sword; this abbreviated form does not appear on any other work by Artemisia (although admittedly she observed anything but a set pattern), and could be a later record (cf. the case of another *Judith*, [34] and Fig. 150) of an oral tradition rather than a signature. Yet the photographic evidence speaks of a highly skilled brush which to all indications was Artemisia Gentileschi's own, that accustomed to producing such variants. I am relatively confident that a direct assessment of the *Judith*'s state of conservation and quality would not dissuade me from this judgment.

BIBLIOGRAPHY: N. Bilous in the catalogue of the Musée des Beaux-Arts, Cannes, pp. 81–83 cat. 22; Biedermann, 1988, pp. 39 color pl., 42; Contini in Contini/Papi, 1991, pp. 79 fig. 64, 85 n. 33; Muzii, 1995, p. 95.

[48] The Three Canvases from the Palazzo del Giardino at Parma: *Bathsheba, Tarquin and Lucretia, Judith and Her Maidservant*

During the 1630s Artemisia Gentileschi conceived the idea of marketing her paintings of Biblical and historical women in sets of two or three. By May of 1636 she had ready for delivery to Prince Karl Eusebius von Liechtenstein large compositions of *Bathsheba*, *Susanna*, and *Lucretia* (see [37]), and pendant pictures of *Bathsheba* and *Susanna* by her once graced the Romeo Collection in Naples (Figs. 159, 162; Color Plates XXIII, XXIV). About a decade later Gentileschi began three companion canvases which, several other works now lost, have come to epitomize her late style.

The known history of this suite begins in 1671 with the visit of Giacomo Barri to the Palazzo del Giardino of Duke Ranuccio Farnese II at Parma. There Barri saw "tre quadroni, nel primo è rappresentato l'historia di Giuditta, che troncò il capo à Oloferne. Il secondo mostra Lugretia Romana sforzato da Tarquinio. Il terzo è Bersabea vista da David dalla finestra del suo Palazzo, dipinto da una donna chiamata Artemisia, opere assai belle." Artemisia's originals, displayed together in the "sala dove è la Fontana," and full-scale copies of them by Francesco Maria Retti, were then described in an inventory of the Palazzo del Giardino compiled about 1680 (published by Campori and recently retranscribed by Bertini):

1. *Bathsheba*
 Un quadro alto braccia cinque, oncie cinque, e mezza, largo braccia quattro, oncia una, e mezza, Bersabea nuda a sedere s'acconcia le trecie davanti a un specchio sostenuto da una fantesca. Un'altra di dietro con filze di perle in mano, alla destra una donna con sechia in mano in lontananza sopra di un poggio Davide, di Artimisia Gentileschi n. 89.
 (Camera, ove è il letto del Seren.mo Sig.r Prencipe Odoardo). Un quadro alto braccia cinque, oncia una, largo braccia quattro, oncie una. Bersabea nuda a sedere s'acconcia le trecie avanti ad un specchio, sostenuto da una fantescha, con altra di dietro con filze di perle in mano, alla destra [i.e., to Bathsheba's right] una donna con secchia in mano in lontananza sopra di un poggio Davide, di Artimisia Gentileschi, copia di Fran.co Maria Retti n. 475.

2. *Tarquin and Lucretia*
 Un quadro alto braccia cinque, oncie una e mezza, largo braccia quattro, oncie una, e mezza. Lucretia ignuda sopra un letto, con Tarquinio con pugnale alla mano, et un moro, che alza un rosso padiglione del letto, di Artemisia Gentileschi n. 89.
 (Camera d'Audentia all'Incontro dell'Oratorio). Un quadro alto braccia cinque, oncia mezzo, largo braccia quattro, oncie una. Lucretia Romana nuda sopra di un letto, che si vedono le lenzuola, Tarquinio col pugnale alla mano in atto di volerla uccidere, alla sinistra un moro, che tiene sollevato il padiglione del letto di veluto cremese, e fragia d'oro, d'Artemisia Gentileschi, copia di Fran.co Maria Retti n. 474.

3. *Judith and Her Maidservant*
 Un quadro alto braccia cinque, oncie mezza, largo braccia tre, oncie una, e mezza. Giudita la quale tiene la mano sinistra opposta al lume, nella destra la spada a piedi, una vecchia con le mani sopra il capo di Oloferne, di Artimisia Gentileschi n. 89.
 (Camera d'Audentia). Un quadro alto braccia cinque, oncie una, largo braccia quattro, oncie una, e mezza. Giudita, che tiene la sinistra avanti un lume, acciò non li dia nella facia, guarda verso certe armature, che sono sopra di un tavolino, alla destra la spada, a mano destra di lei vi è una donna con un drappo bianco involtivi dentro il capo di Oloferne, di Artimisia Gentileschi, copia di Fran.co Maria Retti n. 473.

Some recording errors obviously crept into this unusually detailed list. The width of Artemisia's *Judith* is given as 3 + *braccie*, but this must be mistaken, since her other two canvases and Retti's replica of the *Judith* measured 4 + *braccie* wide. And the height of the *Bathsheba*

emerges—again through a slip?—as 20 cm. greater than that of its copy. That all three originals were inscribed on the reverse with the number 89, and that the copies, although divided between two rooms, were consecutively numbered, indicate that Gentileschi's paintings were thought of as a matched set. In short, the three pictures were no doubt the same size, 2.79 x 2.25 m. (the Parmese *braccia* at 54.52 cm., the *oncia* at 4.54 cm.).

How and when they made their way to Parma is unknown. It is most likely that these pictures were directly commissioned of or presented by the artist as "gifts" to the Farnese of Parma. They do not appear in the inventories (1653; 1662–80) of the Palazzo Farnese in Rome or in that of 1662 concerning the transfer of Farnese pictures to Parma (see Bertini for the specifics). Had they been executed for the Roman branch of the Farnese, Cassiano dal Pozzo, or another of Artemisia's connections in that city acting as an intermediary, there would probably be some mention of them in the Roman records. Furthermore, in 1628 Margherita de'Medici, daughter of Grand Duke Cosimo II of Tuscany, had married Duke Odoardo Farnese of Parma, and the *Bathsheba* (Fig. 201) by Artemisia in Florence is a close variation (see the text) of her canvas of this subject once at Parma. It may therefore have been the Parma-Florence and Gentileschi-Medici ties that occasioned the work now in storage at the Palazzo Pitti.

Fortunately, the Parma pictures have survived, although not without having suffered some indignities. Beginning with Voss and Longhi, scholars have identified the Parma *Judith* as the canvas in the Museo di Capodimonte at Naples (Fig. 192; 2.72 x 2.21 m.), and the *Bathsheba* and *Tarquin and Lucretia* as the paintings of these subjects in the Neues Palais at Potsdam (Figs. 188, 190; 2.58 x 2.18 m. and 2.61 x 2.26 m., respectively).

Notwithstanding Artemisia's habit of repeating her compositions, these identifications are certainly correct. Contini, admitting to not having studied the Potsdam canvases in the originals, has guardedly introduced the thought that they (and the Naples *Judith*) might be the aforementioned copies by Francesco Maria Retti. While not totally dismissing this possibility, Contini appears inclined to accept the

pictures as autograph and to connect them to the Parmese citations. Rossana Muzii, on the contrary, does not equivocate, having recently voiced the conviction that the *Judith* now in Naples is indeed Retti's copy (for her arguments and my rebuttal, see [48c]). The evidence for both the Parmese history and the autograph status of the canvases, even beyond their quality (see Chapter 5 and the individual entries), is compelling. A provenance from the Palazzo del Giardino has been claimed for the *Judith* by Molajoli and Bertini independently of the Potsdam paintings, and some sense of the circumstances under which it arrived in Naples can be achieved. Thus Carlo di Borbone, named Duke of Parma in 1731, had inherited the Farnese holdings from his mother Elisabetta Farnese of Parma, who had married Philip V of Spain in 1714 and who had been the niece of Francesco, former Duke of Parma. The death without issue in 1731 of the last Farnese Duke, Antonio, had cleared the way for Carlo. With the Treaty of Vienna in 1738 he was officially recognized as King of the Two Sicilies, ceding the duchies of Parma and Piacenza to Austria (until 1748, when they were awarded to Carlo's brother Filippo). But already by 1734 Carlo as the head of a Spanish army had wrested Naples from Austria, and in March of that year 350 paintings plus 7 cartoons, an impressive selection from the holdings in the main palace at Parma, had been made ready for shipment to Naples. In 1738 construction of the Palazzo di Capodimonte, destined to house the collection, was begun, and in 1739 the trove arrived in Naples. Following temporary and—Charles de Brosses informs us—highly unsatisfactory lodging in the Palazzo Reale, the pictures were relocated to the new palace in 1759. Although the Capodimonte *Judith* is not cited in the inventory of 1734 compiled pursuant to the shipment order, it is not unreasonable to assume that somewhere along the line it figured in the Parma-to-Naples flow of goods.

Even to the pearl necklace in the *Bathsheba* and the fringed tent curtain of the *Tarquin and Lucretia*, the canvases in Potsdam, like the *Judith*, match detail for detail the Parma descriptions. Yet while the Naples painting corresponds within 7 cm. in height to that noted in 1680, the heights of the Potsdam examples do

not, being on average 19 cm. shorter. To understand this reduction in scale and to ferret out the reasons for the splitting up of the cycle, one must consider the roles which the *Bathsheba* and *Tarquin and Lucretia* came to play at Potsdam. Contiguous to the Marmorsaal on the upper story of the Neues Palais, and identical in size to the Marmor-galerie beneath it, is the so-called Obere Galerie, a Rococo room of some 35 x 10 m. (Figs. 185–186). Six windows give onto the garden and provide illumination for six paintings, neatly falling into three pairs of canvases by three different artists (Fig. 187), on the long wall opposite:

1. Guido Reni, *Suicide of Lucretia*, 2.15 x 1.51 m.
2. Artemisia Gentileschi, *Tarquin and Lucretia*, 2.61 x 2.26 m.
3. Luca Giordano, *Judgment of Paris*, 2.54 x 3.61 m.
4. Luca Giordano, *Rape of the Sabine Women*, 2.60 x 3.65 m.
5. Artemisia Gentileschi, *Bathsheba*, 2.58 x 2.18 m.
6. Guido Reni (School of; Simone Cantarini?), *Diogenes in the Tub*, 1.93 x 1.43 m.

The wall onto which the heavy gilded frames for these pictures are permanently fixed is interrupted functionally by two doors, one in the center and the other setting limits to the wall compartment at the far right (and thus defining, symmetry to be maintained, the compartment at the far left as well). Paired pilasters separate the paintings, the actual widths of the remaining four fields having undoubtedly been determined by the widths of the works by Gentileschi and Giordano that were to occupy them. With the lower frames of all six pictures on the same level, Artemisia's *Tarquin and Lucretia* and *Bathsheba* had then to be trimmed or folded under (as Contini has also commented with respect to the *Bathsheba*), essentially at their tops, in order that they might match the heights of the Giordano canvases which they flank. Apparently even the Reni *Lucretia* was mutilated above, at least as much as possible without severely cramping the composition, so that it might echo the *Diogenes*, also a single-figure painting, at the opposite end. Indeed Pepper, citing the version of the *Lucretia* in the Galleria Spada at Rome (2.34 x 1.50 m.), speculated that the Potsdam example had been cut.

What, then, was the controlling principle that brought these six paintings together, beyond the fact that they are all by Italian masters of the seventeenth century? Bartoschek has written with reference to the Neues Palais in general of the iconographic programs designed to extoll the Master of the House and his achievements, but has not explicated the program of the Obere Galerie. In most respects this latter is self-evident. Five of the six pictures in the hall—the Ballroom, it should be noted—recount the fates endured by women upon the actions of men, sexually aggressive or erotically allusive and according to the values of the day not without excitement for the male viewer. So also do the stucco relief roundels by Pedrozzi and Sartori that encircle the room, among them the *Rape of Proserpina* on the short wall next to Reni's *Suicide of Lucretia*. The sixth painting, *Diogenes in the Tub*, introduced a moralizing note, yet surely not one to be taken all that seriously. Establishing Virtue as the only goal, the Cynic philosopher preached abstinence from sensual indulgence. The Parma/Naples *Judith*, depicting as it does women having gotten the better of a man, would obviously have been out of place, and thus was not acquired for the Neues Palais.

It seems clear that the *Bathsheba* and *Tarquin and Lucretia* were specifically chosen for the Obere Galerie. There is no documentation, however, as to when and where they were purchased. An inventory from 1708 of 550 paintings in the Palazzo del Giardino was destroyed during World War II. From it Filangieri di Candida had cited only 76 works, those not mentioned in the 1680 accounting. Since no canvases that can be identified as those by Gentileschi, even if misattributed, appear in the registers of the Palazzo della Pilotta at Parma dated 1708 and 1731 and in the inventory of March 1734 of works ready for transfer, they apparently had remained in the Palazzo del Giardino, perhaps also soon to be shipped—as hypothesized for the Capodimonte *Judith*—to Naples. But in 1773 the *Bathsheba* and *Tarquin and Lucretia* turned up in Matthias Oesterreich's description of the Obere Galerie in the Neues Palais, misassigned to the painter G. B. Ruggieri, as they continued to be in the nineteenth century. (The irony of including in this scheme pictures by a woman artist was there-

fore not recognized.) Conversely, they are not recorded in Oesterreich's catalogues of 1764 and 1770 of the Bildergallerie in the nearby palace of Sans-Souci; this implies that the *Bathsheba* and the *Tarquin and Lucretia* were not merely spirited from elsewhere in the collection to the Neues Palais upon its completion in 1769. Construction of the new palace was initiated in 1763, but plans for it had been formulated just prior to the beginning of the Seven Years' War in 1756. Foerster writes that among Frederick the Great's agents was "the active Berlin merchant and Manufacturengründer J. Ernst Gotzkowsky, who with his usual diligence shortly before the Seven Years' War brought together a significant number of paintings from Holland, France, and Italy in the expectation that they would pass as a block to the possession of the ruler." It is conceivable that by the mid-1750s the iconography of the Obere Galerie-Tanzsaal had been drafted, and that it was at this moment that Artemisia's pictures, minus the "inappropriate" *Judith* and with the name of the artist by then forgotten, were acquired in Parma or, more likely, in Naples. In Naples Carlo's Dresden-born Queen, Maria Amalia, might have been receptive to a German agent's pleadings to buy paintings which were deteriorating from neglect.

It remains for the catalogue entries that follow to establish to ca. 1645–50 the date of Artemisia's cycle and, with the text, to discuss the individual canvases in greater detail.

BIBLIOGRAPHY: G. Barri, *Viaggio pittoresco*, Venice, 1671, p. 108; M. Oesterreich, *Beschreibung aller Gemälde, Antiquitäten und anderer kostbarer und merkwürdiger Sachen, so in denen beyden Schlössern von Sans-Souci, wie auch in dem Schlosse zu Potsdam und Charlottenburg enthalten sind*, Berlin, 1773, nos. 160–61; Parthey, 1863, I, pp. 494 no. 86, 495 no. 99, and 1864, II, pp. 351 no. 16, 450; G. Campori, *Raccolta di cataloghi ed inventarii inediti di quadri, statue, bronzi, dorerie, smalti, medaglie, avorii ecc. dal secolo XV a secolo XIX*, Modena, 1870, pp. 242–46; C. F. Foerster, *Das Neue Palais bei Potsdam*, Berlin, 1923, pp. 32–33, 53; Voss, 1925, p. 463; B. Molajoli, *Il Museo di Capodimonte*, Cava dei Tirreni, 1960, pp. 12, 19; Longhi, *Scritti*, 1961, I–I, pp. 282–83, 485; Bissell, 1968, pp. 163–64; G. Bartoschek, *Die Gemälde im Neuen Palais*, Potsdam, 1979, pp. 3–4, 9, 26 nos. 208–10, 29 nos. 211–13; F. Strazzulo, *Le manifatture d'arte di Carlo di Borbone*, Naples, 1979, pp. 19–23, 27–28, 33–36, 47–76—for historical background and for the inventories of the Palazzo della Pilotta cited above; D. S. Pepper, *Guido Reni: A Complete Catalogue of His Works with an Introductory Text*, Oxford, 1984, pp. 254 cat. 108, 304 cat. C7, and pl. 130; G. Bertini, *La Galleria del Duca di Parma. Storia di una collezione*, Parma, 1987, pp. 32, 36, 48, 50–51, 66 n. 15, 250–52 (nos. 334, 339, 343, 350, 360, 386), and passim; Garrard, 1989, pp. 129–31, 133–35; Spear, Review, 1989, p. 604; Contini in Contini/Papi, 1991, pp. 85 n. 33, 171, 178–79; *Preussische Königsschlösser in Berlin und Potsdam*, Leipzig, 1992, pp. 196–97.

··

[48a] *Bathsheba*

Potsdam, Neues Palais, Obere Galerie
Oil on canvas, 2.58 x 2.18 m. (see below)
Ca. 1645–1650
Figs. 188–89

COLLECTIONS: Palazzo del Giardino, Parma, by 1671

Acquired for Frederick the Great, probably in the mid-1750s, for the projected Neues Palais at Potsdam, the *Bathsheba*—together with Artemisia's *Tarquin and Lucretia* and *Judith with Her Maidservant* (Figs. 190, 192)—once adorned the Palazzo del Giardino of the Farnese Dukes at Parma, where it was cited first by Barri in 1671. These moments in the painting's early history and the *Bathsheba*'s place in the thematic program of the Obere Galerie are detailed above [48].

In the inventory of the Palazzo del Giardino drawn up about 1680, the canvas is said to measure "alto braccia cinque, oncie cinque, e mezza, largo braccia quattro, oncia una, e mezza," or 2.99 x 2.25 m. according to Parmese equivalents. In view, however, of the stated sizes (2.79 x 2.25 m.) of the companion pictures to the *Bathsheba* and of Francesco Maria Retti's copy of it (2.77 x 2.23 m.), this must be a recording error. Thus the reduction in height, through cutting or folding, which the *Bathsheba* underwent upon its installation at Potsdam may have been no greater than 21 (not 41) cm. A comparison to Gentileschi's next-to-last rendition of the theme, that in Florence (Fig. 201), shows precisely what was lost during the operation. Today the brittle canvas is marred particularly by the deterioration of its more heavily shadowed passages, apparently the re-

sult of absorption of pigment into the preparatory ground.

Scholarly opinion is now unanimous in assigning the picture to the 1640s; that is, to Artemisia Gentileschi's second Neapolitan period. (Borea's statement—inadvertently made but repeated by Gregori—that I dated the *Bathsheba* to the artist's Florentine years is incorrect.) It follows logically upon the *Bathsheba* in Rome (Fig. 184), with which it shares the design of the loggia, the servant at the left, and the *repoussoir* drapery, and from which it adapts the pose of Bathsheba and the motifs of cushion and basin. As noted (Chapter 5), the woman seen from the back, her head twisted toward the left, originated with Orazio Gentileschi's *Apollo and the Muses* (Fig. 182), which Artemisia had seen in England during her stay there in 1638–40.

Yet with respect to the *Bathsheba* in Rome, the Potsdam version is more attenuated still—in compositional concentration and sentiment as in the proportions of the figures. And it is marked by a special lightness of tonality and coloristic brightness. On the right, Artemisia established a column of color—from the silvery-gray and blue apparel of the maid with pearls to the green velvet pillow upon which Bathsheba sits to the yellow drapery in the corner. Red, completing the major triad, serves for the dress of the vessel-bearer at the left. Between these poles are set the burnt-orange and salmon garments of the third attendant. The whole scheme is punctuated by whites.

The Potsdam canvas was succeeded, I believe, by the differently colored but essentially identical *Bathsheba* at Florence (Fig. 201), no doubt close in time to the signed and dated *Susanna* of 1652 that Alessandro da Morrona saw in the Tuscan capital (cf. [52]). Thus the present *Bathsheba* can be placed between 1645 and 1650. Brunetti and Gregori state, and Hagen implies, that the palace in the background evokes the architectural views of Viviano Codazzi. During the previous decade Viviano had lent his expertise and, in at least one instance, his brush to works by Artemisia (Figs. 159, 162; Color Plates XXIII, XXIV). The architecture in the *Bathsheba* is hardly vintage Codazzi, and certainly it lacks his distinctive touch. For Marshall, it "is not very Codazzian," and Pagliarulo rejects any notion of Viviano's participation. At best, Gentileschi once more may have solicited Codazzi's advice. If so, the *Bathsheba* would have reached the design stage by 1647, the year of Codazzi's departure from Naples. I cannot insist upon the possibility of such consultation, but it is intriguing that the landscape is generically in the manner of Viviano's partner and Artemisia's onetime collaborator Domenico Gargiulo (again Figs. 159 and 162; also Fig. 158).

The foregoing has assumed that the Parma/Potsdam *Bathsheba* is an autograph picture by Artemisia Gentileschi. As noted, Contini, who has not confronted the original, holds out the possibility that it is Retti's copy of Artemisia's canvas. And Garrard, finding the "display of stylish flesh" and the "expressive emptiness" to be "embarrassing," believes that "there is good reason to question the authenticity of the late works, and to suggest that an assistant, perhaps even Artemisia's own daughter, was responsible for these as workshop paintings." In my opinion the conception of a picture of this large scale, part of a suite of canvases obviously intended for an important patron and attributed to Artemisia within twenty years of her death, would not have been entrusted by Gentileschi to her daughter or to anyone else in a studio-assistant capacity. Moreover, while it is plausible to suppose that Artemisia employed a helper or two for the execution of secondary areas in her works, the overall quality of the *Bathsheba* (see the text), although somewhat compromised by the loss of transparency in the deepest shadows, is not that of a workshop production.

BIBLIOGRAPHY: See the Bibliography under [48]. Also see Brunetti, 1956, p. 63 n. 28; Voss, 1960–61, pp. 81–82; M. Gregori in Naples, *Civiltà del seicento*, 1984, I, p. 304; Hagen, 1988, p. 84; Marshall, 1993, p. 155; Pagliarulo, 1966, pp. 153–54.

..

[48b] *Tarquin and Lucretia*

Potsdam, Neues Palais, Obere Galerie
Oil on canvas, 2.61 x 2.26 m. (see below)
Ca. 1645–1650
Fig. 190

COLLECTIONS: Palazzo del Giardino, Parma, by 1671

Sharing the same history—for which see [48]—as the Potsdam *Bathsheba* (Figs. 188–89),

the *Tarquin and Lucretia* was accommodated to the scheme of the Obere Galerie in the Neues Palais through a reduction in height of some 18 cm.

Garrard's characterization of the painting as exhibiting "expressive lewdness and philosophical hollowness" and Barnes's comment (quoted in the text) regarding the tradition of sexually suggestive depictions of *Tarquin and Lucretia* underline the extent to which the imagery of most of Artemisia Gentileschi's late works seems primarily directed to male erotic impulses and thus loses its power to speak to deeper human concerns. Gentileschi's composition is quite obviously in the line of the likes of the Master LD etching of *Tarquin and Lucretia* from ca. 1546 and Cornelius Cort's engraving of 1571 after Titian.

Yet it does not follow from all of this, as Garrard is disposed to believe, that the canvas is a workshop production. For not only does Artemisia's last manner (see Chapter 5) seem less "incomprehensible" than has been supposed, the *Tarquin and Lucretia* is a brilliant piece of painting—or so I have maintained in the text. Contini's notion that the Potsdam canvas might just possibly be the copy known to have been executed by Francesco Maria Retti is not supported by direct examination of the work.

As regards sheer presence, the *Tarquin and Lucretia* has greater backbone than the *Bathsheba*, in part the result of a somewhat darker tonality as occasioned by the interior setting and the violence of the theme. Otherwise, even to the physical degeneration of the deepest shadows, implying the use of similar technical procedures, it appears to be contemporaneous with the *Bathsheba*, and may therefore be dated ca. 1645–50 for reasons stated under [48].

BIBLIOGRAPHY: See the Bibliography under [48]. Also see Voss, 1960–61, p. 81; Garrard, 1989, pp. 235–36; B. Barnes in Russell, 1990, pp. 30–31.

...

[48c] *Judith and Her Maidservant*

Naples, Museo di Capodimonte
Oil on canvas, 2.72 x 2.21 m.
Ca. 1645–1650
Fig. 192

On the back of the stretcher and the frame, the letter "L"; and on the frame,

"Anticamera"; on a paper label, "No. 112"; seal in red sealing wax, "Regia Proprietà"

COLLECTIONS: Palazzo del Giardino, Parma, by 1671 and until the later 1730s

The available evidence (see [48]) indicates that about 1739 the *Judith* was shipped to Naples from the Farnese Palazzo del Giardino in Parma, along with the *Bathsheba* and *Tarquin and Lucretia* now in Postdam (Figs. 188–90). Apparently because its theme of women triumphant was incompatible with the proposed iconography of the Obere Galerie in the Neues Palais, the *Judith* was not purchased with the others for Frederick the Great, and thus unlike them has not been trimmed. A cleaning and relining would certainly improve the painting's appearance, but as with the canvases at Potsdam the most deeply shadowed areas (here the table, Judith's billowing mantle, and the sweep of tent curtain behind) have been swallowed by the ground and are probably irretrievable.

Not unexpectedly for this moment in Artemisia's career, the figures and composition draw upon an earlier conception, in this case the *Judith and Her Maidservant* at Cannes (Fig. 191). I have dated the canvas in France to ca. 1640–45 in consideration both of its interpretive and stylistic distance from Gentileschi's *Judith and Her Maidservant* of ca. 1623–25 in Detroit and its prediction of the Naples version. This latter, with features that mark it as belonging to a slightly later moment than the Cannes example, was certainly painted concurrently with its onetime companion pictures; that is, about 1645–50 (see the text and [48]).

Pictorially the three large Parma canvases are impressive, and the possibility contemplated by Garrard that they are no more than products of Artemisia Gentileschi's workshop is to be excluded. Equally untenable in my opinion is the theory, entertained with great caution by Contini but advanced with conviction by Muzii, that the present work is the copy of Artemisia's *Judith* executed in Parma by Francesco Maria Retti, a view said to be shared by Nicola Spinosa. Muzii notes that Retti's replica of Gentileschi's *Judith* in the Palazzo del Giardino was recorded about 1680 with measurements almost exactly those of the Capodimonte canvas, whereas Artemisia's original figured as one *braccia* smaller in width. Muzii also finds the Naples *Judith* lacking with respect

to the Cannes picture, incorrectly said to be of "identical composition." Yet as indicated above, since the three Gentileschi canvases once in Parma were certainly designed as a matched set, the reported smaller dimension of the *Judith* must constitute a slip of the pen or ruler. And as discussed in the text, the Naples canvas is to be seen as carrying its own particular interpretive nuance, not as merely an inferior repetition of the Cannes painting.

BIBLIOGRAPHY: See the Bibliography under [48]. Also see Rinaldis, 1928, p. 109 cat. 377; Ortolani et al., 1938, p. 45; Milan, *Mostra del Caravaggio*, 1951, p. 63 cat. 102; B. Molajoli, *Notizie su Capodimonte*, Naples, 1960, p. 53; Pointon, 1981, p. 366; Garrard, 1989, p. 133; Contini in Contini/Papi, 1991, p. 85 n. 33; Muzii, 1995, pp. 94–95, with full bibliography and Capodimonte inventory references (beginning in 1799).

...

[49] *Galatea*

New York, The Saul P. Steinberg Collection
Oil on canvas, 1.483 x 2.03 m. (but see below)
1648
Figs. 176, 195–96; Color Plate XXII

COLLECTIONS: Don Antonio Ruffo, Messina, by January 1649; Ruffo heirs, at least until the mid-eighteenth century; Private Collection, Switzerland; Hazlitt, Gooden and Fox, London, 1981–82; Richard Feigen and Co., New York

The *Galatea*, having undergone at least two recent restorations, the latest in 1995 by Marco Grassi, has survived as a stunning and evocative picture despite significant paint loss (and the consequent need for extensive in-paintings and some reconstruction) and, I will argue, a past mutilation that reduced both its height and width by approximately 55–60 cm. Accompanied by an entourage of four brown and ruddy-skinned tritons and seated on a throne of exquisite red coral, its footrest a yellow-brown shell, the nymph Galatea in a flowing blue mantle and transparent veil is swept over the dark seas by two dolphins.

Since its reappearance a decade and a half ago, the canvas has been the subject of extended discussion, particularly as regards its authorship, of which the following scholarly opinions are representative: Bernardo Cavallino (Spinosa; Lurie; Percy); possible collaboration between Cavallino and Artemisia Gentileschi (Bissell; Matthiesen catalogue, 1986; Contini); unlikely collaboration between Cavallino and Gentileschi (Cropper); definite collaboration between Cavallino and Gentileschi (Grabski; Garrard; Daniel). I now find the last-noted view fully persuasive, and it is to this issue above all that this entry is dedicated.

Of consequence to this demonstration is the documentation published by Vincenzo Ruffo concerning a *Galatea* which Artemisia Gentileschi executed on commission from Don Antonio Ruffo of Messina:

(1) January 5, 1649: Ruffo records in his account book a payment of 160 ducats to Gentileschi for a *Galatea*—"Fra Don Fabritio Ruffo Prior della Bagnara Mio Nepote *Havere* A. 1649 a 5 Gennaro. . . . E. D.^i 160—Disse Pagati Ad Artemisia Gentilesca per il quadro della Galatea D.^i 160." And in another *Libro di conti* of the years 1644–1655 inclusive: "E oz. 84 p. Prezzo di uno quadro di p.^mi 8 E 10—della favola di Galatea con n.° 5 trittoni fatto di mano di Artemisia Gentileschi mand.^mi da Napoli dal S.^r Prior della Bagnara Mio Nepoti Cioè oz. 64 [160 ducats] Costo di quadro, oz. 18—per la Cornizze adorata e oz. 2 di nolo—dico oz. 84."

(2) January 30, 1649: Writing from Naples, Artemisia expresses hope that Don Antonio had seen the painting that had been shipped to Sicily and claims that out of affection for him she had let it go at a bargain price—"Come è piaciuto a Dio è venuto lo quadro a V. S. Ill.^ma il quale credo per quest'hora l'havera già visto, e credo, che per insino che non ha visto il quadro mi haverà stimato arogante et impertinente. Ma spero al Sig.^re Idio che al aparir de quello giudicherà che non havessi in tutto in torto, et in effeto, se non era V. S. Ill.^ma al quale vivo tanto aff.^ta serva non mi haverei indutto a darli per li centosissanta perchè in qualunque parte io sono stata mi è stato pagato cento scudi l'una la figura. . . ."

(3) March 13, 1649: In the second of what

were to be many letters to Ruffo involving several pictures, Gentileschi communicates her dismay upon learning that, through no fault of her own, the *Galatea* had been damaged during sea transit—"mi dispiace bene, che la Calatea habbia patito per mare, che se mi fusse stato concesso di havere conseguito li suoi comandi, non sarebbe intervento questo, mentre l'havesse comodato io con le mie mani ma quest'altro non riuscirà così, già che starà in mio arbitrio in eseguire i suoi comandi. . . ."

(4) August 5, 1649: Don Antonio Ruffo again accounts for the costs of the packing crate and of the gilded frame (and its crate)—"A. 1649 A dì 5 Agosto. Il S.ʳ Frà Don Fabritio Ruffo, Prior della Bagnara, Mio Nepote, per Conto Mio, deve D.ⁱ *Havere* A di contraposto D.ⁱ 2 per conto di una Cassa per il Quadro della *Galatea* D.ⁱ" and "E D.ⁱ 45 per la Cornizza e Cassa di essa per il quadro della Galatea pagati a Sebastiano Gallone."

(5) December 26, 1673: In a donation *propter nuptias* made to his son Don Placidio Ruffo, Don Antonio designates one hundred pictures in the gallery which under the strictures of primogeniture and deed of trust were to remain together as the inheritance of the generations of eldest sons. This list, confirmed on January 23, 1703, was fixed definitively on August 5, 1710, upon Don Placidio's death, the one hundred works then passing to Don Antonio Ruffo e La Rocca. An inventory compiled in 1739 after the latter's death indicates that the group had survived intact. And in 1750 the primogeniture was reaffirmed. Among these choice paintings was Artemisia Gentileschi's *Galatea*: "*Galatea che siede sopra un granchio, tirata da 2 delfini e accompagnata da 5 tritoni. 8 x 10 palmi.*"

Thus having received her fee on January 5, 1649, Artemisia consigned a canvas of *Galatea* to Don Antonio's nephew, the Prior of Bagnara Fabrizio Ruffo, whose supervision of the packing seems to have been less than knowl-

edgeable. Shortly thereafter the painting, the worse for water, arrived in Messina, where it was still to be found in the Palazzo Ruffo in the mid-eighteenth century, evidently with its original measurements.

All scholars, including those for whom the present canvas is by Bernardo Cavallino, have recognized the relevance of the Ruffo *Galatea* to the issue at hand. The painting and the inventory description correspond on several points: Galatea, seated on a spiky crab shell—the Italian *granchio*—rather than the traditional scallop shell, pulled by two dolphins and surrounded by tritons. Moreover, in pose as in physical type—round-faced, smooth and full-bodied, sensual—the figure of the Nereid is absolutely typical of Artemisia Gentileschi: of the Bathsheba in the Columbus painting (Fig. 159; Color Plate XXIII); of the daughter at the right in the Toledo *Lot* (Figs. 164, 166; Color Plate XX); and, as Contini and I have observed, especially of the Susanna in the much damaged and repainted example at Brno (Fig. 197), datable ca. 1650 or almost contemporaneously with the *Galatea* for Don Antonio. The tasseled pillow comforting Galatea, likened by Grabski and Garrard to the cushions in the *Venus and Cupid* (Fig. 104; Color Plate XIV) and in the *Cleopatra* (Fig. 110; Color Plate XV), is also a feature of the five *Bathsheba*s executed by Artemisia between ca. 1640 and 1652 (Figs. 180, 184, 188, 200, 201). And the motif of the billowing mantle appears in Gentileschi's last interpretation of Judith (ca. 1645–50; Fig. 192).

It is equally obvious, however, that the *Galatea* for Ruffo had five, not four, tritons, and was considerably larger (8 x 10 *palmi*; i.e., 2.04 x 2.55 m. according to the equivalency of .255 m./*palmo* employed by Vincenzo Ruffo) than the known canvas. Furthermore, the presence in the New York *Galatea* of the mind and hand of Bernardo Cavallino is patent. These nervous, plebeian, wiry tritons with their disheveled hair and dark complexions, the latter deepened by technical procedures which often caused Bernardo's pigment to sink into the preparatory ground, are tantamount to Cavallino signatures. One need only compare (Lurie) Cavallino's *Expulsion of Heliodorus* in the Pushkin Museum at Moscow or, the men now dressed, the *Meeting of David and Abigail* at Braunschweig (Fig. 161).

The result of this coexistence of two distinct brushes and mentalities is, as Grabski and Garrard have observed, a certain expressive and stylistic disjunction. Garrard writes that "the jaunty, playful tritons, painterly but unplastic, are of a separate pictorial world and language from the weighty figure in sharp, bright chiaroscuro who sits among and yet apart from them." Finally, I suspect (with Lurie) that the dolphins and reins are also by Bernardo, and (with Garrard) that the coral and shell, being of a block with the nymph, are by Artemisia.

If, then, the *Galatea* for Ruffo and the present picture are judged to be identical, there are only two possible explanations for the discrepancies between the documentation and what one sees: (1) the painting in New York has been reduced in size; (2) without informing Don Antonio, Artemisia had hired Cavallino as a major collaborator, the same Cavallino who toward the end of the previous decade most likely contributed to at least three paintings—the aforementioned works in Columbus and Toledo and the *Susanna* sold at London (Fig. 162; Color Plate XXIV)—that came from Gentileschi's shop (for the arguments, see the individual catalogue entries and Chapter 4).

The fact is, however (and this point must be underlined), that restorers who have worked on the New York canvas believe firmly that it has *not* been substantially cropped. Richard Feigen reports technical evidence of "clean cuts suffered during World War II" and of the possibility that the work was "slightly trimmed in relining," and Marco Grassi records the absence on all four sides of the original tacking edges. Nonetheless, the latter also observes the presence of "original borders," while William Russell speaks of "17th-C. stretcher marks visible on the canvas."

Now Grabski, citing the line that runs horizontally through the top of Galatea's head and other such demarcations near the remaining edges, supposed that the painting was once folded under. In all probability these were caused by the collapsing of the canvas against a stretcher, and the slight shifts in tonality across the junctures by an overlapping frame. Are the aforementioned lines, then, the would-be "17th-C. stretcher marks," and, if so, by what means can their date be thus determined? Or is the reference rather to cusping, that escalloped

distortion along the edges resulting from the stretching and tacking of the canvas prior to its having been painted upon?

While great respect must be accorded evidence gathered from conservation procedures, it need not perforce take precedence over the conclusions of connoisseurship. In the present case the head of Galatea is oppressed above, that of the youth at the far left is incongruously abbreviated, the conch borne by the triton on the right is incomplete, and the lower dolphin sniffs the frame—all peculiarities which suggest that the painting was indeed accommodated to a smaller frame.

Of equal significance to the issue of the initial format of the *Galatea* are the compositional disparities between the painting and its prime source, Raphael's *Galatea* in the Farnesina at Rome (Fig. 193) or, more likely, a print (Lurie suggests that by Marcantonio Raimondi) after the fresco. From the Renaissance work came elements of Galatea's pose (the *contrapposto*, the upward glance, the arms holding the reins), her flying drapery, the triton at the far right, and the positions of the dolphins. Yet, as Grabski (seconded by Garrard) has stressed, while Raphael's composition is centered around the Nereid, that of the New York canvas is unevenly weighted and compressed toward the left without counterpoise to the right side. The Matthiesen catalogue of 1986 takes this to indicate Cavallino's difficulty in designing large-scale paintings. However, if the canvas is extended to the measurements of the Ruffo *Galatea* by opening it up at the left and above, where the cramping is most severe, and slightly below and to the right to complete the dolphin and the conch, Galatea's navel becomes virtually the exact nucleus of the composition. The space above, representing about twenty percent of the total height, could then have been activated by flying cupids toward which Galatea glanced, as Grabski postulates by analogy to Raphael's depiction of the theme and to those by the Carracci and Fetti. Logically the zone at the left, Grabski continues, would have contained the missing fifth triton.

I believe that it is possible to reconstruct with some accuracy the appearance of this triton on the basis of a drawing in the Museo di San Martino at Naples by none other than Bernardo Cavallino (Fig. 194; pencil and charcoal,

325 x 258 mm.). Variously identified as a Bacchus or simply as a male nude half-figure, the tousled-haired young man here is represented from above the knees and with his left arm barely defined. In short, he can be imagined as partially submerged in water, partially obscured by the form of the now fragmentary triton next to him and, his head raised, as fixed upon the source of Galatea's attention. In addition, while the object which he grips in his left hand is best interpreted as a loop of rope provided so that the studio model might sustain his position, one can easily conceive another conch shell or other musical instrument appropriate to a triton. Today, at least, the genitals of the youth in the drawing are covered by what appears to be a leaflike configuration, evoking the garlands that gird the loins of two of the tritons in the New York picture. Restored to the painting and the illumination on his body adjusted accordingly, he would echo in reverse his companion at the far right and with him provide visually satisfying parentheses to the whole.

Thus Grabski's proposals that the ex-Feigen *Galatea* was painted by Artemisia Gentileschi in collaboration with Bernardo Cavallino for the Sicilian nobleman Don Antonio Ruffo (a view which Daniel considers probable) are altogether credible. Conversely, his suppositions that the picture had been trimmed and had left the Palazzo Ruffo already by the late seventeenth or early eighteenth century must be challenged. As noted above, the *Galatea*, measuring 8 x 10 *palmi*, was among the hundred works reserved by Don Antonio in 1673 for successive inheritance by the eldest sons of the family, and Don Antonio's provisions were ratified in 1703, 1710, 1737, and 1750. There is nothing in the documentation collected by Vincenzo Ruffo to indicate that the paintings had not remained in their original states, and everything to suggest that they were still together at the death of Don Giovanni Ruffo e La Rocca in 1755 or 1756. Their fate thereafter cannot be charted. It is possible that the *Galatea*, having been damaged already by the sea voyage in 1649, suffered further during the earthquake of 1783 which ruined some rooms in the Palazzo Ruffo al Regio Campo, was sold out of the collection after 1818 when the Sicilian laws of *fidecommesso* were rescinded, or even that it was partially burned in the devastating

fire of 1848. Since the *Galatea*, according to the arguments presented here, was cut more or less equally at the top and left side, it may be that the specific amount of reduction in one direction or the other was determined by the desire to retain the initial height-to-width ratio. I am therefore unable to accept Grabski's view that representations of *Galatea* by Paolo de Matteis (d. 1728) were inspired by Gentileschi's version in its reduced dimensions. Furthermore, the latter was probably inaccessible to Paolo de Matteis, and any similarities between his rendition and Gentileschi's might best be attributed to a common source in Raphael.

There are further lessons to be learned from the foregoing. The history of the picture now in New York confirms that its protagonist is indeed Galatea, not Amphitrite as was thought as late as 1982. The legend of Galatea and Polyphemus, later recounted by Ovid (*Metamorphoses* 13:750–899) among others, was of Sicilian origin, and it was in Sicily that Polyphemus was said to have resided. The appropriateness of this theme to Don Antonio Ruffo of Messina, who made money from sea trade and who no doubt dictated the subject, is plain. Second, one must reevaluate Lurie's judgment that the figures are within a "nocturnal ambience," that "a half-veiled moon spreads its pale light." To my knowledge there is no literary precedent for this, and the torches borne by cupids in, for example, the *Galatea* compositions of the Carracci and Paolo de Matteis and in Poussin's *Triumph of Neptune and the Marine Venus* symbolize the inflaming power of love and play no roles in the overall illumination. I suspect that abrasion, with the consequent assertion of the dark ground, and Cavallino's technical methods provoked the dusky tonality. Third, the "quatro grande" for the Principe di Cardito for which Cavallino was paid on January 23, 1649, cannot be (as Percy theorized) the *Galatea*.

The hypothesis that the New York canvas is a joint venture of Artemisia and Bernardo, the former responsible for the basic composition and for the conception and painting of the central section and the latter for the execution and no doubt specific design elements of the tritons and dolphins, is founded in the main upon stylistic considerations. Yet it also assumes that (a) Gentileschi would have had need of Cavallino,

(b) Gentileschi would have deceived her patron (here held to have been Antonio Ruffo) by passing off as her own work a picture which in significant part was by another brush, and (c) Cavallino, more than a decade after he had first collaborated with Gentileschi and at a moment when he had reached his artistic peak, would have accepted a call from Gentileschi in the first place.

These assumptions are not implausible. The patron requested a subject that required male nudes, but such figures were not, after all, Artemisia's forte, and it would have been difficult if not impossible (see Chapters 2 and 4) for her as a woman painter to engage nude male models. Don Antonio, to judge by the many accounts and letters published by Vincenzo Ruffo, was unfamiliar with Cavallino's art. In these years (see Chapter 5) Artemisia was chronically short of cash, and the sooner she could finish a painting while maintaining high standards of quality, the sooner she would get paid. Bernardo, although also an artist of great skill, needed the money as well. In support Grabski (backed by Garrard) refers to Dominici's report that monetary considerations had forced Cavallino to work for other painters and to recent research confirming Bernardo's unhealthy financial situation.

Correspondence from Artemisia to Ruffo dated November 13, 1649, would appear to bolster the supposition that she was not above deception. The artist begins by acknowledging that in a letter of October 26 Ruffo had informed her that a certain Cavaliere in Messina, familiar with Ruffo's *Galatea*, was interested in having her paint another canvas of this theme. The Cavaliere stipulated that his *Galatea* was to be different from Ruffo's version and that before proceeding Artemisia was to set her fee and send him a drawing of the proposed composition. Gentileschi reacted strongly to these demands. "Regarding the fact that this gentleman wants to know the price before the work is done," she writes, "I do it most unwillingly, since I account it important not to err and in so doing burden my conscience, which I value more than all the world's gold," and she declares herself afraid that God will withhold his grace because of such offenses. Balking too at providing a drawing, Artemisia claims that she had just been bilked out of a commission when

a drawing she had supplied was turned over to another artist. She considered this a special affront "because when the concept has been arrived at and established through lights and darks and on [spatial] planes, the rest is trifling." So disposed, one can find in these statements oblique allusions to the circumstances surrounding Ruffo's *Galatea*: that she hesitated to quote the Cavaliere a price because she thought again of employing Cavallino and could not speak for his fee; that she rather "protesteth too much" in proclaiming her moral need to be scrupulously honest with patrons; that in putting in writing her belief—one with a long academic tradition, as Garrard notes—that *invenzione* was absolutely primary, she was justifying to her conscience Cavallino's contribution to Ruffo's picture.

It is, however, above all in Artemisia's reaction to the urging that the second *Galatea* be different from the first that the artist reveals herself capable of misrepresentation: "And never has one found in my paintings any repetition of invention, not even of one hand." This, needless to say, is patently false. No more than with male painters of the age, for whom wheeling and dealing was an accepted part of professional life, is there reason to hold Artemisia Gentileschi to complete trustworthiness.

There is no indication in Artemisia's three subsequent letters to Don Antonio that she satisfied the anonymous Cavaliere's wishes. However, in an inventory from 1710 of the Neapolitan collection of Don Diego d'Andrea, housed in the Palazzo d'Andrea near the church of San Carlo alle Mortelle, the following picture appears: "Un quadro grande di palmi 10 e 8 di Artemiggia con una Venere sopra una conchiglia tirata da varij delfini con diversi tritoni con cornice grande de legname intagliata a fiorami, e indorata." Ruotolo, who published this inventory, emphasizes that its measurements were approximate, that confusions of subject are possible, that its attributions cannot as yet be verified and were probably often in error, and that copies passing as originals may have abounded. Concerning the painting assigned to Artemisia, Ruotolo and Contini reasonably suppose that it represented a *Galatea*, Contini adding that the work was "possibilmente non quello Ruffo e magari quella dipinta congiuntamente al Cavallino già

a New York." Since, as noted, Ruffo's painting remained in the family at least until the mid-eighteenth century, the d'Andrea canvas, although of the same size, was obviously another example. Don Diego had inherited his pictures from his brother Gennaro (b. 1637, d. 1710), who in turn had inherited them from his brother Francesco (b. 1625, d. 1698), apparently the prime mover in forming the collection. Thus the supposed *Galatea* in Naples and the hypothetical one for the Messinese Cavaliere are unlikely to have been one and the same. To identify the painting in New York with that once in the Palazzo d'Andrea is to assume that the latter was autograph and that it later came to be cut down from its original size.

Complicating the issue are two additional attributions to Artemisia Gentileschi of representations of Galatea. One of the seventeenth century locates "Una Galatea, dell'Artemisia" in an anonymous Florentine collection ([L-32]), a painting that might have been produced about 1650 when, as the Bathsheba (Fig. 201) in the Palazzo Pitti indicates, Gentileschi was again being patronized by the Medici of Florence. The other, dated 1667, places "La Galatea di Gentileschi con cornice" in the Neapolitan collection of Bernardino Belprato ([L-34]). Bernardino is documented on December 19, 1636 ([L-96]), as having provided Artemisia with the final 20 ducats of a 60-ducat fee for a picture she was to deliver to him. Being 100 ducats less than her rumuneration for the *Galatea* for Ruffo, this transaction is more likely to refer to Gentileschi's *Portrait* (?) *of Giuseppe Giusto*, also with Belprato ([L-36]), if indeed it concerns either painting. Whether Bernardino Belprato's *Galatea* later became the property of Don Diego d'Andrea, or was still another version, is indeterminable.

When all is said, however, the various arguments presented above, including those regarding the vicissitudes of the Ruffo collection and thus the reasons why the Ruffo *Galatea* might have been mutilated, are still heavily weighted toward recognizing the extraordinary work in New York as that created in 1648 for Don Antonio Ruffo, Artemisia's chief supporter in her last years. Still, given the division of labor on it, it cannot stand as the epitome of Gentileschi's late style. For this the cycle of paintings once in the Palazzo del Giardino at Parma

(Figs. 190–92, 194) claims the distinction or—to some writers—must bear the blame.

BIBLIOGRAPHY: Ruffo, 1916, pp. 32, 48, 52, 314–15, 376–80; Ruffo, 1919, pp. 48, 52; N. Spinosa in London, Royal Academy, 1982, pp. 144–45; R. Ward Bissell, paper presented at the Cavallino symposium, Cleveland, November 16, 1984; G. Sestieri in Naples, *Civiltà del seicento*, II, 1984, p. 71 cat. 3:13; Percy/Lurie, 1984, pp. 16, 18–19, 29 nn. 3–5, 186–87 cat. 68, and color pls. XII–XIII; Grabski, 1985, pp. 41–55; R. M. Cavallo et al., *Il disegno barocco a Napoli*, Gaeta, 1985, pp. 110–11 cat. 42; London, Matthiesen, 1986, p. 72; R. Ruotolo, "Artisti, dottori e mercanti napoletani del secondo seicento. Sulle tracce della commitenza 'borghese,'" *Ricerche sul seicento napoletano* (1987), 177–79, 186 (as from Naples, AS, notaio Giuseppe Ragucci, secolo XVII, scheda 508, prot. 63); Garrard, 1989, pp. 123–27 and notes, 390–91, 397–98; Cropper, 1989, p. 864; R. Feigen, New York, letters to the author, August 29, 1990, and October 10, 1991; Contini in Contini/Papi, 1991, pp. 76, 78 fig. 63, 83, 87 n. 77; R. Ward Bissell, letter to Domenic Leo, Curator of the Steinberg Collection, New York, July 14, 1994; Domenic Leo, New York, July 20, 1994, letter to the author; L. Daniel in Prague, 1995, p. 56; Marco Grassi, Fine Arts Conservation Studio, New York, Conservation Schedule #0779, March 10, 1995; idem, letter to Domenic Leo, March 17, 1995; William Russell, Curator of the Steinberg Collection, New York, letter to the author, July 15, 1996.

[50] *Susanna and the Elders*

Brno, Czechoslovakia, Moravskà Galerie v Brne
Oil on canvas, 2.05 x 1.68 m.
1644? (see below)
Fig. 197

Signed on the socle of the balustrade, at the right: reportedly ARTEMITIA / GENTILESCHI. F. / MDCIL, but with only ARTEMITIA / GENTILESCH[] / MDC[] visible in the photograph of the signature.

COLLECTIONS: Heinrich Gomperz, Brno, until 1894; thence by the Gomperz testament of 1892 to the city of Brno

The restoration and relining of the canvas in 1953–54 was only the last and most considered in a series of interventions during which very extensive losses had been filled and in-painted, sections overpainted, and gashes repaired. Among the ruined areas registered in the pho-

tographs published by H. Böhmová-Hájková are basically the entire head of the bearded elder and the top of that of his companion, and portions of Susanna's eyes. Daniel isolates the head, body, and drapery of Susanna (but decidedly not her hands) as better preserved, but hypothesizes—no doubt justly—from the condition of the borders of the canvas and the relationship of the forms to them that the painting has been trimmed on all sides. It is impossible to know with certainty how closely the colors (the browns of the ambient, brownish maroon moving to pinkish maroon for the central elder, blue-gray and blue for the other) approximate their initial appearance.

While discriminating judgments are therefore out of the question, the attribution of the *Susanna* to Artemisia Gentileschi can be confirmed. The former ascription to "Caracci" and the reappearance of the signature under layers of yellowed varnish are signs that the true authorship of the canvas was neither inflated nor prejudged. The baluster at the far left has reasserted itself beneath the thinly painted lip of the basin, and there are *pentimenti* in Susanna's drapery—small clues that the work is not a copy. The elders, insofar as their original physiognomies may be imagined, are familiar from Artemisia's *Birth of Saint John* and *Adoration of the Magi* (Figs. 139, 149). (Conversely, they are unrelated to the voyeurs in the *Susanna* recently at London [Fig. 162; Color Plate XXIV], for which figures Bernardo Cavallino may have been responsible.) Susanna's countenance approximates that of Lucretia (Fig. 190). And although Gentileschi continued to employ nude female models, as proved by her letters of June 12 and November 13, 1649, to Don Antonio Ruffo, she transformed the life studies through affectations and by mining motifs from her own pictures. Thus here the legs of the maiden and the drapery over them are tired variations upon the *Bathsheba* in Columbus (Fig. 159, Color Plate XXIII), as the positions of her arms invite memories of Artemisia's earliest certain painting, the less histrionic *Susanna* at Pommersfelden (Fig. 10; Color Plate I). As Daniel has intimated, the landscape, painted in a heavier impasto, recalls those which Domenico Gargiulo had once contributed to Gentileschi's canvases (again Figs. 159, 162; Color Plates XXIII, XXIV), although I do not think

that the feathery background is either so extensive or so distinctive as to suppose a brush other than Artemisia's in emulation of Gargiulo.

In its expressive artificiality the Brno *Susanna* approaches the conclusion of the artist's life. At the end of the eighteenth century Alessandro da Morrona saw in the Florentine collection of Averardo de'Medici a *Susanna and the Elders* signed and dated by Artemisia Gentileschi in 1652 ([L-104]). Garrard (followed by Hersey) has tentatively identified the present picture as the ex-Medici example; the latter, however, was considerably larger and of horizontal format (approximately 2.63 x 2.34 m.), and depicted Susanna with drapery-covered breasts. And the partially damaged signature on the Brno picture is interpreted by Daniel to read "ARTEMITIA/ GENTILESCHI. F. / MDCIL," although only the second rendering recorded above is indicated by the photograph. (Contini, while having obtained his information regarding the signature from Daniel, gives the form as "ARTEMISIA / GENTILESCHI / MDCIL.") Nonetheless, the record of the Florence *Susanna* can be introduced to corroborate Daniel's dating of the present version, in that it demonstrates that Gentileschi had pursued the theme to the last and to the same moment that she had sent to Florence the *Bathsheba* now in the Palazzo Pitti, a replica of the Potsdam composition of ca. 1645–50 (Figs. 201, 188). Only in the Brno *Susanna* and Florence and ex-Gosford House (Fig. 200) *Bathsheba*s does the costly washbasin rest on lion claws, a small but significant detail from a painter for whom repetitions had become the norm.

BIBLIOGRAPHY: Böhmová-Hájková, 1956, pp. 307–8 (ill. following p. 310) and, in German translation, pp. 309–10; Bissell, 1968, pp. 164–65; Garrard, 1989, pp. 130–31, 134–35, 518 n. 234; Contini in Contini/Papi, 1991, pp. 86 n. 74, 113; Hersey, 1993, pp. 330–31 n. 3; L. Daniel in Prague, 1995, pp. 56–58 cat. A 11, with color ill. And Morrona and Lanzi in the Bibliography to [L-104].

..

[51] *Madonna and Child*

El Escorial, Museo de Pintura
Oil on copper, ca. .58 x .50 m., affixed to a panel of .72 x .52 m.
1650–1651
Fig. 198

Signed on the face of the bench, lower right: *Artemitia Gentileschi*

Along the bottom, left to right, the inventory nos. 689, 121, and 662, and a fleur-de-lis

COLLECTIONS: La Granja, Collection of Isabella (Elisabetta) Farnese, by 1749; El Escorial, sacristy, by 1857; El Escorial, Casita del Príncipe

This still-undervalued *Madonna and Child* was inventoried at La Granja in 1749 before passing to the Escorial, where in 1857 it was catalogued (no. 662) by Poleró under Artemisia Gentileschi's name: "*Nuestra Señora el niño Dios, que juega con un rósario.* (firmada, tabla). Alto, 2 piés, 2 pulg., 3 lin.; ancho, 1 pié, 5 pulg." The date of its transfer is not known; it is not cited in Andrés Ximénez's *Descripción del real monasterio de San Lorenzo del Escorial*, published at Madrid in 1764. Signaled by Pérez Sánchez in 1965 in the Casita del Príncipe, the painting was not accorded close study until the Seville exhibition of 1973.

The copper plate, no doubt retaining its original size, was affixed by rows of tacks (visible all around) to a panel that enlarged the format by narrow margins at the left, right and below and by some 13 cm. above, and necessitated an extension (and partial repainting?) of the olive-green curtain. Since the La Granja inventory no. 689 and the Farnese fleur-de-lis overlap the junctures, this disfigurement had already been effected by the mid-eighteenth century. The picture emerged from restoration with jewel-like beauty, from the exquisite modeling of the Child's flesh to the Virgin's red dress, rich lapis mantle, and transparent white veil.

Nonetheless, the attribution of the painting to Artemisia Gentileschi is at first surprising, for the scale, medium, subject matter, and devotional tone (even to the Virgin's halo and the star of light at the Child's head) are to varying degrees unexpected in her oeuvre. Indeed, Artemisia's authorship has been rejected implicitly by Contini and explicitly by Borea, for whom the copper is a typical work by Angelo Caroselli and the "showy signature" an addition "to increase its value." Yet Caroselli's *Madonna*s (as that in the City Art Gallery at Manchester), while exhibiting similar facial types and delicacy of sentiment, are less purposefully sophisticated. And what supposed forger of

signatures, confronted with this *Madonna* before 1857 ("firmada," Poleró noted), would have conjured up Artemisia's name or considered that this designation would have enhanced the picture's esteem? Moreover, on a forgery one would expect to read "*Artemisia*," not the form "*Artemitia*" that appears on Gentileschi's *Jael and Sisera*, *Judith Decapitating Holofernes*, and *Birth of Saint John the Baptist* (Figs. 72–73, 77–79, 139; Color Plate XII).

Affirming its attribution to Artemisia, Pérez Sánchez and Nicolson nonetheless mistakenly assign the picture to the first decade of Gentileschi's activity. For Pérez Sánchez, its "enameled quality and wooden support" (corrected to "copper" in a letter to the author) indicate a date between 1614 and 1620, close to the *Madonna and Child* and the *Magdalen* in the Palazzo Pitti (Figs. 1, 70; Color Plate V), while for Nicolson the "residue of Mannerism" prompts the same conclusion. However, as the latter observes, a glossy surface is to be expected of a painting on copper, and the buxom physiques and assertive realism of Artemisia's early works are nowhere in evidence. As a euphemism for "artificial" or "affected" the term "mannerism" is better reserved for Gentileschi's last productions. And, as detailed in the text, there are even more particular relationships to works by Gentileschi after 1640 (e.g., Figs. 184, 188, 201). The Neapolitan provenance of the picture is indicated as well by the striking similarities in positions and gestures between Artemisia's Madonna and Child and those in the *Holy Family* from Santa Maria delle Grazie a Caponapoli (now Naples, Incoronata al Buonconsiglio), variously assigned to Filippo Vitale and the Master of Fontanarosa.

I believe that the Escorial *Madonna and Child* may be documented to Artemisia's studio by way of the artist's last-known letters from Naples to her Sicilian patron Don Antonio Ruffo. Writing to Ruffo on August 13, 1650, Gentileschi declared herself pleased that he had reestablished contact with her and hopeful that he would favor her with future commissions. With that she proposed to send to Messina as soon as possible a small *Madonna*, which she is confident will be as much to his liking as were her large paintings (see [49] and [L-27]: "il che mi da speranza che per l'avenire mi favorira in honorarmi coi suoi comandi il che con la occas-

ione si esperimenterà quanto li vivo devota il che spero quanto prima mostrarli senguio con l'occasione di questa Madonina in piccolo già accertandolo che se per il passato hanno piaciuto le cose in grande non meno di quelle le piaceranno queste piccole il che spero farcelo veder fra breve, aspettando più frequenti i commandi di V. S. Ill.ᵐᵃ." Then on January 1, 1651, Artemisia reported that she was convalescing from a recent illness and that when able to work again she would immediately attend to Ruffo's "small [painting on] copper," already more than half-finished: "io questo natale, l'ho fatto nell'letto et ero stata assai male, et al presente sto ancora convalescente il suo rametto è più che mezzo fatto, et subito che io posso dipingere sarà il primo ad essere servito."

The references to a *Madonina in piccolo* and a *rametto* are obviously to one and the same picture. (Signaling Garrard's mistranslation, Cropper pointed out that *rametto* signifies a "small painting on copper," and independently of my thinking on the matter Mann has posited that the Escorial *Madonna* might be the work in question.) According to Vincenzo Ruffo, it figures neither in Don Antonio's account books nor in the inventories of his collection, and thus apparently was never shipped to Messina. However, among Don Antonio's agents in Naples was his nephew Tommaso, a Dominican priest, for whom a painting featuring the rosary would have been especially apposite and who may even have provided the inspiration for the subject. I suspect that Artemisia's small picture passed to Tommaso, eventually made its way west along the busy Naples–Spain sea route, and finally to the Escorial.

BIBLIOGRAPHY: V. Poleró y Toledo, *Catálogo de los cuadros del real monasterio de San Lorenzo llamado del Escorial*, Madrid, 1857, p. 144 no. 662; Ruffo, 1916, p. 53 incl. nn. 3 and 5; Pérez Sánchez, 1965, p. 500; idem, 1973, cat. 22 and pl. 22 (before cleaning); idem, letter to the author, October 31, 1973; B. Nicolson, "Caravaggio and the Caravaggesques: Some Recent Research," *Burlington Magazine*, CXVI (1974), 611; E. Borea, "Caravaggio e la Spagna: osservazioni su una mostra a Siviglia," *Bollettino d'arte*, LIX (1974), 46–47; Garrard, 1989, pp. 399–400, 511 n. 164; Cropper, 1989, p. 866; Contini in Contini/Papi, 1991, pp. 84 n. 23, 86 n. 78; Mann, 1996, p. 45 n. 6.

For the *Holy Family* cited: Spinosa, 1984, pl. 880; F. Bologna in Naples, Castel Sant'Elmo, 1991, p. 298 cat. 2.54.

..

[52] *Bathsheba*

Florence, Palazzo Pitti, storage
Oil on canvas, 2.86 x 2.14 m.
Ca. 1650–1652
Figs. 199, 201

On the reverse, before relining, the numerals 9363, 1803, 2244

COLLECTIONS: Grand Dukes of Tuscany, Florence

Exhibiting major paint loss throughout, most lamentably on Bathsheba's face and body, the picture continued to deteriorate even after the relining and puttying it underwent for the 1970 exhibition at Florence. Apparently the remaining pigment has now been stabilized, and many areas are surprisingly intact, suggesting that the damage is attributable to more than the usual circumstances of time and neglect. The canvas may have been abused within little more than a decade after its completion during the course of its translation into tapestry (Fig. 199 and below). Furthermore, relative to the Potsdam version (Figs. 188–89) the veiling over Bathsheba's abdomen and thighs is considerably more extensive. Since this additional covering does not appear in the tapestry or in the closely related composition once at Gosford House (Fig. 200), it must have been provided for modesty's sake after 1663.

Despite the damaged state, there is no obscurity regarding the approximate date of the picture, which is painted on canvas of typically Neapolitan warp and woof. Gamba, claiming that it was sent to Florence in 1652, may have confused the *Bathsheba* with the now-lost *Susanna* signed and dated by Artemisia in that year and lavishly praised by Alessandro da Morrona in the collection of Averardo de'Medici ([L-104]). Yet the *Bathsheba* does belong, as Garrard and Contini have also argued, to Gentileschi's later years. (Through what I take to be a slip of the pen, Borea assigned the painting to Artemisia's Florentine stay and reported that I had done the same, while Berti, finding "certi riferimenti ancora allo scorcio fiorentino tra Tardomanierismo e Seicento," asks if the Pitti *Bathsheba* might not be the first of Artemisia's several interpretations of the theme.) Specifically, it is the successor to the *Bathsheba* in

Potsdam (Figs. 188–89), which was reduced in height in the mid-eighteenth century. This latter canvas can be traced back to the Palazzo del Giardino of the Farnese at Parma, while the replication in 1663 of the Florence *Bathsheba* in a Medici tapestry implies that it was Medici property. In 1628 Odoardo Farnese had married Margherita de'Medici, daughter of Cosimo II, Artemisia's former patron. One can imagine that the Parma *Bathsheba* had come to the attention of the Medici of Florence, who then commissioned their own version as an addition to their already impressive collection of paintings by Artemisia Gentileschi. Among these was a large *Diana at Her Bath* that entered the Medici Guardaroba in 1619 and was inventoried in 1649 at the Villa Medici at Petraia ([L-26]), where the *Bathsheba* tapestry hangs today and where it may have been displayed from the beginning.

The Florence example is fundamentally a repetition of the Potsdam composition, with (see the text) some cosmetic changes. The canvas hints that Gentileschi experienced some boredom in reproducing her previous work, for the technique is uninspired and at times mechanical. It is not to be excluded that here, more even than in the Potsdam version, which is more ambitious as regards certain drapery configurations and which on the whole is of rather higher quality, Artemisia delegated some of the execution to an assistant.

The destroyed sections of the canvas can be reconstructed from a tapestry in the Villa Medici at Petraia (Fig. 199; 3.58 x 2.33 m.), signed at the lower right "*D. ARTEMI. PINX. / P. FEVERE PARISIIS EXTRAX. / 1663*" and paid for on June 21, 1663. Pietro (Pierre) Fevère (d. 1669), having arrived in Florence by the early 1620s, served as the head of the Grand Ducal tapestry manufactory and introduced into the city the art of weaving with coarse or floss silk in contrast to the traditional fine wool threads. Apparently he was also instrumental in stimulating the taste for reproducing oil paintings as hangings. His tapestry after Gentileschi's *Bathsheba* is for the most part a detail-for-detail translation, although the format was extended above and below (undoubtedly to suit the dimensions of its intended setting). This adjustment, and the precedent of the Potsdam example, suggest that Artemisia had not pre-

pared the Florence painting as a cartoon for a proposed tapestry.

BIBLIOGRAPHY: C. Conti, *Richerche storiche sull' arte degli arazzi in Firenze*, Florence, 1875, pp. 21–24, 73; Voss, 1925, p. 463; C. Gamba in *Enciclopedia italiana*, Milan, 1932, XVI, p. 582; Longhi, *Scritti*, 1961, I–I, p. 262; Bissell, 1968, p. 164; Borea, 1970, pp. 78–79 cat. 50–51; Garrard, 1989, pp. 130–32; Contini in Contini/Papi, 1991, pp. 176–80 cat. 27; Berti, ibid., p. 25; Palmer, 1991, p. 280; Marshall, 1993, p. 154; Pagliarulo, 1996, pp. 153–54.

[53] *Bathsheba*

Formerly (destroyed 1940) Gosford House, Scotland, Earl of Wemyss
Oil on canvas, 2.69 x 2.22 m.
Ca. 1650–1652
Fig. 200

Believed (see below) to be inscribed on the socle of the central baluster: *ARTEMITIA / /*

Reportedly the only painting not to be removed for safekeeping during the stationing of British armed forces at Gosford House, the *Bathsheba* perished in the fire of 1940 that destroyed the Salon in which it was prominently displayed above the portal to the Drawing Room. The condition of the canvas at the time of its loss is now largely indeterminable. The reproduction offered here is but a copy of a copy of a photograph (whereabouts unknown) in which the image had already been rendered partially illegible by raking light. On the assumption that the photograph records the picture in its entirety, and by analogy to the *Bathsheba* in Florence, measuring 2.86 x 2.14 m., to which the ex-Gosford version was most closely related (Fig. 201; see below), it may be posited that the canvas had been trimmed above and very slightly below by a total of approximately 17 cm. (It will be recalled that the example in Potsdam, Fig. 188, today of 2.58 x 2.18 m., was in the eighteenth century reduced from its original size of about 2.79 x 2.25 m. in order to accommodate it to the decorative scheme of the Obere Galerie in the Neues Palais.)

As implied, it was to the *Bathsheba* in storage at the Palazzo Pitti, among all of Gentileschi's formulations of the theme, including the very similar Potsdam version, that the painting

once in Scotland was most intimately bound (cf. Figs. 159, 169, 180, 184, 201; Color Plate XXIII). The pictures shared the black maidservant holding a strand of untwisted pearls, the configuration and particular placement of the *repoussoir* draperies, the special elaborateness of bucket and basin, the section of transparent cloth inserted between the latter and Bathsheba's right foot, and the designs of the landscape and of the fenestration of King David's palace. Still, the details are not identical, the maids at the left and in the center of the ex-Gosford *Bathsheba* having sported different hairdos and she at the left different garment accessories than their Florentine counterparts. The variations are such as to be inconsistent with what one might expect of a copyist of the canvas in Italy, while the similarities suggest that the two compositions were conceived more or less contemporaneously; that is, about 1650–52 if my reasoning (see [52]) is correct. Within this limited time span the ex-Gosford version may have been later, for unlike both the Potsdam and the Florence painting it is without any hint of the tower or chimney at the crest of the distant building. Pagliarulo, to whom is gratefully owed the introduction of the present *Bathsheba* into the Gentileschi literature and the reconstruction of its known history, entertained three possibilities regarding its execution—that it was either painted by Artemisia in Naples and taken by her to England, or in England, or in Naples following her English stay and then shipped back to London. (However, he does not take a definitive stand as to its date or its place within the sequence of *Bathsheba*s.)

Another question of consequence now arises: Was the canvas in Scotland an autograph work by Artemisia Gentileschi, or was it rather a highly competent copy of a now-lost original? I cannot follow Pagliarulo in being able to read from the existing photograph the word ARTEMITIA on the first line of what he takes to be a three-line inscription on the base of the central baluster, although there does appear to be some lettering on that ideal spot for a signature (as in the canvas in Vienna, Fig. 180). There is always the possibility, too, that any such inscription was a later record of a venerable attribution.

Pagliarulo considers the Potsdam, Florence,

and ex-Gosford redactions to be "profondamente variata nella stesura." He then characterizes passages in the first-named example as "sleek and shining" and "precious," a virtuoso display that apparently he looks upon with a certain disapprobation, while judging the quality of the ex-Gosford *Bathsheba* to exceed that of the Florentine one, which he deems harder and drier in execution and in moments "mannered," "cold," and "impoverished." In my opinion, the photograph of the present painting upon which by necessity qualitative judgments must be based simply does not permit such often subtle distinctions. Indeed, one seems more justified, for instance, in finding the folds of the skirt of the maid at the left to be more regularized, even ropelike, and less supple than in the related versions.

Equally inconclusive is the extent to which various pieces of documentation might support a claim for Artemisia's authorship. Pagliarulo reports the tradition that the *Bathsheba* was acquired by Francis Charteris (1723–1808), who assumed the title of Seventh Earl of Wemyss in 1787. He notes further that the canvas is absent from a handwritten list drawn up in 1771 of the family paintings, then hung at Amisfield House near Haddington. In fact, its first known citation is owed to the Tenth Earl of Wemyss, Francis Charteris (1818–1914), who wrote in his *Memoirs* (privately printed between about 1910 and 1914): "[In the Saloon] Then there is over the door leading to the drawing room a most remarkable picture of Bathsheba at her bath with David in the distance spying her out of his window, a splendidly drawn woman's figure with a lovely face, the bath etc., moreover, are beautifully painted, and the maid carrying a pail of water is one of the finest figures I have ever seen in painting. This grand painting is by a woman, and sure I am that none of our 'New Women' have ever done the like. The paintress's name is Artemisia Gentileschi." The *Bathsheba* then appears under Artemisia's name in the 1937 catalogue of the collection, in which its size is given.

The early history of the painting can only be conjectured. It seems clear that it was both slightly too small and considerably later in style to be identified as the *Bathsheba* completed in 1636 on order from Prince Karl Eusebius von Liechtenstein ([L-8]). A picture by Artemisia

in the English Royal Collection at Somerset House as late as 1650, and called variously "Diana washing her with other naked figures" and "Bersabe & other naked figures" (see [L-25]), most likely depicted the former theme. The relevance to the issue at hand of the *Bathsheba* in the Prince Trivulzio sale in 1764 ([L-9]) cannot be judged. More suggestive is the "David and Bathsheba by Artemisia Gentileschi" / "David and Barsheba by Artemisia Gentilischi" recorded in the Spencer Collection at Althorp House in 1746 (George Kapton, *Catalogue of the Pictures at Althorpe and Wimbledon belonging to the late Hon^ble M^r Spencer*, no. 240) and 1750 (*A Catalogue of the Pictures at Althrop* [sic] *taken in the year 1750*) but *not* in the Althorp catalogue of 1802. And what of the "Gentileschi" *David and Bathsheba*, said to be owned by Terry, which did not find a buyer when auctioned at Christie's–London on March 11, 1808 (Lot 68)? Might not the Spencer painting, the sale picture, and the ex-Gosford House *Bathsheba* have been one and the same? Is it merely a coincidence that the year

1808 also marked the death of the Seventh Earl of Wemyss? Did his heirs attempt to sell the *Bathsheba* at that time? Or was it bought by the Eighth Earl, whose additions to the collection included, it is thought, Jan de Braye's *David Harping Before the Ark*, which figured in a sale at Amsterdam on August 23, 1808? Or was the purchaser the Tenth Earl, an enthusiastic collector who, Thomson reports, "bought most of his pictures in London, either from dealers or at auction sales"? As yet there are no answers to these intriguing questions. At this time one can only lament the destruction of the picture and, acting judiciously, declare it to have been an autograph work by Artemisia Gentileschi.

BIBLIOGRAPHY: Garlick, 1974–76, pp. 94, 112; B. Fredericksen, ed., *The Index of Paintings Sold in the British Isles During the Nineteenth Century: 1806–1810*, II, pt. 1, Santa Barbara, Calif., and Oxford, 1990, p. 387; Pagliarulo, 1996.

For the collection history of the Earls of Wemyss: C. Thomson, *Pictures from Gosford House Lent by the Earl of Wemyss and March*, exh. cat. by Colin Thomson, Edinburgh, 1957, pp. 5–8, 19.

INCORRECT AND QUESTIONABLE ATTRIBUTIONS

The attributions to Artemisia Gentileschi of the paintings catalogued below have been put forward by contemporary scholars with varying degrees of conviction and corroborating evidence. Some have been thoughtfully endorsed, while others have elicited little or no subsequent comment. Still others have been challenged or rejected only to be revived, or have been supplanted by attributions which themselves are untenable. In excluding these pictures from the corpus of Artemisia Gentileschi's autograph works and in proposing alternative ascriptions whenever these seem to me to be warranted, I have taken pains to review previous opinions and to justify my decisions even at the risk of belaboring the obvious. Given particularly the sensitivity of this area of inquiry, I believe that this approach is preferable to ex cathedra pronouncements.

I am aware of a number of canvases—although surely not all—that have passed through the art market under Artemisia's name. Unless in my opinion these attributions are arguable or have been reaffirmed in independent art-historical literature, they are not considered in the present study. Copies of extant or now-lost paintings by Gentileschi are discussed in the Catalogue of Autograph Paintings.

..

[X-1] *Allegory of Painting*

Le Mans, Musée de Tessé
Oil on canvas, .957 x 1.326 m.
Fig. 205

COLLECTIONS: La Popelinière family; acquired by the Musée de Tessé in 1836

Easily one of the most bizarre conceptions of the early seventeenth century, this painting is

still in search of an author—should anyone wish to claim it! Attributed to Guido Cagnacci in the museum catalogues of 1864, 1907, and 1932, and subsequently, the canvas was then labeled "a Caravaggesque work of the years 1610–1620, somewhere between Orazio and Artemisia Gentileschi and not without relationship to certain erotic works by Baglione" (Lecoq following Brejon de Lavergnée). Recently Chaserant has thought to assign it specifically to Artemisia Gentileschi's Neapolitan period, without providing any rationale for this viewpoint. Cagnacci's name, which no doubt had been attached to the picture by analogy to such as his (much more svelte and refined) *Young Female Martyr* (*Santa Mustiola?*) in the Musée Fabre at Montpellier, must be removed from consideration. Interestingly, however, as Morselli and Pasini have observed, Cagnacci's *Young Female Martyr* owes some of its character to the Gentileschi (e.g., Figs. 108, 110; Color Plate XV). And it is certain that the Le Mans picture originated in the Rome of the Gentileschi and Baglione.

I believe that one can be even more precise. A mostly nude female model reclines on her right side as if on the floor of a studio and before an easel (with a mahlstick) and the reverse of a canvas, her head resting on her right arm, her legs drawn up, and her eyes closed in daydreaming or sleep. Before her lie a palette, brushes, and compass, while a mask with strings attached is propped against her left forearm. As Lecoq (who presents a detailed iconographical analysis of the painting) points out, the various attributes evoke Cesare Ripa's prescription for the Personification of Painting, *La Pittura*. But what an eccentric adaptation! The mask, which in Ripa refers to the imitative function of art, is here gross, implying evil and deception. Lecoq considers then the possibility that this canvas is a kind of visual manifesto of the new style of naturalistic painting, one dedicated to absolute truthfulness in the face of mannerist falseness.

Yet the openly obscene character of this picture speaks of something other than this relatively benign message. The drapery (dark blue-brown with gold damask) thrown over this inflated figure of huge breasts at once partially hides and calls attention to the anus and/or genital area, implying intercourse after which the woman slumbers.

It is difficult to believe that any self-respecting painter would figure the art of Painting in this compromising guise. Certainly no woman artist would, least of all Artemisia Gentileschi, whose *Self-Portrait* and other obviously self-referential works (Figs. 119, 121, 156, 175; Color Plates XVIII, XXVII) are notable for the positive qualities of dignity and strength which she attributes to her profession. The Le Mans canvas can only be a dirty joke at the expense of someone else.

It was, I believe, Orazio Gentileschi who was meant to suffer this indignity. The *Allegory of Painting* appears to make reference, first, to the buxom reclining female nudes of Orazio (Figs. 210, 211) and to the general Gentileschian precision of detail and liking for elaborate brocaded fabrics. Even more, it brings to mind such hypocritically moralizing paintings by Giovanni Baglione as the so-called *Venus Chastized by Cupid* (Mentana, Federico Zeri Collection) and the *Love Restraining Instinct* (Valencia, Museo de Bellas Artes). Very comparable are the fleshy, full-faced women in suggestive poses, exuding carnality and encouraging sexual encounters, and surrounded by drapery displays. The Orazian component in these pictures by Baglione, observed already by Guglielmi and Zeri, may have been calculated to antagonize Gentileschi. In an even more vicious way, the *Allegory of Painting* is such an assault. It renders lewd what in Gentileschi's nudes was peculiarly erotic. And, again by way of humiliating Orazio, it makes pointed comments about his daughter Artemisia. Since even at the beginning of the second decade Artemisia was the most prominent female painter in Rome, the connection between her and *La Pittura* would have been easy to draw. Here, too, was a woman who had been raped and whose character had been dragged through the mud by Agostino Tassi and his cohorts, who claimed that Artemisia had offered herself to many men and had posed nude for her father. Here, Baglione appears to say, was a woman now unmasked, her lasciviousness showing, and one who had masqueraded as a painter. The Le Mans painting becomes, in this interpretation of it, another invective, produced during or after the Tassi trial but referring to it.

(The dates of Baglione's canvases in Mentana and Valencia are in dispute, but some authorities place them ca. 1613–14, a not unreasonable chronological position for the *Allegory of Painting*.) As discussed in Chapter 1, Tassi's violence against Artemisia had been considered above all an attack upon Orazio's honor, and by indirectly alluding to it in the Le Mans canvas Baglione participated in the mortification.

In his own mind, Baglione had every reason thus to defame the elder Gentileschi. Along with Caravaggio and others Orazio had circulated those scurrilous sonnets about Giovanni and his art that had in part occasioned Baglione's suit for libel in 1603. Verbal sparring between Gentileschi and Baglione over some souvenir Madonnas that the latter had brought the former from Loreto increased the animosity, and even as late as 1615, when the Florentine Ambassador to Rome, Pietro Guicciardini, sought information about Orazio, Baglione was ready with a negative assessment. In fact, in his biography of Gentileschi published in 1642, he wrote that the painter "presented characteristics that were more bestial than human, and . . . had no regard for anyone, however eminent . . . and offended everyone with his satirical tongue. . . ." Of Artemisia Gentileschi, on the other hand, Baglione had only positive things to say in noting her ability to work from nature and the praise that she had received from high-placed patrons for her "beautiful works." It would seem, therefore, that Giovanni's hatred of Orazio ran so deep that he was willing to victimize also Artemisia in the process, even if he had no particular reason to dislike her.

Herwarth Röttgen has argued that Baglione, in his *Sacred Love Overcoming Profane Love* of 1602 in the Galleria Nazionale at Rome, was prompted by the events that provoked the libel suit to portray the devil with Caravaggio's face and in the devil's actions to indict Caravaggio for sodomy. I would suggest that the *Allegory of Painting* at Le Mans is another example of Baglione's penchant for pictorial vilification.

BIBLIOGRAPHY: A.-M. Lecoq in Dijon, Musée des Beaux-Arts, *La peinture dans la peinture*, exh. cat. by A.-M. Lecoq and P. Georgel, 1982, pp. 40–41, reprinted Paris, 1987, pp. 52–53; A. Brejon de Lavergnée et al., *Musées de France. Répertoire des peintures italiennes du XVIIe siècle*, Paris, 1988, p. 161; F. Chaserant in Chambéry, Musée des Beaux-Arts, 1995, pp. 92–93; Le Mans, Musée de Tessé, Registrar's Files.

For Cagnacci's *Young Female Martyr*: P. G. Pasini, *Guido Cagnacci pittore (1601–1663)*, Rimini, pp. 238–40 cat. 40; R. Morselli in Rimini, Museo della Città, *Guido Cagnacci*, exh. cat., ed. D. Benati and M. C. Castellotti, Milan, 1993, pp. 92–95 cat. 13.

For Baglione's erotic paintings: Guglielmi, 1954, pp. 323–24; F. Zeri, "Giovanni Baglione, pittore erotico," *Antologia de belle arti*, 1, no. 4 (1977), 339–42; ; Möller, 1991, pp. 74, 125 cat. 54; E. Borea, "Date per il Baglione," *Storia dell'arte*, nos. 38–40 (1980), 317; H. Röttgen, "Quel diavolo è Caravaggio. Giovanni Baglione e la sua denuncia satirica dell'*Amore terreno*," *Storia dell'arte*, no. 79 (1993), 326–40 for the paintings and their context; Aurigemma, 1994, pp. 28–29, 32, 34, 45 n. 98.

For the Baglione-Gentileschi animosity: R. W. Bissell, "Concerning the Date of Caravaggio's *Amore Vincitore*, p. 113 ff. in *Hortus Imaginum: Essays in Western Art*, eds. R. Enggass and M. Stokstad, Lawrence, Kans., 1974.

··

[X-2] *Allegory of Vanity* (sometimes called *Martha Reproving Mary Magdalen for Her Vanity* or *The Conversion of the Magdalen*)

London, Trafalgar Galleries
Oil on canvas, 1.32 x .96 m.
Fig. 204

The juxtaposition of a young woman in fashionable gold and pinkish-red garments, gazing into a mirror and accompanied by jewelry and a cosmetic jar, and an older woman hooded in blue and gesturing in admonition, obviously evokes the popular Baroque theme of Martha reproving Mary Magdalen for her vanity. Yet the preener, her hairpin or comb in the form of Cupid drawing his bow, has not rejected the bracelet and persists in admiring herself. She gives no sign that the lesson expounded by her companion, to whom she presents her back, has begun to stir her mind or heart; no indication, that is, of the conversion or potential conversion inherent in the Martha and Mary confrontation. Furthermore, a shadowy form, resembling more a personification of Death or the devil than a skull (the death's-head being appropriate only to a penitent Magdalen), lurks behind. The message therefore appears to be

directed primarily to us, the illumination to be ours. As the flowers in the pitcher wilt and the mirror blurs the girl's features, we are given to know of the ephemeral quality of earthly beauty, that death is around the corner and may catch us, as it is about to snare the woman at her toilette, with our souls unprepared. At best, then, the picture is a conflation of the Martha-Mary narrative and of Vanitas iconography, with the latter receiving strong emphasis.

The question of attribution is more critical, for while there is general agreement that this fascinating painting was executed in Naples during the 1630s, its precise authorship has proved elusive. First published as by Artemisia Gentileschi, and then reassigned by Nicola Spinosa to Massimo Stanzione (under whose name it was exhibited in 1985 and 1987), the canvas has continued to bring Artemisia to mind. The problem lies in the hybrid nature of the work, in which scholars have correctly recognized the mode of Stanzione in the older woman, the Gentileschi-Vouet character of the girl (cf. the kneeling midwife in the *Birth and Naming of Saint John the Baptist* [Fig. 139], and the figure of Intellect in Vouet's *Faccoltà dell'-Anima* of ca. 1625), and the distinctive female type of Bernardo Cavallino in the mirror image (cf. Omphale in the *Hercules and Omphale*, London, Matthiesen Fine Art Ltd.). Indeed Schütze, although stating no position on the authorship of the reflected image, has assigned the "Magdalen" to Artemisia's brush and the "Martha" to Massimo's. While the interrelationships of these three artists have been remarked throughout the present book, the execution of the Trafalgar picture does not in my opinion speak clearly of the predominance of any one of them. The drapery of the younger woman, with its sharp edges and unsupple, regularized folds, could not have issued from Artemisia Gentileschi, a magician with material. And the magnificent still-life, painted with special succulence and surety, seems the work of an artist experienced in this genre. More than this, as Ronald Cohen has observed, it "looks just like a Strozzi." One thinks, for example, of the ewer in Bernardo Strozzi's famous *Cook* in the Palazzo Rosso at Genoa. The latter detail, in turn, finds an uncannily exact counterpart, down to the Harpy handle and the head below it, in Giovanni Benedetto Castigli-

one's *Sacrifice to Pan* in the National Gallery of Canada at Ottawa. In 1635, the approximate date indicated for the *Allegory of Vanity* on stylistic grounds, the Genoese-trained Castiglione—whose paintings are filled with still-life objects—arrived in Naples for an initial visit of three or four influential years. Most recently an attribution of the entire painting to Onofrio Palumbo has been offered, but the few certain works by Onofrio do not appear to present parallels sufficient to confirm this proposal.

The best guess is that the canvas emerged as a collaborative effort from the workshop of Massimo Stanzione about 1635, with the master responsible for the overall design and the cowled figure, and perhaps Castiglione for the still life. At this moment specific identifications of the other hands apparently at work here would be problematic.

BIBLIOGRAPHY: *Burlington Magazine*, CXVI (1974), xcii; R. Ward Bissell, letter to Ronald Cohen, Trafalgar Galleries, London, May 21, 1983; Ronald Cohen, Trafalgar Galleries, letters to the author January 25 and June 1, 1983, October 14, 1986, August 14, 1990, and June 4, 1997; London, Trafalgar Galleries, *Trafalgar Galleries at the Royal Academy IV*, 1985, pp. 36–37 cat. 12 (with color pl.); Florence, Palazzo Pitti, 1986, p. 156 fig. 3; Turin, Mole Antonelliana, *Lo specchio e il doppio*, June 24–October 11, 1987, p. 165 no. 49 (with color pl.); Contini in Contini/Papi, 1991, pp. 80, 87 n. 94; Schütze in Schütze/Willette, 1992, pp. 249–50 cat. C16, 408 fig. 382.

For the comparative material: R. Manning in Detroit, 1965, pp. 151–52 cat. 169; C. Marcenaro et al., *Mostra dei pittori genovesi a Genova nel '600 e nel '700*, Genoa, Palazzo Bianco, 1969, pp. 24–25 and 27 cat. 11; Percy in Percy/Lurie, 1974, pp. 92–93 cat. 22; M. N. Schleier in Naples, *Civiltà del seicento*, 1984, 1, p. 120 (biography of Castiglione); London, Matthiesen, 1986, pp. 71–73 cat. 11; Ficacci et al., 1989, pp. 158–61 cat. 14.

[X-3] *Apollo Flaying Marsyas*

Florence, Palazzo Pitti
Oil on canvas, 1.84 x 1.75 m.
Fig. 203

A comely Apollo, swathed in swirling draperies of white, gold, and red, flays the right forearm of a screaming Marsyas, a wild-man satyr with hairy body and cheetah-skin garment.

The long-accepted attribution of this canvas to Giovanni Bilivert was challenged first in 1985 by Roberto Contini, who while noting its strongly Florentine character found in it impressions of Rome—of ancient sculpture, of Mochi and Bernini, of Reni, and "un'accezione 'terribilistica'" evocative of Artemisia Gentileschi. Including the *Apollo Flaying Marsyas* in the Casa Buonarroti exhibition of 1991, Contini again rejected its ascription to Bilivert; emphasizing the picture's expressive urgency and moments of naturalistic observation and, at the same time, its lack of typically Florentine *morbidezza*, he once more introduced Artemisia's name. However, with the primary aim of stimulating further discussion, the Italian scholar approached the questions of Artemisia's authorship and its place within her career with due caution, even considering that it might be the work of Bilivert's pupil Bartolomeo Salvestrini.

Subsequently Spike, without further comment, assigned the painting to an "anonymous Franco-Florentine." Palmer, comparing the color, swirling draperies, background landscape, and other details of the *Apollo Flaying Marsyas* to the *Juno and Argus* in the Galleria Doria-Pamphili at Rome, proposed an attribution to Orazio Riminaldi. Certainly these two canvases, sharing a high-keyed dramatic pitch, also bring to mind the *Cain Slaying Abel* in the Palazzo Pitti, it too given to Riminaldi. And since the Pisan master is documented as having interpreted such mythological pairings as *Atalanta and Meleager*, *Angelica and Medor*, and *Orpheus and Eurydice*, the subject type of the *Apollo and Marsyas* would be consistent with his practice.

Still, as the traditional ascription to Bilivert acknowledged, the present picture fits comfortably only within a strictly Florentine ambient. It is of an iconographical and compositional type that runs from the likes of Gregorio Pagani's *Piramus and Thisbe* (Fig. 88) to Bilivert's *Apollo and Daphne* of 1630 (Fig. 89) to Orazio Fidani's *Pan and Siringa* (Florence, Private Collection). This is not to deny the possible impact upon it of paintings by Artemisia Gentileschi in Florence. For while most of the particularized comparisons drawn by Contini to various images by Artemisia are not especially revealing, his reference to Gentileschi's *Tarquin*

and Lucretia at Potsdam (Fig. 190), with its clamor and agitated garments, is suggestive. Most to the point, however, by virtue of solidity of figure type, rushing movement, and convoluted draperies, is the *Aurora* (Figs. 87, 90), a canvas apparently unknown to Contini, which I believe Artemisia painted about 1625–27 for the Florentine Niccoló Arrighetti and which was to hold immediate interest for Giovanni Bilivert, creator of the Stuttgart *Apollo and Daphne*. One could also suppose that Gentileschi's *Judith Decapitating Holofernes* (Figs. 77–79; Color Plate XII) stood as an accessible model of a gory encounter—of "terribleness"—and, as Contini points out, for the facial expression of Apollo. Yet in their stiffness and sharp handling, Apollo's garments, closer to metallic foil than to cloth, are without the inherent suppleness and painterly highlighting of Aurora's wrap, and the loud red used for the god's mantle finds no parallel in Artemisia's oeuvre. There is too about the picture an artificiality, a decorative thrust that attenuates the brutality of the theme, and a distance from nature observed that are much more Florentine than Caravaggesque, closer to Bilivert and Salvestrini than to Gentileschi, and indicative of a date in the early 1630s.

BIBLIOGRAPHY: Contini, 1985, p. 55; Contini in Contini/Papi, 1991, pp. 169–72 cat. 25; Spike, Review, 1991, p. 732; Palmer, 1991, pp. 278 fig. 2, 280.

..

[X-4] *Bathsheba (The Toilette of Bathsheba)*

Sarasota, Florida, John and Mable Ringling Museum of Art
Oil on canvas, .845 x 1.156 m.
Fig. 206

COLLECTIONS: Excelle Company (?), New York; Acquavella Galleries, New York, 1963; acquired by Asbjorn R. Lunde, New York; gift to the Ringling Museum, December 2, 1976

The known attributional history of this canvas is relatively recent, yet complex. Assigned to Bernardo Cavallino when it entered the art market, the *Bathsheba* was ascribed to Artemisia Gentileschi by Schleier, to Artemisia in collaboration with Viviano Codazzi by Spinosa, and to Artemisia and Domenico Gargiulo (for the figures at the right) by Galante.

The attribution to Cavallino was then revived, soon to be substituted by one to Gargiulo (Micco Spadaro). It is reported that upon seeing the canvas Spinosa was inclined to change his attribution to that of Antonio de Bellis. Contini tentatively reintroduced Artemisia's name, while to Sestieri the *Bathsheba* represents the combined efforts of Gentileschi, Gargiulo, and Viviano Codazzi. In fact, the picture is a pastiche of a number of currents in Neapolitan art during the fourth and fifth decades of the seventeenth century, reflecting the work of each of the painters named above but unlikely to have been executed by any of them.

There are, first, an astonishing thirteen quotations of varying degrees of faithfulness from extant canvases produced by Artemisia Gentileschi between ca. 1635 and ca. 1650, specifically from her several versions of *Bathsheba* (Columbus Museum of Art; Private Collection, Halle; Haas Collection, Vienna; Private Collection, Rome; Neues Palais, Potsdam; Uffizi, Florence; formerly Gosford House, Earl of Wemyss) and *Susanna* (formerly Sotheby's, London; Moravskà Galerie, Brno). Thus: (1) maid with a string of pearls (cf. Figs. 159, 188, 200, 201); (2) maid holding a mirror (Figs. 188, 200, 201); (3) maid drying Bathsheba's right leg (Fig. 169); (4) maid holding a braid of Bathsheba's hair (Figs. 159, 180, 184); (5) Bathsheba tending to her own hair (Figs. 169, 180, 184, 188, 200, 201); (6) palace with a projecting porch (Fig. 169); (7) the gesturing King David on a drapery-hung balcony, leaning or reclining on a pillow (Fig. 159); (8) Bathsheba turned away from David (Figs. 159, 169); (9) landscape with rows of cypresses (Figs. 159, 162, 169, 188, 200, 201); (10) Relief sculpture (Fig. 159); (11) rosebushes behind and over the balustrade (Figs. 162, 197); (12) square and triangular paving stones (Fig. 159); and (13) lion-footed basin (Figs. 188, 197, 200, 201). Although Artemisia was not above repeating her own inventions, she cannot be held accountable for this kind of catalogue of Gentileschian motifs; nor, given her sense of the imposing, for this tableau of elegant manikins in a charming little play.

Rather, the diminutive and delicate bring to mind Cavallino, as do the physiognomies, the pose of the attendant at the right (a figure specified by Contini for its Cavallinesque charac-ter), and Bathsheba's somewhat affected gesture (cf., respectively, the *Finding of Moses*, Capodimonte; *Esther Before Ahasuerus*, Schloss Rohrau; *Singer*, Capodimonte). Yet the painting lacks Bernardo's characteristic nervous animation and the brilliance of his touch.

The landscape—to continue the litany of borrowings—is reminiscent of Gargiulo (to whom Sestieri actually assigns it) and, as noted, particularly of those cypress-filled backgrounds which he contributed to the pendant pictures of *Bathsheba* (Columbus) and *Susanna* (ex-London) by Artemisia Gentileschi. In Domenico's mode as well are the relief sculpture and the architecture, the latter as an adaptation from Codazzi with whom he often worked; the palace, all askew and somewhat loosely rendered, cannot be from the precise mind and brush of Codazzi himself. And the two women arriving from the left in the Sarasota *Bathsheba* have merely stepped out of Gargiulo's *Moses Striking Water from the Rock* now in the Museo Nazionale di San Martino, a *bozzetto* for his fresco in the Coro dei Fratelli Conversi at San Martino, finished by 1640. Yet Domenico Gargiulo was a highly proficient master full of a painterly fire considerably more ardent than anything detectable here.

The improbability of Gargiulo's direct participation in the *Bathsheba* and the liberalness with which pictorial ideas were appropriated in Baroque Naples are both underlined by the case of the *Israelites Celebrating the Return of David* (oil on canvas, .826 x 1.156 m.; Fig. 207), also at Sarasota. While these two pictures entered the Ringling Collection decades apart, they were most likely painted as pendants (or as part of the same series), a connection implied by Pasculli Ferrara and forwarded by Sestieri. Virtually identical in size, both canvases recount episodes in the life of David, one from his youth (1 Samuel 18:6–7), the other from his maturity (11 Samuel 11:2–3). In type and pose the woman with a tambourine at the right in the *Israelites Celebrating* is closely related to the jewel-bearer in the same position in the *Bathsheba*.

Additionally, the attributional debates to which these works have given rise are strikingly similar, the *Israelites* having been assigned to Bernardo Cavallino (Suida), Domenico Gargiulo (Zeri, Coley, Gilbert, Tomoroy, T. Janson,

Pasculli Ferrara, and Galante), and Gargiulo and Artemisia Gentileschi (Daprà and, with some equivocation, Sestieri). Ties to Aniello Falcone and Massimo Stazione have also been noted.

In my opinion, the connections adduced by Sestieri between paintings by Artemisia (Figs. 164, 197) and the foreground figures in the *Israelites* serve only to indicate familiarity with Artemisia's art; conceivably the presence of her brush here would not have been postulated but for her supposed participation in the Ringling *Bathsheba*. Signs of Gargiulo, on the other hand, are everywhere, and are more pronounced than in the *Bathsheba*. Nonetheless if, as it seems, the two works now at Sarasota were painted as part of the same project and thus roughly contemporaneously, and if this moment was as late as 1650 (given some of the specific borrowings in the *Bathsheba* from compositions by Gentileschi), the *Israelites* would have to have been executed at a time when the technique of Gargiulo himself was considerably more dazzling than that displayed here.

The latter canvas, then, is best assigned to an imitator of Domenico Gargiulo. The *Bathsheba* speaks of a related ambient but of a different hand. If it is considered on its own terms, one is inevitably led to the much-debated *Finding of Moses* in the National Gallery at London, to which over the years the names of Artemisia Gentileschi, Cavallino, Gargiulo, the ubiquitous Antonio de Bellis, and Bartolomeo Bassante have been attached. Close analogies to Bartolomeo's signed *Adoration of the Shepherds* in the Prado at Madrid have prompted Prohaska to attribute the *Finding of Moses* to that master as well. This is very likely to be correct, and it is to the London picture with its Bassante doll-like forms and a landscape worthy of Gargiulo that the Sarasota canvas can be most fruitfully compared. Furthermore, passages in a *David* in a private collection at Paris, a work given to de Bellis by Spinosa and to Bassante by Prohaska, are strictly related to the Sarasota *Israelites Celebrating the Return of David*. And, as if that were not enough, Bathsheba's dark maidservant with a headshawl evokes Poussin's elderly women (cf. *Holy Family*, Fogg Museum, Cambridge, Mass., of 1651), perhaps seen in Naples through the eyes of Andrea de Leone or Charles Mellin.

I believe that the Ringling *Bathsheba* is by a Cavallinesque artist, familiar as well with Gargiulo, who was close to the creator of the London *Finding of Moses*. Since it is improbable that this painter journeyed among private collections in Naples and elsewhere seeking out the many appropriations from Artemisia, he must have had access to Gentileschi's studio, an access accorded by way of Bernardo Cavallino, Artemisia's sometime collaborator between—precisely—1635 and 1650.

BIBLIOGRAPHY: Schleier, 1971, pp. 89–90; Spinosa, 1984, pl. 423; Registrar's Files, Ringling Museum; Galante, 1987, p. 49 n. 34; Pasculli Ferrara, 1984–89 (1989), pp. 145 n. 30, 151 fig. 5; R. Alter, Sarasota, letter of April 27, 1989, to M. Pasculli-Ferrara; Contini in Contini/Papi, 1991, p. 179; Marshall, 1993, p. 155 n. 4; Sestieri in Sestieri/Daprà, 1994, p. 89 cat. 21; Daprà, ibid., p. 77.

For the comparative material: Percy/Lurie, 1984, pp. 27 fig. 38, 74–75 cat. 13, 173–74 cat. 61, 190–91 cat. 70, 230 no. 10; Spinosa, 1984, pls. 18, 211, 218, 404; Daprà in Sestieri/Daprà, 1994, p. 145 cat. no. 46; Prohaska in Prague, 1995, pp. 17–18.

Specifically for the *Israelites Celebrating the Return of Joseph*: Sarasota, Ringling Museum (Suida, 1949, p. 49; Gilbert, 1961, no. 17; Tomoroy, 1976, pp. 148–49 cat. 155); Galante, 1987, p. 49; T. Janson, memos of May 7, 1987, Registrar's Files; Pasculli Ferrara, 1984–989 (1989), pp. 145 n. 30, 150 fig. 4; Sestieri in Sestieri/Daprà, 1994, pp. 87–88 cat. no. 20 (with color ill.); Daprà, ibid., p. 77.

..

[X-5] *Child with Cherries and Roses*

Rome, Galleria Nazionale, Palazzo Barberini
Oil on oval panel, .34 x .25 m.
Fig. 202

COLLECTIONS: Acquired in 1911

Restored in 1957. Delicately painted, but with knowing touches of impasto that relieve any potential slickness, this jewel-like panel is of appreciable quality, notwithstanding the reassertion of the underpainting or preparatory ground as a greenish tonality in the flesh.

Meditative to the point of gentle melancholy, a girl child (note the topknot tied with a thin ribbon) in a white shift of soft folds and a plum-colored mantle rests her left hand on a bouquet of cherries and red roses. Papi has suggested by analogy to early works of Caravaggio

that the still-life may have allegorical significance, and a receptive spirit might sense in this depiction of a female cupid-like figure allusions to the bitter-sweet nature of love.

As detailed by Gianni Papi, to whom is owed the publication of the panel, the *Child with Cherries and Roses* was assigned to Angelo Caroselli by Longhi following an earlier attribution to Solimena. The caution with which Papi raises the possibility of Artemisia Gentileschi's authorship is, in my opinion, justified. I am not persuaded by the many, varied, and highly particularized stylistic parallels that the Italian scholar discerns between the Palazzo Barberini painting and works from Artemisia's Neapolitan period. One might better point to Gentileschi's chubby putto type (e.g., Figs. 104, 179) and, as Merkel does in finding the attribution convincing, to the small angel heads in Artemisia's *Annunciation* of 1630 (Fig. 114). On a more substantive level, the picture in Rome seems rather to gravitate toward the late seventeenth and early eighteenth centuries and the proliferation of small oval pictures with subjects mediating between allegory and genre. Its gentle sentiment, its smallness both of scale and feeling, and its ruddy *chiaroscuro* likewise recommend a later date, or at least offer a prelude to such admittedly more painterly and unabashedly charming works as Giuseppe Maria Crespi's *Girl with Flowers* (London, Heim Gallery, 1980) and Giambattista Piazzetta's *Girl with a Basket of Apples* (New York, Suida-Manning Collection).

BIBLIOGRAPHY: Papi in Contini/Papi, 1991, pp. 163–64 cat. 23; Merkel, 1992, p. 354.

For the comparative material: A. Mariuz, *L'opera completa del Piazzetta*, Milan, 1982, p. 95 cat. 90; M. P. Merriman, *Giuseppe Maria Crespi*, Milan, 1980, p. 298 cat. 219; J. Spike, *Giuseppe Maria Crespi and the Emergence of Genre Painting in Italy*, exh. cat., Fort Worth, 1986, pp. 186–87 cat. 37.

..

[X-6] *Cleopatra*

Formerly Milan, Amedeo Morandotti
Oil on canvas, 1.18 x 1.81 m. (but see below)
Ca. 1611–1612
Fig. 211

COLLECTIONS: Palazzo Pietro Gentile, Genoa; Palazzo Durazzo-Adorno (now Cattaneo-Adorno), Genoa, by the mid-nineteenth century; Antichità Rubinacci, Genoa, 1967; Alessandro Morandotti, Rome, by 1978

During the restoration carried out between 1967 and 1978, which revealed breathtaking subtleties of color, light, and handling, a strip of canvas measuring approximately 27 cm. was cut from the top of the painting. Showing coarsely executed extensions of the curtain, it was judged to be a later addition. Yet the *Lucretia*, with which the *Cleopatra* once hung, contained a similar band of space above, without which its composition does not function properly (Fig. 19; Color Plate III). In its previous format the *Cleopatra* had a height-to-width ratio of 1:1.27 (cf. the present 1:1.53), or extremely close to that of the *Danaë* (1:1.3; Fig. 210) to which it is intimately connected. It is therefore very conceivable that the now removed section, having in the past been folded under and damaged (thus necessitating repainting), was original. At an unknown date some veiling over the woman's pubic area was removed, resulting in severe abrasion. Surely this cover-up had been ordered by a later owner for modesty's sake, a common practice, thereby distorting the artist's intentions.

The *Cleopatra* was seen by Ratti and Morrona in the Palazzo Pietro Gentile at Genoa, displayed with three other pictures also given to Orazio Gentileschi—a *Judith with Her Maidservant*, a *Sacrifice of Isaac*, and a *Lucretia*. By the mid-nineteenth century, as indicated by the Genoese guides of Gandolfi and Alizeri, the four paintings had been transferred to the Palazzo Adorno. Orazio's responsibility for the *Sacrifice of Isaac*, now in the Palazzo Spinola at Genoa following its sale by Finarte of Milan in 1986, is demonstrable; the *Judith* was in all probability by Guido Reni; and—as Morassi was the first to propose—the *Lucretia* is by Artemisia Gentileschi (Figs. 18–19; Color Plate III; [3]). The authorship of the *Cleopatra*, however, is not so easily resolved. In opposition to those many scholars (among them Morassi, Torriti, Harris, Marini, Nicolson, Gregori, Matthiesen, Grabski, Garrard, Mann, Contini, Papi, Berti, Stolzenwald, Merkel, Cropper, Hersey, and Volland) who award the canvas to Artemisia are others (Volpe, Schleier and, it is reported, Briganti and Zeri) for whom it is a work by Orazio. Pizzorusso considers possible an attribution to Orazio. After notable equivo-

cation, I have come to conclude that the ascription to Orazio is absolutely correct, for reasons that I now hope to make clear.

The case for assigning the *Cleopatra* to Orazio Gentileschi depends to some extent upon a devaluation of the arguments—chronological, interpretive, and stylistic—that have been mustered in support of Artemisia's authorship. Among the authorities who assign it to the daughter, the *Cleopatra* is most often regarded as having been painted by her in the early 1620s during a stay in Genoa or, in the slight variation proposed by Garrard, as having been executed by Artemisia in Rome about 1621–22, (i.e., immediately after her presumed trip to northern Italy, including Venice) and then brought back to a Genoese client by Orazio. In Garrard's judgment—a valid one in my opinion—the *Cleopatra* is close in time to the *Lucretia*. Yet the theory of a Genoese sojourn by Artemisia, and with it a dating of the *Cleopatra* to the beginning of the third decade, must be challenged.

Before the question of dating is pursued, Garrard's integrated reading of the content and formal peculiarities of the *Cleopatra* should be considered. In more than thirty pages dense with information and insights, Garrard seeks to establish the pictorial and literary contexts of the picture and to explicate its meaning. A summary of Garrard's remarks in their entirety is far beyond the allowable scope of this entry and would inevitably compromise their persuasive power. I must however risk recording here some of Garrard's conclusions as they pertain to the issue of attribution. Thus she contends that in this "provocatively mysterious" image, devoid of the histrionic, the artist set out "to weave larger mythic sense out of the separate strands to which she was heir," presenting the theme of Cleopatra as a "divine apotheosis." The snake, grasped "in a gesture of deliberate and secure control" and not suggestively juxtaposed to Cleopatra's breast, is no longer the phallic symbol implied by other painters. Through these and other means, Garrard holds, the traditional interpretation of the Queen of Egypt as the evil sexual temptress is rejected. Rather, the point is to indicate that "divinity assumes ordinary human form," that "female excellence [is] a reflection of inner worth rather than of conventional external beauty." For Garrard, "the legendary, glamorous Cleopatra is seen as a homely young woman, a privileged mystic glimpse that we are given just as she reverts through apotheosis . . . to her fundamental and eternal identity as the goddess Isis." The implication is that only the female artist Artemisia would have transformed convention in this manner.

Garrard's statement that "there is in this figure a curious disjunction between general pose and specific anatomy, as if the artist had begun with a type and wound up with an individual" prompts additional inferences. Specifically, one senses that Garrard's search for sources and the particular interpretive direction she takes were in part motivated by a need to rationalize features of the painting which otherwise she would find to be unpleasant anomalies in Artemisia's oeuvre: the "overtly erotic pose"; the observer's inclination to view the woman "as yet another sensuous beauty of the type displayed for masculine delectation"; the anatomical awkwardness of this "prosaic, ungainly body" and other characterizations to similar effect. One is reminded of Morassi's portrayal of the *Cleopatra* as a work by Artemisia "in una fase alquanto volgare" and as possessing "una crudezza sensualistica." Nonetheless, for Garrard the painting "exerts a strangely hypnotic force upon the viewer," in some measure because of its "almost hallucinatory clarity of form."

Yet it must be asked: Is one obligated to accept the view that a male painter would simply have been incapable of interpreting Cleopatra as anything but a "sensual, amoral evil temptress" with a "sadoerotic" emphasis? Does not the "hallucinatory clarity" bring to mind above all Orazio Gentileschi, the creator of the electrifying renditions of *Danaë* in the Cleveland Museum of Art and with Richard Feigen in New York (Fig. 107)? Does it not require excessive faith to embrace Garrard's trust in Artemisia's conversancy with a myriad of written and visual antecedents and in the painting's interpretive complexity? Having previously accepted without question Artemisia's authorship of the *Cleopatra*, by 1981 I was moved by certain doubts to consider the attribution to Orazio put forward in the meantime by Volpe, Schleier, Briganti, and Zeri (but, as it happens, not defended by anyone in the past decade and a

half). I recognized, on the one hand, "the extraordinary resemblance between the face of the Cleopatra and that of the lute player to the left of the organist" in Orazio's ceiling fresco of 1611–12 in the Casino of the Muses (Fig. 208), and the anticipation in the handling of the linens of Orazio's *Madonna and Child* at Pommersfelden. On the other hand, citing the Uffizi *Judith*, I noted that Artemisia had picked up the peculiar facial features of her father's women, and I could not harmonize the ponderous physique of the Cleopatra with the more svelte nudes presented by Orazio around 1620—i.e., the versions of *Danaë* and of the *Magdalen* (e.g., Fig. 108). Rather, the physical type accords better with that of Artemisia's *Lucretia*, which I then believed had been painted by her in Genoa in 1621.

It is now evident [3] that the *Lucretia* must have been executed about a decade earlier than all scholars have supposed; that is, around 1611 and thus close upon the *Susanna* (Figs. 10, 15; Color Plate I) which bears a date of 1610 (not 1619 as I once suggested). If so, one of the fundamental pillars to the proposal that Artemisia traveled with her father to Genoa in 1621 is toppled. And there is no indication that she undertook a Venetian trip before 1627 (see Chapter 3). Moreover, in recent years three paintings of reclining female nudes by Artemisia, one of them a *Cleopatra*, have reappeared (Figs. 104, 110, 111; Color Plates XIV, XV). Produced during the 1620s and influenced by Orazio Gentileschi's art at the turn of that decade (see the text and the respective catalogue entries), these pictures underscore the impossibility of dating the *Cleopatra* about 1621–22. The well-understood and decidedly nonawkward bodies of these nudes were certainly meant to be physically attractive and diverge significantly from that of Cleopatra, which even Morrona, with the taste of another era, found unbeautiful ("non abbia il dono delle belle forme").

If, then, Artemisia's responsibility for the *Cleopatra* is to be maintained, the canvas must be assigned a date prior to the 1620s (it is unthinkable later). There being no comparable works from her Florentine period, one is inevitably led back to the *Susanna* and the *Lucretia*, to that moment when Artemisia's style was especially indebted to Orazio's. It was near this time that Artemisia also painted the *Judith De-*

capitating Holofernes at Naples (Fig. 21; Color Plate II; [4]), wherein for the face of Judith, which patently resembles Cleopatra's, she had already appropriated the type of the aforementioned Casino of the Muses of 1611–12, in which Agostino Tassi had provided the perspective framework. It is precisely at this stage in Orazio's development that Schleier, Briganti, and Zeri locate the *Cleopatra*. So also does Mann, noting the connections to Orazio's Casino figures but assigning the *Cleopatra* to Artemisia. Central to the argument, in addition, is the *Danaë* in St. Louis (Fig. 210), which with variations replicates the *Cleopatra*. Generally given to Artemisia (although dismissed by Garrard as a work by either of the Gentileschi), under whose name it is now exhibited, this *Danaë* is surely by Orazio Gentileschi (see [X-7]).

Contini and especially Papi, also recognizing the ties to the Casino of the Muses but wishing strongly to affirm Artemisia's responsibility for the *Cleopatra*, follow Garrard in entertaining the possibility that Artemisia had a part in the execution of that fresco decoration. Yet, as Papi justly observes, while the Casino is mentioned several times in 1612 during the court proceedings involving Agostino Tassi, Artemisia's name is never cited in connection with it, neither by the principals nor by the many witnesses. Since, it can be added, the court records detail other encounters between Tassi and Artemisia and specify the names of an assistant and even of the plasterer in the Casino, their silence with respect to the daughter's presence on the scaffolding alongside Agostino and Orazio in a sense documents her nonparticipation there. Besides, Papi's argument for Artemisia's presence in the Casino depends in part upon first attributing to her the *Cleopatra* and upon considering that the design of the Pommerselfenden *Susanna* (see my text discussion) was her invention.

There is another reason, this in the nature of a hint only, why the *Cleopatra* (and with it Artemisia's *Lucretia*) might be dated about 1611. Immediately before his return to Rome in 1610, Agostino Tassi had executed some fresco projects in Genoa. In the next year, he and Orazio being still intimate friends and working together in the Palazzo del Quirinale and the Casino of the Muses, Agostino could have used his recently acquired connections in Genoa to

arrange patronage there for the Gentileschi. The *Cleopatra* shows a level of technical finesse beyond the reach of Artemisia at the beginning of her career. And because little more than the Hellenistic statue of the *Sleeping Ariadne* (Fig. 209; see Garrard), which in the seventeenth century was thought to depict Cleopatra, is needed to explain the woman's pose, and little more than a patron's instructions to account for her total nudity, the attribution of the *Cleopatra* to Orazio approaches the indisputable.

At this point, account must be taken of fascinating material brought by Pizzorusso to the attention of other scholars on the Gentileschi. On January 17, 1615, one Niccolò Tassi addressed a letter to Galileo Galilei in Florence. The writer described himself as a neighbor and friend to Orazio and as one privileged to have access to the studio where Orazio produced "opere maravigliose," among them a *Cleopatra*. This *Cleopatra*, Niccolò claimed, had recently ("ultimamente") been sent by Gentileschi to the Grand Duke Cosimo II de'Medici. In response to Orazio's courtesies and in celebration of the picture's beauty, Niccolò penned a preamble and an epigram on the *Cleopatra* which he included in the letter to Galileo. Transcribed from the original document by Pizzorusso, it reads:

> In Effigiem Cleopatrae apsidem pectori
> admoventis ab Horatio
> Gentilesco de Lomis, pictore insigni, ac
> celeberrimo depictam, et ad
> Magnum Ducem Hetruriae Serenissimum
> Cosmum Secundum
> Florentiam Roma trasmittendam.
>
> Audijt ut cari faturm Cleopatra mariti,
> Admovit maestis aspida pectoribus;
> Ne pars invisi fieret morituri [*sic*] triumphi
> Neu post terga foret pompa revincta manus
> Evocat hanc audax redivivam Horatius orco
> Est Podaliraea doctior ista manu!
> Quid quod adhuc spirans laevae convolvitur
> anguis!
> Quid quod vibrat adhuc ora, feritque sinus!
> Excute in Augustis non es ducenda
> triumphis,
> Excute iam dentes non timet iste decor.
> Faelix sorte tua es MAGNOS visura penates.
> Adspectu MAGNI es quae fornitura DUCIS
> Ut si regnaret faustis Antonius armis
> Despiceres Romam, despiceresque virum.

That is, in a felicitous English rendering most kindly prepared at my request by Professor Ralph Williams:

> On an image of Cleopatra bringing the asp
> to her breast by Orazio
> Gentileschi di Lomi, the eminent painter,
> brilliantly depicted, and to be
> transmitted from Rome to Florence, to the
> Grand Duke of Tuscany, the
> Most Serene Cosimo II.
>
> When Cleopatra heard the fate of her dear
> spouse,
> She drew the asp to her sorrowing breast;
> That she might not, doomed to die, become
> part of a hated triumph,
> Nor be led in proud procession, hands
> bound behind her back.
> Bold Orazio recalled her to life from Orcus:
> He is more learned than the Podalirean
> hand!
> See how still breathing she is bound in the
> fell serpent's coils!
> See how its tongue vibrates still, how it
> strikes her breast!
> Know that she is not to be led in Augustus'
> triumphs;
> Know that this loveliness does not fear the
> serpent's teeth!
> Happy is your lot, for you shall see the
> GRANDEE's household gods,
> You will bask in the gaze of the GRAND
> DUKE.
> So that if Antony reigned with still
> triumphant arms,
> You would hold Rome full cheap, and cheap
> the man.

Unfortunately, the situation is not as straightforward as it appears. As Pizzorusso is quick to point out, two months later, on March 16, Andrea Cioli, Secretary to the Grand Duke, wrote from Florence to the Tuscan Ambassador in Rome, Pietro Guicciardini. Cioli informed Guicciardini that in Florence "an almost public rumor had been spread that Orazio Lomi Gentileschi was one of the most excellent and famous painters" in Rome, a rumor which the Secretary found "quite easy to believe" in view of the pictures which his daughter Artemisia had already painted in the Tuscan capitol. Grand Duke Cosimo was now seeking confirmation.

Guicciardini's reply, dated March 27, gave a negative assessment of Orazio's art and personality, one biased it appears by the fact that the Ambassador had consulted with Orazio's arch-rivals Agostino Tassi and Giovanni Baglione. Then on April 4 Cioli thanked Guicciardini for his diligence, claiming that Cosimo II was grateful for the assessment but had not yet instructed what further steps, if any, were to be taken.

One source of Orazio's rumored fame must have been Niccolò Tassi, working as the artist's agent and calling upon Galileo as an intermediary. Conversely, the *Cleopatra* itself does not seem to have figured in this reputation-building; for, as Pizzorusso was the first to note, if the painting had been known in Florence, then Cioli's request, which intimates that the Secretary had never seen a picture by Orazio, would probably not have been necessary. I suspect that Tassi's letter, the preamble to its epigram stating that the work was "to be transmitted" (*trasmittendam)* to Florence, was designed to test the waters, to see if the Grand Duke, flattered by the attention, would have any interest in such a painting. With Guicciardini's report in hand, Cosimo is unlikely to have given any signs that the canvas should be shipped from Rome.

Theoretically, then, the *Cleopatra* in question could be the present picture for which Orazio then found another, specifically Genoese, client. However, if I am correct in dating the Morandotti *Cleopatra* ca. 1611–12, Gentileschi would have to have kept the finished work in his studio for two or three years, and in addition there could be no connection between it and a supposed intervention with a Genoese patron on Orazio's behalf by Agostino Tassi before the Agostino-Orazio friendship dissolved in 1612. Nonetheless, there is nothing in Niccolò's poetic description that is contradicted by the evidence of the present *Cleopatra*, and a great deal that coincides: Cleopatra still breathing, bringing toward her breast the serpent, coiled about her arm, its tongue vibrating; no signs of agony or blood, the woman neither fearing the serpent's fangs nor, the sense is, having yet been bitten; and the terms "loveliness" and "basking" implying a nude figure reclining, as a body stretched out in the sun (in this case before the hoped-for gaze of Cosimo

de'Medici). Therefore, even if the evidence does not permit an absolute identification of the extant *Cleopatra* with the picture by Orazio offered to Florence, it does disclose that by early 1615 Orazio Gentileschi—accustomed to repeating his compositions—had created a *Cleopatra* which closely resembled the known canvas, still another reason to attribute the Morandotti painting to him.

BIBLIOGRAPHY: Ratti, 1780, I, pp. 119–20, 122; *Description des beautés de Génes*, Genoa, 1788, p. 58; Morrona, 1792, II, pp. 261–62; Alizeri, 1846, II, p. 432; Gandolfi, 1846, III, p. 294; Morassi, 1947, pp. 101–3 cat. 139; Bissell, 1968, pp. 156–57; Torriti, 1970, pp. 200, 202; Schleier, 1971, p. 89; C. Volpe, "Annotazioni sulla mostra caravaggesca di Cleveland," *Paragone*, XXIII, no. 263 (1972), 68; Harris in Harris/Nochlin, 1975, p. 120; Greer, 1979, p. 195; Marini, "Caravaggio e il naturalismo internazionale," 1981, fig. 306; Bissell, 1981, p. 202 [X-7]; M. Gregori in Naples, *Civiltà del seicento*, 1984, I, p. 147; Grabski, 1985, pp. 58–59; London, Matthiesen, 1986, p. 52 n.; Pizzorusso, 1987, pp. 70 incl. n . 47, 71, as from Florence, Biblioteca Nazionale, MS Galileiani 17, c. 195; Garrard, 1989, pp. 19–20, 54–56, 244–73, 276–77, with extensive notes; Harris, 1989, p. 10; Nicolson/Vertova, 1990, I, p. 110; Contini in Contini/Papi, 1991, pp. 128, 149, 162; Papi, ibid., pp. 48–49, 61 nn. 57 and 64, 153, 210 n. 30; Berti, ibid., p. 25; Stolzenwald, 1991, p. 34; Merkel, 1992, pp. 350–51, 353; Cropper, 1992, p. 209; Hersey, 1993, p. 331 n. 6; G. Volland in Düsseldorf, 1995, p. 300; Mann, 1996, pp. 40, 43.

For the Cioli-Guicciardini correspondence: Crinò, 1960, p. 264, and Crinò and Nicolson, 1961, p. 144.

..

[X-7] *Danaë*

St. Louis, Missouri, Saint Louis Art Museum
Oil on copper, .405 x .525 m.
Ca. 1611–1612
Fig. 210

COLLECTIONS: Sotheby's and Co., Monaco (Monte Carlo), February 22, 1986, Lot 243; purchased by Kate Ganz Ltd., London, by whom sold to the Saint Louis Art Museum, 1986

A cleaning of the picture in 1986 removed layers of yellowed varnishes and restored intensity to the lapis blue of the nurse's dress. Routine degeneration of the shadowed passages, including the face of the nurse, is observable.

The following study of the *Danaë* recognizes the obvious: The painting must be considered in relationship to the *Cleopatra* most recently with Amedeo Morandotti in Milan (Fig. 211). In this regard—to address first the issue of priority—the figure of King Acrisius' daughter shows every sign of having been appropriated from the large canvas in spite of, arguably, its only partial serviceability in the new context. Cleopatra's pose, no doubt influenced by the classical *Sleeping Ariadne* (Fig. 209), then believed to represent Cleopatra, responds to the theme of the soon-to-expire Queen. In the *Danaë* there is to my perception a conflict between the crossed legs and compressed thighs, with their implications of unreceptivity to Jupiter's designs, and the girl's swoon, which in her situation can only be interpreted as having been sexually induced. The fingers of the ruddy right hand, in the Milan painting firmly gripping the asp, now function as slots for coins, a highly curious indicator of the girl's favorable disposition. It is very improbable that Danaë would have assumed precisely this guise had she not already existed, as it were, as Cleopatra. And a step from the ancient "*Cleopatra*" to a Danaë and then back to a Cleopatra is difficult to imagine.

It might be thought that the nature of this transposition implies the presence of another artist, yet there are countless examples of master painters, either by choice or at the request of patrons, quoting their own inventions in different contexts. Nor is the *Danaë* a replica of the *Cleopatra* with the mere addition of a nursemaid. Nor was it intended to be. Throughout the figure of Danaë the extremely buxom proportions of Cleopatra have been moderated, and with her long locks caressing her right shoulder and arm she seems an appropriately younger woman. The curtain, deep red and pulled back at the right in the Milan picture, is now dark olive green and cloisters Danaë in her "chamber secret as the grave." The red bedspread has been augmented, and the white linens of sheet and pillow have been redesigned, fold for fold. These painstaking modifications, some of them substantive, are not to be expected of a copyist, and in themselves suggest that the two pictures are by the same artist.

If, as I have attempted to show ([X-6]), the *Cleopatra* was executed by Orazio Gentileschi at the beginning of the second decade, the attribution to him of the *Danaë*, confirmed by Sidney Freedberg and Erich Schleier, would seem secure. For Matthiesen, however, the St. Louis copper is "almost certainly by Artemisia," whose authorship has been affirmed by Nicolson/Vertova, by Papi ("per le stringenti somiglianze con la *Cleopatra* Morandotti e per la mossa qualità del sentimento"), who suggests that it belongs to Artemisia's second Roman period, and most eloquently by Mann, whose views will be summarized below. For Garrard, assigning the *Cleopatra* to Artemisia Gentileschi, an ascription of the *Danaë* to *either* Orazio or Artemisia is most doubtful (again below).

In my opinion the father's responsibility for the *Danaë* is demonstrable on its own terms, for the painting finds parallels in other works by him in addition to those adduced for the *Cleopatra*. Thus the nursemaid, her body obliquely posed and viewed from the back and her arms extended as she holds out her apron, is a variation upon the servant bearing the head of Holofernes in Orazio's *Judith* of ca. 1605–10 last with Sotheby's (Fig. 39), a picture which Gentileschi then reconceived about 1611–12 for the maidservant in his *Judith* now in Oslo (Fig. 40). Papi too has noted the relationships to the latter *Judith* (while remaining undecided as to the authorship—Orazio or Artemisia—of this Oslo canvas). The lost profile and white headdress/shawl of the Oslo Abra, closely repeated by Artemisia for the *Judith and Her Maidservant* of ca. 1612 in the Palazzo Pitti (Fig. 31; Color Plate IV), are echoed in the *Danaë*. (Orazio's liking for eccentric postures is also exploited in his *Way to Calvary* from the same period; Vienna, Kunsthistorisches Museum.) And although on at least two occasions Artemisia Gentileschi executed paintings on copper (the lost *Saint Apollonia* [L-68] from her Florentine years and the late Escorial *Madonna and Child*, Fig. 198), during the first two decades of the century Orazio counted this art form as one of his specialities (e.g., *Christ's Appearance to Saint Francis*, Rome, Incisa della Rocchetta Collection; *David in Contemplation after the Defeat of Goliath*, Berlin-Dahlem, Staatliche Gemäldegalerie [Fig. 24]; *Madonna and Child in a Landscape*, Stamford, England, Burghley

House). Indeed, writing from Rome in 1615 to Andrea Cioli, Cosimo II de'Medici's Secretary in Florence, Pietro Guicciardini, said of Orazio that "that quality in him that is worth something is diligence . . . and in those alabaster plaques and small things he has made some little works that are diligent and charming." This correspondence is especially relevant in the present context, for it appears to have been prompted in part by Orazio's intention to send to Florence a *Cleopatra* by him, a picture clearly similar to if not identical with the Morandotti example.

This accumulated evidence points to Orazio Gentileschi as the creator of the *Danaë* and, the differences between it and the more idealized, less erotic nudes in his versions of the theme from 1621–22 (New York, Richard Feigen [Fig. 107]; Cleveland Museum of Art) being marked, indicates a date of ca. 1611–12 for it, as for the *Cleopatra*. The quality of the *Danaë* secures the case. The delicate shifts in the tonality of the flesh and the subtlety of the lighting are stunning, and bring to mind the Berlin *David*. Differences in handling between the *Danaë* and the *Cleopatra* may be explained by the much smaller format, the smooth copper support, and the better condition of the former. The exalted level of craftsmanship of which the *Danaë* boasts is that reached by Orazio Gentileschi alone.

Judith Mann, while also dating the *Danaë* to 1611–12, nonetheless staunchly advocates an attribution of the picture to Artemisia, to whom she likewise assigns the ex-Morandotti *Cleopatra*. For Mann, if the quality and style of the St. Louis copper might in themselves indicate Orazio's authorship, the interpretation most definitely does not. Of the Gentileschi it was the daughter, Mann maintains in accepting the thrust of Garrard's iconographical analyses of Artemisia's pictures, who was more given to "interpretive originality" and "narrative sensitivity." According to this line of reasoning she is thus the more likely to have conceived the "new reading" of the Danaë myth, "overtly sexual and aggressive," with Danaë "in the throes of passion brought on by the physical consummation of her amorous liaison," the "coins oozing out of her fist, juxtaposed to those that have come to land on her pudendum."

Mann's citation of the *Danaë* by Jacopo Tintoretto in the Musée des Beaux-Arts at Lyon, a work wherein coins fall through the young woman's fingers and tumble on her thighs, renders the related motifs in the present painting somewhat less eccentric. Yet as Mann observes, Tintoretto imagined another moment, that of "a thoughtful weighing of the choice presented [Danaë]." It could be argued that the artist of the St. Louis picture depicted a swooning Danaë not as the result of a creative leap but of the decision to adapt the *Cleopatra*, with Tintoretto's invention possibly having suggested how that adaptation might be effected. Further, I do not find that Orazio Gentileschi's art is as interpretively wanting, nor the small *Danaë* as iconographically rich, as Mann does. It is true that the work has a kind of raw sensuality that is lacking in Orazio's interpretations in Cleveland and New York (Fig. 107), but these large canvases are of about a decade later. Finally, if the St. Louis *Danaë* speaks as bluntly of "greed . . . lust and sexuality" as Mann (who at one point evokes a tradition that associates Danaë with prostitution, for which see C. Santore, "Danaë: The Renaissance Courtesan's Alter Ego," *Zeitschrift für Kunstgeschichte*, LIV, no. 3 [1991], 412–27) believes, can it really be integrated comfortably into Artemisia's oeuvre?

Garrard, as noted, rejects the attribution of the *Danaë* to either Gentileschi. She correctly observes that before its restoration the *Cleopatra* was extended above by a section of canvas and at one time included veiling over the woman's pubic area. Suspecting that the former was not original but that the latter was, Garrard infers that the *Danaë* must have been painted by a later hand after the *Cleopatra* had been tampered with. Yet it is much more likely, logic and precedent again being valuable guides, that a later owner's false sense of modesty dictated the veiling of a once completely nude body. And (see [X-6]) the once larger size of the *Cleopatra*, which had a height-to-width ratio of 1:1.27, or almost identical to that of the *Danaë*, may have been correct.

BIBLIOGRAPHY: Monaco, Sotheby's and Co., *Tableaux anciens et du début du XIXe siècle*, February 22, 1986, lot 243; Laura Meyer, St. Louis Art Museum, letter to the author, October 8, 1986; London, Matthiesen, 1986, pp. 50 fig. 1 and 52n; Garrard, 1989,

pp. 539–40 n. 85; Nicolson/Vertova, 1990, I, p. 110; The St. Louis Art Museum, *Handbook of the Collections*, 1991, p. 88, with color ill.; Papi in Contini/Papi, 1991, pp. 51, 96, 99; Judith Mann, St. Louis Art Museum, letter to the author, February 20, 1992; Mann, 1996. Also [X-6], including for the Cioli-Guicciardini correspondence.

For Orazio Gentileschi's paintings cited above, see [5] and Bissell, 1981, pp. 142–43 [10], 149–50 [19], 155–56 [27], 168 [39] and figs. 21, 34, 50, 84.

. .

[X-8] *David with the Head of Goliath*

London, Sotheby's, July 9, 1975
Oil on canvas, 2.02 x 1.37 m.
Fig. 212

Having deposited the head of Goliath at his feet, and now with legs crossed and right arm casually thrown over the hilt of a large sword, a smug David gazes at his admirers.

This appealing canvas was shown at Sotheby's–London in 1975, unillustrated and with an attribution to Giovan Francesco Guerrieri accompanied by a one-line description specifying David's outer garment as light brown. In the photograph published by Gianni Papi the right one-third of the painting is illegible, while visible damage on David's left cheek and around his mouth is potentially distorting. The readable portions appear to indicate a picture of such quality as to exclude the possibility that it is a copy of a now-lost original.

Aware of the difficulties of drawing conclusions from an unsatisfactory photograph of a painting of uncertain preservation, Papi ventures to assign the *David* to Artemisia Gentileschi. (The question mark following Artemisia's name in the photo caption seems to represent a retreat from the main argument.) As if in prior support of Gentileschi's authorship as it is to be posited on expressive and stylistic grounds, Papi introduces his study with what he takes to be references to three distinct paintings of David by Artemisia: one belonging to King Charles I of England, as intimated by Walpole, followed by Pilkington; one seen by Joachim von Sandrart upon a visit in 1631 to the artist's Neapolitan studio; and a third inventoried in 1638 in the Giustiniani Collection at Rome. However, as demonstrated under [L-21] and [L-23], these references are almost certainly to a single picture painted by Gentileschi

in Naples and sent to Rome, with no connection to England and, since it featured David holding the Philistine's head, of a different conception from that of the present canvas. Not cited by Papi, on the other hand, is a *David* with Ferdinando d'Afflitto of Naples in 1700. Measuring 8 *palmi* high and 6 *palmi* wide (2.11 x 1.58 m.) and therefore of approximately the same size as the ex-Sotheby's example, this picture is nonetheless surrounded by such confusion (Did Artemisia execute the entire figure, just the head, or none of the painting? See [L-85] and [L-73]) as to have no demonstrable bearing on the issue at hand. To our knowledge, then, Artemisia Gentileschi's involvement with the theme of David and Goliath was by no means as extensive as a first reading of the sources might suggest. Accordingly, one cannot bring much documentary authority to the question of the authorship of the *David*.

The visual evidence is inconclusive as well. Papi writes of "la sinuosa figura di David—che tradisce la maggior dimestichezza della pittrice nel ritrarre le modelle, tanto di sembrare una modella travestita dal volto fiero e protervo, dall'aria virile senza la virilità genetica, come tante eroine di Artemisia . . ." but the interpretation has the perfume of a *scherzo* involving a young man masquerading as the Old Testament hero and putting himself on display. The artist toys with the observer, presenting the subject in a rather too cute manner that would be uncharacteristic of Artemisia. The richly folded white sleeves are justly likened by Papi to Artemisia's way with such stuffs; to the examples singled out by the Italian scholar (e.g., Figs. 131, 139; Color Plate XVII) several others could be added (e.g., Figs. 151, 164, 169, 178; Color Plate XX). Conversely, the remaining comparisons adduced by Papi (David's mantle to materials in Figs. 119 and 121, Color Plate XVIII; certain lighting effects to passages in Fig. 125, Color Plate XVI; the landscape to that in Fig. 131, Color Plate XVII) are of questionable relevance.

Even the observation regarding the Artemisian handling of the shirt loses some of its acuteness in confrontation with that composition which—as Papi duly points out—served as the direct prototype for the present canvas: a *David* by Domenico Fetti known by way of the example in the Gemäldegalerie at Dresden and

in several copies. Taking over from Fetti even the sentiment of self-assuredness, the artist of the ex-London work also adopted the basics of the pose, the mountainous landscape, the placement of Goliath's head, *and* David's mode of dress, including the white concertina-like sleeves. It is not impossible that Artemisia Gentileschi could have been familiar with Fetti's conception, for while there are many uncertainties concerning the histories of the original and its derivations, one such example (today Kensington Palace) had entered the English Royal Collection prior to Artemisia's stay in London. Yet although there are numerous instances in which Gentileschi adapted individual figures and compositional ideas from previous works of art, such a wholesale appropriation of an invention born in the mind of another creative personality would be unprecedented in her career.

Furthermore, there are reasons to situate the *David* at the juncture of the second and third decades and thus effectively to remove Artemisia's name from consideration. Fetti's composition has been dated ca. 1614–15, and the picture type—that of a format-dominating, life-sized male figure set in a landscape and informed by Caravaggesque realism—brings to mind Carlo Saraceni's *Saint Roch* in the Museo di Capodimonte at Naples and the *Saint Roch Ministered by an Angel* in the Galleria Doria-Pamphili at Rome, traditionally given to Saraceni but discussed elsewhere by Papi as possibly by Orazio Borgianni. (The Sotheby's attribution to Guerrieri brings to mind the *Saint Roch* assigned to him in the Galleria Borghese at Rome.) Psychologically the *David* probes less deeply than these representations of the plague saint, thereby recalling not only Fetti's offering but as well the Roman-period *David*s of Guido Reni and Simon Vouet. Thus located, the ex-Sotheby *David* finds no substantive parallels in the contemporary canvases of Artemisia Gentileschi. A tentative conclusion, subject especially in this case to what the actual painting might reveal, would therefore be that the work originated about 1620 in the Roman circle of the Frenchman Vouet.

BIBLIOGRAPHY: London, Sotheby's, *Important Old Master Paintings*, July 9, 1975, p. 44 Lot 45; Papi, 1996. Also see [L-21], [L-23], [L-73], and [L-85].

For the comparative material: A. Ottani Cavina, *Carlo Saraceni*, Vicenza, 1968, pp. 46–47, 52, 109–10 cat. 46, 112–13 cat. 56, color pl. VIII and figs. 73, 74, 78, 80; E. Safarik, *Fetti*, Milan, 1990, pp. 41–44 cat. 6, 44 cat. 7, 46–47 cat. 7g, with ills.; G. Papi, *Orazio Borgianni*, Soncino, 1993, pp. 13–14, 52 color pl. XXII.

..

[X-9] *Female Martyr*

Mentana (Rome), Federico Zeri Collection
Oil on panel, .32 x .245 (reported dimensions, but these are somewhat inconsistent with the panel's height-to-width ratio)
Fig. 213

The panel is fabricated from two pieces of wood, the joint visible on the surface as a thin vertical crack in from the right border. The hair flowing over the woman's proper right shoulder has been partly absorbed into the dark background, while strips of deeper pink along the bottom and on the right of her mantle, once protected by a frame (Contini), indicate that the tonality of the mantle has lightened over time. Conversely, the most deeply shadowed areas of this drapery and the blue of the martyr's dress may have darkened.

Holding a palm and crowned with a halo and a garland of the white roses of purity and the red roses of sacrifice, this youthful figure appears to be presented as an exemplary virgin martyr rather than as a specific saint, be she Saint Dorothy or Saint Rosalie (the most plausible identifications considered by Contini).

The attribution of the *Female Martyr* to Artemisia Gentileschi, proposed by Contini in publishing the painting for the first time, cannot rest upon perceived relationships to her *Jael and Sisera*, *Judith and Her Maidservant*, or *Madonna and Child* (Figs. 73, 31, 1; Color Plate IV), nor upon Baldinucci's claim for Artemisia as an expert in still-life. Baldinucci's story as it applies to Gentileschi at least is unquestionably erroneous (see Chapter 6), and such stylistic comparisons as those above might be said to apply equally well—or poorly—to Artemisia's *Female Martyr* of ca. 1615 (Fig. 56) in the Newhouse Galleries at New York. Although Spike, suggesting a tentative attribution to G. F. Guerrieri, states that the Zeri painting "seems unrelated to Artemisia and its relationship to Artemisia's [Newhouse] *S. Martire* . . . is purely

coincidental," in my opinion the connections between these small panels are so patent as to speak of a direct dependency of one upon the other.

Thus as Contini appears to acknowledge, it is ultimately through a confrontation between the Mentana and New York pictures, the ascription of the latter to Artemisia having found univeral acceptance, that the justness of the attribution to her of the former must be gauged. For Contini, Papi, Berti, and Bionda, the panel in Italy is an autograph work by Gentileschi, Contini assigning it to Artemisia's years in Florence and Papi judging its date of execution to oscillate between the artist's Florentine and second Roman periods. For me, in consideration of the qualitative and expressive differences between the pictures, these views both as to the authorship and the date of the Zeri example are debatable.

Even before its cleaning in 1989 the Newhouse *Female Martyr* spoke of a remarkable subtlety of modeling that endows the flesh with the qualities of life, and spirited touches of impasto that give suppleness to the tunic. In contrast, the flesh of the Zeri martyr approaches the porcelaneous, and the mantle the metallic. Unlike the uniformly dark ground of the Mentana version, the modulated background of the New York picture intimates space and atmosphere. And if, as Contini contends, the gesture of gripping the palm is more convincing in the Zeri panel, the stiff and parallel fingers lack energy. It is only with the long flowing hair, scintillating with light (for which, however, there was precedent in Artemisia's *Penitent Magdalen*, Fig. 68, Color Plate VII), and with the beautifully rendered roses—i.e., with those details that are particular to it alone—that the Zeri example reaches qualitative parity.

In signaling the expressive distinctions between the two panels, Contini rather undermines the argument that they are by the same artist. Whereas the Mentana *Female Martyr* in its sentimental sweetness, as in its attributes of garland and halo, is clearly intended for religious devotion, the New York picture, wherein Artemisia presents herself as the plump turbaned woman of untidy hair and evocative glance ("la terribilità dello sguardo" in Contini's words), asks the observer to muse upon the artist's personal situation. The former is comfortably canonical, "holy"; the latter unorthodox.

The similarities yet substantive differences between these pictures, the probability (see [7]) that the Newhouse painting remained in Florence until the late eighteenth century, and the special *dolcezza* of the Zeri example prompt the conclusion that the latter is a Florentinized variant by another hand of Gentileschi's panel, which itself had been touched by Florentine tastes. In the final analysis the work in Mentana is interpretively closer to the female saints of Carlo Dolci—for example, the equally small *Saint Rose of Lima* in the Palazzo Pitti (oil on panel, .33 x .25 m.), whose superb ring of roses is but one of numerous instances of this speciality of Dolci and members of his workshop, including his daughter Agnese. One is reminded as well of the so-called *Personification of Fame*, rose-garlanded and compositionally almost identical, that appeared at Sotheby's in London on July 8, 1992, with an attribution to Cesare Dandini.

That the Zeri picture was based specifically upon Artemisia's conception, perhaps even as a kind of training exercise, is also indicated by the aforementioned two-piece construction of the panel. The proportions of the Mentana painting, minus the strip at the right, are exactly those of the New York one, and in this smaller format the Zeri martyr sits within the frame in an identical manner. The traces left on the surfaces of both works by once-overlapping frames suggest that the dimensions of the panels have not been altered. It is as if the later artist first ordered a panel to match that of Gentileschi's and that, subsequently, opting to represent a full cascade of hair and a more complete halo and conceivably to modify the assertive closeness that the format of Artemisia's work produces, added a separate board and proceeded to execute the figure in its fuller size.

Finally, if my arguments are correct, the Newhouse *Female Martyr* remains the most likely candidate for the *Testa di Santa* once owned by Ignazio Hugford and/or for the panel billed to Artemisia by a carpenter in 1615.

BIBLIOGRAPHY: See the relevant bibliography under [7]. Also see Contini in Contini/Papi, 1991, pp. 140–43 cat. 16; Papi, ibid., p. 51; Berti, ibid., p. 24; Spike, Review, 1991, p. 734; Bionda, 1992, pp. 26–27.

For the comparative material: Cantelli, 1983, pl. 299; C. McCorquodale in Florence, Palazzo Strozzi, 1986, II, pp. 360–64 cat. 2.327; London, Sotheby's, *Old Master Paintings*, July 8, 1992, pp. 260–61 Lot 286.

..

[X-10] *Jael and Sisera*

Milan, Pinacoteca Ambrosiana
Oil on canvas, 1.32 x 1.03 m.

To my knowledge the traditional attribution of this canvas to Artemisia Gentileschi has never been defended in print, although in 1968 I declared the work to be related to Artemisia's Florentine and Roman pictures. For Szigethi it may be associated with a painting (or paintings?) of *Samson and Delilah* that figured in sales of the Musée Ernst at Budapest under the name of Cristofano Allori (*Catalogue des ventes du Musée Ernst*, XVIII, 1924, no. 6, and XXIX, 1925, no. 10 fig. 11), a work which Szigethi characterizes as mediating between Artemisia's art and that of early seventeenth-century Florence. (I have been unable to consult the Ernst catalogues to verify this judgment or to assess potential connections to the *Samson and Delilah* in Naples (Fig. 152; [35]).

The conventional compositional setup of the Ambrosiana picture holds few clues to authorship; close parallels may be found, for example, in depictions of *Jael and Sisera* by Matteo Rosselli (formerly Rome, Art Market, and formerly Impruneta, A. Briganti Collection) as well as in a canvas of Neapolitan (?) paternity in the Muzeul de Arta at Bucharest. In the latter rendition Jael, her sleeves rolled up, sets upon a screaming and gesturing Sisera, features which mark, respectively, Judith and Holofernes in Artemisia's picture of ca. 1612 (Fig. 21). Yet the Capodimonte *Judith*, wherein Holofernes thrusts out his right arm in a manner reminiscent of Jael in the Milan painting, was inspired in part by Orazio Gentileschi's *David and Goliath* (Fig. 14) and belongs to the same moment as the *Salome with the Head of Saint John* once in the Musée d'Art et d'Histoire at Geneva (Fig. 20). Natale has assigned this *Salome* to Giovan Francesco Guerrieri, whose works speak repeatedly of an alliance with the Gentileschi studio in Rome, and it is to the *Salome* (which is extremely close to Orazio Gentileschi; see [X-39]) that the Ambro-

siana *Jael* seems especially linked in costume and in type. In fact, in its combination of Sisera's crudeness and Jael's girlish charm the Milan canvas, more than the *Salome*, brings to mind Guerrieri's provincialism, and differs in this regard from Artemisia Gentileschi's version of the subject from 1620 (Fig. 73). An attribution to the painter from Fossombrone, who in 1617 executed a larger (and horizontal?) painting of *Jael and Sisera* for the Palazzo Borghese in Campo Marzio, should therefore be considered.

BIBLIOGRAPHY: G. Galbiati, *Itinerario dell'Ambrosiana*, Milan, 1951, p. 124; Bissell, 1968, p. 166; Szigethi, 1979, p. 36 n. 8.

For Guerrieri, and the other comparative material cited above: Pergola, 1956, pp. 228, 234, 236; A. Teodosiu in Bucharest, Muzeul de Arta, *Catalogue de la Galerie d'Art Universel, I: La peinture italienne*, 1974, pp. 21–22 cat. 40 and 162 pl. 99; M. Natale in Geneva, Musée d'Art et d'Histoire, 1979, pp. 64–65 cat. 80 and pl. 46; Bissell, 1981, pp. 71–72 and passim; Cantelli, 1983, p. 132 and pls. 686–87.

..

[X-11] *Joseph and Potiphar's Wife*

Cambridge, Massachusetts, Harvard University, Fogg Art Museum

Oil on canvas, 2.318 x 1.949 m.
Fig. 214

COLLECTIONS: Robert Brothers, New York, from whom acquired in 1950 by the Samuel H. Kress Foundation; Kress donation, 1962, to the Fogg Museum

Having been saddled with sundry ascriptions, most prominently one to Simon Vouet, in 1968 the painting was attributed to Artemisia Gentileschi by Everett Fahy, seconded by Frederick Cummings, Erich Schleier, Mina Gregori, Fern Rusk Shapley and—with considerable confidence—by the present writer (letters of 1968 and 1969), who set it in the 1640s. Nicolson listed it as by an "unidentified imitator of Vouet's Caravaggesque phase." Artemisia's authorship and a date of ca. 1622–23 have since been championed by Mary Garrard (followed by Stolzenwald and Hersey), for whom the *Joseph and Potiphar's Wife* (a) bears compositional relationships to depictions of the subject issuing from the "Florentine-Roman circle of the

Casa Buonarroti group," including Cigoli and Bilivert, with which Gentileschi would have been familiar; (b) exhibits a typically Artemisian female type and manipulation of materials; and (c) inverts the traditional male interpretation of the theme to favor Potiphar's wife.

Yet, as Garrard acknowledges, the attribution to Gentileschi has been questioned. Thus Freedberg announced in 1978 that Fahy had reassigned the painting to the Apulian master Paolo Finoglio (1590–1645), as also has Spinosa and most recently Contini, Bologna, and Rocco. Harris, without comment, has expressed doubts regarding Artemisia's authorship. It is now absolutely clear that the Fogg canvas is fully representative of Finoglio's manner: in the physiognomy of the woman, down to the triangle of hair and shadow caressing her cheek; in the gleaming white draperies, sharp and crumpled; and in the urgency of expression, wherein all sense of poise is rejected. Paolo's *Madonna Appearing to Saints Margherita, Bernard, and Anthony* (Fig. 215), the *Immaculate Conception* (several versions, including Lille, Musée des Beaux-Arts), and the fresco *The Funeral Rites of Saint Martin* (Naples, Certosa di San Martino), to cite but three examples, exhibit analogous features.

The character of the *Joseph and Potiphar's Wife* and its attributional history mark the painting as fundamental to the issues of Vouet's influence in Naples and of the artistic ties between Artemisia Gentileschi and Paolo Finoglio, who collaborated on the Saint John the Baptist cycle for the Buen Retiro at Madrid ([32]). Artemisia might be expected to have tackled the *Joseph and Potiphar's Wife* story on several occasions; one such canvas, embellished with a "bellissimo leto di drappi et bellissima prospettiva di pavimento," is cited by the artist in her letter to Don Antonio Ruffo of January 1, 1651 ([L-45]), as being half-finished. Conceivably an earlier effort served as Finoglio's primary source. In this regard I cannot agree with Bologna that the curtains in Finoglio's *Presentation in the Temple* (Certosa di S. Martino) of 1626 and in the Fogg painting are identical and therefore that the latter is to be assigned the same date as the former, at a moment prior to Artemisia's arrival in Naples. The relationships signaled above to other works by Finoglio suggest that the *Joseph and Potiphar's*

Wife belongs to Paolo's maturity (mid-1630s?), an opinion also expressed by Rocco.

Another *Joseph and Potiphar's Wife*, formerly in a Hungarian collection, has recently been assigned by Szigethi to Artemisia Gentileschi, apparently—the painting is illustrated without comment—on the basis of Artemisia's presumed authorship of the Fogg canvas. Awkward and interpretively naive, it is by still another hand.

BIBLIOGRAPHY: R. Ward Bissell, letters to Everett Fahy, November 26, 1968, and February 19, 1969; E. Fahy, letter to the author, March 30, 1968; Shapley, 1973, pp. 84–85 cat. K1690; S. J. Freedberg, "Lorenzo Lotto to Nicolas Poussin," *Apollo*, CVII (1978), 395; Nicolson, 1979, p. 110; N. Spinosa in Percy/Lurie, 1984, p. 34; Spinosa, 1984, pl. 351; Garrard, 1989, pp. 80–83, 506–7 nn. 127–30, and color pl. 11; Harris, 1989, p. 9; E. P. Bowron, *European Paintings Before 1900 in the Fogg Art Museum: A Summary Catalogue*, Cambridge, Mass., 1990, p. 107; Contini in Contini/Papi, 1991, pp. 70, 85 n. 28; Stolzenwald, 1991, pp. 32 fig. 25 and 36; L. Rocco in Naples, Castel Sant'Elmo, 1991, pp. 291–92 cat. 2.46; F. Bologna, ibid., p. 69; A. Szigethi in Milan, Palazzo della Permanente, 1993, p. 48 ill.; Hersey, 1993, p. 331 n. 5.

For the paintings by Paolo Finoglio cited above: P. Belli in Naples, *Civiltà del seicento*, 1984, I, p. 273 cat. 2.85; Spinosa, 1984, pls. 348, 352, 354.

..

[X-12] *Judith and Her Maidservant*

New York, Sotheby's, sold October 8, 1993
Oil on canvas, 1.105 x 1.368 m.
Fig. 220

COLLECTIONS: Rome, Ugo Jandolo, by 1922; sold Buenos Aires, Argentina, 1925 or 1926 (according to the recollection of Antonio Jandolo in 1964)

When exhibited in 1922 in the Palazzo Pitti at Florence as from the School of Caravaggio, this *Judith* was recognized by Gamba as being related specifically to Orazio Gentileschi, although it was judged by him to be "of an execution too coarse and dark in the shadows to be an original. . . ." Its status as a copy was affirmed by Voss, and then, following the appearance of the canvas now in the Pinacoteca Vaticana ([X-15]; Fig. 219), likewise by Redig de Campos and Longhi. Subsequently, with the reemergence of still a third version of the

composition, the magnificent picture in the Wadsworth Atheneum (Fig. 33), the authenticity of the Vatican example was called into question, even as the present work continued unanimously to be classified as a copy (as by Moir, Bissell, and Nicolson).

In view of the critical history of the ex-Jandolo *Judith*, its publication in 1993 as an autograph canvas by Artemisia Gentileschi came as a surprise. The Sotheby catalogue identifies the authority for this new claim as Mary Garrard, who in 1989 had regarded the painting as "surely by an artist further removed [than was the creator of the Vatican example] from the Gentileschi orbit." Garrard's reattribution of the present *Judith* to Artemisia Gentileschi, following firsthand study of the picture, depends in part upon her prior conviction that the Vatican version is by her, an opinion which I have challenged (again [X-15]). It also requires assessing the painting to be of autograph quality. To quote the catalogue: "Garrard has suggested that the Vatican picture is an early production of the artist and that the less pedantic quality of the present work would seem to indicate that it is a work of Artemisia's maturity."

Yet it may be asked why during her maturity Artemisia would have been moved to produce a version of a composition that had originated with her father. Further, I must continue to agree with the perceptions of previous critics that the ex-Jandolo canvas—which admittedly I know by way of photographs only—does not reach Gentileschian standards. Of the three redactions, it exhibits a particular brittleness of line and schematization of *chiaroscuro*. With little attention to matters of emphasis and subordination, it is as if every fold and every highlight, having been mechanically reproduced rather than spontaneously brushed, carries equal visual force, lending a kind of nervousness to the whole while dissipating the dramatic focus.

The present picture is therefore best considered an anonymous copy. It may be, however, that neither the Hartford nor the Vatican version served as its model. Only it contains (at Judith's neckline) a cameo with a chest-length profile figure of the general type found in other *Judith*s by or inspired by Orazio Gentileschi (cf. Figs. 40, 221), and the configuration of that part of the napkin to the right of the severed head is appreciably different. Conceivably the ex-Jandolo copy was taken from a now lost or unidentified variant from Orazio's brush.

BIBLIOGRAPHY: Florence, Palazzo Pitti, *Mostra della pittura del seicento e settecento*, 1922, p. 51 no. 102; Carlo Gamba, "Orazio Gentileschi," *Dedalo*, I, anno III (1922–23), 262; Voss, 1925, p. 461; Deoclecio Redig de Campos, "Una 'Giuditta' opera sconosciuta del Gentileschi nella Pinacoteca Vaticana," *Rivista d'arte*, XXI, series 2 (1939), 314 n. 1; Longhi, 1943, p. 46 n. 38; Moir, 1967, I, p. 70 n. 10, and II, p. 75; Bissell, 1981, pp. 154–55 (under [26]) and fig. 47; Garrard, 1989, pp. 29 and 494 n. 31; Nicolson/Vertova, 1990, I, p. 113; Mahoney in Hartford, Wadsworth Atheneum, 1991, p. 151 n. 7; New York, Sotheby's, *Old Master Paintings*, October 8, 1993, Lot 197, with ill.

..

[X-13] *Judith and Her Maidservant*

Oslo, Nasjonalgalleriet
Oil on canvas, 1.36 x 1.59 m.
Figs. 40, 50

COLLECTIONS: Galleria Scarpa, Milan, 1895; Jules Sambon; Syndicat de la Presse, Paris, cat. 46, 1917, from whom purchased by U. J. R. Börresen, Bygdö, Sweden; purchased by the Nasjonalgalleriet, 1945, with funds provided by A. M. Vik

Exploiting the strength of the major triad, the artist used burgundy for Judith's patterned gown, golden brown for the maid's dress, and an intermediary diagonal slash of light blue for the latter's sleeve. Stunningly beautiful white linens and a dark curtain, olive in the light, which heightens through contrast the pictorial force of the canvas, complete the color scheme.

With its appearance at the Casa Buonarroti in 1991 the Oslo *Judith and Her Maidservant* staked a claim as central to an understanding of Orazio Gentileschi's role in his daughter's artistic formation and hence of Artemisia's early career. This, at least, is the wider thrust of the present entry, which must first chart the range of attributions that has emerged from the last half-century of scholarship:

Circle of Caravaggio, with relationships to Orazio and Artemisia Gentileschi: De Witt

Orazio Gentileschi: Venturi; Longhi; Sterling; Emiliani; Borea; Bissell; Gregori; Har-

ris; Berti ("almeno stilisticamente" by Orazio); Bionda; Lerberg

Orazio Gentileschi as "the leading candidate": Garrard

Probably by "another, perhaps later hand" than Orazio Gentileschi's: Moir

Perhaps by Giovan Francesco Guerrieri: Pepper

Artemisia Gentileschi: Nicolson

Most likely Artemisia Gentileschi: Spike; Palmer (misstating Bissell's position in 1981)

Orazio or Artemisia Gentileschi: Papi

Papi's restraint in not making a definitive pronouncement is commendable, for he acknowledges that at the time of his writing he knew the picture only by way of photographs. Photographs alone served me as well when in 1981 I catalogued the work as (a) by Orazio Gentileschi, ca. 1611; (b) possibly the *Judith* cited in the Tassi rape trial of 1612; (c) conceivably the painting with the Rondanini at Rome as late as 1710; and (d) the source for Artemisia Gentileschi's *Judith* in the Palazzo Pitti (Fig. 31; Color Plate IV).

My ascription to Orazio of the Oslo canvas was then tepid, for I found the picture less psychologically rich and less formally concentrated than Orazio's version of the theme at Hartford (Fig. 33), and added: "There are even certain features here that are unusual in the art of Gentileschi: the profile of the maid tends toward caricature; the head of Judith is a little nondescript, not to say Caroselliesque; and the overabundance of jewelry is likewise more characteristic of Caroselli's manner." In all, I labeled the picture "very refined if somewhat slight." Having now had the opportunity to experience the original and to consider it alongside other Gentileschi productions, and with the aid of material that has come to light since I last commented upon the *Judith*, I must modify some of my previous opinions and introduce new proposals while enthusiastically embracing the attribution to Orazio (as does Lerberg, for whom the exhibition was also conclusive).

At once much more monumental and much less fussy than I had judged it, the work is also of a quality that begins at superb and rises to an almost transcendent level in the transparent gray shadows of Abra's shawl (also singled out by Papi). Its visual impact equals that of the Hartford *Judith*, and only Orazio Gentileschi among the *Caravaggeschi* was capable of such technical wizardry. Even the peculiar texture of the pigment on sections of the maid's golden dress finds parallels in the Hartford picture. Further, it now seems clear that the would-be Carosellian adornments in the Nasjonalgalleriet *Judith* are best understood as the kinds of items which Caroselli was to appropriate from Orazio. Thus Judith's red gown with its pattern of heart-shaped leaves on thick stems and bursts of spiky clusters may have been the model for the virtually identical dress worn by the heroine in the *Judith* of the Lemme Collection at Rome (Fig. 221), a painting here given to Angelo Caroselli. The brooch with its helmeted Athena that dangles from the elaborate belt of the Judith in Rome is essentially the reverse of that gracing the hair of the present Judith (which in turn can be compared, for example, to an intaglio in the Musei Capitolini published by Righetti, Fig. 51). It seems, then, that with the Oslo painting or one like it Orazio set a fashion for jeweled accessories of antique type and imagery that was most directly to influence Caroselli and Artemisia Gentileschi (cf. Figs. 31, 77; Color Plates II, XII).

Crucial to this reassessment of the Oslo canvas is the *Judith and Her Maidservant* (Fig. 39) first presented in 1984, to which I have devoted an abbreviated discussion under [5] and a full report submitted to Colnaghi. I have concluded of this picture that it (a) was painted by Orazio Gentileschi between 1605 and 1610; (b) is beyond question the work that belonged to the Rondanini; (c) is most likely the *Judith* at issue during the Tassi trial, the date of 1612 on the reverse recording not the date of execution but the court's sequestration of the canvas in that year; (d) served, in conjunction with the Oslo example, as a prototype for Artemisia's *Judith* in the Palazzo Pitti; and (e) firmly links to Orazio Gentileschi the taste for twisted figures in lost profile seen at odd angles from behind, of the sort that appear also in the *Way to Calvary* in the Kunsthistorisches Museum at Vienna and in the St. Louis *Danaë* (Fig. 210).

For Papi, on the other hand, the ex-Colnaghi *Judith* complicates the problem of attributing the Oslo painting by introducing

319

difficulties in placing the work chronologically. Papi, dating the former to the beginning of the second decade, reasons that if the latter is assigned to Orazio it cannot be located about 1611. At the same time, he notes correctly that the Oslo *Judith* is not compatible with Orazio's production later in the decade and then in Genoa. To give the Oslo painting to Artemisia is equally problematic chronologically, Papi continues, for while its connections to the Lemme and Pitti *Judith*s would indicate a date in her first Roman period, this is contradicted by its ties to the *Lucretia* (Fig. 19; Color Plate III), *Cleopatra* (Fig. 211), and *Danaë*, three works thought by Papi to represent Artemisia's style in the early 1620s. However, as argued above and elsewhere in these pages, I believe that the ex-Colnaghi *Judith* belongs rather to the period 1605–10, that the *Cleopatra* and *Danaë* are by Orazio Gentileschi, not by Artemisia, and that Artemisia's related *Lucretia* was painted about 1611. If I am correct, then all impediments to ascribing the Oslo *Judith* to Orazio and dating it (with Sterling and Emiliani) around 1611 are removed.

Garrard is of still another viewpoint. She writes: "If Orazio painted the Oslo *Judith*—and he remains the leading candidate—he manifestly adapted a composition of his daughter's, which he may have had occasion to see, if he was indeed in Florence in 1616, as is believed. Artemisia's Pitti *Judith* thus represents not only the end of the artist's apprenticeship with her father, but perhaps also the first instance of her influence upon him." Again I must state fundamental disagreements: I do not share Garrard's conviction that the Oslo picture shows obvious signs of being "a variation upon a theme rather than an original design," nor do I (nor does Harris) see the justness of the uniformly negative tone of her characterizations of its expression, composition, and drapery treatment. Finally, holding the date of the Oslo painting to be much closer to 1611 than to 1616, and the Pitti *Judith* to have been painted by Artemisia in Rome before her Florentine trip, I must continue to affirm the likelihood that her father's Oslo and ex-Colnaghi canvases were Artemisia's points of departure.

A very fine copy (or so it appears from the photographic evidence available to me) of the *Judith*, extended above by 10 cm. and today at least reduced in width by a total of 42 cm. in containing the figures only within a vertical format, is in the Helsingen Kaupunginmuseo at Helsinki. Dated to the seventeenth century by pigment analysis, the canvas is recorded as having been purchased in St. Petersburg by the Finnish Lieutenant General Otto Wladimir Furuhjelm (1817–87) from the collector Martinoff (Martynov), who had acquired some of his pictures in Vienna at an auction of the Esterhazy Collection. The *Judith* bore an attribution to Pierre Mignard when, subsequent to the transfer of the collection to Helsinki upon the death of Furuhjelm's widow in 1895, it was donated to the Helsingen Kaupunginmuseo in 1912.

BIBLIOGRAPHY: A. de Witt, "Ein Werk aus den Caravaggio-Kreis," *Pantheon*, XXIII (1939), 51–53; Longhi, 1943, p. 46 n. 38; Emiliani, "Orazio Gentileschi," 1958, pp. 42–43; Charles Sterling, letter to Oslo, March 28, 1960; Dr. Willoch, Nasjonalgalleriet, Oslo, letter to the author, February 23, 1964; Moir, 1967, I, p. 71 n. 10; Borea, 1970, p. 76; Oslo, Nasjonalgalleriet, 1973, pp. 346–47 cat. 767; Bissell, 1981, pp. 155–56 cat. 27 and fig. 50; M. Gregori in Naples, *Civiltà del seicento*, 1984, I, p. 147; Garrard, 1989, pp. 39–40, 497–98 n. 56; Harris, 1989, p. 10; Nicolson/Vertova, 1990, I, p. 111; Papi in Contini/Papi, 1991, pp. 96–99 cat. 3; Berti, ibid., p. 20; Spike, Review, 1991, p. 733; Palmer, 1991, p. 278; Bionda, 1992, p. 26; Sinebrychoff, Helsinki, Ulkomaisen Taiteen Museo (Museum of Foreign Art), *Italialaisia Maalauksia/Italian Paintings*, Helsinki, 1992, p. 49; E. J. Lerberg, "Judith i Nasjonalgalleriet," *Kunst og kultur*, LXXVI, no. 3 (1993), 182–91, esp. pp. 187, 189–91 incl. n. 13; Teija Mononen, Helsingen Kaupunginmuseo, letter to the author, April 29, 1996.

For the antique gem: Righetti, 1955, p. 32 no. 66 and pl. VII, fig. 25.

..

[X-14] *Judith and Her Maidservant*

Rome, Fabrizio Lemme Collection
Oil on canvas, 1.29 x .965 m.
Figs. 48–49, 221

COLLECTIONS: Palazzo Albani alle Quattro Fontane, Rome, by 1700 and as late as 1816; Christie's–London, June 29, 1973, Lot 3; Martinoja Antichità, Rome, by 1975; London, Sotheby and Co., April 6, 1977, Lot 92; also reportedly once in Sweden, perhaps through mistaken conflation with the canvas now in

Oslo (Fig. 40), formerly owned by a Swedish collector

With a self-satisfied look and an understated gesture of triumph Judith, in a red patterned gown over a white blouse, presents the head of Holofernes as her maid in an olive-green dress (its sleeve decorated with a dark stripe outlined in gold) and a large white shawl stands by with the sword and sack. The background, washed by oblique illumination, is light tan but for a triangle of darker brown above. The old woman's equipment and the oversized severed head exclude Aurigemma's identification of the subject as that of *Salome and Herodias*.

Striking as a visual image and additionally stimulating for those of us who still delight in the detective work of connoisseurship, this *Judith* has a distinguished provenance which has escaped the notice of scholars. The "Inventario, o sia nota de'quadri, che sono in Casa Albani in Roma" records: "Un quadro in tela da Imperatore rappresentante Giuditta colla testa di Oloferne in mano, e coll'altra mano appoggiata sopra una pietra con un' altra Donna, che tiene una saccoccia insanquinata, e sciabola in mano, di mano di Gentileschi con Cornice liscia dorata comprato da Sua Santità mentre era Cardinale. . . . scudi 100." Headed with the date 1790, this manuscript is in fact a copy made in 1816 of one dated 1790 and then in the Albani archives. The latter document, in turn, was a transcription of an inventory drawn up in 1712 upon the death of Orazio Albani. The *Judith* in question had been purchased by Cardinal Giovanni Francesco Albani before he assumed the papacy in 1700 as "Sua Santità" Clement XI.

The present painting satisfies in every detail the description of the Albani canvas. Yet the reference, although from a relatively early moment, cannot be taken as unimpeachable evidence of Orazio Gentileschi's responsibility for the Lemme *Judith*. Thus, for example, the same Albani inventory registers as by Orazio Gentileschi the immediately succeeding item, a canvas of the *Four Seasons* which beyond doubt is the painting by Bartolomeo Manfredi now in the Dayton Art Institute (or one of the versions of it) and which is obviously by a hand different from that which executed the *Judith:* "Un quadro in tela simile da Imperatore scarsa rappresentante le quattro staggioni, cioè la primavera con Ghirlanda di fiori, che sona il Liuto, e

si abbraccia coll'Autunno, che tiene varj frutti, coll'Estate in forma di Donna con spighe di grano, e l'Inverno in forma di Vecchio con berettone di pelle, di mano del Gentileschi con cornice liscia dorata. Lasciato a Sua Santità quando era Cardinale dalla bona memoria del Signor Abbate Passarini. . . . scudi 150."

As the discussion below will show, however, the attribution of the *Judith* to Gentileschi is understandable. Even without the impetus of the Albani reference, the work was sold by Christie's–London on June 29, 1973, as by Orazio. (Sotheby's catalogued it as by Giovanni Baglione, however, for its sale of April 6, 1977). Palmer's sense that the picture may be a collaborative effort from the Gentileschi studio follows Marini's suggestion that it was created by Orazio and Artemisia Gentileschi in concert.

The preponderance of opinion now favors Artemisia as the artist, from Papi, who in the most detailed study to date cautiously considers the daughter's authorship, to Berti, Contini, Spike, and (reportedly) Mina Gregori, for whom the *Judith* is more certainly Artemisia's work. For these scholars, the Artemisia attribution demands that the canvas be assigned to the very beginning of the painter's career, as early as ca. 1609–10. Only in this way, it is thought, can one simultaneously sustain the attribution and explain various awkward and seemingly unskilled moments: the clumsy disposition at Holofernes' head of the hands of Judith and her maid; the disconcerting sense that Abra's head springs directly from her shoulders; the immobility of pose and general organizational stiffness; the incongruous presence of a patch of background at the compositional center of the painting. Unfortunately for this argument, the overall handling is anything but uncertain; with its precisely rendered details, beautifully managed draperies, and highly refined surfaces, the *Judith* impresses one as the work of a mature technician, not that of an artist, however talented, at the start of his/her career.

Nor is the argument for Gentileschi's authorship bolstered by Papi's hypothesis and Berti's claim that the sixteen-year-old Gentileschi represented herself in the guise of Judith. Orazio's depiction of his daughter as the youthful violinist in the Detroit *Saint Cecilia* (Fig. 32) may be taken as a reliable indication of Artemisia's appearance at the beginning of

321

the second decade, and the points of contact between the two women are not sufficiently close to identify Artemisia as the female hero of the Lemme canvas.

In fact, scholars have implicitly and explicitly conceded that fundamental connections to known early works by Artemisia Gentileschi are lacking. Thus Papi's comment that between the *Judith* and the Pommersfelden *Susanna* (Fig. 10; Color Plate I) there is "un'analoga atmosfera levigata" seems forced, for the pictures present basic noncomparable aspects—one an interior and the other an exterior setting, the latter in itself encouraging "una luce limpida e bianca." And Spike sees the way open for figuring Artemisia "in a more independent light" (and thus for making room for the Lemme *Judith*) by according Orazio Gentileschi significant responsibility for the *Susanna* and, more radically, by having taken from the daughter and given to the father the early *Judith Decapitating Holofernes* at Naples (Fig. 21; Color Plate II). (For my opinion on these matters see Chapter 1 and [4], respectively.)

Further points on which the present canvas and pictures by the Gentileschi, daughter or father, simply do not meet may be observed. The Casa Buonarroti exhibition afforded the opportunity to view the painting in Rome in proximity to Artemisia's *Susanna* and Orazio's *Judith* in Oslo (Fig. 40). The cloth over Susanna's thigh and the sleeve of Orazio's Judith are marked by a greater feeling of impasto than are the white linens of the polished Lemme example, and the same differences obtain with regard to the red dresses of the two Judiths. Additionally, the division of the background, wherein it is the swath of light that dominates, reverses the usual Caravaggesque (e.g., Doria-Pamphili *Magdalen, Calling of Saint Matthew*) and Gentileschian (i.e., Washington *Luteplayer*) pattern, lessening thereby the projecting force of the figures. And in the most substantive sense, even beyond its portrayal of Judith as the traditionally comely female, the Lemme painting seems the product of a mentality distinct from Artemisia's (and Orazio's).

Before this last point is elaborated, however, it must be emphasized that certain aspects of the *Judith* do indeed find correspondences in the Gentileschi ambient. As Papi has seen, these include the garments and the accessories.

In this respect the *Judith and Her Maidservant* at Oslo is central. Except that in color it is a less burgundy red, the gown worn by the Lemme Judith seems identical to that sported by her Oslo counterpart—patterned with heart-shaped leaves attached to broad stems and with occasional bursts of spiked foliage. On the pendant of the gem-studded belt of the seated Judith is a left-facing, helmeted figure shown to the shoulders. Extremely comparable to the Athena/Minerva type found on ancient jewelry (as for example on a carnelian in Berlin, no. 6944, published by Furtwängler; also Fig. 51), this warrior appears in reverse on the cameo adorning the hair of the Judith in Norway. In both cases the Old Testament heroine is obviously associated with the classical goddess of strength and wisdom. Then there is the woman dancing or rushing rightward on the brooch decorating the Roman Judith's hair, again the reverse of a Gentileschian detail (the lower cameo on the bracelet of Artemisia's Uffizi Judith, Fig. 45) and once more of definite antique derivation (Figs. 43, 46). Since Artemisia introduced another such ancient-inspired accessory (a Mars Ultor type) in her Pitti *Judith* (Figs. 31, 44, 47; Color Plate IV; [5]), it is tempting to conclude that the Lemme *Judith* issued directly from the Gentileschi studio. Yet this is a risky conclusion in view of the open attitude at the time toward appropriating features from the pictures of others and of the possibilty that the materials and adornments described above were in fashion at the moment.

Nonetheless, in the contemporaneity of its interpretation, as in its decorative flair and loving craftsmanship, the Lemme *Judith* cannot be dissociated from the Gentileschian manner. The question becomes: If not Orazio or Artemisia, then who? Here again the Oslo *Judith* is relevant. Of this canvas I have written: "There are . . . certain features here that are unusual in the art of [Orazio] Gentileschi: the profile of the maid tends toward caricature; the head of Judith is a little non-descript, not to say Caroselliesque; and the over-abundance of jewelry is likewise more characteristic of Caroselli's manner." Although I have come to accept Orazio's authorship of the Oslo picture without the equivocations in which I once indulged, this may still be taken as the kind of painting

to which Angelo Caroselli would have been especially attracted.

In a letter of July 11, 1981, to Avv. Lemme I argued briefly for a Caroselli attribution of the *Judith* in his collection. Since then, Giffi has cited elements of both expression and style in convincing support of Caroselli. Papi reports that Evelina Borea and Giovanni Previtali have also assigned the canvas to this artist, and Spike has spoken cryptically of "parallels to Caroselli." It is first and foremost the mentality which drove this work that brings Angelo to mind. Thus while the Judiths of Artemisia and Orazio Gentileschi, natural participants in human dramas, do not play to the spectator, many of Caroselli's figures do. The emphasis on the heavily bloodied sack (an "inserto macabre" in Giffi's words), implying that upon request Judith has removed the Persian general's head for one last showing, introduces the kind of bizarre note to be expected of the singular Caroselli. And this head "squints strangely out at the viewer, as though still dimly conscious . . ." (Palmer). These are the kinds of *scherzi* in which the Gentileschi did not indulge. Nor would it be beyond Angelo Caroselli to allude, in the portraitlike heads within the framework of a subject favored by the Gentileschi, to Artemisia's revenge upon Agostino Tassi for the latter's lechery. Carosellian to the core is also the juxtaposition of an ostensibly beautiful featured player with a downright plebeian companion: compare the *Procuress* once in the Gerini Collection at Florence, the *Vanitas* in the Palazzo Corsini at Rome, the *Carite and the Old Woman (Allegory of Vanity)* in the Rijksdienst Beeldende Kunst in the Hague, the *Lesbia Mourning Her Pet Sparrow* formerly with Matthiesen and Colnaghi (Fig. 255), and the *Salome with the Head of Saint John* at Budapest (Fig. 254 and [X-38]).

On the stylistic plane, Caroselli's ability to mimic the manners of others was legendary in its own time and is reported by Baldinucci. Taking off, it would seem, from the Gentileschi, he exhibited an even greater fixation than they with elaborate materials and highly descriptive adornments. The Corsini *Vanitas* (see the billowing sleeves of the undergarment and the bejeweled border of the dress) and the *Lesbia* (the girl wearing at her bodice a cameo of Diana from which a pearl hangs) support these contentions. The years just after 1610 constituted an especially vital moment for Caravaggesque painting, and it is certainly to that period, and probably to Angelo Caroselli, that this beautiful and intriguing *Judith and Her Maidservant* belongs.

BIBLIOGRAPHY: London, Christie's, *Highly Important Pictures by Old Masters*, June 29, 1973, Lot 3, p. 6 and ill. opp.; London, Sotheby's, *Important Old Master Paintings*, April 6, 1977, Lot 92; M. di Macco et al., *Il Cardinale Alessandro Albani e la sua villa: documenti*, Rome, 1980, pp. 31, 70; R. W. Bissell, letter to Avv. Fabrizio Lemme, Rome, July 11, 1981; Marini, "Gli esordi," 1981, pp. 39 n. 1 and 48 fig. 12; E. Giffi, "Per il tempo romano di Pietro Paolini e gli inizi di Angelo Caroselli," *Prospettiva*, no. 46, July (1986), 25–27; Papi in Contini/Papi, 1991, pp. 106–9 cat. 6, 119; Contini, ibid., p. 149; Berti, ibid., p. 20; Spike, Review, 1991, p. 733; R. Feigen, New York, letter to the author, October 10, 1991; Palmer, 1991, p. 278; C. S. Salerno, 1992, p. 355 n. 17; Aurigemma, 1994, p. 40 n. 114. See also [5]; the bibliography of comparative material (Caroselli) under [X-35]; Rotterdam, Museum Boymans–van Beuningen, 1989, pp. 114–15 cat. 56; Nicolson/Vertova, 1990, I, p. 95, and II, fig. 354; C. S. Salerno, 1992, pp. 347–48, 349 fig. 3, 351 fig. 7, 352–53, 355–56 n. 29.

And for the antique gems: Furtwängler, 1900, I, pls. X no. 33 and XL no. 48, and II, p. 52 no. 33 and p. 194 no. 48.

- -

[X-15] *Judith and Her Maidservant*

Vatican, Pinacoteca
Oil on canvas, 1.27 x 1.47 m.
Fig. 219

COLLECTIONS: Signora Agnese De Angelis, widow of Gammarelli, by whom presented to Pope Pius XI (1922–39); gift of Pius XI to the Vatican

The attribution of the *Judith and Her Maidservant* to Orazio Gentileschi proposed by Redig de Campos in 1939 and confirmed unenthusiastically by the present writer in 1981 continues to be debated. Thus for Papi the painting is unquestionably by Orazio, while for Spike it is "probably a studio repetition" of the composition in the Wadsworth Atheneum at Hartford (Fig. 33), whose ascription to Orazio has never been doubted. To Mahoney it "looks clearly to be a studio version."

It is, however, the solution offered by Garrard that must be at the center of the present entry. Garrard assigns the Vatican picture specifically to Artemisia Gentileschi according to the following detailed reasoning: (1) references to the authorship of a *Judith* mentioned several times during the rape trial of Agostino Tassi in 1612 are ambiguous; (2) these discrepancies might be explained by postulating that "the *Judith* given by Artemisia to Tassi was a copy by her of a work by her father—a copy which may even have been destined for sale *as* an Orazio," and for which the Vatican painting is a "promising candidate"; (3) the Vatican canvas is a replica, datable ca. 1610–12, of Orazio Gentileschi's *Judith* at Hartford, but whereas in the father's picture "the forms are treated consistently as tactile volumes," the "surfaces in the Roman painting are flatter, and there is a greater reliance upon strong light and shade contrasts to suggest rather than describe volume"; (4) these stylistic differences point to a copyist and are consistent with the "less *disegno*-oriented" Artemisia; (5) "the character of Judith is almost completely reinvented, as if studied from a different figure entirely," these changes being the probable result of Artemisia's "personal connection" with the canvas and "her reaction to her own appearance [as her father's model] in Orazio's painting. . . ."

Papi considers Garrard's proposals "ingenious but improbable," the more so as he gives the Vatican canvas to Orazio, while Spike observes that Garrard's attribution of it to the daughter "is theoretically possible," although "it is not an easy matter to distinguish her hand in a work that was created to pass for an Orazio." In my judgment (developed under [5]), the *Judith* mentioned during the Tassi proceedings was by Orazio Gentileschi and can in all likelihood be identified as the *Judith and Her Maidservant* last with Sotheby's, which together with Orazio's *Judith* at Oslo served Artemisia for her interpretation of the subject now in the Palazzo Pitti at Florence (Figs. 39, 40, 31, respectively). The lesser quality, upon which all scholars seem to agree, of the Vatican example vis-à-vis the extraordinary Hartford canvas may in part be the result of its inferior state of preservation (although it has now been cleaned). Unlike the picture once owned by the dealer Jandolo in Rome and recently sold in New York ([X-12]; Fig. 220)], it does not exhibit the generally heavy touch of a production-line copyist. If certain sections (e.g., Abra's profile) appear hard, others (e.g., Judith's red gown) are of excellent quality, and Judith's dress has a textured surface that is typical of Orazio's golden yellows. While I am content to repeat my view that "it is safer to regard the Vatican *Judith* as an autograph replica" by Orazio Gentileschi, I am not prepared to reject outright the doubts expressed by Spear, Nicolson, Garrard, and Spike. Nonetheless, while I continue to believe that Orazio devised the composition about 1611–12 (and not during his stay in Genoa a decade later, as Pepper, Papi, and Schleier would have it), I find no cogent evidence either in the trial records or in the Vatican painting itself to indicate that the supposed copyist was Artemisia. Those passages of more schematic treatment and the alterations to Judith's physiognomy (and to Abra's, it should be noted)—which to my perception are not substantive in any case—are not such as to testify specifically to the daughter's brush or mind.

According to Charles Sterling, "a good, exact (and same size) 17th-C. copy" of the Hartford canvas was in Paris in 1958. Papi reports the existence in a private collection in Lombardy of still another version of the composition, brought to his attention by Mina Gregori and judged by Papi from a photograph to be "probably a copy."

BIBLIOGRAPHY: Bissell, 1981, pp. 153–55 [25] and [26], with full bibliographies up to 1979; Pepper, 1984, p. 316; Garrard, 1989, pp. 28–31, 494 nn. 26–33; M. Mahoney in Hartford, Wadsworth Atheneum, 1991, pp. 148, 150, 151 n. 8; Papi in Contini/Papi, 1991, pp. 95, 99–102 cat. 4; Spike, Review, 1991, p. 733; E. Schleier, "Orazio Gentileschi's 'Verspottung Christi.' Zur Neubertung eines wiederentdecken Bildes," *Pantheon*, LI (1993), 196. Also see [5].

..

[X-16] *Lucretia*

London, Art Market, 1992
Oil on canvas, 1.62 x 1.385 m.
Fig. 229

Almost overwhelmed by her jewel-bordered gown of gleaming red satin and her embroidered golden cloak lined in ermine, Lucretia

grimaces as she prepares for suicide. The plum hues of the woman's blouse and of the drapery at the lower left (mostly concealing the scabbard) and the gold-fringed green curtain behind complete the rich color scheme.

The attribution of this canvas to Artemisia Gentileschi, whether (as is thought) about 1635 during her first Neapolitan period or at any other moment of her career, must be challenged. Lucretia, awkwardly posed and somewhat squat, is put on display as if on a stage, and what is stunning at first encounter emerges as an ostentatious exhibition of flashy fabrics, an image of interpretive shallowness. Further exposing her marmoreal chest while with her other hand clutching the dagger at arm's length, the Roman matron solicits us to admire her moral rectitude and would-be courage while at the same time offering us the option of dissuading her from her act should we be so inclined. Gentileschi's protagonists, conversely, go about their momentous business without so obviously playing to an audience. In addition, the harsh, regularized highlights on the drapery edges and the almost unnatural polish are far from the brilliant painterly handling of comparable compositions by Artemisia, among them the *Clio, Muse of History* of 1632 and the *Cleopatra* of about 1630–35 (Figs. 121–23, 136; Color Plates XVIII, XIX).

The claim of a Neapolitan pedigree for the *Lucretia* should also be questioned. The decorativeness which, along with the subject matter, apparently brought Gentileschi to mind has also been likened to the art of Francesco Guarino and Paolo Finoglio; but the relationships, not convincingly close in any case, could as easily be accounted for by a common influence of Simon Vouet. In fact, one is most reminded of the Venetian-period pictures of Vouet's friend and onetime *Caravaggesco* Nicolas Regnier (Nicolò Renieri), and even more particularly of those paintings that have been grouped under the heading "Le figlie di Renieri," Nicolas's four painter-daughters (for whom see P. L. Fantelli, "Le figlie di Nicolò Renieri: un saggio attributivo," *Arte veneta*, XXVIII [1974], 267–72). The *Artemisia* in the Stattsgalerie at Stuttgart, with its porcelaneous finish, excessive costuming, and superficial dazzle, is characteristic. One of Regnier's daughters, married to the Antwerp master Daniele Van Dyck, was named

Lucretia, and of her Boschini wrote in his *Cartar del navegar pittoresco* of 1660: "L'una possiede el nome sì famoso / de la Casta Romana e gran matrona, / che a l'onor col pugnal zonse corona; / questa onor dal penelo ha glorioso." Yet inasmuch as the Lucretia, for all her costly garb, is less elegant than the females painted by Regnier and members of his studio, the present picture must remain in search of a secure attributional niche.

[X-17] *Lucretia*

Naples, Palazzo Reale
Oil on canvas, 2.06 x 1.82 m.
Fig. 216

COLLECTIONS: Naples, Museo di Capodimonte (having entered the Museo Borbonico shortly after 1821)

The critical history of the *Lucretia* from the mid-nineteenth century to 1991, reconstructed by Willette (to whom the reader is referred for the precise citations), is one of attributional ambivalence: Massimo Stanzione (San Giorgio inventory, 1852; Rolfs; Molajoli; Bologna; Leone de Castris); Stanzione or follower (De Rinaldis); debatably by Stanzione (Causa); Artemisia Gentileschi (Longhi, later as Neapolitan school; Garrard; Gash; Hersey); closer to Artemisia Gentileschi than to Stanzione, and perhaps by Agostino Beltrano (Willette). Harris, without additional comment, has expressed doubt regarding the assignment of the work to Gentileschi.

Only Garrard, in reviving the attribution to Artemisia, has offered a detailed defense of authorship. While highlighting the manifold differences between this picture with its "classicizing generalization" and "nobly attired aristocrat, who gestures grandly in a palatial setting" and the blunt *Lucretia* by Artemisia in Genoa (Figs. 18–19; Color Plate III), Garrard nonetheless finds Gentileschi's mind at work in the interpretation of the theme as one of "questioning rather than succumbing" and her brush in the color and in certain details of the setting. The differences, Garrard posits, are to be explained by a willingness on the part of the now mature and secure artist, about 1642–43, to respond to the changing tastes of Neapolitan patronage, including those for the art of Anthony Van Dyck.

Yet, as noted in Chapter 6 and as witness also renditions of the subject by Simon Vouet (Prague) and Guido Reni (Potsdam) from the 1620s, the choice of that moment when Lucretia, dagger suspended, looks away or to Heaven for guidance before delivering the fatal stab wound is not restricted to Artemisia at the time nor then necessarily indicative of a female point of view. And when Gentileschi attempted drama in the grand manner (e.g., Figs. 190, 197), the results were usually patently false, overstepping the agreeable grandiloquence of the *Lucretia*, whose creator appears to have been more comfortable with idealization and rhetorical convention. Massimo Stanzione fits well this profile. Except that it depicts Lucretia plunging the dagger into her chest (the internal debate having been resolved), the *Lucretia* by Massimo in a private collection at Rome, dated by Prohaska and Schütze to the mid-1630s (Fig. 217), is closely comparable: in the tempering of the woman's sexuality (contrast Gentileschi's versions); in the right hand holding the weapon and the left arm thrust outward; and in the pose, in essence the reverse of that assumed by the Naples Lucretia, with the body inclined to one side, one leg extended and covered by a flow of drapery, the other bent, pulled inward, and bare to the calf. The motif of the veil embracing the shoulders and tucked into the bodice, from where it twists and falls, is ubiquitous in Stanzione's oeuvre. These relationships, the particular facial type with the eyes uplifted and the mouth partly open (cf., as two among many, the canvases of the *Martyrdom of Saint Agatha* in the Dupont Collection at Milan and the *Saint Catherine* in the Lemme Collection at Rome), the sense of polish, and the presence of the column, tasseled curtain, and tiled floor (cf. the *Passover Feast / Last Supper*, Certosa di San Martino, Naples, 1639) all again recommend Stanzione as the creator of the Palazzo Reale *Lucretia* and a date in the 1630s. Still, the continuing debate among Stanzione specialists urges caution and the inclination to fall back upon De Rinaldis's classification of the canvas as by "un accademico stanzionesco, se non proprio dello Stanzione."

BIBLIOGRAPHY: Garrard, 1989, pp. 104–5, 233–35, 512–13 n. 173, and color pl. 22; Gash, 1990, p. 67; Harris, 1989, p. 9; Willette in Schütze/Willette, 1992, pp. 252–53 cat. C32, with full bibliography, and p. 416 fig. 397; Hersey, 1993, p. 331 n. 4.

For the works by Stanzione here cited: Schütze/Willette, 1992, p. 191 cat. A5 and 270–71 figs. 97–98; p. 195 cat. A21 and 282 fig. 119; pp. 202–3 cat. A32, 301 fig. 152 and 43 color pl. XIII; pp. 211–12 cat. A52 and 320 fig. 189.

[X-18] *Madonna and Child*

Princeton, New Jersey, The Barbara Piasecka Johnson Collection Foundation
Oil on panel, .915 x .73 m.
Fig. 218

COLLECTIONS: Matthiesen Fine Art Ltd., London, by 1979, from whom purchased 1981

Published simultaneously by Matthiesen Fine Art Ltd. and the author as an example of the art of Orazio Gentileschi around 1605, this superb *Madonna and Child* was reattributed by Garrard to Artemisia Gentileschi and assigned a date of ca. 1608–9. Although acknowledging the picture's debt to Florentine painting of the Quattrocento and its pronounced Orazian character, Garrard argues that its "earthy physicality" and "tender intimacy" are as indicative of the daughter's sensibilities as they are foreign to the father's. In my opinion, Orazio's *Penitent Magdalen* in Sta. Maria Maddalena at Fabriano (Fig. 12), painted I believe by 1610, and his *Madonna and Child* in the Muzeul de Arte at Bucharest, signed and dated 1609 (Fig. 5), alone challenge these latter contentions, while the astonishing finesse of execution is simply not possible for Artemisia at the very beginning of her career. Neither the *Susanna and the Elders* of 1610 (Fig. 10; Color Plate I), in the conception of which Orazio may have played a significant role (see Chapter 1), nor the Spada *Madonna* (Fig. 230; [X-19]), whose attribution to Artemisia I cannot accept, nor certainly the *Madonna* of the Palazzo Pitti (Figs. 1, 6), reaches this level of technical mastery. Yet to remove the Johnson *Madonna* to a succeeding phase of Artemisia's activity would be to create a moment of Orazian nostalgia of an intensity not indicated otherwise.

Orazio's authorship and a date in the middle of the first decade have recently been reasserted by Prohaska, who specifies the panel's condition, notes the prominent *pentimento* at the Virgin's left shoulder, and suggests relation-

ships to early Caravaggio and parallels to prints of the *Madonna and Child* by Annibale Carracci and Guido Reni.

The copies of the Johnson panel to which I referred in 1981 may now be identified more specifically as the canvases once with Vincenzo Bonello on Malta (.888 x .673 m.; as Artemisia) and with Finarte at Milan in 1986 (.94 x .73 m.; as School of Artemisia).

BIBLIOGRAPHY: V. Bonello, *The Madonna in Art*, La Valletta, Malta, 1949, p. 24 cat. 65; Bissell, 1981, pp. 143–44 cat. 12 and fig. 23; London, Matthiesen, 1981, pp. 10–11 cat. 1; Milan, Finarte, February 26–27, 1986, no. 814; Garrard, 1989, pp. 25–26, 32, 493 nn. 21–22; W. Prohaska in *Opus Sacrum: Catalogue of the Exhibition from the Collection of Barbara Piasecka Johnson*, Royal Castle, Warsaw, 1990, pp. 180–83 cat. 30.

[X-19] *Madonna and Child*

Rome, Galleria Spada
Oil on canvas, 1.165 x .865 m.
Fig. 230

Pentimenti along the proper right outline of the Virgin and of the blue mantle on which she sits suggest that the painter's original intention was to set the figure farther to the left.

To a significant and inevitable extent, opinions regarding the authorship and date of this canvas have been formulated in consideration of the related *Madonna and Child* in the Palazzo Pitti at Florence (Figs. 1, 6). In following this pattern while introducing new comparative material, I have assigned the Spada *Madonna* to the circle of Giovanni Baglione. Although in some respects more technically proficient than the Pitti example, which I believe to be an autograph work by Artemisia Gentileschi from an early moment when she confronted reality through the eyes of Orazio Gentileschi, the Spada painting embraces conventions established by such artists as Marcantonio Raimondi, the Cavaliere d'Arpino, and Scipione Pulzone (Figs. 2, 3, 4). For these and other observations, the reader is directed to the detailed discussion under [1].

BIBLIOGRAPHY: See the Bibliography under [1], especially Zeri (1954 and 1957), Garrard, Guglielmi, Röttgen, DeGrazia, Contini, and Papi.

[X-20] *Poetry*

New York, D. Stephen Pepper, 1983
Fig. 222

Attributed by Pepper and Gregori to Artemisia Gentileschi, this superbly painted and winsome picture might better be located in the Florentine ambient of the second quarter of the seventeenth century. Although recollective of such Florentine canvases by Artemisia as the *Female Martyr*, the *Saint Catherine*, the *Inclination*, and the *Magdalen* (Figs. 56, 54, 64, 69–70; Color Plates VI, VIII, V), the *Poetry* appears to be the product of a less aggressive spirit than Gentileschi. Furthermore, its softness and idealization speak less of a Caravaggesque paternity than of those gentle personfications of Virtues and the Arts of which the artists of Baroque Florence (Dandini, Lupicini, L. Lippi, etc.) never tired and of which Francesco Furini's *Allegory of Lyric Poetry* (formerly Milan, Stanza del Borgo) is representative and especially relevant in the present context.

A *Sibyl* (Fig. 223; [X-41]) on the Parisian art market in 1986, ascribed to Artemisia and connected specifically to the *Poetry*, is surely not by her nor by the same hand.

BIBLIOGRAPHY: M. Gregori in Naples, *Civiltà del seicento*, 1984, I, p. 147. For the Furini: Cantelli, 1983, pl. 423.

[X-21] *Portrait of Artemisia Gentileschi as the Personification of Painting (Self-Portrait as "La Pittura"?)*

Private Collection
Oil on oval panel, .339 x .243 m.
Fig. 228

COLLECTIONS: Brazil, Private Collection

Truncation of the tip of the brush and of the knuckles of the painter's left hand, and inspection of the edges, indicate that the small panel has been (very slightly?) trimmed, even as the harmony between the curvilinear rhythms of figure and format prove that the oval shape is original. Surface rubbing and in-painting appear to have undermined the structure of the back of the right wrist and hand, where a *pentimento* is clearly visible.

From the brush, palette, and gold chain with

mask pendant to the *drappo cangiante* (here yellow shot through with greenish tones in the shadows) and the somewhat untidy hair, the imagery follows Cesare Ripa's prescription for the Personification of Painting, "La Pittura" (see also Chapter 4), while the physiognomy and mode of dress are sufficiently particularized as to suggest a specific woman painter. And while it is singularly difficult accurately to judge the ages of sitters in seventeenth-century portraits, appearances being responsive to special iconographical and patronage demands and to the portraitists' inclinations in the direction of either realism or idealization, it seems that the individual presented here is in her early to middle twenties.

When confronted with a Baroque depiction of a female artist, the tendency to think of Artemisia Gentileschi is irresistible, and the young woman clearly bears more than a little resemblance to Artemisia with her pinched mouth, double chin, and casual hairstyle parted in the center and with locks over the forehead. The most relevant points of reference for these features are variously Orazio Gentileschi's portrait of his daughter in the Detroit *Young Woman with a Violin* of ca. 1611–12, Artemisia's own *Self-Portrait as a Female Martyr* of ca. 1615 with Newhouse Galleries at New York, and Jérôme David's engraved *Portrait of Artemisia Gentileschi* of ca. 1628 based, I believe, on a Gentileschi *Self-Portrait* from the early 1620s (Figs. 32, 56, 101; Color Plate VI).

If, then, this picture is a *Self-Portrait* by Artemisia it would by virtue alone of the apparent age of the woman date to Gentileschi's Florentine period (1613–20). (None of the now-lost *Self-Portraits*—[L-88] through [L-92], but see also [L-61] and [L-62]—would qualify.) Further, the support is reported to be Tuscan walnut, and one thinks of what would become an absolute Florentine passion for oval paintings of saints and personifications—e.g., Cesare Dandini's *Saint Catherine of Alexandria* (London Art Market, 1976–77) and *Allegory of Comedy* (Florence, Uffizi) and Giovanni Martinelli's *Allegory of Beauty* and *Allegory of Music* (both Florence, Corsini). Being, however, without the *morbidezza* that came increasingly to dominate Florentine art, the work would be chronologically consistent with Artemisia's years in Florence. It is then a relatively short step to Gentileschi's *Conversion of the Magdalen* of ca. 1617–20 in the Palazzo Pitti (Fig. 70; Color Plate V), with which the panel shares general facial type and the complex folding of the yellow dress with its painterly highlights (although more electric in the *Magdalen*). The sentiment is on the subdued, almost dreamy plane of the *Magdalen* and the *Allegory of Inclination* of 1615–16 in the Casa Buonarroti (Fig. 64; Color Plate VIII). And the modeling of the head is highly accomplished.

It must be questioned, conversely, whether Artemisia Gentileschi, eager to assert her inborn talent, would depict herself seeking artistic inspiration from on high. The weakly rendered chain, which seems to hang free throughout its length, rather than responding to the forms of the body (now puzzlingly unvolumetric) against which it logically should rest, and which does not cast a shadow except in the area of the pendant—all in contrast to Artemisia's *Allegory of Painting* in Kensington Palace (Fig. 175; Color Plate XXVII)—is also cause for pause. More consequential is the apparent fact that among contemporary Florentine paintings it is Giovan Battista Guidoni's *La Pietà Cristiana* of 1615–17 on the ceiling of the Galleria Buonarroti (Fig. 62), it too based upon Ripa's codifications, that most closely parallels the present picture: (a) head tilted and rotund eyes, strongly shaded below in a half-moon pattern, rolled Heavenward; (b) hair fixed with a pearl-decorated diadem; (c) yellow shot-drapery; and, above all, (d) the powerfully plastic quality of the head and neck lit as if by a pronounced light source from the right.

Guidoni would have known Artemisia Gentileschi and her works, including without question the *Allegory of Inclination*, and it has been suggested by more than one scholar (see Chapter 2) that both he and his teacher Sigismondo Coccapani (Fig. 61) were influenced by Artemisia. By this reasoning the panel would be a *Portrait of Artemisia Gentileschi as the Personification of Painting* by G. B. Guidoni, homage to the brilliant and vital young painter from Rome.

Because the Casa Buonarroti canvas is Guidoni's only legible recognized work, however, evidence that might strengthen my suspicion is lacking. Furthermore, Nicholas Hall has force-

fully argued the *fattura* of the *Pietà Cristiana* is considerably less assured. Accordingly, the attribution of this extremely engaging portrait to Artemisia Gentileschi, put forward for serious consideration by John Spike, Stephen Pepper, and others, is not definitively to be dismissed.

BIBLIOGRAPHY: Ripa, ed. Rome, 1603, pp. 404–5; letter from Emily Black, Sotheby's, London, August 21, 1996; R. Ward Bissell, letter to Sotheby's, London, September 25, 1996; letter from John Spike, Florence, November 25, 1996.

For the comparative material: Cantelli, 1983, p. 94 and pls. 229, 232, 464–65, 569, 570; Vliegenthart, 1976, pp. 186–88 cat. 22.

[X-22] *Portrait of a Young Woman*

Naples, Private Collection
Oil on canvas, oval (bust-length)
Fig. 227

Perhaps with the richly detailed *Portrait of a Noblewoman* (Fig. 120) in mind, Gregori has suggested that this haunting picture may be an example of Artemisia Gentileschi's talent as a portraitist. Lacking an insufficient basis for comparison within Artemisia's known oeuvre, this ascription is not compelling enough to supercede the traditional attribution of the canvas to the early Neapolitan *Caravaggesco* Carlo Sellitto (1581–1614). It was as a prolific portraitist to the aristocracy that Carlo was most esteemed during his lifetime. A great many such works are documented, but to my knowledge only a single portrait—that of *A Woman as Saint Cecilia* (Milan, Private Collection)—has entered the literature with an attribution (by Bologna and Navarro) to Sellitto. The face in this recently published work bears more than a little resemblance to that of the woman in the oval portrait, a canvas to which the name of Caracciolo has also been attached.

BIBLIOGRAPHY: M. Gregori in Naples, *Civiltà del seicento*, 1984, I, p. 150; S. Causa in Naples, Castel Sant'Elmo, 1991, p. 189 fig. 10.

For Sellitto as a portraitist: P. Santucci Pari in Naples, Museo di Capodimonte, *Mostra didattica di Carlo Sellitto, primo caravaggesco napoletano*, 1977, pp. 94, 97–107; F. Navarro in Naples, Castel Sant'-Elmo, 1991, p. 266 cat. 2.10.

[X-23] *Portrait of a Woman Painter*

Althorp, Earl Spencer Collection
Oil on canvas, 1.24 x 1.00 m.
Inscribed on the base of the column: *Artemisia Gentileschi*

COLLECTIONS: Lord Sunderland, Althorp, by 1727 (perhaps acquired by Robert, Second Earl of Sunderland, 1640–1702)

While the signature is not authentic and is thought to be by an eighteenth-century hand, it reflects a written tradition going back at least to Vertue, who in 1727 recorded the canvas "at Althrope. Ld Sunderlands the picture of Artemesia Gentilisci." In subsequent early sources (Althorp catalogues of 1746, 1750, 1802, and Walpole) the work is described as a self-portrait, and such it was once considered to be by Longhi, who assigned it to Gentileschi's English period, and by Law. Accompanied by doubts as to its attribution, the painting was exhibited under Artemisia's name at the Royal Academy in 1960, and is listed by Garlick as "attributed to" Artemisia Gentileschi. For the collected edition of his early writings, Longhi reascribed the portrait to the school of Van Dyck, and Artemisia's authorship has also been correctly rejected by Levey and Garrard.

Levey observed that this woman, of narrow face and very long curly hair, bears no resemblance to Artemisia. No doubt recognizing as well that neither the style nor the extensive ambient point to Gentileschi, and following a suggestion made by Neil MacLaren, Levey proposed a tentative attribution to the Dutch painter Adriaen van der Temple. The painting certainly has a Van Dyckian aura, and with the aid of a costume expert to narrow the chronological range the sitter might well be identifiable.

BIBLIOGRAPHY: Walpole, 1765, II, p. 130; G. Vertue, "Note Books (1713–1756)," Vertue II, p. 38, as from British Museum Add. MS 23,070 (1727), V. 47, B. M. 38; Law, n.d., p. 67; C. Wheeler et al. in London, Royal Academy, *Italian Art and Britain*, 1960, p. 31 cat. 46; Longhi, *Scritti*, 1961, I-I, p. 262, and I-II, p. 550; Levey, 1962, pp. 79–80; Garlick, 1974–76, p. 32 cat. 234 with additional bibliography, and pl. 30; Garrard, 1980, p. III n. 67; Garrard, 1989, p. 508 n. 138.

[X-24] *Saint Apollonia*

London, Sotheby's, 1980
Oil on canvas, .89 x .72 m.
Fig. 225

Identification of the figure hinges upon the object in her left hand, apparently a tooth extractor grasping a tooth in reference to the indignity suffered by the virgin martyr Apollonia of Alexandria before her fiery death.

Sold at Sotheby's–London in 1980 as by Artemisia Gentileschi and tentatively reassigned by Contini to Giovan Battista Spinelli, the painting has otherwise occasioned no comment. While the work has a certain urgency that might recall Spinelli, it is without the tense, often mannered, and sometimes bizarre qualities that mark his art. The attributions to him and to Artemisia Gentileschi do, however, correctly signal Naples as the ambient in which the *Saint Apollonia* was born.

Thus the half- or three-quarter-length type of female saint shown close up, leaning on a stone support, and set off by dark rocks which yield to a summarily rendered distant landscape is familiar from Massimo Stanzione during the 1630s and early 1640s, as the *Saint Catherine of Alexandria* (Rome, Fabrizio Lemme) and the *Saint Mary Magdalen* (Rome, Private Collection). These works by Stanzione, as also his *Saint Dorothy* (formerly Buenos Aires, Mauro Herlitzka), are recalled as well by the diagonal sweep of effulgent drapery. One thinks too of the drapery displays of Bernardo Cavallino (e.g., *Saint Cecilia*, Boston, Museum of Fine Arts, and *Saint Catherine of Alexandria*, Birmingham, England, Barber Institute of Fine Arts) and of that master's superb way with velvet fabric. Yet the sentiment of the ex-Sotheby picture, wherein the world-weary woman seems anything but one who is about to enter paradise in reward for her sacrifice, is without Cavallino's characteristic sweetness and innocence, and there is a particularization to the physiognomy that contrasts with the idealization of Stanzione's females. However, these features do not necessarily point to Artemisia Gentileschi. The elaborately arranged stuffs in her pictures are prevented from upstaging the figures who wear them, and in general there is nothing by Artemisia that is truly comparable, nothing in the *Saint Apollonia* that is so clearly

distinctive as to proclaim her authorship. The problem of attribution thus remains, although the parameters for its solution—Naples between 1635 and 1640—seem defined.

BIBLIOGRAPHY: London, Sotheby's, *Important Old Master Paintings*, December 10, 1980, Lot 118, with ill.; Contini in Contini/Papi, 1991, pp. 80–81, incl. fig. 70; Thomas Willette, personal correspondence.

For the comparative material: Percy/Lurie, 1984, pp. 144–45 cat. 47, 194–95 cat. 72; Schütze/Willette, 1992, pp. 29 (color ill.), 55 (color ill.), 195 cat. A21, 212 cat. A53, 224 cat. A72, 282 fig. 119, 321 fig. 190, 351 fig. 259.

[X-25] *Saint Catherine of Alexandria*

El Paso, Texas, El Paso Museum of Art
Oil on canvas, .98 x .75 m.
Fig. 238

COLLECTIONS: Dr. B. Hallauer, Berlin, by 1927; Schmid-Paganini sale, Galerie Fischer, Lucerne, October 23–26, 1946; Otto Schweizer, Switzerland; International Financing Co., Panama City, Panama; Samuel Kress acquisition, 1956

Saint Catherine's crown, barely discernible in the preconservation photograph of the picture (Witt Library), has either been re-created by the restorer or recovered beneath overpainting. Infelicitous as it now sits, the crown may have been in part painted out by the artist who ultimately judged it to be too intrusive. Shapley notes abrasion throughout, and the blue of the Saint's mantle has undergone chemical change.

Published attributions of the *Saint Catherine* to Artemisia Gentileschi begin in 1927, when the canvas was shown as the property of B. Hallauer in the Wertheim Exhibition at Berlin and signaled by Vitale Bloch. According to information in the files of the Witt Library at London, it then figured in the Schmid-Paganini sale at the Galerie Fischer in Lucerne on October 23–26, 1946 (no. 1159 and pl. 11), the ascription to Artemisia affirmed by Frederick Antal and Heinrich Bodmer. The subsequent itinerary of the *Saint Catherine* is recorded by Shapley, who catalogued the picture as by Gentileschi (ca. 1620). In 1968 Gregori assigned it to Artemisia's Florentine period and in 1984 characterized it as a youthful work by her close to Orazio Gentileschi. The attribution to Artemisia has been questioned by Garrard and the

present writer, while recently the issue has been reopened by Contini. Contini notes that on Catherine's dress the decorative motif of heart-shaped leaves attached to a heavy stalk is comparable to that found on the gowns of Judith in the canvases in Rome and Oslo (Figs. 221, 40). This observation underlines the attributional problems surrounding the *Saint Catherine*, since the authorships of the just-named *Judith*s, neither of which is by Artemisia Gentileschi in my opinion (see [X-12] and [X-13]), are still in dispute.

In color and composition the *Saint Catherine* is singularly unimaginative. The young Saint, wearing a blue mantle lined in red over a gold patterned gown, is posed frontally except for the turn of her head, which barely relieves the flatness of the design. The material over her left arm, arranged in repetitive loops and shadowed in a stylized fashion, lacks both suppleness and textural interest.

On a qualitative level, only the head and neck are particularly distinguished, having a three-dimensionality and finesse of *chiaroscuro* that the remainder lacks. And it is primarily in the face, its expression bordering on the sleepy notwithstanding, that the closest parallels to Artemisia Gentileschi may be found, as in the *Allegory of Inclination* and the *Conversion of the Magdalen* (Figs. 64, 70; Color Plates VIII, V) cited by Shapley. Yet these paintings from Artemisia's years in Florence surpass most of the El Paso canvas in technical facility, as also do Artemisia's earliest identifiable works (Figs. 1, 10, 19; Color Plates I, III).

Is one therefore to assign the picture to the very beginnings of Artemisia's career, or to Orazio Gentileschi's initial Caravaggesque phase, to which Contini has likened it while acknowledging "the excessive stylization of the draperies and the poverty of drawing in the right hand"? (To this can be added the bejeweled belt, crude in comparison to the precision with which the Gentileschi rendered such objects.) In view of the qualitative differences between the head and the remainder of the figure, and the Gentileschian stamp of the whole, one is tempted to suppose that Orazio added the head to a youthful essay in drapery painting by his daughter.

Unfortunately, this solution leaves unexplained the picture's apparent ties to canvases produced in Rome during the third decade. Specifically, the stringy hair, the essentially decorative justification for the puffed-up sleeves and heavy robe, the somnolent mood, and the planar design recall paintings that issued from the following of Simon Vouet between ca. 1626 and 1629, among them Virginia da Vezzo's *Judith with the Head of Holofernes* and Claude Mellan's *Samson and Delilah* (Fig. 226), both known today through engravings by the same Mellan—although the *Saint Catherine* lacks the flair of these French artists.

There is a third possible solution that takes account of aspects of the other two: namely, that the El Paso picture is the joint effort of Artemisia Gentileschi and her daughter Prudentia, in which case it would have to be dated around the middle of the 1630s. In her letter of December 11, 1635, to Andrea Cioli, Artemisia announced her intention of sending to Florence a *Saint Catherine* which she had completed some time before and along with it "a youthful attempt by my daughter" which Gentileschi hoped would not be laughed at considering its source (see [L-69]). Prudentia, baptized on August 2, 1617, was just nineteen years old at the time. While the letter cannot be taken to document the present picture, it does set up what is potentially a comparable situation.

Weighing these alternatives, I am most inclined to declare the Texas *Saint Catherine* an early Orazio-Artemisia collaboration compromised by time and restoration, but the other possibilities explored above are sufficiently feasible to dissuade me from taking a firm stand.

BIBLIOGRAPHY: V. Bloch, "La pittura italiana a Berlino," *Vita artistica*, II, nos. 8–9 (1927), 176; Bissell, 1968, p. 167; Gregori, 1968, pp. 416, 420 n. 21, and fig. 3 pl. CLXXXII; Shapley, 1973, p. 84 K2153; M. Gregori in Naples, *Civiltà del seicento*, 1984, I, p. 147; Garrard, 1989, p. 499 n. 72; Contini in Contini/Papi, 1991, p. 149.

For the comparative material: Ficacci et al., 1989, pp. 218–19 cat. 46, 246–47 cat. 60.

..

[X-26] *Saint Catherine of Alexandria*

Florence, Galleria degli Uffizi
Oil on slate, .50 x .40 m.
Fig. 224

On the reverse, before relining, the letters and numerals M. T. 664, 4351, 779, 27

COLLECTIONS: Opificio delle Pietre Dure, Florence, as no. 27

In support of the attribution to Artemisia Gentileschi first proposed by Sricchia, Borea assigned this small picture to Gentileschi's Neapolitan years and speculated that it might be identified as the "Imagine di Santa Caterina" which on December 11, 1635, and again on February 11, 1636, Artemisia offered to Andrea Cioli, Secretary to the Grand Duke of Tuscany ([L-69] for details and bibliography). Although Artemisia's authorship was also affirmed by Nicolson, doubts were expressed by Volpe, Schleier, Garrard, and Spear, the latter holding that "the softness of form, the inquisitive attitude, and the touch of sentimentality are alien to her oeuvre."

Characterized by all that is implied stylistically and expressively by the suggestive word *morbidezza*, this highly refined picture is quintessentially Florentine. Specifically, as Pagliarulo and Contini have observed, it is to be ascribed to Francesco Furini, bearing particular relationships to the figure of Aurora in Furini's documented *Cephalus and Aurora* (Ponce, Museo de Arte) of ca. 1628. While it must therefore be removed from Artemisia's oeuvre, this *Saint Catherine* does hint at her influence in the Tuscan capital, for it has more than one reminder of such canvases by Gentileschi, themselves tailored to Florentine tastes, as the *Penitent Magdalen* and the *Female Martyr* (Figs. 68, 56; Color Plates V, VI).

BIBLIOGRAPHY: Sricchia, 1963, p. 251; Borea, 1970, p. 73 cat. 45 and ill.; Nicolson, 1970, p. 641; Volpe, 1970, p. 116; Schleier, 1971, p. 89; Spear, "Caravaggisti," 1971, p. 109; Garrard, 1989, p. 499 n. 72; Contini in Contini/Papi, 1991, pp. 147, 185, 196 n. 22.

For the Furini *Cephalus and Aurora*: G. Cantelli in Florence, Palazzo Strozzi, 1986, 1, pp. 268–69 cat. 1.130.

..

[X-27] *Saint Catherine of Alexandria*

New York, Sotheby's, 1994
Oil on canvas, .895 x .749 m.
Fig. 233

Elaborately attired in a reddish-pink stole over a white puff-sleeved blouse, this curly-haired woman is to be identified as Saint Catherine of Alexandria by virtue of the martyr's palm and what appears to be a segment of the traditional spiked wheel. Yet the book on which she rests her crossed hands is better associated with a sibyl or with a personification of Poetry or History (although not impossible for Catherine were she to be featured as the patron of education), and there is no apparent justification for the presence of this half-length figure before a wall of rock, the type of setting most often reserved for penitent saints. Further, the overall light tonality is not fully consistent with the strength of the shadows on the woman's face, and (Thomas Willette reports) there is a notable difference in handling between the figure and the blue-toned landscape at the right.

Suspicions are therefore raised that the picture is an incongruous adaptation of another image, notwithstanding the high degree of skill with which the drapery is executed and the caution necessitated by the skinned condition of much of the surface and by appreciable paint loss. Thus the attribution of the *Saint Catherine* to Artemisia Gentileschi becomes even more problematic. The Sotheby's catalogue claims stylistic relationships (unspecified) between it and the *Madonna and Child* and the *Saint Cecilia (Young Woman Playing the Lute)*, both in the Galleria Spada at Rome (Figs. 230, 242), works sometimes assigned to Artemisia but fraught with so many difficulties as to constitute hazardous grounds on which to establish the authorship of still another painting (see [X-19] and [X-28]). More nearly comparable to the *Saint Catherine*, Leonard Slatkes has observed, is the so-called *Saint in Meditation* exhibited in Naples in 1991 as by Paolo Finoglio and likened to the *Joseph and Potiphar's Wife* in the Fogg Museum (Fig. 214; [X-11]). Even closer is the *Female Martyr* in the Keresztény Múzeum Képtára at Eszertgom, a fragment of another painting by Finoglio. Duly recording Slatkes's opinion, the Sotheby's catalogue nonetheless concludes with Garrard's view that the Fogg picture—a characteristic work by Paolo Finoglio—is by Artemisia Gentileschi.

The evidence adduced for Artemisia Gentileschi's authorship of the *Saint Catherine* is thus challengeable at every turn. Only slightly more defensible would be an attribution of it to Finoglio. To the internal inconsistencies noted

above can be added the complicating factors introduced by a painting which in 1974 belonged to Dr. Bernard H. Raymond of Norfolk, Virginia (Fig. 234). For the greater part the figures in these works are interchangeable, yet she in the Norfolk picture is evidently a queen shown with a crown, cup, and dagger. Although the interior setting of the Norfolk work and the table as support for the arms make more sense, and one's first impression is that the author of the *Saint Catherine* merely substituted the book for the dagger in order to prop up the hands, it is questionable whether the former was the prototype for the latter. The example in Virginia is touched by a vaguely Bolognese sweetness; certainly there is nothing about it—to judge from the small and poor photo known to me—that unequivocally declares a Neapolitan provenance.

It is therefore conceivable that the prime version was a now-lost canvas (a sibyl?) produced between 1630 and 1640 by a Neapolitan artist familiar with the works of Artemisia Gentileschi and Paolo Finoglio and, as well, with the distinctive Gentileschian creator of the *Saint Mary Magdalen* and the *Personification of Rhetoric* (respectively, Figs. 243, 244; [X-33]).

BIBLIOGRAPHY: New York, Sotheby's, *Important Old Master Paintings*, May 20, 1993, lot 55, with color ill. and, again, *Important Old Master Paintings*, May 19, 1994, Lot 351, with color ill.

For Finoglio's *Saint in Meditation*: Naples, Castel Sant'Elmo, 1991, pp. 69, 292 cat. 2.47.

For Finoglio's *Female Martyr*: R. Causa, *La pittura del seicento a Napoli dal naturalismo al barocco*, extract from *Storia di Napoli*, Naples, 1972, v, pt. ii, p. 977 n. 81 and fig. 303; A. Szigethi, "Seicenteschi nella galleria di Esztergom: Un'ipotesi per Imperiale Gramatica," *Acta historiae artium*, XXIV, fascs. 1–4 (1978), 290–91.

...

[X-28] *Saint Cecilia (Young Woman Playing a Lute)*

Rome, Galleria Spada
Oil on canvas, 1.08 x .785 m.
Fig. 242

Slightly cramped at the left and above, the composition may have been trimmed, as Zeri suspected. A flattening of form in the deepest shadows is apparently in part the result of the assertion of the reddish ground color through the once opaque pigment.

Noting that the lute is the featured instrument, Garrard suggests that the subject might better be considered an *Allegory of Music* rather than a *Saint Cecilia*, while Papi speaks merely of the *Suonatrice di liuto*. In Baroque art the lute is not restricted to secular themes (angels play the lute in Antiveduto Gramatica's compositions of *Saint Cecilia with Two Angels* in Lisbon and Vienna, and in Bernardo Cavallino's painting of the same title in Florence, for example), and the presence of the organ (Cecilia's invention according to legend), as also the upraised eyes of the woman, recommend the traditional title.

More pressing is the question of the authorship of this attractive, if expressively rather neutral, picture. Inventoried in 1759 as from the school of Titian, the canvas was then (1792, 1816, 1820) ascribed to Caravaggio, an attribution confirmed by L. Venturi, Rouchès, and Hermanin before being definitively rejected. Longhi tentatively proposed the name of Angelo Caroselli. An attribution to Artemisia Gentileschi, advocated by Voss as early as 1911, found several defenders (among them Porcella, Lavagnino, Marangoni, and Zeri) and has recently been sustained by Gregori, Garrard, Papi, Berti, Stolzenwald, and Szigethi, even as others (Moir, Bissell, Nicolson, and Spike) have expressed doubts.

Garrard associates the *Saint Cecilia* with Orazio Gentileschi's frescoes of 1611–12 in the Casino of the Muses (cf. Fig. 208), as had Zeri, and with two *Madonna and Child* compositions assigned by Garrard to Artemisia's early years (Figs. 230, 218). The relationships in subject type and physiognomy, the latter of a sort which Artemisia readily adopted, to Orazio's female musicians seem to me evident, and thus Spike's view that the *Saint Cecilia* is without connections to either of the Gentileschi is puzzling. Conversely, the case for Artemisia's responsibility for the *Saint Cecilia* is not strengthened by invoking the Spada and Princeton *Madonna*s, for the former belongs in all probability to the circle of Giovanni Baglione and is evidently not by the same hand as the *Saint Cecilia* ([X-19]), while the latter is certainly by Orazio ([X-18]). Furthermore,

333

there is about the *Saint Cecilia* a curious remoteness in spite of the girl's proximity and the palpability of her golden gown and of the light that animates it; it is as if the artist were reluctant fully to embed the figure, holy or not, in the world. This does not accord well with the resolute realism of Artemisia's first certain essays in the Caravaggesque manner, the *Susanna, Lucretia,* and *Judith Decapitating Holofernes* (Figs. 10, 19, 21; Color Plates I, II).

Noting correctly that the lighting and drapery treatment of the *Saint Cecilia* find no parallels in the Spada *Madonna* (which, however, he gives to Gentileschi), and recognizing the sentiment as having a "languor unusual for Artemisia," being "a little vacuous" and "vagamente patetica," Papi prefers to locate the *Saint Cecilia* in Artemisia's first years in Florence (a judgment with which Berti, on the other hand, is uncomfortable). All the Florentine or supposed Florentine works by Gentileschi to which variously in color (the golden yellows), drapery style, or expression Papi compares the *Saint Cecilia*—specifically the *Judith and Her Maidservant,* the *Saint Catherine,* the *Inclination,* the Trento *Saint Cecilia,* the *Magdalen,* and the *Jael and Sisera* (Figs. 31, 54, 64, 245, 70, 73; Color Plates IV, VIII, V)—were exhibited at the Casa Buonarroti in 1991. In my opinion this unique opportunity for direct confrontations demonstrated rather the extreme difficulty of accommodating the Spada *Saint Cecilia* to Artemisia Gentileschi's oeuvre, Roman or Florentine; the suggested relationships appeared forced or at best inconclusive. Furthermore, as I have frequently acknowledged in these pages, while Artemisia clearly showed herself receptive to Florentine tastes for the sentimental and for sumptuous costuming, Papi does not bolster his contentions for the *Saint Cecilia* by citing Cristoforo Allori's *Speranza* in the Palazzo Pitti (with its much more elaborate drapery and lingering *maniera* refinement) or *Saint John the Baptist* in the same place (with its veil of softness in contrast to the incisiveness of the *Saint Cecilia*).

As often in these matters, it is easier to take exception than to come up with an alternative. It has not been previously observed, however, that in her facial type, heavy physique, and ample draperies Saint Cecilia approximates Giovanni Baglione's *Saint Margaret* of ca. 1606

in the Galleria Nazionale at Rome (Fig. 235). Yet these paintings are merely two in a line of depictions of isolated saints of which, as Röttgen notes, the Cavaliere d'Arpino's *Saint Catherine* of ca. 1591 for S. Elena dei Credenzieri at Rome was an instrumental prototype. And there is nothing in the handling of the *Saint Cecilia* that brings Baglione to mind. The Spada picture seems to vacillate between Orazio Gentileschi and Giovanni Baglione, with, as has been observed by scholars, intimations of Angelo Caroselli and Antiveduto Gramatica. Placing the painting in the Roman ambient between approximately 1610 and 1615 is, however, a rather sorry solution to a knotty attributional problem.

BIBLIOGRAPHY: Voss, 1925, p. 463; Porcella, 1931, p. 222; Lavagnino, 1933, p. 9; M. Marangoni, *Il Caravaggio,* ed. Florence, 1945, p. 55; Zeri, 1954, pp. 85–86 no. 293, with the early bibliography; Longhi, *Scritti,* 1961, 1–1, p. 502; Moir, 1967, 1, pp. 55–56; Bissell, 1968, p. 167; Nicolson, 1979, p. 51 and Nicolson/Vertova, 1990, 1, p. 111; M. Gregori in Naples, *Civiltà del seicento,* 1984, 1, p. 147; Garrard, 1989, pp. 26–28, 32, and color pl. 3; Mina Gregori, Florence, letter to the author, March 3, 1991; Papi in Contini/Papi, 1991, pp. 45, 132–35 cat. 13; Berti, ibid., p. 24; Spike, Review, 1991, p. 734; Stolzenwald, 1991, p. 18 and color pl. 20; A. Szigethi in Milan, Palazzo della Permanente, 1993, p. 93.

For the d'Arpino: Röttgen, 1973, pp. 73–74 cat. 6 and pl. 6.

For the Baglione: Möller, 1991, pp. 57, 111 cat. 29, and fig. 19; Aurigemma, pp. 39 fig. 16, 40.

..

[X-29] *Saint Cecilia*

Sarasota, Florida, John and Mable Ringling
Museum of Art
Oil on canvas, 1.505 x 1.025 m.
Fig. 239

COLLECTIONS: Acquired by John Ringling,
probably in London

Within the maze of attributions in which the *Saint Cecilia* has become entrapped over the years—Jacopo Vignali (Suida), Rutilio Manetti, Lorenzo Lippi, Angelo Caroselli, Guy François (Sabarot), Artemisia Gentileschi (Spinosa; Tomory), and Massimo Stanzione (A. Janson)—are signs of the way out. In my opinion, these signs lead to Naples.

Characterizing the color (the Saint in a yellow dress and blue mantle) and the tenebrist lighting as Neapolitan, Tomory also likened the pose of the young woman to that of Bathsheba in Artemisia Gentileschi's canvas at Columbus (Fig. 159; Color Plate XXIII). More relevant still, by virtue of her pose and the arrangement and color of her garments, is the daughter at the right in the more recently discovered *Lot and His Daughters* (Figs. 164, 166; Color Plate XX). These connections are suggestive, for as Bernardo Cavallino appears to have contributed to the *Bathsheba* and the *Lot*, so does the *Saint Cecilia* point in Cavallino's direction. With eyes upturned and mouth (teeth showing) open, this charming girl in a laced bodice and garlanded like a May queen is lost in poetic/spiritual rapture of the sort in which Bernardo specialized and of which his *Saint Cecilia* (Florence, Palazzo Vecchio) and *Saint Agatha* (York, City Art Gallery) are notable examples. Cavallinesque as well is the illumination of the Saint's face, with delicate spots of light animating the shadowed side (cf. *Saint Catherine*, Rotterdam, Museum Boymans–van Beuningen; *Saint Lucy*, Milan, DeVito Collection).

Not in evidence, however, are the special energy and magic of Bernardo Cavallino's brushwork, those succulent passages, those astonishing subtleties of highlighting on the draperies. There is about the *Saint Cecilia* a certain polish that recalls rather Francesco Guarino and Massimo Stanzione. Especially close to the Sarasota painting, although not by the same artist in my view, is a *Saint Cecilia* (oil on canvas, 1.00 x .76 m.) sold as a Stanzione on March 8, 1985, by Franco Semenzato. A strongly idealized woman with a powerfully spherical sibylline head wrapped in a turban, a monumental body, and broad hands, this latter Cecilia is considerably more heroic (as a classicist would have it) than the homey, more reality-based Saint of the Sarasota canvas.

The best that might be said currently is that the *Saint Cecilia* is a Neapolitan work of about 1645, close to Cavallino but touched as well by the Stanzionesque mode. For Contini it assumes an intermediate place between these two masters. Willette has offered the intriguing suggestion that the sheet music at the lower right might hold a clue to the attributional puzzle, although clearly I cannot agree with his removal of the Sarasota picture from the Neapolitan school altogether.

BIBLIOGRAPHY: W. Suida in Sarasota, John and Mable Ringling Museum of Art, 1949, p. 121 cat. 134; P. Tomoroy in Sarasota, John and Mable Ringling Museum of Art, 1976, p. 21 cat. 17; M. Sabarot, "Guy François: attributions et propositions à propos d'un ensemble de toiles franciscaines," *Revue du Louvre*, XXIX, nos. 5–6 (1979), 421–22; Anthony Janson, Sarasota, letters to the author, March 4 and May 9, 1985; R. W. Bissell, letters to Anthony Janson, April 10 and 26, 1985; A. Janson, *Great Paintings from the John and Mable Ringling Museum of Art*, Sarasota and New York, 1986, p. 103 cat. 16; Contini in Contini/Papi, 1991, p. 87 n. 94; Willette in Schütze/Willette, 1992, pp. 254–55 cat. C49 and p. 424 fig. 413.

For the comparative material: Percy/Lurie, 1984, pp. 106–7 cat. 28, 138–39 cat. 44, 158–59 cat. 54, and 178–79 cat. 65; M. Cinotti et al., *Catalogo della pittura italiana dal '300 al '700*, Milan, 1985, p. 319 with ill.

..

[X-30] *Saint Cecilia*

Trento, Private Collection
Oil on canvas, .902 x .686 m.
Fig. 245

COLLECTIONS: Edward Speelman, London, 1953; exhibited at the Galerie Heim, Paris, 1955; Drouot Sale, Paris, June 29, 1959; Christie's, London, March 18, 1960, Lot 66, by whom sold to Ridley; Finarte, Milan, October 29, 1964, Lot 25

The young woman, faintly haloed, garlanded with white, pink, and red flowers, and dressed in a garment of white decorated with pink lilies and interlacing over blue sleeves, is seated on a green velvet chair as she plays the virginals or portative organ. Since the keyboard instrument and the lilies (although generally white) are traditionally associated with Saint Cecilia and, as Contini notes, the garland could be taken to allude to that awarded the virgin Saint upon her martyrdom (cf. Orazio Gentileschi's painting in the Brera at Milan), the identification of this musician as Cecilia seems assured.

Between its appearances on the London art market in 1953 and at Milan in 1964 the canvas underwent a restoration, after which the Saint's left hand assumed a dramatically different and much improved character (cf. Fig. 245 and the

illustration in Contini/Papi). Presumably the conservator was guided by vestiges of the original fingers discovered beneath later repaint, rather than by, for example, his/her preferences or the left hand of the Magdalen in Artemisia Gentileschi's picture in the Palazzo Pitti (Figs. 69–70; Color Plate V). In any case, this section of the painting has been heavily worked. Other retouchings and in-paintings, having absorbed the protective varnish, are obvious. The shadows on the girl's neck and face have sunk into the ground or darkened, flattening out these areas, and surface abrasion is discernible throughout.

In the 1950s and 1960s the *Saint Cecilia*, its measurements differing slightly from venue to venue, made the rounds of the European trade (see above) with an attribution to Orazio Gentileschi and a dating to his stays in London or Genoa. In 1979 Nicolson reassigned the picture to Artemisia Gentileschi, while two years later, believing the canvas to be "close in style and affectation to G. F. Guerrieri," I implicitly dismissed Nicolson's suggestion. After reemerging in a private collection at Trento, the *Saint Cecilia* was exhibited at the Casa Buonarroti in 1991 and fully catalogued by Roberto Contini, who located it in Artemisia's Florentine period, judgments with which Papi, Berti, Spike, and Bionda have agreed.

I am not convinced that my previous inclination (on the basis of a photograph) to associate the picture with Guerrieri was as inexplicable as Contini and Papi would have it. Quite aside from the Gentileschian influences on his work, the artist from Fossombrone delighted in depicting charming, flower-garlanded young ladies (e.g., the *Triumph of the Virtues, Religion, and the Sciences* and the *Banquet of the Gods*, both Rome, Palazzo Borghese, and both between 1615 and 1618). Nonetheless, I now believe that the *Saint Cecilia* is properly evaluated with reference to Artemisia Gentileschi's career in Florence. Thus, as others have also observed, the casual hairstyle and facial type are familiar from several of Artemisia's Florentine productions (Figs. 54, 56, 64, 70; Color Plates VI, VIII, V), the pose recalls particularly the *Conversion of the Magdalen* as the evocative glance does the Newhouse *Female Martyr* and the newly discovered *Self-Portrait as a Lutenist* with Sotheby's at London, and a

penchant for decorative draperies marks Gentileschi's art from the outset. (The relationships sensed by Berti between the model here and the face of the artist and musician Arcangiola Paladini as known from her *Self-Portrait* in the Uffizi are not, I think, sufficiently striking to constitute still another indication of the *Saint Cecilia's* Florentine provenance.)

The quality of the Trento picture is another matter. The arm of the chair and the keyboard are poorly drawn and virtually textureless. The repetitive pattern on the Saint's gown gives the impression of having been mechanically stenciled or stamped rather than painted, and pockets of drapery are hinted at by shadows composed of streaks and stylized patches of dark pigment with fuzzy contours which appear as if superimposed upon the surface of the cloth (and at times overlayed with lilies and interlacing that do not curve into the would-be cavities). The floral crown has been related by Berti to the *Female Martyr* in the Zeri Collection (Fig. 213) and to Baldinucci's praise of Artemisia's skills as a painter of still-life. Yet the attribution to Gentileschi of the panel at Mentana is dubious ([X-9]) and the accuracy of Baldinucci's report even more so (see Chapter 6). Besides, the garland in the *Saint Cecilia* is painted with considerably less finesse than is that in the Zeri picture, and is overly assertive. Spike believes the flowers to be "maladroit additions" by a later hand, yet inasmuch as they are appropriate to the subject and are scarcely less technically accomplished than other areas of the painting, they may be original to the conception.

Are these qualitative weaknesses attributable to the *Saint Cecilia's* mediocre state of preservation, as Contini cautiously advances with regard to the modeling of the face and the handling of chair arm and organ? This might serve as a potential explanation were it not for infelicities in the very composition of the canvas, above all its planarity, relieved only by the back of the chair, the turn of the head, and the awkwardly foreshortened instrument, the latter cramming the Saint's knee between itself and the frame.

In short, while the *Saint Cecilia* has undeniable connections to works from Artemisia Gentileschi's Florentine period, it is pictorially unaccomplished and stiffly composed, and thus

simply not up to Artemisia's standards. Since some of the picture's flaws are basic, extending beyond issues of brushwork and condition, it most likely does not copy a now-lost original by Gentileschi but rather is an adaptation of a lost Florentine canvas by her, although by a lesser hand than that which, in my opinion, produced the Zeri *Female Martyr* on the model of Gentileschi's panel in New York.

BIBLIOGRAPHY: "Notable Works of Art Now on the Market," *Burlington Magazine*, xcv (December 1953), suppl. ix; Paris, Galerie Heim, *Caravage et les peintures français au XVIIe siècle*, 1955, no. 3 and pl. 2; *Art Prices Current*, xxxvii (1959–60), 121 no. 3030; *World Collector's Annuary*, xii (1960), 175 no. 1934; Nicolson, 1979, p. 51, and Nicolson/Vertova, 1989/90, I, p. iii; Bissell, 1981, p. 212 and fig. 159; Contini in Contini/Papi, 1991, pp. 138–40 cat. 15; Papi, ibid., pp. 45, 47; Berti, ibid., pp. 24, 27 incl. fig. 8, 30 n. 25; Spike, Review, 1991, p. 734; Bionda, 1992, pp. 26, 28 fig. 11.

[X-31] *Saint Dorothy*

Location unknown
Fig. 237

Introducing this painting into the literature, Ferdinando Bologna identified its subject as Saint Rosalie. Only the garland of roses recommends this identification, whereas the natural crown, the basket of apples and flowers (cf. Fig. 251 and Massimo Stanzione's picture discussed below), and the roses held in the woman's left hand are together the unmistakable attributes of Saint Dorothy.

The photographic evidence upon which one is constrained to rely, the location of the painting being unknown, reveals a work of great exquisiteness and poetic charm. For Bologna, it indicates as well the authorship of Artemisia Gentileschi at a moment "magari fra la sosta a Napoli e i ritorni a Roma"—or, so as not to debate what Bologna might mean by "i ritorni a Roma," a canvas executed by Artemisia after she had established herself in Naples. Bologna offers as partial proof of dating his recognition of the figure as Saint Rosalie, patron saint of Naples and Palermo whose cult was revived following the discovery of her relics in 1624. Further, he likens the still-life to the early works of Luca Forte and finds in it corroboration of

Baldinucci's claim for Artemisia Gentileschi as a skilled practitioner of this genre. However, the designation of the Saint as Dorothy, the rather conventional character of the still-life, and the almost certain erroneousness (see Chapter 6) of Baldinucci's information remove these arguments from consideration.

Conversely, the style of the *Saint Dorothy*—which Bologna does not address beyond implying a relationship of the picture to the *Judith and Her Maidservant* (Fig. 150)—does point in the direction of Gentileschi's Neapolitan years. In physiognomy and mood Dorothy approaches closely the Judith in the just-named canvas, while the treatment of her mantle, crumpled and richly lighted, is comparable to that of the angel's garment in Artemisia's *Annunciation* of 1630 and to the gown of Esther in her painting of ca. 1630–35 (Figs. 114, 125; Color Plate XVI). Additionally, the *Saint Dorothy* exhibits undeniable parallels to a signed *Saint Dorothy* from the 1630s by Massimo Stanzione (formerly Mauro Herlitzka, Buenos Aires, and on the Neapolitan art market in 1991)—three-quarter-length figure of dreamy gaze, head turned to her right, arm resting on a basket of fruit set upon an architectural fragment, decorative abundance of drapery. However, to the extent that the photograph is a reliable guide, the brush that created the present *Saint Dorothy* appears to have moved with a greater delicacy of touch, expending loving care on the varied textures and intricate foldings of materials and on the soft modeling of the flesh areas. Massimo's idealization nears here the realm of the hyperrefined, where gorgeousness becomes almost an end in itself. Yet to place the *Saint Dorothy* in Artemisia Gentileschi's later years, where by virtue of its rarefied atmosphere it would seem to fit more comfortably, would be to ignore the fact that the picture lacks such mannered features as those elegant elongations and affected postures and gestures that mark much of Artemisia's work after 1640. In fact, it recalls as closely the *Flora* of Bolognese-inspired loveliness in the Kunsthistorisches Museum at Vienna, assigned to Stanzione's onetime student Pacecco De Rosa and dated ca. 1645–50.

In short, it is difficult to insert the *Saint Dorothy* into Gentileschi's chronology, for all its obvious merit and Artemisian qualities; and

until the painting can be judged in the original, its attribution to her must be considered tentative.

BIBLIOGRAPHY: F. Bologna in Naples, Castel Sant'Elmo, 1991, pp. 143 fig. 148, 162, 179 n. 298.

For the comparative material: L. Rocco in London, Royal Academy, 1982, pp. 200–201 cat. 90; Willette in Schütze/Willette, 1992, pp. 212 cat. A53, 321 fig. 190. And for the iconography of Saint Dorothy and Saint Rosalie: Réau, 1958, III, pt. I, pp. 403–5, and 1959, III, pt. III, pp. 1070–71, respectively.

[X-32] *Saint Mary Magdalen*

London, Private Collection
Oil on copper, .49 x .397 m.
Figs. 240, 241

COLLECTIONS: Private Collection, France; Sotheby's, London, 1996

Her red drapery serving more as an identifying attribute than as a garment, the mostly nude Magdalen sits in penance within a setting of brown rocks and trees that gives way to a blue sky and a distant blue-green mountain.

Excerpting (and on one key point unintentionally misrepresenting) a report from the author dated May 19, 1996, the entry in the Sotheby's sales catalogue of July 3, 1996, cautiously presented the *Magdalen* (its state then that of Fig. 241) as "Attributed to Artemisia Gentileschi." Mary's physiognomy, full-faced and recollective of Gentileschi's own (e.g., Figs. 32, 56; Color Plate VI), favored Artemisia's authorship. I expressed the additional opinions that in its deftly applied highlights and sense of substance the cloth was also compatible with her practice, while noting a generic relationship of the landscape to that of Orazio Gentileschi's *David* on copper in Berlin (Fig. 24). Among works assigned to Artemisia, however, the closest parallel as a total image was, I suggested, the *Susanna and the Elders* at Burghley House (Fig. 257) dated 1622.

Countering these observations, my report continued, the evidence for Artemisia's skill in painting on copper remained both slim and of no help in the present context (see [51], Fig. 198, [L-11], and [L-68]. Nor could the *Magdalen* fruitfully be compared to her extant renderings of the theme (Figs. 68, 70, 96, 97, 111, 178;

Color Plates V, VII, X, XI) or be recognized in any inventory citation ([L-80], [L-81], [L-82]). Further (as I argue here at some length [X-42]), the attribution to Artemisia of the Burghley *Susanna* is problematic. And the *intonazione sentimentale* of a Bolognese sort sensed in the *Susanna* by Gregori is at least as palpable in the *Magdalen*, for which, then, the hypothesis in favor of Artemisia's hand could not be wholly embraced.

The *Magdalen* has since been restored. Beneath old and ill-advisedly extensive overpainting meant to disguise two areas of paint loss (most of the central branch of the large tree and a small triangular section at the upper-left corner), almost all the elements of the original background landscape were recovered (Fig. 240). Now that the painting has been freed from disfiguring interventions and yellowed varnishes, it is especially clear that the doubts concerning the attribution of the *Magdalen* to Artemisia were justified. Even more directly to the point, as several scholars have recently recognized, the medium and its attendant fineness of touch and subtlety of modeling, the figure type, and the character of the beautiful landscape establish the author of the copper as none other than Orazio Gentileschi. A detailed defense of this position must, however, be reserved for another forum.

BIBLIOGRAPHY: George Gordon, Sotheby's, London, letters to the author, May 8 and May 23, 1996; R. Ward Bissell, report to Sotheby's, London, May 19, 1996; London, Sotheby's, *Old Master Paintings*, July 3, 1996, pp. 80–81 Lot 44; Maurizio Fagiolo dell'Arco, Rome, letters to the author, June and July, 1996; Ferdinando Peretti, London, Walpole Gallery, letter to the author, July 10, 1997.

[X-33] *Saint Mary Magdalen*

Milan, Finarte, 1978
Oil on canvas, 1.00 x .98 m.
Fig. 243

COLLECTIONS: Finarte, Milan, 1971; Gilberto Algranti, Milan, unspecified year

Eyes raised Heavenward and hands locked in a plea for forgiveness, this elaborately dressed woman masquerades as the golden-haired Mary Magdalen, converted but not yet divested.

This canvas is a rather astonishing performance by a highly competent brush, one that relished the challenge of rendering with absolute fidelity the textures of cloths and lace, of metal, gems, skin, and hair, and of the action of light upon them. Artemisia Gentileschi fits this profile, and the attribution to her which the *Magdalen* bore on the Milanese art market has been accepted by both Papi and Contini, the latter expressing uncertainty only as to its position (Rome or Naples?) within Gentileschi's career.

Relationships to Artemisia's pictures abound, beginning with the amply proportioned, moon-faced female, décolleté, of a type familiar in Gentileschi's art virtually from its beginning and here most recollective of the *Judith* with Relarte in 1964 (Figs. 150–51). Artemisian as well are the decorative accessories and the complex arrangements of diverse materials, including luxurious full sleeves of linen and lace. The *Annunciation*, *Cleopatra*, *Self-Portrait*, and *Bathsheba* (Figs. 114, 136, 119, 180; Color Plate XIX) are especially relevant, and indeed no paintings by any other known artist offer such striking parallels.

Nonetheless, there are signs of an idiosyncratic personality. In sheer girth the woman goes beyond buxom, only to be upstaged by her wardrobe, wearing rather than worn. First and last, this is a costume piece, a conspicuous technical tour de force, an advertisement for the latest fashions well before it is an interpretation of a sinner's remorse for a previously materialistic life. There is, in short, a quality of excess, on the edge of which Artemisia Gentileschi herself sometimes teetered but into which she never fell.

Thus it is that the *Personification of Rhetoric* with Colnaghi at London in 1990 (purchased in 1988 from Sotheby's, Florence, where it appeared as by a follower of Artemisia Gentileschi) comes to mind (Fig. 244; oil on canvas, .90 x .715 m.). Old labels recording the subject as the *Persian Sibyl* and an ascription to Simone Cantarini have with obvious justification been disregarded, and an attribution to Artemisia Gentileschi of this captivating canvas proposed. Again one is confronted by a double-chinned Artemisian type and an emphasis on the corporeal driven by a couturier's vision, as well as by a taste for allegory and accoutrements, all worthy even of Angelo Caroselli. In view, too, of the

design and brushwork of the sleeves, on which the painter tends to fixate, the *Rhetoric* would appear to be by the same hand as the *Magdalen*.

In her letter from Naples of December 11, 1635, to Andrea Cioli in Florence (Appendix I), Artemisia announced her desire to send Cioli a *Saint Catherine* by her and a painting by her daughter. The daughter in question was no doubt Prudentia, aged seventeen or eighteen (see Appendix II), who at that moment may not have commanded the skill exhibited by the pictures under consideration. But since these works are so patently indebted to Artemisia as to no other master, and most especially to those paintings cited above, which span the fourth decade, it is tempting to assign the *Magdalen* and the *Rhetoric* to Palmira Gentileschi during the 1640s. Unfortunately, there is as yet no way of testing this hypothesis.

BIBLIOGRAPHY: Milan, Finarte, *Asta di dipinti dal XIV al XVIII secolo*, asta 125, December 16, 1971, p. 7 Lot 8; Milan, Gilberto Algranti, *Seicento/ Arte "moderna," arte di domani*, November 8–30, year unspecified (cited by Contini and Papi); Milan, Finarte, *Asta di dipinti dal XV al XVIII secolo*, asta 283, April 27, 1978, p. 17 Lot 73 and pl. XLVII; *1970–1980: Auction Prices of Old Masters*, ed. R. Hislop, Weybridge, 1982, p. 225; Papi and Contini in Contini/ Papi, 1991, respectively pp. 53, 61 n. 77 and pp. 66, 67 fig. 49, 84 n. 13.

For the *Personification of Rhetoric*: Florence, Sotheby's, *Importanti argenti, ceramiche, tappetti, mobili, orologi, oggetti d'arte, disegni dipinti antichi e del sec. XIX*, November 28, 1988, Lot 882; Jeremy Howard, London, Colnaghi, letters to the author, November 9, 1989 and August 21, 1990; R. Ward Bissell, letter to Colnaghi's, London, November 8, 1990.

[X-34] *Saint Mary Magdalen*

Naples, Conte Matarazzo (?) Cascianelli
Fig. 236

Correctly rejecting the attribution to Massimo Stanzione then recorded on the photograph in the Kunsthistorisches Institut at Florence (no. 27673), Contini assigned this *Magdalen* to Artemisia Gentileschi on the basis of supposed similarities in facial type and drapery treatment to the Esther in Gentileschi's canvas at New York (Fig. 125; Color Plate XVI). One might

better argue relationships to the *Penitent Magdalen* in Seville Cathedral for the iconographical type and pose and to the Johnson *Venus and Cupid* for the physiognomy (Figs. 97 and 104 respectively; Color Plates XI, XIV). Nonetheless, the sentiment, bordering on bathos, the puffy face with half-moon eyes, the broadly conceived mantle with its projecting folds cupping space, and the left arm tightly encased in drapery which turns over at the wrist to reveal the undergarment bring clearly to mind the paintings of Antiveduto Gramatica and his studio. These features occur singly or in combination in such canvases as the *Saint Veronica* in a private collection at Rome, the *Magdalen by Candlelight* formerly with Trafalgar Galleries, and the versions of *Saint Mary Magdalen at the Tomb of Christ* in Saint Petersburg and Vienna (Figs. 250, 248, 249, 247). Yet since neither Contini nor I have as yet seen the canvas itself, which appears from the photograph to be in need of conservation, a definitive judgment must be deferred.

Another (?) *Penitent Magdalen* ascribed to Artemisia is cited by Contini as follows: "Una guasta, ma che si indovina 'ben nata' *Maddalena penitente* della Gentileschi (olio su tela, cm. 160 x 130) è stata resa nota da Nicola Spinosa (cui era stata segnalata da Gemma Cautela) nel catalogo della mostra napoletana sul Cavallino (*Bernardo Cavallino (1616–1656)*, Napoli, p. 188 scheda B. 12)." Conceivably this canvas and the picture thought to be in the Cascianelli Collection at Naples are one and the same, although the proportions do not exactly accord.

BIBLIOGRAPHY: Contini in Contini/Papi, 1991, pp. 84 n. 13, 166 fig. 94, 169.

For the works by Gramatica cited above: [X-36] and [X-37]; London, Trafalgar Galleries, 1976, pp. 51–52 Lot 18; Marini in Celano, Castello Piccolomini, 1984–85, cat. 7 and color pl. opp.; Papi, 1995, pp. 87 cat. 4, 131–32 cat. 92, fig. 63 and color pl. III.

..

[X-35] *Saint Mary Magdalen (Allegory of Vanity)*

West Wycombe Park, Sir Francis Dashwood Bt. Collection
Oil on canvas, .965 x .84 m., oval within a rectangle
Fig. 232

All of the questions concerning the condition, iconography, and authorship of this work are better addressed when the canvas is considered together with an almost identical composition of octagonal format that was on the European art market in 1988 (Fig. 231). Unfortunately, the former is known to me only from a black-and-white photograph, and the latter from a color illustration (extracted from some publication and sent to me without indication of its source). Such comparisons as are possible between the two versions suggest that the quality of the picture once in the trade is not inferior to that of the present example, that the Dashwood painting is an oval canvas adapted to a rectangular mounting, and that the picture of unknown location may originally have been oval as well.

The West Wycombe example has been called a *Self-Portrait of Artemisia Gentileschi with a Casket of Jewels*, but even if its attribution to Gentileschi were correct (see below), there is no particular reason to identify the model here as Artemisia (cf. Figs. 99–101). The title suggested by Mosco (*Magdalen Renouncing Vanity*) and that by Contini (*Magdalen Renouncing Worldly Goods*) are more reasonable. The woman turns away from the goods before her, while with her right arm she appears ready to hurl into blackness a fistful of pearl necklaces, like writhing vipers, snatched from the table. The index finger of her left hand points to a flower, presumably one that, having wilted, has fallen from the carafe of flowers above it. Part of another vessel seems to be reflected in the upright object, an enameled jewelry box or, perhaps better, a two-sided mirror. One cannot be absolutely certain if the individual who disdains these items (and who wears a deep maroon dress and dark blue mantle over a white shift) is intended to represent Saint Mary Magdalen or whether the subject is more generically an *Allegory of Vanity*. In either case, the oval shape evokes a mirror into which we gaze to recognize that the moral message is directed to us.

The traditional ascription of the Dashwood picture to Artemisia Gentileschi, accepted by Mosco, is not without some justification. The following aspects of the canvas are to varying degrees comparable to features that appear, singly or in combination, in several of Artemisia's

works: buxom woman with plunging neckline; richly arranged garments, including the billowing sleeve; oblique pose, one arm of the figure extended to its limit; anxious expression on a full face.

Nonetheless, Roberto Contini (working as well from a photograph), while noting many of these same parallels, believes that the present painting, although possibly inspired by Gentileschi's Florentine works, is by another hand, specifically that of Francesco Furini (to whose *Judith and Her Maidservant* in a private collection he compares the *Madgalen*) or of a Furini student such as Vincenzo Mannozzi.

Contini's rejection of Gentileschi's authorship is well-founded. However, the photographs speak of paintings which are solidly modeled and incisive in drawing, being without the typically Furinian *sfumato* that wraps figures in softness and mystery, endowing them with that Florentine Baroque *morbidezza* of style and sentiment. Furthermore, in my opinion the *Magdalen* (*Allegory of Vanity*) finds its closest parallels in the art of Angelo Caroselli, and especially with such works as the so-called *Vanitas* (*Alchemical Scene*) in the Longhi Collection at Florence and the *Allegory of Vanity* (*Carite and the Old Woman*) in the Rijksdienst Beeldende Kunst in The Hague. As enamored of healthy female physiques and drapery displays as was Artemisia Gentileschi, Caroselli was more given to pseudo-esoteric iconography and to proliferations of still-life accessories, among them jewelry and mirrors. Although the young woman in Angelo's picture in The Hague is posed from the back, the diagonal placement of her body, the twist of her head, and the thrust of her arm into space—indeed the entire urgency of her actions—are strikingly called up by the *Magdalen*. Even the physiognomy of the Saint brings Caroselli to mind, for in type and hairdo she resembles the maiden in the Longhi *Vanitas* and in her somewhat pained expression she of the Hague painting.

Still, being unfamiliar firsthand with the precise natures of the color, tonality, and quality of either version of the *Magdalen*, I am not comfortable in adding this conception to the catalogue of Caroselli's autograph works. I believe, however, that the designation "circle of Angelo Caroselli" more closely establishes the painting's art-historical position than does an attribution either to Artemisia Gentileschi or to Francesco Furini (or follower).

BIBLIOGRAPHY: M. Mosco in Florence, Palazzo Pitti, 1986, p. 155 fig. 2; Contini in Contini/Papi, 1991, pp. 187, 189.

For the comparative material: J. Grabski, "Il quadro alchimistico di Angelo Caroselli nella Fondazione Roberto Longhi a Firenze," *Paragone*, XXIX, no. 341 (1978), 3–13 and pls. I–6; G. Cantelli in Florence, Palazzo Strozzi, 1986, I, pp. 277–78 cat. I.136; Rotterdam, Museum Boymans–van Beuningen, 1989, pp. 114–15 cat. 56.

..

[X-36] *Saint Mary Magdalen at the Tomb of Christ*

St. Petersburg, Hermitage
Oil on canvas, 1.20 x 1.57 m.
Fig. 249

Inscribed below, on the lid of the sarcophagus: QVIA. TVLERVNT DOMINVM. MEVM

COLLECTIONS: Villa Borghese, Rome, by 1650 and as late as 1700; State Museum Reserve, from which transferred in 1919 to the Hermitage

Elaborately garbed in a red dress and dark-blue mantle, both brocaded in gold, the weeping Magdalen responds to two angels in white who have alighted on the empty sarcophagus.

The attribution of the *Magdalen* to Artemisia Gentileschi proposed by Vsevolozhskaya and Linnik must be rejected. Marked by a dolorous sentiment that hovers somewhere between the heartfelt and the contrived, by gestures that seem motivated as much by the theory of *affetti* as by the psychic states of the figures, this canvas exhibits all the trademarks of Antiveduto Gramatica. Thus the Magdalen, with a large globular head from which streams that long hair scintillating with golden highlights upon which Giulio Mancini commented, is wholly comparable to the weeping *Saint Veronica* exhibited in 1984–85 in the Castello Piccolomini at Celano (Fig. 250), by 1987 in the Galleria Laurina at Rome, and now in a Roman private collection. The equally robust angel at the left, wearing that pious expression and those gleaming white linens in which Gramatica also specialized, finds his twin in the angels supporting the Cross in both the *Saint*

Bernard with the Crucified Christ and the Virgin (Madrid, Prado) and the Saint Charles Borromeo and Two Angels with the Instruments of the Passion (London, Sotheby's, December 13, 1978, and then New York, D. Stephen Pepper). And the other angel—in profile, his hair tightly curled and worked into a top bun—is familiar from Antiveduto's signed Saint Cecilia with Two Angels in the Museu Nacional de Arte Antiga at Lisbon.

In all probability the Hermitage Magdalen at the Tomb, whose provenance prior to 1919 was unknown, can be identified as the picture of this theme cited in 1700 by Domenico Montelatici in the Camera del Gladiatore of the Villa Borghese at Rome: "e nell'altro, dipinto dall'Antiveduto, osservasi la Maddalena presso al sepolcro del Signore, tutta dolente, e mesta nel sembiante, per non havervi ritrovato il di lui corpo, credendo fosse stato portato via, ma solo due Angioli à sedere, che richiestala del suo piangere, par che così ne spieghi la causa: Quia tulerunt Dominum meum, & nescio ubi posuerunt eum ['Because they have taken away my Lord, and I do not know where they have laid him'], come appunto si legge in S. Giovanni." Even to the inscription from the Gospel of Saint John, the present painting and Montelatici's description coincide in every detail. The work was no doubt a Borghese commission; certainly it had entered that collection by 1650, when it was recorded by Manilli: "L'altro grande, della Maddalena al Sepolcro, è d'Antiveduto."

Having reached the above conclusions as to authorship and provenance, I communicated the same in a letter dated June 19, 1990, to Dr. Irina Novoselskaja of the Hermitage. Subsequently, and unaware of this correspondence and of the wording in Montelatici's guide, Riedl and Schleier published the Magdalen as by Gramatica, and on the strength of Manilli's citation speculated that it came from the Villa Borghese. These scholars also address the iconography of the canvas, convincingly relate the Magdalen type to Gramatica's Martha and Mary Magdalen with Finarte at Milan in 1991, and date both pictures to ca. 1622–25. Papi now reports that he and Agnes Szigethi had arrived independently at the Gramatica attribution and had so informed Riedl. Overlooking too Montelatici's description, Papi nonetheless supports the proposal that the Magdalen at the Tomb of

Christ was once Borghese property, and accepts the suggested late dating.

The attribution of the St. Petersburg canvas specifically to Antiveduto Gramatica would therefore appear to be secured. However, Papi reassigned to Antiveduto's son Imperiale Gramatica two of the pictures cited above—the Saint Bernard with the Crucified Christ (in which two of the angels are closely related to their counterparts in the Saint Charles Borromeo) and the Saint Veronica. Riedl and Schleier also give the latter to Imperiale. Among the features considered by Papi to characterize Imperiale's response to his father's art are several—tear-streamed face, uncertain spatial relationships, stiff and rather melodramatic gestures, "bamboleggiante pesantezza," and a would-be elegance that compromises a typically earthbound realism—that may be recognized here. Furthermore, the pattern on the Magdalen's dress is virtually identical to that of the brocaded garment worn by Justice in the late Peace and Justice Kissing (location unknown), for which Papi posits the possible participation of Imperiale.

While Papi's views await full evaluation in the scholarly literature, it may be questioned whether the only documented works by Imperiale (Albano, San Pancrazio, Madonna of the Rosary, 1621; Rome, San Salvatore in Lauro, Liberation of Saint Peter, 1623) point unequivocally in the direction of the Saint Bernard and the Veronica and thus of the Hermitage canvas as well. And Papi now considers the Saint Bernard to be a collaborative effort. Given also Manilli's testimony within twenty-five years of Antiveduto's death and the quality of the Magdalen at the Tomb, Antiveduto's authorship of it may more confidently be affirmed, although a modicum of participation by Imperiale need not be ruled out. As a major and revealing addition to the Gramatica oeuvre, it helps to resolve the Gramatica-Gentileschi confusion that has clouded connoisseurship on several occasions.

BIBLIOGRAPHY: I. Manilli, Villa Borghese fuori Porta Pinciana, Rome, 1650, p. 82; D. Montelatici, Villa Borghese fuori di Porta Pinciana, Rome, 1700, p. 222; S. Vsevolozhskaya and I. Linnik, Paintings in Soviet Museums: Caravaggio and His Followers, Leningrad, 1975, p. n.n. and pls. 68–70; R. Ward Bissell, letter to Dr. Irina Novoselskaja, Hermitage,

St. Petersburg, June 19, 1990; Riedl and Schleier, 1992, pp. 66–68, with ill.; Papi, 1995, p. 118 cat. 65 and color pl. xxx.

For the paintings by the Gramatica, father and son, cited above: M. V. Brugnoli, "Imperiale (e non Antiveduto) Gramatica," *Paragone*, XXII, no. 255 (1971), 71–74 and pls. 55–57; Spear, *Caravaggio and His Followers*, 1971, p. 108; Pérez Sánchez, 1973, cat. 26 and pl. 26; M. Marini in Celano, Castello Piccolomini, 1984–85, cat. 7 and color pl. opp.; Papi in *Paradigma*, 1990, pp. 109–12; idem in *Paragone*, 1990, pp. 77–78 and pls. 47, 49; A. Mignosi Tantillo in Rome, Palazzo Venezia, *L'arte per i papi: e per i principi nella campagna romana; grande pittura del '600 e del '700*, exh. cat., 1990, pp. 50–52 cat. 10; Riedl and Schleier, 1992, pp. 67–69, with ills.; Papi, 1995, pp. 90–91 cat. 10 and color pl. vi, 108 cat. 44 and fig. 32, 108–9 cat. 45 and fig. 28, 114 cat. 56 and fig. 37, 120 cat. 69 and fig. 42, 127–28 cat. 82 and fig. 55, 130–31 cat. 91 and color pl. xxxvii, 130–31 cat. 92 and fig. 63.

..

[X-37] *Saint Mary Magdalen at the Tomb of Christ*

Vienna, Kunsthistorisches Museum
Oil on canvas, .97 x .785 m.
Fig. 247

Through ill-fated technical preparation and/or harsh cleaning the Magdalen's sleeves have turned an unpleasant orange and have lost all sense of texture and articulation. There are also numerous signs of repainting and repair.

Exhibited in the reserve collection of the Kunsthistorisches Museum, until very recently the *Magdalen* bore the attribution to Artemisia Gentileschi assigned to it at least as early as Otto Benesch's article of 1926. Unenthusiastically retained in any case, this ascription was clearly incorrect, as Longhi was the first to realize in giving the work to Antiveduto Gramatica and suggesting that it "might be a fragment of a painting described by Montelatici in the Villa Borghese." Rejecting as well Gentileschi's authorship, I proposed in 1968 that the *Magdalen* was by the same hand that painted the *Girl with a Basket of Fruit and Flowers*, with Christie's in 1956. Then, in 1985, I informed Wolfgang Prohaska of the Kunsthistorisches Museum of my belief that the Vienna canvas was indeed by Gramatica, an attribution affirmed in 1990 and 1995 by Papi and in 1992 by Riedl and Schleier.

The painting formerly in the Villa Borghese is in fact now in St. Petersburg (Fig. 249; [X-36]), and the *Girl with a Basket of Fruit and Flowers*, properly labeled *Saint Dorothy*, was acquired by the Milwaukee Art Museum before the apparently prime version of the composition turned up in 1986 (see [L-108] and Fig. 251). Both the St. Petersburg *Magdalen* and the *Saint Dorothy* are by Antiveduto Gramatica, as surely is the present picture (compromised by poor condition) with its telltale display of flowing hair animated by golden highlights. Comparisons to the *Saint Dorothy* and to the *Magdalen by Candlelight* once with Trafalgar Galleries at London (Fig. 248) accentuate other typically Antivedutian features of the Vienna *Magdalen*: the gently melancholic mood; the deeply shadowed eyes with bulging half-moon lids; the bodice of the dress brocaded and bejeweled. Consequently I cannot accept Prohaska's published attribution of the *Magdalen* to Giovan Francesco Guerrieri, said to follow an oral suggestion by John Spike. Due consideration given to the difficulty in constructing a chronology of Gramatica's oeuvre, Papi's dating of the canvas to the first half of the second decade seems reasonable.

BIBLIOGRAPHY: O. Benesch, "Seicentostudien," *Jahrbuch der kunsthistorischen Sammlungen in Wien*, n.f. 1 (1926), 245–46; Longhi, *L'opere completa*, IV, Florence, 1968, p. 139 n. 7, orig. publ. in *Pinacoteca*, I, 1928; Bissell, 1968, p. 167; R. Ward Bissell, letter to A. T. Lurie, Cleveland Museum of Art, May 9, 1984 (with ascription to Gramatica); Papi, "Note al Gramatica," 1990, p. 125 and fig. 25; Vienna, Kunsthistorisches Museum, *Die Gemäldegalerie des Kunsthistorischen Museums in Wien: Verzeichnis der Gemälde*, 1991, p. 64 and pl. 151; Riedl and Schleier, 1992, pp. 67–68; Papi, 1995, pp. 16, 91 cat. 11 and color pl. vii.

For the paintings by Gramatica cited above: [L-108] and [X-33]; London, Trafalgar Galleries, 1976, pp. 51–52 cat. 18; Papi, 1995, pp. 13, 87 cat. 4 and color pl. iii.

..

[X-38] *Salome and an Executioner with the Head of Saint John the Baptist*

Budapest, Szépmüvészeti Múzeum
Oil on canvas, .834 x .905 m.
Fig. 254

COLLECTIONS: Guidi Collection, Faenza, from which sold by the Galleria Sangiorgi, Rome, April, 1902 (as Lot 144); Union des Médecins, 1902 (as no. 222); Enterprise des Magasins de Commission, Budapest, 1970 (as no. 168), from which purchased by the Szépmúvészeti Múzeum

Dressed in a white blouse and brownish-yellow dress with dark blue/black stripes, Salome extends a salver to receive Saint John's severed head from a ruddy executioner clad in a green jacket and red trousers.

A restoration carried out by Anna Bujdosó necessitated the in-painting (judiciously left visible as fine parallel strokes) of extensive areas of canvas. Whatever subtleties the surface may have had have been lost from a presumed earlier intervention that stripped the surface of its glazes as if with steel wool. The condition of the picture is such that, irrespective of the issue (explored below) of which artist might have conceived the composition, it is impossible to know with certainty whether the *Salome* is a ruined original or a damaged copy of a now-lost work.

The known history of the canvas begins in April of 1902 when a *Salome with the Head of Saint John* from the Guidi Collection at Faenza, bearing an attribution to Caravaggio and measuring .85 x .90 m., was sold by the Galleria Sangiorgi at Rome. Subsequently assigned to Artemisia Gentileschi by Voss (information in the Witt Library, London) and by Longhi (recently published manuscript notes from 1920–21), this painting was illustrated by Moir as "attributed to Artemisia Gentileschi" and likened to the "identical, or very similar painting" acquired in 1970 by the Szépmüvészeti Múzeum from the Enterprise des Magasins de Commission at Budapest. Following an attribution to Artemisia by Agnes Czobor, the latter was published in full by Szigethi, who on the basis of the photograph judged the ex-Guidi picture to be a second version of lower quality. However, the Budapest example, it too formerly given to Caravaggio, arrived with a provenance from the Union des Médecins sale of 1902, the same year as the sale in Rome of the Guidi *Salome* of identical size. Too close to be coincidental, these facts suggest that only one painting is involved, a supposition which Szigethi (reply to my letter of June 17, 1990)

now accepts and with which Papi (familiar with my opinion) is apparently inclined to agree.

In her article Szigethi, comparing the *Salome* to Gentileschi's *Judith and Her Maidservant* in Florence (Fig. 31; Color Plate IV), considered that it might be an early, immature work by Artemisia but, bothered by the crudeness of the executioner, concluded that the picture and the would-be second version were most likely replicas of a lost original. Hersey surmises that it is "an old copy of a composition certainly by Artemisia," while in the meantime the question of Artemisia's authorship was reconsidered in detail by Papi, who rightly points to such Gentileschian features as the physiognomy of the double-chinned Salome, her coiffeur, and her stiffly extended arms. Papi offers for discussion the following alternatives: (1) if the canvas is by Artemisia, it most likely belongs to her early years in Rome by virtue of the directness of its Caravaggism and its relationships to the *Salome* formerly in Geneva, the Spada *Madonna and Child*, and the Naples *Judith* (Figs. 20, 230, 21; Color Plate II); (2) the execution of such passages as Salome's sleeves, her hair, and the face of the swordsman, not being up to Gentileschi's standards, raises the possibility that the Budapest picture is a copy of a now-lost work by her or is by a student or follower strongly under her influence; or (3) if the picture is a product of Gentileschi's workshop, it would undoubtedly be tied to the artist's second Roman period on the reasonable grounds that before she left for Florence she had not yet achieved a following.

There are problems with some of these proposals. Thus the attributions to Artemisia of the ex-Geneva *Salome* and the Spada *Madonna* are themselves debatable (see [X-39] and [X-19]), and qualitative judgments for purposes of connoisseurship are perilous given the lamentable physical condition of the picture. Most crucially in my view, the invention of the Budapest composition is best assigned to the Roman master Angelo Caroselli. Comparisons to undoubted paintings by Caroselli are abundant, and include the following: the dark and coarse executioner to the figure of Catullus in the *Lesbia Mourning Her Pet Sparrow* once with Matthiesen at London and Colnaghi at New York (Fig. 255); the pudgy Salome to the *Meekness (Saint Agnes)* in the Palazzo Pitti at Flore-

nce; and the full sleeve of concentric folds to the *Vanitas* in the Galleria Corsini at Rome.

Papi unintentionally provides additional support for connecting Caroselli to the Budapest work by observing that the uncouth figure of the *Fruit Vendor* (location unknown) is so close to the executioner in the *Salome* as to suppose the same model and/or the same painter or atelier. The *Fruit Vendor* is assigned to the Master of the Acquavella Still Life, so called on the basis of a series of paintings gathered around a still-life now in a private collection at Milan. This is not the place to review the scholarship devoted to this intriguing Master (see Papi's overview and the pages by Cottino cited in the Bibliography below), although it should be noted that while there is general agreement that the figures who appear in the majority of the pictures associated with him are by another hand, there is as yet no consensus who this figure painter (or rather painters, I think) might be. Ferdinando Bologna has identified Caroselli as the Master's collaborator. At least in the present context Bologna's insight is persuasive, for there are indeed undeniable similarities between the fruit seller and the executioner of the Budapest *Salome*, and both can only bring to mind the Catullus of Caroselli's *Lesbia*.

Finally, since there is no evidence (see Chapter 6) that Artemisia Gentileschi excelled in the genre of still-life painting, Papi's proposal to locate pictures in the Acquavella group "in an orbit around Artemisia" lacks solid foundation. For Cottino a document of March 15, 1614, thought to cite a painting today attributed to the Master of the Acquavella Still Life and Bartolomeo Cavarozzi, would exclude Artemisia on chronological grounds.

BIBLIOGRAPHY: Rome, Galleria Sangiorgi, *Catalogue de la vente du musée Guidi de Faenza*, 1902, pp. 21–22 Lot 144 and pl. 13; Longhi, 1920–21 (in *Palazzo non finito*, 1995, p. 185); Moir, 1976, p. 135 n. 226x and fig. 116; Nicolson, 1979, p. 51; Szigethi, 1979, pp. 35–38; Nicolson/Vertova, 1990, I, p. 111 (as of "Uncertain Attribution"); R. Ward Bissell, letter to Dr. Ildikó Ember, Szépmüvészeti Múzeum, June 17, 1990; Agnes Szigethi, Szépmüvészeti Múzeum, letter to the author, July 22, 1990; Papi in Contini/Papi, 1991, pp. 56–58 (and notes), 154–57 cat. 20; Hersey, 1993, p. 331 n. 7.

For the additional comparative material: G. Scavizzi in Naples, *Caravaggio e i caravaggeschi*, 1963, pp. 26–27 cat. 16 and pl. 14; Bissell, 1981, p. 205 [X-17] and fig. 160; London, Matthiesen, 1981, pp. 18–19 cat. 5; New York, Colnaghi, 1986, pp. 8–9 cat. 2, catalogued by C. Whitfield and E. Banks; A. Cottino in Rome, Musei Capitolini, *La natura morta al tempo di Caravaggio*, exh. cat., Naples, 1995, pp. 148–55 cat. 37–40.

..

[X-39] *Salome and an Executioner with the Head of Saint John the Baptist*

Geneva, Musée d'Art et d'Histoire (destroyed 1973)
Oil on canvas, 1.13 x .91 m.
Ca. 1610
Fig. 20

COLLECTIONS: Provenance unknown

Reported to have survived in good condition until its destruction by fire on May 17, 1973, this canvas was thought variously to have been executed by Giovanni Baglione, Giuseppe Vermiglio, and Artemisia Gentileschi before being assigned by Natale (later seconded by Emiliani) to Giovan Francesco Guerrieri. Recent comments by Papi, for whom rather the *Salome* was beyond much doubt by Artemisia Gentileschi, have reopened the question.

The sad fact that the painting can no longer be studied directly is not an excuse to avoid the issues, although it may forever prevent a definitive solution to what, as the remarks below ought to underscore, is an extremely complex attributional problem. This entry proposes to place the picture in a context from which future discussions regarding its authorship, sources, and influence might originate.

In support of the attribution to Guerrieri, Natale likens the painting to the *Madonna and Child* in the Galleria Spada (Fig. 230; [X-19]), sometimes given to the Fossombronese artist, and to the canvases in San Pietro in Valle at Fano. But already a conflict has entered the argument. On the one hand, the Spada *Madonna* must be considered outside the present discussion, having little substantively in common with Guerrieri's certain productions and appearing instead to belong to the circle of Baglione. Conversely, the Salome in the ex-Geneva picture is something of a less domesticized sister to the woman at the left of the Fano *Miracle of the Blind Infant*. Natale then notes the obvi-

ous similarities between Salome and the Judith in Artemisia Gentileschi's *Judith Decapitating Holofernes* in the Uffizi (Fig. 77; Color Plate XII)—their arms rigidly extended and parallel, their bodies leaning away slightly in attitudes of physical/psychological avoidance. For Natale these links bolster the attribution to Guerrieri, a painter who arrived in Rome as early as 1606 and whose stay there, punctuated by trips back to the Marche, was to last at least until late 1618. Beginning especially with Emiliani's writings of the late 1950s, a close connection between Guerrieri and the Gentileschi workshop has often been argued, including by the present author. Papi has now denied a Guerrieri-Gentileschi rapport, challenging the validity of some of the pillars of this construct—including calling into question the supposed chronological priority and stylistic influence of Orazio Gentileschi's *Magdalen* (for Sta. Maria Maddalena, Fabriano) and *Circumcision* (for the Chiesa del Gesù, Ancona) with respect to Giovan Francesco's versions of the themes, and reassigning the *Saint Charles Borromeo Praying for the Cessation of the Plague* (San Venanzo, Fabriano) from Guerrieri to Orazio himself.

Because, in my view, a Gentileschi-to-Guerrieri line of derivation in general can still be argued, the ties between Artemisia's *Judith* and the *Salome* are not in themselves irrelevant to the claim of Guerrieri's responsibility for the latter. Moreover, an informed nineteenth-century source locates a *Decapitation of Saint John* by Guerrieri in the Rossi Collection at Ostra, near Fabriano. Some might even introduce as corroborating evidence the *Judith Decapitating Holofernes* belonging to the Banco Popolare Pesarese at Pesaro and published in 1988 by Emiliani and Sapori as a work by Guerrieri, for here the positions and actions of both Judith and the Persian general again bring Artemisia Gentileschi's Uffizi *Judith* to mind. Yet in the ruddy physical type of the spherical-faced Judith and in the placing of her form against the front plane, as in the characterization of the maid as a wizened woman of highly particularized realism, her head enwrapped in a heavy shawl, this picture recalls rather Rubens's *Great Judith* as known today from Cornelius Galle's print (Fig. 25). Indeed, the Pesaro *Judith* is likely to have been executed during the early 1620s in Rome by a North European master fa-

miliar with the conceptions of Artemisia Gentileschi and Rubens. Significantly, Emiliani and Sapori also recognized a Northern-Italian mix. Then there is the *Salome* in the Howell Collection in Chagrin Falls, Ohio, published under Guerrieri's name by Spear, who correctly observed Gentileschian aspects in the female type and richly arranged materials. Yet while Spear's insight helps define the ambient of the present canvas, it does not confirm its attribution to Guerrieri, particularly in view of Papi's convincing suggestion that the Howell *Salome* is in actuality by Antiveduto Gramatica (see also below).

When considered as a total image as well as against such claims and counterclaims, the *Salome* cannot be assigned with any confidence to Guerrieri. Much more certain is its chronological place within the grand scheme of Caravaggesque painting, specifically near 1610. At this moment it would evoke not Artemisia's Uffizi *Judith* but rather her prime version of the composition, the example at Capodimonte (Fig. 21; Color Plate II). It then seems apparent that the ex-Geneva painting was a work of considerably greater pictorial subtlety than the Naples canvas, being marked by transparencies even in the deepest shadows, complex twistings and turnings of linen, and a dazzling demonstration of dexterity in the veil which, tucked under Salome's sash, wraps around her left shoulder and upper arm and flutters into space. The virtuoso handling and understated drama, as well as the obvious debt (see [4]) of Artemisia's Naples *Judith* to works assignable to her father, strongly recommend *Orazio* Gentileschi as the author of the *Salome*. (I do not share Papi's sense that the *Salome* owes something to Giovanni Baglione's *Judith Decapitating Holofernes* of 1608 in the Galleria Borghese at Rome. Papi, convinced that Baglione played a "fundamental role" in Artemisia's formation, introduces his *Judith* as would-be support for Artemisia's authorship of the ex-Geneva canvas.) Additionally, the figure of the executioner is consistent with Orazio's liking for figures seen from the rear; most relevant by virtue of their dates would be the Farnese *Saint Michael*, the Vienna *Way to Calvary*, the ex-Colnaghi and Oslo *Judith*s (both apparent precedents for Artemisia's picture in the Palazzo Pitti; cf.

346

Figs. 13, 39, 40), and the St. Louis *Danaë* (Fig. 210).

In the case of the *Salome*, the ultimate source of the executioner's pose may be found in Caravaggio, either in the *Salome* in the Palacio Real at Madrid (if this canvas is not in fact a derivation by Caracciolo) or in a now-lost work. Caravaggio's conception of the swordsman, his right hand on the weapon's hilt, seems to have spawned two types. One, with the figure seen predominantly from the side, his right arm stretched above his head, is represented by Louis Finson's *Decapitation of Saint John* in the Herzog Anton Ulrich-Museum at Braunschweig and by a *Salome* sold in 1964 by Relarte of Milan as by Antiveduto Gramatica. Examples of the second variation, the executioner viewed almost totally from the back, shoulders strongly inclined, right arm bent, and face approaching lost profile, include the present *Salome* and the *Salome* in a private collection at Rome attributed by Schütze to Massimo Stanzione and dated ca. 1620. Further, the swordsmen in these last named paintings are so closely related that, unless there was a common prototype, presumably by Caravaggio, one figure must have been directly based upon the other. Did, then, Stanzione see the ex-Geneva *Salome* during his stay in Rome in 1617–18?

Additional affinities between the present picture and canvases by Antiveduto Gramatica, in connection with which Papi has already invoked the names of the Gentileschi, further complicate the issue. Gramatica's *Salome with the Head of Saint John the Baptist* with Nouveau Drouot at Paris in 1981 and, less centrally, his variation upon it in the Staatsgalerie at Aschaffenburg are comparable in the young woman's strangely tranquilized response to the brutal act, the transparent veil, the scintillating highlights on the dress, and the ample white undergarment.

Nonetheless, precisely considered, the physiognomy of Salome in the ex-Geneva picture would be as atypical of Antiveduto as it is distinctive to the Gentileschi, of whom the masterful handling likewise speaks more emphatically. Papi has located Gramatica's *Salome* formerly in Paris at the juncture of the first and second decades; as noted, the present *Salome* almost certainly dates about 1610. It seems

equally probable, once all the evidence has been sorted and weighed, that the latter issued directly from the Gentileschi studio. Less demonstrable, although I believe most likely, is that it came from the brush of Orazio Gentileschi. "Un Erodiade grande d'Orazio Gentileschi" owned by Maria and Leonora Cavallerini was exhibited at San Salvatore in Lauro in Rome in December 1707.

BIBLIOGRAPHY: M. Natale in Geneva, 1979, pp. 64–65 cat. 80; A. Emiliani in San Severino Marche, 1988, p. 40; Papi in Contini/Papi, 1991, pp. 38, 40 fig. 21, 59 n. 23; idem, "Guerrieri," 1991, p. 155 n. 19.

For related issues and comparative material: Milan, Relarte, *Maestri italiani del '600 e '700*, October 25–November 15, 1964, pp. 50–51; D. Bodart, *Louis Finson*, XII, pt. 4 of Académie Royale de Belgique: Mémoires, 1970, pp. 141–43 cat. 21, and fig. 44; Spear, 1975, pp. 206, 216, 223; Bissell, 1981, p. 221 [L-68]; Cinotti, 1983, pp. 402, 455–57 cat. 28; A. Emiliani and G. Sapori in San Severino Marche, 1988, pp. 76–77 cat. 7; Papi, "Guerrieri," 1991, pp. 147–48, 150, 154 n. 2; Schütze in Schütze/Willette, 1992, pp. 190 cat. A2, 269 fig. 95; Papi, 1995, pp. 16, 88 cat. 6 and color pl. IV, 105 cat. 38 and fig. 24, 112–13 cat. 53 and fig. 35.

..

[X-40] *Salome with the Head of Saint John the Baptist*

Naples, Museo di Capodimonte
Oil on canvas
Fig. 246

Of Bernardo Cavallino's magnificent *Judith with the Head of Holofernes* in the Nationalmuseum at Stockholm Lurie has written: "However, this *Judith* is the artist's boldest statement in the Caravaggesque idiom, which links the canvas to a wide circle of Italian and French Caravaggesque paintings, such as Simon Vouet's *Salome*, which is a close copy of Artemisia Gentileschi's painting at Capodimonte." The latter reference is to the canvas illustrated here, the former to a picture at Bob Jones University in Greenville, South Carolina. Except that they exhibit differences in handling and color, these two works are identical, and may well be connected as original and replica.

It is equally clear, however, that Artemisia Gentileschi's responsibility for the conception

is to be excluded. The attribution to Vouet of the Greenville version has been rightly questioned, but its association with the Roman circle of the French master is confirmed by a series of intimately related works, variously called *Salome* and *Herodias*, that includes the following: (1) Simon Vouet or workshop, Galleria Nazionale, Palazzo Corsini, Rome; (2) engraving after Vouet, published by Lagniet without indication of the engraver; (3) engraving by Claude Mellan after Vouet; (4) engraved copy, reversed, of (3). It is unthinkable that Vouet, least of all in the mid-1620s (the date established by the style of these depictions), would have copied a composition invented by Artemisia Gentileschi and then made it a part of his stock in trade. The Capodimonte *Salome*, which is uniquely bland in expression and less showy in costume, takes its place in the long line of Vouettian derivations and, while it may have influenced Cavallino, is of importance to Gentileschi studies only insofar as it brings to mind the extent to which on other occasions Artemisia and Vouet utilized a common vocabulary.

BIBLIOGRAPHY: Lurie in Percy/Lurie, 1984, pp. 215–16.

For the comparative material cited above: Greenville, S.C., *The Bob Jones University Collection of Religious Paintings, I (Italian and French Paintings)*, 1962, pp. 172–73 cat. 100; Dargent and Thuillier, 1965, pp. 47 cat. A28 and A30, 56 cat. D6, 156–57 figs. 42, 49, 50; Nicolson, 1979, p. 110; Ficacci et al., 1989, pp. 192–93 cat. 28 with ill.

[X-41] *Sibyl*

> Paris, Galerie Tassel, 1986
> Oil on canvas, .71 x .60 m.
> Fig. 223
>
> COLLECTIONS: Private Collection, France

With her red-striped white turban and open folio this young woman, attired in a deep maroon gown over a white shift, is no doubt to be identified as a sibyl, who turns as if to look to the future as divined in the sibylline book.

Citing such elements as the "graceful highlighting," the décolletage, the richness of texture, and the "slightly puffy" character of the hand, and likening these to Artemisia Gentileschi's *Magdalen* in the Palazzo Pitti (Fig. 70), D. Stephen Pepper assigned the *Sibyl* to Ar-

temisia's Florentine period. The attribution to Gentileschi has been accepted by Biedermann, who, perhaps through an erroneous notion of the dates of the artist's Florentine stay, has placed the canvas "vers 1620–1630."

The particulars isolated by Pepper are insufficiently distinctive to establish Gentileschi's authorship of this striking image, while others speak against it. Thus the triangulated face with its chiseled features contrasts to the full-cheeked, fleshy types favored by Artemisia, whose women (until her later years) appear more personalized than the seemingly stereotypical female here depicted. The somewhat amorphous quality of brooch and book and the soft, cursorily applied highlights on the gown stand apart from that strength of definition upon which Gentileschi would have insisted.

While, then, the present picture may have a generically Artemisian air, it is the product of an artist more inclined toward generalization. Yet like Artemisia this painter, quite conceivably a Northerner in Rome, also appears to have been familiar with the Italian works of Simon Vouet and his shop. In this latter regard, the *Sibyl* may fruitfully be compared in type, feminine allure, pose, and fullness of drapery to the *Judith* of Virginia da Vezzo as engraved by Claude Mellan.

BIBLIOGRAPHY: D. S. Pepper, typescript, 1986; Biedermann, 1988, pp. 41–42; J. Thuillier in Rome, Palazzo delle Esposizioni, 1991, pp. 32, 34–35.

[X-42] *Susanna and the Elders*

> Stamford, England, The Burghley House Collection
> Oil on canvas, 1.615 x 1.23 m.
> On the parapet above Susanna's left knee:
> *ARTEMITIA GENTILESCHI LOMI / FACIEBAT. A. D. M DC XXII.*
> Fig. 257

The bald elder, dressed in deep red and backed by green foliage, crowds his companion in a dark-lavender coat who leans over a balustrade draped with a golden cloth. Susanna, lifting a white undergarment in an effort to hide her nudity from lecherous eyes, stands out in strong relief from the dark architecture.

Considered in the nineteenth-century to be by Caravaggio and eventually reassigned to

Orazio Gentileschi, in 1968 the *Susanna and the Elders* was published by Gregori as by Artemisia Gentileschi, an attribution to which (it is reported) Philip Pouncey and Federico Zeri had also arrived. Gregori reiterated her opinion in 1984, locating the canvas in the artist's "years between Florence and Rome." The ascription to Artemisia was deemed possible by Harris, Contini, Cassidy, and the present author, likely by Somerville and Hersey, and correct by Nicolson. Garrard, to the contrary, firmly excluded the *Susanna* from the list of Gentileschi's autograph works.

There have now arisen new issues with which one must grapple. With the cleaning of the canvas just prior to its showing in 1995, black capital letters highlighted with white and reading "*ARTEMITIA GENTILESCHI LOMI / FACIEBAT. A. D. M DC XXII*" emerged from the darkness above Susanna's knee. For Brigstocke and Somerville this is an autograph signature and thus serves, along with the notation made by Brownlow, the Ninth Earl of Exeter (1725–93), in his *Extracts from an old catalogue of ye furniture at Burghley* ("Susannah and ye Elders by Arta:Gentileschi from ye Barbarini Pallace at Rome"), as proof of Artemisia Gentileschi's authorship.

Then, in August of 1995, with the authorization of the Burghley House Collection, a technical examination of the canvas was undertaken by David Miller, conservator at the Indianapolis Institute of Arts. Among Miller's findings, using visible light, ultraviolet flourescence, infrared reflectography, and finally X-radiography on selected sections: (1) cusping on all four sides, indicating that the canvas retains its original size; (2) appreciable surface wear, especially in the shadows in the flesh tones, the result of past harsh cleaning; (3) no sign of the "trace of another signature . . . to the left side of the canvas above the putto's head" reported by Brigstocke; and (4) numerous *pentimenti*, some of them clearly visible to the naked eye. During the process of execution the positions of Susanna's legs and right shoulder were altered, and pieces of additional drapery over her right shoulder and perhaps her chest were painted out. "A balustrade similar to those found in Artemisia's *Bathsheba* paintings" is detectable beneath the present figure and architecture. Most surprising of all, again to quote Miller's report:

"The radiographs reveal startling changes along the left side. At one time, a completely different fountain was painted in great detail depicting a winged putto standing at the pinnacle of a pedestal adorned with piles of fruit. Water spouts from the pedestal into a wide basin. . . . The putto is also spouting water upwards through a horn held to its mouth with the water also falling into the basin. The basin itself has spouts which shoot water further downwards." Even the contour of the fountain now visible was altered. Miller also signals some features that remain unexplained, including these: (1) the remains of a tree branch against the sky to the left of Susanna's head; (2) the "shadow of what could be a figure above Susannah's head, facing toward the right side of the picture"; and (3), not revealed by X-rays, "the smaller version of the current fountain which can plainly be seen in the pentimento in the sky, clearly meant to be far in the distance due to its scale. This fountain was probably painted after the putto-topped fountain seen in x-ray was discarded. Because of the scale of this fountain, it may relate to the shadowy figure seen above."

As regards what is taken to be the signature and the question as to when the extensive alterations were made, Miller writes:

The signature does not seem to have been strengthened, but it does read somewhat darker in U. V. than might be anticipated. . . . The signature, inscription, and date are contemporary with the painting of the wall to the left of Susannah. The "A" overlaps part of the earlier composition which was not painted out. The technique and craquelure is consistent with the painting as a whole. . . . There is no obvious physical evidence to suggest that the painting was heavily reworked at a later time. The craquelure, paint consistency, pigmentation sizes, types, distribution and technique are all consistent with the given date. . . . [Thus] based on the evidence presented by this examination, and similarity of technique, it seems likely that the compositional changes were performed by the same artist rather than reworking by other hands at later times.

To this I would add that a section of the afore-mentioned balustrade may still be seen in the entire dark area below the bent left elbow of the elder, and that an augmentation of the young woman's hair was thinly painted over the preexistent right sleeve of this same elder.

All of this quite obviously affords powerful, seemingly even unshakable, support for the attribution of the Burghley *Susanna* to Artemisia Gentileschi. And at least on the bases of the quality and visual strength of the image, one would willingly insert it in Artemisia's oeuvre. It is therefore with considerable reluctance that I must express misgivings which in good conscience do not permit me to include it in the Catalogue of Autograph Paintings. What follows focuses first on the signature and purported Barberini provenance in order to open the stylistic evidence to consideration on its own grounds and to whatever conclusions it itself may lead, even if to further defenses of Artemisia's authorship.

Among the signatures on Artemisia's pictures, there is not a single one in which both the maternal and paternal surnames appear. Nor does the artist refer to herself in this way in any of her many letters. Nor is she identified as such in any of the inventory citations of extant or now lost canvases. Among contemporary documents, only some of Michelangelo Buonarroti the Younger's accounts of monies paid to Artemisia for the *Inclination* [8] contain both designations, and then as "Artimisia di Orazio Lomi ovvero Gentileschi" and "Artemisia d'Orazio Lomi o Gentileschi"—that is to say, as the daughter of Orazio and with, as one would expect, the family name preceding the maternal one. (In an epigram dedicated to his *Cleopatra* ([X-6]), Orazio Gentileschi is referred to as "Orazio Gentileschi di Lomi," and by Andrea Cioli in a letter of March 16, 1615, as "Orazio Lomi Gentileschi." His brother Aurelio is called Aurelio di Giovanbat. Lomi Gentileschi in a document of 1611 concerning dues which he owed to the Accademia del Disegno at Florence). Moreover, the appearance of the surname "Lomi" on a painting by Artemisia dating from 1622, up to two years or more after her return to Rome from Florence (where she consistently used "Lomi"), would be unique. (Mann speculates that this "may indicate that [Artemisia] was back in Florence working in

1622 on the painting, or that it was done for a Florentine patron.") And whether on canvas or paper, Artemisia never employed the notation "A.D." or "Anno Domini" or any variant thereof. Thus the wording on the Burghley *Susanna* could arguably be interpreted as a kind of label, by another hand, rather than as a bona fide signature. Now, it is true that Artemisia Gentileschi was not consistent in the way she rendered her name, but the form on the *Susanna* is so far from the known examples and therefore so in opposition to expectations as to raise in my mind serious questions as to its claims to be a signature at all.

When was Artemisia's authorship of the canvas first put forward? As noted, the picture is assigned to her in the Ninth Earl of Exeter's handwritten *Extracts from an old catalogue of ye furniture at Burghley*. In response to my inquiry, John Somerville has written: "The list . . . is in the 9th Earl's hand writing and whilst the title page implies that the list represents a partial transcription of an older list, that earlier catalogue is not readily identifiable (which itself would have been handwritten anyway and not published). The only list compiled for the 5th Earl is the 1688 inventory and the Artemisia anyway was a 9th Earl acquisition (whilst Hugh [Brigstocke] put in the provenance 'probably' bought by the 9th Earl, I can tell you it is 99.9% certain as it does not appear in the 1738 inventory and no one was buying such pictures between the 5th and 9th Earls). Also the fact that it comes from the Barberini, as do so many others purchased by the 9th Earl, confirms this."

My trust in the reliability of the early information is by no means complete. Nine paintings in the recent Burghley exhibition which are known or thought to have been purchased by John Cecil, the Fifth Earl of Exeter, do not figure—according to the catalogue's own information—in the inventory of 1738. The Burghley inventory of 1688 as drawn up by the Fifth Earl and published by John Somerville for the exhibition lists three unattributed compositions of *Susanna and the Elders* and a fourth said to be by Francesco di Maria (the Neapolitan master to whom is given—in an entry immediately following one of the anonymous *Susanna*s—a *Lot and His Daughters*, now thought to be the copy after Orazio Gentileschi still at Burghley).

350

Further, one cannot put full faith in the assertion that the *Susanna* came from the Palazzo Barberini in Rome. Cassidy has tentatively linked it to a picture recorded in 1627 in the collection of Cardinal Francesco Barberini as follows: "Un quadro d'una Susanna, che sta' nel bagno a sedere con una fontana, con testa di leone e due vecchi alta p.mi 7 e large [*sic*] p.mi 5¹/₂." However, the inventory reference (and that of 1631–36, also published by M. Lavin) not only describes a work that was approximately 10 cm. wider than the Burghley one, but assigns it to Passignano. The Burghley canvas has not been cut (see above and cf. Fig. 256), there is no lion's-head in it, and no reason to believe that a picture by Artemisia would have been misattributed to Passignano in 1627. One is left with an unsubstantiated claim, as also with three additional paintings in the show of 1995 for which a Barberini provenance is recorded by the Ninth Earl but which do not appear in any known Barberini documents.

Brownlow's attributions, too, are often in error; one-fifth of the pictures in the exhibition, for example, have been reassigned. It is also known (assuming for the moment that the *Susanna* was bought by him) that the Ninth Earl sometimes acquired works by way of unscrupulous English agents in Italy, men fully capable of manufacturing or passing on false attributions and spurious histories.

In all, then, there is no independent support for the claims for the *Susanna* made by the Ninth Earl of Exeter or by the "signature" on the canvas. Ultimately the stylistic evidence must do the speaking. It speaks with a most complex syntax. What follows does not offer a solution to the attributional problem but merely proposes to set the context within which it might be addressed. The Burghley painting joins other Early Baroque renditions of the subject in a line that originated with Annibale Carracci's etching and engraving of ca. 1590–95 (Fig. 7). In Annibale's work the robust Susanna, encircled by drapery that spreads out on the stone bench, turns away from the elders even as she pivots her head in the opposite direction (see Chapter 1). Her left arm, stretched across her body and shielding her breast, grasps an additional covering. A large fountain in deep shadow and decorated with sculpture, including an energetic putto, serves to enhance

the spatial illusion and delimit the composition. Reinterpreted and rearranged, these features of Carracci's invention seem to stand behind the Stamford canvas. Combined with the influence of Caravaggio and, surely, Domenichino's *Susanna* of ca. 1606–8 in Munich, the print also had implications for a *Susanna and the Elders* (1.80 x 2.08 m.) once with Wildenstein and then the Helikon Gallery, in which the *repoussoir* putto fountain, the overarching foliage, and—strikingly—the facial type of the elder at the right are comparable to the present *Susanna*. These last-named paintings likewise share a clarity of outline, precision of detail, and passion for textural differentiation which for the Wildenstein/Helikon canvas have brought to mind Cecco del Caravaggio (Francesco Buoneri), active in Rome. For the Burghley *Susanna*, wherein the elders, one of them cautioning silence, press in very close to the girl as she seeks to cover herself, the example of Rubens's painting in the Galleria Borghese (Fig. 11) may also have been relevant. Finally, it was with potential knowledge of all these conceptions that about 1615–20 Ottavio Leoni produced his *Susanna* on copper now in the Detroit Institute of Arts, with its Saraceni-like qualities.

I cannot insist upon the elaborate scheme of interrelationships outlined above, but the comparisons do suggest that the *Susanna and the Elders* was painted in Rome during the second decade of the century or even as late as the date of 1622 inscribed on it—but not much later, I think. If this is correct, one would have to remove from consideration the *Susanna* by Artemisia recorded in a Venetian verse of 1627 (quoted and translated under [L-105]), undoubtedly executed by Gentileschi in Venice in that same year. Further, and in disagreement with Hersey, I do not find that the poem describes a work identical with, or even very close to, the Burghley canvas. Taken literally, the verse pictures two hoary men to either side of a Susanna who ventures not to look Heavenward. In the painting, conversely, one of the men is decidedly dark-haired while the other, showing white basically at the left temple, is mostly bald; the latter hovers over the former, and both are behind Susanna (clearly Susanna is not "actually enframed by them" as Hersey

would have it); and Susanna raises her head and rolls her eyes upward.

If the Burghley *Susanna* originated in Rome between 1610 and the early 1620s, nor can it be identified as the picture inventoried at White-hall beginning in 1637–39 ([L-103]). This canvas could not have been any earlier than 1626, the year in which Orazio Gentileschi arrived in England (where he would have called attention to his daughter's art), and more likely belonged to the 1630's, either prior to Artemisia's London stay or during it. Nor, of course, is there reason to connect this picture specifically to the example once in the English Royal Collection.

It has been necessary thus to go on at some length because several features of the *Susanna and the Elders* do and have brought Artemisia Gentileschi to mind, among them the formidable physique and round face of the woman, the lighting on her body, the ruddy elders, the material splendor with special attention to white linen, and the particularization of detail. Besides, the painting is of superb quality, although one should note the overall textural sameness of the whites (instead of painterly variation, with impasto being reserved for the highlights) and the almost wooden character of the hands of the upper elder, conceivably in part a result of the older harsh cleaning(s) noted above. Yet when the work is evaluated against our current understanding of Artemisia's development, the *Susanna* cannot be made to fit at any stage. Nor are there pictures by her that can easily be grouped around it irrespective of the proposed chronology. To assign it to Gentileschi in the second decade would be to bring it close to the *Susanna* of 1610 (Fig. 10; Color Plate I), a much sparer portrayal and one that has none of the Burghley painting's sentimentality. Gregori correctly notes an *intonazione sentimentale* of a Bolognese sort, and Contini and Brigstocke rightly think of Simon Vouet with whom, it is true, Artemisia shows an affinity on several occasions. I cannot accept Garrard's characterization of Susanna as "dreamily responsive" and striking a "seductive, Venus pudica pose . . . [in] an environment swelling with Cupids and spurting fountains." Still, it can be argued that the interpretation is incompatible with Gentileschi's art in these years, as is the extent of and attention to the ambient.

For Harris, Garrard, Contini, and Cassidy the *Susanna*, were it to be by Gentileschi, would have to belong to the 1620s—where, naturally, the date on the canvas professes to place it. Yet in view of the apparent relationships to versions of the theme by other artists as suggested above and of the expanded catalogue of Artemisia's paintings from the 1620s proposed in the present study (cf. Figs. 87, 97, 111; Color Plate XI), neither is this indicated. Beyond general Caravaggesque characteristics and the pattern established early on by Annibale Carracci's print, I find no remarkable links between the *Susanna* and Artemisia's mature works, among them two other versions of the theme (Figs. 162, 197; Color Plate XXIV). And the presence of the balustrade does not imply any connection to Gentileschi's depictions of *Bathsheba*, being a standard part of the iconography of Susanna and the elders.

A final complicating element is introduced by a picture of the same size (1.626 x 1.219 m.) and identical composition which entered the Castle Museum and Art Gallery at Nottingham in 1964 as a gift of Leon H. Willson (Fig. 256), its previous history unknown. The object of an as yet unpublished catalogue entry by Brendan Cassidy, this canvas, which had suffered considerable damage and to which a later hand had added pieces of drapery over Susanna's thigh and breasts, emerged from the restoration of 1985 as a work of very commendable quality—or so the photograph and color transparency testify. This has necessitated a reconsideration of the earlier suppositions of Wright and others, including the Castle Museum authorities, that it was but a copy of the Burghley picture. Depending upon how one chooses to interpret the situation, the against-the-usual-odds presence of both canvases in England either strengthens a case for both having been painted there by the same artist, most reasonably Artemisia Gentileschi, or the case for one being a copy made in England by another hand, as Brigstocke believes. Inasmuch as the Burghley picture shows numerous *pentimenti*, a wider range of lighting (with richer transparencies) and, it would seem, more supple, less sharply delineated draperies, and cannot be accommodated to the style of Artemisia's English period, the second alternative is preferable.

BIBLIOGRAPHY: G. F. Waagen, *Treasures of Art in Great Britain*, London, 1854, III, p. 405; Bissell, 1968, p. 167; Gregori, 1968, pp. 417–19; Lavin, 1975, pp. 87 no. 297 and 107 no. 297; C. Wright, *Old Master Paintings in Britain*, London, 1976, p. 73; R. Ward Bissell, letters to Nottingham, April 15, 1978, and September 27, 1984; Harris in Harris/Nochlin, 1976, p. 121 n. 18; David Phillips, Nottingham, letter to the author, March 17, 1978; Garrard, 1982, pp. 161–62; Brendan Cassidy, Nottingham, letter to the author, September 13, 1984; Jesse Bruton, Codsall Wood, prerestoration condition assessment of the Nottingham *Susanna*, September 11, 1984; M. Gregori in Naples, *Civiltà del seicento*, 1984, I, p. 147; Garrard, 1989, pp. 202–4, 533 nn. 40–42; Nicolson/Vertova, 1990, I, p. III; Neil Walker, Nottingham, letter to the author, August 22, 1990; John Somerville, London, letter to the author, October 8, 1990; Contini in Contini/Papi, 1991, p. 113; Brendan Cassidy, typescript of proposed catalogue entry on the Nottingham *Susanna*; Hersey, 1993, p. 327; H. Brigstocke in *Italian Paintings from Burghley House*, 1995, pp. 80-81 cat. 20 (including references to Burghley catalogues) and passim (including the introductory essays by Somerville and Bristocke concerning the collecting activities of the Ninth and Fifth Earls of Exeter, and the latter's inventory of 1688); John Somerville, Stamford, letters to the author, July 27 and September 1, 1995; David Miller, Indianapolis, technical report, August 19, 1995; Mann, 1997, p. 183 n. 27.

For the comparative material: Pergola, 1955, I, pp. 183–84 cat. 273, and 1959, II, pl. 273; M. Marini, *Io Michelangelo da Caravaggio*, Rome, 1974, pp. 172 fig. 43 and 392 cat. 43, with additional bibliography; Moir, 1976, p. 139 n. 236; Spear, 1982, I, pp. 149–51 cat. 29 and II, p. 49; R. W. Bissell and A. Darr, "A Rare Painting by Ottavio Leoni," *Bulletin of the Detroit Institute of Arts*, LVIII, no. 1 (1980), 46–53; DeGrazia, 1984, p. 235 cat. 14 and fig. 334.

LOST WORKS

Except when there is primary documentation or when citations come from otherwise unimpeachable sources, there is as yet no way of judging the correctness of the attributions to Artemisia Gentileschi in the Catalogue that follows. Some of the references are likely to be to extant paintings, while others may be duplicate records of pictures that have changed collections over the centuries. The entries speak to these points.

When measurements can be provided, height precedes width, although in some cases the format is indeterminable. Obsolete systems are converted into the metric scale as follows:

Florentine *braccia*	= .5836 m.
Neapolitan *palmo*	= .264 m.
Roman *palmo*	= .2234 m.
Spanish *vara*	= .835 m.

It should be stressed, however, that measurements signaled in inventories are often only approximate, and that the Roman-born Gentileschi may or may not have employed the larger Neapolitan *palmo* when calculating and reporting after 1629 the sizes of her canvases.

..

[L-1] *Amoretto (Sleeping Cupid)*
Venice, Jacomo Pighetti, by 1627

In an unsigned pamphlet printed at Venice in 1627 appear verses dedicated to three paintings by Artemisia Gentileschi—a *Lucretia* [L-54], a *Susanna* [L-105], and the work in question here:

Amoretto in Parangone
Dell'istessa
In mano del M. Illustre Sig. Iacomo Pighetti

Quell Pargoletto Amore,
Che par, che dorma, e spiri,
Qual sì vago il formò nobil pittore?
Ah che tanto non lice
A dotta man virile,
Ma sì bello il formò nobil pittrice.
Se al ver tanto è simile,
Maraviglia non è, poiche potea
Far anco un vivo Amor d'Amor la
 Dea.

Who was the anonymous author? Toesca, who discovered the flysheet, rightly questions whether Jacomo Pighetti, although a noted literary figure (see below), would immodestly refer to himself as "M. Illustre." Garrard, while not hazarding a specific identification, labels the poet indisputably male: "No more succinct expression of masculine jealousy of female procreativity—and hence masculine appropriation of artistic creativity—could be found." My own interpretation of the verse (for which see Chapter 3) disputes this reading.

The versifier may in fact have been the Venetian-born Gianfrancesco Loredan (1606–61)—senator, linguist, writer of range, and libertine. Known as well for having founded in 1630 the Accademia degli Incogniti, which met in the Palazzo Loredan, Gianfrancesco was apparently on familiar terms with both Artemisia Gentileschi and Jacomo Pighetti. To the former he composed two undated letters, one of them embellished with a verse (see Appendix III). And the Bergamese Pighetti, only six years Loredan's senior and a lawyer and then *letterato* in Venice, was a member of the Accademia. Further, by 1629 Loredan had become a member of the Venetian Accademia dei Desiosi, a group to which Artemisia may have belonged (see Chapter 3). That Gianfrancesco, age twenty-one in 1627, was already prepared to produce the poetry to Artemisia is indicated by this and by the relatively early dates of some of his other literary activity, including the *Vita de Alessandro III, pontifice romano*, also of 1627, *Gli scherzi geniali* of 1632, and the *Vita del cavalier G.-B. Marino*, issued in 1633. Thus, too, Garrard's suggestion that the commentaries on Gentileschi's pictures were modeled on Marino's *Galleria* is given added force.

Toesca supposes from the title of the verse that the work was on touchstone (i.e., *pietra di paragone*), but with Garrard I believe it likely that the title refers rather to a "comparison" between a hypothetical *Amoretto* by a male artist and Artemisia's example. The poem juxtaposes *nobil pittore* and *nobil pittrice*, and the construction *in para(n)gone* can indeed imply a confrontation of persons or concepts that reveals differences of various sorts (see *Grande dizionario della lingua italiana*, Turin, 1984, XII, pp. 547–49).

The history of Gentileschi's picture after 1627 is unknown. Jacomo Pighetti died on October 10, 1646, and on January 2, 1647, an inventory which presumes to record all his paintings was compiled: "Inventario de tutti li Mobeli che s'atrovato in Casa del quondam Eccellentissimo Signore Jacomo Pighetti posta in Contrada di S. Anzolo—et prima / Nel Portico pur vi sono tutti li quadri di casa cioè:" In this list of forty works neither Artemisia's name nor any picture that could be considered an *Amoretto* appears. Loredan's (?) description is in part satisfied by Gentileschi's *Memento Mori* known from prints (Figs. 112, 113; [L-11]), but the sleeping child in the latter is not a winged cupid (implied by "Amoretto"), and P. de Jode's engraving of it is inscribed "Artemisia Gentilesca pinxit Napoli."

BIBLIOGRAPHY: Toesca, 1971, pp. 89–92 (including a bibliography on Pighetti on p. 89 n.), the verses from Biblioteca Vaticana, "Manoscritti e stampe di materie diverse," cod. Ottoboniano Latino 1100, c. 100–101v; S. Savini-Branca, *Il collezionismo veneziano nel '600*, Padua, 1964/65, pp. 40, 42, 122, 235, 259–60, on Gianfrancesco Loredan and Jacomo Pighetti; Ivanoff, 1965, pp. 186–90; Garrard, 1989, pp. 172–73.

..

[L-2] *Andromeda Liberated by Perseus*
Naples, studio of the artist, 1651, approx. 8 x 10 *palmi* (2.11 x 2.64 m.)

Half-finished on January 1, 1651, when announced together with a *Joseph and Potiphar's Wife* [L-45] in a letter from Artemisia to Don Antonio Ruffo of Messina: "mandai a dire nel altra mia a V. S. Ill.ma come havevo due quadri della medesima misura della Galatea [49] che sono mezzi fatti, è dentro ha uno si rapresenta Antromeda, quando fu liberata da un tal Cavaliero sul cavallo begaseo in Aria, che ammazza

il detto Mostro che hamava da divorar d.ta donna, et ge intraviene bellissimo paesagio et bellis.ma marina; in somma è un vaghissimo quatro. . . ." Pending an advance of 100 ducats on a fee of 90 scudi (= ducats) per painting, Artemisia proposed to complete the canvases by April at the latest. Neither work seems to have been acquired by Ruffo, and no pictures by Gentileschi of these subjects are recorded elsewhere.

BIBLIOGRAPHY: Ruffo, 1916, pp. 53–54; Garrard, 1989, pp. 400–401.

..

[L-3] *Angels with the Instruments of the Passion*

(seven pictures) and an ***Ecce Homo,*** Naples, Francesco de Palma, Duca di S. Elia, 1716, each approx. 4 x 3 *palmi* (1.06 x .79 m.)

Preparatory to renouncing his possessions in favor of his brother Giuseppe and joining the Jesuit Order, Francesco de Palma arranged in 1716 for an inventory of his collection. Valued at 80 ducats in all were "Otto quadri di palmi 4 e 3 in circa con figure uno di Ecce homo, e gl'altri sette con Angioli che ogn'uno tiene qualche mistero della Passione, con cornice mischie e uno stragallo e frondi indorate di mano di Artemisia Gentileschi D. 80."

The attribution of these works to Artemisia is extremely suspect. Rather, one is immediately reminded of Simon Vouet's *Angel with the Lance and Sponge* and *Angel with the Dice* in the Museo di Capodimonte at Naples, each of 1.02 x .78 m. and thus almost exactly the same size as the *Angels* that belonged to Francesco de Palma. Twelve canvases of angels with the Instruments of the Passion were listed in 1699 under Vouet's name among the possessions of Alfonso Filomarino, Duca della Torre, they too measuring 3 x 4 *palmi*. This series had been inherited in 1666 by the nephews Ascanio and Alfonso upon the death of their uncle Cardinal Ascanio Filomarino, and remained with the Principi della Torre until 1799. Another set, thought to be nonautograph replicas, was in 1756 and again in 1769 recorded with the della Rocca branch of the Filomarino.

The two canvases at Capodimonte—which have been dated as early as ca. 1615 and as late as ca. 1626—are judged to be survivors of

Cardinal Filomarino's group. To these can be added the beautiful *Angel with the Superscription* and *Angel with the Bitter Cup* in the Minneapolis Institute of Arts and further angels assigned to Vouet in a private collection and in the Episcopio at Brindisi. Without commenting here on the justness of the various attributions to the French master, I can state my opinions that (1) the publication of the Francesco de Palma inventory complicates the issue by suggesting still a third set and that (2) in the present state of our knowledge it is much more likely that de Palma's paintings were in some way connected to Vouet (to whom no other work in the collection is assigned) than to Artemisia Gentileschi. To be noted, however, is that there were only eight pictures, one of which was an *Ecce Homo*, a companion picture not mentioned in the other sources.

BIBLIOGRAPHY: Labrot, 1992, pp. 283 and 284, from Naples, AS, Archivio Palma d'Artois, fascio 105, fascicolo II, fol. 26v. For the pictures by and attributed to Vouet: Galante, 1987, pp. 40–45 and ills., and J. Thuillier in Rome, Palazzo delle Esposizioni, 1991, pp. 133–34 cat. nos. 4–5 and color pls., both with additional bibliography.

..

[L-4] *Annunciation*

Naples, Casa dei Carafa San Lorenzo, Nicola Pietro Carafa, 1786 and later, approx. 6 x 8 *palmi* (1.58 x 2.11 m.)

Originally belonging to the della Quadra, into which family the Carafa had married, the painting was assigned to Artemisia Gentileschi in seventeenth-century inventories and subsequently (1786, 1837, 1856, 1857) to Agostino Beltrano before being sold or passed down through inheritance. In the listing of 1786 it is recorded as follows: "Due altri quadri sopra tela e cornici dorate di palmi sei e otto in circo rappresentanti uno d'essi l'Annunziata di Agostino Beltrano. . . ." Since, as Ruotolo has noted, for the most part the attributions are inflated in the eighteenth-century inventory, the *earliest* assignment to Artemisia should perhaps be given greater credence than the citations under Artemisia's name of a *David and Abigail*, a *Death of the Firstborn of Egypt*, and a *Lot and His Daughters*, all three owned as well by the Carafa ([L-19], [L-24], and [L-50] respectively).

BIBLIOGRAPHY: Ruotolo, 1974, pp. 161–63, 165, 168, the documents from Naples, AS, Archivi Privati, Carafa San Lorenzo, carte 4.

[L-5] *Apollo with the Lyre*
Naples (?), Girolamo Fontanella, 1694

The object of one of three verses dedicated to Artemisia Gentileschi and her works by Giovanni Canale in his *Poesie—Morali, Varie, Eroiche, Di Lode, Funebri, Sagre* published in Naples in 1694: "Alla signora Artimissa Gentileschi Pittrice famosissima Per uno Apollo con la Lira senz'arco donato al Sig. Girolamo Fontanella." See Appendix III.

BIBLIOGRAPHY: Fastidio, 1897, p. 110, as from the *Poesie*, pp. 67, 465 ff.

[L-6] *Bathsheba*
Althorp, Spencer Collection, 1746 and 1750

For the citation, see [53].

[L-7] *Bathsheba*
English Royal Collection, Somerset House, 1649–1650

The identification of this picture elsewhere in the English documents as a *Diana at Her Bath* is more likely to have been correct. For the arguments, [L-25].

[L-8] *Bathsheba*
for Prince Karl Eusebius von Liechtenstein, 1636, 11½ *palmi* (3.04 m.) high

On May 5, 1636, having received from the Neapolitan agents of Prince Karl von Liechtenstein a final payment of 250 ducats on her fee of 600 ducats, Artemisia was to deliver immediately three pictures, each of 11½ *palmi* high, representing *Bathsheba*, *Susanna*, and *Lucretia*. Unfortunately, this transaction (quoted and discussed under [37]) cannot be shown to document any of Gentileschi's paintings of these themes. There is, however, a possibility that the composition of the *Bathsheba* for Vienna was more or less identical to that of Artemisia's

canvas now in Halle (Fig. 169; see [40] for the argument).

[L-9] *Bathsheba*
Prince Trivulzio Sale, 1764

Sold in 1764 under Artemisia Gentileschi's name as "Bethsabée au bain, 500 florins," but not unquestionably identifiable as one of the artist's several extant canvases of this subject.

BIBLIOGRAPHY: A. Siret, *Dictionnaire historique des peintres de toutes les écoles depuis l'origine de la peinture jusqu'à nos jours*, Paris, 1866, p. 540.

[L-10] *Charity*
Giangerolamo II Acquaviva, Conte di Conversano, 1666

Since the vast majority of the numerous paintings inventoried in 1666 after the Count's death appear without attribution, the assignment of this picture ("La carità d'Artemitia Gentilesca"), along with a *Madonna* [L-56], specifically to Artemisia is likely to have been correct.

BIBLIOGRAPHY: Ruotolo, 1977, p. 73 incl. n. 13, as from Naples, AS, notaio Giov. Batt. dell'Aversana, XVII sec., scheda 295, prot. 40, fol. 588 ff.

[L-11] *Child Sleeping*
Rome, Flavio Orsini, Duca di Bracciano, and heirs, 1698 and 1722/23, copper, 6 *diti* high x 9 *diti* wide

Listed as "Un Rame con un putto che dorme con cornice di pero, et oliva opera di Artemisia Gentileschi sc. 7" in the Orsini inventory compiled in 1698 after the death of Principe Flavio Orsini, this small painting on copper was described in greater detail upon the passing of Principessa Maria Anna in 1722: "Altro dipinto in rame per traverso di d. 9 e alto 6, rapp.te un puttino, che dorme posando il Capo nel coscino rosso, ed un panno bianco, che lo cinge di sopra per traverso, opera d'Artemisia Gentileschi con cornice di pero nero ed oliva. sc. 10." The salient features of the composition— horizontal format, child sleeping with his head on a pillow and his chest encircled by a sheet— are obviously reflected in the *Memento Mori*

painted in Naples by Artemisia Gentileschi and, I believe, sent to France, where it was engraved by Pieter de Jode II and others (Figs. 112, 113; [23]). Whether this example had made its way back to Italy, to figure in the later Orsini inventories, or whether it was a replica of a work executed by Artemisia in Rome or directly for the Orsini of Naples, cannot as yet be determined. (A *Fortune* attributed to Gentileschi was inventoried in 1704 in the Neapolitan collection of Ottavio Orsini. See [L-31] and also the next item.)

BIBLIOGRAPHY: G. Rubsamen, *The Orsini Inventories*, Malibu, Calif., 1980, pp. 38, 82. And [23].

..

[L-12] *Child Reclining, Encircled by Flowers*

Naples, Domenico Perrino, 1716, 5 *palmi* x 4 *palmi* (1.32 x 1.06 m.)

The fascinating inventory reference reads as follows: "Uno quadro di palmi cinque, e quattro, con cornice indorata liscia, con chierchio di fiori, nel mezzo de quali vi è dipinto un bambino corcato, mano di Artimisia . . . 10." Bearing a single figure identified merely as "un bambino" and not as the Christ Child, the picture likely depicted a secular subject. More specifically, it may have been a memento mori, the flowers serving not as glorifying attributes but rather as testimony to the fragility of earthly existence. As such, the painting could have been an elaboration of Artemisia Gentileschi's conception known from engravings (Figs. 112, 113; [23]; also [L-11]). The odds are, too, that the garland was by another hand, that of a specialist among the great Neapolitan flower painters of the time. Baldinucci's claim for Artemisia as a skilled practitioner of still-life has no basis in fact (see Chapter 6). Collaborations on pictures of this type were common, as those of Abraham Breughel and Pieter Paul Rubens (*Madonna and Child Within a Wreath*) and Andrea Belvedere and Francesco Solimena (*Still-Life with Winged Putto*). If, then, the inventory attribution and the foregoing speculation are correct, the chances of the *Still-Life with a Pastry Eater* (Figs. 174, 179; [44]) being indeed a joint venture by Giacomo Recco and Artemisia Gentileschi are enhanced.

BIBLIOGRAPHY: Provenance Index, Getty Art Information Program.

..

[L-13] *Christ [?] Child*

Naples, Casa Antinori, Giacomo Capece Zurlo, 1715, 2 x 1½ *palmi* (.53 x .40 m.)

Inventoried and evaluated on March 15, 1715, as "Un Bambino, misura 2 e 1½, cornice intagliata indorata, mano d'Artemisia Gentilesca. d. 15." My tentative identification of the picture as representing the Christ Child, based on the capitalization of "Bambino," need not be correct; the reference could be to a version of Artemisia's *Memento Mori* recorded in engravings (Figs. 112, 113; [23]).

BIBLIOGRAPHY: Ruotolo, 1973, p. 151.

..

[L-14] *Christ and the Little Children (Suffer the Little Children to Come unto Me)*

Triana (Spain), Cartuja de Sta. Maria de las Cuevas, Alcalá Chapel, by 1637 (acquired 1625/1626)

Purchased in Rome by Fernando Enríquez Afán de Ribera, Third Duque de Alcalá, during his tenure as Ambassador to the Holy See (July 1625–February 1626), and listed in an inventory compiled in November of 1637 of the Casa de Pilatos in Seville: "En el oratorio alto pieca prim^a"—"Un lienço de un Salvador con la mano derecha sobre unos muchachos que es copia del original de artemissa que esta entre los que su Ex^a. trujo de Ytalia para la cartuxa." Neither the original nor the copy has been traced, but Artemisia's interpretation of this infrequently depicted subject—assuming the attribution to have been correct—may be reflected in a canvas attributed by Marini to the Gentileschian painter Bartolomeo Cavarozzi, who died in 1626. The *Sinite parvulos* was one of several pictures assigned to Artemisia purchased by the Duke of Alcalá (also [16], [L-20], [L-61], [L-62], [L-75]).

BIBLIOGRAPHY: M. Marini, *Imagine per una collezione*, auction cat., Rome, Palazzo Borghese, June, 1985, pl. 30; Brown/Kagan, 1987, pp. 239–40, 248 no. 7; and for Orazio Gentileschi and Cavarozzi, Bissell, 1981, pp. 70–71, 95–96.

[L-15] *Christ and the Samaritan Woman*
Naples, studio of the artist, October and
November 1637, 12 x 9 *palmi* (3.17 x 2.38 m.)

First cited without indication of its subject in a
letter dated October 24, 1637, from Artemisia
to Cassiano dal Pozzo in Rome: "Sig. mio, per
concludere e perfezionare questo matrimonio
[of her daughter; see Appendix II], mi manca
qualche poca somma di danari. Tengo per
questo effetto, non avendo altro capitale o as-
segnamento, alcuni quadri d'undici e dodici
palmi l'uno. Fo disegno presentarli alli signori
cardinali Francesco Padrone e D. Antonio. . . ."
Gentileschi, here calling upon Cassiano to
serve as intermediary between her and Cardi-
nals Francesco and Antonio Barberini, to
whom she wished to present pictures, then de-
scribes the canvases in a follow-up letter of No-
vember 24, 1637, to the Roman connoisseur and
secretary as a *Saint John the Baptist in the Desert*
(see [L-76]) and a *Christ and the Samaritan
Woman*: "Coll'antecedente che scrissi a V.S. ac-
cennai che i quadri che tenevo pronti per
mandare, erano di grandezza dodici palmi d'al-
tezza, e nove di larghezza, ma non dissi l'ist-
oria. Ora dico, che l'istoria è la Samaritana col
Messia, e suoi dodici Apostoli, con paesi lon-
tani e vicini, ec., ornati di molta vaghezza. . . ."
Since these paintings do not figure in the vari-
ous Barberini inventories published by Lavin,
it may be that they never reached their hoped-
for destination.

BIBLIOGRAPHY: Morrona, 1792, II, p. 267; Bottari/
Ticozzi, 1822, I, pp. 352–54 letters CXLI and CXLII;
Garrard, 1989, pp. 387–88.

[L-16] *Christ (Head of the Young Christ)* and *Head of the Madonna*
Naples, Davide Imperiale, 1672

Companion pictures of Christ and the Vir-
gin—"Due Teste, una di nostro Signore Gio-
vine, l'altra di nostra signora della medesima
Artemisia"—accompanied two other paintings
attributed to Gentileschi (*Lucretia* and *Saint
Mary Magdalen*, [L-52] and [L-80]) by the
time of Davide Imperiale's death in 1672. Noth-
ing even vaguely resembling this pair of works
is otherwise encountered among the recorded
or extant productions of Artemisia.

BIBLIOGRAPHY: Labrot, 1992, pp. 118 and 139, from
Naples, AS, Notaio Domenico Cardamone, scheda
1221, prot. 32, fol. 34.

[L-17] *Cupid and Psyche*
Rome, Patrizi Collection, 1624 and 1647

Inventoried on February 27, 1624, and again in
July of 1647: "Un alro quadro di Psiche con
Amore di mano d'Artemitia Gentileschi con
cornice tutta dorata scudi centoventi—120" and
"Un quadro di Psiche con Amore mano d'Ar-
temitia del Gentileschi con cornice tutta Indor-
ata—120." These unpublished citations to a
picture which—its provenance and subject sug-
gest—was no doubt executed by Artemisia in
the early 1620s following her resettlement in
Rome, force one to rethink the attribution of a
canvas (1.365 x 1.60 m.) of the same theme now
in the Hermitage at St. Petersburg (Fig. 252).
In 1981, rejecting its ascription to Orazio Gen-
tileschi, I located the Hermitage painting in
the Tuscan-Roman ambient of Orazio Rimi-
naldi (a suggestion which Gash finds "very at-
tractive") and Simon Vouet during the 1620s.
Recently Papi, rightly observing that the *Cupid
and Psyche* is "fortemente segnata di caratteri
gentileschiana" (including the twisting pose of
Psyche), has introduced the possibility of Ar-
temisia Gentileschi's authorship. While I con-
tinue to sense a Vouetian aura and can find no
figures in Artemisia's oeuvre comparable to the
male nude here, I know the canvas only from
photographs and would urge that Papi's cau-
tious proposal, if altered in favor of Artemisia's
second Roman period rather than her Floren-
tine years, be given serious consideration.

BIBLIOGRAPHY: Rome, AS, *30 Notari Capitolini*,
Officio 2, vol. 92, 1624, notary Leonardus Bonanni,
fol. 380, and Officio 11, vol. 187, 1647, notary Jo.
Mattheus Massarius, fol. 465v. For the Hermitage
picture, see Bissell, 1981, p. 203 [X-10], with bibli-
ography; J. Gash, "American Baroque," *Art History*,
VIII (1985), 260 n. 11; and Papi in Contini/Papi,
1991, pp. 44–45, 60 n. 46.

[L-18] *David* (head of only?)
Naples, Ferdinando d'Afflitto, Principe di
Scanno, 1700, 8 *palmi* high x 6 *palmi* wide
(2.11 x 1.58 m.)

The head of David and those of Saint Eustace and Saint Sebastian in identically sized paintings are assigned to Artemisia in the d'Afflitto inventory of 1700. A recently discovered payment to Gentileschi dated August 21, 1631, while documenting her work on the *Saint Sebastian*, makes no mention of collaboration, even though the total fee of only 20 ducats for the *Sebastian* would seem to confirm the claim made in 1700. For the precise reference and bibliography, see [L-85]; also [L-73].

[L-19] *David and Abigail*
Naples, Casa dei Carafa San Lorenzo, Nicola Pietro Carafa, 1786 and later, 10 x 12 *palmi* (2.64 x 3.17 m.)

Purchased by the Carafa, rather than having been inherited by them from the della Quadra (into which family they had married), the canvas appears in an inventory taken in 1786 upon the death of Nicola Pietro Carafa as "Un quadro sopra tela con sua cornice dorata di palmi dieci [high, to judge by other entries], per dodici rappresentante David con Abigail e diverse figure di Artemisia." It reappears in listings of 1837, 1856, and 1857. However, since in the eighteenth-century compilation the attributions are most often inflated, the assignment to Artemisia Gentileschi of this picture, as of the *Death of the Firstborn Sons of Egypt* [L-24] and the *Lot and His Daughters* [L-50] also owned by the Carafa, should be accepted very cautiously. See also [L-4].

BIBLIOGRAPHY: Ruotolo, 1974, pp. 161–63, 165, 167, the documents from Naples, AS, Archivi Privati, Carafa S. Lorenzo, carte 4.

[L-20] *David with a Harp*
half-length, Seville, Casa de Pilatos, Duque de Alcalá, acquired 1625/1626

No doubt purchased in Rome by Fernando Enríquez Afán de Ribera, Third Duque de Alcalá, during his tenure as Ambassador to the Holy See (July 1625–February 1626), and recorded in an inventory compiled in November of 1637 of the Casa de Pilatos: "En el oratorio alto pieca prim^a"; "Un medio cuerpo del S^to Patriarcha David con una harpa en la mano de mano de Artemissa Gentilesca sin g^on." The painting

was inherited by the Duque de Medinaceli and, according to Brown and Kagan, appears in his inventory of 1711. Although the subject strikes one as being highly unusual for Artemisia Gentileschi, the probable circumstance of the purchase, the early date of the inventory, and the presence in the Casa de Pilatos of other works by or of the artist ([16], [L-14], [L-61], [L-62], [L-75]) stand in support of the attribution.

BIBLIOGRAPHY: Brown/Kagan, 1987, pp. 236, 248 no. 17 and n. 10, the original in Madrid, Archivo Zabálburu y Basabe, leg. 215, no. 1.

[L-21] *David with the Head of Goliath*
England?

The existence in England of a *David* by Artemisia is implied by Walpole: "Artemesia Gentileschi . . . was also in England, was reckoned not inferior to her father in history, and excelled him in portraits: Her own is in the gallery at Althorp. King Charles had several of her works. Her best was David with the Head of Goliath. She drew some of the royal family and many of the nobility—but the chief part of her life was at Naples. . . ." Walpole's authority, not independent knowledge, informed Pilkington's subsequent report: "And the most celebrated picture of her [Artemisia's] hand, is the victory of David over Goliath."

Yet no such work figures in the many inventories of Charles I's holdings. And Walpole's reference to a *David* by Artemisia is merely an adaptation, with misplaced chronology, of Joachim von Sandrart's record of a picture of this subject which he saw in Gentileschi's Neapolitan studio in 1631 (see [L-23]) and which, I have argued, was soon to enter the Roman collection of Vincenzo Giustiniani. The bases of Walpole's *Anecdotes,* namely the notebooks of George Vertue (d. 1757), who "turned over all our own authors, and translated those of other countries which related to his subject," were rewritten and subjected to corroborative research: "I have been obliged to compose a-new every article, and have recurred to the original fountains from whence he drew his information; I mean, where it was taken from books." That one of these "fountains" was precisely Sandrart, is proved, to cite but two instances, by Walpole's (correct) references to the German writer

in his sections devoted to Abraham van Diepenbeeck and Honthorst.

In short, it is extremely probable that only one *David*, executed by Artemisia Gentileschi in Naples and sent to Rome, and without any connection to England, is in question. Since, too, it depicted the young hero holding the head of Goliath, it is not to be confused with the canvas recently attributed to the painter (Fig. 212; [X-8]).

BIBLIOGRAPHY: Sandrart, 1675 (ed. 1925), pp. 173, 193, 290; Walpole, 1765, I, pp. vii–viii, and II, pp. 95, 126, 130; Pilkington, ed. 1777, p. 248.

..

[L-22] *David with the Head of Goliath*
Naples, studio of the artist, 1631

To all indications, Artemisia's painting of this subject which was to figure in the Giustiniani inventory of 1638 [L-23].

..

[L-23] *David with the Head of Goliath*
Rome, Marchese Vincenzo Giustiniani, 1638, approx. 9 x 6 *palmi* (2.01 x 1.34 m.)

In the latter months of 1631, the German painter Joachim von Sandrart, having already met Orazio Gentileschi in England and having been to Rome, paid a visit to Artemisia in Naples. He later recorded this event and the presence in the artist's studio of "a very fine David, life-size, who held the horrible head of the enormous Goliath in his hands, which . . . was very judiciously made (*Nicht weniger Lob hat verdienet die tugendsame Artemisia Gentilesca zu Neapel, die mir, als ich ihr von ihrem Vatter, dem hoch berühmten Horatio Gentileschi, meinem sonderbaren lieben Freund, einen Gruss gebracht, ihre schöne Kunstgemälde gezeiget und unter andern einen sehr zierlichen David, Lebensgrösse, der das abscheuliche Haupt des ungeheuren Goliaths in Händen hält, so neben vielen andern Werken von ihrer Hand sehr vernünftig gemacht ware*)."

Returning to Rome, Sandrart became keeper of the Palazzo Giustiniani, where he resided and where in March of 1638 a life-size *David with the Head of Goliath* by Artemisia was inventoried: "Nello stanzino picciolo novo a mano dritta della sudetta stanza grande: Un

quadro con una figura intiegra di David, che tiene la testa del Gigante Golia, dipinto in tela, alta palmi 9 lar. 6 e——in circa di mano di Artemisia Gentileschi con cornice." Christian Klemm's suggestion that the Marchese Vincenzo Giustiniani bought the Neapolitan *David* upon the advice of Sandrart is most reasonable. Conversely, Garrard's hypothesis that a *David and Goliath* in the Galleria Corsini at Rome (once attributed by Longhi to Artemisia, and later by him tentatively to Regnier) may be a replica (not by Gentileschi) of the Giustiniani painting is not convincing, the more so as the Corsini canvas represents *David with the Head of Goliath Saluted by a Woman*. The subsequent history of the Giustiniani Collection—its sale in 1812, its purchase through an intermediary by the King of Prussia, the division of the works between Berlin and various royal residences—has not as yet helped reveal the whereabouts of Artemisia's painting.

BIBLIOGRAPHY: Sandrart, 1675 (ed. 1925), p. 290; Salerno, 1960, pp. 26, 96; Christian Klemm, letter to the author, January 16, 1976; Klemm, 1986, p. 61; Garrard, 1989, pp. 109, 503 n.108.

..

[L-24] *Death of the Firstborn Sons of Egypt (The Tenth Plague,* Exodus 11–12)
Naples, Casa dei Carafa San Lorenzo, Nicola Pietro Carafa, 1786 and later, approx. 12 x 9 *palmi* (3.17 x 2.38 m.)

Acquired by the Carafa through marriage into the della Quadra family, the painting is given to Cavaliere Francesco Antonio Giannone in seventeenth-century inventories, but later (1786, 1837, 1856, 1857) to Artemisia: "Un quadro grande sopra tela con cornice dorata di palmi dodici [high, to judge by other entries] per nove in circa rappresentante la Morte de'primogeniti d'Egitto di Artemisia [1786 inventory]." As with the *David and Abigail* [L-19] and the *Lot and His Daughters* [L-50], also owned by the Carafa, the more prestigious attribution to Gentileschi may be incorrect. See also [L-4].

BIBLIOGRAPHY: Ruotolo, 1974, pp. 161–63, 165, 167, the documents from Naples, AS, Archivi Privati, Carafa S. Lorenzo, carte 4.

[L-25] *Diana at Her Bath*
English Royal Collection, Somerset House,
1649–1650

In "The Inventory of the Effects of Charles I,
1649–1652" from Harley MS 4898, there appears
as no. 281 a "Diana washing her with other
naked figures done by Artemesio Gentillisco
£60." Virtually the same description is later re-
ported by Vertue in his list of the King's goods,
although now under no. 282: "in the Gallery [at
Somerset House], #282: Diana Washing her
with other naked figures done by Artemesio
Gentelisco—60[11]." It is therefore surprising to
meet with three additional documents in which
the painting is thought to represent Bathsheba:

1. LR 2/124, 1649, Somerset House: "Be-
rsabe & other naked figures by Arthe-
misia, 60.00.00."
2. Corsham MS, no. 282, "In ye Gallery"
at Somerset House: "Besabe washing
her wth other naked figures done by ar-
themysia Gentilesco. at 60.00.00. Re-
served: in His Highnesses service."
3. "Estat de quelques tableaux exposés en
vente à la maison de Somerset, Mai
1650," memorandum compiled for the
benefit of Cardinal Mazarin as he con-
sidered purchases from Charles I's es-
tate, no. 281: "Lettre F—Bethsabée au
bain, par Gentilesco—Liv. o ster. 60,"
a painting apparently believed to be by
Orazio Gentileschi.

Obviously only one canvas, catalogued vari-
ously as no. 281 and no. 282, was involved. The
presence of several accompanying nudes is ca-
nonical for the iconography of Diana bathing
(although Jacopo Zucchi's panel formerly in the
Wadsworth Atheneum, to cite one example,
indicates that such an arrangement for a *Bath
of Bathsheba* would not have been unprece-
dented). And while Artemisia interpreted the
Bathsheba story numerous times, she likewise
is recorded as having depicted Diana and her
nymphs on three other occasions ([L-26],
[L-27], [L-28]). Artemisia's painting therefore
was probably—although not certainly—a
Diana. Since it does not appear in Van der
Doort's compilations of 1637–39—which, ad-
mittedly, are not complete—it may have been

shipped to London after the artist's return to
Italy about 1640.

BIBLIOGRAPHY: London, PRO, *Pictures Statues
Plate . . . 1649–1651*, LR 2/124, fol. 192r; Millar,
1970–72, p. 316 no. 282, from Corsham MS, Lord
Methuen, fol. 23v; Vertue IV, p. 128, from London,
BM, Addington MS 23,072 (1736), V. 3, BM 22b,
no. 282; London, BM, Harley MS 4898, fol. 231 no.
281; Cosnac, 1884, app., p. 415, no. 281. For Zucchi's
painting: E. Pillsbury in Hartford, Wadsworth
Atheneum, 1991, pp. 258–59.

[L-26] *Diana at Her Bath*
Florence, Palazzo Pitti, Grand Duke Cosimo II
de'Medici of Tuscany, 1619; Petraia, Villa
Medici, Prince Don Lorenzo de'Medici, by
1649, 5 x 4⅓ *braccia* (1619; 2.92 x 2.53 m.)
or 6 x 5 *braccia* (1649; 3.50 x 2.92 m.)

Entered the Grand Ducal Collection on Febru-
ary 28, 1619 (New Style), to be recorded as "Un
Quadro Grande in tela alto B.5, largo B. 4⅓
dipintovi à olio il Bagnio di Diana con più
Ninfe è Donne Ignude al Natur.[e] con una
Grotta hav.to dall'Artim.a Lomi Pitt.ssa: 28
feb.o." Apparently inherited by Prince Lorenzo
from his brother Cosimo, this canvas, its size
said to be larger still, was signaled in May of
1649, following the death of the former, in the
Medici Villa at Petraia: "Un quadro in tela dip-
intovi il Bagno di Diana, con otto femmine che
parte nude, e veduta di paese, con ornamento
tinto di nero filettato d'oro b.6 largo 5 di mano
dell'Artimisia Lomi. . . ." The painting reap-
pears in the Petraia inventory of 1671, but had
been removed from the villa by 1790, the year
of the Lorraine accounting of ex-Medici hold-
ings.

BIBLIOGRAPHY: Florence, AS, Guardaroba Medi-
ceo: no. 373, Inventario Generale, segn. B, 1618
[Florentine Style], fol. 29; no. 628, fol. 4; no. 782
fol. 4; Gregori, 1968, p. 420 n. 19; Borea, 1970, p.
71; idem, 1977, pp. 22–23, 99, 136 n. 5; Garrard, 1989,
pp. 36, 51, 500 n. 75.

[L-27] *Diana at Her Bath, with Actaeon*
Messina, Don Antonio Ruffo and heirs, 1650
(painted 1649–1650); ca. 1750, 8 x 10 *palmi*
(2.04 x 2.55 m., the *palmo* employed by Ruffo
being equivalent to .255 m.)

The documentation published by Vincenzo Ruffo concerning the commission and execution of this large canvas is extraordinarily complete. It is here reviewed in detail in anticipation of the day when the *Diana*, as already (I believe) the *Galatea* for Ruffo (Figs. 195, 196; Color Plate XXII; [49]), reappears, and because it provides a vivid glimpse of the kinds of difficulties experienced by artists in satisfying themselves and their patrons.

The saga begins on February 21, 1649, when Artemisia in Naples received from Don Antonio Ruffo of Messina a letter bearing a bill of exchange in the amount of 100 ducats. This letter, its enclosure, and their raison d'être are explained by Gentileschi's correspondence of March 13:

> Con questa avviso à V. S. Ill.ma haver ricevuto la sua delli 21 di febraro tutta piena di quella gratia, che sol fare V. S. Ill.ma a la serva sua Artemisia, et insieme la inclusa polisa di cambio di cento ducati, sento poi, quel che mi comanda circa l'opera che li devo fare. . . .

On May 24 Ruffo again contacted the artist, as Artemisia declares in a flattering letter of June 5 in which she attributes the still-unfinished state of the painting to her high standards and to the "indisposition" of her model:

> L'human.ma di V. S. Ill.ma de 24 del passato è stata da me ricevuta in quel grado d'osservanza che richiedono le mie molte obligationi che giornalmente si accrescono con l'eccesso delle benigne gratie che ricevo dalla gentilezza di V. S. Ill.ma che dovrà sapere ritrovarsi il quadro più che mezzato con speranza che debbia riuscire di ogni sua sodisfatione e per indispositione della persona di cui mi servo per modello non e à quest'ora tutto finito. . . .

Then on June 12, citing intolerable expenses for nude female models, Artemisia requested an advance of 50 ducats and claimed the existence of eight figures in the painting:

> La setimana passata resi risposta a una sua che ricievette per mano del s.re d. Pietro ora esforzata da duij ocasioni prima per complire presto il suo quadro e secondariamente per non trovarmi denari per finire il detto prego V. S. Ill.ma per

quanto li sono serva che me embie una poliza de cinquanta docati che vista la presente io finirò il quadro perchè le spese son molte per ocasione di tenere queste femine igniude credetemi s.re d. Antonio che le spese sono intolerabili per che se ne espoglino cinquanta e apena gine bona una, in questo quadro non mi posso servire di un modello solo per che sono otto personaggi è bisognia far varie bellezze. . . .

The two payments totaling 150 ducats were duly recorded by Ruffo in his account book under June 22 (see below), and Gentileschi acknowledged that of 50 ducats in a letter of July 24 in which she again pushes back the delivery date of the picture, this time on the grounds that it required three times the effort of the *Galatea*:

> Ò riciuto la gratissima sua con la litera di cambio de lo qual io lo ringrazio sommamente per la prontezza che vego che V. S. Ill.ma mi favorisce—circa poij che io posa fenire il quatro per li dicie del mese entrante è imposibile per che in questo quatro giè da far per tre volte più de la calatea; Io non resto da lavorare continuamente e con ongni [*sic*] prestezza ma però non voglio sia tale che me abi a danegiare en la perfetione de l'quatro per tutto il mese di agosto credo sara fenito.

Two weeks later, on August 7, Artemisia, once more thanking her Messinese patron for the 50-ducat advance, announced the imminent completion of the work, described now as comprising eight figures and two dogs:

> Col la gratissima di V. S. Ill.ma ho ricevuto la poliza delli denari che subito mi sono stati pagati, è le nè rendo singolarissime gratie, e per ora devo dirli che il quatro stà à buon termine, e per l'ultimo del corrente mese sarà finito, otto figure, e dui cani che io stimo più delle figure. . . .

Even this deadline had passed when, citing excessive heat, illness, and the redoing of two figures as necessitated by a change in the perspective system, the painter wrote to Don Antonio on September 4:

Parerà a V. S. Ill.ma strano la tardanza del quadro ma per maggiomente servirla come devo, nel fare il paese tirando il punto della prospettiva è stato necessario rifare due figure, che sono certissima sarà di gran sodisfat.ne e gusto di V. S. Ill.ma che la prego scusarmi, perchè essendo li caldi eccessivi e molte infermità, io procuro conservarmi, e travagliar poco à poco, assicurandola che la tardanza sarà in beneficio grandissimo del quadro e di particolar contento di V. S. Ill.ma. . . .

Weary of waiting for the canvas that he had ordered nine months before, Ruffo fired off a message on October 12, threatening to cut by one-third the agreed upon fee (although at some point during this month—see below—Artemisia got a 25-ducat advance). This is noted by Artemisia in her reply of October 23, in which she declares herself "mortified" by Ruffo's intentions and unable to accept the compromise:

Ho ricevuto la lettera dell'12 del Corrente piena delle sue solite gentilezze mà però mi ha molto mortificato in sentire che Lei me voglia levare del prezzo che l'ho dimandato tanto scarso il terzo della somma del denaro. Il che le dico à V. S. Ill.ma che è impossibile, che io nè possa mancare sè per valore del quadro come della molta necessità che me trovo, che se non fosse ciò ne farei uno presente a V. S. Ill.ma; e mi dispiace che anco la seconda volta habbia dà fare il noviziato bisogna che in petto di V. S. Ill.ma conosca poco merito in me è ueramente havendo visto V. S. Ill.ma che me sono messa alla prima in prezzo bascio concepisca in della sua mente che il quadro non sia meritevolo. . . .

Gentileschi was still adamant on November 13 when she informed Ruffo that she had finished the picture, now said to contain eight figures, two dogs, a landscape, and water:

Circa al quadro, che già stà finito di V. S. Ill.ma non ge posso passare per meno di quello, che hò chiesto perche me sono messa con ogni scarsezza a dimandargli l'ultimo è giuro per quella serva, che gli sono, chel prezzo che gliò fatto non l'havrei fatto meno per mio padre. Sig.re D.

Antonio mio sig.re lo prego per amore di Dio à non levarme quello che lo hò detto che so' secura, che quando lo vedrà dira, che non sono stata impertinente, è l'istesso sig.re Duca suo Nepote giudica, che io voglia gran bene a V. S. Ill.ma per il prezzo che me sono messa gli aricordo solo, che sono otto è due cani è paesaggi è Aque; che V. S. Ill.ma vederà e gè una spesa intolerabile di Modelli. . . .

The canvas was apparently finished but languishing by December (specific day not recorded), when she sent Christmas greetings to Don Antonio and explained the situation:

Auguro le buone festività del Santiss.mo Natale di N. S. a V. S. Ill.ma et infinite appresso e se desidera d'avere il quadro, ricorri a Dio e facci esponere le 4 ore per Messina, perche qui ci reccola la mano dell'Altissimo per placare la mala volontà che tiene il Sig.re Priore verso di me, che dopo havermi condotta al suo volere d'un vilissimo prezzo pensando haver il denaro vista la presente mi straccia e paga di malissimo talento pascendomi di mille faldonie, lo pone fra l'opere antiche, gia che 3 mesi sta verso la Muralia. . . .

Finally the artist and patron came to an understanding, for on April 12, 1650, Artemisia received one last payment, making a grand total of 230 ducats, upon consigning the picture to Don Flavio Ruffo in Naples acting on behalf of his brother. It is with the source of this information that one moves beyond the exchange of letters to the account books (also found by Vincenzo Ruffo) kept by Don Antonio in Messina, and with them to the title of the painting. Thus on folio 152 one reads:

A. 1649 A di 22 Giugno
Artemisia Gentilleschi di Napoli Dare
 Ducati Cento Contanti Rimessoli per
 avanti li Mesi Passati con lettera di
 Jacopo di Battista da Tasca E Maffetti
 dico . . . Dᵢ100
A dì predetto E D.ᵢ 50—Rimessoli sotto
 questo giorno a vista con mia di Cambio
 da Gio: Battista Tasca et Andrea Maffetti
 dico . . . D.ᵢ 50
A. 1650 A dì 30 Aprile E D.ᵢ
 80—Paghattoli in Napoli il S.r Abbate

Don Flavio Mio Fratello per final pagamento del contradetto quadro, come da sua Recevuta sotto li 12 del Istante ap.^{re} al quale Sig.^r Abbate se ne ha dato credito a conto suo in questo e a fol. 146 . . .

D.ⁱ <u>80</u>

D.ⁱ <u>230</u>

E per la detta D.ⁱ venticinque pagati da Scotti e Maffetti . . . D.ⁱ 25

Havere

A. 1650 A dì 30 Aprile D.ⁱ 230— per un quadro consignato in quel locho al Sig.^r Abbate Don Flavio Mio fratello di palmi 8 e 10—nominato *Il Bagno di Diana* come per le sue Recevute delli detti pagamenti Ap.^{re} dico . . . D.ⁱ 230

The last payment was likewise recorded on folio 146:

1650 A dì 30 Aprile E D.ⁱ 80—Pagati ad Artemisia Gentilleschi a compimento di D.ⁱ 230 per uno quadro consignattogli, detto Il Bagno di Diana, come per la Recevuta della detta apare alla quale se ne ha dato debito a conto suo in questo e a f.^o 152 D.ⁱ . . . 80:

It will be observed that with one exception all these transactions are also familiar from the various letters. The exception is the 25 ducats which Don Antonio Ruffo records as having been paid to Scotti and Maffetti. Another notation (fol. 149) clarifies the situation:

Gio. Battista Tasca e Andrea Maffetti di Napoli

Dare

1650 A dì 26 Febraro E d.ⁱ 25—dissero pagati alla S.a Artemisia Gentilleschi nel Mese di Ottobre Passato come per la fede del Banco ap.^{re} dico . . . D.ⁱ 25

As Vincenzo Ruffo has argued convincingly, Don Antonio's bankers in Naples were on April 30, 1650, being reimbursed for 25 ducats which they had given to Artemisia in October of the previous year and which at the later date were being considered, for accounting purposes, as part of the 80-ducat figure. If so, the final payment sent on April 12 to Gentileschi was in reality for 55 ducats.

Lamentably this picture, on which so much physical and psychic energy was expended, has not been discovered. It was among the one hundred prize paintings which, having been designated by Don Antonio Ruffo in 1673 for successive inheritance by the eldest sons of the family, remained together in the Palazzo Ruffo at least until the mid-eighteenth century. However, in Don Antonio's donation the painting is identified as "Il bagno di Diana con 5 ninfe ed Atteone con due cani, 8 x 10 palmi." The presence of seven figures instead of the eight claimed by Artemisia suggests that one figure was in fact *removed* when the perspective was shifted. It is impossible to know whether Gentileschi's canvas survived the earthquake of 1783, was sold after 1818 when the Sicilian laws of *fidecommesso* were rescinded, or was burned in the fire of 1848.

Hersey, following his conviction (with which I have disagreed in the text) that the subject matter of Artemisia's art was in large part conditioned by and read in relationship to the "youthful psychic wound" of her rape, and assuming that the canvas depicted Actaeon being attacked by his dogs, proposes of Don Antonio Ruffo that "it may well have been he who thought Diana [i.e., Artemis] a specially appropriate heroine for Artemisia's brush. In other words, it may well have been the patron who relished a depiction, *by Artemisia Gentileschi*, of divine revenge for ocular rape."

Another, even larger, painting of the Diana and Actaeon theme appears under Artemisia's name in the inventory compiled following the death of the Duca di Frisa in 1680 (next item).

BIBLIOGRAPHY: Ruffo, 1916, pp. 28, 46–52, 315, 376–80; Ruffo, 1919, pp. 48–52; Garrard, 1989, pp. 128, 391–97, 399; Hersey, 1993, p. 324. And [49].

..

[L-28] *Diana and Actaeon*

Naples, Santo Maria Cella, Duca di Frisa, 1680, 13 x 8 *palmi* (3.43 x 2.11 m.)

Before 1656 the Florentine Santo Maria Cella had transferred to Naples, where he served as agent to the Grand Duke of Tuscany while pursuing a lucrative business career. His death in 1680 occasioned an inventory of his collection, in which "Un quadro grande di palmi 13.8 dipintovi Diana, et Ateone con altre figure ignude cornice indorata, originale d'Artemisia"

appears "Nella Gallaria Grande." By way above all of his connections to the Grand Duke, Santo Maria Cella may have become familiar with Artemisia Gentileschi's art prior to his Neapolitan move, and perhaps specifically with the *Diana at Her Bath* by her which had entered the Grand Ducal Collection in 1619 and which in 1649 was signaled in the Villa Medici at Petraia [L-26]. The *Diana and Actaeon* by Artemisia in his own possession may have been close in time to the canvas of this theme which in 1650 the artist had completed for Don Antonio Ruffo of Messina [L-27].

BIBLIOGRAPHY: Labrot, 1992, pp. 144 and 147, from Naples, AS, Notaio Carlo Celso di Giorgio, scheda 358, prot. 34, fol. 4 (allegato al fol. 146v).

..

[L-29] *Ecce Homo*
Naples, Francesco de Palma, Duca di S. Elia, 1716, approx. 4 x 3 *palmi* (1.06 x .79 m.)

For the *Ecce Homo*, one of eight pictures of equal size assigned in 1716 to Artemisia Gentileschi—the others depicting angels with the Instruments of the Passion—see [L-3].

..

[L-30] *Fame*
English Royal Collection, Whitehall, 1637–1639, 1640, 1649, sold 1653, .99 x .74 m.

Catalogued by Abraham Van der Doort between 1637 and 1639 "In *ju M.* longe gallo = rie towards the Orchard" at Whitehall: "Done by Artemesio Gentellesco *baht bij juw M.* Item a woemans picture *pijntit opan de lijeht* in some bluish draperie = with a trumpett in her left hand Signifying ffame with her other hand having a penn to write being uppon a Straining frame painted uppon Cloath. hight 3 f 3— Breadth 2 f 5." Van der Doort's manuscript was in turn the source for Vertue's closely related description published in 1757. An anonymous English author, writing about 1640, provides further information: "A Halfe figure of a Woeman houlding a Trumpett in her left hand, and a penn in her right being called Fame done by Artimesia Gentilisco." The same canvas, it is here argued, was still at Whitehall in 1649 ("Posea w^th a trumpett by Arthemesia 20.00.00"), and was acquired on March 1, 1653

(New Style), by Charles I's creditors Hunt and Bass.

While Artemisia's so-called *Fame* of 1632 (Figs. 121–23; Color Plate XVIII; [27]) conforms neither to the appearance nor to the size of the King's picture, the latter may have been a smaller variation upon the former, as Fröhlich-Bume and Garrard have theorized.

BIBLIOGRAPHY: Van der Doort, 1637–39, ed. Miller (1958–60), p. 46 (from Bodleian Library, Ashmole MS 1514, fol. 61 no. 22) and p. 203 (from Victoria and Albert MS 86 J. 13, fol. 11); London, PRO, *Pictures Statues Plate . . . 1649–51*, LR 2/124, 1649, fol. 190v, and publ. by Millar, 1970–72, p. 312 no. 228 from Corsham MS, fol. 22; Fröhlich-Bume, 1940, p. 169; "Notable Works of Art," 1955, advertising suppl. pl. XIX; Bissell, 1968, p. 159 and n. 51; Garrard, 1989, p. 514 n. 191.

..

[L-31] *Fortune*
Naples, Ottavio Orsini, Conte di Pacentro e Oppido, Duca di Cancellara, Principe di Frasso, 1704, 6 x 5 *palmi* (1.58 x 1.32 m.)

Neapolitan aristocrat and criminal lawyer, Orsini as an art collector had a taste for Caravaggesque painting. Yet the subject of the picture attributed to Artemisia Gentileschi inventoried upon Orsini's death—"Sopra la porta. Un quadro di palmi 6, e 5 con la Fortuna cornice dorata mano di Artemisia"—brings rather the likes of Reni and Vouet to mind.

BIBLIOGRAPHY: Labrot, 1992, pp. 224 and 228, from Naples, AS, Notaio Giovanni Battista Cava, scheda 686, prot. 15, fol. 6 (allegato al fol. 268v).

..

[L-32] *Galatea*
Florence, collection unspecified, seventeenth century

Identified merely as "Una Galatea, dell'Artimisia," this picture may have been executed by Gentileschi in Florence or, perhaps equally as likely, commissioned in Naples by the Florentine Santo Maria Cella, agent to the Grand Duke of Tuscany (see [L-28]). Another mythological painting by her, a *Diana at Her Bath*, entered the collection of Cosimo II de'Medici in 1619 ([L-26]), but Artemisia would later treat in Naples the Diana subject ([L-27],

[L-28]), as she would the theme of Galatea ([49], [L-34], [L-35]).

BIBLIOGRAPHY: Provenance Index, Getty Art Information Program.

...

[L-33] *Galatea*

Messina, Don Antonio Ruffo, painted 1648, 8 x 10 *palmi* (2.04 x 2.55 m., the *palmo* employed by Ruffo being equivalent to .255 m.)

Here identified as the canvas now in the collection of Saul Steinberg at New York (Figs. 195–96; Color Plate XXII; [49]), a collaborative effort by Artemisia Gentileschi and Bernardo Cavallino.

...

[L-34] *Galatea*

Naples, Bernardino Belprato, Conte di Anversa, 1667

Although assigned in the abbreviated inventory reference merely to "Gentileschi" ("La Galatea di Gentileschi con cornice"), this painting in a Neapolitan collection was beyond doubt specifically by Artemisia. Belprato also owned a picture which, recorded as "Gioseppe Giusto di Gentileschi con cornice," was later identified as by Artemisia (see [L-36]). Furthermore, he is documented as having patronized her by a bank transaction dated December 19, 1636, in which the final 20 ducats of a 60-ducat fee were transferred to Gentileschi for a painting she was to deliver (see [L-96]). Inasmuch as Artemisia commanded 160 ducats for the *Galatea* sent to Don Antonio Ruffo ([49]), the payment of 60 ducats is more likely to refer to Belprato's *Gioseppe Giusto* than to his *Galatea*, if in fact it concerns either of these works. There is insufficient evidence to connect this *Galatea* with the version of the theme attributed to Artemisia cited in 1710 as with Don Diego d'Andrea of Naples ([L-35]).

BIBLIOGRAPHY: Provenance Index, Getty Art Information Program.

...

[L-35] *Galatea*

Naples, Don Diego d'Andrea, 1710, 8 x 10 *palmi* (2.11 x 2.64 m.)

Conceivably a copy and certainly related compositionally to Artemisia's *Galatea* for Don Antonio Ruffo of Messina (that is, I believe, to the picture now in New York). For the citation, discussion, and bibliography, see [49]. Evidence that would link Don Diego's picture and the *Galatea* assigned to Gentileschi in the Belprato inventory of 1667 ([L-34]) is lacking.

...

[L-36] *Gioseppe Giusto, Portrait of* (?)

Naples, Bernardino Belprato, Conte di Aversa, 1667, and then Naples, Giovanni Battista Capece Piscicelli, 1690

Beyond much question the painting inventoried in 1667 as "Gioseppe Giusto di Gentileschi con cornice" and that listed in 1690 in a second Neapolitan collection as "Uno quadro di Gioseppe Giusto grande con cornice liscia indorata mano di Artemisia" were identical. Less certain is whether these cryptic references signal a portrait or, employing the word *giusto* in its sense as "highest morality, unbending virtue," designate a canvas of *Joseph and Potiphar's Wife* (a theme sometimes also labeled *La castità di Gioseppe*). Whatever its subject, this may have been the picture which, according to a bank transaction of December 19, 1636, Gentileschi was to deliver to Bernardino Belprato (below, [L-96]).

BIBLIOGRAPHY: Provenance Index, Getty Art Information Program.

...

[L-37] *Guardian Angel*

Florence, Cardinal Carlo de'Medici and subsequently Cosimo III de'Medici, 1666, 1667, 1669, 2½ x 1¾ *braccia* (1.46 x 1.02 m.)

Among the works of art inherited by the Grand Duke Cosimo III from Cardinal Carlo de'Medici, the canvas was listed on August 14, 1666 as "Un Quadro in Tela Alto B.a 2½ Largo B.a 1¾ entrovi un Angelo Custode Vestito di Bianco, che tiene p[er] la mano una Anima dicesi Mano dell'Artimisia con Adornam.to d'Albero tinto di Nero è dorato in Parete." Almost identical entries appear in Medici inventories of 1667 and 1669.

In letters from Naples of July 20, 1635, to Ferdinando II de'Medici, of October 9, 1635, to Galileo in Arcetri, and of October (?) 20 to Andrea Cioli in Florence (see Appendix I), Ar-

temisia mentions two paintings, their subjects unspecified, which she had sent to the Medici Grand Duke. Borea cautiously suggests that the *Guardian Angel* may have been one of them. It should be noted, however, that the presence of the qualifying word *dicesi* in the above-cited inventories casts doubt on the validity of the attribution to Gentileschi. Furthermore, the description fits well the *Guardian Angel*, now known through various copies, painted before 1618 by Antiveduto Gramatica, whose pictures, as least in recent times, have been assigned repeatedly to Artemisia. Baglione referred to Antiveduto's original, in Sant'-Agostino at Rome as late as 1674, as "L'Angelo Custode, che vestito a bianco tiene, e guida un-'anima per le mani."

BIBLIOGRAPHY: Florence, AS, Quardaroba Medi-ceo 758, "Inventario Originale dell'Eredità del Cardinal Decano," 1666, fol. 14 no. 250 (August 14); idem, Guardaroba Mediceo 741, "Inventario Generale a Capi," 1666–68 (1667), fol. 378, and 1669, fol. 385; Borea, 1970, pp. 71–72.
For Gramatica's *Guardian Angel*: Baglione, 1642, p. 293; Papi, 1995, pp. 101–2 cat. 29 and figs. 16, 91, 92, with full bibliography.

[L-38] *Head*
Florence, collection unspecified, seventeenth century

Cited as "Una testa, dell'Artimisia" and conceivably the "Testa di Santa" lent by Ignazio Hugford to a Florentine exhibition of 1767 ([L-74] and [7]).

BIBLIOGRAPHY: Provenance Index, Getty Art Information Program.

[L-39] *Hercules*
Florence, commissioned by Grand Duke Cosimo II de'Medici, 1620

The first and only reference specifically to a *Hercules* by Artemisia for the Grand Duke of Tuscany occurs in an order of January 16, 1619 (Florentine Style), that the artist reimburse the Medici Guardaroba for 1½ ounces of ultramarine which she had received in connection with the painting: "Maᵃ Artimisia Lomi Pittoressa deve dare Adi 16 di Genn.o 1619 l'appiè datoli

p[er] serv. d'un Quadro d'un Ercole che far p[er] S. A. S. al'Quadro _____ oncia 1½ di Azzurro oltramarᵒ fine _____." This expensive pigment had been sent to Gentileschi pursuant to a charge of three days earlier: "dare all'Artemisia Pittoressa un'oncia et mezzo d'azzurro oltramarino p[er] finire un quadro chela cominciata per SAS. . . ." Evidently because Artemisia failed promptly to discharge the obligations, some of her goods were attached as collateral: "Essendo che La Guardaroba di SAS habbia alli giorni passati sequestrato . . . alcune Masser.e et Robe della Artimisia Lomi Pittoressa p[er] ragione di un debito che ha con d.a Guard.ba . . . per valuta di oncia 1½ d'Azzurro oltramarino tutto datoli più fà aconto di un Quadro che doveva far p[er] SAS. . . ." They were released on February 15 when Francesco Maria Maringhi guaranteed delivery of the picture within six months ("si obliga dela dᵃ Artimisia da hoggi @ sei mesi pross.ma futuri haveva consegniato alla d.a Guardaroba il Quadro che si dice di sopra finito Interam.") or to assume the debt himself.

Clearly all three documents, in each of which the ultramarine figures, relate to a single canvas, a *Hercules*. The same should be said of Artemisia's letter of February 10, in the midst of these negotiations, to Cosimo II containing a pledge to send him within a maximum of two months a painting for which she had already received 50 ducats. Thus, suggestions that the aforementioned blue pigment and the correspondence of February 10 pertain to the *Judith Decapitating Holofernes* now in the Uffizi (Fig. 77; Color Plate XII) are invalidated.

The *Hercules* may never have been brought to completion. No record of it has been discovered in later Medici inventories. Conceivably Artemisia found the subject, which certainly served Medici political ends (see Chapter 2), to be unsympathetic, and continued to procrastinate. Furthermore, in her letter of February 10 she also informed Cosimo of a proposed trip to Rome. If this journey soon materialized, the *Hercules* may have been abandoned altogether.

BIBLIOGRAPHY: Florence, AS, Guardaroba Mediceo 360, "Memoriale," 16 di Genn.o 1619, fol. 146; idem, Guardaroba Mediceo 390, inserto 2, 13 di genn.o 1619, fols. 77–78 (replacing older numeration of fols. 87–88) and inserto 5, 15 di febbr. 1619, fol.

455 (replacing older numeration of fol. 293); Crinò, 1954, pp. 205–6 (as from Florence, AS, Mediceo 998, fol. 204); Sricchia, 1963, pp. 251 and 266 n. 24; Gregori, 1968, pp. 419–20 n. 18; Garrard, 1989, pp. 51–52, 500–501 nn. 78–79.

..

[L-40] *Hercules and Omphale*

Madrid, Alcázar Real, Salón Nuevo, 1636 (painted and delivered in 1628), 2.66 m. square

During his years (1626–28) as Philip IV's Ambassador to Rome, the Conde de Oñate ordered at least four pictures on the King's behalf: two by Domenichino and one each by Guido Reni and Artemisia Gentileschi. As the records of Oñate's embassy, discovered by Véronique Gerard, document, Artemisia's canvas was a *Hercules and Omphale*, for which in 1628 the artist—then in Venice—received, 1,467 giulii, 14 baiocchi. Gentileschi's painting, as the others, was destined for the Alcázar in Madrid, where in 1636 it was inventoried in the Salón Nuevo, soon known as the Hall of Mirrors: "Otro del mismo tamano y moldura de la Ystoria de hercules q esta ylando entre unas mujeres ay un cupido que senala lo que esta haçiendo hercules—es de mano de la Gentilezca, Pintora Romana."

Orso has characterized the program of this room as "an elaborate declaration of the Hapsburgs' commitment to defend and to promote Catholicism, a mission that was founded on the conviction that their superior virtues as Christian princes would inevitably prevail." Further:

> Artemisia Gentileschi's *Hercules and Omphale* was strikingly out of place in such company. Evidently it was commissioned to hang as a pendant to the *Ulysses Discovers Achilles* by Van Dyck and Rubens. They were the same size, they were hung together in 1636, and they both portrayed valorous warriors who, for a time, assumed what were traditionally women's roles. Yet Gentileschi's picture posed a problem: Whereas the point of the *Ulysses Discovers Achilles* was that Achilles' heroic nature could not be repressed, the *Hercules and Omphale* depicted an unheroic Hercules overcome by love for Omphale and reduced to spinning thread

meekly among women. However effective a contrast to Achilles that might have made for didactic purposes, it was hardly the image of his presumed ancestor that the King of Spain wanted to promote. When Philip set about refining the New Room in the late 1630s, he may have commissioned the *Hercules and Antaeus* from Rubens [finished by Jordaens and installed in 1641] with an eye to removing Gentileschi's objectionable painting from the ensemble and introducing an image of his ancestor that better suited the propagandistic intent of the program.

The *Hercules and Omphale* does not appear in later inventories of the Alcázar, and may have perished in the fire of 1734. Lurie's suggestion, seconded by Garrard, that Bernardo Cavallino's *Hercules and Omphale* once in a Swiss private collection and with Matthiesen at London in 1986 might reflect Artemisia's version for Spain of the theme is untenable given the date of the latter, but it is possible that Cavallino was familiar with the *Hercules Spinning* inventoried in 1699 as by Gentileschi in the Neapolitan collection of D. Alfonso de Cárdenas (next item). These last statements assume, of course, that two distinct paintings are in question.

BIBLIOGRAPHY: Gerard, 1982, pp. 11–13, as from Archivo General de Simancas, Tribunal Mayor de Cuentas, 2633; Pérez Sánchez, 1965, p. 501; M. C. Volk, "Rubens in Madrid and the Decoration of the Salón Nuevo in the Palace," *Burlington Magazine*, CXXII (1980), 180, from Madrid, Archivo de Palacio, Sección Administrativa, leg. 768; Steven Orso, letter to the author, February 9, 1983; Percy/Lurie, 1984, pp. 93 cat. 22 and 186–87; S. Orso, *Philip IV and the Decoration of the Alcázar of Madrid*, Princeton, N.J., 1986, pp. 55, 107, 109–10, 113, 190 no. 16; Garrard, 1989, p. 511 n. 164.

..

[L-41] *Hercules Spinning*

Barra (Naples), Alfonso de Cárdenas, heir of Carlo de Cárdenas, Conte di Acerra and Marchese di Liano, 1699, 8 x 10 *palmi* (2.11 x 2.38 m.)

Cited as "Un quadro di palmi 8 e 9 con cornice intagliata e indorata entrovi Erchole che fila, mano d'Artemisia Gentilesca," the painting

figured among the goods passed down from Carlo de Cárdenas (d. 1691), Count, Marchese, Grandee of Spain, and Prince of the Holy Roman Empire, whose Spanish family had settled in Naples already under the Aragonese and who had himself been the beneficiary of an extensive art collection. It is possible—although the recorded sizes do not agree—that Gentileschi's *Hercules and Omphale*, painted in 1628 for the Alcázar at Madrid but seemingly iconographically unsuited to its location and absent from Spanish records after 1636 [L-40], came into the possession of the Cárdenas of Naples by way of Royal gift. Even if two paintings are at issue, it is likely that they were closely related compositionally.

BIBLIOGRAPHY: Labrot, 1992, pp. 202 and 206, from Naples, AS, Notaio Biagio Domenico de Conciliis, scheda 399, prot. 49, fol. 18 (allegato al fol. 630v).

[L-42] *Holy Family with Saints Elizabeth and Zacharias*
France (?)

A folio print by Pieter de Jode II of this subject, said to be inscribed "Artemesia Gentileschi p.," is cited by Le Blanc, Würzbach, and Hollstein. Efforts to locate an example of the engraving have been unsuccessful; one suspects, given the presence of Zachariah and Elizabeth, that the young Saint John was also depicted. Pieter de Jode II (1606–74) likewise engraved a *Child Sleeping near a Skull* (inscribed "Artemisia Gentilesca pinxit Napoli"), as did Jean Ganière (Figs. 112, 113, [23]). Inasmuch as the Ganière version was printed in France in 1640, and de Jode is known to have been in Paris in 1631–32 (in 1632 he engraved Simon Vouet's *Holy Family with the Bird*, for example), Artemisia's *Holy Family* may have been in a French collection, perhaps even as early as 1624–26 during the time of Orazio Gentileschi's Parisian stay, or may be connected with Artemisia's claim on October 9, 1635 (see Appendix I), that she had been patronized by the King of France. The issue is complicated, however, by the scant biographical details concerning the above-named graphic artists.

A "Gentileschi" *Holy Family*, owned by

William Morton Pitt and sold to Spackman for £6.6, was auctioned at Christie's–London (Lot 100) on June 1, 1811.

BIBLIOGRAPHY: Le Blanc, 1856, II, p. 430 no. 5; A. von Würzbach, *Niederländisches Künstler-Lexikon*, Leipzig and Vienna, 1906, I, p. 759 no. 2; Hollstein, IX, n.d., p. 210 no. 5; B. Fredericksen, ed., *The Index of Paintings Sold in the British Isles During the Nineteenth Century: 1811–1815*, III, pt. 1, Munich, London, New York, Paris, 1993, p. 425.

[L-43] *Holy Virgin* (half-length)
Naples, Giovanna Battista d'Aragona Pignatelli, Duchessa di Terranova e Monteleone, 1723, 5 *palmi* high x 3½ *palmi* wide (1.32 x .92 m.)

Characterized by Labrot as a "strange and haughty woman," the highly placed Duchessa left a huge collection upon her death in 1723. Among the pictures: "Due quadri di palmi cinque lungo, e palmi tre e mezo largo l'uno, con due meze figure, una con la Madonna e l'altro una Vergine, uno copia di Luca Giordano e l'altro mano di Artemisia, sue cornice di pero negro con duoi stragalli, intagliati, et indorati." Within their context, the words "una Vergine" may be taken as designating a painting of some virgin martyr—Catherine, Cecilia, Lucy, etc. One thus recalls Dominici's praise of Artemisia Gentileschi's talent as a creator of "mezze figure di sante Vergini. . . ." [L-72].

BIBLIOGRAPHY: Labrot, 1992, pp. 309 and 324, from Naples, AS, Notaio Giuseppe de Vivo, scheda 714, prot. 30, fol. 98v (allegato al fol. 348v).

[L-44] *Holy Virgins* (two paintings)
Naples, Salvatore Ciavarella, 1707, 2 *palmi* x 1½ *palmi* (.53 x 40 m.)

The citation—"Due quadri di vergini d'artemisia di palmi 2 e 1½."—brings to mind additional references to now-lost pictures by Gentileschi and Dominici's tribute to her skill in this genre ([L-43], [L-78], and [L-72]).

BIBLIOGRAPHY: Provenance Index, Getty Art Information Program.

[L-45] *Joseph and Potiphar's Wife*
Naples, studio of the artist, 1651, approx. 8 x 10 *palmi* (2.11 x 2.64)

Half-finished on January 1, 1651, when announced together with an *Andromeda Liberated by Perseus* [L-2] in a letter from Artemisia to Don Antonio Ruffo of Messina: "mandai a dire nel altra mia a V. S. Ill.ma come havevo due quadri della medesima misura della Galatea [49] che sono mezzi fatti . . . è la historia di Gioseffo che la moglie di buttifar li fa forza con bellissimo leto di drappi et bellissima prospettiva di pavimento. . . ." Gentileschi proposed to complete both canvases by April or sooner, were Ruffo to advance her 100 ducats of the fee of 90 scudi (= ducats) per painting. There is no indication that either work entered Don Antonio's collection. It is surprising, in light of Artemisia's specializations in male–female interactions and the female nude, that paintings of these subjects by her are not otherwise signaled by the sources (unless the "Gioseppe Giusto" recorded in 1667 and again in 1690—[L-36]—in fact represented this theme).

BIBLIOGRAPHY: Ruffo, 1916, p. 53 incl. n. 5; Garrard, 1989, pp. 400–401.

[L-46] *Judith*
Naples, D. Cesare di Gennaro, Principe di San Martino, 1646, 5 x 6 *palmi* (1.32 x 1.58 m., including the frame?)

Inherited by the Pio Monte della Misericordia at Naples upon the death of D. Cesare di Gennaro, Principe di San Martino, on September 11, 1646, and described as "Una Gioditta de palmi 5 e 6 con cornice indorata de mano d'Artemisia Gentileschi." Since many of the canvases among D. Cesare's holdings were unattributed, the ascription to Artemisia should be given credence. The painting was then among the select works evaluated independently on November 17, 1646, by Filippo Vitale and Andrea Abate for subsequent sale by the Monte: "Una Giuditta di 5 e 6 con cornice indorato mano d'Artemisia Gentileschi. . . . 40 (40–50)." It is therefore possible, perhaps even likely, that the *Judith* of the same dimensions which in 1648 formed part of the bequest of Giuseppe Carafa (see the discussion under

[L-48]) was the ex-Gennaro picture. It remains an open issue as to whether Artemisia's painting now at Capodimonte (Fig. 21; Color Plate II) is the work cited in one (or both) of these inventories (see [4]). A now lost *Judith* by Artemisia would not qualify if the copy of it (Fig. 150; [34]) was of the same size (.75 x .92 m.) as the original.

BIBLIOGRAPHY: C. Paolillo, "Un inventario dei beni del principe di San Martino redatto da Filippo Vitale ed Andrea Abate," *Ricerche sul '600 napoletano*, 1985, pp. 113–14, 116 n. 1, 119, 128, as from Naples, Archivio del Pio Monte della Misericordia, fasc. De Gennaro, cat. B, reg. n. XIV, numero progressivo 27; Contini in Contini/Papi, 1991, p. 124.

[L-47] *Judith Decapitating Holofernes*
Naples, Casa Colonna, 1688, 5 x 7 *palmi* (1.32 x 1.85 m., format unspecified)

Among the works inherited by Giuliano Colonna from the estate of Ferdinand Vandeneynden in Naples and attributed in 1688 to Orazio Gentileschi, this painting is here discussed in connection with Artemisia's canvas now at Capodimonte (Fig. 21; Color Plate II; [4]), with which it may or may not be identified.

[L-48] *Judith*
Naples, Giuseppe Carafa dei Duchi di Maddaloni (1648) and Eleonora Carafa (1649), 6 x 5 *palmi* (1.58 x 1.32 m.)

In violent ending to a life of illegal activities, imprisonment, and betrayal, all in the face of his high aristocratic position, Giuseppe Carafa was beheaded by the Neapolitan populace on July 10, 1647. With a taste in painting which, as the postmortem inventory of 1648 indicates, favored the *Caravaggeschi*, he owned a *Judith* by Artemisia Gentileschi: "Una Giuditta della medesima misura [sei palmi e cinque] di mano di Artemitia Gentilesca con cornice inorata, et intagliata." Upon the instance of D. Domenico Carafa, son and heir to D. Giuseppe and D. Eleonora, a second inventory was compiled in 1649, Gentileschi's picture appearing now as merely "Uno quatro di Giuditta di mano d'Artemisia." The Carafa *Judith* was therefore the same size as that which in September of 1646 had passed from D. Cesare di Gennaro of Na-

ples to the Pio Monte della Misericordia and which two months later was evaluated for sale by the Monte [L-46], from which Giuseppe Carafa might easily have acquired it. Yet the lack of specificity regarding the moments in the Judith story thus depicted and of the formats (horizontal or vertical), as well as the suspicion that the measurements of the Gennaro/Monte canvas might have included the frame, prevent one from declaring unequivocally that all the citations are to a single picture. Even less definable is the status of Artemisia Gentileschi's *Judith* at Capodimonte with respect to these records (Fig. 21; Color Plate II; [4]).

BIBLIOGRAPHY: Labrot, 1992, pp. 75, 77, 82, as from Naples, AS, Notaio Carlo Piscopo, scheda 1034, prot. 21, fol. 243, and Notaio Carlo Piscopo, scheda 1032, prot. 21, fol. 295.

..

[L-49] *Judith Triumphant, with the Head of Holofernes*
Naples, Antonio Maria Lumaga, 1743, 11 *palmi* x 10 *palmi* (2.90 x 2.64 m.)

The painting figures among the Lumaga holdings as "Un quadro di Artemisia Gentileschi rappresentante Giuditta trionfante con la testa d'Oloferne di palmi 11 e 10 con cornice indorata, dicono esser bene antico." Taken literally, the citation implies an image of Judith triumphantly holding aloft Holofernes' head in the manner of Bernardo Cavallino's canvas in the Museo di Capodimonte at Naples or, if not, at least of the restrained presentations of Massimo Stanzione's pictures in the Museum of Fine Arts at Boston and the Metropolitan Museum of Art at New York. Conversely, while the large scale of the work demands a full-length figure, there is nothing in the description of the Lumaga example that clearly evokes any of Artemisia's known variations on the Judith theme (none of which matches this work in size).

BIBLIOGRAPHY: Provenance Index, Getty Art Information Program.

..

[L-50] *Lot and His Daughters*
Naples, Casa dei Carafa San Lorenzo, Nicola Pietro Carafa, 1786 and later, 6 x 8 *palmi* (1.58 x 2.11 m.)

Obtained from the della Quadra family through marriage, the picture is given to Artemisia in the Carafa inventory of 1786 ("Un altro rappresentante Lot colle sue figlie di palmi sei, ed otto per traverso, d'Artemisia Gentilesca con cornice come sopra [al modello di rosa indorata a mistura]") and in listings of 1837, 1856, and 1857. In the seventeenth century, however, it bore the less prestigious attribution to Francesco Antonio Giannone. Since the later attributions are invariably overly optimistic (Ruotolo), the assignment to Gentileschi of the *Lot*—as with the *David and Abigail* [L-19] and the *Death of the Firstborn Sons of Egypt* [L-24], also in the Carafa Collection—is suspect. This canvas cannot be identified with the larger and vertically oriented painting in the Toledo Museum of Art (Figs. 163–66; Color Plate XX; [39]).

BIBLIOGRAPHY: Ruotolo, 1974, pp. 161–63, 167, the documents from Naples, AS, Archivi Privati, Carafa San Lorenzo, carte 4.

..

[L-51] *Lot and His Daughters*
Naples, Luigi Romeo (?), life-size figures

Cited by Dominici ("Di questa virtuosa donna è eziandio un S. Michele Arcangelo, che discaccia Lucifero dal Paradiso, ed un Loth con le figliuole, e tutti alla grandezza del naturale"), this *Lot* has here been identified as in all probability the impressive canvas in the Toledo, Ohio, Museum of Art (Figs. 163–66; Color Plate XX; [39]).

..

[L-52] *Lucretia*
Naples, Davide Imperiale, 1672, 5 *palmi* high x 4 *palmi* wide (1.32 x 1.06 m.)

A member of the Genoese banking family resident in Naples, Davide Imperiale died without issue in 1672, his inheritance passing to his sister Maria Caterina Imperiale Grimaldi, Marchesa di Petra. At least in number, four pictures assigned to Artemisia Gentileschi dominated the collection: companion canvases of a *Head of the Young Christ*, and a *Head of the Madonna* [L-16], a *Saint Mary Magdalen* [L-80], and this *Lucretia*, described as "Una lucretia della medesima [Artemisia Gentileschi], grande come la

sudetta [alta cinque larga quattro]." No canvas among the extant pictures by Gentileschi of the Lucretia theme (Figs. 19, 190; Color Plate III) or among those cited elsewhere in the literature ([L-53] and [L-54]) can be shown to be identical to the version here under consideration.

BIBLIOGRAPHY: Labrot, 1992, pp. 118 and 139, from Naples, AS, Notaio Domenico Cardamone, scheda 1221, prot. 32, fol. 34

..

[L-53] *Lucretia*
for Prince Karl Eusebius von Liechtenstein, 1636, 11½ *palmi* (3.04 m.) high

To be consigned together with canvases of *Bathsheba* and *Susanna* to Prince Karl Eusebius von Liechtenstein's Neapolitan representatives, from whom on May 5, 1636, Artemisia received 250 ducats as final payment on a contract of 600 ducats. The document of disbursement, quoted and discussed under [37], cannot be connected—or so it would appear—with any of Gentileschi's extant pictures of these subjects.

..

[L-54] *Lucretia*
in Venice by 1627

Three verses, published anonymously in Venice in 1627 but in all probability the efforts of Giovanfrancesco Loredan (see [L-1]), are dedicated to this painting:

LUCRETIA ROMANA
*Opera della Sig. Artemisia Gentileschi
Pittrice Romana in Venetia*
>Stringe il ferro, e minaccia
>A l'amata costante
>Morte, e vergogna il furioso amante.
>Ella sospira, e geme,
>E 'l morir nò, ma l'ignominia teme:
>Poiche vil servo ignudo
>(Ond'altri rea la creda)
>Vuol uccider con lei, quasi suo drudo.
>Ahi, convien, ch'al fin ceda:
>Ma poi torrà con generoso sdegno
>A sé la vita, et à l'amante il Regno.
Nel medesimo soggetto
>O Meraviglia nova!
>Ben è la tua, più ch'altra, iniqua stella,
>Donna famosa, e bella.

>Ti lodò Collatino:
>Ti minacciò Tarquino:
>Pinge il caso Artemisia, e lo rinova:
>Già Roma il ferro insanguinar ti vide:
>Hor più del ferro il suo pennel
> t'uccide.
Nel medesimo soggetto
>Dimmi, chi più t'offende
>Casta Donna infelice:
>Il marito, l'amante, o la pittrice?
>Amor, furor, virtute
>Egualmente contende,
>Donna, la tua salute;
>E congiurati sono à i tuoi dolori
>Le lodi, le minaccie, et i colori.

The verses confirm a trip by Artemisia to Venice and suggest a most forceful pictorialization of the suicide. In the text I have questioned Garrard's view that they also express the male writer's uneasiness at his thought that a woman artist has offered an interpretation in which "the heroine is conspired against by the painter along with the husband and lover, and she is done in by the artist's brush as much by the bloody knife."

BIBLIOGRAPHY: Toesca, 1971, pp. 90–91; Garrard, 1989, pp. 172–73. And [L-1].

..

[L-55] *Madonna*
Florence, collection unspecified, seventeenth century

The abridged reference—"Una Madonna grande, dell'Artimisia"—permits no conclusions.

BIBLIOGRAPHY: Provenance Index, Getty Art Information Program.

..

[L-56] *Madonna*
Giangerolamo II Acquaviva, Conte di Conversano, 1666

With the exception of a small number of paintings identified as by Artemisia Gentileschi, Stanzione, Reni, and Caracciolo, the inventory taken in 1666 of the late Count's vast collection lists pictures anonymously. Thus the attributions to "Artemitia Gentilesca" of "La carità" [L-10] and of "un altro colla Madonna" may have been just.

BIBLIOGRAPHY: Ruotolo, 1977, p. 73, incl. n. 18, as from Naples, AS, Notaio Giov. Batt. dell'Aversana, XVII sec., scheda 295, prot. 40, fol. 588 ff.

[L-57] Madonna

Naples, Ettore Capecelatro, Marchese di Torella, 1655

Recorded in 1655 among the possessions of the recently deceased aristocrat, lawyer, and governmental figure Ettore Capecelatro and of Ottaviano Capecelatro *juniore*: "Un'altro quadro più piccolo con la Madonna d'Artemitia." However, when in 1659 Ettore's inheritance was reinventoried (under the stamp of a second notary) preparatory to its division, "Una Madalena" by Gentileschi, not a *Madonna*, was cited [L-81]. It is easier to assume a slip of the pen or other carelessness in identifying the subject, either in 1655 or 1659, than it is to postulate that in the intervening few years one picture by Artemisia was disposed of by the family and another acquired. Certainly there is no reason to believe that between these dates the *Madonna*—if that is what it was—passed to Giangerolamo II Acquaviva, Conte di Conversano, in whose collection a *Madonna* by Artemisia is listed in 1666 [L-56].

BIBLIOGRAPHY: Labrot, 1992, pp. 101 and 102, from Naples, AS, Notaio Carlo Piscopo, scheda 1032, prot. 21, fol. 412v.

[L-58] Madonna

Naples, studio of the artist, January 1, 1651, small-scale and on copper

Here identified as the *Madonna and Child* now in the Escorial (Fig. 198; [51]).

[L-59] Madonna (Head of)

Naples, Davide Imperiale, 1672

See the entry for its companion picture, the *Head of the Young Christ* [L-16].

[L-60] Mystic Marriage of Saint Catherine

Madrid, Marqués de la Hinojosa, 1626

During his trip to Spain in 1626 in the entourage of Cardinal Barberini, Cassiano dal Pozzo recorded as by Artemisia a *Mystic Marriage of Saint Catherine* in the Madrid collection of the Marqués de la Hinojosa. Inasmuch as Cassiano may have played a role in obtaining for Gentileschi the Spanish commission for the *Hercules and Omphale* [L-40], paid for in 1628, and was to serve as the intermediary between the artist and the Barberini during the 1630s (see Appendix I and [L-15]), he might be expected correctly to have recognized a painting by Artemisia. Yet the subject of the *Mystic Marriage of Saint Catherine* would be unusual for Gentileschi, whereas it was a special favorite with Bartolomeo Cavarozzi (ca. 1590–1625), who visited Spain in 1617–19 and who produced several versions of that theme, two of which are in Madrid (Prado and Academia de San Fernando). Perhaps by 1626 Cassiano was only vaguely familiar with Artemisia's Roman manner and mistook one of the Cavarozzi examples (or one of the copies after them) as her work. Revealingly, some of Bartolomeo's paintings, including the Prado *Mystic Marriage*, were in the past misattributed to Orazio Gentileschi, to whom he was deeply indebted.

BIBLIOGRAPHY: Gerard, 1982, p. 12, as from Biblioteca Vatican, Barb. Lat. 5689. For information on Cavarozzi relevant to the argument presented here, see A. E. Pérez Sánchez, *Borgianni, Cavarozzi, y Nardi en España*, Madrid, 1964, pp. 222–23, 47, and pls. 18, 19b, 20; Spear, 1971, pp. 80–81 cat. 20; and Bissell, 1981, pp. 70–71, 95–96 nn. 56–57.

[L-61] Portrait of Artemisia Gentileschi (Self-Portrait?)

Seville, Casa de Pilatos, Duque de Alcalá, acquired between 1629 and 1631

Purchased in Italy, and surely specifically in Naples, by Fernando Enríquez Afán de Ribera, Third Duque de Alcalá, during his tenure as Viceroy (July 1629–May 1631), and recorded in an inventory compiled in November of 1637 of the Casa de Pilatos: "Tercera quadra que sale la puerta al corredor del Jardin"—"Un rretrato de Artemissa gentilesca q vino en el enrollado segundo de et caxon n.° 7." The citation of the crate number indicates that the acquisition of the painting was effected during Alcalá's viceroyship rather than in 1625–26 (cf. [16], [L-14], and [L-20]) when the Duke served as Ambas-

sador to the Holy See. Brown and Kagan speculate that the canvas was a *Self-Portrait*. However, the context in which it appears (the same crate, for example, contained "Un rretrato de Torcata el tasso," unattributed but obviously not executed by that famous writer), and the presence also in the Casa de Pilatos of another "Retrato de Artemissa gentilesca" ([L-62]), raise strong doubts regarding Artemisia's authorship.

"Una copia ó retrato de Artemisia de tres cuartes maltratado," listed as in the library in the 1751 inventory of the Duque de Medinaceli, heir to the Casa de Pilatos, is either [L-61] or [L-62].

For paintings assigned directly to Gentileschi that belonged to the Third Duque de Alcalá, see [16], [L-14], and [L-20].

BIBLIOGRAPHY: Engel, 1903, pp. 259, 261; Brown/Kagan, 1987, pp. 236, 243, 249 no. 10, the original in Madrid, Archivo Zabálburu y Basabe, leg. 215, no. 1.

[L-62] *Portrait of Artemisia Gentileschi (Self-Portrait?)*
Seville, Casa de Pilatos, Duque de Alcalá, acquired between 1629 and 1631

As the "rretrato de Artemissa gentilesca" discussed in the previous entry, an acquisition of the Third Duque de Alcalá during his Viceroyship to Naples (July 1629–April 1631) and one of the paintings included in the 1637 inventory of the Casa de Pilatos: "Quadra Segunda donde dormia su Exª"—"Retrato de Artemissa gentilesca pintora Romana vino en el enrollado dho. [i.e., "el enrollado segundo de los 16 liencos caxon n.º 7," as recorded in the item preceding it]." The tentative identification of this picture as a *Self-Portrait* must also be called into question for the reasons advanced under [L-61], where the possibility is raised that it is the "copia ó retrato de Artemisia" that figured in the Duque de Medinaceli's inventory of 1751. See also [16], [L-14], and [L-20].

BIBLIOGRAPHY: Brown/Kagan, 1987, pp. 236–43, 249 nos. 16 and 17 and n. 74, the original in Madrid, Archivo Zabálburu y Basabe, leg. 215, no. 1.

[L-63] *Portrait of the Cleric Artigenio*
Rome, 1611

Interrogated on May 14, 1612, during the trial of Agostino Tassi for having raped her in the spring of the previous year, Artemisia was subjected to questions submitted by Tassi concerning one Artigenio and a portrait she was reported to have painted. Earlier (April 8) Tassi had described Artigenio as "a tall young man, dressed in a long silk robe and with a scanty red beard," and claimed (April 12) that he had seen this cleric following Artemisia. Artemisia in turn identified Artigenio as a procurator to Cardinal Tonti and a friend of Tuzia, the woman who with her family had shared the Gentileschi lodgings on Via della Croce between April 10 and June 16, 1611 (see Appendix I). As to the portrait, painted in Tuzia's apartment, she replied: "Yes, Sir, I was sought out to do a portrait for a woman whom he [Artigenio] said was his beloved, and I did it. What do you want to say about that? And it was Tuzia who sought me out to do this portrait (*Signor sì che fui ricercata a fare un ritratto per una donna che diceva essere sua innamorata et lo feci et che volete voi dire per questo et fu Tutia che mi ricercò a fare questo ritratto*)." Artigenio's employer, Cardinal Tonti, was also Tuzia's godfather.

Neither the wording nor the full context of Artemisia's response supports Garrard's reading as "a portrait *of* [italics mine] a woman whom he said was his beloved," although both Berti and Papi have recently interpreted the testimony in the same way. Tassi, after all, was attempting to compromise Artemisia by implying that there was something suspect in her having painted Artigenio's likeness.

The matter was not immediately dropped. In a deposition taken on June 8, Nicolo Bedino Felice of Pesaro, a painter and former *garzone* to Orazio Gentileschi, featured Artemisia as a woman of loose morals who sent letters to Artigenio and a Geronimo Modenese and repeatedly entertained them in her home with touches and kisses. Bedino's testimony on Tassi's behalf, demonstrably perjured, follows an all too familiar pattern. The existence of the portrait, however, cannot be doubted.

BIBLIOGRAPHY: Menzio, 1981, pp. 96, 100, 123, 151, 153–54; Garrard, 1989, pp. 450, 451–52, 462–63, 478,

479, 480; Papi in Contini/Papi, 1991, p. 50; Berti, ibid., p. 18.

..

[L-64] *Portrait of a Duchess*
1630

Cited in a letter of December 21, 1630, from Artemisia in Naples to Cassiano dal Pozzo in Rome: "Nel mio ritorno in Napoli d'onde son stata assente molti giorni con occasione di servire una sig. duchessa del suo ritratto, ho ricevuta la gentilissima di V. S. . . ." The portrait must have been painted during the preceding few weeks; certainly it was executed after Artemisia's correspondence to Cassiano on August 31, 1630 (see Appendix I), in which she asks his help in the matter of Diego Campanile(i), assistance for which she then expresses her gratitude on December 21. The sitter is not otherwise identified, and thus it would be pure speculation to recognize her as the subject of the *Portrait of a Noblewoman* now in Princeton (Fig. 120; [26]).

BIBLIOGRAPHY: Bottari/Ticozzi, 1822, I, p. 350 CXXIX; Garrard, 1989, pp. 378–79.

..

[L-65] *Portraits of English Royalty and Nobility*
1638–1640

Walpole's claim that while in England Artemisia Gentileschi "drew some of the royal family and many of the nobility" was probably based on inference rather than upon actual knowledge. Notwithstanding, it would be surprising if Artemisia, extolled in her day as a portraitist, had not practiced this aspect of her craft in England.

BIBLIOGRAPHY: Walpole, 1765, II, p. 130.

..

[L-66] *Rape of Proserpina*
Florence, Palazzo Pitti, Medici Collection, large scale

Baldinucci saw in the "Palazzo Serenissimo" Artemisia's *Judith Decapitating Holofernes* (Figs. 77–79; Color Plate XII; [12]) and also by her "a very large work [representing] the Rape of Proserpina with a great number of figures

made in very good style [or taste: *gusto*]." Alessandro da Morrona was unable to confirm the existence of this picture, which may have been one of the two large paintings sent to Grand Duke Ferdinando II in 1635 and signaled by Artemisia in letters to the Grand Duke on July 20, 1635, to Galileo in Arcetri (October 9), and to Andrea Cioli in Florence (October ? 20). If so, the loss of this precisely datable, multifigured, and no doubt action-packed composition is especially to be lamented.

BIBLIOGRAPHY: Galilei, 1905, XVI, pp. 318–19; Crinò, "More Letters," 1960, p. 264, as from Florence, AS, Medici 1416, inserto 8, fol. 748; Baldinucci, ed. 1702, p. 293; Morrona, 1792, II, pp. 268–69; Longhi, *Scritti*, I–I, p. 281; Garrard, 1989, p. 500 n. 76; Fuda, 1989, pp. 170–71, as from Florence, AS, Medici 4157, fols. 194–94v. See also [36].

..

[L-67] *Sacrifice of Isaac*
Naples, Vincenzo d'Andrea, 1649, 4 x 3 *palmi* (1.04 x .79 m.)

Listed with a *Saint Cecilia*, also ascribed to Artemisia Gentileschi, in the "Inventario dei beni mobili, stabili et dell'annue entrate che si possiedono per me Vincenzo D'Andrea fatto per osservanza dall'ordine di Sua Maestà a Primo settembre 1649": "Uno del sacrificio d'Abramo di palmi 4 e 3 di mano di Artemisia Gentileschi con cornice d'oro et un altro picciolo di 2 e 3 di S. Cecilia dell'istessa." Vincenzo d'Andrea, a lawyer and key participant in the revolutionary movement in Naples, died in 1650, his collection apprently dispersed through sale or subdivision. Although the attribution to Artemisia of a painting of this otherwise popular Baroque subject is somewhat surprising, there is no independent reason to question its accuracy.

BIBLIOGRAPHY: Pacelli, 1987, pp. 145–46, 148, 150, as from Naples, AS, Coll. Div. II fs 16.

..

[L-68] *Saint Apollonia*
Medici Villa Imperiale, by March 1625, oval on copper, less than 1 *braccia* (.584 m.) high

Described in the "Inventario Originale, Debit.i e Crediti, della Villa Imperiale" begun on

March 17, 1624 (Florentine Style), as "Un Quadretto di B. 1 inc.a alto con adornam.to d'ebano e legnio pardo dentrovi Un'ovato dipinto su Rame Una Santa appollonia di mano dell'Artimisia Lomi pitt.a." This picture of the third-century virgin martyr (said by Voragine to have been "far advanced in years," but invariably represented as youthful) surely belonged to the artist's time (ca. 1613–20) in Florence, where Artemisia used her paternal surname Lomi and where Saint Apollonia was especially venerated. The Saint probably held the traditional symbols of her torture, pincers gripping one of her teeth. There is insufficient evidence to identify this work as the *Testa di Santa*, the property of Ignazio Hugford, which was exhibited in Florence in 1767 [L-74] and which may be the *Female Martyr* now in New York (Fig. 56; Color Plate VI; [7]).

BIBLIOGRAPHY: Florence, AS, Guardaroba Mediceo 479, 17 di marzo 1624 [Florentine style], fol. 19v; Gregori, 1968, p. 419 n. 18; Voragine, ed. 1969, p. 164.

[L-69] *Saint Catherine*
offered to Andrea Cioli, Florence, 1635 and 1636

In gratitude for his past and—she hoped—future efforts in obtaining for her the patronage of the Grand Duke of Tuscany, Artemisia offered (letter from Naples on December 11, 1635) to present to the Duke's Secretary in Florence, Andrea Cioli, a painting of Saint Catherine by her hand which she had finished some time before ("un quatro che un pezzo fa ho finito con l'Imagine di Santa Caterina dedicato per V. S. Ill.ma come per un altra mia li scrissi mesi sono . . ."). In a follow-up letter dated February 11, 1636, the artist sought Cioli's instructions as to whether the picture should be shipped to him or delivered in person. Borea is inclined to identify as this proposed gift the *Saint Catherine* in the Uffizi (Fig. 224), but as argued under [X-26] the Uffizi canvas is in all likelihood by Francesco Furini.

BIBLIOGRAPHY: Crinò, "More Letters," 1960, pp. 264–65, as from Florence, AS, Mediceo 1416, inserto 8, fol. 780 and inserto 9, fol. 860; Garrard, 1989, pp. 375, 385–86; and [X-26].

[L-70] *Saint Catherine and an Angel with a Fiery Sword*
Madrid, Conde de Monterrey, 1653; subsequently Marqués del Carpio y de Heliche, and Casa de Alba, large-scale

D. Manuel de Fonseca y Zúñiga, Conde de Monterrey and brother-in-law of King Philip IV's former minister the Conde-Duque Olivares, died on March 22, 1653. In an inventory of his goods begun four days later there appears under no. 169 "Un quadro [*sic*] de Santa Catalina [English: Catherine], de Artemisia con un Angel que tiene una espada de fuego, con marco negro [in a black frame] T. 800 rs. [tasación 800 reales]." Artemisia's painting undoubtedly formed part of the treasure trove which the Conde de Monterrey had shipped with him upon his return to Spain from Italy, where he had served as Ambassador to the Holy See (1628–31) and Viceroy of Naples (1631–37). It may have been commissioned in Naples directly from the artist.

Upon Monterrey's death, his title and holdings passed to his nephew, D. Luis Méndez de Haro y Guzmán, Marqués del Carpio, then to the latter's son, D. Gaspar de Guzmán, Marqués del Carpio y de Heliche, and then to the Casa de Alba. That Artemisia's *Saint Catherine* figured in these inheritances—as Pérez Sánchez and Garrard have suggested—is indicated by a document belonging to the Alba (see below, *Discursos*) in which are listed pictures formerly the property of the Marqués del Carpio, among them "*Santa Catalina* (Cuadro grande de Artemisa Gentileschi (?)). Tasado en 1.100 reales. El Marqués de Liche [Heliche] pidió per él a Pasca 800 reales para los gastos urgentes del Buen Retiro."

There has been understandable uncertainty as to the correct interpretation of the last part of this document. It may be posited that Artemisia's work, assessed at 800 reales, was offered by the Marqués del Carpio y de Heliche to the Spanish court as a much-needed contribution to the defrayment of expenses accrued at the Buen Retiro. There is no independent evidence that the painting ever entered the Royal Collection; it may be that, for whatever reason, this offer was declined or that the painting was accepted and then immediately sold for cash.

Ainaud, being familiar only with the Mar-

qués del Carpio citation, supposed that the canvas there attributed to Gentileschi might be identified as the copy of Caravaggio's *Saint Catherine* (Lugano, Thyssen-Bornemisza Collection) in San Jerónimo at Madrid. Garrard is puzzled by its description in the Monterrey inventory. Yet while this particular iconography of Saint Catherine was uncommon, it does not seem to have been unprecedented; one thinks of the angels wielding swords (albeit not fiery ones) in Lelio Orsi's *Martyrdom of Saint Catherine* of circa 1560 (Modena, Galleria Estense), which in turn recalls Voragine's account of the "Angel of the Lord [who] struck the monstrous mill," the wheeled contraption devised for Saint Catherine's martyrdom.

BIBLIOGRAPHY: *Discursos leidos ante la Real Academia de Bellas Artes de San Fernando en la recepción pública del Excmo. Sr. Duque de Berwick y de Alba . . . celebrada el día 25 de mayo de 1924*, Madrid, 1924, p. 88; Ainaud, 1947, pp. 402–3, incl. n. 121; Pérez Sánchez, 1965, p. 501; Voragine, ed. 1969, p. 713; A. E. Pérez Sánchez, "Las collecciones de pintura del Conde de Monterrey (1653)," *Boletín de la Real Academia de la Historia*, CLXXIV (1977), 418, 420, 450 no. 169 and n., as from Archivo Histórico de Protocolos, prot. 7684; C. Whitfield in London, Royal Academy, 1982, p. 19; Garrard, 1989, p. 511 n. 164. On the family interrelationships noted above, see M. Burke, *Private Collections of Italian Art in Seventeenth-Century Spain*, Ph.D. diss., New York University, 1984, 1, pp. 69–70.

[L-71] *Saint Cecilia*
Abbé Magi, 1780

The painting is not otherwise described. See the following entry.

BIBLIOGRAPHY: G. Isarlo, *Caravage et le caravagisme européen*, Aix-en-Provence, 1941, II, p. 143.

[L-72] *Saint Cecilia*
Naples, Vincenzo d'Andrea, 1649, 2 x 3 *palmi* (.53 x .79 m.)

Coupled with a *Sacrifice of Isaac*, also attributed to Artemisia Gentileschi, in the "Inventario dei beni mobili, stabili et dell'annue entrate che si possedono per me Vincenzo D'Andrea fatto per osservanza dall'ordine di Sua Maestà a

Primo settembre 1649": "Uno del sacrificio d'Abramo di palmi 4 e 3 di mano di Artemisia Gentileschi con cornice d'oro et un altro piccolo di 2 e 3 di S. Cecilia dell'istessa." Upon the death in 1650 of Vincenzo d'Andrea, a lawyer and major figure in the Neapolitan revolt, his collection was apparently dispersed through sale or subdivision. No connection between this *Saint Cecilia* and the painting with Abbé Magi in 1780 [L-71] can be established.

In a tangential passage to his biography of Belisario Corenzo, Dominici speaks of Artemisia's talent as a creator of paintings containing small figures and of half-length figures of Holy Virgins: "Or oltre alle opere che assai bene di picciole figure ella condusse, e delle mezze figure di sante Vergini. . . ." Although the classes of canvases described by Dominici are more closely associated in Naples with Bernardo Cavallino, this citation of a small-scale *Saint Cecilia* by Gentileschi, one in 1707 to "two paintings of virgins" [L-44], and one in 1723 to a half-length "Vergine" [L-43] render his claim credible.

BIBLIOGRAPHY: Pacelli, 1987, pp. 145–46, 148, 150, as from Naples, AS, Coll. Div. II fs 16; Dominici, ed. 1844, p. 82.

[L-73] *Saint Eustace* (head of only?)
Naples, Ferdinando d'Afflitto, Principe di Scanno, 1700, 8 *palmi* high x 6 *palmi* wide (2.11 x 1.58 m.)

One of three companion pictures of male figures, the others identified as David and Saint Sebastian, for which Artemisia is said in 1700 to have painted the heads. The bank record of final payment to Gentileschi on August 21, 1631, for the *Saint Sebastian* mentions no such collaboration, but the low total fee of 20 ducats renders credible the claim made in 1700. For the precise reference and bibliography, see [L-85]. Also [L-18].

[L-74] *Saint (Female), Head of a*
Florence, Ignazio Enrico Hugford, 1767

Identified only as a *Testa di Santa* by Artemisia Lomi when lent by Ignazio Hugford, a central figure in Florentine artistic circles, to an exhibition mounted by the Accademia del Disegno at

SS. Annunziata in 1767. Conceivably one of the following pictures: the *Sant'Apollonia* recorded in a Medici inventory of 1625 [L-68]; "Una testa, dell'Artimisia" cited in Florence during the seventeenth century ([L-38]); or, most likely, the *Female Martyr* (Fig. 56; Color Plate VI) with Newhouse Galleries datable circa 1615 and thus a product of Artemisia's Florentine stay.

BIBLIOGRAPHY: Borroni Salvadori, 1974, p. 89; for Hugford, see Fleming, 1955, pp. 106–10, 197–200, 203–6. Also [7].

..

[L-75] *Saint John the Baptist*
 Seville, Casa de Pilatos, acquired between
 1629 and 1631, 2 *varas* (1.67 m.) high

Included in an inventory, compiled in November 1637, of the Casa de Pilatos: "Tercera quadra que sale la puerta al corredor del Jardin"—"Un S. Juan Bap.ᵗᵃ de Artemissa Gentilesca vino en el caxon n.° 9." The canvas had been purchased in Italy by the Third Duque de Alcalá, Fernando Enríquez Afán de Ribera, specifically during his tenure as Viceroy of Naples (July 1629–April 1631), as the presence of the crate number indicates. It reappears, with notes regarding its size and condition, in the 1751 inventory of the Duque de Medinaceli, heir to the Casa de Pilatos: "En la libreria"—"Un lienzo de dos varas de alto de Sr. San Juan Bautista original de Artemisia maltratado."

BIBLIOGRAPHY: Engel, 1903, pp. 259, 261; Brown/Kagan, 1987, pp. 236, 243, 250 no. 45, the original in Madrid, Archivo Zabálburu y Basabe, leg. 215, no. 1. For other works by or attributed to Artemisia acquired by the Duke of Alcalá, see [16], [L-14], and [L-20].

..

**[L-76] *Saint John the Baptist
 in the Desert***
 Naples, studio of the artist, October and
 November, 1637, 9 x 9(?) *palmi* (2.38 x
 2.38 m.)

In a letter dated in Naples on October 24, 1637, Artemisia entreated Cassiano dal Pozzo in Rome to serve as an intermediary between her and Cardinals Francesco and Antonio Barberini, to whom she wished to present two pic-

tures, each said to measure 11 x 12 *palmi*. Realizing that she had neglected to specify the subjects of these canvases, on November 24 the artist wrote again to Cassiano, identifying them as a *Christ and the Samaritan Woman* (of 12 x 9 *palmi*) and a *Saint John the Baptist in the Desert* ("un San Giov. Batista nel deserto, di palmi nove d'altezza, e sua larghezza proporzionata"). (See [L-15] for more complete transcriptions of the relevant sections of the letters.) There is no evidence, either in subsequent correspondence or in the various Barberini inventories, that the paintings were ever shipped to Rome.

BIBLIOGRAPHY: Bottari/Ticozzi, 1822, 1, pp. 352–54, letters CXLI and CXLII; Garrard, 1989, pp. 387–88.

..

[L-77] *Saint John the Baptist Sleeping*
 Naples, Palazzo Filomarino de'Duchi della
 Torre, 1685 (Ascanio Filomarino) and 1700
 (Alfonso Filomarino), painted 1637 (?), circa 3
 x 4 *palmi* (.79 x 1.06 m.)

Writing from Naples on October 24, 1637, Artemisia informed Cassiano dal Pozzo in Rome of two pictures (see [L-15] and [L-76]) which she intended for Cardinals Francesco and Antonio Barberini and of another, its subject likewise unspecified, for Monsignor Filomarino (". . . detti quadri, fra quali ve ne sarà uno per Monsignor Filomarino"). The patron was Ascanio Filomarino, who in 1625 had entered the circle of Cardinal Francesco Barberini and who had amassed a collection of art along the lines of Barberini taste. Appointed Archbishop of Naples in December 1641, Ascanio held this post until his death in 1666, when his possessions passed to his nephews, the Duchi della Torre (i.e., the fief of Torre di Teverolazzo).

 An inventory drawn up in 1685 upon the death of the nephew Ascanio Filomarino lists "Un altro dell'istessa misura [3 e 4 incirca] di S. Giovanni Battista di Artemisia Gentileschi coll'istessa cornice [d'oro liscia intagliata]." The same painting almost identically described appears again among the works bequeathed in 1700 by Alfonso Filomarino, brother to Ascanio the Younger: "Nella seconda camera dell'appartamento della Loggia," "un altro quadro dell'istessa misura [palmi tre e quattro in circa] di S. Gio: Batta di Artemisia Gentileschi con l'istessa cornice [d'oro liscia intagliata]."

Whether Gentileschi's canvas was that to which she referred in 1637 or was later purchased in Naples by the Archbishop or his descendants cannot be determined. The former seems more probable, inasmuch as one of the works intended for the Barberini, according to the artist's follow-up letter of November 24, 1637, was a larger picture of *Saint John the Baptist in the Desert* ([L-76]). Artemisia's painting was extolled by Alessandro da Morrona in both the 1792 and the 1812 editions of his *Pisa illustrata*, the passages identical but for a few words added in 1812 and here placed in parentheses: "Riguardo alla Città di Napoli ne siam persuasi sol che si rammenti un opera della nostra Dipintrice, che fà di se bella mostra nella Galleria (Filomarino) de'Duchi della Torre con S. Gio. Battista effigiato (in atto di dormire), figura pregevole pel disegno, per la vivacità del colore, e per l'attitudine." And in 1839 Dal Borgo claimed the following regarding Artemisia: "in appresso pittrice di fiori e frutta, e ne è celebrattisimo il quadro della Galleria Filomarino in Napoli, rappresentante S. Giovanni Battista del deserto addormentato, ove trionfa un tal genere di pittura." Undoubtedly Dal Borgo was merely drawing upon Morrona, conflating his fellow Pisan's accounts of the Filomarino picture and of Artemisia as a still-life painter, and had never seen the *Saint John in the Desert*, in which a still-life of fruit and flowers would seem totally incongruous. (Besides, as I have argued in Chapter 6, the tradition of Gentileschi as a master of still-life is certainly erroneous). In 1799, during the uprising against the Repubblica Partenopea, the Neapolitan populace sacked and burned the Palazzo Filomarino. One cannot assume on the basis of the somewhat greater specificity of his passage of 1812 that after 1799 Morrona had again seen or been further informed about Gentileschi's *Saint John*. It is more likely that in the 1792 edition of the *Pisa illustrata* Morrona simply failed to include the additional wording, and that Artemisia's canvas did not survive the conflagration.

BIBLIOGRAPHY: Labrot, 1992, pp. 160 and 161, from Naples, AS, Notaio Dionisio d'Alterio, scheda 320, prot. 9, fol. 982v; Bottari/Ticozzi, 1822, I, pp. 352–53, letter CXLI; Morrona, 1792, II, pp. 267–68, and ed. 1812, II, p. 485; Dal Borgo, 1839, p. 32 (cited by Contini and Papi in Contini/Papi, 1991, p. 62 n. 81 and pp. 85–86 n. 55); Ruotolo, 1977, pp. 73, 80, as from Naples, AS, Notaio Giuseppe Ragucci, scheda 508, prot. 63, fol. 185 ff.; F. Haskell in London, Royal Academy, 1982, p. 63.

[L-78] *Saint Lucy*
Rossano, Monsignor Stanislao Poliastri, Archbishop of Rossano, 1741, 4 *palmi* high (1.06 m.)

Cited in an inventory dated three years after Poliastri's appointment in 1738 as Archbishop of Rossano and before the prelate's retirement to Naples, where he died in 1763, as "Di palmi 4 in alto un consimile di S. Lucia d'Artemisia con cornice simile [alla modatutta indorata]."

BIBLIOGRAPHY: Labrot, 1992, pp. 401 and 403, from Naples, AS, Notaio Gregorio d'Avantino, scheda 178, prot. 25, fol. 140.

[L-79] *Saint (Male) Holding Fruit*
English Royal Collection, Greenwich, 1649; sold 1651

While not cited in Van der Doort's lists of 1637–39, the picture is recorded in 1649 "In ye Gallery" at Greenwich as "A Sᵗ Laying h[] hand on fruite; by Artemisia 12.00.00" and, in the same place by the same cataloguer (Corsham MS), as "A Sᵗ laying his hand. on fruite by Artemesio 12.00.00." It was acquired on October 23, 1651, by Jackson on behalf of the dividend of Charles I's creditors which he headed.

BIBLIOGRAPHY: London, PRO, *Pictures Statues Plate 1649–51*, LR 2/124, 1649, fol. 192, and published by Millar, 1970–72, p. 315 no. 270, from Corsham MS, Lord Methuen, fol. 23v.

[L-80] *Saint Mary Magdalen*
Naples, Davide Imperiale, 1672, 5 *palmi* high x 4 *palmi* wide (1.32 x 1.06 m.)

"Una Madalena d'Artemisia Gentileschi alta cinque larga quattro," along with a *Lucretia* and companion pictures of the *Head of the Young Christ* and the *Head of the Madonna* ([L-16], [L-52]) also given to Gentileschi, figures in the legacy of Davide Imperiale as detailed in an inventory of 1672. A painting identified as a *Magdalen* and of the same dimensions (and

format?) as the Imperiale picture belonged to the heirs of Ettore Capecelatro in 1659 [L-81], but there is no compelling reason to connect the two citations.

BIBLIOGRAPHY: Labrot, 1992, pp. 118 and 139, from Naples, AS, Notaio Domenico Cardamone, scheda 1221, prot. 32, fol. 34.

..

[L-81] *Saint Mary Magdalen*
Naples, inheritance of Ettore Capecelatro, Marchese di Torella, 1659, 4 x 5 *palmi* (1.06 x 1.32 m.)

In conjunction with its division in 1659 between D. Filippo and D. Francisco Capecelatro, the inheritance of Ettore Capecelatro was registered and evaluated. Included among the collection of paintings was "Una Madalena di Artemisia di 4 e 5 con cornice d'oro D. 26." It is a curious fact, however, that in the inventory compiled in 1655 upon Ettore's death a *Madonna* by Gentileschi, not a *Magdalen* by her, was recorded. It is conceivable that a single painting, its subject either misidentified or inadvertently mislabeled in one of the two lists, is in question. See [L-57]. A *Magdalen* by Artemisia, it too with dimensions of 5 x 4 *palmi*, was among four Gentileschi canvases bequeathed by Davide Imperiale of Naples in 1672 [L-80], but there is insufficient evidence to link the two works.

BIBLIOGRAPHY: Labrot, 1992, pp. 101 and 113, from Naples, AS, Notaio Francesco Mignone, scheda 332, prot. 19, fol. 3 (allegato al fol. 1248v).

..

[L-82] *Saint Mary Magdalen*
Riviera di Chiaia (Naples environs), Francesco Emanuele Pinto, Principe di Ischitella, 1767, 2½ x 2½ *palmi* (.66 m. square)

The death of Francesco Emanuele Pinto on October 24, 1767, and the sesquestration of his goods on behalf of his creditors, occasioned an inventory of the Prince's paintings on October 27. Among the great quantity of works there appear, "nel braccio di detto Appartamento a man sinistra—Nella Seconda Stanza," "Quattro quadri di palmi 2½ in quadro con cornici some sopra [indorati], in uno S. Antonio Abbate di Giordano, in un altra un Apostolo di

Farelli, in un altro S. Pietro di Benasco, e nell'altro la Maddalena di Artemisia." As Pacelli has argued, since the names of specific artists are not provided for the majority of the pictures, one has reason to trust the attributions of the others. There is a distant possibility that Artemisia's *Magdalen* was one of the half-length figures of Holy Virgins claimed for her by Dominici [L-72].

The bulk of the collection had been formed by Luigi Fleyta Pinto y Mendoza (1592–1672) and augmented by Emanuele Pinto (d. 1690). Its fate after 1767 is unknown.

BIBLIOGRAPHY: V. Pacelli, "La collezione di Francesco Emanuele Pinto, Principe di Ischitella," *Storia dell'arte*, nos. 36–37 (1979), 165–68, 170, 178, as from Naples, AS, Sez. Giustizia, Sacro Regio Consiglio, ordinamento Zeni, fasc. 1, fascic. 218, fol. 34.

..

[L-83] *Saint Michael Overcoming the Devil*
Naples, Luigi Romeo(?), life-size

An unlikely subject for Artemisia Gentileschi, but claimed for her by Dominici: "Di questa virtuosa donna è eziandio un S. Michele Arcangelo, che discaccia Lucifero dal Paradiso, ed un Loth con le figliuole [see [39]], e tutti alla grandezza del'naturale."

BIBLIOGRAPHY: Dominici, 1844, III, pp. 414–15.

..

[L-84] *Saint Sebastian*
Castello di Scilla, testament of D. Guglielmo Ruffo di Calabria, Principe di Scilla, 1747, 4 x 3 *palmi* (1.06 x .79 m.)

Described as "un quadro originale, detto Artimisa, antico della Casa, che rappresenta S. Sebastiano, con le cornice nera a tre ordini d'oro di palmi 4 e 3" in D. Guglielmo's testament of March 27, 1747. In view of Gentileschi's many documented dealings with the Ruffo (see the Index), the attribution to her of the *Saint Sebastian* inspires some confidence. Following the death of a subsequent Principe di Scilla in April of 1848, some of the canvases that had remained in the family were transported to Naples, there to be sold in 1853. An inventory of February 1853 lists "Un quadro sopra tavola di palmi 4 x 2½ oncia esprimente il

martirio di S. Sebastiano alquanto restaurato, Scuola antica Napoletana, Doc. 40, cornice Doc. 1.50." Given its wood support and size, this *Saint Sebastian* cannot be identified with certainty as Artemisia's picture of that theme cited in 1747.

BIBLIOGRAPHY: E. Rogadeo di Torrequadra, "La quadreria del Principe di Scilla," *Napoli nobilissima*, VII, fasc. IV (1898), 72–73, and fasc. VII, p. 109.

....................

[L-85] *Saint Sebastian* (head of only?)
Naples, Giovanni Francesco d'Afflitto, Conte di Loreto, 1631, and Ferdinando d'Afflitto, Principe di Scanno, 1700, 8 *palmi* high x 6 *palmi* wide (2.11 x 1.58 m.)

On August 21, 1631, Artemisia received final payment of 12 ducats on a contract totaling 20 ducats: "Da Gio Francesco di Afflitto, conte di Loreto D. 12 a compimento di D. 20 per prezzo d'uno quatro di Santo Sebastiano di palmi otto alto e sei largo fatto di sua propria mano e promette consegnarlo fra otto giorni." However, when the painting was recorded in 1700 with Ferdinando d'Afflitto it was as one of three apparently companion pictures of male figures for which Gentileschi is said to have painted the heads alone: "Tre quadri di 6 larghi et 8 lunghi con cornice nera e con filetto indorato, uno con S. Eustachio e l'altro con Davide l'altro di S. Sebastiano, e le teste sono di mano di Artemisia." It seems to me highly unlikely, considering the large-as-life size of the *Saint Sebastian* and the fees commanded in Naples by Gentileschi (e.g., for [49], [L-2], [L-8], [L-27], [L-45], [L-96]), even during bleak economic times, that 20 ducats would in fact have covered an entire figure. Thus the inventory of 1700, which could have inflated the value of the three works by assigning them in their entirety to Artemisia but did not, may have been correct. Still, prior to the recent publication of the bank document from 1631, and in spite of Artemisia's collaboration with other masters on other occasions, the claim of her responsibility even for the heads had to be viewed with suspicion.

BIBLIOGRAPHY: Nappi, 1992, p. 74, as from Naples, Archivio Storico del Banco di Napoli, Banco di San Giacomo, Giornale copiapolizze, matr. 147, 21 agosto 1631; Provenance Index, Getty Art Information Program. Also [L-18] and [L-73].

....................

[L-86] *Samson*
Naples, Palazzo Filomarino della Rocca, Collection of Paolo Francone, Marchese di Salcito, 1718, 6 x 8 *palmi* (1.58 x 2.11 m.)

On November 17, 1718, Paolo Francone and Ippolita Ruffo celebrated in Naples the marriage which had been arranged for them on June 21, 1717, by their fathers, Francesco Francone (Principe di Pietracupa) and Fabrizio Ruffo (of the Dukes of Bagnara). Two months before the ceremony, on September 22, 1718, an accounting was made of the wedding gifts which Francesco Francone had bestowed on his son ("tutto quanto fu dato in uso al figlio dal principe di Pietracupa in occasione del suo matrimonio"). Among the paintings, "tutti con cornici negre, stracalli et intagli o dorati," was a *Samson* by Artemisia: "Sanzone di palmi 6 e 8 originale di Artemisia Gentileschi di valuta di ducati cento.duc.100."

The newlyweds took quarters in the Palazzo Filomarino della Rocca. In the nineteenth century the collection, having undergone the various changes of residence and inheritances which Caracciolo has charted, passed to the Principe di Torchiarlo, son of the first sister of the last Principe Francone. Presumably Artemisia's *Samson*—not identified as a *Samson and Delilah* as might have been supposed—was still among the holdings, although its subsequent history has not been ascertained.

Since Gentileschi is known to have painted at least three works (see [L-101]) for Don Fabrizio Ruffo, the Prior of Bagnara (testament dated February 21, 1692), it is tempting to identify the *Samson* as one of these. Yet, as noted, it is said to have belonged to the Francone half of the marriage alliance.

BIBLIOGRAPHY: A. Caracciolo, "Alcuni notizie sulla famiglia Francone e l'arredamento di una casa patrizia napoletana al principio del sec. XVIII," *Studi in onore di Riccardo Filangieri*, Naples, 1959, III, pp. 33–35, 37 no. 28, 47–50.

....................

[L-87] *Samson and Delilah*
Budapest, Esterházy Collection, 1820

Listed as no. 914 in the 1820 inventory of Esterházy pictures: "A. Gentileschi: Dalia und der schlafende Simson." The painting, in theme of

a type in which Artemisia specialized, might conceivably be identified as the *Samson and Delilah* in the Museo di Capodimonte, or rather as the original from which the Naples example was copied (Fig. 152; [35]).

BIBLIOGRAPHY: S. Meller, *Az Esterházy Képtár Története* (Histoire de la Collection Esterházy), Budapest, 1915, p. 233, as reported by Szigethi, 1979, pp. 36 n. 8 and 42, incl. nn. 20–21.

..

[L-88] *Self-Portrait*
intended in 1630 for Cassiano dal Pozzo, Rome

Mentioned in three letters from Artemisia in Naples to Cassiano dal Pozzo in Rome (August 24, August 31, and December 21, 1630) and here argued to be the canvas in the Palazzo Barberini at Rome (Fig. 119; [25]).

..

[L-89] *Self-Portrait*
promised to Don Antonio Ruffo in Messina, 1649

In four letters to the Messinese nobleman Antonio Ruffo, Artemisia spoke of (or, in one case, alluded to) a *Self-Portrait* which she intended for him. (1) January 30, 1649: "e se a V. S. gradisce l'opra [the *Galatea*, Figs. 195–96, Color Plate XXII] li mandarò ancora il mio ritratto acciò lo tenga nella sua galleria come fanno tutti l'altri Principi . . ."; (2) March 13, 1649: "Quanto prima manderò il mio ritratto . . ."; (3) June 5, 1649: "circa il mio ritratto che contro mio merito desidera V. S. Ill.ma verrà giunto con il quadro [the *Diana at Her Bath*, [L-27]] . . ."; (4) July 24, 1649: "Il ritratto vendra giunto con il quatro. . . ."

After difficulties with the painting and the patron, Artemisia consigned the *Diana* on April 12, 1650. As to the *Self-Portrait*, there is no record of its having been sent to Messina, if in fact it ever was executed.

BIBLIOGRAPHY: Ruffo, 1916, pp. 48–50; Garrard, 1989, pp. 390–94. See also Appendix I under the dates cited above.

..

[L-90] *Self-Portrait*
English Royal Collection, Hampton Court, 1649, sold 1651

The painting inventoried at Hampton Court in October of 1649 as "Arthemesia gentelisco. done by her selfe" and obtained on October 23, 1651, by Jackson and his dividend of Charles I's creditors is generally thought to be the so-called *Self-Portrait as "La Pittura"* now at Kensington (Fig. 175; Color Plate XXVII). In opposition to this prevailing view, I believe that the Personification of Painting in the Kensington canvas does not bear Artemisia's features and that the "Artemesia gentelisco. done by her selfe," perhaps begun in 1637 as the *Self-Portrait* for Cassiano dal Pozzo and brought by Gentileschi to England, must be considered lost (although it may be the picture sold in London in 1801 by Thomas King, Jr.). See [25] for the arguments and bibliography, and [L-91].

..

[L-91] *Self-Portrait*
London, Thomas King, Jr., by whom sold January 24, 1801, Lot 601, the property of Mr. Sandys of Kentish Town, deceased

Entitled *Artemiscia Gentoleschi* and attributed to Artemiscia Gentoleschi, this *Self-Portrait* cannot be identified as the *Portrait of a Woman Painter* in the Earl Spencer Collection, once thought to depict Artemisia, for the latter has been continuously at Althorp since 1727 at the latest. It is not impossible, however, that the painting with King in 1801 and the "Arthemesia gentelisco. done by her selfe" which belonged to Charles I (see [L-90] and [25]) were one and the same.

BIBLIOGRAPHY: B. Fredericksen, ed., *The Index of Paintings Sold in the British Isles During the Nineteenth Century: 1801–1805*, Santa Barbara, Calif., and Oxford, 1988, I, p. 309.

..

[L-92] *Self-Portrait*
Genoa, Francesco Maria Balbi, 1701

Inasmuch as paintings by both the Gentileschi were to be seen in Genoa, in which city Orazio worked from 1621 to 1623, the presence there also of "Altro ritratto grande al naturale di Artemisia gentileschi di sua mano" occasions no surprise. None of the extant or lost *Self-Portraits* (including that upon which Jérôme David based his engraving, Fig. 101), can be related to this reference.

BIBLIOGRAPHY: Provenance Index, Getty Art Information Program.

..

[L-93] *Souls in Purgatory*
Drawing. Naples, for the Bishop of
Sant'Agata dei Goti

In a letter of November 13, 1649, to Don Antonio Ruffo in Messina, Artemisia, taking offense at the request of a certain Cavaliere who desired a painting by her hand that she first supply him with a preliminary drawing, resolved never again to submit such drawings. She offered the following explanation for her adamancy: "Io ho fatto voto solendissimo di non mandar mai più disegni de mio, perche mie stato fatto belissime burle et in particolare hoggi al presente, mè ritrovo haver fatto un desegno dell'anime del purgatorio al Vescovo di S.ᵗᵃ Gata il quale disegno per spender manco lo fanno fare a de un altro pittore, e quello pittore lavora sopra le fatiche meie, che se fusse homo io no sò come se passarebbe perchè quando è fatta l'inventione, et stabilito con li suoi chiari et uscuri, e fundati sul'loro piani tutto il resto ei baia." Further research may establish the name of the usurper of what appears to have been a rather finished study.

BIBLIOGRAPHY: Ruffo, 1916, p. 52; Garrard, 1989, pp. 397–98.

..

[L-94] *Subject Unspecified*
Florence, Palazzo Stufa, Vincenzo
Traballesi, 1962

In 1962 Peria placed a painting by Artemisia Gentileschi in the Galleria d'Ingresso of the Palazzo Stufa, but in May of 1978 Avv. Vincenzo Traballesi informed me that no such picture existed in the palazzo.

BIBLIOGRAPHY: V. Peria, "Ambientazione settecentesca in clima riniscimentale fiorentino," *Arte figurativa*, X, no. 56 (1962), 24.

..

[L-95] *Subject Unspecified*
Florence, Charles of Lorraine, Fourth Duke of
Guise, 1635

Writing from Naples on October 9, 1635, to Galileo Galilei in Arcetri, Artemisia expressed consternation that Grand Duke Ferdinand II of Tuscany had not acknowledged receipt of two large paintings which she had sent to Florence by way of her brother. This lack of recognition, she reported, was in striking contrast to the usual respect accorded her: "vistomi honorata da tutti li re et potentati dell'Europa alli quali ho mandato l'opere mie, non solo di regali grandissimi, ma etiando di lettere favoritissime, che tengo appresso di me; et ultimamente il S.ʳ Duca di Ghisa in ricompensa d'un quadro mio, che gli presentò l'istesso mio fratello, gli diede per me 200 piastre. . . ."

The editor of the Galileo papers and Garrard have identified "il S.ʳ Duca di Ghisa" as Charles of Lorraine (1571–1640), Fourth Duke of Guise. This is certainly correct (although to my knowledge the details of Guise's biography reported by Garrard are erroneous). Charles, a victim of Cardinal Richelieu's ambition, had quit France in the fall of 1631 to establish residence in Florence, where he would have been known at least by reputation to Galileo. By 1632 Gentileschi had enjoyed the Duke of Lorraine's patronage, or so the probable genesis of the *Clio, Muse of History* suggests (Figs. 121–23; Color Plate XVIII; see [27] for the arguments). At the beginning of 1635 Francesco Gentileschi, Artemisia's business manager and the brother to whom she refers in the above letter, had served her interests in Rome (January) and Modena (February), and had obviously made a another stop in Florence. The intermediary between Artemisia and Ferdinand of Tuscany was Andrea Cioli, the Grand Duke's Secretary, who may also have concerned himself with the Gentileschi-Guise dealings.

BIBLIOGRAPHY: Galilei, 1905, XVI, pp. 318–19 incl. n. 1, as from Florence, Biblioteca Nazionale, MS Gal., P. I., T. XIII, car. 269–70; Garrard, 1989, pp. 89, 509 n. 148. For the relevant documents concerning Francesco Gentileschi's activities, see Appendix I (January 21, January 25, and March 7, 1635) and Bissell, 1981, p. 116. For Artemisia and Cioli, Appendix I, beginning September 24, 1635. Also [27].

..

[L-96] *Subject Unspecified*
Naples, Bernardino Belprato, 1636

On December 19, 1636, Bernardino Belprato transferred to Artemisia Gentileschi from his

Neapolitan bank account 20 ducats as final payment of a total of 60 ducats for a painting which the artist was to deliver. According to Nappi's text: "A Bernardino Belprato D. 20. E per esso alla signora Artemisia Gentileschi a compimento di D. 60, atteso li altri l'ha ricevuti de contanti. E gli li paga in conto di quello che dovrà darli per un quadro che li haverà da consignare. E per essa al capitan Nicolò Amoretti per altritanti." In 1667 two pictures by Artemisia Gentileschi were numbered among Belprato's possessions ([L-34] and [L-36]), but it can only be supposed that one of them corresponds to the work for which she received her full fee in late 1636.

BIBLIOGRAPHY: Nappi, 1983, p. 76, as from Archivio Storico del Banco di Napoli, Banco di San Giacomo, giornale del 1636, matr. 198, partito di ducati 20, estinto il 19 dicembre.

..

[L-97] *Subjects Unspecified*
Florence, Grand Duke Ferdinando II
de'Medici, July, 1635 (sent from Naples)

First in a letter of July 20, 1635, directly to the Grand Duke of Tuscany, and in subsequent correspondence of October 9 to Galileo Galilei and of October (?) 20 to the Grand Duke's Secretary, Andrea Cioli, Artemisia refers to two large, recently executed paintings which she had sent to Florence. These letters, the relevant bibliography provided, are discussed in Appendix I, and very tentative identifications of the pictures in question are suggested under [36] and [L-66].

..

[L-98] *Subjects Unspecified*
Modena, Francesco I d'Este, 1635
(sent from Naples)

As part of her continuing efforts to secure the most prestigious patronage, Artemisia wrote from Naples on January 25, 1635, to Duke Francesco I d'Este in Modena, informing him that her brother (Francesco Gentileschi), having delivered some painting(s) by her hand to Cardinal Antonio Barberini in Rome (see [31]), would continue on the Modena with pictures for the Duke: "Con l'occasione ch'io mando all'Em.mo Card.le D. Antonio alcune opere di Pittura di mia mano mi è parso bene mandar' anco à V. ra Alt.za quelle, che con tanto mio

gusto hò fatto per V.ra Alt.za le quali inuio per il presente mio fratello. . . ." In language characteristic of such letters, the artist added: "scusi dunque q.ta mia ardita ma ambitiosamente honorata dimostratione, e gradisca queste operette. . . ." The works and Artemisia's sentiments met with a positive reception, as witness Francesco d'Este's note of March 7, 1635: "Hò riceuuti da suo fratello il [?] quadri, ch'ella m'ha inuiati, et ho conosciuto nella loro uaghezza La uirtù e nel dono di essi la liberalità di Lei."

To this note the artist, speaking of "le mie tele," replied on May 22, 1635: "Ringrazio V. A. S.ma ch'ingrandisce le mie pitture con aggradirle, mostrandosi ancora generoso nel riceuere le Cose picciole." At least two paintings, executed on canvas, were therefore involved. And it appears that Gentileschi's characterization of them as "operette" and "le Cose picciole" is to be taken at face value as indicating relatively small-scale works, not false modesty.

In her letter of July 20, 1635, to the Grand Duke of Tuscany, Ferdinando II de'Medici, Gentileschi refers for a third time to her contact with the Duke of Modena.

BIBLIOGRAPHY: A. Venturi, 1882, p. 218; Imparato, 1889, p. 424; Garrard, 1989, pp. 380–82; Fuda, 1989, p. 170.

..

[L-99] *Subjects Unspecified*
Modena, Francesco I d'Este, 1639
(sent from London)

Almost four years after her first known letter to Francesco d'Este [L-98], Artemisia, then in London, announced on December 16, 1639, that she had again sent something by her hand to the Duke: "l'inuiarle ancora con quest'altro mio fratello [Giulio Gentileschi], mandato dalla M.ta Regina sua [Queen Henrietta Maria], et mia sig.ra per suoi interessi in Italia, questa mia piccola fatica, quale è bensì nuda di perfettione, ma ricca d'una profonda osseruanza che le professo. . . ." Once again Francesco d'Este was pleased ("Hò graditi con gusto particolare i Quadri ch'ella m'hà mandati, e molto più il termine amoreuole con che hà uoluto accompagnarli"; reply of March 16, 1640), but apparently made no effort to help satisfy Gentileschi's desire to leave England and journey to Modena.

In this instance (cf. [L-98]), Artemisia's

choice of words—"questa mia piccola fatica"—may represent feigned humility rather than indicating a picture of small format, the more so as Francesco d'Este speaks of "i Quadri."

Unfortunately, none of Gentileschi's extant canvases can be traced to Modena.

BIBLIOGRAPHY: A. Venturi, 1882, p. 218; Imparato, 1889, pp. 424–25; Garrard, 1989, pp. 388–89.

..

[L-100] *Subjects Unspecified*
Naples, María of Austria, fall, 1630

In June of 1630, María, sister of Philip IV, was married by proxy in Madrid to Ferdinand II of Austria, Holy Roman Emperor. On August 8 of the same year, escorted by the Duke of Alba, she entered Naples for what was to be a four-month stay before proceeding to Vienna. Scarcely two weeks later (August 24), Artemisia informed Cassiano dal Pozzo in Rome that he would receive the painting commissioned by him ([25]) as soon as she had finished "some works for the Empress": "Ho vista la misura che V. S. illustrissima [*sic*] mi ha fatto grazia mandarmi; e l'averei servita subito, se non mi occorrese fare alcuni quadri per la Imperatrice, et è bisogno che siano finiti a mezzo settembre, che fatto questo, la prima cosa sarà il servire V. S. illustrissima. . . ." Gentileschi spoke again of this situation in a letter to Cassiano dated August 31: "Del ritratto, finiti che haverò alcuni quadri per la Imperatrice, la servirò. . . ." No doubt correctly, Garrard and Brown and Kagan have identified the Empress to whom Artemisia referred as the same María who, to judge by the time constraint reported by the artist, had not intended to remain in Naples past mid-September. As has proved so often the case, no pictures by Artemisia can be associated with precisely dated documentation.

BIBLIOGRAPHY: Bottari/Ticozzi, 1822, I, pp. 348–49 letter CXXXVII and 349–50 letter CXXXVIII (my variant reading from the original letter with Mr. Thomas Brumbaugh, Greencastle, Pa.; Fig. 118); Garrard, 1980, p. 109 n. 53, and 1989, pp. 377–78; Brown/Kagan, 1987, p. 243.

..

[L-101] *Subjects Unspecified*
Naples, Don Fabrizio Ruffo, Prior of Bagnara, 1648–1649

The patronage of Don Antonio Ruffo of Messina which Artemisia was to enjoy during the years 1648–51 (see Appendix I) was preceded by commissions from Don Antonio's nephew in Naples, Don Fabrizio Ruffo, Prior of Bagnara. Thus on September 5, 1648, the latter transferred 30 ducats to Gentileschi as partial payment for a painting then in progress: "Al Principe della Bagnara D. Fabrizio Ruffo. Duc. 30 et per lui alla Signora Artemisia Gentileschi et le paga a conto di un quadro che li sta facendo." By the time of her letter of June 5, 1649, to Don Antonio, Artemisia had completed three pictures for the Prior: "Il S.ʳ Priore alla giornata mi honora con singolarissimi favori, et io li ho fatto tre quadri di molto suo gusto. . . ." The artist again referred to works for the Prior in a letter to Messina dated October 23, 1649. (Ill will was later to develop between Artemisia and her Neapolitan patron, as reported by the artist to Antonio Ruffo in December of 1649.)

With his testament of February 21, 1692, Don Fabrizio designated that the bulk of his collection be sent to the Castello di Maida, to be inherited by Francesco, Duke of Bagnara, his nephew. None of Gentileschi's canvases, not even the *Samson* [L-86], can be traced back to Don Fabrizio Ruffo.

BIBLIOGRAPHY: Ruffo, 1916, pp. 49 incl. n. 3, 51–52; Strazzulo, 1955, p. 44 doc. 128, as from Archivio Storico Banco di Napoli, Banco della Pietà, gior. 359 fol. 406, 5 settembre 1648; Garrard, 1989, pp. 392, 395–96.

..

[L-102] *Susanna*
for Prince Karl Eusebius von Liechtenstein, 1636, 11½ *palmi* (3.04 m.) high

Upon receiving on May 5, 1636, the final 250 ducats of a total fee of 600 ducats, Gentileschi was to deliver a set of three paintings—*Bathsheba*, *Lucretia*, and *Susanna*—to representatives of Prince Karl Eusebius von Liechtenstein in Naples. There is no solid evidence to connect any of Artemisia's renditions of these themes to this transaction, which is quoted and discussed under [37].

..

[L-103] *Susanna and the Elders*
English Royal Collection, Whitehall (1637–1639), Somerset House (1649), sold to

Houghton et al., 1651, and by 1659 with
Ralph Bankes, Gray's Inn

Catalogued by Van der Doort between 1637 and
1639 at Whitehall: "done by Artimi = sio Gen-
tillesco. Item in the Queens withdrawing
chamber above the Chimney A Suzanna with 2
eld.rs." For the sale of the English Royal Col-
lections in 1649 the painting was evaluated at
£20 ("In ye withdrawing roome begins ye Pic-
tures of Somersett house with some few be-
longing to Whitehall. . . . Susanna. done. by.
Arthemesia 20.00.00."), to be acquired on Oc-
tober 23, 1651, by the dividend of Charles I's
creditors headed by Houghton. Eight years
later, in his list entitled "A noate of my pictures
att Grayes Inn / & wt thay Cost. Xber ye 23rd
1659," Ralph Bankes recorded "A Susanna On
a whole length of Gentilesco's / Daughter
CR Mr Bates 30.000.00." Since Bankes's *Su-
sanna* by Artemisia Gentileschi bore Charles I's
stamp, it may be taken as the picture formerly
at Whitehall; and Mr. Bates may be supposed
to have been either a member of Houghton's
dividend or a purchaser from it. Bankes then
owned five paintings once in the King's posses-
sion, none of which appears in two slightly ear-
lier lists from Bankes's hand. Laing presumes
that these five works had to be given over at
the Restoration; certainly I know of no indica-
tion that Artemisia's *Susanna* remained in the
Bankes Collection.

This *Susanna* is not to be confused with a
canvas of the same theme by Orazio Gentil-
eschi, inventoried also in 1649 and in the same
place ("Susanna. wth. y.e 2 elders by gentelisco
30.00.00), sold to Proctor on November 7,
1649, and signaled again by Vertue ("Sussanna
2 Elders painted by Gentelisco—30.0.0). Nor,
in my opinion, is either of the paintings to be
recognized as either of the identical renditions
of *Susanna and the Elders* in Stamford and Not-
tingham (Figs. 257, 256; [X-42]).

BIBLIOGRAPHY: Van der Doort, 1637–39, ed. Mil-
lar (1958–60), p. 177 (from Bodleian Library, Ash-
mole MS 1514, fol. 178 no. 34); London, PRO,
Pictures Statues Plate . . . 1649–51, LR 2/124, 1649,
fol. 190v, and publ. by Millar, 1970–72, p. 306 no.
128 and p. 312 no. 223, from Corsham MS, fols. 19v
and 22; Vertue IV, 1731–36, from British Museum
Addington MS 23, 071, V. 108, BM 62b; Laing, 1993,
pp. 108, 113, 122, 124.

[L-104] *Susanna and the Elders*

Signed and dated 1652. Florence, Averardo
de'Medici, Via Larga, by 1792, 4½ *braccia*
wide x circa 4 *braccia* high (2.63 x 2.33 m.)

The dimensions of this painting and the pres-
ence of the signature and date are reported by
Alessandro da Morrona, who described the
composition in detail:

> Troverà in essa, io mi lusingo, quella
> bontà di disegno, e qual gusto di colorire
> che non s'impara giammai se natural
> genio non lo somministra. Molto pregio
> nell'estremità si ravvisa. La figura della
> Donna ebrea gode il dono dell'espressi-
> one, e d'un bell'atteggiamento. La vesti-
> menta la ricuoprono con vaghe piegature,
> e sul petto di lei son con tal arte distese,
> che l'intelligenza del nudo ne comparisce.
> Non minor decoro spicca ne'panni de'due
> circonstanti vecchioni, et le teste di esse
> indicano a meraviglia qual sia *in vecchia
> membra il pizzicor d'amore*. Quest'opera in
> fine basta a dar saggio dello spiritoso tal-
> ento della nostra pisana Dipintrice, che
> lasciò scritto nell'imbasamento della pic-
> cola loggia, ove posa la Susanna: *Ar-
> temisia Gentileschi F. 1652*.

The same picture was praised at the same
time by Lanzi: "In quest'altro è la Tentazione
di Susanna, opera amena e per la qualità del
luogo e per la grazia della principal figura e pel
vestito delle altre." Garrard tentatively identi-
fies as the ex-Medici painting Artemisia's *Su-
sanna and the Elders* now at Brno (Fig. 197),
which does belong to the artist's last years and
bears on the base of its balustrade a signature
and a date. However, the date on the Brno can-
vas has been read as "MDCIL," and the picture is
smaller in size (2.06 x 1.675 m.) and of decidedly
vertical format and, again unlike the Florentine
example, shows Susanna without the form-
revealing drapery over her breasts mentioned by
Morrona.

BIBLIOGRAPHY: Morrona, 1792, II, pp. 269–70;
Lanzi, ed. 1834, I, p. 214; Bissell, 1968, pp. 164–65
n. 91; Garrard, 1989, pp. 130–31, 518 n. 234.

[L-105] *Susanna and the Elders*

Venice, by 1627

The object of one of several verses, probably by Gianfrancesco Loredan (see [L-1]), directed to pictures by Artemisia and printed anonymously in Venice in 1627:

SOSANNA

Opera dell'istessa

> Ecco l'ignuda, e bella
> Pudica Hebrea fra i due rivali amanti
> Canuti, e calunnianti.
> Vedi (tanto imitar può l'arte) ch'ella
> Orando, al ciel vorria
> Levar gli occhi, e non osa
> Modesta, e vergognosa:
> Né teme, nò, me spera ardita, e pia
> Veder con lieta sorte
> Viva la vita sua ne l'altrui morte.

> Behold the naked and beautiful
> Chaste Jewess between the rival
> suitors
> White-haired and slanderous.
> See (how much art can imitate
> nature!) how she,
> Imploring, wished to lift her eyes to
> Heaven
> But modest and shy ventures not:
> No, she is not afraid, but fearless and
> pious hopes,
> Good fortune with her, to see
> Her life live on in the others' deaths.

Garrard writes that this "formulation . . . stubbornly reasserts the very concept of Susanna as a half-guilty victim" that Artemisia had "studiously avoided" in the Pommersfelden *Susanna* (Fig. 10; Color Plate I). This reading of the verse as implying some responsibility on Susanna's part for having lured the old men, and thus as being stereotypically male, is forced; at best it would be only vaguely indicated were *Pudica* rendered as "modest" rather than "chaste" (then why another "modest" from *modesta*?) and *vergognosa* as "shameful" rather than "shy." For reasons advanced under [X-42], I am unconvinced also by Hersey's perception that the *Susanna* in The Burghley House Collection (Fig. 257) closely conforms to that described by the poet and may be the picture in question.

BIBLIOGRAPHY: Toesca, 1971, p. 91; Garrard, 1989, pp. 172–73; Hersey, 1993, p. 327. And [L-1].

[L-106] *Tarquin and Lucretia*

English Royal Collection, Greenwich House (by 1633/1634; 1637–1639), Somerset House (1649–1651), sold 1651, 23 ft. in perimeter

The earliest unequivocal reference to a *Tarquin and Lucretia* by Artemisia Gentileschi in England is found in Van der Doort's catalogue of Greenwich House compiled between 1637 and 1639: "*bin don bij artumisia guntilescko. itm secondlij a tarqin and luckrecia.*" Transferred by September of 1649 to Somerset House for the sale of the King's goods, it was evaluated at £25: "Pictures out of the Gallaries at Grenew[ch]. Lucretia & Tarquin done by Artemesio." The painting had not found a recipient by the spring of 1650, when it was included in a memorandum drawn up for a M. de Bordeaux to be presented in turn to Cardinal Mazarin of France for purchase consideration: "Estat de quelques tableaux exposés en vente à la maison de Somerset, May 1650. Lettre a: Lucrèce et Tarquin, par Artenesio—Liv. o sterl. 25." Not selected by Mazarin, the *Tarquin and Lucretia* passed on October 23, 1651, to Harrison, head of the eleventh dividend of Charles I's creditors.

It is a virtual certainty that Artemisia's canvas had entered the English Royal Collection at least four years prior to the artist's arrival in London in 1638. The major evidence is a bill tendered by the painters/framemakers Mathewe Goodericke and Ben. Davyson in 1633 or 1634 (perhaps the latter according to modern reckoning): "ffor painting sadd Lute cullo[r] in oyle & varnishing iij[ee] frames for pictures viz: Pharoes Daughter, Joseph and Pottifers wife, and the Muses: and guilding w.[the] fine gold in oyle the moulding cont.: cvj[fo] ob at xij[d] the foote: cxj[s] vj[d] and for paynting one fframe of a Lesser moulding, and varnishing & guilding the Edges thereof being the Picture of *Tarquin & Lucretia* cont.: xxiij[fo] : xj[s] vj[d]." Since, as can be shown, the first three paintings were by Orazio Gentileschi, the anonymous *Tarquin and Lucretia* and Artemisia's painting of that theme as specifically documented by Van der Doort and others were most likely one and the same. Additional support for this contention is offered by Artemisia's letter of October 9, 1635, to Galileo, in which she includes the "Re d'Inghilterra" as among the European elite to

389

whom she had sent pictures ("alli quali ho mandato l'opere mie") and by whom she had been honored, and by her letter of July 20, 1635, to Ferdinando II de'Medici in Florence in which she claims that "molte volte prima" Charles I had extended invitations to her and had even sent her brother (Francesco) to Naples to conduct her to England. Thus the presumed date of the canvas and its size (23 feet in perimeter) alone exclude it from being identified with the *Tarquin and Lucretia* at Potsdam (Fig. 190; [48b]) which, however, may reflect the now-lost composition.

BIBLIOGRAPHY: Chettle, 1937, p. 104 (bill of 1633/34 for the frame); Galileo, 1905, XVI, p. 319; Van der Doort, 1637–39, ed. Millar (1958–60), p. 194 (from Bodleian Library, Ashmole MS 1514, fol. 179v no. 2); London, PRO, *Pictures Statues Plate . . . 1649–51*, LR 2/124, 1649, fol. 6, and publ. by Millar, 1970–72, p. 65 no. 93; British Museum, Harley MS 4898, "The Inventory of the Effects of Charles I, 1649–1652," fol. 137 no. 93; Cosnac, 1884, app., p. 413 no. 93; Hess, 1952, p. 164; Bissell, 1968, p. 161 n. 65; Garrard, 1989, p. 514 n. 187; Fuda, 1989, p. 170.

..

[L-107] *Venus and Cupid* (?)
Rome, Cardinal Antonio Barberini, 1644

The documentation for this painting, perhaps to be identified as the *Venus and Cupid* formerly at Kreuzlingen (Fig. 130), is discussed under [31].

..

[L-108] *Woman with Flowers*
Three-quarter length, formerly Munich, Messinger Collection

A picture of this title was signaled by Voss in 1925 as the "only preserved example of the talent of Artemisia, extolled by Baldinucci, as a painter of flowers." In all probability Voss was referring to one of two almost identical compositions of *Saint Dorothy*: (1) Milwaukee, Wisc., Art Museum, oil on canvas, 1.195 × .94 m.; (2) London, Private Collection, oil on canvas, .84 × .66 m. (Fig. 251).

The Milwaukee canvas appeared at Sotheby's in London on July 4, 1956, as by "O. Gentileschi," but in 1968 I challenged the Gentileschi designation while suggesting that the painting was by the same hand as the *Magdalen*

at the Tomb in the Kunsthistorisches Museum at Vienna (Fig. 247; [X-37]). Richard Spear gave the *Saint Dorothy* to Giacomo Galli (Lo Spadarino), an attribution which the painting bore until the second version was exhibited in London in 1984, Amsterdam in 1986, and New York in 1987, on the latter occasion with the ascription to Antiveduto Gramatica credited specifically to Erich Schleier. The Milwaukee painting was then relegated to the status of a copy, but its quality is such that the possibility that it was produced under Antiveduto's supervision if not by his brush should not be dismissed.

In 1990 Papi referred both the Vienna *Magdalen* and the Amsterdam/New York *Saint Dorothy* to Antiveduto, although without noting that I had assigned the former canvas and the version of *Saint Dorothy* now in Milwaukee (then uncited by Papi) to the same hand, and without signaling the Sotheby sale of 1987. In recently reconfirming his opinions, Papi adds the canvas in the United States as a probable autograph replica. In type, sentiment, and details, as in style, the *Saint Dorothy* manifests all the hallmarks of Gramatica's art as they appear in such pictures—among many possible comparisons—as the *Madonna and Child with Saint Anne* (Nationalmuseum, Warsaw), the *Salome with the Head of Saint John* (Nouveau Drouot, Paris, 1981), the *Allegory of Music* (Serra–De Alzaga Collection, Valencia, 1973), and, very definitely, the *Saint Catherine of Alexandria* formerly on the Roman art market and published by Riedl and Schleier (who also attribute the Vienna *Magdalen* to Antiveduto) and dated by them ca. 1614–17 (and by Papi ca. 1610). Not reaching the monumentality of Gramatica's more mature productions and exhibiting a lingering *maniera* preciousness, the *Saint Dorothy* may be placed in the early years of the second decade (Papi suggests the middle of the decade), not too far removed, that is, from the *Saint Cecilia* in a private collection in Spain, signed and dated in 1611 at Rome and virtually identical in size to the Milwaukee version of the *Saint Dorothy*. It is conceivable that Antiveduto and his shop produced these pictures of young female saints in series. If so, and since according to Giulio Mancini writing in 1619/21 Gramatica sent numerous paintings to Spain, the Italian master might be considered

among the forces that moved Zurbarán to his magnificent cycles of virgin martyrs. Significantly, as the Sotheby's catalogue explains, "an old label on the reverse of the old re-lining identifies the painting as 'No. 2 Sta Rosa de Sulvaran.'"

See also Chapter 6, where Baldinucci's report concerning Artemisia as a skilled practitioner of still-life is discredited.

BIBLIOGRAPHY: Voss, 1925, p. 463; London, Sotheby's, *Fine Old Master and English 18th Century Paintings*, July 4, 1956, p. 25 Lot 140; Bissell, 1968, p. 167; R. Spear, review of Benedict Nicolson, *The International Caravaggesque Movement*, in *Burlington Magazine*, CXXI (1979), 320 fig. 57 and 321; London, Christie's, April 6, 1984, lot 79; E. Ourusoff de Fernandez-Gimenez, Milwaukee, letter to the author, September 17, 1985; advertising page, Amsterdam, Bob P. Haboldt and Co., in A. Blankert and L. Slatkes, *Holländische Malerei in neuem Licht. Hendrick ter Brugghen und seine Zeitgenossen*, exh. cat., Utrecht-Braunschweig, 1986; New York, Sotheby's, *Important Old Master Paintings*, June 4, 1987, lot 94; London, Christie's, December 9, 1988, Lot 27; R. Ward Bissell, letter to the Milwaukee Art Museum, June 19, 1990; James Mundy, Milwaukee, letter to the author, June 25, 1990; Papi, *Paradigma*, 1990, p. 125; Schütze and Willette, 1991, pp. 18, 22 fig. 11, 61 n. 51; Papi, 1995, pp. 96–97 cat. 19 and color pl. XII.

For the other paintings by Gramatica cited above: [X-34]; G. Mancini, *Considerazione sulla pittura*, ed. A. Marucchi and L. Salerno, Rome, 1956, 1, p. 245; Pérez Sánchez, 1973, cat. 28 and pl. 28; J. J. Rivera, "Un inedito de Antiveduto Gramatica," *Boletín del Seminarios de Estudios de Arte y Arqueologia*, XLVI (1980), 501 fig. 2 and 513–15; Braunschweig, Herzog Anton Ulrich–Museum, *Europäische Malerei des Barock aus den Nationalmuseum in Warschau*, exh. cat., 1988, pp. 45–46 cat. 8, entry by K. Murawska; Riedl/Schleier, 1992, pp. 61–63, with ill.; Papi, 1995, pp. 87–88 cat. 5 and fig. 1, 88 cat. 6 and color pls. IV–V, 90 cat. 9 and fig. 3, 91–92 cat. 12 and fig. 7, 125 cat. 77 and fig. 53.

NOTES

PREFACE

1. The formulations of such points of view have been reviewed by Mieke Bal and Norman Bryson, "Semiotics and Art History," *Art Bulletin*, LXXIII, no. 2 (1991), 174–208, and by T. Gouma-Peterson and P. Matthews, 1987, with replies, respectively, by Francis Dowley, *Art Bulletin*, LXXIV, no. 3 (1992), 523–28, and Norma Broude and Mary Garrard, "An Exchange on the Feminist Critique of Art History," *Art Bulletin*, LXXI, no. 1 (1989), 124–26. With importance for an understanding of Garrard's approach as explored in the present study, the last-mentioned authors write (p. 124): "In the Gentileschi articles of 1980 and 1982 . . . Garrard's purpose was not to 'look at art by women in light of its place in a male culture,' valuing it for its male-defined 'progressive innovations,' but rather to discover the hidden, unvalued currents of expression in a woman's work that subtly or boldly criticize—and hence significantly qualify—that surrounding male culture." And (pp. 125–26): "In our view, the business of feminist art history has never been to set up a discrete, self-contained subfield within the discipline; nor has it been to stand aside and call for the tainted discipline's dismantling and demise. Rather, it is to bring a new perspective, like a fresh wind, to the larger enterprise of art history, which, blowing pervasively throughout, might set in motion profound rearrangements of the values, categories, and conceptual structures of our field. . . . Centrist feminist revisionism would bring the consideration of gender to the working practice of *all* art-historical scholarship, as an intrinsic, not extrinsic, perspective that can lead to more accurate understanding of specific monuments, artists, or periods and ultimately—by way of transformation from within—to the reconceptualization of the discipline as a whole." Notable as well for its richness and clarity is the essay by L. Tickner, 1988.

2. Eugene Kleinbauer, *Modern Perspectives in Western Art History*, New York, 1971, p. 43. On p. 11 Kleinbauer characterizes modern criticism as "a many-sided, many-leveled intellectual activity requiring flexibility, insight, and imagination," and contends (correctly in my opinion) that "the problem at hand dictates the treatment, and no single method or approach is always applicable or important to a given area of inquiry." Laurie Schneider Adams (*The Methodologies of Art: An Introduction*, New York, 1996, p. 4) holds that "in the best of all possible worlds, these 'methods' of artistic analysis do not compete, but reinforce one another, and reveal the multifaceted character of the visual arts."

3. Yves-Alain Bois, p. 10 of his "Whose Formalism?" *Art Bulletin*, LXXVIII, no. 1 (1996), 9–12.

CHAPTER I
The Early Career in Rome: 1609–1612

1. "Mi ritrovo una figliuola femina con tre altri maschi, e questa femina, come è piaciuto a Dio, havendola drizzata nella professione della pittura, in tre anni si è talmente appraticata, che posso ardir de dire che hoggi non ci sia pare a lei, havendo per sin adesso fatte opere, che forse principali mastri di questa professione non arrivano al suo sapere, come a suo luogo e tempo farò vedere a vostra altezza serenissima." Published by Tanfani-Centofanti, 1897, p. 221 (the full letter pp. 221–24).

2. Menzio, 1981, pp. 120, 122; Garrard, 1989, pp. 461–62. For the records of the rape trial in the Archivio di Stato at Rome and their publication history, see Appendix I (1612: March–October). Much more will be said and speculated in these pages about this prosecution and its impact upon Artemisia Gentileschi's life and, potentially, upon her art.

3. Tanfani-Centofanti, 1897, p. 223. As late as September 26, 1612, Tassi, through the Tuscan Ambassador to Rome Pietro Guicciardini, was still counting on his Florentine connections to free him (Orbaan, 1927, p. 158).

4. The proposed gift may have been the *Judith and Her Maidservant* (Fig. 31), recorded in the Palazzo Pitti as early as 1638. See below and [5]. Note that numbers in brackets refer to entries in the catalogue. Letter prefixes

indicate the following: [X] Incorrect and Questionable Attributions; [L] Lost Works.

5. See Appendix I for the transcription of the baptismal record, discovered by the present author (1968, p. 153). In July of 1612, in perjury charges brought against Tassi and his witnesses at the rape trial, Orazio stated that Artemisia was then about fifteen years old: "havendo Io una figlia chiamata Artimisia Zitella di età di anni 15 incirca," as I read the passage (fol. 227 in later pagination, fol. 391 in earlier pagination; Fig. 52; Garrard, 1989, p. 481). On the basis of this claim as reported by Bertolotti (1876, pp. 195, 203), most modern scholars assumed that Artemisia was born in 1597 (although with greater accuracy Colnaghi, 1928, p. 158, set her birthdate to 1592). When ordering Artemisia's torture on May 14, 1612, the judge cautioned that consideration be given to the fact that "she is a woman and, as affirmed by her appearance, seventeen years old (*attento quod sit mulier et annorum, ut aspectu dici posset, decem et septem*)." Menzio, 1981, p. 120; Garrard, 1989, p. 461.

6. Garrard, 1989, pp. 15, 183.

7. Which it has received in a thoughtful and spirited manner by Mary Garrard in 1982 and in an expanded version in 1989 (pp. 15–18, 182–209, and passim).

8. Greer (1979, p. 191), Garrard (1989, pp. 199–200), and Palmer (1991, p. 278), among others. See below for the contention that the understanding of the female body exhibited here attests emphatically to Artemisia's authorship of the picture.

9. As noted by Spear, 1989, p. 604, who writes that Domenichino's *Susanna and the Elders* of 1603 in the Galleria Doria-Pamphili "is a more chaste and arguably more sympathetic interpretation of the biblical text." Since in Domenichino's picture one elder suggestively straddles a balustrade and the other is about to rip the sheet from Susanna's (admittedly more covered) body, this conclusion is debatable. See also Spear, 1982, 1, pp. 130–31 cat. 8, and 11, pl. 9. Harris (1989, p. 9), noting that, relative to the Venetian tradition, for example, the appearance of the female nude in Roman Baroque painting was far less common, proposes that "Gentileschi's fleshy young heroine must have been erotically provocative in a way that is difficult for us to appreciate," particularly since, in Harris's view, the "visual conventions of the day . . . required more discretion than Gentileschi adopted." Garrard (1989a, p. 719), however, maintaining that in endowing Susanna with "psychic life" the artist "subvert[ed] the sexist tradition of the female nude," views the argument that the picture was intended to provide sensual pleasure to male viewers as a "return . . . to the archaic position that privileges male over female perceptions, and grants only male artists the right to employ the female body as an expressive instrument." What follows immediately in the present text puts to the test the conviction held by Garrard and many others that the invention of the Pommersfelden *Susanna* is due to the female Artemisia and not to her father Orazio; inevitably, then, it also examines the validity of judgments that take strength from that conviction.

10. Frimmel, 1891, p. 73, and 1894, p. 75 cat. 191; Ortolani et al., 1938, p. 45; Longhi, 1943, p. 47 n. 38; Emiliani, 1958, p. 42; Moir, 1967, 1, p. 100; Gregori, 1968, p. 415; Harris in Harris/Nochlin, 1976, p. 120; Nicolson, 1979, p. 51; Hagen, 1989, p. 79; Garrard, 1989, p. 184; Papi in Con-

tini/Papi, 1991, pp. 34, 109–10. No specific evidence concerning the Gentileschi sustains Cropper's speculations (1992, p. 195) that given its Tuscan roots the family may have observed in Rome the Florentine calendar (its year beginning on March 25), and that therefore the *Susanna*, although bearing the date "1610," might actually have been painted in early 1611.

11. Voss, 1925, p. 463.

12. Bissell, 1968, p. 157; Borea, 1970, p. 71. My suggestion that the date might be read "*1619*" was made before I had an opportunity to study the picture itself and on the basis of a conviction that Artemisia's *Lucretia* (Figs. 18–19; Color Plate III), to which the *Susanna* bears close relationships and which I now believe (see [3]) to have been executed about 1611, was painted at Genoa in 1621.

13. Conducted in 1977 by Susanne P. Sack, chief conservator of the Brooklyn Museum, and reported by Garrard (1982, p. 148, and 1989, pp. 184, 528–29 n. 7). See also [2].

14. Longhi, 1943, p. 47 n. 38; Emiliani, 1958, p. 42; Moir, 1967, 1, p. 100. For Gregori (1968, p. 415), the idea—at the least—is Orazio's, while for Borea (1970, p. 71) an attribution to Orazio must be presumed *if* the date is to be read as "*1610*."

15. Spike, Review, 1991, pp. 732–33, in full knowledge of the latest documentation.

16. Respectively by Harris (Harris/Nochlin, 1976, p. 120; but see note 17 below) and Garrard (1989, p. 185). Artemisia's authorship has also been upheld by Ortolani et al. (1936, p. 45); Borea (1970, p. 71, *if* the date is to be read "*1619*"); Marini (*Storia dell'arte italiana*, 1981, p. 370); and Rave (1989, p. 376, who for various reasons—see [2] and below—believes that the last digit in the date was originally a "*9*" or a "*6*"). Voss (1925, p. 463) thought to recognize Artemisia's individuality in "das weichere Formengefühl," although he later (1960–61, p. 81) acknowledged that the attribution of the *Susanna* was controversial.

17. E.g., Papi and Contini (Contini/Papi, 1991, pp. 34, 110), Lippincott (1990, p. 444), and Hersey (1993, pp. 325–27). Harris's latest discussion of the painting (1989, p. 9) contains no reference to Orazio's possible participation in any capacity.

18. Bissell, 1981, pp. 152–54 [24–25], figs. 43 and 45, and pl. A; E. Schleier in New York, Metropolitan Museum, 1985, pp. 155–57 cat. 43, with color pl. Harris too (Harris/Nochlin, 1976, p. 120) likened the composition to that of the Hartford *Judith* and, as noted, did not then exclude Orazio's intervention in the planning stage of the Pommersfelden painting. Spike (1991, p. 733) writes that the composition is "characteristic of Orazio's devotion to the Caravaggesque lesson of dramatic compression." Mann (1996, pp. 42–43), in line with her conviction that Artemisia was more "attuned to the nuance of narrative" than was Orazio, would credit the daughter with the invention of the composition.

19. Bissell, 1981, pp. 145–46 [14] and figs. 29–30.

20. Ibid., p. 146 cat. 15 and figs. 31–32.

21. Characterizing the *Susanna* as "an incredibly mature assimilation of Orazio's recent style," Garrard (1989, p. 17; also p. 184) has well recognized these parallels in composition, pose, and expression. Contini (Contini/Papi, 1991, p. 110) has also introduced Orazio's *David*, but

embraces the singular notion that the Dublin picture might date to the end of the second decade, in which case Artemisia would emerge as the influential force.

22. Nicolo Felice da Pesaro claimed that although Artemisia could not write he had seen her reading printed and handwritten letters ("Io ho visto leggere detta signora Artimitia litere stampate et anco scitte a mano ma lei non sa scrivere"), but as a witness for the defense wishing to impugn Artemisia's morality by insisting that she made him "deliver letters all over the place," Nicolo might be expected to have exaggerated Artemisia's level of literacy. See Menzio, 1981, pp. 41, 124, and 151; Garrard, 1989, pp. 411, 463, and 478. If in fact Artemisia was incapable of writing in any form, then the signature on the *Susanna*—assuming for purposes of this argument that it came from Artemisia's brush—would have to have been copied. Following comments on the question of Gentileschi's literacy, Harris (1989, p. 10) writes that the artist's ideas in general "must have been formed from knowledge of the visual tradition of the subjects she painted, and from her own emotional experience." For more on Artemisia's level of intellectual sophistication, see Chapter 6 below.

23. Cf. the remarks of Haskell, 1989, p. 37.

24. Rave in Nürnberg, Germanisches Nationalmuseum, 1989, p. 376.

25. Garrard, 1989, with the various links to Michelangelo suggested on pp. 17, 196, 198.

26. Ibid., p. 17. For Artemisia's work for Michelangelo the Younger, see [8] and Chapter 2. See [5] and [10] for other instances in which the authority of Michelangelo's sculpture is thought to inform Artemisia's art.

27. See below for the evidence of this friendship, and Röttgen (1973, opp. p. 26) for a color illustration of the Santa Prassede frescoes.

28. Pergola, 1955, I, pp. 183–84 cat. 273, and II, fig. 273; Jaffe, 1977, p. 90 and color pl. opp. p. 41; J. Müller Hofstede in Köln, 1977, pp. 140–41 cat. 5.

29. These interrelationships and their implications for the "tone of high seriousness" of the *Susanna* are argued by Garrard (1989, pp. 196, 198). Garrard's suggestion that this classical relief served as a source has been positively received by Papi and Contini (Contini/Papi, 1991, pp. 58 n. 9, 110). Following Garrard and because of the easy availability of the photograph, I illustrate the *Orestes Sarcophagus* once in the Museo Profano Lateranese, although this example did not come to light until the nineteenth century. Two other versions—in the Palazzo Giustiniani and the Vatican—were well known in seventeenth-century Rome and had already been mined repeatedly by Renaissance artists. See Bober and Rubenstein, 1986, pp. 136–37 cat. 106, with extensive bibliography. Also C. Robert, *Die antiken Sarkopag-reliefs, II: mythologische Cyklen*, Berlin, 1890, pp. 168–72, 174–75, nos. 155–56, 158 and pls. LIV–LVI.

30. As observed by Garrard, 1989, pp. 198–99.

31. Ibid., p. 199.

32. This has been duly noted by Garrard (1989, pp. 531–32 n. 33), who nonetheless appears to attribute to Artemisia a special understanding of the relief's content.

33. Röttgen, 1973, p. 109 cat. 30 and fig. 30. The Budapest version was preceded by a canvas now in the Louvre (ibid., pp. 108–9 cat. 29 and fig. 29), and a copy of the composition, by 1613 in the collection of Scipione Borghese, was executed by Bernardino Cesare (ibid., pp.

168–69 cat. 151 and fig. 151). D'Arpino's conception was "molto apprezzata dai suoi contemporanei" (ibid., p. 107).

34. In the prime version of d'Arpino's painting, that in the Louvre (see note 33), Actaeon's clutched left hand is especially close to that of Orestes.

35. Bissell, 1981, pp. 99–100, 137–38 [5], and fig. 11.

36. S. Samek Ludovici, *Vita del Caravaggio dalle testimonianze del suo tempo*, Milan, 1956, p. 158.

37. Bissell, 1981, pp. 147–48 [17] and fig. 14.

38. DeGrazia, 1984, p. 235 cat. 14 and fig. 334.

39. As suggested by Harris (Harris/Nochlin, 1979, p. 120) and Rave (1989, p. 376). See also below.

40. DeGrazia, 1984, p. 213 cat. R30 and fig. 291. Brizio's print has been cited by Harris (see note 39) in connection with the Gentileschi *Susanna*, and Garrard (1989, p. 189) grants "a family resemblance" of the *Susanna* to these works from the Carracci circle. Unlikely, conversely, are the specific influences from Caravaggio postulated by Papi (Contini/Papi, 1991, p. 34)—the Doria-Pamphili *Magdalen* for the female type, the fleeing acolyte in the *Martyrdom of Saint Matthew* for Susanna's "gesture of protection-repulsion-attraction," and the *Doubting Thomas* for the "rapacious curiosity and physical oppressiveness" of the elders.

41. This, the position of Garrard (1989, pp. 199–200), was anticipated by Greer (1979, p. 191) and has been followed by Contini (Contini/Papi, 1991, pp. 110, 113) and Stolzenwald (1991, pp. 18–19).

42. As claimed by Garrard (1989, pp. 200 and 532 n. 37, citing a paper delivered by Carl Goldstein in 1979). Harris (1989, p. 9) maintains that "the generic nude of the time was male, male artists being permitted only the study of naked men."

43. Cf. the remarks of Gash, 1989, p. 67.

44. Garrard, 1989, p. 481; Wachenfeld, 1992, p. 155; Lapierre, 1998, pp. 437–38. See also [X-1].

45. Garrard, 1989, p. 200, Harris in Harris/Nochlin, 1976, p. 120, and Stolzenwald, 1991, pp. 18–19.

46. For Orazio's various versions of these subjects: Bissell, 1981, pp. 173–74 [45] and [46], 176–78 [49] and [50], 181–83 [55] and [56], and figs. 96–97, 107–11, 116–17.

47. See the lengthy discussion under [X-6].

48. Garrard, 1989, pp. 189, 204.

49. Ibid., p. 194. This latter assumption has been challenged by Gash, 1989, p. 67.

50. Garrard, 1989, p. 188 and fig. 158; Röttgen, 1973, p. 117 and fig. 38.

51. A. Brejon de Lavergnée, *Dijon, Musée Magnin. Catalogue des tableaux et dessins italiens (XVe–XIXe siècles)*, Paris, 1980, pp. 33–35 cat. 2.

52. The first quotation is from Garrard (1989, p. 189), the others from B. Barnes (in Russell, 1990, pp. 57 cat. 18 and 32).

53. Garrard, 1989, p. 192, and B. Barnes in Russell, 1990, p. 57.

54. Harris (Harris/Nochlin, 1976, p. 120) would see here Artemisia's "strong feelings about the attitudes of men toward women . . ." although (1989, p. 9) she rightly finds forced the attempts somehow to connect the picture of 1610 to the rape of 1611. So also does Merkel, 1992, p. 350. The most extensive exploration of this area of inquiry comes from Garrard (1989, pp. 204–8). Berti (in Contini/Papi, 1991, p. 21) refers to the figure of Susanna as a self-

portrait. Haskell (1989, p. 37) and Spear (1989, p. 604), on the other hand, are to be counted among those who have questioned the proposal that the picture contains autobiographical references. See also below and Chapter 6.

55. Detailed by Garrard (1989, p. 204) and Hersey (1993, pp. 325−26).

56. The conviction that the painting may be related to sexual harassment suffered by Artemisia in the years prior to the rape, that it "gives us a reflection . . . of how one young woman felt about her own sexual vulnerability in the year 1610" was developed by Garrard in her study of 1982 and again in 1989 (see also 1989a, p. 719). It has found favor with Slap (1985, pp. 339, 341), B. Barnes (in Russell, 1990, p. 35 n. 35), Stolzenwald (1991, p. 19), Cropper (1992, p. 202), and Bionda (1992, p. 22). Contini (Contini/Papi, 1991, p. 110) and Haskell (1989, p. 37) are skeptical. Hagen (1989, p. 79), who believes that the picture may have been backdated, views it as one "of resistance and shame that bears witness to the painter's damaged psyche, to her experience with violence." Hersey (1993, p. 326), although accepting the date of 1610, creates a scenario which has Artemisia "adopting Susanna's persona" in order to refute "the charges of unchastity, incest, and prostitution that were made at the trial against Artemisia the person."

57. Respectively Berti in Contini/Papi, 1991, p. 21, and Slap, 1985, p. 340. More will be said about these and related matters in Chapter 6, in which psychoanalytic readings of Artemisia's oeuvre are evaluated as a group.

58. Garrard, 1989, p. 209: "Plainly, a seventeen-year-old girl brought up in an unquestioned patriarchal world could not have consciously intended all this. But as great artists are those who can convert unconscious emotions into palpable form without intervention from the socialized brain—and we accept this in a Michelangelo, a Rembrandt, or a Goya as the explanation for their articulation of more deeply human values than those espoused by the cultures in which they functioned—it is not surprising that the young Artemisia Gentileschi, the victim of a traumatic sexual experience, and later the defiant advocate of female capability, should have drawn subconsciously from the wellspring of her female being and experience to humanize the treatment of a biblical theme that men had distorted almost beyond recognition."

59. In his review of Garrard's book, Haskell writes (1989, p. 36) that "there is little evidence to suggest that artists actually wanted to express their feelings (as distinct from their skills) through the medium of their work. . . . Dearth of evidence has, however, not proved discouraging for biographers, for they have long been convinced by the theory . . . that all artists necessarily reveal themselves in their works, whether or not they wish to do so."

60. Silvers, 1990, p. 373. This, of course, can involve as well the question of gender, which must be confronted often in the pages that follow.

61. Ibid., p. 372.

62. The comments referenced in notes 58−61 are singled out because they appear in texts involving Artemisia Gentileschi; but, needless to say, they are merely part of a much-debated issue in the discipline. At the risk of belaboring the point, this issue will be taken up again toward the end of the text, although with specific reference to feminist and psychoanalytical interpretations of Artemisia's pictures.

63. See Appendix I.

64. See [2]. The reader is here alerted that such statements of fact within the text are documented in the relevant Catalogue entries, the numbers of which appear in brackets in the captions to the illustrations.

65. 1990, pp. 501, 503, and passim. See also Haskell (1989, p. 36) and Spear (1989, p. 604).

66. Additionally, once the painting was displayed to a wider audience, it was vulnerable to a range of interpretations which the artist might not have contemplated, a point made by Pollock (1990, p. 503), who suggests possible variant readings. The question of Artemisia's expectations, if any, for a *female* audience is taken up in Chapter 6.

67. Garrard (1989, p. 202) scrupulously acknowledges that women artists "have been as talented as men in learning the common denominators of style and expression in specific cultures." The potential impact of patronage requirements upon Artemisia Gentileschi's art is addressed throughout the present study.

68. This is also the opinion of Garrard, 1989, pp. 17, 490 n. 3, and 529 n. 8.

69. See [1] for the attribution of this canvas to Artemisia and for its early dating.

70. Ibid.

71. Or so it was claimed by Tassi himself and confirmed by Nicolo Felice (Menzio, 1981, pp. 87, 152; Garrard, 1989, pp. 445, 479).

72. Pedro Hernández, for whose son Artemisia served as godmother, so testified on August 4, 1612 (Garrard, 1989, p. 483).

73. To quote Schleier (in New York, Metropolitan Museum, 1985, p. 157) out of context.

74. Harris in Harris/Nochlin, 1979, p. 120.

75. Garrard, 1989, pp. 32, 185.

76. Cf. ibid., p. 32. One is reminded of the example of Gianlorenzo Bernini setting his own chisel to the relief of the Infant Christ (Paris, Louvre) being carved in France by his seventeen-year-old son Paolo (J. Montagu, *Roman Baroque Sculpture: The Industry of Art*, New Haven and London, 1989, pp. 6−7).

77. Ibid., p. 202 and passim. See also my Chapter 6.

78. Gash, 1989, p. 69.

79. As I have attempted to demonstrate in the Catalogue ([3], [4], and [5]), where also it is contended that all three paintings have suffered reductions in size.

80. A gesture and a juxtaposition finely characterized by Garrard (1989, pp. 228, 230−31, 238), to whose detailed explication of the painting and sense of its context (pt. III, chap. 4) the reader is directed. Garrard's interpretation has found favor with Volland (in Düsseldorf, 1995, pp. 300−301) and Mann (1996, p. 44).

81. Garrard (see previous note).

82. Garrard (1989, p. 227) notes that this evocation of a Christian God, as anachronistic as it is to the Lucretia story, became traditional in Baroque painting.

83. Ibid., pp. 32−34 and chap. 5 for insights into this and other aspects of the Naples *Judith*. Also my Chapter 6.

84. Likewise the object of a close reading by Garrard (ibid., pp. 39−41 and chap. 5).

85. For the attributions of the *Cleopatra* and the related *Danaë* to Orazio Gentileschi, see [X-6] and [X-7].

86. Probably painted in 1611, the *Saint Jerome* is discussed by Bissell, 1981, p. 151 [21] and passim, with fig. 41.

87. A comparison that would have been more obvious before the Naples *Judith* was trimmed at the left ([4]).

88. For the particulars, see [4].

89. Garrard, 1989, p. 313.

90. Spear, Review, 1989, p. 604; Haskell, 1898, p. 37. The section of transparent cloth inserted between Lucretia's fingers and her flesh gives the impression of being an undergarment to an undergarment, organically unrelated to the remainder of the shift. Like the drapery that once covered the pubic area of Orazio's *Cleopatra* in the same collection (Fig. 211), it may be a later prudish addition. Faithful to the literary sources, if not to artistic tradition, Rembrandt depicted his suicidal Lucretia fully clothed; Artemisia did not seize this option.

91. B. Barnes in Russell, 1990, p. 30 (pp. 30–35 for a rich review of the Lucretia narratives and their pictorializations).

92. In this I am in partial agreement with Garrard, 1989, p. 320. Overt eroticism was to increase in Artemisia's art (see below), to the point that the word "pander" (used with overstatement by Lippincott, 1990, p. 448, in reference to the *Susanna* and the *Lucretia*) will become apt.

93. See above and Chapter 6 for comments on her state of literacy at this time. Even later, there is a conspicuous absence of literary allusions in her many letters to knowledgeable patrons, and in my opinion it requires a prodigious leap to accept Garrard's suggestion (1989, p. 230) that "the pro- and contra-Lucretia arguments are likely to have been as familiar to Artemisia as they were to her contemporary, the poet Marino. . . ."

94. See note 2 above. Our knowledge of these proceedings has been greatly enriched through the efforts above all of Menzio, Calingaert, Garrard, Wachenfeld and Lapierre. The reader is urged to consult Garrard's terse summaries and balanced analyses of the events (1989, esp. pp. 20–22, 205–7, 403–6).

95. This nonpublic procedure for gathering evidence is underlined by Elizabeth Cohen (1991, p. 175, and 1992, p. 608), who has undertaken intensive studies of rape cases brought before the Tribunale Criminale of the Governatore di Roma.

96. The many similarities in the testimonies of rape victims in Rome, such as to lead one to "assume prior prompting" as to the kinds of information which the officials would consider most crucial, have been highlighted by Cohen (1991, pp. 170, 176).

97. Because of her presumed promiscuity and also because "according to the canons of moral codes, both Christian and honor-centered, virginity was the essence of a young female's virtue" (ibid., p. 172).

98. Berti (in Contini/Papi, 1991, p. 30 n. 19) insists too strongly upon the confidentiality of the proceedings.

99. As it has been by Cropper, 1992, p. 197.

100. Garrard, 1989, pp. 410 (incl. n. 10), 416; Menzio, 1981, pp. 39, 49. Menzio's transcription of Orazio's claims is here corrected on the basis of the original manuscript (fol. 274).

101. Garrard, 1989, p. 470; Menzio, 1981, p. 49; and especially Lapierre, 1998, pp. 448–49. See also the remarks of Hersey (1993, p. 325) and Cohen (1991, p. 185). Tassi's various protestations that he was deeply in love with Ar-

temisia might easily be construed as self-serving, but the credible witness G. B. Stiattesi also testified to this (Garrard, p. 428; Menzio, p. 73).

102. Garrard, 1989, pp. 467, 470; Menzio, 1981, pp. 132, 138.

103. Ed. 1995, p. 122. Passeri's authority was then relied upon by Morrona (1972, *II*, p. 265), but Bertolotti (1876, p. 195) challenged Passeri's doubts concerning Tassi's gult. In context ("era questa assai bella nella sembianze, e molto manierosa nel praticarla tanto che Agostino se ne invaghi") the word *manierosa* apparently means something like "adoit," in the sense of "artful" or "crafty," with negative connotations (i.e., feminine wiles).

104. Teresa Pugliatti, *Agostino Tassi tra conformismo e libertà*, Rome, p. 24.

105. Bissell, 1968, p. 153. Similar positions were taken by Spear (1971, p. 96) and Hugo Munsterberg (*A History of Women Artists*, New York, 1975, p. 25). Garrard (1982, p. 163) has rightly pointed to the narrow-mindedness of this point of view. Haskell (1989, p. 36) writes that "Artemisia Gentileschi was almost certainly raped (a residue of doubt remains) by a fellow painter."

106. Respectively R. and M. Wittkower (ed. 1969, p. 164) and Rose (1991, p. 14). For the epitaph in question, published in 1653, see Chapter 5 below.

107. Cohen, 1991, p. 169 n. 1.

108. Garrard, 1989, p. 459; Menzio, 1981, p. 115.

109. Garrard, 1989, p. 461; Menzio, 1981, p. 120. Artemisia pronounced herself "prepared to confirm her aforesaid testimony and deposition . . . even under torture." Cohen (1991, p. 191 n. 44) notes that "such torture, its administration regulated by law, was a standard and legitimate practice under Roman rules of evidence."

110. Lapierre, 1998, pp. 214–15, 456–57, as from Rome, AS, Tribunale Criminale del Governatore, *Registrazioni d'atti*, busta 166, fols. 101r, 103r, and busta 167, fols. 165v, 183r, 192r, 222v. Lapierre provides a French translation of the sentence of November 27 and a summary of that of November 28. Previously, the lack of a document of sentencing was not taken, however, as necessarily denoting leniency or exoneration; on the theory that threat of further incarceration convinced the guilty to accept terms stipulated by the wronged party, records of final judgments in such cases were thought to be generally nonobtainable. See Cohen, 1991, p. 175 n. 15; Cropper (1992, p. 203), where it is suggested that Tassi might have obligated himself to contribute financially to Artemisia's marriage arrangements. For the marriage, see below.

111. Tanfani-Centofanti, 1897, p. 223.

112. Cohen, 1992, p. 167. Also Cohen, 1991, pp. 172–73: "In this ideological context intact virginity was valuable as a metaphor for control, a mark both of the family's ability to protect and discipline its members and of the girl's success in restraining herself. . . . Given that an unmarried girl's virginity marked her honor, her loss of virginity, whether voluntary or involuntary, signified both shame and a measure of escape from the control on which the family constructed its collective self-esteem." In his petition to the Pope, Gentileschi stated that action against Tassi would "keep the poor plaintiff from disgracing his other children" (Garrard, 1989, p. 410; Menzio, 1981, p. 39; also see Wachenfeld, 1992, pp. 19–20, without references). On April 6 Tassi told the judge that he had tried to pre-

NOTES

vent men from visiting Artemisia in her living quarters so as to safeguard Orazio's honor ("per provedere all'indennità dell'honor suo"), and six days later claimed that he had spoken with Artemisia about her behavior lest she "bring shame on her father (*e non volesse fare vergogna a suo padre*)." Garrard, 1898, pp. 449, 453, and Menzio, 1981, pp. 96, 102. See also note 116 below.

113. Garrard, 1989, pp. 22, 206; Cohen, 1991, pp. 173–74.

114. Garrard, 1989, p. 418; Menzio, 1981, p. 52.

115. E.g., Garrard, 1989, pp. 411, 416, 425–26, 428, 467, 470, 481–82; Menzio, 1981, pp. 41, 49, 68–69, 73, 132, 138; Wachenfeld, 1992, pp. 157, 160. The emphasis in the trial upon Tassi's broken promises has also been remarked by Merkel, 1992, p. 348.

116. In response to Tassi's question as to why the Gentileschi had not brought suit earlier, Artemisia explained that "something else was to be arranged so that this disgrace would not become known" (Garrard, 1989, p. 464; Menzio, 1981, p. 125). These plans, perhaps similar or identical to one of those that would have led Artemisia to have wed someone other than Tassi and which Tassi is said to have squelched (Garrard, pp. 416, 427–28; Menzio, pp. 50, 71–72), obviously fell through.

117. Garrard, 1989, pp. 411, 416, 427, 439–40, 464, 467, 470, 481; Menzio, 1981, pp. 41, 49, 71, 79–81, 125, 132, 138; Wachenfeld, 1992, p. 157.

118. Tassi claimed that Orazio owed him money and was trying to take over his share of the fresco decoration "in the loggia at Monte Cavallo" (Garrard, 1989, pp. 442, 448, 471; Menzio, 1981, pp. 83, 93, 141). For the loggia— i.e., the Casino of the Muses in the garden of the present Palazzo Pallavicini-Rospigliosi—see Bissell, 1981, pp. 156–58 [29] and passim, and figs. 51–60.

119. See [5] for an account of the machinations and for an attempt to identify the picture in question. That the affair of the *Judith* contributed to Gentileschi's decision to denounce Tassi has been posited by Papi (Contini/Papi, 1991, p. 59 n. 27) and Cropper (1992, p. 200).

120. Garrard, 1989, pp. 413, 428; Menzio, 1981, pp. 43, 72. Also Cropper, 1992, p. 193. The Florentine-born Cosimo Quorli (1565–1612) was highly placed, being a member of the *Fureria del Palazzo Apostolico*. Numerous notices, running from his baptism to his death and postmortem inventory, have emerged from Lapierre's tireless efforts (1998, pp. 428–29, with specific archival citations).

121. For the foregoing remarks on societal beliefs concerning marriage readiness for young women, on the greater likelihood for deception the older a marriageable woman remained single, and on the implications for the reputations of the woman and her male guardian, I am indebted to A. Molho, "Deception and Marriage Strategy in Renaissance Florence: The Case of Women's Ages," *Renaissance Quarterly*, XLI, no. 2 (1988), 193–217. Molho's study was brought to the attention of Gentileschi scholars by Cropper, 1989, p. 864. I have assumed that basic attitudes toward these matters had not changed substantively between fifteenth-century Florence and early seventeenth-century Rome. For Orazio's claims regarding Artemisia's age, see note 5 above.

122. See Appendix I.

123. Moir (1967, I, p. 99 n. 101), followed by Bissell (1968, p. 154 n. 11) and Garrard (1989, p. 406), had posited a family relationship between Pierantonio and Giovanni

Battista. Lapierre has now assembled several notices indicating that they were indeed brothers and further documenting the Stiattesi clan (1998, pp. 444–45, 462, with specific archival citations). See also my Appendix I, December 10, 1619.

CHAPTER 2
Recognition, 1613–1620

1. Bibliographic citations for this and all subsequent references in the text and notes to precise dates may be found in the corresponding dated entries in Appendix I. Prior to the discovery of this document by Elizabeth Cropper, whose research has provided important new insights into Artemisia's personal life during the Florentine years, the earliest specific notice of Gentileschi in Florence was that of November 24, 1614, the date of the first entry on a joiner's bill (Fig. 57). The latest discovery, namely Pierantonio's assignment of power-of-attorney to his brother, is owed to Lapierre (1998, pp. 444–45; and my Appendix I for the specific archival citation).

2. Thus in his letter to Cristina di Lorena on July 3, 1612, Orazio Gentileschi reported that Tassi had promised that through the offices of Lorenzo Usimbardi he would introduce him to the Grand Duke and Grand Duchess, that Agostino had made a similar pledge to Artemisia, and that according to what he had heard letters favorable to Tassi had been sent by Usimbardi from Florence (Tanfani-Centofanti, 1897, pp. 221–24). See also Chapter 1, note 3, and Agostino's deposition of March 26, 1612 (Garrard, 1989, pp. 438–40; Menzio, 1981, pp. 78, 81). Berti (in Contini/Papi, 1991, p. 24) has speculated that Tassi might have helped Artemisia become established in Florence. This is not impossible, especially if it had been part of an agreement exacted from Agostino, but as will be shown Artemisia had her own family support in the city and would not have had to rely upon Tassi.

3. Cropper (1993, p. 760 n. 3) has found baptismal records from 1612 and 1613 of sons born to Margarita di Vincenzo Stiattesi and Lisabetta di Vincenzo Stiattesi, almost certainly sisters of Pietro Antonio (Pierantonio, as he referred to himself) di Vincenzo Stiattesi.

4. Cropper, 1992, p. 203, and 1993, p. 761 n. 20. According to Soprani (1674, p. 316), Orazio exchanged the paternal surname Lomi for the maternal surname Gentileschi after he arrived in Rome, where a maternal uncle served as a Captain of the Guards at Castel Sant'Angelo. Roberto Ciardi has speculated, quite reasonably, that the young Orazio was accompanied to Rome by his older brother Aurelio, who also came under the protection of Captain Gentileschi. In a document of April 17, 1589, Aurelio refers to himself as Aurelio Gentileschi, and it is variously as Aurelio di Giovanbat. Lomi Gentileschi, Aurelio di Giovanbatista Gentileschi, and Aurelio di Giovanbat.a Gentileschi that he appears in three accounts of 1611 from the Accademia del Disegno at Florence (Ciardi et al., 1989, pp. 27, 273 [doc. III], 284 [doc. XLVI]). Also see below, notes 5, 24.

5. This idea, first put forward by the present author (1968, p. 156), has found favor with Garrard (1989, pp. 377 n. 4, 497 n. 47). It is as Artemisia Lomi that the painter

figures in a note to Michelangelo Buonarroti the Younger between September 7 and November 13, 1615, and on her letter of February 10, 1620 (New Style), to Cosimo II; in her signatures on the *Conversion of the Magdalen, Jael and Sisera,* and *Judith Decapitating Holofernes* ([10], [11], and [12]); in payments for the *Allegory of Inclination* [8]; repeatedly throughout the Accademia del Disegno documents, including the registers of her matriculation (May 9, 1616-January 6, 1617; June 13, 1616; July 19, 1616; May 31, 1617; June 26–27, 1618; December 18, 1619); and in Medici inventories of February 28, 1619, and January 16, 1620 (both New Style; [L-26] and [L-39]). See, however, the next note. As indicated (previous note), in three documents dated at Florence in 1611, Artemisia's uncle Aurelio is recorded with the surname Gentileschi, and Ciardi (Ciardi et al., 1989, p. 36 n. 5) postulates that for Aurelio this was a professional expedient in recognition of Orazio Gentileschi's reputation. But even as late as March 16, 1615, as the letter from Andrea Cioli to Pietro Guicciardini in Rome attests, Orazio was apparently little known in Florence. Further (also note 4), Aurelio had already called himself Aurelio Gentileschi in a document of 1589.

6. As posited by Garrard (1989, p. 36) and Papi (Contini/Papi, 1991, p. 43). In Chapter 1 I argued that the Roman code of honor essentially forced Orazio to bring charges against Tassi. If Artemisia understood this, as she must have, it cannot be said that for this "she rightly had reasons to nourish resentment" (Papi) against her father. Further, in the aforementioned baptismal record of September 21, 1613, she is identified as "Artimisia d'Oratio Gentileschi," and in that of another son on November 9, 1615, as "Artemisia d'Oratio Lomi." It was as Artimisia d'Oratio Lomi that she stood as godmother on July 10, 1615. In other documents, including those of her matriculation in the Accademia del Disegno (see below), Orazio is acknowledged as her father. Greer (1979, p. 194) appears to suggest that the adoption of the Lomi name separated Artemisia, de facto, from Orazio, but adds that "to assume that father and daughter were estranged is as unjustifiable as to assume that father and daughter worked and travelled together [see Chapter 3], failing more significant evidence."

7. Garrard, 1989, p. 34.

8. Respectively Procacci, 1967, p. 34 n. 22, and Garrard, 1989, p. 496 n. 41 (also p. 35). Garrard's hypothesis has been accepted by Contini (Contini/Papi, 1991, p. 183). Lapierre (1998, p. 460) proposes that the Stiattesi's use of the term might indicate "familiarity born of gratitude and affection."

9. Contini in Contini/Papi, 1991, p. 127.

10. The documents of payment are recorded and assessed under [8]. To my knowledge, the only published challenges to the prevailing view are from Cropper (1992, p. 205, and 1993, p. 760 n. 5).

11. As implied by Berti (in Contini/Papi, 1991, p. 13).

12. Michelangelo Buonarroti the Younger and Maffeo Barberini, the future Pope Urban VIII, were close friends, and correspondence between them is abundant. Moreover, the Barberini had a house in Florence, and Buonarroti visited them in Rome on several occasions (including in 1609 and 1610). See Vliegenthart, 1976, pp. 7–8, 11–12. Since, however, there is no evidence until 1630 of any contact between Artemisia Gentileschi and the Barberini,

these facts cannot be used to bolster the Artemisia–Michelangelo the Younger case.

13. See [5].

14. Garrard (1989, p. 36), followed by Stolzenwald (1991, p. 22). Stolzenwald (pp. 21–22), speculating on how it was that Artemisia came to work for the Medici, entertains all the various possibilities.

15. In my opinion the Cioli–Guicciardini correspondence was prompted by efforts on behalf of Orazio in Rome regarding a *Cleopatra* by him that he intended to send to Florence as a "gift" to the Medici. For the many particulars, see [X-6].

16. This suggestion was introduced into the Gentileschi literature by Garrard (1989, pp. 37, 497 n. 51), drawing upon Solerti, Florence, 1905. It has been taken up by Lapierre (1998, pp. 458–59), who notes the rarity in Florence of the name Artemisia and Gentileschi's connection to Michelangelo Buonarroti the Younger, who counted Francesca Caccini among his intimate friends. See also n. 23 below. I have used the Solerti edition published in New York, 1968, pp. 89, 92 (incl. n. 1). The performance in question was staged on February 24, 1615 (New Style).

17. See below, including note 20.

18. See below for the supporting evidence.

19. And, at the baptism on July 10, 1615, of a daughter named Artemisia born to Annibale di Nicolo Caroti and Ottavia di Marcantonio Coralli, Gentileschi and Allori assumed the godparenting responsibilities (Cropper, 1993, p. 760 n. 7).

20. Cropper (1993, p. 761) from M. Vigilante in the *Dizionario biografico degli Italiani,* Rome, 1981, XXV, pp. 431–34. July 1, 1618, witnessed a performance in the Boboli Gardens of a Cicognini comedy, and according to a contemporary diary "v'era tutte le dame di casa et quasi tutta la corte. Fu recitata detta commedia dal dottore Iacopo Cicognini, da Filippo Scameroni pittore, da Cosimo Lotti pittore. . . ." See Solerti, 1968, p. 135.

21. As Cropper (1993, p. 761) points out, "Soldani . . . was a close friend of Buonarroti's, and wrote the Latin inscriptions for the main scenes in the *Galleria.*"

22. On July 10, 1615 (as noted), and again on July 4, 1619.

23. Cropper, 1993, p. 760 n. 7. Cropper's research has turned up only four girls, in addition to the two godchildren already mentioned, who were baptized Artemisia in the city between 1612 and 1620.

24. For transcriptions of the two notices of matriculation, both of which cite "Oratio Lomi" as Artemisia's father, see Appendix I. In 1968 (p. 154 n. 14) I expressed uncertainty as to how the phrase "ri conobbe per il padre" at the end of the document of matriculation which I had discovered ought to be interpreted. In 1981 (pp. 34–35) I took this to imply that Orazio Gentileschi was in Florence at the time and was present in the Accademia officially to acknowledge his daughter's induction. Since then Pizzorusso and I located independently a second record, in which the words "con il benef.o di Oratio suo Padre" appear. Pizzorusso maintains (1987, p. 72 n. 53) that the phrases "riconobbe per" and "con il beneficio di" (1) are synonymous, (2) designate that the new inductee is entitled to pay a reduced entrance fee because he or (in the single instance of Artemisia) she had a relative already inscribed in the Accademia, and (3) do not require the phys-

ical presence of that relative. Pizzorusso's understanding of the meaning of the terms has been accepted by Papi (Contini/Papi, 1991, p. 210 n. 28), and I have no grounds on which to question it. It must be acknowledged, however, as indeed it has been by Pizzorusso, that Orazio's name has not been found in the registry of the Accademia del Disegno. Pizzorusso's explanation is that the record of "Aurelio di Lomi" as among the novices (the word used is *noviti*, and the name appears with others within a bracket marked *"Pisa"*) who in December of 1596 entered the Accademia in Florence is an error for Orazio di Lomi, since Aurelio had joined the Accademia many years before, on February 23, 1579. (Pizzorusso, following Colnaghi [1928, p. 157], gives the former date as December 21, 1596. The correct date is December 2, and the full and correct citation is Florence, Archivio di Stato, Accademia del Disegno, *Giornale di Ricordi: 1595–1609*, XXVIII, fol. 51v.) It is true that three records of the Accademia del Disegno from February and March of 1578 (1579 New Style) testify to Aurelio's matriculation at that time. It is now certain, however, that because he had let his membership lapse for many years, paying no annual dues, he was required to reenter as a *novizio* in 1596 (for which he thanked the Accademia in a letter of January 7, 1596/97). Accademia documents indicate that in 1611 Aurelio remained in arrears. For this clarification of the facts, see Ciardi et al., 1989, pp. 38, 55 n. 6, 72–73, 283–84 (docs. XXXIX, XL, XLI, XLII, XLIII, XLIV, XLVI). Papi had already pointed out that the proposal that Orazio was in Florence in 1596 conflicts with the artist's own claim in a letter of July 18, 1633, from London to Grand Duke Ferdinando II that he had not been in Tuscany for fifty-five years (Crinò, 1954, pp. 203–4). In holding (1981, p. 35) that Orazio was in Florence in 1616, I supposed that in this letter Orazio distorted the facts so as to make even more compelling his request for Medici patronage. The same theory has been advanced by Papi with respect to the Accademia document of 1596 and the Gentileschi letter of 1633, but obviously this speculation is no longer viable.

Furthermore, since the aforementioned words "ri conobbe per il padre" are written in a different hand from that of the remainder of the lines in question, and above all since Orazio Gentileschi's paintings from the second half of the second decade and after appear to show a renewed confrontation with Florentine art on its own ground (1981, pp. 32–38 and passim), I am not ready to abandon my hypothesis that the artist visited Florence in 1616.

Another of my judgments regarding Artemisia and the Accademia del Disegno, however, is certainly in error. In 1968 (p. 154, incl. n. 12) I held that the beginning date of November 24, 1614, on a joiner's bill (Fig. 57) filed with Accademia documents meant that Artemisia had been able to use the facilities of the Accademia prior to becoming an official member, and I was followed in this by Garrard (1989, p. 34). Cropper (1993, p. 760 n. 4) has rightly questioned this; it appears rather that the joiner, having been unable to get paid by dealing directly with Artemisia, submitted the cumulative bill (the last item is dated January 23, 1616, New Style) to the Accademia for mediation once Gentileschi was subject to the rules of that body.

25. The publication of Karen-edis Barzman's richly informative book manuscript on the Accademia—hereafter cited as Barzman, 1997—is eagerly awaited as of this writing.

26. Cosimo II's role in arranging Artemisia's matriculation has also been posited by Garrard (ibid., p. 36), Cropper (1993, p. 760), and Barzman (1997). Cropper suggests that the Grand Duke's sponsorship was "a way of protecting Artemisia against her creditors and of mediating their claims." The Accademia did perform these functions (see, for example, Barzman's comments on the records of the tribunal kept by the institution's *cancelliere*), and for various reasons Artemisia did have financial difficulties (see below), to which Cosimo might have been sympathetic. Reasonable as well is Barzman's proposal (1997) that Gentileschi also had the backing of the Dowager Grand Duchess, Cristina di Lorena.

27. Artemisia's acquaintanceship with Galileo is suggested by her letter to him on October 9, 1635 (see Appendix I).

28. I draw upon K.-e. Barzman, "The Florentine Accademia del Disegno: Liberal Education and the Renaissance Artist," pp. 14–32 in A. W. A. Boschloo et al., eds., *Academies of Art Between Renaissance and Romanticism*, Leids Kunsthistorisch Jaarboek V–VI (1986–87), The Hague, 1989. For the professional and social benefits of Academy membership, see K.-e. Barzman, "Liberal Academicians and the New Social Elite in Grand Ducal Florence," in *World of Art: Themes of Unity and Diversity. Acts of the XXVth International Congress of the History of Art*, ed. I. Lavin, 1989, 459–63.

29. Of this Barzman (1986–87, pp. 22–23) writes: "For the Renaissance . . . the external movements of the body were but visible manifestations of the internal movements of the soul; pose, gesture, and facial expression, indeed all aspects of physiognomy including hair color, skin tone, and texture, were dictated by the various humors and emotional states to which men were subject." Barzman (1997) shows that by the second decade of the seventeenth century, and probably considerably earlier, life-drawing classes were part of the Academy's curriculum.

30. See Chapters 1 and 6.

31. Garrard, 1989, pp. 42, 498 n. 61.

32. Although painted in Rome (in my opinion), the *Judith* is included here, for it was commissioned by Grand Duke Cosimo and in all likelihood before Artemisia left Florence.

33. Insufficient evidence excludes the following from the list of works painted by Gentileschi specifically during her Florentine years: a *Rape of Proserpina*, seen by Baldinucci in the Palazzo Pitti [L-66], and a *Guardian Angel* attributed to Artemisia (but perhaps not by her) and in the collection of Cardinal Carlo de'Medici by 1666 [L-37]. The *Aurora* (Figs. 87, 90, 94), although executed for a Florentine client, appears to date about 1625–27.

34. For the record: 3¾ x 2⅔ *braccie* (2.19 x 1.56 m., the Florentine *braccia* at 58.36 cm.); 3½ x 2½ *braccie* (2.04 x 1.46 [wide] m.); 2½ x 1⅞ *braccie* (1.46 x 1.09 [wide] m.); 4 x 3 *braccie* (2.33 [wide] x 1.75 [high] m.); 4 x 3 *braccie* (2.33 x 1.75 m.); 2½ x 1¾ *braccie* (1.46 x 1.02 [long] m.); 2½ x 1¾ *braccie* (1.46 x 1.02 [long] m.).

35. For the supporting evidence for this and the following discussions of subject matter, see the relevant Catalogue entries.

36. Those proposals that would interpret the *Magdalen*

in the light of Artemisia's own experiences and decisions are evaluated below.

37. In an especially creative moment Hersey (1993, p. 329), noting the traditions of Catherine as a woman of beauty, brains, and steadfastness in the face of sexual demands, features the saint as "an Artemisian heroine if ever there was one."

38. The four canvases are discussed and illustrated by Meloni Trkulja, 1973, pp. 44–46. See also Borea, 1970, pp. 57–58 cat. 35, 60–61 cat. 37; A. Bagnoli in Siena, Palazzo Pubblico, 1978, pp. 102–3 cat. 37; F. Guazzelli in Florence, Palazzo Strozzi, 1986, p. 205 cat. 1.89. The villa was purchased in 1622 from Paolo Giordano II by Maria Maddalena, who had it greatly enlarged and enriched. See O. Panichi, "Due stanze della villa del Poggio Imperiale," *Antichità viva*, XII, no. 5 (1973), 32–43, for this and the subsequent history of the fabric. Also E. Fumagalli, "Pittori senesi del seicento e committenza medicea. Nuove date per Francesco Rustici," *Paragone*, XLI, nos. 479–81 (1990), 72–73 and notes.

39. See the detailed analysis by H. Utz, "The *Labors of Hercules* and Other Works by Vincenzo de'Rossi," *Art Bulletin*, LIII, no. 3 (1971), 347–60, who attributes the program to Vincenzo Borghini with input from Cosimo I himself. As Utz notes, Cosimo I's association with Hercules is also indicated by the substitution of his name for that of Hercules on the Florentine seal, by the painted Chamber of Hercules in the Palazzo Vecchio, and by Ammanati's *Hercules and Antaeus* for the Medici villa at Castello, among other projects. Lorenzo il Magnifico (see the three now-lost *Labors of Hercules* by Pollaiuolo, Pollaiuolo's bronze statuette *Hercules and Antaeus*, and Michelangelo's colossal *Hercules*) and Giovanni de'Medici (Pope Leo X, who conceived the frescoed lunette, later executed by Allori, of *Hercules and Fortuna in the Garden of the Hesperides* in the Salone at Poggio a Caiano) had also been associated with Hercules. J. Cox-Rearick, *Dynasty and Destiny in Medici Art*, Princeton, N.J., 1984, pp. 143–52, 186–88, 253–54, 268, and passim. For Hercules in the political arena, see also Brown and Elliott, 1980, pp. 156–61.

40. Spike (Review, 1991, p. 733) has characterized Mary as "soulful rather than repentant, since she neither shows remorse nor rends her finery."

41. Greer, 1979, p. 194.

42. Garrard, 1989, p. 48, speaks of "a barely repressed sensuality that subverts the traditional understanding of the Magdalen as a convert to spirituality even as it subtly sustains her pre-conversion identity as an erotic woman." For Mann (1996, p. 44) the clutching of the breast "alludes to her former vocation and her contemplation of her own sensuality. . . ," while in a later study (1997, p. 172) Mann takes the grasping gesture "to connote contemplation rather than rejection, since the breast is embraced, not covered [contrast the *Venus Pudica* type of the *Medici Venus*], and becomes the object of deep thought rather than revilement." Mann justly entitles Artemisia's painting the *Conversion of the Magdalen*. For more on her reading of the picture, see [10].

43. Garrard, 1989, p. 46.

44. Ibid., pp. 46–47.

45. Harris in Harris/Nochlin, 1976, p. 121.

46. Ibid. and Garrard, 1989, p. 47. To Garrard's claim Lippincott (1990, p. 447) has answered: "This is a serious charge. Is any other painter so hampered by his or her personal experiences?" But Lippincott, too, finds the work "unconvincing," suspecting that "like many male artists of the period she was simply better at portraying active figures than contemplative ones."

47. Respectively by Borea (1970, p. 75) and Berti (in Contini/Papi, 1991, p. 25).

48. M. Mosco in Florence, Palazzo Pitti, 1986, pp. 157, 159, 161.

49. Contini in Contini/Papi, 1991, p. 129.

50. Garrard, 1989, p. 48.

51. The evidence is detailed under [10].

52. Notable examples are listed under [10].

53. C. Pizzorusso (in Florence, Palazzo Pitti, 1986, p. 35 cat. 14) who calls the painting "un'immagine perfetta di contrizione che risponde allo spirito religioso e alle manifestazione pietistiche di Maria Maddalena. . . ."

54. The relevance of the Grand Duchess's devotion to Gentileschi's canvas has been noted by Garrard (1989, p. 46), whose discussion nonetheless shifts attention away from this crucial motive for the commissioning of the work and for its sentiment. The popularity in Florence of Magdalen iconography also owes much to the impact made there by the extraordinary Carmelite nun Maria Maddalena de'Pazzi, whose death in 1607 was therefore a recent event for Artemisia and her contemporaries in the city. See Karen-edis Barzman, "Cultural Production, Religious Devotion, and Subjectivity in Early Modern Italy: The Case Study of Maria Maddalena de'Pazzi," in *Annali d'italianistica: Women Mystic Writers*, ed. D. Cervigni, 13 (1995), 284–305, where also the Magdalen's "potential for multiple meanings" and several Florentine paintings of the Saint are discussed.

55. As Borea (1970, p. 75) implied. See also Merkel, 1992, p. 347.

56. Spear, Review, 1989, p. 604.

57. M. Gregori (in Naples, *Civiltà del seicento* , 1984, I, p. 147) and Spike (Review, 1991, p. 732). See also S. Causa in Naples, Castel Sant'Elmo, 1991, p. 228, and note 29 above.

58. By Cantelli, 1980, pp. 151–52. I cannot agree with Cantelli's attempt (p. 156) to differentiate the psychological plane aspired to by Florentine artists from that reached by Artemisia's *Magdalen*, which he finds "priva di emozioni psicologiche." I do not claim, however, that Gentileschi's picture stands apart by virtue of some special emotional profundity.

59. Ibid., p. 154.

60. G. Vasari, *Le vite dei più eccellenti pittori, scultori, ed architetti* (1568), ed. G. Milanese, Florence, 1907, VII, p. 454.

61. For Titian's *Saint Mary Magdalen in Penitence*—autograph pictures, workshop replicas, lost examples, and copies—see H. E. Wethey, *The Paintings of Titian I. The Religious Paintings*, London and New York, 1969, pp. 143–51 cat. 120–29 and pls. 182–84, 189–91, 235–36. And for Cristofano Allori's extant and lost renditions of the theme: M. Chappell in Florence, Palazzo Pitti, 1984, pp. 82–83 cat. 26.1–26.2, 128. For Contini (Contini/Papi, 1991, pp. 184, 195 n. 15 with bibliography), Allori's original is today in the Florentine collection of Piero Bigongiari (the second of the two examples illustrated by Chappell), the Pitti version being a copy of it.

62. As implied, it would seem, by Harris (Harris/Nochlin, 1976, p. 121). By baring one or both of the Magdalen's breasts, or insisting upon a pronounced cleavage, or designing long, caressing tresses, Gentileschi could have introduced a strong erotic flavor even within the limits of the conversion of the Magdalen iconography.

63. Mosco (Florence, Palazzo Pitti, 1986, p. 159), for whom the *Magdalen* contributed to the Florentine "climato di raffinato esteticismo e di morboso edonismo. . . ."

64. Contini (Contini/Papi, 1991, p. 129), thinking especially of Cristofano Allori.

65. Del Bravo, 1967, p. 76. See also below.

66. Respectively M. Gregori in Naples, *Civiltà del seicento,* 1984, I, p. 147; Spike, Review, 1991, p. 732; Bionda, 1992, p. 26. Also C. Whitfield in London, Royal Academy, 1982, p. 167. For Garrard (1989, p. 40) the court portraits of Bronzino are recalled in the "expressive hyper-refinement of the *Magdalen,* with the tightly oiled locks of her hair, and the elongation and exaggerated jointing of the fingers."

67. Garrard (1989, p. 40) and Contini (Contini/Papi, 1991, p. 182).

68. M. Chappell in Florence, Palazzo Strozzi, 1986, I, pp. 116–17 cat. 1.23, with full bibliography.

69. Defended under [4].

70. M. Chappell in Florence, Palazzo Pitti, 1984, pp. 78–81 cat. 25; J. Shearman, "Cristofano Allori's 'Judith,' " *Burlington Magazine,* CXXI (1979), 2–10; C. Pizzorusso, *Richerche su Cristofano Allori,* Florence, 1982, pp. 48–51, 70–73, 128–29; idem in Florence, Palazzo Strozzi, 1986, I, pp. 189–91 cat. 1.72—all with additional bibliography.

71. By C. Pizzorusso in Florence, Palazzo Strozzi, 1986, III, p. 32. Allori is sometimes thought to have visited Rome about 1610, although such a trip is not documented. Would this explain the striking similarity between the brocaded patterns on the golden gowns worn by the Judiths in Allori's canvas and in Orazio's picture formerly with Colnaghi and Sotheby's (Fig. 39)? I have explored (1981, pp. 16–18) the issue of Orazio Gentileschi's seeming affinity with Florentine art as he searched for his own manner, suggesting that Orazio's "attempt to adapt the works of Caravaggio to his own disposition and in particular to effect a synthesis between Caravaggio's early and mature works was very likely guided partly by the art of his compatriots Santi di Tito and Ludovico Cigoli."

72. See note 24 above.

73. The phrase is C. Whitfield's in London, Royal Academy, 1982, p. 167.

74. M. Chappell in Florence, Palazzo Pitti, 1984, pp. 87–88 cat. 28.1–28.3.

75. G. Cantelli ("Per Sigismondo Coccapani 'celebre fiorentino nominato il maestro del disegno,' " *Prospettiva,* no. 7 [1976], p. 28) has put it this way: "La pittura fiorentina supera cosí l'impatto popolare del caravaggismo con una precisa volontà di nobilitare gli eventi in una sorta di scena che non è certamente quella di un teatro popolare condotto negli angoli delle strade o sulle piazze, ma piuttosto di rappresentazione raffinate e aristocratiche adatte a un *teatro* [emphasis mine] di corte."

76. S. Freedberg, *Painting in Italy: 1500–1600,* Baltimore, 1971, p. 419.

77. See B. Santi and C. Thiem in Florence, Palazzo Strozzi, 1986, I, respectively pp. 166–67 cat. 1.55 and p. 107 cat. 1.17.

78. Thiem, ibid.

79. It is as if Artemisia placed her prominent signature on the pier in the *Jael and Sisera* in an attempt to compensate for the impersonality of the interpretation. See also Chapter 6.

80. A representative sampling: M. Gregori in Florence, Palazzo Strozzi, *70 pitture e sculture del '600 e '700 fiorentino,* 1965, pp. 15–16; idem, "Avant-propos sulla pittura fiorentina del seicento," *Paragone,* XIII, no. 145 (1962), 39; Vliegenthart, 1976, pp. 167, 170–71, 187; Contini in Contini/Papi, 1991, pp. 128, 183.

81. The obvious influence is from his *maestro* Cigoli; Vliegenthart (1976, p. 167 n. 733) has likened the canvas to the aforementioned *Joseph and Potiphar's Wife* by Cigoli in the Galleria Borghese.

82. Catalogued ibid., pp. 177–78 cat. 18.

83. Garrard, 1989, p. 45. Actually, one painting on the ceiling—Tiberio Titi's *Erection of the Tomb Monument at Santa Croce,* commissioned in 1615 and painted in 1618–20—truly distinguishes itself from the others. Showing no sign of having been touched by Artemisia Gentileschi's manner, it does on the other hand display a powerful directed light and particularized realism that one is tempted to call Caravaggesque and may in fact be indebted to that tradition (Vliegenthart, 1976, p. 156). Its spatial composition, designed for the view from below, seems to anticipate the easel pictures of Mattia Preti. For a review of Tiberio's achievement, see S. Lecchini Giovannoni in Florence, Palazzo Strozzi, 1986, III, pp. 176–77.

84. See the related remarks of Contini (Contini/Papi, 1991, p. 183).

85. Obviously, then, I cannot agree with Contini's statement (ibid.) that "pochi c'è . . . da estrarre per sua ultilità nella pittura che si faceva a Firenze al momento dell'ingresso in città dell'artista romana." At issue, too, is the question of Artemisia's importance for subsequent Florentine painting, which Contini explores in some detail (p. 183 ff.). It does seem clear that the following two paintings are indebted to Gentileschi's Florentine manner: (1) the *Female Martyr* in the Zeri Collection (Fig. 213; [X-9]), which in my opinion is a Florentine variant, closest to Carlo Dolci, of Artemisia's painting of ca. 1615 with Newhouse Galleries (Fig. 56; Color Plate VI [7]), and (2) the *Saint Catherine* in the Uffizi (Fig. 224; [X-26]), with good reason attributed by Contini to Francesco Furini. The reader will judge the validity of the other influences liberally adduced by Contini and which in any case belong in large part to the decades following Artemisia's departure from Florence and are therefore beyond the scope of this study. Not considered by the Italian scholar, but the most evident instance of Gentileschi's impact on art in Florence, is the *Aurora* (Figs. 87, 90, 94), produced about 1625–27 for the Florentine Niccolò Arrighetti and important for Giovanni Bilivert and his pupil Orazio Fidani. For the particulars, see [15].

86. Cf. Papi (Contini/Papi, 1991, p. 203) and Garrard (1989, pp. 38–39). Borea (1970, p. iv) has spoken of the Florentine painters' "costituzionale difficoltà, in quanto accademici nati e incorreggibili moderati, a far propria la visione spregiudicata, antitradizionalista, eversiva in ogni senso dei naturalisti."

87. The Grand Duke's openness to Caravaggism has been underlined by Borea (1970, p. vi) and Papi (Contini/Papi, 1991, p. 201).

88. Contini (Contini/Papi, 1991, p. 209) from a document discovered and published by Gino Corti.

89. Ibid.

90. Borea, 1970, pp. 10–11 cat. 4–5; M. Stoughton in Naples, *Civiltà del seicento*, 1984, I, pp. 118–19; and S. Stefano in Naples, Castel Sant'Elmo, 1991, pp. 192–94, 215 cat. 1.6, 222–29 cat. 1.12–1.18, where an expanded catalogue of Caracciolo's Florentine works is constructed and where a *Portrait of Maria Maddalena of Austria* in the Uffizi (ill. p. 189 fig. 9) is tentatively accepted as being the image of the Grand Duchess in question. The only certain, documented picture from Caracciolo's time in Florence is the Pitti *Rest on the Flight into Egypt.*

91. Borea, 1970, pp. 14–15, 17–19 cat. 8–9, 21–22 cat. 12–13; *Dopo Caravaggio. Bartolomeo Manfredi e la manfrediana methodus,* exh. cat. (Cremona), Milan, 1987, pp. 13–15 and 25 (M. Gregori), 37 (R. Morselli), 68–69 cat. 6 and 72–73 cat. 8 (G. Merlo).

92. Borea, 1970, pp. 43–48 cat. 26–28, 50 cat. 30; G. Papi, "Novità sul soggiorno italiano di Gerrit Honthorst," *Paragone,* XLI, nos. 479–81 (1990), 63 n. 17.

93. G. Papi, "Pedro Nuñez del Valle e Cecco del Caravaggio (e una postilla pel Francesco Buoneri)," *Arte cristiana,* LXXIX, no. 742 (1991), 46–50; idem, *Cecco del Caravaggio,* Florence, 1992; Borea, 1970, pp. 48–49 cat. 29. Also on Honthorst, Manfredi, Caracciolo, Cecco, and Spadarino and their dealings with Florence: Papi in Contini/Papi, 1991, pp. 202–6.

94. A point made and demonstrated by Papi, whose "Nuove considerazioni sul naturalismo caravaggesco a Firenze" (in Contini/Papi, 1991, pp. 197–211) should be read in its entirety. In replying to Cioli's letter of March 16, 1615, requesting information about Orazio Gentileschi, Guicciardini on March 27, 1615 (Crinò and Nicolson, 1961, p. 144), leveled scathing criticism against Orazio for his presumed lack of *disegno* and his laborious and merely pleasing-to-the-eye imitation of the model. This, the typical classicist indictment of the *Caravaggeschi,* might be taken as another indication of the Ambassador's partial tolerance only for that tradition, but as Crinò (ibid., p. 144 n. 7) pointed out, and as I (1981, p. 80 n. 3) confirmed, Guicciardini had been in touch with Orazio's enemy Giovanni Baglione (and with Agostino Tassi, I added), and thus was not an objective observer. On September 26, 1612, writing to Guicciardini in connection with a transaction involving paintings by Adam Elsheimer (Orbaan, 1927, p. 158). Further, as suggested by Borea (1970, pp. vi–vii), Guicciardini might have been at pains to support the careers of Jacopo Ligozzi and Cristofano Allori, both of whom he mentions in the letter and claims are better imitators of nature and have a sense of *disegno* a thousand times in advance of Gentileschi's.

95. Following the summary provided by Cropper (1993, p. 760) and the documents collected in Appendix I.

96. The relevant dates in Appendix I are November 24, 1614–January 23, 1616; May 9, 1616–January 6, 1617; August 24–December 16, 1616; May 31 and December 6, 1617; January 24, 1618; March 5, 1618–April 20, 1619; December 18, 1619.

97. Appendix I: September 7, sometime between September 7 and November 13, and November 13, 1615; August 20, 1616.

98. Appendix I: July 26–27, 1618.

99. Appendix I: September 21, 1613; November 9, 1615; August 2, 1617; October 14, 1618.

100. On November 13, 1615, five days after her son Cristofano was born, Artemisia received in bed a loan from Michelangelo Buonarroti the Younger, "essendo in parte."

101. The death of the last-born, Lisabella, on June 9, 1619, is recorded in the Florentine archives. See Appendix I.

CHAPTER 3
Rome and Venice, 1620–1628

1. Appendix I: January 13 and 16, and February 15, 1620.

2. Appendix I. This reference to the *Stati d'anime* of 1622 has escaped the notice of scholars of Gentileschi's art, with the exception of Spike (Review, 1991, p. 734 notes to no. 210), although published years ago by Bousquet (1978, p. 106).

3. Again by the census (Appendix I). On the basis of Gentileschi's letter of October 24, 1637, to Cassiano dal Pozzo, in which the artist asks whether her husband was still living, Garrard (1989, p. 388 n. 40) correctly surmised that Pierantonio had joined Artemisia in Rome.

4. Bissell, 1968, pp. 156–57.

5. In the Palazzo Pietro Gentile, there given by Ratti (1780, I, pp. 119–20) to Orazio Gentileschi. The reader is directed to [3] and [X-6] for detailed discussions of these pictures.

6. Soprani, 1674, pp. 316–17 (misprinted 318); L. Pastor, *Storia dei Papi,* Rome, 1931, XIII, 29 ff.

7. Crinò, 1960, p. 264.

8. Since Don Giovanni died on July 19, 1621, I suggested that Artemisia may not have had an opportunity to contact him, thus implying that she would have been free to accept commissions in Genoa. For the paintings recorded in Venice, see below.

9. Including Garrard (1989, pp. 54–56) and Berti (in Contini/Papi, 1991, p. 25).

10. Contini and Papi in Contini/Papi, 1991, pp. 49–50, 160, and passim. Papi speculates that a false conception of Artemisia's art as being continually dependent upon Orazio's may have contributed to the hypothesis of Artemisia's Genoese journey.

11. See [28], [29], and [30]; Figs. 125, 136, 131; Color Plates XVI, XVII, XIX; and Chapter 4.

12. On numerous occasions during the mid-1630s Artemisia announced to various persons—Francesco I d'Este, Ferdinando II de'Medici, Galileo Galilei, and Andrea Cioli—her intention or desire to leave Naples for Florence (Appendix I: May 22, July 20, October 9, October [?] 20, and December 11, 1635; and February 11 and April 1, 1636). It is to this moment that Contini (Contini/Papi, 1991, pp. 72–73, 166, 189, 191), to whom we owe full recognition of Manetti's importance for Artemisia, tentatively sets Gentileschi's return to Florence. However, in my opinion those pictures by Artemisia in which Manetti's influence is most pronounced ([28] and [29]) fall be-

tween 1630 and 1635. Moreover, notices of Artemisia in Naples continue until November 24, 1637, by which time the pressure for her to go to England had apparently mounted to the point that she could not hold out much longer, particularly since to all indications the parties in Florence did nothing substantive to encourage a trip there.

13. One can assume from Artemisia's letter of October 24, 1637 (Appendix I) to Cassiano dal Pozzo, in which the artist asks whether her husband was then alive, that Pierantonio was still living in 1623. Certainly he was very much alive when in June 1622 (see Appendix I), in a jealous rage, he assaulted a Spaniard whom he suspected of having participated in a serenade at Artemisia's window. Artemisia negotiated on her own the subletting of apartments and work on her house and studio (see Appendix I, November 17, 1621; June 20 and December 9, 1625).

14. As posited also by Toesca (1971, p. 89), Grabski (1985, pp. 59–61), and Contini (Contini/Papi, 1991, pp. 84 n. 1, 162). In her letter of January 30, 1649, to Ruffo, mentioned above, Gentileschi includes Venice in the list of cities in which she had worked.

15. Published by Gerard, 1982, pp. 11–13. See [L-40] for details and further bibliography. Also, the text below. Colluraffi's praise of Artemisia was uncovered by Lapierre (1998, p. 473; see Appendix I, 1627 Unspecified, for further details).

16. The rules for membership were established at the second meeting of the Academy, on November 28, 1593, and appear under the heading "Modo di accetare, e di scrivere gli Accademici." Missirini, 1823, pp. 31–32. Also H. Bodmer, "L'accademia dei Carracci," *Bologna: rivista mensile del comune*, XXII, no. 8 (1935), 62.

17. By 1696, fifteen women painters—among them Elisabetta Sirani, Lavinia Fontana, and Giovanna Garzoni—had been inducted into the Accademia di San Luca. Consult the "Cataloghi Delle Donne Pittrici, ed Accademiche sìdi Honore, come di Merito dell'Insigne Accademia del Disegno, chiamata di S. Luca di Roma" in G. Ghezzi, *Il centesimo dell'anno MDCXCV celebrato in Roma dall'Accademia del Disegno*, Rome, 1696, p. 42.

18. T. Vallauri, *Della società letterarie del Piemonte*, Turin, 1844, pp. 90–91; Spear, 1982, I, p. 260; Maylender, 1927, II, pp. 173–77, and 1930, V, pp. 204–6. Lapierre (1998, p. 470) speculates that an "honorific title" of academician might have been bestowed upon Artemisia by the Roman Accademia dei Desiosi, perhaps the fruit of mutual connections to Galileo. She cites as additional bibliography Ricardo Merolla, "L'Accademia dei Desiosi," *Roma moderna e contemporanea*, III, 1 (1995).

19. Bissell, 1981, pp. 175–76 [48], 220 [L-53], and Figs. 104, 106.

20. In Em. Ant. Cicogna's *Saggio di bibliografia veneziana*, Venice, 1847, as *Raccolta di poesie volgare e latine nel dottorato in filosofia del sig. Gio. Andrea Resio Accademico Desioso l'Osservante, dedicate alla nobilissima e virtuosissima Accademia dei Sigg. Desiosi di Venetia dall'Aveduto loro Accademico. Venezia, Pinelli, 1629*. See Maylender, 1927, II, pp. 178–79. A reader of my manuscript called attention to the fact that "the word 'ne' as opposed to 'dei' is used of women, usually when they join another family in marriage. An interesting inflection here for a female academic." For this usage, see *Grande dizionario della lingua italiana*, Turin, 1972, VII, p. 559.

21. See Appendix III; [L-1], where the evidence for Loredan's authorship of the verses is detailed, [L-54], and [L-105]; and Chapter 5.

22. G. F. Hill, *Portrait Medals of Italian Artists of the Renaissance*, London, 1912, pp. 81–82 no. 67 and pl. XXXI. In cast bronze, the medal measures 54.5 mm. in diameter and is without reverse.

23. 220 × 161 mm. P. Rosenberg, " 'La main d'Artémise,' " *Paragone*, XXII, no. 261 (1971), 69–70 and pl. 54, with history and bibliography.

24. Garrard, 1989, pp. 173, 527 n. 113. Also pp. 63–64.

25. Ibid., pp. 172–73, also for the quotations that follow. The verses in question are given in full in the Catalogue ([L-1], [L-54], and [L-105]).

26. That to the *Fortune-teller* begins: "Non so qual sia più maga / O la donna, che fingi, / O tu che la dipingi." M. Cinotti et al., *Immagine del Caravaggio*, Milan, 1973, p. 51, from Murtola's *Rime* of 1603. Loredan asks of Artemisia's Lucretia: "Dimmi, chi più t'offende / Casta Donna infelice: / Il marito, l'amante, o la pittrice?" For the verse dedicated to Reni's picture, see Garrard, 1989, pp. 250, 540 n. 91. In praising Artemisia, Giovanni Canale (see Appendix III C) wrote: "Ma così vivo in tela ella lo finse / Che 'n dubbio stassi s'è dipinto, ò vivo."

27. See [L-105] for details. With the words "tanto imitar può arte" the poem to the *Susanna* repeats the theme of art's power to bring to life. Although without specifically arguing the case, Cropper (1989, p. 865) writes that "even from a feminist viewpoint the anonymous poems in honor of Gentileschi, published in Venice in 1627, are seriously misread" by Garrard.

28. See the remarks of Garrard, 1989, pp. 173–74.

29. For the writings here in question, see Appendix III.

30. See Chapter 1, note 103.

31. See my detailed discussion of this anecdote and of the unwarranted importance it has had for future scholarship, in Chapter 6.

32. Ed. 1792, II, p. 265.

33. This in a verse entitled "Le chiede un ritratto della sua donna." Toesca, 1971, p. 92. Also Hersey (1993, p. 329), who interprets the final lines ("Cangia dunque costume; / Prendi lo speglio, e te mirando in esso / Forma de la mia Donna il volto istesso") to mean that "the poet's beautiful mistress is none other than Artemisia." This, I think, is what Loredan intends, not that "women . . . are interchangeably divine as beauties" (Garrard, 1989, p. 173).

34. Program notes and a lecture offered on October 12, 1996, by Prof. Louise Stein of the University of Michigan in conjunction with a concert of the music of the Venetian Barbara Strozzi (1619–64?) have dramatized for me the potential rewards of further research into the question of Artemisia's standing in Venice. Of Gianfrancesco Loredan and his fellow freethinking members of the Accademia degli Incogniti (including Giulio Strozzi, Barbara's father) Stein has written: "Questions about the nature of woman and her place in society were subjects of debate at their meetings, but . . . these debates left them caught in a web of contradictions. While their philosophy proclaimed a passionate intolerance of all accepted and official social and moral norms, and this led them naturally to consider the feminist cause, it also called for them to give free rein to their libidinous appetites, which could only be satiated through the submission of women." Loredan and friends

founded the Accademia degli Unisoni above all to show-case Barbara Strozzi's musical talents and to be entertained by her, yet at the same time they satirized the morality of Strozzi, a specialist in "erotic and amorous songs."

35. This is also the opinion of Papi (Contini/Papi, 1991, p. 153) who, however, places more emphasis than I would on the importance for Artemisia's conception of Caravaggio's *Martyrdom of Saint Matthew.*

36. In the words of Spike, Review, 1991, p. 732. Following Mario Modestini, Spike attributes the Naples *Judith* to Orazio Gentileschi. For my reaction to this radical proposal, see [4].

37. See Chapter 6, where I propose a reading of the imagery on the bracelet which differs from that offered by Garrard, who rightly called attention to this detail.

38. Among them Spike (Review, 1991, p. 732) and Berti (in Contini/Papi, 1991, p. 22).

39. This is the view of Garrard (1989, p. 321 ff.), who also argues that in the Uffizi picture Gentileschi "has heightened the very qualities likely to have induced masculine dread" and who finds here "a rare female character who escapes the stereotypes of maiden, virago, and crone."

40. Baldinucci, ed. 1812, X, pp. 253–54.

41. Hersey, 1993, p. 324. See also Chapter 6.

42. For the full references in the original languages, which I first collected in 1983, see [26], where also bibliography is provided.

43. In [26] other related works are cited.

44. It seems equally certain that Artemisia recalled works produced up to two decades earlier by artists stationed in Rome, among them the Cavaliere d'Arpino (Fig. 41) and Adam Elsheimer (Fig. 26). Antonio Tempesta's etched *The Murder of Holofernes* (Fig. 76) may also have played a role. See [14] for a discussion of the specifics and for the relevant bibliography.

45. See Chapter 2, for the details and bibliography, and [14] for bibliographical references to the pictures by Honthorst and Vouet now to be introduced.

46. See [X-36], [X-37], and [L-108]; Figs. 249, 247, 251. Cautiously dating Gramatica's *Judith* in Stockholm to about 1615–16, Papi (1995, pp. 95–96 cat. 18 and color pl. XI) finds some merit in the arguments offered by other scholars for assigning the picture to the last years of the artist's activity. Another instance of the Gentileschi-Gramatica confusion, never followed up in the literature, should be mentioned here. In 1941 a *Girl with a Viol da Gamba*, then the property of the Schaeffer Galleries of New York, was exhibited in San Francisco under Artemisia's name (*Italian Baroque Painting*, Palace of the Legion of Honor, May 16–June 15, 1941, pp. 17 no. 41, 37). In all probability representing the *Muse Erato*, this canvas is absolutely characteristic of Antiveduto Gramatica, by whom the remains of two series of Muses, both in Turin, have been recognized. One, comprised now of three canvases (the two that have not been cut measuring 1.17 x .93 m.), is in the Circolo Ufficiali di Presidio (see Michela de Macco in *Studi e restauri per Moncalieri. Dipinti dalle collezioni civiche, dalle quadrerie sabaude, dalle chiese,* Città di Moncalieri, 1995, pp. 32–35), and the other, reduced to two paintings (1.13 x 1.02 m. and 1.16 x 1.02 m.), is in the Palazzo Chiablese (Papi, 1995, pp. 119–120 cat. nos. 67–68 and figs. 45–46, p. 181). The style of the ex-Schaeffer pic-

ture (at 1.05 x .807 m. somewhat smaller in size than the other examples) is more closely related to the remaining works in the first-named series than to those in the second, yet speaks of an earlier moment still in Antiveduto's career, specifically between 1610 and 1615. The possibility that a third set of Muses by Gramatica once existed is thus held out.

47. See [24], [25], and [36]; Figs. 114, 119, 156; and Chapter 4.

48. In turn Florentine painters, Giovanni Bilivert (Fig. 89) and Orazio Fidani especially, found the *Aurora* very much to their liking. For this and for more on the attribution, dating, and patronage of this large canvas, see [15].

49. Bissell, 1981, pp. 49, 176–77 [49] and passim, and Figs. 108, 110. For the *Magdalen* and *Lot and His Daughters,* also for Sauli, see respectively pp. 173–74 [46] and Fig. 97, and 174–75 [47] and Figs. 102–3. Also Benedict Nicolson's posthumously published "Orazio Gentileschi and Giovanni Antonio Sauli," *Artibus et historiae,* VI, no. 12 (1985).

50. Bissell, 1981, pp. 167–68 [38] and Fig. 85.

51. See the detailed evidence gathered and evaluated in [21] and [22], where credit is given to the insights of other scholars.

52. One cannot be certain about the lost *Cupid and Psyche* for the Patrizi which, as the painting at St. Petersburg (Fig. 252) demonstrates, need not have featured Psyche as nude or partially nude. Is the Hermitage painting in fact by Artemisia Gentileschi, as Papi (see [L-17]) suspects?

53. Garrard, 1989, p. 172. Garrard made this comment with reference to the *Susanna* (Fig. 10; Color Plate I), *Lucretia* (Fig. 19; Color Plate III), and ex-Genoa *Cleopatra* (Fig. 211), the latter by Orazio Gentileschi in my opinion (see [X-6]). In view of the fact that she dates the *Lucretia* to the early 1620s and of her remarks (see below) on the later *Cleopatra,* I have presumed that in principle her comment is applicable as well to the nudes of the 1620s here under consideration. Garrard did not know the *Aurora* and the *Penitent Magdalen.*

54. Ibid., pp. 105, 274, 172, respectively.

55. Ibid., p. 274. Again I must direct the reader to all the evidence, some of it iconographical, which Garrard has mustered in support of her contention. Understood in this way, the *Cleopatra* would hold a powerful message for female viewers. Even accepting for the moment Garrard's interpretation, one would have to deal with the issue of Gentileschi's plans for the women among her audience. See, then, Chapter 6.

56. Ibid., p. 172.

57. I owe this suggestion to Thomas Willette.

58. The Italian text is provided under [15]. Note that Baldinucci appears to have had no qualms about using the word *ingegno* with reference to a woman.

59. Grabski, 1985, p. 58.

60. Kultermann, 1990, pp. 129–61 (pp. 139–40 specifically on Artemisia's painting). Kultermann (p. 135) was reminded of Proust, who speaks of "experiencing a sense of power in watching someone who is defenseless in sleep."

61. See [X-1].

62. See Appendix I (June 12, 1649) and especially [L-27]. In the same letter, Gentileschi adds that in the painting—the *Bath of Diana*—which she was preparing for Ruffo, she could not depend upon "one model alone, be-

cause there are eight figures, and one must paint various kinds of beauty." This indicates that Artemisia embraced ideas of feminine physical beauty and was determined that her patron would find her nudes beautiful. See also Chapter 6.

63. I will return to this important point in Chapter 6.

64. Compare the remarks of Harris in Harris/Nochlin, 1976, pp. 118–19.

CHAPTER 4
Naples and London, 1629–1640

1. See Chapter 3 for Caracciolo's activity for the Medici.

2. For the complex question of Stanzione's Roman stays, see Schütze (Schütze/Willette, 1992, pp. 16, 41–57, 261–62 cat. D14). Schütze's conclusion that Massimo did not reside in Rome for several years at the end of the 1620s, as has often been suggested, is persuasive.

3. For Cassiano dal Pozzo, see Garrard, 1989, pp. 84–88 and passim, and 507–8 n. 135 for bibliography, to which can be added: J. Goldman, *Aspects of Seicento Patronage: Cassiano dal Pozzo and the Amateur Tradition,* Ph.D. diss., University of Chicago, 1978; E. Stumpo in *Dizionario biografico degli Italiani,* Rome, 1986, XXXII, pp. 209–13; *Cassiano dal Pozzo: atti del Seminario Internazionale di Studi,* ed. F. Solinas, Rome, 1989; *Cassiano dal Pozzo's Paper Museum,* Milan, 1992, 2 vols., followed by *The Paper Museum of Cassiano dal Pozzo,* exh. cat. (London, British Museum), Milan, 1993.

4. See [L-100] for more on Maria of Austria's Neapolitan stay.

5. As concluded also by Contini (Contini/Papi, 1991, p. 65).

6. The role of the Duque de Alcalá in Artemisia's transfer to Naples has been suggested by Brown and Kagan (1987, pp. 240, 243), Garrard (1989, p. 91), Contini (Contini/Papi, 1991, p. 65), and Cropper (1992, p. 209). Brown and Kagan (pp. 231–55) offer a full discussion of Alcalá and his patronage, and the factual information presented in the text derives from this source.

7. See [16] and Fig. 97, [L-14], [L-20], and Chapter 3.

8. See [L-75], [L-61], and [L-62].

9. For the arguments, [L-60].

10. See [L-40] and Chapter 3.

11. Garrard (1989, p. 87) quoting G. Lumbroso, "Notizie sulla vita di Cassiano dal Pozzo: protettore delle belle arti fautore della scienza dell'antichità nel secolo decimosettimo," *Miscellanea di storia italiana,* XV (1876).

12. Garrard, 1989, pp. 136, 519 n. 239.

13. This and the biographical information on Garzoni that follows draw upon the monograph by Gerardo Casale, 1991, particularly pp. 6–7, 16–17, 204–6. See also Chapter 6.

14. Her last letter to Cassiano from Naples is dated July 12, 1631.

15. For more on this letter, see Appendices I and III and [32].

16. Tentatively [36] and [L-66].

17. Specifically, to the cycle of the Life of Saint John the Baptist for the Buen Retiro, on which Gentileschi,

Stanzione, and Paolo Finoglio collaborated in 1633–34 and which is here discussed in detail in [32] and below.

18. As confirmed by letters from Artemisia dated January 21 and 25, March 7, May 22, October 9 and 20, 1635—all Appendix I.

19. Bissell, 1981, pp. 47 ff., 50–51 and passim.

20. Garrard (1989, pp. 111, 514 n. 188), while unaware of Artemisia's presence in Venice in 1627–28, conjectured that some of the pictures by Artemisia later recorded in English documents were obtained by the brothers Gentileschi at this time. It will be recalled that a *Lucretia* by her is recorded in a Venetian verse of 1627 [L-54], but it is at least equally likely that Francesco acquired his sister's *Tarquin and Lucretia* during the just mentioned pre-1635 trip (trips?) to Naples. Certainly it was in Venice that Artemisia communicated to Lanier one of the "secrets" of her technique. For more on the buying trip, Lanier, and Gentileschi's technical procedures, see Appendix IV, including note 33.

21. Compensation for the two canvases and, she seems to imply, a call to Florence. In her letter to Galileo Galilei on October 9, 1635, Gentileschi makes it clear that she would like to be called to serve the Grand Duke in person.

22. As proposed by Contini (Contini/Papi, 1991, p. 73).

23. As suggested by Garrard, 1989, p. 176. See also below.

24. Artemisia refers to Henrietta Maria as "the Queen Mother, my Mistress," and says that it was she who was sending Gentileschi's brother back to Italy and who, along with the King, had given her permission to offer a picture to Francesco I. Clearly the Queen kept herself informed of the painter's activities, including those in the Queen's House at Greenwich ([41] and below), another indication that Henrietta may have played a part in enticing Artemisia to England.

25. Casale, 1991, pp. 7–8. Garzoni was to remain in Turin for five years.

26. In the spring of 1637, Francesco Gentileschi, whom Artemisia had entrusted with "the management of all my business affairs" (letter to Cassiano dal Pozzo, January 21, 1635) and who presented her pictures to Cardinal Antonio Barberini and Francesco I d'Este, made a trip from Turin to Genoa in the service of Duke Vittorio Amedeo I of Savoy (Bissell, 1981, p. 116, from A. Baudi di Vesme, "L'arte negli Stati Sabaudi ai tempi di Carlo Emanuele I–di Vittorio Amedeo I e della reggenza di Cristina di Francia," *Atti della Società Piemontese di Archeologia e Belle Arti,* XIV [1932], p. 321). Conceivably Francesco's mission had to do with Artemisia's travel plans.

27. Casale, 1991, p. 9.

28. See [23] and [L-42]. Having worked for the Medici in Florence, her father having worked for Marie de'Medici in Paris, and having certainly come to the attention of Marie de'Medici through these channels and by way of Marie's daughter Henrietta Maria, Artemisia was in an excellent position to be considered for French patronage. See Garrard, 1989, pp. 90, 159–60.

29. Bissell (1968, p. 161) following Moir (1967, I, p. 100) and A. M. Crinò ("Rintracciata la data di morte di Orazio Gentileschi," *Mitteilungen des Kunsthistorischen Institutes in Florenz,* IX [1960], p. 258). Also: Garrard, 1989, p. 110; Fuda, 1989, pp. 168–69; and Contini in Contini/Papi, 1991, p. 73.

30. There is no documentation as to precisely when she left England or got back to Italy, and thus one must deal in conjecture (for which see the next chapter).

31. See respectively [L-8], [L-53], [L-102], [27], and [L-95]. Probably at the urging of Joachim von Sandrart, the famous Roman connoisseur Vincenzo Giustiniani purchased a *David and Goliath* by Artemisia [L-23], and Gentileschi speaks of a painting intended for Monsignor Ascanio Filomarino, later Archbishop of Naples [L-77].

32. A point well taken by Contini (Contini/Papi, 1991, p. 73).

33. See Appendix II.

34. On October 24, 1637, Artemisia asked Cassiano dal Pozzo whether her husband was still alive, obviously hoping that if Pierantonio Stiattesi were around she could get him to contribute to Prudentia's dowry.

35. Ed. 1675 (1925), p. 290. See [L-23] for a more detailed discussion of Sandrart's encounter with Artemisia and her work. I am very grateful to one of my readers for alerting me to this particular sense, among others, of the word "Akademie." A search of Sandrart's text has yielded several other examples of this same usage, two of which should suffice here to make the point: (1) in the biography of Balthasar Gerbier (p. 188): "als dass sie gute Zeichner seyen, in deme ich oft und viel, sonderlich bey den Italienern gesehen, dass ihre junge Leuthe, welche früh zu zeichnen anfangen, die Reglen oder Theoria wol verstanden, mündlich darvon zu reden gewust und alle antiche Gemälde von Raphael meisterhaft nachgezeichnet, nicht weniger auch auf der Academie das Model so vol verstanden. . . ." and (2) in the biography of Johann Jacob von Sandrart (p. 219): "ist mit Fleiss zu den Studien, absonderlich zu der Mahlerkunst erzogen, in der Zeichenkunst auf der Academie, wie auch in der Perspectiv. . . ." Clearer still is Passeri's remark (ed. 1995, p. 22) regarding the three Carracci: "Introdussero li Caracci [sic] lo studio di disegnare il nudo, che chiamano Accademia." Further support is found in Jacob Grimm and Wilhelm Grimm, *Deutsches Wörterbuch*, rev. ed., Leipzig, 1986, II, pt. I, cols. 106–8. I find no evidence in his references to the practice of life drawing—whether by Artemisia or by male painters—that Sandrart ever meant to indicate female models.

36. I am again following the information provided in the Peltzer edition of the *Academie*, published in 1925.

37. B. de Dominici, *Vite dei pittori scultori ed architetti napoletani*, ed. Naples, 1742, III, pp. 763–74. Dominici's claim is corroborated by a contract of January 23, 1636, between Falcone and a male model, who was to pose in the nude for two hours three times a week over a three-month period (F. Saxl, "The Battle Scene Without a Hero. Aniello Falcone and His Patrons," *Journal of the Warburg and Courtauld Institutes*, III [1939–40], 86 n. 3).

38. N. Pevsner, *Academies of Art Past and Present*, Cambridge, 1940, pp. 74 n. 1, 114, 115 n. 2.

39. Years later, on November 13, 1649, Artemisia wrote to Don Antonio Ruffo in Messina: "I must caution Your Most Illustrious Lordship that when I ask a price, I don't follow the custom in Naples, where they ask thirty and then settle for four. I am Roman, and therefore I wish always to act in the Roman manner."

40. Specifically, for readers interested in putting together a complete list, [24]–[42], and [L-8], [L-15], [L-23], [L-25], [L-30], [L-53], [L-61], [L-62], [L-64], [L-66], [L-69], [L-70], [L-75], [L-76], [L-77], [L-79], [L-85], [L-90], [L-95], [L-96], [L-97], [L-98], [L-99], [L-100], [L-102], [L-103], [L-106].

41. See the Bibliography for the contributions of Labrot, Nappi, Pacelli, and Millar, to which should be added the great service rendered by Burton Fredericksen and the researchers of the Getty Art Information Program.

42. When on December 11, 1635, Artemisia announced to Andrea Cioli her desire to send to Florence a painting by her daughter, Prudentia had entered her nineteenth year and therefore was older than her mother had been when she painted the *Susanna and the Elders* (Figs. 10, 15; Color Plate I).

43. Figs. 159 and 162; [L-8], [L-53], and [L-102].

44. See Chapter 3 and [26] for complete references to Gentileschi as a portrait painter.

45. There is an outside chance that the *Annunciation* (Fig. 114) was intended for a church, although my proposal that it came from San Giorgio de'Genovesi in Naples must be rejected (see [24]).

46. Letter to Galileo Galilei, October 9, 1635.

47. Letter of November 24, 1637.

48. Letters to Francesco I d'Este, January 25, 1635, and December 16, 1639.

49. Under [25] I have defended in detail the identification of the woman painter as Artemisia Gentileschi, the attribution of the canvas to her, and the suggestion that the picture was intended for Cassiano dal Pozzo.

50. Ripa, ed. 1603, pp. 404–5.

51. See F. F. Hofrichter, "Judith Leyster's 'Self-Portrait': 'Ut Pictura Poesis,'" in *Essays in Northern European Art Presented to Egbert Haverkamp-Begemann on His Sixtieth Birthday*, Doornspijk, 1983, pp. 106–9, for a picture that parallels Artemisia's *Self-Portrait* on several points.

52. G. Cantelli in Florence, Palazzo Strozzi, 1986, I, pp. 264–65 cat. 1.128.

53. Lurie in Percy/Lurie, 1984, pp. 182–83 cat. 66 and color pl. XI.

54. See below, note 66.

55. Respectively K. Hermann-Fiore, "Due artisti allo specchio. Un doppio ritratto del museo di Würzburg attribuito a Giovanni Battista Paggi," *Storia dell'arte*, no. 47 (1983), 31–32 (including p. 32 n. 19 with references to studies by K. Langheit and H. Keller), and Fig. 8; and J. Spike, *Baroque Portraiture in Italy: Works from North American Collections*, exh. cat., Sarasota, Fla., 1984, pp. 142–43 cat. 50 with color ill. Regnier's picture, which shows the artist, palette in left hand and brush in his right, pausing before an easel bearing an oval portrait of an older gentleman was executed in Rome in the early 1620s; it may have been known to Artemisia.

56. Again [25], including a discussion of Artemisia's letters to Cassiano on August 24, August 31, and December 21, 1630.

57. Garrard, 1989, p. 367. Garrard's study of the Kensington picture, first published in 1980 and then in expanded form in her monograph of 1989 (pp. 85–88, 337–70), is brimming with important insights and comparative material. Although starting from the premise that the painting is a *Self-Portrait as the Allegory of Painting*, Garrard's reading contains much (see below) that can easily be accommodated by my interpretation of the painting.

58. Garrard (1989, p. 355) writes: "The color changes . . . are not simply embellishments added to make it conform to an iconographic specification; rather, they reflect Artemisia's use of Ripa's suggestive phrase as an opportunity to display, through her own interest in and command of color, the technical skill appropriate to Pittura herself."

59. For the medal, see J. Schaefer, "A Note on the Iconography of a Medal of Lavinia Fontana," *Journal of the Warburg and Courtauld Institutes*, XLVII (1984), 232–34 and pl. 23 b–c.

60. By Garrard (1989, p. 337), who introduced the Casoni medal in connection with the Kensington canvas.

61. Ibid., p. 358.

62. Ibid., pp. 95–96. My own claims made for the *Clio* are supported under [27].

63. See [L-30] for the specific references.

64. H. Senie, "The Tomb of Leo XI by Alessandro Algardi," *Art Bulletin*, LVIII (1978), 90–95. The association of Minerva with Marie de'Medici has been underlined by Garrard (pp. 160, 162), who is inclined to see here Anne of Austria (wife of Marie's son, Louis XIII) in the guise of the goddess and to date the painting about 1615 (pp. 48–51, 159–64 and corresponding notes, for the complete discussion).

65. Ripa, ed. 1603, pp. 442–43.

66. My remarks on Gentileschi's fashions are based upon A. C. Mastrocinque in *Storia di Napoli*, Naples, 1970, VI, pt. 2, pp. 789–90, 792–94. Except with regard to color, Mastrocinque does not cite specific works by Artemisia, but what she says appears fully relevant to the paintings now under review.

67. Ibid., p. 789.

68. By Garrard (1989, p. 516 n. 218), citing Cropper's comments (see next note).

69. By Cropper, 1983, p. 105.

70. See J. Thuillier in Rome, Palazzo delle Esposizioni, 1991, pp. 141–42 cat. 11 and color pl. 11, and 148–49 cat. 14 and color pl. 14, respectively

71. By Contini in Contini/Papi, 1991, p. 66. For the so-called *Temptation of Saint Francis* in San Lorenzo in Lucina, see the discussion in Chapter 3; and for the *Investiture of Saint Francis* in the same Alaleone Chapel, J. Thuillier in Rome, Palazzo delle Esposizioni, 1991, pp. 143, 145, 147 cat. 12 and color pl. 12. The names of Vouet and Claude Vignon have been linked by M. Gregori (*Civiltà del seicento*, 1984, I, p. 147) to Artemisia's *Annunciation*.

72. See [L-3]. M. Gregori (*Civiltà del seicento*, 1984, I, p. 147) has characterized the *Minerva*, along with the *Clio*, as being "along the lines of the worldly and idealizing themes introduced by Vouet. . . ."

73. J. Thuillier in Rome, Palazzo delle Esposizioni, 1991, pp. 136–37 cat. 7 and color pl. 7.

74. By F. Ferrante in London, Royal Academy, 1982, p. 264, and again in Naples, *Civiltà del seicento*, 1984, I, p. 181.

75. R. Longhi, "Orazio Borgianni," *Scritti giovanili: 1912–1922*, Florence, 1961, I–I, p. 114.

76. Bissell, 1968, p. 163 n. 81.

77. By Contini in Contini/Papi, 1991, pp. 166, 189–91. What follows in the text is a summary of Contini's insights supplemented by observations of my own.

78. A. Bagnoli in Siena, Palazzo Pubblico, 1978, pp. 100–101 cat. 35.

79. Chapter 2, note 38 for the bibliography. The very subjects of these canvases, as of the ten frescoes in the same room, would have attracted Artemisia's attention.

80. Any influence is generally supposed (as by A. Bagnoli in Siena, Palazzo Pubblico, 1978, pp. 101–2, 109–10) to have passed from Artemisia's Florentine works to Manetti. But as Contini has realized, the relationships just observed (and, I would add, the relative paucity of extant canvases from Artemisia's time in Florence between 1612/13 and 1620) require a reevaluation of this viewpoint. They also raise again the question (see P. Torriti, ibid., pp. 16, 18) as to when Manetti went to Rome. Conceivably, as I think was the case with Vouet and Gentileschi, there was a reciprocal relationship.

81. By Contini in Contini/Papi, 1991, 166, 169, 191, 196 n. 44, who labels the painting here illustrated a *modelletto* for a large canvas also in a private Florentine collection.

82. A. Bagnoli in Siena, Palazzo Pubblico, 1978, p. 120 cat. 55; Brandi, 1931, pp. 122–23 and pl. XXIX.

83. A. Bagnoli in Siena, Palazzo Pubblico, 1978, p. 120 cat. 54; Brandi, 1931, pp. 40–41, 115–17, and pl. XXI. Through her connection with the Medici court, Gentileschi would no doubt have been granted access to the Casino Mediceo and the Villa del Poggio Imperiale. It is less certain that she could have seen the *Magdalen* and *Lot* here cited, although the latter was once in a Florentine collection and, as Artemisia's *Judith* in the Uffizi (Figs. 75, 77–79; Color Plate XII), was engraved for the *Etruria Pittrice*. In any event, the Gentileschi-Manetti question should be pursued.

84. With reference to Manetti's *Lot,* Brandi (1931, p. 40) speaks of a "rifrazione prismatica della luce" and of "una sorta di fragilità nel taffetà brillante."

85. As astutely revealed by Perlove (1989) with regard to Guercino's *Esther Before Ahasuerus* in the University of Michigan Museum of Art.

86. All of this has been observed by Garrard, 1989, pp. 76, 78.

87. Greer, 1979, pp. 197–98.

88. Garrard, 1989, p. 78.

89. B. Barnes in Russell, 1990, p. 33.

90. I quote from *Il Pastor Fido: The Faithful Shepheard,* English trans. by Richard Fanshawe, London, 1664, pp. 68–76.

91. Garrard, 1993. The extensive quotations here and in the Catalogue [30] are not intended to take the place of a careful reading of the article. The reader is also directed to the other depictions of the Corisca and the satyr story listed and in part illustrated by Garrard.

92. Ibid., pp. 34 and 38, respectively.

93. Garrard (1989, p. 249) within the context of a review of the iconography of Cleopatra in sixteenth- and seventeenth-century art.

94. Respectively R. Causa (in Naples, Castel Nuovo, 1964, p. 20) and Novelli, 1974, p. 70.

95. M. Gregori in *Civiltà del seicento,* 1984, I, pp. 147, 150.

96. Dominici, ed. 1844, III, p. 178.

97. See Willette in Schütze/Willette, 1992, p. 176 nn. 10, 15.

98. Dominici, ed. 1844, III, pp. 82–83 (in the Life of Belisario Corenzo). Also my [24]. W. Prohaska (in Prague, 1995, pp. 16–17) cautions that the notion of Reni's

influence in Naples depends in part on the *bella maniera* (Reni) vs. *maniera ignobile* (Caravaggio) topos found in Dominici.

99. Willette in Schütze/Willette, 1992, pp. 38 color pl. x, 199–200 cat. A28, 295 Fig. 141.

100. Both Novelli (1989, p. 151), who attributed the *Corisca* to Annella de Rosa, and L. Rocco (in Naples, Castel Sant'Elmo, 1991, p. 326), who published the work as by Artemisia Gentileschi, recognized but did not specify its ties to Stanzione.

101. By P. Leone di Castris (in Naples, *Civiltà del seicento*, 1984, 1, p. 478 cat. 2.256), who saw these women as evidence of a reciprocal relationship between the two artists, and by Contini (Contini/Papi, 1991, p. 80).

102. Nappi, 1983, p. 78; Schütze/Willette, 1992, p. 265 cat. D33.

103. See [L-66].

104. Ruffo, 1916, pp. 54–55; idem, 1919, p. 48; Schütze/Willette, 1922, pp. 262–63 cat. D15.

105. All of these contentions are supported under [32], where also discussions of the subjects, sizes, and hypothetical arrangement of the canvases may be found.

106. Longhi, *Scritti*, 1961, 1–1, p. 263.

107. Röttgen, 1973, pp. 139–40 cat. 59 and color pl. opp. p. 138.

108. Thus, for example, the contract which Stanzione signed for the vault of the choir in the Gesù Nuovo at Naples stipulated that his frescoes should be in harmony with those already supplied in the church by Belisario Corenzio, and in participating in the completion of the series of altarpieces for the Cappella del Tesoro in the Cathedral, which series Domenichino had not been able to finish before his death, Massimo took great care to fashion his work in the Bolognese master's manner. See Schütze/Willette, 1992, pp. 216, 222, and passim.

109. Specifics in support of these contentions are provided under [32].

110. Garrard, 1989, pp. 97, 99.

111. L. Giusti in London, Royal Academy, 1982, p. 258; P. Leone de Castris in Naples, *Civiltà del seicento*, 1984, 1, p. 475. The pose and position of Stanzione's soldier, however, were probably suggested by Vouet's *Circumcision* (Fig. 115).

112. Garrard, 1989, p. 101.

113. Cropper (1983, p. 105) advocated that such explanations be sought.

114. My sense is that the expressive restraint of Gentileschi's Pozzuoli canvases is more attributable to her inability to give herself to the stories than it is to "the general shift of European art at mid-century, away from the early century's interest in intense emotional states . . . and toward a Cartesian systematization of the passions, epitomized in the philosophical calm of Poussin's pictorial world." Garrard, 1989, p. 103.

115. For the various viewpoints of scholars regarding this matter, see [33].

116. Schütze in Schütze/Willette, 1992, pp. 21 color pl. III, 193 cat. A12, and 277 Fig. 110.

117. Ibid., pp. 210 cat. A47 and 315 pl. 178. Here again there appears that ubiquitous woman with covered head resting on her hand who, as noted, had appeared in Gentileschi's *Birth of Saint John* and Stanzione's *Saint John Preaching*.

118. Among the lost or unidentified paintings datable between 1635 and 1640 are the *Self-Portrait, Fame, Susanna and the Elders,* and *Diana at Her Bath* once in the English Royal Collection; the *Christ and the Samaritan Woman* and *Saint John the Baptist in the Desert* offered to the Barberini; and those of unspecified subject shipped to Francesco I d'Este of Modena in 1639.

119. See [L-8], [L-53], [L-102].

120. Garrard, 1989, p. 123.

121. See also below, note 130, for references to Bernardo Cavallino's renditions of the subject. As Garrard (1989, p. 516 n. 217) notes, Orazio Gentileschi had also rejected blatant sexuality in his various interpretations of the theme from the 1620s. Artemisia may have seen the version painted for Giovan Antonio Sauli in her father's Roman studio, but compositionally her picture owes nothing to Orazio's conception. Bissell, 1981, pp. 174–76 [47] and [48], 180–81 [53], and Figs. 102–6.

122. It might be noted too that all four of the paintings just mentioned likewise manifest the meditative strain in Artemisia's personality.

123. The same model appears to have posed for the *Bathsheba* and for the figure of Venus in the *Venus and Cupid Embracing* (Fig. 130), which is also to be dated near the mid-1630s [31]. Unlike the Bathsheba, however, the body of the goddess of love appears (from the photograph, by which I know the painting) to be rather slick, and the play of the picture to prurient interests is overt, setting the *Venus and Cupid Embracing* far from the chastened renditions of *Bathsheba, Susanna,* and *Lot and His Daughters.* In all, the *Venus* is a difficult canvas whose attribution to Artemisia Gentileschi is unenthusiastically affirmed.

124. For more on the settings and their constituent elements in the *Bathsheba* and *Susanna,* and for the relevant bibliography, see [37] and [38].

125. Percy/Lurie, 1984, pp. 213–15 cat. 81 and color pl. xx.

126. Ibid., pp. 213–15 cat. 80 and color pls. xviii–xix.

127. Ibid., pp. 201–3 cat. 76.

128. Ibid., pp. 54–57 cat. 2–3.

129. Scholars have postulated a Gentileschi-Cavallino collaboration in the *Lot* ([39]) without recognizing the possible role of Bernardo in the *Bathsheba* and *Susanna.*

130. Percy/Lurie, 1984, pp. 126–27 cat. 38, 198–201 cat. 74, and color pls. III, xiv.

131. Artemisia Gentileschi's importance for Guarino and Pacecco De Rosa has often been claimed. Reluctantly, I must leave a discussion of this issue to another time; pictures such as the former's *Birth of the Virgin* (Naples, Catello Collection) and the latter's *Judgment of Paris* (Vienna, Akademie der bildenden Künste) would be integral to the argument.

..

CHAPTER 5
The Later Years in Naples, 1641–1652

1. Baldinucci, ed. 1812, x, p. 256.

2. Bissell (1968, pp. 162–63) followed by Garrard (1989, p. 516 n. 11) and Contini (Contini/Papi, 1991, p. 76).

3. Baglione, ed. 1935, p. 360.

4. Garrard (1989, p. 120) writes that "her hosts' lavish support was coming to an end as the political crisis deep-

ened. By 1642, fighting had broken out between the royalist Cavaliers and the Puritan Roundheads, precipitating the civil war that dominated the rest of the decade. . . ."

5. In 1628 Margherita de'Medici, daughter of the late Grand Duke Cosimo II, married Duke Odoardo Farnese of Parma.

6. See [43]–[53]; [L-2], [L-27], [L-28], [L-34], [L-35], [L-45], [L-46], [L-48], [L-84], [L-85], [L-101], and [L-104]. For many other paintings assigned to Artemisia in Neapolitan inventories and listed in the Catalogue of Lost Works there is no reliable way of determining whether they were executed by her in the 1630s or 1640s or, for that matter, if they came from her brush at all. Thus they cannot properly figure in a reconstruction of Gentileschi's last period.

7. John Berger, *Ways of Seeing*, London, 1972, pp. 45–64, as referenced by Gouma-Peterson and Mathews, 1987, pp. 338–39.

8. B. Barnes in Russell, 1990, pp. 30–31.

9. Many of these have been observed by N. Bilous in the catalogue of the Musée des Beaux-Arts, pp. 81–83 cat. 22.

10. As recognized by Pointon (1981, p. 366) in commenting upon the Naples version.

11. By Garrard (1989, p. 134) who, however, proceeds to offer some very reasonable explanations for it (for which see below).

12. Ibid., pp. 130–35. See the reaction of Spear (Review, 1989, p. 604) and related comments by Lippincott (1990, p. 447).

13. This issue will be taken up in Chapter 6.

14. To a descendant, Vincenzo Ruffo, are owed two lengthy and important articles (1916, 1919) detailing Don Antonio's life, his negotiations with artists, and the fate of his collection. Vincenzo Ruffo's material includes the texts of the letters written by Artemisia to her patron, and excerpts from Don Antonio's account books. For a succinct biography, see Contini in Contini/Papi, 1991, p. 86 n. 78.

15. See Appendix II for discussion of this marriage; Appendix I, the Register of Documents, for the precise bibliographical citations to all the Gentileschi-Ruffo letters; and [49], [51], [L-2], [L-27], [L-45], and [L-89] for the works of art for Ruffo or otherwise mentioned in the correspondence.

16. Letters of June 12, June 24, and October 23, respectively.

17. Letters of November 13 (second item) and January 30, 1649, respectively.

18. Letters of January 1, 1651, and November 13 (first item), 1649, respectively.

19. For an overview of the city of Naples during the first half of the Seicento see Giuseppe Galasso in London, Royal Academy, 1982, pp. 24–30.

20. Letters of January 30 and June 5, 1649, respectively.

21. See Grabski (1985, pp. 45–46 and notes) for a review, with references, of Cavallino's financial situation in these years.

22. Contrast the remarks of Garrard, 1989, p. 397 n. 77.

23. An economic reason for Gentileschi's change of style, obliging her to cater to the preferences of her clients, has also been proposed by Garrard (1989, pp. 135–36), although with rather less emphasis than I accord it. Artemisia's special flexibility in the face of patronage requests

during her last years has been underlined by Cropper (1992, p. 217).

24. Garrard, 1989, p. 137.

25. Bissell, 1981, pp. 50–62 and corresponding catalogue entries, with references to specific court masques and verse.

26. The relationships have also been observed by Garrard, 1989, pp. 130, 518 n. 232.

27. Ibid., pp. 136–37.

28. Letter of January 1, 1651, to Don Antonio Ruffo.

29. Letter of September 4, 1649, to Don Antonio Ruffo.

30. Battisti (1963, p. 297) speculated that Artemisia's statement to Ruffo that she would serve him immediately upon her recovery may have been designed to help secure the advance which she requested and did not in fact reflect the actual state of her failing health. That she did regain her health to the point that she was able to work again is suggested by Morrona's report (see below), not cited by Battisti.

31. Morrona, ed. 1792, II, pp. 269–70. For Morrona's description of this picture, which canvas was no doubt similar to the poorly preserved and heavily restored *Susanna* at Brno (Fig. 197), and for additional bibliography, see [L-104]. As Ruotolo (1982, pp. 9–10) has demonstrated, in 1675 Pietro Andrea Andreini sent from Naples to Filippo Baldinucci in Florence a "Nota de' Pittori, Scultori, et Architettori, che dall'anno 1640 sino al presente giorno hanno operato lodevolmente nella città e regno di Napoli," which Baldinucci had obviously requested in connection with his work on the *Notizie de'professori del disegno*. Andreini's list, published by G. Ceci ("Scrittori della storia dell'arte napoletana anteriori al De Dominici," *Napoli nobilissima*, VIII, fasc. XI [1899], pp. 163–68), includes (p. 165) "Artemisia Gentileschi, donna di gran spirito ed allieva del padre, morì 20 anni sono." Since this list contains numerous errors, it must be used with caution, but in placing Artemisia's death in 1655 it helps in a minor way to corroborate the other evidence. Curiously, in his biography of Gentileschi, Baldinucci did not utilize Andreini's report.

32. These were brought to the attention of Gentileschi scholars in 1963 by Battisti. See the variant translations of Garrard (1989, p. 137) and Hersey (1993, p. 330) and, below, the very different ways in which Garrard and Hersey understand the epitaphs.

33. Morrona, ed. 1812, II, p. 492. This information is not in the 1792 edition of Morrona's text. I have been unable to locate the *Uomini illustri pisani*.

34. For notices regarding San Giovanni dei Fiorentini, see C. d'Engenio, *Napoli sacra*, Naples, 1623, pp. 523–25; G. Galante, *Guida sacra della città di Napoli*, Naples, 1873, pp. 333–34 (with other bibliography); S. di Giacomo, *Nuova guida di Napoli*, 1926, p. 265.

35. The letter "G" in the index for the years 1651, 1653, and 1654 appears on folio 49, but no Gentileschi is listed. The year 1652 is not recorded under "G," but the indexes for other letters show that there were in fact records for 1652 as well. Michael Stoughton (letter of August 31, 1973) pointed out to me that on folio 52 of the index one reads "*1667 Loma 70*" (i.e., fol. 70 of the lost volume). He writes: "In Naples, at any rate, the family name is often adjusted to fit the sex of the person, for example, Caracciolo and

Caracciola. The list of 'L's' runs from 1635 to 1744 and Loma appears only this one time." The date of 1667 is much too late, of course, for Artemisia, who is not known to have used the Lomi surname in Naples, not even when writing to Florence. There is no indication that her daughters had adopted the name Lomi either, and they had taken on married names even before Artemisia's death. For the present, then, the identification of this "Loma" must remain a mystery. Lapierre (1998, p. 480) discusses the transfer of some of the tombs in San Giovanni to Sant'Anna dei Lombardi and Santi Apostoli, but has unearthed no notices of that of Artemisia Gentileschi.

36. Note 33 above.

37. Hersey, 1993, p. 330.

38. Garrard, 1989, pp. 137–38.

39. One-name signs announcing headliners at Las Vegas casinos certainly make their points today.

40. Respectively Garrard (1989, p. 137) and Hersey (1993, p. 330).

41. For this very plausible suggestion Garrard, 1989, p. 137.

42. One should also bear in mind Lapierre's cautions (1998, p. 471) that "burlesque epitaphs belong to an Italian literary genre" and that "Loredan did not reserve his licentious pleasantries for Artemisia Gentileschi alone. All the other poems in the collection are in the same vein."

..

CHAPTER 6
Myths, Misunderstandings, and Musings

1. Although divided by individual headings for purposes of organizational clarity, most of the points of discussion are of course integral parts of one artistic personality.

2. Hersey, 1993, p. 324. Earlier, Shiela ffolliott (review of Mary Garrard's *Artemisia Gentileschi* in *Woman's Art Journal*, XII, no. 1 [1991], p. 41) had supposed that the "Gentileschi must have envisioned great things for their first child . . . whom they named . . . after an ancient queen."

3. All as suggested by Hersey, 1993, including the relevant notes on p. 331.

4. Garrard, 1989, pp. 326–27.

5. As argued in Chapter 1.

6. In addition to the sardonyx ringstone illustrated here (published by Richter, 1956, p. 290 cat. 294 and pl. XLI no. 294), see Furtwängler, 1900, I, pl. LXV no. 35, and II, p. 301 no. 35. I suspect that a methodical search of catalogues of ancient gems and coins will turn up examples that bear more striking visual similarities to Artemisia's figure.

7. In which Garrard (1989, p. 317) thought to recognize a warrior of the Saint George/David type.

8. The amethyst illustrated here as Figure 46 (where in fact the torso of the dancer is shown frontally) is catalogued by Furtwängler, 1900, I, pl. XLI no. 30, and II, p. 197 no. 30. Related examples include a silver ring in the Metropolitan Museum of Art at New York (Fig. 43; Richter, 1956, p. 85 cat. 82 and pl. XV no. 82), a gold finger-ring in Berlin (Furtwängler, 1900, I, pl. X no. 33, and II, p. 52 no. 33), and an elliptical cornelian in the Musei Capitolini at Rome (Righetti, 1955, p. 27 no. 51 and pl. I fig. 4). Orazio

Gentileschi also drew on ancient gems for his *Judith* now at Oslo (Figs. 40, 50; [X-13]), as did the author (probably Angelo Caroselli) of the strongly Gentileschian *Judith* in Rome (Figs. 48, 49, 221; [X-14]).

9. Appendix I, July 10, 1593.

10. Appendix I, July 10, 1615; July 4, 1619; September 29, 1625.

11. Baldinucci, ed. 1812, X, p. 254.

12. Ibid., pp. 254–56.

13. Neither by Garrard (1989, pp. 83–84, 173, 507 n. 134), who while misinterpreting parts of the story correctly signals its "stereotyped amorous overtones," nor by Papi (in Contini/Papi, 1991, pp. 54, 62 n. 94), even though he senses "un po'il profumo dei non sempre attendibili baldinucciani," nor by Contini (ibid., p. 141), nor by F. Bologna (in Naples, Castel Sant'Elmo, 1991, p. 162).

14. By M. Gregori, "Una nota per Artemisia Gentileschi," *Paragone*, XLI, no. 23 (1990), 104–6 and pls. 83 and 11 (color).

15. By M. Gregori (first in Naples, *Civiltà del seicento*, I, p. 150), followed by Papi (in Contini/Papi, 1991, p. 54).

16. Respectively Morrona, 1792, II, pp. 272–73, and ed. 1812, II, pp. 489–90, and Dal Borgo, 1839, p. 32.

17. Papi in Contini/Papi, 1991, p. 62 n. 81. Also Contini, ibid., pp. 85–86 n. 55.

18. In Chapter 4, drawing above all upon the densely documented and magnificently illustrated monograph by Garardo Casale published in 1991, I have reviewed this material and have attempted to show that Gentileschi and Garzoni may have been in contact with each other.

19. By Papi in Contini/Papi, 1991, p. 54.

20. By Bologna (see note 13 above).

21. Papi in Contini/Papi, 1991, pp. 56–57, 62 nn. 92–93. These connections have also been sensed by Berti and reiterated by Contini (ibid., respectively pp. 30 n. 25 and 141).

22. Contini, ibid., p. 141.

23. L. Spezzaferro, "Un imprenditore del primo seicento: Giovanni Battista Crescenzi," *Ricerche di storia dell'arte*, XXVI (1985), 23. Also Contini in Contini/Papi, 1991, p. 62 n. 83.

24. A. Cottino and M. Voena in Voena, Turin, *Dipinti italiani: 1470–1680*, April 4–May 4, 1991, pp. n.n. with color pl.

25. The attributional history is detailed in ibid. and by Papi (in Contini/Papi, 1991, pp. 58, 62 nn. 92–93), who discusses the work in some detail. See also F. Bologna in Naples, Castel Sant'Elmo, 1991, p. 179 n. 297. Bologna reaffirms his belief that the entire canvas was executed by Romanelli, an argument which Cottino and Voena (see previous note) find "very suggestive."

26. Papi in Contini/Papi, 1991, p. 58.

27. By Gregori (see note 14 above).

28. See Chapter 2 for the precise references and further discussion. The Accademia di San Luca at Rome had preceded its Florentine counterpart in entertaining female membership, while at the same time stipulating that women academicians had to absent themselves from its meetings (Harris in Harris/Nochlin, 1976, p. 26 n. 77 citing Missirini, 1823, p. 83). Also ibid., p. 119, and Garrard, 1989, p. 34 and notes.

29. Garrard, 1989, p. 474.

31. Ibid., p. 478; Menzio, 1981, p. 151. Orazio was later to call the court's attention to these discrepancies (Garrard, 1989, p. 482; Wachenfeld, 1992, p. 161).

32. Garrard, 1989, pp. 463, 411; Menzio, 1981, pp. 124, 41.

33. As believed by Garrard, 1989, p. 492 n. 12. Harris (1989, p. 10) rightly emphasizes that it would not have been at all easy for Artemisia to have acquired these skills. She also discusses the signatures on Artemisia's letters of February 10, 1619, and December 11, 1635, believing them to be by different hands. See below.

34. The first and third are reproduced in Garrard, 1989, pp. 374–75 figs. 328–29, and the differences in orthography and handwriting are remarked (pp. 373 and 492 n. 12). The second of the just-cited letters is illustrated here (Fig. 118). Lamentably, the originals of the letters to Ruffo have not been located and may have been destroyed earlier in this century (Garrard, 1989, p. 376).

35. The handwriting of the signature on the letter to Cosimo II appears to be different again.

36. What is needed is not only a handwriting expert but also a specialist who might methodically chart what I take to be signs of Neapolitan and Spanish usage in Artemisia's letters from 1630 on. It might then be possible to group the letters according to the "scribes" who penned them.

37. Garrard, 1989, p. 373.

38. For the specifics, the reader is directed to Garrard (ibid., pp. 373, 380 nn. 14–15, 397 n. 77) and below with reference to Gentileschi's letter to Galileo Galilei.

39. Greer, 1979, p. 198.

40. E.g., Garrard, 1989, pp. 379 n. 9, 399 n. 82.

41. "Resterà servita d'accetare la prontezza dell'animo, che tengo di servirla, e quando tutto ciò non la soddisfacia, potrà a suo bell'agio, sferzare l'imagine dell'autrice, la quale, agitata dal freddo patito in tale operazione, starà nondimeno attendendo che l'innate cortesia di V. S., la sollevi da questo accidente con rimessa di guanti e di pianelle, perchè non le causasse maggior male." Of this Garrard writes (1989, p. 379 n. 9): ". . . Artemisia employs playful hyperbole, as she would do occasionally in writing to other patrons, here achieving a subtly comic effect in her swift transition from grand to mundane concerns in the same letter."

42. Morrona, 1792, II, pp. 266, 273, who knew Artemisia's correspondence with Cassiano as published in 1754.

43. Letters of November 13 (first and second items) and December, 1649. Also Garrard, 1989, p. 399 n. 82.

44. Ibid., p. 398 n. 79.

45. Artemisia began her letter of October 9, 1635, to Galileo Galilei as follows: "I know that your Lordship will say that if the occasion to avail myself of your assistance had not presented itself, I would never have thought of writing to you; and in truth, given the infinite obligations that I bear to you, you could make an infallible argument to that effect, since you do not know how often I have tried to learn of you without being able to get reliable news from anyone (*So che V. S. dirà che se mai mi si fusse presentata occasione di valermi del favor suo, mai haverei pensato di scrivergli; et in vero, stanti le obligationi infinite che gli tengo, ne portebbe fare infallibile argumento, non sapendo quanto spesso habbia proccurato saper di lei, nè da alcuno ne ho potuto saper nuova certa*)." I am not convinced by Garrard's suggestion (1989, p. 383 n. 23) that here "Artemisia seems to intend a joking reference to the proposition-and-proof structure of such philosophical and mathematical writings as Galileo's own *Dialogue on the Two Chief Systems* [1632]."

46. For purposes of this tally, Artemisia's contributions to the ceiling of the Queen's House at Greenwich are counted as a single work.

47. Overall, the subject matter of those lost works which by virtue of their citation in the artist's letters and in contemporary inventories of her known patrons (e.g., the Medici and the English court) can confidently be assigned to Artemisia strengthens this faith.

48. B. Barnes in Russell, 1990, p. 29.

49. As quoted by Harris in Harris/Nochlin, 1976, p. 23.

50. G. Masselli in Florence, Palazzo Pitti, 1837, I, p. n.n.

51. Bionda, 1992, p. 28.

52. On this struggle in general, see White, 1976, pp. 342–43.

53. Cf. the remarks of Greer, 1979, p. 193.

54. Silvers, 1990, pp. 373, 375.

55. Ibid., pp. 367, 372, 378.

56. Ibid., p. 372.

57. Parker/Pollock, 1981, p. 21. Garrard (1989, pp. 278–79) has warned against quickly drawn biography-imagery equations.

58. Rose, 1991, p. 13.

59. Garrard, 1989, pp. 202, 209. Harris (1989, p. 8) speaks of Artemisia's "distinctive, proto-feminist vision." Gouma-Peterson and Mathews (1987, p. 334) report that "a whole body of recent research in psychology, literature, art, music, sociology and education indicates that women perceive reality differently than men, for whatever reasons, and therefore have different expectations of and responses to human experience."

60. Respectively, Stolzenwald (1991, p. 7) and Hersey (1993, p. 323), to cite but two more among the many statements of this viewpoint.

61. Harris in Harris/Nochlin, 1976, p. 119.

62. Respectively, letters of January 30 and November 13 (second item), 1649.

63. Letter of November 13, 1649 (second item).

64. Letter of August 7, 1649.

65. Garrard, 1989, pp. 141–42, 171.

66. Ibid., pp. 175–77 and passim.

67. Ibid., p. 175.

68. Ibid., p. 176.

69. Ibid., pp. 175–76.

70. See the remarks of Spear, Review, 1989, p. 604.

71. Letters of August 7 and November 13 (both items), 1649.

72. As noted by Garrard, 1980, p. 108.

73. B. Barnes in Russell, 1990, p. 29.

74. Harris (in Harris/Nochlin, 1976, p. 120) writes that "we might not approve of a woman today who declared that deep down she was really a man, but we can appreciate Artemisia's declaration in its contemporary context as an exceptional assertion of self-esteem . . ." while for Garrard (1989, p. 138, and 1980, p. 108) Artemisia's comment indicates "pride in honorary masculinity" but also that "ambition could not have been made of sterner stuff." Rose (1991, p. 14), again with no holds barred, remarks

that "the idea that she lived and worked like a man seems unpalatable both to the patriarchal art historical establishment as well as to the feminist revisionists, yet this, I think, is the truth."

75. Garrard, 1989, p. 136.

76. W. Slatkin (*The Voices of Women Artists*, Englewood Cliffs, N.J., 1993, p. 5) has also called attention to what she terms Artemisia's "stated humility paired simultaneously with pride in her achievement."

77. Letters of March 13, January 30, and October 23, 1649, respectively.

78. See White, 1976, pp. 342–43, including quotations from a study by Martina Horner (with bibliography).

79. The quotations are from Garrard (1989, p. 171), but the ideas thus expressed pervade the entire study.

80. Hersey, 1993, p. 324.

81. Ibid.

82. Garrard, 1989, p. 172.

83. Rosini, 1846, VI, pp. 160–61.

84. Baldinucci, ed. 1812, X, pp. 253–54.

85. As by Louis Viardot, *Musées d'Italie*, Paris, 1853, according to Berne-Joffroy, 1959, pp. 115–16. B. Baumgärtel (in Düsseldorf, 1995, p. 245) quotes Wilhelm Lübke (*Die Frauen in der Kunstgeschichte*, Stuttgart, 1862, p. 9) to the effect that in emphasizing the frightful in her (Uffizi) *Judith* Artemisia overstepped the bounds of female propriety.

86. Garrard, 1989, p. 175 and passim.

87. Parker and Pollock (1981, p. 25) write: "Gentileschi's paintings of celebrated heroines should not be seen as evidence of an individual woman's proto-feminist consciousness reflected in art, but rather as her intervention in an established and popular genre of female subjects through a contemporary and influential style." Also Russell (1990, p. 14) with regard to the sanguinary and the erotic in Baroque iconography in general.

88. Garrard (1989, pp. 178–79, 528 n. 128), citing Elisabetta Sirani and her pupil Veronica Franchi, observes that in the catalogues of other women artists themes of women are in the majority.

89. To quote again B. Barnes in Russell, 1990, p. 33.

90. Wethey, 1975, p. 189.

91. To quote again Garrard (1989, p. 274) on this picture.

92. Russell, 1990, p. 13.

93. Garrard (1989, pp. 210, 213–14, 216), who believes that Artemisia's pictures break with this tradition.

94. Garrard, 1993, p. 36, and 1989, p. 83, the latter with reference to the Fogg *Joseph and Potiphar's Wife*, which in the opinions of many (myself included) is by Paolo Finoglio (Fig. 214; [X-11]).

95. This question was inspired by Tickner, 1988, p. 105.

96. M. Olin in *Critical Terms for Art History*, ed. R. Nelson and R. Shiff, Chicago and London, 1996, p. 209, with reference to one of the projects of contemporary feminism.

97. Ibid., p. 216.

98. Garrard, 1989, p. 46.

99. Appendix I: correspondence of January 21 (the *Venus and Cupid*, Fig. 130?) January 25, and October 9, 1635; October 24, 1637; December 16, 1639; March 16, 1640; June 5 and October 23, 1649.

100. Appendix I: correspondence of December 11 and

February 11, 1635; October 24 and November 24, 1637; January 1, 1651.

101. Garrard, 1989, pp. 310, 312–13, 320, 324–35, 328.

102. Among them Stolzenwald, 1991, p. 64; Bionda, 1992, p. 24; Wachenfeld, 1992, pp. 31, 34.

103. Garrard, 1989, pp. 21, 312; Wachenfeld, 1992, p. 34. See also the comments of Merkel, 1992, pp. 348–49.

104. Garrard, 1989, p. 330.

105. Which I propose to do in the section below, evaluating theories that involve links between the imagery and Gentileschi's rape by Tassi.

106. In a talk given by Elena Ciletti at the 72d annual meeting of the College Art Association in Toronto, February, 1984. Also Garrard, 1989, pp. 316, 555 n. 97. For more on Ciletti's presentation, see below.

107. See previously in the text and the relevant Catalogue entries. The role of Orazio's *Judith* at Hartford is acknowledged by Garrard (1989, pp. 310, 313), for whom (pp. 39–40) the Oslo *Judith*, for the authorship of which Orazio Gentileschi "remains the leading candidate," postdates and was influenced by Artemisia's Pitti *Judith*. Garrard (p. 498 n. 56) considers the London *Judith* to be highly problematic and its significance for Artemisia's Pitti *Judith* to be very debatable.

108. B. Barnes in Russell, 1990, pp. 61–62 cat. 21.

109. Referring the reader to Garrard (1989, p. 291), Barnes (ibid.) writes of the Mocetto print after Mantegna: ". . . the image does not present Judith as a seductress. The maid, who is often presented as a foil for Judith's beauty, seems in this print to be used to emphasize the unity of purpose that the two women shared."

110. The painting, measuring 1.40 x 1.80 m., signed *IACOBVS/PALMA*, and today in the Louvre, is dated ca. 1610 by Mason Rinaldi. The print is inscribed *Iacobus Franco — Formis con Priuilegio*, and apparently followed closely upon the canvas, whose composition it reverses. A pen-and-brown-ink drawing (90 x 97 mm.) by Palma is identified by Mason Rinaldi as the initial idea for the Louvre picture; but inasmuch as it depicts a slightly later stage in the drama and cannot accommodate the body of Holofernes, one wonders whether it is not a study for another painting entirely. In either case, the composition thus sketched out is remarkably similar to that of Orazio Gentileschi's Hartford *Judith*. See S. Mason Rinaldi, *Palma il Giovane. L'opera completa*, Milan, 1984, pp. 100–101 cat. 206, 382 fig. 491, and the same author in Venice, Museo Correr, *Palma il Giovane 1548–1628. Disegni e dipinti*, exh. cat., Milan, 1990, p. 168 cat. 71a. Independently, B. Bäumgartel (in Düsseldorf, 1995, p. 246) has considered the possible relevance of Palma's invention to Artemisia's Naples *Judith*.

111. Garrard (1989, pp. 216, 220, 228, 231–32, 236, 238, and passim), who writes that Artemisia's rape by Tassi "had exposed her to the same moral criticisms as those leveled at Lucretia," and that "although one must be careful not to put thoughts into the mind of the artist . . . it is very difficult to avoid concluding in this instance that as Artemisia conceived, designed, and executed the picture, reinterpreting Lucretia's situation as an anguishing private decision, she must have relived her own experience. . . ." Haskell (1989, p. 37) also entertains this possibility.

112. B. Barnes in Russell, 1990, p. 44 cat. 6.

113. Ibid., p. 42 cat. 4.

114. Garrard, 1989, pp. 105, 235.

115. For the arguments, see [X-17].

116. Garrard, 1989, p. 232.

117. Gash, 1990, p. 67. Garrard (1989, p. 171) comments that Artemisia "was heir to a Caravaggesque vocabulary within which she might develop a set of characters who were persuasively real," but in my opinion understates the importance of this as a factor contributing to the plausibility of Gentileschi's figures.

118. Cf. the remarks of Garrard, 1989, p. 105.

119. Silvers, 1990, p. 372.

120. Hersey, 1993, p. 330.

121. Among them Munsterberg, 1975, p. 25; C. Whitfield in London, Royal Academy of Arts, 1982, p. 168; Stolzenwald, 1991, p. 16; Bionda, 1992, p. 21. See also note 123.

122. See Chapter 1, especially note 56.

123. This viewpoint has been put forward with varying degrees of certainty by (among many others) Bissell, 1968, p. 156; Gabhart and Broun, 1972, n.p.; Tufts, 1974, p. 60; Szigethi, 1979, p. 36, and in Milan, Palazzo della Permanente, 1993, p. 93; Harris, 1989, p. 9; Haskell, 1989, p. 37; Berti in Contini/Papi, 1991, p. 22. See also the discussion below of Garrard's position.

124. The idea comes from Greer, 1979, p. 193.

125. Hersey, 1993, pp. 323–24.

126. Garrard, 1989, pp. 32, 278–79, 311, 324 and passim for what follows. Ciletti (1984, *CAA Abstracts*, p. 35) has spoken of "a crude form of psychoanalysis" with reference to the facile biography–*Judith* associations that have been made.

127. Ciletti, 1991, pp. 38–39.

128. Slap, 1985, p. 341; Pointon, 1981, p. 353. This does not however prevent these same authorities from some psychoanalytical observations of their own, for which see below.

129. Lippincott, 1990, pp. 447–48. B. Bäumgartel (in Düsseldorf, 1995, p. 246), too, has questioned the linking of Artemisia's creative inventiveness and her rape experience, the justness of connecting her depictions of Judith to the violence visited upon her. For Bäumgartel, the prominence of *femmes fortes* in Gentileschi's oeuvre is better understood as satisfying a need to identify with and feature various positive aspects of women, many of them minimized by men.

130. Some of these have been signaled by Gorsen, 1980, pp. 78–79.

131. See above, especially note 87. It should be unnecessary in the present context to probe into the reasons for these phenomena.

132. One is reminded of the popularity in Florence of the Jael and Sisera episode, which Artemisia interpreted for a Florentine client (Figs. 73, 74).

133. Garrard (1989, pp. 168, 527 n. 101), citing a study by Ian Maclean.

134. In the paper by Elena Ciletti cited in note 106 above. The quotations are from *CAA Abstracts*, no. 72, p. 35. To my knowledge this paper has not been published, and the abstract does not contain sufficient information to allow me here to pass judgment on the persuasiveness of her arguments. In 1991 (see the Bibliography) there appeared a study by Ciletti on the iconography of Judith during the Renaissance, with some comments on seventeenth-century developments.

135. Ciletti, 1991, pp. 42–43. Also Garrard, 1989, p. 289.

136. I do not, however, find admissible the following remark by Hersey (1993, p. 330): "Artemisia's by no means dishonorable, indeed rather dashing enterprise . . . was to play the beautiful defamed rape-victim by painting unsettling protest pictures about rape, its variations and antitheses."

137. See J. Elkins, review of H. Foster, *Compulsive Beauty*, Cambridge, Mass., 1993, in *Art Bulletin*, LXXVI (1994), 546, and the reply by E. H. Spitz, "Construction Versus Deconstruction in Psychoanalytic Interpretation," *Art Bulletin*, LXXVII (1995), 341–42. Also A. Hauser, *The Philosophy of Art*, Cleveland and New York, 1965, pp. 88–89, 92, 103–4, and passim.

138. Slap, 1985, pp. 340–41.

139. Garrard, 1898, p. 453; Menzio, 1981, p. 102.

140. Jacobus, 1986, p. 112.

141. I am thinking above all of Laurie Schneider's famous essay, "Donatello and Caravaggio: The Iconography of Decapitation," *American Imago*, XXXIII, no. 1 (1976), 76–91. As Schneider (p. 80) puts it: "Decapitation, Freud and Ferenczi have said, is symbolic castration in which the aggression is displaced from phallus to head."

142. H. Kleinschmidt, "Discussion of Laurie Schneider's Paper," *American Imago*, XXXIII, no. 1 (1976), 95. Needless to say, Kleinschmidt then recalls Gentileschi's rape by Tassi. Taylor (1984, pp. 103–4) references Kleinschmidt, but appears (p. 104) to find even more compelling Pointon's reading of the imagery (see below). Also on castration: Pointon, 1981, p. 315; Slap, 1985, p. 338.

143. Jacobus, 1986, p. 130.

144. Cantelli, 1983, fig. 329.

145. Pointon, 1981, pp. 353, 351, and 352 respectively.

146. Ibid., p. 353, footnoting J. Slap, "A Note on the Drawing of Dream Details," *Psychoanalytical Quarterly*, XLV (1976), 455–56.

147. Pointon, 1981, pp. 351–52.

148. Ibid., p. 359.

149. Slap, 1985, p. 335.

150. Ibid., p. 338.

151. Taylor, 1984, p. 104.

152. Jacobus, 1986, p. 303 n. 43.

153. Another indication of how the compulsion to tie Artemisia's imagery to her life experiences, in this case again to her rape, clouds perception is furnished by Hersey (1993, p. 328) with reference to the *Judith*: "And Judith's servant wedges her knee against Holofernes' crotch just as Agostino had wedged his against Artemisia's leg." Abra does no such thing.

154. Slap, 1985, p. 338.

155. Garrard (1989, p. 202), referring in this instance to the Pommersfelden *Susanna*. See also pp. 5–6 and Garrard, 1993, p. 38 ("any approach to attribution that does not take the treatment of theme into account is—at least as far as Artemisia is concerned—an incomplete mode of connoisseurship") for statements of this principle.

..

APPENDIX IV
Amber Varnish and the Technique of the Gentileschi

1. See below for more on Mayerne and his extraordinary manuscript.

2. Published in London, 1847, and in a retitled edition in New York, 1960. See the Bibliography for complete references to these and to the other oft-cited publications abbreviated in the following notes.

3. Trevor-Roper, 1993, pp. 284–85.

4. Carlyle and Southall, 1993, p. 24.

5. Maroger, 1948, entitling his book *The Secret Formulas and Techniques of the Old Masters*.

6. Carlyle and Southall, 1993, pp. 23–24.

7. BL Sloane MS 2052, fol. 9. See note 22 below.

8. Carlyle and Southall, 1993, p. 24.

9. Ibid., p. 25.

10. Max Doerner, *The Materials of the Artist*, New York, 1962, p. 363.

11. Helmut Ruhemann, *The Cleaning of Paintings*, London, 1968, pp. 307–8.

12. Ibid., pp. 355–58.

13. Maroger, 1948.

14. A. E. A. Werner, "The Vicissitudes of the Maroger Medium," *Studies in Conservation*, III (1957–58), 80–82.

15. Eastlake, ed. 1960, p. v.

16. Ibid., pp. 30–89.

17. Ibid., pp. 263–67, 289–91.

18. Advocacy of the hard-resin oil varnishes may be found in the works of Sir Arthur Church, A. P. Laurie, Jacques Blockx, and Frederick Taubes. Advocates of the soft resins include Ralph Mayer, Max Doerner, and Jacques Maroger.

19. Ella Hendricks and Karin Groen, "Lely's Studio Practice," *Bulletin of the Hamilton Kerr Institute*, II (1994), 34.

20. Noël Heaton, *Outlines of Paint Technology*, London, 1940, p. 284; Rutherford J. Gettens and George L. Stout, *Painting Materials*, New York, 1946, p. 14.

21. White and Kirby, 1994, pp. 71–73.

22. BL Sloane MS 2052. See under Mayerne in the Bibliography for citations of the three published editions (by Berger, Van de Graaf, and Faidutti and Versini) of this manuscript. Begun in 1620, as the title page in Mayerne's hand attests, the manuscript contains entries dating until 1646.

23. A biography of Mayerne and a thorough history and background of the Mayerne MS are provided by Trevor-Roper, 1993.

24. Eastlake's transcriptions (not always completely accurate) of the passages devoted by Mayerne specifically to the Gentileschi, and his comments on them, may be found in ed. 1960, pp. 303–5. English translations of these passages, derived from Van de Graaf's compilation, also appear in Talley, 1981, pp. 143–48. The latter work is valuable for its offering of detailed summaries with extensive quotations from more than twenty technical works on painting between the years 1573 and 1692. For the present study, new translations have been made using the Berger edition.

25. BL Sloane MS 2052, fol. 9; Berger ed., 1901, pp. 112, 114.

26. Van de Graaf (1958, p. 196 no. 133) reads "s'embroyuent," and Faidutti and Versini (1968, p. 142) render the words "s'emboivent."

27. BL Sloane MS 2052, fol. 146; Berger ed., 1901, p. 324.

28. The verb *puir* means "to exude a foul odor" or "to stink." It has been suggested that Mayerne refers here not so much to the odor per se but rather, by metonymy, to a potential cause, namely spoilage, hence Talley's reading (1981, p. 146) and Berger's "Es wird nicht ranzig" (1901, p. 335). Support for this interpretation may be found in Mayerne's recipe for and description of Artemisia's alleged lutemakers' varnish in fol. 151: "Appres le pouués garder tante que vous voudrés" (ibid., p. 334).

29. BL Sloane MS 2052, fol. 150; Berger ed., 1901, pp. 332, 334.

30. R. D. Harley, *Artist's Pigments*, New York, 1970, p. 9.

31. BL Sloane MS 2052, fol. 10.

32. Arthur K. Wheelock, *Anthony Van Dyck*, New York, 1990, pp. 207–9.

33. William Noël Sainsbury, *Original Unpublished Papers Illustrative of the Life of Sir Peter Paul Rubens*, London, 1859, pp. 311–13: a letter of March, 1629, from Orazio Gentileschi to Secretary Lord Dorchester in which Orazio gives account of the expenses incurred by his sons during their Italian trip; idem, "Artists' Quarrels in Charles I's Reign," *Notes and Queries*, VII, 2d series (1859), 121–22: a letter dated January 29, 1629, from Orazio Gentileschi to Charles I, again referring to his sons' dealings with Lanier. These are signaled for a third time by Baltasar Gerbier in his account of "The Sommes of Monnys Gentilesco Hath Recaeved" from September 12, 1629 (Sainsbury, *Original Unpublished Papers*, pp. 314–15). Also Bissell, 1981, pp. 104, 108–9.

34. R. Ward Bissell, personal communication. Also Chapters 3 and 4.

35. BL Sloane MS 2052, fol. 43.

36. E. René De la Rie, "The Influence of Varnish on the Appearance of Paintings," *Studies in Conservation*, XXXII (1987), 3, 8.

37. BL Sloane MS 2052, fol. 48.

38. Ibid., fol. 10.

39. Maximillian Toch, "Dammar as a Picture Varnish," *Technical Studies in the Field of the Fine Arts*, II, no. 3 (1934), 149.

40. A. P. Laurie, *The Painter's Methods and Materials*, New York, 1967, p. 169.

41. Ralph Mayer, *The Artist's Handbook*, New York, 1970, pp. 172, 175, 196–97.

42. A. P. Laurie, *Materials of the Painter's Craft*, Philadelphia, 1911, p. 290.

43. Henry Violette, *Guide pratique de la fabrication des vernis*, Paris, 1866, pp. 303–6.

44. Eastlake, ed. 1960, pp. 240–46.

45. Alvah Horton Sabin, *The Industrial and Artistic Technology of Paint and Varnish*, New York, 1905, p. 30.

46. Eastlake, ed. 1960, p. 235.

47. BL Sloane MS 2052, fol. 150.

48. Ibid., fol. 151.

49. Richard Hakluyt, *The Principal Navigations Voyages Traffics & Discoveries of the English Nation*, New York, 1965, p. 394.

50. John Geddes McIntosh, *The Manufacture of Varnishes and Kindred Industries*, London, 1908, p. 41.

51. BL Sloane MS 2052, fol. 48.

52. Ibid., fol. 51.

53. R. Ward Bissell, personal communication.

54. Paula De Cristofaro, Conservator, National Gal-

NOTES lery of Art, examination report, August 22, 1990. The author is indebted to Diane De Grazia, former Curator of Paintings at the National Gallery, and Catherine A. Metzger, Painting Conservator, for supplying this information.

55. Karin Groen, "Scanning Electron-Microscopy as an Aid in the Study of Blanching," *Bulletin of the Hamilton Kerr Institute*, I, (1988), 49.

56. R. Ward Bissell, personal communication. The same opinion with regard to the state of the colors in the Fogg *Madonna* was expressed to the author by Kate Olivier, Paintings Conservator, Fogg Museum, Harvard University.

57. Elizabeth Mention, Paintings Conservator, J. Paul Getty Museum, Malibu, Calif., personal communication.

58. Massing, 1988, p. 100.

59. Gisela Helmkampf, former Paintings Conservator, Metropolitan Museum of Art, New York, personal communication.

60. Barbara Heller, Chief of Conservation, Detroit Institute of Arts, personal communication.

61. Personal communications from David Bull, Chairman of Conservation, National Gallery of Art, Washington, D.C., and Mark Leonard and Elizabeth Mention, Paintings Conservators, J. Paul Getty Museum, Malibu, Calif.

62. Massing, 1988, pp. 90, 99–104. Karin Groen, "A Seventeenth Century Use of Bituminous Paint," *Bulletin of the Hamilton Kerr Institute*, II (1994), 84

63. Paul Coremans, "La recherche scientifique et la restauration des tableaux," *Bulletin de l'Institut Royal du Patrimoine Artistique*, IV (1961), III.

64. John Mills and Raymond White, "Organic Analysis in the Arts: Some Further Paint Media Analyses," *National Gallery Technical Bulletin*, II (1978), 72.

65. Paul Coremans, *L'Agneau Mystique au laboratoire*, Antwerp, 1953, p. 76; P. Coremans, R. J. Gettens, and J. Thissen, "La technique des 'Primitifs flamands,'" *Studies in Conservation*, I (1952), 1–29.

66. Leopold Kockaert and Monique Verrier, "Applications des colorations à l'identification de liants de Van Eyck," *Bulletin de l'Institut Royal du Patrimoine Artistique*, XVIII (1978–79), 122–27.

67. Some examples: John S. Mills and Raymond White, *The Organic Chemistry of Museum Objects*, London, 1987; idem, "Natural Resins of Art and Archaeology: Their Sources, Chemistry, and Identification," *Studies in Conservation*, XXII (1977), 12–31; L. Masschelein-Kleiner, J. Heylen, and F. Tricot-Marckx, "Contribution à l'analyse des liants, adhésives et vernis anciens," *Studies in Conservation*, XIII (1968), 109–26; L. Masschelein-Kleiner, "Per-

spectives de la chimie des liants picturaux anciens," *Bulletin de l'Institut Royal du Patrimoine Artistique*, VI (1963).

68. White and Kirby, 1994, pp. 73–74.

69. John Mills and Raymond White, "Organic Mass-Spectrometry of Art Materials: Work in Progress," *National Gallery Technical Bulletin*, VI (1982), 3–18; R. White, 1981; idem, "An Examination of Varnish from Three Eighteenth Century Musical Instruments," ICOM Committee for Conservation, 5th triennial meeting, Zagreb, 1978.

70. White, 1981, pp. 3–8; D. A. Leathard and B. C. Shurlock, *Identification Techniques in Gas Chromatography*, London, 1970, pp. III–17; J. H. Greaves, "Use of Gas-Liquid Chromatography in the Field of Drying Oils and Oleoresinous Media," *Journal of the Oil and Colour Chemists' Association*, XLVII (1964), 508–9.

71. Alexander M. Shedrinsky et al., "Application of Pyrolysis–Gas Chromatography and Pyrolysis–Gas Chromatography/Mass Spectometry to the Unmasking of Amber Forgeries," *Journal of Analytical and Applied Pyrolysis*, XXV (1993), 77–95.

72. White, 1981, pp. 1–2.

73. Richard Wolbers and Gregory Landrey, "The Use of Direct Reactive Fluorescent Dyes for the Characterization of Binding Media in Cross Sectional Examinations" (preprint), American Institute for Conservation, 15th annual meeting, Vancouver, B.C., 1987.

74. Ibid., p. 178.

75. The author is grateful to Dr. Arie Wallert and Ms. Elizabeth Mention of the J. Paul Getty Museum for permission to use their findings on the Bucharest *Madonna*.

76. W. Jütte, "Mikrochemischer Nachweis natüralicher Harze mit Alkanna Farbstoffen in Querschliffen von Malschictproben," *Wiener Berichte über Naturwissenschaft in der Kunst*, VI–VIII (1989–91), 85–93.

The author wishes especially to thank Dr. R. Ward Bissell for his generous assistance and encouragement, along with the following individuals, whose help of various kinds made this study possible: Dr. John S. Mills of the National Gallery, London; Ms. Elizabeth Mention; Dr. Arie Wallert and Mr. Mark Leonard at the J. Paul Getty Museum, Malibu; Ms. Jane Nelson and Jennie Sherman at the M. H. De Young Memorial Museum, San Francisco; Ms. Gisela Helmkampf; Mr. Richard Wolbers at Winterthur, Del.; Mr. John Brealey; M. Jacques Blockx; Dr. Leopolod Kockaert at the Institut Royal du Patrimoine Artistique, Brussels; Dr. Leslie Carlyle at the Canadian Conservation Institute; and Mr. R. O. Innes of the O. G. Innes Corporation.

BIBLIOGRAPHY

With the exception of archival material, infrequently cited writings are excluded from this bibliography. They are referenced in full throughout the notes, appendixes, and catalogue entries.

ALIZERI, FEDERIGO. *Guida artistica per la città di Genova*. Genoa, 1846, vol. II.

AURIGEMMA, MARIA GIULIA. "Del cavalier Baglione." *Storia dell'arte*, no. 80 (1994), 23–53.

BAGLIONE, GIOVANNI. *Le vite de'pittori, scultori et architetti dal pontificato di Gregorio XIII del 1572, in fino a'tempi di Papa Urbano Ottavo nel 1642*. Rome, 1642.

BAGNOLI, ALESSANDRO: *See* Siena, Palazzo Pubblico, 1978.

BALDINUCCI, FILIPPO. *Notizie de'professori del disegno da Cimabue in qua*, ed. Florence, 1812, vol. X.

BARZMAN, KAREN-EDIS. *The Discipline of* Disegno: *The Florence Academy and the Early Modern State, 1563–1737*. Ithaca, N.Y., 1997 (manuscript for forthcoming publication; here cited as Barzman, 1997).

BATTISTI, EUGENIO. "La data di morte di Artemisia Gentileschi." *Mitteilungen des Kunsthistorischen Institutes in Florenz*, X (1963), 297.

BERNE-JOFFROY, A. *Le dossier caravage*. Paris, 1959.

BERTOLOTTI, A. "Agostino Tassi: suoi scolari e compagni pittori in Roma." *Giornale erudizione artistica*, V, fascs. VII and VIII (1876).

BIEDERMANN, GUENTHER. "La Gentileschi femme peintre expressionniste et caravaggesque." *L'Estampille*, no. 215 (1988), 38–43.

BIONDA, CLAIRE-LISE. "Artemisia Gentileschi." *L'Oeil*, no. 442 (1992), 20–29.

BIRRINGER, HELGA. "'Bathsheba im Bade' in Museum der bildenden Künste zu Leipzig." In *Erbe und Gegenwart: Festschrift Johannes Jahn zum 70. Geburtstag*, pp. 393–97. Leipzig, 1963.

BISSELL, R. WARD. "Artemisia Gentileschi: A New Documented Chronology." *Art Bulletin*, L (1968), 153–68.

———. *Orazio Gentileschi and the Poetic Tradition in Caravaggesque Painting*. University Park, Pa., and London, 1981.

BÖHMOVÁ-HÁJKOVÁ, HEDVIKA. "Restaurace obrazu Zuzana a starci od A. Gentileschi." *Casopis Moravského musea*, XLI (1956), 307–8 and ill. Trans. into German as "Die Restaurierung des Bildes 'Susanna und die beiden Alten,'" 309–10.

BOLOGNA, PALAZZO DEL PODESTÀ. *La raccolta Molinari Pradelli*, exh. cat. Florence, 1984.

BOREA, EVELINA. *Caravaggii e caravaggeschi nelle gallerie di Firenze*, exh. cat. Florence, 1970.

BORRONI SALVADORI, FABIA. "Le esposizioni d'arte a Firenze dal 1674 al 1767." *Mitteilungen des Kunsthistorischen Institutes in Florenz*, XVIII, heft I (1974), 1–166.

BOTTARI, GIOVANNI, AND STEFANO TICOZZI. *Raccola di lettere sulla pittura, scultura ed architettura scritte da'più celebri personaggi dei secoli XV, XVI, e XVII*. Milan, 1822, vol. I.

BOUSQUET, JACQUES. "Valentin et ses compagnons: réflexions sur les caravagesques français à partir des archives paroissiales romaines." *Gazette des beaux-arts*, CXX (1978), 101–14.

BRANDI, CESARE. *Rutilio Manetti 1571–1639*. Siena, 1931.

BROWN, JONATHAN, AND J. H. ELLIOTT. *A Palace for a King: The Buen Retiro and the Court of Philip IV*. New Haven and London, 1980.

BROWN, JONATHAN, AND RICHARD KAGAN. "The Duke of Alcalá: His Collection and Its Evolution." *Art Bulletin*, LXIX (1987), 231–55.

BRUNETTI, ESTELLA. "Situazione di Viviano Codazzi." *Paragone*, VII, no. 79 (1956), 48–69.

CANTELLI, GIUSEPPE. "Mitologia sacra e profana e le sue eroine nella pittura fiorentina della prima metà del seicento." *Paradigma*, no. 3 (1980), 147–69.

———. *Repertorio della pittura fiorentina del seicento*. Fiesole, 1983.

CARLYLE, LESLIE, AND ANNA SOUTHALL. "No Short Mechanic Road to Fame." In *Robert Vernon's Gift*, ed. Robin Hamlyn. London, 1993.

CASALE, GERARDO. *Giovanna Garzoni "Insigne miniatrice," 1600–1670*, with contributions by Paolo Lanzara and Marisa Ceccarelli. Milan, 1991.

CAUSA, SEFANO: *See* Naples, Castel Sant'Elmo, 1991.

CELANO, CASTELLO PICCOLOMINI. *Una quadreria d'antiquariato (dipinti dal XVI al XX secolo)*, exh. cat., Maurizio Marini. Celano, 1984–85.

CHAMBÉRY, MUSÉE DES BEAUX-ARTS. *Du maniérisme au baroque: art d'élite et art populaire*, exh. cat. Chambéry, 1995.

CHETTLE, GEORGE. *The Queen's House, Greenwich*. Greenwich, n.d. [1937].

CIARDI, ROBERTO, MARIA GALAZZI, AND PIERLUIGI CAROFANO. *Aurelio Lomi. Maniera e innovazione*. Ospedaletto (Pisa), 1989.

CILETTI, ELENA. "Ma questa è una donna terribile: Artemisia Gentileschi and Judith," paper presented to the College Art Association, Toronto, February, 1984. *CAA Abstracts*, no. 72, p. 35.

———. "Patriarchal Ideology in the Renaissance Iconography of Judith." In *Refiguring Women: Perspectives on Gender and the Italian Renaissance*, pp. 35–70, ed. and introd. Marilyn Migiel and Juliana Schiesari. Ithaca, N.Y., and London, 1991.

CINOTTI, MIA, AND GIAN ALBERTO DELL'ACQUA. *Michelangelo Merisi detto il Caravaggio*, extract from *I pittori bergamaschi: il seicento*. Bergamo, 1983, vol. I.

CLEVELAND, OHIO, MUSEUM OF ART: *See* Percy and Lurie, 1984.

COHEN, ELIZABETH. "No Longer Virgins: Self-Presentation by Young Women in Late Renaissance Rome." In *Refiguring Women: Perspectives on Gender and the Italian Renaissance*, pp. 169–91, ed. and introd. Marilyn Migiel and Juliana Schiesari, Ithaca, N.Y., and London, 1991.

———. "Honor and Gender in the Streets of Early Modern Rome." *Journal of Interdisciplinary History*, XXII, no. 4 (1992), 597–625.

COLNAGHI, SIR DOMINIC ELLIS. *A Dictionary of Florentine Painters from the 13th to the 17th Centuries*, ed. P. G. Konody and S. Brinton. London, 1928.

CONTINI, ROBERTO. *Bilivert: saggio di ricostruzione*. Florence, 1985.

CONTINI, ROBERTO, GIANNI PAPI, AND LUCIANO BERTI. *Artemisia*, exh. cat. (Casa Buonarroti, Florence). Rome, 1991.

COSNAC, GABRIEL-JULES. *Les richesses du Palais Mazarin*. Paris, 1884.

CRINÒ, ANNA MARIA. "Due lettere autografe inedite di Orazio e di Artemisia Gentileschi De Lomi." *Rivista d'arte*, XXIX (1954), 203–6.

———. "More Letters from Orazio and Artemisia Gentileschi." *Burlington Magazine*, CII (1960), 264–65.

CRINÒ, ANNA MARIA, AND BENEDICT NICOLSON. "Further Documents relating to Orazio Gentileschi." *Burlington Magazine*, CIII (1961), 144–45.

CROPPER, ELIZABETH. Review of the exhibition *Painting in Naples from Caravaggio to Giordano, 1982*. In *Burlington Magazine*, CXXV (1983), 104–6.

———. Review of Mary Garrard, *Artemisia Gentileschi*. In *Renaissance Quarterly*, XLII, no. 4 (1989), 864–66.

———. "Artemisia Gentileschi, la 'pittora.'" In *Barocco al femminile*, pp. 191–218. Rome and Bari, 1992.

———. "New Documents for Artemisia Gentileschi's life in Florence." *Burlington Magazine*, CXXXV (1993), 760–61.

DAL BORGO, BACCIO. *Canzone—nel solonne consesso in Pisa delli scienziati europei nell'autunno dell'anno 1839*. Pisa, 1839.

DEGRAZIA, DIANE. *Le stampe dei Carracci*. Bologna, 1984.

DEL BRAVO, CARLO. "Su Cristofano Allori." *Paragone*, XVIII, no. 205 (1967), 68–83.

DETROIT, INSTITUTE OF ARTS. *Art in Italy: 1600–1700*, exh. cat. Detroit, 1965.

DOMINICI, BERNARDO DE. *Vite dei pittori scultori ed architetti napoletani*. Ed. Naples, 1844, vol. III.

DONATI, PIERO, ET AL. *Domenico Fiasella*, exh. cat. Genoa, Palazzo Reale, June 9–August 5, 1990.

DÜSSELDORF, KUNSTMUSEUM. *Die Galerie der Starken Frauen: Regentinnen, Amazonen, Salondamen*, exh. cat., Bettina Baumgärtel, Silvia Neysters, et al. Munich, 1995.

EASTLAKE, SIR CHARLES LOCK. *Materials for a History of Oil Painting*. London, 1847. Reprinted

New York, 1960, under the title *Methods and Materials of Painting of the Great Schools and Masters (Materials for a History of Oil Painting)*.

EMILIANI, ANDREA. "Orazio Gentileschi: nuove proposte per il viaggio marchigiano." *Paragone*, IX, no. 103 (1958), 38–57.

ENGEL, A. "Inventaire de la 'Casa de Pilatos' en 1752 [*sic*]." *Bulletin hispanique*, V, no. 3 (1903), 259–71.

FICACCI, LUIGI, ET AL. *Claude Mellan, gli anni romani: un incisore tra Vouet e Bernini*, exh. cat. Rome, 1989.

FLEMING, JOHN. "The Hugfords of Florence." *Connoisseur*, CXXXVI (1955), 106–10, 197–200, 203–6.

FLORENCE, ARCHIVIO DELL'OPERA DEL DUOMO. Registro di Battesimo, *Femmine*, 1614–15 (July 1615, fol. 3), 1616–17 (August 1617, fol. 59v), 1618–19 (October 1618, fol. 29v; July 1619, fol. 3); Registro di Battesimo, *Maschi*, 1612–13 (September 1613, fol. 108v), 1614–15 (November 1615, fol. 74).

FLORENCE, ARCHIVIO DI STATO. *Grascia*, 194, fol. 316r.

FLORENCE, ARCHIVIO DI STATO. Accademia del Disegno: *Atti e Sentenze*, LXIV (fol. 422 by recent numeration; c. n.n., August 26–December 16, 1616; fols. 651r and v by recent numeration, fol. 724 by recent numeration), LXV, 1595–1616 (fol. 160 by count; fol. 437 by recent numeration; fol. 877 by count; nos. 152, 169 attached to fol. 877 by count); *Debitori e creditori delle Matricole: 1596–1627*, LVII, fol. 152; *Entrata et Uscita: Entrata E dal 1602 al 1624*, CIII, fol. 54; *Partiti e Deliberazioni*, segnato B, XVI (fols. 41, 47).

——. Mediceo 344 (fol. 386v), 360 (Memoriale, fol. 146), 373 (Inventario Generale, segnato B, 1618, fol. 29), 390 (inserto 2, 13 di. genn.o 1619, fols. 77–78 replacing numeration 87–88 and inserto 5, 15 di febbr. 1619, fol. 455 replacing numeration 293), 479 (fol. 19v), 525 ("Inventario de Pitti," 3 marzo 1637, fol. 45v), 628 (fol. 4), 725 ("Inventario del Palazzo de Pitti," 1663, fols. 69v, 113v), 741 ("Inventario Generale a Capi," 1666–68, fol. 378, and 1669, fol. 385), 758 ("Inventario Originale dell'Eredità del Cardinal Decano," 1666, fol. 14 no. 250), 782 (fol. 4), 998 (fol. 204), 1416 (inserto 8, fols. 748, 780; inserto 9, fol. 860; inserto 10, fol. 892), 3508, 4157 (fols. 194r and v), and reportedly fil. 2.LVI segn. di N. moderno 6003, 1612.

FLORENCE, CASA BUONARROTI: *See* Contini, Papi, and Berti, 1991.

FLORENCE, CASA BUONARROTI, ARCHIVIO BUONARROTI. MSS 97 (c. 15, 16, 17), 101–4 [A] (fols. 32, 36), 103 (fols. 67, 68v, 69).

FLORENCE, PALAZZO PITTI: *See* Borea, 1970.

——. *La galleria dei quadri esistente nel imperiale e reale Palazzo Pitti*. Fiesole, 1834.

——. *L'imperiale e reale Galleria Pitti illustrata*, ed. Luigi Bardi. Florence, 1837, vol. I.

——. *Sustermans: sessant'anni alla corte dei Medici*, exh. cat., Karla Langedijk, Claudio Pizzorusso, Marco Chiarini. Florence, 1983.

——. *Cristofano Allori 1577–1621*, exh. cat., Miles Chappell. Florence, 1984.

——. *La Maddalena fra sacro e profano*, exh. cat., Marilena Mosco et al. Florence, 1986.

FLORENCE, PALAZZO STROZZI. *70 pitture e sculture del '600 e '700 fiorentino*, exh. cat., Mina Gregori. Florence, 1965.

——. *Il seicento fiorentino*, exh. cat. Florence, 1986, 3 vols.

FREDERICKSEN, BURTON B., AND FEDERICO ZERI. *Census of Pre-Nineteenth-Century Italian Paintings in North American Public Collections*. Cambridge, Mass., 1972.

FRIMMEL, THEODOR VON. *Kleine Galeriestudien*. Bamberg, 1891, vol. I.

——. *Verzeichnis der Gemälde in gräflich Schönborn-Wiesentheid'schem Besitze*. Pommersfelden, 1894.

FRÖHLICH-BUME, L. "A Rediscovered Picture by Artemisia Gentileschi." *Burlington Magazine*, LXXVII (1940), 165 fig. B, 169.

FUDA, ROBERTO. "Un'inedita lettera di Artemisia Gentileschi a Ferdinando II de'Medici." *Rivista d'arte*, XLI (1989), 167–71.

FURTWÄNGLER, ADOLF. *Die antiken Gemmen: Geschichte der Steinschneidekunst im klassischen Altertum*. Leipzig and Berlin, 1900, 3 vols.

GABHART, ANN, AND ELIZABETH BROUN. "Old Mistresses: Women Artists of the Past." *Bulletin of the Walters Art Gallery*, XXIV, no. 7 (1972), unpaginated.

GALANTE, LUCIO. "Appunti per Vouet, Gargiulo e Finoglio." *Itinerari di ricerca storica*, I (1987), 39–53.

GALILEI, GALILEO. *Le opere di Galileo Galilei*, XVI (Carteggio 1634–36), Florence, 1905.

GANDOLFI, GIOVAN CRISTOFORO, ET AL. *Descrizione di Genova e del genovesato*. Genoa, 1846, vol. III.

GARLICK, K. J. "A Catalogue of Pictures at Althorp." *Walpole Society*, XLV (1974–76).

GARRARD, MARY. "Artemisia Gentileschi's Self-Portrait as the Allegory of Painting." *Art Bulletin*, LXII (1980), 97–112.

——. "Artemisia and Susanna." In *Feminism and Art History: Questioning the Litany*, pp. 146–71, ed. Norma Broude and Mary Garrard. New York, 1982.

———. *Artemisia Gentileschi: The Image of the Female Hero in Italian Baroque Art*. Princeton, N.J., 1989.

———, Letter to the Editor, *Times Literary Supplement*, June 30–July 6, 1989, p. 719. Cited as Garrard, 1989a.

———. "Artemisia Gentileschi's 'Corisca and the Satyr.'" *Burlington Magazine*, CXXXV (1993), 34–38.

GASH, JOHN. Review of Mary Garrard, *Artemisia Gentileschi*. In *Art in America*, LXXVII, no. 5 (1990), 67, 69.

GENEVA, MUSÉE D'ART ET D'HISTOIRE. *Peintures italiennes du XIVe au XVIIIe siècle*, cat. by Mauro Natale. Geneva, 1979.

GENOA, PALAZZO REALE: *See* Donati et al., 1990.

GERARD, VÉRONIQUE. "Philip IV's Early Italian Commissions." *Oxford Art Journal*, V, no. 1 (1982), 9–14.

GORSEN, PETER. "Venus oder Judith? Zur Heroisierung des Weiblichkeitsbildes bei Lucas Cranach und Artemisia Gentileschi." *Artibus et historiae*, no. 1 (1980), 69–81.

GOUMA-PETERSON, THALIA, AND PATRICIA MATHEWS. "The Feminist Critique of Art History." *Art Bulletin*, LXIX, no. 3 (1987), 326–57.

GRABSKI, JÓZEF. "On Seicento Painting in Naples: Some Observations on Bernardo Cavallino, Artemisia Gentileschi and Others." *Artibus et historiae*, no. 11 (1985), 23–63.

GREER, GERMAINE. *The Obstacle Race*. New York, 1979.

GREGORI, MINA. "Su due quadri caravaggeschi a Burghley House." In *Festschrift Ulrich Middeldorf*, pp. 414–21 and pls. CLXXX–CLXXXIII (figs. 1–6). Berlin, 1968.

GUGLIELMI, CARLA. "Intorno all'opera pittorica di Giovanni Baglione." *Bollettino d'arte*, XXXIX (1954), 311–26.

HAGEN, ROSE-MARIE. "Artemisia, die entehrte Malerin." *Art*, no. 8 (1988), 72–84, 87.

HARRIS, ANN SUTHERLAND, AND LINDA NOCHLIN. *Women Artists: 1550–1950*, exh. cat. Los Angeles and New York, 1976.

———. "Fresh Paint," review of Mary Garrard, *Artemisia Gentileschi*. In *Women's Review of Books*, VI, no. 12 (1989), 8–10.

HARTFORD, CONN., WADSWORTH ATHENEUM. *Wadsworth Atheneum Paintings II. Italy and Spain. Fourteenth Through Nineteenth Centuries*, Jean Cadogan, Michael Mahoney, George Kubler, Craig Felton. Hartford, 1991.

HASKELL, FRANCIS. "Artemisia's Revenge?" review of Mary Garrard, *Artemisia Gentileschi*. In *New York Review* (July 20, 1989), 36–38.

HERSEY, GEORGE. "Female and Male Art: *Postille* to Garrard's *Artemisia Gentileschi*." In *Parthenope's Splendor: Art of the Golden Age in Naples*, pp. 322–34, VII of Papers in Art History from the Pennsylvania State University Press. University Park, 1993.

HESS, JACOB. "Die Gemälde des Orazio Gentileschi für das 'Haus der Königin' in Greenwich." In *Kunstgeschichtliche Studien zu Renaissance und Barock*, I, pp. 241–47, 421–22 and II, pls. 171–83 (figs. 1–25). Rome, 1967. First published in *English Miscellany*, III (1952), 159–87.

HOFRICHTER, FRIMA FOX. "Artemesia [*sic*] Gentileschi's Uffizi *Judith* and a Lost Rubens." *Rutgers Art Review*, I (1980), 9–15.

HOLLSTEIN, F. W. H. *Dutch and Flemish Etchings, Engravings, and Woodcuts: Ca. 1450–1700*. Amsterdam, n.d.

IMPARATO, FRANCESCO. "Document relativi ad Artemisia Lomi Gentileschi." *Archivio storico dell'arte*, II (1889), 423–25.

JACOBUS, MARY. *Reading Woman: Essays in Feminist Criticism*. New York, 1986.

JUDSON, RICHARD. *Gerrit van Honthorst*. The Hague, 1959.

KULTERMANN, UDO. "Women Asleep and the Artist." *Artibus et historiae*, XI, no. 22 (1990), 129–61.

LABROT, GÉRARD. *Collections of Paintings in Naples: 1600–1780*. Munich, London, New York, Paris, 1992.

LAING, ALASTAIR. "Sir Peter Lely and Sir Ralph Bankes." In *Art and Patronage in the Caroline Courts*, pp. 107–31, ed. D. Howarth. Cambridge, 1993.

LANGEDIJK, KARLA, ET AL.: *See* Florence, Palazzo Pitti, 1983.

LANZI, LUIGI. *Storia pittorica della Italia dal risorgimento delle belle arti fin presso al fine del XVIII secolo*. Ed. Florence, 1834, vol. I.

LAPIERRE, ALEXANDRA. *Artemisia: un duel pour immortalité*. Paris, 1998.

LAVAGNINO, EMILIO. *La Galleria Spada in Roma*. Rome, 1933.

LAVIN, MARILYN ARONBERG. *Seventeenth-Century Barberini Documents and Inventories of Art*. New York, 1975.

LAW, EARNEST. *The New Authorised Historical Catalogue of the Pictures and Tapestries in the King's Collection at Hampton Court Palace*. London, n.d.

LE BLANC, CHARLES. *Manuel de l'amateur d'estampes*. Paris, 1856, vol. II, and 1858, vol. III.

LERBERG, ELLEN. "Judith i Nasjonalgalleriet." *Kunst og kultur*, LXXVI, no. 3 (1993), 182–91.

LEVEY, MICHAEL. "Notes on the Royal Collection—II: Artemisia Gentileschi's 'Self-Portrait'

at Hampton Court." *Burlington Magazine*, CIV (1962), 79–80.

LIPPINCOTT, KRISTEN. Review of Mary Garrard, *Artemisia Gentileschi*. In *Renaissance Studies*, IV, no. 4 (1990), 444–48.

LONDON, COLNAGHI AND CO., LTD. *Paintings by Old Masters*. May 16–June 15, 1963.

LONDON, MATTHIESEN FINE ART LTD. *Important Italian Baroque Paintings 1600–1700*. London, 1981.

———. *Baroque III: 1620–1700*. London, June 13–August 15, 1986.

LONDON, PUBLIC RECORD OFFICE. *Pictures Statues Plate and Effects of King Charles I: 1649–1651* (Inventories, LR 2/124, fols. 6, 60, 117v no. 5, 119 no. 97, 188, 190v, 192). Published as "The Inventories and Valuations of the King's Goods 1649–1651," ed. Oliver Millar, *Walpole Society*, XLII (1970–72). And, reportedly, A. O. 1, 63/2427.

LONDON, ROYAL ACADEMY OF ARTS. *Painting in Naples 1606-1705 from Caravaggio to Giordano*, exh. cat., ed. Clovis Whitfield and Jane Martineau. London, 1982.

LONDON, SOTHEBY'S. *Old Master Paintings*. December 6, 1995.

LONDON, TRAFALGAR GALLERIES. *In the Light of Caravaggio*. London, 1976.

———. *Trafalgar Galleries at the Royal Academy III*. London, 1983.

LONGHI, ROBERTO. "Gentileschi padre e figlia." In *Scritti giovanili: 1912–1922*, pp. 219–83. Florence, 1961, I–I and I–II. First published in *L'Arte*, XIX (1916), 245–314.

———. "Ultimi studi sul Caravaggio e la sua cerchia." *Proporzioni*, I (1943), 5–63 and pls.

———. "Giunte e varianti ai due Gentileschi 1920–1921." In *Il palazzo non finito. Saggi inediti 1910–1926*, ed. Francesco Frangi and Cristina Montagnani. Milan, 1995.

LOS ANGELES, CALIF., LOS ANGELES COUNTY MUSEUM OF ART: *See* Harris and Nochlin, 1976.

LURIE, ANN T.: *See* Percy et al., 1984.

MADRID, ARCHIVO ZABÁLBURU Y BASABE. Legajo 215, no. 1.

MADRID, PALACIO DE VILLAHERMOSA. *Pintura napolitana de Caravaggio a Giordano*, exh. cat., Alfonso E. Pérez Sánchez and Manuel Mena Marques. Madrid, 1985.

MANN, JUDITH W. "The Gentileschi *Danaë* in the St. Louis Art Museum. Orazio or Artemisia?" *Apollo*, CXLIII, no. 412 (1996), 39–45.

———. "Caravaggio and Artemisia: Testing the Limits of Caravaggism," *Studies in Iconography*, XVIII (1997), 161–85.

MARINI, MAURIZIO. "Caravaggio e il naturalismo internazionale." In *Storia dell'arte italiana*, pp. 347–445. Turin, 1981, vol. VI, pt. 1.

———. "Gli esordi del Caravaggio e il concetto di 'natura' nei primi decenni del Seicento a Roma. Equivoci del caravaggismo." *Artibus et historiae*, II, no. 4 (1981), 39–83.

MAROGER, JACQUES. *The Secret Formulas and Techniques of the Old Masters*. London and New York, 1948.

MARSHALL, DAVID. *Viviano and Nicolò Codazzi and the Baroque Architectural Fantasy*. Milan, 1993.

MASSING, ANN. "Orazio Gentileschi's *Joseph and Potiphar's Wife*: A 17th Century Use of 'Bituminous' Paint." *Bulletin of the Hamilton Kerr Institute*, no. 1 (1988), 99–104.

MAYERNE, SIR THEODORE TURQUET DE. *Pictoria, Sculptoria & quae subalternarum artium*, 1620 (on title page), British Museum Library Sloan MS 2052. Published in the following editions: Ernst Berger, *Quellen für Maltechnik während der Renaissance und deren Folgezeit (XVI–XVIII Jahrhundert) . . . nebst dem de Mayerne MS. Beiträge zur Entwicklungsgeschichte der Maltechnik, IV Folge*, Munich, 1901; J. A. Van de Graaf, *Het de Mayerne manuscript als bron voor Schildertechniek van de Barok*, Mijdrecht, 1958; and M. Faidutti and C. Versini, *Le manuscript de Turquet de Mayerne*, Lyon, n.d. [1968].

MELONI TRKULJA, SILVIA. "Appendice: I quadri della Sala dell'Udienza." *Antichità viva*, XII, no. 5 (1973), 44–46.

MENZIO, EVA, ED. *Artemisia Gentileschi / Agostino Tassi, Atti di un processo per stupro*. Milan, 1981.

MERKEL, KERSTIN. Review of Mary Garrard, *Artemisia Gentileschi*, and of Roberto Contini and Gianni Papi, *Artemisia*. In *Kunstchronik*, XLV, no. 8 (1992), 346–55.

MILAN, PALAZZO DELLA PERMANENTE. *L'Europa della pittura nel XVII secolo: 80 capolavori dai musei ungheresi*, exh. cat. Milan, 1993.

MILLAR, OLIVER, ED.: *See* London, Public Record Office, 1649–51, and Van der Doort, 1960.

MISSIRINI, MELCHIOR. *Memorie per servire alla storia della romana Accademia di San Luca*. Rome, 1823.

MODENA, ARCHIVIO DI STATO. Archivio Segreto Estense, Cancelleria Ducale, Archivio per Materie, Arti Belle e Pittori, busta 14/2.

MOIR, ALFRED. *The Italian Followers of Caravaggio*. Cambridge, Mass., 1967, 2 vols.

———. *Caravaggio and His Copyists*, New York, 1976.

MÖLLER, RENATE. *Der römische Maler Giovanni Baglione*. Munich, 1991.

MORASSI, ANTONIO. *Mostra della pittura del seicento e settecento in Liguria*, exh. cat. Genoa, 1947.

MORRONA, ALESSANDRO DA. *Pisa illustrata nelle arti del disegno*. Pisa, 1792, vol. II, and ed. Livorno, 1812, vol. II.

MUZII, ROSANNA, ET AL. *La collezione Farnese. I dipinti lombardi, liguri, veneti, toscani, umbri, romani, fiamminghi. Altre scuole. Fasti farnesiani.* Naples, 1995.

NAPLES, ARCHIVIO DEL PIO MONTE DELLA MISERICORDIA. Fasc. De Gennaro, cat. B, reg. n. XIV, numero progressivo 27.

NAPLES, ARCHIVIO DI STATO. Archivi Privati: Carafa San Lorenzo, carte 4; Palma d'Artois, fasc. 105, fascic. II, fol. 26v.

———. Coll. Div. II fs 16.

———. Notaii: Dionisio d'Alterio, scheda 320, prot. 9, fol. 982v; Gregorio d'Aventino, scheda 178, prot. 25, fol. 140; Giov. Batt. dell'Aversana, XVII sec., scheda 295, prot. 40, fol. 588 ff.; Domenico Cardamone, scheda 1221, prot. 32, fol. 34; Giovanni Battista Cava, scheda 686, prot. 15, fol. 6 (allegato al fol. 268v); Carlo Celso di Giorgio, scheda 358, prot. 34, fol. 4 (allegato al fol. 146v); Biagio Domenico de Conciliis, scheda 399, prot. 49, fol. 18 (allegato al fol. 630v); Francesco Mignone, scheda 332, prot. 19, fol. 3 (allegato al fol. 1248v); Carlo Piscopo, scheda 1032, prot. 21, fols. 295 and 412v, and scheda 1034, prot. 21, fol. 243; Giuseppe Ragucci, scheda 508, prot. 63, fol. 185 ff.; Giuseppe de Vivo, scheda 714, prot. 30, fol. 98v (allegato al fol. 348v).

———. Sezione Giustizia, Sacro Regio Consiglio, ordinamento Zei, fasc. I, fascic. 218, fol. 34.

NAPLES, ARCHIVIO STORICO DEL BANCO DI NAPOLI. Banco della Pietà, giornale 359, 1648, 5 settembre 1648, fol. 406; Banco dello Santo Spirito, giornale del 1636, matr. 270, partita di ducati 250, estinto il 5 maggio; Banco di San Giacomo, giornale copiapolizze, matr. 147, 21 agosto 1631, and giornale del 1636, matr. 198, partita di ducati 20, estinto il 19 dicembre.

NAPLES, CASTEL NUOVO. *La Madonna della pittura del '600 a Napoli*, exh. cat., Raffaello Causa. Naples, 1964.

NAPLES, CASTEL SANT'ELMO. *Battistello Caracciolo e il primo naturalismo a Napoli*, exh. cat., Stefano Causa et al. Naples, 1991.

NAPLES, MUSEO DI CAPODIMONTE AND MUSEO PIGNATELLI. *Civiltà del seicento a Napoli*, exh. cat. Naples, 1984, 2 vols.

NAPLES, PALAZZO REALE. *Caravaggio e i caravaggeschi*, exh. cat., Giuseppe Scavizzi. Naples, 1963.

NAPPI, EDUOARDO. "Pittori del '600 a Napoli." In *Ricerche sul '600 napoletano: saggi vari*. Milan, 1983.

———, ed. *Ricerche sul '600 napoletano. Catalogo delle pubblicazioni edite dal 1883 al 1990 riguardanti le opere di architetti, pittori, scultori, marmorari ed intagliatori per i secoli XVI e XVII, pagate tramite gli antichi banchi pubblici napoletani*. Milan, 1992.

NATALE, MAURO: *See* Geneva, Musée d'Art et d'Histoire, 1979.

NEW YORK, COLNAGHI. *Italian, Dutch, and Flemish Baroque Paintings*, cat. by Clovis Whitfield and Elaine Banks. New York, April 4–May 5, 1984.

NEW YORK, METROPOLITAN MUSEUM OF ART. *The Age of Caravaggio*, exh. cat. New York, 1985.

NICOLSON, BENEDICT. "Caravaggesques in Florence." *Burlington Magazine*, CXII (1970), 636–41.

———. *Caravaggism in Europe*, 2d ed., revised and enlarged by Luisa Vertova. Turin, 1990, 3 vols. Cited as Nicolson/Vertova, 1990.

"NOTABLE WORKS OF ART NOW ON THE MARKET." *Burlington Magazine*, XCVII (1955), pl. XIX.

NOVELLI, MAGDA. "Agostino Beltrano, uno 'stanzionesco' da riabilitare." *Paragone*, XXV, no. 287 (1974), 67–82 and pls. 49–58.

———. "Una traccia per Annella De Rosa." *Napoli nobilissima*, XXVIII (1989), 147–54.

NÜRNBERG, GERMANISCHES NATIONALMUSEUM. *Die Grafen von Schönborn. Kirchenfürsten, Sämmler, Mazene*, exh. cat. Nürnberg, 1989.

ORBAAN, J. A. F. "Notes on Art in Italy III: A Lost Masterwork of Adam Elsheimer?" *Apollo*, VI (1927), 157–58.

ORTOLANI, SERGIO, ET AL. *La mostra della pittura napoletana dei secoli XVII-XVIII-XIX*. Naples, 1938.

OSLO, NASJONALGALLERIET. *Katalog over utenlandsk Malerkunst*. Oslo, 1973.

PACELLI, VINCENZO. "La quadreria di Vincenzo D'Andrea, giurista e rivoluzionario, da un inventario del 1649." In *Ricerche sul '600 napoletano*, pp. 145–51, 1987.

PAGLIARULO, GIOVANNI. "Artemisia: La Betsabea di Gosford House." *Nuovi studi*, I (1996), 151–56 and figs. 270–72.

PALMER, RODNEY. "The Gentler Sex—and Violence. Artemisia Gentileschi at the Casa Buonarroti." *Apollo*, CXXXIV, no. 356 (1991), 277–80.

PAOLUCCI, ANTONIO. " 'I seguaci italiani del Caravaggio,' di A. Moir." *Paragone*, XVIII, no. 213 (1967), 67–78.

PAPI, GIANNI. "Note al Gramatica e al suo ambiente." *Paradigma*, no. 9 (1990), 107–27.

———. "Note in margine alla mostra 'L'arte per i papi e per i principi nella campagna romana.

Grande pittura del '600 e '700.' " *Paragone*, XLI, no. 485 (1990), 73–88.

———. "Due o tre precisiazioni sul naturalismo di Giovan Francesco Guerrieri." *Bollettino d'arte*, LXXVI, nos. 68–69 (1991), 147–56.

———. *See* Contini et al., 1991.

———. *Antiveduto Gramatica*. Soncino, 1995.

———. "Un David e Golia di Artemisia Gentileschi." *Nuovi studi*, I (1996), 157–60 and fig. 273.

PARIS, BIBLIOTHÈQUE NATIONAL, DEPARTMENT DES ESTAMPES. *Inventaire du fonds français. Graveurs du XVIIe siècle*. Paris, 1954.

PARKER, ROZSIKA, AND GRISELDA POLLOCK. *Old Mistresses: Women, Art, and Ideology*. New York, 1981.

PARTHEY, G. GUSTAV. *Deutscher Bildersaal: Verzeichnis der in Deutschland vorhandenen Oelbilder verstorbener Maler aller Schulen*. Berlin, 1863, vol. I, and 1864, vol. II.

PASCULLI FERRARA, MIMMA. "Un Micco Spadaro poco conosciuto." *Ricerche sul sei-settecento in Puglia*, III (1984–89), 137–53.

PASSERI, GIOVANNI BATTISTA. *Vite de pittori scultori et architetti dall'anno 1641 sino all'anno 1673*, ed. Jacob Hess, Worms am Rhein, 1995, under the title *Die Künsterbiographien von Giovanni Battista Passeri*.

PEPPER, D. STEPHEN. "New York: Baroque Painting at Colnaghi's." *Burlington Magazine*, CXXVI (1984), 315–16.

PERCY, ANN, ANN T. LURIE, ET AL. *Bernardo Cavallino of Naples, 1616–1656*, exh. cat. Cleveland, Ohio, and Fort Worth, Tex., 1984.

PÉREZ SÁNCHEZ, ALFONSO E. *Pintura italiana del siglo XVII en España*. Madrid, 1965.

———. *Caravaggio y el naturalismo español*, exh. cat. Madrid, 1973.

PÉREZ SÁNCHEZ, ALFONSO E., AND MANUEL MENA MARQUES: *See* Madrid, Palacio de Villahermosa, 1985.

PERGOLA, PAOLA DELLA. *Galleria borghese: i dipinti*. Rome, 1955, vol. I, and 1959, vol. II.

———. "Giovan Francesco Guerrieri a Roma." *Bollettino d'arte*, XLI (1956), 214–37.

PERLOVE, SHELLEY. "Guercino's *Esther Before Ahasuerus* and Cardinal Lorenzo Magalotti, Bishop of Ferrara." *Artibus et historiae*, X, no. 19 (1989), 133–47.

PEVSNER, NIKOLAUS. "Einige Regesten aus Akten der Florentiner Kunstakademie." *Mitteilungen des Kunsthistorischen Institutes in Florenz*, IV (1932–34), 128–31.

PILKINGTON, M. *The Gentleman's and Connoisseur's Dictionary of Painters*. Ed. London, 1777.

PIZZORUSSO, CLAUDIO. "Rivedendo il Gentileschi nelle Marche." *Notizie da Palazzo Albani*, XVI, no. I (1987), 57–75.

POINTON, MARCIA. "Artemesia [*sic*] Gentileschi's *The Murder of Holofernes*." *American Imago*, XXXVIII, no. 4 (1981), 350–59.

POLLOCK, GRISELDA. Review of Mary Garrard, *Artemisia Gentileschi*. In *Art Bulletin*, LXXII, no. 3 (1990), 499–505.

PORCELLA. AMADORE. *Le pitture della Galleria Spada*. Rome, 1931.

PRAGUE, NÁRODNÍ GALERIE. *Tra l'eruzione e la peste. La pittura a Napoli dal 1631 al 1656*, exh. cat., Ladislav Daniel. Prague, 1995.

PROCACCI, UGO. *La Casa Buonarroti a Firenze*. Milan, 1967.

RATTI, CARLO GIUSEPPE. *Istruzioni di quanto può vedersi di più bello in Genova in pittura, scultura, ed architettura ecc*. Genoa, 1780, vol. I.

RÉAU, LOUIS. *Iconographie de l'art chrétien*. Paris, 1958–59, vol. III, pts. I–III.

RICHARDSON, E. P. "A Masterpiece of Baroque Drama." *Bulletin of the Detroit Institute of Arts*, XXXII, no. 4 (1952–53), 81–83.

RICHTER, GISELA. *Catalogue of Engraved Gems: Greek, Etruscan, and Roman*. New York, Metropolitan Museum of Art, published Rome, 1956.

RIEDL, HELMUT PHILIPP, AND ERICH SCHLEIER. "Ein unbekanntes Hochaltarbild Antiveduto della Grammaticas in Todi und weitere Neuzuweisungen." *Pantheon*, L (1992), 61–73.

RIGHETTI, ROMOLO. *Gemme e cammei delle collezioni comunali*. Rome, 1955.

RINALDIS, ALDO DE. *Pinacoteca di Museo Nazionale di Napoli*. Naples, 1928.

RIPA, CESARE. *Iconologia*. Ed. Rome, 1603, and Siena, 1613.

ROME, ARCHIVIO DEL VICARIATO. San Giovanni in Laterano. *Cresime III: 1601–1608*, 12 giugno 1605.

———. San Lorenzo in Lucina, *Liber Baptizatorum: 1590–1603*, VII, fols. 78 no. 157, 167v no. 154.

———. Santa Maria del Popolo: *Liber Tertius Baptizatorum: 1584–1595*, fol. 128; *Liber IV Baptizatorum: 1595–1619*, fols. 52v, 80v; *Liber V Baptizatorum: 1620–1639*, fols. 47, 52v; *Libro de'Morti IV: 1595–1620*, LI, fols. 96v, 114, 140; *Status Animarum*, LXIII, 1601 (fol. 25), 1602 (fol. 15), 1603 (fol. 67v), 1604 (fol. 129); *Status Animarum*, LXIV, 1605 (fol. 15bv), 1606 (fol. 17), 1607 (fol. 13), 1610 (fol. 39), 1611 (fol. 33), 1621 (fol. 9); *Status Animarum ab Anno 1622 usque ad 1649*, LXV, 1622 (fol. 20), 1623 (fol. 11), 1624 (fol. 11v), 1625 (fol. 27v), 1626 (fol. 6).

———. Santo Spirito in Saxia, *Libro de'Matrimoni II: 1607–1630*, XVII, fol. 17.

ROME, ARCHIVIO DI STATO. *Archivio del Tribunale Criminale del Governatore di Roma*, processo no. 104 ("Stupri et Lenocinij—Pro Curia et fisco Con^e Augustinum Tassum Pictorem"), anno 1612, fols. 270–448; processo no. 181, anno 1622, fols. 52–55.

―――. *Archivio del Tribunale Criminale del Governatore di Roma*, Miscellanea Artisti, secolo XVII, busta 2, fascs. 108a–c.

―――. *Archivio del Tribunale Criminale del Governatore di Roma, Registrazioni d'Atti*, busta 166, fols. 101r, 103r; busta 167, fols. 165v, 183r, 192r, 222v.

―――. *Tribunale Civile del Governatore, Sentenze*, busta 309, 1621–23.

―――. *30 Notai Capitolini*, Officio 2, vol. 92, 1624, Leonardus Bonanni, fol. 380; Officio 11, vol. 187, 1647, Jo. Mattheus Massarius, fol. 465v; Officio 19, vol. 121, 1621, fols. 385r and v, 396r; Officio 19, vol. 136, 1625, fol. 735; Officio 19, vol. 138, 1625, fol. 523; Officio 36, vol. 24, 1612, fols. 646r and v.

ROME, GALLERIA BORGHESE: *See* Pergola, 1955 and 1959.

ROME, GALLERIA SPADA: *See* Lavagnino, 1933; Porcella, 1931; Zeri, 1954.

ROME, PALAZZO BARBERINI: *See* Ficacci et al., 1989.

ROME, PALAZZO DELLE ESPOSIZIONI. *Vouet*, exh. cat., Jacques Thuillier et al. Rome, 1991.

ROME, PALAZZO VENEZIA: *See* Röttgen, 1973.

ROSE, BARBARA. "The Gentileschi Papers." *Journal of Art*, IV, no. 9 (1991), 12–13.

ROSINI, GIOVANNI. *Storia della pittura italiana*. Pisa, 1846, vol. VI.

ROTTERDAM, MUSEUM BOYMANS–VAN BEUNINGEN. *Van Titiaan tot Tiepolo / From Titian to Tiepolo*, exh. cat. Rotterdam, 1989.

RÖTTGEN, HERWARTH. *Il Cavalier d'Arpino*. Rome, 1973.

RUFFO, VINCENZO. "Galleria Ruffo del secolo XVII in Messina." *Bollettino d'arte*, X (1916), 21–64, 95–128, 165–92, 237–56, 284–320, 369–88.

―――. "La Galleria Ruffo (Appendice)." *Bollettino d'arte*, XIII (1919), 43–56.

RUOTOLO, RENATO. "La raccolta Carafa di S. Lorenzo." *Napoli nobilissima*, XIII, no. 5 (1974), 161–68.

―――. "Aspetti del collezionismo napoletano: il Cardinale Filomarino." *Antologia di belle arti*, I, no. 1 (1977), 71–82.

―――. *Mercanti-collezionisti fiamminghi a Napoli: Gaspare Roomer e i Vandeneynden*. Naples, 1982.

RUSSELL, H. DIANE, WITH BERNADINE BARNES. *Eva/Ave: Women in Renaissance and Baroque Prints*, exh. cat. Washington, D.C., National Gallery of Art, 1990.

SALERNO, CARLO STEFANO. "Precisazioni su Angelo Caroselli." *Storia dell'arte*, no. 76 (1992), 346–61.

SALERNO, LUIGI. "The Picture Gallery of Vincenzo Giustiniani." *Burlington Magazine*, CII (1960), 21–27, 93–105, 135–48.

SÁNCHEZ CANTÓN, F. J. *Fuentes literarias para la historia del arte español*. Madrid, 1933, vol. II.

SANDRART, JOACHIM VON. *Academie der Bau-, Bild-, und Mahlerey-Künste von 1675*, ed. A. R. Peltzer. Munich, 1925.

SAN SEVERINO MARCHE, PALAZZO DI CITTÀ, AND BOLOGNA, SAN GIORGIO IN POGGIALE. *Giovan Francesco Guerrieri: dipinti e disegni—un accostamento all'opera*, exh. cat., Sergio Anselmi, Andrea Emiliani, and Giovanna Sapori. 1988.

SARASOTA, FLA., JOHN AND MABLE RINGLING MUSEUM OF ART. *A Catalogue of Paintings in the John and Mable Ringling Museum of Art*, cat. by W. E. Suida. Sarasota, 1949.

―――. *Baroque Painters of Naples*, exh. cat., Creighton Gilbert. Sarasota, 1961.

―――. *Catalogue of the Italian Paintings Before 1800*, cat. by Peter Tomory. Sarasota, 1976.

SCAVIZZI, GIUSEPPE: *See* Naples, Palazzo Reale, 1963.

SCHLEIER, ERICH. Review of *Caravaggio e caravaggeschi nelle gallerie di Firenze*. In *Kunstchronik*, XXIV (1971), 85–102.

SCHÜTZE, SEBASTIAN, AND THOMAS WILLETTE. *Massimo Stanzione: l'opera completa*. Naples, 1992.

SESTIERI, GIANCARLO, AND BRIGITTE DAPRÀ. *Domenico Gargiulo detto Micco Spadaro, paesaggista e 'cronista' napoletano*. Milan, 1994.

SEVILLE, ALCAZAR: *See* Pérez Sánchez, 1973.

SHAPLEY, FERN RUSK. *Paintings from the Samuel H. Kress Collection: Italian Schools, XVI–XVIII Century*. London and New York, 1973.

SIENA, PALAZZO PUBBLICO. *Rutilio Manetti, 1571–1639*, exh. cat., Alessandro Bagnoli et al. Siena, 1978.

SIMANCAS, ARCHIVO GENERAL DE. Tribunal Mayor de Cuentas 2633, 1626–28.

SLAP, JOSEPH. "Artemisia Gentileschi: Further Notes." *American Imago*, XLII, no. 3 (1985), 335–42.

SOLERTI, ANGELO. *Musica, ballo, e drammatica alla Corte Medicea dal 1600 al 1637*. Ed. New York, 1968.

SOPRANI, RAFFAELLO. *Le vite de'pittori, scoltori et architetti genovesi*. Genoa, 1674.

SPEAR, RICHARD. "Caravaggisti at the Palazzo Pitti." *Art Quarterly*, XXXIV, no. 1 (1971), 108–10.

―――. *Caravaggio and His Followers*, exh. cat. Cleveland, Ohio, 1971, and rev. ed., 1975.

———. *Domenichino.* New Haven and London, 1982, 2 vols.

———. Review of Mary Garrard, *Artemisia Gentileschi.* In *Times Literary Supplement* (June 2–8, 1989), 603–4.

SPIKE, JOHN. Review of the Casa Buonarroti *mostra.* In *Burlington Magazine,* CXXXIII (1991), 732–34. Cited as Spike, Review, 1991.

SPINOSA, NICOLA, ED. *La pittura napoletana del '600.* Milan, 1984.

SPRETI, VITTORIO, ET AL. *Enciclopedia storico-nobilare italiana.* Milan, 1930, vol. III, and 1932, vol. V.

SRICCHIA, FIORELLA. "Lorenzo Lippi nello svolgimento della pittura fiorentina della prima metà del '600." *Proporzioni,* IV (1963), 242–70 and pls. CLXII–CXCIX (figs. 1–68).

STOLZENWALD, SUSANNA. *Artemisia Gentileschi. Bindung und Befreiung in Leben und Werk einer Malerin.* Stuttgart and Zurich, 1991.

SZIGETHI, AGNÈS. "Quelques contributions a l'art d'Artemisia Gentileschi." *Bulletin du musée hongrois des beaux-arts,* no. 52 (1979), 35–44.

TALLEY, MANSFIELD K. *Portrait Painting in England: Studies in the Technical Literature Before 1700,* The Paul Mellon Center for Studies in British Art. London, 1981.

TANFANI-CENTOFANTI, LEOPOLDI. *Notizie di artisti tratte dai documenti pisani.* Pisa, 1897.

TAYLOR, GRAEME J. "Judith and the Infant Hercules: Its Iconography." *American Imago,* XLI, no. 2 (1984), 101–15.

THUILLIER, JACQUES, ET AL.: *See* Rome, Palazzo delle Esposizioni, 1991.

TICKNER, LISA. "Feminism, Art History, and Sexual Difference." *Genders,* no. 3 (November 1988), 92–128.

TOESCA, ILARIA. "Versi in lode di Artemisia Gentileschi." *Paragone,* XXII, no. 251 (1971), 89–92.

TORRITI, PIERO. *Tesori di Strada Nuova, la via aurea dei genovesi.* Genoa, 1970.

TREVOR-ROPER, HUGH. "Mayerne and His Manuscript." In *Art and Patronage in the Caroline Courts,* pp. 264–93, ed. David Howarth. Cambridge, 1993.

TUFTS, ELEANOR. *Our Hidden Heritage: Five Centuries of Women Artists.* New York, 1974.

VAN DER DOORT, ABRAHAM. "Catalogue of the Collections of Charles I," ed. Oliver Millar. *Walpole Society,* XXXVII (1960), xi–xxiv, 1–235.

VANNUGLI, ANTONIO. "Stanzione, Gentileschi, Finoglia: Le *Storie di San Giovanni Battista* per il Buen Retiro," *Storia dell'arte,* no. 80 (1994), 59–73.

VATICAN, ARCHIVIO SEGRETO VATICANO. Sacra Congregazione del Concilio, *Relationes ad limia,* fasc. Pozzuoli, relazioni dei vescovi, vescovo Martino de Leòn de Càrdenas, 1640, fol. 3.

VATICAN, BIBLIOTECA VATICANA. Codice Barberini Latino 5698; "Manoscritti e stampe di materie diverse," Codice Ottoboniano Latino 1100 (fols. 100–100v).

VENTURI, ADOLFO. *La R. Galleria Estense in Modena.* Modena, 1882.

VERTUE, GEORGE. "Note Books (1713–1756)." *Walpole Society,* XX (1931–32; Vertue II) and XXIV (1935–36; Vertue IV).

VLIEGENTHART, ADRIAAN. *La galleria Buonarroti: Michelangelo e Michelangelo il Giovane.* Florence, 1976.

VOLLMER, H. "Jérôme David." In U. Thieme and F. Becker, *Allgemeines Lexikon der bildenden Künstler,* p. 456. Leipzig, 1913, vol. VIII.

VOLPE, CARLO. "Caravaggio e caravaggeschi nelle gallerie di Firenze." *Paragone,* XXI, no. 249 (1970), 106–18.

VOSS, HERMANN. "Artemisia Gentileschi." In U. Thieme and F. Becker, *Allgemeines Lexikon der bildenden Künstler,* pp. 408–9. Leipzig, 1920, vol. XIII.

———. *Die Malerei des Barock in Rom.* Berlin, 1925.

———. "*Venere e Amore* di Artemisia Gentileschi." *Acropoli,* I, pt. 1 (1960–61), 79–82.

WACHENFELD, CHRISTA, AND ROLAND BARTHES. *Die Vergewaltigung der Artemisia: Der Prozess.* Freiburg, 1992.

WALPOLE, HORACE. *Anecdotes of Painting in England.* Strawberry Hill, 1765, vol. II.

WASHINGTON, D.C., NATIONAL GALLERY OF ART: *See* Russell and Barnes, 1990.

WETHEY, HAROLD. *The Paintings of Titian III: The Mythological and Historical Paintings.* London, 1975.

WHITE, BARBARA. "A 1974 Perspective: Why Women's Studies in Art and Art History?" *Art Journal,* XXV, no. 4 (1976), 340–44.

WHITE, RAYMOND. "A Review, with Illustrations, of Methods Applicable to the Analysis of Resin/ Oil Varnish Mixtures," ICOM Committee for Conservation, 6th triennial meeting. Ottawa, 1981.

WHITE, RAYMOND, AND JO KIRBY. "Rembrandt and His Circle: Seventeenth Century Dutch Paint Media Re-examined." *National Gallery Technical Bulletin,* XV (1994).

WHITFIELD, CLOVIS, AND ELAINE BANKS: *See* New York, Colnaghi, 1984.

ZERI, FEDERICO. *La Galleria Spada in Roma: catalogo dei dipinti.* Florence, 1954.

ZURICH, HELMHAUS. *Die Frau als Künstlerin,* exh. cat. n.d. [1958].

425

INDEX

Unless stipulated otherwise, all paintings listed are by Artemisia Gentileschi or are assigned to her by early sources. Arabic numerals in **boldface** type designate the numbers of the black-and-white illustrations. Roman numerals in **boldface** type designate the numbers of the color plates. Numbers in [] signal catalogue entries.





433

QUESTIONABLE AND INCORRECT ATTRIBUTIONS

435

443

PHOTO CREDITS

Newhouse Galleries, 55, 56, VI; Private Collection, 121, 122, 123, XVIII; Sotheby's, 233, 251; Saul P. Steinberg, 176, 195, 196, XXII.

NOTTINGHAM: Castle Museum, 256.

OLSO: Nasjonalgalleriet, 40, 178.

OSMANNORO (SESTO FIORENTINO), Bardazzi Fotografia: IV, V, XII, XXI.

PARIS: Bibliothèque National, 101, 102, 112, 226; Galerie Tassel, 223; Réunion des Musées Nationaux, 92, 127; Société Labatut & Cie., 136, XIX.

POMMERSFELDEN, Graf von Schönborn Kunstsammlungen, I.

POTSDAM: Staatliche Schlösser und Gärten Potsdam-Sanssouci, 188, 190.

PRINCETON, N.J.: The Barbara Piasecka Johnson Collection Foundation, 103, 104, 120, XIV.

PRIVATE COLLECTION, 96, X.

ROME: Archivio di Stato, 52; Istituto Centrale per il Catalogo e la Documentazione, 11, 23, 28, 38, 77, 78, 79, 86, 100, 119, 184, 202, 208, 230, 235; Martinoja Antichità, 221; Alessandro Morandotti, 211; Foto Vasari, 13.

ST. LOUIS, MO.: Art Museum, 210.

SARASOTA, FLA.: John and Mable Ringling Museum of Art, 206, 207, 239.

SEVILLE: Taller de Restauraciones de la Catedral de Sevilla, 97, XI.

STAMFORD: Burghley House Collection, 257.

STOCKHOLM: Nationalmuseum, 85.

TOLEDO, OHIO: Museum of Art, 163, 164, 165, 166, XX.

TURIN: Galleria Voena, 253.

VATICAN CITY: Musei Vaticani, Archivio Fotografico, 219.

VIENNA: Albertina, 8; Alexander Haas, 180; Kunsthistorisches Museum, 247.

WASHINGTON, D.C.: Mary Garrard, 15; Library of Congress Photoduplication Service, 138; National Gallery of Art, 7, 36, 76.

ILLUSTRATIONS

NB: All works are by Artemisia Gentileschi unless designated otherwise.

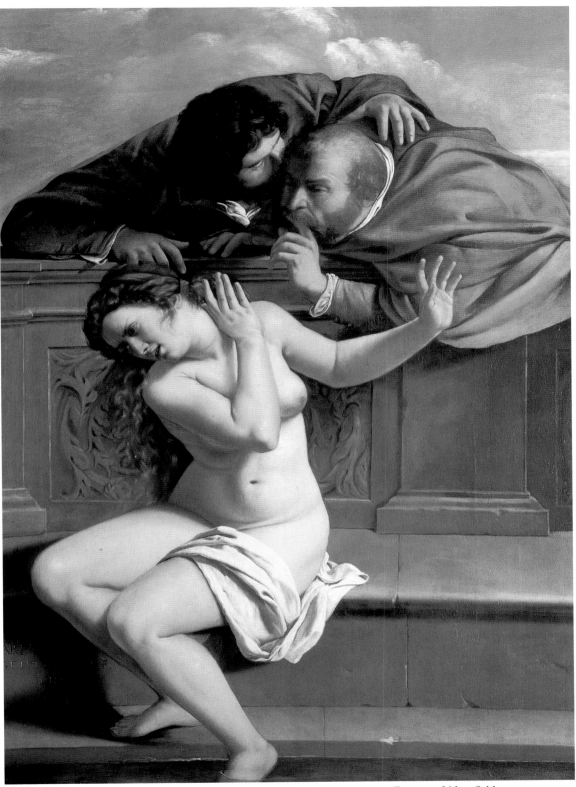

COLOR PLATE I *Susanna and the Elders*, 1610, Pommersfelden, Schloss
Weissenstein, Dr. Karl Graf von Schönborn-Wiesentheid [2]

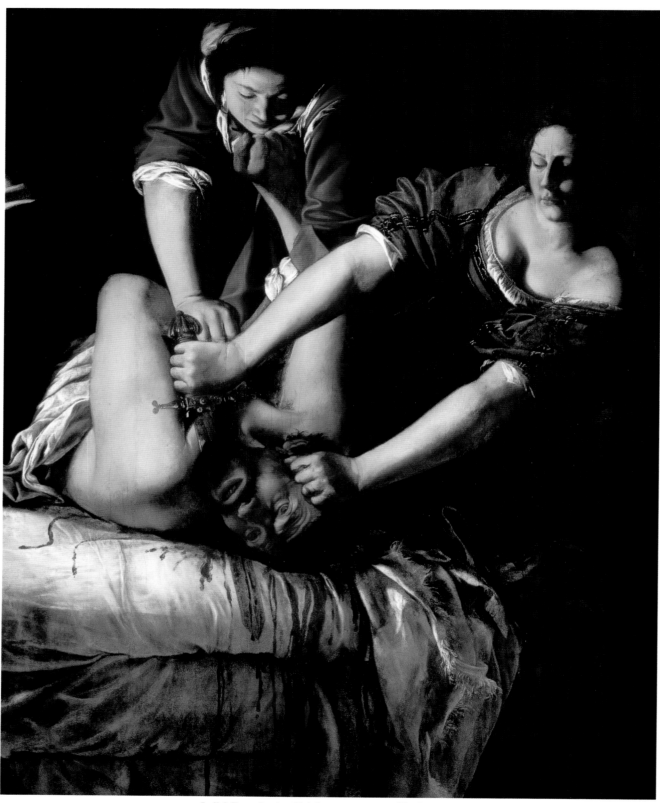

COLOR PLATE II *Judith Decapitating Holofernes*, ca. 1611–12, Naples, Museo di Capodimonte [4]

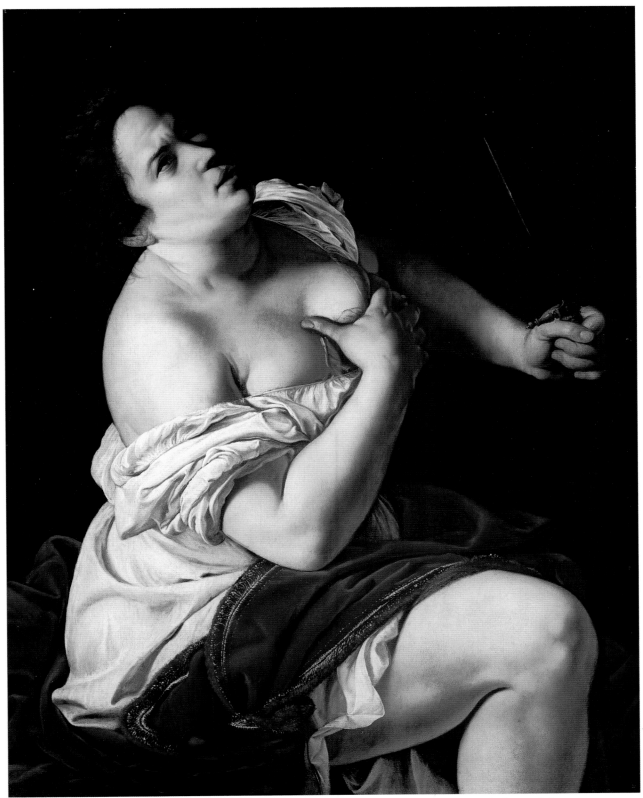

COLOR PLATE III *Lucretia*, ca. 1611, Genoa, Pagano Collection [3]

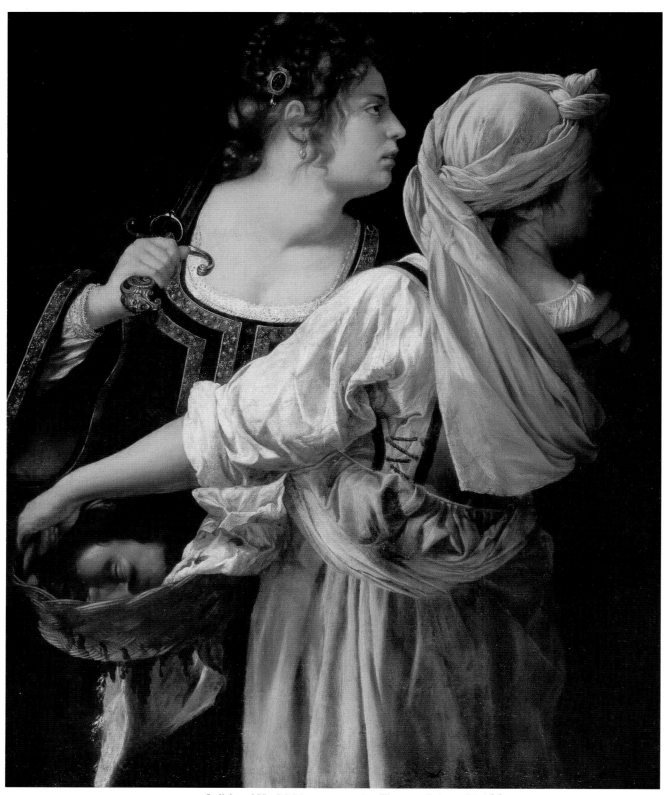

COLOR PLATE IV *Judith and Her Maidservant*, ca. 1612, Florence, Palazzo Pitti [5]

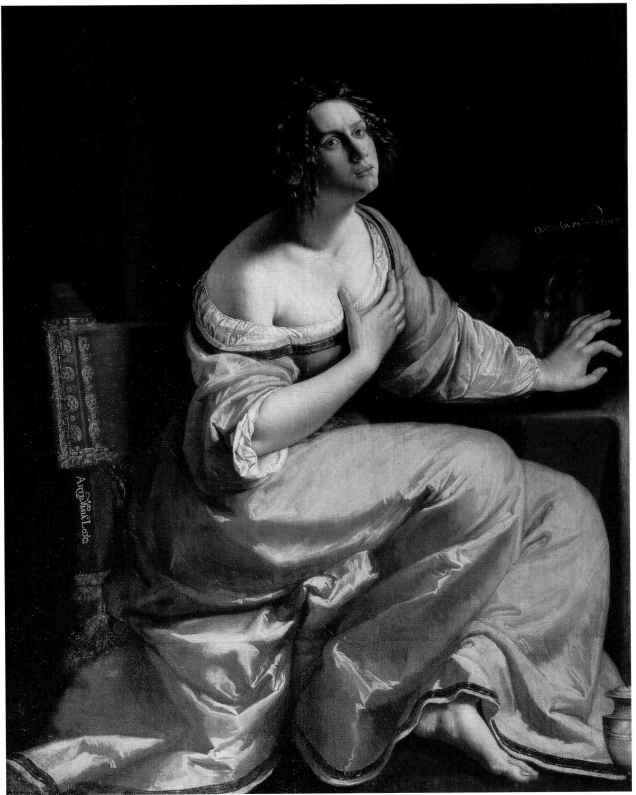

COLOR PLATE V *Conversion of the Magdalen*, ca. 1617–20, Florence, Palazzo Pitti [10]

COLOR PLATE VI *Female Martyr*, oil on panel, ca. 1615, New York, Newhouse Galleries, Inc. [7]

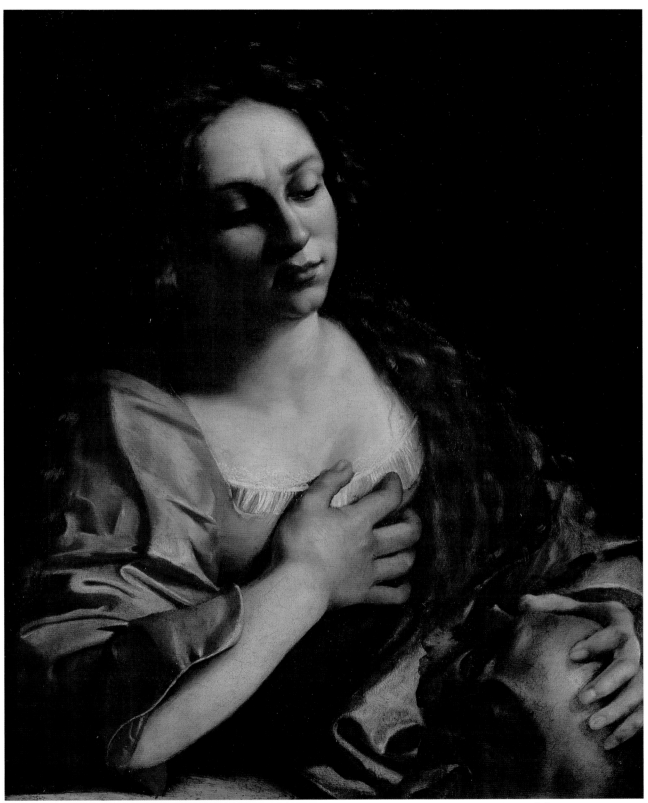

COLOR PLATE VII *Penitent Magdalen*, ca. 1615–16, Los Angeles, California, Marc A. Seidner Collection [9]

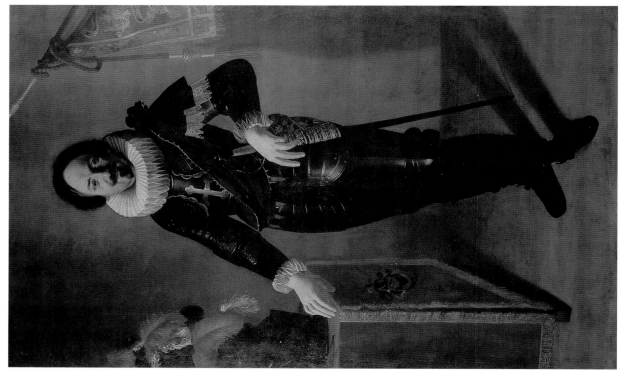

COLOR PLATE IX *Portrait of a Condottiere*, 1622, Bologna, Collezioni
Comunali d'Arte, Palazzo d'Accursio [13]

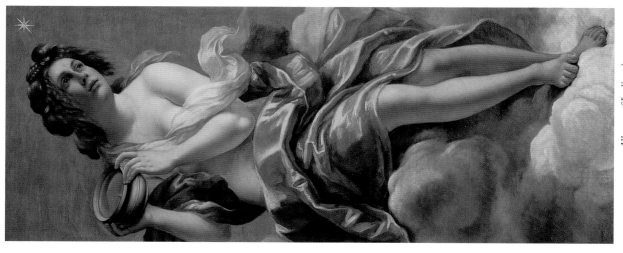

COLOR PLATE VIII *Allegory of Inclination*,
1615–16, Florence, Casa
Buonarroti, Galleria [8]

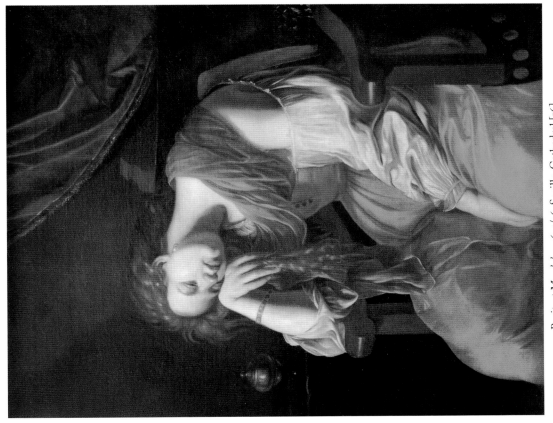

COLOR PLATE XI *Penitent Magdalen*, 1625/26, Seville, Cathedral [16]

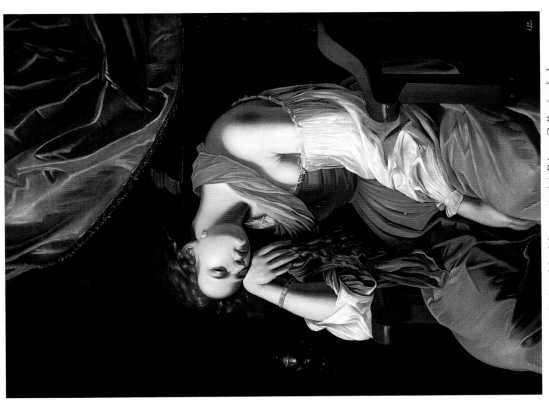

COLOR PLATE X *Penitent Magdalen*, ca. 1625/26, Private Collection [17]

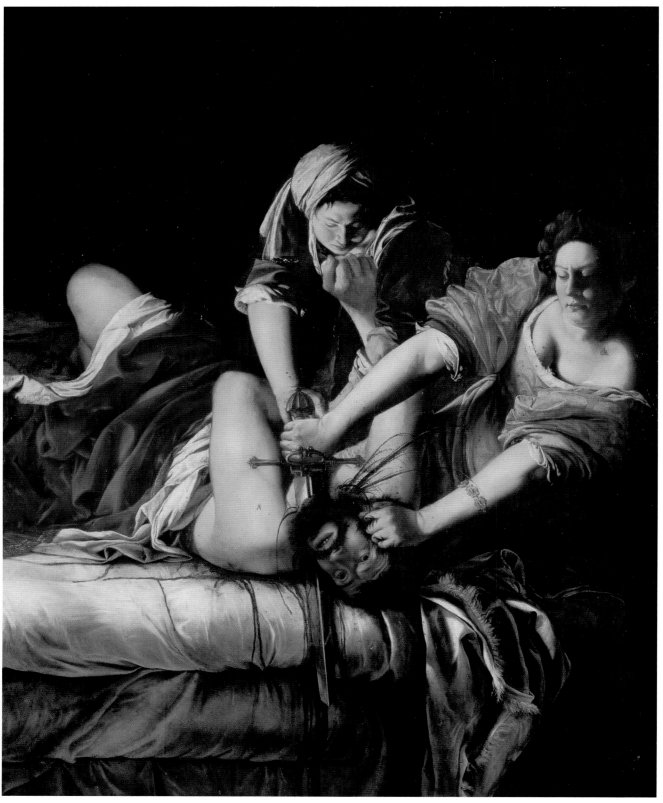

COLOR PLATE XII *Judith Decapitating Holofernes*, ca. 1620, Florence, Galleria degli Uffizi [12]

> COLOR PLATE XIII *Judith and Her Maidservant*, ca. 1623–25,
Detroit, Michigan, Institute of Arts,
Gift of Mr. Leslie H. Green [14]

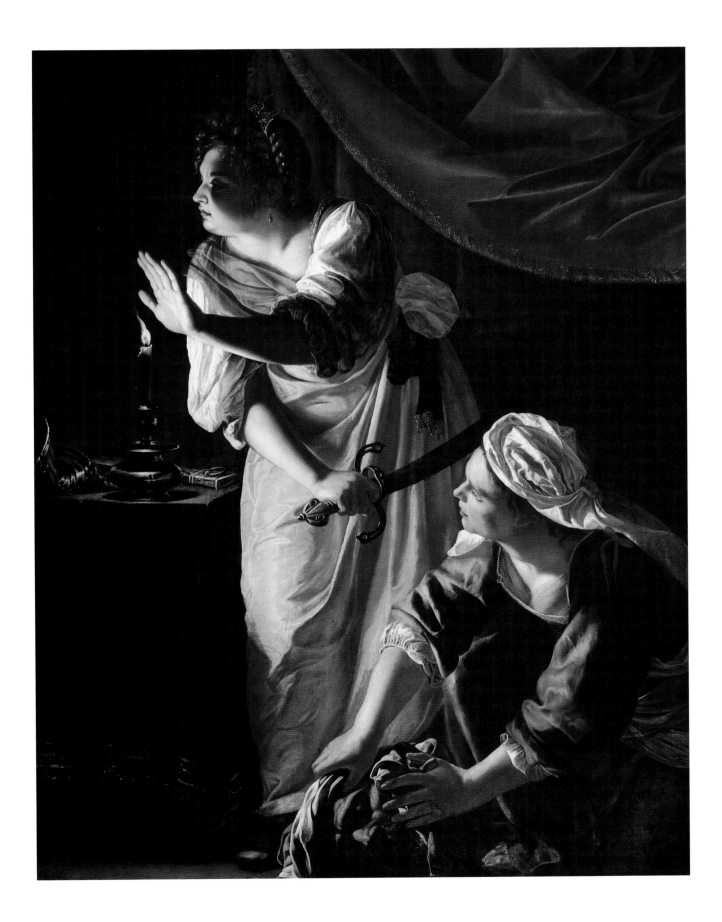

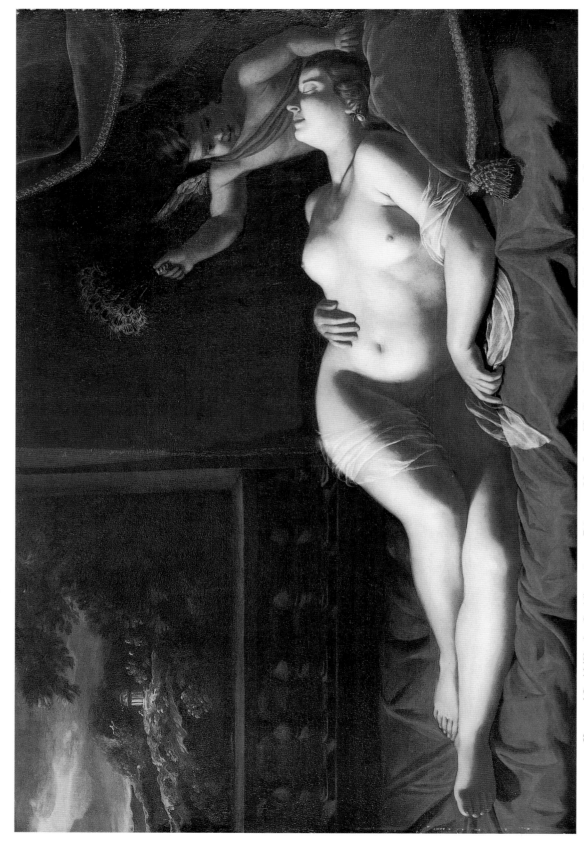

COLOR PLATE XIV *Venus and Cupid (Sleeping Cupid)*, ca. 1625–27, Princeton, New Jersey, The Barbara Piasecka Johnson Collection Foundation [18]

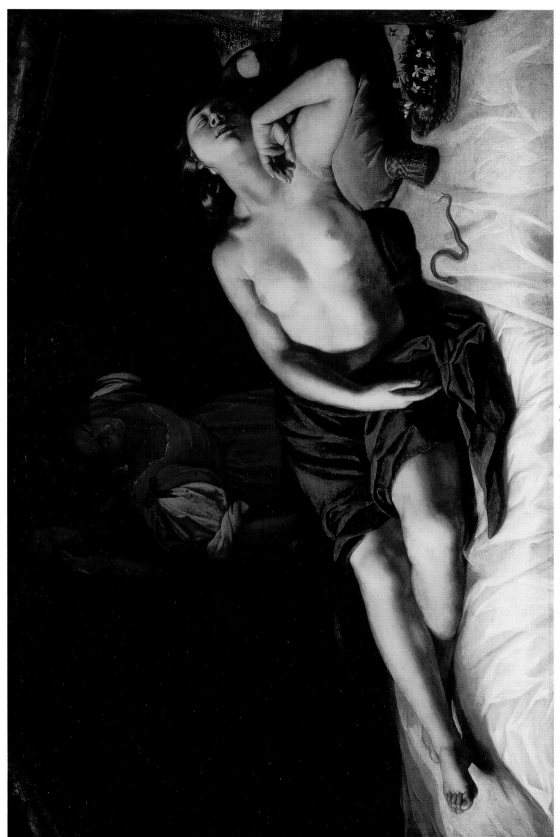

COLOR PLATE XV *Cleopatra*, ca. 1627–29, formerly London, Matthiesen Fine Art Limited [22]

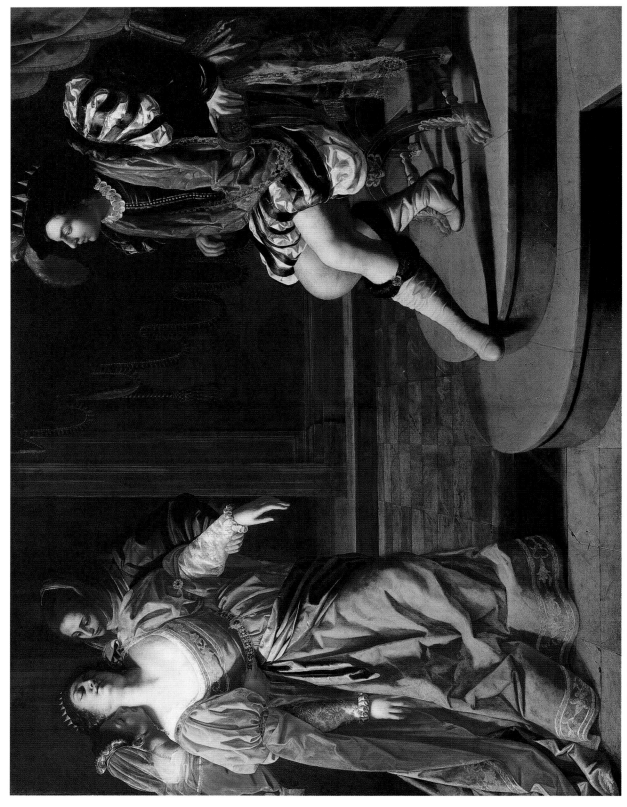

COLOR PLATE XVI *Esther Before Ahasuerus*, ca. 1630–35, New York, Metropolitan Museum of Art, Gift of Elinor Dorrance Ingersoll, 1969. (69.281).
Photograph © 1991 The Metropolitan Museum of Art [28]

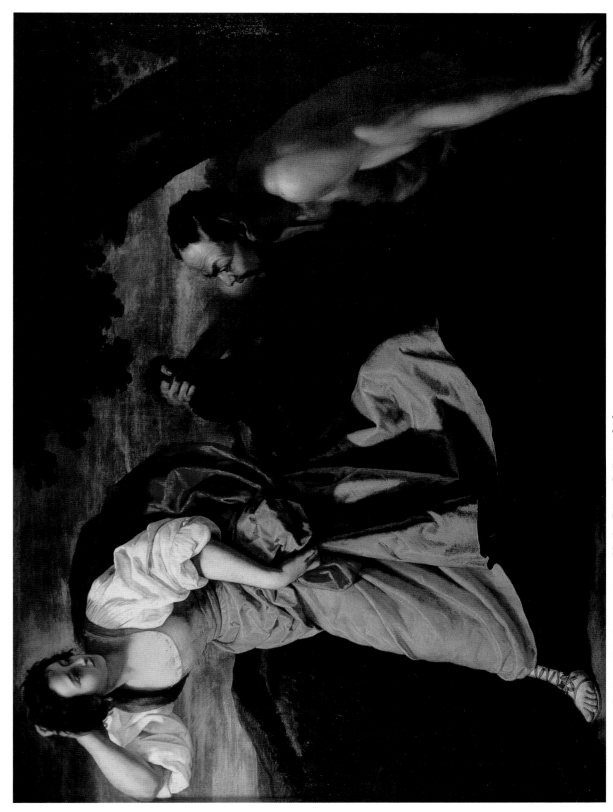

COLOR PLATE XVII *Corisca and the Satyr*, ca. 1633–35, Naples, Private Collection [30]

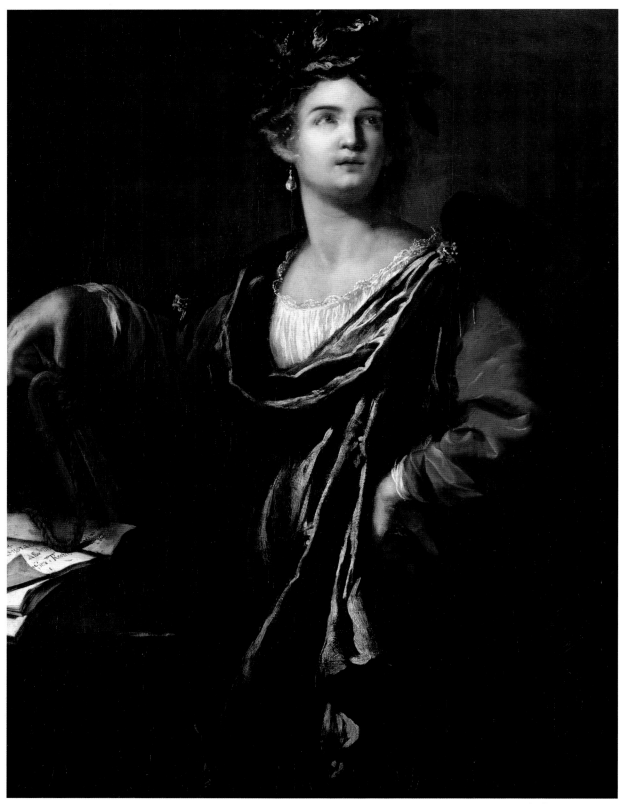

COLOR PLATE XVIII *Clio, Muse of History (*so-called *Fame)*, 1632, New York, Private Collection [27]

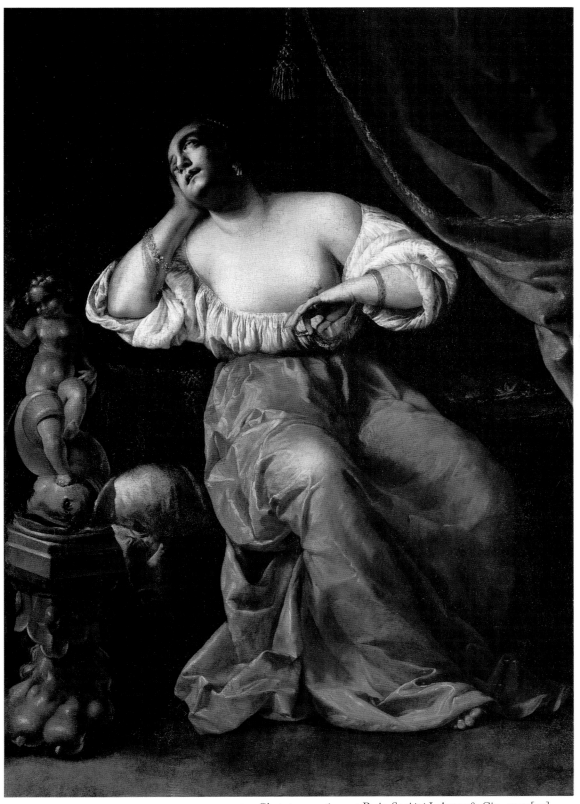

COLOR PLATE XIX *Cleopatra*, ca. 1630–35, Paris, Société Labatut & Cie., 1997 [29]

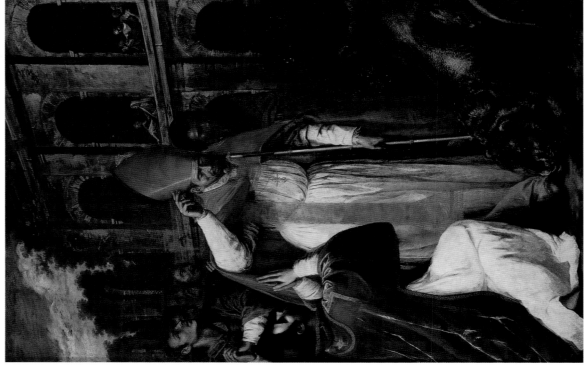

COLOR PLATE XXI Artemisia Gentileschi, with Domenico Gargiulo, *Saint Januarius and His Companions in the Amphitheater at Pozzuoli*, ca. 1635, Naples, Museo Nazionale di San Martino (on deposit from the Cathedral of Pozzuoli) [33b]

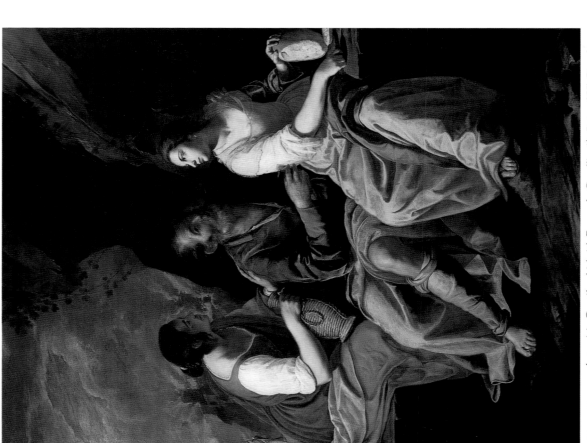

COLOR PLATE XX Artemisia Gentileschi (with Bernardo Cavallino?), *Lot and His Daughters*, ca. 1636–37/38, Toledo, Ohio, Museum of Art, Clarence Brown Fund [39]

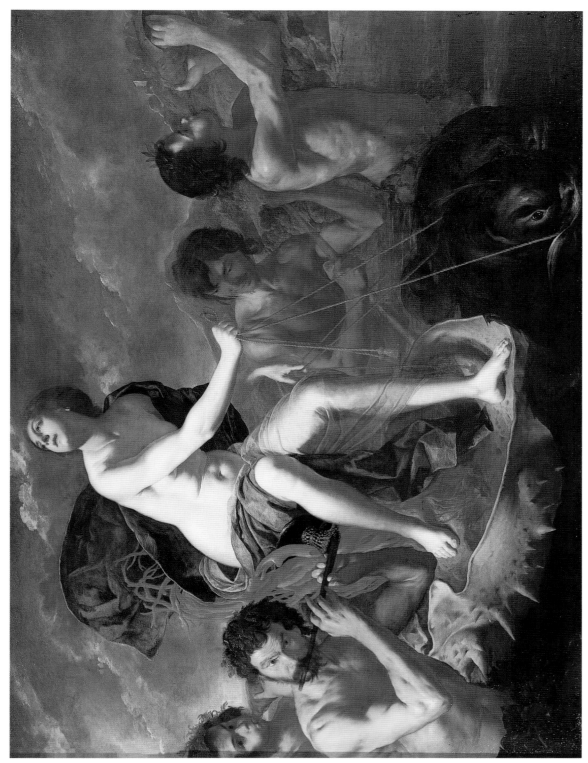

COLOR PLATE XXII Artemisia Gentileschi and Bernardo Cavallino, *Galatea*, 1648, New York, The Saul P. Steinberg Collection [49]

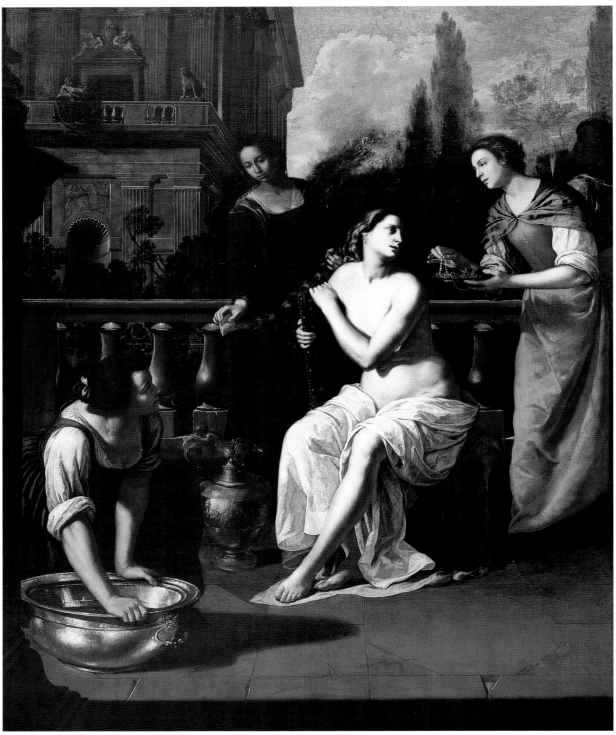

COLOR PLATE XXIII Artemisia Gentileschi, with Viviano Codazzi and Domenico Gargiulo (and Bernardo
Cavallino?), *Bathsheba*, ca. 1636–37/38, Columbus, Ohio, Museum of Art, Museum Purchase:
Frederick W. Schumacher Trust Fund [37]

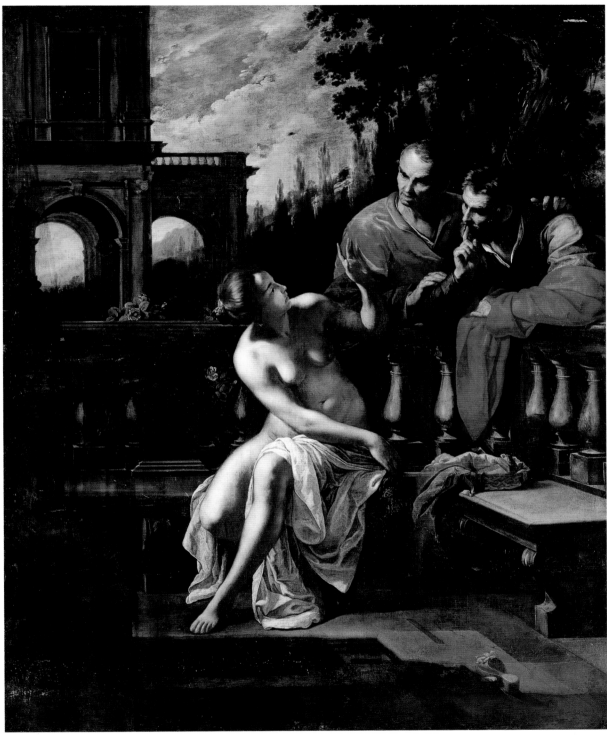

COLOR PLATE XXIV Artemisia Gentileschi, with Domenico Gargiulo (and Bernardo Cavallino?),
Susanna and the Elders, ca. 1636–37/38, London, Sotheby's, 1995 [38]

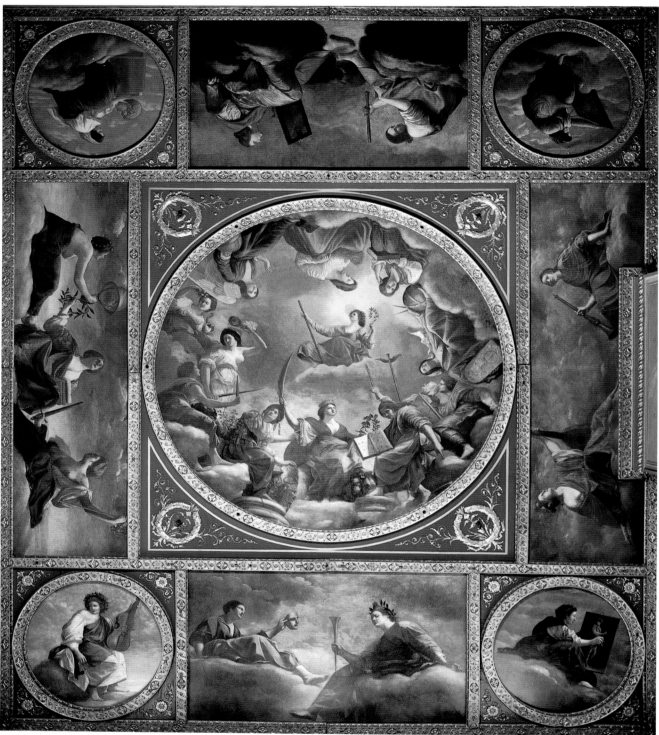

COLOR PLATE XXV Orazio Gentileschi (with Artemisia Gentileschi), *Allegory of Peace and the Arts under the
English Crown*, ca. 1636–38, London, Marlborough House, ceiling of the Main Hall (formerly
Greenwich, Queen's House, Great Hall) (see [41]), Royal Commission on the Historical
Monuments of England, Crown Copyright

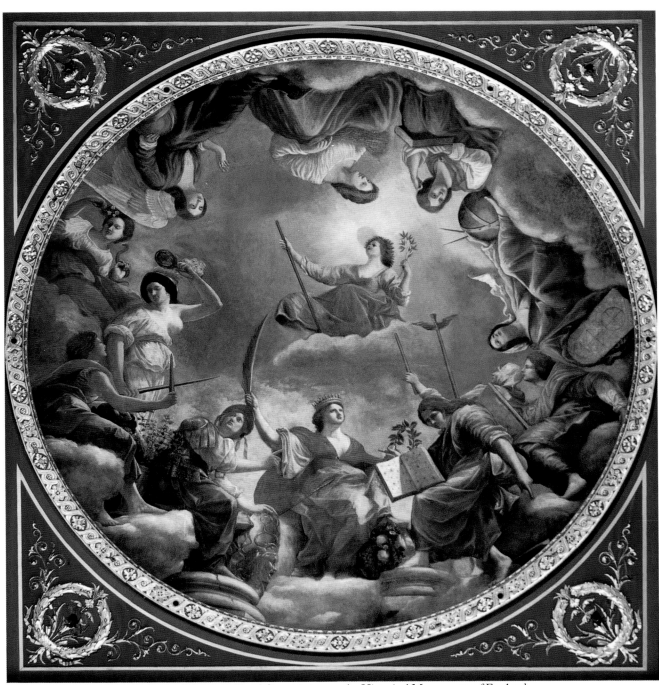

COLOR PLATE XXVI Detail of Color Plate XXV, Royal Commission on the Historical Monuments of England, Crown Copyright

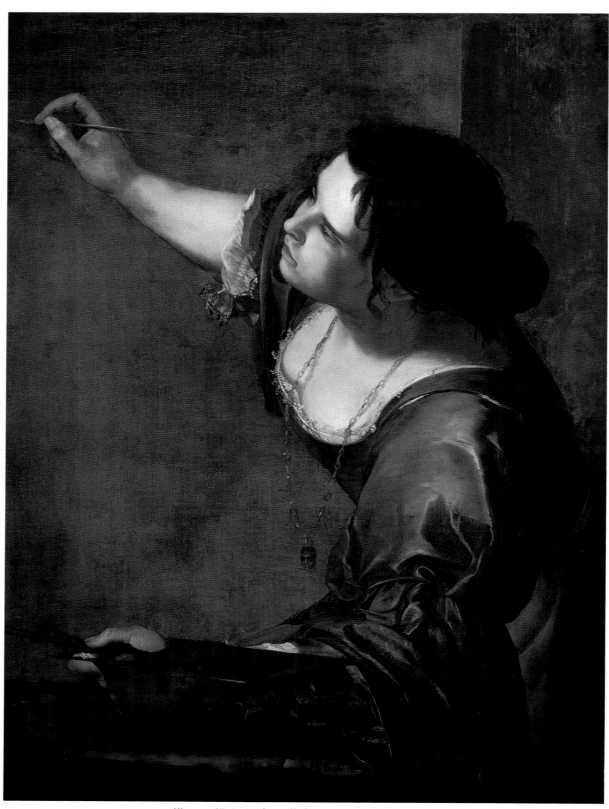

COLOR PLATE XXVII *Allegory of Painting* (so-called *Self-Portrait as "La Pittura"*), ca. 1638–39,
London, Kensington Palace, Collection of Her Majesty the Queen [42],
Royal Collection Enterprises, Crown Copyright

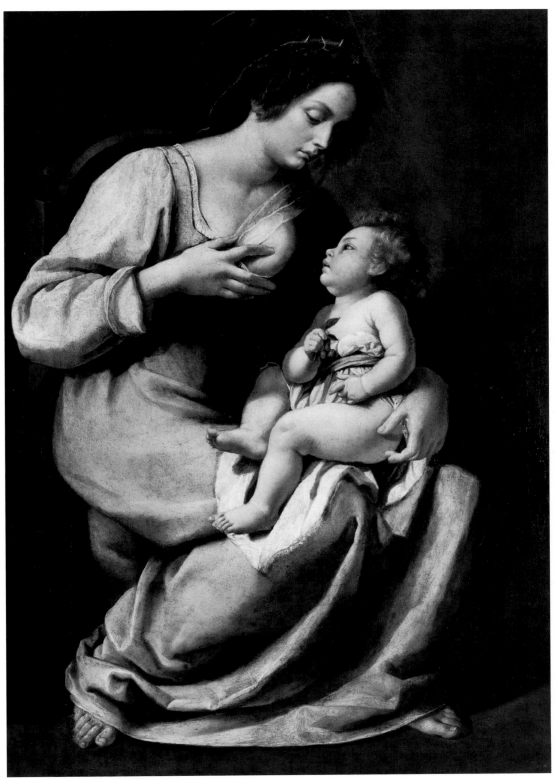

FIGURE I *Madonna and Child*, ca. 1609–10, Florence, Palazzo Pitti [1]

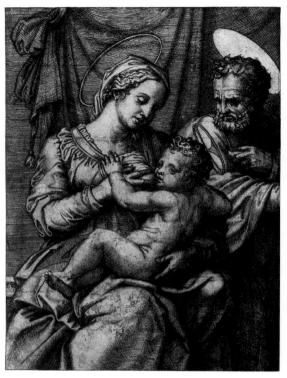

FIGURE 2 School of Marcantonio Raimondi,
 Holy Family, engraving, London,
 British Museum, Print Room

FIGURE 3 Cavaliere d'Arpino, *Holy Family
 with the Young Saint John the Baptist*,
 ca. 1593–95, Madrid, Prado

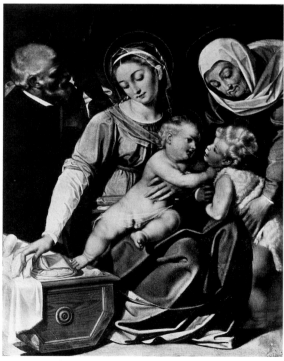

FIGURE 4 Scipione Pulzone, *Holy Family with Saints
 Elizabeth and John the Baptist*, ca. 1588–90,
 Rome, Galleria Borghese

FIGURE 5 Orazio Gentileschi, *Madonna and Child*, 1609,
 Bucharest, Muzeul de Arta

> FIGURE 6 Detail of Figure 1

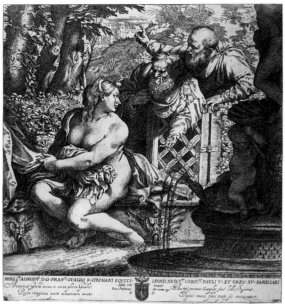

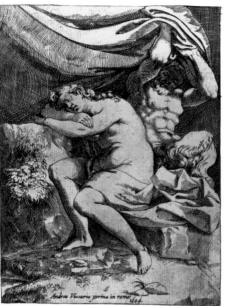

FIGURE 7 Annibale Carracci, *Susanna and the Elders*, etching and engraving, ca. 1590–95, Washington, D.C., National Gallery of Art, Ailsa Mellon Bruce Fund

FIGURE 8 Francesco Brizio after Agostino Carracci, *Satyr Spying on a Sleeping Nymph*, engraving, 1604, Vienna, Albertina

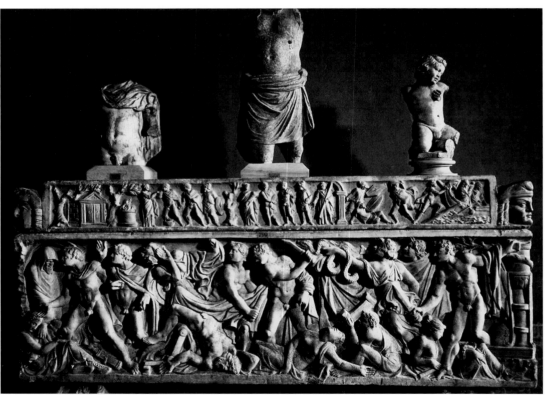

FIGURE 9 Roman, *Orestes Sarcophagus*, marble, second century, Vatican, Museo Vaticano

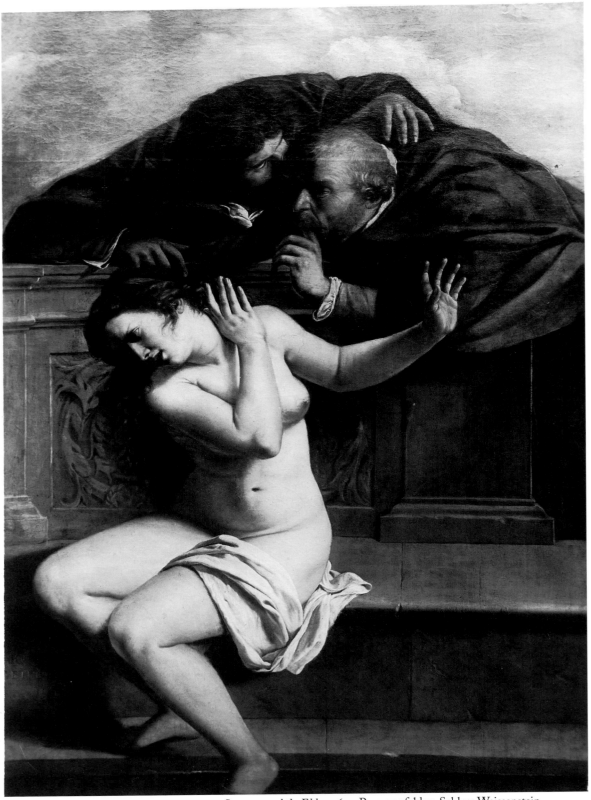

FIGURE 10 *Susanna and the Elders,* 1610, Pommersfelden, Schloss Weissenstein,
Dr. Karl Graf von Schönborn-Wiesentheid [2]

FIGURE 11 Peter Paul Rubens, *Susanna and the Elders*, pre-1608, Rome, Galleria Borghese

FIGURE 12 Orazio Gentileschi, *Penitent Magdalen*, ca. 1605, Fabriano, Santa Maria Maddalena

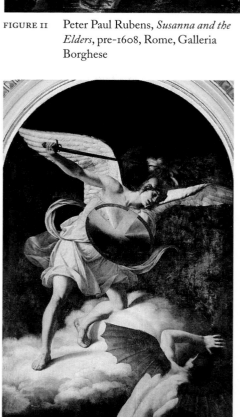

FIGURE 13 Orazio Gentileschi, *Saint Michael Overcoming the Devil*, ca. 1605–8, Farnese, San Salvatore

FIGURE 14 Orazio Gentileschi, *David Slaying Goliath*, ca. 1605–10, Dublin, National Gallery of Ireland

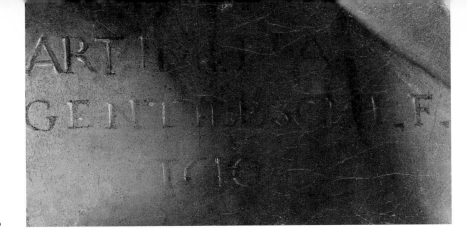

FIGURE 15

Detail of signature on Figure 10

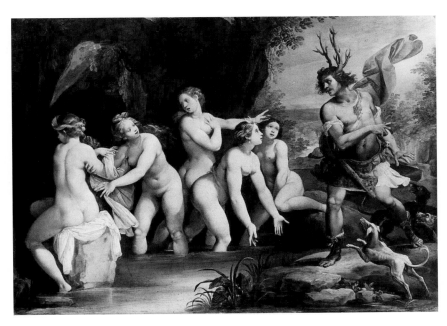

FIGURE 16

Cavaliere d'Arpino, *Diana and Actaeon*, oil on copper, ca. 1603–6, Budapest, Szépmüvészeti Múzeum

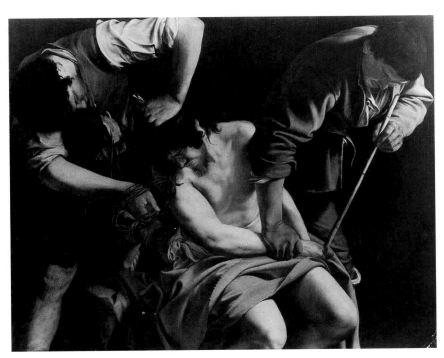

FIGURE 17

Orazio Gentileschi, *Mocking of Christ*, ca. 1610–15, Braunschweig, Herzog Anton Ulrich-Museum

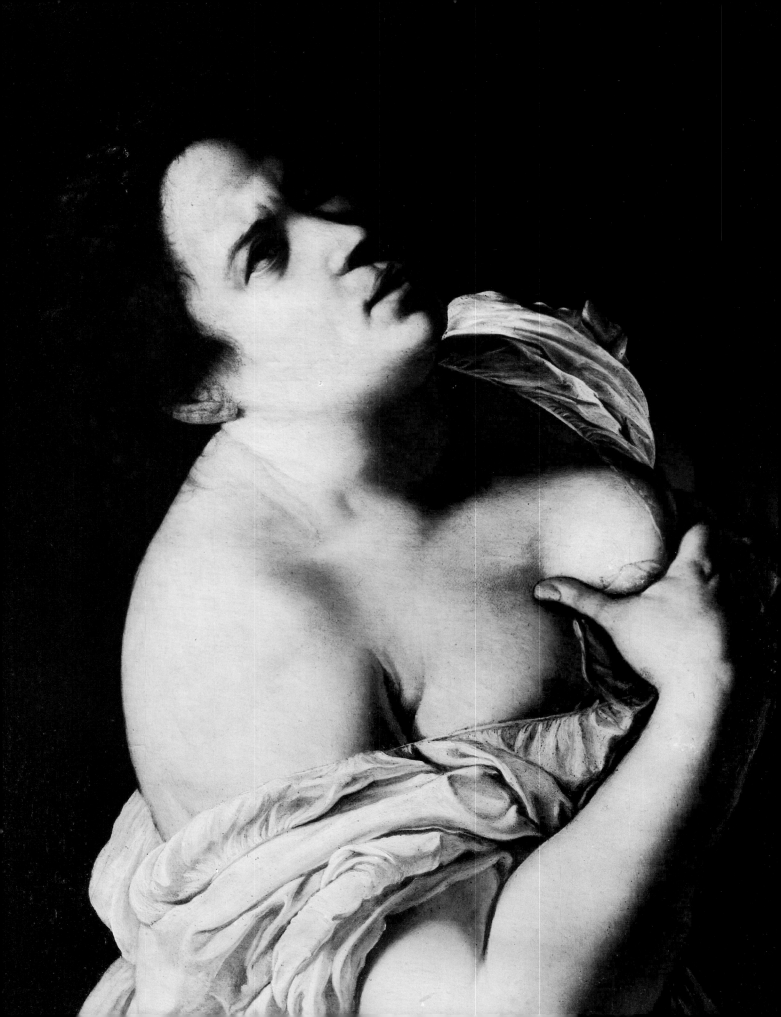

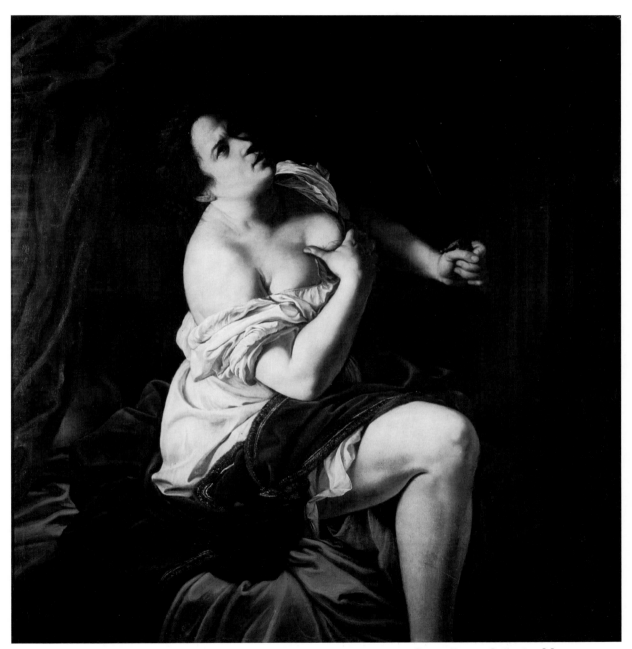

FIGURE 19 *Lucretia*, ca. 1611, Genoa, Pagano Collection [3]

< FIGURE 18 Detail of Figure 19

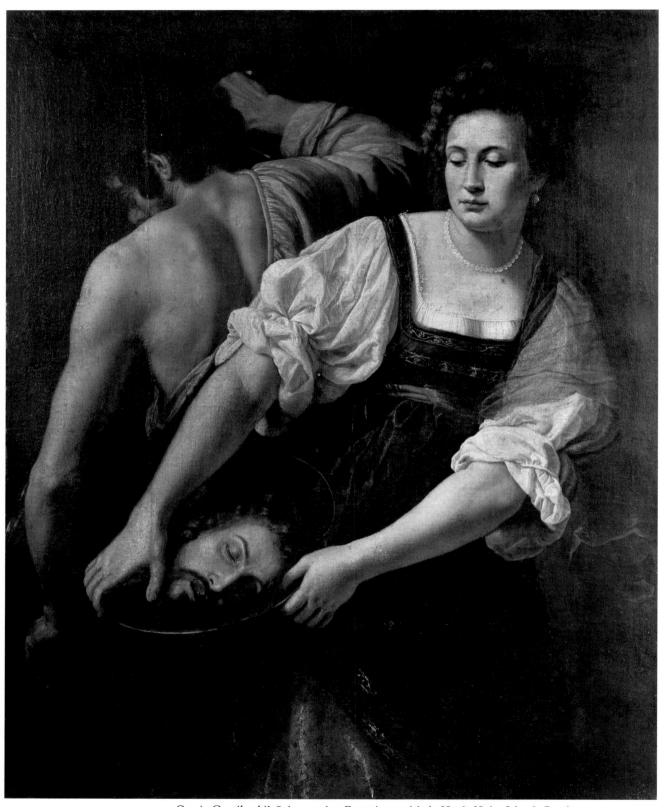

FIGURE 20 Orazio Gentileschi? *Salome and an Executioner with the Head of Saint John the Baptist*, formerly (destroyed 1973) Geneva, Musée d'Art et d'Histoire [x-39]

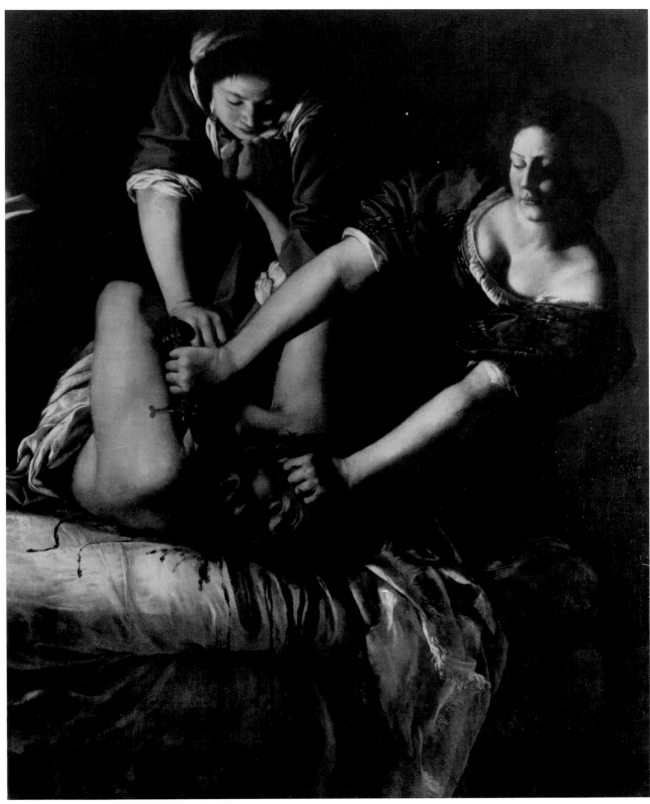

FIGURE 21 *Judith Decapitating Holofernes*, ca. 1611–12, Naples, Museo di Capodimonte [4]

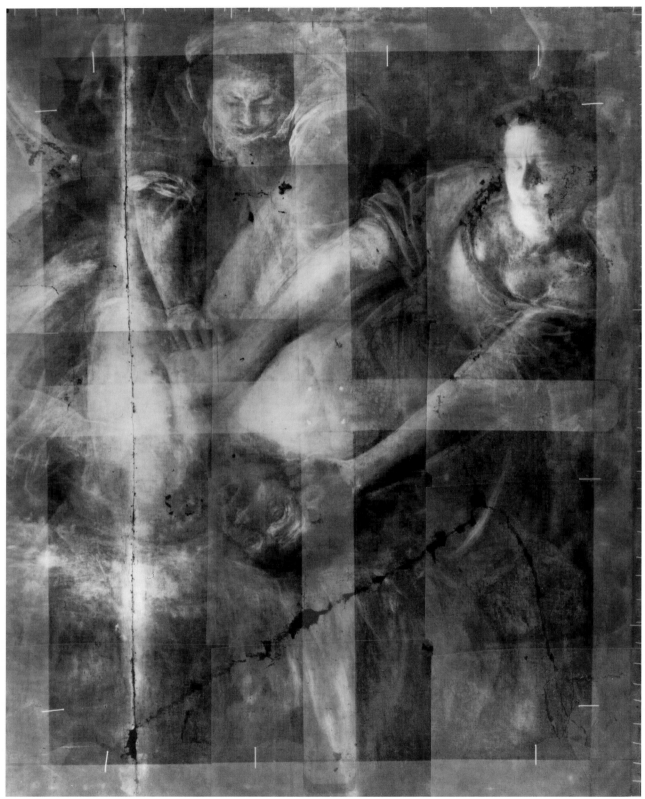

FIGURE 22 X-radiograph of Figure 21

FIGURE 23 Orazio Gentileschi, *David in Contemplation After the Defeat of Goliath*, ca. 1610, Rome, Galleria Spada

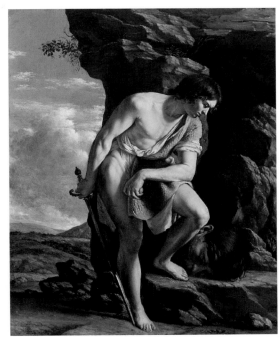

FIGURE 24 Orazio Gentileschi, *David in Contemplation After the Defeat of Goliath*, oil on copper, ca. 1610, Berlin Staatliche Museen, Gemäldegalerie

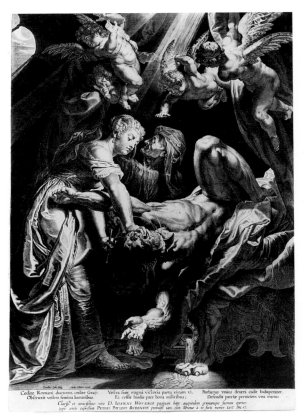

FIGURE 25 Cornelius Galle the Elder after Peter Paul Rubens, *Judith Decapitating Holofernes*, engraving, ca. 1610

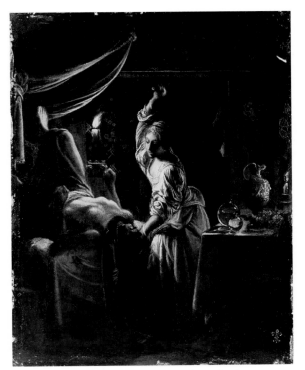

FIGURE 26 Adam Elsheimer, *Judith Decapitating Holofernes*, oil on copper, ca. 1601–3, London, Apsley House, Wellington Museum

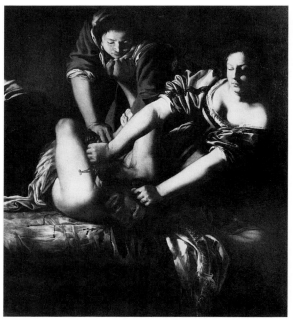

FIGURE 27 Copy after Artemisia Gentileschi, *Judith Decapitating Holofernes*, Bologna, Pinacoteca Nazionale (see [4])

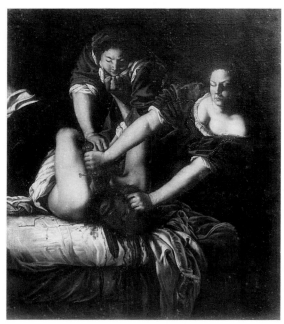

FIGURE 28 Copy after Artemisia Gentileschi, *Judith Decapitating Holofernes*, location unknown (see [4])

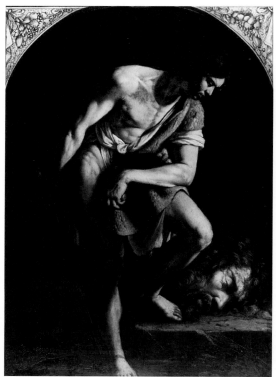

FIGURE 29 Copy after Orazio Gentileschi, *David in Contemplation After the Defeat of Goliath*, oil on touchstone, Milan, Quadreria Arcivescovile (see [4])

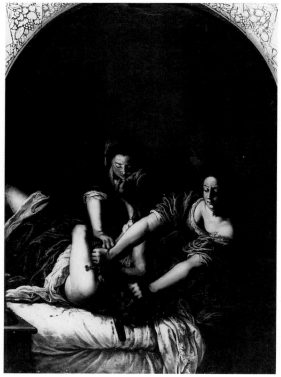

FIGURE 30 Copy after Artemisia Gentileschi, *Judith Decapitating Holofernes*, oil on touchstone, Milan, Quadreria Arcivescovile (see [4])

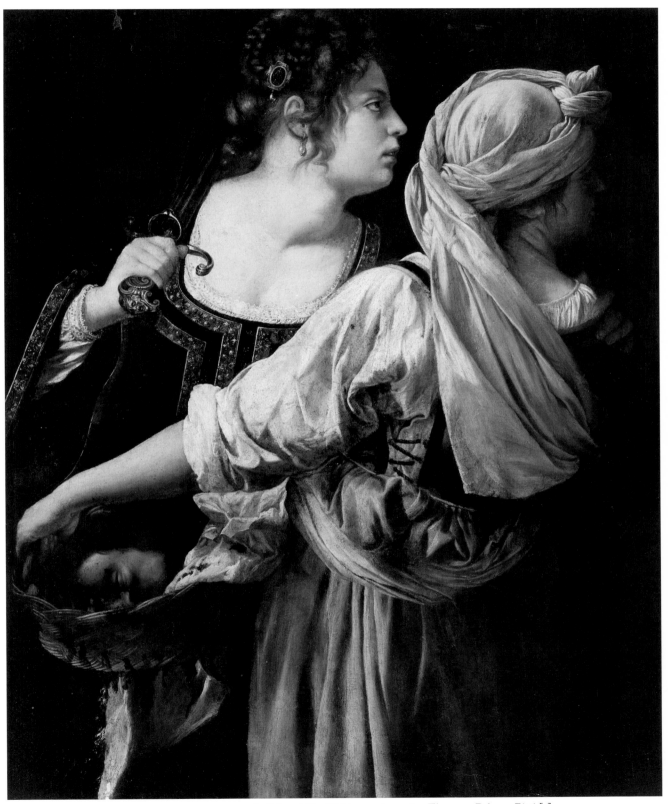

FIGURE 31 *Judith and Her Maidservant*, ca. 1612, Florence, Palazzo Pitti [5]

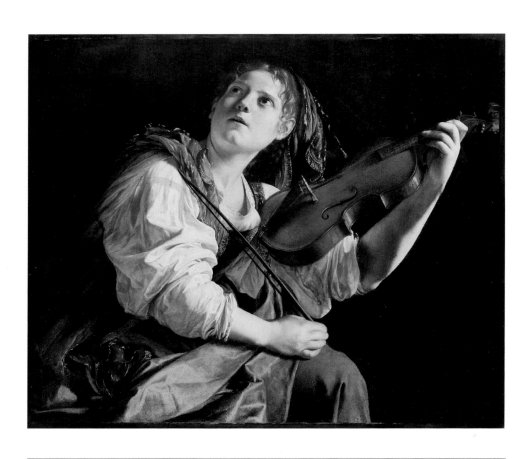

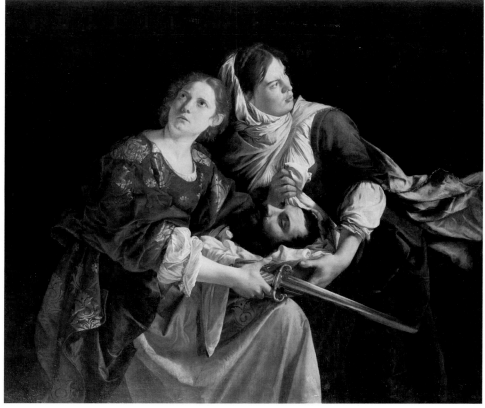

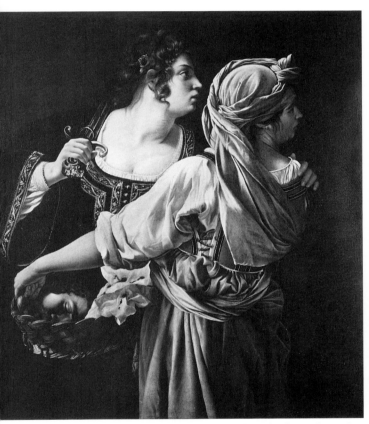

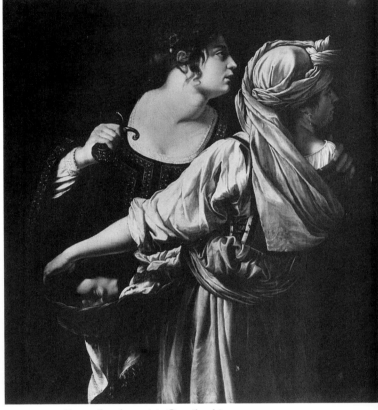

FIGURE 34 Copy after Artemisia Gentileschi, *Judith and Her Maidservant*, formerly Florence, Galleria Corsini (see [5])

FIGURE 35 Copy after Artemisia Gentileschi, *Judith and Her Maidservant*, Lugano, Hilmer Klages, 1972 (see [5])

< FIGURE 32 Orazio Gentileschi, *Saint Cecilia (Young Woman with a Violin)*, ca. 1611–12, Detroit, Michigan, Institute of Arts, Gift of Mrs. Edsel B. Ford

< FIGURE 33 Orazio Gentileschi, *Judith and Her Maidservant*, ca. 1611–12, Hartford, Connecticut, Wadsworth Atheneum, Ella Gallup Sumner and Mary Catlin Sumner Collection

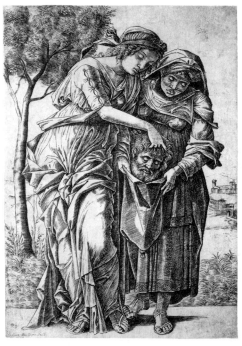

FIGURE 36 Girolamo Mocetto after Andrea
 Mantegna, *Judith and Her Maidservant*,
 engraving, ca. 1500–1505, Washington,
 D.C., National Gallery of Art, Print
 Purchase Fund (Rosenwald Collection)

FIGURE 37 Giacomo Franco after Palma il Giovane,
 Judith and Her Maidservant, etching,
 ca. 1610

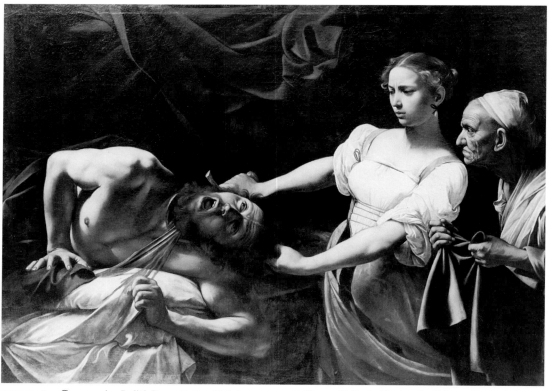

FIGURE 38 Caravaggio, *Judith Decapitating Holofernes*, ca. 1598, Rome, Galleria Nazionale, Palazzo Barberini

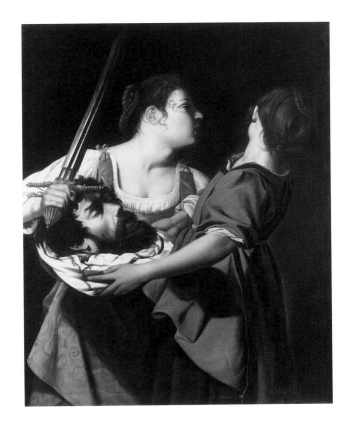

> FIGURE 39

Orazio Gentileschi, *Judith and Her Maidservant*, ca. 1605–10, New York, Sotheby's, 1993

∨ FIGURE 40

Orazio Gentileschi, *Judith and Her Maidservant*, ca. 1611, Oslo, Nasjonalgalleriet, photo J. Lathion [X-13]

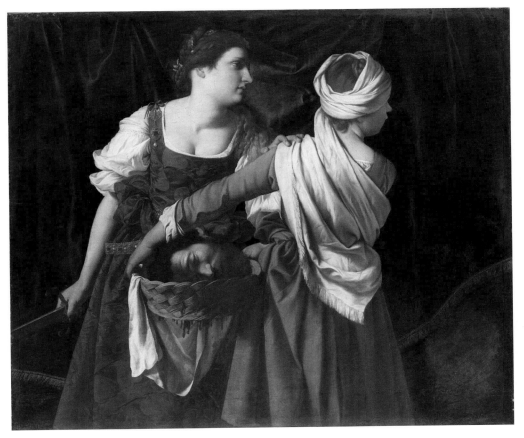

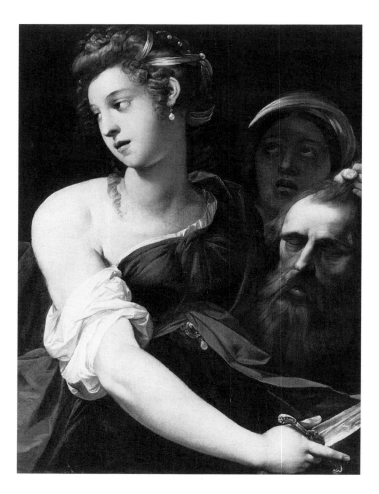

FIGURE 41

Cavaliere d'Arpino, *Judith and Her Maidservant*, ca. 1605–10, Berkeley, University of California, University Art Museum, Gift of Andrew C. Lawson

FIGURE 42 Inscriptions on reverse of Figure 39

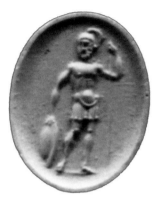

FIGURE 43

Greek, Maenad, silver ring
(impression of), 400 B.C.E.
or later, New York,
Metropolitan Museum
of Art, Fletcher Fund, 1925

FIGURE 44

Roman, Ares, sardonyx
ringstone (impression of),
New York, Metropolitan
Museum of Art, Gift of
John Taylor Johnson, 1881

FIGURE 45 Detail of Figure 77

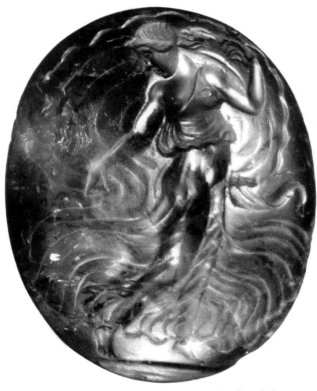

FIGURE 46 Ancient amethyst, Dancer, Berlin, Staatliche
Museen, Antikensammlung

FIGURE 47 Detail of Figure 31

FIGURE 50 Detail of Figure 40

FIGURE 49 Angelo Caroselli, detail of
Figure 221

FIGURE 51 Greco-Roman (?) intaglio in
pietra verde, Minerva, Rome,
Musei Capitolini

FIGURE 48 Angelo Caroselli, detail of
Figure 221

FIGURE 52 Portion of the deposition of Orazio Gentileschi, July 1612, "Stupri et Lenocinij—Pro Curia et fisco Con^e Augustinum Tassum Pictorem," Rome, Archivio di Stato, Archivio del Tribunale del Governatore di Roma, busta 104, anno 1612, fol. 227 (new pagination)

FIGURE 53 Itemized account of goods supplied to Artemisia Gentileschi by a druggist, May 9, 1616–January 6, 1617 (New Style), Florence, Archivio di Stato, Accademia del Disegno, *Atti e Sentenze*, LXIV, fol. 422 by recent numeration (see Appendix I).

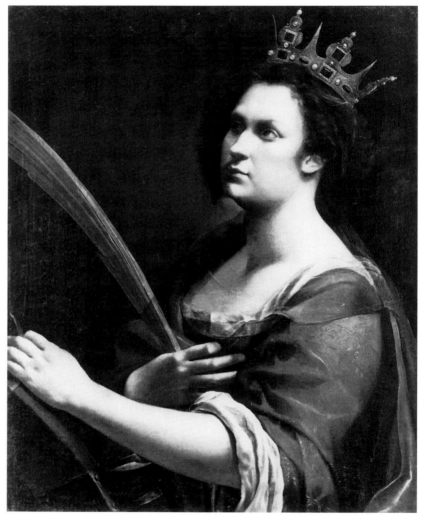

FIGURE 54 *Saint Catherine of Alexandria*, ca. 1614–15, Florence, Galleria degli Uffizi [6]

FIGURE 55 Inscription on reverse of Figure 56

FIGURE 56 *Female Martyr*, oil on panel, ca. 1615, New York, Newhouse Galleries, Inc. [7]

FIGURE 57 Joiner's bill of charges and partial payments for items supplied to Pierantonio di Vincenzo Stiattesi and Artemisia Gentileschi, November 24, 1614–January 23, 1616 (New Style), Florence, Archivio di Stato, Accademia del Disegno, *Atti e Sentenze*, LXV, fol. 877 by count (see Appendix I).

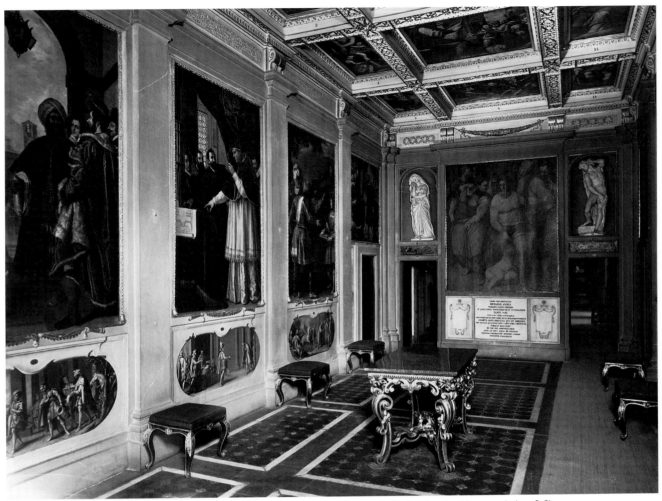

FIGURE 58 Florence, Casa Buonarroti, Galleria, view looking north (see [8])

> FIGURE 59

Schematic diagram showing the proposed
positions of the Personifications on the ceiling
of the Galleria, Casa Buonarroti (adapted
from Michelangelo Buonarroti il Giovane,
Archivio Buonarroti, MS 97 c. 17r) (see [8])

>> FIGURE 60

Florence, Casa Buonarroti, Galleria, schematic
diagram of ceiling canvases (O=original position
of Figure 64, conjectured; P=present position of
Figure 64) (see [8])

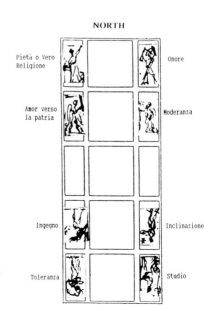

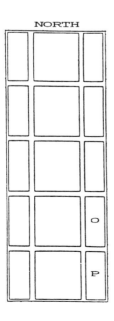

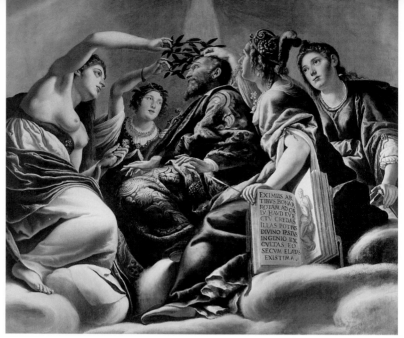

FIGURE 61 Sigismondo Coccapani, *Michelangelo Crowned by the Arts*, 1615–17, Florence, Casa Buonarroti, Galleria

EXIMIIS AR
TIBVS BONAR
ROTAM AD CÆ
LV HAVD EVE
CTV CREDAS
ILLAS POTIVS
DIVINO IPSIVS
INGENIO EX
CVLTAS EO
SECVM ELAVS
EXISTIMA

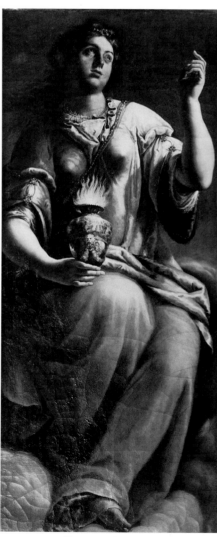

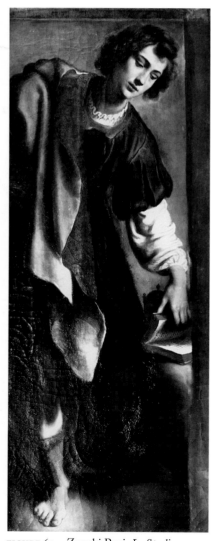

FIGURE 62 Giovanni Battista Guidoni,
La Pietà, 1615–17, Florence,
Casa Buonarroti, Galleria

FIGURE 63 Zanobi Rosi, *Lo Studio*,
1617–20, Florence, Casa
Buonarroti, Galleria

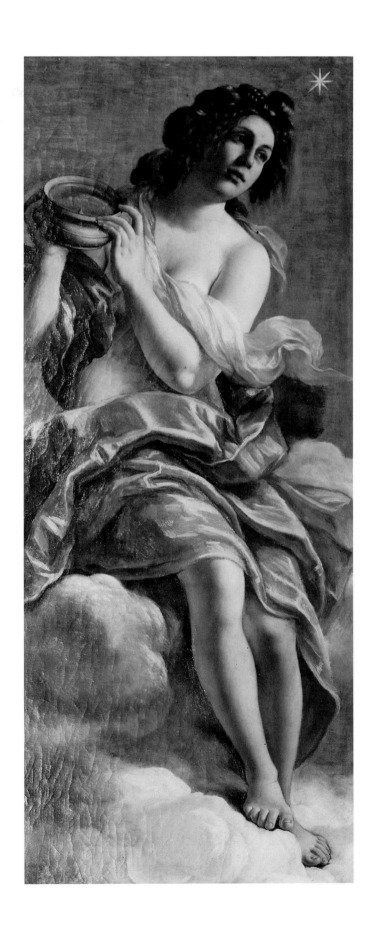

FIGURE 64

Allegory of Inclination, 1615–16,
Florence, Casa Buonarroti,
Galleria [8]

FIGURE 65 Cristofano Allori, *Saint Mary Magdalen in the Desert*, ca. 1610–12, Florence, Palazzo Pitti

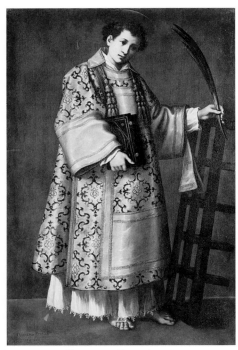

FIGURE 66 Francesco Curradi, *Saint Lawrence*, 1608, Florence, Santa Maria Maddalena de'Pazzi

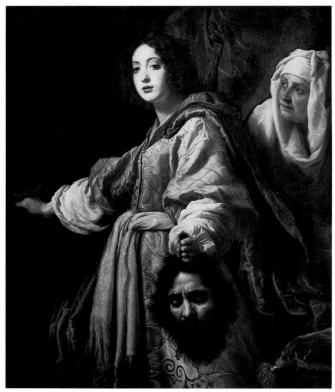

FIGURE 67 Cristofano Allori, *Judith and Her Maidservant*, ca. 1610–12, Florence, Palazzo Pitti

FIGURE 68 *Penitent Magdalen*, ca. 1615–16, Los Angeles, California, Marc A. Seidner Collection [9]

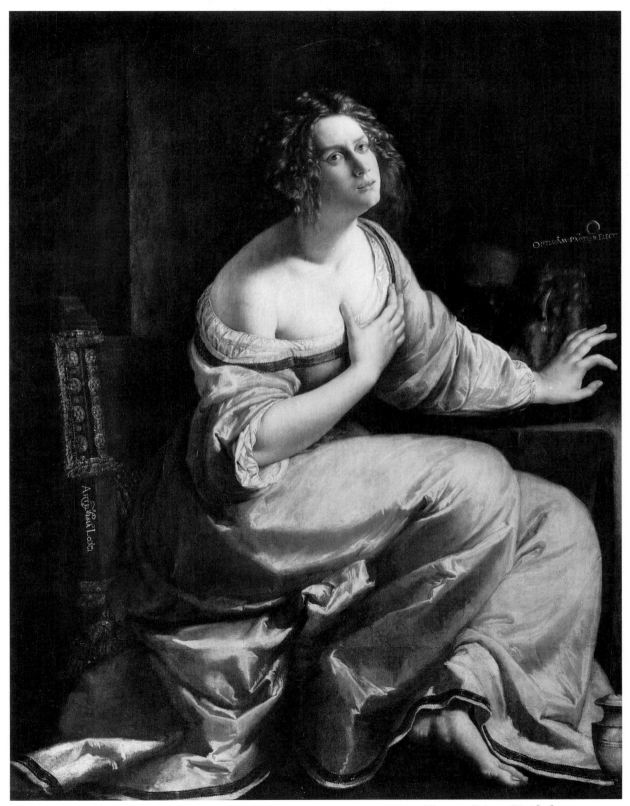

FIGURE 70 *Conversion of the Magdalen*, ca. 1617–20, Florence, Palazzo Pitti [10]

< FIGURE 69 Detail of Figure 70

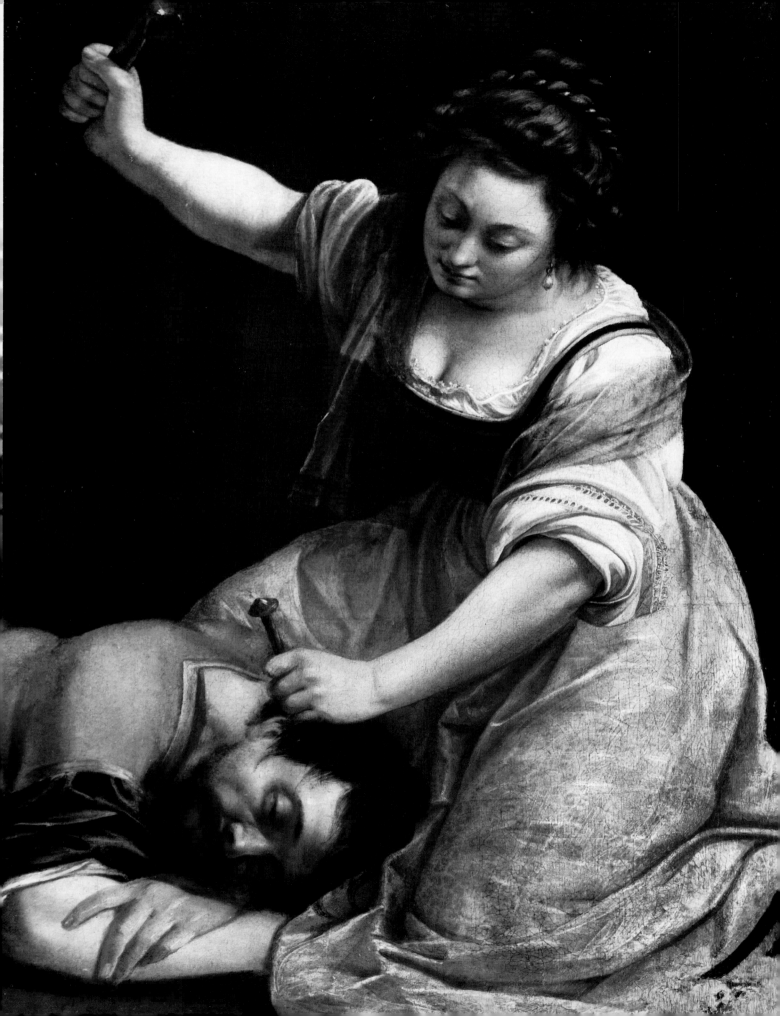

FIGURE 71 Philips Galle, *Jael and Sisera*, engraving, ca. 1610, from the series *Women's Tricks in the Old Testament*, Amsterdam, Rijksmuseum

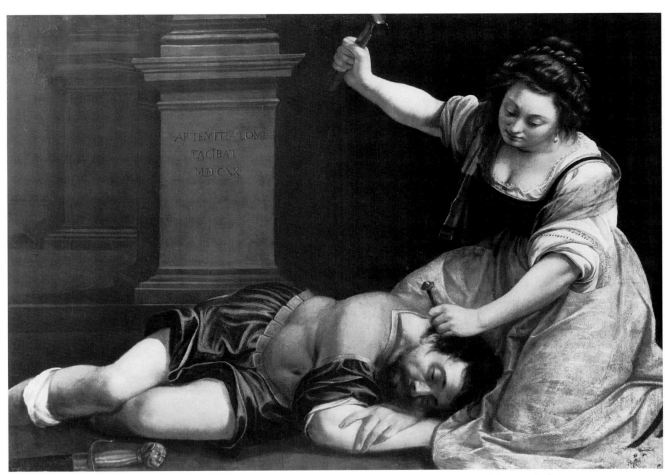

FIGURE 73 *Jael and Sisera*, 1620, Budapest, Szépmüvészeti Múzeum [11]

< FIGURE 72 Detail of Figure 73

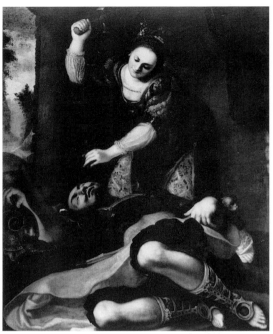

FIGURE 74 By or after Ludovico Cardi, Il Cigoli, *Jael and Sisera*, Florence, Private Collection

FIGURE 75 After Artemisia Gentileschi (Fig. 77), *Judith Decapitating Holofernes*, engraving in Marco Lastri, *L'Etruria pittrice*, 1791, pl. LXXXIV

Hic ubi fœda rubent cõspersa conopea. talo
Obrute fœminea Ductor ab arte iaces.

OLOFERNES OCCIDI:
TVR.

Exitio forma illa tuo se compserat at tu
Nocturnam properas ebrietate necem.

FIGURE 76 Antonio Tempesta, *The Murder of Holofernes*, etching from the *Biblical Battles Series*, 1613, Washington, D.C., National Gallery of Art, Ailsa Mellon Bruce Fund

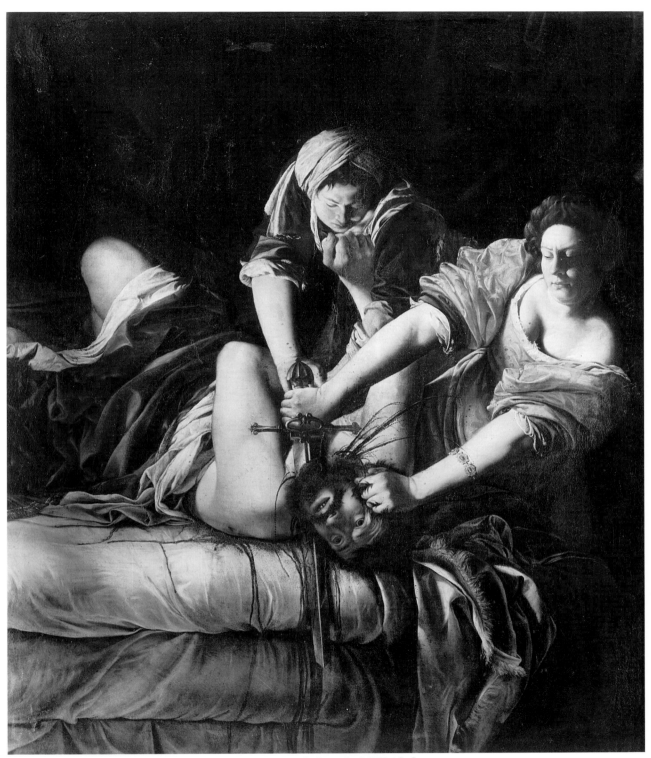

FIGURE 77 *Judith Decapitating Holofernes*, ca. 1620, Florence, Galleria degli Uffizi [12]

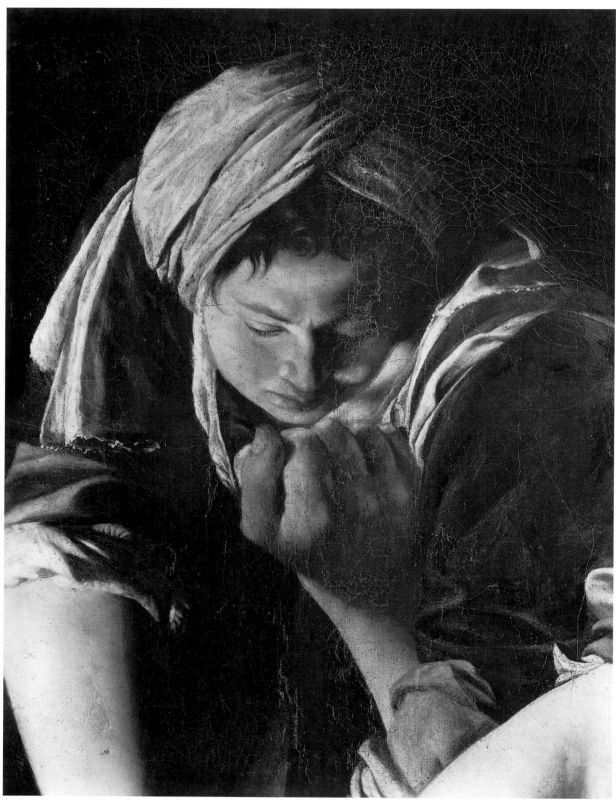

FIGURE 78 Detail of Figure 77

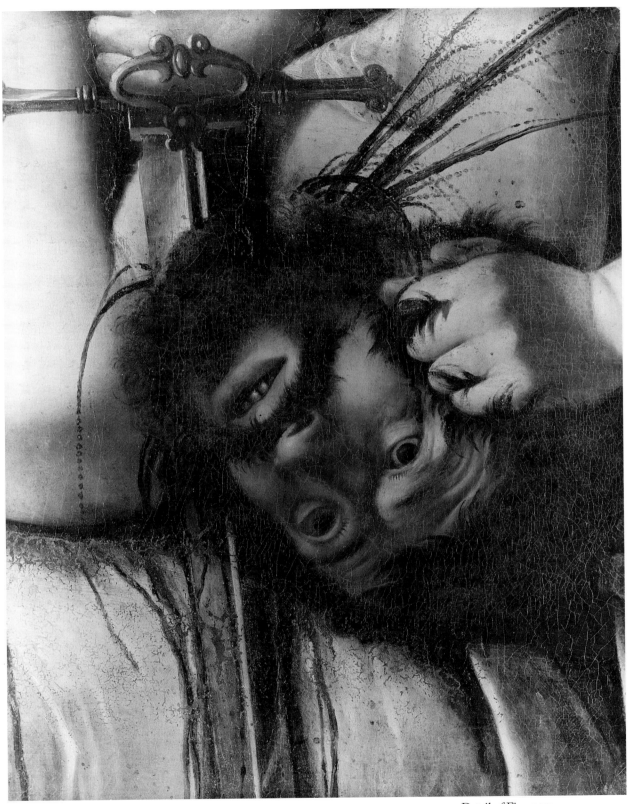

FIGURE 79 Detail of Figure 77

FIGURE 80 Jacopo da Empoli, *Portrait of Concino Concini*,
1610, London, Christie's, 1972

FIGURE 81 Inscription formerly on the reverse of Figure 82

> FIGURE 82 *Portrait of a Condottiere*, 1622, Bologna, Collezioni
Comunali d'Arte, Palazzo d'Accursio [13]

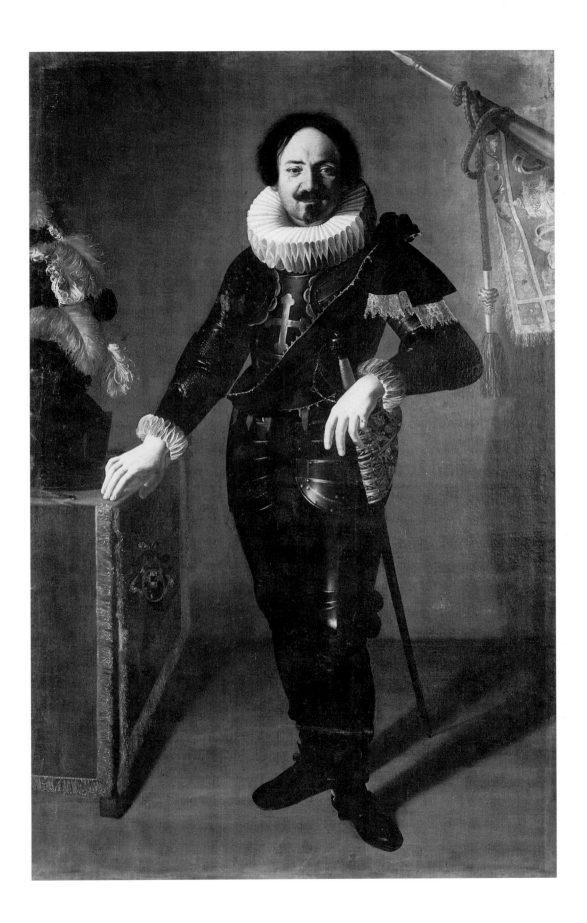

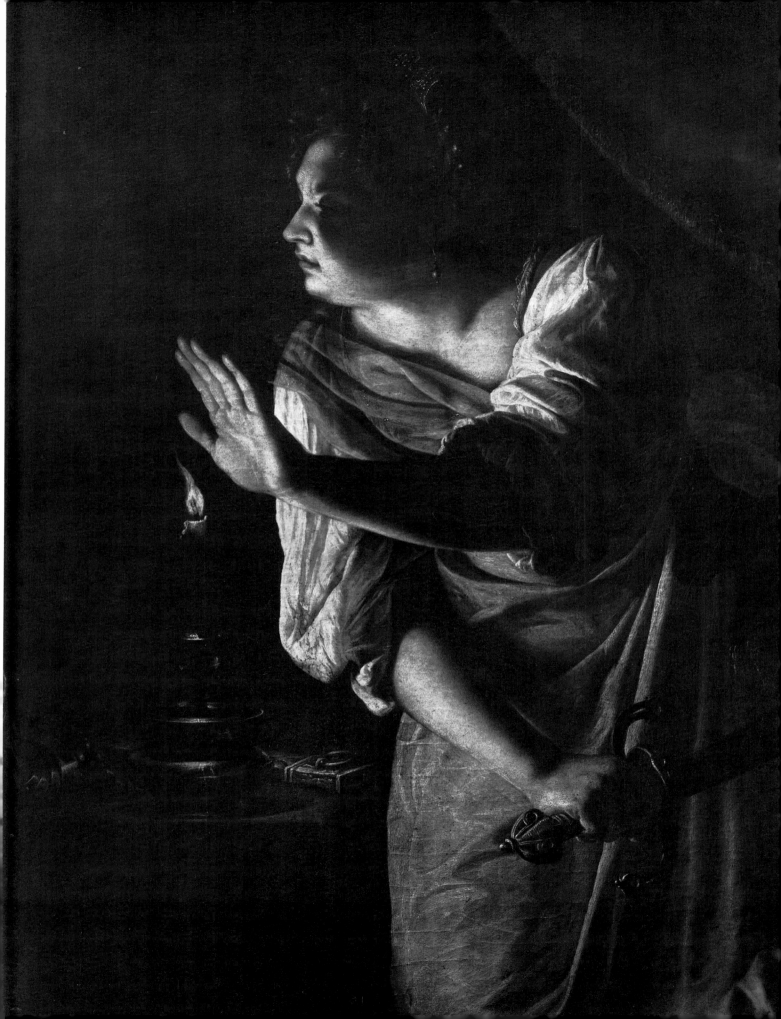

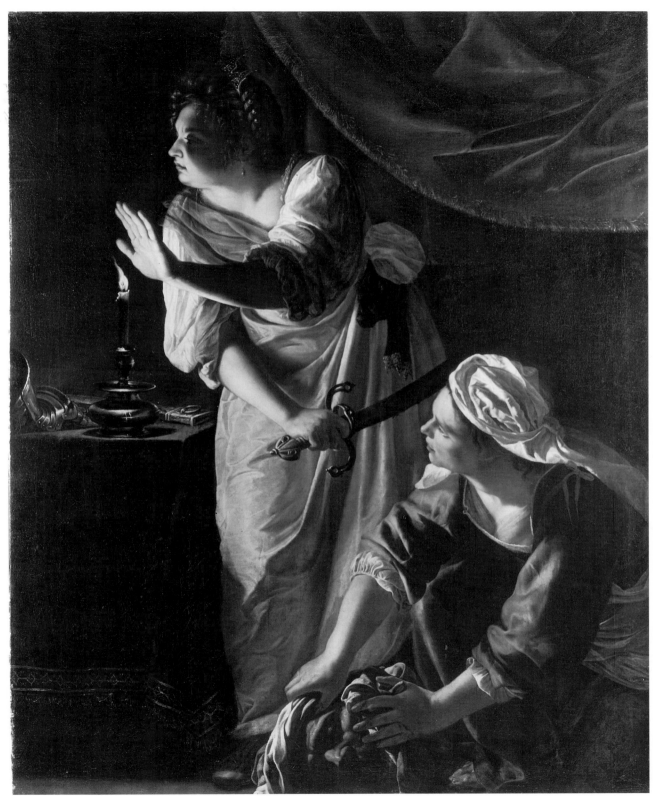

FIGURE 84 *Judith and Her Maidservant*, ca. 1623–25,
Detroit, Michigan, Institute of Arts,
Gift of Mr. Leslie H. Green [14]

< FIGURE 83 Detail of Figure 84

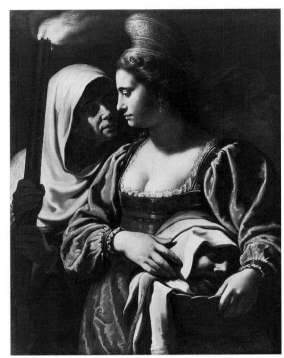

FIGURE 85 Antiveduto Gramatica, *Judith and Her Maidservant*, early 1620s, Stockholm, Nationalmuseum

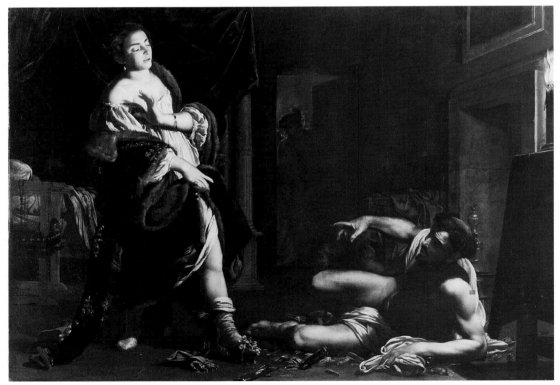

FIGURE 86 Simon Vouet, *Temptation of Saint Francis*, 1623–24, Rome, San Lorenzo in Lucina, Alaleone Chapel

FIGURE 87 *Aurora*, ca. 1625–27, Rome, Private Collection [15]

FIGURE 88

Gregorio Pagani, *Piramus and Thisbe*,
Florence, Galleria degli Uffizi

FIGURE 89

Giovanni Bilivert,
Apollo and Daphne, 1630,
Stuttgart, Staatsgalerie

> FIGURE 90 Detail of
Figure 87

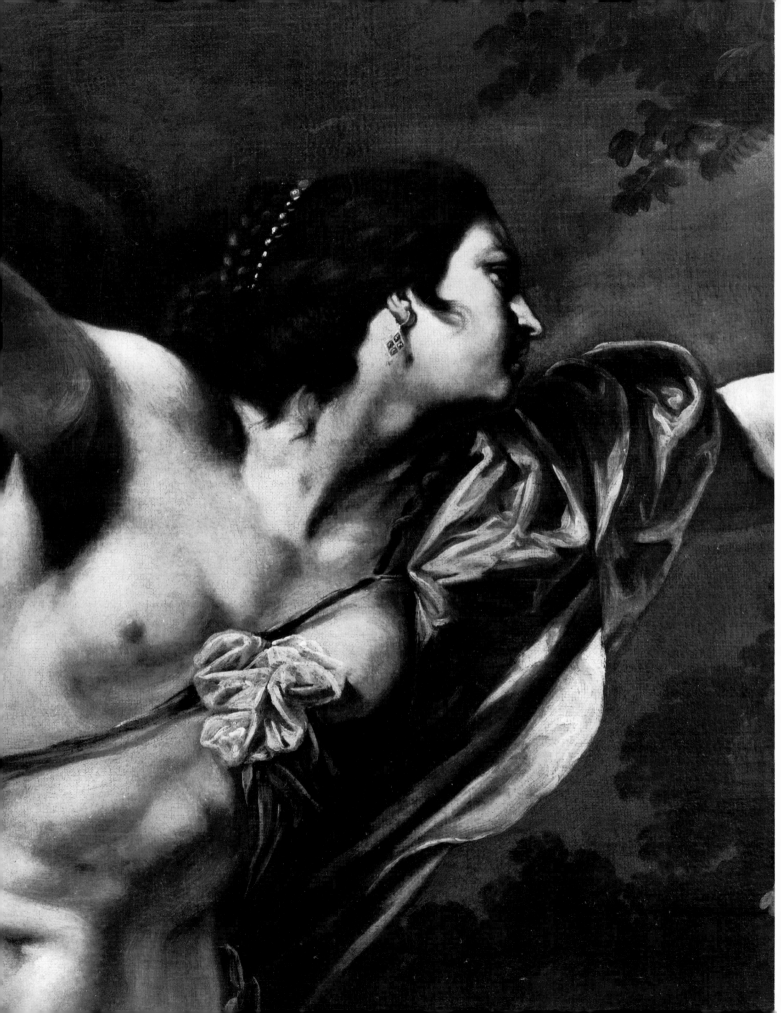

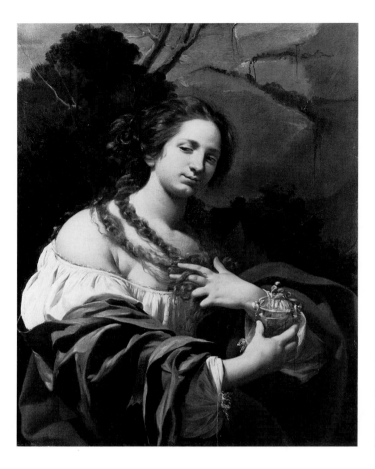

FIGURE 91

Simon Vouet, *Virginia da Vezzo as Saint Mary Magdalen*, ca. 1625–26, Los Angeles County Museum of Art

FIGURE 92

Roman (Neo-Attic), *Maidens Decorating a Candelabrum*, marble, Paris, Musée du Louvre

FIGURE 93 Detail of Figure 84

FIGURE 94 Detail of Figure 87

FIGURE 95 Detail of Figure 104 (rotated)

FIGURE 96 *Penitent Magdalen*, ca. 1625/26, Private Collection [17]

FIGURE 97 *Penitent Magdalen*, 1625/26, Seville, Cathedral [16]

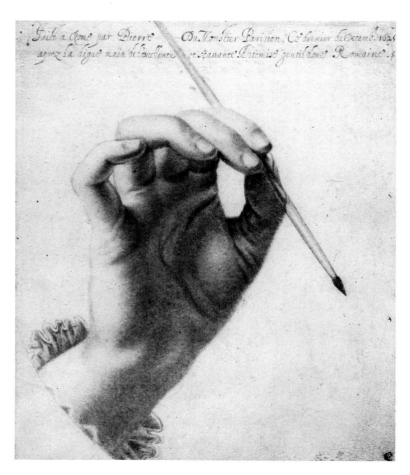

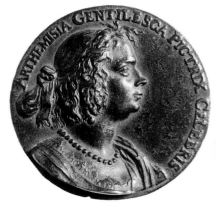

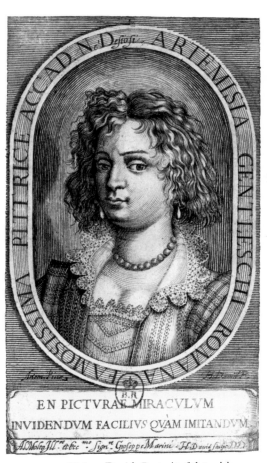

FIGURE 101 Jérôme David, *Portrait of Artemisia Gentileschi* after a painted *Self-Portrait*, engraving, 1620s, Paris, Bibliothèque National, Cabinet des Estampes [20]

FIGURE 102 Jérôme David, *Portrait of Antoine de Ville* after a painted *Portrait of Antoine de Ville* by Artemisia Gentileschi, engraving, 1627, frontispiece to *Les fortifications du chevalier Antoine de Ville*, Lyon, 1628 [19]

FIGURE 103 Detail of Figure 104

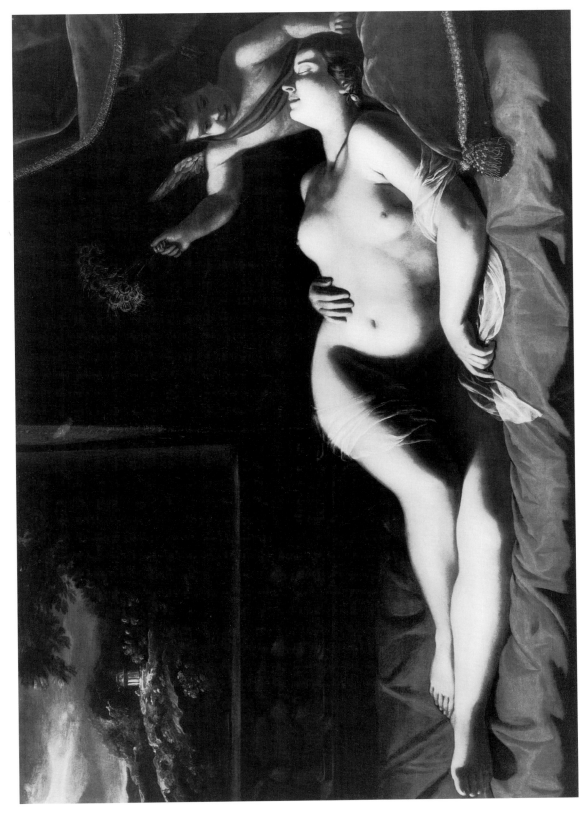

FIGURE 104 *Venus and Cupid (Sleeping Venus)*, ca. 1625–27, Princeton, New Jersey,
The Barbara Piasecka Johnson Collection Foundation [18]

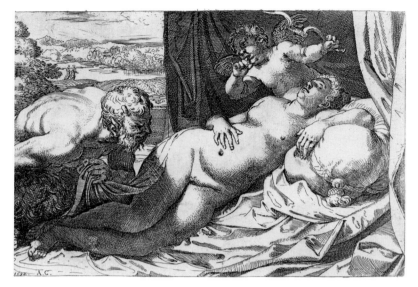

FIGURE 105

Annibale Carracci,
*Sleeping Venus with a Satyr
and Cupid*, etching and
engraving, 1592, Cambridge,
Massachusetts, Fogg Art
Museum, Harvard University
Art Museums, Alpheus
Hyatt Fund

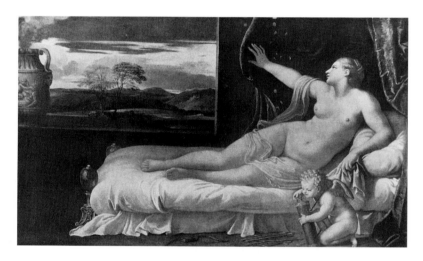

FIGURE 106

Studio of Annibale Carracci,
Danaë and the Shower of Gold,
ca. 1605, formerly London,
Bridgewater House

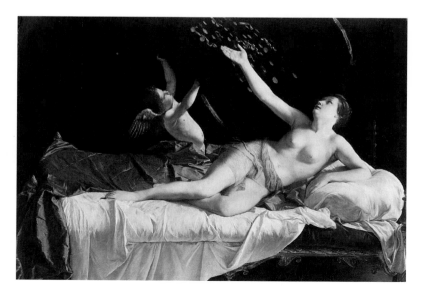

FIGURE 107

Orazio Gentileschi, *Danaë
and the Shower of Gold*,
ca. 1621, New York, Richard
L. Feigen Collection

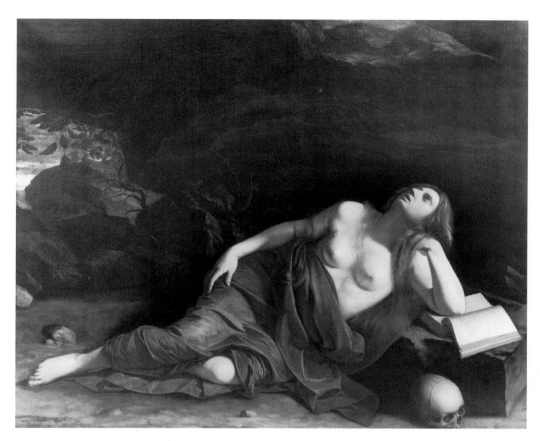

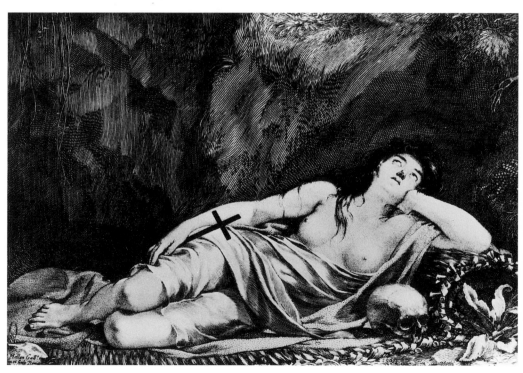

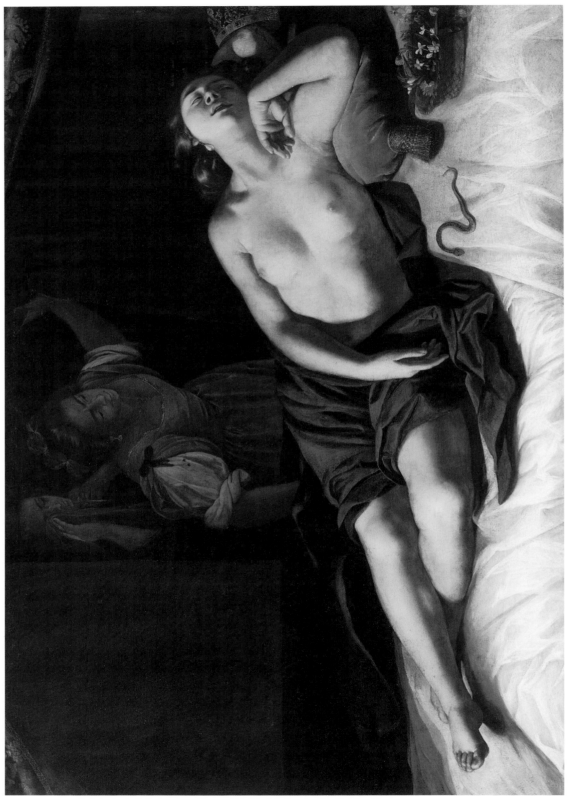

FIGURE 110 *Cleopatra*, ca. 1627–29, formerly London, Matthiesen Fine Art Limited [22]

FIGURE III *Penitent Magdalen*, ca. 1627–29, Naples, Private Collection? [21]

FIGURE 112 Jean Ganière, *Child Sleeping Near a Skull (Memento Mori)*, after a painting by Artemisia Gentileschi, engraving, 1640, Paris, Bibliothèque National, Cabinet des Estampes [23]

FIGURE 113 Pieter de Jode II, *Child Sleeping Near a Skull (Memento Mori)*, after a painting by Artemisia Gentileschi, engraving, Antwerp, Museum Plantin-Moretus, Stedelijk Prentenkabinet [23]

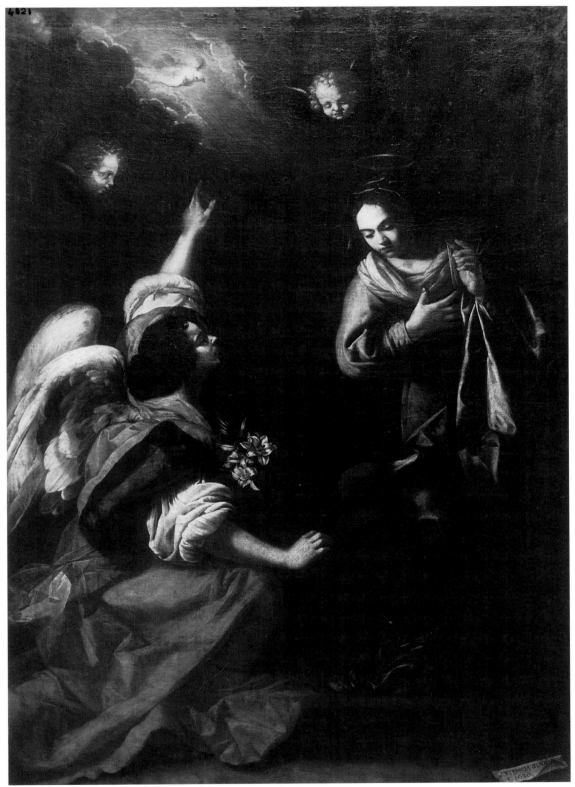

FIGURE 114 *Annunciation*, 1630, Naples, Museo di Capodimonte [24]

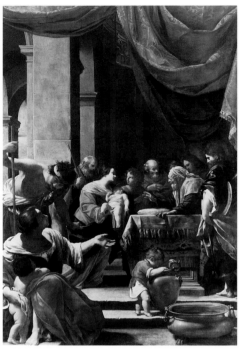

FIGURE 115 Simon Vouet, *Circumcision of Christ*,
1622, Naples, Museo di Capodimonte
(from Naples, Sant'Angelo a Segno)

FIGURE 116 Simon Vouet, *Saint Bruno Receiving the
Rule of the Carthusian Order*, ca. 1626,
Naples, Certosa di San Martino

FIGURE 117 Giovanni Battista Caracciolo,
Assumption of the Virgin, 1631, Naples,
Museo Nazionale di San Martino

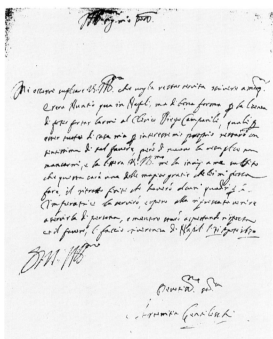

FIGURE 118 Artemisia Gentileschi, letter from Naples,
August 31, 1630, to Cassiano dal Pozzo in
Rome, now Greencastle, Pennsylvania,
Mr. Thomas Brumbaugh

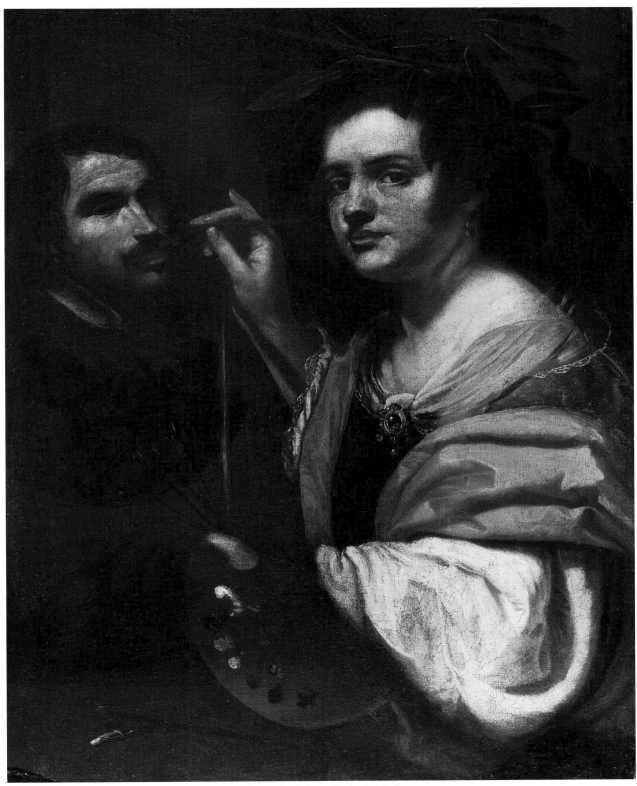

FIGURE 119 *Self-Portrait*, 1630? Rome, Galleria Nazionale, Palazzo Barberini [25]

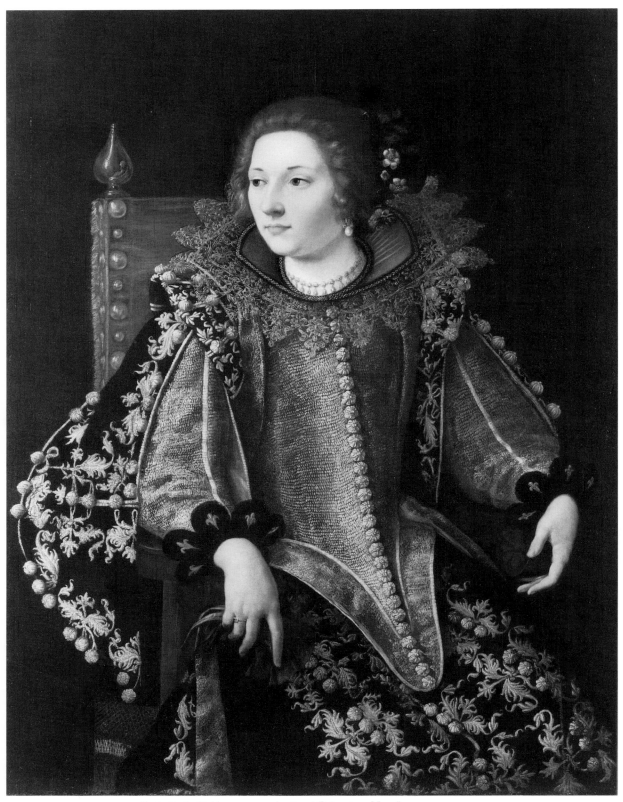

FIGURE 120 *Portrait of a Noblewoman*, early 1630s? Princeton, New Jersey,
The Barbara Piasecka Johnson Collection Foundation [26]

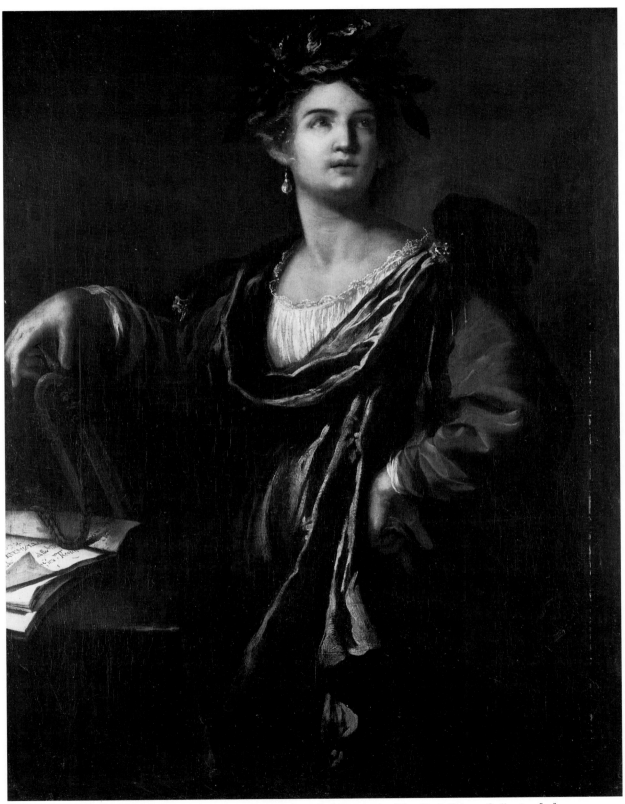

FIGURE 121 *Clio, Muse of History (so-called Fame)*, 1632, New York, Private Collection [27]

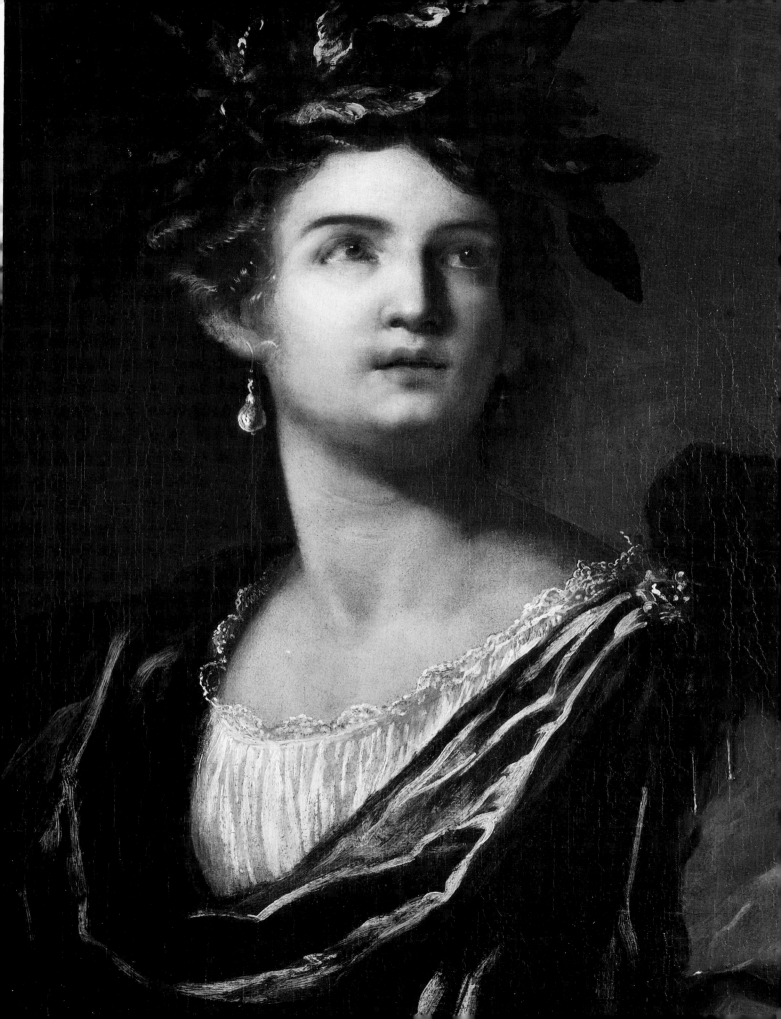

FIGURE 123 Detail of Figure 121

< FIGURE 122 Detail of Figure 121

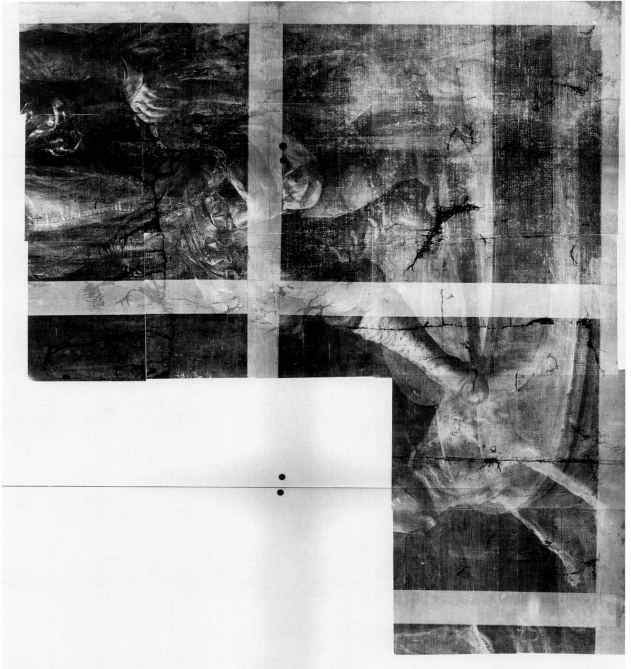

FIGURE 124 X-radiograph of a portion of Figure 125

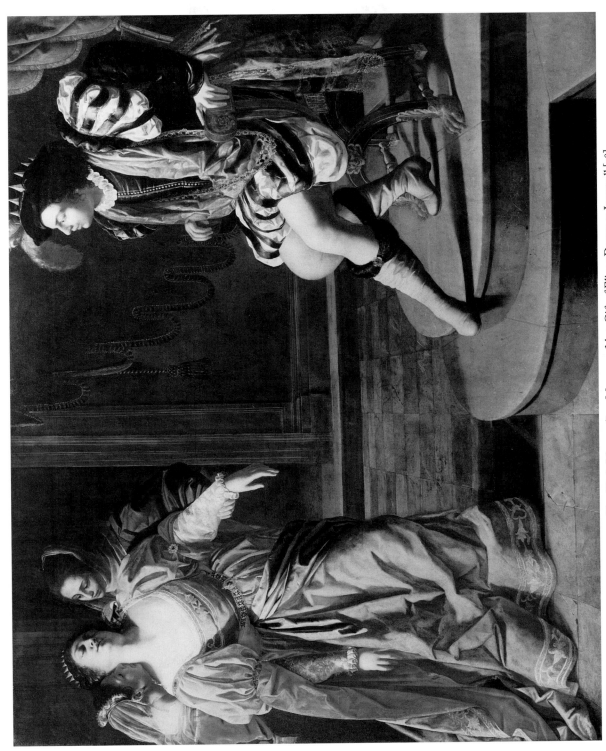

FIGURE 125 *Esther Before Ahasuerus*, ca. 1630–35, New York, Metropolitan Museum of Art, Gift of Elinor Dorrance Ingersoll [28]

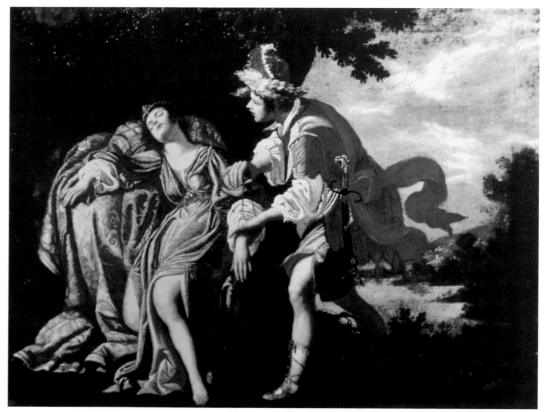

FIGURE 126 Attributed to Bartolommeo Salvestrini, *Theseus and Ariadne*, Florence, Private Collection

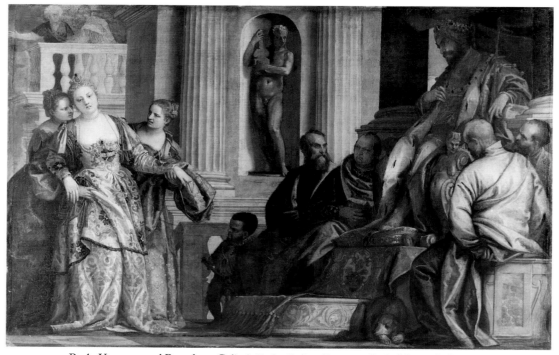

FIGURE 127 Paolo Veronese and Benedetto Caliari, *Esther Before Ahasuerus,* Paris, Musée du Louvre

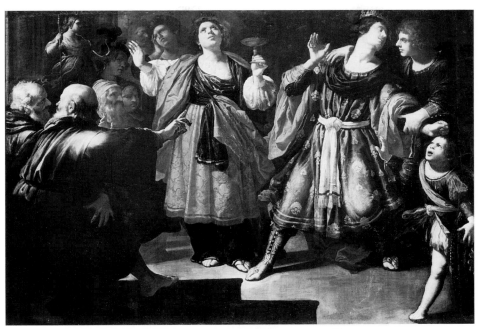

FIGURE 128 Rutilio Manetti, *Massinissa and Sophonisba*, ca. 1623–24, Florence,
 Galleria degli Uffizi

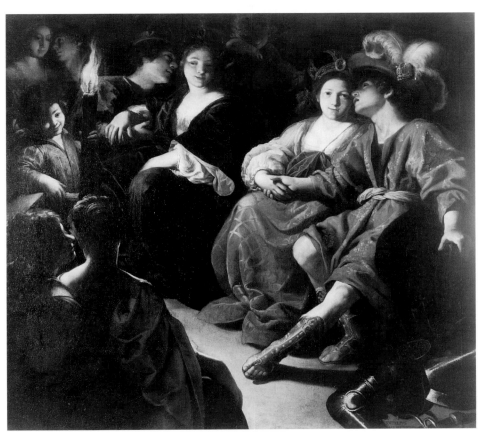

FIGURE 129 Rutilio Manetti, *Roger and Alcina*, 1622–23, Florence, Palazzo Pitti

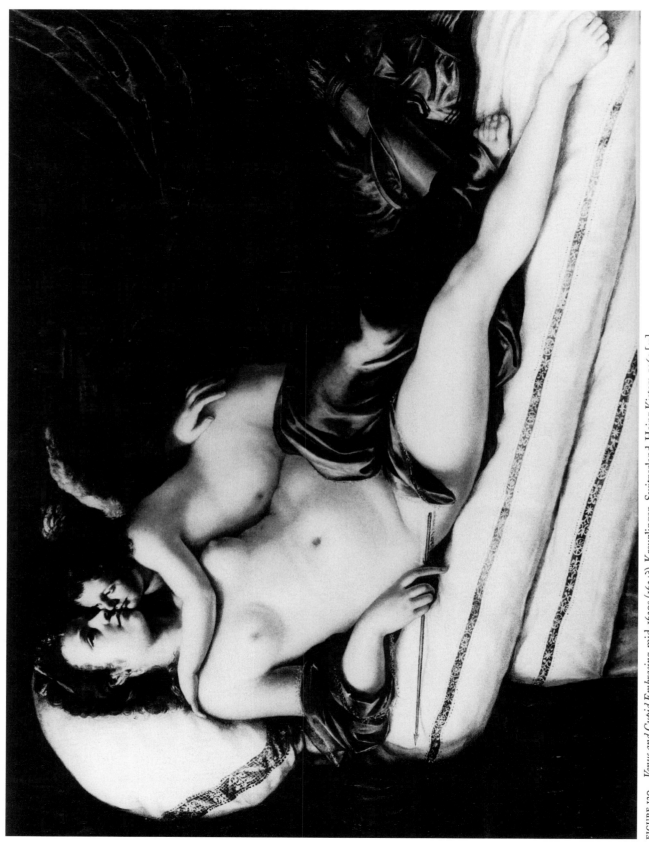

FIGURE 130 *Venus and Cupid Embracing*, mid-1630s (1634?), Kreuzlingen, Switzerland, Heinz Kisters, 1963 [31]

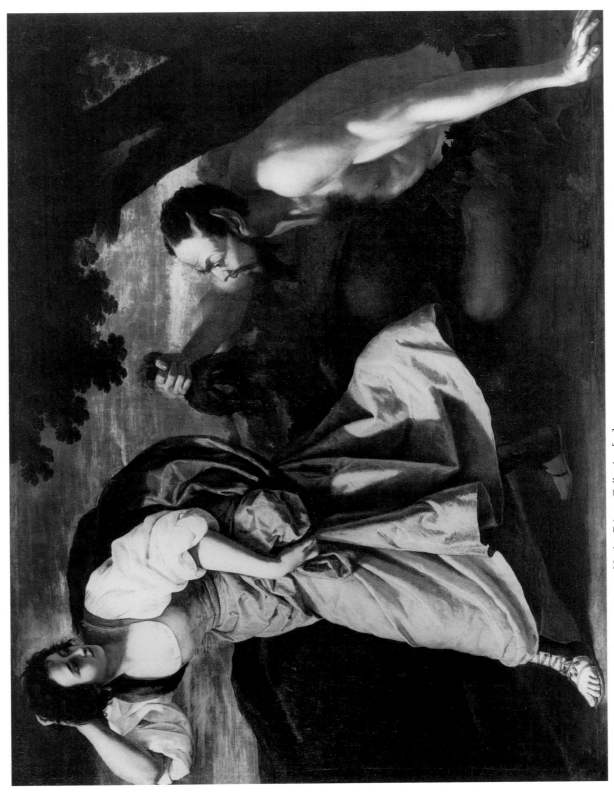

FIGURE 131 *Corisca and the Satyr*, ca. 1633–35, Naples, Private Collection [30]

FIGURE 132 Detail of Figure 159

FIGURE 133 Detail of Figure 130

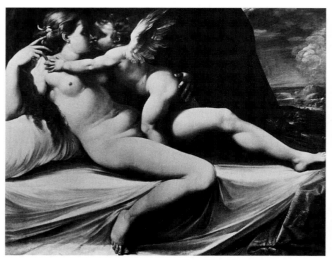

FIGURE 134 Cavaliere d'Arpino, *Venus and Cupid Kissing*, ca. 1600, Rome, Fabio Failla Collection

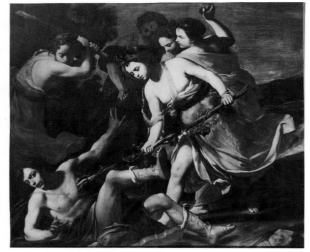

FIGURE 135 Massimo Stanzione, *Death of Orpheus*, early 1630s, Milan, Banco Manusardi & Co.

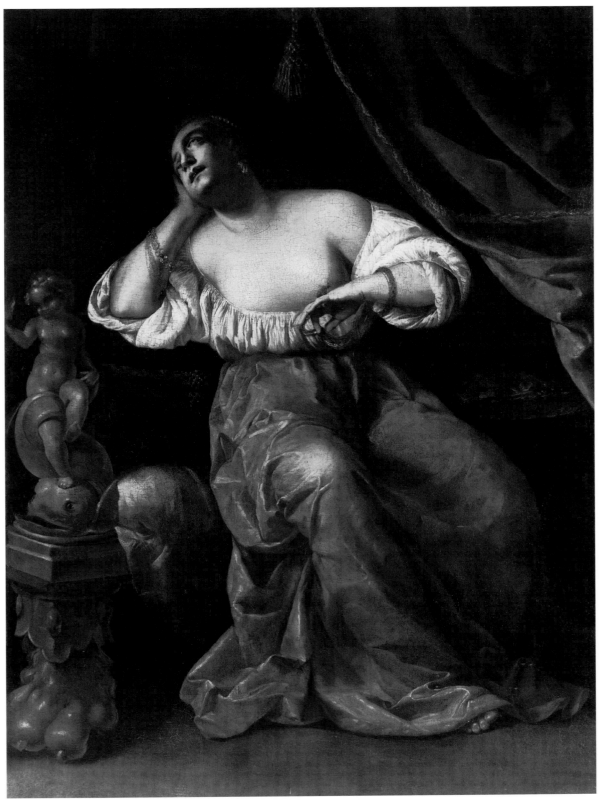

FIGURE 136 *Cleopatra*, ca. 1630–35, Paris, Société Labatut & Cie., 1997 [29]

FIGURE 138 Pedro Texeira, Ermita de San Juan Bautista at the Buen Retiro,
detail from the Map of Madrid, 1656

FIGURE 137 Pedro Texeira, Buen Retiro complex, detail from the Map of Madrid,
1656 (1=Ermita de San Juan Bautista; 2=Ermita de San Pablo)

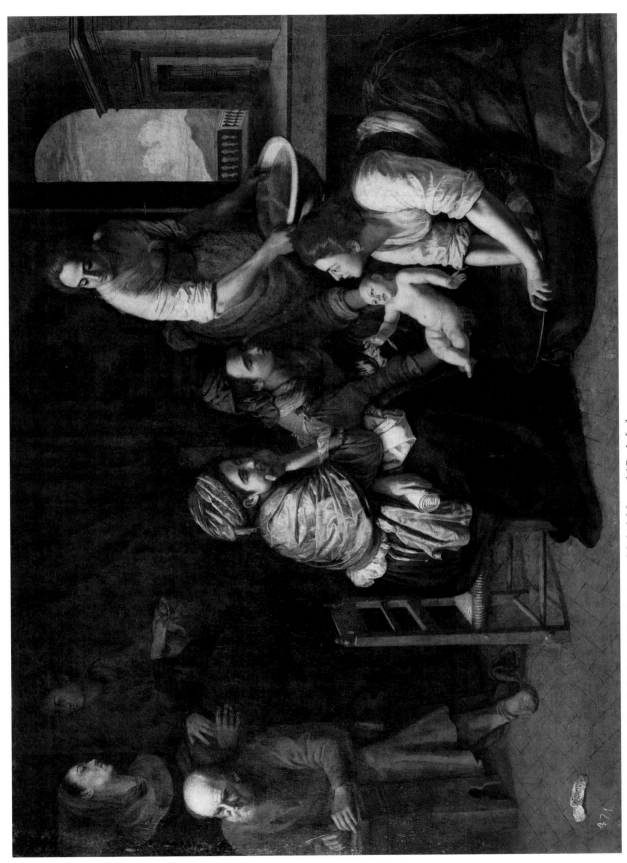

FIGURE 139 *Birth and Naming of Saint John the Baptist,* 1633–34, Madrid, Museo del Prado [32]

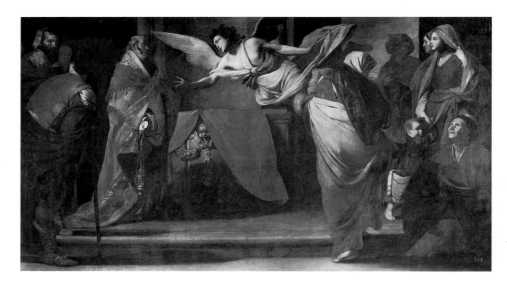

FIGURE 140

Massimo Stanzione,
Annunciation to Zacharias,
1633–34, Madrid, Museo
del Prado (see [32])

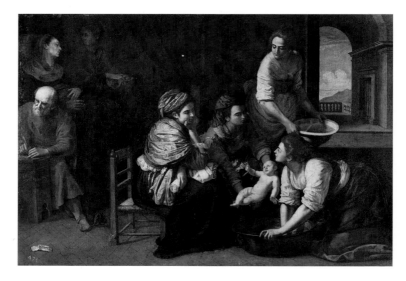

FIGURE 141

Artemisia Gentileschi,
*Birth and Naming of Saint John
the Baptist*, 1633–34, Madrid,
Museo del Prado [32]

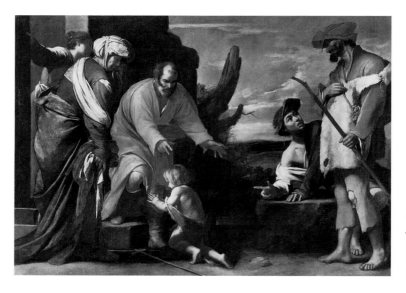

FIGURE 142

Massimo Stanzione, *Saint
John the Baptist Taking Leave
of His Parents*, 1633–34,
Madrid, Museo del Prado
(see [32])

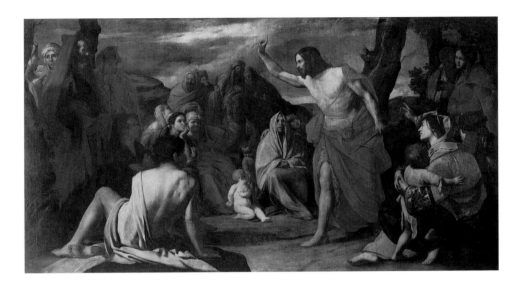

FIGURE 143

Massimo Stanzione, *Saint John the Baptist Preaching to the Multitude*, 1633–34, Madrid, Museo del Prado (see [32])

PAOLO FINOGLIO,
ST. JOHN THE BAPTIST IN PRISON
1633–34
(LOST OR UNIDENTIFIED: SEE [32])

FIGURE 144

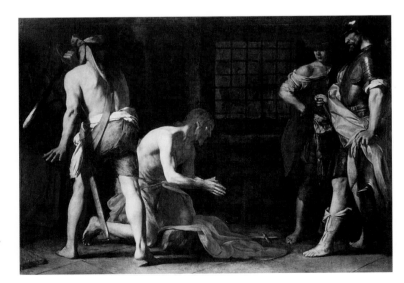

FIGURE 145

Massimo Stanzione, *Decapitation of Saint John the Baptist*, 1633–34, Madrid, Museo del Prado (see [32])

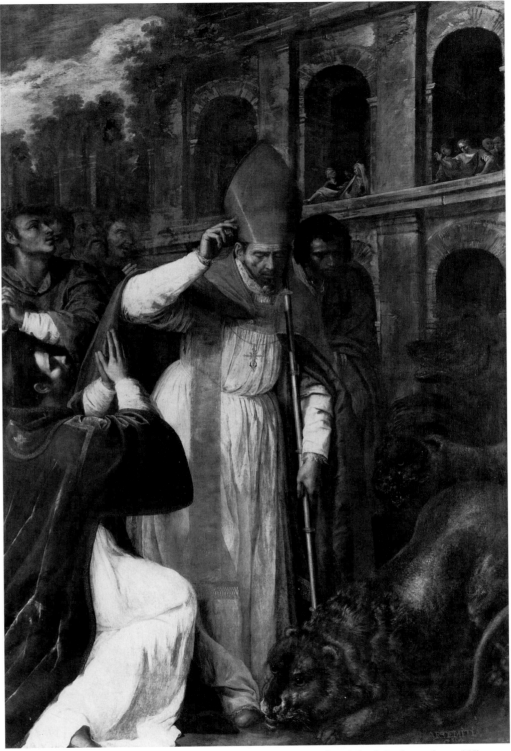

FIGURE 147 Artemisia Gentileschi, with Domenico Gargiulo, *Saint Januarius and His Companions in the Amphitheater at Pozzuoli*, ca. 1635, Naples, Museo Nazionale di San Martino (on deposit from the Cathedral of Pozzuoli) [33b]

< FIGURE 146 Artemisia Gentileschi (with Domenico Gargiulo?), *Saints Proculus and Nicea*, ca. 1635, Naples, Museo Nazionale di San Martino (on deposit from the Cathedral of Pozzuoli) [33a]

FIGURE 149 *Adoration of the Magi*, ca. 1635, Naples, Museo
Nazionale di San Martino (on deposit from
the Cathedral of Pozzuoli) [33c]

< FIGURE 148 Detail of Figure 149

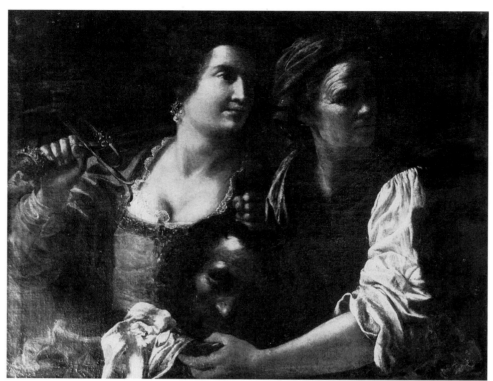

FIGURE 150 Copy after Artemisia Gentileschi, *Judith and Her Maidservant*, original ca. 1635,
 when sold at London, Sotheby's, 1958 and 1959 [34]

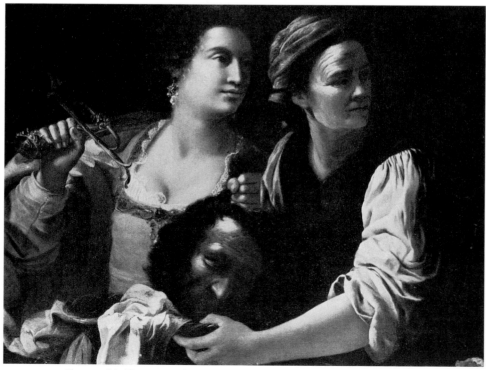

FIGURE 151 Presumably Figure 150 after restoration and rephotographing,
 when sold at Milan, Relarte, 1964 [34]

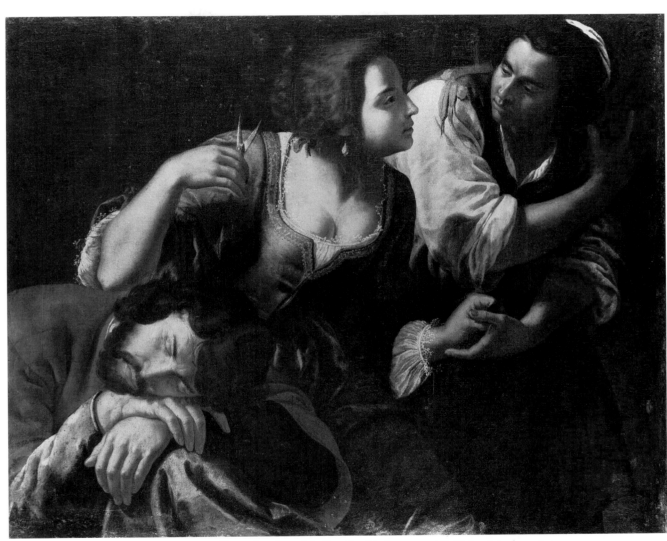

FIGURE 152 Copy after Artemisia Gentileschi, *Samson and Delilah*, original ca. 1635, Naples, Museo di Capodimonte, Banco di Napoli Collection [35]

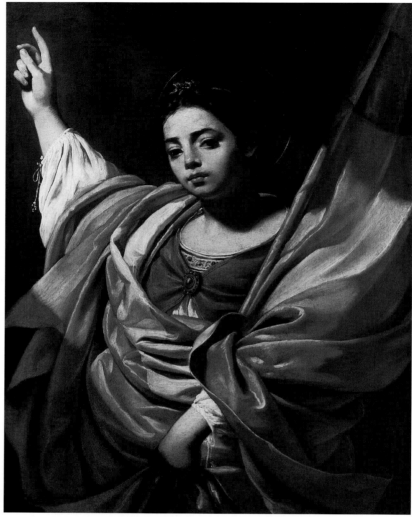

FIGURE 153 Simon Vouet, *Saint Ursula*, 1620s, Hartford, Connecticut, Wadsworth
Atheneum, Ella Gallup Sumner and Mary Catlin Sumner Collection

FIGURE 154 Coat of arms of the
Pellegrini, Capua (see [37])

FIGURE 155 Coat of arms of the Romeo,
Naples (see [37])

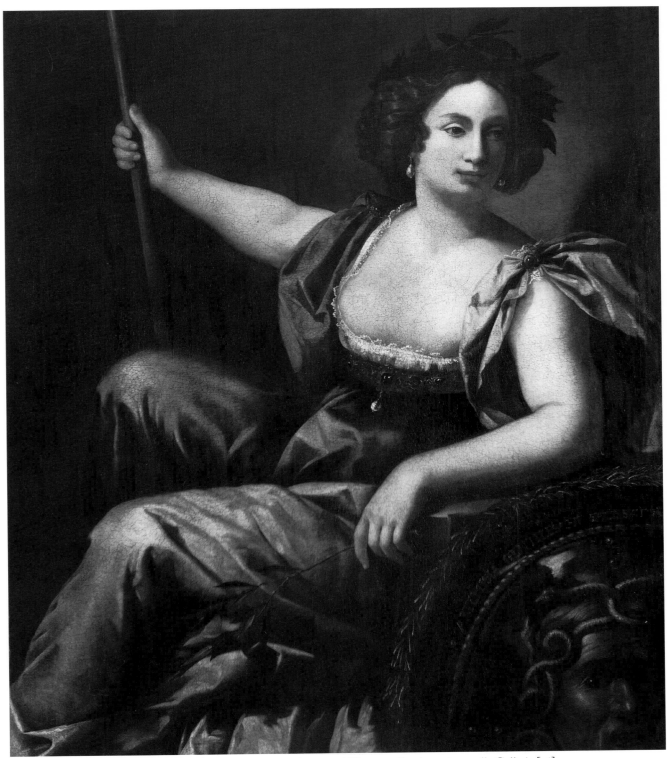

FIGURE 156 *Minerva (Sapienza)*, 1635–36? Florence, Soprintendenza alle Gallerie [36]

FIGURE 157 Detail of Figure 159

FIGURE 158 Viviano Codazzi and Domenico Gargiulo, *Architectural Caprice with Figures*, Brescia, Private Collection

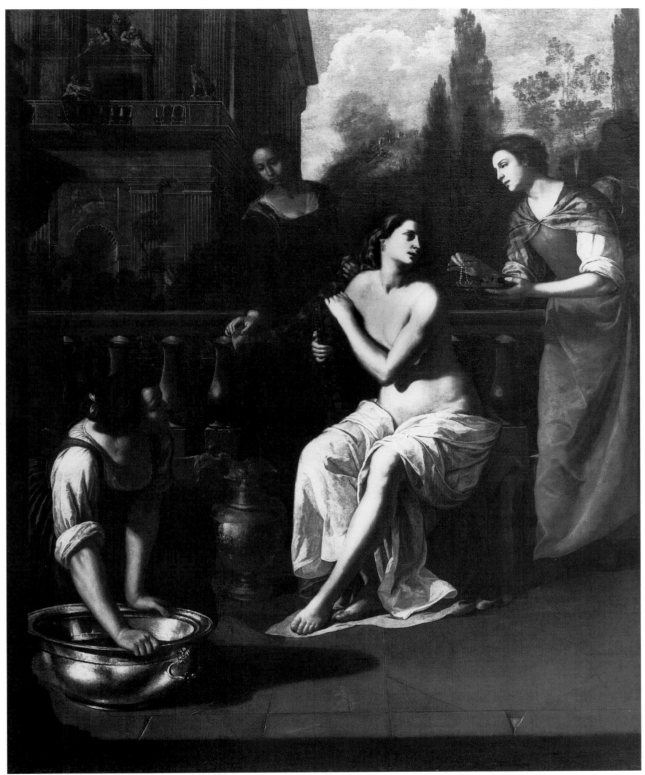

FIGURE 159 Artemisia Gentileschi, with Viviano Codazzi and Domenico Gargiulo (and
Bernardo Cavallino?), *Bathsheba*, ca. 1636–37/38, Columbus, Ohio, Museum of
Art, Museum Purchase: Frederick W. Schumacher Trust Fund [37]

FIGURE 160 Bernardo Cavallino, *Finding of Moses*, ca. 1650, Braunschweig,
Herzog Anton Ulrich-Museum

FIGURE 161 Bernardo Cavallino, *The Meeting of David and Abigail*, ca. 1650,
Braunschweig, Herzog Anton Ulrich-Museum

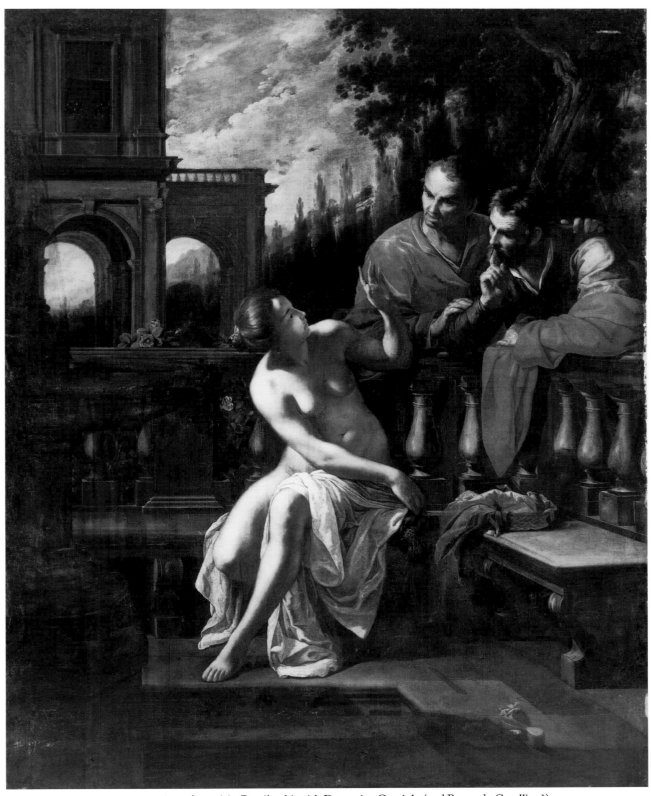

FIGURE 162 Artemisia Gentileschi, with Domenico Gargiulo (and Bernardo Cavallino?),
Susanna and the Elders, ca. 1636–37/38, London, Sotheby's, 1995 [38]

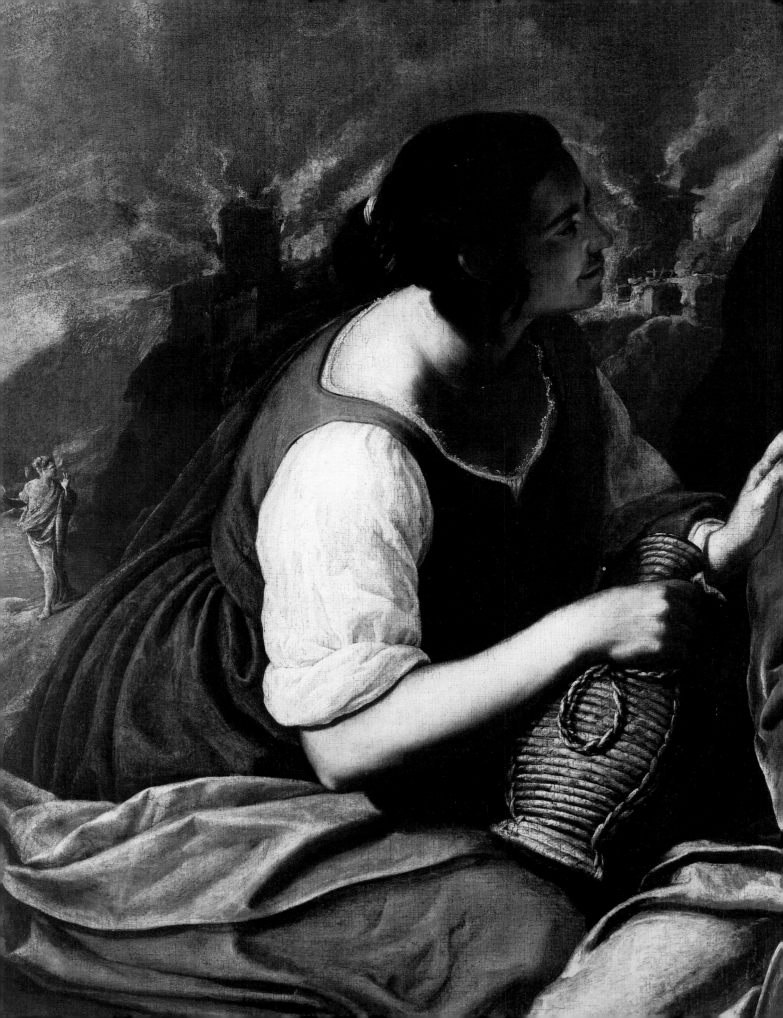

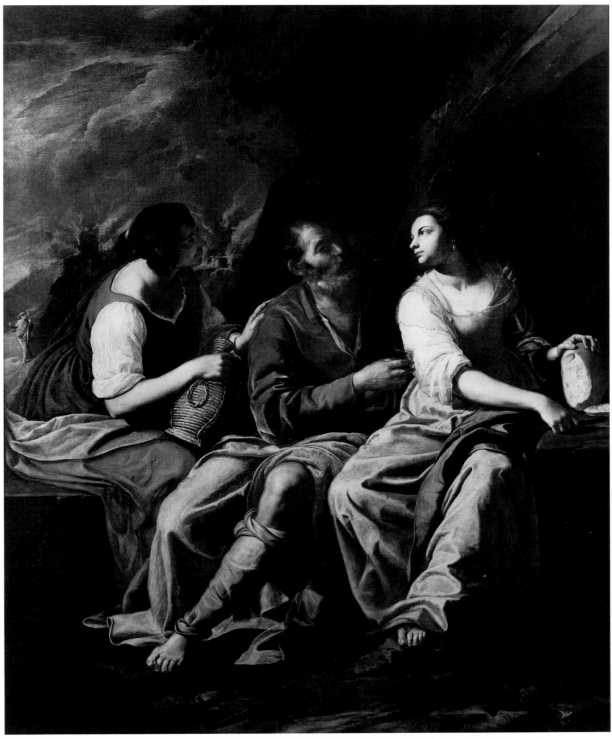

FIGURE 164 Artemisia Gentileschi (with Bernardo Cavallino?), *Lot and His Daughters*, ca. 1636–37/38, Toledo, Ohio, Museum of Art, Clarence Brown Fund [39]

< FIGURE 163 Detail of Figure 164

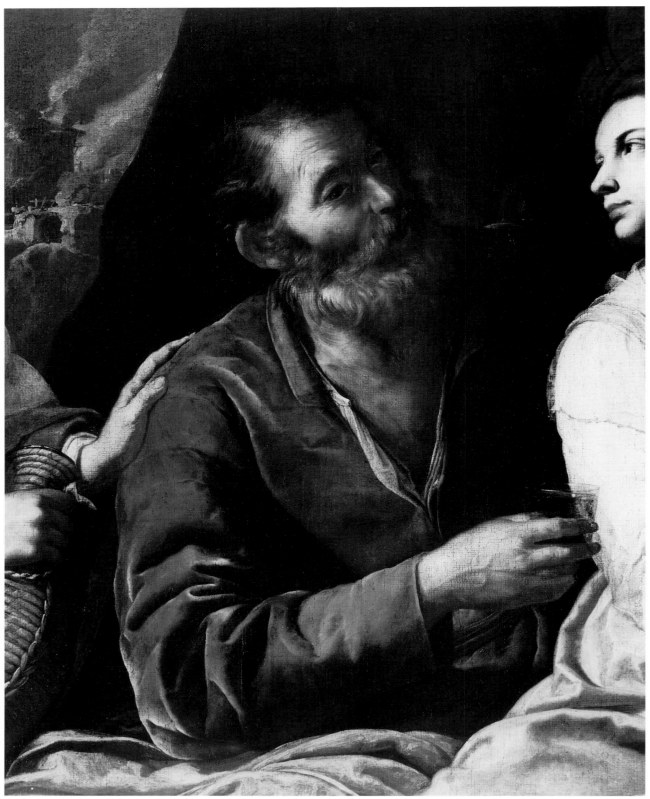

FIGURE 165 Detail of Figure 164

> FIGURE 166 Detail of Figure 164

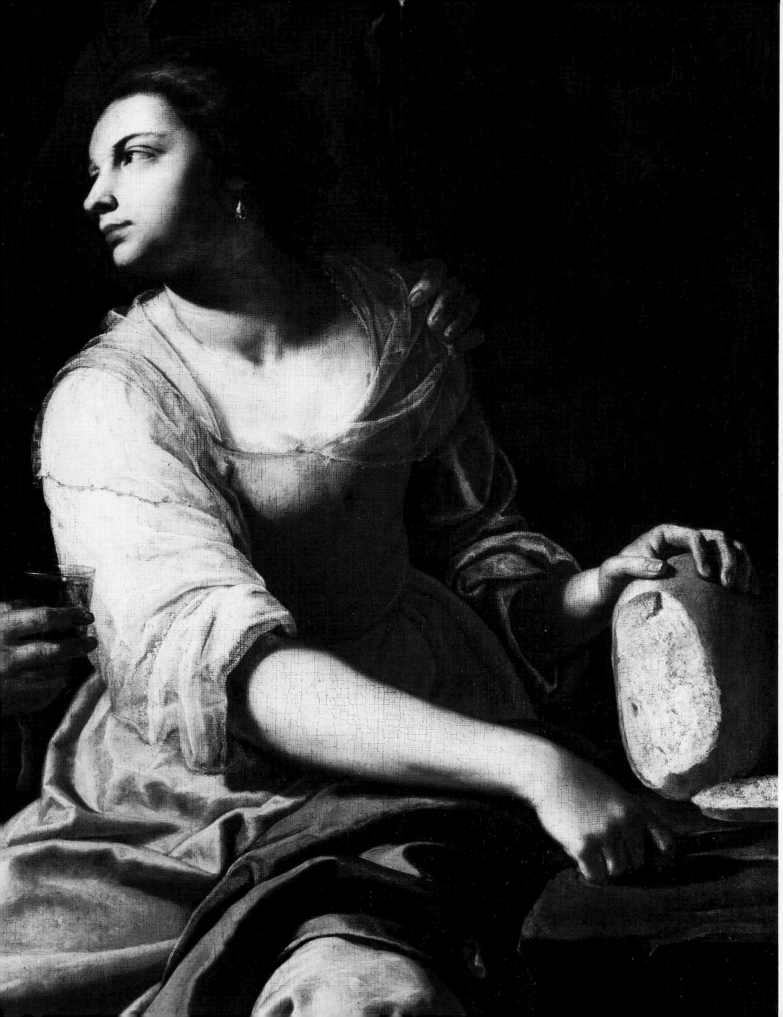

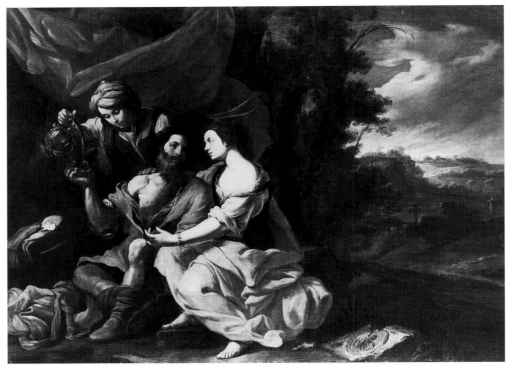

FIGURE 167 Agostino Beltrano, *Lot and His Daughters*, 1640s, Marano di Castenaso, Molinari Pradelli Collection

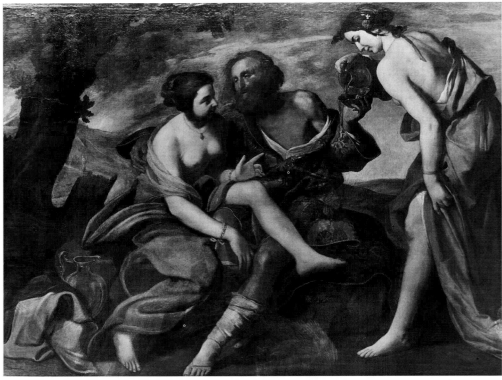

FIGURE 168 Massimo Stanzione, *Lot and His Daughters*, 1630s, Besançon, Musée des Beaux-Arts et d'Archéologie (Cliché Ch. Choffet)

FIGURE 169 *Bathsheba*, ca. 1637/38, Halle, Germany, Private Collection [40]

FIGURE 170 Orazio Gentileschi (with Artemisia Gentileschi), *Allegory of Peace and the Arts Under the English Crown*, ca. 1636–38, London, Marlborough House, ceiling of the Main Hall (formerly Greenwich, Queen's House, Great Hall), Royal Collection Enterprises, Crown Copyright (see [41])

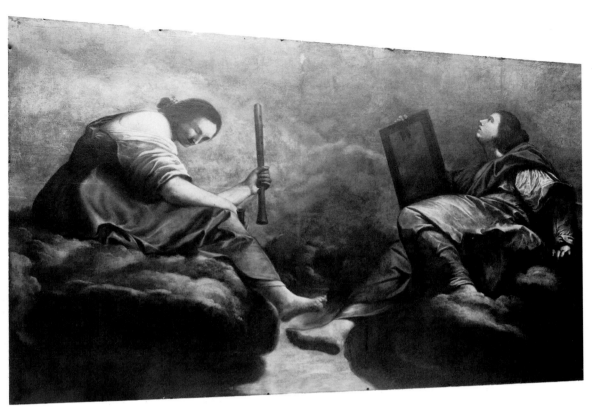

FIGURE 171 Orazio Gentileschi, *Muse Euterpe*, and Artemisia Gentileschi, *Muse Polyhymnia*, detail of Figure 170,
Royal Collection Enterprises, Crown Copyright [41]

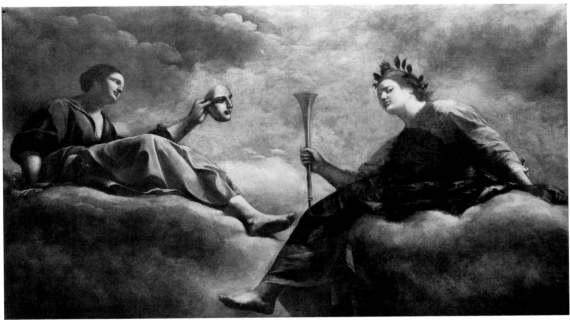

FIGURE 172 Orazio Gentileschi, *Muse Thalia*, and Artemisia Gentileschi (?), *Muse Clio*, detail of Figure 170,
Royal Collection Enterprises, Crown Copyright [41]

FIGURE 173 Felice Antonio Casoni, portrait medal of Lavinia Fontana, bronze, 1611, London, British Museum

FIGURE 174 Reverse of Figure 179

> FIGURE 175 *Allegory of Painting* (so-called *Self-Portrait as "La Pittura"*), ca. 1638–39, London, Kensington Palace, Collection of Her Majesty the Queen, Royal Collection Enterprises, Crown Copyright [42]

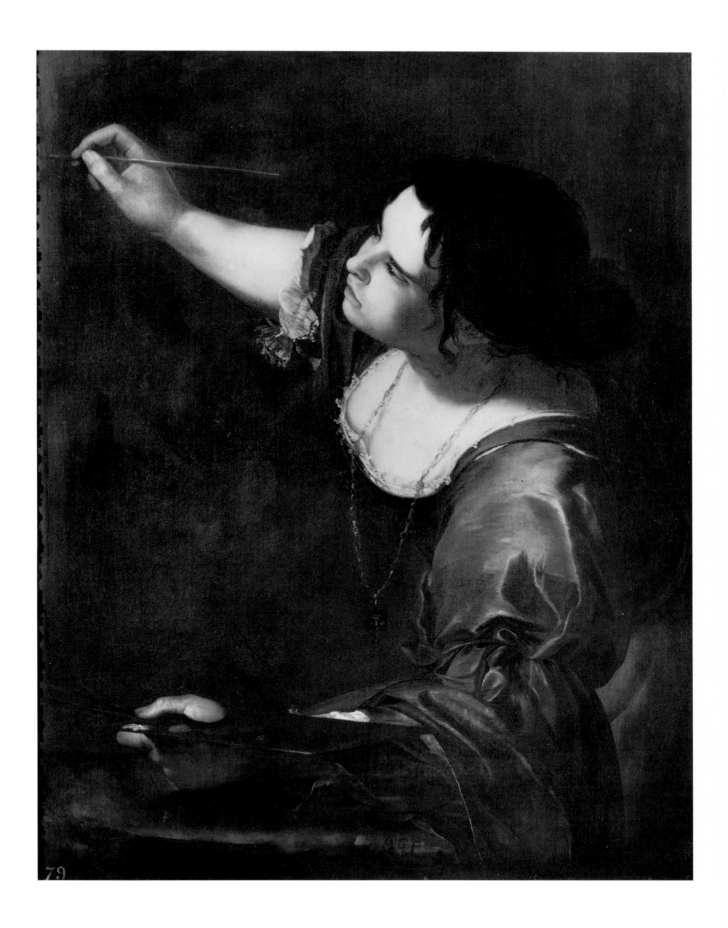

FIGURE 176 Detail of Figure 195

FIGURE 177 Detail of Figure 178

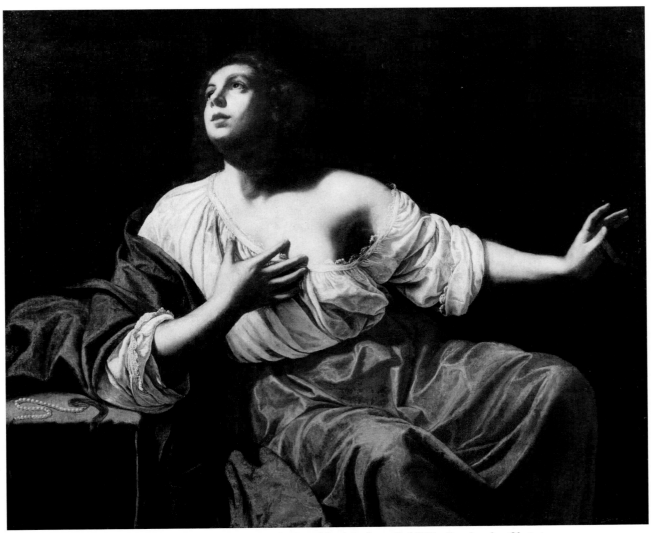

FIGURE 178 *Penitent Magdalen* (so-called *Dido Abandoned* or *Cleopatra Abandoned*), early 1640s? Oslo, Nasjonalgalleriet [43]

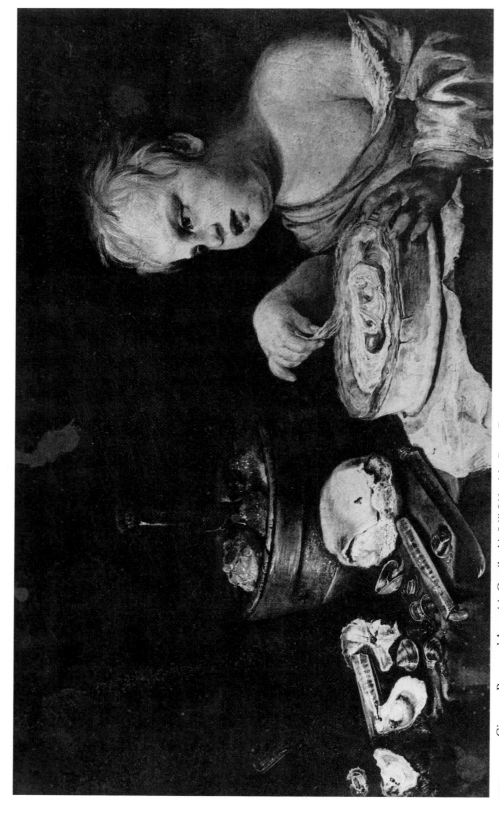

FIGURE 179 Giacomo Recco and Artemisia Gentileschi, *Still-Life with a Pastry Eater*, oil on panel, ca. 1640? location unknown [44]

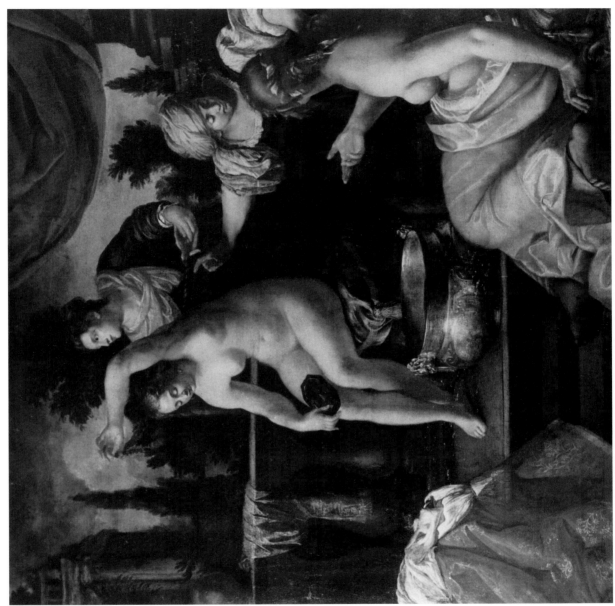

FIGURE 180 *Bathsheba*, ca. 1640, Vienna, Alexander Haas Collection [45]

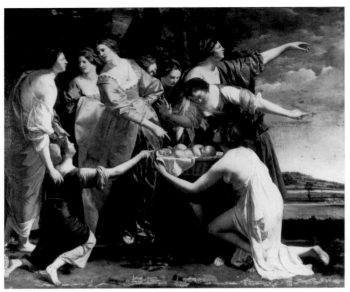

FIGURE 181 Orazio Gentileschi, *Finding of Moses*, ca. 1633, London, Sotheby's, 1995

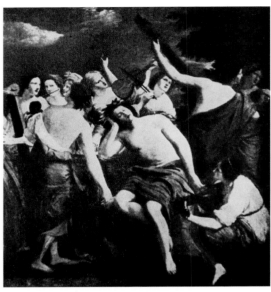

FIGURE 182 Orazio Gentileschi? *Apollo and the Nine Muses*, ca. 1630, formerly New York, Lily Lawlor?

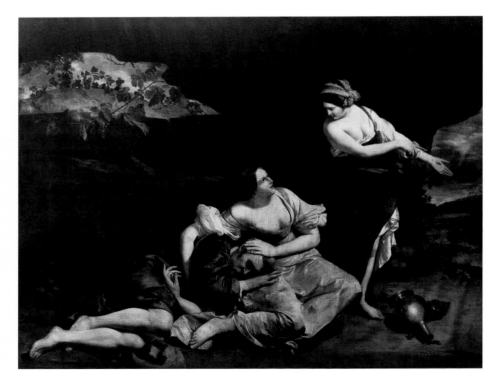

FIGURE 183

Orazio Gentileschi, *Lot and His Daughters*, ca. 1628, Bilbao, Museo de Bellas Artes © photograph, Museo de Bellas Artes de Bilbao

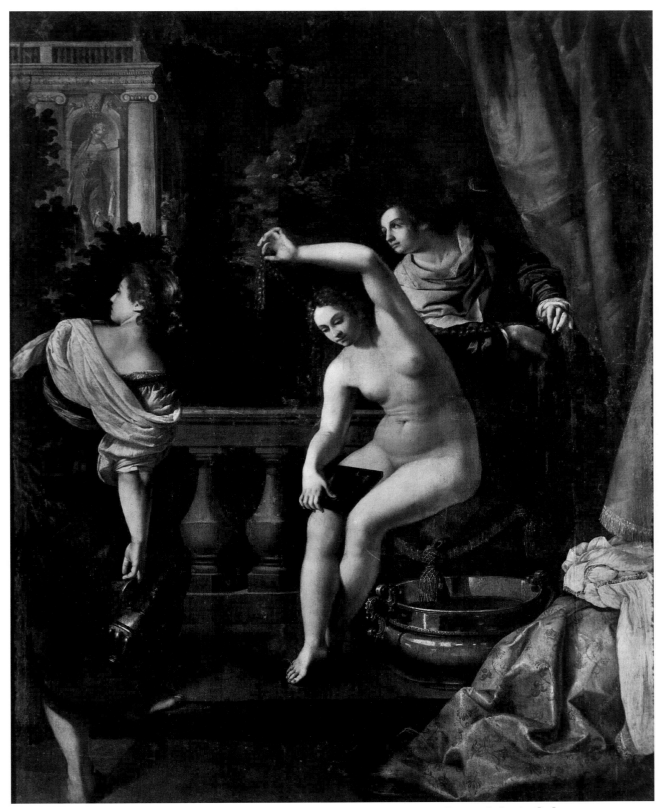

FIGURE 184 *Bathsheba*, ca. 1640–45, Rome, Private Collection [46]

FIGURE 185 Potsdam, Neues Palais, plan of the upper story indicating the Obere Galerie (see [48])

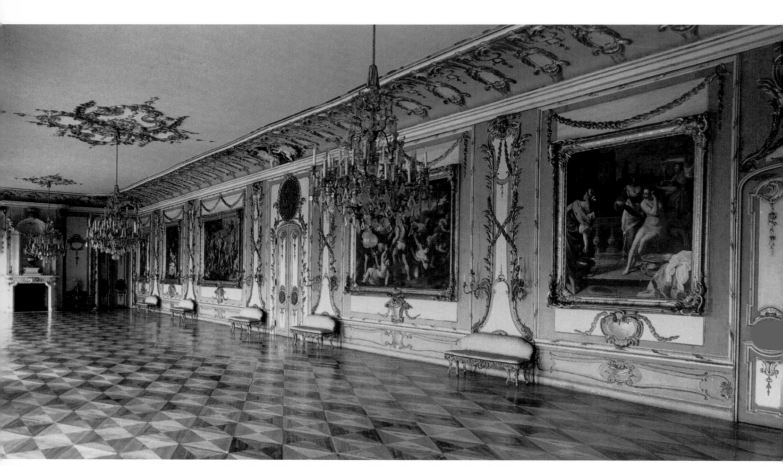

FIGURE 186 Potsdam, Neues Palais, view of the Obere Galerie (see [48])

Guido Reni *Suicide of Lucretia*	Artemisia Gentileschi *Tarquin and Lucretia*	Luca Giordano *Judgment of Paris*	Luca Giordano *Rape of the Sabine Women*	Artemisia Gentileschi *Bathsheba*	School of Guido Reni *Diogenes in the Tub*

FIGURE 187 Schematic diagram showing the disposition of the paintings (cf. Fig. 186) in the Obere Galerie, Neues Palais, Potsdam (see [48])

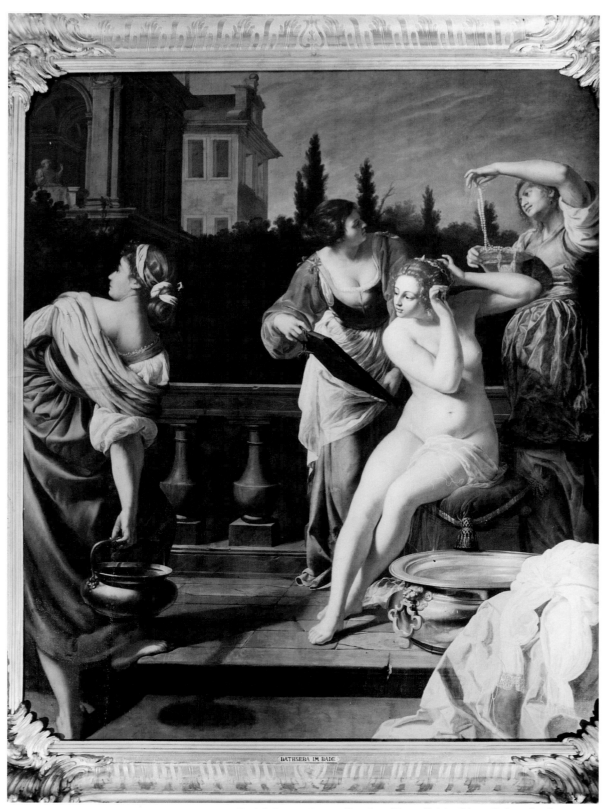

BATHSEBA IM BADE

FIGURE 188 *Bathsheba*, ca. 1645–50, Potsdam, Neues Palais, Obere Galerie [48a]

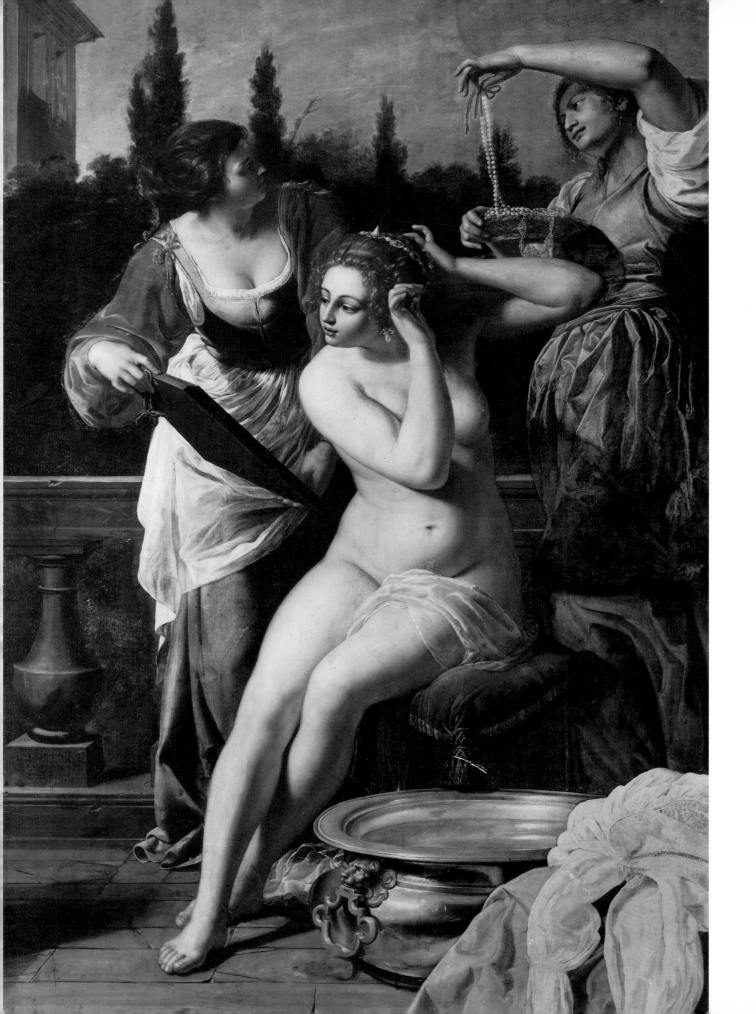

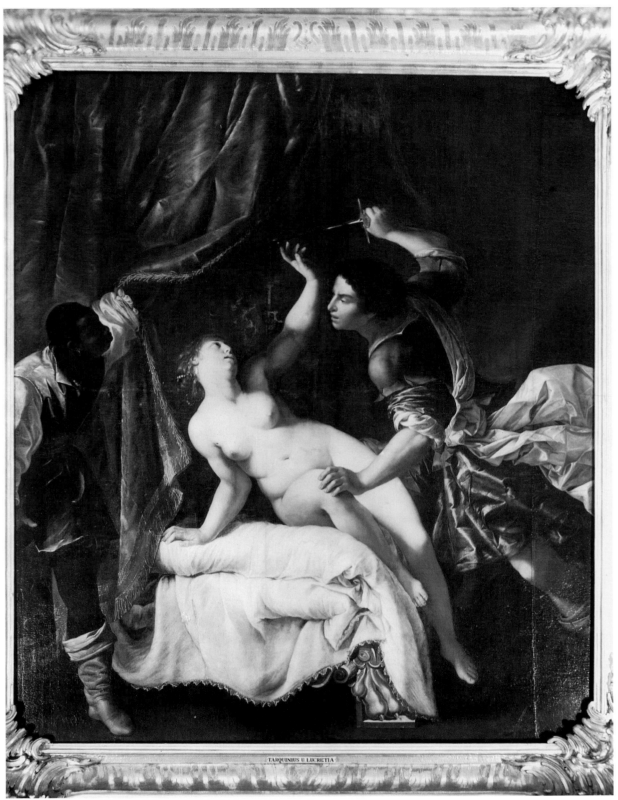

TARQUINIUS U. LUCRETIA

FIGURE 190 *Tarquin and Lucretia*, ca. 1645–50, Potsdam,
Neues Palais, Obere Galerie [48b]

< FIGURE 189 Detail of Figure 188

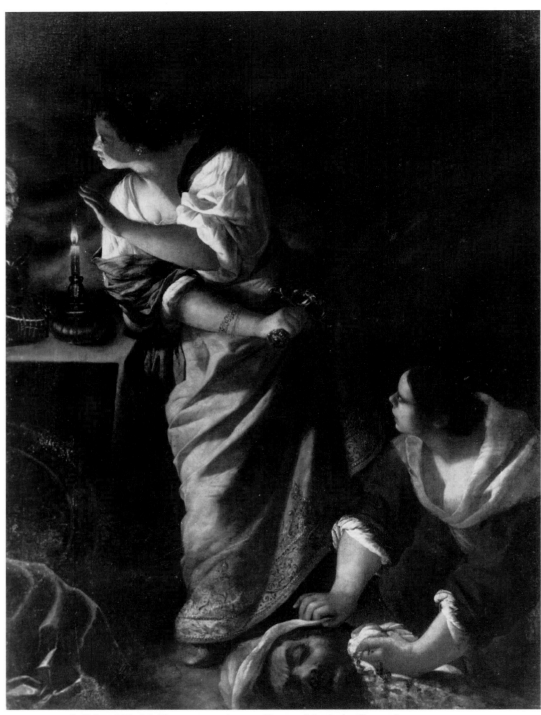

FIGURE 191 *Judith and Her Maidservant*, ca. 1640–45, Cannes, Musée des Beaux-Arts,
gift of Mme. Derive to the Musée de la Castre, Cannes [47]

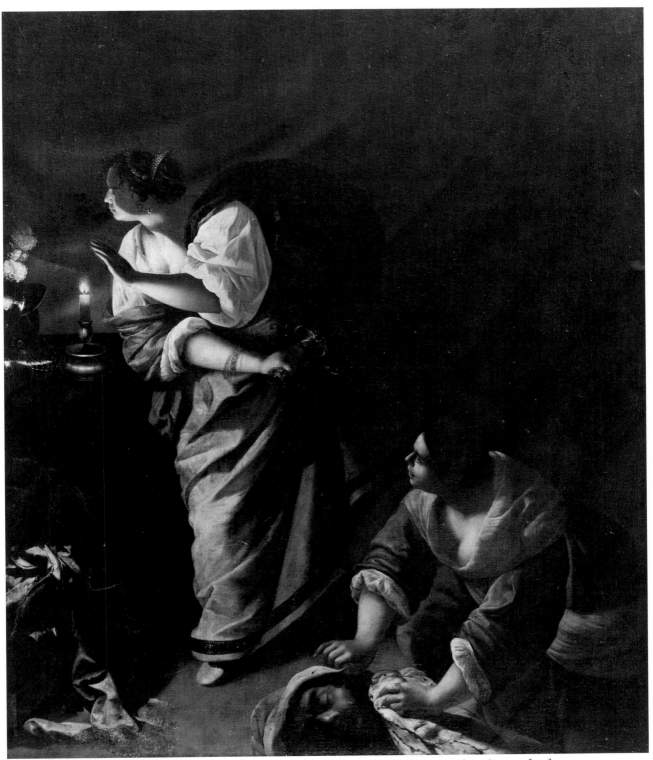

FIGURE 192 *Judith and Her Maidservant*, ca. 1645–50, Naples, Museo di Capodimonte [48c]

FIGURE 194 Bernardo Cavallino, *Male Model*, pencil and charcoal,
1648, Naples, Museo Nazionale di San Martino

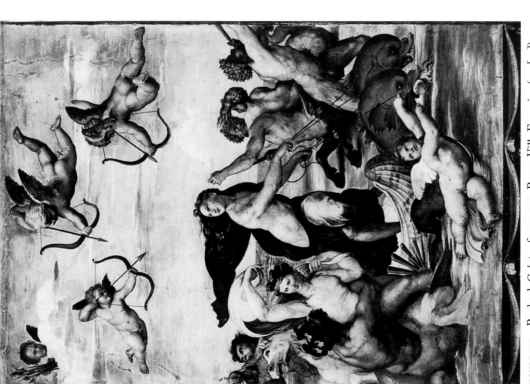

FIGURE 193 Raphael, *Galatea*, fresco, 1513, Rome, Villa Farnesina (see [49])

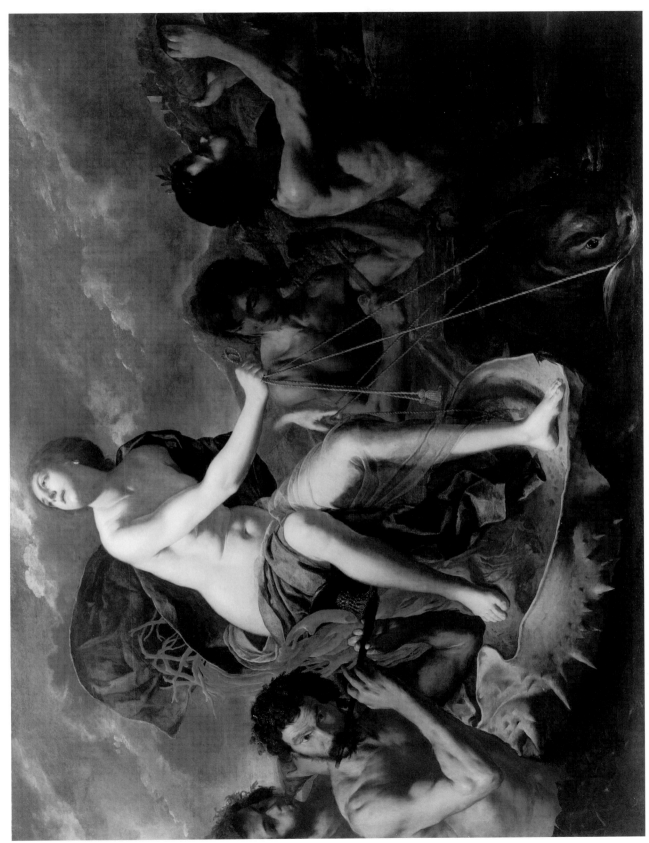

FIGURE 195 Artemisia Gentileshi and Bernardo Cavallino, *Galatea*, 1648, New York, The Saul P. Steinberg Collection [49]

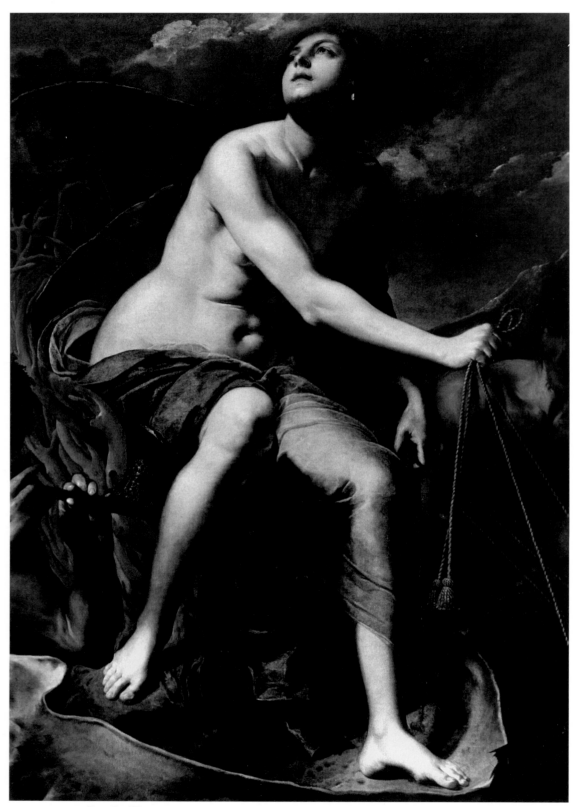

FIGURE 196 Detail of Figure 195

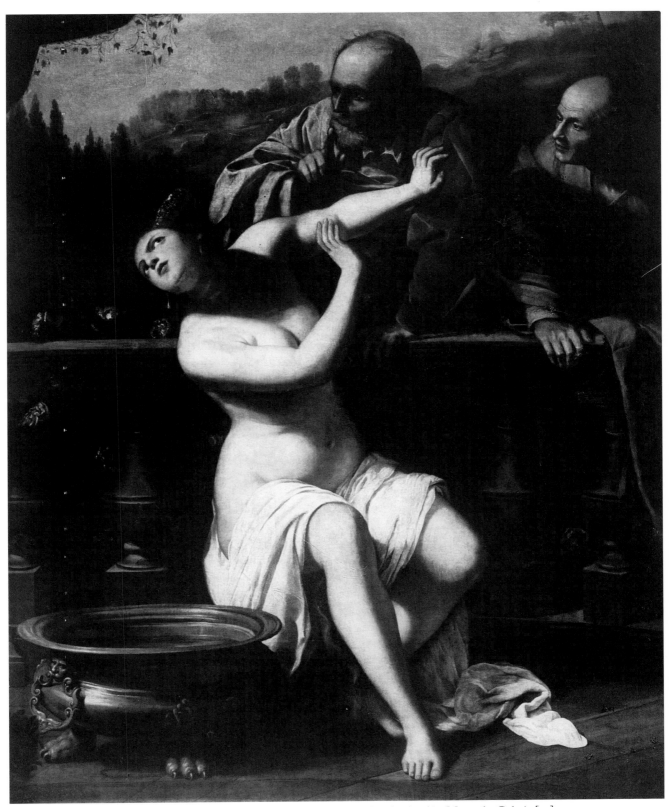

FIGURE 197 *Susanna and the Elders*, 1649? Brno, Czechoslovakia, Moravskà Galerie [50]

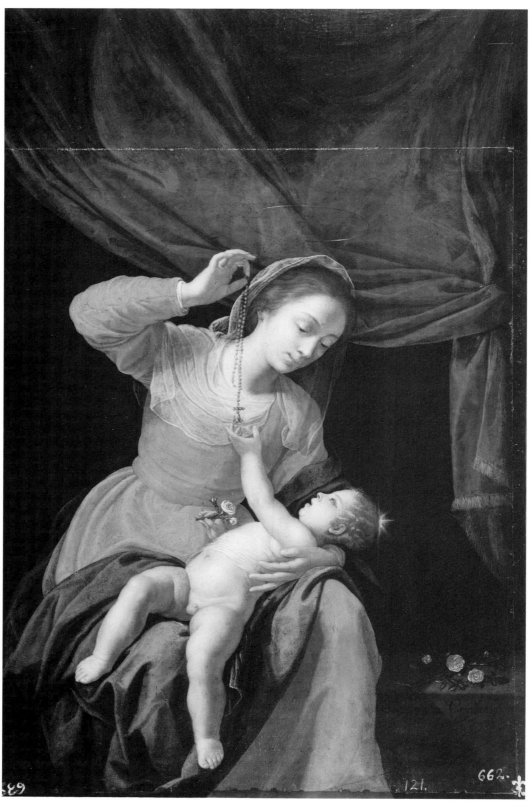

FIGURE 198 *Madonna and Child*, oil on copper mounted on panel, 1650–51, El Escorial, Museo de Pintura [51]

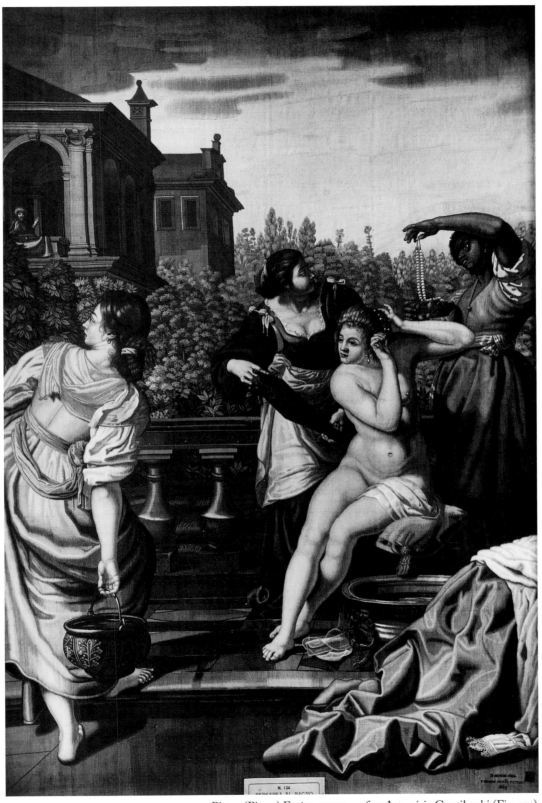

FIGURE 199 Pietro (Pierre) Fevère, tapestry after Artemisia Gentileschi (Fig. 201), 1663, Petraia, Villa Medici (see [52])

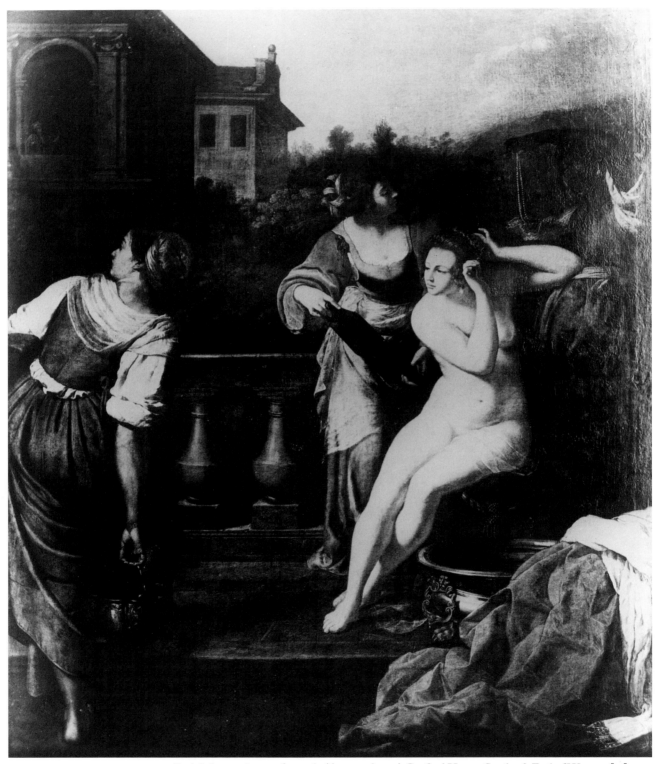

FIGURE 200 *Bathsheba*, ca. 1650–52, formerly (destroyed 1940) Gosford House, Scotland, Earl of Wemyss [53]

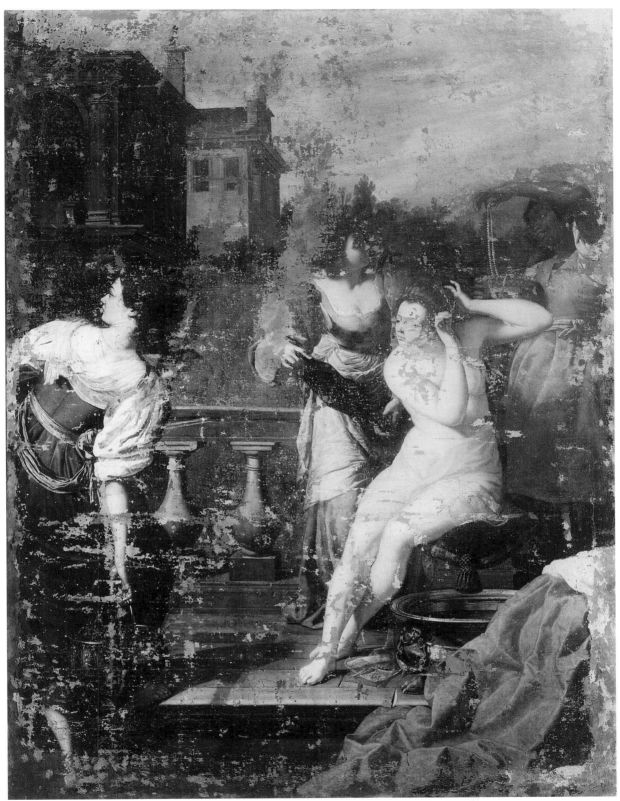

FIGURE 201 *Bathsheba*, ca. 1650–52, Florence, Palazzo Pitti, storage [52]

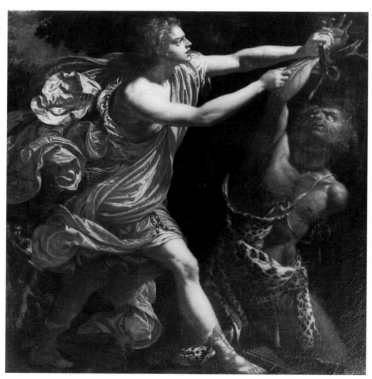

FIGURE 203 Giovanni Bilivert or follower, *Apollo Flaying Marsyas*, early 1630s, Florence, Palazzo Pitti [x-3]

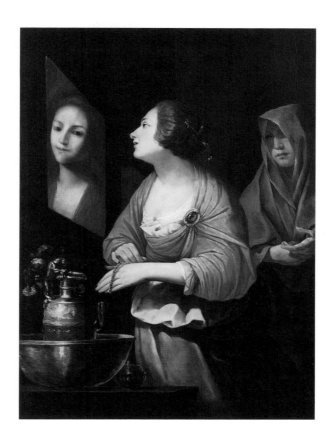

Collaborative canvas from the studio of
Massimo Stanzione, *Allegory of Vanity*
(so-called *Martha reproving Mary Magdalen
for Her Vanity* or *The Conversion of the
Magdalen*), ca. 1635, London, Trafalgar
Galleries [X-2]

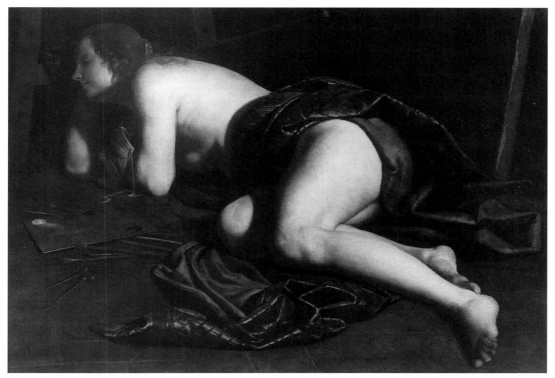

FIGURE 205 Giovanni Baglione, *Allegory of Painting*, Le Mans, Musée de Tessé [X-1]

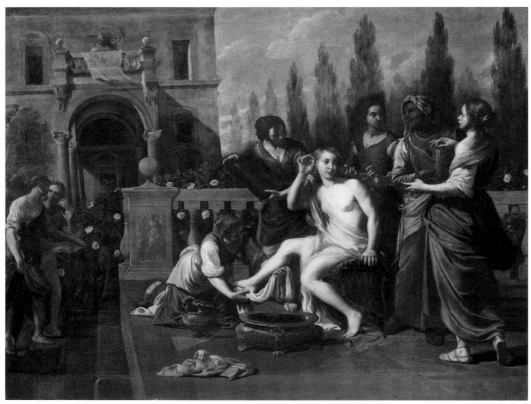

FIGURE 206 Neapolitan artist in the following of Bernardo Cavallino and Domenico Gargiulo,
 Bathsheba, ca. 1650, Sarasota, Florida, John and Mable Ringling Museum of Art [x-4]

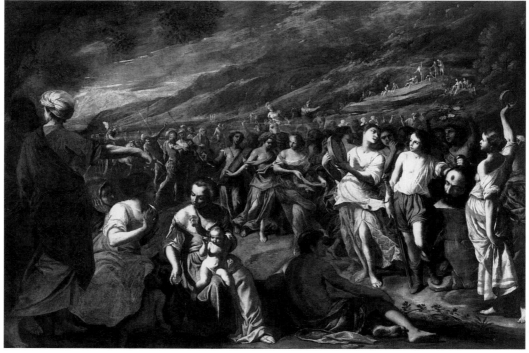

FIGURE 207 Studio of Domenico Gargiulo, *Israelites Celebrating the Return of David*, ca. 1650,
 Sarasota, Florida, John and Mable Ringling Museum of Art (see [x-4])

FIGURE 208 Orazio Gentileschi, detail of the *Musical Concert*, fresco, 1611–12,
Rome, Palazzo Pallavicini-Rospigliosi, Casino of the Muses

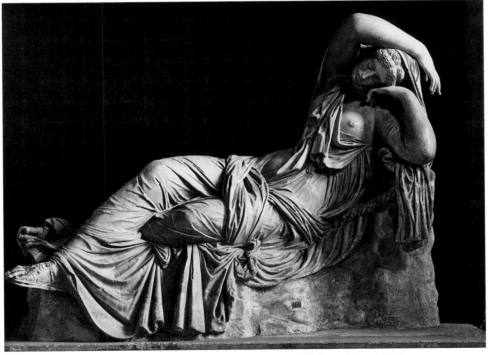

FIGURE 209 Hellenistic, *Sleeping Ariadne*, third century B.C.E., Vatican, Museo Vaticano

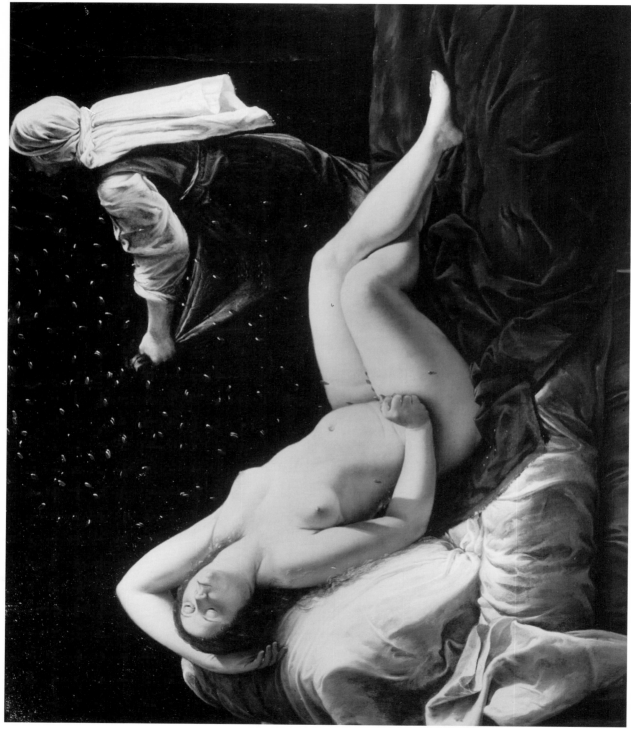

FIGURE 210 Orazio Gentileschi, *Danaë*, oil on copper, St. Louis, Missouri, Saint Louis Art Museum [x-7]

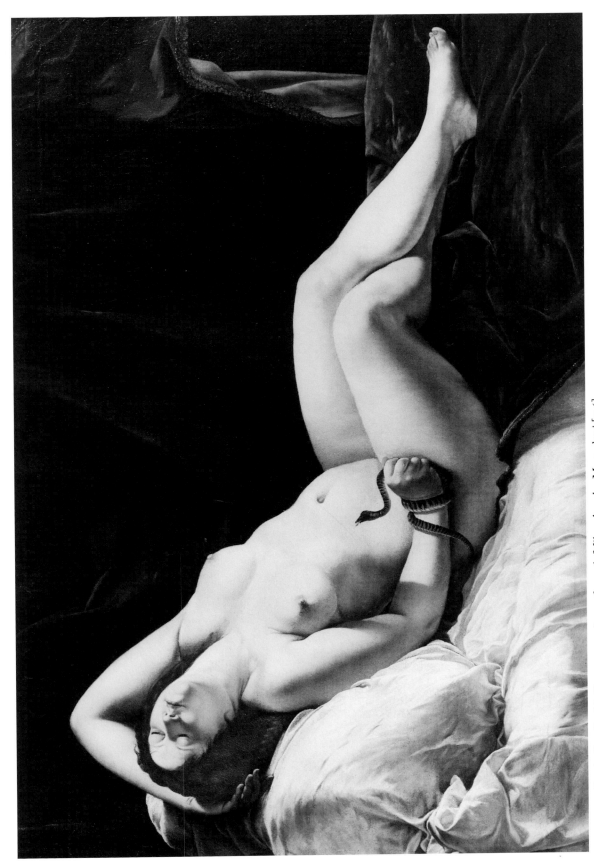

FIGURE 211 Orazio Gentileschi, *Cleopatra*, ca. 1611–12, formerly Milan, Amedeo Morandotti [x-6]

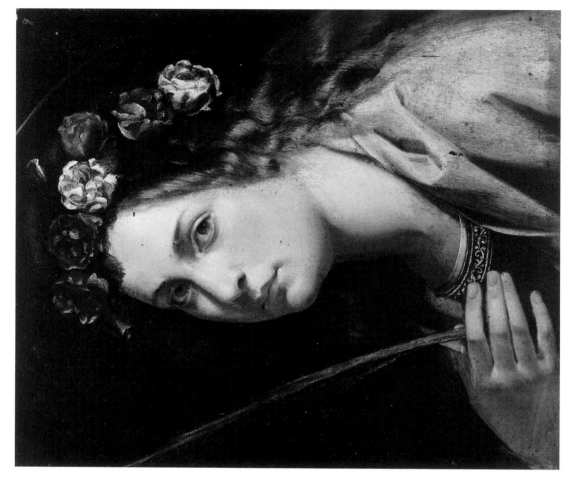

FIGURE 213 Florentine Master, *Female Martyr*, variation upon Artemisia Gentileschi (cf. Fig. 56), oil on panel, Mentana (Rome), Federico Zeri Collection [x-9]

FIGURE 212 Roman Master, *David with the Head of Goliath*, ca. 1620, London, Sotheby's, 1975 [x-8]

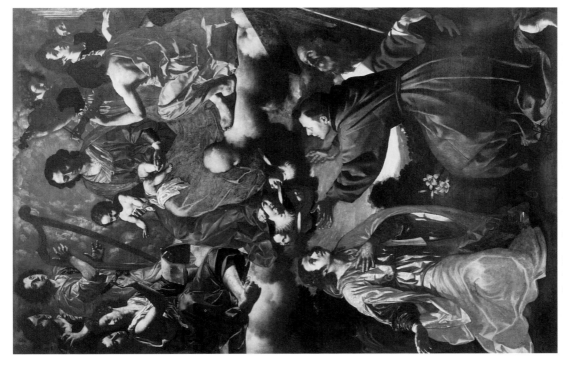

FIGURE 215 Paolo Finoglio, *Madonna Appearing to Saints Margherita, Bernard, and Anthony,* mid-1630s, Naples, SS. Bernardo e Margherita a Fonseca

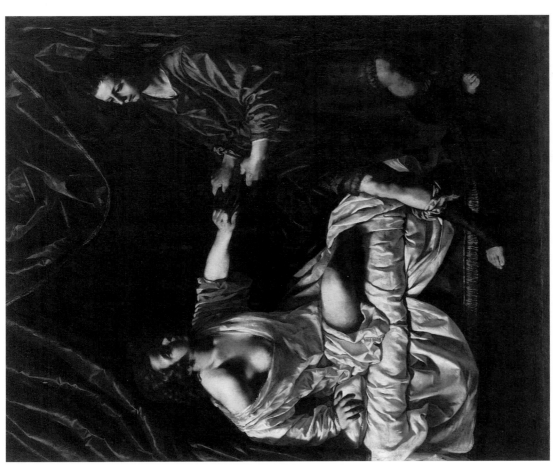

FIGURE 214 Paolo Finoglio, *Joseph and Potiphar's Wife,* 1630s, Cambridge, Massachusetts, Fogg Art Museum, Harvard University Art Museums, Gift of Samuel H. Kress Foundation [x-11]

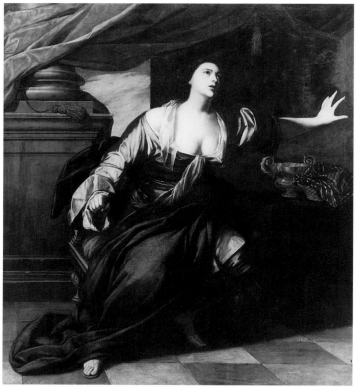

FIGURE 216 Massimo Stanzione or Circle, *Lucretia*,
 Naples, Palazzo Reale [x-17]

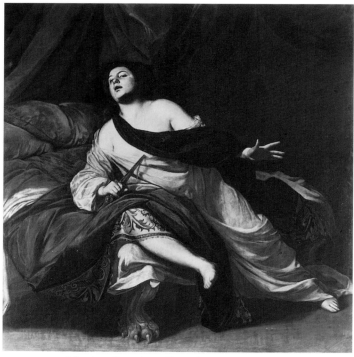

FIGURE 217 Massimo Stanzione, *Lucretia*,
 ca. 1635, Rome, Private Collection

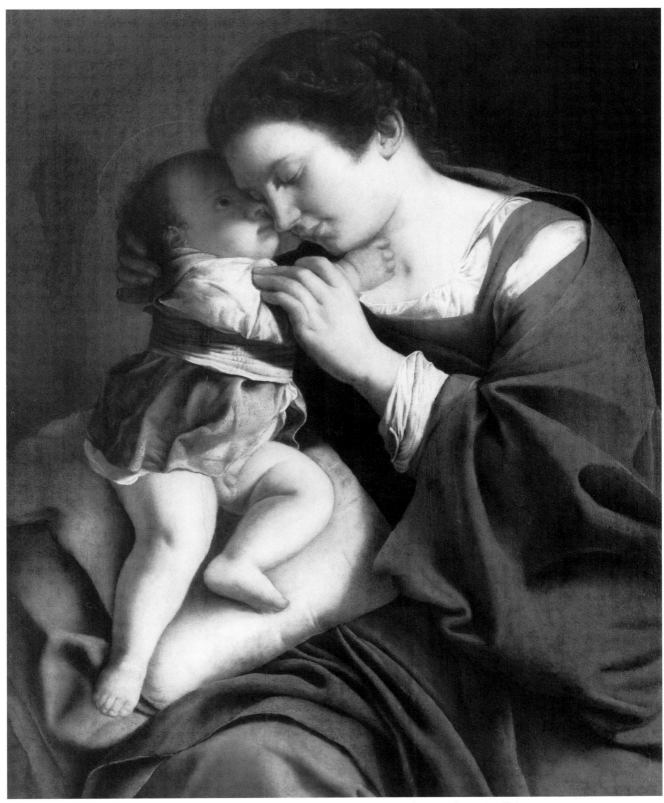

FIGURE 218 Orazio Gentileschi, *Madonna and Child*, oil on panel, ca. 1605, Princeton,
New Jersey, The Barbara Piasecka Johnson Collection Foundation [x-18]

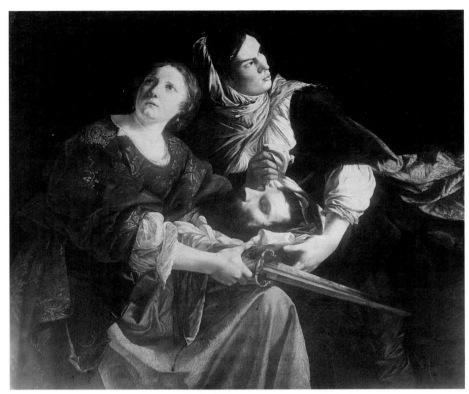

FIGURE 219 Orazio Gentileschi, *Judith and Her Maidservant*,
ca. 1611–12, Vatican, Pinacoteca [X-15]

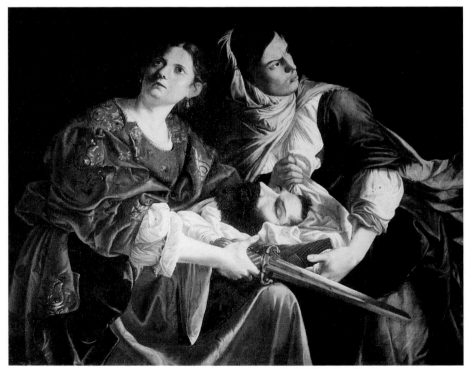

FIGURE 220 Copy after Orazio Gentileschi, *Judith and Her Maidservant*,
New York, Sotheby's, 1993 [X-12]

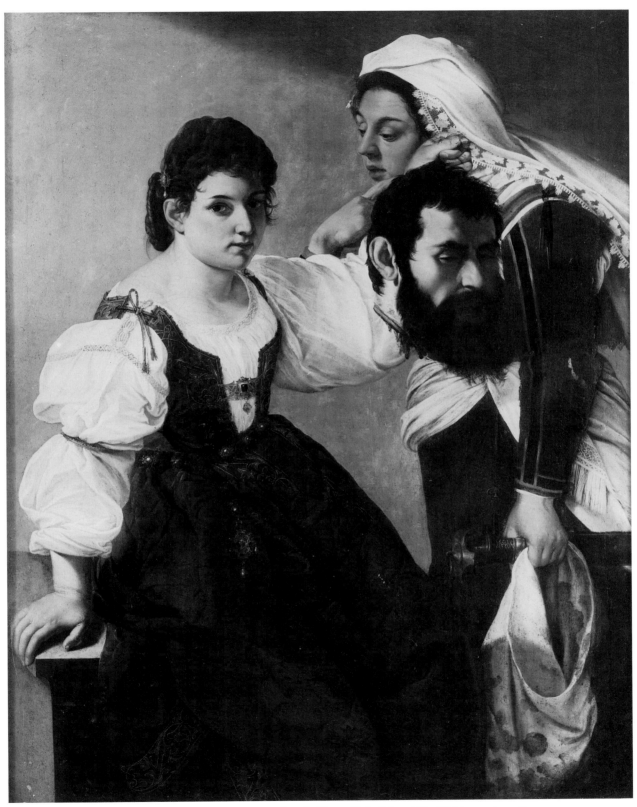

FIGURE 221 Angelo Caroselli, *Judith and Her Maidservant*, ca. 1610–15,
Rome, Fabrizio Lemme Collection [x-14]

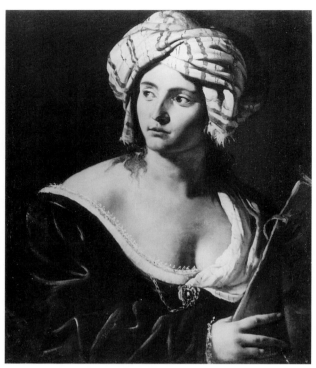

FIGURE 222 Florentine Master, second
quarter of the seventeenth
century, *Poetry*, New York, D.
Stephen Pepper, 1983 [x-20]

FIGURE 223 Northern Master in the
following of Simon Vouet
at Rome? *Sibyl*, Paris,
Galerie Tassel, 1986 [x-41]

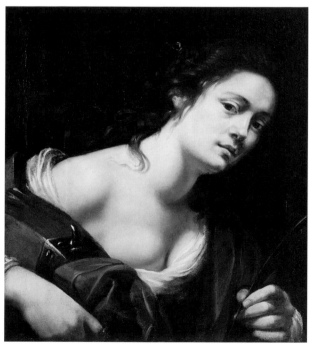

FIGURE 224 Francesco Furini, *Saint Catherine of Alexandria*,
oil on slate, ca. 1630, Florence, Galleria degli
Uffizi [x-26]

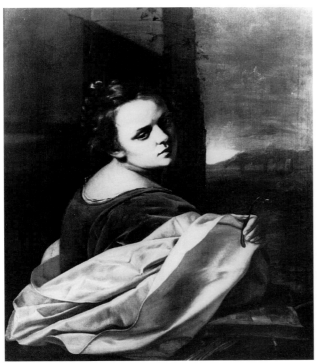

FIGURE 225 Neapolitan Master, *Sant'Apollonia*, ca. 1635–40,
London, Sotheby's, 1980 [x-24]

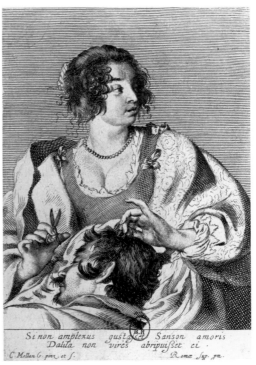

Si non amplexus gustasset Sanson amoris
Dalila non vires abripuisset ei.
C. Mellan G. pinx. et s. Romæ Sup. pa.

FIGURE 226 Claude Mellan, *Samson and Delilah*,
engraving, ca. 1629

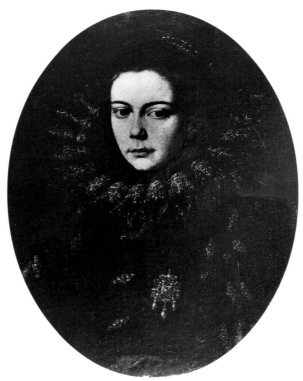

FIGURE 227 Carlo Sellitto? *Portrait of a Young Woman*,
Naples, Private Collection [x-22]

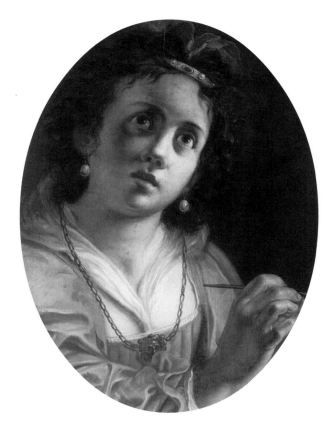

FIGURE 228

Giovan Battista Guidoni?
*Portrait of Artemisia Gentileschi
as the Personification of Painting*,
oil on panel, ca. 1615–20,
Private Collection [x-21]

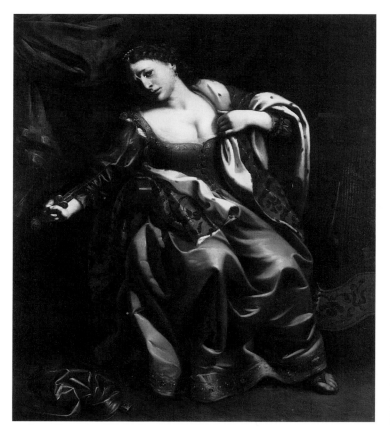

FIGURE 229

Venetian Circle of Nicolas
Regnier? *Lucretia*, 1630s,
London, Art Market, 1992 [x-16]

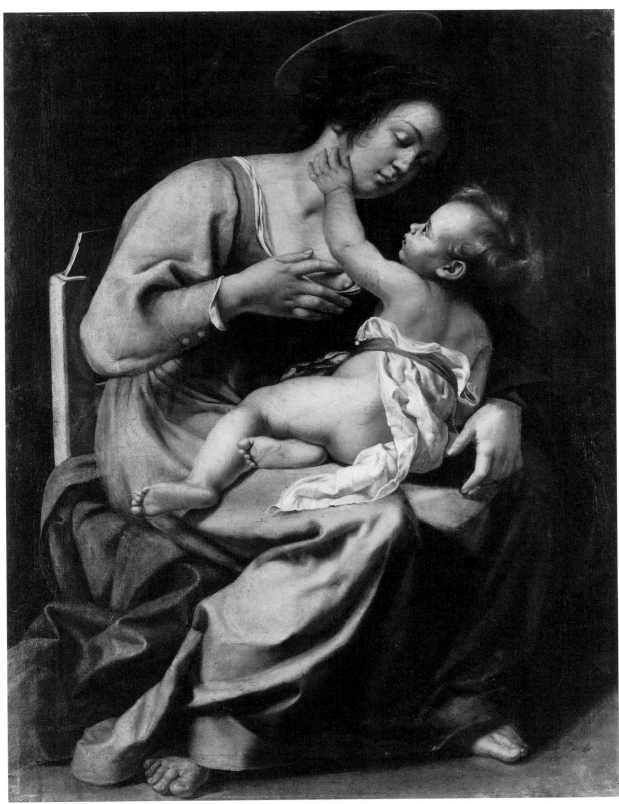

FIGURE 230 Circle of Giovanni Baglione, *Madonna and Child*, Rome, Galleria Spada [x-19]

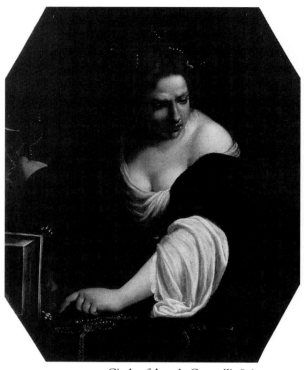

FIGURE 231　Circle of Angelo Caroselli, *Saint Mary Magdalen (Allegory of Vanity)*, location unknown (see [x-35])

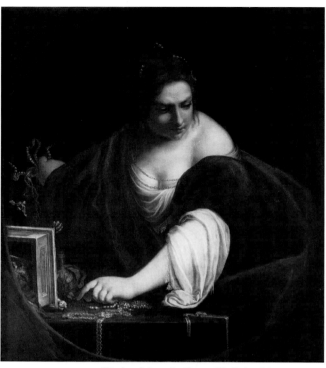

FIGURE 232　Circle of Angelo Caroselli, *Saint Mary Magdalen (Allegory of Vanity)*, West Wycombe Park, Sir Francis Dashwood Collection [x-35]

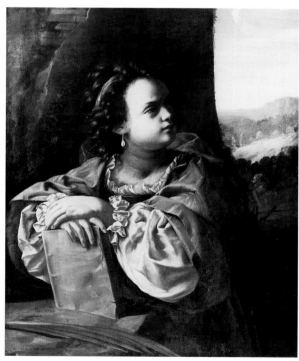

FIGURE 233　Anonymous, *Saint Catherine of Alexandria*, New York, Sotheby's, 1994 [x-27]

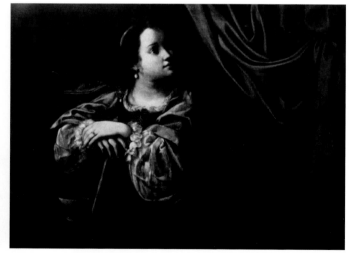

FIGURE 234　Anonymous, *Queen with Cup and Dagger*, Norfolk, Virginia, Dr. Bernard H. Raymond, 1974 (see [x-27])

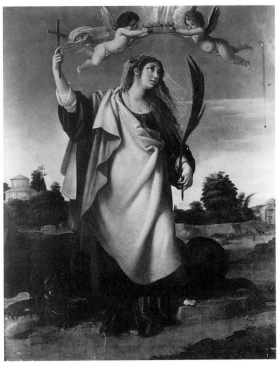

FIGURE 235 Giovanni Baglione, *Saint Margaret
of Cortona*, ca. 1606, Rome, Galleria
Nazionale (see [x-28])

FIGURE 236 Antiveduto Gramatica? *Saint Mary
Magdalen*, Naples, Private Collection
[x-34]

FIGURE 237 Neapolitan Master, *Saint Dorothy*,
1640s, location unknown [x-31]

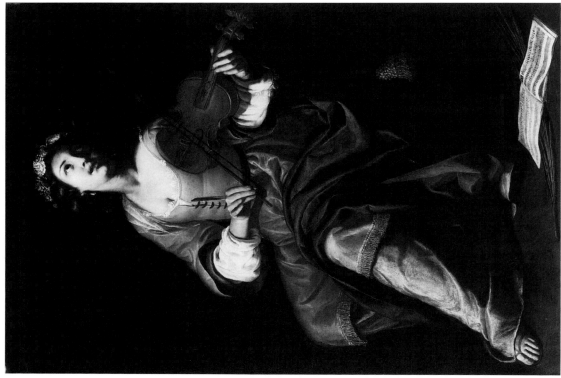

FIGURE 239 Neapolitan Master close to Bernardo Cavallino, *Saint Cecilia*, ca. 1645, Sarasota, Florida, John and Mable Ringling Museum of Art [x-29]

FIGURE 238 Orazio and Artemisia Gentileschi before 1610? *Saint Catherine of Alexandria*, El Paso, Texas, El Paso Museum of Art, Samuel H. Kress Collection [x-25]

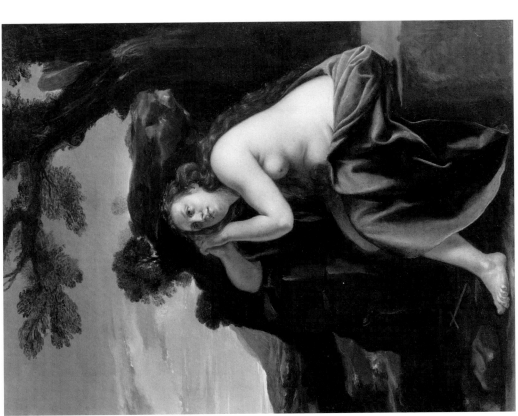

FIGURE 240 Orazio Gentileschi, *Saint Mary Magdalen*, oil on copper, after restoration, London, Private Collection [x-32]

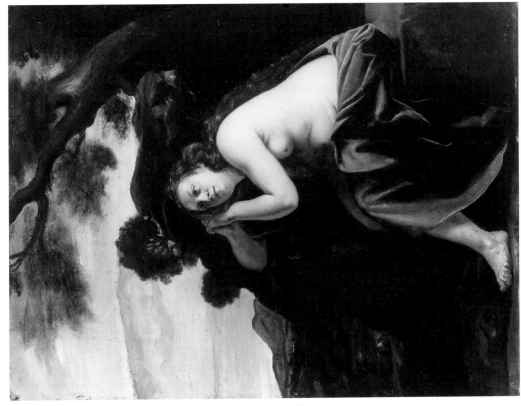

FIGURE 241 Figure 240 before restoration

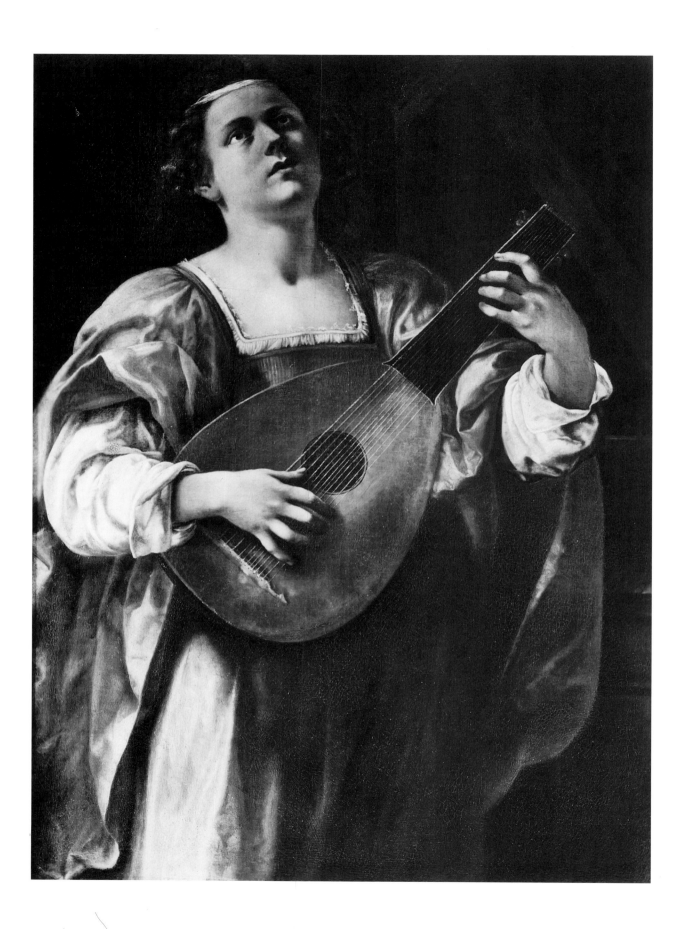

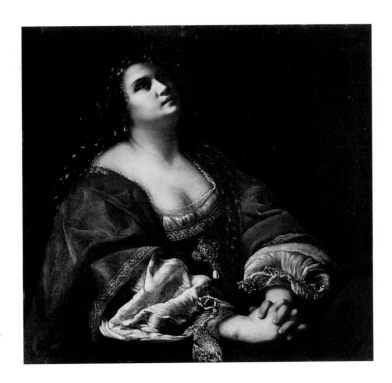

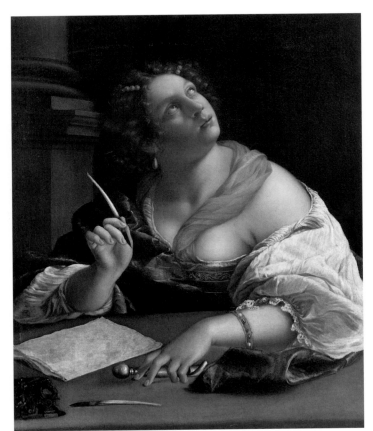

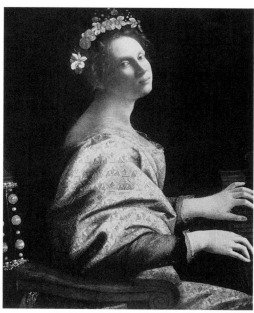

FIGURE 245 Florentine Master, adaptation
after Artemisia Gentileschi,
Saint Cecilia (before restoration),
Trento, Private Collection [x-30]

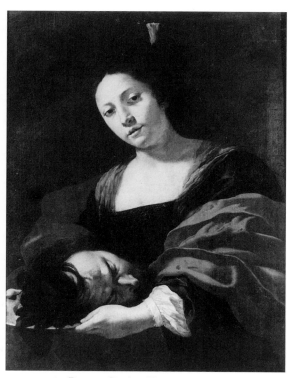

FIGURE 246 Roman Circle of Simon Vouet, *Salome with
the Head of Saint John the Baptist*, 1620s,
Naples, Museo di Capodimonte [x-40]

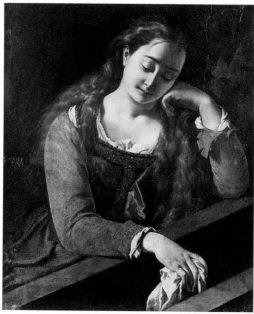

FIGURE 247 Antiveduto Gramatica,
*Saint Mary Magdalen at the
Tomb of Christ*, 1610s, Vienna,
Kunsthistorisches Museum [x-37]

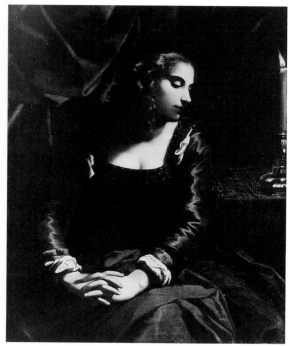

FIGURE 248 Antiveduto Gramatica, *Saint Mary
Magdalen by Candlelight*, London,
Trafalgar Galleries, 1976

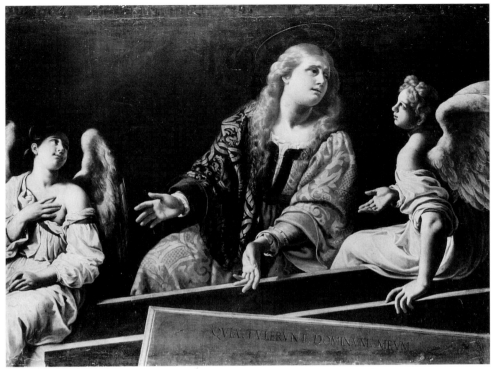

FIGURE 249 Antiveduto Gramatica, *Saint Mary Magdalen at the Tomb of Christ*,
1610s, St. Petersburg, Hermitage [x-36]

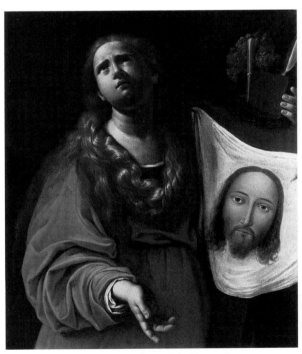

FIGURE 250 Antiveduto or Imperiale Gramatica,
Saint Veronica, Rome, Private Collection

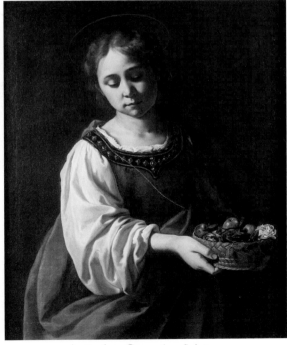

FIGURE 251 Antiveduto Gramatica, *Saint
Dorothy*, early 1610s, New York,
Sotheby's, 1987 (see [L-108])

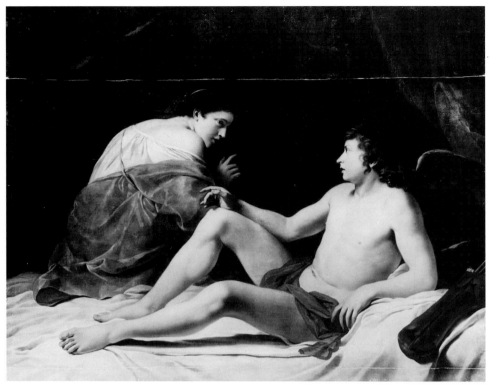

FIGURE 252 Roman Studio of Simon Vouet? *Cupid and Psyche*, 1620s, St. Petersburg, Hermitage (see [L-17])

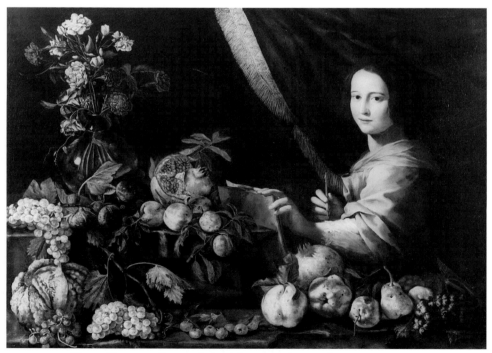

FIGURE 253 Giovan Francesco Romanelli (and Giovanna Garzoni?), *Still-Life with the Allegory of Painting*, Turin, Galleria Voena

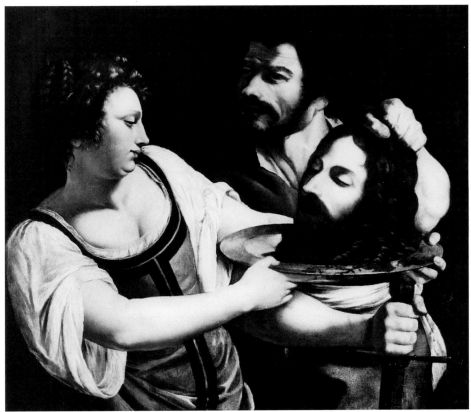

FIGURE 254 Angelo Caroselli or copy after, *Salome and an Executioner with the Head of Saint John the Baptist*, Budapest, Szépmüvészeti Mùzeum [x-38]

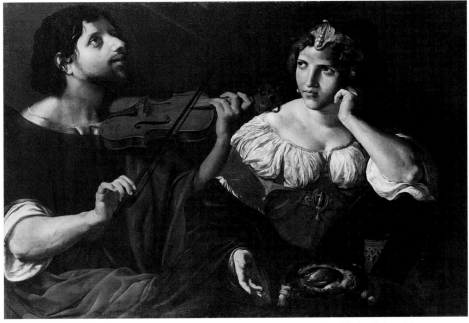

FIGURE 255 Angelo Caroselli, *Lesbia Mourning Her Pet Sparrow*, New York, Colnaghi, 1984

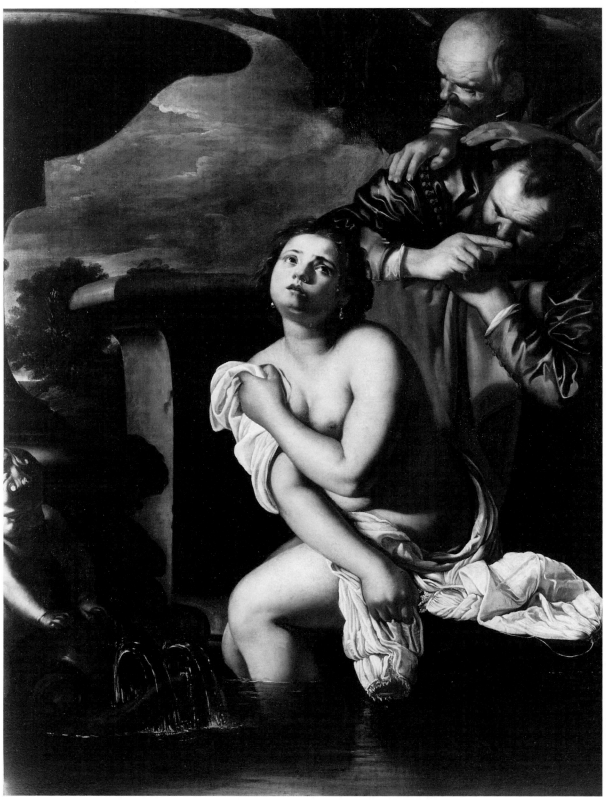

FIGURE 256 Probable copy after Figure 257, Nottingham, Castle Museum and Art Gallery (see [x-42])

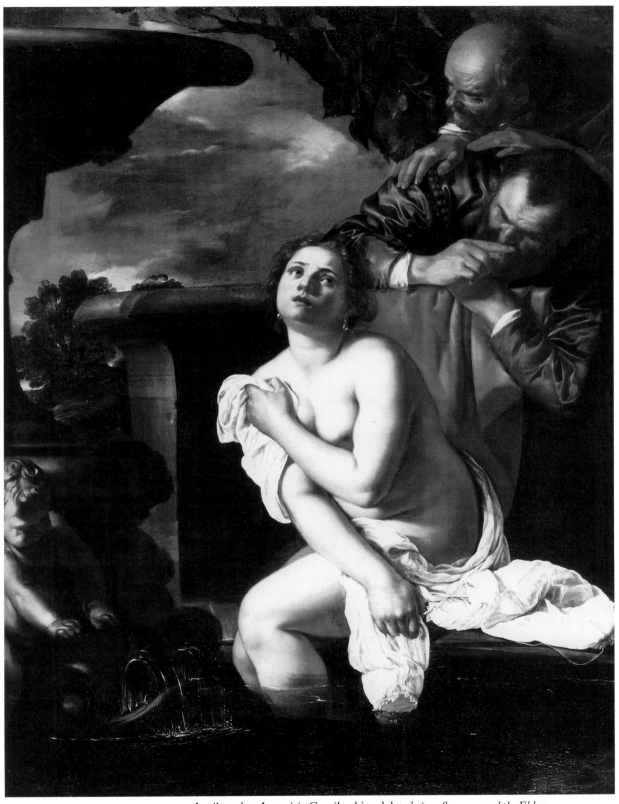

FIGURE 257 Attributed to Artemisia Gentileschi and dated 1622, *Susanna and the Elders*, Stamford, England, The Burghley House Collection [x-42]